THE NOTEBOOKS

OF

LEONARDO DA VINCI

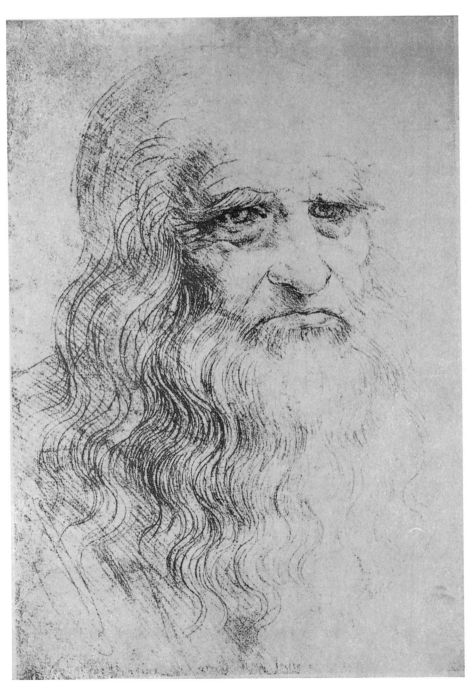

SELF PORTRAIT
Biblioteca Reale, Turin, Italy

THE NOTEBOOKS

OF

LEONARDO DA VINCI

Arranged, Rendered into English
and Introduced
by

EDWARD MacCURDY

KONECKY&KONECKY

Konecky & Konecky
72 Ayers Point Road
Old Saybrook, CT 06475

ISBN: 1-56852-468-4

Printed and bound in the U.S.A.

DEDICATED

BY PERMISSION

TO

HIS MOST GRACIOUS MAJESTY

KING GEORGE THE SIXTH

ACKNOWLEDGMENTS

I ACKNOWLEDGE with gratitude my indebtedness to the work of Paul
Müller-Walde, Ettore Verga and Jean Paul Richter, pioneers.

I am indebted to Sir Kenneth Clark, to the Librarian of the Royal
Library at Windsor, and the Secretary of the Syndics of the Cambridge
University Press for permission to reprint the translation of the passages
on the Nature of the Winds from the *Catalog of the Drawings of Leonardo
da Vinci at Windsor*.

My special thanks are also due to the Librarian of the Royal Library for
his kindness in allowing me to select as many illustrations as I desired from
the incomparable collection of Leonardo's drawings at Windsor.

CONTENTS

LIST OF ILLUSTRATIONS

INTRODUCTORY NOTE

1517, 10 October.

IN ONE of the outlying parts [of Amboise] Monsignor and the rest of us went to see Messer Lunardo Vinci the Florentine. . . . This gentleman has written of anatomy with such detail, showing by illustrations the limbs, muscles, nerves, veins, ligaments, intestines and whatever else there is to discuss in the bodies of men and women, in a way that has never yet been done by anyone else. All this we have seen with our own eyes; and he said that he had dissected more than thirty bodies, both of men and women, of all ages. He has also written of the nature of water, of divers machines and of other matters, which he has set down in an infinite number of volumes all in the vulgar tongue, which if they should be published will be profitable and very enjoyable.

(Extract from *The Journey of Cardinal Luis of Aragon through Germany, the Netherlands, France and Northern Italy*, 1517-1518, written by Antonio de Beatis. Edited by Ludwig Pastor and published at Freiburg im Breisgau, 1905.)

PREFACE

I

IN THE year nineteen hundred and six in the audacity of youth I ventured to apply a comprehensive title to what was in reality a comparatively small selection from the contents of *Leonardo da Vinci's Notebooks*.[1] I have now attempted to redeem the promise of my title in some degree of completeness. More than half a century ago, when the work of transcription of the Leonardo manuscripts was first commenced, a controversy arose among scholars as to whether the best method of publication was by individual manuscripts or collectively with some attempt at classification. Time has a way of proving most controversies vain, and in this instance it has shown the essential rightness of the position of both disputants. The publication of the transcripts of the original manuscripts, with facsimiles, has served as the foundation of all subsequent study. Some classification of the material, however, has been found to be necessary on account of the extraordinary diversity of the subjects treated of in the same manuscript, in the majority of cases. Leonardo himself admitted as much in a prefatory note to the manuscript now in the British Museum (Arundel 263), and the action of Pompeo Leoni in compiling the Codice Atlantico out of other manuscripts by the use of scissors and paste has only made confusion worse confounded. I have therefore arranged the subject-matter under various main headings, but beyond this I have made no change of order, the passages in each section appearing in the same sequence as in the manuscripts, those of Milan coming first followed by those in Paris, London and Windsor. In the few cases, however, in which the whole or substantially the whole of a manuscript falls within the same section I have given it priority, e.g. in 'Anatomy', 'Flight', 'Painting', and 'Optics'.

About a dozen pictures are all that can be attributed to Leonardo

[1] *Leonardo da Vinci's Notebooks*, Edward MacCurdy, M.A., crown 8 vo, 14 illustrations, pp. xiv, 289. London: Duckworth & Co., 1906.

with any degree of certitude or even of probability, and the witness of contemporary record, however credulously interpreted, does not do more than double or treble the number. How he disposed of his time would be an enigma but for the existence of the vast collection of drawings, and particularly of the notebooks. These number upwards of five thousand pages, the contents of which I have attempted to classify under some fifty headings. The classification is, as I know, rough and imperfect, this the wellnigh infinite variety of the contents having rendered almost inevitable. For, of this man who did a few works of art most divinely well, it may be said that he took all knowledge as his province, and that in his individual achievement he symbolizes the diversity of an epoch as fully as can be said of any man at any period in the world's history. To one who has studied them intermittently for more than a quarter of a century these manuscripts —the product of how many thousand hours of intellectual activity!— are the records of the working of the mightiest machine perhaps that has ever been a human brain: fragments of a larger purpose, charted, defined, explored, but never fulfilled, of which the treatises containing the sum of his researches in anatomy, physiology and geology form component parts, fragments of a vast encyclopaedia of human knowledge.

What thinker has ever possessed the cosmic vision so insistently? He sought to establish the essential unity of structure of all living things, the earth an organism with veins and arteries, the body of a man a type of that of the world. The perceptions of his brain are hardly if at all fettered by bondage of time and place. At rare times, however, the personal note supervenes and moods of exultation or depression flash out their meaning in a phrase. The mood of the seer finds expression in fable or allegory, or in the series of 'the Prophecies', revealing the depth of his mordant humour and his power of analysis of the motives which guide human conduct, or in speculation as to results that would follow possible extension of man's power—in which time has confirmed his prescience and his foreboding.

The manuscripts are a wellnigh inexhaustible quarry in which the student of every phase of Leonardo's mental activity will find material. They are of peculiar value for the biographer, both in their revelation of personality and in the manner in which they react on contemporary

record. Thus they tend to confirm Vasari in his more picturesque statements. He has told how Leonardo when he passed the places where birds were sold would often take them from their cages, pay the price demanded, and restore their liberty by letting them fly into the air. 'The goldfinch', wrote Leonardo, 'will carry spurge to its little ones imprisoned in a cage—death rather than loss of liberty.' The purport of the note becomes clear from the fact that certain varieties of the spurge form a violent poison. His account of how Leonardo collected lizards, hedgehogs, newts, serpents and all sorts of strange creatures, and from these constructed the head of a hideous monster, when in his youth he received a commission to paint something on a shield which should cause terror to the beholder, is directly confirmed by the painter's own precept, 'how to make an imaginary animal appear real'; the method being that each part should have a basis of reality, thus the body of a serpent, head of a mastiff or setter, eyes of cat, ears of porcupine, nose of greyhound, eyebrows of lion, temples of an old cock and neck of turtle. So also with reference to Leonardo's activities as master of pageant at the Court of Milan, the automatic lion which according to Vasari formed part of the pageant on the occasion of the entry of the French King, that advanced a few steps and opened its breast to show it filled with lilies, is drawn in different positions on a page of the Anatomy MSS. at Windsor.

The letters and fragments of letters are also of primary importance for the biographer. They sound the whole gamut of sensations from the proud confidence of the first letter to Ludovic and that to the Commissioners of the Cathedral of Piacenza, through the terse appeals of the later days in Milan when 'the horse' was ready for the casting and foreign subsidies had exhausted the Treasury, to those written in the depression of the Roman period, when his hopes of employment had been frustrated and he had been denounced to the Pope for his practice of anatomy, while his nerves were reacting helplessly to the misbehaviour of an apprentice.

Of the real ultimate value of the results of Leonardo's various scientific researches and investigations I have no title to attempt to speak. They can be judged only by specialists, and when a section is thus passed under review the result from the time of Dr. William Hunter onwards has been to confirm the impression of their great worth, es-

tablishing him as a thinker of very exact powers of analysis as well as a fertile investigator whose work shows a firm grasp of the principles of experimental science. For example, among the anatomical investigations which find record in the Windsor Manuscripts is that of the spinal cord and intestines of the frog. 'The frog', he says, 'retains life for some hours when the head, the heart, and all the intestines have been taken away. And if you prick the said cord it instantly twitches and dies' (Quaderni V 21 r.). On the reverse of the same sheet is written: 'the frog instantly dies when the spinal cord is pierced; and previous to this it lived without head, without heart, or any bowels or intestines or skin; and here therefore it would seem lies the foundation of movement and life.'

The originality of his methods of anatomical investigation is illustrated by the details he gives of the making of wax casts in order to discover the true form of the ventricles of the brain:

'Make two air holes in the horns of the great ventricles and insert melted wax by means of a syringe, making a hole in the ventricle of the memoria, and through this hole fill the three ventricles of the brain; and afterwards when the wax has set take away the brain and you will see the shape of the three ventricles exactly. But first insert thin tubes in the air holes in order that the air which is in these ventricles may escape and so make room for the wax which enters into the ventricles' (Quaderni V 7 r.).

Leonardo, as the learned editors of the Quaderni d'Anatomia inform us, was the first to make casts of the cerebral ventricles, and several hundred years elapsed before the idea occurred to any other anatomist.

It is on the fringe of this uncharted knowledge that the gift of expression often haunts and tantalizes by its beauty.

'Every weight tends to fall towards the centre by the shortest way' (C 28 v.) is the kernel of Newton's law of gravitation. 'The earth is moved from its position by the weight of a tiny bird resting upon it. The surface of the sphere of the water is moved by a tiny drop of water falling upon it' (B.M. 19 r.). Is this also the language of mechanics?

In the section of his treatise on 'Painting', in which he institutes comparison between painting and the other arts, he has no divided allegiance; but, in 'the Prophecies', he has expressed his sense of the potentialities of literature, although somewhat enigmatically: 'Feathers

shall raise men even as they do birds, towards heaven; that is by letters written with their quills.'

Although disclaiming for himself all title to the rank of literary artist he displays a remarkable power of lucid expression, so that his language seems exactly to mirror his thought and his phrases arrest by their simplicity. This literary quality pervades his humour, which is on occasion terse and trenchant, e.g. 'that venerable snail the sun'; 'Man has great power of speech but the greater part thereof is empty and deceitful. The animals have little but that little is useful and true; and better is a small and certain thing than a great falsehood'. The latter sentence might fitly serve as proem to the 'A Bestiary' in Manuscript H, where it is stated of the great elephant that he has by nature qualities which rarely occur among men, namely probity, prudence, and the sense of justice and of religious observance. There is perhaps something of the same mood to be discerned in the instruction that the leather bags, intended to prevent an aviator from doing himself any harm if he chance to fall a height of six braccia on water or on land, should be tied after the fashion of the beads of a rosary; or when after referring to the damage caused to great things by the firing of a cannon he speaks of the spiders' webs being all destroyed. So also where under the rubric 'Of local movement of flexible dry things' he discusses the movement of dust when a table is struck—of the dust which is separated into various hillocks descending from the hypotenuse of these hillocks, entering beneath their base and raising itself round the axis of the point of the hillock, and so moving as to seem a right-angled triangle. One finds one's self wondering when if ever the table was dusted, and reflecting as to how much his powers of observation would have been cramped by matrimony.

I have not considered it necessary to transcribe the numerous pages of Latin declensions and conjugations or the various portions of a Latin-Italian glossary which are to be found in Manuscript H of the 'Institut'. It has been suggested that they were compiled for the instruction of Maximilian and Francesco Sforza, who were born in January 1493 and February 1495, and whose features are familiar as they kneel in chubby complacency in the Zenale altar-piece in the Brera, and the elder of whom is the boy seen sitting reading Cicero in the fascinating fresco by a Milanese painter now in the Wallace Collection. It is some-

what difficult to fit Leonardo into the part of a private tutor to the
Sforza princes although he performed various functions at the court,
but it is quite possible that these lists, although as usual they are in
'left-handed writing', were compiled for the purpose of imparting
information. The fact that the allegories about animals, which are for
the most part a compilation from Pliny and medieval bestiaries, are
also found in Manuscript H suggests the possibility that if the Latin
grammar and glossary were written for the instruction of the Sforza
princes, Leonardo's book of beasts may have been put together for their
edification as a sort of antidote, so that the acerbities of the Latin
conjugations might be varied by such rare and refreshing fruit as the
story of the amphisbaena—a four-footed beast that resembled the Push-
mipullyou of Hugh Lofting's Dolittle books in having a head at each
end, both of which, however, discharged poison, unlike those of the
modern story. Leonardo's imagination is seen perhaps in completest
freedom in the fragment of a fantastic tale in the form of letters, in the
Codice Atlantico. The giant of such stature that when he shook his
head he dislodged showers of men who were clinging to the hairs, is a
fantasy curiously suggestive of the actions of Gulliver in Lilliput.

The problem of the interpretation of the letters purporting to be
written from Armenia has been a vexed question ever since Dr. Jean
Paul Richter made their existence known. The evidence, I think, tends
to confirm the view that they are a record of fact and that Leonardo
was for a time in the East, nor as it seems to me is this interpretation
rendered untenable as Dr. Verga would seem to suggest, by the circum-
stance of Leonardo having used the classical nomenclature of Ptolemy
in these letters. The references to books which occur in Leonardo's
manuscripts show that he was in the habit of studying all classical and
medieval authorities obtainable on the subjects in which he was inter-
ested. Ptolemy was one of the chief sources from which he gratified his
curiosity as to the distant and dimly recorded places and peoples of the
earth. Pliny, Strabo, and even Sir John Mandeville also figure in the
category. The system of nomenclature of Ptolemy supplied the forms
he must inevitably have used in expressing his first conceptions of dis-
tant places. The same consideration must certainly have operated in
the minds of many contemporary travellers. Geography was one of the
sciences in which the knowledge of classical literature may be said to

have lain like a dead hand. Leonardo's debt to Ptolemy was great. In a passage in his treatise on anatomy in which he described how his system of dissection of the various parts of man is to be so co-ordinated that the result may reveal the structure or mechanism of the whole body, he pays a tribute to Ptolemy as a master of synthetic arrangement whom he is proud to follow: 'therefore there shall be revealed to you here in fifteen entire figures the cosmography of the "minor mondo" [the Microcosmos or 'lesser world'] in the same order as was used by Ptolemy before me in his cosmography'. May not his debt to Ptolemy have been much the same in the one case as in the other—in the one the arrangement, in the other the nomenclature, and perhaps the first interest in places?

The manuscripts are the repository of much practical wisdom designed to sweeten the intercourse of life and revealing itself in divers unexpected ways. A social reformer might profitably stand upon the precept: 'Let the street be as wide as the universal height of the houses'. The evils of absentee landlordism and those resulting from the amassing of huge estates—'field laid unto field, that they may be placed alone in the midst of the earth'—are alike exorcized in the sentence, 'Happy is that estate which is seen by the eye of its lord'. Riches had lost some of their chief lures for the man who could write thus: 'Small rooms or dwellings set the mind in the right path, large ones cause it to go astray'; and, 'Wine is good but water is preferable at table'.

The golden mean in all things—failing this, renunciation. 'Entbehren sollst du, sollst entbehren.' 'Neither promise yourself things nor do things', he wrote, 'if you see that when deprived of them they will cause you material suffering'. The sentence serves to recall a remark once uttered by Dr. Jowett on the subject of smoking: 'Do not set up for yourself any new necessities'.

This practical sense is always perceptible when he is discussing the subject of art. In his 'Botany for Painters' he pauses in the act of defining the laws of branch structure to address the painter who, as he recognizes, is bound to be unacquainted with these laws, and to assure him that he may escape the censure of those who have studied them if he is zealous to represent everything according to Nature. So also in discussing the flight of birds (C.A. 214 r. a) he turns for parallel to the movement of the fish's tail; and this, he says, may be proved with a pair

of oars. And in stating the variation in a bird's weight as it spreads
itself out or draws itself together (E 43 v.) he adds, 'and the butterflies
make experiments of this in their descents'. At times, however, the
operation of this practical sense is obscured by the insistence upon pri-
mary laws: e.g. 'In order to give the exact science of the movement of
the birds in the air it is necessary first to give the science of the winds,
and this we shall prove by means of the movements of the water. This
science is in itself capable of being received by the senses: it will serve
as a ladder to arrive at the knowledge of flying things in the air and the
wind' (E 54 r.).

Of the closeness and exactness of his power of observation certain of
the anatomical drawings afford example, equally with the studies for
pictures. The lines seem to have the spontaneity and inevitability of life
itself. The same power translated is visible in his descriptions of Nature
in her changeful moods. These have something of the effect of studies
taken with a camera at close range. As when for example he speaks of
the waves made by the wind in May running over the cornfields with-
out the ears of corn changing their place; of reeds scarcely visible in
the light but standing out well between the light and the shade
(L 87 r.); of waves which intersect after the manner of the scales of a fir
cone, reflecting the image of the sun with the greatest splendour be-
cause the radiance of so many reflections is blended together (B.M.
25 r.); of water in impact with a larger fall turning like the wheel of a
mill (F 81 r.). A statement in the Leicester Manuscript (13 r.) as to the
surface of tiny shadowed waves shaping itself in lines that meet in an
angle, as though formed by the sand, this being proof of its shallow-
ness, might serve as an exact description of the treatment of waves in
Botticelli's 'Birth of Venus', as also in certain of his illustrations to
Dante. Botticelli, who frequented Verrocchio's studio when Leonardo
was there as a pupil, is the only one of his Florentine contemporaries
whose practice was cited by him in his writings on art. While thus on
the one hand his teaching might serve to interpret the practice of Botti-
celli, it bridges the wellnigh bottomless gulf in which the votaries of
classicism forgather, and anticipates the freedom of composition and
subtilty of atmospheric effects of the period of naturalism. His precept
that the mind should seek stimulation to various inventions from the
spectacle of the blend of different stains on a wall, postulates utmost

liberty in arrangement. The most delicate evanescent effects of Anton Mauve, or of Courbet at the time when he painted his 'Duck Shooter', are brought before us by such a sentence as the following: 'No opaque body is without shadow or light except where there is a mist lying over the ground when it is covered with snow, or it will be the same when it snows in the country' (Quaderni II 6 r.).

Similarly the spirit of Whistler's creations is evoked in the directions under the rubric, 'How to represent white figures' (MS. 2038 Bib. Nat. 20 r.); and Turner's most characteristic effects are recalled by the ethereal simplicity and directness of Leonardo's description of the phenomena of sunrise:

'At the first hour of the day the atmosphere in the south near to the horizon has a dim haze of rose-flushed clouds; towards the west it grows darker, and towards the east the damp vapour of the horizon shows brighter than the actual horizon itself, and the white of the houses in the east is scarcely to be discerned; while in the south, the farther distant they are, the more they assume a dark rose-flushed hue, and even more so in the west; and with the shadows it is the contrary, for these disappear before the white' (C.A. 176 r. b).

Who having witnessed the sequence of the effects of sunrise from the angle of observation afforded by a hilltop, can doubt Leonardo's description to be a record of what he had actually seen?

'Pre-imagining—the imagining of things that are to be. Post-imagining—the imagining of things that are past.' So in a passage in the Windsor Manuscripts Leonardo defines with singular felicity two fields of thought over which his spirit ranged with a freedom only limited by the necessity of interpreting natural phenomena. The Leicester Manuscript contains the sum of his researches in the natural history of the earth; in the records that time has written in the rocks and the high deposits of the mountain ranges, of the period when as he says 'above the plains of Italy where now birds fly in flocks fishes were wont to wander in large shoals'. 'Sufficient for us', he states, 'is the testimony of things produced in the salt waters and now found again in the high mountains far from the seas.' Elsewhere in the same manuscript he refers to the discovery of a prehistoric ship found during the digging of a well on the country estate of one of Ludovic Sforza's retinue, and the decision taken to change the position of the well in

order to leave it intact. In a passage in the Arundel Manuscript he apostrophizes as a once-living instrument of constructive nature the form of a great fish whose bones despoiled and bare, as it lies in a hollow winding recess of the hills of Lombardy, are become as an armour and support to the mountain that lies above it. The lines seem charged with just such sensations as must have animated that first scientist in the Dordogne whom a fortunate chance led to enter the caves of Les Eyzies.

But it is in the realm of pre-imagining, 'the imagining of things that are to be', that the manuscripts constitute the most impressive revelation of his creative thought. That a single mind could conceive and anticipate the growth of knowledge at such divers points as the circulation of the blood, the heliocentric theory, the law of inertia, the *camera obscura,* is only to be believed because the evidence for it exists.

In the fragment of a torn letter written apparently to Ludovic Sforza during the embarrassed later years of his rule in Milan, Leonardo reveals how disastrous from the standpoint of the artist were the exigencies of the time. The same may also be said with regard to the conditions which prevailed over Europe during a considerable period of the Great War: the arts put to silence and altar-piece and fresco hidden away in bomb-proof shelters or protected with sand-bags. To the completeness of this silence, however, as affecting the great names in art, that of Leonardo formed a unique exception. In war as in peace the course of events demonstrated that as Sirèn has said, 'no one can be indifferent to Leonardo'. All the most characteristic developments of the Great War, those which distinguish it from all in the long roll of its predecessors—the use of the bombing aeroplane, the use of poison gas, the tank and the submarine—all afford examples of his prescience. He foretold the construction of each, not with the enigmatic utterance of the seer, but with such precision of scientific and mechanical detail as would be natural in one who held, as did Leonardo, the office of military engineer in the Romagna under Caesar Borgia during the brief tenure of his power, and had offered his services in a similar capacity to Ludovic Sforza. It may seem something of an enigma that such activities should have emanated from the brain of one who has stigmatized warfare as 'bestialissima pazzia' (most bestial madness). The clue to its solution is to be found, however, in a passage in one of the

Leonardo Manuscripts in the Bibliothèque Nationale (MS. 2037, 10 r.) in which he refers to the difference between offensive and defensive warfare, and emphasizes the necessity of preparation for the one as a safeguard of all that life holds most dear: 'When besieged by ambitious tyrants I find a means of offence and defence in order to preserve the chief gift of Nature, which is liberty', and so he goes on to speak first of the position of the walls, and then of how people may maintain their good and just lords.

He envisaged the scientific possibilities of the use of poison gas in naval warfare, gave a formula for its composition and described how a mask might be made to act as a preventive. It is impossible lightly to assume that Leonardo, who has written: 'It is an infinitely atrocious thing to take away the life of a man', would have regarded the use of poison gas against the civil population as permissible under any cir-cumstances.

The prototype of the tank or armoured car appears in one of Leo-nardo's drawings in the British Museum. He has thus foreshadowed its use in breaking the line: 'these take the place of the elephants. One may tilt with them. One may hold bellows in them to spread terror among the horses of the enemy, and one may put carabiniers in them to break up every company' (B 83 v.).

In this as in his attempts to construct a machine for flight, he was hampered by the lack of knowledge of a suitable motive power for propelling such a machine. He studied the laws of flight and the con-ditions under which it existed in Nature with inexhaustible zeal, and his scientific deductions from these go far to create the type of the modern aeroplane. He thought of flight as man's natural entry into the deferred inheritance of the air, and did not, apparently, foresee that such was man's nature that his wings would inevitably become the wings of war. Had he envisaged the extension of man's power as en-abling him to rain death from the skies his attitude might conceivably have been that of the artist in Johnson's *Rasselas*, of whom it is related that having mastered the art of flying by the invention of wings on the model of those of the bat he refused to divulge his secret. 'If men were all virtuous', he said, 'I should with great alacrity teach them all to fly. But what would be the security of the good, if the bad could at pleasure invade them from the sky? Against an enemy sailing through

the clouds neither walls nor mountains and seas could afford any se-
curity. A flight of northern savages might hover in the wind and light
at once with irresistible violence upon the capital of a fruitful region
that was rolling beneath them. Even this [the Amharic] valley the
retreat of princes . . . might be violated.'

The conjecture that such would in fact have been Leonardo's attitude
is further strengthened by the nature of his remarks, on the subject
of the unrestricted use of the submarine. The passage, in the Leicester
Manuscript (22 v.), is as follows:

'How by an appliance many are able to remain for some time under
water. How and why I do not describe my method of remaining under
water for as long a time as I can remain without food; and this I do not
publish or divulge, on account of the evil nature of men, who would
practise assassinations at the bottom of the seas by breaking the ships in
their lowest parts and sinking them together with the crews who are in
them.'

'To preserve the chief gift of Nature which is liberty'—this if not
the motive underlying all his study of mechanisms of warfare was
undoubtedly a controlling factor; for in the world as he envisaged it
there is sovereign liberty for the individual to think and devise.

As the long labour of preparation of this edition of Leonardo's
writings draws to an end, a letter comes to me from the United States
telling me of the fact of the Faculty of Princeton University having
drawn up a list of ten names of men of all time who have done most to
advance human knowledge. The names are: Socrates, Plato, Aristotle,
Galileo, Leonardo, Pasteur, Shakespeare, Newton, Darwin and Ein-
stein. No such list is ever likely to win general agreement, for the lack
of a common standard of values. It may at any rate be claimed for this
one that each name is cut deep in the rock of achievement. In thought
of some of the names the strange prescience which has caused Leonardo
to be styled 'the forerunner' recurs inevitably to the mind. As, inde-
pendently of the researches of Galileo, he wrote 'the sun does not move',
so he enunciated the root principle of Newton's law of gravitation in
the words: 'every weight tends to fall towards the centre by the shortest
way'; so also in several passages the nature of which is indicated by
such a sentence as the following: 'write of the quality of time as distinct
from its mathematical divisions', he would seem to have been pointing

along the road which in our own times has been travelled by Einstein.

Where his energy shows itself most inexhaustible is in the investigation of the working of the elemental forces, as in the sections, 'Movement and Weight' and 'Water'. As water may be seen winding in wonder-working coils through his landscape backgrounds, so with infinite zeal he set himself to study how the elements are situated one within the other, why water moves and why its motion ceases, how it rises in the air through the heat of the sun, and afterwards falls in rain: the artist's love of beauty transforming the scientist's purpose even while he is in the act of wresting from its infinite variety its underlying principles.

Certain of the results of these investigations formed that volume on 'The Nature of Water' which was one of those seen in the manor house at Cloux near Amboise, where Leonardo passed the last three years of his life, and where in October 1517 he was visited by a Cardinal of Aragon and his retinue. To the fortunate circumstance of the Cardinal's secretary Antonio de Beatis having kept a diary in which he set down particulars of the visit, we owe our knowledge of the fact that the Leonardo manuscripts there formed 'an infinite number of volumes . . . which if they should be published will be profitable and very enjoyable'.

II

THE early biographers of Leonardo da Vinci cultivated the picturesque with an almost metrical licence. Their narratives, which together constitute what Pater has termed the *légende*, are as inadequate to reveal his work and personality as the fables of Vulcan's forge and the like are unsatisfying as an origin for Etna's fire. Moreover, in the different aspects which Etna has assumed to the imagination, seeming at first a caprice of the gods and a thing of rhapsody, and subsequently—as the tenor of thought changed—a field for the scientific study of the forces of Nature, there is presented a contrast no less sharply defined, and in its main features somewhat closely corresponding to that presented by the personality of Leonardo as shown in the earliest biographies and in the light of modern research. For the capricious volatile prodigy of youthful genius which the *légende* has bequeathed, the latter has substituted a figure less romantic, less alluringly inexplicable, but of even

more varied and astonishing gifts. His greatness as an artist has suffered no change, but modern research has revealed the ordered continuity of effort which preceded achievement. It has made manifest how he studied the structure of the human frame, of the horse, of rocks and trees, in order the better to paint and make statues, in that his work would then be upon the things he knew, and no sinew or leaf would be conventional, but taken directly from the treasury of Nature; since the artist should be 'the son, not the grandson of Nature'.

This habit of scientific investigation in inception subsidiary to the practice of his art, so grew to dominate it as to alienate him gradually from its practice to the study of its laws, and then of those which govern all created Nature. The fruits of these studies lay hidden in manuscripts of which the contents have only become fully known within the last half century. So by a curious appositeness he is associated in each age with the predominant current of its activity. His versatility in the arts caused him to seem an embodiment of the spirit of the Renaissance. Alike as painter, sculptor, architect, engineer and musician, he aroused the wonder and admiration of his contemporaries. But to them, the studies which traversed the whole domain of Nature, prefiguring in their scope what the spirit of the Renaissance should afterwards become, were so imperfectly comprehended as to seem mere trifles, 'ghiribizzi', to be mentioned apologetically, if at all, as showing the wayward inconstancy of genius, and with regret on account of the time thus wasted which might have been spent on painting. Modern savants have resolved these trifles, and in so doing have estimated the value of Leonardo's discoveries and observations in the realms of exact science. They have acclaimed him as one of the greatest of savants: not in completed endeavour which of itself reached fruition, but in conjecture and prefigurement of what the progress of science has in course of centuries established. Such conjecture, moreover, was not grounded in fantasy, but was the harvest of a lifetime of study of natural phenomena, and of close analysis of their laws. Anatomist, mathematician, chemist, geologist, botanist, astronomer, geographer—the application of each of these titles is fully justified by the contents of his manuscripts at Milan, Paris, Windsor and London.

To estimate aright the value of his researches in the various domains of science would require an almost encyclopaedic width of knowledge.

In respect to these Leonardo himself in his manuscripts must be accounted his own best biographer, in spite of what may appear the enigmatic brevity of some of his statements and inferences. It is not possible to claim for him originality in discovery in all the points wherein his researches anticipated principles which were subsequently established. So incomplete is the record of the intellectual life of Milan under the Sforzas, which has survived the storms of invasion that subsequently broke upon the city, as to cause positive statement on this point to be wellnigh impossible; something, however, should be allowed for the results of his intercourse with those who were occupied in the same fields of research. We are told that at a later period he was the friend of Marc Antonio della Torre who held the Chair of Anatomy in the University of Pavia, and that they mutually assisted each other's studies. He was also the friend of Fra Luca Pacioli, the mathematician, and drew the diagrams for his *De Divina Proportione*, and the two were companions for some time in the autumn and winter of 1499 after leaving Milan together at the time of the French invasion. Numerous references and notes which occur throughout the manuscripts show that he was indefatigable in seeking to acquire knowledge from every possible source, either by obtaining the loan of books or treatises, or by application to those interested in the same studies. From the astrologers then to be found at Ludovic's court—Ambrogio da Rosate and the others—he learnt nothing. He rated their wisdom on a par with that of the alchemists and the seekers after perpetual motion. His study of the heavens differed from theirs as much in method as in purpose. His instruments were scientific, and even at times suggestively modern. The line in the Codice Atlantico, 'construct glasses to see the moon large', (fa occhiali da vedere la luna grande) refers, however, only to the use of magnifying glasses; the invention of the telescope is to be assigned to the century following.

At the commencement of the sixteenth century, the Ptolemaic theory of the Universe was still held in universal acceptance. Leonardo at first accepted it, and in his earlier writings the earth is represented as fixed, with the sun and moon revolving round it. He ended at some stage farther on in the path of modern discovery. On a page of mathematical notes at Windsor he has written in large letters, 'the sun does not move' (il sole no si muove).

He has been spoken of as the forerunner of Francis Bacon, of James Watt, of Sir Isaac Newton, of William Harvey. He cannot be said to have anticipated the discoveries with which their names are associated. It may, however, be claimed that he anticipated the methods of investigation which, when pursued to their logical issue, could not but lead to these discoveries.

The great anatomist Vesalius, after having given up his Chair of Anatomy in 1561 in order to become the court physician at Madrid, spoke of himself as still looking forward to studying 'that true bible as we count it of the human body and of the nature of man'. Sir Michael Foster takes these words as the keynote of the life-work of Vesalius: 'the true bible to read is nature itself, things as they are, not the printed pages of Galen or another; science comes by observation not by authority'. In method Leonardo was the forerunner of Vesalius, and consequently of William Harvey, whose great work was the outcome of Vesalius's teaching. No passage in his writings constitutes an anticipation of Harvey's discovery. He knew that the blood moved just as he also knew that the sun did not move, but the law of the circulation of the blood was as far beyond the stage at which his deductions had arrived as was the discovery of Copernicus. It was his work to establish, even before the birth of Vesalius, that 'science comes by observation not by authority'. Yet he was no mere empiric. He knew the authorities. He quotes in his manuscripts from Mundinus's *Anatomia*, and he must have known the work of Galen to which Mundinus served as an introduction. At a time when the Church 'taught the sacredness of the human corpse, and was ready to punish as a sacrilege the use of the anatomist's scalpel', Leonardo practised dissection; and he suffered in consequence of his temerity, since it was subsequent to the malicious laying of information concerning these experiments that the withdrawal of the papal favour brought about his departure from Rome in 1515. Of such temerity the anatomical drawings are a rich harvest. The pall of authority was thrown aside; the primary need was for actual investigation, and of this they are a record. He would agree, he says, as to it being better for the student to watch a demonstration in anatomy than to see his drawings, 'if only it were possible to observe all the details shown in these drawings in a single figure; in which, with all your ability, you will not see nor acquire a knowledge of more than

some few veins, while, in order to obtain an exact and complete knowledge of these, I have dissected more than ten human bodies, destroying all the various members and removing even the very smallest particles of the flesh which surrounded these veins, without causing any effusion of blood other than the imperceptible bleeding of the capillary veins'.

It was after his examination of these drawings that the great anatomist Dr. William Hunter wrote that he was fully of opinion that 'Leonardo was the best Anatomist at that time in the world'.

Coleridge called Shakespeare 'myriad-minded'. If the Baconian contention were established the result would afford a parallel to the myriad-mindedness of Leonardo. Morelli speaks of him as 'perhaps the most richly gifted by nature among all the sons of men'. Equally emphatic is the tribute of Francis I recorded by Benvenuto Cellini: 'He did not believe that any other man had come into the world who had attained so great knowledge as Leonardo, and that not only as sculptor, painter, and architect, for beyond that he was a profound philosopher.'

In regard to this undefined, ungarnered knowledge, the prevalent note of the early biographers is frankly the marvellous. To us his personality seems to outspan the confines of his age, to project itself by the inherent force of its vitality down into modern times and so to take its due place among the intuitive influences of modern thought. To them, on the other hand, his personality projecting beyond the limits of his own age seemed to stretch back into the age of legend, to gather something of its insouciance and its mystery. The figure—never sufficiently to be extolled for beauty of person—wandering through princes' courts improvising songs, bearing a lute as a gift from one patron to another, and playing upon it in such skilled fashion that that alone out of all the arts of which he had knowledge would suffice as 'open sesame' to win him welcome, seems indeed rather to have its habitation in Provence at the close of the twelfth century than to be that of a contemporary and fellow-citizen of Machiavelli and Savonarola. In lieu of any such period of toilsome apprenticeship as Vasari's biographies lead us customarily to expect, there seems almost a Pallas-like maturity at birth. The angel painted by him when an apprentice causes his master to abandon the use of the brush, in chagrin that a mere child had surpassed him; and so, in like manner, we are told that a monster which he painted on a shield filled his own father with dismay. Unsatisfied with this mastery

of the arts he sought to discern the arcana of Nature; and whither the quest had led him it was not for a mere biographer to say. But each will help us to conjecture, with hints more expressive than words, and less rebuttable. Leonardo's scornful references to the pretended wisdom of alchemists, astrologers and necromancers lay hidden meanwhile in the manuscripts, not available to contravene such suppositions.

The personality as represented in the early biographies is substantially that which is expressed in the phrase of Michelet, 'Léonard, ce frère italien de Faust'. It tells of him that he chose rather to know than to be, and that curiosity led him within the forbidden portals. It represents in fact the popular medieval conception of scientific study. Much of the modern aesthetic appreciation is in its essential conception a more temperate restatement of the same point of view. Errors—or at any rate some of them!—are corrected in the light of the results of critical research from Amoretti downwards: the outlook, nevertheless, remains that of Vasari and the Anonimo Fiorentino. Ruskin's dictum, that 'he debased his finer instincts by caricature and remained to the end of his days the slave of an archaic smile', is at one with the opinion of the folk of Wittenberg who lamented Faust's use of the unhallowed arts which had made him Helen's lover. The true analogy lies not with Faust but with Goethe, between whom and Leonardo there is perhaps as great a psychological resemblance as ever has existed between two men of supreme genius.

In each the purely artistic and creative faculties became subordinate, mastered by the sanity of the philosophical faculties.

In each alike the restless workings of the human spirit desiring to *know*, ranged over the various mediums of artistic expression, tempered them to its uses, and finally passed on, looking beyond the art to the thought itself, unsatisfied with what—even in its perfection of utterance—was but a pale reflex of the phenomena it would observe. The two parts of Goethe's Faust-drama symbolize the gradual change of purpose, and may perhaps serve to represent Leonardo's two spheres of activity. Verrocchio's *bottega* and all the influences of the art-world of Florence in the Quattrocento were for him tutelage and training, as the medieval chap-book legends and the newly-arisen literature of the Romantic School were for the poet of Weimar. The result in each case was limpid, serene, majestic, for the elements which had gone to the

making of it had been fused molten in the flame-heat of genius. Yet the man behind the artist is still unsatisfied. He never shares the artist's accomplishment with such measure of absorption as characterized Raphael and Giovanni Bellini. He has something of the aloofness of Faust. There is that within him which art's appeal to the senses never kindled into life, never impelled to utter to one of its moments the supreme shibboleth of Hedonism, 'Stay, thou art so fair'. All the allurements of the medieval chap-book legend were revealed in the first part of the Faust-drama; then, this invocation being as yet unuttered, the thinker essays the problem. No beaten footsteps as before in this new avenue of approach. No clear limpidity of ordered effort. Titanic energy struggles painfully amid the chaos of dimly-perceived primeval forces. The result—even the very effort itself—according to much critical opinion, was an artistic mistake.

The same judgment was passed on Leonardo's work as philosopher and scientist by the earliest of his biographers. Yet in each case the thinker is nearer to the verities. Faust is regenerated by the service of man from out of the hell of medieval tradition. It was the cramping fetter of medieval tradition upon thought which Leonardo toiled to unloose. It was his aim to extend the limits of man's knowledge of himself, of his structure, of his environments, of all the forms of life around him, of the manner of the building up of the earth and sea, and of the firmament of the heavens. To this end he toiled at the patient exposition of natural things, steadfastly, and in proud confidence of purpose. 'I wish', he says, 'to work miracles: I may have fewer possessions than other men who are more tranquil and than those who wish to grow rich in a day.'

Inchoate and comparatively barren of result as was his investigation of natural phenomena, it nevertheless was actual investigation, and it attained results.

We may instance the passages in the manuscript formerly at Holkham Hall, in which the fact of fossil shells being found in the higher mountain ridges of Lombardy is used by a process of deductive reasoning to show how at one time the waters covered the earth. The hypothetical argument that the presence of these shells is to be attributed to the Flood, he meets by considering the rate of the cockel's progress. It is a creature possessed of no swifter power of motion when out of

water than the snail. It cannot swim, but makes a furrow in the sand by means of its sides, and travels in this furrow a space of three to four braccia daily, and by such a method of progression it could not in forty days have travelled from the Adriatic to Monferrato in Lombardy, a distance of two hundred and fifty miles. Neither is it a case of dead shells having been carried there by the force of the waves, for the living are recognizable by the shells being in pairs. Many other passages in the manuscripts might be cited to show by what varied paths he anticipated the modern methods of scientific investigation. The words which Pater uses of the Renaissance of the fifteenth century, 'in many things great rather by what it designed or aspired to do than by what it actually achieved'—applicable to Leonardo in respect of his work as an artist—are no whit the less applicable in reference to his work in science. Painting and sculpture filled only two of the facets of a mind which, as a crystal, took the light from whatever quarter light came. As, however, it was in these arts that he accomplished most, so such of his writings as treat of them are on the whole the most practical. In science, for the most part he heralded the work of others: in respect of his writings on art, we may apply to him the words which Dürer uses of himself in a similar connection: 'what he set down with the pen he did with the hand'. It is this very factor of experience working in the mind which at times causes an abrupt antithesis, in the transition from the general principle to discussion of the means whereby it should be realized. His work may perhaps be considered to lose somewhat of its literary value in consequence, but it acquires an almost unique interest among treatises on art by its combination of the two standpoints of theory and practice. Of this, one of the most striking instances occurs in a passage which is only to be found in the recension of the treatise on 'Painting' in the Vatican (Ludwig, cap. 180). Leonardo there sums up, tritely and profoundly, what should be the painter's purpose: 'a good painter has two chief objects to paint, man and the intention of his soul; the former is easy the latter hard'; after which follows the eminently reasonable, if perhaps unexpected, explanation, 'because he has to represent it by the attitudes and movements of the limbs'; and the knowledge of these, he proceeds to say, should be acquired by observing the dumb, because their movements are more natural than those of any other class of persons. This very practical direction how to

approach towards the realization of an apparently abstract aim is entirely characteristic of his intention. The supreme misfortune, he says, is when theory outstrips performance. This essential practicality of mind brought about the result that in the more abstract portions of this branch of his writings his zest for first principles is most apparent. The sun, the origin of light and shade, is recognized as the first artist, and we are told that 'the first picture consisted merely in a line which surrounded the shadow of a man cast by the sun upon a wall'; and the comparison of poetry and painting resolves itself into a consideration of the relative importance of the senses to which the two arts make their appeal.

It is perhaps in the passages indicating the manner in which particular scenes and actions should be represented in art that Leonardo's powers as a writer find their most impressive utterance. His natural inclination impelled him to the contemplation of the vast and awe-inspiring in Nature; but in these terse, vivid, analytic descriptions, the consideration of the ultimate purpose operates throughout to restrain and co-ordinate. The descriptive passage entitled 'The way to represent a battle', in which the effect is built up entirely by fidelity of detail, forms an absolute triumph of realism. There can be no possibility of difference of opinion as to how Leonardo regarded warfare. It was a grim necessity, and he was himself busied on occasions in devising its instruments; but he had no illusions as to its real nature, he characterizes it elsewhere as 'most bestial madness' (bestialissima pazzia). Here, however, he never suffers his pen to digress from the work of simple description. To generalize would be alien to his purpose, which is to show how to portray a battle in progress. Consequently he shows what it is that is actually happening amid the clouds of dust and smoke and the rain of gunshot and falling arrows; and describes tersely, graphically, relentlessly, the passions and agonies of the combatants as shown in their faces and their actions, the bitterness of the deaths of the vanquished, the fury and exhaustion of the victors and the mad terror of the horses, since these should find a place in the work of whosoever would represent war; 'and see to it', he says in conclusion, 'that you make no level spot of ground that is not trampled over with blood'. The passage enables us in part to realize what he sets himself to represent in the picture of the Battle of Anghiari. It is, however, far more

than a mere note for a picture. It possesses an interest and value apart either from this fact or from the mastery in the art of writing which it reveals. Its ultimate value is moral and didactic. He forbears to generalize but constrains the reader in his stead. His description is of the identical spirit which has animated the creations of Tolstoy and Verestchagin. Like these, Leonardo seeks to make war impossible, by showing it stripped of all its pageantry and trappings, in its naked and hideous reality.

The passages which describe a tempest and a deluge, and their representation in painting, possess the same vigorous realism and fidelity of detail, and contain some of Leonardo's most eloquent and picturesque writing; and among the other notes connected with pictures we may instance that for the 'Last Supper', descriptive of the actions of the disciples, which, although of far slighter mould than any of the passages already referred to, yet possesses a restrained but very distinct dramatic power. These same qualities may be discerned perhaps even to more advantage in one of the very rare comments on public events which are to be found in his writings. After Ludovic Sforza's attempt to regain possession of Lombardy had ended with his defeat and capture at the battle of Novara in April 1500, Leonardo wrote among notes on various matters, 'The Duke has lost his State, his possessions, and his liberty, and he has seen none of his works finished'. (Il Duce perse lo Stato e la roba e la libertà, e nessuna sua opera si finì per lui.) Leonardo was a homeless wanderer in consequence of the events referred to, and one of the works of which the Duke had not witnessed the completion was that of the statue on which Leonardo had been engaged intermittently during sixteen years, and the model of which had served as a target for the French soldiery; but this terse impassive comment is the only reference to these occurrences found in his writings. There is a certain poignant brevity and concentration in the sentence, which suffices even to recall some of the most inevitable lines of Dante.

It is within the narrow limits of the short sentence and the apothegm that Leonardo's command of language is most luminous. In some of these the thought expressed is so wedded to the words as scarcely to suffer transference. 'Sì come una giornata bene spesa dà lieto dormire così una vita bene usata dà lieto morire' must lose something of its grace in any rendering. Certain of these sentences record the phenom-

ena of Nature so simply as to cause us almost to doubt whether they are intended to do more than this. 'All the flowers which see the sun mature their seed, and not the others, that is those which see only the reflection of the sun', is perhaps written as an observation of Nature without thought of a deeper meaning; but it is hard to suppose that a similar restriction applies to the sentence: 'tears come from the heart not from the brain'; although it is found in a manuscript which treats of anatomy.

It would seem that it was natural to him as a writer to use words as symbols and figuratively, thus employing things evident and revealed in metaphor. Of this habit of veiled utterance the section of his imaginative writings known as 'the Prophecies' affords the most impressive and sustained series of instances. Some few of these are, as their name implies, a forecast of future conditions; many attack the vices and abuses of his own time. In the succinct, antithetical form of their composition Leonardo apparently created his own model.

There are questions more intimate than any of those which arise from the consideration of his achievement in these various arts and sciences; questions which the mere number of these external interests tends to veil in comparative obscurity, causing us to regard Leonardo almost as a resultant of forces rather than as an individual, to see in him as it were an embodiment of the various intellectual tendencies of the Renaissance—as though the achievements were the man. The figure crosses the stage of life in triumph, playing to perfection many parts. But of these enough. Let us try to come nearer, to get past the cloak of his activities, and essay to 'pluck the heart out of this mystery'. As a means towards this end, let us consider his attitude with regard to certain of the problems of life.

His writings inculcate the highest morality, though rather as a reasoned process of the mind than as a revelation from an external authority. He preserves so complete a reticence on the subject of doctrinal belief as to leave very little base for inference as to his faith or lack of faith. The statement of Vasari, that he did not conform to any religion, deeming it better perhaps to be a philosopher than a Christian, was omitted in the second edition of the *Lives*, and may therefore be looked upon as probably merely a crystallization of some piece of Florentine gossip. It would be idle to attempt to surmise as to the reason of the

withdrawal. To whatever cause this may have been due, its significance is no whit the less as outweighing a mass of suggestion and vain repetition on this subject by later writers. In temperament Leonardo has something akin to certain of the precursors of the Reformation. In any conflict between the dictates of reason and of authority he would be found on the side of freedom of thought. 'Whoever', he wrote, 'in discussion adduces authority uses not his intellect but rather memory.'

The cast of his mind was anti-clerical. His indignation at the abuses and corruption of the Church found expression in satire as direct and piercing as that of Erasmus. His scorn of the vices of the priesthood, of their encouragement of superstition, of the trade in miracles and pardons, which is eloquently expressed in the section of his writings known as 'the Prophecies', may not unnaturally have earned for him the title of heretic from those whom he attacked. His quarrel lay, however, not with the foundations on which faith rested, but with what he conceived to be its degradation in practice by its votaries. His own path lay along the field of scientific inquiry; but where the results of this research seemed at variance with revealed truth, he would reserve the issue, disclaiming the suggestion of antagonism. Nature indeed cannot break her own laws. The processes of science are sure, but there are regions where we cannot follow them. 'Our body is subject to heaven, and heaven is subject to the spirit.' So at the conclusion of a passage describing the natural origin of life, he adds, 'I speak not against the sacred books, for they are supreme truth'. The words seem a protest against the sterile discussion of these things. There is, indeed, a reticence in the expression of the formulas of faith, but the strands of its presence may be seen in the web of life.

The impelling necessity to use life fully is the ever-recurrent burden of his moral sayings:

'Life well spent is long.'

'Thou, O God, dost sell unto us all good things at the price of labour.'

'As a well-spent day brings happy sleep, so life well used brings happy death.'

This vision of the end is steadfast. Death follows life even as sleep rounds off the day, and as we work well in the day, so sleep when it comes is happy and untroubled. During the passing of the day there is

so much to be done, such opportunity to construct and to observe, so much knowledge to be won about this world wherein the day is passed, that there is scarce time remaining in which to stand in fear and wonder at thought of what chimeras the coming shadow may hold within it. It is better to use to-day than to spend it by questioning of to-morrow. Duty in life is clear and we must follow it. When he speaks of what comes after, it is with that hesitance common to all, unless to speak of it be made habituate by custom, for to all, whatever be their belief, there yet remains something unknowable in the conditions of the change.

In one of the most beautiful passages of his writings—a fragment on time, the destroyer—Leonardo describes Helen in her old age as looking into her mirror and seeing there the wrinkles which time had imprinted on her face, and then weeping, and wondering why she had been twice carried away. Beautiful as is the description the hand which penned it is pre-eminently that of the scientist; we seem to see the anatomist at work with the scalpel, so minute is the observation therein revealed as to the effect of age and of the relentless approach of death upon the human frame.

'In her the painter had anatomized Time's ruin.'

And yet, as modern erudition in the person of the late Gerolamo Calvi has recently shown, Leonardo was not the original author of the passage. He amplified it and transformed it into a richer harmony by placing the apostrophe to Time the destroyer at the beginning as well as at the end, but the description of Helen he found in Ovid's *Metamorphoses* (Book xv, ll. 232-6).

The fact illustrates the difficulty of interpreting the contents of the Notebooks. They contain matter some of it unoriginal and some of this doubtless is as yet unidentified.

The frequent recurrence in his writings and in his drawings and grotesques of the physical tokens of decay and death argues no morbid predilection, such as that shown by the painters of the *danse macabre*. It forms a proportioned part of his study and 'patient exposition' of the origin and development of the whole structure of man. In the results as we may read them, there is no incursion of the personal note. His attitude is always that of an observer, looking with curious eyes, noting all the phenomena of physical change, but yet all the while pre-

serving a strange impassivity. He never in any of his works or in his manuscripts gives the suggestion of possessing any of that regret at the passing of time which rings through Giorgione's sun-steeped idylls. Indeed, from all such lament he expressly dissociates himself. Time, he maintains, stays long enough for those who use it. The mere fact of the inevitability of death forbids regret. It therefore cannot be an evil. He speaks of it as taking away the memory of evil, and compares it with the sleep which follows after the day. The thought of this sleep brings silence: when on rare occasion the silence is broken, he stands with Shakespeare and Montaigne, revealing, as they do, when they address themselves to the same question, a quiet confidence, serene and proud.

The author of *Virginibus Puerisque*, discoursing whimsically upon the incidence and attributes of the tender passion, professes his utter inability to comprehend how any member of his own sex, with at most two exceptions, can ever have been found worthy to be its object. 'It might be very well', he says, 'if the Apollo Belvedere should suddenly glow all over into life, and step forward from the pedestal with that god-like air of his. But of the misbegotten changelings who call themselves men and prate intolerably over dinner-tables, I never saw one who seemed worthy to inspire love—no, nor read of any except Leonardo da Vinci and perhaps Goethe in his youth.'

The suggestion as to the Apollo Belvedere is in entire harmony with the association of the names which follow. For if it had ever come to pass, as is conjectured in Heine's fantasy, that the gods of Greece, after their worship ceased, fallen on days of adversity, and constrained to baser uses, had walked the earth as men, surely no lives whereof record holds had come more naturally to Apollo's lot than would those of Goethe and Leonardo.

It would be vain to attempt to find better instances, yet these give only a capricious support at best to Stevenson's contention. They afford far more proof of his amazing temerity in attempting to view the kingdom of sentiment from the feminine standpoint.

These two names he ranks together in isolation from the rest of their sex—and this in respect precisely of that condition wherein the records of their lives reveal the least resemblance. Goethe was as susceptible and almost as fickle as Jupiter himself. The story of his heart is a romance with many chapters, each enshrining a new name, and all end-

ing abruptly at the stage at which the poet remembers—at times somewhat tardily—the paramount claims of his art.

But in the case of Leonardo there are no grounds for supposing that any one such chapter was ever begun. None of his biographers connect his name with that of any woman in the way of love, nor do his own writings afford any such indication. They show that he lived only for the things of the mind. He would seem to have renounced deliberately all thought of participation in the tenderness of human relationship. He looked upon it as alien to the artist's supreme purpose: he must needs be solitary in order to live entirely for his art. His conception of the mental conditions requisite for the production of great art presupposes something of that isolation expressed in Pater's phrase: 'each mind keeping as a solitary prisoner its own dream of a world'.

The praise of solitude has ever been a fecund theme, although much of the fervour of its votaries has resulted in little more than a reverberation of the monkish jingle, 'O beata solitudo, O sola beatitudo.' In so far as praise of solitude is dispraise of the world and one's fellow-men and the expression of desire to shun them and their activities, it is a sterile thing and worse. Solitude is unnatural and only the use of it can justify the condition. Maybe that even then the dream will never come to birth! Certain it is that if it does we must suffer the pangs alone!

Concentration of the mind comes by solitude; and in this, according to Leonardo, its value to the artist consists. (Se tu sarai solo tu sarai tutto tuo.) 'If you are alone you belong entirely to yourself. If you are accompanied even by one companion you belong only half to yourself, or even less in proportion to the thoughtlessness of his conduct. . . . If you must have companionship choose it from your studio; it may then help you to obtain the advantages which result from different methods of study.'

Such companionship of the studio implies some such measure of equality of attainment as it can never have been his own lot to meet with after leaving the circle of Verrocchio and the art world of Florence. His own lesser companions of the studio were his pupils and servants, and the only one of these whom he admitted to any degree of personal intimacy was Francesco de' Melzi, who seems to have stood to him in the concluding years of his life almost in the position of a son to a father.

Behind all his strength lay springs of tenderness; in life confined within the strait limits whereby his spirit proposed that its work should be more surely done, in his art they are manifest, therein revealing the repression of his life. His pictures are now so few that it would be to his drawings that we should chiefly look for support of this statement, and of these primarily perhaps to the many studies for Madonna pictures, and the sketches of children made in connection with them; also, however, to the two versions of the composition of the Madonna and Child with St. Anne. The differences between that in Burlington House and that in the Louvre show the artist's gradual growth of purpose. One motive, however, is found in both, namely that the Madonna is represented as so entirely absorbed in her Child that she is entirely unconscious of aught else. With the exception of the Madonna della Seggiola, and perhaps certain others of Raphael's Madonnas, there is no Madonna picture in Italian art in which the conception is more human or the ecstasy of motherhood is rendered with greater tenderness. So 'l'art console de la vie'; and the same may be said in Leonardo's case of Nature perhaps even more truly than of art. If indeed any thought of consolation can be suffered in connection with a life so confident and full! For man's work is his ultimate self. Such human hopes as begin and end in the individual are puny even in their highest fulfilment, and the processes of Nature, whatever their final end, seem eternal in contrast with their transience.

He interpreted man's highest aim to consist in seeking to know and to hand on the lamp of knowledge.

A RECORD OF THE MANUSCRIPTS

In the opening lines of the volume of manuscript notes 'begun at Florence in the house of Piero di Braccio Martelli, on the 22nd day of March, 1508', now in the British Museum (Arundel MSS. 263), Leonardo explains the method of its composition. The passage may serve to summarize the impression made by the whole mass of Leonardo's manuscripts. 'This', he says, 'will be a collection without order, made up of many sheets which I have copied here, hoping afterwards to arrange them in order in their proper places according to the subjects of which they treat; and I believe that before I am at the end of this I shall have to repeat the same thing several times; and therefore, O reader, blame me not, because the subjects are many, and the memory cannot retain them and say "this I will not write because I have already written it". And if I wished to avoid falling into this mistake it would be necessary, in order to prevent repetition, that on every occasion when I wished to transcribe a passage I should always read over all the preceding portion, and this especially because long periods of time elapse between one time of writing and another.' Certain pages in the volume of manuscript in the British Museum would indeed seem to be of a much earlier date than this introductory sentence, and the whole body of the manuscripts, as may be shown by the time-references contained in them, extend over a period of some forty years, from Leonardo's early manhood to his old age. He commenced them during the time of his first residence in Florence, and was still adding to them when at Amboise.

The contents of this 'collection without order' are so diversified as to render wellnigh impossible any attempt at formal classification. In addition to the numerous fragments of letters, the personal records, the notes relating to his work as an artist, and the fragments of imaginative composition which are to be found therein, it presents by far the most complete record of his mental activity, and this may be said without exaggeration to have extended into practically all the avenues of hu-

man knowledge. These manuscripts serve in a sense to show the mind in its workshop, busied in researching, in making conjecture, and in recording phenomena, tempering to its uses, in so far as human instrument may, the vast forces of Nature.

He projected many treatises which should embody the results of these researches. Notes in the manuscripts themselves record the various stages of their composition. Some still exist in a more or less complete form. Of the fragments of others the order of arrangement is now only a matter of conjecture. In the manuscripts at Windsor, which treat mainly of anatomy, a note, dated April 2nd, 1489, speaks of writing the book 'about the human figure'. The manuscript given to the Ambrosian Library by Cardinal Federico Borromeo, now MS. C of the Institut de France, which is a treatise on light and shade, contains a note that 'on the 23rd day of April 1490, I commenced this book and recommenced the horse'—the latter reference being to the equestrian statue of Francesco Sforza. In August 1499 a note in the Codice Atlantico states that he was then writing 'upon movement and weight'. These dates are, however, of relatively less importance, because each of these subjects occupied his thoughts during a long period of years. The two first formed a part of the artist's complete equipment as Leonardo conceived it: the third found practical issue in his undertakings in canalization and engineering in Lombardy, Tuscany, Romagna and elsewhere. In connection with the former of these two divisions of his activities may be cited the treatise on the nature of water formerly in the possession of the Earl of Leicester, and the same subject is also treated of among others in MS. F of the Institut, which according to a note, was commenced at Milan on September 12th, 1508.

The manuscripts as a whole are picturesquely described in the diary of a certain Antonio de Beatis, the secretary of the Cardinal of Aragon, who with his patron visited Leonardo at Amboise in October 1517. The many wanderings of the painter's life were then ended, and he was living with Francesco Melzi and his servant Battista de Villanis in the manor house of Cloux, the gift of Francis I. The diary relates that he showed his guests three pictures, the St. John, the Madonna with St. Anne, and the portrait of a Florentine lady, painted at the request of Giuliano de' Medici, which cannot now be identified. It further states that paralysis had attacked his right hand, and that therefore he could

no longer paint with such sweetness as formerly, but still occupied himself in making drawings and giving instruction to others. (May the inference be that he then drew with the left hand? If so he presumably used it in the manuscripts, which are written backwards.)

'This gentleman has', he continues, 'written of anatomy with such detail, showing by illustrations the limbs, muscles, nerves, veins, ligaments, intestines and whatever else there is to discuss in the bodies of men and women, in a way that has never yet been done by anyone else. All this we have seen with our own eyes; and he said that he had dissected more than thirty bodies, both of men and women, of all ages. He has also written of the nature of water, of divers machines and of other matters, which he has set down in an infinite number of volumes all in the vulgar tongue, which if they should be published will be profitable and very enjoyable.'

This description of the manuscripts—the only one by an eyewitness during Leonardo's lifetime—leads to the supposition that, if not all, at any rate by far the greater part of them were in Leonardo's possession at the time that he went to France, and were at Cloux at the time of his death.

The manuscripts then passed into the possession of Francesco Melzi, to whom Leonardo in his will, dated April 23rd, 1518, bequeathed 'in return for the services and favours done him in the past', 'each and all of the books of which the said Testator is at present possessed, together with the other instruments and portraits which belong to his art and calling as a Painter'. Melzi returned to Milan shortly after Leonardo's death and took the manuscripts with him, and four years later a certain Alberto Bendedeo, writing from Milan to Alfonso d'Este, said that he believed that the Melzi whom Leonardo made his heir was in possession of 'such of his notebooks as treated of anatomy and many other beautiful things'.

Vasari visited Milan in 1566, and he states that Melzi whom he saw, and who was then 'a beautiful and gentle old man', possessed a great part of Leonardo's papers of the anatomy of the human body, and kept them with as much care as though they were relics. Some of the manuscripts had already at this time passed into other hands, for Vasari refers to some which treated of painting and methods of drawing and colouring as being then in the possession of a certain Milanese painter

whose name he does not mention. The care which had been taken of those in Melzi's possession ceased at his death, which occurred in 1570. Some years later no restriction was placed by Melzi's heirs upon the action of a certain Lelio Gavardi di Asola, a tutor in the Melzi family, who took thirteen of the volumes of manuscripts with him to Florence for the purpose of disposing of them to the Grand Duke, Francesco. The duke's death, however, prevented the realization of this project, and Gavardi subsequently took the volumes with him to Pisa. Giovanni Ambrogio Mazzenta, a Milanese who was then at the University of Pisa studying law, remonstrated with Gavardi upon his conduct, and with such success that on Mazzenta's return to Milan in 1587 he took the volumes with him for the purpose of restoring them to the Melzi family. When, however, he attempted to perform this duty Dr. Orazio Melzi was so astonished at his solicitude in the matter that he made him a present of all the thirteen volumes, telling him further that there were many other drawings by Leonardo lying uncared-for in the attics of his villa at Vaprio. In 1590 Giovanni Ambrogio Mazzenta joined the Barnabite Order and the volumes were then given by him to his brothers. They seemed to have talked somewhat freely about the incident, and in consequence, according to Ambrogio Mazzenta's account, many people were filled with the desire to obtain similar treasures, and Orazio Melzi gave away freely drawings, clay models, anatomical studies, and other precious relics from Leonardo's studio.

Among the others who thus came into possession of works by Leonardo was the sculptor Pompeo Leoni, who was employed in the service of the King of Spain. He afterwards induced Orazio Melzi, by the promise of obtaining for him official honours and preferment, to appeal to Guido Mazzenta, in whose possession they then were, to restore the volumes of Leonardo's manuscripts so that he might be enabled to present them to Philip II. Melzi's entreaties were successful in obtaining the return of seven volumes, and three of the others subsequently passed into Pompeo Leoni's possession on the death of one of the Mazzentas. Of the remaining three, one according to Mazzenta's account was given to the Cardinal Federico Borromeo, and passed into the Ambrosian Library which he founded in 1603; another was given to the painter Ambrogio Figini, who afterwards bequeathed

it to Ercole Bianchi; it was subsequently in the possession of Joseph Smith, English Consul at Venice, and with the sale of his effects in 1759 all record of it ends; the third was given to Charles Emmanuel, Duke of Savoy, and nothing further is known as to its history. Professor Govi has conjectured that it was perhaps burnt in one of the fires which occurred in the Royal Library at Turin in 1667 or 1679.

Some of the volumes of the manuscripts which had passed into the possession of Pompeo Leoni were afterwards cut in pieces by him in order to form one large volume from the leaves, together with some of the drawings which he had obtained from Melzi's villa at Vaprio. This volume, known as the Codice Atlantico on account of its size, contains four hundred and two sheets and more than seventeen hundred drawings, and bears on its cover the inscription:

DISEGNI DI MACHINE ET
DELLE ARTI SECRETI
ET ALTRE COSE
DI LEONARDO DA VINCI
RACOLTI DA
POMPEO LEO
NI

Apparently the collector's instinct proved stronger in Pompeo Leoni than his original intention. He was subsequently in Madrid, where he was engaged in executing bronzes for the royal tombs in the Escurial, but there is no evidence to show that he ever parted with any of Leonardo's manuscripts to Philip II. The Codice Atlantico remained in his possession until his death in 1610, and then passed to his heir, Polidoro Calchi, by whom it was sold in 1625 to Count Galeazzo Arconati. Two of Leonardo's manuscripts in Pompeo Leoni's possession were included among his effects sold after his death at Madrid, and were then bought by Don Juan de Espina. It would seem probable that others of the manuscripts in Pompeo Leoni's possession descended to his heir Calchi, and from him passed into the possession of Count Arconati, because the latter in 1636 presented twelve volumes of Leonardo's manuscripts to the Ambrosian Library at Milan. The volume which Mazzenta had given to Cardinal Federico Borromeo had already been placed there in 1603, and in 1674 yet another volume of

Leonardo's manuscripts was added by the gift of Count Orazio Arch-
inti.

Of the list of twelve manuscripts as described in Count Archonati's
deed of gift to the Ambrosian Library, the second was afterwards lost,
and the fifth was removed from the Library—it being, as the descrip-
tion shows, identical with the manuscript of Leonardo's which in about
the year 1750 was bought from a certain Gaetano Caccia of Novara by
Carlo Trivulzio and is now in the possession of Prince Trivulzio at
Milan. The remaining ten manuscripts of the Arconati donation, to-
gether with the two from Cardinal Federico Borromeo and Count
Archinti respectively, were in the Ambrosian Library until 1796. There
was then also with them a manuscript of ten sheets which treated of
the eye, the *provenance* of which is unknown, but which it is con-
jectured had been substituted for the manuscript now in the collection
of Prince Trivulzio. These thirteen manuscripts were all removed to
Paris in the year 1796 in pursuance of the decree of Bonaparte as Gen-
eral-in-Chief of the Army of Italy of 30 Floreal An. IV (May 19th,
1796), providing for the appointment of an agent who should select
such pictures and other works of art as might be worthy of transmis-
sion to France. The words of the decree authorizing and justifying the
removal arrest attention by the naivety of their ὕβρις. 'All men of gen-
ius', it ran, 'all who have attained distinction in the republic of letters
are French, whatever be the country which has given them birth'.
(Tous les hommes de génie, tous ceux qui ont obtenu un rang dis-
tingué dans la république des lettres, sont Français, quelque soit le pays
qui les aît vus naître.)

The Codice Atlantico was in the Bibliothèque Nationale at Paris in
August 1796. The other twelve volumes of the manuscripts were de-
posited in the Institut de France. In 1815 the Austrian Ambassador, as
representing Lombardy, made application for the return of all the
Leonardo manuscripts. The request was complied with as regards the
Codice Atlantico, which was then restored to the Ambrosian Library
at Milan, but the twelve volumes in the library of the Institut de
France were apparently overlooked, and there they have since re-
mained.

On their arrival in France the manuscripts were described by J. B.
Venturi, who then marked them with the lettering whereby they have

subsequently been distinguished. He gave their total number as four-teen, because MS. B contained an appendix of eighteen pages which could be separated and considered as the fourteenth volume.

This manuscript is identical with No. 3 in the Arconati donation, which is described as having at the end a small 'volumetto' of eighteen pages containing various mathematical figures and drawings of birds. This 'volumetto' seems in fact to have been treated somewhat as Venturi suggests by Count Guglielmo Libri, who frequently had access to the manuscripts in the Institut de France in the early part of last century, and who apparently abstracted it at some time previous to 1848, at which date its loss was discovered. In 1868 it was sold by Libri to Count Giacomo Manzoni of Lugo, and in 1892 it was acquired from Count Manzoni's heirs by M. Sabachnikoff, by whom it was published in the following year as *Il Codice sul Volo degli Uccelli* (edit. Piumati e Sabachnikoff, Paris, 1893). It has subsequently been presented to the Royal Library at Turin.

Two other manuscripts by Leonardo, of sixty-eight and twenty-six pages respectively, now in the Bibliothèque Nationale (Nos. 2038 and 2037), must have originally formed part of the manuscripts A and B of the Institut de France. They tally both in the dimensions of the pages and in the subjects of which they treat, and their total numbers added to those of Manuscripts A and B respectively do not amount to quite the full numbers of the leaves which these two manuscripts possessed in 1636, as described in the list of the Arconati donation.

These two manuscripts in the Bibliothèque Nationale were formerly in the collection of the late Earl of Ashburnham, who purchased them in 1875 from Count Libri, from whom, as we have seen, Count Manzoni had purchased the 'volumetto' 'On the flight of birds'. The mutilation of Manuscripts A and B of the Institut de France and the removal of the 'volumetto' were first discovered in the year 1848. It is impossible to avoid the inference that the action in each case was the work of Count Libri. The two manuscripts of the Bibliothèque Nationale have been included in the edition of the manuscripts of the Institut de France published in facsimile, with a transcript and French translation by M. Ravaisson-Mollien, in six volumes (Paris, 1880-91).

The Codice Atlantico has also been published in facsimile, with a transcript, under the direction of the Accademia dei Lincei, at Rome

(1894-1904); and the manuscript in the possession of Prince Trivulzio, which as we have seen was formerly in the Ambrosian Library as one of the Arconati bequest, has been published in facsimile with a transcript by Signor Beltrami (Milan, 1892).

We may now consider the Arconati bequest from another standpoint. The count's munificence was commemorated in the following inscription which was set in marble on the wall of the staircase of the Ambrosian Library:

LEONARDI . VINCII
MANU . ET . INGENIO . CELEBERRIMI
LUCUBRATIONUM . VOLUMINA . XII
HABES . O . CIVIS
GALEAZ . ARCONATUS
INTER . OPTIMATES . TUOS
BONARUM . ARTIUM . CULTOR . OPTIMUS
REPUDIATIS . REGIO . ANIMO
QUOS . ANGLIAE . REX . PRO . UNO . TANTUM . OFFEREBAT
AUREIS . TER . MILLE . HISPANICIS
NE . TIBI . TANTI . VIRI . DEESSET . ORNAMENTUM
BIBLIOTHECAE . AMBROSIANAE . CONSECRAVIT
NE . TANTI . LARGITORIS . DEESSET . MEMORIA
QUEM . SANGUIS . QUEM . MORES
MAGNO . FEDERICO . FUNDATORI
ADSTRINGUNT
BIBLIOTHECAE . CONSERVATORES
POSUERE
ANNO MDCXXXVII

'The glorious (boasting) inscription'—so described in the *Memoirs of John Evelyn*—has naturally attracted the attention of English travellers. Evelyn records his failure to obtain a sight of the manuscripts when he visited Milan in 1646, owing to the keeper of them being away and having taken the keys, but he states that he had been informed by the Lord Marshal, the Earl of Arundel, that all of them were small except one book, a huge folio containing four hundred leaves 'full of scratches of Indians', and 'whereas', he says, 'the inscription pretends that our King Charles had offered £1000 for them, my lord himself told me that it was he who treated with Galeazzo for himself in the name and by the permission of the King, and that the Duke of Feria,

who was then Governor, should make the bargain: but my lord having seen them since did not think them of so much worth'. The inscription, however, does not mention the name of the King. Addison, in his *Remarks on Several Parts of Italy* in describing his visit to Milan in 1701, mentions the Ambrosian Library as containing 'a manuscript of Leonardus Vincius, wich King James I could not procure, tho' he profer'd for it three thousand spanish pistoles'; and the monarch in question is also stated to have been James I in the fuller record of the Arconati donation. The Duke of Feria was Governor of Milan from 1610 to 1633, during a part of the reign of both monarchs.

Apparently, however, the manuscripts only passed into the possession of Count Arconati in 1625, the year of the death of James I, and this renders it probable that the monarch referred to was Charles I. But the question of under which king has relatively little import, and with regard to the inscription, it may perhaps be well to recall the dictum of Dr. Johnson that 'in lapidary inscriptions a man is not upon oath'. The only inference that can fairly be drawn from the present instance is that the manuscripts by Leonardo now in the Royal Collection at Windsor did not form part of the Arconati Collection. This is also confirmed by the testimony of Lord Arundel, as recounted by Evelyn. That some of the Leonardo manuscripts at Windsor were once in the possession of Lord Arundel is established by the fact of the existence of an engraving of one of the drawings by Hollar, whom Lord Arundel brought from Prague and established in London. It is inscribed Leonardus da Vinci sic olim delineavit. W. Hollar fecit ex collectione Arundeliana'.

That some of these Windsor manuscripts were also formerly in the Collection of Pompeo Leoni is clearly shown by the fact that one of the volumes is inscribed 'Disegni di Leonardo da Vinci Restaurati da Pompeo Leoni'.

Two of the manuscripts in Pompeo Leoni's collection, as already stated, were purchased in Madrid after his death by Don Juan de Espina; and Mr. Alfred Marks—from whose important contributions to this branch of the subject in the *Athenaeum* of February 23rd and July 6th, 1878, many of the foregoing facts are derived—has shown that for one at any rate of these volumes, the Earl of Arundel was in treaty with Don Juan de Espina. The evidence of this is to be found

in a note by Endymion Porter, of the date 1629, printed by Mr. Sainsbury in his *Original Unpublished Papers illustrative of the Life of Rubens*: '. . . . of such things as my Lord Embassador S^r Francis Cottington is to send out of Spain for my Lord of Arondell; and not to forget the booke of drawings of Leonardo de Vinze w^ch is in Don Juan de Espinas hands' (p. 294). Don Juan seems for a time to have proved obdurate, for Lord Arundel wrote on January 19th, 1636, to Lord Aston, who was then ambassador to Spain: 'I beseech y^u be mindfull of D. Jhon de Spinas booke, if his foolish humour change' (p. 299). There the record breaks off. But as Mr. Marks truly observes, there can be little doubt that eventually a change did take place in Don Juan's 'foolish humour'. At whatever date this happened the volume passed into Lord Arundel's possession. The earl may either have been negotiating for himself or for the King. If the former was the case, the book may presumably have passed into the Royal Collection at any time after 1646, when on the death of Lord Arundel his collections were partially dispersed. If it was not acquired previously the volume may have been bought in Holland by an agent of Charles II.

The earliest record of any of Leonardo's manuscripts or drawings as being in the royal possession occurs in an inventory found by Richter in the Manuscript Department of the British Museum, which states that some drawings of Leonardo da Vinci, marked with a cross, were delivered for Her Majesty's use in the year 1728.

Richter also cites a note in an inventory at Windsor Castle written at the beginning of last century, in which a drawing of Leonardo's is referred to as not having been in the volume compiled by Pompeo Leoni, but in one of the volumes in the Buonfigliuolo Collection bought at Venice. Nothing apparently is known about the collection here referred to, but the note is important as tending to prove that the manuscripts by Leonardo now at Windsor were not all acquired at the same time, and did not all form part of Pompeo Leoni's collection.

The volume of manuscript now in the British Museum (Arundel MSS. 263) was certainly once in the possession of Lord Arundel. Nothing is known of its history previous to this, and whether or no it belonged to Pompeo Leoni, or was acquired by purchase from Don Juan de Espina, it would be idle to attempt to conjecture. Lord Arundel had numerous agents in various parts of Europe, who were em-

ployed in collecting antiquities and works of art. It may, however, be noted that the greater part of his collection of manuscripts was acquired by the earl himself at Nuremberg in 1636, and had formerly belonged to Wilibald Pirkheimer, the humanist, the friend of Erasmus and Dürer. If any opportunity presented itself to him, Pirkheimer would certainly have possessed himself of any manuscript of Leonardo's; but to suppose him to have done so would be to assume that some of the manuscripts passed into other hands during Leonardo's lifetime, and this, though by no means impossible, is at any rate improbable.

The only other manuscripts by Leonardo now known to exist, with the exception of a few separate sheets of sketches and diagrams with explanatory text, are three small notebooks in the Forster Library at South Kensington, and a volume of seventy-two pages long in the possession of the Earls of Leicester at Holkham Hall. The histories of these manuscripts, insofar as they are known, are worth giving. The former were acquired in Vienna for a small sum by the first Earl of Lytton and by him presented to Mr. Forster; the latter, according to a note on the title-page, once belonged to the painter Giuseppe Ghezzi, who was living in Rome at the beginning of the eighteenth century, it having presumably been acquired by the first (Holkham) Earl of Leicester, who spent some years in Rome previous to 1775, and there acquired many art treasures. Its previous history is unknown. This volume—a treatise on the nature of water—is in all probability that referred to by Rafaelle du Fresne in the sketch of Leonardo's life which appears in his edition of the *Trattato della Pittura*, published in Paris in 1651, where it is stated that 'the undertaking of the canal of the Martesana was the occasion of his writing a book on the nature, weight, and motion of water, full of a great number of drawings of various wheels and engines for mills to regulate the flow of water and raise it to a height'.

Of the manuscripts at Windsor which in the main are those that treat of anatomy, two volumes with facsimiles (60 leaves with about 400 drawings), transcripts and translations, have been issued by Messrs. Piumati and Sabachnikoff, *Dell' Anatomia Fogli A* (Paris, 1898), *Fogli B* (Turin, 1901), and the *Quaderni d'Anatomia,* six volumes (129 leaves with about 1050 drawings), by Messrs. Vangenstan, Fonahn and Hopstock (Oslo, 1911-16). Facsimiles of other leaves at Windsor

were issued by Rouveyre from plates prepared for the use of Sabach-nikoff. The manuscript in the British Museum and the three in the Forster Library were published in Rome by the Reale Commissione Vinciana at various dates from 1923-34, and an edition of the Leicester manuscript has been edited by Gerolamo Calvi (Milan, 1909).

As Leonardo's fame as a writer has chiefly rested upon the *Treatise on Painting*, it may not be out of place here to attempt to state the relation which this work bears to the original manuscripts.

The *Treatise* was first published by Rafaelle du Fresne, in Paris, in 1651, a French translation by Roland Fréard, sieur de Chambrai, being also issued in the same year. Du Fresne derived his text from two old copies of MS. 834 in the Barberini Library, which manuscript has now presumably been transferred to the Vatican, at the same time as the other contents of that Library. One of these copies had been made by the Cavaliere Cassiano del Pozzo, who had given it in 1640 to M. Chanteloup, by whom it was presented to du Fresne for the preparation of his edition; the other was lent him for the same object by M. Thevenot.

Another edition of the *Treatise* was issued in 1817 by Guglielmo Manzi, who took as his text a manuscript in the Vatican Library (Cod. Vat. [Urbinas], 1270), which had formerly belonged to the Library of the Dukes of Urbino. This manuscript is by far the more complete of the two, five out of the eight books which it contains being wanting in the version followed by du Fresne. There are, however, many omissions in Manzi's edition, and the only adequate critical edition of the Vatican manuscript is that published by H. Ludwig (*Leonardo da Vinci: Das Buch von der Malerei* [Bd. xv-xviii of *Quellenschriften für Kunstgeschichte*, etc., Edit. R. Eitelberger v. Edelberg], Vienna, 1882, Stuttgart, 1885). This contains the complete text, together with a German translation and commentary, and also an analysis of the differences which exist between the manuscripts in the Vatican and Leonardo's own manuscripts.

The Vatican manuscript probably dates from the beginning of the sixteenth century. It has been ascribed to some immediate pupil of Leonardo's, for choice either Francesco Melzi or Salai, but there is no evidence which can be held to establish this view. Its close connection with Leonardo is, however, indisputable. Whether this be the original

form or no, the compilation was undoubtedly made previous to the dispersal of the manuscripts. About a quarter of the whole number of paragraphs (two hundred and twenty-five out of nine hundred and forty-four) are identical with passages in the extant manuscripts. Many others, which are not now to be found in any form in the manuscripts, yet carry their lineage incontestably, and would afford a sufficient proof, were this lacking in the chequered history of the various volumes, that some of the manuscripts have now perished: that, as with Leonardo as painter so also as writer, time has spared only the fragments of his work. The compiler of the *Treatise on Painting* had access to manuscripts, and also probably to sources of information as to the artist's intentions, of which we have no record. He presumably followed what he conceived to be the scheme of the artist's work. Nevertheless, Leonardo cannot be adjudged directly or even indirectly responsible for the arrangement and divisions of this treatise, and it is somewhat difficult to credit him with the whole of the contents. Certain of the passages read rather as repetitions by a pupil of a theme expounded by the master.

Did Leonardo himself ever give his work definite shape? Did he write a treatise on painting or only parts of one? In Fra Luca Pacioli's dedication to Ludovic Sforza of the *De Divina Proportione,* dated February 9th, 1498, he speaks of Leonardo as having finished 'il Libro de Pictura et movimenti humani', and Dr. Ludwig, who apparently accepts this statement, puts forward the supposition that the treatise was in the possession of Ludovic and probably became lost at the time of the French invasion of Milan.

On this same occasion, according to both Vasari and Lomazzo, there also perished a treatise by Leonardo on the anatomy of the horse, which he had written in the course of his studies for the Sforza statue.

Vasari, as we have seen, mentions some writings by Leonardo 'which treat of painting and of the methods of drawing and colouring' as being then in the possession of a Milanese painter, who had recently been to see him in Florence to discuss their publication, and had taken them to Rome in order to carry his intention into effect, though with what result Vasari could not say. These writings are stated to be 'in characters written with the left hand, backwards', and therefore they cannot possibly be identical either with the Barberini or the Vatican manu-

scripts. Seeing that Vasari wrote during Melzi's lifetime, it is reasonable to infer that this manuscript had at an early date become separated from the others and therefore did not form part of the general mass of the manuscripts which passed into Melzi's possession at Leonardo's death, since Vasari states that he kept these as though they were relics. As to whether this manuscript was identical with the work to which Fra Luca Pacioli referred, there is no sufficient evidence on which to form an opinion. Moreover, the Frate's evidence must not be interpreted too literally. The words of the dedication of the *De Divina Proportione*, 'tutta la sua ennea massa a libre circa 200000 ascende', would naturally also suggest that the statue of Francesco Sforza was actually cast in bronze, but the general weight of evidence, including that of Leonardo's own letters, forbids any such supposition. So, in like manner, it may perhaps have been that in the case of the *Treatise on Painting* he may have spoken of the rough drafts and fragments as though they were the completed work.

The work itself grew continually in the mind of the author. It was moulded and recast times without number, as his purpose changed and expanded in his progress along each new avenue of study that revealed afresh the kinship of art and nature. It is certain that he never wrote 'finis'. It is at any rate possible that he never halted in investigation for so long a time as would be necessary to arrange and classify what he had written—that he left all this to a more convenient season. Genius, we should remember, is not apt to be synthetic.

LIST OF ABBREVIATIONS

IN THE references to the manuscripts which follow these abbreviations occur:

C.A. = Codice Atlantico.

Tr. = Codice Trivulziano.

A, B, etc., to I, and K, L, M = MSS. A, B, etc., to I and K, L, M of the Library of the Institut de France.

MSS. 2037 and 2038 Bib. Nat. = Nos. 2037 and 2038, Italian MSS., Bibliothèque Nationale.

B.M. = Arundel MSS., No. 263, British Museum.

Forster I, II, III = Forster Bequest MSS. I, II, III, Victoria and Albert Museum.

Leic. = MS. in possession of Earl of Leicester.

Sul Volo = MS. 'Sul Volo degli Uccelli' in Royal Library, Turin.

Sul Volo (F.M.) = 'Sul Volo' Fogli Mancanti. Fatio Collection, Geneva.

Fogli A and B = Dell' Anatomia Fogli A and B, Royal Library, Windsor.

Quaderni I-VI = Quaderni d'Anatomia I-VI, Royal Library, Windsor.

R. = J. P. Richter, *Literary Works of L. da V.*

PROEM

IF INDEED I have no power to quote from authors as they have, it is a far bigger and more worthy thing to read by the light of experience, which is the instructress of their masters. They strut about puffed up and pompous, decked out and adorned not with their own labours but by those of others, and they will not even allow me my own. And if they despise me who am an inventor how much more should blame be given to themselves, who are not inventors but trumpeters and reciters of the works of others?

* * * * * *

Those who are inventors and interpreters between Nature and Man as compared with the reciters and trumpeters of the works of others, are to be considered simply as is an object in front of a mirror in comparison with its image when seen in the mirror, the one being something in itself, the other nothing: people whose debt to nature is small, for it seems only by chance that they wear human form, and but for this one might class them with the herds of beasts.

C.A. 117 r. b

Seeing that I cannot choose any subject of great utility or pleasure, because my predecessors have already taken as their own all useful and necessary themes, I will do like one who, because of his poverty, is the last to arrive at the fair, and not being able otherwise to provide himself, chooses all the things which others have already looked over and not taken, but refused as being of little value. With these despised and rejected wares—the leavings of many buyers—I will load my modest pack, and therewith take my course, distributing, not indeed amid the great cities, but among the mean hamlets, and taking such reward as befits the things I offer.

I am fully aware that the fact of my not being a man of letters may cause certain arrogant persons to think that they may with reason

censure me, alleging that I am a man ignorant of book-learning. Foolish folk! Do they not know that I might retort by saying, as did Marius to the Roman Patricians: 'They who themselves go about adorned in the labour of others will not permit me my own'? They will say that because of my lack of book-learning, I cannot properly express what I desire to treat of. Do they not know that my subjects require for their exposition experience rather than the words of others? And since experience has been the mistress of whoever has written well, I take her as my mistress, and to her in all points make my appeal.

Many will believe that they can with reason censure me, alleging that my proofs are contrary to the authority of certain men who are held in great reverence by their inexperienced judgments, not taking into account that my conclusions were arrived at as a result of simple and plain experience, which is the true mistress.

These rules enable you to discern the true from the false, and thus to set before yourselves only things possible and of more moderation; and they forbid you to use a cloak of ignorance, which will bring about that you attain to no result and in despair abandon yourself to melancholy.

The natural desire of good men is knowledge.

I know that many will call this a useless work, and they will be those of whom Demetrius said that he took no more account of the wind that produced the words in their mouths than of the wind that came out of their hinder parts: men whose only desire is for material riches and luxury and who are entirely destitute of the desire of wisdom, the sustenance and the only true riches of the soul. For as the soul is more worthy than the body so much are the soul's riches more worthy than those of the body. And often when I see one of these men take this work in hand I wonder whether he will not put it to his nose like the ape, and ask me whether it is something to eat.

C.A. 119 v. a

Begun in Florence in the house of Piero di Braccio Martelli, on the 22nd day of March, 1508. This will be a collection without order, made up of many sheets which I have copied here, hoping afterwards to

arrange them in order in their proper places according to the subjects of which they treat; and I believe that before I am at the end of this I shall have to repeat the same thing several times; and therefore, O reader, blame me not, because the subjects are many, and the memory cannot retain them and say 'this I will not write because I have already written it'. And if I wished to avoid falling into this mistake it would be necessary, in order to prevent repetition, that on every occasion when I wished to transcribe a passage I should always read over all the preceding portion, and this especially because long periods of time elapse between one time of writing and another. B.M. 1 r.

I

Philosophy

'Nature is full of infinite causes which were
never set forth in experience.'

WE HAVE no lack of system or device to measure and to parcel out
these poor days of ours; wherein it should be our pleasure that they be
not squandered or suffered to pass away in vain, and without meed of
honour, leaving no record of themselves in the minds of men; to the
end that this our poor course may not be sped in vain. c.a. 12 v. a

Our judgment does not reckon in their exact and proper order things
which have come to pass at different periods of time; for many things
which happened many years ago will seem nearly related to the present,
and many things that are recent will seem ancient, extending back to
the far-off period of our youth. And so it is with the eye, with regard
to distant things, which when illumined by the sun seem near to the
eye, while many things which are near seem far off. c.a. 29 v. a

Supreme happiness will be the greatest cause of misery, and the per-
fection of wisdom the occasion of folly. c.a. 39 v. c

Every part is disposed to unite with the whole, that it may thereby
escape from its own incompleteness.

The soul desires to dwell with the body because without the mem-
bers of that body it can neither act nor feel. c.a. 59 r. b

[*Drawing: bird sitting in cage*]
The thoughts turn towards hope.[1] c.a. 68 v. b

O Time, thou that consumest all things! O envious age, thou destroy-
est all things and devourest all things with the hard teeth of the years,

[1] The sketch at the side of this sentence serves to recall the fact that as Vasari states
Leonardo was in the habit of paying the price demanded by the owners of captive birds
simply for the pleasure of setting them free.

little by little, in slow death! Helen, when she looked in her mirror and saw the withered wrinkles which old age had made in her face, wept, and wondered to herself why ever she had twice been carried away.

O Time, thou that consumest all things! O envious age, whereby all things are consumed! [1] C.A. 71 r. a

The age as it flies glides secretly and deceives one and another; nothing is more fleeting than the years, but he who sows virtue reaps honour. C.A. 71 v. a

Wrongfully do men lament the flight of time, accusing it of being too swift, and not perceiving that its period is yet sufficient; but good

[1] Gerolamo Calvi has shown in an article in the Archivio Storico Lombardo, Anno XLIX (1916) Fasc. III that the source of this passage is to be found in Ovid's *Metamorphoses*, Book XV, lines 232-6:

> 'Flet quoque, ut in speculo rugas aspexit aniles
> Tyndaris, et secum, cur sit bis rapta, requirit.
> Tempus edax rerum, tuque, invidiosa vetustas,
> Omnia destruitis, vitiataque dentibus aevi
> Paulatim lenta consumitis omnia morte.'

'Helen also weeps when she sees her aged wrinkles in the looking-glass, and tearfully asks herself why she should twice have been a lover's prey. O Time, thou great devourer, and thou, envious Age, together you destroy all things; and, slowly gnawing with your teeth, you finally consume all things in lingering death!' (Loeb.)

The passage as it appears in the Codice Atlantico serves to show how Leonardo in borrowing enriched the Roman poet's thought with the melody of music by introducing the apostrophe to time and envious age as prelude as well as finale:

'O tempo, consumatore delle cose, e o invidiosa antichità, tu distruggi tutte le cose e consumi tutte le cose da duri denti della vecchiezza a poco a poco con lenta morte!

Elena quando si specchiava, vedendo le vizze grinze del suo viso, fatte per la vecchiezza, piagnie e pensa seco, perchè fu rapita due volte.

O tempo, consumatore delle cose, e o invidiosa antichità, per la quale tutte le cose sono consumate.'

Immediately below this passage Leonardo wrote these words: 'this book belongs to Michele di Francesco Bernabini and his family'. It is a reasonable inference that they refer to the copy of Ovid from which the lines were taken. Farther below in writing of the same time is a fragment: 'tell, tell me how things are passing yonder and whether Caterina wishes to make . . .'

Caterina was the name of Leonardo's mother. He wrote the name when his thoughts had just been turning to the poet's description of the changes that time had made in Helen's beauty. From this has arisen the conjecture—it is nothing more!—that the sentence refers to her and that he was making some provision for her in her old age.

memory wherewith Nature has endowed us causes everything long past to seem present.

Whoever would see in what state the soul dwells within the body, let him mark how this body uses its daily habitation, for if this be confused and without order the body will be kept in disorder and confusion by the soul. c.a. 76 r. a

O thou that sleepest, what is sleep? Sleep is an image of death. Oh, why not let your work be such that after death you become an image of immortality; as in life you become when sleeping like unto the hapless dead.

Man and the animals are merely a passage and channel for food, a tomb for other animals, a haven for the dead, giving life by the death of others, a coffer full of corruption. c.a. 76 v. a

Behold a thing which the more need there is of it is the more rejected: this is advice, listened to unwillingly by those who have most need of it, that is by the ignorant. Behold a thing which the more you have fear of it and the more you flee from it comes the nearer to you: this is misery, which the more you flee from it makes you the more wretched and without rest. c.a. 80 v. a

Experience the interpreter between resourceful nature and the human species teaches that that which this nature works out among mortals constrained by necessity cannot operate in any other way than that in which reason which is its rudder teaches it to work.

c.a. 86 r. a

To the ambitious, whom neither the boon of life, nor the beauty of the world suffice to content, it comes as penance that life with them is squandered, and that they possess neither the benefits nor the beauty of the world. c.a. 91 v. a

The air as soon as there is light is filled with innumerable images to which the eye serves as a magnet. c.a. 109 v. a

In youth acquire that which may requite you for the deprivations of old age; and if you are mindful that old age has wisdom for its food,

you will so exert yourself in youth, that your old age will not lack sustenance. C.A. 112 r. a

There is no result in nature without a cause; understand the cause and you will have no need of the experiment. C.A. 147 v. a

Experience is never at fault; it is only your judgment that is in error in promising itself such results from experience as are not caused by our experiments. For having given a beginning, what follows from it must necessarily be a natural development of such a beginning, unless it has been subject to a contrary influence, while, if it is affected by any contrary influence, the result which ought to follow from the aforesaid beginning will be found to partake of this contrary influence in a greater or less degree in proportion as the said influence is more or less powerful than the aforesaid beginning. C.A. 154 r. b

Experience is not at fault; it is only our judgment that is in error in promising itself from experience things which are not within her power.
Wrongly do men cry out against experience and with bitter reproaches accuse her of deceitfulness. Let experience alone, and rather turn your complaints against your own ignorance, which causes you to be so carried away by your vain and insensate desires as to expect from experience things which are not within her power!
Wrongly do men cry out against innocent experience, accusing her often of deceit and lying demonstrations! C.A. 154 r. c

O mathematicians, throw light on this error.
The spirit has no voice, for where there is voice there is a body, and where there is a body there is occupation of space which prevents the eye from seeing things situated beyond this space; consequently this body of itself fills the whole surrounding air, that is by its images.
 C.A. 190 v. b

The body of the earth is of the nature of a fish, a grampus or sperm whale, because it draws water as its breath instead of air.
 C.A. 203 r. b

How the movements of the eye of the ray of the sun and of the mind are the swiftest that can be:

The sun so soon as ever it appears in the east instantly proceeds with its rays to the west; and these are made up of three incorporeal forces, namely radiance, heat, and the image of the shape which produces these.

The eye so soon as ever it is opened beholds all the stars of our hemisphere.

The mind passes in an instant from the east to the west; and all the great incorporeal things resemble these very closely in their speed.

<div align="right">c.a. 204 v. a</div>

When you wish to produce a result by means of an instrument do not allow yourself to complicate it by introducing many subsidiary parts but follow the briefest way possible, and do not act as those do who when they do not know how to express a thing in its own proper vocabulary proceed by a method of circumlocution and with great prolixity and confusion. c.a. 206 v. a

Two weaknesses leaning together create a strength. Therefore the half of the world leaning against the other half becomes firm.

<div align="right">c.a. 244 v. a</div>

While I thought that I was learning how to live, I have been learning how to die. c.a. 252 r. a

Every part of an element separated from its mass desires to return to it by the shortest way. c.a. 273 r. b

Nothingness has no centre, and its boundaries are nothingness.

My opponent says that nothingness and a vacuum are one and the same thing, having indeed two separate names by which they are called, but not existing separately in nature.

The reply is that whenever there exists a vacuum there will also be the space which surrounds it, but nothingness exists apart from occupation of space; it follows that nothingness and a vacuum are not the same, for the one is divisible to infinity, and nothingness cannot be divided because nothing can be less than it is; and if you were to take part from it this part would be equal to the whole, and the whole to the part. c.a. 289 v. b

Aristotle in the Third [Book] of the Ethics: man is worthy of praise

and blame solely in respect of such actions as it is within his power to do or to abstain from. c.a. 289 v. c

He who expects from experience what she does not possess takes leave of reason. c.a. 299 r. b

For what reason do such animals as sow their seed sow with pleasure and the one who awaits receives with pleasure and brings forth with pain? c.a. 320 v. b

Intellectual passion drives out sensuality. c.a. 358 v. a

The knowledge of past time and of the position of the earth is the adornment and the food of human minds. c.a. 373 v. a

Among the great things which are found among us the existence of Nothing is the greatest. This dwells in time, and stretches its limbs into the past and the future, and with these takes to itself all works that are past and those that are to come, both of nature and of the animals, and possesses nothing of the indivisible present. It does not however extend to the essence of anything. c.a. 398 v. d

CORNELIUS CELSUS [1]

The chief good is wisdom: the chief evil is the suffering of the body. Seeing therefore that we are made up of two things, namely of soul and body, of which the first is the better and the inferior is the body, wisdom belongs to the better part and the chief evil belongs to the worse part and is the worst. The best thing in the soul is wisdom, and even so the worst thing in the body is pain. As therefore the chief evil is bodily pain, so wisdom is the chief good of the soul, that is of the wise man, and nothing else can be compared to it. Tr. 3 a

The lover is drawn by the thing loved, as the sense is by that which it perceives, and it unites with it, and they become one and the same thing. The work is the first thing born of the union; if the thing that is loved be base, the lover becomes base. When the thing taken into union is in harmony with that which receives it, there follow rejoicing

[1] Cornelii Celsi de medicina liber incipit (libri VIII), Florentiae, 1478; Mediolani, 1481; Venice, 1493 and 1497.

and pleasure and satisfaction. When the lover is united to that which is loved it finds rest there; when the burden is laid down there it finds rest. The thing is known with our intellect. Tr. 9 a

As a well-spent day brings happy sleep, so life well used brings happy death. Tr. 28 a

Where there is most power of feeling, there of martyrs is the greatest martyr. Tr. 35 a

All our knowledge originates in our sensibilities. Tr. 41 a

Science, knowledge of the things that are possible present and past; prescience, knowledge of the things which may come to pass. Tr. 46 r.

Demetrius was wont to say that there was no difference between the words and speech of the unskilled and ignorant and the sounds and rumblings caused by the stomach being full of superfluous wind. This he said not without reason for as he held it did not in the least matter from what part of them the voice emanated, whether from the lower parts or the mouth, since the one and the other were of equal worth and importance. Tr. 52 a

Nothing can be written as the result of new researches. Tr. 53 a

To enjoy—to love a thing for its own sake and for no other reason. Tr. 59 a

The senses are of the earth, the reason stands apart from them in contemplation. Tr. 60 a

Life well spent is long.
In rivers, the water that you touch is the last of what has passed and the first of that which comes: so with time present. Tr. 63 a

Every action must necessarily find expression in movement.
To know and to will are two operations of the human mind.
To discern to judge to reflect are actions of the human mind.
Our body is subject to heaven, and heaven is subject to the spirit. Tr. 65 a

Many times one and the same thing is drawn by two violences, namely necessity and power.

Water falls in rain; the earth absorbs it from necessity of moisture; and the sun raises it up not from necessity but by its power.

Tr. 70 a

The soul can never be infected by the corruption of the body, but acts in the body like the wind which causes the sound of the organ, wherein if one of the pipes becomes spoiled no good effect can be produced because of its emptiness.

Tr. 71 a

If you kept your body in accordance with virtue your desires would not be of this world.

You grow in reputation like bread in the hands of children.

B 3 V.

There cannot be any sound where there is no movement or percussion of the air. There cannot be any percussion of the air where there is no instrument. There cannot be any instrument without a body. This being so a spirit cannot have either sound or form or force, and if it should assume a body it cannot penetrate or enter where the doors are shut. And if any should say that through air being collected together and compressed a spirit may assume bodies of various shapes, and by such instrument may speak and move with force, my reply to this would be that where there are neither nerves nor bones there cannot be any force exerted in any movement made by imaginary spirits. Shun the precepts of those speculators whose arguments are not confirmed by experience.

B 4 V.

OF WHAT FORCE IS

Force I define as a spiritual power, incorporeal and invisible, which with brief life is produced in those bodies which as the result of accidental violence are brought out of their natural state and condition.

I have said spiritual because in this force there is an active, incorporeal life; and I call it invisible because the body in which it is created does not increase either in weight or in size; and of brief dura-

tion because it desires perpetually to subdue its cause, and when this is subdued it kills itself. B 63 r.

One ought not to desire the impossible. E 31 v.

THE CONFIGURATION OF THE ELEMENTS

Of the configuration of the elements and first against those who deny the opinion of Plato, saying that if these elements invest one another in the shapes which Plato attributed to them a vacuum would be occasioned between one and the other which is not true. I prove this here but first of all it is necessary to set forth certain conclusions.

It is not necessary for any of the elements which invest one another to be of equal size in all its extent as between the part that invests and that which is invested. We see that the sphere of the water is manifestly of different degrees of thickness from its surface to its base, and that it would not only cover the earth if it had the shape of a cube that is of eight angles as Plato would have it, but it covers the earth having innumerable angles of rocks covered by the water and various protuberances and hollows without creating any vacuum between the water and the earth. Moreover as regards the air which clothes the sphere of the water together with the mountains and valleys which rise about this sphere there is not left any vacuum between the earth and the air. So that whoever has said that a vacuum is there produced has spoken foolishly.

To Plato one would make answer that the surfaces of the figures that the elements would have according to him could not exist.

Every flexible and liquid element has of necessity its spherical surface. This is proved with the sphere of water but first must be set forth certain conceptions and conclusions. That thing is higher which is more remote from the centre of the world, and that is lower which is nearer this centre. Water does not move of itself unless it descends and in moving itself it descends. These four conceptions placed two by two serve me to prove that water that does not move of itself has its surface equidistant to the centre of the world, speaking not of drops or other small quantities that attract one another as the steel its filings, but of the great masses. F 27 r.

Conception: Necessity wills that the corporeal agent be in contact with that which employs it. F 36 v.

Observe the light and consider its beauty. Blink your eye and look at it. That which you see was not there at first, and that which was there is no more.

Who is it who makes it anew if the maker dies continually? F 49 v.

The other proof that Plato gave to those of Delos is not geometrical, because it proceeds by instruments, the compass and the rule, and experience does not show it; but this is all mental and in consequence geometrical. F 59 r.

Man has great power of speech, but the greater part thereof is empty and deceitful. The animals have little, but that little is useful and true; [1] and better is a small and certain thing than a great falsehood. F 96 v.

You who speculate on the nature of things, I praise you not for knowing the processes which nature ordinarily effects of herself, but rejoice if so be that you know the issue of such things as your mind conceives. G 47 r.

Words which fail to satisfy the ear of the listener always either fatigue or weary him; and you may often see a sign of this when such listeners are frequently yawning. Consequently when addressing men whose good opinion you desire, either cut short your speech when you see these evident signs of impatience, or else change the subject; for if you take any other course, then in place of the approbation you desire you will win dislike and ill-will.

And if you would see in what a man takes pleasure without hearing him speak, talk to him and change the subject of your discourse several times, and when it comes about that you see him stand fixedly without either yawning or knitting his brows or making any other movement, then be sure that the subject of which you are speaking is the one in which he takes pleasure. G 49 r.

[1] i.e. 'vero' (the reading adopted by Dr. Richter). MS. has 'verso'.

Every evil leaves a sorrow in the memory except the supreme evil, death, and this destroys memory itself together with life. H 33 v.

Nothing is so much to be feared as a bad reputation. This bad reputation is caused by vices. H 40 r.

Though nature has given sensibility to pain to such living organisms as have the power of movement,—in order thereby to preserve the members which in this movement are liable to diminish and be destroyed,—the living organisms which have no power of movement do not have to encounter opposing objects, and plants consequently do not need to have a sensibility to pain, and so it comes about that if you break them they do not feel anguish in their members as do the animals. H 60 [12] r.

OF THE SOUL

Movement of earth against earth pressing down upon it causes a slight movement of the parts struck.

Water struck by water creates circles at a great distance round the spot where it is struck; the voice in the air goes further, in fire further still; mind ranges over the universe but being finite it does not extend into infinity. H 67 [19] r.

[Parallel of organism of nature and man]

The water which rises in the mountains is the blood which keeps the mountain in life. If one of its veins be open either internally or at the side, nature, which assists its organisms, abounding in increased desire to overcome the scarcity of moisture thus poured out is prodigal there in diligent aid, as also happens with the place at which a man has received a blow. For one sees then how as help comes the blood increases under the skin in the form of a swelling in order to open the infected part. Similarly life being severed at the topmost extremity (of the mountain) nature sends her fluid from its lowest foundations up to the greatest height of the severed passage, and as this is poured out there it does not leave it bereft of vital fluid down to the end of its life. H 77 [29] r.

Every wrong shall be set right. H 99 [44 v.] r.

Movement is the cause of all life. H 141 [2 v.] r.

He who does not value life does not deserve it. I 15 r.

Nature is full of infinite causes which were never set forth in experience. I 18 r.

What is it that is much desired by men, but which they know not while possessing? It is sleep. I 56 [8] r.

Wine is good, but water is preferable at table. I 122 [74] v.

Science is the captain, practice the soldiers. I 130 [82] r.

FLAX AND DEATH

Flax is dedicated to death and human corruption: to death by the lakes with nets for birds beasts and fishes; to corruption by the linen cloths in which the dead are wrapped when they are buried, for in these cloths they suffer corruption.

And moreover this flax does not become separated from its stalks until it commences to soften and become corrupt; and it is this which one should use to make garlands and adornments for funeral processions. L 72 v.

Truth alone was the daughter of time. M 58 v.

Small rooms or dwellings set the mind in the right path, large ones cause it to go astray. MS. 2038 Bib. Nat. 16 r.

Just as eating contrary to the inclination is injurious to the health, so study without desire spoils the memory, and it retains nothing that it takes in. MS. 2038 Bib. Nat. 34 r.

Call not that riches which may be lost; virtue is our true wealth, and the true reward of its possessor. It cannot be lost; it will not abandon us unless life itself first leaves us. As for property and material wealth, these you should ever hold in fear; full often they leave their possessor in ignominy, mocked at for having lost possession of them. MS. 2038 Bib. Nat. 34 v.

The earth is moved from its position by the weight of a tiny bird resting upon it.

The surface of the sphere of the water is moved by a tiny drop of water falling upon it. B.M. 19 r.

Every action done by nature is done in the shortest way.

<div style="text-align:right">B.M. 85 v.</div>

Where the descent is easier there the ascent is more difficult.

<div style="text-align:right">B.M. 120 r.</div>

That which is termed nothingness is found only in time and speech. In time it is found between the past and the future and retains nothing of the present; in speech likewise when the things spoken of do not exist or are impossible.

In the presence of nature nothingness is not found: it has its associates among the things impossible whence for this reason it has no existence.

In the presence of time nothingness dwells between the past and the future and possesses nothing of the present; and in the presence of nature it finds its associates among things impossible, whence for this reason it is said that it has no existence. For where nothingness existed there would be a vacuum.

Amid the immensity of the things about us the existence of nothingness holds the first place, and its function extends over the things that have no existence, and its essence dwells in respect of time between past and future, and possesses nothing of the present. This nothingness has the part equal to the whole and the whole to the part, the divisible to the indivisible, and its power does not extend among the things of nature, for inasmuch as this abhors a vacuum this nothingness loses its essence because the end of one thing is the beginning of another.

It is possible to conceive everything that has substance as divisible into an infinite number of parts.

Amid the greatness of the things around us the existence of nothingness holds the first place, and its function extends among the things which have no existence, and its essence dwells as regards time between the past and the future, and possesses nothing of the present. This nothingness has the part equal to the whole and the whole to the part, the divisible to the indivisible, and it comes to the same amount

whether we divide it or multiply it or add to it or substract from it, as is shown by the arithmeticians in their tenth sign which represents this nothingness. And its power does not extend among the things of nature. B.M. 131 r.

[Of the end of the world]

The watery element remaining pent up within the raised banks of the rivers and the shores of the sea, it will come to pass with the upheaval of the earth that as the encircling air has to bind and circumscribe the complicated structure of the earth, its mass which was between the water and the fiery element will be left straitly compassed about and deprived of the necessary supply of water.

The rivers will remain without their waters; the fertile earth will put forth no more her budding branches; the fields will be decked no more with waving corn. All the animals will perish, failing to find fresh grass for fodder; and the ravening lions and wolves and other beasts which live by prey will lack sustenance; and it will come about after many desperate shifts that men will be forced to adandon their life and the human race will cease to be.

And in this way the fertile fruitful earth being deserted will be left arid and sterile, and through the pent up moisture of the water enclosed within its womb and by the activity of its nature it will follow in part its law of growth until having passed through the cold and rarefied air it will be forced to end its course in the element of fire. Then the surface of it will remain burnt to a cinder, and this will be the end of all terrestrial nature. B.M. 155 v.

[A disputation]

Against.—Why nature did not ordain that one animal should not live by the death of another.

For.—Nature being capricious and taking pleasure in creating and producing a continuous succession of lives and forms because she knows that they serve to increase her terrestrial substance, is more ready and swift in creating than time is in destroying, and therefore she has ordained that many animals shall serve as food one for the other; and as this does not satisfy her desire she sends forth frequently certain noisome and pestilential vapours and continual plagues upon the vast accumulations and herds of animals and especially upon hu-

man beings who increase very rapidly because other animals do not feed upon them; and if the causes are taken away the results will cease.

Against.—Therefore this earth seeks to lose its life while desiring continual reproduction for the reason brought forth, and demonstrated to you. Effects often resemble their causes. The animals serve as a type of the life of the world.

For.—Behold now the hope and desire of going back to one's own country or returning to primal chaos, like that of the moth to the light, of the man who with perpetual longing always looks forward with joy to each new spring and each new summer, and to the new months and the new years, deeming that the things he longs for are too slow in coming; and who does not perceive that he is longing for his own destruction. But this longing is in its quintessence the spirit of the elements, which finding itself imprisoned within the life of the human body desires continually to return to its source.

And I would have you to know that this same longing is in its quintessence inherent in nature, and that man is a type of the world.

<div align="right">B.M. 156 V.</div>

Therefore the end of nothingness and the beginning of the line are in contact one with another, but they are not joined together, and in such contact is the point which divides the continuation of nothingness and the line.

It follows that the point is less than nothing, and if all the parts of nothingness are equal to one we may the more conclude that all the points also are equal to one single point and one point is equal to all.

And from this it follows that many points imagined in continuous contact do not constitute the line, and as a consequence many lines in continuous contact as regards their sides do not make a surface, nor do many surfaces in continuous contact make a body, because among us bodies are not formed of incorporeal things.

The point is that which has no centre because it is all centre, and nothing can be less.

The contact of the liquid with the solid is a surface common to the liquid and to the solid, and the lighter liquids with the heavier have the same.

All the points are equal to one and one to all.

Nothingness has a surface in common with a thing and the thing has a surface in common with nothingness, and the surface of a thing is not part of this thing. It follows that the surface of nothingness is not part of this nothingness; it must needs be therefore that a mere surface is the common boundary of two things that are in contact; thus the surface of water does not form part of the water nor consequently does it form part of the atmosphere, nor are any other bodies interposed between them. What is it therefore that divides the atmosphere from the water? It is necessary that there should be a common boundary which is neither air nor water but is without substance, because a body interposed between two bodies prevents their contact, and this does not happen in water with air because they are in contact without the interposition of any medium.

Therefore they are joined together and you cannot raise up or move the air without the water, nor will you be able to raise up the flat thing from the other without drawing it back through the air. Therefore a surface is the common boundary of two bodies which are not continuous, and does not form part of either one or the other for if the surface formed part of it it would have divisible bulk, whereas however it is not divisible and nothingness divides these bodies the one from the other.　　　　　　　　　　　　　　　　B.M. 159 V.

OF TIME AS A CONTINUOUS QUANTITY

Although time is numbered among continuous quantities yet through its being invisible and without substance it does not altogether fall under the category of geometrical terms, which are divided in figures and bodies of infinite variety, as may constantly be seen to be the case with things visible and things of substance; but it harmonises with these only as regards its first principles, namely as to the point and the line. The point as viewed in terms of time is to be compared with the instant, and the line resembles the length of a quantity of time. And just as points are the beginning and end of the said line so instants form the end and the beginning of a certain given space of time. And if a line be divisible to infinity it is not impossible for a space of time to be so divided. And if the divided parts of a line may

bear a certain proportion one to another so also may the parts of time.

<div align="right">B.M. 173 V. and 190 V.</div>

Given the cause nature produces the effect in the briefest manner that it can employ.

<div align="right">B.M. 174 V.</div>

Write of the nature of time as distinct from its geometry.

<div align="right">B.M. 176 R.</div>

DISCOURSE

Heat and cold proceed from the propinquity and remoteness of the sun.

Heat and cold produce the movement of the elements.

No element has of itself gravity or levity.

Gravity and levity without increase arise from the movement of the element in itself in its rarefaction and condensation, as we see happen in the atmosphere in the creation of clouds by means of the moisture which is diffused through it.

Gravity and levity when increased proceed along a perpendicular line from one element to another. And these unforseen events have as much more power as they have more of life, and as much more of life as they have more of movement.

The movement originates in the fact that what is thinner can neither resist nor support above it what is more dense.

Levity is born of gravity and gravity of levity; repaying in the same instant the boon of their creation they grow the more in power as they grow in life and have the more life in proportion as they have more movement; in the same instant also they destroy one another in the common vendetta of their death.

For so it is proved: levity is not created unless it is in conjunction with gravity, nor is gravity produced unless it is continued in levity. But the levity has no existence unless it is underneath gravity, and gravity is as nothing unless it is above levity. And so it is with the elements. If for example a quantity of air lay beneath water then it follows that the water immediately acquires gravity; not that it is changed from its first condition but because it does not meet with the due amount of resistance; it therefore descends into the position oc-

cupied by the air which was beneath it and the air fills up the vacuum
which the gravity so created has left in it. B.M. 204 r.

Every continuous quantity is infinitely divisible; therefore the di-
vision of this quantity will never result in a point which is given as the
extremity of a line. It follows that the breadth and depth of the natural
line is divisible to infinity.

It is asked whether all the infinites are equal or whether they are
greater the one than the other. The answer is that every infinite is
eternal and eternal things are of equal permanence but not of equal
length of existence. For that which functioned first commenced to
divide and has passed a longer existence, but the periods to come are
equal. B.M. 204 v.

No element has in itself gravity or levity unless it moves. The earth
is in contact with the water and with the air and has of itself neither
gravity nor levity. It has no consciousness of the water or air which
surrounds it except by accident which arises from their movement.
And this we learn from the leaves of plants which grow upon the earth
when it is in contact with water or air, for they do not bend except by
the movement of the air or water.

From the foregoing we should say that gravity is an incident created
by the movement of the lower elements in the higher.

Levity is an incident created when the thinner element is drawn
beneath the less thin which then moves being unable to resist and then
acquires weight this being created so soon as the element lacks the
power of resistance; which resistance being subdued by weight it does
not change without change of substance; and in changing it acquires
the name of levity.

Levity is not produced except together with gravity, nor gravity
without levity: this may be produced: for let air be suspended under
water by blowing through a pipe, then this air will acquire levity from
being beneath the water and the water will acquire gravity from hav-
ing beneath it the air which is a body thinner and lighter than itself.

Therefore levity is born of weight and weight of lightness, and they
give birth one to another at the same time repaying the boon of their
existence, and at the same instant they destroy one another as the
avengers of their death.

Levity and gravity are caused by immediate movement.

Movement is created by heat and cold.

Movement is an incident created by inequality of weight and force.

The atmosphere has not of itself a natural position and always closes up over a body that is thicker than itself, never over the lighter when it is in contact with it except by violence.

The movement of the elements arises from the sun.

The heat of the universe is produced by the sun.

The light and heat of the universe come from the sun and its cold and darkness from the withdrawal of the sun.

Every movement of the elements arises from heat and cold.

Gravity and levity are created in the elements. B.M. 205 r.

The earth is in contact with the water and the air, and acquires as much weight from the water as from the air; and this is nothing unless they have movement.

This we may learn from the leaves of plants born in the depths of the water which lies upon the meadows, and the leaves and branches of the trees, and similarly from the fact of plants born in the bed of the waters not bending down it is manifest that the air and the water do not give their weight to the earth. B.M. 266 v.

EXAMPLE OF THE CENTRE OF THE WORLD

Suppose the earth to be drawn to the position of the moon together with the water, and that the element of the air fills with itself the vacuum in the air which the earth in separating has left of itself, and that from the air there falls a vase full of air, it is certain that this vase after many wavering movements, that is falling and reflex, will come to a stop at about the centre of the elements. And the centre of the elements will remain in the air that is within the vase and it will not touch the vase. Or suppose the earth hollowed out like a ball full of wind, you will then be certain that this centre is not in the earth, but in the air clothed by the earth. B.M. 267 r.

Why does the eye see a thing more clearly in dreams than the imagination when awake? B.M. 278 v.

Wisdom is the daughter of experience, which experience . . .

Forster III. 14 r.

And this man excels in folly in that he continually stints himself in order that he may not want, and his life slips away while he is still looking forward to enjoying the wealth which by extreme toil he has acquired.

Forster III. 17 v.

Here nature seems in many or for many animals to have been rather a cruel step-mother than a mother, and for some not a step-mother but a compassionate mother.

Forster III. 20 v.

I obey thee, O Lord, first because of the love which I ought reasonably to bear thee; secondly, because thou knowest how to shorten or prolong the lives of men.

Forster III. 29 r.

Shun those studies in which the work that results dies with the worker.

Forster III. 55 r.

Lo some who can call themselves nothing more than a passage for food, producers of dung, fillers up of privies, for of them nothing else appears in the world, nor is there any virtue in their work, for nothing of them remains but full privies.

Forster III. 74 v.

And thou, man, who by these my labours dost look upon the marvellous works of nature, if thou judgest it to be an atrocious act to destroy the same, reflect that it is an infinitely atrocious act to take away the life of man. For thou shouldst be mindful that though what is thus compounded seem to thee of marvellous subtlety, it is as nothing compared with the soul that dwells within this structure; and in truth, whatever this may be, it is a divine thing which suffers it thus to dwell within its handiwork at its good pleasure, and wills not that thy rage or malice should destroy such a life, since in truth he who values it not does not deserve it.

For we part from the body with extreme reluctance, and I indeed believe that its grief and lamentation are not without cause.

Fogli A. 2 r.

The idea or the faculty of imagination is both rudder and bridle to the senses, inasmuch as the thing imagined moves the sense.

Pre-imagining is the imagining of things that are to be.
Post-imagining is the imagining of things that are past.

Fogli B. 2 v.

[*Of new necessities*]¹

Neither promise yourself things nor do things if you see that when deprived of them they will cause you material suffering.

Fogli B. 21 v.

OF NECROMANCY

But of all human discourses that must be considered as most foolish which affirms a belief in necromancy, which is the sister of alchemy, the producer of simple and natural things, but is so much the more worthy of blame than alchemy, because it never gives birth to anything whatever except to things like itself, that is to say lies; and this is not the case with alchemy, which works by the simple products of nature, but whose function cannot be exercised by nature herself, because there are in her no organic instruments with which she might be able to do the work which man performs with his hands, by the use of which he has made glass, etc. But this necromancy, an ensign or flying banner, blown by the wind, is the guide of the foolish multitude, which is a continual witness by its clamour to the limitless effects of such an art. And they have filled whole books in affirming that enchantments and spirits can work and speak without tongues, and can speak without any organic instrument,—without which speech is impossible,—and can carry the heaviest weights, and bring tempests and rain, and that men can be changed into cats and wolves and other beasts, although those first become beasts who affirm such things.

And undoubtedly if this necromancy did exist, as is believed by shallow minds, there is nothing on earth that would have so much power either to harm or to benefit man; if it were true, that is, that by such an art one had the power to disturb the tranquil clearness of the air, and transform it into the hue of night, to create coruscations and tempests with dreadful thunder-claps and lightning-flashes rushing through the darkness, and with impetuous storms to overthrow high

¹ The phrase is one used by Benjamin Jowett with regard to smoking. His advice was: 'Do not set up for yourself any new necessities.'

buildings and uproot forests, and with these to encounter armies and break and overthrow them, and—more important even than this—to make the devastating tempests, and thereby rob the husbandmen of the reward of their labours. For what method of warfare can there be which can inflict such damage upon the enemy as the exercise of the power to deprive him of his crops? What naval combat could there be which should compare with that which he would wage who has command of the winds and can create ruinous tempests that would submerge every fleet whatsoever? In truth, whoever has control of such irresistible forces will be lord over all nations, and no human skill will be able to resist his destructive power. The buried treasures, the jewels that lie in the body of the earth will all become manifest to him; no lock, no fortress, however impregnable, will avail to save anyone against the will of such a necromancer. He will cause himself to be carried through the air from East to West, and through all the uttermost parts of the universe. But why do I thus go on adding instance to instance? What is there which could not be brought to pass by a mechanician such as this? Almost nothing, except the escaping from death.

We have therefore ascertained in part the mischief and the usefulness that belong to such an art if it is real; and if it is real why has it not remained among men who desire so much, not having regard to any deity, merely because there are an infinite number of persons who in order to gratify one of their appetites would destroy God and the whole universe?

If then it has never remained among men, although so necessary to them, it never existed, and never can exist, as follows from the definition of a spirit, which is invisible and incorporeal, for within the elements there are no incorporeal things, because where there is not body there is a vacuum, and the vacuum does not exist within the elements, because it would be instantly filled up by the element. Fogli B. 31 v.

Therefore O students study mathematics and do not build without foundations. Quaderni I. 7 r.

Mental things which have not passed through the understanding are vain and give birth to no truth other than what is harmful. And because such discourses spring from poverty of intellect those who make

them are always poor, and if they have been born rich they shall die poor in their old age. For nature as it would seem takes vengeance on such as would work miracles and they come to have less than other men who are more quiet. And those who wish to grow rich in a day shall live a long time in great poverty, as happens and will to all eternity happen to the alchemists, the would-be creators of gold and silver, and to the engineers who think to make dead water stir itself into life with perpetual motion, and to those supreme fools, the necromancer and the enchanter. Quaderni 1 13 v.

[*The certainty of mathematics*]

He who blames the supreme certainty of mathematics feeds on confusion, and will never impose silence upon the contradictions of the sophistical sciences, which occasion a perpetual clamour.

The abbreviators of works do injury to knowledge and to love, for love of anything is the offspring of knowledge, love being more fervent in proportion as knowledge is more certain; and this certainty springs from a thorough knowledge of all those parts which united compose the whole of that thing which ought to be loved.

Of what use, pray, is he who in order to abridge the part of the things of which he professes to give complete information leaves out the greater part of the matters of which the whole is composed?

True it is that impatience the mother of folly is she who praises brevity; as though such folk had not a span of life that would suffice to acquire complete knowledge of one particular subject such as the human body. And then they think to comprehend the mind of God which embraces the whole universe, weighing and dissecting it as though they were making an anatomy. O human stupidity! Do you not perceive that you have spent your whole life with yourself and yet are not aware of that which you have most in evidence, and that is your own foolishness? And so with the crowd of sophists you think to deceive yourself and others, despising the mathematical sciences in which is contained true information about the subjects of which they treat! Or you would fain range among the miracles and give your views upon those subjects which the human mind is incapable of comprehending and which cannot be demonstrated by any natural instance. And it seems to you that you have performed miracles when

you have spoiled the work of some ingenious mind, and you do not perceive that you are falling into the same error as does he who strips a tree of its adornment of branches laden with leaves intermingled with fragrant flowers or fruits, in order to demonstrate the suitability of the tree for making planks. Even as did Justinus, maker of an epitome of the histories of Trogus Pompeius, who had written an elaborate account of all the great deeds of his ancestors which lent themselves to picturesque description, for by so doing he composed a bald work fit only for such impatient minds as conceive themselves to be wasting time when they spend it usefully in study of the works of nature and of human things.

Let such as these remain in the company of the beasts, and let their courtiers be dogs and other animals eager for prey and let them keep company with them; ever pursuing whatever takes flight from them they follow after the inoffensive animals who in the season of the snow drifts are impelled by hunger to approach your doors to beg alms from you as from a guardian.

If you are as you have described yourself the king of the animals—it would be better for you to call yourself king of the beasts since you are the greatest of them all!—why do you not help them so that they may presently be able to give you their young in order to gratify your palate, for the sake of which you have tried to make yourself a tomb for all the animals? Even more I might say if to speak the entire truth were permitted me.

But do not let us quit this subject without referring to one supreme form of wickedness which hardly exists among the animals, among whom are none that devour their own species except for lack of reason (for there are insane among them as among human beings though not in such great numbers). Nor does this happen except among the voracious animals as in the lion species and among leopards, panthers, lynxes, cats and creatures like these, which sometimes eat their young. But not only do you eat your children, but you eat father, mother, brothers and friends; and this even not sufficing you you make raids on foreign islands and capture men of other races and then after mutilating them in a shameful manner you fatten them up and cram them down your gullet. Say does not nature bring forth a sufficiency of

simple things to produce satiety? Or if you cannot content yourself with simple things can you not by blending these together make an infinite number of compounds as did Platina and other authors who have written for epicures?

And if any be found virtuous and good drive them not away from you but do them honour lest they flee from you and take refuge in hermitages and caves or other solitary places in order to escape from your deceits. If any such be found pay him reverence, for as these are as gods upon the earth they deserve statues, images and honours. But I would impress upon you that their images are not to be eaten by you, as happens in a certain district of India; for there, when in the judgment of the priests these images have worked some miracle, they cut them in pieces being of wood and distribute them to all the people of the locality—not without payment.

And each of them then grates his portion very fine and spreads it over the first food he eats; and so they consider that symbolically by faith they have eaten their saint, and they believe that he will then guard them from all dangers. What think you Man! of your species? Are you as wise as you set yourself up to be? Are acts such as these things that men should do, Justinus? Quaderni II 14 r.

Let no one read me who is not a mathematician in my beginnings.
Quaderni IV 14 v.

Every action of nature is made along the shortest possible way.
Quaderni IV 16 r.

Thou, O God, dost sell unto us all good things at the price of labour.[1]
Quaderni V 24 r.

[1] MS. 'Idio ci vende tutti li beni per prezzo di faticha.' Above it is the word 'oratio' and 'tu' to the right of it is perhaps connected by a stroke with 'idio'. 'Oratio' may either be interpreted as meaning 'a prayer' or it may be a reference to the poet Horace. The latter interpretation receives some support from the fact of the similarity of thought between the sentence which follows and a passage in the *Satires* of Horace, Bk. I, 9, 58-9:

'Nil sine magno
Vita labore dedit mortalibus'.

JOHANNES ANTONIUS DI JOHANNES AMBROSIUS DE BOLATE [1]

He who suffers time to slip away and does not grow in virtue the more one thinks about him the sadder one becomes.

No man has a capacity for virtue who sacrifices honour for gain. Fortune is powerless to help one who does not exert himself. That man becomes happy who follows Christ.

There is no perfect gift without great suffering. Our triumphs and our pomps pass away; gluttony and sloth and enervating luxury have banished every virtue from the world; so that as it were wandering from its course our nature is subdued by habit. Now and henceforth it is meet that you cure yourself of laziness. The Master has said that sitting on down or lying under the quilts will not bring thee to fame.

He who without it has frittered life away leaves no more trace of himself upon the earth than smoke does in the air or the foam on the water. Windsor: Drawings 12349 v.

Nothing grows in a spot where there is neither sentient, fibrous nor rational life. The feathers grow upon birds and change every year; hair grows upon animals and changes every year except a part such as the hair of the beard in lions and cats and creatures like these. The grass grows in the fields, the leaves upon the trees, and every year these are renewed in great part. So then we may say that the earth has a spirit of growth, and that its flesh is the soil; its bones are the successive strata of the rocks which form the mountains; its cartilage is the tufa stone; its blood the springs of its waters. The lake of blood that lies about the heart is the ocean. Its breathing is by the increase and decrease of the blood in its pulses, and even so in the earth is the ebb and flow of the sea. And the vital heat of the world is fire which is spread throughout the earth; and the dwelling place of its creative spirit is in the fires, which in divers parts of the earth are breathed out in baths and sulphur mines, and in volcanoes, such as Mount Etna in Sicily, and in many other places. Leïc. 34 r.

[1] The sentence that commences 'The Master has said' seems to suggest that these are notes of Leonardo's precepts by a pupil, who apparently began by writing his own name.

Falsehood is so utterly vile that though it should praise the great works of God it offends against His divinity. Truth is of such excellence that if it praise the meanest things they become ennobled.

Without doubt truth stands to falsehood in the relation of light to darkness, and truth is in itself of such excellence that even when it treats of humble and lowly matters it yet immeasurably outweighs the sophistries and falsehoods which are spread out over great and high-sounding discourses; for though we have set up falsehood as a fifth element in our mental state it yet remains that the truth of things is the chief food of all finer intellects—though not indeed of wandering wits.

But you who live in dreams, the specious reasonings, the feints which *palla* players might use, if only they treat of things vast and uncertain, please you more than do the things which are sure and natural and of no such high pretension. Sul Volo 12 [11] r.

II

Aphorisms

*'Iron rusts from disuse, stagnant water loses
its purity and in cold weather becomes frozen;
even so does inaction sap the vigour of the mind.'*

WHOEVER in discussion adduces authority uses not intellect but rather
memory.

Good literature proceeds from men of natural probity, and since one
ought rather to praise the inception than the result, you should give
greater praise to a man of probity unskilled in letters than to one
skilled in letters but devoid of probity. C.A. 76 r. a

As courage endangers life even so fear preserves it.
Threats only serve as weapons to the threatened.
Who walks rightly seldom falls.
You do ill if you praise but worse if you censure what you do not
rightly understand. C.A. 76 v. a

To devise is the work of the master, to execute the act of the servant.
He who has most possessions should have the greatest fear of loss.
 C.A. 109 v. a

The natural desire of good men is knowledge. C.A. 119 v. a

Aristotle says that everything desires to keep its own nature.
 C.A. 123 r. a

A thing that moves acquires as much space as it loses. C.A. 152 v. a

Who goes not ever in fear sustains many injuries and often repents.
 C.A. 170 r. b

The acquisition of any knowledge whatever is always useful to the
intellect, because it will be able to banish the useless things and retain
those which are good. For nothing can be either loved or hated unless
it is first known. C.A. 226 v. b

88

Inequality is the cause of all local movements.

There is no rest without equality. c.a. 288 v. a

The words freeze in your mouth and you will make ice on Mount Etna.

Iron rusts from disuse; stagnant water loses its purity and in cold weather becomes frozen; even so does inaction sap the vigour of the mind. c.a. 289 v. c

Happy is that estate which is seen by the eye of its lord.

Love conquers everything.

This by experience is proved, that he who never puts his trust in any man will never be deceived. c.a. 344 r. b

The instruments of swindlers are the seed of human revilings against the gods. c.a. 358 v. a

ANAXAGORAS

Everything comes from everything, and everything is made out of everything, and everything returns into everything, because whatever exists in the elements is made out of these elements. c.a. 385 v. c

Savage is he who saves himself. Tr. 1 a

Folly is the buckler of shame as importunity is of poverty.

Tr. 52 a

[Sketch]

Truth brings it here to pass that falsehood afflicts the lying tongues.

F cover 2 r.

The memory of benefits is frail as against ingratitude.

Reprove a friend in secret but praise him before others.

He who walks in fear of dangers will not perish in consequence thereof.

Lie not about the past. H 16 v.

[Concerning fame]

Nothing is more to be feared than ill fame.

Toil flees away bearing in its arms fame almost hidden. H 17 v.

Lust is the cause of generation.
Appetite is the stay of life.
Fear or timidity is the prolongation of life.
Deceit is the preservation of the instrument. H 32 r.

Moderation curbs all the vices.
The ermine would rather die than soil itself.

OF FORESIGHT

The cock does not crow until he has flapped his wings three times.
The parrot passing from branch to branch never puts his foot where
he has not first fixed his beak.
 Vows begin when hope dies.
 Movement tends towards the centre of gravity. H 48 v.

[*With drawings*]
 To take away pain.
 To know better the direction of the winds.
 From a light thing there proceeds a great ruin. H 100 [43 v.] r.

It is by testing that we discern fine gold.
As is the mould so will the cast be. H 100 [43 r.] v.

He who strips the wall bare on him will it fall.
He who cuts the tree down on him will it take vengeance in its fall.
 Let the traitor avoid death: other punishments if he undergo them
do not mark him. H 118 [25 v.] r.

Ask counsel of him who governs himself well.
Justice requires power, intelligence and will. It resembles the queen
bee.
 He who neglects to punish evil sanctions the doing thereof.
 He who takes the snake by the tail is afterwards bitten by it.
 He who digs the pit upon him will it fall in ruin. H 118 [25 r.] v.

Whoso curbs not lustful desires puts himself on a level with the
beasts.
 You can have neither a greater nor a less dominion than that over
yourself.

He who thinks little makes many mistakes.

It is easier to resist at the beginning than at the end.

No counsel is more trustworthy than that which is given upon ships that are in peril.

Let him expect disaster who shapes his course on a young man's counsel. H 119 [24 r.] v.

Think well to the end, consider the end first. H 139 [4 r.] v.

[*Fear*]

Fear springs to life more quickly than anything else. L 90 v.

He who injures others does not safeguard himself. M 4 v.

Give to your master the example of the captain, for it is not he who conquers but the soldiers by means of his counsel and yet he deserves the reward. Forster II 15 v.

It is as great an error to speak well of a worthless man as to speak ill of a good man. Forster II 41 v.

Necessity is the mistress and guardian of nature.

Necessity is the theme and artificer of nature—the bridle, the law, and the theme. Forster III 43 v.

Poor is the pupil who does not surpass his master. Forster III 66 v.

[*Sketch—head of old woman*]

In life beauty perishes and does not endure.[1] Forster III 72 r.

Dust makes damage. Quaderni III 10 v.

[1] The text of this sentence *Cosa bella mortal passa e non dura* as has been pointed out by Sir Eric Maclagan in a letter in *The Times Literary Supplement* (March 8th, 1923) occurs as a line in a sonnet of Petrarch: 'Chi vuol veder quantunque può Natura', No. cxc, line 8.

In the former edition of *Leonardo's Notebooks* I translated this sentence as 'in life beauty perishes, not in art', having in my reading of the text followed Dr. Richter in supposing the last word to be 'dart' for 'd'arte'. A further examination of a photograph of the page kindly supplied to me by Sir Eric Maclagan has convinced me of my error.

It is in the erroneous form *cosa bella mortal passa e non d'arte* which originated merely in an error of transcription that the sentence occurs on the title-page of d'Annunzio's tragedy *La Gioconda*.

The heavy cannot be created without it being joined with the light and together they destroy each other. Quaderni III 12 r.

[*Studies of emblems with mottoes*]
Obstacles cannot bend me.
Every obstacle yields to effort.
Not to leave the furrow.
He who fixes his course by a star changes not.
 Windsor: Drawings 12282 r.

[*Drawings of same*]
Persistent effort.
Predetermined effort.
He is not turned who is fixed to such a star.
 Windsor: Drawings 12701

May I be deprived of movement ere I weary of being useful.
Movement will fail sooner than usefulness.
Death rather than weariness.
I never weary in being useful. I am not tired of serving others.
I weary not in welldoing is a motto for carnival.
Without fatigue.
No labour suffices to tire me.
Hands into which fall like snow ducats and precious stones, these never tire of serving, but such service is only for its usefulness and not for our own advantage.
I never weary of being useful.
Naturally nature has so fashioned me. Windsor: Drawings 12700 r.

He who wishes to become rich in a day is hanged in a year.
 Windsor: Drawings 12351 r.

III

Anatomy

*'I reveal to men the origin of their second—first or
perhaps second—cause of existence.'*

*'Would that it might please our Creator that I were
able to reveal the nature of man and his customs
even as I describe his figure.'*

[*Precepts for the study of the foot*]

You will make these two feet with the same contours turned in the
same direction, and do not pay any regard to the fact that they remain
the one right and the other left, because by making them so they will
be easier to understand.

First you will make all these bones separated the one from the other,
arranged in such a way that each part of each bone may be seen, or
may be turned towards the side of that bone from which it is separated,
and to which it should be reunited when you join up all the bones of
these feet together in their first state.

And this demonstration is made in order to be better able to recog-
nise the true shape of each bone in itself; and you will do the same with
each demonstration of each limb in whatever direction it may be
turned. Fogli A 1 r.

[*Method for the study of the arm and the forearm*]

You will first have these bones sawn lengthwise and then across, so
that one can see where the bones are thick or thin; then represent them
whole and disjoined, as here above, but from four aspects in order that
one can understand their true shape; then proceed to clothe them by
degrees with their nerves, veins and muscles.

[*Method for the study of the parts of the human body*]

The true knowledge of the shape of any body will be arrived at by
seeing it from different aspects. Consequently in order to convey a

93

notion of the true shape of any limb of man who ranks among the animals as first of the beasts I will observe the aforesaid rule, making four demonstrations for the four sides of each limb, and for the bones I will make five, cutting them in half and showing the hollow of each of them, one being full of marrow the other spongy or empty or solid.

[*Of the bones of the arm*]

The arm, which has the two bones that interpose between the hand and the elbow, will be somewhat shorter when the palm of the hand is turned towards the ground than when it is turned towards the sky, if the man is standing on his feet with his arm extended. And this occurs because these two bones, in turning the palm of the hand towards the ground, come to intersect in such a way that that which proceeds from the right side of the elbow goes towards the left side of the palm of the hand, and that which proceeds from the left side of the elbow ends on the right side of the palm of this hand.

The arm is composed of thirty pieces of bone, because there are three in the arm itself and twenty seven in the hand. Fogli A 1 v.

[*Of the attachment of the muscles*]

The above-mentioned muscles are not firm except at the extremities of their receptacles and at the extremities of their tendons; and this the Master has done in order that the muscles may be free and ready to be able to grow thicker or shorter or finer or longer according to the necessity of the thing which they move. Fogli A 2 r.

Commence your anatomy with the head and finish it with the soles of the feet.

[*Voice production—mechanism of*]

Rule to see how the sound of the voice is produced in the front of the trachea. This will be understood by separating this trachea together with the lung of the man, and if this lung be filled with air and then closed rapidly one will be able immediately to see in what way the pipe called the trachea produces this sound; and this can be perceived and heard well in the neck of a swan or a goose which often continues to sing after it is dead.

One cannot swallow and breathe or make a sound at the same time.

One cannot breathe by the nose and by the mouth at the same time; and this is shown if one should attempt to play a whistle or flute with the nose and another with the mouth at the same time.

WHY THE VOICE GROWS THIN IN THE OLD

The voice grows thin in the old because all the passages of the trachea become restricted as do the other intestines. Fogli A 3 r.

The pieces of the bone of which a man's foot is composed number twenty seven, taking into account the two which are beneath the base of the great toe of the foot. Fogli A 3 v.

THE NATURE OF THE VEINS

The origin of the sea is the contrary to that of the blood, for the sea receives within itself all the rivers, which are entirely caused by the aqueous vapours that have ascended up into the air; while the sea of the blood is the source of all the veins.

OF THE NUMBER OF THE VEINS

The vein is one whole, which is divided into as many main branches as there are principal places which it has to nourish, and these branches are subdivided in an infinite number.

[*Movements of the neck*]

The neck has four movements, of which the first consists of raising the second of lowering the face, the third of turning right or left, the fourth of bending the head right or left. [. . .] are mixed movements, namely raising or lowering the face with an ear near to a shoulder, and similarly raising or lowering the face after turning it towards one of the shoulders; also raising or lowering the face after turning it to one of the shoulders while keeping one eye lower or higher than the other, and this is called separated movement.

And to these movements should be assigned the cords and muscles which are the cause of these movements, and consequently, if a man should be found lacking in power to make one of these movements as a

result of some wound, one can discern with certainty which cord or muscle is impeded. Fogli A 4 r.

[*The true conception of figures*]

One possesses a true conception of all figures when one knows their breadth, length and depth; if therefore I observe the same in the figure of the man I shall give a true conception of it in the opinion of everyone of sound intelligence.

Explain these words for they are confused.

[*Arrangement of muscles of neck and thorax*]

Make it twice as much larger with a corresponding thickness of ribs and muscles, and it will be easier to understand.

Again this figure would be confused unless you first of all made at least three demonstrations before this with similar threads; demonstrations of which the first should be merely of the bones, then follow with the muscles which start in the breast above the ribs, and finally the muscles that start from the thorax together with the ribs and last of all that above.

Make the ribs so thin that in the final demonstration made with the threads the position of the shoulder-blade may be visible.

[*Precepts for the study of the muscles*]

Before you represent the muscles make, in place of these, threads which may serve to show the positions of these muscles, which should abut with their extremities in the centre of the attachment of the muscles above their bones. And this will supply a speedier conception when you wish to represent all the muscles one above the other. And if you make it in any other way your representation will be confused.

Fogli A 4 v.

[*Precepts for the study of the cervical vertebrae*]

These three vertebrae should be shown from three aspects as has been done with three from the backbone.

The vertebrae of the neck are seven of which the first above and the second differ from the other five.

You should make these bones of the neck from three aspects united and from three separated: and so you will afterwards make them from two other aspects, namely seen from below and from above, and in this

way you will give the true conception of their shapes, which neither ancient nor modern writers have ever been able to give without an infinitely tedious and confused prolixity of writing and of time.

But by this very rapid method of representing from different aspects a complete and accurate conception will result, and as regards this benefit which I give to posterity I teach the method of reprinting it in order, and I beseech you who come after me, not to let avarice constrain you to make the prints in . . . Fogli A 8 v.

The act of procreation and the members employed therein are so repulsive, that if it were not for the beauty of the faces and the adornments of the actors and the pent-up impulse, nature would lose the human species.

[*Movement and force of animals subject to mechanical laws*]
Arrange it so that the book of the elements of mechanics with examples shall precede the demonstration of the movement and force of man and of the other animals, and by means of these you will be able to prove all your propositions.

[*Anatomy of hand*]
Describe how many membranes intervene between the skin and the bones of the hand.

[*Precepts for study of muscles of hand*]
These muscles of the hand may be made first of threads and then according to their true shape.

And they are the muscles that move all the palm of the hand.

When you have represented the bones of the hand and you wish to represent above this the muscles which are joined with these bones make threads in place of muscles. I say threads and not lines in order to know what muscle passes below or above the other muscle, which thing cannot be shown with simple lines; and after doing this make another hand afterwards at the side of it where there may be the true shape of these muscles as is shown here above. Fogli A 10 r.

REPRESENTATION OF THE HAND

The first demonstration of the hand will be made of the bones alone. The second of the ligaments and various chains of nerves that bind them together. The third will be of the muscles which spring up upon these bones. The fourth will be of the first tendons which rest upon these muscles and go to supply movement to the tips of the fingers. The fifth will be that which shows the second set of tendons which move all the fingers and end at the last but one of the bones of the fingers. The sixth will be that which will show the nerves that impart sensation to the fingers of the hand. The seventh will be that which will show the veins and arteries that nourish and invigorate the fingers. The eighth and last will be the hand clothed with skin, and this will be shown for an old man, a young man and a child, and for each there should be given the measurement of the length, thickness and breadth of each of its parts. Fogli A 10 v.

[Precepts for the study of the foot]

Make a demonstration of this foot with the simple bones; then leaving the membrane that clothes them make a simple demonstration of the nerves; and then over the same bones make one of tendons, and then one of veins and artery together. And finally a single one to contain artery, veins, nerves, tendons, muscles and bones.

The muscles that move the toes at their points, both below and above, all appear in the leg between the knee and the joint of the foot; and those that move the whole toe upwards and downwards appear on the upper and lower side of the foot; and as the hand works with its arm so does the foot with the leg. Fogli A 11 r.

[Precepts for the study of the foot]

Make a demonstration of these feet without the membrane that clothes the bones, which membrane takes possession of these bones, interposing itself between these bones and the muscles and tendons that move them; and by this way you will be able to show under which tendons, nerves, veins or muscle are the joints of the bones.

[Representation of the limbs in action]

After the demonstration of all the parts of the limbs of man and of

the other animals you will represent the proper method of action of these limbs, that is in rising after lying down, in moving, running and jumping in various attitudes, in lifting and carrying heavy weights, in throwing things to a distance and in swimming, and in every act you will show which limbs and which muscles are the causes of the said actions, and especially in the play of the arms.

REASON WHY TWO MUSCLES ARE JOINED TOGETHER

It often occurs that two muscles are joined together although they have to serve two limbs; and this has been done so that if one muscle were incapacitated by some injury the other muscle in part supplied the place of that which was lacking. Fogli A 11 v.

[*Precepts for the study of the bones of the foot*]

You will represent these bones of the feet all equally spread out, in order that their number and shape may be distinctly understood. And this difference you will represent from four aspects in order that the true shape of these bones in all their aspects may be more accurately known.

Make the bones of the foot somewhat separated one from another in such a way that one may readily distinguish one from another, and this will be the means of imparting the knowledge of the number of the bones of the feet and of their shape.

At the end of every representation of the feet you will give the measure of the thickness and length of each of the bones and its position.

The aspects of the foot are six, namely: below, above, within, outside, behind and before; and to these is added the six demonstrations of the separated bones between them; and there are those of the bones sawn lengthwise in two ways, that is, sawn through the side and straight so as to show all the thickness of the bones. Fogli A 12 r.

[*Motor muscles of hands and wings*]

No movement either of the hand or the fingers is produced by the muscles above the elbow; and so it is with birds and it is for this reason that they are so powerful because all the muscles which lower

the wings spring from the breast and these have in themselves a greater weight than that of all the rest of the bird. Fogli A 12 v.

[*Insertion of muscles*]

You will make a second representation of the bones in which you will show how the muscles are fastened upon the bones.

Fogli A 13 r.

[*Precepts for the study of the bones and the muscles of man and horse*]

Note where the lowest parts of the muscles of the shoulder *a b c d* are fixed, and which are those that are attached above the bone called humerus, and which are attached above the other muscles.

Make for each bone separated by itself its muscles, that is the muscles which grow upon it.

Show all the causes of the movement of the skin, flesh and muscles of a face, and whether the muscles derive their movement from the nerves that come from the brain or no.

And do this first of all with the horse which has big muscles and parts very distinct.

See whether the muscle that raises the horse's nostrils is the same as is found here in the man at *f*, which comes out of the hole in the bone *f*.

[*Arrangements of vessels and nerves of fingers*]

Have you seen the diligence of nature in having situated the nerves, arteries and veins not in the centre but in the sides of the fingers so that they are not in any way pierced or cut by the movements of the fingers?

[*Nerves of sensibility and movement of the fingers and their independence of function*]

See if you understand that this sense is employed by the player of an organ, and that the mind at such time waits on the sense of hearing.

Fogli A 13 v.

[*Necessary to represent and to describe*]

And you who think to reveal the figure of man in words, with his limbs arranged in all their different attitudes, banish the idea from you, for the more minute your description the more you will confuse the mind of the reader and the more you will lead him away from the

knowledge of the thing described. It is necessary therefore for you to represent and describe.

Should the actual thing being in relief seem to you to be more recognisable than what is here drawn, which impression springs from the fact of your being able to see the object from different aspects, you must understand that in this representation of mine the same result will be obtained from the same aspects; and therefore no part of these limbs will be hidden from you.

[Precepts for study of muscles of shoulder]

Describe each muscle, what finger it serves and what limb; represent it therefore simply, without any impediment from any other muscle that is placed over them, and in this way you will afterwards be able to recognise the parts which are injured.

You will never know the shape of the shoulder without this rule.

Write how each muscle can become extended or contracted or made thinner or thicker, and which is more or less powerful.

Represent here always together the veins and nerves with the muscles, so that one may see how the muscles are embraced by these veins and nerves, and take away the sides in order that one may see better how the larger muscle is joined to the shoulder-blade.

Fogli A 14 v.

[Of the muscles]

Make a demonstration with muscles lean and thin so that the space that is produced between the one and the other may make a window in order to show that which is found behind them.

As in this representation of a shoulder made here in charcoal.

The muscles are of two shapes with two different names, of which the shorter is called muscle and the longer is called lacert.

NATURE OF MUSCLES

The tendons of the muscles are of greater or less length as a man's fleshy excrescence is greater or less. And in leanness the fleshy excrescence always recedes towards the point at which it starts from

the fleshy part. And as it puts on fat it extends towards the beginning of its tendon.

HOW THE MUSCLES ARE ATTACHED TO THE JOINTS OF THE BONES

The end of each muscle becomes transformed into tendon, which binds the joint of the bone, to which this muscle is attached.

OF THE NUMBER OF THE TENDONS AND OF THE MUSCLES

The number of the tendons which successively one above the other cover each other and all together cover and bind the joint of the bones to which they are joined, is as great as the number of the muscles which meet in the same joint.

If the junction of the muscle *b* is made with the bone of the thigh and actually with the muscle *a*, or the muscle *b* and the muscle *a* since they are joined together, they unite and establish themselves upon this bone of the thigh. And this third manner is more useful for the benefit of the movement of this thigh, and more certain, for if the muscle *a* were cut or otherwise injured the muscle *b* would itself move the thigh, which it could not do if it were separated from the bone between *b a*. Fogli A 15 r.

[*Action of muscles in breathing*]

These muscles have a voluntary and an involuntary movement seeing that they are those which open and shut the lung. When they open they suspend their function which is to contract, for the ribs which at first were drawn up and compressed by the contracting of these muscles then remain at liberty and resume their natural distance as the breast expands. And since there is no vacuum in nature the lung which touches the ribs from within must necessarily follow their expansion; and the lung therefore opening like a pair of bellows draws in the air in order to fill the space so formed. Fogli A 15 v.

[*General precepts*]

Begin your anatomy with a man fully grown: then show him

elderly and less muscular: then go on to strip him stage by stage right down to the bones.

And you should afterwards make the child so as to show the womb.

[Relation between size and function of muscles]

In all the parts where man has to work with greater effort nature has made the muscles and tendons of greater thickness and breadth.

Fogli A 16 r.

[Function of muscles in breathing]

TREATS OF MAN ACCORDING TO THE INSTRUMENTAL METHOD AND THE CONTRARY

With the muscles it happens almost universally that they do not move the limb where they are fixed but move that where the tendon that starts from the muscle is joined, except that which raises and moves the side in order to help respiration.

All these muscles serve to raise the ribs and as they raise the ribs they dilate the chest, and as the chest becomes dilated the lung is expanded, and the expansion of the lung is the indrawing of the air which enters by the mouth into this lung as it enlarges.

OF THE DEMONSTRATION OF HOW THE SPINE IS FIXED IN THE NECK

In this demonstration of the neck one will make as many shapes of muscles and tendons as are the uses of the movements of the neck. And the first as is here noted is how the ribs in their strength keep the spine of the neck straight, and by means of the tendons which go up to this spine these tendons serve a double use, that is they support the spine by means of the ribs and support the ribs by means of the spine.

And this duplication of powers situated at the opposite extremities of this tendon works with this tendon in the same manner as the tendon works with the extremities of the arch.

But this convergence of muscles in the spine keeps it upright, just as the ropes of the ship support its mast; and the same ropes bound to the mast also support in part the edges of the ships to which they are joined.

OF THE METHOD OF REPRESENTING THE CAUSES OF THE MOVEMENTS OF ANY LIMB

Make first the motor muscles of the bone called the humerus; then make in the humerus the motor muscles of the arm which cause it to straighten or bend; then show separately the muscles that have their origin in this humerus, which only serve to turn back the arm when it turns the hand upside down; then represent in the arm only the muscles which move the hand up and down and from side to side without moving the fingers in it; then represent the muscles which merely move the fingers, locking them together or extending them or spreading them out or bringing them together; but first represent the whole as is done in the cosmography, and then divide it into the aforesaid parts, and do the same for the thigh, the leg and the feet.

OF THE MUSCLES THAT START IN THE RIBS REPRESENTED ABOVE

I have for a long time and not without reason doubted whether the muscles which start beneath the shoulder-blades above the third, fourth and fifth right rib, and the same also on the left side, are made for the purpose of keeping straight the spinal column of the neck to which they attach themselves with their tendons, or whether in fact these muscles, as they contract, draw themselves together with the ribs towards the nape of the neck, by means of the aforesaid tendons attached to the spinal column; and reason moves me to believe that these muscles are intended to support the spinal column, so that it may not bend in having to support the heavy head of the man, as it bends down or is raised, for the help of which the muscles of the shoulders or of the pit of the throat do not serve, seeing that the man will relax these which start in the shoulders or the pit of the throat when he raises his shoulders towards his ears, and will so take away force from his muscles; and by this loosening and contracting the movement of the neck will not be impeded, nor will the resistance of the spinal column in supporting this head. And I am further confirmed in this same opinion by the powerful shape of the ribs where these muscles are situated, which is extremely adapted to resist every weight or force which would draw

the tendon *a b* in the contrary direction, which drawing it against the rib *b r* fixes it in greater power in the position *r*. And if this tendon had to raise the rib in order to facilitate and increase the breathing, nature would have placed this cord not in the slant *a b*, but in the greater slant *a c*. And read the propositions set forth below and in the margin, which are to the purpose. Fogli A 16 v.

[Muscles of hand, leg and foot. Dated note: 1510]

When you represent the hand represent with it the arm as far as the elbow, and with this arm the sinews and muscles which come to move this arm away from the elbow. And do the same in the demonstration of the foot.

All the muscles that start at the shoulders, the shoulder-blade and the chest, serve for the movement of the arm from the shoulder to the elbow. And all the muscles that start between the shoulder and the elbow, serve for the movement of the arm between the elbow and the hand. And all the muscles that start between the elbow and the hand, serve for the movement of the hand. And all the muscles that start in the neck, serve for the movement of the head and shoulders.

When you represent the muscles of the thigh, represent with these the bone of the leg, so that one may know where these muscles attach themselves to these bones of the legs.

You will then make the leg with its muscles attached to the bones of the leg, and make the bones bare. And you will follow the same plan for all the sinews.

The muscles of the feet serve for the movement of its toes, and in this movement they are aided by the tendons which spring from the muscles of the leg.

Which are the muscles of the leg which serve merely for the simple movement of the foot, and which are those of this leg that serve merely for the simple movement of the toes of this foot? And remember, in clothing the bones of the leg with its muscles to represent first the muscles that move the feet, which you will join to the feet.

Represent here the foot of the bear, the monkey and other animals, in so far as they differ from the foot of man; and put also the feet of some of the birds.

The muscles of the leg from the knee to the joint of the foot are as

many in number as the tendons attaching to the upper part of the toes of the feet; and it is the same below, adding to them those which move the feet upwards and downwards and to and fro, and of these those which raise the toes are five. And there are as many muscles of the feet above and below as the number of the fingers doubled. But as I have not yet finished this discourse I will leave it for the present, and this winter of the year 1510 I look to finish all this anatomy.

The tendons that lower the toes of the feet start from the muscles which have their beginning in the sole of this foot; but the tendons that raise these toes do not have their beginning in the outer part of the thigh as some have written, but they start in the upper part of the foot called the instep. And if you desire to make certain of this, clasp the thigh with your hands a little above the knee and raise the toes of the feet, and you will perceive that the flesh of your thigh will not have any movement in it in its tendons or muscles; so it is quite true.

Fogli A 17 r.

[Precepts for the study of the foot]

Use the same rule for the foot that you have used for the hand; that is representing first the bones from six aspects, namely: behind, in front, below and above, on the inside and on the outside.

[Considerations upon the origin of the muscles of the foot]

Mondinus says that the muscles which raise the toes of the feet are to be found in the outer part of the thigh; and then adds that the back of the foot has no muscles because nature has wished to make it light so that it should be easy in movement, as if it had a good deal of flesh it would be heavier; and here experience shows that the muscles $a\ b\ c\ d$ move the second pieces of the bones of the toes; and that the muscles of the leg $r\ S\ t$ move the points of the toes. Here then it is necessary to enquire why necessity has not made them all start in the foot or all in the leg; or why those of the leg which move the points of the toes should not start in the foot instead of having to make a long journey in order to reach these points of the toes; and similarly those that move the second joints of the toes should start in the leg.

[Precepts]

Set down first the two bones of the leg from the knee to the foot, then show the first muscles that start upon the said bones, and pro-

ceeding thus you will make one above the other in as many different demonstrations as are the stages in their positions, one above the other; and you will do it thus as far as the end of one side, and you will do the same for four sides in their entirety with all the foot, because the foot moves by means of tendons which start in these muscles of the leg; but the side where is the sole is moved with muscles that start in this sole; and the membranes of the joints of the bones start from the muscles of the thigh and of the leg.

After you have made the demonstration of the bone, show next how it is clothed by those membranes which are interposed between the tendons and these bones.

Remember, in order to make certain as to the origin of each muscle, to pull out the tendon produced by this muscle in such a way as to see this muscle move and its commencement upon the ligaments of the bones.

Avic[enna]. The muscles that move the toes of the feet are sixty.

[*By way of note*]

You will make nothing but confusion in your demonstration of the muscles and their positions, beginnings and ends, unless first you make a demonstration of the fine muscles by means of threads; and in this way you will be able to represent them one above another as nature has placed them; and so you will be able to name them according to the member that they serve, that is, the mover of the point of the big toe, and of the middle bone, or the first bone, etc.

And after you have given these details you will show at the side the exact shape and size and position of each muscle; but remember to make the threads that denote the muscles in the same positions as the central lines of each muscle, and in this way these threads will show the shape of the leg and their distance in rapid movement and in repose.

[*The extensor and flexor muscles of the foot*]

The muscles which are only used to move the foot as it rises forward are *m n*, which start in the leg from the knee downwards; and those which bend it towards the outside of the ankle are the muscles *f n*; therefore *n* is common to both these movements.

[*Atrophy of the muscles*]

I have stripped of skin one who by an illness had been so much wasted that the muscles were worn away and reduced to a kind of thin pellicle, in such a way that the tendons instead of becoming converted into muscle were transformed into loose skin; and when the bones were clothed with skin their natural size was but slightly increased.

[*Topography of the muscles and motor and sensory nerves of the lower limb*]

You will show first the bones separated and somewhat out of position, so that it may be possible to distinguish better the shape of each piece of bone by itself. Afterwards you join them together in such a way that they do not diverge from the first demonstration, except in the part which is occupied by their contact. Having done this you will make the third demonstration of those muscles that bind the bones together. Afterwards you will make the fourth of the nerves which convey sensation. And then follows the fifth of the nerves that move or give direction to the first joints of the toes. And in the sixth you will make the muscles above the feet where are ranged the sensory nerves. And the seventh will be that of the veins which feed these muscles of the foot. The eighth will be that of the nerves that move the points of the toes. The ninth of the veins and arteries that are interposed between the flesh and the skin. The tenth and last will be the completed foot with all its powers of feeling. You will be able to make the eleventh in the form of a transparent foot, in which one is able to see all the aforesaid things.

[*Precepts for the study of the leg*]

But make first the demonstration of the sensory nerves of the leg, and their ramification, from four aspects, so that one may see exactly from whence these nerves have their origin; and then make a representation of a foot young and soft with few muscles.

All the nerves of the legs in front serve the points of the toes, as is shown with the great toe.

[*By way of note*]

After making your demonstrations of the bones from various aspects then make the membranes which are interposed between the bones and

the muscles; and in addition to this, when you have represented the first muscles, and have described and shown their method of working, make the second demonstration upon these first muscles, and the third demonstration upon the second, and so in succession.

Make here first the simple bones, then clothe them gradually stage by stage in the same way that nature clothes them.

When defining the foot it must necessarily be joined with the leg as far as the knee, because in this leg start the muscles which move the points of the toes, that is the final bones.

In the first demonstration the bones should be somewhat separated one from another, in order that their true shape may be revealed. In the second the bones should be shown sawn through, in order that it may be seen what part is hollow and what part solid. In the third demonstration these bones should be joined together. In the fourth should be the ligaments that connect one of these bones with another. In the fifth the muscles that strengthen these bones. Sixth the muscles should be shown with their tendons. Seventh the muscles of the leg with the tendons that go to the toes. Eighth the nerves of sensation. Ninth the arteries and veins. Tenth the muscular skin. Eleventh the foot in its final beauty.

And each of the four aspects should have these eleven demonstrations. Fogli A 18 r.

[*Notes*]

Of the nerves which raise the shoulders and which raise the head, and those which lower it and which turn it and which bend it across:

To lower the back. To bend it. To twist it. To raise it.

You will write upon physiognomy.

I find that the veins serve no other function than to heat, as nerves and things that have to give sensation. Fogli B 1 r.

[*Vital functions of the body*]

Cause of breathing.

Cause of the movement of the heart.

Cause of vomiting.

Cause of the food descending into the stomach.

Cause of the emptying of the intestines.

Cause of the movement of the superfluous matter through the intestines.

Cause of swallowing.

Cause of coughing.

Cause of yawning.

Cause of sneezing.

Cause of the numbness of various limbs.

Cause of loss of sensation in any limb.

Cause of the tickling sensation.

Cause of sensuality and other necessities of the body.

Cause of urination.

And so of all the natural actions of the body.　　　　Fogli B I v.

The sense of touch clothes all the surface skin of man.

HOW THE FIVE SENSES ARE THE MINISTERS OF THE SOUL

The soul apparently resides in the seat of the judgment, and the judgment apparently resides in the place where all the senses meet, which is called the common sense; and it is not all of it in the whole body as many have believed, but it is all in this part; for if it were all in the whole, and all in every part, it would not have been necessary for the instruments of the senses to come together in concourse to one particular spot; rather would it have sufficed for the eye to register its function of perception on its surface, and not to transmit the images of the things seen to the sense by way of the optic nerves; because the soul—for the reason already given—would comprehend them upon the surface of the eye.

Similarly, with the sense of hearing, it would be sufficient merely for the voice to resound in the arched recesses of the rock-like bone which is within the ear, without there being another passage from this bone to the common sense, whereby the said mouth might address itself to the common judgment.

The sense of smell also is seen to be forced of necessity to have recourse to this same judgment.

The touch passes through the perforated tendons and is transmitted

to this sense; these tendons proceed to spread out with infinite ramifications into the skin which encloses the body's members and the bowels. The perforating tendons carry impulse and sensation to the subject limbs; these tendons passing between the muscles and the sinews dictate to these their movement, and these obey, and in the act of obeying they contract, for the reason that the swelling reduces their length and draws with it the nerves, which are interwoven amid the particles of the limbs, and being spread throughout the extremities of the fingers, they transmit to the sense the impression of what they touch.

The nerves with their muscles serve the tendons even as soldiers serve their leaders, and the tendons serve the common sense as the leaders their captain, and this common sense serves the soul as the captain serves his lord.

So therefore the articulation of the bones obeys the nerve, and the nerve the muscle, and the muscle the tendon, and the tendon the common sense, and the common sense is the seat of the soul, and the memory is its monitor, and its faculty of receiving impressions serves as its standard of reference.

How the sense waits on the soul, and not the soul on the sense, and how where the sense that should minister to the soul is lacking, the soul in such a life lacks conception of the function of this sense, as is seen in the case of a mute or one born blind. Fogli B 2 r.

How the nerves sometimes work of themselves, without the command of other agents or of the soul:

This appears clearly for you will see how paralytics or those who are shivering or benumbed by cold move their trembling limbs such as the head or the hands without permission of the soul; which soul with all its powers cannot prevent these limbs from trembling. The same happens in the case of epilepsy or with severed limbs such as the tails of lizards.

FUNCTION OF LIVER, BILE, AND INTESTINES

The liver is the distributor and dispenser of vital nourishment to man.

The bile is the familiar or servant of the liver which sweeps away

and cleans up all the dirt and superfluities left after the food has been distributed to the members by the liver.

The intestines. As to these you will understand their windings well if you inflate them. And remember that after you have made them from four aspects thus arranged you then make them from four other aspects expanded in such a way that from their spaces and openings you can understand the whole, that is, the variations of their thicknesses. Fogli B 2 v.

[Chyle. Mesentery]

By the ramification of the vein of the chyle in the mesentery nourishment is drawn from the corruption of the food in the intestines, and in the last instance it returns by the final ramifications of the artery to these intestines where this blood being afterwards dead it is corrupted and acquires the same stench as comes from the faeces.

The mesentery is a thick sinewy and greasy membrane in the ramifications of which are twelve chief veins, and it is joined to the lower part of the diaphragm.

See whether the mesentery has arteries or no.

In this mesentery are planted the roots of all the veins, which unite at the gate of the liver and purify the blood in the liver; and it then enters the vein of the chyle, and this vein goes to the heart and makes purer the blood which penetrates in the arteries as spirituous blood.

 Fogli B 3 r.

OF THE FORCE OF THE MUSCLES

If any muscle whatsoever be drawn out lengthwise a slight force will break its fleshy tissue; and if the nerves of sensation be drawn out lengthwise slight power tears them from the muscles where their ramification weaves them together and spreads and consumes itself; and one sees the same process enacted with the sinewy covering of the veins and arteries which are mingled with these muscles. What is therefore the cause of so great a force of arms and legs which is seen in the actions of any animal whatsoever? One cannot say other than that it is the skin which clothes them; and that when the nerves of sensation thicken the muscles these muscles contract and draw after them the tendons in which their extremities become converted; and in this proc-

ess of thickening they fill out the skin and make it drawn and hard;
and it cannot be lengthened out unless the muscles become thinner;
and not becoming thinner they are a cause of resistance and of making
strong the before mentioned skin, in which the swollen muscles per-
form the function of a wedge.

[*Precepts for demonstrations*] [*With drawing*]

Only represent in this demonstration the first upper rib, for this of
itself suffices to show where the neck is divided from the bust.

Represent the proportionate length and thickness that the nerves of
the arms and legs have to each other.

[*Of the neck*]

You will use extreme diligence in making this demonstration of the
neck inside, outside and in profile, and the proportions of the tendons
and of the nerves between them, and with the positions where they
begin and end; for if you were to do otherwise you would neither be
able to treat of nor demonstrate the office or use for which nature or
necessity has intended them. And in addition to this you should de-
scribe the distances interposed between the nerves themselves both
as regards their depth and breadth, and the differences in the heights
and depths of their origins; and you will do the like with the muscles
veins and arteries; and this will be extremely useful to those who have
to dress wounds. Fogli B 3 v.

[*Umbilical vein*]

Note if the umbilical veins are four both in males and females.

By *x v* umbilical vein is composed the life and the body of every ani-
mal of four feet, except those that start from the egg, such as frogs,
tortoises, green lizards, chameleons and the like.

I believe that these four nerves are those of the reins or arteries.

I have found that they are of the greater veins of the reins.

The navel is the gate from which our body is formed by means of
the umbilical vein. Fogli B 4 r.

This demonstration is as necessary for good draughtsmen as the
derivation from Latin words is to good grammarians; for anyone must
needs make the muscles of figures badly in their movements and ac-

tions unless he knows which are the muscles that are the cause of their movements.　　　　　　　　　　　　　Fogli B 4 v.

[*Reason for position of veins in knee*]

Nature has placed the principal veins of the leg in the middle of the thickness of the knee joint, because in the process of bending this joint the veins are less compressed than if they were situated in front of or behind the knee.

[*Relation of nerves with muscles*]

There are as many ramifications of the nerves as there are muscles, and there cannot be either more or less, because these muscles can only be contracted or distended by reason of these nerves from which the muscles receive their sensation. And there are as many tendons that move the limbs as there are muscles.　　　　　　　Fogli B 5 r.

[*Nerves*]

The nerves in some parts of a man are round, in others flat.

The nerves start lower than the veins of the kidneys.

There are as many nerves as there are muscles in the thigh.

　　　　　　　　　　　　　　　　　　　Fogli B 6 r.

The vertebrae of the back behind the kidneys number five.

[*List of anatomical demonstrations*]

Three men complete.

Three with bones and veins.

Three with bones and nerves.

Three with simple bones.

These are twelve demonstrations of whole figures.　　Fogli B 6 v.

The vein *saphena* with its other collaterals and adherents which serve to supply the nourishment of the thigh ought to be inclosed by the lines that form the boundaries of the whole leg.　　　　Fogli B 8 r.

At about the centre of the height, breadth and bulk of the man there is more intricacy of structure than in any other part of him; and it is even greater in the woman who in the same part has bladder, womb, ovaries, rectum, hæmorrhoidal veins, nerves, muscles, cartilages and like things.　　　　　　　　　　　　　　　Fogli B 8 v.

Draw the arm of Francesco the miniaturist which shows many veins.

[*Precepts for anatomical drawings and demonstrations*]

In demonstrations of this kind you should show the exact contours of the limbs by a single line; and in the centre place their bones with the true distances from their skin, that is the skin of the arm; and then you will make the veins which may be whole upon a clear ground; and thus there will be given a clear conception as to the position of the bone, vein and nerves.

[*Changes of the arteries in age*]

In proportion as the veins become old they lose their straightness of direction in their ramifications, and become so much the more flexible or winding and of thicker covering as old age becomes more full with years.

You will find almost universally that the passage of the veins and the passage of the nerves are on the same path, and direct themselves to the same muscles and ramify in the same manner in each of these muscles, and that each vein and nerve pass with the artery between one muscle and the other, and ramify in these with equal ramification.

[*Expansibility of the vessels*]

The veins are extensible and expansible; and of this there is testimony afforded in the fact that I have seen one who has chanced to wound the common vein and has immediately bound it up again with a tight bandage and in the space of a few days there has grown a blood-coloured tumour as large as a goose's egg, full of blood, and it has remained so for several years; and I have also found in the case of a decrepit man that the mesaraic veins have contracted the passage of the blood and doubled in length. Fogli B 10 r.

[*Changes of the arteries, hepatic veins, and abdominal organs in the old*]

The artery and the vein which in the old extend between the spleen and the liver, acquire so great a thickness of skin that it contracts the passage of the blood that comes from the mesaraic veins, through which this blood passes over to the liver and the heart and the two greater veins, and as a consequence through the whole body; and apart from the thickening of the skin these veins grow in length and twist

themselves after the manner of a snake, and the liver loses the humour of the blood which was carried there by this vein; and consequently this liver becomes dried up and grows like frozen bran both in colour and substance, so that when it is subjected even to the slightest friction this substance falls away in tiny flakes like sawdust and leaves the veins and arteries.

And the veins of the gall and of the navel which entered into this liver by the gate of the liver all remain deprived of the substance of this liver, after the manner of maize or Indian millet when their grains have been separated.

The colon and the other intestines in the old become much constricted, and I have found there stones in the veins which pass beneath the fork of the breast, which were as large as chestnuts, of the colour and shape of truffles or of dross or clinkers of iron, which stones were extremely hard, as are these clinkers, and had formed bags which were hanging to the said veins after the manner of goitres.

And this old man, a few hours before his death, told me that he had lived a hundred years, and that he did not feel any bodily ailment other than weakness, and thus while sitting upon a bed in the hospital of Santa Maria Nuova at Florence, without any movement or sign of anything amiss, he passed away from this life.

And I made an autopsy in order to ascertain the cause of so peaceful a death, and found that it proceeded from weakness through failure of blood and of the artery that feeds the heart and the other lower members, which I found to be very parched and shrunk and withered; and the result of this autopsy I wrote down very carefully and with great ease, for the body was devoid of either fat or moisture, and these form the chief hindrance to the knowledge of its parts.

The other autopsy was on a child of two years, and here I found everything the contrary to what it was in the case of the old man.

The old who enjoy good health die through lack of sustenance. And this is brought about by the passage to the mesaraic veins becoming continually restricted by the thickening of the skin of these veins; and the process continues until it affects the capillary veins, which are the first to close up altogether; and from this it comes to pass that the old dread the cold more than the young, and that those who are very

old have their skin the colour of wood or of dried chestnut, because this skin is almost completely deprived of sustenance.

And this network of veins acts in man as in oranges, in which the peel becomes thicker and the pulp diminishes the more they become old. And if you say that as the blood becomes thicker it ceases to flow through the veins, this is not true, for the blood in the veins does not thicken because it continually dies and is renewed. Fogli B 10 v.

[Principal vessels of the thorax]
You will make the veins which are in the heart and also the arteries which give it life and nourishment.

[Heart and vessels]
The heart is the nut which produces the tree of the veins; which veins have their roots in the dung, that is the mesaraic veins which proceed to deposit the blood they have acquired in the liver from which afterwards the upper veins of the liver are nourished.

[Precepts for anatomical drawings]
Make first the ramification of the veins by themselves, then the bones by themselves, and then join the bones and veins together.

[Heart and vessels proceeding from the heart, and comparison with the roots and ramifications of plants]
The plant never springs from the ramification for at first the plant exists before this ramification, and the heart exists before the veins.

All the veins and arteries proceed from the heart; and the reason is that the maximum thickness that is found in these veins and arteries is at the junction that they make with the heart; and the farther away they are from the heart the thinner they become and they are divided into more minute ramifications. And if you should say that the veins start in the protuberance of the liver because they have their ramifications in this protuberance, just as the roots of plants have in the earth, the reply to this comparison is that plants do not have their origin in their roots, but that the roots and the other ramifications have their origin in the lower part of these plants, which is between the air and the earth; and all the parts of the plant above and below are always less than this part which borders upon the earth; therefore it is evident that the whole plant has its origin from this thickness, and, in

consequence, the veins have their origin in the heart where is their greatest thickness; never can any plant be found which has its origin in the points of its roots or other ramifications; and the example of this is seen in the growing of the peach which proceeds from its nut as is shown above. Fogli B 11 r.

[*Precepts for the measurements of the fingers*]

Give the measurements for the fingers of man, anatomized from every limb and its positions.

[*Alterations in the inner coating of the blood vessels in the old*]

One asks why the veins in the old acquire great length, and those which used to be straight become bent, and the skin thickens so much as to close up and stop the movement of the blood, and from this arises the death of the old without any disease.

I consider that a thing which is nearer to that which feeds it increases more; and for this reason these veins being a sheath of the blood that nourishes the body it nourishes the veins so much the more as they are nearer to the blood.

[*Arteries of the abdomen. Causes of death in the old*]

The veins *a b* become so much constricted in the old that the blood loses its power of movement through them, and so usually becomes foul, and can no longer penetrate the new blood which sweeps it away as it used to do as it comes from the gate of the stomach, whence this good blood grows corrupt away from the bowels, and so the old fail without fever when they are of great age.

And why the bowels in the old are much constricted.

[*Impossibility of the removal of the spleen in the living*]

It is shown here that it is impossible to remove the spleen from men as is believed by those who are ignorant of its constituent substance, because as is here shown it cannot be extracted from bodies without causing death; and this happens because of the veins with which it nourishes the stomach.

[*Vessels which provide for the nutrition of the abdominal organs*]

The vein which extends between the gate of the liver and the gate of the spleen has its roots with five ramifications that ramify in the five

coverings of the liver, and at the middle of its trunk there starts a branch which spreads out in nourishment from the base of the peritoneum and extends in all its parts. And a little farther away a branch raises itself up and joins itself to the left part below the stomach, and then ends somewhat farther on in two branches at the junction with the spleen, and goes ramifying through all its substance.

[Cause of death in the old]

Veins which by the thickening of their tunicles in the old restrict the passage of the blood, and by this lack of nourishment destroy their life without any fever, the old coming to fail little by little in slow death.

And this happens through lack of exercise since the blood is not warmed. Fogli B 11 v.

OF THE REASON OF THE HEAT OF THE BLOOD

The heat is produced by the movement of the heart, and this manifests itself because in proportion as the heart moves more swiftly the heat increases more, as is shown by the pulse of those suffering from fever which is moved by the beating of the heart.

[Drawing of heart—below:—]

Marvellous instrument, invented by the supreme Master.

[Mechanism of action of the heart]

Heart open in the receptacle of the spirits, that is in the artery; and in M it takes or rather gives the blood to the artery, and by the mouth, B, it refreshes itself with air from the lung, and by c it fills the auricles of the heart s.

N Firm muscle is drawn back, and it is the first cause of the movement of the heart, and as it draws back it thickens, and as it thickens it becomes shortened and draws back with it all the lower and upper muscles, and closes the door M, and shortens the space that intervenes between the base and the apex of the heart, and consequently comes to empty it and to draw to itself the fresh air. Fogli B 12 r.

Of the heart. This moves of itself and does not stop unless for ever.

[Function of the lung in relation to the circulation]

Of the lung. This is moved by others, that is, by the first mover which is the heart which as it becomes constricted draws the veins after it, with which it restores the heated air to the lung, and opens it, and this lung can close either voluntarily or through oblivion, that is, forgetfulness through excess of thought; and by this means the heart draws back from it the heated air which it has given it; but this act cannot be repeated many times for if it were not for its refreshing itself with new air it would come to suffocate.

Testicles, witnesses of coition. These contain in themselves ardour that is they are augmenters of the animosity and ferocity of the animals; and experience shows us this clearly in the castrated animals, of which one sees the bull, the boar, the ram and the cock, very fierce animals, which after having been deprived of these testicles remain very cowardly; so one sees a ram drive before it a herd of wethers, and a cock put to flight a number of capons; and I have seen the same thing happen with a hen, and also with oxen.

Della verga. This confers with the human intelligence and sometimes has intelligence of itself, and although the will of the man desires to stimulate it it remains obstinate and takes its own course, and moving sometimes of itself without licence or thought by the man, whether he be sleeping or waking, it does what it desires; and often the man is asleep and it is awake, and many times the man is awake and it is asleep; many times the man wishes it to practise and it does not wish it; many times it wishes it and the man forbids it. It seems therefore that this creature has often a life and intelligence separate from the man, and it would appear that the man is in the wrong in being ashamed to give it a name or to exhibit it, seeking the rather constantly to cover and conceal what he ought to adorn and display with ceremony as a ministrant.

[Organs which function independently of the will]

No inferior instrument in the human body is able to suspend its action voluntarily except the lung. You see the heart which carries on its function of itself, and the stomach also and the other intestines which are joined to it, and similarly the liver the gall the spleen the testicles the kidneys and the bladder.　　　　　　Fogli B 13 r.

In fact man does not vary from the animals except in what is accidental, and it is in this that he shows himself to be a divine thing; for where nature finishes producing its species there man begins with natural things to make with the aid of this nature an infinite number of species; and as these are not necessary to those who govern themselves rightly as do the animals it is not in their disposition to seek after them.

[*Drawing of right kidney*]

Cut it through the centre and represent how the channels of the urine are constricted and how they fall drop by drop.

Describe the distance of these kidneys from the flanks and the false ribs. Fogli B 13 v.

[*Passage of the urine from the kidneys into the bladder by means of the ureters*]

The authorities say that the uretary ducts do not enter directly to carry the urine to the bladder; but that they enter between skin and skin by ways that do not meet each other; and that the more the bladder becomes filled the more they become contracted; and this they say nature has done merely in order that when the bladder is filled it should turn the urine backwards whence it came; in such a way that in finding the ways between membrane and membrane to penetrate into the interior by narrow ways and not opposite to that of the first membrane, the more the bladder is filled, the more it presses one membrane against the other, and consequently it has no cause to spread itself out and turn back. This proof however does not hold, seeing that if the urine were to rise higher in the bladder than its entrance which is near the middle of its height it would follow that this entrance would suddenly close and no more urine would be able to pass into the bladder and the quantity would never exceed the half of the capacity of this bladder; the remainder of the bladder therefore would be superfluous, and nature does not create anything superfluous. We may say therefore, by the fifth [section] of the sixth [book] concerning waters, that the urine enters the bladder by a long and winding way, and when the bladder is full the uretary ducts remain full of urine, and the urine that is in the bladder cannot rise higher than their surface when the man is upright; but if he remains lying down it can turn back through

these ducts, and even more can it do this if he should put himself up-
side down which is not often done; but the recumbent position is very
usual, in which if a man lies on his side one of the uretary ducts re-
mains above the other below; and that above opens its entrance and
discharges the urine into the bladder, and the other duct below closes
because of the weight of the urine; consequently a single duct trans-
mits the urine to the bladder, and it is sufficient moreover that one of
the emulgent veins purify the blood of the chyle of the urine which is
mixed with it because these emulgent veins are opposite to one another
and do not all proceed from the vein of the chyle. And if the man sets
himself with his back to the sky both the two uretary ducts pour urine
into the bladder, and enter through the upper part of the bladder, be-
cause these ducts are joined in the back part of the bladder, and this
part remains above when the body is facing downwards, and conse-
quently the entrances of the urine are able to stand open, and to supply
so much urine to the bladder that it fills it.

When the man is upside down the entrance of the urine is closed.

Fogli B 14 r.

*[Reason of the arrangement of the human intestine in relation to nu-
trition]*
Animals without legs have a straight bowel, and this is why it al-
ways remains lying down, for the animal not having feet cannot raise
itself on them, and if it should raise itself it returns immediately to a
level position; but in the case of the man this would not take place by
reason of his holding himself quite straight, because the stomach would
suddenly empty itself if the twisted nature of the intestines did not
check the descent of the food; and if the bowel were straight each part
of the food would not come in contact with the bowels as it does in
the twisted bowels.

And consequently there would remain much nutritive substance in
the superfluous parts of this food which would not be able to be sucked
by the substance of these bowels and transported in the mesaraic veins.

[Defecation. Intestinal movements in relation to the diaphragm]
When with the transversal muscles of the body one presses out the
superfluous parts from the intestines, these muscles would not perform
their function well or powerfully unless the lung were filled with air;

seeing that if this lung were not full of air it would not fill with itself all the diaphragm; consequently this diaphragm remains loose, and the intestines pressed by the said transversal muscles bend towards the side that gives way to them, which would be the diaphragm. But if this lung should stay full of air and you do not afford it outlet above, then the diaphragm is taut and firm and offers resistance to the rising up of the intestines when pressed by the transversal muscles; consequently of necessity the intestines rid themselves through the straight intestine of a great part of the superfluity which is enclosed within them.

[Precepts for the study of the liver]

I wish to cut the liver which covers the stomach in that part which covers the stomach as far as the vein which enters and afterwards emerges from this liver, and to see how this vein ramifies through this liver. But first I will have represented how all this liver stands and how it clothes the stomach. Fogli B 14 v.

All the muscles of the body are enveloped in extremely thin cartilage, and then they become changed to thicker cartilage and in that their substance ends.

[Action of the transversal muscles of the abdomen upon defecation]

The transversal muscles squeeze the intestines but not the longitudinal ones, because if it were so when the man holds himself bent and relaxes these muscles he would not have force to perform the office of squeezing them; but the transversal muscles never relax as the man bends but rather become stretched.

[Muscles of the anterior wall of the abdomen and their function]
[Drawing n r b a s h m]

a b are final longitudinal muscles; the membranes in which they become transformed pass at a right angle below the longitudinal *a m*.

The muscles *n r s h* are four and have five tendons and were not made of a single piece as the others, so that each was shorter; although where there is life with thickness there is strength, and where there is such great length of movement there it is necessary to divide the mover into several parts, and its greater extension exceeds its lesser extension by the third part of one of its arms, and by so much more as

it makes greater concavity of arch in its back, as one sees done by those contortionists who bend themselves so far backwards that they cause their hands to touch their feet, and this excess of capacity is produced by the contraction of their feet with their hands, and these muscles are made in two rows, that is right and left, from the necessity of bending to right and left.

The transversal muscles *c d* are those which, as they are drawn, constrict and raise the intestines and push up the diaphragm and drive out the air from the lung; afterwards as these muscles become relaxed the bowels drop and draw back the diaphragm and the lung opens.

a b is all made up of cartilage which borders on the sifac and starts from the fleshy muscles *c d,* which muscles enter under the ribs and are latitudinal muscles starting in the bone of the spine, and it is these alone which squeeze out the superfluities from the body.

Above the membrane *a b* descend the longitudinal muscles *n m,* mentioned above, which start in the last ribs, [run up] to the side of the Adam's apple and end below in the pubis. Fogli B 15 r.

[*Muscles of the trunk*]

Note how the flesh increases above the bone as one grows fat, and how it decreases as one grows thin, and what shape it assumes and . . .

The muscle *a b* becomes fleshy at its end beneath the arm and in the upper part and in the lateral, or lower in the flank, and behind in the bone of the back, and in front in the middle longitudinal section of the body, and behind it ends in the vertebrae of the spine.

The muscles *n m o p q* are situated above the ribs, and with their angles they are converted into short thick cartilage, and they unite with the ribs where they rest, and immediately there start other muscles namely *a m n,* and that which is shown appears after the skin has been removed.

a b c is covered by the muscle *a* above, in the second demonstration.

All the muscles which start in the body are converted into membranes, which membranes continue with the opposite muscle, passing above the lower part of the belly, as are the transversal and the slanting muscles; but the longitudinal or straight muscles go fleshy from the height of the Adam's apple to the pubis; and the muscle of the breasts which starts from all the middle of the thorax and ends in the bone of

the shoulder, when it has passed a short distance below the breasts is converted into membrane and clothes the whole body. Fogli B 15 v.

The first muscle of the lower part of the belly starts in its upper part in the sixth rib of the breast and ends towards the arms after the manner of a saw in the muscles which start over the ribs, and below being changed into cartilage it ends in the bone of the hip as far as the pubis.

The muscle *n m* is the lower transversal, which starts in the vertebrae behind the navel, passes through the soft parts of the flank, and ends in the penultimate false rib, and becomes changed into cartilage above the longitudinal muscles; it becomes fleshy and continues as far as the pubic region. Fogli B 16 r.

[*Precepts for the demonstration of the muscles of the thorax*]
The demonstration of the region of the ribs requires first the plain sides bare with open spaces; afterwards the muscles which are joined to their sides with which they are chained together; then the muscles that interlace above them which serve for the movements of expansion and contraction of these sides; in addition to this the other muscles crossed above the aforesaid muscles, at different angles, serving for various movements.

[*Reason of the movement of the ribs*]
Of the maximum raising and lowering of the shoulders which checks the movement of the sides. Because the maximum raising and lowering of the shoulders by means of the muscles of the neck which have their base in the vertebrae of the spine, impedes when these shoulders are raised, the movement of the ribs in their descent; and as these shoulders are lowered the movement of raising these sides is impeded.

For which fact nature has made provision by means of the muscles of the diaphragm which lower this diaphragm in its concave centre; and when it is raised again this proceeds from the compressed wind enclosed in the intestines, which wind is caused by the fact that the excrements as they dry give off gases; and if the raised shoulders keep the ribs high by means of the muscle *b* then the diaphragm by merely moving itself by means of its muscles performs the function of opening *and closing* the lung; and the compressed intestines together with the

condensed wind which is generated in them push back the diaphragm upwards; which diaphragm presses the lung and expels the air.

[Muscles of the anterior wall of the thorax and of the abdomen]

The muscle *a* contains in itself the breast, and descends fleshy as far as the seventh rib by the side of the Adam's apple; then having been converted into membrane it proceeds to form a covering over all the lower part of the belly and ends by joining itself to the bone of the pubis; and this muscle of the breast is composed of several muscles which all start in the thorax, and converge and end in the part of the muscles of the humerus.

a d c ends in the bone of the shoulder, and starts in the middle of the thorax, and below it does not go so far as to cover *b*, shown above, except by its cartilage, with which it covers all the lower part of the belly, and it ends in the flank and in the bone of the pubis. Fogli B 16 v.

[Lung]

When the lung has sent out the wind and so is diminished in quantity by an amount corresponding to the amount of the wind which emerged from it, one ought then to consider from where the space of the cavity of the lessened lung attracts to itself the air which fills up its increase, because in nature there is no vacuum.

And one asks also, since after the lung has been expanded it drives out the air from its receptacle, by what way this air escapes and where it is received after it has escaped.

[Mechanism of respiration. Action of intercostal muscles]

The lung is always full of a quantity of air, even when it has driven out that air which is necessary for its exhalation; and when it is refreshed by new air it presses on the sides of the chest, dilates them a little and pushes them outwards, for as may be seen and felt by placing the hand upon the chest during its breathing, the chest expands and contracts, and even more so when one heaves a big sigh. For nature has so willed that this force should be created in the ribs of the chest and not in the membrane that ends the substance of the lung, lest by an excessive ingathering of air in order to form some unusually deep sigh this membrane may come to break and burst itself.

[*Function of the diaphragm*]

The diaphragm, that is the large membrane which is below the points of the lung, is not altered nor pushed in any part by the increase of the lung, for this lung increases in width and not in length, unless this diaphragm has been driven by the wind or air which gives place to the increase of the lung, for it would then be possible for the diaphragm driven by the air to give place to its increase, and for the air to push the liver and the liver the stomach to which it serves as cover, and thus would follow the pushing of all the intestines, and this continual movement would bring about the evacuation of the intestines with so much greater speed as the exercise of the man was performed with greater vigour.

[*Cause of the formation of gas in the intestines*]

Of the wind that is produced in the intestines we may say that it is caused by the superfluous quantity which collects in the rectum, which becomes drier as the moisture in it evaporates more; and this vapour in the form of air distends the bowels and produces pains on finding itself confined within the colon.

[*Latitudinal increase of the lung in breathing. How its expansion acts upon the functions of the stomach*]

The increase of the lung when it is filled with air is latitudinal and not in its length, as may be seen by inflating the lung of a pig; and the air which is interposed between the lung when not inflated and the ribs which surround it, as the lung becomes extended escapes in the part below between the lung and the diaphragm, and causes this diaphragm to swell downwards, against the stomach, whereat this stomach being pressed transmits the things contained within it to the intestines.

[*Action of the expansion of the lungs upon the pericardium and function of the pericardial fluid*]

Moreover this air pressed between the lung and the diaphragm rests in the case which encloses the heart, and that small quantity of fluid which is at the bottom of this case raises itself and bathes the whole heart, and so continually by thus bathing it it moistens the heated heart and prevents it from becoming parched through the extent of its movement.

Fogli ʙ 17 r.

[Origin of the whole body from the heart]

The whole body has origin from the heart as regards its first cre-ation; and the blood therefore and the veins and nerves do the like, although these nerves seem manifestly all to start from the spinal mar-row, and to be remote from the heart, and the spinal marrow to be of the same substance as the brain from whence it is derived.

[Origin of the spinal nerves]

Tree of all the nerves, and it is shown how these all have origin from the spinal marrow and the spinal marrow from the brain.

[Precepts for the demonstration of the nerves]

Make in every demonstration of the whole quantity of the nerves the external lineaments which denote the shape of the body.

Fogli B 17 v.

[Precepts for anatomical demonstrations]

Remember never to change the contour lines of any limb by any muscle that you remove in order to uncover another; and if you only remove muscles of which one of its contour lines is contour line of a part of the limb from which you detach it, you ought then to indicate with frequent dots the contour line of that limb which was removed by the separation of any muscle; and this you will do so that the shape of that limb which you describe may not remain an unnatural thing through having its parts taken away. And in addition to this there ensues a greater knowledge of the whole, for when the part has been taken away you see in the whole the true shape of the part whence it was taken.

Fogli B 18 r.

[Of the muscles]

The long muscle *a b* and the long muscle *a c* serve to raise the thigh forward.

And they also give this thigh lateral movements, namely in spread-ing out and contracting these thighs; and the process of the thickening and contraction of the muscle *a c* comes into play in the spreading out of this thigh, and of the long muscle *a b* in its contraction.

[Of the rotatory movement of the thigh]

The part of the rotatory movement of the thigh to right and left is caused by the aforesaid muscles; that is the muscle *a c* turns the thigh

inward, and the long muscle *a b* turns it back outward, and the two together raise the thigh.

[*Reason of the insertions of the muscles*]

The muscles always begin and end in the bones that touch one another, and they never begin and end in the same bone, for it would not be able to move anything unless this was itself in a state of rarity or density.

Which are the muscles which begin and finish on one side upon one bone and on the other upon another muscle?

[*Topography of muscles of front region of thigh*]

I wish to separate the muscle or tendon *a b* and show that which follows below it.

[*Insertion of the muscles of the thigh at the knee*]

On to the knee arrive all the muscles of the thigh which are changed first into nerve, and then, below the nerve, each is transformed into a thin cartilage with which is bound the joint of the knee with as many peels or membranous jackets as are the muscles which descend from this thigh to the knee; and these ligaments extend four fingers' space above the joint of the knee and four below.　　　　Fogli B 18 v.

[*Muscles of the thigh in relation to nutrition*]

Which muscles are those which as they become lean divide themselves into several muscles, and form one out of many as they become fleshy?　　　　Fogli B 19 v.

[*Various anatomical themes*]

Ramification of the veins from the shoulders upward, and from the spleen to the lung.

Ramification of the nerves and of the reversive nerves to the heart.

Of the shape and position of the intestines.

Where the umbilical cord is fastened.

Of the muscles of the body and of the kidneys.

[*Origin and insertion of the muscles of the foot*]

The muscles which raise and lower the foot start in the leg; that is those which raise the front part start in the outside part of the leg and stop at the beginning of the big toe.

[Precepts for the study of tendons]

Note which are the principal cords and those which inflict greater injury to the animal if they were cut, and which are of less importance; and you will do this for each limb.

[Precepts for the demonstration of the bones and muscles of the leg]

Observe the proportion of the bones one with another.

And for what purpose each serves.

In this demonstration made from different aspects you take count of all the muscles which move the leg, which muscles are attached to the edges of the pelvis, in which also start the muscles that move the thigh from the knee upwards.

And also of those which bend the leg when one kneels.

[Notes concerning the muscles which become uncovered and hide themselves in their movement]

Different muscles become uncovered in the different movements of the animals, and different muscles are those which hide themselves in such diversity of movement; and concerning this it is necessary to make a long treatise for the purpose of recognising the places that have been injured by wounds, and also for the convenience of sculptors and painters.

[Origin of the movements of the legs and feet]

All the movements of the leg start from the muscles of the thigh, which movements are the cause of the bending of the leg, of the straightening of it when bent and of its turning to right or left.

But the movements of the feet are caused by the muscles which start in the leg; of the movements of the toes some start in the leg and some in the foot.

[Insertion of the motive muscles of the leg]

And of the motive muscles of the leg part start in the hip and part in the thigh; and of all you will give the true position. Fogli B 20 r.

OF THE ORDER OF THE BOOK

This work should commence with the conception of man, and should describe the nature of the womb, and how the child inhabits it,

and in what stage it dwells there, and the manner of its quickening and feeding, and its growth, and what interval there is between one stage of growth and another, and what thing drives it forth from the body of the mother, and for what reason it sometimes emerges from the belly of its mother before the due time.

Then you should describe which are the limbs that grow more than the others after the child is born; and give the measurements of a child of one year.

Then describe the man fully grown, and the woman, and their measurements, and the nature of their complexions colour and physiognomy.

Afterwards describe how he is composed of veins, nerves, muscles and bones. This you should do at the end of the book.

Then represent in four histories four universal conditions of mankind namely, joy, with various modes of laughing, and represent the cause of the laughter; weeping, the various ways with their cause; strife with various movements expressive of slaughterings, flights, fear, acts of ferocity, daring, homicide and all the things which connect with cases such as these.

Then make a figure to represent labour, in the act of dragging, pushing, carrying, restraining, supporting and conditions such as these.

Then describe the attitude and movement.

Then perspective through the office of the sight or the hearing. You should make mention of music and describe the other senses.

Afterwards describe the nature of the five senses.

We shall describe this mechanical structure of man by means of diagrams of which the three first will treat of the ramification of the bones; that is one from the front which shows the positions and shapes of the bones latitudinally; the second as seen in profile and shows the depth of the whole and of the parts and their position; the third diagram will show the bones from behind. Then we shall make three other diagrams from the same points of view with the bones sawn asunder so as to show their thickness and hollowness; three other diagrams we shall make for the bones entire, and for the nerves which spring from the nape of the neck and showing into what limbs they ramify; and three others for the bones and veins and where they ram-

ify; then three for muscles and three for the skin and the measurements, and three for the woman to show the womb and the menstrual veins which go to the breasts.　　　　　　　Fogli B 20 v.

THEMES PHYSIOLOGICAL AND ANATOMICAL

Figure to show how catarrh is caused.
Tears.
Sneezing.
Yawning.
Trembling.
Epilepsy.
Madness.
Sleep.
Hunger.
Sensuality.
Anger when it works in the body.
Fear likewise.
Fever.
Disease.
Where poison injures.
Describe the nature of all the limbs.
Why the thunderbolt kills a man and does not wound him, and if the man blew his nose he would not die. Because it hurts the lungs.
Write what the soul is.
Of nature which of necessity makes the vital and actual instruments of suitable and necessary shapes and positions.
How necessity is the companion of nature.
Figure to show from whence comes the semen.
Whence the urine.
Whence the milk.
How nourishment proceeds to distribute itself through the veins.
Whence comes intoxication.
Whence vomiting.
Whence gravel and stone.
Whence colic.
Whence dreaming.

Whence frenzy by reason of sickness.

Why it is that by compressing the arteries a man falls asleep.

Why it is that a prick on the neck may cause a man to drop dead.

Whence come tears.

Whence the turning of the eyes when one draws the other after it.

Of sobbing.

[Relation of breasts and shoulder-blades in different positions of trunk]
OF THE REINS WHEN ARCHED

When the reins or the back is arched the breasts are always lower than the shoulder-blades of this back.

And when the chest is arched the breasts are always higher than the shoulder-blades of the back.

When the reins are straight the breasts will always be found of the height of these shoulder-blades. Fogli B 21 r.

[Connection between object and sense]
The object moves the sense.

[Contrast between the perfection of the body and the coarseness of the mind in certain men]
Methinks that coarse men of bad habits and little power of reason do not deserve so fine an instrument or so great a variety of mechanism as those endowed with ideas and with great reasoning power, but merely a sack wherein their food is received, and from whence it passes away.

For in truth one can only reckon them as a passage for food; since it does not seem to me that they have anything in common with the human race except speech and shape, and in all else they are far below the level of the beasts.

[Attitude in ascending]
In proportion as the step by which a man rises is of greater height his head will be so much the more in front of the foot which is uppermost.

[*Attitude in stopping a course*]

When the man wishes to arrest his course and to consume his impetus, necessity causes him to lean back and to make short quick steps.

[*Mechanism of certain movements of the human body and foundation of human statics*]

The centre of the weight of the man who raises one of his feet from the ground rests above the centre of the sole of the foot.

[*Mechanism of the ascent*]

The man who goes up stairs puts as much of his weight in front and at the side of the upper foot as he puts as counterpoise to the lower leg, and in consequence the work of the lower leg only extends to moving itself.

The first thing that the man does when he ascends by steps is to free the leg which he wishes to raise from the heaviness of the bust which is resting upon this leg, and in addition to this he loads the opposite leg with all the rest of the bulk of the man together with the other leg; then he raises the leg and places the foot upon the step where he wishes to raise it; having done this he gives back to the higher foot all the rest of the weight of the bust and of the leg, leans his hand upon his thigh, thrusts the head forward and makes a movement towards the point of the higher foot, raising swiftly the heel of the lower foot, and with the impetus thus acquired raises himself up, and at the same time extends the arm which he was resting upon the knee, and this extension of the arm pushes the bust and head upwards and thus straightens the curve of the back. Fogli B 21 v.

[*Veins*]

OF THE OLD MAN

Veins which mark with their main lines here and there the base of the stomach and proceed to ramify through the network that covers the intestines.

b a c is the vein which extends from the spleen to the gate of the liver and passes behind the stomach, and from *a* divide the vein and the artery which ramify in the net that covers the intestines; that is from *a* there proceed two veins which pass under the bottom of the

stomach, the one behind between the ribs and the stomach, and the other in front, and proceed as has been said to ramify through the peritoneum behind and through the peritoneum in front, which is double as the figure shows; and that which the veins do is found to be done by the artery.

[Change of the vessels in the old]

I have found in the decrepit how the vein which proceeds from the door of the liver crosses behind the stomach and ramifies in the spleen, as this ramification, the veins in the young being straight and full of blood, and in the old they are twisted, flattened, wrinkled and emptied of blood.

[Changes in the liver in age]

And thus the liver which in youth is usually of a deep colour and of uniform consistency, in the old is pale, without any redness of blood, and the veins stay empty amidst the substance of this liver, which substance may be likened for its thin texture to bran steeped in a small quantity of water, and so readily disintegrating on being washed, leaving the veins that ramify within it freed from all the substance of the liver.

Fogli B 22 r.

[Precepts upon the topography of the intestines]

Remember to mark the height of the stomach above the navel and with the Adam's apple, and how the spleen and the heart stand with the left breast, and how stand the kidneys or reins with the hips, and the colon and bladder and other intestines, and how much more or less remote they are from the spine than from the longitudinal muscles, and describe thus all the body with the veins and nerves.

[Thinness of the colon in the old]

The colon in the old becomes as slender as the middle finger of the hand, and in the young it is equal to the maximum breadth of the arm.

[Retraction of the omentum in the old]

The net which stands between the sifac and the intestines in the case of the old uncovers all these intestines of itself and withdraws between the bottom of the stomach and the upper part of the bowels.

Fogli B 22 v.

[Spinal marrow and nerves]

These two crusts which clothe the spinal marrow are the same as clothe the brain, that is, the pia and dura mater.

Vertebrae of the neck sawn through and removed from the middle in front, and the situation of the spinal marrow revealed and how it lives and ramifies outside these vertebrae.

[Anatomical and functional relations between nerves and muscles]

The substance of the spinal marrow enters for a certain distance within the origins of the nerves, and then follows the hollow nerve as far as its last ramifications; by which perforation it conveys sensation in each muscle, which muscle is composed of as many other very minute muscles as there are threads into which this muscle can be resolved; and each of the least of these muscles is wrapped up in almost imperceptible membranes into which the final ramifications of the before mentioned nerves become changed, for these obey in order to contract the muscle as they retire, and to cause it to expand again with each demand of the sensation which passes through the vacuity of the nerve. But to return to the spinal marrow, this is wrapped in two membranes of which only one clothes the pith-like substance of the spinal marrow, and in emerging from the hollow of vertebrae is transformed into nerve; the other clothes the nerve, together with its principal branches, and ramifies together with each branch of the nerve, and thus forms the second cover of the spinal marrow, interposing itself between the bone of the vertebrae and the first membrane of this spinal marrow.

The spinal marrow is the source of the nerves which give voluntary movement to the limbs.

The pia and the dura mater clothe all the nerves which start from the spinal marrow. Fogli B 23 r.

[Precepts for the demonstration of the nerves of the arm]

You will make a ramification of nerves with all their muscles attached.

And then you will make this ramification with the muscles attached to the nerves and to the bones which form the whole arm.

Here each nerve of the arm is joined with all the four nerves that issue from the spinal marrow.

Here will be shown all the muscles of the arm with the nerves and veins.

Make the man with arms open and showing all his nerves and their purposes according to the list; and you should use the greatest diligence with the reversive nerves in all their ramifications.

[List of demonstrations of different parts of the human body]

A demonstration of the peritoneum without the bowels.

A demonstration of bones cut through by the saw.

A demonstration of simple bones.

A demonstration of bones and nerves.

A demonstration of bones and veins.

A demonstration of nerves and muscles.

A demonstration of veins and muscles.

A demonstration of bones and intestines.

A demonstration of the mesentery.

A demonstration of limbs and muscles that interpret the spirit.

A demonstration of woman.

A demonstration of bones nerves and veins.

A demonstration of nerves alone.

A demonstration of bones alone.

A demonstration of nerves in bones that have been sawn through.

A demonstration of nerves in bones that are closed in.

A demonstration of bones and of the nerves which join themselves together, which nerves are extremely short, and those especially that join the vertebrae within. Fogli B 23 v.

[Precepts for the topographical demonstration of the upper limb and specially the hand]

ORDER OF ANATOMY

Make first the bones, that is to say the arms, and show the motive power proceeding from the shoulder to the elbow in all its lines; then from the elbow to the arm; then from the arm to the hand, and from the hand to the fingers.

And in the arm you should show the movements of the fingers as they open; and these in their demonstration you will place alone.

In the second demonstration you will clothe these muscles with the second movements of the fingers; and you will do this stage by stage so as not to cause confusion; but first place upon the bones those muscles which join themselves with these bones without other confusion of other muscles, and with these you will place the nerves and veins which feed them, having first made the tree of the veins and nerves above the simple bones.

[*Of the nature of the teeth and their position and removal from the axis of their movements*]

That tooth has less power in gripping which is more remote from the centre of its movement. As if the centre of the movement of the teeth were *a* the axis of the jaw I say that in proportion as these teeth are more distant from this centre *a* they have less power in their grip; therefore *d e* is less powerful in its grip than the teeth *b c*; and from this follows the corollary which says:—that tooth is more powerful which is nearer to the centre of its movement or the axis of its movement; that is the grip of the teeth *b c* is more powerful than that of the teeth *d e*. (Nature made them less able to penetrate into food and with heavier points which are of greater power.) Therefore the teeth *b c* will have their points so much the more obtuse as they are moved by greater power; and for this reason the teeth *b c* will be more obtuse in proportion to the teeth *d e* when they are nearer the axis *a* of the jaws *a d* and *a e*; and for this reason nature has made the molars with large crowns to enable them to grind the food and not to penetrate it or cut it; and in front has made the teeth sharp and penetrating and not suitable for grinding this food, and has made the eye teeth between the molars and the incisors. Fogli B 24 r.

[*Reaction of pupil to stimulus of light, dilation and constriction*]

In the nocturnal animals the pupil proceeds to vary from a large to a larger size according to the great or greater obscurity of the night.

In these nocturnal animals the pupil also varies from a small to a smaller size according to the great or greater brightness of the day.

From what has been said one concludes that these nocturnal animals have always the same power of visual faculty in all the varieties of brightness or obscurity which can occur in times of day and of night.

The visual faculty is all in the whole pupil and all in each of its parts.

It follows that the half of the pupil sees the object in its entirety as if it was whole.

In proportion as the pupil is greater in quantity it will see its object as of greater shape and clearness; and thus conversely in proportion as it is less it will see this object as so much smaller and more obscure.

It follows that if one eye be closed the power of sight is diminished by half; and this may be proved with luminous bodies such as the sun the moon and the stars, and also with a light or fire.

This diminution of brightness may be observed without closing one of the eyes; but in lieu of closing it you must interpose the hand or the finger in front of one of the pupils between the air and the eye, and you will see with the two pupils a tract of air which will have the same boundary as the air seen by the one pupil alone, and that which is seen by one pupil will be just as much darker than that which is seen by two pupils. And the reason is as the diagram shows. Fogli B 25 r.

[*Precepts for the topographical demonstration of the muscles of the back*]

You will make the rule and the measurement of each muscle and you will give the reason of all their functions, and the manner in which they use them and who moves them.

You will make first the spine of the back; then proceed to clothe it in stages, one above the other, of each of these muscles, and place the nerves and arteries and veins of each muscle by themselves, and in addition to this note to how many vertebrae they are joined, and which intestines are opposite to them, and what bones and other organic instruments.

The higher parts of the thin are higher in those who have well developed muscles, and similarly with fat ones; but the difference that there is between the shape of the muscles of those who are fat in comparison with those who have well developed muscles will be described here below. Fogli B 27 r.

OF THE FUNCTION OF THE INTERCOSTAL MUSCLES

The three muscles which draw up the ribs we call the drawing muscles.

To the five [four?] muscles *c d e f* being created for the expansion of the breast we give the name of the expanding muscles.

The intercostal are the minute muscles interposed between the ribs which serve for the dilatation and attraction of those of these ribs; and these two so diametrically opposite movements are ordained for the purpose of collecting and breathing out the air in the lung which is enclosed in the region of the ribs; and the dilatation of these ribs proceeds from the external muscles of the ribs which are arranged as in the slant *m n* with the help of the three muscles *o p q*, which as they draw the ribs with great force upward extend their capacity in the manner that one sees done with the ventricles of the heart; but the ribs having to turn downwards would not of themselves be able to descend if the man remained lying down, if it were not for the internal muscles which have an opposite slant to the external muscles, which slant extends along the line *f n*.

OF THE POWER OF THE INTERCOSTAL [MUSCLES]

The function of the external intercostal muscles is to raise and expand the ribs and they are of admirable power in their position; seeing that they are established with their last upper extremities upon the same spine where begin the loose ribs, and their slant descends towards the navel. Fogli B 27 v.

[Of fingers and toes]

Each protuberance formed by the joints of the toes and fingers has a hollow in the toes and fingers contiguous to it which receives within itself this roundness; and this nature has done in order not to render their width misshapen, seeing that if the said protuberances were in contact between them the feet would become of great width, and one of two effects would also be necessary, that is that either the fingers would all be of the same length, or that one would have two joints and the other one as will be demonstrated concerning the bones, in its place.

HOW THE BODY OF THE ANIMAL CONTINUALLY DIES AND IS RENEWED

The body of anything whatsoever that receives nourishment continually dies and is continually renewed. For the nourishment cannot enter except in those places where the preceding nourishment is exhausted, and if it is exhausted it no longer has life. Unless therefore you supply nourishment equivalent to that which has departed, the life fails in its vigour; and if you deprive it of this nourishment, the life is completely destroyed. But if you supply it with just so much as is destroyed day by day, then it renews its life just as much as it is consumed; like the light of this candle formed by the nourishment given to it by the fat of this candle, which light is also continually renewed by swiftest succour from beneath, in proportion as the upper part is consumed and dies, and in dying becomes changed from radiant light to murky smoke. And this death extends for so long as the smoke continues; and the period of duration of the smoke is the same as that of what feeds it, and in an instant the whole light dies and is entirely regenerated by the movement of that which nourishes it; and its life receives from it also its ebb and flow, as the flicker of its point serves to show us. The same process also comes to pass in the bodies of the animals by means of the beating of the heart, whereby there is produced a wave of blood in all the veins, and these are continually either enlarging or contracting, because the expansion occurs when they receive the excessive quantity of blood, and the contraction is due to the departure of the excess of blood they have received; and this the beating of the pulse teaches us, when we touch the aforesaid veins with the fingers in any part whatsoever of the living body.

But to return to our purpose, I say that the flesh of the animals is made anew by the blood which is continually produced by that which nourishes them, and that this flesh is destroyed and returns by the mesaraic arteries and passes into the intestines, where it putrifies in a foul and fetid death, as they show us in their deposits and steam like the smoke and fire which were given as a comparison. Fogli B 28 r.

OF THE MUSCLES WHICH MOVE THE TONGUE

No member needs so great a number of muscles as the tongue,— twenty four of these being already known apart from the others which I have discovered; and of all the members which are moved by voluntary action this exceeds all the rest in the number of its movements.

And if you shall say that this is rather the function of the eye, which receives all the infinite varieties of form and colour of the objects set before it, and of the smell with its infinite mixture of odours, and of the ear with its sounds, we may reply that the tongue also perceives an infinite number of flavours both simple and compounded; but this is not to our purpose, for our intention is to treat only of the particular movement of each member.

Consider carefully how by the movement of the tongue, with the help of the lips and teeth, the pronunciation of all the names of things is known to us; and how, by means of this instrument, the simple and compound words of a language arrive at our ears; and how these, if there were a name for all the effects of nature, would approach infinity in number, together with all the countless things which are in action and in the power of nature; and these would not be expressed in one language only, but in a great number of languages, and these also would tend to infinite variety, because they vary continually from century to century, and in one country and another, through the intermingling of the peoples, who by wars or other mischances are continually becoming mixed with each other; and these same languages are liable to pass into oblivion, and they are mortal like all the rest of created things; and if we grant that our world is everlasting we shall then say that these languages have been, and still must be, of infinite variety, through the infinite number of centuries which constitute infinite time.

Nor is this true in the case of any other sense; for these are concerned only with such things as nature is continually producing, and she does not change the ordinary kinds of things which she creates in the same way that from time to time the things which have been created by man are changed; and indeed man is nature's chiefest instrument, because nature is concerned only with the production of elementary things, but man from these elementary things produces an infinite

number of compounds, although he has no power to create any natural thing except another like himself, that is his children. And of this the old alchemists will serve as my witnesses, who have never either by chance or deliberate experiment succeeded in creating the smallest thing which can be created by nature; and indeed this generation deserves unmeasured praises for the serviceableness of the things which they have invented for the use of men, and would deserve them even more if they had not been the inventors of noxious things like poisons and other similar things which destroy the life or the intellect; but they are not exempt from blame in that by much study and experiment they are seeking to create, not, indeed, the meanest of nature's products, but the most excellent, namely gold, which is begotten of the sun inasmuch as it has more resemblance to it than to anything else that is, and no created thing is more enduring than this gold. It is immune from destruction by fire, which has power over all the rest of created things, reducing them to ashes, glass or smoke. If, however, insensate avarice should drive you into such error, why do you not go to the mines where nature produces this gold, and there become her disciple? She will completely cure you of your folly by showing you that nothing which you employ in your furnace will be numbered among the things which she employs in order to produce this gold. For there is there no quick-silver, no sulphur of any kind, no fire nor other heat than that of nature giving life to our world; and she will show you the veins of the gold spreading through the stone,—the blue lapis lazuli, whose colour is unaffected by the power of the fire.

And consider carefully this ramification of the gold, and you will see that the extremities of it are continually expanding in slow movement, transmuting into gold whatever they come in contact with; and note that therein is a living organism which it is not within your power to produce. Fogli B 28 v.

OF THE MUSCLES WHICH MOVE THE LIPS OF THE MOUTH

The muscles which move the lips of the mouth are more numerous in man than in any other animal; and this order is a necessity for him on account of the many undertakings in which these lips are continually employing themselves, as in the four letters of the alphabet *b f*

m p, in whistling, laughing, weeping and other actions like these.
Also in the strange contortions used by clowns when they imitate faces.

WHAT MUSCLE IS THAT WHICH SO TIGHTENS THE MOUTH THAT ITS LATERAL BOUNDARIES COME NEAR TOGETHER?

The muscles which tighten the mouth lessening thus its length are
in the lips themselves; or rather these lips are the actual muscles which
close themselves. It is true that the muscle alters the position of the lip
below the other muscles which are joined to it, of which one pair are
those that distend it and move it to laughter; and that which contracts
it is the same muscle of which the lower lip is formed, which restrains
it by drawing in its extremities toward its centre; and the same process
goes on at the same time with the upper lip; and there are other mus-
cles which bring the lips to a point and others that flatten them, others
are those which cause them to curl back, others that straighten them,
others which twist them all awry, and others that bring them back to
their first position; and so always there are found as many muscles
as correspond to the various attitudes of these lips and as many others
as serve to reverse these attitudes; and these it is my purpose here to
describe and represent in full, proving these movements by means of
my mathematical principles.

OF THE MOVEMENTS OF THE MUSCLES OF THE MOUTH WITH ITS LATERAL MUSCLES

There are many occasions when the muscles that form the lips of the
mouth move the lateral muscles that are joined to them, and there are
an equal number of occasions when these lateral muscles move the lips
of this mouth, replacing it where it cannot return of itself, because the
function of muscle is to pull and not to push except in the case of the
genitals and the tongue. But if the contracting of the mouth draws
back its lateral muscles equally this mouth will not of itself regain its
lost length unless the said lateral muscles go back there; and if these
lateral muscles extend the length of the mouth for the creation of
laughter it is necessary for these lateral muscles to be drawn back by
the contracting of the mouth when laughter ceases. Fogli B 29 r.

[Umbilical cord and vein]

These four nerves have not in themselves any portion of blood; but when they enter the navel they become changed into a thick vein which then extends to the gate of the liver and goes ramifying through its lower part, in which part each of its lowest ramifications ends and does not extend any higher.

Of the aforesaid four umbilical veins the outer pair form the sifac, the membrance adjacent to the peritoneum, and then bend downwards and end in the first ramification of the vein and the greater artery, which lies over the spine of the back.

The exterior ramification of the umbilical vein is enclosed between the first and the second membranes with which frequently the child is born.

[Origin of the umbilical vein; its relation with the artery and its course]

This umbilical vein is the origin of all the veins of the creature that is produced in the matrix, and it does not take its origin in any vein of the pregnant woman, because each of these veins is entirely separated and divided from the veins of the pregnant woman, and the veins and arteries are found together in pairs; and it is extremely rare for one to be found without the other being in company with it, and the artery is almost always found above the vein because the blood of the artery is the passage for the vital spirit, and the blood of the veins is that which nourishes the creature. And of these ramifications represented those which are raised up are ordained for the nourishment of the third thin membrane of the matrix, and the lower veins, set obliquely, are those which feed the last membrane which is contiguous to the animal that is clothed by it; and both the one and the other of these membranes often emerges, together with the creature, out of the matrix of the mother; and this occurs when the animal is not able to break it for then it emerges enveloped; and this is an easy thing, because these two extremely thin membranes as has been said above are not in any way connected with the said matrix which is also equipped with two membranes of considerable thickness, fleshy and covered with nerves.

Fogli B 29 v.

[Intercostal muscles]
CONCERNING THE NERVES THAT COMMUNICATE SENSATION TO THE INTERCOSTAL MUSCLES (MESOPLEURI)

The small muscles situated slantwise which descend from the upper part of the spine and terminate towards the Adam's apple derive their name from the pleura, and they are interposed between one rib and another merely in order to contract the intervening spaces; and the nerves which communicate sensation to these muscles have their origin in the spinal marrow which passes through the backbone, and the lowest point at which they start in the spinal marrow is where the spine borders upon the reins. *Fogli* B 30 r.

OF SPIRITS

We have just now stated that the definition of a spirit is a power united to a body, because of itself it can neither offer resistance nor take any kind of local movement; and if you say that it does in itself offer resistance, this cannot be so within the elements, because if the spirit is a quantity without a body, this quantity is what is called a vacuum, and the vacuum does not exist in nature, and granting that one were formed, it would be instantly filled up by the falling in of that element within which such a vacuum had been created. So by the definition of weight which says that gravity is a fortuitous power created by one element being drawn or impelled towards another, it follows that any element, though without weight when in the same element, acquires weight in the element above it, which is lighter than itself; so one sees that one part of the water has neither gravity nor levity in the rest of the water, but if you draw it up into the air then it will acquire weight, and if you draw the air under the water then the water on finding itself above this air acquires weight, which weight it cannot support of itself, and consequently its descent is inevitable, and therefore it falls into the water, at the very spot which had been left a vacuum by this water. The same thing would happen to a spirit if it were among the elements, for it would continually create a vacuum in whatsoever element it chanced to find itself; and for this reason it would be neces-

sarily in perpetual flight towards the sky until it had passed out of these elements.

WHETHER THE SPIRIT HAS A BODY AMONG THE ELEMENTS

We have proved how the spirit cannot of itself exist among the elements without a body, nor yet move of itself by voluntary movement except to rise upwards. We now proceed to say that such a spirit in taking a body of air must of necessity spread itself through this air; for if it remained united, it would be separated from it and would fall, and so create a vacuum, as is said above; and therefore it is necessary, if it is to be able to remain suspended in the air, that it should spread itself over a certain quantity of air; and if it becomes mingled with the air two difficulties ensue, namely that it rarefies that quantity of air within which it is mingled, and consequently this air, becoming rarefied, flies upwards of its own accord, and will not remain among the air that is heavier than itself; and moreover, that as this aetherial essence is spread out, the parts of it become separated, and its nature becomes modified, and it thereby loses something of its former power. To these there is also added a third difficulty, and that is that this body of air assumed by the spirit is exposed to the penetrating force of the winds, which are incessantly severing and tearing in pieces the connected portions of the air, spinning them round and whirling them amid the other air; and therefore the spirit which was spread through this air would be dismembered or rent in pieces and broken, together with the rending in pieces of the air within which it was spread.

WHETHER THE SPIRIT HAVING ASSUMED A BODY OF AIR CAN MOVE OF ITSELF OR NO

It is impossible that the spirit diffused within a quantity of air can have power to move this air; and this is shown by the former section in which it is stated that the spirit rarefies that quantity of air within which it has entered. This air consequently will rise up above the other air, and this will be a movement made by the air through its own levity, and not through the voluntary movement of the spirit; and if this air meets the wind, by the third part of this section this air will be moved by the wind and not by the spirit which is diffused within it.

WHETHER THE SPIRIT CAN SPEAK OR NO

Wishing to prove whether or no the spirit can speak, it is necessary first to define what voice is, and how it is produced, and we may define it as follows:—the voice is movement of air in friction against a compact body, or of the compact body in friction against the air, which is the same thing; and this friction of compact with tenuous substance condenses the latter, and so makes it capable of resisting; moreover, the tenuous substance, when in swift motion, and a similar substance moving slowly, condense each other at their contact, and make a noise or tremendous uproar; and the sound or murmur caused by one tenuous substance moving through another at a moderate pace [is] like a great flame which creates noises within the air; and the loudest uproar made by one tenuous substance with another is when the one swiftly moving penetrates the other which is unmoveable, as for instance the flame of fire issuing from the cloud, which strikes the air and so produces thunderbolts.

We may say therefore, that the spirit cannot produce a voice without movement of air, and there is no air within it, and it cannot expel air from itself if it has it not, and if it wishes to move that within which it is diffused it becomes necessary that the spirit should multiply itself, and this it cannot do unless it has quantity. And by the fourth part it is said that no tenuous body can move unless it has a fixed spot from whence to take its motion, and especially in the case of an element moving in its own element, which does not move of itself, except by uniform evaporation at the centre of the thing evaporated, as happens with a sponge squeezed in the hand, which is held under water, since the water flows away from it in every direction with equal movement through the openings that come between the fingers of the hand within which it is squeezed.

Of whether the spirit has articulate voice,—and whether the spirit can be heard,—and what hearing is, and seeing;—and how the wave of the voice passes through the air,—and how the images of objects pass to the eye. Fogli B 31 r. and 30 v.

[*Skull and vertebral column*]
If nature had added the muscle *a c* in order to bend the head towards

the shoulder it would have been necessary that the spinal column of the neck should bend as the bow bends by reason of its cord; consequently nature in order to avoid this inconvenience created the muscle *a b* which draws down the side of the skull *a* with a slight bending of the bone of the neck, because the muscle *a b* draws the side of the skull *a* towards *b*, the root of the spinal column of the neck, and as the skull is fixed on a small axis above the front of the bone of the neck it bends very readily to right and left without there being too much curve of the bone of the neck. Fogli B 32 r.

[*Precepts for demonstration of vessels of the neck and their importance for the life*]

But make this demonstration from three different aspects, namely in front, at the side and behind.

If you tighten the four veins on each side where they are in the throat he whose veins are pressed will suddenly fall on the ground asleep and as though dead, and will never wake of himself; and if for the hundredth part of an hour he is left in this condition he will never wake any more either of himself or by the help of others.

[*with drawing*]

a are ramifications of arteries.

b is the ramification of the veins.

c is the cephalic vein.

n are two veins which enter into the vertebrae of the neck in order to nourish them.

o is the basilical vein.

S are the apoplectic veins. Fogli B 32 v.

[*Trachea. Œsophagus. Stomach*]

How the rings of the trachea do not join for two reasons; the one is because of the voice, and the other is in order to allow space for the food between these and the bone of the neck.

[*Wandering nerve and its function, and varied structure of the brain*]

Note in what part the left reversive nerve turns, and what function it serves.

And note the substance of the brain whether it is thinner or thicker above the starting of the nerves than in its other parts; and see in what

manner the reversive nerves communicate sensation to the rings of the trachea, and which muscles are those that give the movement to these rings in order to produce the voice deep, medium or shrill.

The reversive nerves start in *a b*, and *b f* is the reversive nerve that descends to the door-keeper of the stomach, and its companion the left nerve descends to the case that encloses the heart, and I believe this to be the nerve that enters into the heart.

[*The heart a muscle nourished like the others by arteries and veins*]

The heart in itself is not the beginning of life; but it is a vessel formed of thick muscle, vivified and nourished by the artery and vein as are the other muscles. True it is that the blood and the artery which purges itself in it are the life and nutriment of the other muscles, and it is of such density that fire can hardly injure it; and this is seen in the case of men who have been burnt, in whom after the bones have been burnt to cinders the heart within still bleeds; and nature has made this great capacity of resistance to heat so that it may be able to resist the great heat generated in the left side of the heart by means of the blood of the artery which becomes attenuated in this ventricle.

The variation of the voice starts from the dilatation and contraction of the rings of which the trachea is composed; dilatation which is produced by the muscles which join with these rings; and the contraction is produced I believe by itself because it is formed of cartilage which bends of its own accord in order to return to the shape first given to it.

Fogli B 33 v.

[*Varying relation of size of artery and vein of neck*]

Note whether the artery is thicker than the vein, or the vein than the artery, and do the same with children, young people and old ones males and females and creatures of the earth air and water.

Fogli B 34 r.

[*Origin of all the veins of the gibbous part of the heart*]

The root of all the veins is in the gibbous part of the heart, that is of the skin of the blood; and this is manifest because there it is thicker than elsewhere, and goes on ramifying an infinite number of times through every limb of the creature.

[Veins from the liver to the spleen and their function]

Of the two thick veins which go from the liver to the spleen, which come from the larger veins of the spine, I think that these are amassers of the superfluous blood, which being every day evacuated by the mesaraic veins is deposited in the bowels, causing the same stench when it has reached there that arises from the dead in the sepulchres, and that is the stench of the excrements.

[With figure]

Ramification made by the navel and the vein and the artery in the gate of the liver.

Represent first all the ramifications of the veins which come to the gate of the liver, all together, and then each by itself separately in three or if you prefer four demonstrations; I said three because the vein and the artery make the same journey. Fogli B 34 v.

[The olfactory and optic nerves and their relations] *[With figures]*

a b c d are the nerves that convey odours.

The nerves start from the last membrane which clothes the brain and the spinal marrow.

e n nerves are the optic nerves which are situated below the nerves called caruncular; but the optic serve the visual faculty and the caruncular the olfactory.

[Process for examination of the brain and the basilar nerves]

You will take to pieces the substance of the brain as far as the confines of the dura mater which is interposed between this basilar bone and the substance of the brain; then note all the places where this dura mater penetrates the basilar bone, with the nerves clothed by it together with the pia mater; and this knowledge you will acquire with certainty whenever by diligence you raise this pia mater little by little, commencing with the extremities, and noting from one part to another the position of the before mentioned perforations, commencing first at the right or left side, representing this in its entirety; and then you will follow the opposite part, which will give you knowledge as to whether the foregoing is well situated or no, and it will also bring you to an understanding of whether the right part is similar to the left part; and if you find that it varies you will look again in the other

anatomies whether this variation is universal in all men and women.
Note where the exterior parts meet the interior parts.

Fogli B 35 r.

[Preparation of the hæmorrhoidal veins]

Cut the subject in the middle of the spine; but first bind the chyle
(vein) and artery, so that it may not pour out, and thus you will be
able to see the hæmorrhoidal veins in halves, that is in each division
of this subject.

OF THE FOOD WHICH MAKES CORRUPTION

I say that the extremities of the mesaraic veins which attract to them-
selves the substance of the food enclosed in the intestines are enlarged
by means of the natural heat of the man, because the heat separates
and enlarges and the cold assembles and constricts; but this would not
be sufficient if to this heat were not added the stench formed by the cor-
ruption of the blood returned by the arteries to these intestines, which
blood acts in these intestines not otherwise than it does in bodies that
have been buried; which stench enlarges the intestines and penetrates
into all the interstices and swells and puffs out the bodies in the shape
of casks; and if you should say that this stench arose from the heat
in the bodies this would not be found to be the case with the inflated
bodies which are covered with snow, and the power of the stench is
much more active and multiplies much more than does that of the
heat.

Fogli B 36 v.

DEMONSTRATION OF THE BLADDER OF THE MAN

[Reins, ureters, bladder and urethra]

First demonstration

Of these three demonstrations of bladders, in the first are represented
the ureteral pores and how they part from the reins *L h*, and join to-
gether at the bladder two fingers space above the starting point of
the neck of this bladder, and at a short distance on the inside of this
meeting point these pores discharge the urine into the bladder, from
p b into *n f*, in the manner that is shown in part in the channel *S*,
whence it is then poured through the pipe of the penis *a g*.

It remains for me in this case to represent and describe the position of the muscles which open and close the passage of the urine to the mouth of the neck of this bladder.

Second demonstration

In the second demonstration one represents the four ramifications namely right and left of the veins that feed this bladder, and the right and left artery which gives it life, that is spirits.

And the vein is always situated above the artery.

Third demonstration

In the third demonstration is contained how the vein and artery surround the beginning of the ureteral pore *m n* in the position *n*, and there is shown the interlacing of the ramification of the vein with the ramification of the artery.

[*Entry of the urine into the bladder*]

The urine, after departing from the kidneys, penetrates in the ureteral pores, and from these passes into the bladder, near the centre of its height, entering into this by means of small perforations made transversely between one coat and another; and this slanting perforation was not made because nature doubted whether this urine could return to the kidneys, because this is impossible by the fourth [rule] concerning channels (de' condotti) where it is stated:—'the water which from a height descends by a thin vein and penetrates under the bottom of the sheet of water cannot be compared as to its reflex movement, unless there is as great thickness in the sheet of water as the thickness of the descending vein, nor any greater height of water in this than the depth in the sheet of water.' And if you were to say that the more the bladder fills the more it closes, to this one will reply that the fact of such perforations being pressed together by the urine which closed these walls would prevent the entrance of the rest of the urine as it descends, which cannot be by the fourth mentioned previously, which states that the thin raised-up urine is more potent than the low and wide which is in the bladder.

Fogli B 37 r.

You will make this demonstration.

Trachea, whence the voice passes.

Œsophagus (meri), whence passes the food.

Nerves (ipopletiche), whence pass the vital spirits.

Backbone, where the ribs begin.

Vertebrae, whence start the muscles which terminate in the nape of the neck and raise the face towards the sky.

[Precepts for the demonstration of the intestines]

Describe all the heights and breadths of the intestines, and measure them by fingers in halves and thirds of fingers of a dead man's hand, and for all put at what distance they are from the navel the breasts or the flanks of the dead.

[The relation of the lungs to the bronchial tubes]

The substance of the lung is expansible and extendible, and it is interposed between the ramifications of the trachea, so that these ramifications may not be dislodged from their positions; and this substance interposes itself between this ramification and the ribs of the chest, after the fashion of a soft feather bed.

Remember to represent the mediastinum (heart cavity) with the case of the heart, with four demonstrations, from four aspects, in the manner that is written below.

[How to describe the thoracic organs]

Make first the ramification of the lung, and then make the ramification of the heart, that is of its veins and arteries; afterwards make the third ramification of the mixture of the one ramification with the other; and these mixtures you will make from four aspects, and you will do the like with the said ramifications which will be twelve; and then make a view of each from above and one from below, and this will make in all eighteen demonstrations.

You will first make this lung in its entirety, seen from four aspects, in its entire perfection; afterwards you will represent it so that it is seen perforated merely with the ramification of its trachea in four other aspects.

After you have done this do the same in the demonstration of the heart, first entire, and then with the ramification of its veins and arteries.

Afterwards you will make it seen from four aspects how the veins

and arteries of the heart mingle with the ramification of the trachea; then make a ramification of nerves alone from four aspects, and then weave them in four other aspects of the heart and lung joined together; and observe the same rule with the liver and spleen, kidneys, matrix and testicles, brain, bladder and stomach. Fogli B 37 v.

[Description of the region of the mouth]

Here the lips become muscles, moving the lateral muscles with themselves.

And then the lateral muscles move the lips.

It is necessary to note first as to the bones of the face, in what part arise and whence come the nerves which first open and then close the lips of the mouth, and where the muscles are attached which are penetrated by these nerves.

[Nerves and muscles of the mouth and their functions in various movements]

The nerve *n m* in the lower lip and the nerve *o p* in the upper lip are the cause why the mouth closes with the help of the muscles of which these lips of the mouth are formed.

The muscles called lips of the mouth as they become compressed towards their centre draw the lateral muscles after them; and as the lateral muscles draw back in themselves, contracting, they then draw back the lips of the mouth and so this mouth expands.

The final contraction of the mouth makes it equal to half what it is when it is at its greatest extension, and it is the same with regard to the greatest breadth of the nostrils of the nose and of the interval interposed between the tear-ducts of the eyes.

OF THE NERVES WHICH TIGHTEN THE LIPS

The movements that the lips make as they tighten are two, of which one is that which presses and strains the one lip against the other, the second movement is that which compresses or shortens the length of the mouth; but that which presses the one lip against the other does not proceed beyond the last molars of the mouth, and these when they are drawn are of such great power that, keeping the teeth somewhat open,

they would draw the lips of the mouth within the teeth, as is shown in the mouth *g h* which is drawn by the muscles *r* by its sides.

[*Which muscles are those that tighten the mouth across?*]

The muscles that tighten the mouth across as is shown above are the lips themselves, which draw the sides of the mouth towards the centre; and this is shown us by the fourth [rule] of this which says:—the skin which forms the covering of the muscles that draw always points with its wrinkles to the spot where is the cause of the movement; and by the fifth: no muscle uses its power in pushing but always in drawing to itself the parts that are joined to it; therefore the centre of the muscles called the lips of the mouth draws to itself the extremities of this mouth with part of the cheeks, and for this reason the mouth in this function is always filled with wrinkles. Fogli B 38 v.

[*How to describe the cranium*]

Where the line *a m* intersects the line *c b* there will be the meeting place of all the senses; and where the line *r n* intersects the line *h f* there will be the axis of the cranium in the third of the divisions of the head.

Remember when you represent this half head from the inside to make another which shall show the outside turned in the same direction as this, so that you may better apprehend the whole.

Fogli B 40 r.

[*Orbital cavities (The antrum of Highmore)*]

I wish to take away that part of the bone, the support of the cheek, which is found within the four lines *a b c d*, and to show through the opening revealed the breadth and depth of the two cavities which hide behind it.

In the cavity above is hidden the eye, the instrument of sight, and in that below is the humour which nourishes the roots of the teeth.

The cavity of the bone of the cheek resembles in depth and breadth the cavity which receives the eye within it, and in capacity it is very similar to it and receives veins within it by the holes *m* which descend from the brain passing through the passage which discharges the excess of the humours of the head in the nose.

Other perceptible holes are not found in that of the cavity above which surrounds the eye. The hole *b* is where the visual faculty passes

to the sense, the hole *n* marks the spot at which tears rise from the heart to the eye, passing by the channel of the nose. Fogli B 40 v.

[*Cavity of the cranium. Seat of the concourse of all the senses and its relations*]

The concourse of all the senses has below it in a perpendicular line the uvula where one tastes the food at a distance of two fingers, and it raises itself above the tube of the lung and above the orifice of the heart for the space of a foot; and it has the junction of the bone of the cranium half a head above it; and it has before it in a horizontal line at a third of a head away the tear-duct of the eyes; and behind it it has the nape of the neck at two thirds of a head and on the sides the two pulses of the temples at equal distance and height. The veins which are shown within the cranium in their ramification produce an imprint of the half of their thickness in the bone of the cranium, and the other half is hidden in the membranes which clothe the brain; and where the bone has a dearth of veins within it is replenished from without by the vein *a m*, which after having issued forth from the cranium passes into the eye and then in the . . . Fogli B 41 r.

[*Cavities of the face and their relation*]

The cavity of the socket of the eye and the cavity of the bone that supports the cheek, and that of the nose and of the mouth are of equal depth, and end below the seat of the senses[1] in a perpendicular line.

And each of these cavities has as much depth as the third part of a man's countenance, that is from the chin to the hair.

[*The different kinds of teeth and their function*]

Six upper molars have three roots each and they have two roots in the outer side of the jaw and one in the inner side, and the two last of these are cut in two or four years or thereabouts.

Next come four premolars of two roots each, one on the inside and outside of the jaw, then follow the two maestre (canines) with only one root, and in front are the four teeth which do the cutting and have one root only.

The lower jaw has also sixteen teeth as above; but its molars have only two roots; the other teeth are as those in the upper jaw; in animals

[1] MS. il senso comune.

the teeth of which there are two fasten on the prey, the four cut it up, the six grind it. Fogli B 41 v.

ON THE SECOND DAY OF APRIL 1489 THE BOOK ENTITLED 'OF THE HUMAN FIGURE'

[*Veins of the face*]

The vein *m* is raised up and enters under the bone of the cheek, and through the hole of the socket of the eye passes between the under side of the eyeball and the bone that supports it, and in the middle of the said passage this vein pierces the bone, and drops down half a finger's space, having pierced through the surface of the bone under the edge of the socket *n* mentioned above; there it commences to raise itself up, and after marking for some distance the edge of the eye passes from the tear-duct and finally within the eyelids after having raised itself for a space of two fingers, and there commences the ramification which spreads through the head. Fogli B 42 r.

[*Various themes in anatomy and physiology*]

What nerve is the cause of the eye's movement and makes the movement of one eye draw the other?

Of closing the eyelid.

Of raising the eyebrows.

Of lowering the eyebrows.

Of shutting the eyes.

Of opening the eyes.

Of raising the nostrils.

Of parting the lips with teeth clenched.

Of bringing the lips to a point.

Of laughing.

Of wondering.

Set yourself to describe the beginning of man when he is created in the womb.

And why an infant of eight months does not live.

What sneezing is.

What yawning is.

Epilepsy.

Spasm.

Paralytic.

Trembling from cold.

Perspiration.

Fatigue.

Hunger.

Sleep.

Thirst.

Sensuality.

Of the nerve which is the cause of the movement from the shoulder to the elbow.

Of the movement that is from the elbow to the hand.

From the wrist to the beginning of the fingers.

From the beginning of the fingers to the middle of them.

And from the middle to the last joint.

Of the nerve which is the cause of the movement of the thigh.

And from the knee to the foot and from the ankle to the toes.

And so to their centres.

And of the turning movement of this leg. Fogli B 42 v.

[*How nature gives animals the power of motion*]
ON MACHINES

Why nature cannot give the power of movement to animals without mechanical instruments, as is shown by me in this book on the works of movement which nature has created in the animals. And for this reason I have drawn up the rules of the four powers of nature without which nothing through her can give local movement to these animals. We shall therefore first describe this local movement and how it produces and is produced by each of the other three powers. Then we shall describe the natural weight, for though no weight can be said to be other than accidental, it has pleased us to style it thus in order to distinguish it from the force which in all its operations is of the nature of weight and is for this reason called accidental weight, and this is the force which is produced by the third power of nature, that is, the inherent or natural power. The fourth and last power will be called percussion, that is, the end or restraint of movement. And we shall

begin by stating that every local insensible movement is produced by a sensible mover, just as in a clock the counterpoise is raised up by man who is its mover. Moreover the elements repel or attract each other, for one sees water expelling air from itself, and fire entering as heat under the bottom of a boiler and afterwards escaping in the bubbles on the surface of the boiling water. And again the flame draws to itself the air, and the heat of the sun draws up the water in the form of moist vapour which afterwards falls down in thick heavy rain. Percussion however is the immense power of things which is generated within the elements. Quaderni 1 1 r.

[*Description of the human body in process of dissection*]
THE ORDER OF THE BOOK

This plan of mine of the human body will be unfolded to you just as though you had the natural man before you. The reason is that if you wish to know thoroughly the parts of a man after he has been dissected you must either turn him or your eye so that you are examining from different aspects, from below, from above and from the sides, turning him over and studying the origin of each limb; and in such a way the natural anatomy has satisfied your desire for knowledge. But you must understand that such knowledge as this will not continue to satisfy you on account of the very great confusion which must arise from the mixture of membranes with veins, arteries, nerves, tendons, muscles, bones and the blood which of itself tinges every part with the same colour, the veins through which this blood is discharged not being perceptible by reason of their minuteness. The completeness of the membranes is broken during the process of investigation of the parts which they enclose, and the fact that their transparent substance is stained with blood prevents the proper identification of the parts which these cover on account of the similarity of the blood-stained colour, for you cannot attain to any knowledge of the one without confusing and destroying the other.

Therefore it becomes necessary to have several dissections: you will need three in order to have a complete knowledge of the veins and arteries, destroying all the rest with very great care; and three others for a knowledge of the membranes, 'panniculi', three for the tendons,

muscles and ligaments, three for the bones and cartilages, three for the anatomy of the bones, for these have to be sawn through in order to show which are hollow and which not, which are full of marrow, which spongy, which thick from the outside inwards, and which thin. And some have great thinness at one part and thickness at another, and at another part they are hollow or filled with bone or full of marrow, or spongy. Thus it may be that all these conditions will sometimes be found in the same bone and there may be another bone which has none of them. Three also must be devoted to the female body, and in this there is a great mystery by reason of the womb and its foetus.

Therefore by my plan you will become acquainted with every part and every whole by means of a demonstration of each part from three different aspects; for when you have seen any member from the front with the nerves, tendons and veins which have their origin on the opposite side, you will be shown the same member either from a side view or from behind, just as though you had the very member in your hand and went on turning it from side to side until you had a full understanding of all that you desire to know.

And so in like manner there will be placed before you three or four demonstrations of each member under different aspects, so that you will retain a true and complete knowledge of all that you wish to learn concerning the figure of man.

Therefore there shall be revealed to you here in fifteen entire figures the cosmography of the 'minor mondo' (the microcosmos or lesser world) in the same order as was used by Ptolemy before me in his Cosmography. And therefore I shall divide the members as he divided the whole, into provinces, and then I shall define the functions of the parts in every direction, placing before your eyes the perception of the whole figure and capacity of man in so far as it has local movement by means of its parts.

And would that it might please our Creator that I were able to reveal the nature of man and his customs even as I describe his figure!

And I would remind you that the dissection of the nerves will not reveal to you the position of their ramification nor into which muscles they ramify by means of bodies dissected either in flowing water or in lime water; because, although the origin of their derivation may be discerned without the use of the water as well as with it, their ramifica-

tions tend to unite in flowing water all in one bunch just as does flax or hemp carded for spinning, so that it becomes impossible to find out again into which muscles the nerves are distributed or with which or how many ramifications they enter the said muscles.

[*Dissection of the human hand*]
OF THE HAND FROM WITHIN

When you begin the hand from within first separate all the bones a little from each other so that you may be able quickly to recognise the true shape of each bone from the palmar side of the hand, and also the real number and position of each, and have some sawn through down the centre of their thickness, that is lengthwise, so as to show which is empty and which full. And having done this place the bones together at their true contacts and represent the whole hand from within wide open. Then set down the complete figures of the first ligaments of the bones. The next demonstration should be of the muscles which bind together the wrist and the remainder of the hand. The fifth shall represent the tendons which move the first joints of the fingers. The sixth the tendons which move the second joints of the fingers. The seventh those which move the third joints of these fingers. The eighth shall represent the nerves which give them the sense of touch. The ninth the veins and the arteries. The tenth shall show the whole hand complete with its skin and its measurements, and measurements should also be made of the bones. And whatever you do for this side of the hand you should do the same for the other three sides, that is from the palmar or under side, from the dorsal side and from the sides of the extensor and the flexor muscles.

And thus in the chapter on the hand you will make forty demonstrations; and you should do the same with each member.

And in this way you will attain complete knowledge.

You should afterwards make a discourse concerning the hands of each of the animals, in order to show in what way they vary, as with the bear, in which the ligaments of the tendons of the toes are joined above the neck of the foot. Quaderni 1 2 r.

Not abbreviators but forgetters (obbliatori) should they be called who abridge such works as these. Quaderni 1 4 r.

Make a discourse on the censure deserved by scholars who put obstacles in the way of those who practise anatomy and by the abbreviators of their researches.[1]

[*Nothing superfluous or lacking in nature*]

Nothing is superfluous and nothing is lacking in any species of animal or product of nature unless the defect comes from the means which produce it. Quaderni 1 4 v.

IF THE WIND WHICH ESCAPES FROM THE TRACHEA CONDENSES ITSELF IN ITS TRANSIT OR NO

All the air that enters into the trachea is of equal quantity in all the degrees which are produced by its ramification; after the manner of the branches born during the seasonal growth of the plants which every year, if the various thicknesses of all the branches that have been produced are reckoned together, equal the thickness of the stem of their plant.

But the trachea contracts itself in the larynx in order to condense the air, which seems a thing of life as it comes from the lung to create the various kinds of voices, and also to press and dilate the different passages and ventricles of the brain, because if the trachea were thus dilated at its upper end as it is in the throat, the air would not be able to condense itself and perform the duties and benefits which are necessary to life and to man, that is in speaking, singing and the like. And the wind which is suddenly expelled from the lung as it produces the deep sighs proceeds by the help of the wall of the abdomen (mirac?) which squeezes the intestines, and they raise the diaphragm that presses on the lung. Quaderni 1 5 v.

[1] There may be a veiled significance in the use of the word 'abbreviatori' as the term was also applied to the secretaries at the Chancery of the Vatican. Leonardo in one of his letters complains of having been impeded in his anatomical researches as a result of information laid before the Pope.

IF THE HEART AT ITS DEATH CHANGES POSITION OR NO

The change of the heart at its death is similar to the change which it undergoes during the expulsion of its blood, and is somewhat less. This is shown when one sees the pigs in Tuscany, where they pierce the hearts of the pigs by means of an instrument called a borer, which is used for drawing wine out of casks. And thus turning the pig over and tying it up well they pierce its right side and its heart at the same time with the borer, thrusting it in in a straight line. And if this borer pierces the heart when it is distended the heart as it expels the blood becomes contracted and draws the wound to the top together with the point of the borer; and the more it raises the point of the borer within the more it lowers the handle of the borer outside; and afterwards when the heart is distended and drives this wound downwards the part of this borer which is outside makes a movement that is the opposite to that of the part within which moves together with the movement of the heart. And this it does many times, so that at the end of life that part of the borer that is outside remains in the middle of the two extremities, where were the last contrary movements of the heart when it was alive. And when the heart becomes quite cold it shrinks somewhat and contracts as much as it had extended when warm because heat causes a body to increase or diminish when it enters into it or leaves it; and this I have seen many times and have observed such measurements having allowed the instrument to remain in the heart until the animal was cut up. . . .

And from the greatest to the smallest movement of the heart of this animal is about the thickness of a finger, and at the end the heart remains with its point out of its usual position by about half the thickness of a finger; and pay attention lest you make a mistake in taking this measurement because sometimes the handle of this borer will not make any change whether the heart is living or dead; and this occurs when the heart receives its wound half way in the process of its contracting, in which position it remains when it is dead. And sometimes this handle makes the greater change and this occurs when the heart receives its wound during its period of greater or less length, and thus it will make as many varieties of distances as are the variations in the length or shortness of the heart when it is wounded. More-

over this handle will make greater or less changes according as the point of the borer penetrates further or less into the heart; for if the point of the iron transfixes the heart it makes a lesser movement from the centre of its movement, that is from the place, than it would do if the iron had only wounded the heart in the front part of its anterior wall; and on this point I will not dwell further because a complete treatise on these movements has been compiled in the twentieth book on the forces of the lever. And if you should consider that when the heart had been transfixed the length of the borer could not follow the movement spoken of above through it being impeded by the anterior wall of the heart you must understand that in the extension and dilation of the heart, it draws or drives the point of this iron along with its motion; and the iron which finds itself in the anterior wall enlarges its wound both upwards and downwards, or to put it better moves it seeing that the roundness of the thick part of the iron does not enlarge since it does not cut, but carries with it the front wound of the heart, compressing the part of the heart in contact with it now from the upper part of the wound, now from the lower part, and such rarefaction and compression is easily made by this heart when it is warm because it is less dense. Quaderni 1 6 r.

[Notes on anatomy]

You should make the liver in the embryo differing from that of man, that is with the right and left parts equal.

But you should make first the anatomy of the hatched eggs.

Say how at four months the child is half the length and so is one eighth the weight that it will be at birth.

Describe which and how many are the muscles that move the larynx in the production of the voice. Quaderni 1 10 r.

[Development of embryo]

Do this demonstration also as seen from the side, in order to give information how much one part may be behind the other; and then do one from behind in order to give information as to the veins covered by the spine and by the heart and greater veins.

Your order shall commence with the formation of the child in the womb, saying which part of it is formed first and so on in succession, placing its parts according to the times of pregnancy until the birth,

and how it is nourished, learning in part from the eggs which hens make. Quaderni 1 12 r.

And you who say that it is better to look at an anatomical demonstration than to see these drawings, you would be right, if it were possible to observe all the details shown in these drawings in a single figure, in which, with all your ability, you will not see nor acquire a knowledge of more than some few veins, while, in order to obtain an exact and complete knowledge of these, I have dissected more than ten human bodies, destroying all the various members, and removing even the very smallest particles of the flesh which surrounded these veins, without causing any effusion of blood other than the imperceptible bleeding of the capillary veins. And as one single body did not suffice for so long a time, it was necessary to proceed by stages with so many bodies as would render my knowledge complete; and this I repeated twice over in order to discover the differences.

But though possessed of an interest in the subject you may perhaps be deterred by natural repugnance, or, if this does not restrain you, then perhaps by the fear of passing the night hours in the company of these corpses, quartered and flayed and horrible to behold; and if this does not deter you then perhaps you may lack the skill in drawing essential for such representation; and even if you possess this skill it may not be combined with a knowledge of perspective, while, if it is so combined, you may not be versed in the methods of geometrical demonstration or the method of estimating the forces and strength of muscles, or perhaps you may be found wanting in patience so that you will not be diligent.

Concerning which things, whether or no they have all been found in me, the hundred and twenty books which I have composed will give their verdict 'yes' or 'no'. In these I have not been hindered either by avarice or negligence but only by want of time. Farewell.

Quaderni 1 13 v.

[*Drawings describe natural things better than words*]
[*Note at side of drawing of heart showing the arrangement of the veins and arteries*]

With what words O writer can you with a like perfection describe the whole arrangement of that of which the design is here?

For lack of due knowledge you describe it so confusedly as to convey but little perception of the true shapes of things, and deceiving yourself as to these you persuade yourself that you can completely satisfy the hearer when you speak of the representation of anything that possesses substance and is surrounded by surface.

I counsel you not to cumber yourself with words unless you are speaking to the blind. If however notwithstanding you wish to demonstrate in words to the ears rather than to the eyes of men, let your speech be of things of substance or natural things, and do not busy yourself in making enter by the ears things which have to do with the eyes, for in this you will be far surpassed by the work of the painter.

How in words can you describe this heart without filling a whole book? Yet the more detail you write concerning it the more you will confuse the mind of the hearer. And you will always then need commentators or to go back to experience; and this with you is very brief, and has to do only with a few things as compared with the extent of the subject concerning which you desire complete knowledge.

Quaderni II 1 r.

[*Praise of the Creator in anatomy*]
[*Drawing of action of the muscles of the heart, followed by descriptive note in which occurs the sentence:*]

This the Inventor made for the cause shown in the figure above, which reveals how the Creator does not make anything superfluous or defective.

Quaderni II 3 r.

[*Anatomy of neck—Praise of the Creator*]

Each of the vertebrae of the neck has ten muscles joined to it.

You should show first the spine of the neck with its tendons like the mast of a ship with its shrouds without the head; then make the head with its tendons which give it its motion upon its axis.

a b are muscles which keep the head upright, and so do those which originate in the clavicle, *c b,* joined to the pubes by means of the longitudinal muscles.

Show in the second demonstration which and how many are the nerves that give sensation and movement to the muscles of the neck.

n is one of the vertebra of the neck to which is joined the beginning

of three muscles, that is of three pairs of muscles which are opposite each other, so that the bone where they have their origin may not break.

O speculator concerning this machine of ours let it not distress you that you impart knowledge of it through another's death, but rejoice that our Creator has ordained the intellect to such excellence of perception. Quaderni II 5 v.

Why the heart does not beat nor the lung breathe during the time that the child is in the womb which is filled with water; for if it should draw a breath it would instantly be drowned. But the breathing and the beating of its mother's heart works in the life of the child which is joined to her by means of the umbilical cord as it works in the other members.

Therefore during every harmonic or as you may say musical tempo the heart makes three movements, as is contained below, of which tempos an hour contains one thousand and eighty. The heart therefore moves three thousand five hundred and forty times in each hour in the process of opening and shutting. And it is this frequency of movement which warms the thick muscles of the heart, and this heat warms the blood that continually beats within it. It heats it more in the left ventricle, where the walls are very thick, than in the right ventricle with the thin wall. And this heat makes the blood grow thinner and turns it to vapour and changes it into air, and would change it to elemental fire, if it were not that the lung renders help at this crisis with the coolness of its air.

But the lung cannot send air into the heart, nor is this necessary since, as has been said, air is generated in the heart, and this, as it becomes mingled with the warm thick moisture, evaporates through the extremities of the capillary veins at the surface of the skin in the form of perspiration; and moreover the air which is breathed in by the lung, enters continually dry and cold, and issues forth moist and warm. But the arteries which are joined by continual contact to the network of branches of the trachea, spreading through the lung, are what catches the coolness of the air as it enters into this lung. Quaderni II 11 r.

[*Balance of heart in man and animals*]

And if you say that the left external wall (of the heart) has been

made thick in order that it might acquire greater weight, so that it should make a counterpoise to the right ventricle, which has a great weight of blood, you have not reflected that this balancing was not necessary, seeing that all the land animals except man have the heart in a recumbent position; and the heart of man also lies thus when he is lying in his bed. But you would not be weighing the matter well in your conclusion, because the heart has two supports which descend from the collar bone, from which by the fourth of 'De Ponderibus' the heart is not able to balance itself, if there is not a single support above, and these two supports are the Arteria Aorta and the Vena cava; and furthermore if the heart is deprived of the weight of the blood as it becomes restricted and gives it in deposit to its upper ventricles, the centre of gravity of the heart would then be on the right side of the heart and thus its left side would be lightened. But this theory of balancing is not a true one as was said above because the animals which lie or which stand on four feet have the heart lying as they are themselves, and with these no balancing of the heart is sought.

And in the case of the bat which when it sleeps always places itself upside down, how does the heart balance with the right and left ventricle? Quaderni II 17 r.

WHY THE PRINCIPAL VALVES OF THE RIGHT VENTRICLE ARE MADE WITH SO LITTLE MEMBRANE AND SUCH A NETWORK OF CORDAE

This thing was ordained by nature in order that as the right ventricle commences to shut, the escape of the blood from its huge capacity should not suddenly cease, because a portion of that blood had to be given to the lung, and it would not be given if the valve had stopped the exit. But this ventricle shut itself when the lung had received its quantity of blood and so [from] the right ventricle it was able to press through the pores of the median wall into the left [MS. right] ventricle; and at the same time the right auricle became the depositary of the excess of the blood which it passes to the lung, and this suddenly gives it to the opening of this right ventricle restoring itself through the blood with which the liver supplies it.

HOW MUCH BLOOD IS THE LIVER ABLE TO GIVE IT THROUGH THE OPENING OF THE HEART?

It restores as much of it as it consumes; that is a minimum part, because in an hour the heart opens about two thousand times. There is great weight.

The right ventricle was made heavier than the left one in order that the heart may stand in a slanting direction; and when the blood rises out of the left ventricle and lightens it this blood goes from it towards the left side with the centre of its gravity when it is in the upper ventricles.

The heart has four ventricles, that is two upper ones called auricles of the heart, and two lower than these called the right and left ventricles. *Quaderni* II 17 v.

[*Definitions*]

Definition of the instruments.

Discourse on the nerves, muscles, tendons, 'panniculi' (membranes) and ligaments.

The function of the nerves is to convey sensation; they are the team of drivers of the soul, for they have their origin from its seat and command the muscles so that they move the members at the consent of the will of this soul.

The muscles the ministers of the nerves draw to themselves the sinews which are joined to these members in a similar manner.

The tendons are mechanical instruments which have no sensation of themselves but carry out as much work as is entrusted to them.

The membranes (panniculi) are joined to the flesh being interposed between the flesh and the nerve, and most frequently they are joined to the cartilage.

The ligaments are joined to the tendons and are of the nature of membranes (panniculi) which bind together the joints of the bones and are converted into cartilage, and they are as many in number at every joint as are the tendons which move the joint and as are the tendons opposite to these which come to the same joint, and these ligaments join and mingle together, helping strengthening and connecting one with another.

The cartilage is a hard substance, like, let us say, hardened tendon or softened bone, and its position is always between the bone and the tendon because it partakes of both substances, and it is flexible and unbreakable, the flexibility acting in it like a spring.

Pellicles are certain muscular parts which are made up of flesh, tendons and nerves, the union of these forming a composition which is capable of being extended in any direction; flesh is a mixture made up of muscles, tendon, nerve, blood and artery.

Bone is a hardness, inflexible, adapted for resistance, and is without sensation and terminates in the cartilages which form its extremities; and its marrow is composed of sponge, blood, and, soft fat coated over with a very thin tissue. The sponge-like substance is a mixture of bone, fat and blood.

The membranes (panniculi) are of three kinds, that is, made up of tendons, made up of nerves, and made up of nerves and tendons; and the mixed membrane is woven of tendon, nerve, muscle, vein and artery.

The membranes that are between the tendons and the cartilages are so formed as to unite tendon with cartilage in a large and continuous joint so that it may not break through excess of force; and when the muscle itself thickens it does not draw to itself the tendon or any member, but the muscle is drawn by the tendon towards the membrane and the cartilage, as happens with the muscles inside the ventricles of the heart when they shut their openings. But the muscles of the other members are drawn towards the bone where they are joined, and draw their tendon behind them together with the member that is joined to this tendon.

The tears come from the heart and not from the brain.

Define all the parts of which the body is composed, commencing with the skin with its outer coating which often detaches itself through the action of the sun. Quaderni II 18 v.

[Six constituent parts of movement]

There are six things which take part in the composition of the movements; namely bone, cartilage, membrane, tendon, muscle and nerve, and these six consequently are in the heart. Quaderni II 23 r.

[With sectional drawing 'in congressu']

I reveal to men the origin of their second—first or perhaps second—cause of existence.

Through these figures will be shown the cause of many dangers of ulcers and diseases.

Division of the spiritual from the material parts.

And how the child breathes and how it is nourished through the umbilical cord; and why one soul governs two bodies, as when one sees that the mother desires a certain food and the child bears the mark of it.

And why the child [born] at eight months does not live.

Here Avicenna contends that the soul gives birth to the soul and the body to the body and every member, but he is in error.

Quaderni III 3 v.

The child does not draw breath in the body of its mother because it lies in water, and whoever breathes in water is immediately drowned.

Whether the child while within the body of its mother is able to weep or to produce any sort of voice or no.

The answer is no; because it does not breathe neither is there any kind of respiration; and where there is no respiration there is no voice.

Ask the wife of Biagino Crivelli how the capon rears and hatches the eggs of the hen when he is in the mating season.

They hatch the chickens by making use of the ovens by the fireplace.

Those eggs which are of a round form will be cockerels and the long-shaped ones pullets.

Their chickens are given into the charge of a capon which has been plucked on the under part of its body, and then stung with a nettle and placed in a hamper. When the chickens nestle underneath it it feels itself soothed by the sensation of warmth and takes pleasure in it, and after this it leads them about and fights for them, jumping up into the air to meet the kite in fierce conflict. Quaderni III 7 r.

Book 'On the Water' to Messer Marco Antonio.[1]

[1] Marco Antonio della Torre. Context shows that text refers to presence of water in uterus during gestation.

[With drawing of child in womb]·

In the case of this child the heart does not beat and it does not breathe because it lies continually in water. And if it were to breathe it would be drowned, and breathing is not necessary to it because it receives life and is nourished from the life and food of the mother. And this food nourishes such creature in just the same way as it does the other parts of the mother, namely the hands feet and other members. And a single soul governs these two bodies, and the desires and fears and pains are common to this creature as to all the other animated members. And from this it proceeds that a thing desired by the mother is often found engraved upon those parts of the child which the mother keeps in herself at the time of such desire; and a sudden fear kills both mother and child.

We conclude therefore that a single soul governs the bodies and nourishes the two [bodies]. Quaderni III 8 r.

[How one mind governs two bodies]

As one mind governs two bodies, in as much as the desires the fears and the pains of the mother are one with the pains that is the bodily pains and desires of the child which is in the body of the mother, in like manner the nourishment of the food serves for the child and it is nourished from the same cause as the other members of the mother, and its vital powers are derived from the air which is the common living principle of the human race and of other living things.

[Colour of skin due to parents—seed of mother as potent as that of father]

The black races in Ethiopia are not the product of the sun; for if black gets black with child in Scythia, the offspring is black; but if a black gets a white woman with child the offspring is grey. And this shows that the seed of the mother has power in the embryo equally with that of the father. Quaderni III 8 v.

[On sheet with drawings and notes of foetus in uterus]

See how the birds are nourished in their eggs. Quaderni III 9 v.

[Representation of lungs with bronchiae and vessels]

When you represent the lung make it perforated so that it may not obstruct what is behind it, and let the perforation be all the ramifica-

tions of the trachea and the veins of the artery (aorta) and of the vena cava and then outside these draw a contour line round about them to show the true shape, position and extent of this lung.

Quaderni III 10 r.

[With drawings of action of lungs]

Represent first all the ramification which the trachea makes in the lung and then the ramification of the veins and arteries separately, and then represent everything together. But follow the method of Ptolemy in his Cosmography in the reverse order: put first the knowledge of the parts and then you will have a better understanding of the whole put together.

Quaderni III 10 v.

[With drawing]

This is the lung in its case.

The question arises where the lung becomes cooler or more heated, and the same is searched for in the heart.

It has to be ascertained whether the wall of the heart interposed between its two ventricles is thinner or thicker as the heart becomes longer or shorter, or one may say as it expands or contracts.

It is our opinion that during the process of dilation it increases its capacity and the right ventricle draws blood from the liver and the left ventricle at such time draws blood from the right one.

As many times as the pulse beats so many times does the heart expand and contract.

Quaderni IV 3 r.

[Of the muscles]

No one can move others if he does not move himself.

Quaderni IV 5 r.

[Relation of reversive nerves to heart and brain. Seat of soul. Origin of vital powers. Action of heart. Relation of movement of heart and lung]

Follow up the reversive nerves as far as the heart, and observe whether these nerves give movement to the heart or whether the heart moves of itself. And if its movement comes from the reversive nerves which have their origin in the brain then you will make it clear how the soul has its seat in the ventricles of the brain, and the vital powers derive their origin from the left ventricle of the heart. And if this

movement of the heart originates in itself then you will say that the seat of the soul is in the heart and likewise that of the vital powers, so that you should attend well to these reversive nerves and similarly to the other nerves, because the movement of all the muscles springs from these nerves which with their ramifications pour themselves into these muscles. Many are the times when the heart draws into itself some of the air which it finds in the lung, and returns it after it is heated without this lung having gathered other air from outside.

It is proved that it must of necessity be as is here set forth, and this is that the heart which moves of itself only moves in opening and shutting itself; this opening and shutting creates motion along the line that lies between the cusp and the base or corona of the heart; and it cannot open without drawing into itself air from the lung, which it immediately blows out again into the lung, where it will afterwards be seen that this lung will be restored by a vigorous movement of sudden deep breathing from the new refreshment of cold air; and this occurs when a fixed purpose of the mind banishes into oblivion the respiration of the breath.

In closing itself the heart with its nerves and muscles draws behind it the powerful vessels which proceed from the heart to unite with the lung; and this is the principal cause of the opening of the lung, because it cannot open unless the vacuum increases, and the vacuum cannot acquire any increase unless it refills itself, and finding the air more suitable for this restoration of the vacuum it refills itself with it. This heart afterwards as it contracts comes to reopen itself, and as it reopens itself it relaxes the drawn-out nerves and vessels of the lung, from which it follows that the lung closes itself up again and at the same time restores the increase in the vacuum of the heart through the wind which it blows out of itself, and in part sends out of the mouth the superfluous air for which neither in it nor in the heart is there any capacity. Quaderni IV 7 r.

[*Subcutaneous vessels in the groin and armpit*]

From the inner parts of the arms and of the thighs go veins that form branches from their main stems and these run all over the body between the skin and the flesh.

And remember to note where these arteries part company from the veins and the nerves. Quaderni IV 8 r.

[Tonsils]

The two tonsils are formed on the opposite sides of the base of the tongue and are in the shape of two small cushions interposed between the bone of the maxilla and the base of the tongue so as to create a space between the two, so that on one side it may be capable of receiving the lateral roundness of the convex formation of the tongue caused by it bending, and may with its convex part wipe away the food from the angle of the maxilla round the lateral parts of the base of the tongue.

Twenty-eight muscles in the roots of the tongue.

[Of tongues]
[Leonine and bovine species]

This is the reverse of the tongue [*drawing*], and its surface is rough in many animals and especially in the leonine species, such as lions, panthers, leopards, lynxes, cats and the like which have the surface of their tongues very rough as though they were covered with very small nails, somewhat flexible; and when they lick their skin these nails penetrate down to the roots of the hairs, and after the fashion of combs they carry away the minute animals which feed upon them.

And I once saw how a lamb was licked by a lion in our city of Florence, where there are always from twenty five to thirty of them and they bear young. With a few strokes of his tongue the lion stripped off the whole fleece with which the lamb was covered, and having thus made it bare he ate it; and the tongues of the bovine species are also rough. Quaderni IV 9 v.

[Pronunciation of vowels]

The membrane interposed between the passage that the air makes in part through the nose and in part through the mouth is the only one which man uses in order to pronounce the letter *a*, that is the membrane *a n*, and though the tongue and lips may do what they can, this will never prevent the air which streams out from the trachea from forming the sound *a* while in this concavity *a n*. Moreover *u* is formed at the same place with the help of the lips which tighten and thrust

themselves out a little; and the more these lips thrust themselves out the better do they pronounce the letter *u*. True it is that the epiglottis *m* rises somewhat towards the palate.

And if it were not for it doing thus, the *u* would be changed into *o*, and this *o* . . .

And whether when *a o u* are pronounced distinctly and rapidly it is necessary that in pronouncing them continuously without any interval of time the opening of the lips should go on continually contracting, that is that in pronouncing *a* they should be wide apart, closer together in pronouncing *o* and much closer still in pronouncing *u*.

It is proved how all the vowels are pronounced with the back part of the movable palate which covers the epiglottis; and moreover such pronunciation comes from the position of the lips by means of which a passage is formed for the air as it streams out carrying with it the created sound of the voice, which even when the lips are closed streams out through the nostrils, but when issuing through such passage will never become a demonstrator of any of these letters.

From such an experiment one may conclude with certainty that the trachea does not create any sound of vowel but that its office only extends to the creation of the aforesaid voice and especially in *a o u*.

[*The muscles of the tongue*]

The tongue is found to have twenty-four muscles which correspond to the six muscles of which the mass of the tongue which moves in the mouth is composed.

The present task is to discover in what way these twenty-four muscles are divided or apportioned in the service of the tongue in its necessary movements, which are many and varied; and in addition to this it has to be seen in what manner the nerves descend to it from the base of the brain, and in what manner they pass into this tongue distributing themselves and breaking into ramifications. And it must further be noted how and in what manner the said twenty-four muscles convert themselves into six in the formation they make in the tongue. And furthermore you should show whence these muscles have their origin, that is in the vertebrae of the neck at the contact with the oesophagus, and some in the maxilla on the inside, and some on the trachea on the outside and laterally. And similarly how the veins

nourish them and how the arteries give them the spiritus, (and how the nerves give them sensation).

Moreover you shall describe and represent in what way the procedure of varying and modulating and articulating the voice in singing is a simple function of the rings of the trachea moved by the reversive nerves, and in this case no part of the tongue is used.

And this is proved by what I have proved before, that the pipes of the organ do not become deeper or sharper through the change of the fistula (that is that place in which the voice is produced), in making it wider or narrower; but only through the change of the pipe to be wide or narrow or long or short as is seen in the expansion or compression of the winding trumpet, and also in the pipe which is of fixed width or length, the sound varies according as the wind is let into it with greater or less impetus. And this amount of variation is not found in the case of objects struck with a greater or less blow, as is perceived when bells are struck by very small or very large clappers; and the same thing occurs with pieces of artillery similar in width but differing in length, but in this case the shorter piece makes a louder and deeper noise than the longer one. And I do not go into this at greater length because it is fully treated in the book about harmonical instruments. And for this reason I will resume my discourse concerning the functions of the tongue where I left it.

The tongue works in the pronunciation and articulation of the syllables which are the constituent parts of all words. This tongue is also employed during the necessary revolutions of the food in the process of mastication and in the cleansing therefrom of the inside of the mouth together with the teeth. Its principal movements are seven; namely stretching out, drawing together and drawing back, thickening, shortening, spreading out and pointing; and of these seven movements three are composite because one cannot be created without another also being created joined to it of necessity; and this is the case with the first and the second, that is with stretching out and drawing together, for you cannot stretch out a substance which is capable of being expanded without it contracting and straightening itself on all its sides. And a similar result occurs in the third and fourth movements which are contrary to the two first, that is in the thickening and shortening.

After these come the fifth and sixth movements which together form its third movement made up of three movements, namely spreading out pointing and shortening.

Although human subtlety makes a variety of inventions answering by different means to the same end, it will never devise an invention more beautiful more simple or more direct than does nature, because in her inventions nothing is lacking, and nothing is superfluous; and she needs no countervailing weights when she creates limbs fitted for movement in the bodies of the animals, but puts within them the soul of the body which forms them, that is the soul of the mother which first constructs within the womb the shape of the man, and in due time awakens the soul that is to be its inhabitant. For this at first remained asleep, in the guardianship of the soul of the mother, who nourishes and gives it life through the umbilical vein, with all its spiritual members; and so it will continue for such time as the said umbilical cord is joined to it by the secundines and the cotyledons by which the child is attached to the mother. And this is the reason why any wish or intense desire or fright experienced by the mother, or any other mental suffering, is felt more powerfully by the child than by the mother, for there are many cases in which the child loses its life from it.

This discourse does not properly belong here, but is necessary in treating of the structure of animated bodies; and the rest of the definition of the soul I leave to the wisdom of the friars, those fathers of the people who by inspiration know all mysteries. I speak not against the sacred books, for they are supreme truth. Quaderni iv 10 r.

HERE FOLLOWS [CONCERNING] THE ARTICULATION OF THE HUMAN VOICE

The extension and restriction of the trachea together with its dilation and contraction are the cause of the variation of the voice of the animals from high to deep and from deep to high; and as regards the second of these actions, as the shortening of the trachea is not sufficient when the voice is raised it dilates itself somewhat towards the top part, which does not receive any degree of sound but produces a raising of the voice of this remnant of the shortened pipe. But of this we

shall make an experiment in the anatomy of the animals, by pumping air into their lungs and compressing them, and so narrowing and dilating the fistula which produces their voice. Quaderni IV 10 v.

Here is a doubt as to the pannicles which close up the blood in the antechamber of the heart that is in the base of the aorta, whether nature could have dispensed with them or no, since one may clearly see how the three walls or hinges where such pannicular valves of the heart are established, are those which by their swelling shut this blood out from the heart when the heart reopens on the side below these valves.

And this last closing nature carries out in order that the great force which the heart employs in this left ventricle, as it reopens in order to draw into itself the blood that percolates through the narrow interstices of the wall that divides it from the left ventricle, should not for the restoring of the vacuum be obliged to draw with it the most delicate pannicles of the said valves of the heart.

The revolution of the blood in the antechamber of the heart, the base of the aorta, serves two effects, of which the first is that this revolution multiplied in many aspects causes great friction in itself, and this heats and lightens the blood and increases and vivifies the spiritus vitales which always maintain themselves in warmth and moisture. The second effect of this revolution of the blood is to close up again the opened gates of the heart with a complete system of fastening with its first reflex movement.

As many as are the times which this gate expels the blood so many are those which the heart beats, and for this reason those who are feverish become inflamed. Quaderni IV 11 r.

Between the cords (cordae) and threads of the muscles of the right ventricle there are interwoven a quantity of minute threads of the nature and shape of the minute muscles which form the worm in the brain and of those which weave the rete mirabile; and these wind themselves round the most minute and imperceptible nerves and weave themselves with them. And these muscles are in themselves very capable of expansion and contraction, and they are situated within the fury of the rush of the blood, which passes in and out among the

minute cords of the muscles before they are converted into the mem-branes (panniculi) of the valves.

Before you open the heart inflate the ventricles of the heart com-mencing from the artery of the aorta; and then tie them up and consider their size. Afterwards do the same with the right ventricle or the right 'orecchio'; and by so doing you will see its shape and its pur-pose, for it was created in order to expand and contract and so cause the blood to revolve as it passes through its cells which are full of tor-tuous passages divided by rounded walls without any angles, in order that the motion of the blood not finding any angular obstructions may have an easier revolution in its eddying course. And thus it comes to warm itself with so much more heat in proportion as the movement of the heart is the more rapid. So it sometimes attains to such great heat that the heart is suffocated; and I have already seen one case where it was burst as a man was fleeing before his enemies, and he poured out perspiration mingled with blood through all the pores of his skin; and this heat forms the spiritus vitales. And thus heat gives life to all things; as one sees the heat of the hen or of the turkey-hen giving life and growth to the chickens, and as the sun in returning causes all the fruits to blossom and burgeon. Quaderni IV 13 r.

[*Division of surface of heart by vessels. Peeling the flesh off to find cer-tain vessels*]
The heart has its surface divided into three parts by three veins which descend from its base, of which veins two terminate the extremities of the right ventricle and have two arteries in contact below them. As regards the third vein I have not yet seen whether it has an artery with it, and consequently I am about to remove some of the flesh of the surface in order to satisfy myself. But the surface space of the heart enclosed within its arteries occupies half the surface circle of the thick-ness of the heart and forms the outer wall of the right ventricle.

[*Heating by churning, and by the action going on in the heart*]
Observe whether when butter is being made the milk as it revolves becomes heated; and by such means you will be able to prove the efficacy of the ventricles of the heart, which receive and expel the blood from their cavities and other passages, as made only in order to heat

and refine the blood and make it more suitable for penetrating the wall through which it passes from the right to the left ventricle, where by means of the thickness of its wall, that is of that of the left ventricle, it conserves the heat which this blood brings to it. Quaderni IV 13 v.

[Tendons]

Describe the tendons of any limb from four aspects and how they are diffused through the muscles, and how the muscles produce the tendons and the tendons the joints etc. Quaderni IV 15 r.

[The tree of the vessels (with drawing)]
ANATOMY OF THE VESSELS

Here shall be represented the tree of the vessels generally, as Ptolemy did with the universe in his Cosmography; then shall be represented the vessels of each member separately from different aspects.

Make the view of the ramification of the vessels from behind, from the front and from the side; otherwise you would not give true knowledge of their ramifications, shape and position.

The ventricles of the brain and the ventricles of the semen are equally distant from the ventricles of the heart. Quaderni V 2 r.

[Muscles represented by strings of fire-heated copper wire]

Make this leg in full relief, and make the tendons of copper wire that has been heated in the fire; and then bend these according to their natural form; and having done this you will be able to draw them from four sides, and to place them as they are in nature and to speak about their functions.

The immediate causes of the movements of the legs are entirely separated from the immediate cause of the movement of the thigh, and this is what makes the power.

[Of the muscles]

When you have finished the bones of the legs put the number of all the bones, and at the end of the tendons set down the number of these tendons. And you should do the same with the muscles, the sinews, the veins and arteries, saying:—the thigh has so many, and the leg so many and the feet so many and the toes so many; and then you should say:—

so many are the muscles which start from the bones and end in the bones, and so many are those which start from the bones and end in another muscle; and in this way you describe every detail of each limb, and especially as regards the ramifications made by certain muscles in producing different tendons.

These four legs should be on one and the same sheet of paper so that you may be the better able to understand the positions of the muscles and to recognise them from different sides. *Quaderni v 4 r.*

[Anatomy of the brain with details of an experiment to discover the true form of the ventricles]

After we have clearly seen that the ventricle *a* is at the end of the neck where pass all the nerves which communicate the sense of touch we may judge that this sense of touch passes into such ventricle, seeing that nature works in all things in the briefest time and way possible; therefore the sense would go with longer time.

[Experiment]

Make two air holes in the horns of the great ventricles and insert melted wax by means of a syringe, making a hole in the ventricle of the memoria, and through this hole fill the three ventricles of the brain; and afterwards when the wax has set take away the brain and you will see the shape of the three ventricles exactly. But first insert thin tubes in the airholes in order that the air which is in these ventricles may escape and so make room for the wax which enters into the ventricles.[1]

Drawing with names of parts:—imprensiva, sensus communis, memoria.

Model of the sensus communis.

Cast in wax at the bottom of the base of the cranium through the hole *m* before the cranium was sawn through. *Quaderni v 7 r.*

[Anatomy of intestines]

Draw the intestines in their position and detach them ell by ell, first tying up the ends of the part removed and the part remaining. And after you have removed them you must draw the margins of the mes-

[1] According to the editors of the Quaderni, Leonardo was the first to make casts of the cerebral ventricles, and several hundred years elapsed before the idea occurred to any other anatomist.

entery from which you detach such part of the intestine; and when you have drawn the position of this intestine you will draw the ramification of its vessels; and so you will go on in succession until the end.

And you will commence on the right intestine but you will make the entry on the left side at the colon. But first of all you must remove with your chisel the pubic bone and the bones of the hips in order to observe accurately the position of the intestines.　　Quaderni v 24 r.

Nature has made all the muscles which connect with the movements of the toes attached to the bone of the leg and not to the thigh, for if they were attached to the bone of the thigh, they would fold up when the knee-joint was bent and become fixed under the knee-joint, and not be able without great difficulty and fatigue to serve these toes; and the same happens with the hand, by means of the bending of the elbow of the arm.　　Quaderni vi 17 r.

Uncover gradually all the parts on the front side of a man when you make your anatomy; and so continue to do even to the bones.
　　Quaderni vi 21 r.

CONCERNING THE HUMAN FORM

Which part is that in man which never puts on flesh as he grows fat?

Which is that part which as a man becomes thin is never reduced with too perceptible a thinness?

Among the parts which grow fat which is that which grows most fat?

Among the parts which become emaciated which is that which becomes most emaciated?

Among men who are powerful in strength which muscles are of greater thickness and more prominent?

You have to represent in your anatomy all the stages of the limbs from the creation of man down to his death, and down to the death of the bones, and (to show) which part of these is first consumed and which part is preserved longer.

And similarly from the extreme of leanness to the extreme of fatness.

ON PAINTING

Which muscles are those which stand out as people grow old or in the young when they become lean?

Which are the places in the human limbs in which the flesh never increases on account of any degree of fatness or diminishes on account of any degree of leanness.

What has to be sought for in this question will be found in all the surface joints of the bones, as shoulder, elbow, joints of the hands and fingers, hips, knees, ankles and toes and similar things which shall be spoken of in their places.

The greatest thickness which the limbs acquire is in the part of the muscle that is farthest away from their attachments.

The flesh never increases upon the parts of the bones which are near the surface of the limbs.

In the movement of man, nature has placed all those parts in front which on being struck cause a man to feel pain; so it is felt in the shins of the legs and in the forehead and nose. And this is ordained for man's preservation, for if such power of enduring suffering were not inherent in these limbs the numerous blows received on them would be the cause of their destruction. Quaderni VI 22 r.

OF THE MOVEMENTS OF THE FINGERS OF THE HANDS

The movements of the fingers are chiefly those of extension and bending. Extension and bending are done in various ways, that is sometimes by bending all in one piece at the first joint, at another time by bending or straightening themselves half way at the second joint, and at another time by bending in their whole length and at the same time in all the three joints. If the two first joints are prevented from bending the third joint will bend more readily than before, but it can never bend of itself alone if the other joints are free, but all the three joints must bend. In addition to the above-mentioned movements there are four other chief movements, of which two are upwards and downwards, and the two others go from side to side, and each of these is produced by a single tendon. From these there follow an infinite number of other movements made always with two tendons; and if one of

these tendons does not function properly the other takes its place. The tendons are made thick on the inside of the finger and thin on the outside; and on the inside they are attached to every joint but not on the outside.　　　　　　　　　　　　　　　C.A. 99 V. a

OF THE MUSCLES

Nature has provided man with functional muscles which draw the sinews and these are able to move the limbs according to the will and desire of the common sense, after the manner of officials stationed by their lord through various provinces and cities to represent and carry out his will in these places. And the official who on more than one occasion has carried out the commission given him by the mouth of his lord will then himself at the same time do something which does not proceed from the will of the lord. So one often sees with the fingers how after having with utmost docility learnt things upon an instrument as they are commanded by the judgment they will afterwards play them without the judgment accompanying. The muscles which move the legs do not however perform their functions without the man becoming conscious of it.　　　　　　　　C.A. 119 V. a

Saw a head in two between the eyebrows in order to find out by anatomy the cause of the equal movement of the eyes, and this practically confirms that the cause is the intersection of the optic nerves, that is of the equality of movement, if the eyes observe minutely the parts of a circle, and there are nerves which cause them to make a circular movement.　　　　　　　　　　　C.A. 305 V. b

OF ARTERIES

There are three varieties of arteries, of which one is wide at the bottom and narrow at the mouth, another wide at the mouth and narrow at the bottom, and the third is of uniform width.　　　C.A. 369 V. e

The navel is the point of junction of the offspring with the sheath which clothes it; it spreads out branches and is attached to the matrix as a button is to a buttonhole, a briar to a briar or a burr to a burr.

C.A. 385 r. a

OF THE NERVES

The hand that holds the stone within it when it is struck with a hammer feels a part of the pain which the stone would feel if it were a sentient body. A 33 r.

OF THE BLOOD THAT THERE IS IN THE CROWN OF THE HEAD

It would seem to be a simple proposition that if anyone should break the crown of a man's head nothing would flow forth from this fracture except such blood as lay between its edges. In fact every heavy thing seeks low places; blood possesses weight and it appears impossible that of itself it could ever rise to a height like an aerial and light thing. And if you wished to say that by the extension that the lung makes in the lake of blood, when this lung in the ingathering of the breath fills itself with air, and in becoming deflated drives from the lake the blood, which escapes into the veins and makes them increase and swell, and that it is this swelling which causes this blood to flow out from the above named fracture of the crown of the head, this opinion is at once confuted by the fact that the veins are quite capable and adapted to serve as a convenient receptacle for the increase of the blood without it having to flow out by the fracture of the head as though deprived of such receptacle.

WHY THIS BLOOD ESCAPES BY THE CROWN OF THE HEAD

The spiritual parts have power to move and to carry with them in their course the material parts. We see that fire by reason of its spiritual heat sends out of the chimney amid the steam and smoke matter that has body and weight, as is seen with soot which if you burn you will see reduced to ashes. So the heat that is mingled with the blood finding itself evaporate by the fracture of the head desiring to return to its element, carries in its company the blood with which this heat is infused and intermingled. The reason why the smoke rises up with such fury and carries substances with it is that as the fire attaches itself to the wood it is nourished and fed by a fine moisture, and as this moisture

becomes thicker than can be consumed by the heat that is within the fire, the fire desires to return to its element, and carries the heated vapours with it, as may be seen if you distil quicksilver in a retort; you will see that when this silver of so great weight is mingled with the heat of the fire it ascends and then in smoke falls down again into the second container and retakes its former nature. A 56 v. and 57 r.

Observe how the shoulder changes with all the movements of the arm, moving up and down, inwards and outwards, backwards and forwards, and so also with turning movements or any other movements. And do the same with the neck the hands and feet and the chest above the hips. E 17 r.

PAINTING

O painter skilled in anatomy, beware lest the undue prominence of the bones sinews and muscles cause you to become a wooden painter from the desire to make your nude figures reveal all their emotions. And if you wish to remedy this you should consider in what way the muscles of old or lean persons cover or clothe the bones, and furthermore note the principle on which these same muscles fill up the spaces of the surface which come between them, and which are the muscles that never lose their prominence in any degree of fatness whatsoever, and which those whereof the tendons become indistinguishable at the least suggestion of it. And there are many cases when several muscles grow to look one from the increase of fat, and many in which when any one becomes lean or old a single muscle divides into several; and in this treatise all their peculiarities shall be set forth each in its place, and especially with regard to the spaces that come between the joints of each limb. Further you should not fail to observe the variations of the aforesaid muscles round the joints of the limbs of any animal, due to the diversity of the movements of each limb; for on no side of these joints does the indication of these muscles become completely lost by reason either of the increase or diminution of the flesh of which these muscles are composed.

And you should do the same for a child from its birth down to the time of its decrepitude, through all the stages of its life, such as infancy,

childhood, adolescence, youth etc. And in all you should describe the changes of the limbs and joints and show which grows fat and which thin.

<div align="right">E 19 V. and 20 r.</div>

Describe which are the muscles and tendons that become prominent or concealed through the different movements of each limb, and which do not do either. And remember that such action is very important and very necessary for such painters and sculptors as profess to be masters.

<div align="right">E 20 r.</div>

Which nerves or sinews of the hand [or foot] are those that bring close together and separate from each other the fingers and toes of the hands and the feet?

<div align="right">F 95 V.</div>

The heart is a principal muscle in respect of force, and it is much more powerful than the other muscles.

I have written of the position of the muscles which descend from the base to the point of the heart, and the position of the muscles which spring from the point of the heart and go to the summit.

The auricles of the heart are the ante-chambers of this heart which receive the blood from the heart when it escapes from its ventricle from the beginning to the end of the pressure, for unless a part of this quantity of blood escaped the heart would not be able to shut.

<div align="right">G 1 V.</div>

Give the anatomy of the leg up to the hip from all its sides, in every action, so as to show everything; veins, arteries, nerves, tendons and muscles, skin and bones; then with the bones in section in order to show the thickness of the bones.

<div align="right">K 108 [28] r.</div>

[Sinews and muscles]

The sinew which guides the leg which is joined to the kneecap feels it more effort to raise the man up in proportion as the leg is more bent. The muscle which acts upon the angle formed by the thigh at its junction with the bust has less difficulty and has less weight to raise because it does not have the weight of the thigh; and besides this it has stronger muscles because they are those which form the buttocks.

<div align="right">L 27 V.</div>

Piscin da Mozania at the hospital of Brolio has many veins.

For the arms and legs.

<div align="right">Forster II 65 r.</div>

The simple members are eleven, namely cartilage, bones, nerves, veins, arteries, membranes, ligaments and tendons, skin and flesh and fat.

OF THE HEAD

The parts of the vessel of the head are ten, namely five external and five internal.

The external are:—hair and skin, muscular flesh, large membrane and the skull. The internal are these:—dura mater, pia mater, brain; below return the pia mater and the dura mater which enclose the brain between them, then there is the rete mirabile, and then the bone foundation of the brain, and from thence proceed the nerves.

Forster III 27 v.

[*Drawing—head in median section*]

a hair, *n* skin, *c* muscular flesh, *m* large membrane, *o* skull, that is bone of skull.

b dura mater, *d* pia mater, *f* brain.

r pia mater below, *t* dura mater, *l* rete mirabile, *s* bone foundation.

Forster III 28 r.

Hippocrates says that the origin of our semen is derived from the brain, and from the lungs and testicles of our forefathers where the final decoction is made; and all the other members transmit their substance to this semen by sudation, because there are no apparent channels by which they could arrive at this semen. Forster III 75 r.

IV

Comparative Anatomy

'Second demonstration interposed between the anatomy and the life.

For this comparison you should represent the legs of frogs, for these have a great resemblance to the legs of the man both in the bones and in the muscles.'

[*Comparative Anatomy*]

Represent here the foot of the bear and of the monkey and of other animals as far as they differ from the foot of man; and put also the feet of certain of the birds. Fogli A 17 r.

[*Comparative Anatomy*]
[*Drawing of arm*] Man *a b m n.*
[*same*] Monkey *c d p o.*

In proportion as the nerve *c d* takes the bone *o p* nearer to the hand so this hand raises a greater weight; and this is the case with the monkey which is more powerful in its arms than the man is according to his proportion. Fogli B 9 v.

[*Man, Lion, Horse, Bull*]

Man. The description of man, in which is contained those who are almost of the same species just as the baboon, the ape and others like these which are many.

Lion and its followers, such as panthers, lions, tigers, leopards, lynxes, Spanish cats, *gannetti* and ordinary cats and the like.

Horse and its followers such as the mule, the ass and the like which have teeth above and below.

Bull and its followers which are horned and without upper teeth, such as buffalo, stag, fallow-deer, roebuck, sheep, goats, ibex, milch cows, chamois, giraffes. Fogli B 13 r.

[*Organs of the senses in man as compared with those of other animals*]

I have found in the constitution of the human body that as among all the constitutions of the animals it is of more obtuse and blunt sensibilities, so it is formed of an instrument less ingenious and of parts less capable of receiving the power of the senses. I have seen in the leonine species how the sense of smell forming part of the substance of the brain it descends in a very large receptacle to meet the sense of smell which enters among a great number of cartilaginous cells with many passages that go to meet the above-mentioned brain.

The eyes of the leonine species have a great part of their head as their receptacle, so that the optic nerves may be in immediate conjunction with the brain. With man the contrary is seen to be the case for the cavities of the eyes occupy but a small part of the head, and the optic nerves are thin and long and weak; consequently as one sees they work feebly by day and worse by night, whereas the aforesaid animals see better by night than by day; and the sign of this is seen in the fact that they hunt their prey by night and sleep by day as do also the nocturnal birds.

The light or pupil of the human eye as it expands or contracts gains or loses the half of its size; and in the nocturnal animals its increase or decrease is more than a hundred times. This may be seen in the eye of the owl a nocturnal bird by bringing a lighted torch near to it, and still more by making it look at the sun, for then you will see the pupil which once occupied the whole of the eye diminished to the size of a grain of millet, and by this diminution it becomes equal to the pupil of the eye of man and clear shining things seem the same colour to it as they appear at this time to man, and as much more as the brain of this creature is less than the man's brain: from which it comes about that as the pupil increases in the night time a hundred fold more than that of the man it sees a hundred times as much light as the man does, in such a way that this power of sight is not afterwards subdued by the darkness of night. And the pupil of man which only doubles its quantity sees only faint light and almost like the bat which does not fly in times of too great darkness. Fogli B 13 v.

[*Differences between the human intestines and those of other animals*]

Write of the varieties of the intestines of the human species, apes and

such like; then of the differences that are found in the leonine species, then the bovine and lastly in birds; and make this description in the form of a discourse. Fogli B 37 r.

Then you shall make a discourse on the hands of each animal in order to show how they vary, as in the bear in which the ligaments of the tendons of the toes of the foot are connected over the neck of the foot. Quaderni I 2 r.

Describe the tongue of the woodpecker and the jaw of the crocodile. Quaderni I 13 v.

Take out a bull's liver to make an anatomy. Quaderni II 6 v.

Look at the dead dog, its lumbar muscles and diaphragm and the movement of its ribs. Quaderni II 7 v.

Analyse the movement of the tongue of the woodpecker.
 Quaderni IV 10 r.

[*With drawings of onion and human head in section*]
If you cut an onion down the centre you will be able to see and count all the coatings or rinds which form concentric circles round the centre of this onion.

Similarly if you cut a man's head down the centre you will cut through the hair first, then the skin and the muscular flesh and the pericranium, then the cranium and within the dura mater and the pia mater and the brain, then the pia and dura mater again and the rete mirabile and the bone which is the foundation of these.
 Quaderni V 6 v.

[*With figures*]
[*Comparative anatomy. Bones and joints. Muscular contours in obesity and in emaciation*]
Junction of the fleshy muscles with the bones, without any tendon or cartilage—and you should do the same for several animals and birds.

Show a man on tiptoe so that you may compare a man better with other animals.

Represent the knee of a man bent like that of the horse.

To compare the bone structure of the horse with that of the man you should show the man on tiptoe in representing the legs.

Of the relationship that exists between the arrangement of the bones and muscles of the animals and that of the bones and muscles of the man.

Show first the bones separated with the sockets where they join, and then join them together, and especially the hip-joint or the joint of the thigh.

Describe which muscles disappear in the process of growing fat, and which are uncovered as one becomes emaciated.

And note that those portions of the surface of the fat which protrude most will stand out most when one grows thin.

Where the muscles are separated from one another you should show outlines, and where they are tightly fastened together; and you should draw only with the pen. Quaderni v 22 r.

SECOND DEMONSTRATION INTERPOSED BETWEEN THE ANATOMY AND THE LIFE[1]

For this comparison you should represent the legs of frogs, for these have a great resemblance to the legs of the man, both in the bones and in the muscles; you should afterwards follow this with the hind legs of the hare, for these are very muscular and the muscles are well defined because they are not hampered by fat. Quaderni v 23 r.

[Diagrams]
PUPIL OF OWL. PUPIL OF MAN

The pupil c represents its size in the daytime, that is at the greatest brightness of the day.

$a\ c$ shows how it increases in the maximum darkness of the night, and so it goes changing from a greater to a less quantity according to the greater or less obscurity of the night.

[1] This passage is cited by the editors of the Quaderni d'Anatomia as a proof of Leonardo having acquired a full understanding of the difference between scientific anatomical dissection and contour anatomy.

PUPIL OF CAT

If the darkness of night is a hundred degrees more intense than that of evening, and the eye of man doubles the size of its pupil in darkness, this darkness is lessened by half in this eye because it has redoubled half its visible potency: there remain therefore fifty degrees of intensity of darkness. And if the eye of the owl has its pupil increased a hundred times in the aforesaid darkness it increases its visual capacity one hundred times, so that one hundred degrees of visual capacity are acquired, and because things which are equal do not overcome one another the bird sees in the darkness with the pupil increased a hundredfold as in the day with the pupil diminished ninety nine parts in the hundred.

And if you were to say that this animal does not see light by day and for this reason it remains shut up, to this I reply that the bird only shuts itself up in the day in order to free itself from the mobbing of birds which in a great multitude always surround it with a loud clamour, and frequently they would be put to death if they did not hide themselves in the grottos and caverns of the high rocks.

Of the nocturnal animals only the lion species changes the shape of its pupil as that enlarges or lessens: for when it is at the utmost stage of diminution it is long in shape, when half way it is oval, and when it has attained to its utmost expansion it is circular in shape.

C.A. 262 r. d

[*With sketches of head of horse*]

The distance between the one ear (of a horse) and the other should equal the length of one of the ears.

The length of the ear should be the fourth part of the face.

A 62 v.

Death in the old without fever is caused by the skin of the veins which go from the spleen to the gate of the liver becoming so thick that they close up and no longer allow a passage to the blood which feeds them.

The continual passing of the blood in these veins makes them thicken and harden so that at last they close up and prevent the passage of the blood.

The spaces or hollows in the veins of the animals and the long course of the humour that nourishes them harden and finally contract. The hollows of the veins of the earth come to be enlarged through the long continuous passage of the water. F I r.

MUSCLES OF ANIMALS

The hollows interposed between the muscles should not be of such a kind that the skin seems as though it covers two sticks placed to touch each other, as in *c*; and not in such a way as to seem like two sticks at a little distance from each other and with the skin hanging idly with a loose curve as in *f*; but it should be as in *i*, laid over the spongy fat that lies between the angles, as in the angle *n m o*, which angle springs at the end of the contact of the muscles. And because the skin cannot descend into such an angle nature has filled it with a small quantity of spongy or as I prefer to call it vesicular fat, that is containing small cells full of air, which become condensed or rarefied according to the increase or rarefaction of the substance of the muscles; in which case the hollow *i* has always a greater curve than the muscle. G 26 r.

Make an anatomy of different eyes and see which are the muscles that open and close the above mentioned pupils of the eyes of animals.

OF THE EYES OF ANIMALS

The eyes of all animals have pupils which have power to increase or diminish of their own accord according to the greater or less light of the sun or other luminary. In birds however the difference is greater, and especially with nocturnal birds of the owl species such as the long-eared the white and the brown owls; for with these the pupil increases until it almost covers the whole eye or diminishes to the size of a grain of millet, preserving all the time its round shape. But in the lion species such as panthers, leopards, lionesses, tigers, wolves, lynxes, Spanish cats and others the pupil as it diminishes changes from the perfect circle to an elliptical figure thus [*fig.*] as is seen in the margin. Man however having a more feeble vision than any other animal is less

hurt by excessive light and his pupil undergoes less increase in dark places. As regards the eyes of the above-mentioned nocturnal animals, in the horned owl which is the largest nocturnal bird the power of vision is so much increased that even in the faintest glimmer of night which we call darkness it can see more distinctly than we in the radiance of noon, when these birds stay hidden in dark recesses; or if they are compelled to emerge into the sunlit air the pupil contracts so much that the power of vision diminishes at the same time as the size of the pupil. G 44 r.

[*Drawings of part of skeleton of horse*]
Of the muscles that attach themselves to the bone. Horse.
 K 102 [22] r.

[*Drawing: part of skeleton of horse*]
Here I make a note to show the difference there is between man and horse and in the same way with the other animals.

I commence first with the bones, and then go on to all the muscles which proceed from and end in the bones without tendons, then to those which proceed from and end in the bones with tendons and then those which have a single tendon on one side. K 109 [29-30] v.

When the eye of the bird closes with its two coverings it closes first the secondina, and this closes it from the lachrymal gland as far as the angle of the eye, and the first (covering) closes it from below upwards. And these two movements having intersected cover it first from the direction of the lachrymal gland, because they have already seen themselves safeguarded in front and below; and they only reserve the upper part because of the dangers from birds of prey which descend from above and behind, and they will first uncover the membrane in the direction of the angle, for if the enemy comes behind the bird will have the opportunity of flying forward. It also has the membrane called the secondina of such texture as to be transparent, for if it did not possess this shield it would not be able to keep its eyes open against the wind which strikes the eye in the fury of its swift flight. And its pupil expands and contracts as it beholds less or greater light, that is, radiance. B.M. 64 v.

[*Sketch—bust of man and measurements*]

The trunk *a b* will be one foot at its narrowest part, and from *a* [to] *b* will be two feet which will form two squares.

And the horse in its narrowest part goes three times into the length which makes three squares. Quaderni VI 4 r.

V

Physiology

'The frog instantly dies when the spinal cord is
pierced; and previous to this it lived without
head without heart or any bowels or intestines
or skin; and here therefore it would seem lies
the foundation of movement and life.'

[Experimental investigations of spinal cord and intestines of frog]
[with drawing]
 Sense of touch
 cause of movement
 origin of the nerves
 transit of the animal powers

REPRODUCTIVE POWER

The frog retains life for some hours when the head the heart and all the intestines have been taken away. And if you prick the said cord it instantly twitches and dies.

All the nerves of the animals derive from here: when this is pricked it instantly dies. Quaderni v 21 r.

[Experimental investigation of the spinal cord of frog]
The frog instantly dies when the spinal cord is pierced; and previous to this it lived without head without heart or any bowels or intestines or skin; and here therefore it would seem lies the foundation of movement and life.

Hand of monkey *[drawing]*

[Drawing] In this manner originate the nerves of movement above . . . knot of the spine.

[Drawing] Whichever of these is pricked is lost in the frog.
 Quaderni v 21 v

Where there is life there is heat; where there is vital heat there is movement of the watery humours. c.a. 80 r. b

The common sense is that which judges the things given to it by the other senses.

[*The common sense is set in motion by the things given to it by the five senses*]
And these senses are moved by the objects, and these objects send their images to the five senses by which they are transferred to the organ of perception (imprensiva) and from this to the common sense; and from thence being judged they are transmitted to the memory, in which according to their potency they are retained more or less distinctly.

[*The five senses are these: seeing, hearing, touch, taste, smell*]
The ancient speculators have concluded that that faculty of judgment which is given to man is caused by an instrument with which the other five are connected by means of the organ of perception (imprensiva), and to this instrument they have applied the name common sense, and they say that this sense is in the centre. And this name common sense they use simply because it is the common judge of the other five senses, namely seeing, hearing, touch, taste and smell. The common sense is set in movement by means of the organ of perception (imprensiva) which is situated in the centre between it and the senses. The organ of perception acts by means of the images of the things presented to it by the superficial instruments, that is the senses, which are placed in the middle between the external things and the organ of perception; and the senses act in the same way through the medium of objects.

The images of the surrounding things are transmitted to the senses, and the senses transmit them to the organ of perception, and the organ of perception transmits them to the common sense, and by it they are imprinted on the memory, and are retained there more or less distinctly according to the importance or power of the thing given. That sense functions most swiftly which is nearest to the organ of perception; this is the eye, the chief and leader of the others; of this only we will treat and leave the others in order not to lengthen out our material.

Experience tells us that the eye has cognisance of ten different quali-- ties of objects; to wit, light and darkness—one serving to reveal the other nine, the other to conceal them—colour and substance, form and position, distance and nearness, movement and rest. c.a. 90 r. b

OF THE GROWTH OF MAN

A man at three years will have reached the half of his height.

A woman of the same size as a man will weigh less than he does.

A dead woman lies face downwards in water, a man the opposite way. c.a. 119 v. a

How radiating lines carry visual potency with them as far as the striking point:

This our mind or common sense which the philosophers affirm makes its dwelling in the centre of the head keeps its spiritual members at a great distance away from itself, and this is clearly seen in the lines of the visual rays which after terminating in an object transmit imme- diately to their cause the characteristics of the form of their breaking.

Also—in the sense of touch which derives from the common sense— does not one see it extending itself with its power as far as the tips of the fingers, for as soon as these points have touched the object the sense is immediately made aware of whether it is hot or cold or hard or soft or pointed or smooth. c.a. 270 v. b

OF THE GAIT OF MAN

The gait of man is always after the manner of the universal gait of four-footed animals; seeing that as these move their feet crosswise, as a horse does when it trots, so a man moves his four limbs crosswise, that is if he thrusts the right foot forward as he walks he thrusts the left arm forward with it, and so it always continues. c.a. 297 r. b

Men born in hot countries love the night because it makes them cool, and they hate the sunlight because it causes them to grow hot again; and for this reason they are of the colour of the night, that is black; and in the cold countries everything is the opposite. c.a. 393 v. a

That cause which moves the water through its springs against the

natural course of its gravity is like that which moves the humours in all the shapes of animated bodies. c.a. 396 r. a

The potencies are four: memory and intellect appetite and concupiscence.

The two first are of the reason the others of the senses.

Of the five senses, seeing, hearing, smelling may be partially withheld—touch and taste, not.

The sense of smell leads that of taste with it, in the dog and other greedy animals. Tr. 12 a

All the spiritual powers, in proportion as they are farther away from their primary or secondary cause, occupy more space and become of less potency. Tr. 18 a

As to the bendings of the joints and in what manner the flesh grows on them in their folds and extensions. Of this most important study make a separate treatise in the 'Description of the movements of animals with four feet', among which is man who also in infancy goes on four feet. E 16 r.

When a man is walking he carries his head in advance of his feet.

When a man in walking traverses a level expanse he bends forward at first and then bends as far backward. F 83 r.

It is impossible to breathe through the nose and through the mouth at the same time. The proof of this is seen when anyone breathes with the mouth open taking the air in through the mouth and giving it out through the nose, for then one always hears the sound of the gate set near to the uvula when it opens and shuts. G 96 v.

Dead bodies when male float in water on their backs, when female face downwards. H 31 v.

If when going up a staircase you rest your hands upon your knees all the strain which comes upon the arms is so much taken away from the tendons below the knees. H 75 [27] r.

We make our life by the death of others.

In dead matter there remains insensate life, which, on being united

to the stomachs of living things, resumes a life of the senses and the intellect. H 89 [41] v.

Every body is composed of those members and humours which are necessary for its support; which necessity is well known and provided for it by the soul, which has chosen such shape of body for a time as its habitation.

Consider the fish, which on account of the continuous friction that of necessity it makes with the water, from its own life being a daughter of nature, it is prepared to be delivered, by reason of the porosity that is found to exist between the joints of the scales, of a certain slimy discharge, which with difficulty becomes separated from this fish and performs that function towards the fish that pitch does to the ship.

Forster III 38 r.

If you draw in breath by the nose and send it out by the mouth you will hear the sound made by the partition, that is the membrane in . . .

Fogli A 3 r.

VI

Natural History

*'Why is the fish in the water swifter than the
bird in the air when it ought to be the con-
trary, seeing that the water is heavier and thicker
than the air, and the fish is heavier and has
smaller wings than the bird?'*

LOBSTERS and crabs are empty at the waning of the moon, for there
is little light for them to feed themselves by, and if one brings them a
light at night they all hasten to this light.

And when the moon is at the full they see their food well and eat of
it abundantly. c.a. 165 v. b

Why is the fish in the water swifter than the bird in the air when it
ought to be the contrary seeing that the water is heavier and thicker
than the air and the fish is heavier and has smaller wings than the
bird? For this reason the fish is not moved from its place by the swift
currents of the water as is the bird by the fury of the winds amid the
air; and in addition to this we may see the fish speeding upwards on
the very course down which water has fallen abruptly with very rapid
movement, after the manner of lightning amid the incessant clouds,
which seems a marvellous thing. And this results from the immense
speed with which it moves which so exceeds the movement of the
water as to cause it to seem motionless in comparison with the move-
ment of the fish. The proportion of the said movements is as one is to
ten; the movement of the water being as one and that of the fish ten
and exceeding it therefore by nine. Therefore although the fish has the
power ten it is left with the power nine, for as it leaps up the descent—
its power being ten and the water taking away one from it—nine
remains.

This happens because the water is of itself thicker than the air and
in consequence heavier, and therefore it is swifter in filling up the

vacuum which the fish leaves behind it in the place from whence it departs, and also the water which it strikes in front of itself is not compressed as is the air in front of the bird but rather makes a wave which by its movement prepares the way for and increases the movement of the fish, and for this reason it is swifter than the bird in front of which the air is condensed. c.a. 168 v. b

HOW OXEN FEED ON TALL PLANTS

Oxen in order to feed on the leaves of tall slender plants such as young poplars and the like are in the habit of raising themselves up, so that they stride with their legs across the base of the plant and press continually forward in such a way that the plant, being unable to bear up against the oppressive weight, is obliged to give way and bow down its lofty top. c.a. 297 r. b

[*With drawing of moth*]

The *pannicola* flies with four wings, and when those in front are raised those behind are lowered.

But it is necessary for each pair to be of itself sufficient to sustain the whole weight.

When the one is raised the other is lowered.

In order to see the flying with four wings go into the moats and you will see the black *pannicole*. c.a. 377 v. b

VII

Human Proportions

'The span of a man's outstretched arms is equal to his height.'

[*Proportions of the human figure*]

From the chin to the starting of the hair is a tenth part of the figure.

From the junction of the palm of the hand as far as the tip of the middle finger a tenth part.

From the chin to the top of the head an eighth part.

And from the pit of the stomach to the top of the chest is a sixth part.

And from the fork of the ribs as far as the top of the head a fourth part.

And from the chin to the nostrils is a third part of the face.

And the same from the nostrils to the eyebrows, and from the eyebrows to the starting of the hair.

And the foot is a sixth part, and the forearm to the elbow a fourth part. The breadth across the shoulders a fourth part. c.a. 358 r. a

There is as great a distance between the commencement of the one ear and that of the other as there is from the space between the eyebrows to the chin.

The size of the mouth in a well proportioned face is equal to the distance between the parting of the lips and the bottom of the chin.

A 62 v.

[*With sketches of heads*]

The cut or angle of the lower lip is midway between the bottom of the nose and the bottom of the chin.

The face in itself forms a square, of which the breadth is from one extremity of the eyes to the other, and the height is from the top of the nose to the bottom of the lower lip, and what is left over above and below this square has the height of a similar square.

206

The ear is precisely as long as the nose.

The slit of the mouth when seen in profile points to the angle of the jaw.

The length of the ear should equal the distance from the bottom of the nose to the top of the eyelid.

The space between the eyes is equal to the size of one eye.

In profile the ear is above the middle of the neck. A 63 r.

[Proportions]

The foot from the toe to the heel goes twice into the space from the heel to the knee, that is to say where the bone of the leg is joined to that of the thigh.

The hand as far as where it unites with the bone of the arm goes four times into the space from the tip of the longest finger to the joint of the shoulder. B 3 v.

Every man at the third year is half his height. H 31 v.

[Weight and movements of man]

The leg as far as its junction with the thigh is a quarter of the whole weight of the man.

The man draws more weight downwards than upwards, first because he gives more of his weight out of his central line, then because he passes all his foot from the central line; and thirdly because he does not slip with his feet. L 28 r.

The space between the line of the mouth and the beginning of the nose *a b*, is the seventh part of the face.

The space from the mouth to the bottom of the chin *c d*, is the fourth part of the face and equal to the width of the mouth.

The space from the chin to the beginning of the bottom of the nose *e f*, is the third part of the face and equal to the nose and to the forehead.

The space from the middle of the nose to the bottom of the chin *g h* is half the face.

The space from the beginning of the top of the nose where the eyebrows begin, *i k*, to the bottom of the chin is two thirds the face.

The space between the line of the mouth and the beginning of the chin above, *l m*, that is where this chin ends terminating with the

under lip, is the third part of the distance from the line of the mouth to the bottom of the chin and the twelfth part of the face; from the top to the bottom of the chin *m n* is the sixth part of the face, and it is the fifty-fourth part of the man.

From the point of the chin to the throat *o p*, is equal to the space from the mouth to the bottom of the chin and the fourth part of the face.

The space from the top of the throat to its beginning below, *q r*, is half the face and the eighteenth part of the man.

From the chin to the back of the neck *s t* is the same distance as is between the mouth and the beginning of the hair, that is three quarters of the head.

From the chin to the jaw *v x* is half the head and equal to the thickness of the neck in profile.

The thickness of the neck goes one and three quarter times from the eyebrow to the nape of the neck. Quaderni VI 4 r.

The whole foot will go between the elbow and the wrist, and between the elbow and the inner angle of the arm towards the breast when the arm is folded. The foot is as long as the whole head of the man, that is from beneath the chin to the very top of the head as is here shown.

The foot goes three times from the tip of the long finger to the shoulder, that is to its joint.

The nose will make two squares; that is the breadth of the nose at the nostrils will be contained twice between the point of the nose and the beginning of the eyebrows; and similarly in profile the distance from the extreme edge of the nostril, where it unites with the cheek, to the tip of the nose, will be equal to the width of the nose in front from one nostril to the other.

If you divide into four equal parts the whole length of the nose, that is from its tip to the insertion of the eyebrows, you will find that one of these parts extends from the top of the nostrils to the bottom of the point of the nose, and the upper part extends from the lachryma-tory duct of the eye to the insertion of the eyebrows; and the two parts in the middle are equal to the length of the eye from the lachrymatory duct to its corner. Quaderni v 5 r.

From the roots of the hair to the top of the breast *a b* is a sixth of a man's height; and this measure never varies.

It is as far from the outside part of one shoulder to another as it is from the top of the breast to the navel, and this goes four times into the distance from the sole of the foot to where the bottom of the nose begins.

The arm, from where it separates itself from the shoulder in front, goes six times into the space between the two extremities of the shoulders and three times into a man's head and four into the length of the foot and three into the hand whether on the inside or the outside.

Quaderni vi 6 r.

The foot from its beginning in the leg as far as the extremity of the big toe is equal to the space between the beginning of the top of the chin and the starting of the hair *a b*, and it is equal to five sixths of the face. Quaderni vi 7 v.

If anyone kneels down he will lessen his height by a fourth part.

If a man be kneeling with his hands across his breast the navel will be at the half of his height and so will be the points of the elbows.

The half of a man seated, that is from the seat to the crown of the head, will be from the arm below the breast and below the shoulder; this seated portion, that is from the seat to the crown of the head, will exceed the half the man's height by the breadth and length of the testicles. Quaderni vi 8 r.

A cubit is the fourth part of a man's height and it is equal to the greatest width of the shoulders. From the one shoulder joint to the other is twice the head, and it is equal to the distance from the top of the breast to the navel. From this top to the commencement of the penis is the length of a head. Quaderni vi 8 v.

The foot is as much longer than the hand as the thickness of the arm to the wrist, that is where it is thinnest, seen in front.

Also you will find that the foot is as much longer than the hand as the space on the inner side from the join of the little toe to the last projection of the big toe, taking the measure along the length of the foot.

The palm of the hand without the fingers goes twice into the foot without the toes.

If you hold your hand with its five fingers extended and close together you will find that it is as wide as the maximum width of the foot, that is where it is joined to the toes.

And if you measure from the point of the ankle on the inside to the end of the big toe, you will find that this measure is as long as the whole hand.

From the top of the joint of the foot to the top of the insertion of the toes is as far as from the commencement of the hand to the point of the thumb.

The smallest width of the hand is equal to the smallest width of the foot between its joining with the leg and the commencement of the toes.

The width of the heel at its under side is equal to the thickness of the arm where it joins the hand, and also to the leg where it is thinnest viewed in front.

The length of the longest toe from where it begins to be divided from the big toe to its extremity is the fourth part of the foot, that is from the centre of the ankle bone on the inner side to its tip; and it is equal to the width of the mouth. And the space that there is between the mouth and the chin is equal to that between the knuckles of the three middle fingers and their first joints, when the hand is extended, and equal to the [distance from] the joint of the thumb to the beginning of the nail when the hand is extended, and it is a fourth part of the hand and of the face.

The space between the inner and outer extremities of the poles of the feet called the heels or ankles or bands of the feet, *a b*, is equal to the space between the mouth and the lachrymatory duct of the eye.

Quaderni VI 9 r.

The big toe is the sixth part of the foot, measuring it in profile on the inside, where this toe springs, from the ball of the sole of the foot towards its extremity *a b*; and it is equal to the distance from the mouth to the bottom of the chin. If you are doing the foot in profile from the outside make the little toe begin three quarters up the length

of the foot, and you will find the distance that there is from the beginning of this toe to the farthest projection of the big toe.

<div align="right">Quaderni vi 9 v.</div>

Width across shoulders one quarter of the whole. From the joint of the shoulder to the hand one third, from the line of the lip to below the shoulder-blade is one foot.

From the top of the head to the bottom of the chin one eighth. From the commencement of the hair to the chin is one ninth of the distance there is from this commencement to the ground. The greatest width of the face is equal to the space between the mouth and the commencement of the hair, and it is one twelfth of the whole height. From the top of the ear to the top of the head is equal to the distance from the bottom of the chin to the lachrymatory duct of the eyes. And equal to the distance from the point of the chin to that of the jaw, and it is the sixteenth part of the whole. The bit of cartilage 'pincierolo' which is within the hole of the ear towards the nose is half way between the nape of the neck and the eyebrow.

The greatest thickness of a man from the breast to the spine goes eight times into the height and is equal to the space between the chin and the crown of the head.

The greatest width is at the shoulders and this goes four times.

The breadth of the neck in profile is equal to the space there is from the chin to the eyes, and equal to the space from the chin to the jaw, and it goes fifteen times into the whole man.

The arm bent is four heads.

The arm from the shoulder to the elbow in bending increases its length, that is the length from the shoulder to the elbow; and this increase is similar to the thickness of the arm at the wrist when you see it in profile, and similar to the distance from the bottom of the chin to the line of the mouth. And the thickness of the two middle fingers of the hand, and the width of the mouth, and the distance from where the hair begins on the forehead to the crown of the head—these things that I have mentioned are similar to each other, but not similar to the above named increase in the arm.

The arm from the elbow to the hand never increases when it is bent or straightened.

The arm when bent will measure twice the head from the top of the shoulder to the elbow, and two from this elbow to where the four fingers begin on the palm of the hand. The distance from where the four fingers begin to the elbow never changes through any change of the arm.

The lesser thickness of the leg as seen in front goes into the thigh three times.

The thickness of the arm at the wrist goes twelve times into the whole arm, that is from the tips of the fingers to the shoulder-joint, that is three into the hand and nine into the arm.

The minimum thickness of the arm in profile, m n, goes six times from the joint of the hand to the dimple of the elbow extended, fourteen times into the whole arm, and forty-two times into the whole man.

The maximum thickness of the arm in profile is the same as the maximum thickness of the arm in front. But the one is placed in the third of the arm from the joint to the breast, the other in the third from the joint to the hand. Quaderni vi 10 r.

A man is the same width below the arms as at the hips.

A man's width across his hips is the same as the distance from the top of the hips to the bottom of the buttocks when he is standing equally balanced on both his feet; and it is the same distance from the top of the hips to the joining of the shoulders. The waist or the part above the hips will be half way between the joining of the shoulders and the bottom of the buttocks. Quaderni vi 11 r.

The maximum thickness of the calf of the leg is in the third of its height a b, and it is a twentieth part larger than the maximum breadth of the foot.

When a man lies down his height is reduced to a ninth.

The thickness of the thigh in front is equal to the greatest breadth of the face as seen, that is two-thirds of the distance from the chin to the crown of the head.

I would know how much one increases when raising one's self on tip-toe; and when bending how much p q decreases, and how much n q increases; and so also with the bend of the foot.

<div align="right">Quaderni vi 11 v.</div>

The minimum thickness of the leg in front goes eight times from the sole of the foot to the joint of the knee, and it is the same as the arm in front at the wrist, and as the maximum length of the ear and the three spaces in which the face is divided; and this breadth goes four times from the wrist to the point of the elbow.

The foot is as broad as the width of the knee between *a b*; the patella is as broad as the leg between *r s*.

From the tip of the longest finger to the shoulder-joint is four hands, or, if you prefer it, four heads.

The minimum thickness of the leg, as seen from the side, goes six times from the sole of the foot to the joint of the knee, and it is equal to the space between the corner of the eye and the orifice of the ear, and to the maximum thickness of the arm as seen from the side, and to that from the lachrymatory duct of the eye to the attachment of the hairs. Quaderni vi 12 r.

Strong nudes will seem muscular and thick.

Those who are of little strength will be flabby [1] and thin.
 Quaderni vi 14 r.

The architect Vitruvius states in his work on architecture that the measurements of a man are arranged by Nature thus:—that is that four fingers make one palm, and four palms make one foot, six palms make one cubit, four cubits make once a man's height, and four cubits make a pace, and twenty four palms make a man's height, and these measurements are in his buildings.

If you set your legs so far apart as to take a fourteenth part from your height, and you open and raise your arms until you touch the line of the crown of the head with your middle fingers, you must know that the centre of the circle formed by the extremities of the outstretched limbs will be the navel, and the space between the legs will form an equilateral triangle.

The span of a man's outstretched arms is equal to his height.

From the beginning of the hair to the end of the bottom of the chin is the tenth part of a man's height; from the bottom of the chin to the crown of the head is the eighth of the man's height; from the top of the breast to the crown of the head is the sixth of the man; from the

[1] MS. *laciertoso.*

top of the breast to where the hair commences is the seventh part of the whole man; from the nipples to the crown of the head is a fourth part of the man. The maximum width of the shoulders is in itself the fourth part of a man; from the elbow to the tip of the middle finger is the fifth part; from this elbow to the end of the shoulder is the eighth part. The complete hand will be the tenth part. The penis begins at the centre of the man. The foot is the seventh part of the man. From the sole of the foot to just below the knee is the fourth part of the man. From below the knee to where the penis begins is the fourth part of the man.

The parts that find themselves between the chin and the nose and between the places where the hair and the eyebrows start each of itself compares with that of the ear, and is a third of the face.

<div align="right">Venice Academy R 343</div>

VIII

Medicine

'Medicine is the remedying of the conflicting elements: sickness is the discord of the elements infused in the living body.'

'You know that medicines when well used restore health to the sick: they will be well used when the doctor together with his understanding of their nature shall understand also what man is, what life is, and what constitution and health are. Know these well and you will know their opposites; and when this is the case you will know well how to devise a remedy.' c.a. 270 r. c

TO BREAK A STONE IN THE BLADDER

Take the shell of a filbert, date stones, saxifrage, nettle seed in equal quantities, and make of them a fine powder and mix it with your food after the manner of spice, or take it if you wish in the form of syrup made with white wine which has been warmed.

Also asparagus or privet or a decoction of red chick peas.

c.a. 270 v. b

Medicine is the remedying of the conflicting elements: sickness is the discord of the elements infused in the living body. Tr. 6 a

Anyone who suffers from seasickness should drink the sap of ·wormwood. Tr. 44 a

Every man desires to acquire wealth in order that he may give it to the doctors, the destroyers of life; therefore they ought to be rich.

f 96 v.

Make them give you their diagnosis and treatment in the case of

Sancto and of the other and you will see that men are chosen as physicians for diseases which they do not know. B.M. 147 V.

Strive to preserve your health; and in this you will the better succeed in proportion as you keep clear of the physicians, for their drugs are a kind of alchemy concerning which there are no fewer books than there are medicines. Fogli A 2 r.

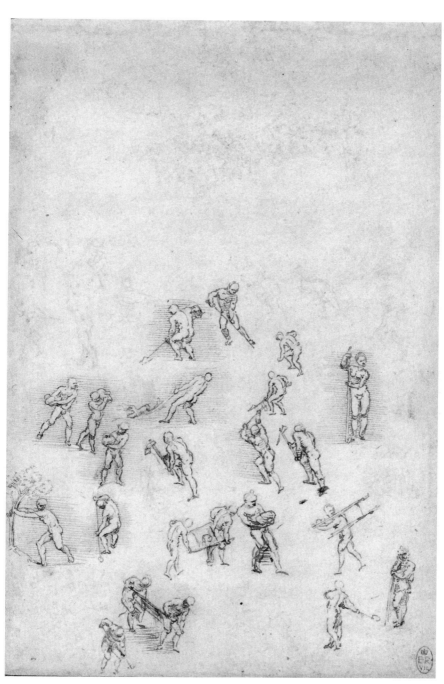

FIGURES TO REPRESENT LABOUR
The Royal Collection © 2003, Her Majesty Queen Elizabeth

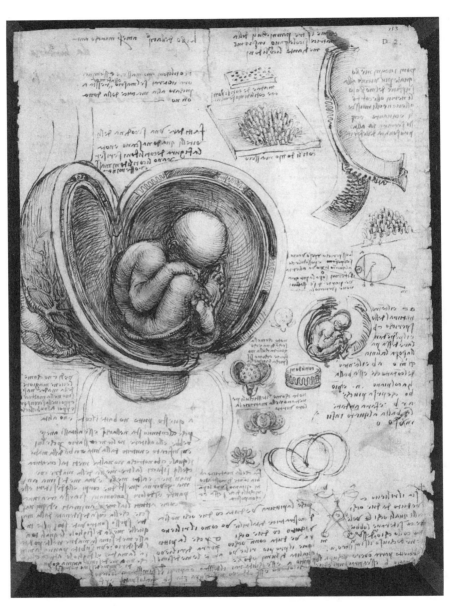

CHILD IN WOMB

The Royal Collection © 2003, Her Majesty Queen Elizabeth

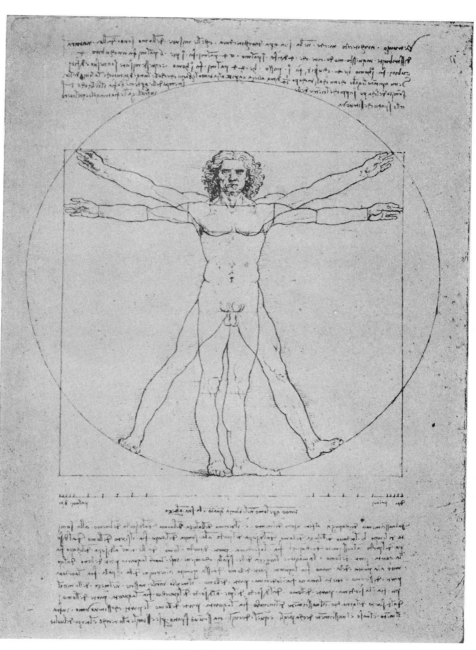

PROPORTIONS OF THE HUMAN FIGURE
Galleria dell'Accademia, Venice, Italy/Bridgeman Art Library

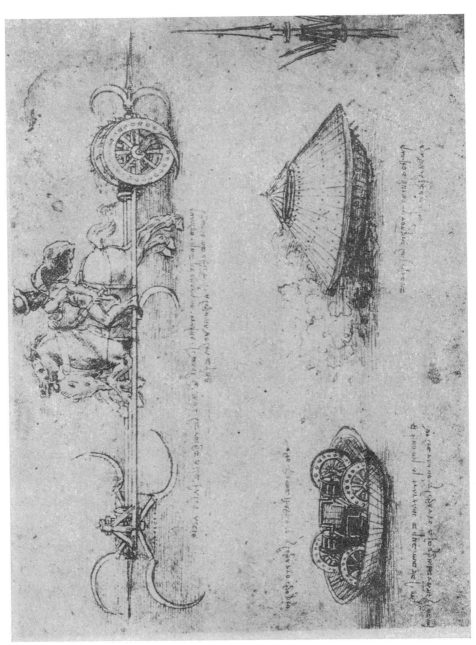

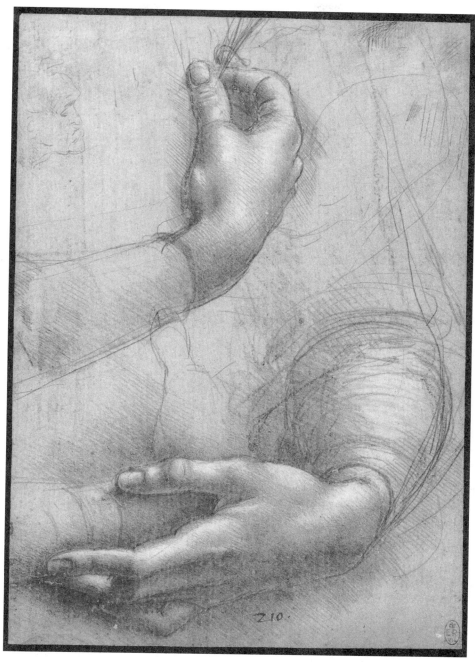

STUDY OF HANDS
The Royal Collection © 2003, Her Majesty Queen Elizabeth

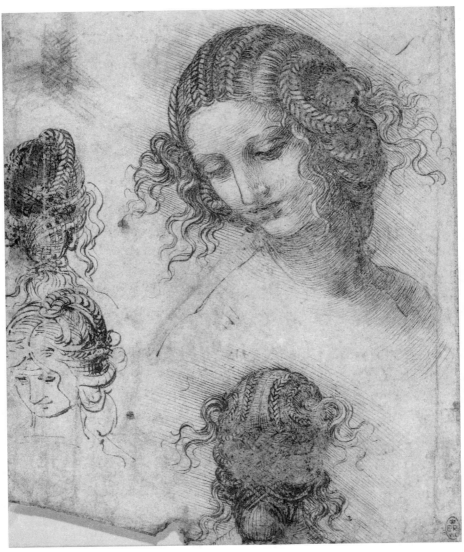

STUDY FOR THE HEAD OF LEDA
The Royal Collection © 2003, Her Majesty Queen Elizabeth

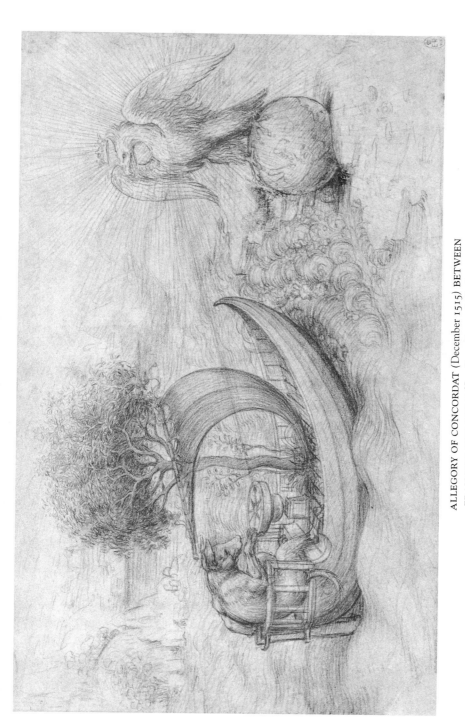

ALLEGORY OF CONCORDAT (December 1515) BETWEEN
FRANCIS I AND LEO X (See Popp: *Leonardo Zeichnungen*)
The Royal Collection © 2003, *Her Majesty Queen Elizabeth*

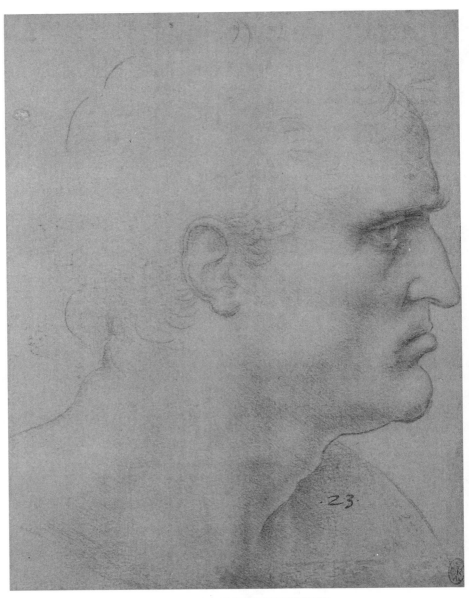

HEAD OF A MAN IN RIGHT PROFILE
The Royal Collection © 2003, Her Majesty Queen Elizabeth

IX

Optics

'These are the miracles—forms already lost mingled together in so short a space, it can recreate and reconstitute by its dilation.'

WHY nature did not make a uniform power in the visual faculty:

Nature has not made a uniform power in the visual faculty but has given this faculty greater power in proportion as it is nearer to its centre, and this it has done in order not to break the law given to all other powers which have more potency in proportion as they approach nearer to this centre.

And this is seen in the act of the percussion of any body, and in the supports of the arms of the balance where the gravity of the weight is lessened as it draws nearer; it is seen in the case of columns walls and pillars; it is seen with heat and in all the other natural powers.

Why nature made the pupil convex, that is raised up like part of a ball:

Nature has made the surface of the pupil situated in the eye convex in form so that the surrounding objects may imprint their images at greater angles than could happen if the eye were flat. D I r.

OF THE EYE

Why the rays of luminous bodies become larger in proportion as they are farther removed from their source:

The rays of luminous bodies increase the more as they proceed farther from their beginnings. This is proved thus: let *a* be the luminous body of which the image is impressed in the pupil of the eye of the beholder and let us say that *c* is the pupil upon which the impression is made, and the same image is impressed also upon the thick part of the upper lid *b* and on the lower lid *o*, and from the upper

and lower lids the second images are reflected in the pupil of the eye *c*.
But as regards the pupil that receives the three said images which are
divided by the images of the lids of the eyes (in this instance almost
closed), it seems that the images of the luminous bodies impressed on
the thick parts of the lids of the eyes are as though actually subdivided
and that these divisions are pyramidal because the intervals between
the lids are also pyramidal. And since to the pupil which receives
these three images it seems that the two images which rebound upon
it from the lids are joined together above and below to the image of
the centre which represents the luminous body, it seems to this pupil
that the image *b* is in *a n*, and the image *o* appears to be in *a m*, and
that the two images are divided by the image of the luminous body *a*.

And since in closing together the rims of the eyelids it is necessary
that the watery substance continually keeps the lids moistened as they
rub upon the eye, so this moisture fills up the angle that is produced by
the contact made by the lids with the pupil of the eye, and the surface
of this watery substance is concave, as is proved in the fourth of the
eighth of water where it states that 'the contact which water makes
with its moist bank will always have its surface concave', and that 'if
this bank is dry the surface of the water that borders upon it will be
convex'.

This angle therefore finding itself created by the contact between the
lid of the eye and its pupil will have the surface of the aqueous humour
filling up this angle of the concave figure. And since every concave
mirror shows within the pyramidal concourse of its rays the image of
its object upside down, it follows therefore that the weights or lids of
the eyes mirrored within this hollow together with the image of the
light will show these lids inverted; and this is the reason why when
the pupil is within the concourse of the pyramidal rays of the concave
mirror the pupil sees the pyramids formed by the rays of the spaces
between the lids upside down.

And this is the true reason of the rays of luminous bodies which the
more they extend seem to approach nearer to the eye. Such a demon-
stration however ought to be divided into its parts in order to render
it more intelligible, setting out first its conceptions and other proposi-
tions necessary for such proof. D I V.

Whether the images of objects are taken by the visual faculty to the surface of the eye or whether they pass within it:

The glasses of spectacles show us how the images of objects pause at the surface of these glasses and then by bending themselves penetrate from this surface to the surface of the eye, from which surface it is possible for the eye to see the shapes of the aforesaid objects.

This is proved to be possible because this surface is the common boundary between the air and the eye, in that it separates the vitreous humour from the air and separates the air from this vitreous humour. And if we wish to affirm that the images of the objects stop on the surfaces of the spectacles one might say that in the spectacles of old men the object would seem much larger than the reality, and but for the interposition of this glass between the eye and the object this object would show itself of its natural size; therefore [this not being so] is a clear proof that the convergence of the images of any object which is cut by the interposition of transparent bodies will impress itself on the surface of these bodies and will there create a new convergence which will lead the images of these objects to the eye. D 2 r.

How the images of any object whatsoever which pass to the eye through some aperture imprint themselves on its pupil upside down and the understanding sees them upright:

The pupil of the eye which receives through a very small round hole the images of bodies situated beyond this hole always receives them upside down and the visual faculty always sees them upright as they are. And this proceeds from the fact that the said images pass through the centre of the crystalline sphere situated in the middle of the eye; and in this centre they unite in a point and then spread themselves out upon the opposite surface of this sphere without deviating from their course; and the images direct themselves upon this surface according to the object that has caused them, and from thence they are taken by the impression and transmitted to the common sense where they are judged. This may be proved thus:—let $a\ n$ be the pupil of the eye $k\ h$, and let p be a small round hole made in the paper with the fine point of a style, and let $m\ b$ be the object placed beyond this opening. I maintain that the upper part of this object cannot come to the upper part of the pupil of the eye through the straight line $m\ a$ because at v its

passage is impeded by the interposition of the paper. But this upper extremity *m* passes in a straight course through the hole to *n* the lower part of the pupil, or you would say of the crystalline sphere, and from there it directs its course to the centre of this sphere, then rises to the upper part of the opposite side and from there as has been said it runs to the common sense. D 2 V.

Why the mirror in its images of objects changes the right side to the left and the left to the right:

The image of every object is changed in the mirror so that its right side is opposite to the left of the object reflected and similarly the left to the right. This is of necessity the case because every natural action is performed by nature in the shortest manner and the briefest time possible. Let *a b* be a face which sends its image to the mirror *c d*, this face will have another face in this mirror turned towards it, so that it will have the left eye *c* opposite to the right *a* and similarly the right eye *d* will be opposite to the left eye *b*.

And if it should be urged by the opponent that the right eye of the image was opposite to the right of the object we might project the lines from the right eye of the image to the right eye of the object and similarly from the left to the left, these lines being *a d* and *b c* which are seen to intersect; and it is proved that in all cases of lines intersecting the right extremity of the one is always opposite to the left extremity of the other, and this result is not produced by the shortest line because the diagonal of a square is always longer than its side, and here *a d* is the diagonal of the square *a b c d* of which *a c* is one of its sides; and thus is concluded what was necessary in order to prove such a result.

And this effect in the mirror would be as though someone who was looking at you, someone that is who has the left eye opposite to your right, were as by a miracle transposing left and right as is the case with letters used in stamping and wax which takes the impress of the cornelian. D 4 r.

OF THE HUMAN EYE

The pupil of the eye changes to as many different sizes as there are differences in the degrees of brightness and obscurity of the objects which present themselves before it:

In this case nature has provided for the visual faculty when it has been irritated by excessive light by contracting the pupil of the eye, and by enlarging this pupil after the manner of the mouth of a purse when it has had to endure varying degrees of darkness. And here nature works as one who having too much light in his habitation blocks up the window half-way or more or less according to the necessity, and who when the night comes throws open the whole of this window in order to see better within this habitation. Nature is here establishing a continual equilibrium, perpetually adjusting and equalising by making the pupil dilate or contract in proportion to the aforesaid obscurity or brightness which continually presents itself before it. You will see the process in the case of the nocturnal animals such as cats, screech-owls, long-eared owls and suchlike which have the pupil small at midday and very large at night. And it is the same with all land animals and those of the air and of the water but more, beyond all comparison, with the nocturnal animals.

And if you wish to make the experiment with a man look intently at the pupil of his eye while you hold a lighted candle at a little distance away and make him look at this light as you bring it nearer to him little by little, and you will then see that the nearer the light approaches to it the more the pupil will contract.

Whether the eye sees bright and dark things at the same time:

The crystalline humour which dwells within the pupil is condensed on meeting with shining things and becomes rarefied on meeting with dark things; and the truth of this is shown in closing the eye, for then the images retained which were of bright things seem dark and those of dark things seem bright; and this happens more with weak eyes than with those that are strong, and of this I will speak more fully in its place.

There follows the discourse concerning the eye of the nocturnal animals which see better by night than by day. And this comes about because the size of the eyes is greater than the whole of the brain, especially in the case of the long-eared and short-eared owls, the white owls, the little owls and horned owls and suchlike creatures, but it does not occur with man who has a greater brain in proportion to the size

of his eyes than any other animal that lives on land, and can see but
little light after day-time. D 5 V.

There follows concerning the eye of the nocturnal animals which
see more by night than by day, and this arises in great part from the
fact that as was said before there is a much greater difference between
the size of the pupil when dilated and contracted than there is in the
case of the animals which are active by day, for if the pupil of the man
doubles its diameter at night, that is to say it is increased to four times
what it is by day, the diameter of the pupil of the horned owl or the
long-eared owl is increased to ten times what it is by day which
amounts to saying that the pupil is a hundred times as large as it is
by day.

Furthermore the ventricle situated in the brain of man called the
imprensiva is more than ten times the whole of the eye of man, and of
this the pupil in which the sight has its origin is less than a thousandth
part; and in the case of the long-eared owl the pupil at night is con-
siderably larger than the ventricle of the imprensiva situated in its
brain. From this it follows that the imprensiva in man is greater in
proportion to the pupil, it being in fact ten thousand times as great
whereas in the case of the horned owl they are almost equal.

And this imprensiva of man in comparison with that of the long-
eared owl is like a great room which receives the light through a small
hole as compared with a small room which is entirely open. For within
the great room there will be night at midday and in the small one
which is open there will be day at midnight when the weather is not
overcast. And herewith may be shown the workings of the most pow-
erful causes by means of the anatomy of the eyes and the imprensiva
of these two animals, namely of man and of the horned [long-eared?]
owl.

That object will seem of greater radiance and size which is seen by a
larger pupil. One may make an experiment of this with our eyes by
making as small a hole as possible in a sheet of paper and then bring-
ing it as near as possible to the eye, and if then you look at a star
through this hole you are only making use of a small part of the pupil,
which sees this star with a wide space of sky round it and sees it so small
that hardly anything can be less. And if you make the hole near to the
edge of the said paper you will be able to see the same star with the

other eye at the same time and it will appear to you to be large, and thus in the said time you will see the one star twice with your two eyes and once it will be small and the other time large. Further you will be able to see the whole body of the sun and with only a moderate amount of radiance, for the more its size is diminished so in proportion is its radiance as was set forth above. And from this it arises that the large pupils (luce?) see but little of the daylight because the excess of radiance impedes their vision. D 5 r.

The image of the sun is unique in all the watery sphere which sees and is seen by this sun, but it seems divided into as many parts as are the eyes of the animals which from different positions behold the surface of the water.

This that is set forth is proved because however far the eyes of the navigators carried by ships may move through the universe they behold at the same time the image of the sun through all the waters of their hemisphere in all the movements made in all the aspects.

If the eye was as large as the sphere of the water it would see the image of the sun covering a great part of the ocean.

This is shown because if you were to move yourself upon a bridge from which you can see the image of the sun in the waters of its river, and you move yourself about twenty-five braccia, you will see the image of the sun move just as far in the surface of the said water. And so if one were to put together all the images that are seen during this movement you would have a single image which would be of the shape of a fiery beam. Now imagine yourself to make a circle of which this beam is the diameter, and that the whole of this circle is full of these images, without doubt you would see one image the diameter of which would be twenty-five braccia; now you must understand that if a pupil were to have its diameter the same twenty-five braccia it would without moving itself see in the same water an image of the sun which would revolve in seventy-eight braccia and four sevenths.

If through the long distance at which the eye was from the watery sphere the watery sphere should become diminished to the size of an ordinary image of the sun, as is shown in perspective, you would see the sphere of this water which is seen by the sun was a single image of this sun.

This is proved in perspective how things remote from the eye even

when they are exceedingly large seem very small in bulk, and this may be seen without any elaborate demonstration if you raise your eyes to the sky when it is bedecked with stars, for you will see there many stars which are many times larger than the earth and yet appear very small on account of their great distance, and the light which you perceive in them is not their own but is merely an image of the sun reflected in them. For of themselves these stars have no light, but they have a surface like the watery sphere suitable for receiving and giving back the light of the sun which is reflected in them. D 6 r.

OF THE HUMAN EYE

The pupil of the eye has a power of vision all in the whole and all in each of its parts; and an object placed in front of the eye which is less than its pupil does not occupy the place in the eye of any other distant object, and although it is compact it serves the function of a transparent object.

Here the adversary says that the power of vision is reduced to a point and that it follows from this that every object placed in front of the pupil which is greater than this point will occupy the attention [of the eye]. I say in reply to him that if it were true that the power of vision was reduced to a point, the convexity of the eye which with its parts is turned towards a great part of the universe which is opposite to it would not be able to have such a curve unless it were equidistant from this point and its surface were cut at an equal distance from this point, so that each of them with the same actual proportions correspond in the points of the angles to the proportions of the images of the bodies that meet at this point.

To such a one it is necessary to appeal to experience and then to show this experience to be conclusive; and first as regards experience if you place in front of the pupil the thick end of a sewing needle of medium width as near as possible you will see that the perception of any object placed behind this needle at however great a distance will not be interfered with.

What I say is entirely borne out by experience and necessity confirms it; for if this visual faculty be reducible to a point every object however small placed in front of it would occupy the attention of a

great part of the heaven, for if a great part of the heaven transmits the images of its stars to the pupil an object placed near to it and equal to the half of its diameter would cover almost the half of the sky. This is why nature in order that nothing may be lacking for the eyes of the animals has caused this pupil to have the smallest number of obstructions and less than may seem possible, among which the faculty of vision would be the greatest because as has been said every object however small set over against it would take up a great amount of space.

Moreover, experiment proves that sheets of canvas made out of thick horse-hair and placed in front of the eyes do not cover anything behind them and conceal it the less in proportion as they are nearer to the eye, whereas if the faculty of vision were focused in a point the nearer to it were the horse-hairs, the larger would be the space that they would occupy. As therefore experience demonstrates the contrary it is true that the visual faculty is infused through the whole pupil and makes use of every part of it and looks beyond this horsehair encompassing it and penetrating through the thickest part of it, and of necessity forming pyramids near the aforesaid horse-hairs. D 6 v.

Every concave place will appear darker if seen from the outside than from within.

And this comes about because the eye that is outside in the air has the pupil much diminished, and that which is situated in a dark place has the pupil enlarged and with the lesser eyeball the power is diminished, and in like manner this power increases in proportion to the increase of its pupil, and when the pupil is of feeble power every small obscurity will appear dark, and as it grows in power every great obscurity will appear lit up.

Excess of light injures the eye and in order to protect it from being injured in this way the visual faculty takes the help which any one gets who shuts part of a window in order to lessen the excessive brightness which the sun produces in his dwelling. D 7 r.

Why the right object does not seem the left to the eye:
The images of the objects in the eye when making their entry into the eye deflect their rays in a way that is proved in perspective when these images pass from the density of the water to the thinness of the air. But to come back to the proposition that the right object does not

appear the left in the eye, we see clearly by experiment that the images which penetrate into the vitreous humour by the pupil of the eye meet together in the sphere of the crystalline humour, as to which two considerations present themselves, namely whether the visual faculty resides in it or at the extremity of the optic nerve, which extremity catches these images and transmits them to the common sense as do the nerves of the sense of smell. And if this faculty resides in the centre of the crystalline humour it catches the images with its surface, and they are referred there from the surface of the pupil, where the objects are mirrored or reflected there from the surface of the uvea which bounds and clothes the vitreous humour which has darkness behind its transparency, just as behind the transparency of the glass we find the darkness of the lead in order that objects may be the better mirrored in the surface of this glass. But if the visual faculty is in the centre of the crystalline sphere all the objects which are given it from the surface of the pupil of the eye will appear in the true position in which they are, and will not change from the right to the left and will seem larger, as is shown in perspective. And if this crystalline sphere takes these images reflected from the concavity of the uvea it will take them upright although the uvea is a concave mirror, and it will take them upright because the centre of the crystalline sphere is concentric with the centre of the sphere of the uvea.

It is true that the images which pass to this uvea as they are outside the eye pass to it through the centre of the crystalline sphere, and having arrived at the uvea they become inverted as also are those which pass to the uvea without passing through this humour. We may surmise therefore, admitting this visual faculty to reside at the extremity of the optic nerve, that from here it may be seen in the crystalline sphere that all the objects caught by it are upright, for it takes those that were inverted in the uvea and inverts them once again, and consequently this crystalline sphere presents the images upright which were given to it inverted. To such master in optics one would perhaps say that the spherical surface of the crystalline sphere united to the sphere of the vitreous humour does not change its nature, and it is as though the whole was vitreous, and that for this reason the vitreous sphere does not fulfil the same function as it would if it were surrounded by the air. The reply to this however is that this result can-

not occur because a ball of crystal placed in water fulfils the same function as it does in air. D 7 V.

The images of the objects placed before the eye pass to the vitreous sphere by the gate of the pupil, and they intersect within this pupil in such a way that the vitreous sphere is struck on its left side by the right ray of the right sphere, and it does the same on the opposite side; afterwards it penetrates this vitreous sphere, and the rays contract and find themselves much closer together when they are on the opposite side of this sphere than when they strike it in the beginning.

And this process of contraction proceeds from the fact that the rays of the images approach the perpendicular when they pass from the thin to the dense, and that the albugineous humour is here much thinner and more subtle than the space enclosed by the surface of the vitreous sphere. Afterwards (the image) ought to enlarge as it returns into this albugineous humour, but it does not follow this rule because it is constrained to obey the nature of the vitreous sphere from whence it proceeds rather than that of the albugineous humour through which it passes.

And this is why it makes a pyramid as it issues forth from the vitreous sphere and passes through the albugineous humour, and intersects its sides at the point *f*; and passes to the visual faculty *g* at the extremity of the optic nerve *g s*.

Of the intersection of the images of the objects received by the eye within the albugineous humour:

Experience which shows that the objects transmit their images or likenesses intersected within the eye in the albugineous humour shows [what happens] when the images of the illuminated objects penetrate through some small round hole into a very dark habitation. You will then receive these images on a sheet of white paper placed inside this habitation somewhat near to this small hole, and you will see all the aforesaid objects on this paper with their true shapes and colours, but they will be less, and they will be upside down because of the said intersection.

These images if they proceed from a place that is lit by the sun will actually seem painted upon this paper, which should be very thin and seen in reverse; and the said hole should be made in a very thin sheet

of iron. Let *a b c d e* be the said objects lit by the sun, *o x* be the façade of the dark habitation in which is the said hole at *n m*, *s t* the said paper where the rays of the images of these objects inverted are cut, for as their rays are straight *a* which is right becomes left at *k* and *e* which is left becomes right at *f*, and so it is within the pupil.

<div align="right">D 8 r.</div>

Why the point of the style when placed across the pupil of the eye throws a great shadow upon the object:

When the point of the style is placed crosswise before the pupil of the eye, the diameter of its thickness being considerably less than the diameter of this pupil, it will occupy more or less space against other objects in proportion as it is nearer or more remote from the eye; and this occupation of space will obscure but will not prevent the passage of the images of the aforesaid objects.

<div align="right">D 9 r.</div>

Why the rays of the luminous bodies increase in proportion to the space that is interposed between them and the eye:

The lengths of the rays created by the luminous bodies increase with the increase of the space that is interposed between these bodies and the eye. It is necessary here first to define what are the rays of the luminous bodies, and whether they have their origin in the eye which looks at these bodies or in fact proceed from these luminous bodies, and if we should conclude that they proceed from the eye it is necessary to define why and in what manner.

Why the luminous bodies show their contours full of straight luminous rays:

The rays which reveal the contours of luminous bodies do not derive their origin from these bodies but from their images which imprint themselves upon the thickness of the lids of the eyes that look upon these bodies. This we learn in the first place by the inductive method which teaches us that the eye when wide open does not show us such rays round luminous bodies, and that if the image of a star or other light should pass to the eye through the smallest perforation made in the paper placed before the eye, such luminous [images] will always be without rays. But the real proof is shown by the ninth of Perspective where it is stated:—the angle of the incidence is always equal to the

angle of the reflection,—therefore, the rays, which seem as though they
extend from the luminous body to make contact with the eye that be-
holds it, start when the eye, being almost closed up, looks through the
narrow crack that intervenes between the eyelids, at that luminous
body of which the image is reflected in the thick parts of the lids which
end these coverings, and after making this impress is reflected on the
pupil of the eye; which pupil receives three images from the same lu-
minous body, namely two in the thick parts of the lids of the coverings
of the eye and one in the pupil, and through these three images being
very near one to another, they seem to the eye to be continuous and
joined to the image of the pupil.

And the proof that experience offers us to confirm this proposition is
shown when you raise or lower the face while keeping the eye firmly
fixed upon the luminous body; for as the face is raised the eye will
lose all the lower rays of this luminous body. This comes about because
*the image of this luminous body does not proceed to imprint itself in
the thick part of the lower lid of this eye* [1]; where the luminous body
does not see it, it cannot there imprint its image, and where the falling
ray does not strike it does not produce the reflex ray, and for this rea-
son the pupil does not take it. And so it will happen when the face is
lowered, for then the thick part of the upper covering of the eye neither
sees nor is seen by that luminous body, for which cause the image as has
been said cannot imprint itself there, and in consequence the eye can-
not there discern what is not there; but it sees this image in the lower
covering, and this lid sees and is seen by the luminous body, and thus
we have proved our intent.

The adversary says that the ray bends because it goes to the sense
from the thin to the dense. D 9 v.

The images of the objects infused in the opposite air are all in all this
air and all in every part of it. This is proved:—

Conception of the objects. All that air sees the object opposite to itself
which is seen by the same object.

This is proved by the third of this which says that all the visions
made in the same quality of air are rectilinear.

Therefore since it is possible to draw a straight line from the eye to

[1] The words in italics are crossed out in the manuscript.

each part of the air seen by this eye this vision is rectilinear. And this is also proved by what Aristotle says:—'every natural action is made in the briefest way possible'. The vision therefore will be made by the shortest line, that is by a straight line.

OF THE IMAGES OF THE OBJECTS INFUSED THROUGHOUT THE AIR

The objects have their images infused in all the air that is seen by these objects: which images are all in all the above-mentioned air and are all in every part of it.

How the eye does not know the boundary of any body:

The eye will never be capable of [perceiving] the true boundary of the figures of any body when they show up against the far distance. This may be proved: let a b be the pupil of the eye and c p the body placed opposite to the eye of which we have noted that c is the upper extremity, and let n m be the background against which this extremity ought to be perceived by the eye. I maintain that it is not possible to ascertain in what part of this background the extremity of this body terminates, and this is proved by the help of the third [section] of this [treatise] in which it is stated that the faculty of vision is not in a point as the painters who have treated of perspective would have us to suppose, but is all in the whole of the pupil into which the images of the objects penetrate, and within the eye in a larger space than that occupied by this pupil. But these images are the more clearly to be perceived in proportion as they are nearer to the centre of this faculty [of vision] located in the said space and the less clearly in proportion as they are farther removed from this centre.

If therefore the visual faculty a b takes in the extremity of the object c the centre line of the visual faculty r sees c in the part of the background f, and the upper extremity of this visual faculty that is s sees c in the background h and the lower part of the visual faculty sees c in the background d; and thus it goes spreading itself through the whole background d h; and through this such extremity is not known to the eye because the sense of the visual faculty is spread through all this faculty which offers to the judgment a vague perception of this ex-

tremity *c*, and so much more or less as it is nearer or more remote from this centre line of the visual faculty, and so much more or less as it is more remote or nearer to the eye. D 10 V.

A stone thrown through the air leaves in the eye which sees it the impression of its movement, and drops of water do the same as they descend from the clouds when it rains. C.A. 79 r. c

OF THE NATURE OF SIGHT

I say that sight is exercised by all animals through the medium of light; and if against this any one should instance the sight of nocturnal animals, I would say that these in exactly the same way are subject to the same law of nature. For, as one may readily understand, the senses, when they receive the images of things, do not send forth from themselves any actual power; but on the contrary the air which is between the object and its sense, serving as a medium, incorporates within itself the images of things, and by its own contact with the sense presents them to it, if the objects either by sound or smell project themselves to the eye or the nose by virtue of their incorporeal powers. Here the light is not necessary, nor is it made use of.

The forms of objects do not enter into the air as images unless they are luminous; this being so, the eye cannot receive the same from that air which does not contain them, but only touches their surface.

If you wish to speak of the many animals which hunt their prey by night, I answer that when that small amount of light sufficient for them to see their way fails them, they avail themselves of their powers of hearing and smell, which are not impeded by the darkness, and in which they are far in advance of man. If you watch a cat in the daytime leaping among a lot of pieces of crockery you will see that these will remain whole; but if it does the same by night it will break a considerable number. Night birds do not fly unless the moon is shining either full or in part, but their time of feeding is between the hour of sunset and the total darkness of the night.

No substance can be comprehended without light and shade; light and shade are caused by light. C.A. 90 r. b

OF THE EYE

Since the eye is the window of the soul, the latter is always in fear of being deprived of it, to such an extent that when anything moves in front of it which causes a man sudden fear, he does not use his hands to protect his heart, which supplies life to the head where dwells the lord of the senses, nor his hearing, nor sense of smell or taste; but the affrighted sense immediately not contented with shutting the eyes and pressing their lids together with the utmost force, causes him to turn suddenly in the opposite direction; and not as yet feeling secure he covers them with the one hand and stretches out the other to form a screen against the object of his fear.

Preamble to perspective—concerning the functions of the eye:
Consider now, O Reader, what trust can we place in the ancients who have set out to define the nature of the soul and of life,—things incapable of proof,—whilst those things which by experience may always be clearly known and proved have for so many centuries either remained unknown or have been wrongly interpreted.
The eye which thus clearly offers proof of its functions has even down to our own times been defined by countless writers in one way, but I find by experience that it acts in another. c.a. 119 v. a

All the images of the things set over against the eye converge in shining lines on the surface of the eye; and these intersect on the surface of the eye at equal angles.
The atmosphere is all in all and all in every part of it filled with the images of the bodies which are enclosed within it. c.a. 120 r. d

I find by experience that the black or almost black fringe of colour (colore crispo ovver rasposo) which appears round the pupil serves for no other purpose except to increase or diminish the size of this pupil; to increase it when the eye is looking towards a dark place; to diminish it when it is looking at the light or at a luminous thing.
And you should make the experiment of holding a light near to the eye, and make it when you are looking into the darkness and then turn the eye to this light, and you will be convinced by this experiment.
c.a. 125 r. a

If the object in front of the eye sends its image to it the eye also sends its image to the object, so of the object and of the image proceeding from it no portion is lost for any reason either in the eye or the object. Therefore we can sooner believe that it is the nature and power of this luminous atmosphere that attracts and takes into itself the images of the objects that are within it than that it is the nature of the objects which transmits their images through the atmosphere.

If the object in front of the eye were to send its image to it the eye would have to do the same to the object, whence it would appear that these images were incorporeal powers. If it were thus it would be necessary that each object should rapidly become less; because each body appears as an image in the atmosphere in front of it, that is the whole body in the whole atmosphere and the whole in the part, and all the bodies in the whole atmosphere and all in the part, referring to that portion of it which is capable of receiving into itself the direct and radiating lines of the images transmitted by the objects. For this reason then it must be admitted that it is the nature of this atmosphere which finds itself among the objects to draw to itself like a magnet the images of the objects among which it is situated.

A proof how all the objects placed in one position are all in the whole of it and all in each part:

I maintain that if the front of a building or some piazza or field which is illuminated by the sun has a dwelling over against it, and in that part of the front which does not face the sun you make a small round hole, all the objects which are lit by the sun will transmit their images through this hole, and will be visible inside the dwelling on the opposite wall which should be made white. And they will be there exactly, but inverted; and if in different parts of the same wall you make similar holes you will produce the same effect in each.

Therefore the images of the illuminated objects are all everywhere on this wall and all in each of its smallest parts. The reason is this: we know clearly that this hole ought to give some light to this dwelling and the light which passes through it is caused by one or by many luminous bodies: if these bodies are of different colours and shapes the rays which make their images will be of different colours and shapes and so also will be the representations on the wall. c.a. 135 v. b

The flea and the man can approach the eye and enter into it at equal angles. For this reason does not the judgment deceive itself in that the man does not seem larger than this flea? Enquire as to the cause. c.a. 190 v. b

The greater the spherical body the less is the proportion of itself that it shows to the eye when the eye does not change its position.

c.a. 216 r. a

A proof of the manner in which glasses aid the sight:

Let *a b* be the glasses and *c d* the eyes, and suppose these to have grown old. Whereas they used to see an object at *e* with great ease by turning their position very considerably from the line of the optic nerves, but now by reason of age the power of bending has become weakened, and consequently it cannot be twisted without causing great pain to the eyes, so that they are constrained of necessity to place the object farther away, that is from *e* to *f*, and so see it better but not in detail. But through the interposition of the spectacles the object is clearly discerned at the distance that it was when they were young, that is at *e*, and this comes about because the object *e* passes to the eye through various mediums, namely thin and thick, the thin being the air that is between the spectacles and the object, and the thick being the thickness of the glass of the spectacles, the line of direction consequently bends in the thickness of the glass, and the line is twisted, so that seeing the object at *e* it sees it as though it was at *f*, with the advantage that the position of the eye with regard to its optic nerves is not strained and it sees it near at hand and discerns it better at *e* than at *f* and especially the minute portions. c.a. 244 r. a

In just such proportion as the eye when it functions is nearer than the ear it will the more preserve the images of the objects imprinted upon it. c.a. 250 r. a

Among the solar images preserved within the eye that which the eye has retained for a less time will appear more luminous. c.a. 262 r. b

I say that the power of vision extends by means of the visual rays as far as the surface of bodies which are not transparent, and that the power possessed by these bodies extends up to the power of vision, and

that every similar body fills all the surrounding air with its image. Each body separately and all together do the same, and not only do they fill it with the likeness of their shape, but also with that of their power.

Example

You see with the sun when it is at the centre of our hemisphere, how there are images of its form in all the parts where it reveals itself, and you see how in all these same places there are also the images of its radiance, and to these must also be added the image of the power of its heat; and all these powers proceed from the same source by means of radiant lines which issue from its body and end in the opaque objects without it thereby undergoing any diminution.

The north star remains continually with the images of its power spread out, becoming incorporated not only in thin but in thick bodies, in those transparent and those opaque, but it does not on this account suffer any loss of its shape.

Confutation

Those mathematicians, then, who say that the eye has no spiritual power which extends to a distance from itself, since, if it were so, it could not be without great diminution in the use of the power of vision, and that though the eye were as great as the body of the earth it would of necessity be consumed in beholding the stars: for this reason they maintain that the eye takes in but does not send forth anything from itself.

Example

What will these say of the musk which always keeps a great quantity of the atmosphere charged with its odour, and which, if it be carried a thousand miles, will permeate a thousand miles with that thickness of atmosphere without any diminution of itself?

Or will they say that the sound which the bell makes on its contact with the clapper, which daily of itself fills the whole countryside with its sound, must of necessity consume this bell?

Certainly, it seems to me, there are such men as these—and that is all that need be said of them.

Is not that snake called lamia seen daily by the rustics attracting to itself with fixed gaze, as the magnet attracts iron, the nightingale, which with mournful song hastens to her death?

It is said also that the wolf has power by its look to cause men to have hoarse voices.

The basilisk is said to have the power by its glance to deprive of life every living thing.

The ostrich and the spider are said to hatch their eggs by looking at them.

Maidens are said to have power in their eyes to attract to themselves the love of men.

The fish called linno, which some name after St. Elmo, which is found off the coasts of Sardinia, is it not seen at night by the fishermen, shedding light with its eyes over a great quantity of water, as though they were two candles? And all those fishes which come within the compass of this radiance, immediately come up to the surface of the water and turn over, dead. c.a. 270 v. c

If you take a light and place it in a lantern tinted green or other transparent colours you will see by experiment that all the objects which are illuminated by this light seem to take their colour from the lantern.

You may have also seen in churches how the light which comes through stained-glass windows assumes the colour of the glass of these windows. If this does not convince you, watch the sun at its setting when it shows itself red through the vapour, how it dyes red all the clouds which take their light from the sun.

Opinions

All these instances are given in order to prove how all things or certainly many things transmit the appearance of their powers together with the image of their form without any injury to themselves; and this also may happen with the power of the eye.

Contrary opinion

Furthermore if anyone wished to say that the eye was not adapted to receive like the ear the images of objects without transmitting some potency in exchange for these, this may be proved by the instance of the small hole made in a window which gives back all the images of the bodies which are opposite to it; therefore one may say that the eye does the same.

Refutation

If the small hole cited as an example without sending forth anything except its form without incorporeal power gives back to the house the images of objects in their colour and form and there inverts them, the eye would have to do the same so that everything seen would appear there inverted.

Proof to the contrary

The circle of the light which is in the middle of the white of the eye is by nature suitable to apprehend objects. This same circle has in it a point which seems black and this is a nerve bored through it which goes within to the seat of the powers charged with the power of receiving impressions and forming judgment, and this penetrates to the common sense. Now the objects which are over against the eyes act with the rays of their images after the manner of many archers who wish to shoot through the bore of a carbine, for the one among them who finds himself in a straight line with the direction of the bore of the carbine will be most likely to touch the bottom of this bore with his arrow; so the objects opposite to the eye will be more transferred to the sense when they are more in the line of the transfixing nerve.

That water which is in the light that surrounds the black centre of the eye serves the same purpose as the hounds in the chase, for these are used to start the quarry and then the hunters capture it. So also with this, because it is a humour that derives from the power of the imprensiva and sees many things without seizing hold of them, but suddenly turns thither the central beam which proceeds along the line to the sense, and this seizes on the images and confines such as please it within the prison of the memory. C.A. 270 r. b

Why objects as they come upon the small surface of the eye appear large arises from the fact that the pupil is a concave mirror; and so one sees for example with a glass ball filled with water that anything placed at the side either inside or outside appears larger.

<div align="right">c.a. 309 r. b</div>

Nothing can be seen that does not transmit its image through the air.

Therefore nothing that is spiritual or transparent can see anything set over against it, for this requires that it have within itself a thick opaque instrument and being thus it is not termed a spirit.

Prove how nothing can be seen except through a small fissure, through which the atmosphere passes filled with the images of objects that intersect within the thick and opaque sides of the above-mentioned fissures. And for this reason nothing which has not substance can discern either the shape or colour of any object, seeing that it is necessary that there should be a thick opaque instrument in order that through the fissure in it the images of the objects may assume their colours and shapes. c.a. 345 r. b

Seeing that the images of the objects are all spread throughout all the air which surrounds them, and are all in every point of the same, it must be that the images of our hemisphere enter and pass together with those of all the heavenly bodies through the natural point in which they merge and become united, by mutually penetrating and intersecting each other, whereby the image of the moon in the east and the image of the sun in the west at this natural point become united and blended together with our hemisphere.

O marvellous Necessity, thou with supreme reason constrainest all effects to be the direct result of their causes, and by a supreme and irrevocable law every natural action obeys thee by the shortest possible process!

Who would believe that so small a space could contain the images of all the universe? O mighty process! What talent can avail to penetrate a nature such as these? What tongue will it be that can unfold so great a wonder? Verily, none! This it is that guides the human discourse to the considering of divine things.

Here the figures, here the colours, here all the images of every part of the universe are contracted to a point.

O what point is so marvellous!

O wonderful, O stupendous Necessity thou by thy law constrainest all effects to issue from their causes in the briefest possible way!

These are the miracles, . . . forms already lost, mingled together in so small a space, it can recreate and reconstitute by its dilation.

How it may be that from indistinct causes there may issue effects manifest and immediate, as are the images which have passed through the aforesaid natural point.

Write in thy Anatomy what proportion there is between the diameters of all the lenses of the eye, and the distance from these to the crystalline lens. c.a. 345 v. b

The point is in itself an indivisible part, separated from and similar to all, and possessing the capacity of all, and all the indivisible parts are similar to the one and are such as may all be contained in that one, as is shown by experience in the points of the angles of the air-holes, for when the solar rays have passed through these the angles become the termination and point of the primitive and derived pyramid.

This derived pyramid although of less force is none the less capable of going a long way enlarging and expanding itself with the concourse of its rays much more than the primitive.

And this same phenomenon may be seen in concave mirrors, for these after taking the solar rays according to their capacity lead them in pyramid fashion to the divisible part of the point, and although it is the least part of the sun or rather of the solar rays which illumine and warm all the surface of the mirror, this point nevertheless contains within itself the whole sum and power whether of heat or radiance of which all the surface of the mirror is capable. The derived pyramid when equal in bulk is similar in all its powers to the primitive, and when this equality is exceeded it becomes so much weaker in proportion as its size surpasses the bulk of the primitive. c.a. 347 r. a

EYE

The thing seen through an aperture that is less than the base of the visual pyramid will be seen along a line that goes crosswise, and the

thing on the right hand will go to the left eye, and will not be able
to be seen by two eyes at one and the same time and if it is seen it will
be imperfectly discerned. c.a. 347 v. a

OF THE EYE AND LIGHT

If you look at a luminous body in the far distance through a small
hole it will seem to grow less, and if you look at it near at hand it will
not undergo any change. That is that if you look at this light at a
distance of one or two braccia from the aforesaid hole it will not
undergo any change whether you are looking at it through this hole
or outside of it. c.a. 351 v. b

How and why many things seen in a mirror come to the eye upside
down.

Why anything seen in a mirror appears greater than it is.

Why anything looking at itself in a mirror appears less.

What sort of mirror it is which shows the things exactly.

What sort of mirror shows them outside itself.

How the mirror is the master of painters.

Why the eye goes varying hour by hour, enlarging and lessening.

Why the pupil in proportion as it has a greater light in front of it
becomes less, and why on the other hand it increases in the dark.

Why the things seen by the eye when continuing are small within
the eye and appear large.

Why a thing seen through a chink with both the eyes becomes dou-
ble and is transposed; that is to say the thing seen on the right hand
goes to the left eye, and similarly that on the left hand goes to the right.

Why a building among clouds appears greater.

Why the eye cannot see perfectly except in a straight line.

Why pyramidal lines which start from the eyes come to a point in
the thing seen.

Why when the said pyramid proceeds from the eyes and comes to a
point in an object that is in water the lines bend as they reach the water
and do not keep their straightness.

How the things seen form a pyramid only in the eye.

How the two eyes form a pyramid in the thing seen. c.a. 360 r. c

That eye will preserve within itself more images of the sun which is looked upon a greater number of times by this sun. c.a. 369 r. c

A dark place will seem sown with spots of light and a shining place with dark round spots, when seen by the eye which has recently gazed many times and rapidly at the body of the sun. c.a. 369 v. d

Method of seeing the sun in an eclipse without causing suffering of the eye:
Take a sheet of paper and make holes in it with a knitting-needle and look at the sun through these holes. Tr. 10 a

The eye which finds itself in the centre between the shadows and the lights that surround the shaded bodies, will see in these bodies the greater shadows that are in them meeting themselves within equal angles that is of the visual incidence. Tr. 16 a

Every man always finds himself in the centre of the earth's circumference and below the centre of its hemisphere and above the centre of this earth. Tr. 24 a

The movement of an object near to a stationary object often causes this stationary object to seem to transform itself to the movement of the moving object and the moving object to seem stationary and fixed.

PAINTING

Things in relief seen close at hand with one eye will seem like a perfect picture.
[*Diagram*]
If with the eyes *a b* you observe the point *c*, this point *c* will appear at *d f*.
But if you look at it with one eye only it will seem to you *h* in *m o*, and painting will never of itself have these two varieties. Tr. 69 a

The medium that is between the eye and the object seen transforms this object to its own colour. So the blueness of the atmosphere causes the distant mountains to seem blue; red glass causes anything that the eye sees through it to seem red. The light created by the stars round

about them is obscured by the darkness of the night that lies between the eye and the radiance of the star. Tr. 70 a

PERSPECTIVE AND MOVEMENT

Every body that moves rapidly seems to colour its path with the impression of its hue. The truth of this proposition is seen from experience; thus when the lightning moves among dark clouds the speed of its sinuous flight makes its whole course resemble a luminous snake. So in like manner if you wave a lighted brand its whole course will seem a ring of flame. This is because the organ of perception acts more rapidly than the judgment. A 26 v.

Why the movement of water although slower than that of man always seems swifter:

The reason of this is that if you look at the movement of the water your eye will not be able to fix on anything, but its action is as that of things seen in your shadow when you are walking; for if the eye attempt to distinguish the nature of the shadow, the wisps of straw or other things contained in it appear of rapid movement and it seems that these are much more swift to flee from the said shadow than the shadow is to proceed. A 58 v.

If the eye looks at the light of a candle at a distance of four hundred braccia, this light will appear to this eye which looks at it increased a hundred times its true quantity; but if you place a stick in front of it somewhat larger than this light, this stick which would appear two braccia wide will hide it. This error therefore comes from the eye which takes the luminous images not only with the point of its light but also with the whole of this light, and of this I will define the reason in another place. c 6 r.

The eye will retain and preserve better within itself the images of luminous things than of shaded things.

The reason is that the eye in itself is completely dark, and since like amid like cannot be distinguished, the night or other dark things can [not] be retained or recognised by the eye. The light is entirely contrary, and the more it is divided the more it tends to destroy and

change the customary darkness of the eye and so leaves its image imprinted. c 7 v.

A rod or cord in rapid oscillation appears to be double.

This occurs when a knife is fastened, and the top of it is forcibly pulled to one side and released, so that it quivers many times. The same thing happens with the cord of a lute when one tests it to see if it is a good one. The double movement takes place because when the movement extends to the extremity of the thing moved it is much swifter at this extremity. But this extremity stops and turns back when its desire has been fulfilled, and as the pause is made first at one and then at the other extremity of the movement, the eye must necessarily take the impression of two images of the same thing moved. But tell me why a false cord of a lute makes, as it quivers, two or three images and sometimes four? c 15 r.

[*The effect on the eye of sudden light*]

The eye which is used to the darkness is hurt on suddenly beholding the light and therefore closes quickly being unable to endure the light. This is due to the fact that the pupil in order to recognise any object in the darkness to which it has grown accustomed, increases in size, employing all its force to transmit to the receptive part the image of things in shadow. And the light, suddenly penetrating, causes too large a part of the pupil which was in darkness to be hurt by the radiance which bursts in upon it, this being the exact opposite of the darkness to which the eye has already grown accustomed and habituated, and which seeks to maintain itself there, and will not quit its hold without inflicting injury upon the eye.

One might also say that the pain caused to the eye when in shadow by the sudden light arises from the sudden contraction of the pupil, which does not occur except as the result of the sudden contact and friction of the sensitive parts of the eye. If you would see an instance of this, observe and note carefully the size of the pupil when any one is looking at a dark place, and then cause a candle to be brought before it, and make it rapidly approach the eye, and you will see an instantaneous contraction of the pupil. c 16 r.

PAINTING

First—The pupil of the eye contracts as the light reflected in it increases.

Second—The pupil of the eye expands as the brightness of day or of any other light reflected in it grows less.

Third—The eye sees and knows objects of vision with greater intensity when the pupil is more dilated; and this is proved in the case of the nocturnal animals such as cats and others, and birds such as the owl and suchlike in which the pupil undergoes a great variation from large to small in the dark and in the light.

Fourth—The eye when placed in an illuminated atmosphere can discern the darkness within the windows of habitations which are themselves in light.

Fifth—All colours when placed in shadow seem to be equally dark.

Sixth—But all colours placed in light keep their essence unchanged.

E 17 V.

If the object interposed between the background and the eye is less than the pupil of the eye no part of the background will be covered by this object. F 28 V.

The rays of luminous bodies that are remote from the eye will seem of great length, because no object which sends an image is in closer proximity to the pupil of the eye than the object imprinted on the rim of the eye which touches the pupil and from there sends the image to the eye.

The rays of luminous objects will seem shorter when these objects are near to the eye than when they are far away, because, if the lids of the eyes are half closed as is done by those who wish to see rays round the light, and these lids occupy little space below and above this light, and the rays therefore are not able to open more than whatever may be this space seen by the eye, it is necessary that in this short space one sees short rays, and in a long space long rays as is shown above [diagram]. F 29 r.

How the rays that are seen around a luminous body in contracting the eyelids are produced in the eyes and not elsewhere:

Convex mirrors will reflect the rays that they receive from the luminous body in all the parts that see the mirror where the luminous body sees it.

The luminous body sends three images of itself to the eye, of which one goes straight to the pupil; the other two strike upon the convexity of the eyelids and from there leap back in opposite movements to the opposite edges of the eyes, and from the edges they leap back into the eyeball ('luce'), and join themselves below and above to the first image, with the brilliance which has been imprinted on the eyelids in the form of rays; and the luminous body does this when the eye is drawn together as when one takes aim at a target.

This is proved:—let the eye be inclined as has been said and you will see two groups of rays around the luminous separated body, of which one part goes upwards and the other downwards; and if you hold your finger up against the light, putting it crosswise a little below the luminous body, and raise it towards the light with a slow movement until you reach the origin of the light from below, and then observe how instantly this luminous body will lose all its rays above; and if you make a contrary movement crosswise with your finger, commencing above the light, and with slow movement lower your finger until it meets the summit of the light, you will then see that all the rays below are lacking; and this proves our proposition, for if a be the luminous body, then a o the first ray from its centre goes straight to the pupil of the eye, that below, a m, strikes upon the convexity of the eyelids below the eyelashes, and makes several images, and these, as soon as they are formed, are reflected upon the lid n, which forms the thick part of the covering of the eye; and from there it leaps back into the eyeball ('luce'), together with all the images formed in the hairs of the eyelids, and these are somewhat long and are separated and proceed with points raised spreading themselves out towards the extremities as do the real eyelashes.

Now to bring our purpose to a conclusion, I call t s the part between the commencement of the light and your eye; you will cut the ray a m, consequently, because of this the ray will not make its impression on the convexities or curves of the eyelids below, and therefore the ray above will cease at n and consequently in the eyeball ('luce'), for if the cause of the images m be lacking the effects of the rays m n will

be lacking. Here then is the explanation of why when the ray is covering the light below, the ray above is lost altogether.

The adversary here says that it seems to him that this image proceeds from the luminous body and passes between the eyelids and imprints itself on the thick part of the edges of the eyelids, and that from there they leap to the pupil, and that this image emits rays because it is divided by the hairs through which it passes.

To this the reply is that in this event whatever might fill the image below the rays above would not fail.　　　　　　　F 30 r. and 29 v.

There is the same proportion one with another between the spaces that there are between the images of the stars upon the surface of the eye and that of the spaces interposed between the stars of the heaven.

Although the images of the stars may be all in all the surface of the eye and all in each of its parts, and each image may be superimposed upon each of the other images as it appears to another eye which regards it after the manner of the surface of a mirror, it remains none the less the fact that from the inner side of the pupil which covers for it the arrival from without of an image of the star, this image will not turn to imprint itself in another part of the eye but will remain without impression in the eye, because the spot to which it directed itself is impeded by the aforesaid interposition.　　　　　　　F 31 v.

The images of opaque bodies do not superimpose themselves one upon another when the eye that scrutinises them is without movement.

In the same mirror or pupil is the image of all the objects placed before it, and each of these objects is all in the whole surface of the mirror and all in each of its smallest parts.

There is an example of this in the movement of the eye; if it sees the moon with all the stars in this mirror, and marks them on its surface, and then the eye moves a little, it will be able to distinguish them so many times upon this mirror, clearly marked one above the other, and this it will be able to do an infinite number of times.　　　F 32 r.

The whole pupil of the eye which with each of these circles from the greater to the less goes diminishing an infinite number of times can

see the whole body of the star; but it will see it as much smaller as it
sees it with a less expansion.

Why in looking at the heaven one sees many stars of great radiance,
and in looking at them through a very minute hole made in a sheet of
paper placed in contact with the eye you see again the same number
of stars but they will be much diminished. F 32 v.

OF THE FACULTY OF SIGHT

If all the images which come to the eye met in an angle, by the
definition of the angle they meet in a mathematical point which is
proved to be indivisible; then all things seen in the universe would
seem one and that would be indivisible, and there would be no more
space from one star to another which would be reckoned in such an
angle.

And if experience shows us all things separated with spaces pro-
portioned and definite, this power which imprints the images of objects
is also itself divisible into as many larger and smaller parts as there are
images of the things seen. We conclude therefore that the sense takes
the images which are reflected on the surface of the eye, and then
judges them within, and therefore they do not meet in a point nor as
a consequence in an angle.

Every surface of a transparent body both within and without is
formed fitted to receive the images of its objects.

In no part of transparent bodies enclosed by their surfaces is there
lacking the power to receive or create some image, but each is well
fitted to afford a passage to the images of the surface. F 34 r.

That luminous body will show itself of less size at the same distance
which loses more of its radiance.

This is shown by an iron rod heated through part of its length when
in a dark place; although it is of uniform thickness, it appears to be
considerably bigger in the heated part, and the more so as it is more
heated. The reason for this follows:—

Every luminous body makes visible rays in the image which it trans-
mits to the eye; and the rays are so much longer as it is of greater
brilliance; and so conversely. F 37 r.

Many are the times that the images of one and the same luminous body will be two or three times at the same time in the same eye.

They will be twice there when the eye closes somewhat as it does when it looks at light which is too strong and when the head is some-what bending as in the figure *a*, in this case it makes two rays; one strikes against the humid circumference of the lower eyelid and then leaps back to the pupil, and the other ray goes straight to this pupil; it will recur three times as in the figure *b*, one on the eyelid above, one on that below and one in the centre of the pupil. And the aforesaid two or three images of the light arriving at the same sense appear one single image, but greater than corresponds to the image of the same body which transmits to the two eyes two images, and the sense takes them for one single image. F 36 v. and 37 r.

As regards the pupil of the eyes of all animals both those of the land and those of the water, nature has so ordained that when they are affected by greater or less brightness the pupil that is the black portion of the eye contracts or expands. This happens because as the excess of brightness causes a change in the eye the eye or pupil closes up after the manner of a purse, consequently the great brightness becomes small in size and in splendour in proportion to its contraction or diminution. When these pupils are in darkness they become large and the bright-ness is diminished; in this way it comes about that they increase ac-cording to the increase of this brightness, and so the quantity of the objects seen by such a pupil is increased.

And this supplies a reason why when the light of a candle is removed farther away from the eye, this light having thereby its brightness diminished the pupil increases and it causes the figure of the light to increase. F 39 v.

The image of the sun imprinted on the surface of the water creates rays which shine over a great distance both within and outside the water as though it was a real light.

Why when the image of the light of the candle diminishes upon the eyeball when this candle is removed to a great distance from this eye it does not diminish in the judgment of the spectators except in degree of radiance. F 40 r.

The eye contracts and diminishes the pupil to such an extent in looking at luminous things that when afterwards looking at things of less radiance they appear shaded.

If the eye which has been in a shaded place should then see objects of only a moderate degree of brightness they will appear extremely bright.

And the reason of this is that the pupil increases so much while in the dark places that it afterwards sees objects of a moderate degree of brightness incorrectly. F 50 r.

In every spot in which the sun sees the water the water also sees the sun, and in each of its parts it can present the sun's image to the eye.

F 61 v.

If you bring your eye as near as you can to the surface of the sea you will see the image of the sun in a wave of the water, and you will be able to measure it and you will find that it is very small.

If you bring your eye near the surface of the water of the sea or of a pool which is between your eye and the sun you will find that the image of the sun on this surface shows itself very small. But if you retire a distance of several miles from this sea you will perceive a proportionate increase in the image of the sun; and if the first image preserves the true shape and radiance of the sun as do mirrors, the second does not keep either the shape or the radiance of the sun but is a figure with broken contour lines and a lesser degree of radiance.

The figure of the image with contour lines broken and confused is formed by the blending of many images of the sun reflected to your eye by many waves of the sea, and the lesser degree of radiance springs from the fact that the shadowed and luminous images of the waves come to the eye all mingled together and consequently their light is affected by their shadows.

This however cannot happen with the surface of a single wave when you have approached very near to it with your eye. F 63 v.

The image of the sun in the convex mirror increases as it recedes from this mirror and the solar body disappears as it recedes. F 76 r.

Show first how every light remote from the eye makes rays which

appear to increase the figure of this luminous body; and from this it follows that . . .

The eye does not diminish its light at any distance, because the image of the light which imprints itself on the surface of the eye illuminates within as do the windows of paper, which diffuse the light taken by them through those places which see this paper, and which at first could not see the cause of the illumination of this paper when the paper was not there. The sun also on being reflected in the mirrors causes the image without passing within to be reflected outwardly as though it were a real light; and if the lead were not behind this glass of the mirror, the image of the sun which imprints itself on the surface of the glass would pass within and cast its light within or behind this mirror. And thus does the eye which receives within the light of this image and spreads it considerably in the visual faculty. F 94 v.

[*Distant lights and reflection*]

Why as the image of the light of the candle diminishes when it is removed to a great distance from the eye the size of this light does not diminish but it lacks only the power and brightness of its radiance.

A light that is less in quantity is less also in illuminating power, but in that it does not change its position it does not lose its first quantity of radiance in all the places where it formerly shone. This is proved: the light of the sun given to the surface of the water is reflected back and emits rays as though it were a material light both within and without, and actually illuminates the objects set over against it and also those within. F 95 r.

[*Presbyopia*]

Why when men are somewhat advanced in years they see better at a distance.

Sight is better at a distance than near at hand with men who are somewhat advanced in years because the same thing transmits a smaller impression of itself to the eye when it is remote than when it is near.

 G 90 r.

Things near to the eye will seem of greater bulk than those remote.

Things seen with both eyes will seem rounder than those seen with one eye.

Things seen between light and shadow will appear to have the highest relief.

H 49 [1] r.

[Man and owl]

All things seen will appear larger at midnight than at midday and larger in the morning than at midday.

This takes place because the pupil of the eye is considerably smaller at midday than at any other time.

To just such extent as the eye or pupil of the owl is greater in proportion to the creature than is that of man it sees more light at night than man does; as a consequence at midday it sees nothing unless its pupil grows smaller and in the same way at night it sees things larger than by day.

H 86 [38] r.

The larger the pupil the larger will be the appearance of the objects it sees.

This is evident when we look at luminous and especially at heavenly bodies. When the eye emerges from the darkness and suddenly looks at these bodies they will appear larger at first and will then diminish. And if you look at these bodies through a small hole you will see them smaller because a smaller part of the pupil is functioning in this act.

H 88 [40] r.

When the eye emerging from darkness suddenly sees a luminous body it will appear much larger at the first glance than as it goes on looking at it.

A luminous body will seem larger and more luminous when seen with both eyes than when seen with one.

This luminous body will appear of less size when it is seen by the eye through a smaller hole.

The luminous body of elongated shape will show itself rounder in form when it is situated at a greater distance from the eye.

H 91 [43] v.

When at night the eye finds itself between the light and the eye of a cat it will see this eye looking like fire. H 109 [34 v.] r.

Objects seen by the same eye will sometimes appear large and sometimes small.

H 133 [10 r.] v.

Example of the enlargement and contraction of the pupil through the movement of the sun or other luminous body:

The darker the sky the greater the stars will seem, and if you light up the atmosphere these stars will show themselves less. And this change proceeds only from the pupil which expands and contracts according to the clearness of the atmosphere which finds itself between the eye and the luminous body. Let the experiment be made with a candle placed above the head while you are looking at this star; afterwards proceed to lower this candle, little by little, until it is near the ray that comes from the star to the eye, and you will then see the star diminish so much that you will almost lose sight of it. I 19 v.

The pupil of the eye in the open air varies its size with every degree of the sun's movement. And as it varies its size the same object when seen by it will appear of different sizes, although it often happens that the comparison with surrounding things does not allow this change to be discerned when you look at a particular object. I 20 r.

No opaque body of spherical shape seen by two eyes will ever show itself of perfect roundness.
[Diagram]
 a is the position of your right eye; b is the position of the left. If you close the right eye you will see your spherical body around the centre b, and if you close the left eye, then the said body will surround the centre a.[1] I 43 r.

The more nearly an object approaches to the eye the more it shows itself at a greater angle; and the image of this thing does the opposite, seeing that in proportion as it is found by measurement to be nearer to the eye it shows itself less in shape. I 49 [I] v.

[Eyeball of glass]
 In order to see what function the eyeball ('luce')[2] serves in the pupil cause a thing resembling the eyeball to be made out of glass.
 K 118 [38] v.

[1] MS. has b.
[2] A note in M. Ravaisson-Mollien's edition of the Paris Manuscripts is as follows: 'Le mot "luce" est souvent pris pour prunelle, mais signifie proprement (voir la page suivante) (118 [38] r.) toute la partie de l'œil qui luit, la prunelle avec l'iris.'

[The structure and anatomy of the eye]

The pupil of the eye is situated in the centre in the eyeball ('luce') which is of the shape of part of a sphere which takes the pupil at the centre of its base. This 'luce' forming part of a sphere takes all the images of the objects and transmits them by the pupil within to the place where the vision is formed.

In the anatomy of the eye, in order to be able to see the inside well without spilling its watery humour, you should place the complete eye in white of egg and make it boil and become solid, cutting the egg and the eye transversely so that no part of the middle portion may be poured out. K 119 [39] r.

[Optical illusions. A brand of fire]

There is as much to move the eye when the luminous object remains fixed as there is to move this object when the eye remains fixed.

What is said in the first part is proved by the past, and I will prove the second part by the help of this same past.

For if when the eye is fixed you draw a brand of fire in a circle or from below the eye upward this brand will seem to be a line of fire which rises upwards from below, and yet this brand cannot actually be in more than one part of this line at one time.

And in the same way if this brand remain fixed and the eye move downward from above it will appear to this eye that the brand is rising up from below in a continuous line. K 119 [39] v.

[Optical illusions. Brands of fire. Stars]

If the eye that looks at the star turns swiftly in an opposite direction, it will appear to it that this star forms itself into a curving line of fire. *[Diagram]*

Let *a b c* be the eyeball ('luce') of the eye which looks at the star *d*; I maintain that if the eyeball moves the part *a* rapidly to *c* then *b* in coming to the place *a* will take the appearance of a continuous line of the colour of the star. And this occurs because the eye preserves for a certain space of time the image of the thing that shines, and because this impression of the radiance of the star is more enduring in the pupil than was the time of its movement, this impression continues together with the movement in all the positions which pass opposite to the star. K 120 [40] r.

When the eye changes its position which has been fixed in relation to a near object it will seem to it that distant objects are very rapid and that the first is without movement and that the star moves by the line of the eye.

[*Diagram*]

Let us say that the eye *a* has fixed its range of vision upon the object *c* and that while having its vision fixed upon *c* it itself moves actually from *a* to *b*; the star *d* when seen by the lines of the eye other than the central ones will appear to it very swift, and in the time during which the eye goes from *a* to *b*, the star will appear to it to have moved the whole part of the sky *d e*. K 122 [42] v.

But if the eye which changes its position keeps its vision fixed upon the star it will seem to it that all the objects seen on the lines that are not central are fleeting and vanish away in movement contrary to that of the eye.

[*Diagram*]

Let us say that the eye *b* having its vision fixed upon the star *d e* itself moves actually from *b* to *a*; it will then appear to the eye that as its lines which are not central have exchanged so many times the images of the object *c* it will be moved in a direction contrary to that of the eye from *n* to *c*. K 122 [42] r.

In proportion as a thing that descends shall descend from a higher position it will appear at the beginning of its movement to be obliged to descend nearer to the eye that sees it than does a thing that descends from a low position.

[*Diagram*]

This which has been said springs from the background of the movable thing, which is the sky where this movable thing shows up prominently, and the lower the movable thing upon this background the more does the eye see it on a more distant background; as if the eye *p* sees the movable thing at *e* and sees it occupy the part of the sky *d* which seems almost above it; and if it sees the movable thing below at *h* this eye sees it occupy the part of the sky *a*, and in proportion as the distance is from *a* to *d* so to the eye *p* it seems that it has it more at the zenith when at *e* than at *h*, that is that when falling from *d* it seems to it that it ought to fall nearer than when falling from *a*.

 K 123 [43] r. and 122 [42] v.

If the proportion of the movement of two movable things is the same as that of their distance from the eye in the same direction the movements of these movable things will always appear equal although they may be of almost infinite diversity.

If half the diameter of the base of a pyramid measures three-quarters of its hypotenuse nothing can remain stable upon the said hypotenuse; but if this should be longer it will support anything. K. 123 [43] v.

Among the things of equal movement that will appear swifter which is nearer, and the thing will seem slower which is more remote.
[*Diagram*]
Because everything that moves is seen on the field where it ends, and the distant thing in like movement to that of the near thing will occupy less of the field than this near thing in the same time, for which cause occupying a greater space of field it appears so much swifter as the field that it has covered is greater. K 124 [44] r.

[*Spherical bodies*]
If the spherical body is equal to the pupil that sees it even though it may be at infinite varieties of distances, provided that it can be defined and that the eye is able to discern it it will never be seen as more or less than half. And this happens because its diameter with its extremities always terminates within equal angles between parallel visual lines.

But if the pupil be less than the spherical body situated in front of it it will never at any variety of distance be able to see the half; and it will see as much less in proportion as it is nearer to it, and as much more as it is more remote. K 124 [44] v.

An object less than the pupil placed before the eye will not cover up any distant object for this pupil.

No spherical body less than the pupil will ever be seen by a single pupil without it seeing more than half of it although it be at whatever distance it may wish. And it will see so much more of it as the medium is nearer and so much less as it is more remote from the eye that sees it. K 125 [45] r.

[*Movements*]
In the cases of the movement of the thing between the eye and the perforation of the paper you have to make the perforations with very

small holes and to pull the thing which moves as thin as a wisp of straw, and in the movement to touch yourself with it on the eyelashes, the paper in front to be a quarter of a braccio distant from the eye and the air to be visible through the openings. Furthermore if you approach nearer to the paper so that the eyelashes almost touch, and move the face at *d* to right and left, with a short movement, you will see that the hairs appear to be moving beyond this hole in a contrary direction to the movement made by your eye. But if the movement of the object is beyond the perforated paper the eye will then see the true movement of the object. 　　　　　　　　　K 125 [45] v. and 126 [46] r.

[*Contrary movements seen at the same time*]

Again it is possible for the same pupil to see the same object at the same time make two opposite movements without the pupil changing. [*Diagram*]

That which is set forth above is seen by the pupil when it sees through a small hole made in the paper by the point of a needle, and keeping the eye close to it and interposing between the eye and the hole a very fine straw, which as you move it from right to left your eye will see in its true movement between the hole and it, in the true position in which this straw actually finds itself moving; and beyond this hole it will see it moving in the opposite direction to its true movement; so that at one and the same time it sees the true and the false movements separately the one from the other. 　　　　K 127 [47] r.

[*Visual faculty*]

And the reason of this is that as every vision transmits itself by a straight line if the medium be uniform, the part *a* of the pupil sees *o* beyond the hole at *s*, and it would be impossible to see it through this hole at *q* through *a b q*, that is by a line that is not straight. Suppose now that *o* is lowered to *n*; *p* will see *o* at *r*, and if *o* is lowered as far as *m* then *o* will appear to the lower part of the eye *c* to be raised to the extremity *q*.

The pupil which sees beyond the hole something smaller than itself and near to it, will see with the right part of the pupil the left part of the object, and with the left part it will see the right part of this object; and with the centre of the pupil it will see the centre of the surface of

the object, given that it is visible and that the centre of the pupil has in itself visual faculty. K 126 [46] v.

PUPIL SEEING AN OBJECT TWICE

It is possible for the same pupil to see the same object twice, in two places at the same time.

[*Diagram*]

The lower part *b* of the pupil *a b* sees the object *c* cover *d*, and the upper part *a* of the same pupil sees the same object *c* cover the wall *g f*, beyond the hole *e*, in the position *g*.

Therefore the object *c* is seen at the same time at *d* and *g*, and it is this that I wished to demonstrate. K 127 [47] v.

As the light diminishes so the pupil of the eye that beholds this light expands. Therefore the eye which looks through a pea-shooter has a larger pupil than the other, and sees the object larger and clearer than the other eye does. You may make a proof of this if you look with both eyes at a white line against a black background, one looking at it through a pea-shooter and the other through the luminous air.

L 13 v. and 14 r.

When the eye in the luminous air is looking at a place that is in shadow this space will seem of much greater darkness than it is.

This happens simply because the eye which is in the air diminishes its pupil the more as the air which reflects it is more luminous; and as the pupil becomes more contracted so the thing seen by it shows itself less luminous.

But when the eye enters into any shaded spot immediately the obscurity of this shaded spot will appear to diminish.

This takes place because in proportion as the pupil enters into the more shaded air so its outline increases and this increase causes the great darkness to seem to diminish. L 41 v.

Of concave mirrors of equal diameter, that which is of less concavity will unite a greater sum of rays in the percussion of the concourse of these rays, and as a consequence it will kindle a fire with greater rapidity and force. B.M. 86 v.

It is impossible for the reflection of anything upon the water to be similar in shape to the object which is reflected, in view of the fact that the centre of the eye is above the surface of the water. B.M. 93 v.

If the seat of judgment of the eye lies within it the direct lines of the images are broken at its surface because they pass from the thin to the dense.

If you stand under water and look at something within the air you will see this thing out of its position, and it will be the same with a thing within the water seen from the air. B.M. 220 r.

The concourse of the lines created by the images of the objects placed before the eye does not meet in the point within this eye by straight lines. B.M. 221 v.

Here let us treat of actual movements because as regards spiritual movements there has been some treatment by others.

Actual movement made with swift impetus will never conceal from the eye the object which is behind the body that is moving, if only it be near to the eye and not too much greater than this eye. As would be the movement of certain instruments worked by women, made for convenience of gathering their threads together, which are called 'winders' ('arcolai') among the Florentines and by the Lombards 'turrets' ('bicocche'). For these in their revolving movement are so swift that through being perforated they do not obstruct to the eye anything behind them. Forster II 101 r.

[*Central line and other lines of eye*]

The eye has one central line and all the things that come to the eye along this line are seen distinctly.

Round about this line are an infinite number of other lines that adhere to this centre line and these have so much less strength in proportion as they are more remote from the central line.

 Quaderni IV 12 r.

[*Phenomenon of sun shining on rain-drops*]

And the drop that falls in rain as seen by the eye seems illuminated by the sun, and in its course it seems continuous over so great a space as it shows all the colours of the rainbow, and this it makes greater or less according to the distance.

[Brand moved in circle seems an unbroken circle]

The firebrand whirled in a circle passes through an infinite number of adjacent lines and therefore this circle appears united in the air.

Quaderni IV 12 v.

Necessity has provided that all the images of bodies set over against the eye intersect in two places, of which the one intersection is formed within in the pupil the other within in the crystalline sphere; and if this were not the case the eye would not be able to see so great a number of things as it does. This is proved because all the lines that intersect form this intersection at a point, since of bodies nothing is visible except their surfaces, the edges of which are lines by the converse of the definition of the surface, and every smallest part of the line is equal to a point, because smallest is said of that thing than which nothing else can be smaller, and this definition is like that of the point. It is possible therefore for the whole circumference of a circle to transmit its image to its intersection as is shown in the fourth [section] of this [treatise] which says:—all the smallest parts of the images penetrate one another without occupation one of another. These demonstrations are as an example of the eye:—no image of however small a body enters within the eye without being turned upside down, and as it penetrates the crystalline sphere it is turned again upside down, and so the image within the eye becomes upright as was the object outside the eye.

Windsor: Drawings 19150 v.

How every great mass sends forth its images which have the capacity of diminishing to infinity:

The images of every great mass which is divisible to infinity may be diminished to infinity. Windsor: Drawings 19151 r.

OF THE CENTRAL LINE OF THE EYE

There is only one line of the images that penetrate to the visual faculty that has no intersection, and this has no sensible dimensions because it is a mathematical line and has its origin in a mathematical point which has no dimensions.

Necessity requires according to my opponent that the central line of all the images which enter through the fine and narrow openings into

a dark place shall be turned upside down together with all the images of the bodies that surround it.

OF THE INTERSECTION OF THE IMAGES IN THE PUPIL OF THE EYE

The intersections of the images at the entrance of the pupil do not mingle one in another in that space where this intersection unites them; and this is evident because if the rays of the sun pass through two panes of glass in contact one with another, the one of these being blue and the other yellow, the ray that penetrates them does not assume the hue of blue or yellow but of a most beautiful green. And the same process would occur with the eye if the images yellow and green in colour should come to mingle one with the other at the intersection which they make within themselves at the entrance of the pupil, but as this does not happen such a mingling does not exist.

OF THE NATURE OF THE RAYS FORMED BY THE IMAGES OF BODIES AND THEIR INTERSECTION

The straight line of the rays which transmit through the air the form and colour of the bodies whence they proceed does not itself tinge the air nor can they tinge one another at the contact of their intersection, but they only colour the place where they lose their existence, because this place sees and is seen by the original source of these rays, and no other object that surrounds this original source can be seen from the place where this ray is cut off and destroyed, leaving there the spoil it has carried off. This is proved by the fourth, on the colour of bodies, which says the surface of every opaque body shares in the colour of surrounding objects; so we conclude that the place which by means of the ray that carries the image sees and is seen by the source of this image is tinged by the colour of this object.

How innumerable rays from innumerable images can converge in a point:

As in a point all lines pass without occupation the one of the other through their being without body, so may pass all the images of the surfaces, and as each given point faces every object opposite to it and

every object faces the opposite natural point, also through this point may pass the converging rays of these images which after passing it will reform and increase again to the size of these images. But their impressions will appear reversed as is shown in the first above, where it is said that every image intersects at the entrance of the narrow openings made in an extremely thin substance.

In proportion as the opening is smaller than the shaded body by so much the less will the images transmitted through this opening penetrate one into another. The images which pass through the openings in a dark place intersect at a point so much nearer the opening as this opening is of less width. . . .

It is impossible that the images of bodies should be seen between the bodies and the openings through which the images of these bodies penetrate; and this is evident because where the atmosphere is illuminated these images do not become visible.

When images are duplicated by mutually penetrating one another they always have double depth of tone.

Windsor: Drawings 19152 r. and v.

Describe how no object is itself defined in the mirror but is defined by the eye which sees it within the mirror, for if you look at your face in the mirror the part resembles the whole, seeing that the part is all in the whole of the mirror and it is all in every part of the same mirror, and the same happens with the whole image of every object placed opposite to this mirror.

Windsor MSS. R 209

X

Acoustics

'If you cause your ship to stop, and place the head of a long tube in the water, and place the other extremity to your ear, you will hear ships at a great distance from you.'

[*Acoustics*]

Of the sounds that may be made in the waters as yonder from the ditch at Sant' Angelo. c.a. 65 r. a

THE NOTE OF THE ECHO

The note of the echo is either continuous or intermittent, it occurs singly or is united, is of brief or long duration, finite or endless in sound, immediate or far away.

It is continuous when the surface on which the echo is produced is uniformly concave. The note of the echo is intermittent when the place which produces it is broken and interrupted. It is single when it is produced in one place only. It is united when it is produced in several places. It is either brief or long-continuing, as when it goes winding round within a bell which has been struck, or in a cistern or other hollow space, or in clouds wherein the note recurs at fixed distances in regular intervals of time, ever uniformly growing fainter, and is like the wave that spreads itself out in a circle over the sea.

The sound often seems to proceed from the direction of the echo, and not from the place where the real sound is; and similarly it happened at Ghiera d'Adda, when a fire which broke out there caused in the air twelve lurid reflections upon twelve clouds, and the cause was not perceived. c.a. 77 v. b

Whether the whole circle made in the air by the sound of a man's voice carries with it all the word spoken, since the part of this circle

having struck upon another man's ear does not leave the part of this speech in this ear but the whole:

What has been said is shown in the case of light, and you would be able to say whether the whole of the light illumines the whole of a building, since the part of this building would not be illumined merely by a part of this light.

If you wish to dispute the point and say that this light illumines the said part of the habitation not with the whole but with its part, I will give you the instance of one or two mirrors set in different positions on this spot, each part of this mirror will have within itself the whole of the said light; this shows therefore that this light is all in all and all in every part of this habitation; and it is the same with the voice in its circle.

<div align="right">C.A. 199 v. b</div>

[*Diagram*]

In these two rules, that is of the blow and of the force one may employ the proportions which Pictagoras made use of in his music.[1]

<div align="right">C.A. 267 r. a</div>

OF THE SOUND WHICH SEEMS TO REMAIN IN THE BELL AFTER THE STROKE

'That sound which remains or seems to remain in the bell after it has received the stroke is not in the bell itself but in the ear of the listener, and the ear retains within itself the image of the stroke of the bell which it has heard, and only loses it by slow degrees, like that which the impression of the sun creates in the eye, which only by slow degrees becomes lost and is no longer seen.'

A proof to the contrary

If the aforesaid proposition were true, you would not be able to cause the sound of the bell to cease abruptly by touching it with the palm of the hand, especially at the beginning of its strength, for surely if it were touched it would not happen that as you touched the bell with the hand the ear would simultaneously withhold the sound; whereas

[1] The reference is presumably to Pythagoras's discovery of the dependence of the musical intervals on certain arithmetical ratios.

we see that if after the stroke has taken place the hand is placed upon the thing which is struck the sound suddenly ceases. c.a. 332 v. a

[*Ventriloquism*]

The ear is deceived by the perspective of the voice which seems to send itself to a distance and does not change its position.

c.a. 357 v. b

If a man jumps on the points of his feet his weight does not make any sound. Tr. 5 a

I ask whether a slight sound close at hand can seem as loud as a big sound afar off. Tr. 12 a

THE NATURE OF THE EFFECT OF THE ROAR OF THE CANNON

The rumbling of the cannon is caused by the impetuous fury of the flame beaten back by the resisting air, and that quantity of the powder causes this effect because it finds itself ignited within the body of the cannon; and not perceiving itself in a place that has capacity for it to increase, nature guides it to search with fury a place suitable for its increase, and breaking or driving before it the weaker obstacle it wins its way into the spacious air; and this not being capable of escaping with the speed with which it is attacked, because the fire is more volatile than the air, it follows that as the air is not equally volatile with the fire it cannot make way for it with that velocity and swiftness with which the fire assails it, and therefore it happens that there is resistance, and the resistance is the cause of a great roar and rumbling of the cannon.

But if the cannon were to be moved against the oncoming of an impetuous wind it would be the occasion of a greater roar made by reason of the greater resistance of the air against the flame, and so it would make a less rumbling when moved in the line of the wind because there would then be less resistance.

In marshy places or other wide tracts of air the cannon will make a louder report close at hand, and at a lesser distance it will be perceived that up on the mountains or in other places where the air is rarefied, if

the air be thick or thin equally and without direct movement of winds, the roar will be equally perceptible round about its cause, and it would go on expanding from circle to circle just as the circles of water do when caused by a stone thrown into it; and in that place where similar instrumenti are being used the adjacent air will break or scatter all the things of weak power of resistance. All the large vessels with wide mouths will become broken, the windows of paper and such like things; the neighbouring roofs will all be shaken on their supports; and this will take place though many windows and doors stand open, and walls which are thin and without buttresses will become dangerous.

This happens because the air swells and presses itself out and wishes to escape in all directions in which movement is possible. Doors windows trees and such things as these will all be moved, and if you set an arrow lightly fastened with a small stone it will be carried about a distance of six miles through the movement of the air. Tr. 44 a

WHAT THING IS SOUND CAUSED BY THE BLOW?

The time in which the blow is produced is the shortest thing that can be done by man, and no body is so great but that being suspended it makes an instant movement at a sudden blow; which movement beats back in the air and the air sounds as it touches the thing moved.

WHETHER THE SOUND LIES IN THE HAMMER OR IN THE ANVIL

I say that because the anvil is not suspended it cannot resound. The hammer resounds in the jump that it makes after the blow, and if the anvil were to re-echo the sound made on it by every small hammer as does the bell with every different thing which strikes it with the same depth of tone, so would the anvil when struck by each different hammer; and as therefore you hear different notes with hammers of different sizes it follows that the note is in the hammer and not in the anvil.

Why the thing which is not suspended does not sound and when suspended every slight contact takes away the sound from it:

The bell when struck makes a sudden tremor and the sudden tremor causes it instantly to strike the circumscribing air, which instantly resounds.

On being impeded by any slight contact it does not make the tremor or strike and so the air does not resound.

If the bird suddenly beats the air ought this to resound or no:
I maintain it does not because as the air penetrates through the thing that beats it it does not receive the blow and consequently it cannot make sound.

OF THE BOMBARD OR ARROW

Here sounds movement of air more powerful than the resisting air.
Tr. 64 a

CONCERNING VIOLENCE

I say that every body moved or struck keeps in itself for a time the nature of this blow or movement, and keeps it so much more or less in proportion as the power of the force of this blow or movement is greater or less.

Example

Observe a blow given on a bell how much it preserves in itself the noise of the percussion.

Observe a stone projected from a bombard how much it preserves the nature of the movement.

The blow given on a thick body will keep its sound longer than on a thin body, and that will be of longest duration which is made upon a body that is suspended and thin. The eye keeps within itself the images of luminous bodies for a certain interval of time. Tr. 73 a

It is possible to recognise by the ear the distance of a clap of thunder, on first seeing its flash, from its resemblance to the note of the echo.

The voice is all in all and all in the part of the wall surface where it strikes. And that part which is formed in such a way as to be fitted to send back the percussion, gives back the voice in as many different small portions of itself as there are different positions of the hearers.

The ear receives the images of sounds by straight curved and broken lines and no twists can break its function. A 19 r.

The voice after it has struck on the object will return to the ear by a line at a slant equal to that of the line of the incidence; that is the line which carries the voice from its cause to the place where this voice can reform itself; and this voice acts in the manner of a thing seen in a mirror which is all in all the mirror and all in the part of it. Let us say therefore that the mirror is a b and the thing seen is c; just as c sees all the parts of the mirror so all the parts of the mirror see c; therefore c is all in all the mirror because it is in all its parts; and it is all in the parts because it sees itself in as many different parts as there are different positions of spectators . . .

Let us take the sun as an example: if you should walk along the bank of a river and watch the sun's reflection in it, for so long a time as you walk along the bank of the river it will seem that the sun moves with you, and this because the sun is all in the whole and all in the part. A 19 v.

OF A BLOW

The blow given in the bell leaves its likeness behind it impressed as is that of the sun in the eye or the scent in the air; but we wish to discern whether the likeness of the blow remains in the bell or in the air, and this is ascertained by placing your ear to the surface of the bell after the blow.

The blow given in the bell will cause a slight sound and movement in another bell similar to itself, and the chord of a lute as it sounds produces movement and response in another similar chord of like tone in another lute, and this you will perceive by placing a straw upon the chord similar to that which has sounded. A 22 v.

OF THE VOICE

Whether many tiny voices joined together will make as much sound as one large one. I maintain they will not; for if you were to take ten thousand voices of flies all together they would not carry as far as the voice of a man, and if such voice of a man were split up into ten

thousand parts no one of these parts would be equal to the size of the voice of a fly. A 23 r.

OF SOUND

Whether a sound that is double another will be heard twice as far. I maintain that it will not for if it were so two men shouting would be heard twice as far as one; but experience does not confirm this.

A 43 r.

If you cause your ship to stop, and place the head of a long tube in the water, and place the other extremity to your ear, you will hear ships at a great distance from you.

You can also do the same by placing the head of the tube upon the ground, and you will then hear anyone passing at a distance from you. B 6 r.

[*Of the echo*]

The voice after having proceeded from the man and having been beaten back by the wall will fly upwards. If there be a ledge above this wall with a right angle the surface above will send back the voice towards its cause.

How one should make the voice of the echo which whatever thing you may say will be repeated to you in many voices:

[*Drawing*]

Braccia one hundred and fifty from one wall to the other.

The voice which issues forth from the horn forms itself on the opposite wall and from there leaps back to the second, and from the second [it returns] to the first, as a ball that rebounds between two walls which diminishes its bounds; and so the voices grow less.

B 90 v.

OF THE SOUND MADE BY PERCUSSION

Sound cannot be heard at such close proximity to the ear that the eye does not first see the contact of the blow, and the reason is this:— if we admit that the time of the blow is indivisible, that the nature of the blow does not produce its expansion upon the body which has been struck without time, that no body struck can resound whilst the thing

that strikes is touching it, and that the sound cannot travel from the body struck to the ear without time, then you must admit that the thing which strikes is separated and divided from the thing struck before this thing struck can of itself have any resonance; and not having this it cannot give it to the ear. c 6 v.

OF REFLEX MOVEMENTS

I wish to define why bodily and spiritual movements after the percussion made by them upon the object spring back within equal angles.

OF BODILY MOVEMENTS

I say that the note of the echo is cast back to the ear after it has struck, just as the images of objects strike the mirror and are thence reflected to the eye. And in the same way as these images fall from the object to the mirror and from the mirror to the eye at equal angles, so the note of the echo will strike and rebound within the hollow where it has first struck, at equal angles to the ear. c 16 r.

OF SOUNDS

Why the swift wind which passes through a reed makes a shrill sound:

The wind passing through the same reed will make a sound so much deeper or shriller in proportion as it is slower or swifter. And this is seen in the changes in the sounds made by trumpets or horns without holes and also in the winds that howl in the chinks of doors or windows. This originates in the air, where the sound having issued forth from the instrument traverses the valley and proceeds to spread itself in a greater or less degree according as the air is driven by a greater or smaller force. This may be proved. E 4 v.

Why the reflex movement of the stone makes more noise in the air than its incidental movement, the reflex movement being less powerful than the incidental, and whether this reflex movement makes a greater or less sound as the angle of its incidence is more or less obtuse. But as regards the first question the reflex movement is made by the composite

movement of this projectile, and the incidental movement is made by the same movement of the same projectile; and for this reason the sound is in the reflex movement of the projectile and not in the incidental movement. As regards the second question in proportion as the angle is more obtuse the projectile is more disposed to revolve than when the percussion is made between acute angles. E 28 v.

[*Acoustics*]

The sound caused by the wind or by a blow will grow fainter when as a result of time or distance it is further removed from its cause.

The stroke given to the bell will go on growing less as more time passes and it is the same whether the distance is far or near.

H 72 [24] v.

[*Of separated forces:—rivers, bells, ropes*]

Of dividing the force of rivers:

If the excessive size of the rivers damages and destroys the sea coasts, then if such rivers cannot be diverted to other places they should be parted into small streams.

Comparison

If a bell which sounds is heard at six miles and weighs six thousand pounds, six miles being eighteen thousand braccia . . . But not to extend myself in too many arguments I maintain that if I were to split it up into tiny bells it will not be heard at an eighth of a mile even though all the metal rings in the bells at the same time.

Similarly if a rope supports a hundred thousand ounces and you separate it into a hundred thousand strands, each strand of itself will not support one eighth part of an ounce. And so it follows with all the separated powers. I III [63] r.

SOUND OF THE ECHO

If the sound of the echo answers in two divisions of time at thirty braccia, in how many divisions will it answer if it is a hundred braccia away?

If the sound of the echo answers me in two divisions of time at a distance of thirty braccia, with two degrees of power in its noise, with

how many degrees of noise will it reveal itself to me at a distance of a hundred braccia? 		ı 129 [81] v.

[*Sound—laws of*]

Why will the deep-toned vessel with contracted mouth have a much deeper and lower sound in its percussion when it has a narrow mouth than when it is wide? 		L 63 r.

How the sound of the voice is lost by reason of distance:
[*With diagram*]

At the distance *a b* the two voices *m n* are diminished by half; consequently although there are two half voices they are not as powerful as one whole voice but merely as a half.

And if an infinite number of halves should find themselves at such distance they would only amount to a half.

And at the same distance the voice *f* which is double *n* and *m* having lost the fourth part of its power remains consequently as a voice and a half, and surpasses in three times the power, so that at three times the distance, that is at *g*, *f* will be as powerful as *m n* are at the distance *a b*. 		L 79 v.

[*Voice in distance*]

Where one voice does not carry, a multiple however great made up of voices equal to the aforesaid will not carry. 		L 80 r.

[*Noise of the mortar*]
[*With drawing*]

One proves by this example how the noise made by the mortar (bombarda) is nothing but a separation of compressed air. 	L 89 v.

[*Sound of bombards—how produced*]

The wave of the flame created by the setting fire to the powder of the bombards is that which striking the air opposite to it creates the sound. 		M 82 r.

If flies made with their mouths the sound that is heard when they fly then since it is very long and sustained they would need a great pair of bellows for lungs in order to drive out so great and so long a wind, and then there would be a long silence in order to draw into them-

selves an equal volume of air; therefore where there was a long dura-
tion of sound there would be a long intermission. B.M. 257 v.

If a bell were to be heard with its sound two miles, and then it were
to be melted down and cast again into a number of small bells, cer-
tainly if they are all sounded at one time they will never be heard at
as great a distance as when they were all in one bell.

Forster II 32 v.

If you make two bells of the same shape and the one double the size
of the other but of the same weight the larger will have twice the depth
of tone. Forster III 5 r.

[*Of the buzzing of flies*]

That the sound which flies make proceeds from their wings you will
see by cutting them a little, or better still by smearing them a little with
honey in such a way as not entirely to prevent them from flying, and
you will see that the sound made by the movement of the wings will
become hoarse and the note will change from high to deep to just the
same degree as it has lost the free use of its wings. Fogli A 15 v.

XI

Astronomy

'The moon has every month a winter and a summer. And it has greater colds and greater heats and its equinoxes are colder than ours.'

MAKE glasses in order to see the moon large. c.a. 190 r. a

If you know the distance of a body you will know the size of the visual pyramid if you take a section of it near the eye upon a wall and then remove the line so far from the eye as to double the size of the section. Then note the distance from the first to the second section and ask yourself:—if within such a space the diameter of the moon increases for me so much above the first section what will it do in the whole space that is between the eye and the moon? It will form the exact diameter of this moon.

[*Diagram*]

Measure of the size of the sun, knowing the distance. c.a. 243 r. b

If the water of the moon had its centre of gravity at the centre of the earth, it would strip the moon and fall upon us . . . suspended from the centre of its sphere.

If you should be moving towards the sun along that line of water which lies between this sun and its image, you will be sailing along a continuous image which will be of the length of your movement.

Why the moon when surrounded by the luminous part of the sun in the west has greater radiance in the centre of this circle than when there is an eclipse of the sun. This comes about because as it eclipses the sun it casts a shadow upon our ocean, and this does not occur when it is in the west, for then the sun lights up this ocean.

Why in the eclipse of the sun the body of the moon when it is opposite to us shows itself in the middle of the sun with part of its radiance somewhat like that of molten iron. This proceeds from the

273

moon which derives its radiance from the stars, and not from the earth, because this is darkened. . . . c.a. 243 v. a

The image of the sun is all in all the water which sees it, and all in every minutest part of it.

This is proved because there are as many images of the sun as there are positions of the eyes which see the water between themselves and the sun.

Moreover as the eye moves when carried along the line of the ship it sees the image of the sun moving along the same line as that of the movement of the eye; but it will not be parallel for as the sun moves to the west the line of the images moves in a curve towards the sun, in such a way as to seem finally to unite with the image of the sun when it has reached the horizon.

If the ship's movement be to the south and the sun is in the middle of the heaven the line of the image of the sun will be curved, and it will always go on extending itself, so that at the last it will unite with the sun on the horizon and the image will seem equal in size to this sun. c.a. 243 v. b

How bodies send forth from themselves their form heat and potency:

When the sun during an eclipse assumes the shape of a crescent, take a thin plate of iron and make a small hole in it, and turn the face of this plate towards the sun, holding a sheet of paper behind it at a distance of half a braccio, and you will see the image of the sun appear on this sheet in the shape of a crescent, similar in form and colour to its cause.

Quality of the sun:

The sun has substance, shape, movement, radiance, heat and generative power; and these qualities all emanate from itself without its diminution. c.a. 270 v. b

The solar rays after penetrating the little holes which come between the various rounded particles of the clouds take a straight and continuous course to the ground where they strike, illuminating with their radiance all the air through which they pass. c.a. 297 v. a

If the moon is a mirror of our earth, when it is at the full the earth will be half dark and half illuminated, or perhaps more than half dark.

And of dark things we cannot discern the shapes of the objects which are within their boundaries.

The adversary says that the light of the moon illumines the portion of the earth seen by it, and for this reason, as the earth is surrounded by water, that only the water reflects the light of the moon, and the earth as it is not smooth or polished in its surface as is the water, does not transmit the image of itself to this water, and so it remains dark, and thus our water shines in the moon with the darkness of the islands which it surrounds. c.a. 300 r. b

The moon has every month a winter and a summer.

And it has greater colds and greater heats and its equinoxes are colder than ours. c.a. 303 v. b

How it is possible for the quantity of the images of the sun to pass through the indivisible point of the primitive into the derivative pyramid:

The sun is composed of a very great number of indivisible parts; and although this sun is possessed of bodily substance its powers are incorporeal consisting of heat and radiance; and since an incorporeal power has no substance not having substance it does not occupy space, and not occupying space it does not close the aperture, and consequently the passage through this aperture to and fro is permitted to each spirit at the same time.

It is possible that the solar rays reduced through a pyramid to a point by the concave mirror is redoubled in warmth and radiance; as these rays are in the derived pyramid they are thrown back by a similar mirror to an equal distance from the point. c.a. 347 v. a

OF THE CIRCLES OF THE MOON

I find that those circles which at night seem to surround the moon, varying in circumference and in their degree of redness, are caused by the different degrees of thickness of the vapours which are situated at different altitudes between the moon and our eyes. And the circle that is larger and less red is in the first part lower than the said vapours; the

second, being less, is higher and appears redder, because it is seen through two sets of vapours; and so the higher they are the smaller and the redder will they appear, for between the eye and them there will be more layers of vapours, and this goes to prove that where there appears greater redness, there is a greater quantity of vapours. c.a. 349 v. e

BURNING MIRROR [*sketch*]

As many times as the point of the solar pyramid cut in any part whatever is contained in its base so many times is it hotter than this base.

a 54 r.

WHAT THE MOON IS

The moon is not luminous in itself, but it is well fitted to take the characteristics of light after the manner of the mirror or of water or any other shining body; and it grows larger in the east and in the west like the sun and the other planets, and the reason of this is that every luminous body grows larger as it becomes more remote.

It may be readily understood that every planet and star is farther away from us when in the west than when it is overhead, by about three thousand five hundred [miles] according to the proof given at the side [of the page];[1] and if you see the sun and moon reflected in water which is near at hand it will seem to be the same size in the water as it does in the sky, while if you go away to the distance of a mile it will seem a hundred times as large. And if you see it reflected in the sea at the moment of its setting the image of the sun will seem to you to be more than ten miles long, because it will cover in the reflection more than ten miles of sea. And if you were where the moon is, it would appear to you that the sun was reflected over as much of the sea as it illumines in its daily course, and the land would appear amid this water like the dark spots that are upon the moon, which when looked at from the earth presents to mankind the same appearance that our earth would present to men dwelling in the moon.

[1] Here the margin of the MS. contains a diagram representing the earth with the sun shown in two positions.

OF THE NATURE OF THE MOON

When all that we can see of the moon is illumined it gives us its maximum of light, and then from the reflection of the rays of the sun which strike upon it and rebound towards us its ocean throws off less moisture to us, and the less light it gives the more it is harmful.

A 64 r.

EXPLANATION OF WHY THE SUN SEEMS LARGER IN THE WEST

Certain mathematicians contend that the sun grows larger when it is setting, because the eye sees it continually through atmosphere of greater density, alleging that objects seen through mist and in water seem larger.

To this I reply that this is not the case, for the things seen through the mist are similar in colour to those which are at a distance, but as they do not undergo the same process of diminution, they appear greater in size.

In the same way nothing seems larger in smooth water, and this you may prove by tracing upon a board which is placed under water.

The real reason why the sun grows larger is that every luminous body appears larger, as it is farther away.

A 64 v.

PRAISE OF THE SUN

If you look at the stars without their rays,—as may be done by looking at them through a small hole made with the extreme point of a fine needle and placed so as almost to touch the eye,—you will perceive these stars to be so small that nothing appears less; and in truth the great distance gives them a natural diminution, although there are many there which are a great many times larger than the star which is our earth together with the water. Think, then, what this star of ours would seem like at so great a distance, and then consider how many stars might be set longitudinally and latitudinally amid these stars which are scattered throughout this dark expanse. I can never do other than blame those many ancients who said that the sun was no larger

than it appears,—among these being Epicurus; and I believe that such a theory is borrowed from the idea of a light set in our atmosphere equidistant from the centre [of the earth]; whoever sees it never sees it lessened in size at any distance, and the reasons of its size and potency I shall reserve for the Fourth Book.

But I marvel greatly that Socrates should have spoken with disparagement of that body, and that he should have said that it resembled a burning stone, and it is certain that whoever opposes him in such an error can scarcely do wrong. I could wish that I had such power of language as should avail me to censure those who would fain extol the worship of men above that of the sun, for I do not perceive in the whole universe a body greater and more powerful than this, and its light illumines all the celestial bodies which are distributed throughout the universe.

All vital principle descends from it, since the heat there is in living creatures proceeds from this vital principle; and there is no other heat or light in the universe as I shall show in the Fourth Book, and indeed those who have wished to worship men as gods, such as Jupiter, Saturn, Mars and the like, have made a very grave error seeing that even if a man were as large as our earth he would seem like one of the least of the stars, which appears but a speck in the universe; and seeing also that these men are mortal and subject to decay and corruption in their tombs.

The *Spera*, and Marullo, and many others praise the Sun.

F 5 r. and 4 v.

The stars are visible by night and not by day owing to our being beneath the dense atmosphere which is full of an infinite number of particles of moisture. Each of these is lit up when it is struck by the rays of the sun and consequently the innumerable radiant particles veil these stars; and if it were not for this atmosphere the sky would always show the stars against the darkness. F 5 v.

Epicurus perhaps perceived that the shadows of columns striking the opposite walls were equal in diameter to the column from which they proceeded. As therefore the mass of the shadow from beginning to end was a parallelogram he thought he might infer that the sun also was opposite to this parallelogram and as a consequence would not be larger

than this column, not perceiving that such a diminution of the shadow would be imperceptible on account of the great distance of the sun.

If the sun were smaller than the earth, the stars in a great part of our hemisphere would be without light: this is contrary to Epicurus who says that the sun is only as large as it appears. F 6 r.

Epicurus says that the sun is as large as it shows itself; as therefore it appears to be a foot we have to reckon it as such.

It would follow that when the moon obscured the sun the sun would not surpass it in size as it does; therefore the moon being smaller than the sun the moon would be less than a foot, and consequently when our earth obscured the moon it would be less by a finger's breadth, seeing that if the sun be a foot across and our earth casts a pyramidal shadow towards the moon it is inevitable that the luminous body which is the cause of the shaded pyramid must be greater than the opaque body which casts this pyramid. F 8 v.

A calculation of how many times the sun will go into its course in twenty four hours:

Make a circle and set it to face south after the manner of sundials; place a rod in the middle of it so that its length is pointing to the centre of the circle and note the shadow made by the sun from this rod upon the circumference of the circle, and let us say that the breadth of the shadow is all *a n* (diagram). Now measure how many times this shadow will go into this circumference of the circle, and this will be the number of times that the solar body will go into its course in twenty four hours. In this way one may see whether Epicurus was right in saying that the sun is as large as it seems to be, for as the apparent diameter of the sun is about a foot and as the sun would go a thousand times into its course in twenty four hours, the length of its course would be a thousand feet, that is five hundred braccia, which is the sixth of a mile; so then the course of the sun between day and night would be the sixth part of a mile, and this venerable snail the sun would have travelled twenty five braccia an hour. F 10 r.

THE ORDER OF PROVING THAT THE EARTH IS A STAR

First explain the mechanism of the eye, then show how the scintilla-
tion of each star originates in the eye, and why the scintillation of one
star is greater than that of another. And how the rays of the stars origi-
nate in the eye. I affirm that if the scintillation of the stars was as it
appears, in the stars, this scintillation would show itself as widely ex-
tended as the body of the star; and since it is larger than the earth this
movement made instantaneously would swiftly be found to cause the
star to seem double in size. See afterwards how the surface of the air
on the confines of the fire, and the surface of the fire at its boundary, is
that in which the solar rays penetrating carry the resemblance of the
heavenly bodies, large in their rising and setting and small when they
are in the centre of the sky. F 25 v.

AN EXPERIMENT IN ORDER TO SHOW HOW RAYS PENETRATE LIQUID BODIES

Make two vessels each of parallel sides, the one four fifths of the
other and of equal height. Then fix one within the other as you see in
the drawing, and cover outside with colour and leave an opening of the
size of a lentil, and allow a ray of the sun to enter there which makes
its exit through another dark hole or by the window. Then observe
whether the ray that passes within the water enclosed between the two
vessels keeps the direction that it has outside or no; and from this de-
duce your rule.

In order to see how the solar rays penetrate this curve of the sphere
of the air have two balls made of glass one twice as large as the other,
and let them be as round as possible. Then cut them in half, place one
inside the other, close them in front and fill them with water, then let
the solar ray pass within as you have done above, and observe whether
the ray is bent or curved and from this deduce your rule. And in this
way you can make an infinite number of experiments.

Observe as you place yourself with your eye in the centre of the ball
whether the light of a candle keeps its size or no. F 33 v.

OF THE SUN

Some say that the sun is not hot because it is not the colour of fire but is much paler and clearer. To these we may reply that when liquified bronze is at its maximum of heat it most resembles the sun in colour, and when it is less hot it has more of the colour of fire.

F 34 v.

The solar rays reflected by the surface of the undulating water cause the image of the sun to seem continuous over all that water which is between the universe and the sun.
F 38 v.

Why the image of the sun is all in all the sphere of the water which sees the sun and all in each part of the said water:

All the sky which sees the part of the sphere of the water seen by the sun sees all this water covered by the image of the sun, and each part of the sky sees all.

The surface of the water without waves lights equally the places struck by the reflected rays of the image of the sun in the water.

The image of the sun is unique in the sphere of the water seen by the sun, which shows itself however to all the sky that finds itself before it, and every point of this sky itself sees an image, and that which sees one in one position is seen by the other in another position, in such a way that no part of the sky sees it all.

That image of the sun will cover a greater space in the surface of the water which is seen from a place more distant from it. F 39 r.

How the earth is not in the centre of the circle of the sun, nor in the centre of the universe, but is in fact in the centre of its elements which accompany it and are united to it. And if one were to be upon the moon, then to the extent to which it together with the sun is above us,[1] so far below it would our earth appear with the element of water, performing the same office as the moon does for us. F 41 v.

All your discourse points to the conclusion that the earth is a star almost like the moon, and thus you will prove the majesty of our universe; and thus you will make a discourse concerning the size of many of the stars according to the authorities. F 56 r.

[1] MS. sotto. I have followed M. Ravaisson-Mollien's rendering.

Whether the friction of the heavens makes a sound or no:

Every sound is caused by the air striking a dense body, and if it is made by two heavy bodies one with another it is by means of the air that surrounds them; and this friction wears away the bodies that are rubbed. It would follow therefore that the heavens in their friction not having air between them would not produce sound. Had however this friction really existed, in the many centuries that these heavens have revolved they would have been consumed by their own immense speed of every day. And if they made a sound it would not be able to spread, because the sound of the percussion made underneath the water is but little heard and it would be heard even less or not at all in the case of dense bodies. Further in the case of smooth bodies the friction does not create sound, and it would happen in a similar manner that there would be no sound in the contact or friction of the heavens. And if these heavens are not smooth at the contact of their friction it follows that they are full of lumps and rough, and therefore their contact is not continuous, and if this is the case the vacuum is produced, which it has been concluded does not exist in nature. We arrive therefore at the conclusion that the friction would have rubbed away the boundaries of each heaven, and in proportion as its movement is swifter towards the centre than towards the poles it would be more consumed in the centre than at the poles; and then there would not be friction any more, and the sound would cease, and the dancers would stop, except that the heavens were turning one to the east and the other to the north.

F 56 v.

Whether stars have light from the sun or in themselves:

It is said that they have light in themselves, since if Venus and Mercury had no light of their own, when they come between our eye and the sun they would darken as much of the sun as they cover from our eyes. This however is false, because it has been proved how a dark object placed against a luminous body is surrounded and entirely covered by the lateral rays of the remainder of this luminous body, and so it remains invisible. As is shown when the sun is seen through the ramification of leafless trees in the far distance these branches do not conceal any part of the sun from our eyes. The same thing happens with the above mentioned planets, for though they are themselves without

light they do not as has been said cover any part of the sun from our eyes.

It is said that the stars at night appear most brilliant in proportion as they are higher up, and that if they have no light of their own the shadow cast by the earth when it comes between them and the sun would come to darken them, since these stars neither see nor are seen by the solar body.

But those who say this have not considered that the pyramidal shadow of the earth does not reach many of the stars, and that in those which it does reach the pyramid is so diminished that it covers little of the body of the star, and all the rest is illuminated by the sun.

F 57 r.

Why the planets appear greater in the east than above us, though it ought to be the opposite seeing that they are three thousand five hundred miles nearer to us when they are in the middle of the sky than when they are on the horizon:

All the degrees of the elements through which pass the images of the celestial bodies which come to the eye are curved, and the angles by which the central line of these images penetrates there are unequal, and the distance is greater as is shown by the excess of *a b* over *a d*; and by the Ninth of the Sixth the size of heavenly bodies on the horizon is proved.

F 60 r.

Explain the earth with its longer and shorter day in the north and in the south, and do the same for the moon and define them accurately.

F 63 r.

DARKNESS OF SUN MOON AND EARTH

The moon has its days and nights as has the earth: the night in the part which does not shine and the day in that which does.

Here the night of the moon sees the light of the earth, that is to say of its water, grow dim—and the darkened water sees the darkness of the sun, and to the night of the moon there is lacking the reverberation of the solar rays which are reflected there from this earth.

In this other figure it is shown that the day of the moon is darkened and the night of the earth remains deprived of the solar rays reflected from the moon.

When the moon is in the east and the sun in the west, all the day that the moon enjoyed, such as it was with the sun in the west, is changed into night.

Such day as has the moon which from the east looks at the sun in the west will all be night when this moon is with the sun in the west.

F 64 v.

OF THE RAINBOW

Whether the rainbow is produced by the eye, that is its curve, or by the sun by means of the cloud:

The mirror does not take any images except those of visible bodies, and the images are not produced without these bodies; therefore if this arch is seen in the mirror, and the images converge there which have their origin in this rainbow, it follows that this arch is produced by the sun and by the cloud.

The rainbow is seen in the fine rains by those eyes which have the sun behind and the cloud in front, and a perpetually straight imaginary line which starts from the centre of the sun and passes through the centre of the eye will end in the centre of the arch.

And this arch will never be seen by one eye in the same position as by the other eye; it will be seen in as many positions of the cloud where it is formed as there are eyes that see it.

Therefore this arch is all in all the cloud where it is produced, and all in each of the positions in which it may find itself, and so it will appear larger or smaller, half, whole, double, triple.

If two spheres of metal transmit the solar rays into a dark place, as the water is turned into vapour it will make the solar spectrum [1] long in shape.

This occurs also with the water turned into vapour when the solar ray is passing into a dark place with the sun behind it, and also with the light of torches or of the moon. F 67 v.

How the earth in performing the function of the moon has lost a considerable amount of the ancient light in our hemisphere by the lowering of the waters, as is proved in Book Four 'Of the Earth and the Waters':

[1] Thus Rav.-Moll.—'le spectre solaire'. MS. 'arco iris'.

The earth is heavy in its sphere, but so much the more as it is in a lighter element.

Fire is light in its sphere, and so much the more as it is in a heavier element.

No simple element has gravity or levity in its own sphere, and if a bladder filled with air weighs more in the scales than an empty one, this is because this air is compressed; and fire might be so compressed that it would be heavier than the air or equal to the air, and perhaps heavier than the water, and making itself equal to the earth. F 69 v.

This will follow the treatise on light and shade:

The extremities of the moon will be more illuminated and will show themselves more luminous because nothing will appear in them except the summits of the waves of its waters; and the shadowy depths of the valleys of these waves will not change the images of those luminous parts which from the summits of these waves come to the eye.

F 77 V.

Omne grave tendit deorsum nec perpetuo potest sic sursum sustineri, quare jam totalis terra esset facta spherica.[1]

THE SPOTS ON THE MOON

Some have said that vapours are given off from the moon after the manner of clouds, and are interposed between the moon and our eyes. If this were the case these spots would never be fixed either as to position or shape; and when the moon was seen from different points, even although these spots did not alter their position, they would change their shape, as does a thing which is seen on different sides. F 84 r.

OF THE SPOTS ON THE MOON

Others have said that the moon is made up of parts, some more, some less transparent, as though one part were after the manner of alabaster, and another like crystal or glass. It would then follow that when the rays of the sun struck the less transparent part the light would stay on

[1] Every heavy substance presses downwards, and thus cannot be upheld perpetually; wherefore the whole earth has been made spherical.

the surface, and consequently the denser part would be illuminated, and the transparent part would reveal the shadows of its obscure depths. Thus then they define the nature of the moon, and this view has found favour with many philosophers, and especially with Aristotle; but nevertheless it is false, since in the different phases which the moon and the sun frequently present to our eyes we should be seeing these spots vary, and at one time they would appear dark and at another light. They would be dark when the sun is in the west and the moon in the centre of the sky, because the transparent hollows would then be in shadow, as far as the tops of their edges, since the sun could not cast its rays into the mouths of these same hollows; and they would appear bright at full moon, when the moon in the east faces the sun in the west; for then the sun would illumine even the lowest depths of these transparent parts, and in consequence as no shadow was created, the moon would not at such times reveal to us the above-mentioned spots, and so it would be, sometimes more sometimes less, according to the change in the position of the sun to the moon, and of the moon to our eyes, as I have said above. F 84 v.

It has also been said that the spots on the moon are created in the moon itself, by the fact of it being of varying thinness or density. If this were so, then in the eclipses of the moon the solar rays could pierce through some part where it is thin, as has been stated, but since we do not see this result the aforesaid theory is false.

Others say that the surface of the moon is smooth and polished, and that, like a mirror, it receives within itself the reflection of the earth. This theory is false, since the earth, when not covered by the water, presents different shapes from different points of view; so when the moon is in the east it would reflect other spots than when it is overhead or in the west, whereas the spots upon the moon, as seen at full moon, never change during the course which it makes in our hemisphere. A second reason is that an object reflected in a convex surface fills only a small part of the mirror, as is proved in perspective. The third reason is that when the moon is full it only faces half the orb of the illuminated earth, in which the ocean and the other waters shine brightly, while the land forms spots amid this brightness; and consequently the half of our earth would be seen girded round about by the radiance of the sea,

which takes its light from the sun, and in the moon this reflection would be the least part of that moon. The fourth reason is that one radiant body cannot be reflected in another, and consequently as the sea derives its radiance from the sun, as does also the moon, it could not show the reflected image of the earth, unless one also saw reflected there separately the orb of the sun and of each of the stars which look down upon it. F 85 r.

SOLAR RAYS

The solar rays pass through the cold region of the air and do not change their nature. They pass through glasses filled with cold water and lose nothing of their nature thereby; and whatever may be the transparent place through which they pass it is as though they passed through so much air.

And if you maintain that the cold rays of the sun are clothed with the heat of fire as they traverse its element, just as they assume the colour of the glass they penetrate, it would follow that in penetrating the cold region they put on this mantle of cold after they have already put on the said mantle of heat, and thus the cold would counteract the heat, and therefore the solar rays would come to us deprived of heat, and as this is not confirmed by experience such method of reasoning as to the sun being cold is vain.

But if you were to say that the cold through which the fiery rays of the sun pass somewhat modifies the excessive heat of these rays it would follow from this that one would feel greater heat on the high peaks of the Caucasus the mountain of Scythia than in the valleys, because the mountain towers above the middle regions of the air, and no clouds are found there nor anything that grows.

And if you say that these solar rays thrust towards us the element of fire from whence they pass by local movement, this cannot be admitted because the local movement of such [a volume of] air cannot occur without the passing of a period of time, and this is greater in proportion as the sun is more on the horizon, for when there it is 3,500 miles farther away from us than when it is in the centre of our heaven. If it acted thus it would cool the part of our horizon opposite to it, because it would carry away in its rays such part of the element of fire opposite to it as it penetrated.

If the lesser fire is attracted to and deflected by the greater fire as one sees happen by experience, it must needs be that the sun draws the element of fire to itself rather than that it banishes it from itself and drives it towards us.

And the heat of the fire does not descend unless it follows burning matter, and in acting thus it is material and in consequence it is visible.

F 86 r.

How if the moon is polished and spherical the image of the sun upon it is powerfully luminous, and is only on a small part of its surface:

You will see the proof of this by taking a ball of burnished gold and placing it in the darkness and setting a light at some distance from it. Although this illuminates about half the ball, the eye only sees it reflected on a small part of its surface, and all the rest of the surface reflects the darkness which surrounds it. For this reason it is only there that the image of the light is apparent, and all the rest remains invisible because the eye is at a distance from the ball. The same thing would happen with the surface of the moon if it were polished, glittering and solid, as are bodies which have a reflecting surface.

Show how if you were upon the moon or upon a star our earth would appear to you to perform the same function for the sun as now the moon does. And show how the reflection of the sun in the sea cannot itself appear a sun as it does in a flat mirror. F 93 r.

My book attempts to show how the ocean with the other seas makes our world by means of the sunshine after the manner of a moon, and to the more remote worlds it appears a star; and this I prove.

Moon cold and moist.

Water is cold and moist.

Our sea has the same influence on the moon as the moon has on us.

F 94 v.

EXPLANATION OF THE MOON WITH THE IMAGE
OF THE SUN

If the sun f reflected in the surface of the water n m should seem to be at d (that is to say seems to be as far below the water as it is above), and to the eye b appears to be of the size a, and this image doubles itself

as the eye is removed from *b* to *c*, how much would this image grow if the eye were removed from *c* to the moon?

Work with the rule of three and you will see that the light which there is in the moon on its fifteenth day can never be the light that this moon receives from it being spherical; therefore it is necessary that this moon contains water. G 20 r.

[Of the nature of the sun's heat]
OF THE PROOF THAT THE SUN IS HOT BY NATURE AND NOT BY POWER

That the sun is hot in itself by nature and not by power is shown very distinctly by the radiance of the solar body on which the human eye cannot continue to look. And this moreover the rays reflected by concave mirrors show very clearly, for when their percussion is of such radiance that the eye cannot endure it, this percussion will have a radiance resembling that of the sun in its own position. And the truth of this is proved by the fact that if such a mirror has such a concave surface as is required in order to produce this ray, no created thing will be able to support the heat of such percussion of ray reflected from any mirror. And if you say that the mirror also is cold and yet throws warm rays, I say in reply that the ray comes from the sun and will have to pass through the mirror in order to resemble its cause and can pass through whatever medium it wishes. . . .

The ray of the concave mirror having passed across the windows of the furnaces where are cast . . . has not great heat nor any longer has whiteness. G 34 r.

THE SOLAR RAYS

Where there is the finer and more rarefied medium the solar rays meet with a less resistance and where there is the less resistance it is less permeated by the nature of the agent. Consequently for this reason one may infer that where the air is more rarefied the percussion of the said solar rays transmits less radiance, and as a consequence it is darker, and so also conversely. K 118 [38] r.

A proof how the nearer you are to the source of the sun's rays the greater will the sun appear when reflected upon the sea:

If the sun produces its radiance from its centre fortified by power from the whole body it must needs be that the farther its rays proceed from it the more they go on separating. This being so when you have your eye near water that reflects the sun, you see a very small part of the sun's rays carrying upon the surface of the water the form of the sun reflected; and if you are nearer to the sun as would be the case when the sun is at the meridian and the sea is to the west, you will see the sun reflected in the sea of very great size, because as you are nearer to the sun your eye as it takes the rays near to the point takes in more of them and so greater radiance ensues. For this reason it might be proved that the moon is another world similar to ours, and that the part of it which shines is a sea that reflects the sun and the part which does not shine is earth. MS. 2038 Bib. Nat. 16 v.

If you keep the details of the spots of the moon under observation you will often find great differences in them, and I have myself proved this by making drawings of them. And this comes about because the clouds rise from the waters of the moon and come between the sun and this water, and with their shadows cut off the rays of the sun from it, and consequently it remains dark because it cannot reflect the solar body. B.M. 19 r.

OF THE MOON

As wishing to treat of the nature of the moon it is necessary in the first place that I should describe the perspective of mirrors, whether flat concave or convex, and first of all what is meant by a luminous ray and how it is refracted by various kinds of media. Then whether the reflected ray is more powerful if the angle of incidence be acute or a right angle or obtuse, or if the surface be convex or flat or concave, or the substance opaque or transparent. Furthermore how it is that the solar rays which strike the waves of the sea show themselves of the same width in the angle close to the eye as in the farthest crest of the waves on the horizon, notwithstanding which the solar radiance reflected by the waves of the sea is of the shape of a pyramid, and as a

consequence at every stage of distance acquires an access of breadth, although to our sight it may appear parallel.

Nothing extremely light is opaque.

Nothing that is lighter remains below what is less light.

Whether the moon has its station in the midst of its elements or no.

If it has not a particular station as has the earth in its elements why it does not fall to the centre of our elements.

And if the moon is not in the midst of its elements and does not descend it is therefore lighter than the other element.

And if the moon is lighter than the other element why it is solid and not transparent.

Of things of different size which when placed at different distances show themselves equal, there will be the same proportion between their distances as there is between their sizes. B.M. 94 r.

OF THE MOON

The moon has no light of itself but so much of it as the sun sees, it illuminates. Of this illuminated part we see as much as faces us. And its night receives as much brightness as our waters lend it as they reflect upon it the image of the sun, which is mirrored in all those waters that face the sun and the moon.

The crust or surface of the water of which the sea of the moon and the sea of our earth are composed is always wrinkled whether little or much or more or less; and this ruggedness is the cause of the expansion of the innumerable images of the sun which are reflected in the hills and valleys and sides and crests of the innumerable furrows, that is in as many different spots in each furrow as there are different positions of the eyes that see them. This could not happen if the sphere of water which in great part covers the moon were of uniform roundness, because then there would be an image of the sun for every eye, and its reflection would be distinct and the radiance of it would always be spherical in shape, as is clearly shown in the gilded balls placed on the summits of lofty buildings. But if these gilded balls were furrowed or made up of many small globules like mulberries. which are a black fruit composed of minute round balls, then each of the parts of this rounded mass visible to the sun and to the eye will reveal to the eye

the radiance produced by the reflection of the sun. And thus in the same body there will be seen many minute suns and very often on account of their great distance they will blend one with another and seem continuous.

The lustre of the new moon is brighter and more powerful than when it is full; and this is due to the fact that the angle of its incidence is much more obtuse in the new moon than in the full moon, where the angles are extremely acute, and the waves of the moon reflect the sun both on their hollows and on their crests, and the sides remain dark. But at the sides of the moon the troughs of the waves do not see the sun, for it only sees the crests of these waves, and in consequence the reflections are less frequent and more mingled with the shadows of the valleys. And this intermixture of shaded and luminous images all blending together comes to the eye with only a moderate amount of radiance, and at its edges it will be even darker, because the curve of the side of these waves will be insufficient to reflect the rays which it receives to the eye.

For which reason the new moon by its nature reflects the solar rays more towards the eye through these last waves than through any other place, as is shown by the figure of the moon striking with the rays a on the wave b and reflected in $b\ d$ where the eye d is situated. And this cannot happen at full moon, where the solar ray standing in the west, strikes the last rays of the moon in the east from n to m, and does not reflect towards the eye in the west; but leaps back to the east, slightly bending the direction of this solar ray; and so the angle of the incidence is very great.

The countless images which are reflected by the innumerable waves of the sea from the solar rays that strike upon these waves, cause a continuous and far reaching splendour upon the surface of the sea.

The moon is an opaque and solid body, and if on the contrary it were transparent it would not receive the light of the sun. B.M. 94 V.

You have to prove how the earth performs all those same functions towards the moon which the moon does towards the earth.

The moon does not shine with its reflected light as does the sun, because the moon [1] does not receive the light of the sun on its surface

[1] MS. has 'il lume della luna'.

continuously, but in the crests and hollows of the waves of its waters, through the sun being indistinctly reflected in the moon through the mingling of the shadows which are above the waves that shed the radiance. Its light therefore is not bright and clear as is that of the sun.

<div align="right">B.M. 104 r.</div>

To observe the nature of the planets have an opening made in the roof and show at the base one planet singly: the reflected movement on this base will record the structure of the said planet, but arrange so that this base only reflects one at a time. B.M. 279 v.

The circles of the celestial spheres together with the elements equally drive and thrust away from themselves everything that has weight, whence for this reason it must be confessed that it is necessary for the centres of these spheres to meet and become stationary.

Whence through this it is necessary to confess that the things falling towards the centre are rather thrust from above than drawn by this centre downwards; because if it were possible that this earth should be withdrawn in part in such a manner that the space occupied by the position of the earth were filled with air, you would see a stone thrown off from our world into this air become stationary in the centre of the two elements and of the spheres. Forster III 6 v.

The centre of the world cannot be the centre of the universal circles made by the course of the glittering stars, because in a like position it cannot be taken for granted that the universal parts of the earth, the encompasser and enveloper of this centre, are not of equal weight when removed at an equal distance from this centre.

Naturally every heavy thing is thrust towards the centre because the centre is farthest removed from these expelling and rotatory forces.

I conclude: the centre of the weight of the earth with the water is the centre of the spheres and not the centre of the mass of this world.

<div align="right">Forster III 7 r.</div>

These heavy parts which were thrust down from there above, have of themselves already created bodies which always stand in continual desire of returning there above. Forster III 8 r.

The sun does not move. Quaderni v 25 r.

Between the sun and us there is darkness, and therefore the air appears blue. Windsor MSS. R 868

If you wish to prove that the moon appears larger than it is when it reaches the horizon, you take a lens convex on the one side and concave on the other and place the concave side to your eye and look at the object beyond the convex surface; and by this means you will have made a true imitation of the atmosphere which is enclosed between the sphere of fire and that of water, for this atmosphere is concave towards the earth and convex towards the fire. Windsor: Drawings 12326 v.

Memorandum that I have first to show the distance of the sun from the earth and by means of one of its rays passing through a small hole into a dark place to discover its exact dimensions, and in addition to this by means of the sphere of water to calculate the size of the earth.
And the size of the moon I shall discover as I discover that of the sun, that is by means of its ray at midnight when it is at the full.
 Leic. I r.

Reply to Maestro Andrea da Imola who said that the solar rays reflected by the surface of the convex mirror intermingled and became lost at a short distance, and that for this reason it is altogether denied that the luminous side of the moon is of the nature of a mirror, and that in consequence this light is not produced by the innumerable multitude of the waves of that sea, which I have demonstrated to be that part of the moon which is illuminated by the solar rays. Leic. I v.

OF THE MOON

No solid body is lighter than air.
As we have proved that the part of the moon which shines consists of water and it serves the body of the sun as a mirror which reflects the radiance it receives from it; and that if this water were without waves it would show itself as small but of a radiance almost equal to that of the sun, it is necessary now to show whether the moon is a heavy or light body. Thus if it were a heavy body—considering that in progression upwards from the earth at every stage of altitude there is an accession of lightness, inasmuch as water is lighter than earth, air than

water and fire than air and so continuing in succession—it would seem that if the moon had density, as it has, it would have weight, and that having weight the space in which it finds itself would not be able to support it, and as a consequence it would have to descend towards the centre of the universe and to join itself to the earth; or if not the moon itself its waters at any rate would fall away and become lost to it and would fall towards the centre leaving the moon stripped of them and devoid of radiance. The fact however that these events do not occur as might with reason have been anticipated is a clear sign that the moon is clothed with her own elements, namely water air and fire and so sustains itself by itself in that part of space as does our earth with its elements in this other part of space; and that the heavy bodies perform the same function in its elements which the other heavy bodies do in ours.

[*Diagram*] sun, moon, earth.

When the eye in the east sees the moon in the west near the setting sun it sees it with its shaded part surrounded by the luminous part; of which light the lateral and upper portions are derived from the sun and the lower portion from the western ocean, which still receives the solar rays and reflects them in the lower seas of the moon, and moreover it imparts as much radiance to the whole of the shaded part of the moon as the moon gives to the earth at midnight, and for this reason it does not become absolutely dark. And from this some have believed that the moon has in part a light of its own in addition to that which is given it by the sun, and that this light is due to the cause already mentioned, namely that our seas are illumined by the sun.

[*Diagram*] moon, solar body, earth.

Further it might be said that the circle of radiance which the moon shows when it is in the west together with the sun is derived entirely from the sun, when its position with regard to the sun and the eye is as is shown above.

Some might say that the air which is an element of the moon as it catches the light of the sun as does our atmosphere was that which completes the luminous circle on the body of the moon.

Some have believed that the moon has some light of its own, but this opinion is false, for they have based it upon that glimmer which is visible in the middle between the horns of the new moon, which ap-

pears dark where it borders on the bright part, and where it borders
on the darkness of the background seems so bright that many have
assumed it to be a ring of new radiance which completes the circle
where the radiance of the tips of the horns illuminated by the sun
ceases.

And this difference in the background arises from the fact that the
part of it which borders on the illuminated portion of the moon, by
comparison with that brightness shows itself darker than it is, and in
the part above where appears a portion of a luminous circle of uniform
breadth it comes about that there the moon being brighter than the
medium or background upon which it finds itself, in comparison with
this darkness shows itself on that extremity brighter than it is, this
brightness at such a time being derived from our ocean and the other
inland seas, for they are at that time illumined by the sun which is
then on the point of setting, in such a way that the sea then performs
the same office for the dark side of the moon as the moon when at the
full does for us when the sun is set, and there is the same proportion
between that small quantity of light on the dark side of the moon and
the brightness of the illuminated part, as there is between . . .

If you want to see how much brighter the shaded part of the moon is
than its background, cover from your eye with your hand or with some
other object farther away the luminous part of the moon, so that . . .

<div align="right">Leic. 2 r.</div>

I say that as the moon has no light of its own, but is luminous, it
must needs be that this light is caused by some other body: this being
so it is of the nature of a spherical mirror; and if it is spherical it takes
the light pyramid-wise; and of this pyramid the sun is the base, and its
angle ends in the centre of the body of the moon, and it is cut by the
surface of this body, and only takes as much as corresponds to the
section of this pyramid on its surface. And to the human eye this moon
would only seem the size of this section of the pyramid. Whence there
would follow from the light of the moon the contrary effect to that
which experience shows us; for this is that as the moon turns it has its
whole orb luminous as is shown us by this; for this clearly shows us
that this lunar body has more than half its orb illuminated. But this
would not happen if it were a polished body like the mirrors; conse-
quently for this reason we are constrained to admit, by my fifth [rule],

that the surface of the moon is furrowed; and this roughness only exists in liquid bodies when they are stirred by the wind, as we have seen with the sea how the sun is reflected by tiny waves near to the eye, and stage by stage over a distance of more than forty miles these illuminated waves grow larger. Wherefore we conclude that the luminous part of the moon is water, which if it were not in movement would not be luminous to the same degree; but by the movement of this water which has been stirred up by the winds it becomes filled with waves; and every wave takes the light from the sun; and the great multitude of waves beyond number reflect the solar body an infinite number of times; and the sun thus reflected will be as bright as the sun, for as is seen when the water does not move it gives back the sun to the eye in the pristine splendour that it has by nature.

But the shadows also are beyond number as well as the waves, and these are interspersed between the waves; and their shapes blend with the shapes of the images of the sun, which are upon the waves; and each shadow shape becomes blended with a luminous shape and so they come to obscure the luminous rays and make them weak, as is clearly shown us by the light of the moon. And when the sea of the moon is stirred to tempest by the winds the waves are larger and the lights less frequent and the enlarged shadows intermingle more with the sparse images of the sun upon the waves, and for this reason the moon becomes less luminous. But when the moon is in its circle and has a position at about the centre of our hemisphere, each wave shows the reflection of the sun both in the centre of the valleys interposed between the waves and in the summits of these waves; and for this reason the moon shows itself more luminous than ever, through having the number of the parts in light doubled.

It shows itself also strongly luminous a short time after its turn, because the sun which stands beyond the moon, striking the waves upon their summits, when these summits are near together and seem almost to clash one against another when the eye is on this side, causes the shadows which come between the waves not to transmit to the eye their images mingled with the luminous images; and for this reason the light of the moon is more powerful.

And what is proved of one luminous body holds true of all the rest.

Leic. 30 r.

Of the moon: all the objections of the adversary, to say that in the moon there is no water.

Objection: Every body thicker than the air is heavier than this air and cannot be supported upon it without other cause; and the more it rises the less it is resisted by its medium: therefore, if there were water in the moon, it would despoil the moon of itself, and would come to cover our earth, because in this moon the water would be above its air. Here the answer is that if there is water in the moon there is also earth there upon which this water supports itself, and consequently the other elements: and water is supported up there among the three other elements, as down here our water is among its accompanying elements; if however as the adversary holds the water had to fall from the moon, it would rather be that the moon would have to fall as being a body heavier than the water; therefore not falling it is a clear proof that the water up there and the earth are supported with their other elements just as the heavy and light elements down here are supported in space that is lighter than themselves.

The adversary says that the light of the moon, if not the whole of it, is the same in itself; and that it shows itself more or less illuminated, according as the eye sees more or less of its shaded part, that is, if it is more in the east than the west.

Here, at this point, one replies, that if the . . . Leic. 36 v.

XII

Botany

*'All seeds have the umbilical cord, which breaks
when the seed is ripe. And in like manner they
have matrix and secundina, as is seen in herbs
and all the seeds which grow in pods.'*

WHEN a tree has had part of its bark stripped off, nature in order to
provide for it supplies to the stripped portion a far greater quantity of
nutritive moisture than to any other part; so that because of the first
scarcity which has been referred to the bark there grows much more
thickly than in any other place. And this moisture has such power of
movement that after having reached the spot where its help is needed,
it raises itself partly up like a ball rebounding, and makes various
buddings and sproutings, somewhat after the manner of water when
it boils.

Many trees planted in such a way as to touch, by the second year
will have learnt how to dispense with the bark which grows between
them and become grafted together; and by this method you will make
the walls of the gardens continuous, and in four years you will even
have very wide boards.

When many grains or seeds are sown so that they touch and are then
covered by a board filled with holes the size of the seeds and left to
grow underneath it, the seeds as they germinate will become fixed
together and will form a beautiful clump. And if you mix seeds of
different kinds together this clump will seem like jasper.

C.A. 76 r. a

The branches of plants are found in two different positions: either
opposite to each other or not opposite. If they are opposite to each other
the centre stem is not bent: if they are not opposite the centre stem
is bent. C.A. 305 v. a

[*Of barking trees*]

If you take away a ring of bark from the tree *d* it will wither from the ring upwards and all below will remain alive.

If you make the said ring incompletely and then graft the plant near the foot deftly, the part that has been deftly treated will be preserved and the rest will be spoilt. B 17 v.

OF THE RAMIFICATION OF PLANTS

The plants which spread out very much have the angles of the divisions which separate their ramifications more obtuse in proportion as their point of origin is lower down, that is nearer to the thicker and older part of the tree; whereas in the newer part of the tree the angles of its ramifications are more acute. E 6 v.

The trunks of the trees have a bulbous surface which is caused by their roots which carry nourishment to the tree; and these excrescences have their surface of bark containing few fissures, and their intervals are hollows where the bark has become dried because the nourishment comes to it less abundantly. G 1 r.

The shadows on transparent leaves seen from beneath are the same as those on the right side of the leaf, for the shadow is visible in transparence on the under side as well as the part in light; but the lustre can never be seen in transparence. G 3 v.

The lowest branches of the trees which have big leaves and heavy fruits such as coco-palms, figs and the like always bend towards the ground.

The branches always start above the leaf. G 5 r.

Young trees have more transparent leaves and smoother bark than old ones: the walnut especially is lighter in colour in May than in September. G 8 r.

That plant will preserve its growth in the straightest line which produces the most minute ramification. G 13 r.

OF BRANCH STRUCTURE

The beginning of the branch will always have the central line of its thickness taking its direction by the central line of the plant. G 14 r.

OF THE BIRTH OF LEAVES UPON THEIR BRANCHES

The thickness of a branch is never diminished in the space there is between one leaf and another except by as much as the thickness of the eye that is above the leaf, and this thickness is lacking in the branch up to the next leaf.

Nature has arranged the leaves of the latest branches of many plants so that the sixth is always above the first, and so it follows in succession if the rule is not impeded.

This serves two uses for the plants, the first being that as the branch or fruit springs in the following year from the bud or eye which is above it in contact with the attachment of the leaf, the water which wets this branch is able to descend to nourish the eye by the fact that the drops are caught in the axil where the leaf springs; and the second use is that when these branches grow in the succeeding year one will not cover the other, because the five branches come forth turned in five different directions and the sixth comes forth above the first but at a sufficient distance. G 16 v.

[Of branch structure]

Between one ramification and the other if there are no other particular branches the tree will be of uniform thickness. And this takes place because the whole sum of the humour that feeds the beginning of this branch continues to feed it until it produces the next branch. And this nourishment or equal cause produces equal effect. G 17 r.

Trees which divide near to the ground seldom put forth branches in the space that intervenes between them; and if however there should be one it will have but a short life and will not make much growth on account of the shadow that the one gives to the other.

There are many bends in the branches where there are none of the six lesser branches that usually surround them; for these failed in their

youth, and death passed over their stumps and spread to the more vital parts.

The principal branches of the trees which rise the most are always nearer the centre of the plant than any of its brothers or sons.

<div align="right">G 24 V.</div>

The small branches of the same year grow in all the parts of the tree only in those places where there were its old ramifications, produced in the order of the birth of their leaves, that is to say each is produced the one above the other.

The occasional dents in the big branches of trees are not in the same order as that of the inception of the leaves which are near to them.

Because its lesser branches never traverse such dents in their infancy the chief branch as it carries more sap keeps its course straight for a long space.

<div align="right">G 25 r.</div>

DESCRIPTION OF THE ELM

This ramification of the elm has the largest branch in front, and its smallest are the first and the penultimate when the chief branch is straight.

From the starting point of one leaf to the other is the half of the greatest length of the leaf; a little less because the leaves form an interval which is about a third the width of the leaf.

The elm has the tips of its leaves nearer the extremity of the branch than its starting point, and in width they vary but little when looked at from the same side.

<div align="right">G 27 r.</div>

The leaf always turns its upper side towards the sky so that it may be better able to receive over its whole surface the dew which drops down with the slow movement of the atmosphere; and these leaves are arranged on the plants in such a way that one covers another as little as possible, but they lie alternately one above the other as is seen with the ivy which covers the walls. And this alternation serves two ends; that is in order to leave spaces so that the air and the sun may penetrate between them,—and the second purpose of it is that the drops which fall from the first leaf may fall on to the fourth, or on to the sixth in the case of other trees.

<div align="right">G 27 v.</div>

[*Structure of the walnut tree*]

The leaves of the walnut tree are distributed over the whole branch of that year, and they are so much farther away the one from the other, and in greater number, as the branch from which the shoot springs is younger. And they are so much nearer at their beginning and less in number, as the shoot that bears them springs from an older branch.

Its fruits grow at the extremity of its shoot, and its largest branches are on the under side of the bough from which they spring. And this happens because the weight of its sap inclines it more to descend than to rise; and for this reason the branches that start above them and go toward the sky are small and thin. When the shoot looks towards the sky its leaves spread out from its extremity with equal distribution of their tips, and if the shoot looks towards the horizon the leaves remain spread out; this springs from the fact that the leaves invariably turn their underneath side towards the ground.

The branches are proportionately smaller as they start nearer to the birth of the bough which produces them. G 28 r.

[*The elder*]

Observe on the lower branch of the elder which has its leaves in twos placing them crosswise one above the other, if the stem goes straight up towards the sky this order never fails, and its larger leaves occur on the thicker part of the stem and the smaller on the thinner part that is towards the top. But to come back to the branch below, I maintain that the leaves which are placed crosswise to those on the upper branch, being constrained by the law which causes the leaves to turn part of their surface towards the sky in order to catch the dew at night, must necessarily twist round when so placed and be no longer crosswise. G 29 r.

OF THE RAMIFICATIONS OF TREES WITH THEIR LEAVES

Of the ramifications of trees some such as the elm are wide and thin after the fashion of a hand open foreshortened, and these are visible in their whole mass. Below they are seen in their upper side, and those that are highest are seen from beneath; those of the centre show themselves part below and part above, and the part above is at the end of the

ramification; and this part that is in the centre is more foreshortened than any other of those which are turned with their points towards you. Of these parts that are in the centre of the height of the tree the longest will be towards the extremities of these trees; and these make ramifications like the leaves of the common willow which grows upon the banks of rivers.

Other ramifications are round, such as those of the trees that put forth their shoots and leaves so that the sixth is above the first. Others are thin and diaphanous as the willow and such like trees. G 30 v.

OF THE BEGINNING OF THE BRANCHES IN TREES

The beginning of the ramifications of trees upon their principal branches is the same as the beginning of the leaves upon the shoots of the same year as the leaves. And these leaves have three ways of proceeding one higher than the other; the first and most usual is that the sixth on the upper side always is born above the sixth on the under side; the second is that the two thirds above are over the two thirds below; and the third way is that the third above is over the third below.

WHY FREQUENTLY THE VEINS OF WOOD ARE NOT STRAIGHT

When the branches which follow the second year above that of the previous year are not of equal thickness above the preceding branches but are one-sided, the strength of the branch below is bent to nourish that which is higher although it is somewhat on one side.

But if such ramifications are equal in their growth, the veins of their branch will be straight, and at an equal distance at every stage of the height of the plant.

Do you therefore O painter who are not acquainted with these laws, if you would escape the censure of those who have studied them, be zealous to represent everything according to nature and not to disparage such study, as do those who work only for gain. G 33 r.

Every branch and every fruit comes above the insertion of its leaf, which serves it as a mother by bringing it the water of the rains and the

moisture of the dew that falls there at night from above, and often takes from them the excessive heat of the sun's rays.　　 G 33 v.

There is no protuberance on a branch except where there has been some branch which has failed.

The lower shoots of the branches of trees increase more than the upper shoots, and this simply arises from the fact that the sap which feeds them having gravity moves downwards more readily than upwards. And also because those which grow downwards separate themselves from the shade which there is in the centre of the tree.

The older the branches the greater the difference will be between their upper and lower shoots and between those of the same year or period.　　 G 34 v.

OF THE CICATRICES OF TREES

The cicatrices of trees grow in thickness more than the sap that flows through them and nourishes them requires.　　 G 35 r.

The lower branches after they have formed the angle of their separation from their trunk always bend down, so as not to press against the other branches which follow above them on the same trunk and to be better able to take the air which nourishes them.　　 G 35 v.

The elm always puts greater length into the latest branches of the year's growth than it does into those of the same year which are lower. Nature does this because the higher branches are those which are to increase the size of the tree; while those below tend to dry up because they remain in the shadow, and their growth would be a check to the entry of the solar rays and the air among the chief branches of the tree.

The chief of the lower branches bend down more than the upper ones both in order to be more slanting than the upper ones and also because they are larger and older; and in order to seek the air and escape from the shade.　　 G 36 r.

[*Branch structure and the sun*]

Universally almost all the upright parts of trees are found to bend somewhat turning their convex part towards the south. And the branches are longer thicker and more numerous towards the south

than towards the north. This arises from the fact that the sun draws the sap towards that part of the surface of the tree which is nearest to it. This is evident in the trees which are frequently pollarded, for they renew their growth every three years. And one notices this unless the sun is screened off by other trees. G 36 v.

All the flowers which see the sun mature their seed, and not the others, that is those which see only the reflection of the sun. G 37 v.

The cherry is of the same nature as the fir in that its ramification is made in steps round its stem; and its branches grow in fours fives or sixes opposite one another; and the sum of the extremities of the branches forms an equilateral pyramid from its centre upwards; and the walnut and the oak from the centre upwards form a half sphere.

 G 51 r.

[*Symmetry of nature—ramifications of trees and water*]

All the branches of trees at every stage of their height, united together, are equal to the thickness of their trunk.

All the ramifications of the waters at every stage of their length being of equal movement are equal to the size of their parent stream.

 I 12 v.

[*Laws as to growth of plants*]

Every year when the branches of the trees have completed their growth, they have attained when joined together to such thickness as the thickness of their trunk, and at each stage of their ramification you will find the thickness of the said trunk as in *ik*, *gh*, *ef*, *cd*, *ab*. They will all be equal to each other if the tree has not been pollarded; otherwise the rule will not fail. M 78 v.

If the plant *n* grows to the thickness of *m* its branches will make the whole conjunction *ab* through the swelling of the branches within as well as outside.

The branches of plants form a curve at every commencement of a tiny branch, and as this other branch is produced they bifurcate, and this bifurcation occurs in the middle of two angles the greater of which will be that on the side of the thicker branch, and this will be in proportion unless some accident has marred it. M 79 r.

All the branches produced towards the centre of the tree wither and

fall on account of the excess of shade; only such part of the system of ramification endures as lies in the extremities of the tree.

B.M. 180 v.

[Unity in nature—all seeds have the umbilical cord]

All seeds have the umbilical cord, which breaks when the seed is ripe. And in like manner they have matrix and secundina, as is seen in herbs and all the seeds which grow in pods. But those which grow in shells, such as hazel-nuts, pistachio-nuts and the like have the umbilical cord long, and this shows itself in their infancy. Quaderni III 9 v.

A discourse concerning the herbs some of which have the first flower placed at the very top of the stalk, others have it at the bottom.

Quaderni IV 15 r.

XIII

Geology

'When nature is on the point of creating stones it produces a kind of sticky paste, which, as it dries, forms itself into a solid mass together with whatever it has enclosed there, which, however, it does not change into stone but preserves within itself in the form in which it has found them.'

THE lying interpreters of nature assert that mercury is a common factor in all the metals; they forget that nature varies its factors according to the variety of the things which it desires to produce in the world.

<div align="right">C.A. 76 V. a</div>

The streams of rivers move different kinds of matter which are of varying degrees of gravity, and they are moved farther from their position in proportion as they are lighter, and will remain nearer to the bottom in proportion as they are heavier, and will be carried a greater distance when driven by water of greater power.

But when this power ceases to be capable of subduing the resistance of the gravel this gravel becomes firm and checks the direct movement of the water which led it to this place. Then the water, as it strikes on the gravel which has been increased in this manner, leaps back crosswise and strikes upon other spots to which it was unaccustomed, and takes away other deposits of soil down to their foundations. And so the places where first the said river used to pass are deserted and become silted up anew by a fresh deposit from the turbid waters, and these in due course become choked up in these same places. C.A. 77 V. b

Of the rivers greatly swollen by the falling down of the mountains along their sides which bring about the formation of very great lakes at high altitudes:

The avalanches from the mountains falling down upon their bases

which have been worn away by the continuous currents of the rivers rushing precipitously at their feet with their swift waters, have closed up the mouths of the great valleys situated in the high places.

These are the causes why the surface of the water is raised by the creation of lakes, and why new streams and rivers are formed in high places.

<div align="right">C.A. 84 r. a</div>

The ebb and flow of the sea is continually moving the earth with all its elements away from the centre of the elements. This is proved by the first [chapter] of this [treatise], which states that the centre of the world takes count of that which is higher than it because no hollow lies deeper than it. The centre of the world is in itself immovable, but the place in which it is found is in continual movement towards different aspects. The centre of the world changes its position continually, and of these changes some have a slower movement than the others, for some changes occur every six hours and some take many thousand years.

But that of six hours proceeds from the ebb and flow of the sea, the other comes from the wearing away of the mountains through the movements of the water produced by the rains and the continual course of the rivers. The site changes in its relation to the centre of the world and not the centre to the site, because this centre is immovable and its site is continually moving in a rectilinear movement, and such movement will never be curvilinear.

<div align="right">C.A. 102 r. b</div>

The rains wear away more of the roots of the mountains than they do the summits for two reasons; and the first is that the percussion of the rain in falling from the same height is more powerful on the bases of the mountains than on their summits by my seventh [rule], which says that a heavy thing becomes so much swifter as it descends farther in the air, and as it becomes swifter so it becomes heavier. As therefore there is more space between the roots of the mountains and the cloud than between these clouds and the summit of the mountain, the rain, as has been said, is heavier and more powerful upon these roots of the mountains than on the summit of the same mountain, and so stage by stage its power to wear away is less as it has a less fall.

The second reason is that the greater mass of water is that which descends from the centre of the mountain to its roots rather than from

the summit of this mountain to the said centre; and so we have discharged our purpose.

Valleys grow wider with the progress of time: their depth undergoes but little increase; because the rains bring as much soil to the valley almost as the river washes away, and in some parts more in others less.

Very great rivers flow underground.

The rivers make greater deposits of soil when near to populated districts than they do where there are no inhabitants. Because in such places the mountains and hills are being worked upon, and the rains wash away the soil that has been turned up more easily than the hard ground which is covered with weeds.

The heights of mountains are more eternal and more enduring when they are covered with snow during the whole winter.　　c.a. 160 v. a

In between water and stone in equal quantities are an almost infinite number of different grades of weight, that is there are as many varieties of the weights as there are of the thicknesses; so there will be pure water, then water with a very small quantity of earth in it, and then this is increased little by little until it forms mud, and then this mud becomes more solid, and at last it becomes solid earth, and then goes on to become like the hardest stone and is even transformed into the metals.

And this I say because I have to take away like things in order to press the water out of its vessels.

Of the rising of the water to the mountains, which acts like water that rises up through the plants from the roots to the summits, as is seen in vines when they are cut; and as the blood works in all the animals so water does in the world, which is a living body.

　　　　　　　　　　　　　　　　　　　　c.a. 367 v. b

If the earth of the antipodes which sustains the ocean rose up and stood uncovered far out of this sea but being almost flat, how in process of time could mountains valleys and rocks with their different strata be created?

The mud or sand from which the water drains off when they are left

uncovered after the floods of the rivers supplies an answer to this question.

The water which drained away from the land which the sea left, at the time when this earth raised itself up some distance above the sea, still remaining almost flat, commenced to make various channels through the lower parts of this plain, and beginning thus to hollow it out they would make a bed for the other waters round about; and in this way throughout the whole of their course they gained breadth and depth, their waters constantly increasing until all this water was drained away and these hollows became then the beds of torrents which take the floods of the rains. And so they will go on wearing away the sides of these rivers until the intervening banks become precipitous crags; and after the water has thus been drained away these hills commence to dry and to form stone in layers more or less thick according to the depth of the mud which the rivers deposited in the sea in their floods. F II V.

Of creatures which have their bones on the outside, like cockles, snails, oysters, scallops, 'bouoli' and the like, which are of innumerable kinds:

When the floods of the rivers which were turbid with fine mud deposited this upon the creatures which dwelt beneath the waters near the ocean borders, these creatures became embedded in this mud, and finding themselves entirely covered under a great weight of mud they were forced to perish for lack of a supply of the creatures on which they were accustomed to feed.

In course of time the level of the sea became lower, and as the salt water flowed away this mud became changed into stone; and such of these shells as had lost their inhabitants became filled up in their stead with mud; and consequently during the process of change of all the surrounding mud into stone, this mud also which was within the frames of the half-opened shells, since by the opening of the shell it was joined to the rest of the mud, became also itself changed into stone; and therefore all the frames of these shells were left between two petrified substances, namely that which surrounded them and that which they enclosed.

These are still to be found in many places, and almost all the petri-

fied shellfish in the rocks of the mountains still have their natural frame round them, and especially those which were of a sufficient age to be preserved by reason of their hardness, while the younger ones which were already in great part changed into chalk were penetrated by the viscous and petrifying moisture. F 79 r.

OF THE BONES OF FISHES FOUND IN THOSE THAT HAVE BEEN PETRIFIED

All the creatures that have their bones within their skin, on being covered over by the mud from the inundations of rivers which have left their accustomed beds, are at once enclosed in a mould by this mud. And so in course of time as the channels of the rivers become lower these creatures being embedded and shut in within the mud, and the flesh and organs being worn away and only the bones remaining, and even these having lost their natural order of arrangement, they have fallen down into the base of the mould which has been formed by their impress; and as the mud becomes lifted above the level of the stream, the mud runs away so that it dries and becomes first a sticky paste and then changes into stone, enclosing whatsoever it finds within itself and itself filling up every cavity; and finding the hollow part of the mould formed by these creatures it percolates gradually through the tiny crevices in the earth through which the air that is within escapes away —that is laterally, for it cannot escape upwards since there the crevices are filled up by the moisture descending into the cavity, nor can it escape downwards because the moisture which has already fallen has closed up the crevices. There remain the openings at the side, whence this air, condensed and pressed down upon by the moisture which descends, escapes with the same slow rate of progress as that of the moisture which descends there; and this paste as it dries becomes stone, which is devoid of weight, and preserves the exact shapes of the creatures which have there made the mould, and encloses their bones within it. F 79 v.

SHELLS AND THE REASON OF THEIR SHAPE

The creature that resides within the shell constructs its dwelling with joints and seams and roofing and the other various parts, just as man

does in the house in which he dwells; and this creature expands the house and roof gradually in proportion as its body increases and as it is attached to the sides of these shells.

Consequently the brightness and smoothness which these shells possess on the inner side is somewhat dulled at the point where they are attached to the creature that dwells there, and the hollow of it is roughened, ready to receive the knitting together of the muscles by means of which the creature draws itself in when it wishes to shut itself up within its house.

When nature is on the point of creating stones it produces a kind of sticky paste, which as it dries, forms itself into a solid mass together with whatever it has enclosed there, which, however, it does not change into stone but preserves within itself in the form in which it has found them. This is why leaves are found whole within the rocks which are formed at the bases of the mountains, together with a mixture of different kinds of things, just as they have been left there by the floods from the rivers which have occurred in the autumn seasons; and there the mud caused by the successive inundations has covered them over, and then this mud grows into one mass together with the aforesaid paste, and becomes changed into successive layers of stone which correspond with the layers of the mud. F. 80 r.

OF SHELLS IN MOUNTAINS

And if you wish to say that the shells are produced by nature in these mountains by means of the influence of the stars, in what way will you show that this influence produces in the very same place shells of various sizes and varying in age, and of different kinds?

SHINGLE

And how will you explain to me the fact of the shingle being all stuck together and lying in layers at different altitudes upon the high mountains? For there there is to be found shingle from divers parts carried from various countries to the same spot by the rivers in their course; and this shingle is nothing but pieces of stone which have lost their sharp edges from having been rolled over and over for a long

time, and from the various blows and falls which they have met with during the passage of the waters which have brought them to this spot.

LEAVES

And how will you account for the very great number of different kinds of leaves embedded in the high rocks of these mountains, and for the *aliga*, the seaweed, which is found lying intermingled with the shells and the sand?

And in the same way you will see all kinds of petrified things together with ocean crabs, broken in pieces and separated and mixed with their shells. F 80 v.

In every hollow at the summits of the mountains you will always find the folds of the strata of the rocks. B.M. 30 v.

XIV

Physical Geography

'The earth wears away the mountains and fills up the valleys and if it had the power it would reduce the earth to a perfect sphere.'

THE wave travels beneath the surface[1] of the sea, and leaves behind itself all the foam which is produced in front of it.

The space of the surface of the water that intervenes between the waves as they come to the shore is polished and smooth; and this comes about because the greatest wave is swifter than the lesser waves of which it is made up [in the univer]sal surface of the sea; and this greatest wave draws back the surface of the sea, and the first foam of the wave descends as it opens at the spot where the remainder is fleeing away.

And the figure of the foam which then remains behind in the wave is always triangular, and its angle is made up of the first foam and that in front of the course where the wave first descended.

<div align="right">C.A. 63 r. b</div>

The lowest parts of the world are the seas where all the rivers run.

The river never ceases its movement until it reaches the sea; the sea therefore is the lowest part of the world.

Water does not move from place to place unless it is drawn by a lower position. Lowness therefore serves as a magnet for water.

<div align="right">C.A. 80 r. b</div>

Make a sketch to show where the shells are at Monte Mario.

<div align="right">C.A. 92 v. c</div>

OF THE SEA WHICH GIRDLES THE EARTH

I perceive that the surface of the earth was from of old entirely filled up and covered over in its level plains by the salt waters, and that the

[1] *la pelle*, literally 'the skin' of the sea.

mountains, the bones of the earth, with their wide bases, penetrated and towered up amid the air, covered over and clad with much high-lying soil. Subsequently the incessant rains have caused the rivers to increase and by repeated washing have stripped bare part of the lofty summits of these mountains, leaving the site of the earth, so that the rock finds itself exposed to the air, and the earth has departed from these places. And the earth from off the slopes and the lofty summits of the mountains has already descended to their bases, and has raised the floors of the seas which encircle these bases, and caused the plain to be uncovered, and in some parts has driven away the seas from there over a great distance. c.a. 126 v. b

DOUBT

Here a doubt arises, and that is as to whether the Flood which came in the time of Noah was universal or not, and this would seem not to have been the case for the reasons which will now be given. We have it in the Bible that the said Flood was caused by forty days and forty nights of continuous and universal rain, and that this rain rose ten cubits above the highest mountain in the world. But consequently if it had been the case that the rain was universal it would have formed in itself a covering around our globe which is spherical in shape; and a sphere has every part of its circumference equally distant from its centre, and therefore on the sphere of water finding itself in the afore-said condition, it becomes impossible for the water on its surface to move, since water does not move of its own accord unless to descend. How then did the waters of so great a Flood depart if it is proved that they had no power of motion? If it departed, how did it move, unless it went upwards? At this point natural causes fail us, and therefore in order to resolve such a doubt we must needs either call in a miracle to our aid or else say that all this water was evaporated by the heat of the sun. c.a. 155 r. b

[*Diagram*]

Three is the number of the winds which bend the rivers to the west as they discharge themselves into the Mediterranean Sea on the shores that face south. This is proved as follows: the sand that is driven by the winds into the water is no longer subject to the winds, through

being weighed down by the water which covers it over and forms a screen for it against these winds.

Therefore the river *n m* which flows into the sea will half way in its course make a beginning of a movement to the west, when it feels the breath of the winds known as Greco, Levante and Scirocco, which at various times set the dry sand of the shore spinning, and hurl it into the sea, where it becomes submerged and settles upon the bed of the sea. But the north wind called Greco throws it to the south-west, and the Scirocco throws it to the north-west. But the southern waves striking on the shore throw this sand back towards the river, and the river strikes it back towards the sea; and when the waves struck back from the shore come to an encounter with the waves advancing to the shore the movement of these waves then ceases because the power of their movement is lacking. Therefore the sand having made the water turbid descends to the bottom, and it is this same sand which forms itself into a bank and bends in a westerly direction the aforesaid river. Why does it not bend the course of the river to the east as well as to the west? Because the sea has been proved to run to the west and not to the east.

Let us therefore make a bridge as wide and low as the shore out of large planks. C.A. 167 v. a

The water wears away the mountains and fills up the valleys, and if it had the power it would reduce the earth to a perfect sphere.

C.A. 185 v. c

INSTANCES AND DEDUCTIONS AS TO THE EARTH'S INCREASE

Take a vase, fill it full of pure earth, and set it up on a roof. You will see how immediately the green herbs will begin to shoot up, and how these, when fully grown, will cast their various seeds; and after the children have thus fallen at the feet of their parents, you will see the herbs having cast their seeds, becoming withered and falling back again to the earth, and within a short time becoming changed into the earth's substance and giving it increase; after this you will see the seeds springing up and passing through the same course, and so you will always see the successive generations after completing their natural course, by their death and corruption giving increase to the earth. And if you let ten

years elapse and then measure the increase in the soil, you will be able
to discover how much the earth in general has increased, and then by
multiplying you will see how great has been the increase of the earth in
the world during a thousand years. Some may say that this instance of
the vase which I have mentioned does not justify the deduction based
upon it, because one sees in the case of these vases that for the prize of
the flowers that are looked for a part of the soil is frequently taken
away, and its place is filled up with new rich soil; and I reply to them
that as the soil which is added there is a blend of rich fat substances
and broken bits of all sorts of things it cannot be said to be pure earth,
and this mass of substances decaying and so losing in part their shape
becomes changed into a rich ooze, which feeds the roots of the plants
above them; and this is the reason why it may appear to you that the
earth is lessened; but if you allow the plants that grow in it to die, and
their seeds to spring up, then in time you will behold its increase.

For do you not perceive how, among the high mountains, the walls
of ancient and ruined cities are being covered over and concealed by
the earth's increase?

Nay, have you not seen how on the rocky summits of the mountains
the live stone itself has in course of time swallowed up by its growth
some column which it supported, and stripping it bare as with shears
and grasping it tightly, has left the impress of its fluted form in the
living rock? c.a. 265 r. a

When mountains fall headlong over hollow places they shut in the
air within their caverns, and this air, in order to escape, breaks through
the earth, and so produces earthquakes.

My opponent says this cannot be the case, for either the whole
mountain which covers the cavern falls or else only the inner part of it;
and if the whole falls, then the compressed air escapes through the
opening of the cave which is uncovered, while if only the inner part
falls then the compressed air escapes into the vacuum which is left by
the falling earth. c.a. 289 v. b

Similarly the movements of the waters running through all the pas-
sages of the sterile earth are its life-giving force. And just as the mois-
ture spread through the vine rises up and pours through the severed
members, (the utmost heights of the mountains through the severed

veins), so it is with the water which rises to a height and pours through the chasms in the topmost heights of the mountains.

In the same way the waters from the base rise to a height, pouring through the chasms in the topmost heights of the highest mountains.

And as the moisture which pours through the severed vine desires only the centre of the earth and moves towards it, so the waters pouring from the heights of the mountains move of their own free will towards this centre.

And as the water from the severed vine falling down upon its roots and penetrating into these raises itself up to a height and pours itself out again at the very place where the cutting was, so the water falling from the summits of the mountains and penetrating through the passages of the earth returns upwards. C.A. 309 v. a

The surface of the Red Sea is on a level with the Ocean.

This made the Mediterranean light both in the bed which is lowered and in the surface where formerly was the water.

Lacking the weight of the waters of the Mediterranean which had been diminished the earth rose and changed in itself its centre of gravity.

The waters of the sea which descend into the Ocean from the Mediterranean Sea have through the force of their impact on the bottom hollowed out this bed considerably beneath the surface of this Ocean; and in their fall this hollowing out has withdrawn itself to the point at which it arrives at the end of the channel of Gades, and there it is visible to-day.

A mountain may have fallen and blocked the mouth of the Red Sea and prevented the outlet to the Mediterranean, and thus swirling in a flood this sea will have as its outlet the passage between the mountains of Gades, for in the same way we have seen in our time a mountain fall seven miles and block up a valley and make a lake; and thus the greater number of the lakes were made by mountains, as the lake of Garda, of Como and Lugano and Lake Maggiore. . . .

All the plains which lie between the seas and the mountains were once covered by the salt waters.

Every valley has been made by its river, and the proportion between valleys is the same as that between rivers.

The greatest river in the world is the Mediterranean which is a river that moves from the source of the Nile to the Western Ocean.

c.a. 328 v. b

The water given to the Mediterranean by rain and rivers is restored to the Ocean through the straits of Gades [Gibraltar], with so much less water in proportion as the springs are beneficent to it and the sea evaporates it.

And this excess is the cause of the ebb and flow, because in the flow the Mediterranean is swollen up by the Ocean and this turns back and ebbs away through the Mediterranean which discharges it.

c.a. 353 v. c

Just as the snow as it falls in flakes upon various rounded objects covers them with itself but with as many varying degrees of thickness as there are variations in the curves of this roundness, so the earth, borne by the floods of the rivers after the mass of the waters, descends upon the various rounded objects which are at the bottom of the waters and covers these with itself in the manner shown above. c.a. 383 v.

OF THE CENTRE OF THE OCEAN

The centre of the sphere of water is the true centre of the orb of our world which is compounded of land and water in the shape of a sphere. But if you wish to find the centre of the element of the earth this is situated at a point equidistant from the surface of the ocean and not equidistant from the surface of the earth. For it is easy to understand that this globe of the earth has no perfect roundness whatever except in those parts in which are the sea or lakes or other surfaces of still water; and every part of the land which rises above the water is farther removed from the centre.

A 58 v.

OF THE MOVEMENT OF AIR AND WATER

This air which bounds and continually moves upon this terrestrial machine is mixed with moisture similar to that with which the earth is compounded, and the excess of this moisture falls back continually upon the earth once in twenty-four hours and then springs back raised

a little by the heat of the sun and sustained by it so long as it remains in our hemisphere. Then being left abandoned by it at its departure and still having weight it falls back on the earth.

In summer this moisture is called dew and in winter as the cold condenses it and freezes it it is called hoar frost. c 6 r.

OF HOW THE SEA CHANGES THE WEIGHT OF
THE EARTH

The shells of oysters and other similar creatures which are born in the mud of the sea testify to us of the change in the earth round the centre of our elements. This is proved as follows:—the mighty rivers always flow turbid because of the earth stirred up in them through the friction of their waters upon their bed and against the banks; and this process of destruction uncovers the tops of the ridges formed by the layers of these shells, which are embedded in the mud of the sea where they were born when the salt waters covered them. And these same ridges were from time to time covered over by varying thicknesses of mud which had been brought down to the sea by the rivers in floods of varying magnitude; and in this way these shells remained walled up and dead beneath this mud, which became raised to such a height that the bed of the sea emerged into the air.

And now these beds are of so great a height that they have become hills or lofty mountains, and the rivers which wear away the sides of these mountains lay bare the strata of the shells, and so the light surface of the earth is continually raised, and the antipodes draw nearer to the centre of the earth, and the ancient beds of the sea become chains of mountains. E 4 V.

The destruction of marshes will be brought about when turbid rivers flow into them.

This is proved by the fact that where the river flows swiftly it washes away the soil, and where it delays there it leaves its deposit, and both for this reason and because water never travels so slowly in rivers as it does in the marshes of the valleys the movement of the waters there is imperceptible. But in these marshes the river has to enter through a long narrow winding channel, and it has to flow out over a large area

of but little depth; and this is necessary because the water flowing in the river is thicker and more laden with earth in the lower than in the upper part; and the sluggish water of the marshes also is the same, but the variation between the lightness and heaviness of the upper and lower waters of the marshes far exceeds that in the currents of the rivers, in which the lightness of the upper part differs but little from the heaviness of the part below.

So the conclusion is that the marsh will be destroyed because it is receiving turbid water below, while above, on the opposite side of the same marsh, only clear water is flowing out; and consequently the bed of the marsh will of necessity be raised by means of the soil which is being continually discharged into it. E 5 r.

How by running waters one should conduct the soil of the mountains into marshy valleys and so render them fertile and purify the surrounding air:

The ramifications of the canals which are led from the high hills according to their natural course are those which in their changes carry the soil from these hills to the low marshes, filling them up with earth and rendering them fertile.

Let a be the main stream which enters the marshes at b f s; let the canal start from the height of the hills a c n, from which suppose various branches to have fallen, changing it where it is all united into different places, and thus their fury tears away the soil and after they have run their course they deposit it in the low swamps; and thus you will be able to change so much the fall of the whole canal, abounding as it does in water, that you will have levelled the soil left uncovered from these marshes. F 14 r.

Why pools are formed near the sea, and why their great floods are poured into the sea through so narrow a channel, upon the sides of which between the pool and the sea so great a bank is formed:

The storms of the sea cast up on to the shore a great quantity of sand, and this is heaped up all along the shore both at the mouth of the pool and elsewhere; and as the storm ceases the mouth of the pool remains closed by the aforesaid matter thrown up by the sea. And as the water that the pool receives from the neighbouring rivers cannot find any other exit it proceeds to rise and acquire weight and power; and there-

fore it either bursts through the bank interposed between it and the sea or flows over it and with its outpouring wears away as much of the bank as it touches, pursuing its course until it has cleared out of its path all the matter that impeded its necessary dispersion.

Moreover it only consumes what is necessary; at first it is very large because the water that flows towards where the mouth should be is clear, and at the end the course of the water becomes contracted, because it has become thicker as it acquires depth; and this is the reason why such outlet from the pools to the sea is always narrow. F 40 v.

OF THE WAVES

Sometimes the waves are swifter than the wind, and sometimes the wind is much swifter than the wave; the ships prove this upon the sea. The waves can be swifter than the wind through having been commenced by the great winds, the wind then having ceased and the wave having still preserved a great impetus. F 48 v.

One asks whether a river which passes through a lake changes the uniform distance at which the surface of this lake was from the centre of the earth before this river passed through the said lake.

This is an interesting question; and one shows that this surface disturbs the uniformity of its distance from the centre of the earth in order to give a passage to the said river, by the fourth [rule], which shows that water does not move unless to descend. And here it is necessary to understand whether the exit of the river has a width equal to that of the entrance and if this is so it is necessary that the water be of uniform course, by the seventh [rule], which shows that the movement of every river in an equal time gives to every part of its length an equal weight of water. Now if the river emitted water which required a drop of a braccio in a mile, the width of the exit being as has been said equal to the width of the entrance, it would be necessary that all the river which passes through the lake should also have a drop of one braccio per mile, and consequently the water of this lake would have its surface at a varying distance from the centre of the earth. But the water will have this course. . . .

That part of the water of the lake will be of slowest movement which

finds itself farthest removed from the shortest line from the entrance to the exit of the river which passes through this lake.

Here it follows that the Sea of Azov which borders upon the Don is the highest part of the Mediterranean Sea; and it is three thousand five hundred miles distant from the straits of Gibraltar, as is shown by the navigators' chart; and it has a descent of three thousand five hundred braccia, that is a mile and a sixth, this sea consequently being higher than any mountain that there is in the west. F 68 r. and v.

OF THE WIND

Since the eddies of the winds are below and above as well as cross-wise the countryfolk cannot tell what wind it is that is blowing, that is those who dwell under the hills by the sea shores do not know if the wind is from an eddy or if it is the straight wind.

The wind that strikes upon the sea coasts or borders or sides of the mountains raises itself up to the summit where it presses itself against the course of the other straight wind, and then it spreads itself out moistening the opposite. . . . I 130 [82] v.

Why the thunder lasts for a longer time than that which causes it; and why, immediately on its creation, the lightning becomes visible to the eye, while the thunder requires time to travel, after the manner of a wave, and makes the loudest noise when it meets with most resistance.

 K 110 [30] v.

WINDS AND THUNDERBOLTS

The winds which rise from the cloud continue in movement; in such a way that the more they move the farther they rise in the lighter air because they are less impeded there. And if they meet each other they leap back, and it is in these encounters that thunderbolts are produced.

If the wind originates at a low altitude, what is it that drives it more to the east than to the west? K 113 [33] r.

[*Watery sphere and centre of world*]

The surface of the watery sphere is always more remote from the centre of the world:

This comes about by reason of the soil brought by the inundations of turbid rivers. These deposit the soil which causes their turbidity on the shores of the ocean and so narrow the sea beach; beside this they raise their bed and so of necessity the surface of this element comes to be raised.

The centre of the world continually changes its position in the body of the earth fleeing towards our hemisphere.

This is shown by the above-mentioned soil which is continually carried away from the declivities or sides of the mountains and borne to the seas; the more it is carried away from there the more it becomes lightened and as a consequence the more it becomes heavy where this soil is deposited by the ocean waves, wherefore it is necessary that such centre changes its position. L 13 v.

[*Surface of the earth and centre of gravity*]

That part of the surface of any heavy body will become more distant from the centre of its gravity which becomes of greater lightness.

The earth therefore, the element by which the rivers carry away the slopes of the mountains and bear them to the sea, is the place from which such gravity is removed; it will make itself lighter and in consequence will make itself more remote from the centre of the gravity of the earth, that is from the centre of the universe which is always concentric with the centre of the gravity of the earth. L 17 r.

[*Changes in mountains and valleys*]

The summits of the mountains in course of time rise continually.

The opposite sides of the mountains always approach one another.

The depths of the valleys which are above the watery sphere in course of time constantly draw near to the centre of the world.

During the same period of time the valleys sink much more than the mountains rise.

The bases of the mountains are always drawing closer together.

As the valley grows deeper so its sides become worn away in a shorter space of time. L 76 r.

[*Cosmography of Ptolemy*]

A line commenced at one extremity of the world may still be parallel and equidistant to another line commenced at the opposite side of the

world, as Ptolemy shows in his Cosmography when he shows that cities situated in the opposite extremities of the earth are in the same parallel.

M 5 v.

[*Water upon sand*]

Why as smooth sand is formed of grains uneven in shape and size the water which flows above them drives these grains with varying degrees of movement? Just as the bodies that vary in weight and shape make different movements in the still air so do the air and the water as they move among still bodies. And this is why the sand loses its smoothness by the movement of the water that passes over it. And the moved water performs the same function upon the sand as the moved air does upon the water. And if you prove that the bed of the flat sand makes its waves and becomes uneven through the unevenness of its granules, and that such unevenness could not exist on the surface of the water which is a smitten and uniform body, I will maintain that the air is full of parts which have a movement that is not uniform and therefore the parts moved by the contact of the air move without uniformity.

M 41 r.

The cause which makes water move in the springs contrary to the natural course of its gravity works in the same way in all the humours in all species of animated bodies. And just as the blood from below surges up and then falls back should a vein burst in the forehead, so the water rises from the lowest depth of the sea to the summits of the mountains, and there, finding the springs burst open, is poured out through them and returns to the depths of the sea. Have you ever seen how the water that drips from the severed branches of the vine and falls back upon its roots penetrates these and so rises up anew? Thus it is with the water that falls back into the sea, for it penetrates through the pores of the earth and having returned into the power of its mover, whence it rises anew with violence and descends in its accustomed course, it then returns. Thus adhering together and united in continual revolution it goes moving round backwards and forwards; at times it all rises together with fortuitous movement, at times descends in natural liberty. Thus moving up and down, backwards and forwards, it never rests in quiet either in its course or in its own substance: and as the mirror is changed to the colour of the objects which pass before it,

it has nothing of itself but moves or takes everything, and is changed to as many different natures as the places are different through which it passes. B.M. 58 v.

That principle which moves the watery humours contrary to the natural course of their gravity in all living species moves the water also through the springs in the ground, and with continual solicitude renders aid in all those places in which necessity teaches it. And that which is seen falling down from high places and forming the commencement of the course of every river, acts in the same manner as the blood that rises up from the lower part and pours itself away through a cleft in the forehead. B.M. 59 r.

From the two lines of shells one must needs suppose that the earth in disdain plunged beneath the sea and so formed the first layer and that the Flood afterwards formed the second. B.M. 156 v.

How the rivers widen the valleys and wear away the roots of the mountains along their sides:
The windings which the rivers make through their valleys as they leap back from one mountain to another cause the bank to form curves, and these curves move with the current of the water and in course of time seek out the whole valley, unless they are checked by the fact of it becoming increased in length and depth and diminished in breadth. B.M. 168 v.

And as from the lower part of the vine the water rises to the severed branches, and falls back upon its roots and by penetrating these rises up again to the point where they are broken and falls back afresh, even so does the water.
So from the lowest depth of the sea the water raises itself and rises to the summits of the mountains, and as the water pours through the severed branches of the vine and falls back upon its roots, penetrating them, even so does the water which. . . . B.M. 233 r.

So does the water which is moved from the deep sea up to the summits of the mountains, and through the burst veins it falls down again to the shallows of the sea, and so rises again to the height where it burst through, and then returns in the same descent. Thus proceeding alter-

nately upwards and downwards at times it obeys its own desire at times that of the body in which it is pent. B.M. 233 V.

Every heap of sand whether it be on level ground or sloping will have its base twice the length of its axis. Forster II 16 r.

OF THE SEA

If the water becomes so salt through the earth being burnt up by the sun it should follow that when the earth is boiled in water this water becomes salt. Quaderni II 19 r.

[Influence of sun and moon on tides]
That power shows itself greater which is impressed upon a lesser resistance. This conclusion is universal and we may apply it to the flow and ebb in order to prove that the sun or moon impresses itself more on its object, that is on the waters, when these are of less depth. Consequently the shallow waters of swamps ought to receive with greater potency the cause of the flow and ebb, than the great depths of the ocean. Quaderni II 22 v.

[Filling of footprints in sand]
When the foot is drawn up out of wet sand the water runs back right to the surface of the sand, and this occurs because the water which is mingled with the sand is quicker to fill up the vacuum left by the foot than the sand is, and the air would be even quicker if it could enter; but the wet sand always keeps the way closed up by which the leg entered the sand, and so prevents the air from entering to fill up the vacuum. Quaderni IV 15 r.

How the valleys were formerly in great part covered by lakes because their soil always forms a bank for rivers, and by seas which afterwards through the unceasing action of the rivers that form the store of water that is in the m[ountains], cut through the mountains; and the rivers in their wandering courses carried away the wide open plains enclosed by the mountains; and the cuttings of the mountains are perceptible from the strata of the rocks which correspond to the sections made by the said courses of the rivers:

The Haemus range which crosses Thrace and Dardania and joins on

the west the Sardonius range as it proceeds towards the west changes the name of Sardus to Rebi as it approaches Dalmatia, and then continuing towards the west crosses Illyria now called Slavonia, and changes the name of Rebi to Albanus, and still continuing westward changes it to the Ocra range.

To the north and south above Istria it is named Caruancas (Carusadius?), and to the west above Italy it unites with the Adula range where the Danube[1] rises, which flows for a course of fifteen hundred miles and for about a thousand miles in the most direct line; and for just as far or thereabouts the spur of the Adula range is changed to the names of the mountains already mentioned.

To the north stands the Carpathian range which encloses the breadth of the valley of the Danube which as I have stated stretches eastwards for a distance of about a thousand miles and has a width of sometimes two hundred and sometimes three hundred miles. Through the midst of it flows the Danube, the first river of Europe in magnitude, and this Danube as it flows leaves on the south Austria and Albania and on the north Bavaria, Poland, Hungary, Wallachia and Bosnia. The Danube or as it is called the Donau then flows into the Black Sea which used to extend almost as far as Austria and covered all the plain where to-day the Danube flows; and the sign of this is shown by the oysters and cockleshells and scollops and bones of great fishes which are still found in many places on the high slopes of the said mountains; and this sea was created by the filling up of the spurs of the Adula range which extend to the east and unite with the spurs of the Taurus range extending to the west. And near Bithynia the waters of this Black Sea discharged themselves into the Propontis, falling into the Aegean Sea, that is the Mediterranean Sea, where at the end of their long course the spurs of the Adula range are severed from those of the Taurus range, and the Black Sea sank down and laid bare the valley of the Danube with the above-named provinces, and the whole of Asia Minor beyond the Taurus range to the north, and the plain which stretches from the Caucasus to the Black Sea to the west, and the plain of Tanais (the Don) this side of the Ural mountains that is at their feet.

So the Black Sea must have sunk about a thousand braccia to uncover such vast plains. Leic. 1 v.

[1] MS. has Rhine.

In this work of yours you have first to prove how the shells at a height of a thousand braccia were not carried there by the Deluge, because they are seen at one and the same level, and mountains also are seen which considerably exceed this level, and to enquire whether the Deluge was caused by rain or by the sea rising in a swirling flood; and then you have to show that neither by rain which makes the rivers rise in flood nor by the swelling up of the sea could the shells being heavy things be driven by the sea up the mountains or be thrown there by the rivers contrary to the course of their waters. Leic. 3 r.

When a river flows out from among mountains it deposits a great quantity of large stones in its gravelly bed, and these stones still retain some part of their angles and sides; and as it proceeds on its course it carries with it the lesser stones with angles more worn away, and so the large stones become smaller; and farther on it deposits first coarse and then fine gravel, and after this big and then small shingle, and after this follows sand at first coarse and then more fine; and thus continuing the water turbid with shingle and sand reaches the sea.

The shingle is deposited over the shores of the sea by the backwash of the salt waves, until at last the sand becomes so fine as to seem almost like water. Nor does this remain upon the sea shores but goes back with the wave by reason of its lightness, being formed of rotting leaves and other things of extreme lightness; and consequently being as has been said almost of the nature of water in time of calm weather it drops down and settles at the bottom of the sea, where by reason of its fineness it becomes compressed and resists the waves which pass above it on account of its smoothness; and in this shells are found and this is the white earth that is used for making jugs. Leic. 6 v.

OF THE FLOOD AND OF MARINE SHELLS

If you should say that the shells which are visible at the present time within the borders of Italy, far away from the sea and at great heights, are due to the Flood having deposited them there, I reply that, granting this Flood to have risen seven cubits above the highest mountain, as he has written who measured it, these shells which always inhabit near the shores of the sea ought to be found lying on the moun-

tain sides, and not at so short a distance above their bases, and all at the same level, layer upon layer.

Should you say also that the nature of these shells causes them to keep near the edge of the sea, and that as the sea rose in height the shells left their former place and followed the rising waters up to their highest level:—to this I reply (*that in forty days the shells cannot travel* [1]) that the cockle is a creature incapable when out of water of more rapid movement than the snail, or is even somewhat slower, since it does not swim, but makes a furrow in the sand, and supporting itself by means of the sides of this furrow will travel between three and four braccia in a day; and therefore with such a rate of motion it would not have travelled from the Adriatic Sea as far as Monferrato in Lombardy, a distance of two hundred and fifty miles, in forty days,— as he has said who kept a record of this time.

And if you say that the waves carried them there,—they could not move by reason of their weight except upon their base. And if you do not grant me this, at any rate allow that they must have remained on the tops of the highest mountains, and in the lakes which are shut in among the mountains, such as the lake of Lario or Como, and Lake Maggiore [2], and that of Fiesole and of Perugia and others.

The water of the contingent seas forms the sphere of the water which has for the centre of its surface the centre of the world but not as the centre of its gravity, because in many places it is of great depth and in many of small depth, and for this reason as it is not of uniform thickness it is not of uniform weight. But merely because that thing is higher which is more remote from the centre of the world, therefore this surface not being in movement cannot remain in any place higher in one part than in another, because the highest part of the water always seeks to fill up with itself the part of it which is lower.

If the Flood passed as has been said, above the mountains of our hemisphere, without doubt it made the gravity of this our habitable part greater than that of the antipodes, and as a consequence it brought it nearer to the centre of the world than it was at first; and the part opposite was removed farther away from this centre, for which reason

[1] Words crossed out in MS.

[2] MS. 'come lago di Lario, e'l Maggiore, e di Como'. Larius was however the Latin name for Lake Como.

the aforesaid Flood submerged more than would have been submerged if such gravity had not been acquired by it on this side.

If you should say that the shells were empty and dead when carried by the waves, I reply that where the dead ones went the living were not far distant, and in these mountains are found all living ones, for they are known by the shells being in pairs, and by their being in a row without any dead, and a little higher up is the place where all the dead with their shells separated have been cast up by the waves. Near to there the rivers plunged into the sea in great depth; like the Arno which fell from the Gonfolina near to Monte Lupo and there left gravel deposits, and these are still to be seen welded together, forming of various kinds of stones from different localities and of varying colour and hardness one concrete mass. And a little farther on, where the river turns towards Castel Fiorentino the hardening of the sand has formed tufa stone; and below this it has deposited the mud in which the shells lived; and this has risen in layers according as the floods of the turbid Arno were poured into this sea, and so from time to time the bed of the sea was raised.

This has caused these shells to be produced in pairs, as is shown in the cutting of Colle Gonzoli, made sheer by the river Arno which wears away its base, for in this cutting the aforesaid layers of shells may be seen distinctly in the bluish clay, and there may be found various things from the sea.

And the earth of our hemisphere became raised up more than it was before as by degrees it became lightened of the water that flowed away from it through the straits of Gibraltar; and it was raised so much the more because the weight of the water which flowed away from it was added to that of the earth that was turned to the other hemisphere.

And if the shells had been in the turbid water of a deluge they would be found mixed up and separated one from another, amid the mud, and not in regular rows in layers as we see them in our own times.

Leic. 8 v.

As for those who say that these shells are found to exist over a wide area having been created at a distance from the sea by the nature of the locality and the disposition of the heavens, which moves and influences the place to such a creation of animal life, to these it may be answered

that granted such an influence over these animals it could not happen that they were in one line except in the case of animals of the same species and age; and not the old with the young, nor one with an outer covering and another without its covering,[1] nor one broken and another whole, one filled with sea sand, and the fragments great and small of others inside the whole shells which stand gaping open; nor the claws of crabs without the rest of their bodies; nor with the shells of other species fastened on to them like animals crawling over them and leaving the mark of their track on the outside where it has eaten its way like a worm in wood; nor would there be found among them bones and fishes' teeth which some call arrows and others serpents' tongues; nor would so many parts of different animals be found joined together, unless they had been thrown up there upon the borders of the sea.

And the Flood would not have carried them there because things heavier than water do not float upon the surface of the water, and the aforesaid things could not be at such heights unless they had been carried there floating on the waves, and that is impossible on account of their weight.

Where the valleys have never been covered by the salt waters of the sea there the shells are never found; as is plainly visible in the great valley of the Arno above Gonfolina, a rock which was once united with Monte Albano in the form of a very high bank. This kept the river dammed up in such a way that before it could empty itself into the sea which was afterwards at the foot of this rock it formed two large lakes, the first of which is where we now see the city of Florence flourish together with Prato and Pistoia; and Monte Albano followed the rest of the bank down to where now stands Serravalle. In the upper part of the Val d'Arno as far as Arezzo a second lake was formed and this emptied its waters into the above-mentioned lake. It was shut in at about where now we see Girone, and it filled all the valley above for a distance of forty miles. This valley received upon its base all the earth carried down by the turbid waters and it is still to be seen at its maximum height at the foot of Prato Magno for there the rivers have not worn it away.

Within this soil may be seen the deep cuttings of the rivers which

[1] MS. e l'altro essere *colla* sua copritura.

have passed there in their descent from the great mountain of Prato Magno; in which cuttings there are no traces visible of any shells or of marine earth.

This lake was joined to that of Perugia.

A great quantity of shells may be seen where the rivers empty themselves into the sea, because in such places the water is not very salt on account of the mixture of the fresh water which unites with it. A proof of this is to be seen where the Apennines once emptied their rivers into the waters of the Adriatic, for there among the mountains in most parts a great quantity of shells are visible together with bluish marine clay; and all the rocks which are broken away in such places are found to be full of shells.

We know that the Arno did the same when it fell from the rock of Gonfolina into the sea which was not very far below it, because in those times it must have stood higher than the top of San Miniato al Tedesco, since in the highest summits of this [mountain] one sees the rocks full of shells and oysters within its banks; the shells did not extend in the direction of Val di Nievole because the fresh waters of the Arno did not extend so far.

How the shells were not carried from the sea by the Deluge, because the waters which came from the earth to the sea although they drew the sea towards the earth were those which smote its base, because the water which comes from the earth has a stronger current than that of the sea, and as a consequence is more powerful and enters beneath the other water of the sea, and stirs up the bottom and carries with it all the movable objects which are to be found in it such as the above-mentioned shells and other like things; and as the water which comes from the land is muddier than that of the sea it is so much the more powerful and heavier than it. I do not see therefore in what way the said shells could have come to be so far inland unless they had been born there.

If you should tell me that the river Loire which passes through France spreads itself over more than eighty miles of country when the sea is increased, because the country forms a great plain and the sea rises about twenty braccia, and that shells are sometimes found in this plain at a distance of eighty miles from the sea, the reply is that the flow and ebb in our Mediterranean seas does not cause so much varia-

tion because in the Gulf of Genoa it does not vary at all, at Venice and in Africa only a little, and where it varies only a little it covers but little of the country. *Leic. 9 r.*

Refutation of such as say that the shells were carried a distance of many days' journey from the sea by reason of the Deluge.

I hold that the Deluge would not be able to carry up into the mountains objects native to the sea unless the sea had become so swollen as to form a flood so great that it even mounted above the height of these same places, and this process could not have occurred because it would have created a vacuum; and if you should say that the air would rush in there we have already concluded that what is heavy cannot be supported on what is light wherefore we conclude of necessity that this Deluge was caused by rain water; and if this was the case all this water flowed into the sea and the sea does not flow up the mountains; and if it ran into the sea it pushed the shells along the shore into the sea and did not draw them to itself. And if you should say that because the sea was raised by rain water it carried these shells to such a height, we have already stated that things heavier than water cannot float upon its surface but remain at the bottom and are not moved from there unless by pressure from the waves. And if you were to say that it was the waves which had carried them to these high places we have proved that the waves when of great depth move in an opposite direction at their base to their movement above, this being shown by the turbidity of the sea arising from the soil that has been washed away near its shores.

An object lighter than water moves with its wave and it is left on the highest spot of the bank by the highest wave; an object heavier than water moves only when driven by its wave along the surface of its bed. And from these two conclusions which in their places will be fully proved we may conclude that the wave of the surface cannot carry shells because they are heavier than water; and consequently they will be driven by the lower wave when the wind comes from the land, because when the wind comes from the land the wave at the bottom of the sea moves in the opposite direction to the course of the wind which is then prevailing; and this moreover will not cause the shells to be carried to the mountains, because the water at the bottom which moves

in the opposite direction to the wind will be so much slower than the wave of the surface as it is deeper than the height of the wave. This is evident because if the wave of the surface is the height of one braccio and there are a hundred braccia of water below it then without doubt the lower wave will be a hundred times slower than the upper wave, as is shown in the seventh proposition. The upper wave will never turn back on its base with any great force unless the depth of the water that is below the wave is equal to that of the wave.

The tiny wave which may be seen on the high seas travelling against the course of the wind will not pass over its base, that is it will not touch it but will dissolve at contact with the surface wave. I hold that such movement of water, changing from its surface to its base, resembles that which takes place on the surface between two banks, seeing that if a third of the expanse of the river be moving towards the west, another third will move towards the east and the remainder to the west; and if there should be another similar part there that would return to the east. The lateral movements of rivers will become slower in proportion as they are farther removed from the first current. As regards the friction created by water inside other water and moving more swiftly, whether it divides immediately, that is whether the edges of this body of water are worn away or follow one after another, that is the swifter portion carrying the less swift with it,—I maintain that this is not the case, for if it carried with it more water than usual it would grow to such a size during its long course that it would be carrying with it all the water of the river.

Why the oysters are very seldom found dead on the shores of the sea is because usually they live fastened to the rocks at the bottom of the sea and are incapable of movement except in the half which is sensitive and light. The other valve is fixed to the stone or if not fixed nature has caused them to grow larger and so to become so heavy that the small amount of undulation which takes place in the vast depths of the sea cannot easily dislodge them. But the valve that has the power of movement is very light and performs the same function for it as the lid does for a chest. And when the oyster feeds, its food walks into the house of its own accord, for it consists of certain animalculae which feed round the shells of the dead ones and which consequently are found where there are a great many shells of dead oysters. If the

Deluge had carried the shells for distances of three and four hundred miles from the sea it would have brought them with the various different species mixed up, all heaped up together; but even at such distances from the sea we see the oysters all together and also the shell-fish and the cuttle-fish and all the other shells which stand together in companies, found all together dead, and the single shells are found one at a distance from another as we see them every day on the sea shores.

And we find the oysters together in very large families, among which some may be seen with their shells still joined together, which serves to indicate that they were left there by the sea and that they were still living when the straits of Gibraltar were cut through.

In the mountains of Parma and Piacenza multitudes of shells and corals filled with worm-holes may be seen still adhering to the rocks, and when I was making the great horse at Milan a large sack of those which had been found in these parts was brought to my workshop by some peasants, and among them were many which were still in their original condition.

Under the ground and down in the deep excavations of the stone-quarries timbers of worked beams are found which have already become black. They have been found during my time in the excavations made at Castel Fiorentino, and they were buried there before the sand deposited by the Arno in the sea which then flowed over the spot had been raised to such a height, and before the plains of the Casentino had been so much lowered by the removal of the earth which the Arno was continually washing away from them.

In Candia, in Lombardy, near to Alessandria della Paglia, while some men were engaged in digging a well for Messer Gualtieri who has a house there, the skeleton of a very large ship was found at a depth of about ten braccia beneath the ground; and as the timber was black and in excellent condition, Messer Gualtieri thought fit to have the mouth of the well enlarged in such a way that the ends of the ship should be uncovered.

The red stone of the mountains of Verona is found with shells all intermingled which have become part of this stone, and their mouths have become sealed up by the cement of which the stone has been formed, and portions of them have remained separated from the rest of the mass of stone which enclosed them, because the outer covering of

the shell intervened and thus prevented them from uniting; and in other cases this cement has petrified the old broken outer covering.

And if you should say that these shells have been and still constantly are being created in such places as these by the nature of the locality and through the potency of the heavens in those spots, such an opinion cannot exist in brains possessed of any extensive powers of reasoning because the years of their growth are numbered upon the outer coverings of their shells; and both small and large ones may be seen, and these would not have grown without feeding or feed without movement, and here they would not be able to move. Leic. 9 v.

How the northern bases of certain Alps are not yet petrified; this is seen clearly where the rivers which cut through them flow towards the north, for these cut through the strata of the living rock in the mountain heights; and where they unite with the plains these strata are all of clay that serves to make pots, as is seen in the Val di Lamona where the river Lamona as it issues from the Apennines does these same things in its banks.

How the rivers have all sawn through and divided the members of the great Alps one from another; and this is revealed by the arrangement of the stratified rocks, in which from the summit of the mountain down to the river one sees the strata on the one side of the river corresponding with those on the other. How the stratified rocks of the mountains are all in layers of mud deposited one above another by the floods of the rivers. How the different thicknesses of the strata of the rocks are created by the different floods of the rivers, that is the greater and the less floods.

How between the various layers of the stone are still to be found the tracks of the worms which crawled about upon them when it was not yet dry. How all the marine clays still contain shells, and the shell is petrified together with the clay. Of the stupidity and ignorance of those who imagine that these creatures were carried to such places distant from the sea by the Deluge.

How another set of ignoramuses maintain that nature or the heavens have created them in these places through celestial influences; as though in those places one did not find the bones of fishes which have taken a long time to grow; as though one could not count on the shells

of cockles and snails the number of the months and years of their lives, just as one can on the horns of bulls and wethers and in the ramification of plants when they have never been cut in any part. And having shown by these signs that the length of their life is evident, it must needs be admitted that these animals could not live without the power of movement in order to seek their food, and we cannot see that they are equipped with any instrument for penetrating the earth or stone in which they find themselves enclosed. But how could one find in the shell of a large snail fragments and bits of many other sorts of shells of different kinds unless they had been thrown into it by the waves of the sea as it lay dead upon the shore like the other light things which the sea casts up on the land?

Why do we find so many fragments and whole shells between the different layers of the stone unless they had been upon the shore and had been covered over by earth newly thrown up by the sea which then became petrified? And if the above-mentioned Deluge had carried them to these places from the sea, you would find the shells at the edge of one layer of rock only, not at the edge of many where may be counted the winters of the years during which the sea multiplied the layers of sand and mud brought down by the neighbouring rivers, and spread them over its shores. And if you should wish to say that there must have been many deluges in order to produce these layers and the shells among them it would then become necessary for you to affirm that such a deluge took place every year. Further as regards the fragments of these shells, it must be presumed that in such a locality there was a sea beach, where the shells were all cast up broken and divided and never in pairs as they are found in the sea when alive, with two valves which form a covering the one to the other. And within the layers of the banks of rivers and of sea shores they are found broken; and on the edges of the rocks they are found infrequently and with the two valves together, like those which were left by the sea buried alive within the mud which afterwards dried up and in time became petrified. Leic. 10 r.

And if you should say that it was the Deluge that carried these shells away from the sea for hundreds of miles, this cannot have happened for the Deluge came about as the result of rains, because the rains natu-

rally cause the rivers together with the objects carried by them to rush towards the sea and they do not draw up to the mountains the dead things on the sea shores.

And if you should say that the Deluge then rose with its waters above the mountains, the movement of the sea in its journey against the course of the rivers would have been so slow that it would not have been able to carry things heavier than itself floating in it; or if somehow it had had them floating in it then as it subsided it would have left them strewn about in various places. But how are we to account for the fact of the corals being found every day round about Monferrato in Lombardy with worm-holes in them, sticking to the rocks which have been left bare by the currents of the rivers? And the said rocks are all covered with stocks and families of oysters, which as we know do not move but always remain fixed by one of their valves to the rock, having the other open in order to feed upon the animalculae that are swimming about the waters and which while hoping to find good pasture become the food of the above-mentioned shells. Is it not found that the sand that is mixed with the seaweed has become petrified when the seaweed which has divided it has become less? And of this the Po affords instances every day in the debris of its banks.

At Alessandria della Paglia in Lombardy there is no other stone from which to make lime except such as is made up of an infinite number of things native to the sea; but it is now more than two hundred miles distant from the sea.

In eighty-nine [the year 1489] there was an earthquake in the sea of Satalia near to Rhodes, and it opened the depths of the sea and into the opening that was made such a torrent of water was poured that for more than three hours the bed of the sea lay bare because of the water which had been lost from it, and then it closed up again to its former level. Whatever changes may occur in the weight of the earth the surface of the sphere of waters will never cease to be equidistant from the centre of the world.

The bosom of the Mediterranean like a sea received the principal waters of Africa, Asia and Europe; for they were turned towards it and came with their waters to the base of the mountains which surrounded it and formed its banks.

And the peaks of the Apennines stood up in this sea in the form of

islands surrounded by salt water. Nor did Africa as yet behind its Atlas mountains reveal the earth of its great plains naked to the sky some three thousand miles in extent; and on the shore of this sea stood Memphis; and above the plains of Italy where flocks of birds are flying to-day fishes were once moving in large shoals. Leic. 10 v.

That there are springs which as a result of earthquakes or other unforeseen causes suddenly burst forth and as suddenly fail. And this happened in a mountain in Savoy where certain woods sank in and left a very deep abyss; and at about four miles distance from there the ground opened on the slope of a mountain and threw out suddenly an immense flood of water, which swept through a whole valley of tilled fields vineyards and houses and did irreparable damage wherever it spread.

That there are many springs which come to fail suddenly: and this happens through some subsidence in a cavern that is pent up within the body of the earth whereby the passage of the said springs is blocked and hindered.

That there are many springs which spring up suddenly and are permanent; and this occurs when some river in its long course has worn away so much of the mountain that it bursts open springs of water which have a passage there; it may also occur as I said before when a cave has fallen in ruin and blocked up a spring, so that its water has been forced up to such a height in this cavern that it reaches the level of some fissure in the rock and so has made its escape, creating a new river.

That many springs of salt water are found at great distances from the sea; and this may have come about because these springs have passed through some mine of salt like that in Hungary where the salt is hewn out of immense quarries just as blocks of stone are.

That within rocks surrounded by salt waters and within these salt waters themselves in the same way there rise in many places springs of fresh water.

That there are in many places springs of water which rise for six hours and sink for six hours; and I have myself seen one above Lake Como called Fonte Pliniana which increases and decreases in this way to such an extent that when it is flowing it grinds two mills, and when

it fails it falls so low that it is as though one were looking at the water
in a deep well. Leic. 11 v.

A tempest on the sea is much more violent near to the shore than on
the high sea; and this is the case because the recoil of the waves is strik-
ing the sea on the one side and the wind strikes it on the other, and this
causes the wave to be higher and more topped with spray. Leic. 12 r.

How the flow and ebb of the tide is not uniform, for on the coast of
Genoa there is none; at Venice it makes a variation of two braccia; be-
tween England and France of eighteen braccia. How the current that
flows through the straits of Sicily is very powerful because through
these there pass all the waters of the rivers which discharge themselves
into the Adriatic.

When the surface of the water consists of small shaded waves which
form themselves into lines that meet in an angle,[1] the fact shows that
the bed of the river is not far away, and it is also produced by the sand
thrown off by the water as it passes through a confined space such as
the arch of a bridge or the like. When the lines of its surface form a
curved or crescent shaped figure this is a sign of its lack of depth, for
it is caused by the sand carried by the greater current into the lesser,
that is by the less sluggish to the more sluggish, since both of them have
but little speed or depth. When the surface of the water shows itself as
a straight line or just a little bent with tiny waves and these with but
little sheen or brightness there is very little depth there; and this is
caused by two currents one slower than the other which join together
again below the island that divides them higher up; for these have
caused the sand which each bore with it to settle, because it is deposited
at the point of their junction, since at this spot their movement ended.
Leic. 13 r.

Why the bones of great fishes and oysters and corals and various
other shells and sea-snail are found on the high tops of mountains that
border on the sea, in the same way in which they are found in the
depths of the sea?

[1] These words serve exactly to describe the treatment of the waves in Botticelli's
'Birth of Venus'.

How the rocks and promontories of the seas are being continually destroyed and worn away.

How the Mediterranean seas will lay bare their depths to the air, and will only keep the channel of the greatest river that flows there which will run to the ocean and there discharge its waters together with those of all the rivers which are its tributaries.

How the brightness of the atmosphere is caused by the water that is dissolved in it and that has formed itself into imperceptible particles which after taking the light of the sun from the opposite side give back the brightness that is visible in this atmosphere; and the blue that appears in it is caused by the darkness which is hidden behind this atmosphere.

Why the Adige rises every seven years and falls every seven years, and is the cause of famine or abundance?

Why following on great pestilences the rivers become deeper and run clear though previously they were wide and of but little depth and always turbid? Leic. 20 r.

The sea shuts itself in among the great valleys of the earth; and this earth serves as a cup for the sea; and the lips of the cup are the shores of the seas, and if these were taken away the sea would cover all the earth; but because every part of the earth that is uncovered is higher than the greatest height of the sea this sea cannot flow over it, but merely contents itself with covering that earth which serves as its bed. Many, however, in ignorance of this thing, have presumptuously written how the surface of the water of the sea is higher than the highest mountain that can be found; as regards which thing, although they see the bank higher than the water, they are extremely blind who say that it is a miracle for the water in the midst of the sea to be higher than its shore or than the promontories which jut out over the sea. But this fallacy arises from the fact that they imagine a straight line of indefinite length extended above the middle of the sea, which without doubt will be higher than the said shores, because the earth is a sphere and its surface forms a curve, and the farther it is removed from its middle the more it becomes remote from the said straight line; the fact of it becoming lower in this condition is that which has deceived them; and it is this reason which will be brought forward

by the adversary. 'That part of the water will be higher which is more remote from the centre of the world'.

Observe that here there is no place for the straight unending *a b* of the adversary, because *b g* exceeds the line *e g* by the whole part *b n*; and by this it is confirmed that the surface of the seas which are joined together are equally distant from the centre of the earth. 'The highest mountains are as far above the sea as the lowest depths of the sea are below the air.'

For a long time the water of the Mediterranean flowed through the Red Sea which is a hundred miles wide and fifteen hundred miles long, all full of reefs; and it has worn away the sides of Mount Sinai, which circumstance does not point to a flood from the Indian Ocean having struck upon these shores but to a great deluge of water which carried with it all the rivers which are very numerous round the Mediterranean, and also the ebb of the sea. And afterwards Mount Calpe was cut through in the west, three thousand miles distant from this spot, and separated from Mount Abyla; and this cutting took place at the lowest spot in the wide plains which lie between Abyla and the ocean, in the low part at the foot of the mountain, helped by the hollowing out of some valley caused by some river which must have flowed there. Hercules came to open the sea in the west, and then the waters of the sea commenced to flow into the western ocean; and as a consequence of this great fall the Red Sea remained the higher, and therefore the waters have ceased to flow in that direction but have always ever since poured through the Straits of Spain [Gibraltar].

On the shores of the Mediterranean three hundred rivers are found discharging their waters and there are some forty thousand two hundred harbours, and this sea is three thousand miles in length. Many times the swollen waters of the sea have been heaped up by its reflux, by the western gales, the flooding of the Nile and of the rivers which flow into the Black Sea. So the seas came to be so much raised that they have flowed over many countries causing immense floods; and these floods occur at the time when the sun melts the snow on the high mountains of Ethiopia which rise into the cold regions of the air; even so is it as the sun approaches near to the mountains of Sarmatia in Asia and to those in Europe; so that the accumulations occasioned by these three above-mentioned things are and have been

the cause of the greatest floods, namely the ebb of the sea, the western wind and the melting of the snows. And all things have been overwhelmed in swirling flood in Syria, Samaria, Judaea between Sinai and Lebanon, and in the rest of Syria between Lebanon and Mount Taurus, and in Cilicia within the mountains of Armenia, and in Pamphylia and in Lycia within the Celenian mountains, and in Egypt as far as Mount Atlas. The Persian Gulf which was once a vast lake of the Tigris and had its outlet into the Indian Ocean, has now worn away the mountain which served it as a bank, and become the same level as the Indian Ocean. And if the Mediterranean had continued to find an outlet through the Gulf of Arabia it would have produced the same result, that is it would have caused its level to become the same as that of the Indian Ocean.

[*With drawing*]

In this one has to imagine the earth sawn through the centre; and it will show the depth of the sea and of the earth; [and how] the springs start from the bottoms of the seas, and wind their way through the earth, and raise themselves to the summits of the mountains, and flow back again through the rivers, and return to the sea.

Since things are far more ancient than letters, it is not to be wondered at if in our days there exists no record of how the aforesaid seas extended over so many countries; and if moreover such record ever existed, the wars, the conflagrations, the changes in speech and habits, the deluges of the waters, have destroyed every vestige of the past. But sufficient for us is the testimony of things produced in the salt waters and now found again in the high mountains, sometimes at a distance from the seas. Leic. 31 r.

That part of the flow and ebb of the sea will be of greater variety from its greatest height to its lowest depth which is nearest to its cause.

There is great variation between the ebb and flow of the sea in the vicinity of those places at which the springs of the waters depart from the depths of the seas in order to supply a perpetual stream of water to the rivers which afterwards descend from the high mountains.

These springs are of two natures, of which one is of those that are

continually discharging themselves in the rivers; and there are others that pour themselves into the sea, and rise fresh above the other salt waters: which thing proceeds from the fact of them being born from the lakes that lie open to the air, which are higher than the waters of the sea, otherwise this rising would not take place. And yet one might say that just as the springs of the mountains are poured to their feet, so such springs might also be poured beneath the sea.

There is a spring in Sicily which as it rises at certain seasons of the year throws out chestnut leaves in large quantities. Since however chestnut trees do not grow in Sicily this spring must have come originally from some underground lake in Italy and then passed beneath the sea and afterward found outlet in Sicily.[1]

In the Bosphorus the Black Sea always flows into the Aegean, never the Aegean into it. This is due to the fact that the Caspian Sea, five hundred miles to the east, together with the rivers that flow into it, is always discharging itself through subterranean channels into the Black Sea; and the Don and also the Danube do the same; so that as a consequence the waters of the Black Sea are always higher than those of the Aegean, and it follows that the higher always descend into the lower and never the lower into the higher.

Some say that the waters which rise in the summits of the high mountains, are part of the water of the sea which is higher than the summits of the highest mountains that exist; which serves them to prove that the surface of the sea is lower than any part of the earth that stands above the waters, or that any part of the surface of a river which flows into this sea.

Others say that the waters which flow above the high summits of the mountains are descended from the higher mountains of the world which are covered with snow that melts during the summer. But this opinion is shown to be incorrect, for if it were the case that the melting snows of summer entering into subterranean caverns and through the springs in the ground had sent the water in the tops of the mountains lower than the mouths of the springs, there would be

[1] Richter points out that the chestnut is a common tree in Sicily and suggests that Leonardo may have written 'Cicilia' in mistake for Cilicia.

more water in these springs in summer than in winter, but experience shows that the opposite is the case.

All the outlets of the waters which proceed from the mountain to the sea carry stones from the mountains with them to the sea; and by the backwash of the ocean surges against their mountains these stones were thrown back towards the mountain; and as the waters moved towards the sea and returned from it the stones turned with them, and as they were rolled back their corners struck together, and such parts of them as offered least resistance to the blow were worn away and make stones without angles of a round shape, such as are to be seen on the shores of Elba. And those remain bigger which are carried the least distance from their native spot, and in like manner the stone becomes smaller which is transported farther away from the aforesaid spot, for in the course of its progress it becomes changed to fine shingle and then to sand and finally to mud. After the sea had receded from the aforesaid mountains the salt deposit which it left behind with the other moisture from the earth formed a compound with the shingle and sand so that the shingle became changed to rock and the sand to tufa.

And of this we may see an example in the Adda where it emerges from the mountains of Como, and in the Ticino the Adige the Oglio and the Adriano from the Austrian Alps; and in the same way with the Arno from Monte Albano round about Monte Lupo and Capraia, where the largest rocks are all formed of solidified shingle of different varieties of stone and of different colours.

That thing which is lighter will be carried farther by the rivers from the place whence its waters snatched it away; and so that which is heavier will be removed a less distance from the place at which it was separated. That percussion of the water carries away more of the bank of rivers which strikes this bank at more equal angles; and so conversely it will carry away less when the angles are more unequal.

<div style="text-align: right">Leic. 31 v.</div>

There are as many differences in the resistance made by water beneath that which is supported by it as there are differences in its heat or cold.

Given two rivers of equal volume of water at their entrances, their

exits will be equal; that is, given an equal volume of water in an equal time, even though the rivers may vary in length, breadth, slant and depth and the one be twisted and the other straight; or though both be twisted but the shapes of their curves are unlike; or one be of uniform breadth and the other of varying breadth; and if both vary their variation may be different; one may be of uniform depth and the other of varying depth; and should both depths vary in themselves their variation may not have any kind of likeness; and the whole of one may be uniformly swift and the other uniformly slow, or the slowness and swiftness of one may be mixed, that is where it runs and where it lingers, where the waters fall perpendicularly and where they rise in a swirling flood; and the fact that there exist in these two rivers infinite varieties of currents in breadth, length, slant and depth will not therefore prevent the equal entrance of the one from being equal to its exit, and the equal entrances of the one and the other from being equal in their exits.

If the Mediterranean Sea departs from its site it raises the sphere of the water and occupies new valleys, and consequently the centre of gravity of this increase will be round the antipodes; and so on that side the weight grows, and on this there is lacking the whole amount of the weight of the water that has departed from there; and although this position may be filled up by that earth which was carried by the rivers into this Mediterranean, the centre of its gravity will be opposite to that of the sphere which has been increased in the antipodes; and so on this side the weight is not increased by the earth which has been removed as a substitute for the sea which has been expelled, because this earth remains in our hemisphere, that is, the centre of its gravity, but it is nevertheless true that the whole weight of the water is here diminished. Therefore the centre of the world will become nearer to our antipodes, lightening itself here of the weight of the water which has departed; and the summits of the mountains will raise themselves more from this centre: until such a point that the rivers which accompany the Nile after much rambling about through the great plain into which the Mediterranean is divided will carry through the straits of Gibraltar all the part of the soil that makes it turbid; and in the course of time they will place as much soil in the ocean beyond the straits of Gibraltar as is found between Libya and

the sea, and between the Alps and the said sea; and so again the centre of the world will become nearer the centre of the weight increased to the ocean, and the parts lightened will become more remote from this centre. So then it is concluded that the more the soil is removed from us the more it lightens our regions; as a consequence the more it is removed from the centre of the earth the more the waters consume it and the more again it becomes light; and so it will continue until all the earth laid bare is carried to the sea by the Nile or by the rivers that are poured into it.

And so the earth that is found in the rivers that now pour themselves into the Mediterranean will be carried by the Nile together with the turbid water that remains in it to the ocean.

So then the sea will return to cover the places where were formerly the roots and bases of the mountains, and it will cover the earth.

It is not denied that the Nile is always turbid as it enters the Egyptian sea, and that this turbid condition is due to the soil which this river carries away continually from the places through which it passes, and this soil never returns back nor does the sea receive it except just to cast it back upon its shores; behold the ocean of sand beyond Mount Atlas where it was once covered with salt water.

The water that is found in the highest mountains is not there because it has been drawn there by the heat of the sun for but little of this heat passes downwards, as is seen below La Vernia, where the power of the sun is not sufficient to melt the ice during the greatest heat of summer, but it remains there in the hollows in which it has been lying since the winter. And on the northern slopes of the Alps, where the sun does not strike, the ice never melts, because the heat of the sun cannot penetrate the small thickness of the mountains; still less therefore will the vast space that lies between the summits of the great mountains and the depths of the watery sphere be penetrated by this heat of the sun which would have to pass beneath the base of this mountain. If you should say that the earth's action is like that of a sponge which when part of it is placed in water sucks up the water so that it passes up to the top of the sponge, the answer is that even if the water itself rises to the top of the sponge, it cannot then pour away any part of itself down from this top, unless it is squeezed by

something else, whereas with the summits of the mountains one sees it is just the opposite, for there the water always flows away of its own accord without being squeezed by anything.

Perhaps you will say that water can only rise the same distance as it descends; and that the surface of the sea is higher than the summits of the highest mountains. The answer to this is that the exact opposite is the case, for the lowest part visible to the sky is the surface of the sea, since water does not move of itself unless to descend, and so descends when it moves; as therefore the rivers which stretch from the summits of the mountains to the sea are everywhere in movement they are therefore everywhere descending, and when they come to the sea they stop and end their movement; for which reason one must conclude that they are stationary in the lowest reaches of the river. But if you should say that the farther the sea is away from the shore the more it rises up and so it comes to equal the height of the high mountains; it is shown here that a thing is higher which is farther removed from the centre of the earth, and if the element of water is spherical the definition of spherical bodies is those in which every part of the surface is equidistant from the centre. So therefore the shore of the sea is as high as its centre, and whatever may be discerned from the shore is higher than any part of the sea; and the distance that there is from the summits of the high mountains to the centre of the earth is greater than the distance from this centre to the sea shore: this then is our conclusion.

And if you should say as has been said that the sun sucks up and draws the waters from the roots of the mountains to their summits, then as the heat draws the moisture to itself the heat which is more powerful would draw to itself a greater amount of water than the less powerful. In summer therefore during the fiery heats the springs of the waters would have to rise higher into the summits of the mountains than they do in winter; but we see it is the contrary seeing that in summer the rivers lack a great part of their waters. Leic. 32 v.

OF THE ORIGIN OF RIVERS

The body of the earth like the bodies of animals is interwoven with a network of veins which are all joined together, and are formed for

the nutrition and vivifying of this earth and of its creatures; and they originate in the depths of the sea, and there after many revolutions they have to return through the rivers formed by the high burstings of these veins. And if you should wish to say that rains in winter or the melting of the snow in summer were the cause of the origin of the rivers, one may offer as an instance the rivers which originate in the torrid regions of Africa in which it does not rain still less does it snow, because the excessive heat always dissolves into air all the clouds which are driven there by the winds. And if you should say that these rivers which become big in July and August are from the snow which melts in May and June as the sun approaches nearer to the snowfields of the mountains of Scythia, and that the snow thus melted collects in certain valleys and forms lakes, into which it enters by springs and underground caverns, afterwards emerging to form the source of the Nile, this is incorrect because Scythia lies below the source of the Nile, and Scythia moreover is only four hundred miles from the Black Sea whereas the source of the Nile is a distance of three thousand miles from the Egyptian sea into which it pours its water. Leic. 33 v.

In the western parts near to Flanders the sea rises and falls about twenty braccia every six hours; and twenty-two when the moon is favourable; but twenty braccia is its usual variation and this as is clearly seen is not caused by the moon. This variation in the rising and falling of the sea every six hours may occur through the swelling up of the waters which are poured into the Mediterranean by the number of the rivers from Africa Asia and Europe that pour their waters into this sea; and this gives back to the ocean through the straits of Gibraltar between the promontories Abyla and Calpe the waters given to it by these rivers.

This ocean as it extends between the island of England and other islands farther north, comes to swell up and form a bore at the mouths of certain gulfs, which, being as it were seas, with the surface separated from that of the central body of the earth, have acquired weight, and this, as it exceeds the force of the incoming waters that occasioned it, causes this water to take again an impetus contrary to that of its approach, and so creates an impetus contrary to that which the waters have given the straits, and especially against the straits of Gibraltar, which for as long as this is going on remain in swirling flood, holding

back all the water recently given them at that time by the aforesaid rivers; and this would seem to be one of the reasons which may be assigned for this ebb and flow; as is proved in the twenty-first of the fourth of my book on Theory. This would occur when the water that formed the springs of rivers was caused by rain or melting snow. But if these springs had their origin in the depths of the sea this reason would not exist, for at their beginning the sea would give them as much water as the rivers gave the sea, namely what they received from the ends of their springs; and so for this cause the sea would not increase or grow less.

The stratified rocks are created in the vast depths of the seas because the mud which the storms detach from the sea coasts is carried out to the deep sea by the recoil of the waves; and after these storms it is deposited upon the bottom of the sea, and as no storm can penetrate the sea on account of the great distance that it is below the surface it lies there motionless and becomes petrified; and sometimes it remains in the form of white clay which serves for making pots; and thus with blocks set at different angles it is made up of layers of as many different thicknesses as are the differences in the storms whether greater or less. Leic. 35 r.

WHETHER THE EARTH IS LESS THAN THE WATER

Some assert as a fact that the earth which is not covered by the waters is much less than that which is covered by them; but since the size of the diameter of the earth is seven thousand miles, it may be concluded that as the water is almost universally of but little depth its weight bears no comparison to that of the earth. The answer to these is that the water which is poured into the atmosphere which becomes united as it rises to the cold region of the atmosphere is very heavy in weight and falls in great deluges and floods. And how do we know whether the earth has enormous caverns with reservoirs of water?

And the innumerable springs which are fed by as many streams of water, as are seen in the formation of the rivers? Take as an instance the Caspian Sea which is very great.

Always the centre of the sphere of the water, but not of its weight, because it is not of equal thickness spread over the earth, will be concentric with the centre of the world; and it is the same as regards the centre of the gravity of the earth and of the waters joined together, but not of its gravity nor of its magnitude; and if the earth of itself were spherical and without water within itself, then the water would clothe it with uniform size and weight; and so the centre of the world would remain centre of the sphere and magnitude of the water and of its weight; and so it would remain centre of the sphere and magnitude of the earth, and centre of its gravity; consequently as the earth is mixed and full of the ramifications of the waters within itself, is in some parts spread out in some compact, in some soil, in some rock, this earth has not in itself a centre of sphericity or a centre of gravity, and this especially through it having water and earth above the sphere of the water, which give weight to it as though it was the weight of the earth.

Consequently by this one concludes that the gravity of the earth and the water joined and mingled together have usually their centre concentric with the centre of the world, which centre is also the centre of the spherical surface of the water, and not of its weight, as I have said above; and this surface of the sphere of the water is broken and divided by the earth which borders on the air.

If the earth were entirely submerged by the water, even though it was of varied and irregular shape it would have the centre of its natural gravity concentric with the centre of the world and of the surface of the sphere of water, but not with the centre of its natural or even of its accidental gravity.

That earth which is not covered by the waters will be much heavier than that which is beneath this water.

The centres of the heavy bodies are three and they are differently situated, seeing that sometimes they are joined together; and here accidental gravity dies; sometimes there are two together and the third is separated from them; and here accidental gravity arises; and sometimes they are placed together in three different positions, the one from the other: and the first is the centre of the magnitude, the second is the centre of its natural gravity, and the third the centre of the accidental gravity.

The centre of the magnitude is that which is separated equally from the opposite extremities of the body that encloses it whether it be uniform or not; and it is sufficient that it is situated at an equal distance from the opposite extremities of a staff, as of a cloth of any material. And these are joined together in a body of perfect sphericity and uniform substance and density, because here there are only two and they are concentric.

Necessity makes the machine of the earth empty of earth and full of water, after the fashion of a vessel filled with water:

This is confirmed by the tenfold proportion which the four elements have between them, which is seen of the air with the earth of which the proportion is a hundredfold, because the thickness of the air has been measured between the comet which is in the uppermost part of the air and with the surface of the sphere of the water which is in the lowest part of the sphere of the air. Now the water may be said to have as much earth uncovered which projects above the surface of the sphere of the water, as that which is lacking from the surface of the water towards the centre of the world, that is, I consider that the highest mountain that there is in the earth is as far above the surface of the sphere of the water as the greatest depth of the sea is below this surface of the sea. It follows that if one were to fill up the part wanting in the sea with the excess of the earth, that this earth would remain spherical and entirely covered by the sphere of the water. But, so far as one can discern, this sphere of water, or you may say element, would not be ten times as great as the sphere of the earth, but far from being ten times it would not attain to the relation of equality, because one sees clearly that the sphere of the water would not rise a mile above the sphere of the water, that is it would not raise itself to the altitude of the highest mountain; which thing however would take place when all the earth uncovered was everywhere as high as this highest mountain.

Therefore it is concluded that the remainder of this water stays in the body and springs of the earth, in which it may have fallen over a wide area, and lightened the spot from whence it separated itself, as is represented opposite in B.

In two ways the gravity of the earth can have its centre concentric with the centre of the world, that is if it is either altogether submerged

by the waters or has its opposite side out of the waters of equal weight.

The centre of the gravity of the water and of the earth might be concentric with the centre of the world if the earth were perfectly spherical. The centre of the world would then be the centre of the sphere of the earth, as of the sphere of the water. But it would not produce land animals. Leic. 35 v.

OF THE EARTH IN ITSELF

The fact of the summits of the mountains projecting so far above the watery sphere may be due to the fact that a very large space of the earth which was filled with water, that is the immense cavern, must have fallen in a considerable distance from its vault towards the centre of the world, finding itself pierced by the course of the springs, which continually wear away the spot through which they pass, having in them some of the air above; because water has no weight unless it sends a wave out of its level through the air, and it is this wave alone that has weight and falls and wears away the base. Now this great mass has the power of falling, being the centre of the world within the water: it balances itself with equal opposing weights round the centre of the world, and lightens the earth from which it is divided; and it removed itself immediately from the centre of the world and rose to the height, for so one sees the layers of the rocks, formed by the changes which the water has undergone, at the summits of the high mountains.

Subsidence of lands, as in the Dead Sea in Syria, to wit Sodom and Gomorrah.

It must needs be that the water is more than the land; and the part uncovered by the sea does not reveal it; it must needs be therefore that there is a great mass of water within the earth, in addition to that which is diffused through the lower parts of the atmosphere and runs through the rivers and springs.

I say that it is not necessary that the centre of the world be situated more in the earth than in the water, because the gravity of the earth and of the water, joined together in any manner whatever, rests with

weights of gravity situated oppositely around the centre of the world; and the earth does not expect to have parts of itself equally distant from this centre, but weights equally heavy placed opposite; and in this case the water being mingled with various ramifications of springs together with the earth, cannot give of itself weights equally distant from this centre, but will have a surface equidistant from this centre.

Now if it is as has been said, it is possible, the centre of the world being situated in the water, that on some occasion, through the constant friction that the water has through the springs through which it passes, it may have so widened these springs that the part of the earth which is interposed between these springs, exhausting the tenacity of the remainder, [brings it about] that the gravity, which it has acquired through being above the water, has detached itself from this remainder and has fallen towards the centre and made this concentric with the centre of its gravity. And through this the remainder of the earth having made itself lighter by that part from whence the said gravity fell, will of necessity remove itself from the centre of the world, and the earth and the mountains will emerge out of the sphere of the water lightened by this part, and will also make itself lighter by the weight of the water which rested upon it, and will come so much the more to raise itself towards the sky. And the sphere of the water in this case does not change its position, because its water fills up the place from which the gravity of that part of the earth that fell divided itself; and thus the sea remains in itself without change of height. And this may also be the reason why the marine shells and oysters that are seen in the high mountains, which have formerly been beneath the salt waters, are now found at so great a height, together with the stratified rocks, once formed of layers of mud carried by the rivers in the lakes swamps and seas; and in this process there is nothing that is contrary to reason.

Given a perfectly smooth surface the water will not rest upon it: given a spherical surface the water will instantly rest there: which sphericity will be the sphere of the water.

The strata or layers of stone do not continue to any great distance underneath the roots of the mountains because they are made of earth that is used for making vessels and is full of shells; and also these go only a short distance below because one finds the ordinary earth there,

as is seen in the rivers which flow through the Marches and the Romagna, after they have issued from the Apennines.

You have now to prove how the shells are not produced except in salt waters, and that this is the case with almost all kinds; and how the shells of Lombardy are found at four levels. And so it is with all which are made at different periods of time; and these are found in all the valleys that open out into the seas. Leic. 36 r.

Topographical Notes

*'How in all travels one may learn This benign
nature so provides that all over the world
you find something to imitate.'*

[*With drawings*]

Four braccia in length, two and a half braccia in width two and a
quarter braccia in thickness.

And thus are the stones which stand in the front of the mole which
is at the harbour of Civita Vecchia.

Projection.

Half a braccio. Front of the wall of the harbour of Civita.

<div align="right">C.A. 63 v. b</div>

IN SARDINIA AT ANTENORO

[*Drawing a b*]

Here the two streams of the waters clash together in the line *a b*,
and in such percussion they make a complete circle, one with another,
striking from the surface to the base.

And this revolving mass after being formed is driven away from the
position where it was created by the rush of the waters coming above
it; and in such a change this revolving mass has acquired two move-
ments, that is the natural movement round its centre and secondly that
which it acquires from one place to another. This therefore will be a
direct revolving movement, which when it occurs in the water or amid
the air dislodges the soil with much hollowing of it out and scraping
of it away.

Where the streams of the waters are equal[1] the revolutions made by
the waters as they meet will follow a straight line; but if the streams of
the waters are unequal the shock of the waters clashing together will

[1] MS. has 'non sono equali'.

impel the revolving movements towards the bank of the less powerful stream, which as it burrows down with its two sets of movements, namely the straight and the revolving, goes hollowing out the base of the banks, and the upper parts which were upheld by these falling headlong as their foundations crumble, are worn away anew by this eddying movement.

When the streams of the waters are unequal these waters as they meet go ranging round, the less powerful stream entering with the branches of its lower eddies underneath those of the upper eddies which are made by the more powerful stream.

When the water of greater power strikes the water of less power the line of eddies describes a curve, entering in convex form into the body of the water of greater power.

When the curving line of the eddies enters in its convexity within the water of less power this water remains within its limits without moving; at this stage it swells up and raises itself and acquires gravity, and so from the weight that it has acquired it multiplies in power and makes headway against the water which at first overcame it, so that the line of eddies is curved in a contrary direction and becomes concave where it was formerly convex, and thus the lesser water is often driven by the greater and the greater by the lesser, but the lesser is driven farther in proportion as it is of less power.[1] c.a. 77 r. b

Mortar-pieces for the [fleet?] at Venice, in the way that I said at Gradisca, in Friuli, and in the V[eneto].

(Bombarde [. . .] llio [naviglio?] a Vinegia, col modo che io detti a Gradisca [. . .] friglioli [?] e in v[. . .]) c.a. 79 r. c

Mount Caucasus the mountains of the Komedoi and the Parapanisos range are joined together between Bactria and India and give birth to the river Oxus, for it is in these mountains that it rises, and it flows five hundred miles to the north and as far to the west, and discharges its waters into the Hyrcanian sea, and it is accompanied by the Osus, the Dragodos, the Artamis, the Xariaspis, the Dragamaim, and the Margus, all very large rivers. On the opposite side towards the south

[1] The most natural interpretation of this passage in conjunction with the topographical note and the drawing is to regard it as a record of travel. In this case Leonardo must have visited Sardinia.

rises the great river the Indus, which guides its waves for six hundred miles in a southerly direction, and while in this course it receives as tributaries the rivers Zaradrus, Bibasis, Vadris, Vandabal and Bilaspus, from the east Suastus and Coe from the west, and after having gathered these rivers into its waters it turns and flows in a westerly direction for eight hundred miles, and checked by the Arbeti mountains it makes an elbow there and turns southwards, and so after a further course of five hundred miles it comes to the Indian Ocean into which it discharges itself by seven mouths.

Within sight of the same mountain the mighty Ganges rises, and this river flows southwards for five hundred miles and to the south east for a thousand miles, and Sarabus, Diamuna, Soas, and Scilo with their mighty flow accompany it. It pours into the Indian Ocean by many mouths.[1] c.a. 95 v. b

[*With drawing*]

Canal of Ivrea, made from the river of Dora.[2]

Mountains of Ivrea in their wild part; it continues towards the north.

The great weight of the barge which passes through the river which is supported by the arch of the bridge does not add weight to this bridge, because the barge weighs exactly as much as the weight of the water that the barge displaces from its position. c.a. 211 v. a

LAKE COMO

Valley of Chiavenna

Above Lake Como in the direction of Germany lies the valley of Chiavenna where the river Mera enters the lake. Here the mountains are barren and very high with huge crags. In these mountains the water

[1] MS. Comedorum. Ptolemy refers to the Komedoi as the inhabitants of the hill country that lay to the east of Bactriana.

Ptolemy is obviously the authority from whom Leonardo has derived his lists of tributaries. Those of the Oxus appear in Leonardo as Osus, Dragodos, Artamis, Xariaspis, Dragamaim and Margus, and these are given by Ptolemy as Okhos, Dargoidos, Artamis, Zariaspis, Dargamanes and Margos.

For the Indus Leonardo has Zaradrus, Bibasis, Vadris, Vandabal and Bilaspus. Ptolemy has Zaradros, Bibasis, Adris, Sandabal and Bidaspes. (See McCrindle, Ptolemy: Ancient India edit. Majumbar, Calcutta 1927.)

[2] i.e. the Dora Baltea.

birds called cormorants are found; here grow firs larches and pines, and there are fallow deer, wild goats, chamois and savage bears. One cannot make ascents there without using hands and feet. In the season of the snow the peasants go there with a great trap in order to make the bears fall down over these rocks. The river runs through a very narrow gorge: the mountains extend on the right and the left in the same way for a distance of twenty miles. From mile to mile one may find good inns there. Higher up the river there are waterfalls six hundred braccia high which are very fine to see, and you may find good living at four soldi for your bill. A large quantity of timber is brought down by this river.

Val Sasina

Val Sasina runs in the direction of Italy. It has almost the same shape and characteristics. The *mappello* [1] grows here plentifully: there are great floods and waterfalls.

Valley of Trozzo

In this valley firs pines and larches grow plentifully; and from here Ambrogio Fereri has his logs brought down.

At the head of the Voltolina are the mountains of Bormio which are terrible and always covered with snow. Here ermines breed.

At Bellagio

Opposite the castle of Bellagio is an insignificant stream which falls from a height of more than a hundred braccia from the spring where it rises sheer into the lake with inconceivable din and uproar. This spring flows only in August and September.

The Voltolina

The Voltolina as has been said is a valley surrounded by lofty and terrible mountains; it produces a great quantity of strong wine but has so great a stock of cattle that the peasants reckon that it produces more

[1] The meaning of this word is unknown. The Italian for maple is *acero.*

milk than wine. It is this valley through which the Adda passes which first flows through Germany for more than forty miles. In this river is found the grayling [1] which feeds on silver of which much is to be found in its sand.

Everyone in this district sells bread and wine, and a jug of wine is never more than a soldo, veal is a soldo the pound, and salt ten denari and butter the same and eggs a soldo for a quantity. c.a. 214 r. e

At Bormio

At Bormio are the baths; eight miles above Como is the Pliniana, which rises and falls every six hours, and as it rises it supplies two mills with water and there is a surplus, and as it falls it causes the spring to dry up for a distance of more than two miles. It is in this district that a river falls with a great impetus through a mighty chasm in the mountain. These journeys should be made in the month of May, and the largest bare rocks which exist in these parts are the mountains of Mandello near to those of Lecco and Gravidonia; towards Bellinzona thirty miles from Lecco are those of the valley of Chiavenna; but the greatest is that of Mandello, which has at its base a gully towards the lake that descends two hundred steps, and here at all seasons there is ice and wind.

In Val Sasina

In Val Sasina between Vimognio and Introbbio on the right hand where you enter the road to Lecco you come upon the Trosa, a river which falls from a very high rock and as it falls goes underground and so the river ends there. Three miles farther on you come to the buildings of the copper and silver mines near to the district known as Prato San Pietro, and the iron mines, and various strange things. La Grignia is the highest mountain in these parts and it is without any vegetation.

c.a. 214 v. e

[1] MS. has 'il pescio temere'. I have followed Richter's suggestion 'temolo'.

WHY THE CURRENT FROM SPAIN IS ALWAYS GREATER TOWARDS THE EAST THAN TOWARDS THE WEST

The reason is that if you were to place together the mouths of the rivers which come into this Mediterranean sea you would find that there was a greater volume of water than that which this sea pours through the straits into the ocean. You see that Africa discharges into this sea such of its rivers as flow to the north, among these being the Nile which waters three thousand miles of Africa, the river Bragada, the Mauretanus and others like these. Europe pours there the Don and the Danube, the Po and the Rhone, the Arno and the Tiber. It is clear therefore that these rivers together with an infinite number of lesser-known rivers make up a greater breadth depth and current than are found in the eighteen miles of ocean straits which divide Europe from Africa at their western extremities. And if you should wish to say that the rivers which empty themselves into the ocean act differently, it is certain that the aforesaid rivers almost all have their origin in mountains near to this ocean, and if these mountains were to empty them there there would be no river in the vicinity of as great current as the Nile and the Danube, and if moreover there were a resemblance, consider that these rivers, in emptying themselves into the ocean, can give it but little increase so as to restore the current towards the east, unless it always is that the clouds contain a greater volume than that which the rivers place there, and these clouds becoming constricted compress the air with swift movement within the other air, like a hand which squeezes a sponge with water amid the other water, so that that which flies away gives place to the rest.

Water moves within water with the same facility as air moves within air although it is more . . . [t . . .] [?] as is seen in its circles.

Current only exists in the seas which communicate with the ocean; the Caspian sea and the swamps have no current; while the Indian Ocean flows eastwards the western Mediterranean flows westward.

<div align="right">

C.A. 215 v. d

</div>

Write to Bartolomeo the Turk about the ebb and flow of the Black Sea and ask whether he knows if there is the same ebb and flow in the Hyrcanian or Caspian Sea. C.A. 260 r. a

OF THE CONSUMPTION OR EVAPORATION OF THE
WATER OF THE MEDITERRANEAN SEA

The Mediterranean Sea a vast river interposed between Africa Asia and Europe gathers within itself about three hundred principal rivers, and in addition to these it receives the rains which fall upon it over a space of three thousand miles. It gives back to the mighty ocean its own waters and the others that it has received, and without doubt it gives less back to the sea than those it receives; for from it descend many springs which flow through the bowels of the earth and vivify this terrestrial machine. This is necessary by reason of the fact that the surface of this Mediterranean is more remote from the centre of the world than the surface of this ocean, as is proved by my second [rule]; and in addition to this the heat of the sun is continually evaporating a portion of the water of the Mediterranean, and as a consequence this sea can acquire but little increase from the aforesaid rains, and is but little diminished through the water that has been added to it being poured into the ocean, or from it being evaporated by the heat of the sun or the course of the parching winds. c.a. 263 v. b

The watery sphere desires perfect roundness, and that part which projects above its general surface cannot continue, and in a short time becomes smooth; and if you should wish that the water should be drawn aside in order to allow space for the earth and uncover it, and that in this way it should remain spherical, this would be impossible because the water that flows from Syria would be low, and at the island Aritella which is four hundred miles distant from the strait of Gibraltar it would be the high sea, which is three thousand four hundred miles distant from the shores of Syria, and at this island the water is very shallow, and beyond it there is little depth to be found.

 c.a. 264 r. b

Amboise has a royal fountain which has no water. c.a. 296 r. a

[*Mechanical drawings with various numbers, 'minutes of the hour', 'hours', 'moon'*]

Clock of the tower of Chiaravalle, which shows the moon, the sun, hours and minutes. c.a. 399 v. b

Why there is water in the high parts of the mountains:

From the straits of Gibraltar to the Don is three thousand five hundred miles, that is to say one mile and one sixth, allowing a fall of one braccio per mile for all water that moves at a moderate rate of speed. And the Caspian Sea is considerably higher, and none of the mountains of Europe rises a mile above the surface of our seas. One might therefore say that the water which is in the summits of our mountains comes from the heights of these seas, and from the rivers which pour themselves down there and which are higher. 　F 50 r.

[Of sand-hills. Libya]

Describe the mountains of 'flexible dry things'. Treat that is of the formation of the waves of sand borne by the wind, and of its hillocks and hills as it occurs in Libya; you may see examples in the great sand banks of the Po and the Ticino and other large rivers. 　F 61 r.

Map of Elephanta[1] in India which belongs to Antonello the merchant. 　F cover 2 r.

At Santa Maria at O. in the valley of Ravagnate in the mountains of Brianza[2] the rods of the chestnut are nine braccia and fourteen: five lire for a hundred of nine braccia.

At Varallo Pombia near Sesto upon the Ticino the quinces are large white and firm. 　G 1 r.

[Water of a mill at Florence]
[Drawing] Small mill at Florence.

This water in its general descent turns a right angle; but in the floods it goes straight. And its percussion is so powerful that as it burrows down it carries the stones in its course, rolling over the strand

[1] Elephanta is the name of an island in the harbour of Bombay named from a colossal statue that stood on it and containing Brahmanic rock caves of vast dimensions which served the Hindus as temples, the largest, hewn out of hard trap rock, being one hundred and thirty feet across with columns and sculptures. The note may be due to the fact of some account of these caves having come to the knowledge of Leonardo. His interest in rock caves is shown from a passage in the Arundel Manuscript (B.M. 155 r.).

[2] MS. 'Nella valle di ranvagnan ne monti brigantia'. I have followed the translation of Richter. Ravaisson-Mollien points out however that Leonardo on the following page of the MS. mentions Monte Viso, which is not far from the mountains of Briançon (Brigantio), and hazards the conjecture that there may be a locality of a name resembling ranvagnan in a valley of this region.

formed by the other stones; and so the water following the leap out of its surface leaves the driven stones on the extremity of the mountain. But when the bed or the floods fail the water cannot pass the already formed hill of shingle, and consequently it turns in its first course made by the fall of the other water, which is found in excess at the fishing pool, which forms this hollow at the place where the water falls. 1 75 [27] v.

The shepherds in the Romagna make at the base of the Apennines certain huge hollows in the mountains of the shape of a horn and they set a horn by its side so that this small horn becomes one with the cavity already made and by means of it a very loud noise is produced. κ 2 r.

Rhodes contains five thousand houses. L cover v.

[*Notes made in Romagna*]

Dove-cot at Urbino. 30 July 1402 (1502). L 6 r.

[*With sketch of wave*]
Made by the sea at Piombino.
The water *a b c* is a wave which has traversed the slope of the shore and which as it turns back meets with the wave that comes upon it; after striking each other they leap upwards and the weaker yields to the stronger so that it traverses again the slope of the said shore.
 L 6 v.

Acquapendente belongs to Orvieto. L 10 v.

[*With drawing*]
Fortress of Cesena. L 15 v.

[*With drawing of bell*]
Siena. L 19 v.

[*With architectural drawings*]
Steps of Urbino. L 19 v.

The foundation must be as broad as the thickness of any wall upon which this foundation rests. L 20 r.

[*With drawing*]

Bell of Siena, that is the manner of its movement and the position of the attachment of its clapper. L 33 v.

[*With architectural drawing*]

St. Mary's Day, the middle of August, at Cesena, 1502. L 36 v.

[*With drawing*]

Stairs of the Count of Urbino—rough. L 40 r.

At the Fair of San Lorenzo at Cesena, 1502. L 46 v.

[*With drawing*]

Window at Cesena.

A for the frame of linen cloth, *b* for the window of wood; and the angle rounded off is a quarter of a circle. L 47 r.

Porto Cesenatico on the sixth day of September 1502 at fifteen hours.

How bastions ought to project beyond the walls of towns to be able to defend the outer slopes so that they may not be struck by the artillery. L 66 v.

The fortress of the harbour of Cesena is at Cesena four points to the south-west. L 67 r.

[*With drawing*]

Grapes carried at Cesena.

The number of the men who dig the trenches takes the form of a pyramid. L 77 r.

Make a harmony with the different falls of water as you have seen at the fountain of Rimini, as you have seen on the eighth day of August 1502. L 78 r.

[*With plan*]

Fortress of Urbino. L 78 v.

[*With drawing*]

Cart of Cesena. L 82 r.

First day of August 1502.

At Pesaro, the Library. L cover r.

[*The Arno*]

No simple reflex movement is ever as much raised as the commencement of the falling movement.

To guard against the percussion of the Arno at Rucano and to turn it with a gentle curve towards Ricorboli, and to make the bank so wide that the fall of its leap may be above it. L 31 r.

BRIDGE OF PERA AT CONSTANTINOPLE

Width forty braccia, height above the water seventy braccia, length six hundred braccia, that is four hundred above the sea and two hundred resting on land thus forming abutments to itself.[1] L 66 r.

In Romagna where all the dullards congregate they use carts with four equal wheels, or they have two low in front and two high ones behind, and this is a great restraint on movement because more weight is resting upon the front wheels than upon those behind as I have shown in the first of the fifth 'Concerning Elements'.

And these first wheels move less easily than the large ones, so that to increase the weight in front is to diminish the power of movement and so to double the difficulty.

[*Diagram*]

Here the larger wheel *a* has three times the leverage of the small wheel; consequently the small one finds three times as much resistance and to add a hundred pounds [necessitates adding] two hundred more to the small [wheel] *a*; look how this works. L 72 r.

[*A note on relative positions of towns between Bologna and Forli*]

Imola sees Bologna at five points from the west towards the north-west at a distance of twenty miles.

Castel San Pietro is seen from Imola midway between west and north-west at a distance of seven miles.

Faenza is as regards Imola exactly in the centre between east and south-east at a distance of ten miles.

[1] The time references in this manuscript point to this note as having been written in or about the year 1502. The project seems to have gone no farther. Richter records how four years later when Michelangelo suddenly left Rome he entertained the idea of going to Constantinople where, as both Vasari and Condivi state, his services had been requisitioned to make a bridge to connect Constantinople with Pera.

Forli is as regards Faenza exactly in the centre between south-east and east at a distance of two miles from Imola and ten from Faenza.

Forlimpopoli is in the same direction at twenty-five miles from Imola.

Bertinoro is as regards Imola at five points from the east towards the south-east, at a distance of twenty-seven miles. L 88 v.

From Bonconvento to Casanova 10 miles; from Casanova to Chiusi 9 miles; from Chiusi to Perugia 12 miles; from Perugia to Santa Maria degli Angeli and then to Foligno. L 94 v.

[*With drawing*]
Solid rock of Mugnone hollowed out by the water in the form of vessels. It seems a work done with the hand, because it is so exact.

B.M. 29 v.

OF THE CUTTING OF ABYLA AND CALPE IN THE STRAITS OF CADIZ

The cutting of Abyla and Calpe in the straits of Cadiz reduces considerably the rivers which descend from the Alps and run to the north. And this is proved by reason of the fact that before this cutting in the mountains of Cadiz was formed the surface of the Mediterranean Sea was very high, and surpassed the height of three parts of the Alps, and the penetration of the sea through the passages and veins of the earth was very high and abundant; and after this cutting of Cadiz the surface of the Mediterranean Sea there was lowered, and the aforesaid high passages remained emptied of their waters, and the rivers lost the abundance of their streams. B.M. 168 v.

[*With drawings*]
When two rivers together intersect that will be of less depth which is of slower course.

When Rifredi *b* meets with the sluggish Arno, this Arno raises its bed, and the stream of Rifredi wears it away and makes sudden depth.

B.M. 271 r.

They do not know why the Arno never keeps its channel. It is because the rivers which enter it deposit soil where they enter and take

it away from the other side, thus forming a bend in the river there.

The course of the Arno is six miles from La Caprona to Leghorn, and twelve through the marshes which have an expanse of thirty-two miles, and sixteen up from La Caprona which makes forty-eight; by the Arno from Florence there is a space of sixteen miles; to Vico is sixteen miles and the canal is five; from Florence to Fucechio is forty miles by the water of the Arno.

Fifty-six miles by the Arno from Florence to Vico; and by the Pistoia canal is forty-four miles; therefore it is twelve miles shorter by the canal than by the Arno.[1] Windsor: Drawings 12279

The direction of Imola from Bologna is five points north-west of west and its distance is twenty miles.

The direction of Castel San Pietro from Imola is midway between west and north-west at a distance of seven miles.

The direction of Faenza from Imola is exactly midway between east and south-east at a distance of ten miles, so also is that of Forli from Imola at a distance of twenty miles, and of Forlimpopoli from Forli at a distance of twenty-five miles.

The direction of Bertinoro from Imola is two points south-east of east at a distance of twenty-seven miles. Windsor: Drawings 12284

FOR THE SHRINE OF VENUS

You should make steps on four sides by which to ascend to a plateau formed by nature on the summit of a rock; and let this rock be hollowed out, and supported with pillars in front, and pierced beneath by a great portico, wherein water should be falling into various basins of granite and porphyry and serpentine, within recesses shaped like a half-circle; and let the water in these be continually flowing over; and facing this portico towards the north let there be a lake with a small island in the centre, and on this have a thick and shady wood.

Let the water at the top of the pillars be poured down into vases

[1] Vasari refers to Leonardo's interest in the project of a canal from Pisa to Florence. Documents showing his activity in project of turning the Arno in war with Pisa in 1503 are given in Gaye, *Carteggio Inedito*, and by Milanesi, *Arch. Stor. Ital.*, Serie III, Tom. XVI.

standing at their bases, and from these let there be flowing tiny rivulets.

From the coast.—Setting out from the coast of Cilicia towards the south, you discover the beauty of the island of Cyprus, which . . .

<div align="right">Windsor: Drawings 12591 r.</div>

From the southern sea-board of Cilicia may be seen to the south the beautiful island of Cyprus, which was the realm of the goddess Venus; and many there have been, who, impelled by her loveliness, have had their ships and rigging broken upon the rocks which lie amidst the seething waves. Here the beauty of some pleasant hill invites the wandering mariners to take their ease among its flowery verdure, where the zephyrs continually come and go, filling with sweet odours the island and the encompassing sea. Alas! How many ships have foundered there! How many vessels have been broken upon these rocks! Here might be seen an innumerable host of ships; some broken in pieces and half-buried in sand; here is visible the poop of one, and there a prow; here a keel and there a rib; and it seems like a day of judgment when there shall be a resurrection of dead ships, so great is the mass that covers the whole northern shore. There the northern winds resounding make strange and fearful noises.

<div align="right">Windsor: Drawings 12591 v.</div>

Of the waters of the lake of Viterbo which are changed into vapour: How the fire of Mongibello [1] is fed thousands of miles away from its mouth.

<div align="right">Leic. 18 r.</div>

How at Bordeaux, which is near Gascony, the sea rises about forty braccia before it ebbs, and the salt waters flood the river for more than a hundred and fifty miles; and the vessels which have been laid up to be caulked are left high and dry on the top of a high hill above where the sea has receded.

How above Tunis there is a greater ebb than [elsewhere] in the Mediterranean, namely about two braccia and a half; and at Venice the fall is two braccia; and in all the other parts of the Mediterranean the fall is little or nothing.

How within a short time the river Po will cause the Adriatic Sea to dry up in the same way as it has dried up a great part of Lombardy.

[1] Mount Etna.

<div align="right">Leic. 27 v.</div>

XVI

Atmosphere

*'The air moves like a river and carries the
clouds with it; just as running water carries
all the things that float upon it.'*

SURFACE is the name given to the boundaries of bodies with the air or I
would rather say of the air with bodies, that is what is enclosed between
the body and the air that surrounds it; and if the air makes contact with
the body there is no space to put another body there; consequently it
may be concluded that surface has no body and therefore no need of
position.

Surface is the name given to that which divides bodies from the air
which surrounds them; or as you may prefer to say which divides or
separates the air from the things which are located within it.

And if the atmosphere and the bodies which are enclosed within it
are in perpetual contact and there is not any space between them, the
surface being that which shows the shape of the bodies this surface has
existence of itself. And if the atmosphere and the body are touching
each other no space will remain there, so we conclude that the surface
has existence and not space. Consequently this surface is equal to noth-
ing, and all the nothingness of the world is equal to the smallest part
if there can be a part. Wherefore we may say that surface, line, and
point are equal as between themselves, and each is of itself equal to the
other two joined together.

Surface is the name of that division which the body of the air makes
with the bodies which are enclosed within it. And it does not partake
of the body by which it is surrounded, nor of that which it surrounds;
on the contrary it is the actual contact which these bodies make to-
gether.

Therefore if these bodies are in continual contact it is necessary that
nothing should interpose between them, and consequently the surface,

which is enclosed there, is nothing. This surface has name and not substance because that which has substance has place. Not having place it resembles nothingness which has name without substance; consequently the part of nothing not having anything except the name and not the substance this part is equal to the whole; so that by this we conclude that the point and the line are equal to the surface.

c.a. 68 v. a

ELEMENT OF FIRE. MIDDLE REGION OF THE ATMOSPHERE

[*With drawing*]

The atmosphere interposed between the fire and the water participates in the water and the fire, but so much more in one than the other as it is nearer one than the other. It follows that the less it participates in each the more remote it is from them. And this remoteness occurs in the middle region of the atmosphere; therefore this middle region is in the first stage of cold. From which it follows that that part of the cloud which is in closest contact with the middle region becomes coldest; consequently the warmth of the sphere of fire of this cloud which is the attracter and mover is of less potency, and from this it follows that the movements of the particles of moisture which form the clouds are slower; and from this it follows that, in the process of these particles of moisture rising, the nearer they come to the vicinity of this middle region the slower the movement becomes, and the movement of that which follows is swifter than it, and consequently it overtakes it. And it often happens that it strikes underneath and mingles with it and thus increases its quantity and weight. The atmosphere in consequence not being able to support it makes way for it to descend, and in doing this it strikes all the drops which interrupt its course, and incorporates many in itself, and acquiring weight it acquires velocity in its descent [. . . .]. And this is the reason why after it has penetrated the whole of the cloud in every stage of descent its pace will become slower, and there will be many occasions when these particles will not arrive at the ground. If then these particles at the highest part of their height acquire so much gravity that the weight produces a swift descent, then without doubt this movement will increase their size, inasmuch as this speed will cause it to overtake the drops which are de-

scending below it and incorporate them in itself, and this will bring about an increase of weight at every stage of its descent.

The descent of the drops which strike together without wind will not be straight but at an angle.

This is proved by the fact that if two bodies strike one another in the air the one which is less in bulk will be diverted more from its course.

And if two particles of dew or of quicksilver varying in size become joined together each will be removed from its position and the proportion of their movements will be as that of their size.

The drop of that liquid is of the most perfect roundness which is of less . . .

Why if two spherical liquids unequal in quantity come to the beginning of contact with each other does the greater draw to itself the lesser and incorporate it immediately without destroying the perfection of its own roundness.

It is difficult to give an answer; but I will not for this reason refrain from stating my opinion. Water clothed with atmosphere naturally desires to be united in its sphere, because in such a position it is deprived of gravity, which gravity is double; for the whole has a gravity which depends on the centre of the elements, and there is a second gravity dependent on the centre of this watery sphere, for if it were not so it would form by itself a half sphere only which is that which stands from the centre upwards; and I do not perceive that the human intellect has any means of acquiring perception of this except by saying as one says of the action of the magnet when it draws the iron, that such virtue is a hidden property of which there are in nature an infinite number.

But it may be asked why there is greater perfection in the little sphere of the liquid than in the large one. To this the reply is that the little drop has a lightness which more resembles the atmosphere that surrounds it than the large drop has, and from the fact of this small difference it is more sustained from its centre downwards by this atmosphere than the large drop. And as a proof of this, one may take as an instance the little drops which are so small in shape as to be of themselves almost invisible but which are visible when there are a large

quantity together; and these are the particles which go to form clouds and mist.

Why the atmosphere when it has been submerged rises enveloped in a sheet of water. Which settles on its surface in the shape of a half sphere.

And if it is slimy water it moves through the atmosphere in the form of a sphere.

[*Drawing*] Bubble or rather vesicle of water.

You will make an experiment with these bubbles of water which over a little water set in a basin produce by means of the solar rays images of the form of a cross on the bottom of this basin.

C.A. 75 v. a

Air and fire are capable of an infinite amount of compression as is seen with mortar-pieces and thunderbolts. C.A. 97 v. a

The body of the air is filled with an infinite number of radiant pyramids formed by the objects situated in it, and these pyramids inter secting and interweaving without displacement one of another blend together in their separate courses throughout the whole of the surrounding air; and they are of equal power, and all have as much capacity as each one and each has as much as all; and through them the image of the body is carried all into the whole and all into a part, and each receives of itself in its every smallest part the whole cause.

C.A. 101 v. b

The movement of the thunderbolt which originates in the cloud is curved, because it bends from thickness to thinness, this thickness being occasioned by the fury of the aforesaid movement. For this thunderbolt not being able to extend in the direction in which it commenced, bends into the course that is freest and proceeds by this until it has created the second obstacle, and so following this rule it continues on to the end. C.A. 121 r. b

Why flame does not occur except above some space where there is smoke, and why it does not strike except through its smoke. This happens because the flames as they strike the air divide in pyramids, connected by ends which curve concavely and not convexly, and air within water does the same. C.A. 131 r. b

That the atmosphere attracts to itself like a magnet all the images of the things which surround it, and not only their bodily shapes but also their nature, is clearly to be seen in the case of the sun, which is a hot and luminous body. All the atmosphere which is exposed to its influence is charged in all its parts with light and heat, and it all receives within itself the shape of that which is the source of this heat and radiance and does the same also in each minutest part. The north star is shown to do the same by the needle of the compass; and each of the planets does the like without itself undergoing any diminution.

Among the products of the earth the same is found to happen with musk and other scents. C.A. 138 v. b

The cloud carried by the warmth which is shut up within it thrusts itself towards [. . . .] disc of fire, comes to the cold region of the air, which is frozen on the outer side but is not frozen within, because the warmth which has carried it up there preserves it from such cold; and this brings to pass three circumstances, the first being the evaporation of the moisture which after being pent up through the cold separates and dissolves into vapour and produces a raging wind; the second is the rain that is produced by the accumulation of the particles of moist vapour, for those of swift movement driven by the heat clash against those which are moving more slowly, and as they encounter that part of the cloud which becomes cold towards its extremities the particles of the moisture fasten themselves together and acquire weight, and so it descends to earth in big drops; and on the very extremity of this cloud the particles of moisture are continually freezing into balls of various sizes, and these cannot expand because of the intensity of the cold, but come together with swift movement at the spot where the sphericity of the drop is produced, and therefore the hail is composed of [. . . .] of many roundnesses which are joined together. C.A. 162 r. a

The elements are changed one into another, and when the air is changed into water by the contact it has with its cold region this then attracts to itself with fury all the surrounding air which moves furiously to fill up the place vacated by the air that has escaped; and so one mass moves in succession behind another, until they have in part

equalised the space from which the air has been divided, and this is the wind.

But if the water is changed to air then the air which first occupied the space into which the aforesaid increase flows must needs yield place in speed and impetus to the air which has been produced, and this is the wind.

The mist that is in the wind is produced by heat, and it is smitten and banished by the cold, and this cold drives it before it, and from where it has been driven the warmth is left cold. And because the mist which is driven cannot turn upwards because of the cold that presses it down, and cannot turn downwards because of the heat that raises it up, it therefore becomes necessary for it to proceed across, and I for my part consider that it has no movement of itself, for as the said powers are equal they confine the middle substance equally, and should it chance to escape the fugitive is dispersed and scattered in every direction, just as with a sponge filled with water, which is squeezed so that the water escapes out of the centre of the sponge in every direction. So therefore does the northern wind become the producer of all the winds at one and the same time. c.a. 169 r. a

[Of winds]

The north wind comes to us from high and frozen places and therefore it cannot give off moisture, and consequently it is pure and clean, because it is cold and dry, and for this reason it is very light in itself but its speed makes it powerful wherever it strikes.

The south wind has not the same purity, and since it is warm and dry it dissolves the thicknesses of the watery vapours which the Mediterranean Sea exhales, and these then follow in the wake of this wind and become dissolved in it; and so for this reason this wind as it strikes Europe comes to be warm and damp and heavy in its nature, and although its movement is sluggish its stroke is no less powerful than that of the north wind.

Every wind is by nature cold and dry but it takes to itself as many different attributes as are those of the places through which it passes, leaving behind it in passing dampness and cold to the dry and hot places and taking from these same hot dry places their dryness and heat. So in its movement in each region it puts on different attributes,

and in becoming warm and dry it weakens its power, and in resuming the things it had left behind it resumes the aforesaid forces together with them, for when there is the same swiftness of movement that thing which is of greater weight will give a greater percussion, and so conversely the lighter thing will give a less percussion.

When in summer the sun returns to the parts of Africa the humidity which had been increased there by the winter becomes dissolved and its bulk increases, and it searches in fury for places to contain this increase. And this is the south wind, which in autumn drives the maritime vapours of the Mediterranean before it, and condenses them above our regions, until they fall down again through lack of power to maintain themselves.

When many winds strive together then the waves of the sea have not a free course, but they clash together and raise themselves up and at times cause ships to founder; and in such a contest the stronger wind will be the victor through its being lighter and less interwoven or mingled with the other winds. c.a. 169 v. a

All objects have all their images and likenesses projected and mingled together throughout the whole extent of the surrounding atmosphere. The image of every point of their bodily surfaces exists in every point of this atmosphere, and all the images of the objects are in every point of this atmosphere. The whole and a part of the likeness of the atmosphere exists in every point of the surface of the objects which are over against it. Therefore the part and the whole of the images of the objects appear in all and in each part of the atmosphere which is opposite to them; and the substance of the atmosphere is seen reflected in the whole and in each part of the surface of these objects. Therefore clearly we may say that the likeness of each object either whole or in part is interchangeably in each part and in the whole of the objects opposite to it, as is seen with mirrors when placed one opposite to another. c.a. 179 v. c

Those winds which descending scour the parts of the mountains that lean towards the sea, penetrate to its bed and make waves, with sides that resemble the shores from which they descend, and these waves consequently have often deep narrow spaces between them, as I said in the book on the movement of water. And this tempest lasts only a

short time after the stroke of the wind, for after it has struck it leaps back into the air until it finds the other wind, and striking against this it compresses it and again leaps downward after the manner of the rivers as they strike the shores.

On the summits of the mountains the wind is of great density, and in the mouths of the valleys when the mountains which shut in these valleys are of great height. The entry of opposite winds one beneath the other with contrary movements may occur for two reasons, namely either through the reflex movement of the wind which turns back after having struck upon the mountains, or by the clashing together when the weaker parts of opposing winds strike against the stronger parts. The revolutions or eddies of the winds are born in the winds as they open out in the embrace of the mountains or of some building, and afterwards join together and strike with impetus; and their reflex movements are not made in a straight line, for it is checked in its own sphere, being moved by a substance like itself which has the power to check and bend its direct impetus. So therefore this wind not being able to extend proceeds to exhaust its impulse by a [curving] movement, and goes upwards in order to consume its impetus, this being necessary for three reasons; firstly because it cannot at once turn on the very lines of its descent, secondly because they strike at angles less than right angles, and because they cannot leap back on lines equal to those of their incidence.　　　　　　　　　　　　　　C.A. 180 v. a

[Cloud, wind and thunderbolt]

As water flows in different directions out of a squeezed sponge, or air from a pair of bellows, so it is with the thin transparent clouds that have been driven up to a height through the reflection occasioned by the heat, the first part which finds itself uppermost being that which comes first to the cold region, and here remaining through the cold and dryness awaits its companion. That part below as it ascends towards the part that is stationary treats the air which happens to be in the centre as though it was a syringe, and this then escapes crosswise and downwards, not going upwards because it finds the cloud so thick that it cannot penetrate it.

So for this reason all the winds that make war upon the earth's surface come down from above, and as they strike upon the resisting earth

they produce a movement of recoil, and this as it desires to raise itself up again to a height finds there the other wind, which descends and subdues its ascent, whereby the said upward movement is constrained to break its natural order, and taking a transverse route it pursues a violent course which grazes incessantly the surface of the earth.

And when the aforesaid winds strike upon the salt waters the form is clearly visible, in the angle that is created by the line of incidence and that of the recoil from which proceed the proud menacing and engulfing waves, of which the one for the most part is the cause of the other.

Here someone perhaps may think to censure me by putting forward as against my contention as to the winds the argument that these cannot be produced by the clouds because then it would be necessary for one to remain stationary and give movement to another, and this does not appear to be so, because when the north wind blows the clouds all collect together and fly before it. The reply to this is that when the air is still and a full company of clouds have risen to a height, and there above as has been said press themselves together, they squeeze out so much air from themselves, which through the violence exerted creates such movement in the air, that as you may see it communicates its movement to the other lesser clouds. And as they also drive the air forwards in the same way they even furnish themselves with a reason for greater flight; for when a cloud either finds itself in the midst of others or apart from them, if it produces the wind behind itself that air which is between it and its neighbour following comes to multiply, and by multiplying acts in the same way as the powder does in the mortar, for this expels from the position near to it the less heavy body and the lighter weight. And this being the case it follows that the cloud in driving the wind towards the others which offer resistance is the cause of putting these themselves to flight. And by sending this vanguard of the winds before itself it also adds volume to the rest. And if it should send them crosswise it would form a kind of rotatory circle around some cloud and then return in concert with the others.

As the natural warmth spread through the human limbs is driven back by the surrounding cold which is its opposite and enemy, and flowing back to the lake of the heart and the liver fortifies itself there, making of these its fortress and defence, so the clouds being made up

of warmth and moisture, and in summer of certain dry vapours, and finding themselves in the cold dry region, act after the manner of certain flowers and leaves which when attacked by the cold hoar-frost press themselves close together and offer a greater resistance.

So these in their first contact with the cold air commence to resist and not to wish to pass farther forward; the others below continue constantly to rise, the part above being stationary proceeds to thicken, the warmth and dryness recede to the centre, the part above abandoned by the warmth commences to freeze or to express it more exactly to dissolve, and as the clouds below continue to rise their warmth is brought nearer to the cold and so being constrained to reduce itself to its primary element is suddenly transformed into fire, and this twines itself among the dry vapour and in the centre of the cloud makes a great increase, and as it kindles itself within the cloud which has become cool it makes a noise that resembles that of water falling on boiling pitch or oil, or of molten copper when plunged into cold water. Even so driven forth by its opposite it shatters the cloud that would withstand it, and hurtling through the air breaks and destroys everything that opposes it, and this is the thunderbolt. c.a. 212 v. a

The air is compressible to infinity, and this is shown by the extremely swift movement of the radiance which produces the mighty thunder of the heavens, which bends and twists itself in different directions so much the more as the air and cloud before it is compressed and . . .

Example of thunder

The process of evaporation of water thrown upon burning coals is as that of the fire when kindled among the clouds which evaporate with such fury as to restrict the course of the brightness that has been created; that is to say that as the water is changed into vapour and becomes steam as it increases so the cloud evaporates and becomes changed into air, which by its increase hems in and restricts the flame which is produced in it. c.a. 213 r. a

Flame has its beginning and end in smoke.

The smoke out of which the flame is produced is of much greater heat than the smoke in which this flame ends, because in the first

smoke there is the nascent power of the flame, and the last is the dying away of the same flame.

Wood that is young and dry will produce smoke of a more intense blue than wood that is old and damp.

 • • • • •

The blue flame which is midway between the darkness and the light comes into being between the nutritive portion of the candle and its flame, and is of greater heat and radiance than the smoke and of less heat and radiance than its flame; and the vapour cannot transform itself into flame, without first becoming changed to this blue colour, and this is known in the case of smoke.

Flame is condensed smoke, formed out of the meeting together of the air that is in this blue smoke, which . . .

The blue smoke is the transit of the material nutriment that is the grease that is in the candle. The white smoke that surrounds the vestige of the flame is the spiritual transit of the flame of this candle, which in its lowest part is mingled with the topmost part of the aforesaid blue smoke, and in the upper part is mingled with the smoke which proceeds from the flame of the candle. C.A. 237 v. a

Write why the campanile shakes at the sound of its bells.
 C.A. 242 v. a

The southern winds are more powerful in the northern than in the southern regions and in summer than in winter; and this is because the sun dissolves all the moisture that rises from the Mediterranean Sea, which cannot dissolve during the cold of winter, and of these vapours few rise and these few are dissolved in water. But when the sun passes beyond the circle of the equinox, and it is winter here at hand and summer over yonder the sun dissolves all the vapours as they rise, so that they glide in aerial waves as far as the chief [mountains] of Europe, and there coming upon the cold in the autumn they turn into rain, and in the winter they are knit together in snow, and fall in snowstorms and so proceed little by little to stifle the breath of the aforesaid winds. C.A. 246 v. a

Where flame cannot live no animal that draws breath can live.
Excess of wind puts out flame, moderate wind nourishes it.
 C.A. 270 r. a

[*Of flame and wind*]

The bottom part of the flame is the first beginning of this flame through which passes all its nutriment of fat; and this is of so much less heat than the rest of the flame as it is of less brightness; and it is blue in colour and is the part in which its nutriment is purged and disposed of.

That has the brighter flame, and this is the first to come into existence when the flame is created, and it comes into existence in spherical shape, and after a span of life produces above itself a very small flame, radiant in colour and shaped like a heart with its point turned to the sky, and this proceeds to multiply continuously on towards infinity, by means of its acquiring possession of the substance that feeds it.

The blue flame is formed of spherical shape because it is not of such great heat as exceeds the lightness of the air; and for this reason it does not in itself form a pyramidal figure, but remains in spherical shape until it has warmed sufficiently the air which surrounds it, and because the chief warming of the air is above the principal heat of this blue flame, this heat being produced by that part where the natural desire of the flame is to move itself, that is to the sphere of fire by the shortest way. Therefore the fire comes into existence in the upper part of the blue spherical flame, in a small round figure, the roundness of which immediately undergoes some extension and assumes the shape of a heart, of which the point is turned towards the sky. And this shape immediately and with swift dilation overcomes the power that feeds it, and penetrates the air which serves it as a covering. But this blue colour remains in the base of this flame as may be seen in the light of the candle; and this comes to pass because in this position the flame is always less warm than elsewhere, because there is the first encounter which provides the nourishment of the flame with this flame, and it is there that the first heat is produced, and this is feebler and causes less warmth because it is only the commencement of the heat. . . .

That wind will be of briefer movement which is of more impetuous beginning; and this the fire has taught us as it bursts forth from the mortars, for it shows us the form and speed of the movement in the smoke as it penetrates the air opposite to it in brief and spreading revolution.

But the impetuosity of the wind is fitful, as is shown by the dust that it raises in the air in its various twists and turns. One perceives also in the chains of the Alps how the clashing together of the winds is caused by the impetus of various forces. One sees also how the flags of ships flutter in different ways; how on the sea one part of the water is struck and not another; and the same thing happening in the piazzas and on the sandbanks of the rivers, where the dust is swept together furiously in one part and not in another. And since these effects give us experience of the nature of their causes we can say with certainty that the wind which has the more impetuous origin will have the briefer movement, from the experience that has been referred to above as to the brief movement of the smoke from the mouth of the mortar. And this arises from the resistance that the air makes on being compressed by the percussion of this smoke, which also itself, as has been seen clearly shows compression when it offers resistance to the wind. But if the wind is of slow movement it will extend a long way in a straight course, because the air penetrated by it will not become condensed opposite to it and thus thwart its movement, but will readily expand spreading its course over a very great space.

OF EDDYING WINDS

When a wind has been divided by mountains or other erections, if on coming together again it should assume the shape of a rectangle, the movement which it makes after this reunion will be of a rotatory nature in the shape of a twisted column; and if the winds which are thus reunited should be equal then this column will not change its position; but if the winds are unequal the column will move in the direction of the weaker wind. C.A. 270 v. a

Fire or other heat lightens moisture and makes it lighter than the air; for which cause this moisture rises to the middle region of the air, and finding there the maximum cold of the air, the fire or heat infused through this cloud flies towards the centre, and there becoming strong separates the moist vapour from the dry, and it is for this reason that the fire becomes kindled there and turns into steam a great part of the moisture which is round about this fire. And this process of vaporisa-

tion as it increases restricts the fire, and the fire thus restricted acquires potency and bursts through the cloud in the part in which it is weakest, and forms a gate for the movement of the thunderbolt and the wind.

Whether the wind is caused amid the air, and cannot make any movement unless it is supported in the place where it resists by the opposite side of the movement, as is seen to be the case with the rays driven by the fire, for through the percussion that the fire makes in the air which offers some resistance to it, these fly more slowly than this fire; and if this were not the case such ray would be without movement.

Further we may say: the wind moves in a straight line and not as Aristotle would have it in a circular line; and this we learn from the movement of a storm at sea when there is no wind, for it is a sign that such wind follows its straight line leaving below it the curve of the sea.

Why the clouds are formed with various round shapes which are separated at different spaces one from another:

The movements of the air spring from the dispersal and collection of moisture.

Heat separates and disperses and cold assembles and freezes or condenses. C.A. 279 r. b

OF THE DROPS THAT FORM IN THE AIR

Drops are formed in the air through the mists or clouds by various movements, as when they encounter each other and become condensed or unite in the movement of the same cloud in the same direction, when one part of the cloud is swifter or slower than the other; for as the swifter part is behind the slower it conquers it in its course and overtakes it, and condenses it and out of many small drops makes one large one, and this acquires weight and falls. But unless the drops are so formed as to be of considerable size they are consumed by the friction they make with the air as they traverse it. C.A. 292 r. a

The moist wind which is found in the caverns that have both entrance and exit can produce water, and this especially when these caverns have twisted and shapeless sides; but this production of water is not permanent in its effect for when the wind is lacking the supply ceases, and if a contrary wind should enter by the opposite mouth of

this cavern the water which bathed its walls will become evaporated
and changed into air; and if this cavern have an entrance but no exit
the moist wind which strikes its mouth could not enter there unless
the air within that filled it were expelled. And since two opposite
movements cannot penetrate each other it must needs be that the air
that dwells within the cavern will find it easier to be condensed than
to escape, and for this reason it will resist the entrance of the wind
which beats upon it. C.A. 296 v. b

The images of every visible object are all infused in all the air over
against them, and are all separated in every part of the same air.

The images of objects which confusedly as they mingle fill with
themselves the air over against them are all in all this air and all in
every part of it. C.A. 345 r. b

Every body situated within the luminous air fills the infinite parts of
this air circle-wise with its images, and it is all in all and all in the part,
and goes lessening its images throughout the equidistant surrounding
space like a . . .

Of the four elements and two . . .

1. The stone thrown into the water becomes the centre of various
circles, and these have as their centre the spot which has been struck.

2. And the air in the same way is filled with circles, the centres of
which are the sounds and voices formed within them.

How the various circles of the water form round the spot which has
been struck by the stone.

The stone where it strikes the surface of the water creates circles
round itself which proceed to expand so much that they die away; and
the air also when struck by a voice or a noise departing circle-wise in
the same way proceeds to lose itself so that the nearest perceives better,
and the more distant hears less.

COMPARISON OF HOW THE THINGS COME TO THE EYE

Just as the air struck by the voice, the water by the stone proceed
in circular movement revealing their cause, and these circles make their
centre in the place which has been struck, and the farther away they
proceed from it . . . C.A. 373 r. b

The fifth essence is infused through the air as is the element of fire, although each of these may have its reason in itself or through itself; and since each particle is supplied with nutritive matter it acquires growth and increase of form; and if the nourishment be taken away from them they suddenly abandon this body and return to their first nature.
<div align="right">c.a. 393 v. a</div>

The air is all in all and all in its image in the part set over against it.

If within the air there be no opaque body the whole of it has a capacity which extends over the whole and over the part, and the part has a capacity which extends over the part and over the whole.

Therefore we may say that the air is all entwined in all of it, and is filled with the infinite rays of the images of the bodies which are situated within it, and this air is full of an infinite number of points, and every point is indivisible, and the parts of this indivisibility of all the images of the parts of bodies set over against them have capacity, and in these points they are entirely united and entirely divided and separated without confusion the one from the other.

And the pyramids of the images are spread throughout the whole of this air without occupation of space the one of the other, and each for itself, and are all divided through all and united through all.

And although the images approach the eye in the form of pyramids the eye is not conscious of this unless it forms a pyramid opposite to the thing seen.
<div align="right">c.a. 396 r. b</div>

Just as the stone thrown into the water becomes the centre and cause of various circles, and the sound made in the air spreads itself out in circles, so every body placed within the luminous air spreads itself out in circles and fills the surrounding parts with an infinite number of images of itself, and appears all in all and all in each *smallest* part.
<div align="right">A 9 v.</div>

OF COLD

I say that cold proceeds from two causes; the first is from the air being deprived of heat; the second is from the movement of the air. The air of itself is cold and dry and it is void of all matter or vapours, and it changes readily or to put it more exactly steeps itself in the nature and image of the things which touch it and which it has oppo-

site to it. As regards things that touch it, when a pungent thing such as musk or sulphur or some other powerful odour touches it it instantly permeates it; also if a luminous body be placed within it the whole of the surrounding air will be lit up.

Now to return to this question of cold I say that just as the many rays of a concave mirror converging at one point produce an extreme of heat even so many bellows blowing on the same point produce an extreme cold. A 20 r.

[*Concerning visibility*]

Men naturally if they wish to know whether the rain has commenced look in the air that is between the eye and some dark place; and then the fine threads which the minute drops of water cause to appear in the air being lighted up are easily visible against a dark background. But men reckon the threads which are near at hand and first as though they were the last and almost touched the dark place, not perceiving that this dark place is sometimes so remote that it would not be possible to be able to see a neighbouring tower there.

 C 5 v.

The colours of the middle of the rainbow mingle with each other.

The bow itself is neither in the rain nor in the eye that sees it, although it is produced by the rain, the sun, and the eye.

The rainbow is invariably seen by the eye which is situated between the rain and the body of the sun, and consequently when the sun is in the east and the rain in the west the rainbow is produced upon the western rain. E cover I v.

OF THE POWER OF A VACUUM FORMED INSTANTANEOUSLY

I saw at Milan a thunderbolt strike the Torre della Credenza on its northern side. It travelled along it with a slow movement and then all at once parted from the tower and carried with it and tore away a part of the wall, three braccia in breadth and length and two in depth. The wall was four braccia in width and was built of old bricks which were thin and small. It was torn away through the vacuum caused by the flame of the thunderbolt. I have found traces of the same power in the

rocks of the high Apennines and especially in the rock of La Vernia. The same thing occurs with a cannon in the vacuum left by the flame.

E I r.

Which will darken the earth more? A thick dark cloud that comes between the earth and the sun, or a quantity of water equal in bulk to the said cloud, the cloud touching the ground as does the water?

F 46 v.

[*Of fire and light*]
Fire would increase to infinity if the wood were indefinitely increased.

The light of the candle will be proportionately less as it is placed in a colder spot.

F 56 r.

OF THE WIND

The air moves like a river and carries the clouds with it; just as running water carries all the things that float upon it. This is proved because if the wind were to penetrate through the air and drive the clouds these clouds would be condensed between the air and the moving force and would take a lateral impress from the two opposing extremities, just as wax does when pressed between the fingers.

OF THE MOVEMENT OF AIR

Air moves when it is drawn away to fill a vacuum, or driven by the rarefaction of the humidity of the clouds.

G 10 r.

[*Reflex course of wind and water*]
The reflex wind as it turns back upon its course subdues the oncoming wind until this reflex wind becomes enfeebled, and then it regains its force when it becomes joined with the falling movement; and such power springs from its condensation acquired at the place of the percussions, which condensation always penetrates into the falling wind up to the point at which it becomes separated and its speed of movement becomes less.

The water does the same; not however by condensation but because it rises in the air and acquires weight.

G 69 r.

Why do the northern winds commence to blow at the winter solstice, and continue until melancholy January?

At the winter solstice, that is at the middle of December, the northern winds are at their maximum strength. G 91 r.

HOW THE WIND THAT STRIKES THE CLOUD ON ONE SIDE MAKES IT TURN ROUND

If the wind strikes the cloud on one side only, then although its opposite side, that is of the clouds, is in the motionless air, this cloud will be driven forward and turned round, and it will make a circular movement like that of the wheel of a mill turned by the water.

WHAT IS THE CAUSE THAT MAKES THE CLOUDS INCREASE THEIR HEIGHT?

When the movement of two contrary winds brings two clouds to strike together these clouds then become incorporated in each other, and not being able either to expand or lower themselves because of the wind passing beneath them, these clouds extend in that direction in which their passage is least impeded, that is upwards.

OF THE MEETING OF TWO CLOUDS MOVING DIFFERENTLY IN THE SAME PATH

When with the same wind two clouds meet together, the greater in order to have part of the more powerful wind covers the smaller; and the two become condensed at their common contact, and this causes rain. G 91 v.

If the wind is created by excess or dearth the southern parts which separate the humidity drawn to them come to condense themselves, and not being able to receive such multiplication they drive it back; it is then drawn by the vacuum created in the cold region where this humidity becomes contracted in forming clouds, or in the southern parts where the other clouds are formed.

OF THE SWIFTNESS OF CLOUDS

The course of the cloud is less swift in itself than its shadow which moves over the earth. This is proved:—Let e be the solar body, a the cloud, and c its shadow: then as the cloud moves from a to b the shadow will move from c to d, from which it follows that as the shadows that pass from the earth to the cloud are made by lines that converge in the centre of the sun, we may say by my fourth [rule] that what is set forth is true, for this fourth says:—the equidistant sections at the angle of the two converging lines will be so much less as they are nearer the place of meeting; therefore as the clouds are nearer the sun than their shadow there can be no doubt that the shadow will travel a greater distance over the earth than the cloud does through the air in the same time. G 92 v.

The atmosphere is blue because of the darkness which is above it, for black and white together make blue. H 77 [29] v.

The part of the cloud which is nearest to the eye will seem swifter than that which is higher; and for this reason they often appear to be moving in contrary directions, one to the other. H 89 [41] r.

Of the shapes that one element assumes as it penetrates into another:
Air falling from fire will turn the mill as fire issuing from air will, and in the same way air falling from water as water from air, and as earth falling from water; and you should describe the equality of the powers and resistances and the shapes that they assume as they pass.
 I 76 [28] v.

[*Compressed air in rose-water at barber's*]
Whether air can be compressed in itself is shown by the barber's vessel for supplying rose-water, in which it is doubled.
Fire is quadrupled by the force of the place where it cannot increase.
 I 133 [85] r.

OF THE RISING OF THE WIND

Every movable thing continues its movement in the shortest way and either shuns the obstacle or is bent by the obstacles; therefore the

wind curves in penetrating the thick air, and bends upwards towards
the light air. K 113 [33] v.

OF WATER AND AIR

Air that moves with impetus within the other air is compressed
within itself as is shown in the expansion of the solar rays; for if the
wind moves their atoms in various revolutions you see these atoms
form themselves into marbled waves after the manner of watered silks
or camlets (gianbellotti); and that which you see done to these atoms
is done by the air which bears them shut up within itself.

The water in such cases cannot become compressed, and having all
these like movements in its body it is necessary for it to drive the other
water from its place, so that they may all appear on the surface.

 L 78 r.

When the sun strikes upon concave mirrors and leaps back from
them with pyramidal course, that part of the pyramid will be propor-
tionately as much warmer than its base as it is less in size, and it does
so in as much as its moisture becomes restricted. The hot steam which
is mingled with it becomes so much more powerful as it is more united,
and as it is confined within a less space it generates more heat. Conse-
quently it often catches fire and increases, forming itself into a thun-
derbolt out of the cloud; and so it bursts the cloud with devastating
lightning and thunder. The little particles of water, when the cloud
has been contracted by the cold, fasten themselves together and fall by
reason of their weight. And in this way the clouds break up, and so
they return in rain to the low position. B.M. 57 r.

The surfaces of transparent and polished bodies always mirror the
objects which look upon their surfaces and are looked upon by them.

Therefore that which stands underneath the water is mirrored in the
surface of the air which borders upon this water, and that which is in
the air is mirrored in the surface of the water which borders upon
this air. B.M. 196 r.

The course of the winds changes and follows the movement of some
other wind by reason of the mouths of the valleys which it enters and
issues forth from, and this happens more with the low winds than with

the high ones, and this it does from its being flexible and able to be bent in any direction except that directly opposite to its course. And desiring to move and to give place to the new wind it has to do as does the water that enters a pool by a line and then turns in various channels, but more by the line that follows that of the movement it makes at its entrance, and less by that farthest away from this entrance.

The wind is condensed above the places where it strikes, and more in the summits of the mountains than on the sea coasts visited by it; for there gather all the reflex winds, that is on summits of the straight sides of the mountains where these winds strike; for they do not extend all crosswise following the shape of the summit of the mountain, but many proceed up in a straight line and especially those that strike nearest the bases of the mountains, although after they are above the summit of the mountain they describe a curve, and after such process of curving straighten themselves into the course of the other wind which struck them and which first made them describe a curve. B.M. 276 r.

OF THE WIND

Many are the times when the course of one wind is diverted into that of another, and this arises from the percussion which they make at the meeting of their courses when as they are not able to penetrate one into the other necessity constrains them to leap back in opposite directions.

If however the said winds are not of equal power one with another their reflex movements will not follow the movement of their striker, but the angle of percussion of the more powerful will be as much greater than that of the less powerful as is the excess of the greater power over the lesser.

Winds which blow in the same direction may be simple or mixed with other winds, that is along one part of its side the wind may be all taut because the free wind strikes it and leaps back at equal angles, but never opposite to its source because it would have to re-enter into itself and the movement of two bodies cannot penetrate within themselves. Therefore it follows that the part of the greater wind which is struck by the lesser wind would turn backwards and follow the course of the lesser wind which has struck it, but it encounters it along the

remainder of its width and this causes it to curve gradually until finally it has changed back to its former course.

The same wind therefore in striking produces within itself different movements and different degrees of power, for the part of its breadth before mentioned which drives before it the part which flies away also takes a reflex movement upon the wind which it strikes, and so after it does the part which when struck puts to flight the second; and the fourth which strikes the third in such a way that in these parts it becomes denser. But the first density is greater than the last, after the manner of two streams of water striking together, as I have demonstrated in the fourth of the seventh of the elements of mechanics, for there is an angle formed at the place of the first percussion which makes the water that first strikes leap up more than any other part of it.

B.M. 276 v.

[Movement of the winds]

If the movement of the winds proceeds from Jupiter the cause of the wind must be in the twenty-four hours during which the movement of Jupiter is from the east to the west and not from the north to the south; and this arises from the fact that a thing moved by something else has the form and time of the movement of its mover.

Quaderni II 20 v.

QUESTIONS: THE MATERIALS WHICH PRODUCE WIND

If (the wind) is a vapour of the earth and of cold and dryness, and is carried by heat, it rises to the cold region of the air, and, abandoned by heat, its conductor, it remains there. Such is the reason why the vapour, being similar to the vapours in that place, that is to say cold and dry, leaves the place and vapour, and flies from its similar; and this, indeed, having ceased its upward movement and entering a place entirely similar to itself is free to remain without motion. And yet if you concede it its movement, it must still move in the cold region by itself. But we shall say that such a vapour being cold and dry in its slow and late birth, becomes successively mixed with the hot, and so with a gradual expansion it generates an almost imperceptible motion in proportion to this expansion. But the motion of the heat which car-

ries it upward is swift and so conducts it as far as the cold region of the air, where, having expelled the first part, the heat which conducts it there leaves it there, and so diminishes the vapour, which being without wind by the same amount as that of the heat which was mixed with it, being thus diminished in quantity, grows in weight above the air which sustains it, and so descends below the other vapour, and having descended there the heat which is divided from it is reunited with the heat and with the other vapour; and this giving it an upward movement and so raising all the vapour little by little it chills the upper part which penetrates the cold; and so little by little it falls back through the weight it has acquired, in such a way that the whole is composed of a greater weight than it was formerly. Hence it descends in the form of clouds, and approaching the heat refracted by the earth warmed by the sun, it becomes dissolved and dilates with great movement; and this is the wind.

The winds descend from above to below at various angles, and, striking the water or the earth, set up lateral movements along various lines, as does the water which penetrates other water.

You say that the movement of an effect follows the movement of its cause; and then say that the twelve signs of the Zodiac are the cause of the motion of winds, and that the three fiery signs, the Ram, the Lion and the Archer are of the east and move the eastern winds; and that the three cold and dry signs, the Bull, the Virgin and the Goat move the southern winds, and the other three signs move the western winds. This theory leaves the inventor of such causes in confusion from the first proposition which you agreed on, viz. that all bodies in motion follow the movement of their motive force. Now these signs of the Zodiac are moving from east to west and go round the world in twenty-four hours. How then do you account for the fact that these signs which move towards the west will move the western winds; and yet these winds should move towards the east which would be contrary to the motion of their motive force? This is contrary to your first assumption, which is true, but your consequent theory is false.

You say that the vapour which generates the wind is carried upwards by heat and pressed down again by cold; which having been said, it follows in course that this vapour, finding itself between two contrary motions, escapes to the sides; and this lateral movement is the wind,

which has a tortuous movement because it cannot descend to the earth because the heat pushes it up, and it cannot move very high up because the cold presses it down; hence this necessity gives it a latitudinal and tortuous movement. Now many drawbacks will follow from this theory of yours, of which the first is that the wind will never descend to the plain, and secondly that the cold in being driven down by such a vapour would be acting contrary to its inert nature.

Windsor: Drawings 12671 r.

Then again, it is possible that the vapour which collects in the cold region, through being abandoned by the heat which conducts it there, comes to be compressed and makes itself larger (heavier?); and the air which formerly sustained it no longer resists it, and in consequence gives place to it; and this vapour being heavy descends rapidly into the hot region near to the earth. There it is entirely permeated with heat and in consequence completely dilated and resolved, and moves in every direction which is round about it, and strikes the sea on its surface. And here one can see the cause of the origin of such wind as makes the movement of the sea, for it is flying from the first place it struck. And in this cause (case?) the courses of the parts of this wind are not parallel because they move from the centre to the circumference in direct lines.

The congregation of humidity scattered through the air, which comes together for the creation of clouds, creates wind in the air. And similarly the breaking up of the clouds makes the fine and penetrable humidity through the air; and this is the wind. The proof: one may see the water churned up on a fire which makes a wind in the chimney that is above this fire; and again, boiling water which is shut into vases escapes through little vents of such a vase with great force in the manner of wind. And again, fires made in small rooms suck in the air through little cracks in the windows with great force and noise.

Windsor: Drawings 12671 v.

The force inherent in moving bodies has the result that movement is often contrary to the nature of the thing moved.

You say that the vapour of the wind is driven up by the heat which lifts it and is then pushed down again by the cold which joins with

it; and yet necessity gives it a lateral and a curved movement, since being enclosed between two contrary forces it flies out sideways all over the earth.

But this theory denies that the vapour which has been mixed in the cold region of the air is pushed down by this cold, because it is necessary to say either that the vapour flies before the cold from its nature, or that the cold really removes it of itself, which is being contrary to the nature of the vapour. And if such a vapour moves of itself, it does so after it has increased and not before, because at first it is the power of the heat pressing it down which makes itself greater than the power of the vapour which wishes to descend. Here it must be confessed that such a vapour in increasing acquires weight, and that with this weight it overcomes the force of the heat which sustains it, and that here cold does not press it down because, if it were natural to such cold to press it down, it would have been easier to expel it when the vapour was small in quantity and weak than when it was increased in quantity and in force. And so here we shall say that the vapour of the wind, having reached the cold region, stops there, because the heat which has conducted it to this place becomes consumed in cold; and the heat being consumed the vapour remains without motive force, and so it stays there and awaits the parts which succeed and adjoin it. And these not being at such an altitude are not yet completely deprived of heat and in consequence of movement; and so not being stationary they move until at last they arrive at the same altitude as the part which has been chilled and they penetrate this and unite with it, and the heat being there condensed leaves it [the vapour]. And so subsequently rising, one part after the other, and penetrating the higher part, they are prevented from condensing, and from that weight of such a nature that the lower region cannot sustain it above itself. Hence by necessity it descends united with it until the heat makes it light and again lifts it upwards, and does the same as it did the first time, and so once more joining with the cold part it again acquires weight and again sinks down and again turns to vapour in the upper air. And so this would go on continually and from this arises the motion of the wind spreading itself from high to low and not from here to there [vertically and not horizontally]. Well then this theory given above is false, because experience shows itself in disagreement.

You say that the winds begin by being weak and go on growing in strength, because in the beginning there was a small quantity of vapour generated by a small blast; but when such a vapour was increased in a greater quantity, being struck by the cold, it descends with greater force and from this arises the growth of wind. To this we answer that any movement is born of a void or a deficiency. If vapour which is raised by the heat, which though it penetrates the said heat, dissolves such a vapour and makes a movement sideways or rather upwards because that is the true [direction] of the movement of fire, and when, the more this evaporation rises the more it is pressed in, its exterior moves itself inwards towards the centre of the bulk. And this second movement is contrary to the first, because the first moved from the centre to the extremities and the second movement is from the extremities to the centre, and from one to the other the movement is more rapid in proportion as it is more remote from the centre, because the extremities are more affected by heat and cold than are the parts which are near the middle. But to return to the matter in hand; the more the vapour rises the more it is pressed in because it grows nearer to the cold, the exact opposite of the heat which conducts such a vapour and presses it in.

This cannot make wind which flows from it, but can make it if it runs contrary to it because it does not allow a vacuum, and the place from whence its parts are flying would remain a vacuum if the air did not fill them up, and this air rushes to fill up [the vacuum] with the same speed as the vapour when it is rushing away from the cold. And since the material joined with the motive force which moves it, moves itself in the same amount of time as the movement made by this motive force, therefore here the vapour will move itself in such time as the fire, its first motive force, accompanies it, and when the fire is parted from it the vapour loses its movement which [movement] the cold does not give it if it is not against the half of its quantity (?), or it may be that that part of the vapour which touches the cold first of all is the first to rush backwards towards the centre, but one cannot classify this as actual flight but as the loss of its elevation.

You say that the wind does not blow continuously, but with various gusts divided one from the other; and the cause of this is the vapour which rises to the cold carried by heat in various quantities. Here one

may answer that the cold does not expel the vapour but (that this is produced); but that the heat which is escaping from the cold brings back the vapour which it formerly carried with it to the cold regions. And again one may say that the heat, in the first contact which it makes with the cold, warms this cold in proportion as it touches it [the cold]; and similarly the cold chills the heat in proportion as it receives it [the heat] into itself. Hence there arises a storm; which has the result that the heat and cold lose some of their original force; and in this case the way is prepared for the transformation into vapour which succeeds, together with the heat, in penetrating more deeply into the cold and warming it to a greater altitude. And so the vapour penetrates farther in such a way that it passes through the cold region and penetrates towards the element of fire [the source of heat]; and being united with it the vapour makes a great outburst through all the surrounding regions, which outbursts are rapid movements in direct lines and result in a flood of air which [strikes] the sea above the horizon and proves to be the cause of your solution.

Windsor: Drawings 12672

OF THE COLOUR OF THE ATMOSPHERE

I say that the blue which is seen in the atmosphere is not its own colour, but is caused by the heated moisture having evaporated into the most minute imperceptible particles, which the beams of the solar rays attract and cause to seem luminous against the deep intense darkness of the region of fire that forms a covering above them. And this may be seen, as I myself saw it, by anyone who ascends Mon Boso (Monte Rosa), a peak of the chain of Alps that divides France from Italy, at whose base spring the four rivers which flow as many different ways and water all Europe, and there is no other mountain that has its base at so great an elevation.

This mountain towers to so great a height as almost to pass above all the clouds; and snow seldom falls there, but only hail in summer when the clouds are at their greatest height; and there this hail accumulates, so that if it were not for the infrequency [1] of the clouds thus rising and

[1] MS. has reta which Dr. Richter reads in sense of 'malanno'. I have adopted Dr. Solmi's suggestion 'rarità'. (Note, Dec. 1929. Calvi reads [ra]retà.)

discharging themselves, which does not happen twice in an age, there would be an enormous mass of ice there, built up by the various layers of the hail; and this I found very thick in the middle of July. And I saw the atmosphere dark overhead, and the rays of the sun striking the mountain had far more brightness than in the plains below, because less thickness of atmosphere lay between the summit of this mountain and the sun.

As a further example of the colour of the atmosphere, we may take the case of the smoke produced by old dry wood, for as it comes out of the chimneys it seems to be a pronounced blue when seen between the eye and a dark space, but as it rises higher and comes between the eye and the luminous atmosphere, it turns immediately to an ashen grey hue, and this comes to pass because it no longer has darkness beyond it, but in place of this the luminous atmosphere. But if this smoke comes from new green wood, then it will not assume a blue colour, because, as it is not transparent, and is heavily charged with moisture, it will have the effect of a dense cloud which takes definite lights and shadows as though it were a solid body.

The same is true of the atmosphere, which excessive moisture renders white, while little moisture acted upon by heat causes it to be dark and of a dark blue colour; and this is sufficient as regards the definition of the colour of the atmosphere, although one may also say that if the atmosphere had this transparent blue as its natural colour, it would follow that wherever a greater quantity of atmosphere came between the eye and the fiery element, it would appear of a deeper shade of blue, as is seen with blue glass and with sapphires, which appear darker in proportion as they are thicker. The atmosphere, under these conditions, acts in exactly the opposite way, since where a greater quantity of it comes between the eye and the sphere of fire, there it is seen much whiter, and this happens towards the horizon; and in proportion as a lesser amount of atmosphere comes between the eye and the sphere of fire, of so much the deeper blue does it appear, even when we are in the low plains. It follows therefore, from what I say, that the atmosphere acquires its blueness from the particles of moisture which catch the luminous rays of the sun.

We may also observe the difference between the atoms of dust and those of smoke seen in the sun's rays as they pass through the chinks

of the walls in dark rooms, that the one seems the colour of ashes, and the other—the thin smoke—seems of a most beautiful blue. We may see also in the dark shadows of mountains far from the eye that the atmosphere which is between the eye and these shadows will appear very blue, and in the portion of these mountains which is in light, it will not vary much from its first colour.

But whoever would see a final proof, should stain a board with various different colours, among which he should include a very strong black, and then over them all he should lay a thin transparent white, and he will then perceive that the lustre of the white will nowhere display a more beautiful blue than over the black,—but it must be very thin and finely ground. Leic. 4 r.

Smoke is swift at its beginning and becomes slower at every stage of its ascent, because it becomes colder and heavier, owing to the fact that a great part of it is condensed through the parts striking against each other and being pressed together and made to adhere one to another; and water does the same for it is swift at the beginning of its movement. Leic. 12 v.

Air even if it changes its position preserves the impression of its eddies more than water does, from the fact of it being swifter and thinner. Leic. 30 v.

An excess of smoke acts as a veil, a small quantity of it does not render the perfection of this blue: it is by a moderate admixture of smoke therefore that the beautiful blue is created.

Experience it is that shows how the air has darkness behind it and yet appears blue.

Make smoke of dry wood in a small quantity; let the rays of the sun fall upon this smoke, and behind it place a piece of black velvet, so that it shall be in shadow. You will then see that all the smoke which comes between the eye and the darkness of the velvet will show itself of a very beautiful blue colour; and if instead of the velvet you put a white cloth, the smoke will become the colour of ashes.

How water blown in the form of spray into a dark place, through which the solar rays pass, produces this blue ray; and especially when this water has been distilled: and how the thin smoke becomes blue.

This is said in order to show how the blue colour of the atmosphere is caused by the darkness that is above it; and the above-mentioned instances are offered for the benefit of anyone who cannot confirm my experience on Mon Boso.[1] Leic. 36 r.

[1] See Leic. 4 r. in which Leonardo refers to his ascent of Mon Boso (Monte Rosa) in the month of July and the atmospheric conditions which he found prevailing.

XVII

Flight

'I have divided the "Treatise on Birds" into four books; of which the first treats of their flight by beating their wings; the second of flight without beating their wings and with the help of the wind; the third of flight in general, such as that of birds, bats, fishes, animals and insects; the last of the mechanism of this movement.'

THOSE feathers which are farthest away from their points of attachment will be most flexible.

The tips of the feathers of the wings therefore will always be higher than their roots, wherefore we may with reason say that the bones of the wings will always be lower when the wing is lowered than any part of the wing; and when it is raised these bones of the wing will be higher than any part of this wing. Because the heavier part will always be the guide of the movement.

I ask in what part of the under surface of the breadth of the wing does this wing press the air more than in any part of the length of the wings.

Every body that does not bend, although these are each in itself of different size and weight, will throw equal weights upon all the supports which are equidistant from their centre of gravity, this centre being in the middle of the breadth of this body.

But if the said body is flexible with varying thicknesses and weights, although the centre of gravity may be in the centre of its magnitude, this will not prevent the support that is nearest the centre of its gravity, or of other inequality of gravity, from being more charged with weight than that which is above the lighter parts.

<div align="right">Sul Volo 4 v.</div>

The man in a flying machine [has] to be free from the waist upward in order to be able to balance himself as he does in a boat, so

that his centre of gravity and that of his machine may oscillate and change where necessity requires through a change in the centre of its resistance.

When the bird desires to turn to the right or left side by beating its wings, it will beat lower with the wing on the side on which it wishes to turn, and thus the bird will twist its movement behind the impetus of the wing which moves most, Sul Volo 6 [5] r.

and makes the reflex movement under the wind from the opposite side.

When the bird desires to rise by beating its wings it raises its shoulders and beats the tips of the wings towards itself, and comes to condense the air which is interposed between the points of the wings and the breast of the bird, and the pressure from this air raises up the bird.

The kite and the other birds which beat their wings only a little, go in search of the current of the wind; and when the wind is blowing at a height they may be seen at a great elevation, but if it is blowing low down then they remain low.

When there is no wind stirring in the air then the kite beats its wings more rapidly in its flight, in such a way that it rises to a height and acquires an impetus; with which impetus, dropping then very gradually, it can travel for a great distance without moving its wings.

And when it has descended it does the same over again, and so continues for many times in succession.

This method of descending without moving the wings serves it as a means of resting in the air after the fatigue of the above-mentioned beating of the wings.

All the birds which fly in spurts rise to a height by beating their wings; and during their descent they proceed to rest themselves, for while descending they do not beat their wings. Sul Volo 6 [5] v.

OF THE FOUR REFLEX AND FALLING MOVEMENTS MADE BY BIRDS UNDER DIFFERENT CONDITIONS OF THE WIND

The slanting descent of birds made against the wind will always be made beneath the wind, and their reflex movement will be made upon the wind.

But if this falling movement is made to the east when the wind is blowing from the north then the north wing will remain under the wind and it will do the same in the reflex movement, wherefore at the end of this reflex movement the bird will find itself with its front to the north.

And if the bird descends to the south while the wind is blowing from the north it will make this descent upon the wind, and its reflex movement will be below the wind; but this is a vexed question which shall be discussed in its proper place for here it would seem that it could not make the reflex movement.

When the bird makes its reflex movement facing and upon the wind it will rise much more than its natural impetus requires, seeing that it is also helped by the wind which enters underneath it and plays the part of a wedge. But when it is at the end of its ascent it will have used up its impetus and therefore will depend upon the help of the wind, which as it strikes it on the breast would throw it over if it were not that it lowers the right or left wing, for this will cause it to turn to the right or left dropping down in a half circle.

Sul Volo 7 [6] r.

[Of a flying machine]

The movement of the bird ought always to be above the clouds so that the wing may not be wetted, and in order to survey more country and to escape the danger caused by the revolutions of the winds among the mountain defiles which are always full of gusts and eddies of winds. And if moreover the bird should be overturned you will have plenty of time to turn it back again following the instructions I have given, before it falls down again to the ground.

If the point of the wing is struck by the wind and the wind enters underneath the point the bird will then find itself liable to be overturned unless it employs one of two remedies; that is either it suddenly enters with this point under the wind or lowers the opposite wing from the middle forward.

(*Figure*) *a b c d* are the four cords above for raising the wing, and they are as powerful in action as the cords below, *e f g h*, because of the bird being overturned so that they may offer as much resistance above as they do below, although a single strip of hide dressed with

alum thick and large may chance to suffice: but finally however we must put it to the test. Sul Volo 7 [6] v.

The bird I have described ought to be able by the help of the wind to rise to a great height, and this will prove to be its safety; since even if all the above-mentioned revolutions were to befall it, it would still have time to regain a condition of equilibrium; provided that its various parts have a great power of resistance, so that they can safely withstand the fury and violence of the descent, by the aid of the defences which I have mentioned; and its joints should be made of strong tanned hide, and sewn with cords of very strong raw silk. And let no one encumber himself with iron bands, for these are very soon broken at the joints or else they become worn out, and consequently it is well not to encumber one's self with them.

The cord a set for the purpose of extending the wing ought to be of thick dressed hide, so that if the bird should be turned upside down it may be able to subdue the fury of the wind which strikes it on the wing and seeks to close it, for this would be the cause of the destruction of the bird. But to make it more safe you should make exactly the same system of cords outside as within, and you will then avoid all suspicion of danger.

a b c are the terminating points of the cords from the three joints of the fingers of the wings; d marks the position of the mover of the lever a d which moves the wing. Sul Volo 8 [7] r.

When the edge of the point of the wing meets the edge of the wind for a brief moment this wing sets it either below or above this edge of the wind, and the same happens with the point and sides of the tail and in like manner with the helms of the shoulders of the wings.

The descent of the bird will always be by that extremity which is nearest to its centre of gravity.

The heaviest part of the bird which descends will always be in front of the centre of its bulk.

3rd. When without the help of the wind the bird is stationary in the air without beating its wings in a position of equilibrium, this shows that its centre of gravity is identical with the centre of its bulk.

4th. The heaviest part of the bird which descends head foremost will never remain above or level with the height of its lightest part.

If the bird falls with its tail downwards by throwing its tail backwards it will regain a position of equilibrium, and if it throws it forwards it will come to turn right over.

1st. When the bird being in a state of equilibrium sends the centre of resistance of its wings behind its centre of gravity it will descend with its head below.

2nd. And this bird which is in a state of equilibrium will have the centre of resistance of its wings in front of its centre of gravity; this bird will then drop with the tail turned to the ground.[1]

Sul Volo 8 [7] v.

If the wing and the tail are too far above the wind lower half the opposite wing and so get the impact of the wind there within it, and this will cause it to right itself.

If the wing and the tail should be beneath the wind raise the opposite wing and it will right itself as you desire, provided that this wing which rises slants less than the one opposite to it.

And if the wing and the breast are above the wind it should lower the half of the opposite wing, and this will be struck by the wind and thrown back upwards, and this will cause the bird to right itself.

But if the wing and the spine are below the wind it ought then to raise the opposite wing and expand it in the wind, and the bird will immediately right itself.

And if the bird is situated with the hinder part above the wind the tail ought then to be placed beneath the wind, and thus there will be brought about an equilibrium of forces.

But if the bird should have its hinder parts below the wind (*raising its tail*[2]) it should enter with its tail above the wind and it will right itself.

Sul Volo 9 [8] r.

When the bird is above the wind, turning its bill with its trunk to the wind the bird would be liable to be overturned unless it lowered its tail and received in it a great volume of wind; and if it acts thus it is impossible for it to be overturned. This is proved by the first section

[1] The odd order of the numbered paragraphs here and elsewhere in the MSS. suggests that the numbers may have been added with the intention of amending the order when the work should take its final form.

[2] Words crossed out in MS.

of the Elements of Mechanics, which shows how things in equilibrium which are struck outside their centre of gravity send down the opposite sides which are situated on this side of the aforesaid centre. . . .

(*Example*)

And if the bird is situated with its length under the wind it is liable to be thrown upside down by the wind unless it instantly raises up its tail. . . .

How the expanse of the wing is not all used in compressing the air; and for the truth of this see how the openings between the chief feathers are much wider spaces than the actual breadth of the feathers.

You therefore who make research into winged creatures do not take into your reckoning the whole expanse of the wing, and note the different characteristics of the wings of all winged creatures.

Sul Volo 9 [8] v.

When the wind strikes the bird under its course from its centre of gravity towards this wind then the bird will turn with its spine towards the wind; and if the wind was more powerful below than above the bird would be turned upside down if it were not instantly alert to draw to itself the lower and stretch out the upper wing; and by this means it rights itself and returns to the position of equilibrium.

This is proved thus:—let $a\ c$ be the wing folded up beneath the bird, and $a\ b$ the wing extended; I say that the forces of the wind which strike the two wings will have the same proportion as that of their extension, that is $a\ b$ as against $a\ c$. It is true that c is wider than b, but it is so near the bird's centre of gravity that it offers small resistance in comparison with b.

But when the bird is struck under the wind, beneath one of its wings, it would be possible for the wind to overturn it if it were not that so soon as ever it is turned with its breast to the wind it extended the opposite wing towards the ground, and drew up the wing which was first struck by the wind which remains uppermost, and thus it will come to return to a position of equilibrium. This is proved by the fourth of the third according to which that object is more mastered which is opposed by a greater force; also by the fifth of the third

which is that this support resists less and is situated farther away from its fixed point; also by the fourth of the third: among winds of equal force that will be of greater force which is of greater volume, and that will strike with a greater volume which finds a greater object; wherefore *m f* being longer than *m n*, *m f* will obey the wind.

Sul Volo 10 [9] r.

If the bird should wish to turn itself rapidly on one of its sides and to follow its circular movement it will beat its wings twice on that side, moving the wing back like an oar and keeping the other wing steady or making only one beat with this as against two of the opposite wing.

Since the wings are swifter to press the air than the air is to escape from beneath the wings the air becomes condensed and resists the movement of the wings; and the motive power of these wings by subduing the resistance of the air raises itself in a contrary movement to the movement of the wings.

That bird will descend with the swifter movement when its descent is at a less angle.

The descent of a bird will be at a less angle when the tips of the wings and their shoulders are nearer together.

The lines of the movements made by birds as they rise are of two kinds, of which one is always spiral in the manner of a screw, and the other is rectilinear and curved.

That bird will rise up to a height which by means of a circular movement in the shape of a screw makes its reflex movement against the coming of the wind and against the flight of this wind, turning always upon its right or left side.

Thus if the north wind should be blowing, and you coming above in reflex movement, should glide against the said wind, until, in this straight process of rising, the wind was in such a condition that it might turn you over, you are then at liberty to bend with the right or left wing, and holding the inner wing low you will pursue a curving movement, with the help of the tail, curving in the direction of the lower wing, and continually descending and pivoting round the wing that is held low, until you again make the reflex movement anew above the wind, behind the course of the wind; and when you are

on the point of being turned over this same lower wing will curve your line of movement, and you will return against the wind, under-neath it, until you have acquired the impetus, and then raise yourself above the wind, facing its approach, and by means of the already acquired impetus, you will make the reflex movement greater than the falling movement.

A bird as it rises always sets its wings above the wind and without beating them, and it always moves in a circular movement.

And if you wish to go to the west without beating your wings, when the north wind is blowing, make the falling movement straight and beneath the wind to the west, and the reflex movement above the wind to the north. Sul Volo (F.M.) 11 [10] r.

A bird makes the same use of wings and tail in the air as a swimmer does of his arms and legs in the water.

If a man is swimming with his arms equally towards the east, and his body exactly faces the east, the swimmer's movement will be to-wards the east. But if the northern arm is making a longer stroke than the southern arm then the movement of his body will be to the north-east. And if the right arm is making a longer movement than the left the man's movement will be to the south-east.

The impetus of one of the wings extended edgewise towards the tail will occasion the bird a sudden circling movement following on the impetus of the above-mentioned wing.

When the bird raises itself in circles to a height above the wind, without beating its wings, by the force of the wind, it will be trans-ported by this wind out of the region where it desires to return, still without beating its wings; then it turns so that it faces the approach of the wind, entering slantwise underneath this wind, and comes to descend slightly until it finds itself above the spot where it desires to return.

The edge *a* of the helm of the wing or the thumb (dito grosso) of the hand of the bird *b a* is that which sets the shoulder of the wing immediately below or above the wind. And if this shoulder did not have the power of cutting with a keen and strong edge, the wing would not be able suddenly to enter below or above the wind when it happened to be necessary for the bird, seeing that if this shoulder

were round, and the wind *f e* were to strike the wing below and it should immediately befall the wing to be . . .

<div align="right">Sul Volo (F.M.) 11 [10] v.</div>

. . . struck from above, the power of the wind which strikes it from above is not at its full strength, seeing that the wedge of the wind which is separated from the middle of the shoulder downwards raises the wing up almost with the same power as that exerted by the wind above to send the wing downwards.

But if the wind strikes the bird on the right or left wing, it is necessary for it to enter below or above this wind, with the point of the wing struck by this wind, and this change occupies as much space as the thickness of the points of these wings. As this change is beneath the wind the bird turns with its bill to the wind, and if it is above the wind the bird will turn with its tail as it pleases; and here arises the danger of the bird being turned upside down, if nature had not provided for this by placing the weight of the body of this bird lower than the position of the extension of the wings, as will be shown here.

<div align="right">Sul Volo 10 [9] v.</div>

When the bird flies by beating its wings it does not extend its wings wholly, because the points of the wings would be too far removed from the lever and cords which move them.

If as the bird descends it moves its wings back as though they were oars the bird will make swift movement; and this comes about because the wings are striking in the air which is continually flowing in the wake of the bird to fill up the void from whence it has departed.

<div align="right">Sul Volo 12 [11] r.</div>

TO ESCAPE THE DANGER OF DESTRUCTION

The destruction of these machines may come about in two ways, the first of which is when the machine breaks, the second is when it turns edgewise or almost on its edge because it ought always to descend with a long slant and almost in a level line.

As regards the preventing of the machine from being broken one may guard against this by making it as strong as possible in whatever

line it may turn, that is either edgewise falling with head or tail in front, or with the point of the right or left wing, or along lines that bisect or are the quarterings of these lines as the sketch shows [*figure*] against this by turning almost edgewise one ought at the outset to guard.

As regards constructing the machine in such a way that in descending whatever may be the direction that it takes it finds the remedy prepared; and this you will do by causing its centre of gravity to be above that of the weight which it carries, always in a vertical line, and the one always at a sufficient distance from the other, that is that if the machine is thirty braccia in width the centres are four braccia apart, and as has been said one is beneath the other, and the heavier is below because as it descends the heavier part always constitutes itself in part the guide of the movement. In addition to this if the bird wishes to fall with its head downwards with a fraction of the slant that would cause it to turn over this will not be able to happen, because the lighter part would be beneath the heavier and the light would be descending before the heavy, which is impossible in a descent of any length, as is proved in the fourth of the Elements of Mechanics.

And if the bird should fall head downwards with the body partly slanting towards the ground the underneath sides of the wings ought to turn flat against the earth, and the tail to rise towards the back, and the head or the underpart of the jaw is also turned towards the ground, and from this there will immediately originate in this bird its reflex movement which will cast it up again towards the sky; for which reason the bird at the close of its reflex movement will come to fall back unless it should while rising lower one of its wings slightly, which would curve such movement and cause it to turn into a half circle; then this bird will find itself at the close of this movement with its bill turned to the spot at which this reflex movement started. And if this is done against the course of the wind the end of the reflex movement will be much higher than was the commencement of the falling movement. And this is the way in which the bird rises up to a height without beating its wings and circling. And the remainder of the circle of which I have spoken is completed by the help of the wind, by a falling movement, with one of the wings always kept low and similarly one side of the tail. And it subsequently makes a reflex

movement towards the direction of the wind and is left at the end with its bill turned in the direction of the wind, and then makes again the falling and reflex movements against the wind always going in circles.

When the bird wishes suddenly to turn on one of its sides it pushes out swiftly towards its tail, the point of the wing on that side, and since *every movement tends to maintain itself*, or rather *every body that is moved continues to move so long as the impression of the force of its mover is retained in it*, therefore the movement of this wing with violence, in the direction of the tail, keeping still at its termination a portion of the said impression, not being able of itself to follow the movement which has already been commenced, will come to move the whole bird with it until the impetus of the moved air has been consumed.

When the tail is thrust forward with its face and the wind strikes upon it it makes the bird move suddenly in an opposite direction.

Sul Volo 13 [12] r. and v.

[With drawing of bird with wings outstretched]

Here the big fingers of the wings are those which keep the bird motionless in the air against the movement of the wind; that is the wind moves, and it maintains itself upon it without beating its wings, and the bird does not change its position.

The reason is that the bird arranges its wings so as to slant so much that the wind which strikes it below does not form itself into a wedge of such a kind as tends to raise it, raising it however just so much as its weight wishes to lower it, that is to say if the bird's impulse to fall be expressed by two units of power the wind's impulse to rise will be expressed by two units also, and because things which are equal cannot overcome one another the bird remains in its position without either rising or falling. It remains for us to speak of the motion which does not impel it either forward or backward; and that is if the wind should wish to accompany it or drive it out of its position with a power expressed by four units and the bird with the same power is slanting at the same angle against the wind. Here also as the powers are equal the bird will not move forward nor will it be driven back when the wind is equal. But inasmuch as the movements and powers

of the winds are variable the angle of the wings ought not to change, because if the wind grows and it should alter the angle in order not to be driven upward by this wind. . . .

In the aforesaid instances the wind does not enter like a wedge underneath the slanting wings, but only meets the wing along the edge which wishes to descend against the wind; and there strikes it on the edge of the shoulder which serves as a shield for all the rest of the wing; and there would be here no protection against the descent of the wing if it were not for the big finger *a* which then comes to the front and receives the whole force of the wind full upon it, or less than full according to the greater or less power of the wind.

<div align="right">Sul Volo 14 [13] r.</div>

[*With drawing of wing*]

The big finger *n* of the hand *m n* is that which when the hand is lowered comes to lower itself more than the hand, in such a way as to close and prevent the exit of the stream of air compressed by the lowering of the hand, in such a way that in this place the air becomes condensed and offers resistance to the oarage of the wing. And for this reason nature has formed in this big finger a bone of such great strength, to which are united very strong sinews with the feathers short and of greater strength than the feathers which are on birds' wings, because the bird leans upon it, upon the air which is already compressed, with all the power of the wing and of its strength, because it is this by means of which the bird moves forward.

And this finger here performs for the wings the function which its claws do for a cat when it climbs up trees.

But when the wing regains fresh force with its return upward and forward, the big finger of the wing then puts itself in a straight line with the other fingers, and thus with its sharp edge it strikes the air and performs the office of a helm or rudder, which strikes the air continually in some movement high or low when the bird wishes to rise.

The second helm or rudder is placed on the opposite side beyond the bird's centre of gravity, and this is its tail, which if it is struck by the wind below, through being beyond the aforesaid centre will come to lower the bird in its front part.

But if the tail is struck above, the bird is raised in its front part. And if the tail is somewhat twisted, and shows its front slanting under the right wing, the front part of the bird will be turned towards the right side. And if the slant of the lower side of the tail is turned to the left wing, it will turn with its front part to the left side; and in each of the two conditions the bird will descend. But if the tail in a slanting position is struck by the wind in its upper part the bird will turn revolving slowly on that side on which the upper surface of the tail shows its slant. Sul Volo 14 [13] v.

The axis of the shoulder of birds is that which is turned by the muscles of the breast and back; and it is here that the discretion of lowering or raising the tail originates according to the will or necessity of the animal that moves.

I conclude that the rising of birds without beating their wings is not produced by anything other than their circular movement amid the movement of the wind, which movement when it ceases to have the support of the wind continues to descend as far as the place at which the reflex movement starts, after which, and having thus revolving described a semicircle it finds itself again with its face turned to the wind, and follows the reflex movement, above the wind, continually revolving until with the help of the wind it makes its highest ascent between its lowest descent and the arrival of the wind, and remains with its left wing to the wind; and from this maximum elevation circling anew it drops again to the last falling movement, remaining with its right wing to the wind.

The equal power of resistance of a bird's wings is always due to the fact of their being equally remote in their extremities from the bird's centre of gravity.

But when one of the extremities of the wings is nearer the bird's centre of gravity than the other the bird will then descend on the side on which the extremity of the wing is nearer to the centre of gravity. Sul Volo 15 [14] r.

The hand of the wing is the part that causes the impetus; and the elbow is then held edgewise in order not to check the movement which creates the impetus; and when this impetus is afterwards created the

elbow is lowered and set slantwise and in slanting it makes the air upon which it rests almost into the form of a wedge, upon which the wing comes to raise itself, and if it did not do thus the movement of the bird during the time that the wing returns forward would cause the bird to fall as the impetus gradually becomes consumed; but it is not able to fall because as the impetus fails so in proportion does the pressure exerted by the elbow resist the descent and again raise the bird up.

The elbows of the creature are not lowered quite at the commencement, because in the chief flight of the impetus the bird will bound upwards, but they are lowered by as much as may be necessary to check the descent, according to the desire and discretion of the bird.

When the bird wishes to soar upwards suddenly it immediately lowers its elbows, after it has produced the impetus.

But if it wishes to descend it keeps its elbows rigid and raised up after the creation of the impetus. Sul Volo 15 [14] v.

Remember that your bird should have no other model than the bat, because its membranes serve as an armour or rather as a 'means of binding together the pieces of its armour, that is the framework of the wings.

And if you take as your pattern the wings of feathered birds, these are more powerful in structure of bone and sinew because they are penetrable, that is to say the feathers are separated from one another and the air passes through them. But the bat is aided by its membrane, which binds the whole together and is not penetrated by the air.

OF THE METHOD OF BALANCING ONESELF

It will always be the heaviest part of bodies which constitutes itself the guide of their movement.

The bird which has to raise itself without beating its wings sets itself so that it slants against the wind, presenting its wings to it with the elbows in front, with its centre of gravity more towards the wind than the centre of the wings. Whence it comes about that if the power which impels the bird when slanting to descend is represented by two

and the force with which the wind strikes it by three the movement obeys the three and not the two. Sul Volo 16 [15] r.

[*With drawing of pulley with bird suspended with wings outstretched*]

This is made in order to find the bird's centre of gravity, and without this instrument this machine would have little value.

When the bird drops down its centre of gravity is outside the centre of its resistance.

And if the bird wishes to raise itself its centre of gravity remains behind the centre of its resistance.

The bird can stay poised in the air without keeping its wings in a position of equality because owing to its not having the centre of gravity in the middle of its axis as balances have, it is not necessarily obliged to keep its wings at an equal height like the said balances. But if these wings are outside this position of equality the bird will descend by the line of the slant of the wings. And if the slant is complex, that is double, as if we say that the slant of the wings points to the south, and the slant of the head and tail points to the east, then the bird will descend slanting towards the south-east. And if the slant of the bird is double the slant of its wings the bird will descend by a line midway between the south-east and the east, and the slant of its movement will be between the two positions that have been mentioned. Sul Volo 16 [15] v.

AN ARGUMENT TO DISPOSE OF THE OBJECTIONS TO THE ATTEMPT

You will perhaps say that the sinews and muscles of a bird are incomparably more powerful than those of man, because all the girth of so many muscles and of the fleshy parts of the breast goes to aid and increase the movement of the wings, while the bone in the breast is all in one piece and consequently affords the bird very great power, the wings also being all covered with a network of thick sinews and other very strong ligaments of gristle, and the skin being very thick with various muscles.

But the reply to this is that such great strength gives it a reserve of power beyond what it ordinarily uses to support itself on its wings,

since it is necessary for it whenever it may so desire either to double or treble its rate of speed in order to escape from its pursuer or to follow its prey. Consequently in such a case it becomes necessary for it to put forth double or treble the amount of effort, and in addition to this to carry through the air in its talons a weight corresponding to its own weight. So one sees a falcon carrying a duck and an eagle carrying a hare; which circumstance shows clearly enough where the excess of strength is spent; for they need but little force in order to sustain themselves, and to balance themselves on their wings, and flap them in the pathway of the wind and so direct the course of their journeyings; and a slight movement of the wings is sufficient for this, and the movement will be slower in proportion as the bird is greater in size.

Man is also possessed of a greater amount of strength in his legs than is required by his weight. And in order to show the truth of this, place a man to stand upon the sea-shore, and observe how far the marks of his feet sink in; and then set another man on his back, and you will see how much deeper the marks of his feet will be. Then take away the man from his back, and set him to jump straight up as high as he can; you will then find that the marks of his feet make a deeper impression where he has jumped than where he has had the other man on his back. This affords us a double proof that man is possessed of more than twice the amount of strength that is required to enable him to support himself. [*With drawing*] Leather bags with which a man falling from a height of six braccia will not do himself any harm, whether he falls into water or on land; and these leather bags tied after the fashion of the beads of a rosary are wrapped round by others. Sul Volo 17 [16] r.

If you should fall with the double chain of leather bags which you have tied underneath you so manage that these are what first strike the ground.

[With drawing of part of mechanism of flying machine]
Since the wings have to row downwards and backwards, in order to keep the machine up and so that it may progress forward, it moves by the lever *c d* with a slanting track, guided by the strap *a b*.

I might so make it that the foot which presses the stirrup *g* was that

which in addition to its ordinary function pulled down the lever *f*. But this would not serve our purpose, because it is necessary that the lever *f* should first rise or descend before the stirrup *g* moves from its place, in order that the wing—as it throws itself forward and raises itself up at the time at which the already acquired impetus of itself drives the bird forward without it beating its wings—can present itself edgewise to the air, because if it did not do this the surface of the wings would clash upon the air, would hinder its movement, and would not allow the impetus to carry the bird forward.

<div align="right">Sul Volo 17 [16] v.</div>

If the bird drops to the east with its right wing extended above the south wind then undoubtedly it will be turned over unless it suddenly turns its bill to the north; and then the wind will strike the palms of its hands beyond the centre of its gravity and will raise up again the part of the bird which is in front.

When the bird has great breadth of wings and a small tail and wishes to raise itself up it will raise its wings vigorously and will in turning receive the wind under its wings; this wind forming itself into a wedge will drive it up to a height with swiftness as is the case with the cortone, a bird of prey which I saw going to Fiesole above the place of the Barbiga in 5 (the year 1505) on the fourteenth day of March.

Movements of the tail: how sometimes it is flat and the bird as it moves has it in a level position; sometimes it has the extremities equally low and it is then that the bird rises; sometimes it has the extremities equally high and this occurs when it descends. But when the tail is low and the left side is lower than the right the bird will then rise with a circling movement towards the right side; this may be proved but not here. And if when the tail is low the right extremity is lower than the left the bird will turn towards the left side. And if when the tail is high the left side of its extremities is higher than the right the bird will then turn with its head towards the right side; but if when the tail is high the right side of its extremities is higher than the left then the bird will circle towards the left side.

<div align="right">Sul Volo (F.M.) 18 [17] v.</div>

[With drawings of birds' wings]

Always in raising the hand the elbow is lowered and presses the air,

and as this hand is lowered the elbow rises and remains edgewise, in order not to check the movement by means of the air which would strike into it.

The lowering of the tail at the time that the bird sends its wings forward again edgewise a little above the wind, guided by the impetus already acquired, is the reason why the wind strikes under this elbow and forms itself into a wedge, upon which the bird proceeds to rise with the aforesaid impetus without beating its wings.

And if the bird be three pounds and the breast a third the width of the wings the wings will only bear two thirds of the bird's weight.

The hand feels great fatigue towards the thumb or rather the helm of the wing because this is the part that strikes the air.

The palm of the hand goes from *a* to *b* always between almost equal angles, dropping and pressing the air, and at *b* it turns immediately edgewise and goes backwards, rising by the line *c d*, and having arrived at *d* it turns suddenly opposite and goes dropping by the line *a b*, and as it turns it always turns round the centre of its breadth.

The turning of the hand backwards edgewise will be done with great rapidity, and the pressing of it backwards open will be done with such rapidity as the final urge of the motive power requires.

The course of the point of the fingers is not the same in going as in coming back but it follows a higher line in returning; and beneath this is the figure made by the higher and lower line, and it is oval with a long and regular curve. Sul Volo 18 r.

The great bird will take its first flight upon the back of the great swan, filling the whole world with amazement and filling all records with its fame; and it will bring eternal glory to the nest where it was born. Sul Volo, cover, 2 r.

1505 on the evening of Tuesday the fourteenth day of April Lorenzo came to live with me: he said that he was seventeen years of age.

And on the fifteenth day of this April I had twenty-five gold florins from the treasurer of Santa Maria Nuova.

From the mountain which takes its name from the great bird, the

famous bird will take its flight, which will fill the world with its great renown.[1] Sul Volo 18 v.

If the bird wishes to make headway against the wind it beats its wings and moves them as oars backwards. c.a. 37 r. b

Unless the bird beats its wings downwards with more rapidity than there would be in its natural descent with its wings extended in the same position, its movement will be downwards. But if the movement of the wings is swifter than the aforesaid natural descent then this movement will be upwards, with so much greater velocity in proportion as the downward stroke of the wings is more rapid.

The bird descends on that side on which the extremity of the wing is nearer to the centre of its gravity.

You will make an anatomy of the wings of a bird together with the muscles of the breast which are the movers of these wings.

And you will do the same for a man, in order to show the possibility that there is in man who desires to sustain himself amid the air by the beating of wings. c.a. 45 r. a

[*With figures*]

The bird which descends above or below the wind keeps its wings closed in order not to be held up or checked by the air; it keeps them well above its body, so that it may not be turned upside down by the impetus.

When the bird keeps the shoulders of its wings closed and their points wide it makes the air thicker than the other air where it does not pass; and it does this in order to check its movement and not deviate from the line of this movement.

[1] This passage should be regarded as a key to the one before it. In the phrase 'sopra del dosso del suo magnio cecero', 'upon the back of the great swan', Leonardo was apparently referring to Monte Ceccri, the mountain above Fiesole immediately to the south. It was from the summit or from a ridge of this mountain that he intended to make a trial of his flying machine. The locality is also referred to in another page of the same manuscript where he speaks of 'the cortone a bird of prey which I saw going to Fiesole above the place of the Barbiga in the year 1505 on the fourteenth day of March' (Sul Volo, Fogli Mancanti 18 [17] v.). This points to the probability that 1505 was the year in which the trial took place. It may have been this trial of which Cardan chronicled the ill success.

But when the bird opens the shoulders more than the points of its wings it wishes to delay the movement more forcibly.

When the points and the shoulders of the wings are equally near to each other the bird wishes to descend without being checked by the air.

When the bird uses its wings as oars, or beats the wings backwards in their descent, it is a clear sign that it increases the speed of its descent.

Here by means of the attitudes of the birds one sees the results of the effects and both of these joined together show the intention of the bird.

The wing extended on one side and drawn up on the other show the bird dropping with a circular movement round the wing that is drawn up.

Wings drawn up equally show that the bird wishes to descend in a straight line.

The bird above the wind at the end of the reflex movement will never keep its wings open equally, because it would be turned upside down by the wind. But it draws that wing in to itself round which it desires to make the revolving movement, and descends behind it and moves in a circle behind it, when it wishes to rise or descend.

The opponent says that he has seen the proofs of how the bird standing with its wings entirely open cannot descend perpendicularly to its own hurt or the damage of any part, and that he admits the proofs that it cannot fall backwards edgewise because he cannot deny the proofs assigned, and also it cannot fall with its head below it; but that he doubts whether if it should find itself with the line of the breadth of the wings perpendicular to the ground it would not descend edgewise along this line. Here the reply is that in this case the heaviest part of the bodies would not be a guide of the movement, and such movement would be contrary to the fourth of this, which was proved to be impossible. C.A. 66 r. a

The rudders of the wings of birds are the parts which immediately place the bird above or below the coming of the wind, and with their tiny movement cleave the air in whatever line along the opening of which the bird can then penetrate with ease.

The bird will never descend backwards because its centre of gravity is nearer to the head than towards the tail.

The descent of the bird in all or part of its movement will always be along that line in which its centre of gravity is nearest to the extremities of the width of the bird.

I have said the descent will be entirely towards that part which is nearest to the centre of gravity when one part only is near to this centre of gravity, and the extremities of the other opposite parts remain equidistant from this centre; as when the bird presses its head close in to its body and the wings remain equally distant from the centre tail straight and wide, the bird will then descend with its head in front, and the body in its central line will direct itself by this movement.

But when in such movement one of the wings narrows itself towards the said centre the line of the bird's descent will be between the gathered-in wing and the head of the bird.

And if during the movement of the wings, when opened equally, the tail should bend towards one of the wings, the movement will then continue between the head of the bird and the opposite wing.

And if the head only is bent down towards one of the wings open equally, the slanting descent will then proceed between the head and the wing which the head is near.

Swimming upon water teaches men how birds do upon the air.

c.a. 66 r. b

HOW THE BIRD STOPS ON THE WING ABOVE THE WIND AND DOES NOT MOVE FROM ITS POSITION

If the wind which drives the bird forward is of the same power as the bird, that stays above the wind and desires to drop towards this wind, the bird will then be motionless; and the movement which it was on the point of making will be made by the wind from the opposite side.

And if the wind is more powerful and the bird moves its wings backwards as oars, the bird will be motionless.

And if the wind comes from above and in front, and the bird resists it below and behind, then according to the conditions of the places whence it may fall the bird remains motionless.

But when the wind comes in front and below it will be more powerful than the weight of the bird; it will then be necessary for the wings

to contract and occupy less of the atmosphere, and consequently they will be smitten by a lesser quantity of wind, and for the strokes which it takes to have rather a backward direction, and then the bird will remain motionless. c.a. 71 r. b

The simple power of the man will never work the wing of the crow with such swiftness as the crow did when it was attacked.

And the proof of this will be shown in the uproar they make, for that of the man will never produce so great a noise as the wing of the bird made when it was attacked.

WHY THE BIRD SUSTAINS ITSELF UPON THE AIR

The air which is struck with most swiftness by the movable thing is compressed to the greatest degree in itself.

This is proved by the fact that the less thick flexible body will never support the thicker upon itself, as for example one sees the anvil floating upon melted bronze, and gold and silver when liquefied staying beneath a fusion of lead; and for this reason, as the atmosphere is a body capable of being itself compressed when it is struck by something which is moving at a greater rate of speed than that of its flight, it is compressed into itself and becomes like a cloud within the rest of the air, that is it is of the same density.

But when the bird finds itself within the wind, it can sustain itself above it without beating its wings, because the function which the wing performs against the air when the air is motionless is the same as that of the air moved against the wings when these are without motion.

c.a. 77 r. b

WHY THE BIRD FALLS IN A PARTICULAR LINE

On whatever side the weight of the bird is as it drops from a position of equality, on that side its descent will be.

And at whatever angle the bird sets itself, in the same angle its descent will be.

And if a part is bent forward and the wings spread out at an equal slant, the movement of the bird will be in the centre of the two inclined parts.

And this movement will slope more towards the part which bends more.

[*Drawing*]

That circle will be of less size in which the bird sets itself on a less slanting line.

The slant of the wings always tends to be equal to the slant of the body of the bird.

[*Drawing a b*]

If the wings are held slanting and the bust in a position of equality, without doubt the bird will descend along the line of the slant of the wings; but this slant will be varied to the right or left as is in the movement *a b*. c.a. 77 v. b

HOW MANY ARE THE WAYS IN WHICH A BIRD TURNS ITS STRAIGHT MOVEMENT INTO A CURVING MOVEMENT?

The bird that wishes to turn its straight course into a curved one without raising or lowering its height, moves the wing on the convex side of its curving movement more frequently than it does that on the concave side of this movement.

The wing of the bird as it beats its wings has the shoulder raised more in front than behind; and this it does in order to acquire movement, because if the wings were to move equally up and down the bird would not move from its first position.

The bird bends its straight course towards that side on which the wing is most lowered. And it is as though this wing were more smitten by the wind than the other.

OF THE BIRD AS IT FLIES WITH BOUNDS (BALZI)

The bird which flies with a bound acquires impetus in its descent, because in the course of this by closing its wings it acquires weight, and consequently velocity; it follows therefore that the reflex movement is more powerful, and adding to this the fact of it beating its wings, it creates double the power which is produced by the simple reflex movement, and by the fact of this duplication the reflex movement becomes longer than it would have been without the addition

made by the beating of its wings. And this is the real cause why the reflex movement is equal to its falling movement and why at the end of the flight there is equality in the extent of its descent and of its ascent.

When the bird descends with a great slant without beating its wings all the extremities of the wings and tail bend upwards, and this movement is slow, for the bird is not only supported by the air beneath it but by the lateral air towards which the convex surface of the bent feathers spreads itself at equal angles.

When the bird rises from the ground to a height and leaps and closes its open wings with impetus, and makes a wave of the air which is compressed and strikes upwards at its breast from below, the impetus of this tending to continue, the movement drives the bird to a height, and it flaps its wings many times quite regularly in the course of this movement until it has risen up sufficiently.

The bird which rises with a circular movement stays in a slanting position with the breadth of its wings, and the circle in which it revolves will be so much greater in proportion as its position is more slanting; and this circle will be so much smaller as its position is less slanting.

The bird which makes a greater movement with one wing than the other will describe a circular movement, and the movement will also be circular when the wing is beaten on one side and held motionless on the other; and the circle will be so much greater or less according as this wing is moved more slowly or more rapidly.

Movement of the bird driven by the wind:

The bird which is driven by the wind, when it raises itself without beating its wings lengthens the turning process more in the falling movement than in the reflex movement; but in the reflex movement it rises and in the falling movement it lowers itself.

The bird in descending against the wind lowers its feet as the wind strikes them, and this it does in order not to disarrange the tail from the direction of the whole body when it wishes to lower itself.

C.A. 97 V. a

The bird which makes the shortest revolving movement prepares the extreme extension of its wings with less slant, and for this reason the

circle of its revolving movement is so much more curved as the revolving movement is shorter.

The bird can never move backward, because the points of the wings when extended are never farther in front than the centre of gravity which the length of the bird has of itself, and this must of necessity be the case; whereas if it should move backwards its feathers would turn right over in front and restrain the movement with their resistance; and this the bird shows us, for when it is resting it always turns its beak to the wind.

If the left horn of the tail is as far above the centre line of movement, and above the centre line of the weight which the bird has in the line of its movement, as the right horn of this tail is below the said centres, the movement of the bird will of necessity be straight, because the left horn of the tail is as powerful to bend the straight movement of the bird to the right when it is above the bird as the right horn of this tail is to bend the bird to the left when it is below the bird.

The bird will always descend in the direction in which it weighs most.

The bird weighs most in the direction in which its breadth is least. [*Diagram*] Therefore it will descend by the line *a b* and not by the line *b a*.

I have seen the sparrow and the lark fly upward in a straight line when they were in a level position. And this happens because the wing raised with swift movement remains filled with holes, and only rises with the impetus it has acquired, and this is renewed in the lowering of the wings, for the wing then reunites and presses one feather in beneath another, as is said in the eighth of this.

The bird which descends with the wind that strikes it below increases this descent by raising its tail, exposing the under part of it to the percussion of the wind.

The bird whenever it rests upon any spot always takes up its position with its beak against the approach of the wind.

It is always the under side of the branches of any plant that show themselves to the wind which strikes it, and one leans against another.

<div style="text-align: right">c.a. 160 r. b</div>

Unless the movement of the wing which presses the air is swifter

than the flight of the air when pressed, the air will not become condensed beneath the wing, and in consequence the bird will not support itself above the air.

That part of the air which is nearest to the wing will most resemble in its movement the movement of the wing which presses on it; and that part will be more stable which is farther removed from the said wing.

That part of the air which is nearest to the wing which presses on it, will have the greatest density.

The air has greater density when it is nearer to water, and [greater rarity] when it is nearer to the cold region, and midway between these it is purer.

The air of the cold region offers no resistance to the movement of the birds unless they have already passed through a considerable space of the air beneath them.

The extremities of the wings of birds are of necessity flexible.

The properties of the air are such that it may become condensed or rarefied. c.a. 161 r. a

No impetus created by any movement whatever can be immediately consumed, but if it finds an object which has a great resistance it consumes itself in a reflex movement.

The impetus acquired by the beating of the wings in the slanting descent of birds is the reason for these birds descending for a long space without beating their wings and for the said slant.

Define what impetus is and what slanting movement consists in, and which has the greater or less slant, and how the reflex movement of birds becomes more or less slanting according to the greater or less opening of the tail and wings.

The impetus acquired will be more permanent when the movement of the descent slants less.

Impetus is a power of the mover applied in a movable thing which causes the movable thing to move after it is separated from its mover.

[There will never be impetus unless the resistance of the movable thing is completely subdued by its mover.] And especially when the dense friction of the bodies moved resists the movable thing.

This may be seen in the case of a beam drawn by oxen which only

moves so long as the oxen are in movement, and when the cause has ceased the effect fails, that is that the movement of the beam ends together with the movement of the oxen.

When the friction of the movable thing over the place where it is moved is of slight density, the power of the mover will be united for so great a space with the movable thing, since this is separated from the mover in proportion as the friction is of less density. So one sees a barge drawn through the water for a certain distance of its own accord after it has been separated from the power of its mover; and the bird, after it has beaten its wings, moves upon the compressed air without any further beating of its wings, carried for a long distance by its impetus.

Movable things and movers are of three kinds, of which one moves through as much space as the movement made by its mover, and this is only slightly dominated by the power of the mover; another moves through a much less space than that traversed by the mover, and this in itself is of greater resistance than the power of its mover, not taking into account the space that intervenes between the mover and the movable thing; the third moves in the same time through a considerably greater space than that over which its mover is moved; and this movable thing in itself not taking into account the intervening space has much less power of resistance than its mover.

There are other powers of mover and movable things, in which the movable thing follows or is followed by its movement over such space and direction as has that of its mover, and after the mover remains without movement the movable thing exerts the power of the mover, and by means of this it moves through a long tract of space, as the arrow does when shot from the cord of the bow, which moves for a long time by itself, after the cord of the bow has separated itself from it.

C.A. 161 v. a

The bird may stay in the air without change of position, even if the power of the wind is greater than the power of the weight of this bird; and it does this with a slight swift movement of the wings using them as oars behind the flight of the wind with greater speed than that of this wind, and so it is in a position of equilibrium.

The bird may stay in the air without change of wings or of position, even if the power of the movement of the air is more powerful than

the weight of the bird. And this contrast is due to its slant and it is in a slanting line.

When there is the same span of wing the bird which is in a more sloping line will be the heavier in the air. c.a. 180 r. a

The bird which beats its wings with equal movement without beating its tail will have a straight movement; but if one of the wings drop more than the other the straight movement will be changed to a curve and it will circle downwards round a spot below to which the lower wing is pointing. c.a. 184 v. c

[*With diagrams*]

Sudden changes of the wings and tail of birds make sudden changes in the lines of their movements. For suppose the bird is moving in an eastward direction and suddenly turns towards the west; this sudden turn is effected by extending one of its wings on the side on which it wishes to turn, and turning it so that it faces the percussion of the air in the line in which it is moving, drawing the opposite wing to itself and bending the tail in such a way that that extended wing, that is as in the bird *a d f*, is flying towards you, and as it flies it immediately turns itself backward by its right side in *f*, and then extends this wing *d f* more than usual, displaying it more in front to the wind; and the opposite wing *a c* will be bent as in *c b*, and the tail *c d* will turn as in *e d*; then the fury of the impetus is struck by the air, and works more in that part of the bird which is more remote from its centre of gravity, and less in that nearer to it.

When the bird rises in a circle without beating its wings it keeps its centre of gravity much lower than the tips of its wings, and receives the wind underneath it from whatever side it may come, after the manner of a wedge, that is either under its tail or its breast or each of its wings.

If the water *a b* strikes the tail of the fish which is in the axis above the centre of its accidental gravity there is no doubt that this fish will bend round this centre; but its tail will bend more in the current of the water than its trunk will, for this being firmer offers more resistance in its contrary movement.

The impetus which was circular in its commencement may follow out in itself the same circular movement upon its axis as that of the millstone or the revolving wheel, and may follow it circular or straight,

as the wheel of the cart revolving naturally outside of its axis or as the reflex movement made in a slanting line by the spherical bodies. Similarly the flight of birds, even though the beginning of the bird's impulse may be caused by direct movement, may continue in circular movement for as great a distance as this impetus endures.

The level movement of birds when they fly may swiftly be changed either to a slanting or vertical movement towards the sky or towards the earth. The movement towards the sky occurs when the helms of the wings and also the tail are turned towards the earth.

When a bird is descending it keeps a straighter course and has less risk of being overturned if it has its wings bent beneath it than if it keeps them straight.

When a bird's centre of gravity is below its wings it has so much the less risk of being turned upside down, as is seen above.

Make a small one to go over the water, and try it in the wind without much depth of water over some part of the Arno, with the wind natural, and then as you please, and turn the sail and the helm.

See to-morrow to all these matters and the copies, and then efface the originals and leave them at Florence, so that if you lose those that you take with you the invention will not be lost . . .

There is as much power of movement in the water or the air against an object as there is in this object against the air or the water.

The centre of gravity of the fish lying level in the water or of the bird lying level in the air is situated midway between the extremities which offer equal resistance.

Write of swimming under water and you will have the flight of the bird through the air. There is a suitable place there where the mills discharge into the Arno, by the falls of Ponte Rubaconte.

There are two different ways in which a bird can turn in any direction while continually beating its wings. The first of these is when at the same time it moves one wing more rapidly downwards than the other with an equal degree of force, the movement approximating towards the tail; the second is when in the same space of time the movement of one wing is longer than that of the other. Also in striking with the wings downwards slantwise, if they become bent or moved one lower down and the other farther back, the part which drives the wing lower down will be higher in the first case, and the opposite part

of the wings which has the longer movement backward will go farther forward through this first; consequently for this reason the movement of the bird will form a curve round that part of it which is highest.

These then are all the movements made by the bird without beating its wings, and they are each and all subject to a single rule, for all these movements rise upon the wind, for they expose themselves to it slantwise receiving it under their wings after the manner of a wedge.

C.A. 214 r. d

[*Figure*]

The centre of gravity of this bird forms the axis of its equilibrium.

When this bird raises itself in circles by a single wind without beating its wings it keeps the impetus of the wind under its wings so that they raise it as though it was a wedge.

When the wind enters under the left wing it passes above the right wing, and this wind would throw the bird over, if it were not that the tail is suddenly twisted so that the wind passes over it and makes a wedge opposite to it, and so drives it in and turns it.

When it has turned so much that the wind strikes it in the beak the tail will only work in a straight line; but it bends upwards so that the wind strikes it above and at the same time the breast and wings are struck from below, but since the force of impact on the left wing is greater because it is more bent the bird has to wheel round and turn its right wing to face the wind.

When the tip of the right wing enters into the line of the wind, nothing is so useful in order to make the wind strike at more equal angles as is the bending of the head and also the neck against the approach of this wind.

When the tail enters into the line of the wind then this tail is struck beneath by the movement of the wind, and the head is struck above, and each of the wings are struck beneath. But the right wing in twisting is more exposed to and affected by the stroke of the wind than is the left, and therefore it travels more with the right than with the left, and therefore its movement becomes a curve and continually rises being pushed up from below by the wind.

The movement of the wing against the air is as great as that of the air against the wing.

The wing which is most extended strikes against a greater quantity

of air, and as a consequence descends less than the wing which is more folded up; therefore the descent of this flying thing will be made along the line of that wing which is more folded up.

That wing is more delayed which is struck by the air at more equal angles or by a greater quantity of air.

Therefore when the bird descends in a slanting direction and perceives itself to be dropping with its left wing it will extend this wing more than the other, that is it will bend it more in face of the air where it strikes. c.a. 214 v. a

[*Drawing*]

A bird raises itself more swiftly when the circles in which it rises are smaller.

What is here set forth occurs because the bird as it rises without beating its wings by the help of the wind receives the wind underneath it in the manner of a wedge, and this wedge has its greater angle upon the side that slopes less, and therefore it raises the object above it more and more.

The bird never moves upward unless the wind enters underneath it and forms itself into a wedge, driving it for a certain distance along the line of its course.

[*Diagram*]

See to-morrow morning whether the bird as it turns coming against the wind *n* remains in the line *a b* keeping its head at *b* or whether it remains in the line *c d*.

Here there rises a doubt, namely, whether the wedge does not raise the object which is situated above itself in a perpendicular line, if this object is not supported in such a way that it has no power to fly before the blow together with the wedge, as the bird will be able to rise above the wind which serves it as a wedge, so that this wind will not carry it with it; it will be so much the more difficult therefore for this bird to rise to a height against the wind if it has not already mounted after the manner in which water falls in an empty screw. c.a. 220 r. a

HOW A BIRD LOWERS ITSELF WITHOUT THE USE OF THE WIND OR BEATING ITS WINGS

[*Diagram*]

When the centre of gravity of the bird is in front of the centre of resistance of the wings the bird will then descend by a slanting line always observing this slant.

The bird's descent will be found to be of swifter movement when the slant is less.

That bird travels with the longer course when its descent is interrupted by many reflex movements, that is in waves, as is shown above; let us say that the movement of the bird is so arranged as to go from *a* to *b*, and when it has travelled half a mile it makes in *c d* as great reflex movement as gives the nature of the impetus of such descent, and then brings back its wings to their first slanting position and descends afterwards in another movement of half a mile, and then rises up again and reascends until it finishes its course at the place indicated.

[*Diagram*]

If the bird which does not beat its wings should not wish to descend rapidly to a depth, then after a certain amount of slanting descent it will set itself to rise by a reflex movement and to revolve in a circle, mounting after the manner of the cranes when they break up the ordinary lines of their flight and come back into a troop and proceed to raise themselves by many turns after the manner of a screw, and then, having gone back to their first line they follow their first movement again which drops with a gentle descent, and then return again to a troop and moving again in a circle raise themselves.

[*Diagram*]

The bird which takes longer strokes with one wing than with the other will progress with a circular movement. c.a. 220 v. c

With wings expanded the pelican measures five braccia, and it weighs twenty-five pounds; its measurement thus expanded therefore is the square root of the measurement of the weight.

The man is four hundred [pounds] and the square root of this figure is twenty; twenty braccia therefore is the necessary expanse of the said wings.

The width of the wings of the pelican is three quarters of a braccio, so you will divide the five braccia which it measures when open into quarters, so that there are twenty quarters in its length and three quarters in its width, and you may say that the width is three twentieths of the length.

If therefore the span of the man's wings be twenty braccia you would say that they are also three braccia in width, and three twentieths of this length of twenty braccia, that is, where the width is greatest.

<div align="right">c.a. 302 r. b</div>

The imperceptible fluttering of the wings without any actual strokes keeps the bird poised and motionless amid the moving air.

The reverse movement against the direction of the wind will always be greater than the advancing movement; and the reverse movement when made with the course of the wind will be increased by the wind, and will become equal to the advancing movement.

The ways in which birds rise, without beating their wings but by circles, with the help of the wind, are of two kinds, simple and complex. The simple comprise those in which, in their advancing movement, they travel above the flight of the wind, and at the end of it turn and face the direction of the wind, receiving its buffeting from beneath, and so finish the reverse movement against the wind.

The complex movement by which birds rise is also circular, and consists of an advancing and reverse movement against the direction of the wind in a course which takes the form of a half circle, and of an advancing and reverse movement which follows the course of the wind.

The simple circular movement by which birds rise is also circular, and consists of an advancing and reverse movement against the direction of the wind in a course which takes the form of a half circle, and of an advancing and reverse movement which follows the course of the wind.

The simple circular movement of rising without beating the wings will always occur when there is great agitation of the winds, and this being the case it follows that the bird in so rising is also carried a considerable distance by the force of the wind. And the complex movement will be found to occur when there are light winds, for experience shows that in these complex movements the bird rises through the air without

being carried too far by the wind in the direction in which it is travelling.

The down and feathers underneath the wings are plentiful, and at the ends of the wings and tail the tips of the feathers are flexible or capable of being bent, whilst those on the front of the wing, where it strikes the air, are firm. C.A. 308 r. b

My opponent says that he cannot deny that the bird cannot fall either backwards or with head underneath in a perpendicular line; but that it seems to him that its descent may be sheer if it keeps the wings wide open and has one of the wings as well as the head below its centre of gravity.[1] To this argument the answer is the same as to what preceded it; that is, that if this bird being in such a position without having other means of aiding itself were to drop perpendicularly, it would be contrary to the fourth part of the second book of the Elements, where it was proved that every body which falls freely through the air will fall in such a way that the heaviest part of it will become the guide of its movement; and here the heaviest part is found to be midway between the extremities of the open wings, that is midway between the two lightest parts, and therefore, as has been proved, such a descent is impossible.

We have therefore proved that when a bird has its wings spread out and its head somewhat raised, it is impossible for it ever to fall or descend in a perpendicular line; on the contrary, it will always descend by a slanting line, and every tiny movement of wings or tail changes the direction and slanting descent of this line to the reflex movement.

Nature has so provided that all the large birds can stay at so great an elevation that the wind which increases their flight may be of straight course and powerful. For if their flight were low, among mountains where the wind goes wandering and is perpetually full of eddies and whirlwinds, and where they cannot find any spot of shelter by reason of the fury of the icy blasts among the narrow defiles of the mountains, nor can so guide themselves with their great wings as to avoid being dashed upon the cliffs and high rocks and trees, would not this sometimes prove to be the cause of their destruction? Whereas at great alti-

[1] The MS. has here an explanation of a diagram: 'that is, it will drop in the line *a b*, the wings *d c* being wide apart at their natural extension'.

tudes whenever through some accident the course of the wind is changed in any way whatsoever the bird has always time to redirect its course, and in safety take a calm flight, which will always be entirely free; and it can always pass above clouds and thereby avoid wetting its wings.

Inasmuch as all beginnings of things are often the cause of great results, so we may see a small almost imperceptible movement of the rudder to have power to turn a ship of marvellous size and loaded with a very heavy cargo, and that, too, amid such a weight of water as presses on its every beam, and in the teeth of the impetuous winds which are enveloping its mighty sails. Therefore we may be certain in the case of those birds which can support themselves above the course of the winds without beating their wings, that a slight movement of wing or tail, which will serve them to enter either below or above the wind, will suffice to prevent the fall of the said birds. c.a. 308 v. b

The thrushes and other small birds are able to make headway against the course of the wind, because they fly in spurts; that is they take a long course below the wind, by dropping in a slanting direction towards the ground, with their wings half closed, and they then open the wings and catch the wind in them with their reverse movement, and so rise to a height; and then they drop again in the same way.

c.a. 313 r. b

When the slanting movement of the bird as it drops against the wind makes the weight of the bird more powerful than the wind that strikes it in front, the movement of this bird will become swift against this wind.

The bird which descends under the straight approach of the wind turns the wing somewhat over from the shoulder to the tip; and it does this in order to have as much leverage as possible in the more slanting movement against the wind. c.a. 353 r. c

The swallow has its wings quite different from those of the kite, for it is very narrow in the shoulder and long in the span of the wing. Its stroke when it flies is made up of two distinct actions, that is the span of the wing is spread out like an oar in the direction of the tail, the shoulder towards the earth; and in this way while the one movement

impels it forward the other keeps it at its height, and the two combined
carry it a stage onward wherever it pleases. c.a. 369 r. a

The movement of the air against a fixed thing is as great as the move-
ment of the movable thing against the air which is immovable.

And it is the same with water which a similar circumstance has
shown me to act in the same way as does the air, as with the sails of
ships when accompanied by the lateral resistance of their helm.

 c.a. 395 r. b

[*Of the flight of the bat and of the eagle*]

I say that if the bat weighs two ounces and measures half a braccio
with wings expanded the eagle ought according to this proportion to
measure with wings expanded not less than sixty braccia, and we see
by experience that its breadth is not more than three braccia. And it
would seem to many who neither see nor have seen similar creatures
that one of the two would not be able to fly, considering that if there
exists the proper proportion between the bat's weight and the breadth
of its wings then in the case of the eagle they are not large enough, and
if the eagle is properly equipped the other has them too large and they
will be inconvenient and unsuitable for its use. We see however both
the one and the other borne with the utmost dexterity by their wings,
and especially the bat which by its swift turns and feints overcomes the
rapid twists and retreats of the flies and gnats and other similar
creatures.

The reason why the eagle supports itself with its small wings as the
bat does with its large ones is contained in the comparison. . . .

When a single rush has the same proportion between its size and its
length as a bundle of similar rushes has, it will in itself have the same
strength and power of resistance as the said bundle. Therefore if the
bundle has nine heads and supports nine ounces a single one of these
similar rushes of which there are nine heads will by chance support one
ounce.

Place on the top of a rush a *danaro*[1] as a weight and you will see it
bend down as far as the ground. Take a thousand of these rushes and
tie them together stretched out, fix them at the foot and make the heads
level and load them; you will perceive that whereas by the first reason

[1] A small coin, about 20 grains Troy in weight.

it ought to support about three and a half pounds it will in fact support more than forty.

So for this reason it follows that the expanse of air that supports the bat which weighs the two hundred and twentieth part of the weight of an eagle, if it had to be trodden down and pressed by the beating of the wings of the eagle would need to be sixty times larger. B 89 v.

When a bird in beating its wings raises them higher above its centre of gravity than it lowers them beneath it it will have its head higher than its tail during its movement. This is proved by the fourteenth of this:—the movable thing will bend its straight movement more towards the side where its movement is less impeded than to that where it is more impeded; and by the eighth which says:—it is as much to move the air against the immovable thing as to move the thing against the immovable air. Therefore the wing when it moves farther downward than upward makes more percussion with the air that borders on it below than with that which touches it above; and for this reason its straight movement will slant upwards.

If the bird while moving its wings an equal distance below and above its centre of gravity moves them more rapidly downwards than upwards it will curve its level movement upwards. This is proved by the ninth of the foregoing which said:—Of the equal movements made by the wings of birds those which are the most rapid will have most power to compress the air which borders on them below; and by the seventeenth which says:—the percussion of a movable thing is more deflected which has struck against a spot that offers more resistance; therefore it is concluded that if the wing making equal movement downward and upward moves down more rapidly than up it will curve its level movement upwards rather than downwards.

And by the converse of what has gone before if the wings while making equal movement below and above the bird's centre of gravity should rise more swiftly than they fall, the bird's movement will slant inclining towards the ground. E 21 v.

The inclination of the wings of birds desiring to move with equidistant movement to the earth must necessarily always produce as much more fatigue when moving downwards than upwards, as the bird weighs more downwards than in the movement of equality. This

is proved by the thirteenth of this where it is said:—the weight of every heavy thing is in the line of its movement and so much more or less as this movement is swifter or slower.

Definition of impetus

Impetus is a power created by movement and transmitted from the mover to the movable thing; and this movable thing has as much movement as the impetus has life.

The wings of birds feel as much more effort downwards than upwards when the bird wishes to rise upwards, in proportion as the bird weighs more downwards than upwards. E 22 r.

A bird supporting itself upon the air against the movement of the winds has a power within itself that desires to descend, and there is another similar power in the wind that strikes it which desires to raise it up.

And if these powers are equal one to the other so that the one cannot conquer the other, the bird will not be able either to raise or lower itself, and consequently will remain steady in its position in the air.

This is proved thus:—let *m* be a bird set in the air in the current of the wind *a b d c*. As this wind strikes it under the slant of the wing *n f* it comes to make a wedge there which would bear it upwards and backwards by a slanting movement if it were not for the opposing power of its weight, which desires to drop down and forward, as is shown by its slant *g h*, and since powers that are equal to each other do not subdue but offer a complete resistance the one to the other, for this reason the bird will neither raise itself nor lower itself; therefore it will remain steady in its position.

[*Figures*]

If the bird shown above lowers its wings it makes itself more stable upon the air and supports itself with less difficulty, because it occupies more space by keeping its wings in a position of equilibrium than in either lowering or raising its wings. In keeping its wings high however it cannot bend them either to the right or the left with the same ease that it would if it kept them low. But it is more certain not to be overturned in keeping its wings high than in keeping them

low and bending them less to the right or the left, because as it lowers itself on the right side, through using its tail as a rudder, there is an increase of resistance, because the wing embraces more air than the other wing on the side on which it descends abruptly in returning to a position of equilibrium. Consequently it is a good expedient to descend with a straight and simple slant, and this it would not be able to do if it held its wings lower than its body, for if it were to bend itself about one of its sides by using its tail as a rudder it would immediately turn upside down, the wing that is farther extended embracing more air and offering more resistance to the slanting descent than the other. E 22 V.

The extremities of the wings bend much more in pressing the air than when the air is traversed without the beating of the wings.

The simple part of the wing is bent back in the swift slanting descent of the birds. This is proved by the third of this which says:—among things which are flexible through the percussion of the air, that will bend most which is longest and least supported by the opposite side.

Therefore the longest feathers of the wings not being covered by the other feathers that grow behind them and not touching each other from their centre to their tip will be flexible, and by the ninth of this which said:—of things equally flexible that will bend the most which first opens the air. And this we shall prove by the eleventh which says:—of equal and similar things bent by the wind that will bend the most which is struck by air of greater density.

The helms placed on the shoulders of wings are extremely necessary for it is these parts which keep the bird poised and motionless in the air facing the course of the winds.

[*With drawing of wing*]

This helm *a* is placed near the spot where the feathers of the wings bend, and through being very strong it bends but little or not at all, being situated in a very strong place and armed with powerful sinews and being itself of hard bone and covered with very strong feathers, one of which serves as a support and protection of the other.

E 23 r.

Simple slant

If the slanting movement of the bird be made simply according to the direction of its length this slant will be rectilineal.

Compound slant

But if to the slant of the length of the bird there be added the slant of the breadth of its open wings the movement of this bird will be curved, and the curve will have its concave side in the direction of the lower wing.

Irregular movement

And if the bird is struck by the wind on the tip of its lower wing its compound movement with its slanting curve will become broken and will merely form a straight slant.

The wing of the bird is always concave in its lower part as far as the part that extends from the elbow to the shoulder, and in the rest it is convex.

In the concave part of the wing the air is whirled round, and in the convex it is pressed and condensed. E 23 v.

WHY THE BIRD MAKES A REVOLVING MOVEMENT BY BENDING ITS TAIL

All the bodies that have length and move through the air, with their lateral extremities equidistant from the central line of their bulk, will make straight movements; the power of the impetus which impels these bodies varying neither in the natural movement nor even in the violent or the semi-natural movement.

If however the lateral extremities of the bodies that have length are at an uneven distance from the central line of their bulk the movement of the body will form a curve in the air as it moves; and such curve will have its concave part on the side on which the extremity of the body mentioned is more remote from the said central line.

Concerning complex slants in birds' flight

A complex slant is said to be that which birds make when they move in the air keeping their tail higher than their head and one wing lower than the other.

When a bird flies in a complex slant the movement in the one slant will be so much swifter than in the other as the one is less oblique than the other.

The movement made by birds that fly with a complex slant is curved.

The curve created by the complex movement made by birds as they fly will be greater or less as the lateral slant is less or greater. E 35 V.

The flight of birds has but little force unless the tips of the wings are flexible. This is proved by the fifth of the Elements which says:—lateral power checks the descent of heavy things; as may be seen in the case of a man pressing with his feet and back against two sides of a wall as one sees chimney sweepers do. Even so in great measure the bird does by the lateral twistings of the tips of its wings against the air where they find support, and bend.

When the bird in its direct descent is struck by the wind under its wings this descent will become so much more slanting as the wind is of greater power. Proved by the ninth of this which says:—of direct descents which similar and equal heavy bodies make in the air that will slant most which is struck by the wind with most impetus.

If a bird fly with its wings at equal height and lower one of the sides of its tail its direct flight will become curved, and this curve will have its concave side towards the lowered side of the tail, and the wing on this side will be as much slower than the opposite wing as the movement of the bird is more curved.

This is proved by the seventh of this which says:—that part of a wheel as it revolves will have least movement which is nearest to the centre of this revolution. As therefore the tip of the wing *a* touches *a*, the centre round which it revolves, it will have less movement, and the opposite wing will have its extremity *d* with the movement *g b*.

E 36 r.

The descent of birds is of two kinds, of which one is with certainty upon a fixed position, the other is uncertain upon two positions or

more. In the first its wings are open and the points are raised above
the back, and with these at equal height it drops with straight simple
slant to its appointed place. The second bird as it descends has the
points of its wings held lower than the breast and bends its tail now
to the right now to the left, with slant now simple now complex and
sometimes irregular.

[*Figure*]

The bird that is struck on its side by the wind moves the wing that
is towards the wind with greater swifter motion than it does the other
as the wind is more impetuous in its movement. This may be proved:—
let *a b c* be the bird that moves along the line *a f* and to the wind *d*,
which strikes it at the side on the wing *a b*, and would carry it along
the line of its course if the wing *a b* was not swifter in its movement
than the wind. And this is why when the wind has struck the side of
the bird and by some eddying recoil has folded itself up against the
wing which has closed itself by flapping, this wing has thus had a
second support against the said bending of the straight movement of
the bird. It must therefore be concluded that the wide swift move-
ment, which the wing that is struck by the wind makes in excess of
that made by the opposite wing, at the same time as the wind which
has struck the bird and been bent back against the said wing, is that
which prevents the straight course of birds from being deflected by
the wind. And moreover unless the opposite wing was slow and of
little movement it would strike into the course of the wind and the
wind [would strike] against it; and thus the wind would be most
powerful to accompany this bird in its course. E 36 v.

WHY THE FLIGHT OF BIRDS WHEN THEY MIGRATE IS MADE
AGAINST THE APPROACH OF THE WIND

The flight of birds when they migrate is made against the move-
ment of the wind not indeed in order that their movement may be
made more swiftly but because it is more lasting and less fatiguing.
And this comes about because with a slight beating of their wings
they enter the wind with a slanting movement, this movement being
below the wind. After this impetuous movement they place themselves
slantwise upon the course of the wind.

This wind after entering under the slant of the bird after the manner of a wedge raises it up during such time as the acquired impetus takes to consume itself, after which it descends afresh under the wind and again acquires speed; then repeating the above-mentioned reflex movement upon the wind until it has regained the elevation that it lost, and so continuing in succession.

WHY BIRDS SELDOM FLY IN THE DIRECTION OF THE CURRENT OF THE WIND

It very seldom happens that the flight of birds is made in the direction of the current of the wind, and this is due to the fact that this current envelops them and separates the feathers from the back and in addition to this chills the bared flesh. But the greatest loss is that after the descent slantwise its movement cannot enter upon the wind and by the help of it be thrown back to the elevation it has left unless it has already turned backwards, which would not help it to make progress in its journey.

The bird spreads out the feathers of its wings more and more as its flight becomes slower; and this is according to the seventh of the Elements which says:—that body will become lighter which acquires greater breadth. E 37 r.

A bird descending makes itself so much swifter as it contracts its wings and tail. This is proved by the fourth of Gravity, which says:— that heavy body makes a more swift descent which occupies a less quantity of air.

That bird is more rapid in its descent which descends by a less slanting line. This is proved by the second of Gravity, which says:—that heavy body is swiftest which descends by the shortest way.

A bird in descending lessens its speed more and more as it is more extended. This is proved by the fifth of Weight, which says:—that heavy body is most checked in its descent which is most extended.

A bird in making a reflex movement rises in proportion as it acquires greater breadth. This is proved by the fourteenth of Local Movement, which says:—the heavy body that occupies a less space of air in the line of its movement penetrates it more rapidly. Therefore the widest expan-

sion of the wings produces the greatest diminution in the bulk of the whole bird, and in consequence the impetus of its reflex movement is less impeded; and therefore it rises farther at the end of this reflex movement.

When the bird descends upon the spot where it wishes to settle, it raises its wings and spreads out the half of its length and so descends slowly upon the aforesaid low place. E 37 v.

There is as much to move the air against the immovable thing as to move the thing against the immovable air.

When the bird moves with slow descent on a long course without beating its wings and the incline leads it more quickly to the ground than its intention is, it then lowers its wings and moves them against the immovable air, and this movement raises the bird up just as though a wave of wind struck it below: and this is proved by the last but one.

OF TWO CONTRARY SLANTS OF WHICH ONE IS DESCEND-ING AND THE OTHER IS A REFLEX MOVEMENT

The movement of the bird that descends by two contrary slants will be longer in proportion as the slant on which it rises more resembles the slant by which it descends.

This may be proved:—suppose that of itself the slant with which the bird descends makes a hundred miles an hour in order to descend to earth with a descent of a hundred braccia, and that the opposite slant along which it makes its reflex action at this time spares it the half of this descent, I affirm that the movement which was a hundred miles an hour will become fifty, as is proved in its place. E 38 r.

Birds always fly more slowly when they raise their wings than when they lower them. This is caused by the necessary period of rest that is required after the adjacent fatigue of the tired limbs, and moreover speed is not necessary in raising these limbs as it is in lowering them, seeing that the impetus that carries the bird is generated through a long space of movement in this bird. It is sufficient merely for it to have raised its wings from where they first descended when the said impetus commences to decline, which reveals itself through the falling of the bird. But when the bird wishes to acquire speed it resumes the

impetus nearer to its inception and beats its wings more frequently and with the longest and most rapid movement possible.

OF THE CIRCLING MOVEMENT MADE BY THE KITE IN RISING

The circling movement made by birds as they rise above the wind is produced by the bird entering upon the wind with one of its wings, and balancing itself with the other in the direct line of the wind.

In addition to this it lowers one of the corners of its tail towards the centre of its circular movement, and because of this the wind that strikes it on the inside checks the movement of the side that is lower and nearer to the centre of this circle. And this is the cause of the circling movement, and the wing held above the wind causes the bird to rise to the maximum height of the wind. E 38 v.

The simple movement which the wings of birds make is more easy when they rise than when they are lowered. And this ease of movement springs from two reasons of which the first is that the weight in falling somewhat raises the wings up of themselves, the second is due to the fact that owing to the wing being convex above and concave below the air flows away more easily from the percussion of the wings as they rise than when they are lowered, for then the air being pent up within the concavity of the wing becomes compressed more easily than it escapes.

OF THE EXPANSION OF THE TAIL IN THE REFLEX MOVEMENT OF BIRDS

Birds spread out their tails in their reflex movement because the air is compressed beneath them and resists the penetration of the bird in its maximum breadth, so that the impetus is consumed with just the edge or front of the wing. If this were not so the impetus acquired in the falling movement would consume itself partly in the direction of the earth and partly in the reflex movement; and then this reflex movement would be as lacking in height as that which drops down by keeping the tail straight.

The bird acquires more lightness the more it spreads itself out and expands its wings and tail.

That heavy body shows itself lightest which extends in greatest breadth.

From this conclusion one infers that by means of a wide expanse of wings a man's weight can support itself in the air.

That body shows itself less heavy which extends in greater breadth.

E 39 r.

OF THE CAUSE OF THE CIRCULAR MOVEMENT OF BIRDS

The circular movement of birds is produced by the unequal movement of their wings, and this is caused by the percussion created in the air by one of the corners of the tail that projects above or below the route made by the bird in the air traversed by it.

Of the things that are moved by others with simple movement the thing moved is as swift as the swiftness of its mover: therefore the bird carried by the wind in the same direction as this wind will have a speed equal to it.

But if the objects carried by the wind slant more towards the ground than the direction of the course of this wind the thing moved will be swifter than its mover. And if the slant of the objects carried by the wind turns towards the sky this is a clear sign that the movement of the thing moved is slower than that of the wind. The reason is that when the slant is turned towards the ground it produces this movement by reason of its gravity and not by the help of the wind. But when the slant of the movement made by the thing moved is towards the sky, this slant is caused merely by the shape of the thing moved, for it bears itself like a leaf which caught by the wind in its breadth raises itself up merely by the help of the wind, and moves as much as its mover, as has been shown in its place. E 39 v.

When the bird is driven by the wind and has a more slanting course than the course of the wind it is so much swifter than the said wind.

When the bird driven by the wind has its movement parallel to that of the wind it also has a speed equal to that of the wind.

When birds are driven by the wind without beating their wings the

bird is swifter than the wind in proportion as its course is more slanting than that of the wind. This is proved as follows: suppose the wind in a position of equality to move one degree of space in one degree of time and the bird driven by the same wind to move the same degree in the same time, these movements up to this point will be equal. But on account of the slant in the bird's movement let us assume it to acquire a second degree of movement in the same time that the wind is acquiring its first degree; it follows therefore that the bird in the same time can be twice as fast as the wind that drives it.

But this same slanting movement does not acquire its distance within a position of equilibrium, but between this position of equilibrium and the centre of the earth, as if the position of equilibrium was the line *a c* along which the wind moves from *a* to *c*, and the bird moves by the help of the wind and by help of its gravity from *a* to *d*. I say that in the same time in which the bird shall be moved (without the help of its gravity) from *a* to *b*, it will be moved by the help of the wind and of its gravity from *a* to *d*, the one movement being in the proportion of one and a half as compared with the other, from *a* to *d* upon the movement *a b*. But as regards the distance of the aspects, *a d* is the same as *a b*, as is shown us by the perpendicular *b d*. E 40 r.

OF BIRDS WHICH FLY IN COMPANIES

When the birds which fly in companies come to make long journeys, and the wind chances to strike them on one side, they are greatly helped in their flight because the flight is made in loops without working their wings; because the falling movement is made beneath the wind, with the wings somewhat close together, and in the direction in which they are travelling. But the reflex movement is made above the wind; and with the wings held open it rises up as the wind meets it, and consequently, the wind entering beneath the bird lifts it up towards the sky, after the manner of a wedge, when it penetrates beneath a heavy body which is set above it. By this means, after the birds have been lifted up to their proper height, which is the equivalent of that at the beginning of the falling movement, they return to their first

course, recommencing always in this course their falling movements; and their reflex movements are always made against the wind.

<div align="right">E 40 V.</div>

OF FLYING THINGS

Before birds start on long journeys they wait for the winds favourable to their movements, and these favourable winds are of a different kind with different sorts of birds, because those which fly in jerks or bounds are obliged to fly against the wind, others receive the wind on one of their sides at different angles and others receive it on both sides. But the birds that fly by jerks such as fieldfares and other birds like these which fly in companies, have the feathers of their wings weak and poorly protected by the lesser feathers which form a covering for the larger ones. And this is why it is necessary that their flight should be against the course of the wind, for the wind closes up and presses one feather upon another and so renders their surface smooth and slippery when the air tries to penetrate it. It would be the contrary if the wind were to strike these birds towards the tail, because then it would penetrate under each feather and turn them over towards the head, and thus their flight would have a confused movement, like that of a leaf blown about in the course of the winds which goes perpetually whirling through the air continually revolving, and in addition to this their flesh would be without protection against the buffeting of the cold winds. And in order to avoid such accidents they fly against the course of the wind with a curving movement, and their bounds acquire great impetus in their descent, which is made with wings closed under the wind. And the reflex movement proceeds with wings open above the wind, which brings the bird back to the same height in the air as that from which it first descended, and so it continues time after time until it arrives at the desired spot.

The reflex movement and the falling movement vary in birds in two ways, of which one is when the reflex movement is in the same direction as the falling movement, the second is when the reflex movement is in one direction and the falling movement is in another.

The bird in the falling movement closes its wings and in the reflex movement it opens them: it does this because a bird becomes heavier in

proportion as it folds its wings and so much lighter as it opens its wings more.

The reflex movement is always made against the wind and the falling movement is made in the direction in which the wind is moving.

E 41 r.

If the flight of the bird turns to the south without beating its wings when the wind is in the east, it will make the falling movement rectilinear with its wings somewhat contracted and underneath the wind. But the reflex movement which succeeds this falling movement will be with the wings and tail open and it will have been directed towards the east.

At the end of this movement it will turn its front back again to the south and with its wings folded it will create again the succeeding falling movement which will be of the same nature at the first, desiring to make a long course with the help of this wind; and the junction of the falling movement with the reflex movement will always be of the nature of a rectangle, and so will be that of the reflex movement with the falling movement.

There are two ways in which the wind causes birds to become stationary in the air without beating their wings.

The first is when the wind strikes against the sides of steep mountains or other rocks by the sea, as the bird then sets itself at such an angle that it carries in front as much of its weight against the reflex wind as this wind in front has power in its resistance. And since equal powers cannot prevail over each other it follows that in such a position a bird through its imperceptible vibration remains motionless. The second way is when the bird sets itself at such a slant above the course of the wind that it has as much power to descend as the wind has to resist its descent.

When by the help of the wind the bird rises without beating its wings and makes a circular movement, and when it spreads its tail at the uprising of the wind, it is being driven by two powers, one of which is that of the wind which strikes the wings in the hollow beneath them and the other is the weight of the bird which is descending by a complex slant. And from the fact of its acquiring such velocity it comes to pass that as it turns its breast to meet the onset of the wind

this wind acts under the bird after the manner of a wedge which lifts
up a weight; thus the bird makes its reflex movement much higher
than the commencement of its falling movement; and this is the true
cause why birds rise some distance without beating their wings.

E 41 V.

DEFINITION OF THE MOVEMENTS

Straight movement is that which extends from one point to another
by the shortest line.

Curved movement is that in which there is found some part of
straight movement.

Spiral movement is formed out of slanting and curved lines in which
the lines drawn from the centre to the circumference are all found to
be of varying length, and it is of four kinds, namely convex spiral,
level spiral and concave spiral and the fourth is a spiral in cylindrical
form. There is also the circular movement always made round about a
point at equal distance, which is said to be revolving, since there are
there irregular movements which although they are infinite are made
up of a blend of each of the aforesaid movements.

The commencement of the simple falling movement is always higher
than the termination of its simple reflex movement, the mobile genera-
tor of these movements being immobile in the air.

But the complex falling movement in conjunction with the complex
reflex movement will have the contrary result to the simple, provided
that the falling movement is lower than the reflex movement, and this
arises out of the fact that the bird which below the wind creates this
falling movement presses down and lowers the course of this move-
ment; but the reflex which is produced above the wind with wings open
raises it considerably higher than the commencement of this falling
movement.

E 42 r.

DEFINITION OF THE WAVES AND IMPETUS OF THE WIND
AGAINST FLYING THINGS

The bird maintains itself in the air by imperceptible balancing when
near to the mountains or lofty ocean crags; it does this by means of the
curves of the winds which as they strike against these projections,

being forced to preserve their first impetus bend their straight course towards the sky with divers revolutions, at the beginning of which the birds come to a stop with their wings open, receiving underneath themselves the continual buffetings of the reflex courses of the winds, and by the angle of their bodies acquiring as much weight against the wind as the wind makes force against this weight. And so by such a condition of equilibrium the bird proceeds to employ the smallest beginnings of every variety of power that can be produced.

Of the movement and the eddies made by the current of the air striking upon various projections of the mountains, and how the birds steer themselves in the various tempests of the winds by the imperceptible balancing of their wings and tail:

The falling movement is always united with the reflex movement and the beginning of the reflex movement is united with the end of the falling movement; and if such movements form a continuous succession always following each other, one will be the cause of the other, and the death of one will immediately produce the other, so that they will never both exist at the same time; and the falling movement has a weak beginning and is continually increasing and the reflex movement is the opposite.

HOW THE TAIL OF THE BIRD IS USED AS A RUDDER

When the bird lowers its tail equally it descends by a straight slanting movement. But if it is more lowered on the right side then the straight line of the descent will become curved and will bend towards the right side with a greater or less curve of movement in proportion as the right point of the tail is higher or lower, and if the left point of the tail is lowered it will do the same on the left side.

But if the tail is raised equally a little above the level of the back of the bird it will move along a straight line slanting upwards; but if it raises the right point of the tail more than the left this movement will be curved towards the right side, and if it raises the left point of the tail this straight movement will curve on the left side. E 42 v.

When two movements of impetus meet, the percussion is more powerful than if they were without encounter. As therefore the im-

petus of the bird encounters the impetus of the wind its simple impetus increases and the reflex movement is greater and higher.

The bird moves against the wind without beating its wings and this is done beneath the wind as it descends, and then it makes a reflex action above this wind until it has consumed the impetus already acquired, and here it is necessary that the descent should be so much swifter than the wind that the death of the acquired impetus at the end of the reflex movement may be equal to the speed of the wind that strikes it below.

WHY SMALL BIRDS DO NOT FLY AT A GREAT HEIGHT AND LARGE ONES DO NOT LIKE TO FLY LOW

This arises from the fact that the small birds being without feathers cannot endure the intense cold of the great height of the air at which fly eagles and other large birds which have more power of movement and are covered with many rows of feathers. Also the small birds having feeble and simple wings support themselves in the lower air which is thick and would not support themselves in the rarefied air which offers less resistance.

The end of the reflex movement is much higher (for the birds which fly against the wind) than the beginning of their falling movement; and by this Nature does not break her own laws, and this is shown by what has gone before. E 43 r.

HOW THE BIRD RISES BY MEANS OF THE WIND WITHOUT BEATING ITS WINGS

The bird rises to a great height without beating its wings by means of the wind, which strikes it in a great mass underneath its wings and tail placed slantwise and above its back placed at an opposite slant.

This may be proved:—suppose the wind compressed beneath the bird to have the same effect beneath it that one sees happening when a wedge is driven beneath a weight, for the wedge at each degree of its movement causes the weight to acquire a degree of height. But since the opposite slant of the body which the bird has is disposed to descend against the approach of the wind with the same power as that with

which the wind raises it up, through the slant of the body being contrary to that of the wings, it is covered as much.

[*A drawing of a sector*]

Here it is necessary to calculate the degrees of the slant, for in no degree of slant either of an object upon the water or a bird in the air do they stop, but their speed will be greater or less as their position slants less or more.

The bird weighs less which spreads itself out more, and conversely that weighs more which draws itself together more tightly; and the butterflies make experiments of this in their descents. E 43 v.

HOW THE BIRD FALLING HEAD DOWNWARDS HAS TO GUIDE ITSELF

The bird that falls head downwards guides itself by bending its tail towards its back. This is proved by the tenth which says:—the centre of a heavy object that descends in the air will always remain below the centre of its lightest part. Therefore as *c d* the central line of the gravity of the bird is at a distance from *a b* the central line of the levity of the tail of this bird, the two lines will necessarily form the same line over a short space of the descent of this bird. And this being so one must needs admit that the direct descent will of necessity become a slant and in becoming a slant the descent will be as much slower as the movement is longer, or that the movement will be as much longer as the descent is slower, and as much longer and slower as the descent is more slanting.

HOW THE BIRD STEADIES ITSELF AS IT FALLS BACKWARDS

But if the bird turns over in the air because of the wind the tail ought to close up as much as it can and the wings rise behind the head. And with the part in front of the centre it becomes heavy and with that behind light, the centre of gravity not being in the centre of its volume; and by the ninth which says:—the fact that the centre of the volume is not concentric with the centre of gravity is the reason why the body in which these centres are contained will never remain in a state of equilibrium with its greatest breadth; and by the tenth of

this:—the centre of the gravity of bodies suspended in the air will always be below the centre of the volume of the same bodies. E 44 r.

Why the bird makes use of the helm placed in the front of the wings although it has other ways of curving its straight movement:

The bird only makes use of one of the helms placed in the front of its wings when it wishes to bend its straight movement into a level position.

When however it comes to pass that this bending process is complex, that is it is a slanting curve, it will then draw in one of its wings a little, and thus will make a curved movement which will descend on that side on which the wing is drawn in, showing there the convex movement.

But such a process as this involves the danger of its turning over on its side and leaving the point of the wing extended towards the sky, and as a means of protection against this it is necessary to extend the wing that is drawn in, always showing the under side of the wing to the ground, for if you were to show it the right side the bird would turn upside down. When therefore in these conditions you have extended the folded wing towards the ground you will at the same time gather up the upper wing which was extended, until such time as you return to a position of equality.

In having shown one of the dangers which occur to deflect the straight movement of the birds in the air, by disturbing the equal resistance which wings make when they are equally open upon the air and have their centre of gravity between them midway between their extremities, we have at the same time proved that it is safer to bend one of the two helms of the winds than it is to bend one of the two wings. E 44 v.

WHICH OF THE MOVEMENTS OF THE WINGS IS THE SWIFTEST

The movement of the wings is twofold inasmuch as part of the movement descends towards the earth and part towards the place from whence the bird is flying. But that part of the movement which is

made towards the earth checks the bird's descent and the backward movement drives it forward.

What it is in the bird that causes it to bend its straight movement without it either descending or raising itself:

The bird bends its straight movement made in a position of equilibrium without raising or lowering itself, by means of the right or left helm placed in the front part of the wings. This is proved thus: let *a p o g* be the bird which moving in a position of equilibrium bends the straight movement *m p a* to the curving movement *a b* by means of the helm *t* which is set in the front part of the left wing, and this comes about by the ninth of this which says:—the bodies with equal sides about the central line of their gravity will always keep the straight line of their movement in the air—and if the volume of one of the sides is increased or diminished the straight movement will describe a curve, showing the concave part of the curve on the side of the greater inequality of the thing that is moved. E 45 r.

OF THE UNDERSIDE OF THE WINGS [*with drawing*]

They form coverings one to the other *b* to *a*, the resisting parts of the feathers beneath the wings of the birds behind the flight of the air or wind, so that this air or wind shuts up a part of the feathers that offer weak resistance upon the opposite feathers which offer powerful resistance.

WHY THE FEEBLE RESISTANCES ARE BENEATH THE POWERFUL ONES

The feathers that offer a feeble resistance are set beneath those which offer a powerful resistance with their extremities turned towards the tail of the bird, because the air underneath flying things is thicker than it is above them and in front than it is behind; and the necessity of flight brings it about that these lateral extremities of the wings are not found by the stroke of the wind because then they would immediately become spread out and separated one from another, and would be instantly penetrated by the wind. Consequently these resistances being so placed that the parts which have a convex curve are turned towards

the sky, the more they are struck by the wind the more they lower themselves and draw closer to the lower resistances with which they are in contact, and so prevent the entry of the wind beneath the front of the lateral parts of these resistances.

WHAT TEXTURE OF AIR SURROUNDS BIRDS AS THEY FLY

The air which surrounds the birds is as much lighter above than the ordinary lightness of the other air as it is heavier below, and as much lighter behind than above as the bird's movement is swifter in its transverse course than is that of its wings towards the ground, and similarly the heaviness of the air is greater in front of the contact of the bird than below it in proportion to the two above mentioned degrees of lightness of the air.

The straight movement of birds in the air forms a curve towards the side on which the wing is drawn together, and this arises entirely out of the fact that every heavy body descends on that side on which it has less resistance; this movement therefore may be described as a complex curve formed out of a lateral curve and the declining curve made by the bird upon that side which is lower than itself. E 45 v.

OF RAISING AND LOWERING THE WINGS

Birds raise their wings when open with greater ease than they lower them. And this is proved by the third of this which says:—parts of bodies which are convex are more suitable for penetrating the air than those which are concave.

It follows that as birds have their wings convex on the side that is uppermost and concave on the side below they will raise their wings with greater ease than they lower them.

OF THE SPREADING OUT OF THE FEATHERS AS THE WINGS ARE RAISED

The feathers spread out one from another in the wings of birds when these wings are raised up, and this happens because the wing rises and penetrates the thickness of the air with greater ease when it is per- forated than when it is united.

OF THE CLOSING UP OF THE FEATHERS AS THE WINGS ARE LOWERED

The spaces between the feathers in the wings of birds contract as the wings are lowered, in order that these wings by becoming united may prevent the air from penetrating between these feathers, and that with their percussion they may have a more powerful stroke to press and condense the air that is struck by these wings.

OF THE RESISTANCES OF THE FEATHERS IN THE WINGS OF BIRDS

The resistances of the feathers in the wings of birds form with their powerful curves shields one of another in the upper part against the penetration of the air or the onset of the wind, so that this wind may not as it enters cause them to spread themselves out and raising open them and so separate the feathers one from another.

It is shown here below how as the feathers under the wings in order to support themselves have to rest and rub themselves upon the air which sustains them, part of the resistance that there is in the feathers remains beneath the strong part of the other feathers, for the feathers underneath the wings have their long weak portions situated underneath the short strong parts of the next row of feathers.

Why the sinews beneath the birds' wings are more powerful than those above. It is done for the movement:

The shoulder where the helm of the wing is placed is hollow below after the manner of a spoon, and being thus concave below it is convex above. It is fashioned thus in order that the process of rising may be easy and that of lowering itself difficult and may meet with resistance, and especially it is of use to go forward drawing itself back in the manner of a file. E 46 r.

OF THE EXTREMITIES OF THE WINGS WHEN RAISED

The extremities of the wings when raised to their maximum height are farther away from each other than when lowered as far as possible.

And when these wings re-ascend their extremities continue the

descent that has been begun until they straighten the curve that they have formed, and then bend in the opposite curve and continue it nearly to the end of their elevation; and as the wings recede from this elevation the extremities pursue the elevation that has been begun until the first curve has been destroyed and another has been formed in the contrary direction.

In the impetus made in the air by the birds it is better and easier to bend a part of the wings than the whole. The part of the bird which bends in the air will cause the whole of it to bend, as one sees happen to a ship through the turning of its rudder.

By what has been said above the points of the wings produce a greater movement than is demanded by their length since they are not flexible. This is proved:—let there be the movement of the points of the wings which are flexible *a c* and of those which are not flexible *b d*; the movement *a c* of the flexible extremities of the wings exceeds *b d* the movement of the non-flexible wings, and of these two lines of movement the one is proved to be less than the other because the one is part of the other.

But because the points of the wings as they are raised and lowered make a less movement than the parts of the feathers joined to them, and before these points of the wings commence to extend the parts of the feathers united to these points they turn in a contrary movement, it is necessary for part of the extremity of these feathers to turn back with the rest of the feather, and for the point to come forward like a finger that raises itself as much as the hand descends, which finger one would describe as immovable because it does not change its position; and for this reason we may say that the point of the flexible wing has a movement resembling that of the wings that are not flexible.

E 46 v.

WHETHER THE CURVES OF THE END PARTS OF THE WINGS ARE NECESSARY OR NOT

The air which is underneath the curves of the end parts of the wings as they descend is more compressed than any other portion of the air that is found underneath the bird, and this is brought about by the beating of the wings. This is proved by the seventh which treats of

percussion, where it is stated that percussion is greater in proportion
as the movement of that which strikes is more long continuing. There-
fore in the case of the whole wing descending at the same time that
part has most rapid movement which is most distant from the fixed
part, and as a consequence that air is most compressed which is struck
by the swiftest blow. It follows also that the flexion of the point of
the wing is after the manner of a spring or a bow bent by force, and
that this process of bending compresses the air with which it comes in
contact.

But when these wings rise up their points follow the line of their
descent until they straighten themselves and then they bend back in the
opposite direction, that is that if the concavity which there is in the
end of the wing as it descends turns towards the sky the concavity of
the same end as the wing rises will be turned towards the earth.

That part of the shaft is most rapid which is furthest away from its
motive power, and the proportion of speed to speed is as the distance,
the shaft as it moves not bending. E 47 r.

If the movement of the wind had uniform power in its expanse the
bird would not be so often engaged in beating the wind and balancing
itself with its wings.

The air in itself is capable of being compressed and rarefied to an
infinite degree.

WHETHER THE FOLDS IN THE EXTREMITIES OF THE WINGS ARE NECESSARY OR NOT

The curve which is created in the extreme parts of the wings when
these wings strike and press upon the air which is condensed beneath
them has the effect of greatly increasing the bird's power of flight, for
in addition to pressing on the air that is below them they compress the
adjacent lateral air, by the fourth of the second which says 'every
violence seeks to undo itself on the very lines of the movement which
has produced it'; and by the seventh 'every straightness which is bent
by force has the lines of its power converging in the centre of a com-
plete circle formed by the curve commenced by this extremity of wing'.
As if the wing *a b c d* being curved at its extremity *c d b*, I come to

finish the circle *c d b r* of which the centre is *n*, and from this I draw the line *n f* touching the point of the wing; and the others will be the lines *n e* and *n f*, and thus in the centre are the infinite images of the others.

And by what is said below all these lines have the same boundaries as the curve of the wings *b d c* by the rule of the perpendicular; therefore the force of this extremity of wing *b d c* is directed along the lines *b f, d e, c m*, and of these *b f* is outside the space occupied by the bird as the line *b o* informs us. E 47 V.

OF FLYING THINGS

If the lateral parts change from a position of equilibrium the straight slanting movement will change to a curved slanting movement.

The bird which after its descent is thrown back in the air will never regain its former height unless it beats its wings and has the help of the wind.

The bird that drops down before the approach of the wind with a straight slant will always have its reflex movement more raised than its falling movement.

The curving slant that is seen to occur when birds are flying to meet the approaching wind with a falling reflex movement is much more steady than the same movements made in a straight slant.

OF REFLEX WINDS

If the birds are driven by the wind without beating their wings and the wind meets the wall set over against it, in avoiding this wall [the bird] immediately encounters the reflex wind.

If the bird moves towards the north upon the wind and the wind wishes to turn it to the east, the bird in order not to spoil the equal expanse of wing which keeps it at its maximum levity will lower the right tip of the tail and receive the stroke of the wind upon it more than it does upon the left tip, keeping thus its straight movement direct to the north upon the wind. E 48 r.

OF THE THINGS THAT MOVE IN THE AIR AND THEIR DESCENT

A parallel board of uniform thickness and weight placed flat in a position of equality in uniform resistance will descend uniformly in each of its parts. And if this board is placed in the air in a slanting position the descent will slant uniformly, and this is proved in its place.

The shape of the front part or back part of the thing that moves in the air or water is what bends its straight course.

An irregularity attached either in front or behind the extremities of the equality that moves in the air is what diverts to right or left or up or down or in some slant the straight movement of the aforesaid equality.

A bird which descends with a straight slant in one direction will not change the equal position of its side parts.

A bird in the air makes itself heavy or light whenever it pleases; and it does this by spreading out its wings and expanding its tail when it wishes to check its swift descent, or by contracting wings and tail when it wishes to quicken a descent which has been delayed.

E 48 v.

The helms placed on the shoulders of the wings are [formed] of very strong feathers because they bear a greater strain than all the other feathers.

[*Figure*] *a b* the helms of the wings come into use when the bird is in swift descent. When it wishes to capture its prey and to turn from one direction to another without checking its movement it uses these helms, and if these were not there it would be necessary for it to employ the whole wing, and this by reason of its size would greatly hinder the movement commenced, contrary to its intention.

OF THE SLANTING MOVEMENT OF BIRDS

The bird which consumes the impetus against the coming of the wind with its wings open without any movement, except for their necessary balancing, if it finds itself above this wind, will always rise.

but with greater or less increase of height as the impulse which moves it is of greater or less power and of less or greater slant in itself.

But if the bird moves without beating its wings underneath the wind the impetus will be consumed in the descent of the bird but the impetus will be the more permanent as the descent is less slanting.

If the bird moves with its wings open and without beating them, at the same time as the wind and in the same direction, this bird will then acquire a degree of descent with each degree of movement; but this descent will be as much more slanting as the wind is swifter, as is proved when heavy substances are thrown into running water.

And if a bird is struck behind and below by the wind then the bird will rise up, but this is only done on very rare occasions by birds, because such a movement turns the feathers over and down so that they point towards the head of the bird. E 49 r.

OF EVERY KIND OF FLIGHT MAKE ITS OPPOSITE

When the bird is driven by the wind it proceeds continually to descend by a slanting movement, and when it desires to rise to its former height it turns backwards and uses the impetus of the wind as a wedge.

Science

The impetus that the bird acquires by its falling movement may be reflected in each direction by a movement that is either straight or a gradual curve whichever it may be until this impetus is consumed.

Rule

When the bird struck beneath the right side by the wind desires to descend upon some spot it lowers the one of its wings upon the side where it wishes to settle.

Science

The bird that desires rapidly to consume the impetus it has acquired turns its wings in their full extent against the spot where it wishes to halt—and this it does without the help of the wind.

When a bird desires to rise straight up without the wind by means of beating its wings the turning movement is necessary.

But if the bird's movement is to be in a straight line without the help of the wind it is necessary that the movement should be made by frequent beatings of the wings, and for this cause the movement will be extremely slanting. E 49 V.

THEORY OF FLYING THINGS

The movement made by a movable thing which is long in shape and of uniform sides round about its centre-line will take a straight course through the air for so long a time as the impetus lent to it by its mover lives within it.

The bird which flies in a curved line in a level position moves one wing with a longer and more rapid movement than the other, but such movement does not raise or lower the one wing more than the other.

But if the curved movement of birds is made up of curve and slant, then in addition to the movement in one wing being swifter and longer than in the other the one wing will also go higher and lower than the other. And this is proved by the fourth which says, 'wings of equal movement propel the bird in a straight line', and by the converse 'wings of which the movement is unequal in length make a curved movement'. And if the movement of wings which are unequal is of equal height but of varying length the movement of the bird will then be a curve in a level position. And if the movement of the wings in addition to being unequal in length is also unequal in height and depth, this being more in the case of one wing than the other, this movement is composed of curve and slant. E 50 r.

OF THE REVOLVING MOVEMENT

[*With three sketches of a top spinning*]

The pegtop or 'chalmone' which by the rapidity of its revolving movement forgoes the power that comes from the inequality of its weight round the centre about which it revolves, on account of the impetus that controls this body, is a body which will never have such a

tendency to fall as the inequality of its weight desires, so long as the power of the impetus that moves this body does not become less than the power of this inequality.

But when the power of the inequality exceeds the power of the impetus it makes itself the centre of the revolving motion and so this body brought to a recumbent position completes upon this centre the remainder of the aforesaid impetus.

And when the power of the inequality is equal to the power of the impetus the top is bent obliquely, and the two powers contend in a concerted movement and move one another in a great circuit until the centre of the second variety of revolving movement is established, and in this the impetus ends its power. E 50 V.

The rows of feathers on the wings placed one above the other are set there for the purpose of strengthening the largest feathers.

Make first the anatomy of the birds, then that of their wings stripped of feathers and then with the feathers.

Parallel lines which between their extremities are equidistant from the same point are always curved, and the one is shorter than the other if they are in contact with the two sides of the same triangle.

All the feathers of the wings that grow beneath the penultimate feathers of the same wings are in process of bending during the bird's flight, and the most flexible are those which do not form a covering one to another, that is those which are pierced during the flight.

In order that a bird flying against the wind may be able to settle on a high spot it has to fly above the spot and then turn back and without beating its wings descend upon the above-mentioned place. This is proved, for if the bird should wish to abandon its flight in order to settle, the wind would throw it backwards, and this cannot happen when it acts in the aforesaid manner.

If the flight of the bird is conditioned by the length of the bird and the wind strikes it on the side the movement of its flight must needs be between its length and the said side: as though the bird a b should wish to fly from a to c and the wind f should strike it on the flank or at the side, this bird will then direct its movement by the line a g, and the wind will continually bend the movement along the curve m n c; thus it will go where it wishes and will find itself at the spot marked c.

But should the wind deflect the bird's course in a more pronounced curve than its will consents to, the bird will then resume its flight against the wind as it did at first, and then with a second curving movement the wind will lead it to the desired place. E 51 r.

Whether or no equal striking forces made with equal lengths of movement at different times will create equal lengths of movement in the objects moved: this is answered by the seventh of the ninth which says:—among moving forces of equal powers and of movements united with their objects moved, that which divides its movable thing most swiftly from itself will be that which will move this movable thing farthest from itself. At this point the adversary says that moving forces of equal power will not vary their speed and cannot therefore with similar movement drive one of two equal movable things farther from them than the other. The reply to this is that there are two kinds of moving forces of which one is sensitive and the other is not: that which is sensitive has life, and the other is without life. But that which has life moves its movable things by means of the expansion and contraction of the muscles that form parts of its limbs, this expansion and contraction being made with a greater or less amount of speed with the same power, the cause that is swiftest not being the most powerful.

No other difference is found except that the greater or less speed compresses more or less the air through which the arm of the moving force is exerted. But the insensitive moving force such as catapults or mangonels or other similar engines which by means of trapezes or by the force of cords or bent wood drive forth from themselves. . . .

The bird which one sees, carried on by its impetus, flying higher than the spot on which it desires to settle, spreads out its tail and lowers it; and striking the air with it in the course of its movement it bends its straight course and causes it to curve and makes it end upon the spot where it settles down.

The kite which descends to the east with a great slant with the wind in the north will have its movement bent to the south-east by this wind unless it lowers the right tip of its tail and bends its movement slightly to the north-east. This is proved thus:—let $a\ b\ c\ d$ be the bird, moving to the east in the direction $n\ m$, and the north wind strikes it crosswise by the line $f\ n$, and would cause it to bend to the south-east

if it were not that it has the right tip of the tail lowered to meet the wind, as it strikes it behind the centre of gravity over a longer space than existed in front of this centre of gravity, *and so its straight movement is not deflected.*[1] E 52 r.

When the bird desires, with its wings extended, to make a circular movement which shall raise it to a height with the help of the wind, it lowers one of its wings and one of the tips of its tail towards the centre of the circle in which it is revolving.

And when the movement of the bird is circular in order to raise itself to a height without beating its wings it receives the wind under one of its wings over a fourth part of this circle; and in this way the wind makes itself a wedge and raises it up. It would turn it upside down if it were not that the other wing supported it and sustained it upon the air which strikes with a whirling movement underneath this wing, which is the one that was struck and pressed together beneath the other wing.

THINGS THAT FLY

The helms formed on the shoulders of the wings of birds are provided by resourceful nature as a convenient means of deflecting the direct impetus which often takes place during the headlong flight of birds, for a bird finds it much more convenient to bend by direct force one of the smallest parts of the wings than the whole of them; and this is why their feathers are made very small and very strong so that they may serve as a cover for one another and by so doing arm and fortify each other with marvellous power. And these feathers have their base in the small and very thick bones, moved by the sinews which bend them over their joints and which are very great in these wings.

The movement and position of these bones on the shoulders of the wings is ordered and established in the same way as the thumb in the human hand, which being in the centre of the four sinews that surround it at the base with four equal spaces between them, produces by means of these sinews an infinite number of movements both curved and straight.

[1] Words crossed out in MS.

We may say the same of the rudder placed behind the movement of the ship, imitated from the tails of birds; as to which experience teaches us how much more readily this small rudder is turned during the rapid movements of great ships than the whole ship itself.

Why the inventors of ships do not place their rudders in front as is the case with the rudder placed in front of the shoulders of the wings:

This was not done with ships because the waves of the water are thrown up in the air to such a great height when smitten by the impetuous blow of the moving ship as would render the movement of the rudder very difficult from the gravity it would have acquired, and moreover it would often get broken. But since air within air has no weight but has condensation which is very useful the rudders (or helms) of the wings have a better use in a thick substance than in a thin one, the thick offering more resistance than the thin. The ship does the same in the added gravity of the water as has been said, and for this reason the rudder has been placed behind the ship where the water furrowed and cleft open by its course falls back from the dikes which have been made in the depth of the hollow created, and in its descent strikes the rudder with greater or less power as the falling water strikes it at angles greater or less; and in addition to this the volume of water pent up in the centre of the said concavity falls with impetus at the blow of the rudder as has been stated.

But at the tail of the kite there is the stroke of the air which presses with fury closing up the void which the movement of the bird leaves of itself, and this occurs on each side of the void so created.

The void which the bird leaves of itself successively as it penetrates in the air is struck on its sides by that part of the bird which most exceeds the space about its central line.

If the percussion which the sides of the bird make on the sides of the air they penetrate, with those parts that is which are at the greatest distance from the centre line of their movement, is above the middle of its right side, then the straight movement will curve towards the right side, and if it is below the middle upon the opposite side this straight movement will then curve upon the left side; it will also do the same if struck above the middle of the left side as if struck below it on the left (right?) side and of the side above or of that below; and of the appearance of each we will speak in its place.

The tail of the bird spread out takes the same proportion of the bird's whole weight as is the proportion that the open tail bears to the other parts of the bird, the bust, neck, head and open wings,—and so much less in proportion as the centre of gravity of the whole bird is nearer the centre of the bust than of the tail.

[The air] runs after the vacuum which the bird leaves of itself as it pierces the air as much as the bird flies forward in the air which continually receives its contact. Consequently it is not the closing up of the air behind the bird that drives the bird before it but the impetus which moves the bird forward opens and drives the air, which becomes a sheath and draws the air behind it.

The bird which without moving its wings rises up by the help of the wind descends half the distance that it rises as it moves above the wind when its tail is turned to this wind. And as much more as the circle is larger. E 52 v. and 53 r.

The bird that flies with a curving movement as it beats its wings beats the wing on the convex side of this movement more frequently and with a longer movement than it does on the concave side.

If the bird were to raise its wing above the wind on the side on which it is struck by this wind, this bird would be turned upside down, but for the fact that the opposite wing is lowered and bent underneath the percussion of the wind beyond the centre of its gravity, which percussion would immediately restore it to a position of equilibrium in the tips of its wings.

The bird which spreads its bulk out longer and thinner will have its flight less affected by the percussion of the wind as it receives the aforesaid percussion.

When the bird has arranged itself so that it receives the percussion of the wind slantwise, the extreme part of the lower wing bends considerably and assumes the shape of a foot and in this way it serves somewhat as a support to the weight of the bird.

Birds with short tails have very wide wings; by their width they take the place of the tail, and they make considerable use of the helms set on the shoulders of the wings when they wish to turn to any spot.

The bird that receives the wind full in front turns over as it rises and stretches out its neck towards the sky; and by lowering and open-

ing its tail it stops itself from turning over. And this proceeds from the fact that a greater volume of wind strikes the bird below its centre of gravity than above it. E 53 V.

In order to give the true science of the movement of the birds in the air it is necessary first to give the science of the winds, and this we shall prove by means of the movements of the water. This science is in itself capable of being received by the senses: it will serve as a ladder to arrive at the perception of flying things in the air and the wind.

Wind

The wind in passing the summits of mountains becomes swift and dense and as it flows beyond the mountains it becomes thin and slow, like water that issues forth from a narrow channel into the wide sea.

When the bird passes from a slow to a swift current of the wind it lets itself be carried by this wind until such time as it has devised a new assistance for itself, as is proved in this book.

When the bird moves with impetus against the wind it makes long quick beats of its wings with a slanting movement, and after thus beating its wings it remains for a time with all its members contracted and low.

The bird will be overturned by the wind when in a less slanting position it so arranges itself as to receive beneath it the percussion of any lateral wind.

But if the bird that is struck laterally by the wind is on the point of being overturned by this wind it will fold its upper wing, and so immediately go back to the position of having its body turned towards the ground, but if it fold its lower wing it will be immediately turned upside down by the wind. E 54 r.

OF THE BIRD'S MOVEMENT

Of whether birds when continually descending without beating their wings will proceed a greater distance in one sustained curve, or by frequently making some reflex movement; and whether when they wish to pass in flight from one spot to another they will go more

quickly by making impetuous headlong movements, and then rising up with reflex movement, and again making a fresh descent, and so continuing: to speak of this subject you must needs in the first book explain the nature of the resistance of the air, in the second the anatomy of the bird and of its wings, in the third the method of working of the wings in their various movements, in the fourth the power of the wings and of the tail, at such time as the wings are not being moved and the wind is favourable, to serve as a guide in different movements.

Dissect the bat, study it carefully, and on this model construct the machine.

OF SWIMMING AND FLIGHT

When two forces strike against each other it is always the swiftest which leaps backwards. So it is with the hand of the swimmer when it strikes and presses upon the water and makes his body glide away with a contrary movement; so it is also with the wing of the bird in the air. F 41 V.

Before you write about creatures which can fly make a book about the insensible things which descend in the air without the wind and another [on those] which descend with the wind.

When the bird is moving to the east with the wind in the north and finds itself with its left wing above the said wind it will be turned over, unless at the onset of this wind it puts its left wing under the wind and by some such movement throws itself towards the north-east and under the wind. F 53 V.

AIR

Its onset is much more rapid than that of water, for the occasions are many when its wave flees from the place of its creation without the water changing its position; in the likeness of the waves which in May the course of the wind makes in the cornfields, when one sees the waves running over the fields without the ears of corn changing their place.

When the heavy substance descends in the air, and this air moves in a contrary direction in order to fill up continuously the space left by

this heavy substance, the movement of this air is a curve, because when it desires to rise by the shortest line it is prevented by the heavy substance which descends upon it, and so of necessity it is obliged to bend and then to return above this heavy substance and fill up the vacuum that has been left by it. And if it were thus the air would not be compressed beneath the speed of the heavy substance, and this being so the birds would not be able to support themselves upon the air that is struck by them; but it is necessary to say here that the air is compressed beneath that which strikes it and it becomes rarefied above in order to fill up the void left by that which has struck it. F 87 V.

BIRDS IN SLANTING MOVEMENT

The adversary says that if the bird is struck below by the wind this bird will always rise up, and this will not fail to be the case if the bird be flying against the wind. But if the bird and the wind go with equal movement along the same path it must needs be that at every degree of movement made by the wind the bird acquires a degree of descent; we may therefore say that in such time as the wind moves a degree in a horizontal position, a degree to which we may apply a name . . .

The bird that flies in an easterly direction without beating its wings as it crosses the course of the south wind gathers in its right wing and extends its left; and this inequality of wings is according to the ninth of the first which says: the birds that support themselves without beating their wings in the course of the wind, or descend through the motionless air bend their straight movement towards the side where one of the wings is pressed together.

Therefore the bird p flying along the line a f with an equal expansion of wings n b will bend this movement from c f towards d, gathering in the right wing from m to n. G 41 V.

The adversary says that if the movement of the bird be slanting in the course of the wind and made in a position of equality, this bird will be struck by the wind on the side underneath; and the bird which is struck underneath continually rises upward.

Birds always fly low when the course of the wind is contrary to their

path, and this teaches us how the wind is more powerful at a height than low down. Here the adversary says that the wind which strikes the earth suddenly acquires more density than it had at first, and consequently it becomes more powerful and heavier.

When the bird is driven by the wind it proceeds to lower itself continually with a slanting movement; and when it wishes to raise itself again to its former altitude, it turns back with the speed of the impetus it has acquired; and this is consumed against the wind which acts as a wedge and raises it to a greater altitude than it left; from thence it afterwards descends with the slant mentioned before, after which it acts as we said above, and so continually acquiring degrees of altitude it raises itself at last to the spot that it desires. G 42 r.

The bird which without beating its wings descends with a great slant beneath the approach of the wind bends its straight course towards the side where one of its wings is contracted. G 49 v.

OF THE END OF THE FLIGHT OF BIRDS

The end of the flight of birds in certain species is made with a straight and slanting movement and in others it is made with a curved slanting movement. But in the case of that which is made with a straight slant it is necessary that this movement should slant very considerably, that is that the slant is almost horizontal as is shown in *m n* [diagram].

And if the movement of these birds drops very much then of necessity this is intermingled with many reflections, and especially toward the end as will be shown in its place.

OF THE END OF THE FLIGHT THAT IS MADE UPWARDS FROM BELOW

When it is near the end [of its flight] the bird makes itself slant only a little in its length, and opens its wings and its tail very widely, but the wings reach this end with frequent tiny beats in the course of which the impetus is consumed, and so as they contract it remains for a very brief space above the spot where it finally settles with a very slight percussion of its feet.

Bats when they fly have of necessity their wings covered completely with a membrane, because the creatures of the night on which they feed seek to escape by means of confused revolutions and this confusion is enhanced by their various twists and turns. As to the bats it is necessary sometimes that they follow their prey upside down, sometimes in a slanting position, and so in various different ways, which they could not do without causing their own destruction if their wings were of feathers that let the air pass through them. G 63 v.

OF THE COMMENCEMENT OF BIRDS' FLIGHT

When birds wish to commence their flight it is necessary for them to do so in one of two ways, one of which commences by lowering themselves with their body to the ground and then making a leap in the air by extending very rapidly their folded legs.

At the close of this leap the wings have completed their extension and the bird immediately lowers them swiftly towards the ground and reascends the second stage which is slanting like the first; and thus continuing in succession it rises to whatsoever height it pleases. Some others first raise their wings to slant forward and lower themselves as far as they can with their breasts on the ground, and in this position they extend their legs very rapidly leaping up and slanting forward, and then at the end of the effort they drop their wings so that they are slanting downwards and backwards. Thus they find themselves considerably above and in front of the place from which they set out and at the end of the effort they are in another; and so their movement continues.

There are other birds which after having lowered themselves to the ground and having their wings extended high and forwards, lower the wings and extend the legs at the same time, and thus the power produced by the first beating of the wings allied to the power acquired by extending the legs becomes very great, and this power united is the greatest that it is possible to create for the beginnings of the flights of these birds.

The second method employed by birds at the commencement of their flight is when they are descending from a height: they merely throw themselves forward and at the same time spread their wings

high and forwards and then in the course of the leap lower their wings downwards and backwards, and so using them as oars continue their slanting descent.

Others have the habit of throwing themselves forward with wings closed and then opening the wings as they descend, and having opened them are stopped by the resistance of the air, and then close them and fall again.　　　　　　　　　　　　　　　　　　　　　　G 64 r.

THE FLIGHT OF THE FOURTH SPECIES OF BUTTERFLIES THE DEVOURERS OF THE WINGED ANTS

The butterflies with four equal and separated wings (ant lions) always fly with the tail high using it as a rudder for any sort of movement. That is that if one of these insects wishes to descend it lowers its tail and if it wishes to ascend it raises its tail, and if it wishes to turn to the right or left it bends its tail to the right or left and the same with all sorts of angles of movement which lie between the said four principal movements. And this is the largest butterfly of the aforesaid species, black and yellow in colour.

It uses its four wings in short wheeling flights when it wishes to prey on the small winged ants, moving sometimes the right forward and the left backward and sometimes the left forward and the right backward because the rudder formed by the tail is not sufficient to regulate the speed of its movement.

OF THE THREE CHIEF POSITIONS WHICH THE WINGS OF BIRDS ASSUME AS THEY DESCEND

Of the three chief positions which the wings of birds assume as they descend slantwise without beating their wings, the first is *a b c* in which the wings have their extremities of equal height and so also the opposite angles of the tail, whence their movement will descend by the slant *a d*. The second arrangement will be *a e f*, in which the extremities of the wings and the angles of the tail are of different heights, the left wing being higher, and its slanting movement being *a g*. The third arrangement of the slant of the same wings is the converse of the second, for in it the left wing is lower than the right; and its movement is at *a o*, and the position of the wings is *n m*.　　　G 64 v.

A SCREEN TO PREVENT THE WIND FROM TURNING THE BIRD UPSIDE DOWN

I have seen the bird turned upside down by the wind on its left when it entered above the wind with its left wing.

In the case of all the birds that fly high as they raise their wings they remain perforated, as is shown in its place. And as the wings descend they remain united; so as the compressed and condensed air does not yield place to the descent of the wings with the same speed as the wing, it becomes necessary for the bird to have the reflex of such percussion, by which it rises and is carried to a height, by the impetus acquired, through as great a span of height as the impetus of the reflex has of life. And in this time the wings reopen and become perforated with the spaces interposed between the said feathers, then the bird lowers its wings again violently as it closes up its feathers, and so acquires anew the impetus that it had lost. And in this way all the birds act which rise in straight movement such as the lark and the like. And those birds which do not possess such a wide expanse of feathers such as birds of prey, it is necessary for them to raise themselves by turning round, that is in the form of a screw or otherwise in circular movement.

The butterfly and many similar insects all fly with four wings having those behind smaller than those in front. Those in front form a partial covering to those behind, and all the insects of this class possess the power to rise with straight movement, for as they raise themselves on these wings they remain perforated because they keep the front wings much higher than those behind. And this continues almost to the end of that impulse which urges them upwards, and then as they lower their wings the larger become joined to the lesser, and so as they descend they again acquire a fresh impulse.

There are also other kinds of flying insects which fly with four wings equal, but these do not cover each other in their descent any more than in their rise; and those of this kind cannot rise with straight movement. G 65 r.

OF PERCUSSION—FLIGHT OF MAN

Of the things that fall in the air from the same height, that will produce less percussion which descends by the longer route: it follows that that which descends by the shorter route will produce more percussion.

This first movable thing formed of paper slightly curved has its first descent with the front *b* and moves from *a* to *c*, in which movement *a* descends farther than *b*; consequently *a* at the end of the reflex movement finds itself at *c*, and *b* is raised to *d*. And this is proved by the ninth of this which says:—the thing that strikes the air with a greater part of itself has less power to penetrate this air. And by the tenth:—that thing is swifter in penetrating the air which strikes it with less breadth. And by the eleventh:—the heaviest part of a body that moves through the air becomes the guide of the movement of this body.

This may be proved:—let *a b* be the heavy substance, which, although in itself of uniform thickness and weight, being in a slanting position, has a front that has more weight than any other part of its breadth equal to the front which can serve as its face, and for this reason the front will become the guide of this descent. And by the twelfth:—that air offers most resistance to its moving thing which is most compressed; therefore that face weighs least with its parts which has below it the compressed air. And by the thirteenth:—the air that has the swiftest movement moves most—it follows that the man can descend as is shown below.

This [man] will move on the right side if he bends the right arm and extends the left arm; and he will then move from right to left by changing the position of the arms. G 74 r.

GRAVITY

Every slanting movement made by a heavy substance through the air divides the gravity of the movable thing in two different aspects, one of which is directed to the place towards which it moves and the other to the cause that restrains it. G 74 v.

[*Of the wings of the fly*]

The lower wings are more slanting than those above, both as to length and as to breadth.

The fly when it hovers in the air upon its wings beats its wings with great speed and din, raising them from the horizontal position up as high as the wing is long. And as it raises them it brings them forward in a slanting position in such a way as almost to strike the air edgewise; and as it lowers them it strikes the air and so would rise somewhat if it were not that the creature threw its weight in the opposite direction by means of its slant. As though the slant of the fly when stationary in the air was along the line *e f*, and the slant of the movement of the wings between the straight up and the straight down position followed the lines *a b, c d* which intersect with the line of the descent *e f* between right angles, in such movement that the power of the descent by the slant *e f* is equal to the power that it has to raise itself by the slant of the movement of the wings by the slant *d b c a*.

And the back legs serve it as a rudder, and when it wishes to fly it lowers its wings as much as possible. G 92 r.

The ascent[1] of birds or their rebound near to any object will never extend as far as the descent or will not exceed it. H 33 v.

The bird rises to a height in a straight line without beating its wings when the reflex movement of the wind strikes it from underneath.

I have divided the Treatise on Birds into four books; of which the first treats of their flight by beating their wings; the second of flight without beating the wings and with the help of the wind; the third of flight in general, such as that of birds, bats, fishes, animals and insects; the last of the mechanism of this movement. K 3 r.

If one of the wings is lowered rapidly and then folded, the bird drops a little on that side; and if it is lowered rapidly and extended the bird drops on the opposite side; and if it is lowered slowly and extended the bird moves in a circle round this wing, falling as it proceeds; and if it is lowered slowly and with hesitation and folded up the bird then descends in curves on that side. K 4 r. and 3 v.

All birds driven by the water or by the wind keep their heads in the

[1] MS. calare.

direction from whence the water or the wind is coming. They do this in order to prevent the wind or the water penetrating up from the extremities to the roots of the feathers, so that each of the feathers may be pressed against one another, and thus they may remain drier and warmer. 						K 3 v.

When the bird lowers one of its wings necessity constrains it instantly to extend it, for if it did not do so it would turn right over. The bird when it wishes to turn does not beat its wings with equal movement, but moves the one which makes the convex of the circle it describes more than that which makes the concave of the circle.

K 4 v.

If the rudder or tail of the bird is beneath the wind the bird will be pulled down by the wind from its middle backwards, and turned with its front towards the wind.

And if the bird is struck on the slant of its tail above the wind it will be pulled down in front and turn towards the wind. 		K 5 r.

The bird often beats twice with one wing and once with the other and it does this when it has got too far over to that side.

It also does the same when it wishes to turn on one side; it takes two strokes with one wing backwards, keeping the opposite wing almost stationary pointing towards the spot to which it ought to turn.

K 5 v.

The helms of the wings are used when the bird is struck from behind by the wind and rests slantwise upon the air that supports it: the bird is then struck by the wind in the front of these helms and so is driven upwards, its reflex movement being increased by the movement of the wind. 						K 6 r.

If the extent of the slant of the tail from the centre of the bird backwards is more than that of the wing from the centre of the bird forwards the bird will turn to face the wind. But if the slanting part of the wing is greater in extent than that of the tail then the tail will turn towards the approach of the wind. 				K 6 v.

The bird beats its wings repeatedly on one side only when it wishes to turn round while one wing is held stationary; and this it does by

taking a stroke with the wing in the direction of the tail, like a man rowing in a boat with two oars, who takes many strokes on that side from which he wishes to escape, and keeps the other oar fixed.

<div align="right">K 7 r.</div>

Of the flexion of the tip of the wing even when the wing does not beat.

The helms which are on the shoulders of the wings are necessary when the bird in its flight without beating its wings wishes to maintain itself in part of a tract of air, upon which it is either slipping down or rising, and when it wishes to bend either upwards or downwards or to right or left. It then uses these helms in this manner:—if the bird wishes to rise it spreads the helm in the opposite direction to the way the wind strikes it; and if to descend it spreads the top part of the helm slanting to the course of the wind. If it turns to the right it spreads the right helm to the wind, and if it turns to the left it spreads the left helm to the wind.

<div align="right">K 7 v.</div>

The helm of the wing is used by the bird when in flying it supports itself upon its wings raised so that by their vibration they prevent it from descending; and in addition to this these helms or fingers show themselves fronting the air down which the slant of the bird is gliding, and by thus striking upon it with these helms it resists it as it glides.

That bird descends most rapidly which has the least distance between the extremities of the tips of its wings.

<div align="right">K 8 r.</div>

The birds which seek to penetrate within the approaching wind are in the habit of fluttering to the right and to the left, like sailors tacking against the direction of the winds; and this they do in order not to make a long descent, for if the bird did not guard against descending for any great distance, it would be driven right against the current of the wind; and, entering under the wind slanting lengthwise, it will present so much of its weight by this line as to subdue the resistance of the wind.

<div align="right">K 8 v.</div>

The 'hands' of the bird show themselves in front, close to the spot where it descends by a straight slant in order to consume the impetus it has acquired.

By beating its wings in order to support itself at a height and to advance from the 'hand' behind, it supports itself at the height and the 'hand' causes it to make progress. K 9 r.

When the bird is carried along by the wind and wishes to turn quickly towards it, it will then enter beneath the wind with the wing turned towards it; and then with the feathers of the tail turned towards the wind, it will enter upon it, and so by the help of the wind striking upon its tail it turns much more rapidly. K 9 v.

The wing bends so much the more in proportion as the bird is swifter in the same space of time.

What difference there is between the tips of the wings of birds which bend and those which do not, and whether to bend up and down thus is necessary for the flight of these birds or no, since one sees that however slightly these tips are cut the bird's power of flight is almost stopped. K 10 r.

When the bird rises up by the assistance of the wind without beating its wings, it spreads out and raises its wings so that they form an arch with the concave side towards the sky, and it receives the wind under its wings continually, in its movement to and fro, and this would cause it to turn right over if it were not that the point of its tail is turned to the wind as it enters beneath the wind; and this afterwards by its power of resistance acts to prevent the said movement of turning over, because the wings are restrained by the tail in such a way that their various parts are of equal power, and so the tail becomes partly lowered and the bird is raised forward slightly. K 10 v.

Always the wind that strikes the tail is farther removed from the centre and more powerful than that of the wing.

What has been set forth before is here proved. I say that if the wing be in such a position in relation to the tail that the amount of the wind $a\ b$ which strikes the wing $m\ o$ is equal to the amount of the wind $b\ c$ which strikes the tail above at $o\ n$, the bird will not turn, but will be carried in the line of the course of the wind. But if the wind that strikes the tail above is more powerful than the wind that strikes beneath the wing, then the tail will move away and will be dominated by the power of the wind, and the wing will turn to the wind which will be more

powerful than it was before, because the movement that the wing makes against the wind increases in speed and power, and so the wind entering beneath it forms a wedge there and raises and turns it.

<div align="right">K 11 r.</div>

When the bird wishes to ascend it drives the centre of its gravity behind the centre of its wings, and it does this in order to be in a slanting position. It is of the nature of an equable wind to straighten all the uneven parts of the bird, placing it with its extremities equidistant from the centre of its bulk, this being understood of such as support themselves without beating their wings in the air by the help of the wind; and consequently it makes first a circling movement and then a straight movement.

<div align="right">K 11 v.</div>

When the bird wishes to avoid being turned over by the wind it has two expedients, one of which is to move the wing that was above the wind and place it suddenly below the wind, that is to say the one that was turned to the wind; the other is to lower the opposite wing so that the wind that strikes it on the inside is more powerful than on the wing that faces the wind.

<div align="right">K 12 r.</div>

The bird in its flight without the help of the wind drops half the wing downwards, and thrusts the other half towards the tip backwards; and the part which is moved down prevents the descent of the bird, and that which goes backward drives the bird forward.

When the bird raises its wings it brings their extremities near together; and while lowering them it spreads them farther apart during the first part of the movement, but after this middle stage as they continue to descend it brings them together again.

<div align="right">K 12 v.</div>

The point of the wing of the bird serves to guide it through the air as the point of the oar does through the water or the arm or hand of the swimmer beneath the water. But here arises a doubt as to whether, if for instance the bird be travelling along the line $f\,a$ and the wing or rather the point move backward moving from a to f, it makes its path by $a\,b\,f$, driving the bird forward, and returns towards a by the path above $f\,c\,a$, or whether it really acts as the hand of the swimmer does under the water which forces itself back by the line above $a\,c\,f$ and returns by $f\,b\,a$.

<div align="right">K 13 r.</div>

When the bird is borne along by the help of the north wind, and moves with it to the south, it keeps one wing fixed to the north-east, a little above the wind, and lowers the wing that is to the south-west and makes it serve as a cover to the wind by receiving there beneath it the percussion of the wind slantwise. It seldom beats this wing but it is entirely by means of it that it maintains its equilibrium, whether the wind be greater or less.

When the bird ascends by reflex movement against the wind, if it did not turn round on its lower wing it would by this reflex movement turn back with its breast to the wind, and this wind would over-throw it.

And ascending by reflex movement with its spine to the wind it would turn back with its spine below the wind. K 13 v.

The thrushes and the other birds fly readily against the wind.

When the bird wishes to let itself fall on one of its sides it throws its wing down rapidly on the side on which it wishes to descend, and the impetus of this movement causes the bird to drop on this side.

When the north wind blows and the bird is carried by the wind and wishes to return facing the wind, it drives the wing downwards and turns and enters with its spine beneath the wind. K 14 r.

A bird beats its wings frequently as it settles when it has descended from a height, in order to break the impetus of the descent, to settle itself on the ground and to diminish the force of the impact.

K 58 [9] r.

When birds ascend by wheeling round with the wind they keep their wings very high so that the wedge of the wind and of the impetus may raise them.

When they move in a downward direction they lower their wings for two reasons; the first is because less air sustains them, the other because the wind serves as a wedge above them and drives them down and continually lowers them. K 58 [9] v.

Many are the times when the bird beats the corners of its tail in order to steer itself, and in this action the wings are used sometimes very little, sometimes not at all. K 59 [10] r.

When the kite rises or sinks without beating its wings, it holds them slanting, and keeps the tail slanting in the same way but not to the same extent, for if this were so the bird would fall to the ground by the line of the slant of the wings and of the tail; but as this tail is away from the centre of the bird's length it meets with somewhat more resistance than the wings, and this in consequence checks its movement, and so the tail has less movement than the wings. Necessity causes the bird to move with a circular motion, and as the tail is less slanting so in proportion the circles are less in diameter, and so also conversely.

<div align="right">K 59 [10] v. and 60 [11] r.</div>

When the bird flies along a level line it seems that the nearer it approaches the eye the more it rises.
[Diagram]
Let g h be the level line and let the bird be moving along g c s, and let n be the eye. I say that as the images of the bird rise in every stage of its movement in every stage of height in the pupil it seems to the eye that this bird is rising. K 121 [41] v.

And if the bird flies along a level line separating itself from the eye it will seem to be descending stage by stage with the stages of its movement. K 121 [41] r.

The slanting movement made by the descent of birds commences with the wings straight and low. Gradually they stretch out their wings in order to consume the access of impetus which heavy bodies acquire at each stage of their descent. And when such a movement is retarded by the too great expansion of wings then this bird again contracts its wings and so again the descent commences to become swift.
[Drawing]
Route made through the air by flying things which descend, with their expansion and contraction of wings. L 54 r.

[Slanting flight of birds]
When the bird descends by any slant whatever it brings the humerus of the wings near to its shoulders and draws together the points of the wings towards the tail, and this tail is also drawn together into itself and by so doing it meets with a less volume of air to resist its descent.
But when this bird wishes to turn to the right or to the left it will

extend its right or left wing, that is to say the wing that is on the side on which it wishes to turn. This extended wing finds a greater volume of air and in consequence comes to meet with a greater resistance, with result that it slackens its pace more than the opposite wing does which is more contracted, and as the one wing moves more than the other the bird transforms its straight movement into a circling movement; but if the wing which is more contracted towards the bird's body than the other cannot expand with that ease which the bird requires, then it spreads out its tail and twists it thus open towards the side where this wing is contracted. This bird will then fly in a straight movement and so as you see it will leave the circular movement.

There are two helms on the humerus of the wings of each bird, and these without making any change of wings have power to cause the birds various movements between ascending and descending; it is only in the transversal movements that the helm of the tail takes part.

<div align="right">L 54 v. and 55 r.</div>

[The flight of birds with the wind]

The movement of things that fly is much swifter than that of the wind. For if it were not so no bird would move against the wind. But its movement against the wind is as much less than its natural course within the still air as the degrees of movement of the wind are less than that of the bird.

Let us say the bird moves in the still air at a speed of six degrees and the wind of itself moves at a speed of two degrees, then this wind following its natural course takes away two degrees of speed from this bird and consequently of the six degrees there remain four.

But if such bird were to fly at six degrees of speed together with the course of the wind which imparts to it its two degrees, this bird would be flying at eight degrees of speed. Here however one should observe how the wing is supported in its percussion in the motionless air, the retreating air or the air that follows after it, and guide one's self according to these rules.

<div align="right">L 55 v.</div>

[Flight of birds—the lark]

When the bird finds itself upside down, as is seen at *a*, the tips of the wings are driven towards the ground as is shown at *b*; and then

this flying thing will straighten itself in its first position, but it bends the tail spread out towards its spine.

And if it falls edgewise it will raise its wings towards its spine and then straighten itself.

There are many varieties of birds which can only raise themselves spirally, that is by revolving movements; the lark is an exception because as it raises its wings it proceeds to transpierce them with air in such a way that they offer no resistance being almost entirely transpierced.

When the bird wishes to go down it throws its wings backward in such a way that the centre of their gravity comes away from the middle of the resistance of the wings and so it comes to fall forward.

L 56 r.

The flight of many birds is swifter than is the wind which drives them. And this arises from driving the wings in the wind which carries this bird. If it were not so the birds that rest upon the wind would not be able to fly against the wind.

The bird in raising its wings sends them partly forward and partly upward, and the whole wing comes to go edgewise, and each feather of itself, and in addition to this it remains transpierced; and as it proceeds downward it thrusts it back in face of the air or of the wind and the transpiercing of the feathers and of the whole wing become united. L 56 v.

[*With drawings*]

The manner of resistance of the feathers as the bird drops down.

The resisting *a b* as it is flexible is bent by the line of any movement of air, and there will be the same result with paper protected as with ribs by the stems of the reeds. L 57 r.

[*Wings of birds*]

The bird which is swifter in lowering than in raising its wings is that which raises itself more by pressing the underpart of the wings towards the centre of the earth.

But if they press this underpart of the wings towards the horizon they will make equal movements.

[Drawing]

You will note if the feathers of *c a* are placed above in the manner and order of *a b*.

A b n m is the position of the shutters (sportelli). L 58 r.

The opening and lowering of the tail and the spreading out of the wings at the same time to their full extent, arrests the swift movement of birds.

When birds in descending are near to the ground, and the head is below the tail, they then lower the tail, which is spread wide open, and take short strokes with the wings; and consequently the head becomes higher than the tail, and the speed is checked to such an extent that the bird alights on the ground without any shock.

In all the changes which birds make in their lines of movement they spread out their tails.

There are many birds which move their wings as swiftly when they raise them as when they let them fall: such as magpies and birds like these. L 58 v.

There are some birds which are in the habit of moving their wings more swiftly when they lower them than when they raise them, and this is seen to be the case with doves and such like birds.

There are others which lower their wings more slowly than they raise them, and this is seen with rooks and other birds like these.

The birds which fly swiftly, keeping at the same distance above the ground, are in the habit of beating their wings downwards and behind them, downwards to the extent necessary to prevent the bird from descending, and behind when they wish to advance with greater speed.

The speed of birds is checked by the opening and spreading out of the tail. L 59 v.

When the slant of the flying thing is struck by the wind in its lower part this flying thing will rise upwards.

But when this slant is struck in its upper part this flying thing will be constrained to descend from its height.

But if the wind which strikes the said birds in the part below were to overturn them the flying thing will then contract its wings some-what, with result that it will descend by its heaviest part. L 60 r.

When the kite in descending turns itself right over and pierces the air head downwards, it is forced to bend the tail as far as it can in the opposite direction to that which it desires to follow; and then again bending the tail swiftly, according to the direction in which it wishes to turn, the change in the bird's course corresponds to the turn of the tail, like the rudder of a ship which when turned turns the ship, but in the opposite direction.

When the wind is about to throw the bird backward the bird draws together the shoulders of its wings, so that its weight is massed more to the front than it was at first, and consequently the part that is heaviest is first in its descent, while in addition the tail is spread out and bent down. L 62 r.

[Tail and wings of birds]

When one of the sides of the tail of the flying body is lowered with a swift movement, then the air where it strikes is more compressed and as a consequence offers more resistance, whence of necessity the bird bends with its opposite side, and so the movement of this bird is curved circling round the part of the tail which is lower.

But when it is sometimes the one and sometimes the other point of the tail which impels it to lower itself sometimes to the right and sometimes to the left, it does not make a circling movement but it is merely a way of striking the air as wings would do. When this bird feels itself dropping on one of the sides this tail beats the air on the opposite side and in this way it resists this tendency. L 62 v.

[A goose swimming and flight]

OF MOVEMENT

Swimming illustrates the method of flying and shows that the weight which is largest finds most resistance in the air. Observe a goose's foot: if it was always open or closed in the same manner the creature would not be able to make any kind of movement. It is true that the curve of the foot outwards would have more perception of the water in going forward than the foot would have as it was drawn back; this shows that with the same weight the wider it is the slower its movement becomes.

Observe the goose moving through the water, how as it moves its foot forward it closes it and covers but little water and consequently acquires speed, and as it draws it back it spreads it out and so makes itself slower, and then the part that has contact with the air becomes swifter. M 83 r.

When one wing bends with the same speed as the other but with a longer movement it will cause the straight movement to bend to a curve. B.M. 43 r.

CONCERNING THINGS THAT CAN FLY

In the case of every heavy thing descending freely the heaviest part will become the guide of its movement. B.M. 96 r.

[Drawing—bird with wings extended]
This raises itself in circles by means of the wind. This creature is always struck below by the wind by a slanting line; and when this wind strikes it in front it bends its wings with its shoulders towards the sky; and when the wind catches it in the tail it bends its shoulders towards the ground. And so always this bird takes the wind at its centre of gravity in front or behind or at the side. B.M. 134 r.

The tail adds or takes away the weight from the wings of the bird.
Every heavy substance moves by the line where it has least resistance.
The heavy substance finds least resistance by the line in which it weighs most. B.M. 146 r.

That bird will raise itself in flight more readily which gets the impetus of its movement by dropping somewhat at the beginning of its flight.
When a bird flies against the wind it is necessary that the progress which it makes against the wind should be made in a slanting line towards the earth, entering underneath the wind. And this because its weight is more powerful than that of the amount of wind which strikes it at unequal angles, and would wish to press it down towards the ground if it were not that the air which is in front in the line of its movement is far less in amount than the air which happens to be below it and which touches it. This movement alone suffices to subdue that

air which offers less resistance, and that will offer less resistance which is less in quantity.

Therefore from what has been stated we are certain that the bird will move itself against that part of the air which offers less resistance and which meets the helms of the wings, rather than against that which meets it from below along the whole extent of these wings.

Rectilinear movement

But when this bird wishes to rise to a height it will enter above the wind, and it will retain enough of the impetus it has acquired in the descent we have spoken of, so that by means of the speed thus gained it will lower its tail and likewise the elbows of its wings and will raise up its helms. It will then be above the wind, and as this impetus is constrained neither to cease nor to be consumed its nature forthwith compels it to follow along the line where the least amount of air impedes its movement, which will be in that line in which the wings show themselves edgewise to the air where they strike, that is along the line where the air as it is met is always divided by the helms which are in the thickness of the wings and never along the line of their width.

After having done this then the bird rises up without beating its wings, for the wind which passes underneath it raises it up as a wedge raises a weight, and for this reason would cause it to turn backwards, if it were not that in this act of rising it is continually becoming slower and consuming the impetus already acquired. And after this impulse has been consumed the bird would be overturned by the wind which has carried it up to a height if it did not immediately lower the helms of the shoulders of the wings, enter underneath the wind and lower its tail. Then the movement which has just ended commences anew, and as it drops it acquires again the impetus which it has lost, with which it again rises up to a height with reflex movement until it again loses the impetus that it has acquired.

If however such movement were circular then the bird would follow other rules which will subsequently be defined in due order.

<div align="right">B.M. 166 V.</div>

FLIGHT

OF THE BIRD THAT MOVES WITHOUT WIND OR BEATING OF WINGS

The movement of a bird without beating of wings or help of wind is along a line that slants steeply downwards and then rises with a reflex movement. By this reflex movement it raises itself seven eighths of the height of its falling movement and it goes on doing this little by little until it reaches the ground.

OF THE MOVEMENT AGAINST THE WIND WITHOUT BEATING OF WINGS WHICH RAISES THE BIRD

Here the falling movement is below the wind and the reflex movement will be above the wind. B.M. 277 r.

[*Diagram wing* $\begin{smallmatrix} b & d & f \\ a & c & e \end{smallmatrix} g$]

I find in the wings of birds three causes of power, of which the first is b which derives its strength from the muscle a; the second may be $d\ c$; the third may be $f\ e$; now I ask: if the part g produces its force by means of $f\ e$ what force penetrates to $b\ a$, or to put it more exactly what weight? Forster II 34 v.

The reflex movement made by the bird against the course of the wind becomes considerably greater than its falling movement; and it is the same with the succeeding reflex movement because it is driven by the same course of the wind. Quaderni II, 16 r.

XVIII

Flying Machine

'I find that if this instrument made with a screw
be well made—that is to say, made of linen of
which the pores are stopped up with starch—and
be turned swiftly, the said screw will make its
spiral in the air and it will rise high.'

THE man in the bird rests on an axis a little higher than his centre
of gravity. C.A. 129 V. a

A bird is an instrument working according to mathematical law,
which instrument it is within the capacity of man to reproduce with all
its movements, but not with a corresponding degree of strength,
though it is deficient only in the power of maintaining equilibrium.
We may therefore say that such an instrument constructed by man is
lacking in nothing except the life of the bird, and this life must needs
be supplied from that of man.

The life which resides in the bird's members will without doubt
better conform to their needs than will that of man which is sepa-
rated from them, and especially in the almost imperceptible move-
ments which preserve equilibrium. But since we see that the bird is
equipped for many obvious varieties of movements, we are able from
this experience to declare that the most rudimentary of these move-
ments will be capable of being comprehended by man's understanding;
and that he will to a great extent be able to provide against the destruc-
tion of that instrument of which he has himself become the living
principle and the propeller. C.A. 161 r. a

[*Diagrams of mechanism of flying machine*]

I conclude that the upright position is more useful than face down-
wards, because the instrument cannot get overturned, and on the other
hand the habit of long custom requires this.

And the raising and lowering movement will proceed from the lowering and raising of the two legs, and this is of great strength and the hands remain free; whereas if it were face downwards it would be very difficult for the legs to maintain themselves in the fastenings of the thighs.

And in resting the first impact comes upon the feet, and in rising they touch at *r S t*; and after these have been raised they support the machine, and the feet moving up and down lift these feet from the ground.

Q is fastened to the girdle; the feet rest in the stirrups *K h*; *m n* come beneath the arms behind the shoulders; *o* represents the position of the head; the wing in order to rise and fall revolves and folds . . . the same. C.A. 276 v. b

[*With drawings of parts of flying machine*]
Spring of horn or of steel fastened upon wood of willow encased in reed.

The impetus maintains the birds in their flying course during such time as the wings do not press the air, and they even rise upwards.

If the man weighs two hundred pounds and is at *n* and raises the wing with his block, which is a hundred and fifty pounds, when he was above the instrument, with power amounting to three hundred pounds he would raise himself with two wings. C.A. 307 r. b

[*Drawing of wing of flying machine*]

5 Spring with lock *n o* is a wire that holds the spring, and it is not straight. Spring of wing.

6 The spring *b* should be strong, and the spring *a* feeble and bendable, so that it may easily be made to meet the spring *b*, and between *a b* let there be a small piece of leather, so that it is strong, and these springs should be of ox-horn, and to make the model you will make it with quills.

1 Let *a* be the first movement.

2 Undo one and remove. . . .

3 Double canes . . . soaped. . . .

4 of rag or [skin] of flying fish.

7 Take instead of the spring filings of thin and tempered steel, and

these filings will be of uniform thickness and length between the ties, and you will have the springs equal in strength and power of resistance if the filings in each are equal in number. c.a. 308 r. a

[*Drawing of wing of flying machine*]
 Net. Cane. Paper.
 Try first with sheets from the Chancery.
 Board of fir lashed in below.
 Fustian. Taffeta. Thread. Paper. c.a. 309 v. b

[*Drawing of wing of flying machine*]
 For Gianni Antonio di Ma[. . .]olo, (Mariolo).
 Not to be made with shutters but united.[1] c.a. 311 v. d

THE NATURE OF THE STAFF WHEN UNTIED AND ITS CORD

The cord should be of oxhide well greased, and the joints also where the play is, or they should be soaped with fine soap.

The staff should be of stout cane or it may be of various different pieces of cane, and of any length you choose since you make it in pieces. The springs should be made with bands of iron between the joints of each spring, uniform in thickness, number and length, so that they may all bend at the same time and not first one and then the other; and each spring should of itself have many of these bands of iron, of which it is made up. But if you prefer not to use bands of iron take strips of cow's horn to make these springs. c.a. 308 v. a

[*With drawing of wing of flying machine*]
It requires less effort to raise the wing than to lower it, for as it is being raised the weight of the centre which desires to drop assists it considerably. c.a. 317 v. a

To-morrow morning on the second day of January 1496 I will make the thong and the attempt.

[*Drawing—apparently of strip of leather stretched on frame*]
To make the paste, strong vinegar, in which dissolve fish-glue, and

[1] Note referring probably to the construction of a machine for flight as a commission for a patron, Gian Antonio di Mariolo, who desired that the wings should be so made that they could not be penetrated by the wind.

with this glue make the paste, and attach your leather and it will be good.[1] c.a. 318 v. a

[*With drawing of flying machine*]
The foundation of the movement. c.a. 314 r. b

[*Various diagrams in which figure of man is seen exerting force with arms and legs*]

Make it so that the man is held firm above, *a b*, so that he will not be able to go up or down, and will exert his natural force with his arms and the same with his legs.

Close up with boards the large room above, and make the model large and high, and you will have space upon the roof above, and it will be more suitable in all respects than the Piazza d'Italia.

And if you stand upon the roof at the side of the tower the men at work upon the cupola will not see you.

a b produces force estimated at three hundred, and the arms at two hundred, which makes five hundred, with great speed of

The lever one braccio and the movement a half, the counter-lever eight braccia, and for the weight of the man I will say four, so that it comes to three hundred with the instrument.[2] c.a. 361 v. b

There is as much pressure exerted by a substance against the air as by the air against the substance.

Observe how the beating of its wings against the air suffices to bear up the weight of the eagle in the highly rarefied air which borders on the fiery element! Observe also how the air moving over the sea, beaten back by the bellying sails, causes the heavily laden ship to glide onwards!

[1] The words (soatta) 'thong' and (corame) 'leather' seem to point to the probability that these two sentences refer to the construction and trial of the same instrument, probably a flying machine.

[2] On the same page of the manuscript Leonardo has drawn a rough map of Europe with names of provinces inserted. Below this the Iberian peninsula is repeated with lists of provinces arranged under the three heads:—Spain, France and Germany. It is not perhaps entirely fantastic to suppose that these maps and lists of provinces, occurring on the same sheet as the foregoing memoranda of the construction of an instrument for flight, may have been connected in his mind with possibilities of travel that the invention of flying would open up and that the sketches were in intention aviators' maps. The reference to the roof at the side of the tower as being out of sight of the men working upon the cupola shows that the model was being made in a house not far from the Cathedral.

So that by adducing and expounding the reasons of these things you may be able to realise that man when he has great wings attached to him, by exerting his strength against the resistance of the air and conquering it, is enabled to subdue it and to raise himself upon it.

[*Sketch—man with parachute*]

If a man have a tent made of linen of which the apertures have all been stopped up, and it be twelve braccia across and twelve in depth, he will be able to throw himself down from any great height without sustaining any injury.

[*With drawing of pair of balances in one of which the figure of a man is seen raising a wing*]

And if you wish to ascertain what weight will support this wing place yourself upon one side of a pair of balances and on the other place a corresponding weight so that the two scales are level in the air; then if you fasten yourself to the lever where the wing is and cut the rope which keeps it up you will see it suddenly fall; and if it required two units of time to fall of itself you will cause it to fall in one by taking hold of the lever with your hands; and you lend so much weight to the opposite arm of the balance that the two become equal in respect of that force; and whatever is the weight of the other balance so much will support the wing as it flies; and so much the more as it presses the air more vigorously. c.a. 381 v. a

[*With drawings*]

a b c causes the part *m n* to raise itself up quickly in the rising movement, *d e f* causes *m n* to descend rapidly in the falling movement, and so the wing performs its function.

r t lowers the wing by means of the foot, that is by stretching out the legs, *v s* raises the wing by the hand and turns it.

The way to cause the wing to turn just as it rises or descends.

Device which causes the wing as it rises to be all pierced through and as it falls to be united. And this is due to the fact that as it rises *b* separates from *a* and *d* from *c* and so the air gives place to the rising of the wing, and as it falls *b* returns to *a* and similarly *c* to *d*; and the net bound to the canes above makes a good protection, but take care

that your direction be from *a* to *f* so that the landing[1] does not find any obstacle. B 73 v.

[With drawings: section of wing]

Device so that when the wing rises up it remains pierced through and when it falls it is all united. And in order to see this it must be looked at from below.

[Sketch of wing]

Make the meshes of this net one eighth wide.

A should be of immature fir wood, light and possessing its bark.

B should be fustian pasted there with a feather to prevent it from coming off easily.

C should be starched taffeta, and as a test use thin pasteboard.

 B 74 r.

With drawing of flying machine

a twists the wing, *b* turns it with a lever, *c* lowers it, *d* raises it up, and the man who controls the machine has his feet at *f d*; the foot *f* lowers the wings, and the foot *d* raises them.

The pivot *M* should have its centre of gravity out of the perpendicular so that the wings as they fall down also fall towards the man's feet; for it is this that causes the bird to move forward.

This machine should be tried over a lake, and you should carry a long wineskin as a girdle so that in case you fall you will not be drowned.

It is also necessary that the action of lowering the wings should be done by the force of the two feet at the same time, so that you can regulate the movement and preserve your equilibrium by lowering one wing more rapidly than the other according to need, as you may see done by the kite and other birds. Also the downward movement of both the feet produces twice as much power as that of one: it is true that the movement is proportionately slower.

The raising is by the force of a spring or if you wish by the hand, or by drawing the feet towards you, and this is best for then you will have the hands more free. B 74 v.

[1] MS. has 'lariua'.

[*With drawing*]

The manner of the rods of the wings.

How one ought to have the canes strengthened and able to bend by means of joints. B 77 v.

[*With drawing—figure of man lying face downwards working machine*]

This can be made with one pair of wings and also with two.

If you should wish to make it with one, the arms will raise it by means of a windlass, and two vigorous kicks with the heels will lower it, and this will be useful.

And if you wish to make it with two pairs, when one leg is extended it will lower one pair of wings and at the same time the windlass worked by the hands will raise the others, helping also considerably those that fall, and by turning the hands first to the right and then to the left you will help first the one and then the other. This instrument resembles the large one on the opposite page (B 80 r.) except that in this the traction is twisted on the wheel *M* and goes to the feet.

In place of the feet you should make a ladder in three parts of three poles of fir, light and slender, as is represented here in front, and it should be ten braccia in length. B 79 r.

[*With drawing—figure of man lying face downwards working machine*]

Under the body between the pit and the fork of the throat should be a chamois skin and put it there with the head and the feet.

Hold a windlass with the hands and with feet and hands together you will exert a force equal to four hundred pounds, and it will be as rapid as the movement of the heels. B 79 v.

[*With drawing—figure of man in vertical position working machine*]

This man exerts with his head a force that is equal to two hundred pounds, and with his hands a force of two hundred pounds, and this is what the man weighs.

The movement of the wings will be crosswise after the manner of the gait of the horse.

So for this reason I maintain that this method is better than any other.

Ladder for ascending and descending; let it be twelve braccia high, and let the span of the wings be forty braccia, and their elevation eight braccia, and the body from stern to prow twenty braccia and its height five braccia and let the outside cover be all of cane and cloth. B 80 r.

[With drawing of screw revolving round vertical axis]

Let the outer extremity of the screw be of steel wire as thick as a cord, and from the circumference to the centre let it be eight braccia.

I find that if this instrument made with a screw be well made—that is to say, made of linen of which the pores are stopped up with starch—and be turned swiftly, the said screw will make its spiral in the air and it will rise high.

Take the example of a wide and thin ruler whirled very rapidly in the air, you will see that your arm will be guided by the line of the edge of the said flat surface.

The framework of the above-mentioned linen should be of long stout cane. You may make a small model of pasteboard, of which the axis is formed of fine steel wire, bent by force, and as it is released it will turn the screw. B 83 v.

[With drawing]

If you wish to see a real test of the wings make them of pasteboard covered by net, and make the rods of cane, the wing being at least twenty braccia in length and breadth, and fix it over a plank of a weight of two hundred pounds, and make in the manner represented above [1] a force that is rapid; and if the plank of two hundred pounds is raised up before the wing is lowered the test is satisfactory, but see that the force works rapidly, and if the aforesaid result does not follow do not lose any more time.

If by reason of its nature this wing ought to fall in four spaces of time and you by your mechanism cause it to fall in two the result will be that the plank of two hundred pounds will be raised up.

You know that if you find yourself standing in deep water holding your arms stretched out and then let them fall naturally the arms will proceed to fall as far as the thighs and the man will remain in the first position.

But if you make the arms which would naturally fall in four spaces

[1] In the drawing the figure of a man is seen working a lever.

of time fall in two then know that the man will quit his position and moving violently will take up a fresh position on the surface of the water.

And know that if the above-named plank weighs two hundred pounds a hundred of these will be borne by the man who holds the lever in his hand and a hundred will be carried upon the air by the medium of the wing. B 88 v.

Make the ladders curved to correspond with the body.

When the foot of the ladder *a* touches the ground it cannot give a blow to cause injury to the instrument because it is a cone which buries itself and does not find any obstacle at its point, and this is perfect.

Make trial of the actual machine over the water so that if you fall you do not do yourself any harm.

These hooks that are underneath the feet of the ladder act in the same way as when one jumps on the points of one's toes for then one is not stunned as is the person who jumps upon his heels.

This is the procedure when you wish to rise from an open plain: these ladders serve the same purpose as the legs and you can beat the wings while it is rising. Observe the swift, how when it has settled itself upon the ground it cannot rise flying because its legs are short. But when you have raised yourself, draw up the ladders as I show in the second figure above. B 89 r.

[*Artificial wings*]

In constructing wings one should make one cord to bear the strain and a looser one in the same position so that if the one breaks under the strain the other is in position to serve the same function. H 29 v.

[*Artificial wings*]

SHUTTERS IN FLYING MACHINES

The smaller these shutters the more useful are they.

And they will be protected by a framework of cane upon which is drawn a piece of gauze and as it slants upward the movement of the

whole is transversal, and such lines of shutters come to open by a slant-
ing line and consequently the process of rising is not impeded.

<div align="right">L 57 v.</div>

HELM OF FLYING MACHINES

Here the head n is the mover of this helm, that is that when n goes
towards b the helm becomes widened, and when it goes in the opposite
direction the tail is contracted; and similarly when f is lowered the tail
is lowered on this side, and so lowering itself on the opposite side it will
do the same.

Of necessity in flight at uniform altitude the lowering of the wings
will be as great as their elevation.

<div align="right">L 59 r.</div>

When the mover of the flying body has power divisible in four
through its four chief ministering members, it will then be able to
employ them equally and also unequally and also all equally and all
unequally, according to the dictates of the various movements of the
flying body.

If they are all moved equally the flying body will be of regular
movement.

If they are used unequally, as it would be in continuous proportion,
the flying body will be in circling movement.

<div align="right">L 60 v.</div>

Suppose that here there is a body suspended, which resembles that
of a bird, and that its tail is twisted to an angle of various different
degrees; you will be able by means of this to deduce a general rule as
to the various twists and turns in the movements of birds occasioned
by the bending of their tails.

In all the varieties of movements the heaviest part of the thing which
moves becomes the guide of the movement.

<div align="right">L 61 v.</div>

XIX

Movement and Weight

*'Force with material movement and weight
with percussion are the four accidental powers
in which all the works of mortals have their
being and their end.'*

SPEAK first of the movement then of the weight because it is produced
by the movement, then of the force which proceeds from the weight
and the movement, then of the percussion which springs from the
weight the movement and often from the force. c.a. 155 v. b

The action of a pole drawn through still water resembles that of
running water against a stationary pole. c.a. 79 r. c

Nothing that can be moved is more powerful in its simple move-
ment than its mover. c.a. 91 v. b

WHERE THE SCIENCE OF WEIGHTS IS LED INTO ERROR
BY THE PRACTICE

The science of weights is led into error by its practice, and in many
instances this is not in harmony with this science nor is it possible to
bring it into harmony; and this is caused by the poles of the balances
by means of which the science of such weights is formed, which poles
according to the ancient philosophers were placed by nature as poles of
a mathematical line and in some cases in mathematical points, and
these points and lines are devoid of substance whereas practice makes
them possessed of substance, since necessity so constrains as needful to
support the weight of these balances together with the weights which
are reckoned upon them.

I have found that the ancients were in error in their reckoning of
weights, and that this error has arisen because in a considerable part of

their science they have made use of poles which had substance and in a considerable part of mathematical poles, that is such as exist in the mind or are without substance; which errors I set down here below.

<div align="right">c.a. 93 v. b</div>

OF MOVEMENT AND WEIGHT

In equal movements made in equal time the mover will always have more power than the thing which is moved. And the mover will be so much the more powerful than the thing moved in proportion as the movement of this thing moved exceeds the length of movement of its mover; and the difference of the power of the mover over that of the thing moved will be so much less in proportion as the length of the movement made by the thing moved is less than the movement of this mover.

But observe, O reader, that in this case you must take count of the air which becomes so much the more condensed in front of the thing moved as this thing moved is of greater speed; for this air is capable of being condensed in an infinite degree. This however could not happen with the movements made by things which are moved within water, for this is not capable of being condensed, as may be proved by placing it in a vessel with a narrow mouth, since for lack of the knowledge of some motive power you will not be able to place within it more than the natural capacity the vessel will contain. And it is just the contrary with the air, for if it is forced into vessels with very narrow mouths which contain a quantity of water, and the vessel is tilted at such an angle that the water shut up in it is between the mouth of the vessel and the air which has been condensed, the power of the condensed air drives the water of the vessel with such fury as to penetrate through the air for some distance, until the air that remains in the vessel can return to its first natural state.

But to return to our proposition, we may say that among movable things of the same gravity that one will have the slower movement of which the front that cleaves the air takes up more space; and so conversely as it occupies less air, not however extending itself in such a degree of thinness as to cause its weight to fail, for where there is no weight there is no local movement through the air.

There can be no local movement through the air unless it proceeds from greater or less density than the density of this air.

And if my opponent should maintain that the density which the condensed air acquires in front of the thing moved is the same in front of the mover, and is so much the more in the case of the mover in proportion as it comes in contact with a greater quantity of air in front of itself when struck and condensed than does the thing moved by it, as we see with a hand when it throws a stone through the air: the answer to this is that it is impossible for the movement of the mover added to the movement of the thing moved to be either swifter or less swift than the movement made by the thing moved, nor can it ever be that in any part of its accidental movement its speed equals that of its mover; and this is proved in the accidental movement, where the thing moved lessens its speed at every stage of its movement, although the percussion of the thing moved is greater at some distance from the mover than it is when close at hand.

And this we see with an arrow from a bow when its point is resting against wood, for though the cord drive it with all the force of the bow it only penetrates the wood a very little distance, but does the contrary if it has some movement. Some say that the arrow in moving propels a wave of air in front of itself, and that this wave by means of its movement prevents the course of the arrow from being impeded. This is incorrect however because everything which is moved exhausts and impedes its mover. The air therefore which passes in waves in front of the arrow does so because of the movement of this arrow, and it lends little or no help of movement to its mover, which has to be moved by the same mover, but rather checks and shortens the movement of the thing moved.

The impetus generated in still water has a different effect from that generated in still air. This is proved from the fact that water in itself is never compressed by means of any movement made below its surface, as the air is within itself when struck by a moving thing. And this we may readily learn from the bubbles with which the water is encumbered from its surface to its bed, which cluster round about as the water fills up the vacuum of itself that the fish leaves behind it as it penetrates; and the movements of this water strike and drive this fish, because water only has weight within water when it has movement,

and this is the primary cause of the increase of movement for its mover.

C.A. 108 r. a

I find that force is infinite together with time; and that weight is finite together with the weight of the whole globe of the terrestrial machine.

I find that the stroke of indivisible time is movement, and that this movement is of many varieties, namely natural, accidental and participating; and this participating movement ends its greatest power when it changes from the accidental to the natural, that is in the middle of its course; and the natural is more powerful at the end than in any other place; the accidental is strongest in the third and weakest at the close.

C.A. 117 r. c

Weight, force, a blow and impetus are the children of movement because they are born from it.

Weight and force always desire their death, and each is maintained by violence.

Impetus is frequently the cause why movement prolongs the desire of the thing moved.

C.A. 123 r. a

Of water of uniform weight, depth, breadth and declivity that portion is swifter which is nearest the surface; and this occurs because the water that is uppermost is contiguous to the air, which offers but little resistance through its being lighter than the water; and the water that is below is contiguous to the earth, which offers great resistance through being immovable and heavier than water. It follows that the part which is more distant from this base has less resistance than that above which is contiguous to the air, for this is light and mobile.

C.A. 124 r. a

Gravity and levity are accidental powers which are produced by one element being drawn through or driven into another.

No element has gravity or levity within its own element.

C.A. 131 r. b

If all the bed of the sea were covered with men lying down these men would sustain the whole of the element of water, consequently each man would find that he had a column of water a mile long upon his back. For if the whole sea is all supported upon its bed each part of the bed sustains its part of the water.

C.A. 153 r. a

Impetus at every stage of time becomes less by degrees, and the prolongation of its essence is caused by the air or the water, which closes up behind the movable thing, filling up the vacuum which the movable thing that penetrates it leaves of itself. And this air is more powerful to strike and compress the movable thing by direct percussion, than is the air which is so placed as to resist the penetration of this movable thing by becoming compressed; and it is this compression of the air which diminishes the fury of the aforesaid impetus in the movable thing.

Impetus is the impression of local movement transmuted from the mover to the movable thing and maintained by the air or by the water as they move in order to prevent the vacuum.

The impetus of the movable thing within the water is different from the impetus of the movable thing within the air, and these differences result from the varieties of the aforesaid liquids, because air is condensable to infinity and water is not.

The impetus of the water is divided into two parts through its being of two natures, one of which is simple and the other complex. The simple is entirely beneath the surface of the water, the other is complex, that is it is between the air and the water, as is seen with boats.

The simple impetus does not condense the water in front of the movement of the fish, but moves the water behind the movement of the fish with the same speed that the mover has; and the wave of the water that is over against it will never be swifter than its mover.

But the movement of the boat, called complex movement because it shares with the water and the air, is divided into three chief parts because this movement is carried on in three directions, namely against the course of the river, in the direction of its current, and crosswise, that is along the breadth of the river. c.a. 168 v. b

If the movement of the oar or of the wing be swifter than the water or the air driven by them, that amount of movement which is left in the water or the air is completed by the oar or the wing in an opposite movement.

But if the movement of this water or air be in itself swifter than that of the oar or wing this oar and wing will not move against this water or air.

And if the movement of the water or of the air be in itself of the same swiftness as that of the oar or the wing that moves in it then the oar and wing will follow the movement of the water and the air.

<div align="right">C.A. 175 V. b</div>

The compression which the flame produces of itself, which increases within the resisting wall of the mortar, is that which produces the impetuous movement of its ball; and this impetus cannot be created with less density of flame or less swiftness in its rate of increase. Such swiftness of increase cannot take place within a wall of less resistance than that of this mortar. It follows therefore that the expansion which the flame makes as it rushes out of the mortar into the air, losing this density and directness of course, causes a loss of as much density as it acquires in its expansion and it ceases to follow the flight of the ball to the extent to which it bends to the . . .

<div align="right">C.A. 176 V. a</div>

The movement of water within water acts as the movement of air within air.

<div align="right">C.A. 184 V. a</div>

Anything which descends freely acquires fresh momentum at every stage of its movement.

If a power can move a body through a certain space in a certain time it does not necessarily follow that the half of this power will move the whole of the body over half the space in the whole of that time, or over the whole of the space in double the time.

<div align="right">C.A. 202 V. b</div>

Movements are of [. . .] kinds of which the first is called temporal, because it is concerned solely with the movement of time, and this embraces within itself all the others; the second is concerned with the life of things; the third is termed mental, and this resides in animated bodies; the fourth is that of the images of things which are spread through the air in straight lines: this class does not appear to be subject to time, for it is made indivisible in time and that which cannot be divided in the mind is not found among us; the fifth is that of sounds which proceed through the air, and this will be treated of later, as also of odours and savours, and this we may call movement of the senses; the other is called material movement, concerning which we shall make our treatise.

But we shall define movements merely as being of two kinds, of which one is material and the other incorporeal, because it is not perceptible to the visual sense, or we may say that the one is visible the other invisible, although among the invisible movements there are a considerable number of material movements, such as the movement of Saturn, and as there would be with a number of wheels revolving. Wherefore we may say that the two kinds of movement are such that the one is that which is united with bodies the other with the spirit. But among these movements that of the images of things amid the air is swiftest, because it covers a great space at the same time as it is very brief, and this loses [. . .] through distance, because the air thickens; the second is that of the mind.

Of the movements of the senses we will only mention that of hearing because it operates in visible bodies, and works by means of time, as is shown in noises, peals of thunder, sounds and voices. Of smell taste and touch we will not speak, because they do not form part of our subject.

Also one might speak of the influences of the planets and of God.

C.A. 203 v. a

THE HEAVIEST PART OF A MOVABLE BODY BECOMES THE GUIDE OF ITS MOVEMENT

If a power moves a weight a certain distance in a certain time the same power will move the half of this weight double the distance in the same time.

Or this whole power [will move] all the weight half the distance in half the time, or the whole power in the same time will move double the weight half the distance, or the whole power in half the time [will move] the whole weight half the distance.

C.A. 212 v. b

WHAT IS IMPETUS?

Impetus is a power transmitted from the mover to the movable thing, and maintained by the wave of the air within the air which this mover produces; and this arises from the vacuum which would be produced contrary to the natural law if the air which is in front of it did not fill up the vacuum, so causing the air which is driven from its place by

the aforesaid mover to flee away. And the air that goes before it would not fill up the place from which it is divided if it were not that another body of air filled up the place from whence this air was divided; and so of necessity it follows in succession. And this movement would continue to infinity if the air were capable of being condensed to infinity.

<div align="right">C.A. 219 v. a</div>

WHAT DIFFERENCE THERE IS BETWEEN FORCE AND WEIGHT

Force is spiritual essence which by fortuitous violence is united to weighty bodies, restrained from following their natural inclination, in which, although of brief duration, it nevertheless often shows itself of marvellous power.　　　　　C.A. 253 r. c

[*A hymn to force*]

Force is all in the whole of itself and all in every part of itself.

Force is a spiritual capacity, an invisible power which is implanted by accidental violence in all bodies that are withheld from their natural inclination.

Force is nothing else than a spiritual capacity, an invisible power which is created and implanted by accidental violence by sensible bodies in insensible ones, giving to these a semblance of life; and this life is marvellous in its workings, constraining and transforming in place and shape all created things, running with fury to its own destruction, and producing different effects in its course as occasion requires.

Tarrying makes it great and quickness makes it weak.

It lives by violence and dies from liberty.

It transforms and constrains every body with change of position and form.

Great power gives it great desire of death.

It drives away with fury whatever opposes its destruction.

Transmuter of various forms.

Lives always in hostility to whoever controls it.

Always sets itself against natural desires.

From small beginnings it slowly becomes larger, and makes itself a dreadful and marvellous power.

And constraining itself it constrains everything.

. . . dwells in bodies which are kept away from their natural course and use.

. . . willingly consumes itself.

. . . force is all in all and all through all the body where it is produced.

. . . Power (. . . nza) [potenza?] is only a desire of flight.

Always it desires to grow weak and to spend itself.

Itself constrained it constrains every body.

Without it nothing moves.

Without it no sound or voice is heard.

Its true seed is in sentient bodies.

Weight is all in all its vertical obstacle and all in every part of it.

If the oblique obstacle opposed to the weight is loosened and free it will not make any resistance to this weight but will fall down with it in ruin.

Weight naturally passes to its desired position.

Every part of this force contains the whole opposite to weight.

And often they are victors one over the other.

They are in the grip of the same natural law, and the more powerful conquers the less.

Weight changes [its position] unwillingly and force is always on the point of fleeing.

Weight is corporeal and force is incorporeal.

Weight is material and force is spiritual.

If the one desires flight from itself and death, the other wishes for stability and permanence.

They are often producers one of another:

If weight brings forth force and force weight.

If weight conquers force and force weight.

And if they are of like nature they make long company.

If the one is eternal the other is fleeting. c.a. 302 v. b

OF THE PROPORTION OF FORCE AND MOVEMENT

I ask whether if an arrow is shot from a cross-bow [a distance of] four hundred braccia a cross-bow made in the same proportions but of

four times the force and size will not send the arrow four times as far.

I ask if you have cross-bows, of equal weight, and elevated in these various thicknesses, [*diagram*] of the same length, what effect will it make in the distances upon the same arrow.

And if a cross-bow sends an arrow weighing two ounces a distance of four hundred braccia how many braccia will it send one of four ounces?

Force

Force cannot exist in bodies without either force or weight together with movement.

Force is caused by violent movement by means of weight or other force.

If a thing which moves continuously is given fresh momentum by greater movement the thing moved redoubles the velocity of its movement: for example a revolving wheel, such as the potter's lathe which revolves;—by adding to it the movement of the foot this wheel becomes swifter; also if a ball moving in a certain direction be struck by the player along the line of its movement this movement will be accelerated.

C.A. 314 v. b

THE MOVEMENT OF A HEAVY SUBSTANCE

The movement made by a spherical heavy substance in the air.

There are two movements which can be made by a spherical heavy substance in the air, one of which is called simple, the other compound. Simple is that movement in which the surface of the movable thing moves as much as its centre; compound is that in which the surface of the movable thing is in itself more swift than its centre.

Simple movement

Simple movement is that in which the movable thing moves equally in every part.

In compound movement there is no part which moves with a movement equal to that of the whole, unless it is the diameter, which makes itself the seat of the revolving movement.

The compound movement is transformed into as many different aspects as there are different sides with which it strikes against the obstacles that are in its path.

The simple movement is changed into compound movement, if its movement is impeded in any part of its sides.

In a long course compound movement made in the air resolves itself into simple movement; and the fact of this happening makes it more certain that the cause of the simple movement is also the cause of the compound movement; and this is shown in every wheel to which the revolving impulse is imparted, for it endures but little and is constantly growing less. c.a. 315 r. a

Every impetuous movement bends towards the less resistance as it flies from the greater. c.a. 315 r. b

Force is caused by the movement of the lever in its counterlever, and by this it is infused into the bodies which it moves. c.a. 316 v. b

Every heavy substance not held back out of its natural place desires to descend more by a direct line than by an arc. This is shown because every body whatever it may be, that is away from its natural place, which preserves it, desires to regain its first perfection in as brief a space of time as possible; and since the chord is described in a less time than the arc of the same chord it follows from this that every body which is away from its natural place desires to descend more speedily by a chord than by an arc.

From this three things follow:—the first is that the movement of gravity in the balance is not entirely natural. This is evident from the fact that the arms of this balance as they descend describe an arc, and as a consequence curved lines. The second is that the heavy movement in the arm of the balance which descends is not entirely violent, since in this manner it acquires in its descent natural movement.

The third is that the heavy movement in the balance is half-way between the natural and the violent.

This is evident seeing that every natural movement is violent or indeed is beyond nature. c.a. 335 v. f

Among bodies of varying substance and of similar shape that which has most weight descends most rapidly.

Proposition

That spherical and heavy body is of the slowest movement in which the contact that it makes with the plane where it touches is nearest to the perpendicular drawn from its centre. c.a. 338 r. b

Weight. [With diagrams]

The middle of each weight is in a perpendicular line with the centre of its support.

When a man standing or sitting takes a weight in his arms it is necessary for the support on which he is resting to be in the middle between this weight and himself.

It is impossible for the force exerted by a man's arm to be able with the weight supported by it to extend beyond the upright position without the counter action of the above named opposite weight.

Suppose you were to say:—I wish to lean my whole back against a wall, and sit on the ground with legs extended in such a way as to touch the whole corner with legs and back, and I will take a weight in my hands and bring it near to me and move it away with the actual force of my arms, and I shall not be moving my back or my head or any part of me so as to create any counterpoise to the weight moved by my arms, and nevertheless this will be done effectively.

To this I reply that the effect which the force exerts will not in this case extend to any other function than that of keeping the arms united with the trunk, as though without flexible joints and in one single piece, making this piece like a bar of iron bent in two right angles, the extremity of the upper part carrying itself in a perpendicular line as far as the middle of the base or the opposite lower part, and if there is the burden of a weight superimposed upon this upper extremity this weight will exert force below itself upon the perpendicular line of its base. c.a. 349 r. b

A man about to give a great blow with his arms so places himself that all his power is on the opposite side to that of the place at which he intends to strike, for the thing which moves most exerts most power upon the thing that resists the movement. c.a. 352 v. c

Every impression is preserved for a time in its sensitive object; and that which was of greater power will be preserved in its ob-

ject for a longer time, and for a shorter time with the less powerful.

In this connection I apply the term sensitive to such object as by any impression is changed from that which was at first an insensitive object;—that is one which, while changing from its first state preserves within itself no impression of the thing which has moved it. The sensible impression is that of a blow received upon a resounding substance, such as bells and suchlike things, or like the note in the ear, which, indeed, unless it preserved the impression of the notes, could never derive pleasure from hearing a voice alone; for when it passes immediately from the first to the fifth note the effect is as though one heard these two notes at the same time, and thus perceived the true harmony which the first makes with the fifth; but if the impression of the first note did not remain in the ear for an appreciable space of time, the fifth, which follows immediately after the first, would seem alone, and one note cannot create any harmony, and consequently any song whatsoever occurring alone would seem to be devoid of charm.

So, too, the radiance of the sun or other luminous body remains in the eye for some time after it has been seen; and the motion of a single firebrand whirled rapidly in a circle causes this circle to seem one continuous and uniform flame.

The drops of rain water seem continuous threads descending from their clouds; and so herein one may see how the eye preserves the impressions of the moving things which it sees.

The insensitive objects which do not preserve the impressions of the things which are opposite to them are mirrors, and any polished substance, which, so soon as ever the thing of which it bears the impression is removed from before it, becomes at once entirely deprived of that impression. We may, therefore, conclude that it is the action of the mover pressing against the body moved by it which moves this body in the direction in which it moves.

Amongst the cases of impressions being preserved in various bodies we may also instance the wave, the eddies of the water, the winds in the air, and a knife stuck into a table, which on being bent in one direction and then released, retains for a long time a quivering movement, all its movements being reciprocal one of another, and all may be said to be approaching towards the perpendicular of the surface where the knife is fixed by its point.

The voice impresses itself through the air without displacement of air, and strikes upon the objects and returns back to its source.

The concussion of liquid with solid bodies is of a different character from the above-mentioned cases of concussion; and the concussion of liquid with liquid also varies from the foregoing.

Of the concussion of solid with liquid there is seen an example in the shores of the ocean, which receive the waters full on their rocks and hurl them against the steep crags; and oftentimes it happens that before the course of the wave is half completed, the stones carried by it return to the sea from whence they came; and their power of destruction is increased by the might of the wave which falls back from the lofty cliffs. c.a. 360 r. a

Force never has weight, although it often performs the function of weight.

The force is always equal to the weight which produces it.

This is proved by the . . . c.a. 382 r. a

That body weighs less upon the air which rests upon a greater expanse of air. We may take as an example the gold from which money is made which is extremely heavy, but which when spread out in fine leaf for gilding maintains itself upon the air with each slightest movement of this air.

[*With drawing*]

The hollows of the wings underneath the shoulders receive the revolution of the air near the starting point of the wings, and nature has so conditioned them near to the starting point of these wings by the fourth proposition concerning weight where it is stated that that part of the support is most powerful which is nearest to its starting point.
 c.a. 395 r. b

No element when united will have weight within its element; therefore the parts of the air do not weigh upon the lower parts.

No body of dissimilar quality will come to rest within this if it is at liberty, because as this body has not the same quality as the air it must needs be either heavier or lighter, and if it is heavier it will drop down, and if lighter it will penetrate upward.

That thing which has most conformity with the element that surrounds it will issue forth from it with the slowest movement.

And the thing which is most unlike will separate itself from it with more impetuous movement.

When the force generates swifter movement than the flight of the unresisting air this air becomes compressed after the manner of feathers pressed and crushed by the weight of the sleeper. And that thing which drove the air finding resistance in it rebounds after the manner of a ball struck against a wall. Tr. 10 a

The line that is straightest offers most resistance. Tr. 24 a

That thing which within the line of equality shall find itself at a greater distance from its support will be less sustained by it, as is shown below in *m n* [*diagram*].

That thing which is at a greater distance from its support will be less sustained by it, and consequently· will fulfil its natural desire with greater liberty.

Violent movement the more it is exerted the more it grows weaker: natural movement does the opposite.

That thing which is at a greater distance from its support will be less sustained by it: being less sustained it will partake more of its liberty, and since the weight that is free always descends the thing therefore being weighty will descend more swiftly.

That part of the pole which is farther from its support will be less sustained by this support. Being less sustained it continues to follow its nature more freely, and this being heavy and the nature of heavy things being to desire to descend it will therefore descend more swiftly than any other part. Tr. 30 a

The air is capable of compression and water is not; and when the movements which drive it are swifter than the flight of this air, as the part which is more caught by its mover becomes denser and consequently offers more resistance; and when the movement made in it is more rapid than the escaping power of this air its mover comes to take a contrary movement. As is shown in the case of the birds which are not able to drive the points of their wings downwards with the speed with which they are moving, because their motive power moves them

so much the less as the bird raises itself up as the extremity of the wing
fails to go down. After the fashion of the man who keeps hands and
breast close to a wall and presses with his hands upon this wall so that
if the wall does not give way the man must needs turn back.

<div align="right">Tr. 42 a</div>

[Sketches]

That part of the cloth that is farthest away from its support will sur-
render itself most to the movement of the wind.

That earth which is most mixed with water will offer least resistance
to weights placed upon it.

That water which is most intermingled with earth will offer resist-
ance to greatest weight.　　　　　　　　　　　　　　　　　Tr. 60 a

OF THE BLOW

Everything hit against a resisting object leaps back from this object
at an angle equal to that of the percussion.

Note concerning water. [Diagram]

The same is proved in the tenth proposition of the book concerning
the nature of the blow where it treats of the ball struck against a wall.
And if you wish to know the depth of a fall of water observe the line
of the fall in $c\ b$, of what degree of slant it shows itself; then observe
the part that lies between the point of impact b and the point a to
which it rises; and make the angle $a\ b\ d$ and measure how it is shown
in the tenth of Percussion. And if you should be of opinion that the
water in this case would not be able to deflect owing to some resisting
object intervening in the line of its recoil know that if the fall is of long
continuance it will have worn away every obstacle which was set in the
path of its springing force.　　　　　　　　　　　　　　Tr. 66 a

AGAINST PERPETUAL MOTION

No inanimate object will move of its own accord; consequently
when in motion it will be moved by unequal power, unequal that is in
time and velocity, or unequal in weight; and when the impulse of the
first motive power ceases the second will cease abruptly.　　A 22 v.

[Of force and spherical body]

Every spherical body of thick and resisting surface when moved by a like force, will make as much movement in the rebounds caused by its impact upon a concrete ground as if it were thrown freely through the air.

How admirable Thy justice, O Thou First Mover! Thou hast not willed that any power should lack the processes or qualities necessary for its results; for if a force have the capacity of driving an object conquered by it a hundred braccia, and this object while obeying it meets with some obstacle, Thou hast ordained that the force of the impact will cause a new movement which by divers rebounds will recover the entire amount of the distance it should have traversed.

And if you were to measure the track made by these bounds you will discover it to be of the same length as it would be if a similar object were impelled freely through the air by the same force.

You may make an experiment of this with a small glass ball as it strikes upon a surface of smooth polished stone. Take a long staff and mark it with different colours from end to end, and then give it someone to hold, and set yourself at some distance away [to watch] the rebounds [and see] against the height of the staff to what colours the ball rises successively with each rebound, and make a note of them. If there are as many observers as the number of times the ball rebounds each will keep it more easily in memory. But either have the staff fixed at the top or with the end in a hole, for if anyone held it with his hand he would interrupt the line of sight of the judge. Arrange that the first bound be made between two right angles so that the ball may always fall in the same spot, because then the height of the rebounds against the staff may be more accurately discerned.

Then have this ball discharged by the same power in free course and make a note of the spot where it strikes; and measure it and you will find that the length of the second course is identical with the first.

A 24 r.

If you should be in a boat, and you there exert your utmost force, the boat will never stir from its position unless the said force has a greater obstacle outside this boat than that made within it.

Again if you are all huddled up in a sack and within it make efforts

to move yourself you will find it impossible to change your position, but if you draw a foot out of the sack and use it as a lever on the ground putting your head to the bottom of the sack you will be able to draw it off backwards.

The flame also does the same with its desire to multiply and extend itself in the bombard, for while it is entirely inside it the bombard does not recoil. But when this flame strikes and pushes the resisting air while remaining united to that which pushes on the bottom, it is the cause of the bombard recoiling; for that portion of the flame that strikes, not being able to find in the air that instant passage that it requires, throws its force upon the opposite side. A 28 r.

WHAT IS FORCE?

Force I define as an incorporeal agency, an invisible power, which by means of unforeseen external pressure is caused by the movement stored up and diffused within bodies which are withheld and turned aside from their natural uses; imparting to these an active life of marvellous power it constrains all created things to change of form and position, and hastens furiously to its desired death, changing as it goes according to circumstances. When it is slow its strength is increased, and speed enfeebles it. It is born in violence and dies in liberty; and the greater it is the more quickly it is consumed. It drives away in fury whatever opposes its destruction. It desires to conquer and slay the cause of opposition, and in conquering destroys itself. It waxes more powerful where it finds the greater obstacle. Everything instinctively flees from death. Everything when under constraint itself constrains other things. Without force nothing moves.

The body in which it is born neither grows in weight nor in form. None of the movements that it makes are lasting.

It increases by effort and disappears when at rest. The body within which it is confined is deprived of liberty. Often also by its movement it generates new force. A 34 v.

Every weight desires to descend to the centre by the shortest way; and where there is the greater weight there there is the greater desire. and that thing which weighs the most if it is left free falls most

rapidly. The less the slant of the opposing substance the greater its resistance. But the weight passes by nature into all that supports it, and thus penetrating from support to support it grows heavier as it passes from body to body until it realises its desire. Necessity draws it and abundance drives it away. It is all in all its vertical opposition and all in each of its degrees. And that opposition which slants the most will not offer resistance to its descent, but, being free, will fall together with it. In its function of pressing and making heavy it is like force. Weight is subdued by force, as force is by weight. One can see weight without force, but one cannot see force without weight. If weight has no neighbour it seeks one with fury and force drives it away with fury. If weight desires an unchangeable position force readily flies from it. If weight desires stability and force is always desirous of flight, weight of itself is without fatigue, while force is never exempt from it.

The more weight falls the more it increases and the more force falls the more it diminishes. If one is eternal, the other is mortal. Weight is natural and force is accidental. Weight desires stability and permanence, and force desires flight and death of itself. Weight, force and a blow resemble each other in respect of pressure. A 35 r.

In the centre of the direct path taken by heavy bodies which traverse the air with violent movement, there is greater power and greater striking force when an obstacle is met with than in any other part of its line.

The reason of this is that when the weight parts from the force of its mover, although this separation is in the initial stage of its power, it finds nevertheless the air without movement, and finds it in the initial stage of its resistance, and although the sum total of the resistance of the air is greater than the power of the weight which is pushed upon it, nevertheless as it strikes only a small part it succeeds in remaining the conqueror. Consequently it drives it from its place and in so driving it it somewhat impedes its own velocity. This air therefore after having been pushed pushes and drives the other, and generates revolving movements in its wake, of which the weight that is moved within it is always the centre, after the fashion of circles formed in the water, which have their centre at the spot struck by the stone. And so as the one circle drives the other, the whole air that is along the line in front

of its mover becomes prepared for movement, and this increases in pro
portion as the weight that drives it presses the more. In consequence
this weight finding less resistance in the air redoubles the speed of its
course, the same as a barge drawn through the water, which moves
with difficulty at the beginning of the movement although the force of
its mover may be at its maximum, but as with arched waves this water
commences to take its movement the barge in following this movement
meets only with slight resistance and therefore moves with greater ease.
The bullet likewise finding but slight resistance follows the course it
has begun until the point at which abandoned in part by its first force
it commences to grow weak and to drop, and as its course changes the
way already prepared for its flight by the fleeting air contains it no
longer; the more it drops however the more it finds fresh resistance in
the air and the more it delays, up to the point at which resuming its
natural movement it acquires fresh speed, and even so the barge as it
turns delays its course. Now therefore I conclude according to what is
demonstrated in the eighth proposition that that part of the movement
which occurs between the first resistance of the air and the beginning
of its drop is of the greater power, and it is the centre of the course
made in the air in a straight direct line. A 43 V.

OF THE BLOW AND THE DISPLACEMENT CAUSED BY
WEIGHT OR BY FORCE

I maintain that the displacement caused by the weight which falls
is equal to the displacement caused by the force.

The body that receives the blow is not injured in the part opposite
as it is in the part which is struck. The proof of this is shown when a
stone is struck while lying in a man's hands, for the hand is not in-
jured when it is holding the stone that is struck as much as it would be
injured if it actually received the blow. A 53 V.

DEFINITION OF FORCE AND MOVEMENT IN ANIMALS

I affirm that the said movement is based upon several points of
support.

Force is produced by the lessening and contraction of the muscles

which draw back, and of the nerves which stretch as far as the sensation communicated by the empty cords dictates. **B 3 v.**

OF THE NATURE OF MOVEMENT

If a wheel of which the movement has become very rapid continues to make many revolutions after its motive power has abandoned it, then if this motive power continues to cause it to turn with the same quickness of movement, it would seem that this continuance necessitates but little force.

And I conclude that in order to maintain this movement only a slight effort by the motive power would be needed, and so much more as by nature it tends to become fixed. **B 26 v.**

CONCERNING WEIGHTS

I ask if a weight of a pound falling two braccia bury itself in the earth the depth of a hand how deeply will it bury itself if it falls forty braccia, and how far a weight of two pounds will bury itself if it falls two braccia?

One may ask also if the size of this weight be represented by a quantity a and then this quantity be doubled, its weight remaining the same and falling from the same height, how much greater impress the lesser bulk will make than the greater if the ground offer equal resistance? **B 61 r.**

EXAMPLE OF THE BLOW AND OF THE DIFFERENCE BETWEEN WEIGHT AND FORCE

The blow since it is of very short and even of indivisible life produces suddenly its full and quick effect upon what is opposed to it, and this effect ends before it reaches the base of the thing struck. For this reason therefore you will find more enlargement at the summit of the thing struck than at its base. And if you wish to ascertain how much greater the power of the blow is upon the thing struck at its summit than at its base, calculate how many times the circumference of the base $m\ n$ will go into that of the summit $a\ c$; as many times as $m\ n$

goes into *a c* so many times will *a c* receive into itself greater force than *m n*. But if this support *a m* is pressed down by weight or by force, *m n* will be as much enlarged as *a c*, because their powers move more slowly than that of the blow. c 6 v.

The Blow

Since the blow is more swift than the movement, the thing touched by the blow although it may be in movement will rather obey the effect of this blow than that which accelerates the movement. c 7 r.

If two make the same journey in the same time he who runs often, with frequent intervals for rest, will undergo as much fatigue as he who goes gently and continuously. c 7 v.

Percussion

If two balls strike together at a right angle one will deviate more from its first course than the other in proportion as it is less than the other. c 15 r.

The part of a log first severed from the end of it by the stroke of the axe flies off to a greater distance than any other part carried away by the same blow.

This is because the part of the log that first receives the blow receives it in the first stage of its power and consequently goes farther. The second part flies a less distance because the fury of the blow has already subsided, the third still less and so also the fourth.

The wood which is divided from the rest by the stroke of the axe will fly off with greater violence at one time than at another as the stroke is more powerful at one time than another, and the piece will fly off to a greater distance. This is because as the blow is the most powerful and instant thing that a man can do, as is shown in the fourth proposition which treats of the nature of the blow, when the axe, driven by man's strength and by the movement of the hands in falling, from the weight and blow of the hatchet has entered within the surface of the close-grained wood, so soon as this fine edge has entered immediately the thick part of the hatchet follows and proceeds with such

vigour and swiftness to widen and enlarge the edges of the cut that it pulls it asunder with great force, and the quicker it is the more the cut will be enlarged and deepened, and if (part) is entirely severed it flies from the blow with great swiftness, as may be shown by experiment.

Water air and fire produce the same effect in their rebound from objects that oppose their course:

A piece of wood separated from the rest by the blow of an axe will fly off from it at an equal angle to that of the blow.

Everything of a compact surface that falls upon a resisting object will have the line of its rebound at the same angle as the line of its incidence. c 22 v.

Movement and percussion

Among bodies of equal movement and size that which is of greater weight will give a greater blow to the thing that opposes its course, and since turbid water is heavier than clear, the blow which it gives upon the thing that opposes its course will be greater.

Movement of water

A body with a thicker harder surface will cause the objects that strike against it to separate from it with a more powerful and rapid rebound.

Water

Water that falls upon gravel mixed with sand and earth will hollow it out more deeply and more rapidly for the aforesaid cause than if it fell upon plain soft mud, for as it falls upon gravel it takes a swift powerful leap and gnaws away more of what first opposes its bound and rises more.

The angle caused by the percussion of equal spherical bodies is always equal to that of the rebound. c 28 r.

Every weight tends to fall towards the centre by the shortest way.

 c 28 v.

OF HUMAN MOVEMENT

When you wish to represent a man in the act of moving some weight reflect that these movements would be made in different directions, that is in the case of simple movement from below upwards, as that which a man makes when he stoops to lift a weight with the intention of raising it as he straightens himself; or when he wishes to pull something backward or push it forward or draw it down with a cord that passes over a pulley. Here one should remember that a man's weight drags in proportion as the centre of his gravity is distant from that of his support, and to this must be added the force exerted by his legs and bent spine as he straightens himself. E 15 r.

The mover is always more powerful than the thing moved.

E 20 v.

Of the knowledge of the weights proportioned to the forces of their movers:

The force of the mover ought always to be in proportion to the weight of its movable thing and to the resistance of the medium in which the weight moves. But one cannot deduce the law of this action unless one first gives the quantity of the condensation of the air when struck by any movable thing whatever; and this condensation will be of greater or less density according to the greater or less speed of the mobile thing pressing on it, as is shown in the flight of birds, for the sound that they make with their wings in beating the air is deeper or more shrill according to whether the movement of the wings is slower or swifter. E 28 v.

The weight of every heavy thing suspended is all in the whole length of the cord that supports it and all in each part of it. E 32 v.

OF COMPOUND IMPETUS

Compound impetus is the name given to that which participates in the impetus of the mover and the impetus of the thing moved, as is the movement *f b c* which is between two simple movements one of which is near the beginning of the movement and the other near the end: *a g*

is the first and $d\ e\ c$ is at the end. But the first only obeys the mover and the last is only of the semblance of the thing moved.

OF IRREGULAR IMPETUS

The irregular [dechonpossto] impetus accompanies the thing moved with three kinds of impetus, of which two spring from the mover and the third from the thing moved. The two that originate in the mover are the straight movement of the mover mingled with the curved movement of the thing moved, and the third is the simple movement of the thing moved which tends merely to turn in the middle of its convexity at contact with the plane where it turns and lays itself down.

FRICTION

Friction is divided into three parts: these are simple, compound and disordered.

Simple friction is that made by the thing moved upon the place where it is dragged. Compound is that which the thing moved makes between two immovable things. Irregular is that made by corners of different sides. E 35 r.

OF THE WEIGHT DISTRIBUTED OVER THE LENGTH OF THE CORD WHICH SUPPORTS IT

The weight distributed over the whole length of the cord which supports it will give less strain to this cord than if it was suspended to its lowest part, and this is proved by one of the Elements which says 'Among cords of equal thickness the longest is the least strong'.

Consequently the cord $a\ b$ which supports the weight distributed over all the remainder of the cord $b\ t$ is so much stronger than the opposite part of the cord $a\ c$ as it is shorter.

One cord supports as many times the weight of another as the number of the curves is greater in the one than the other.

The division made by the cord with its pulley is never rectangular; this is proved from the two simple cords that hang from the same pulley which would meet at the centre of the earth.

DIVISION OF WEIGHT

There are three conditions of gravity, of which the one is its simple natural gravity, the second is its accidental gravity, the third the friction produced by it. But the natural weight is in itself unchangeable, the accidental which is joined to it is of infinite force, and the friction varies according to the places wherein it occurs, namely rough or smooth places. E 54 v.

DEFINITION OF COMPOUND BALANCES

We may define the nature of compound balances both as regards circular balances that is to say pulleys and wheels and also rectilinear balances. But first I will make some experiment before proceeding farther because it is my intention first to cite experience then to show by reasoning why this experience is constrained to act in this manner. And this is the rule according to which speculators as to natural effects have to proceed. And although nature commences with reason and ends in experience it is necessary for us to do the opposite, that is to commence as I said before with experience and from this to proceed to investigate the reason.

I see that it is necessary in the compound rectilinear balance in the second demonstration that as much as the one of the extremities descends so much the opposite extremity rises, and the cause of this is the equality of their arms. E 55 r.

OF GRAVITY AND ITS SUPPORTS

Gravity suspended or supported is all in all its support and all in each of its parts.

The cord bent over its pulley supports more weight in its pendent extremities than when it is stretched out in a continuous straight line. This may be proved thus: suppose the cord bent over the said pulley to be $d\ c\ e\ f$ and the ultimate strength of its resistance to be represented by 10; I affirm that if the same cord be stretched straight as is shown at $a\ b$ it will not support more than five.

And this proceeds from the seventh of this where it is stated: 'Each

cord gains as much in strength as it loses in length; consequently the cords *c d* and *e f* in order each to have their length double that of the cord *a b* must necessarily have double the strength of the cord *a b*.'

WHAT PART OF THE CURVED CORD IS STRONGEST

The maximum strength of the curved cord is in the middle of its bend: this is proved by the eighth of this which says 'That cord is strongest which is thickest'. It follows that as the cord is compressed in its fold over the pulley where it is bent it becomes widened and lowers itself a little, and for this cause necessity constrains it to become thus compressed. E 55 v.

OF MOVEMENT MADE BY A HEAVY SUBSTANCE

Every heavy substance moves on that side on which it weighs most.

And the movement of the heavy substance is made on that side where it encounters least resistance.

The heaviest part of bodies that move in the air becomes the guide of their movements.

That heavy substance is of more slow descent in the air which falls in greater width.

It follows that that heavy substance will have the swiftest descent which confines itself within the least width.

The free descent of every heavy substance is made along the line of its greatest diameter.

That heavy substance will be swiftest in movement which reduces itself to the smallest bulk.

The descent of a heavy substance is as much slower as it extends in greater breadth. E 57 r.

WHY A BALANCE FORMED OF BEAM AND EQUAL WEIGHTS STOPS IN A STATE OF EQUILIBRIUM

Every liquid heavy substance settles down with its opposite extremities in a state of equilibrium when it is of natural uniform weight. And it is lowered as much on one side as it is raised on the other and

acts round its centre, as one sees with the extremities of the balance round its axis with their oscillations upwards and downwards until the impetus is consumed; and this is brought about solely through the inequality of the opposite sides round the centre of the water or of the balance. E 57 V.

[Gravity and movement. Balances]

By what is said below the balance does not have all its natural weight upon the centre of its revolution, but it has as much less as the weight that moves the upper arm has the more slanting movement, as is proved in this discourse.

The heavy substance in suspension is all in all and all in every part of the centre line of its support.

The staff placed slantwise has two kinds of gravity of which one weighs slantwise between the centre of the earth and the horizon. The other weighs vertically upon the centre of the earth. And of these one is accidental and the other natural. And this occurs where the mathematical centre is not the centre of the revolution of the balance. This is proved thus, let *a b c d* be the balance and *s* its mathematical centre; the centre of the revolution will be *f*. I affirm that when the balance is in such a position the mathematical centre *s* is the same in the line that points towards the centre of the earth, that is *g h*, as the centre of the revolution *f*, and this line *g h* divides the staff of the balance into two equal and similar parts namely the part *a b e f* and the part *c d e f*. Whether one wishes to rest the balance upon the point *s* or the point *f* is immaterial for both the one point and the other are in the central line *g h* which divides the weight equally.

There still remains the above-mentioned slanting weight which is above the centre of the revolution *f*, that is the weight which is above the line *n o* that is *a b r f*, to which the counter weight *c d r f* offers no resistance in the above-mentioned slanting movement. E 58 r.

OF THE MOVER OR THE MOVABLE THING

The power of the mover is always greater than the resistance of the thing moved.

OF LEVER AND COUNTERLEVER

There is added as much accidental weight to the mover placed at the extremity of the lever as the movable thing placed at the extremity of the counterlever exceeds it in natural weight.

And the movement of the mover is as much greater than that of the thing moved as the accidental weight of this mover exceeds its natural weight.

This may be proved; for let us say that the movement of the mover is from *b* to *d* and of the thing moved from *a* to *c*; I maintain that the movement *b d* will be as much greater than the movement *a c* as the accidental weight of *b* exceeds the [natural] weight *b*; and as this exceeds it by one, the natural weight therefore also . . . E 58 v.

OF WEIGHTS

A balance of equal arms and weights when removed from a position of equality will have its arms and bows unequal because it changes the mathematical centre, and consequently necessity constrains it to regain the lost equality of arms and weight. This is proved by the second passage.

Transcript of the above

A balance with equal arms and weights removed from a position of equality will make arms and weights unequal, and consequently necessity constrains it to regain the lost equality of arms and weights. This is proved by the second of this, and it is proved because the higher weight is more removed from the centre of the revolution than the lower weight, and consequently having a more feeble support it descends more easily and lifts up the opposite side of the weight joined to the extremity of the lesser arm.

OF ACCIDENTAL AS AGAINST NATURAL WEIGHT

The accidental weight set in the balance against the natural weight is worth as much as this natural weight, and this is proved by means of the weight that the pole of the balance receives from it, for it loads

itself so much more with the accidental than the natural weight in proportion as the greater arm of this balance exceeds the smaller in length. E 59 r.

THE COMMENCEMENT OF THIS BOOK CONCERNING WEIGHTS

First. If the weights, arms and movements slant equally these weights will not move each other.

Second. If the weights equal in slant, and equal, move each other the arms of the balance will be unequal; for 'Equal weights maintain equal gravity in an equal slant'.

Fourth. If the weights and the arms of the balance with the slant of the movements of these weights are equal, then these weights will show themselves unequal if their appendices have their slants unequal.

Third. But if the equal weights in the arm and the balance move one another then the movements of the weights will be of unequal slant.

First. Why it is a definition. The cord that hangs from the opposite sides of the pulley or beam where it rests, is always divided and joined in rectangular division and union by the opposite ends of the half diameters of this pulley or beam or other round instrument, no matter what the slant of the cords may be. E 59 v.

WEIGHT AND FORCE

The potential lever will never be consumed by any power.

This is proved by the first which says:—'Every continuous quantity is divisible to infinity'. But that which is divisible in act is also divisible in power: but it is not the case that that which is divisible in power is divisible in act. And if the divisions made potentially towards the infinite change the substance of the matter divided, these divisions will return to the composition of their whole, the parts reuniting in the same stages in which they were divided. For example let us take ice and divide it towards infinity; it will become changed into water, and from water into air, *and from air into fire*[1]; and if the air should come to

[1] Words crossed out in MS.

thicken again it will change itself into water, and from water into hail, etc.

<div align="right">E 60 r.</div>

A cord of any thickness or strength whatever placed in a level position as regards its opposite extremities will never be able to straighten itself if it has any weight placed in the centre of its length.

OF THE RESISTANCE OF THE ARCHED CORD

Given the straight cord suspended by one of its ends which breaks itself exactly where it is fastened by its own weight, one asks what weight it will support in any arch that may be made of this cord, this arch having its extremities in the position of equality.

Where the potential lever is in existence the force will also be in existence.

The force will be of so much the greater excellence as the potential lever is less in quantity.

The force is always created at the same time as the potential lever and so it dies when this lever fails.

<div align="right">E 60 v.</div>

OF GRAVITY AND ITS ORDER

[Levers real and potential]

It is necessary first to describe the real powers in whatever aspect, second the semi-real powers, third the potential virtue. Next define how the centre of the circumvolution is that which divides the power of the lever from the power of its counterlever.

And the movements of the lever and of its counterlever are always contrary in their movement of circumvolution round the above-mentioned centre. And all the powers joined to the lever and counterlever are always in rectangular conjunction with this lever both real and potential. And this angle has always one of its sides which proceeds from the centre of the circumvolution, and the real arms of the balance will never contain within themselves the potential arms unless they are in a position of equality. And always the junction of the real or potential appendix with the arm of the balance is the nearest part of this appendix.

The first direction taken by the appendix after its junction with the

arm of the balance shows the direction of the potential appendix which in rectangular conjunction meets the extremity of the potential lever.

<div align="right">E 65 v.</div>

Always the cords folded in an angle in which the heavy substance is supported joined to the ring will bear equally the burden of this weight at their extremities, and this comes from the fact that the cord is of uniform slant.

The cords which with equal slant meet at the point of suspension of a heavy substance always support equally the weight of this substance.

If two cords converging or diverging descend to a suspended beam situated at any angle and are joined to it in any part of its length, so that the centre of the beam is placed between them, when these parts find themselves in these conditions the centre of gravity of the beam will be in the intercentric line which passes through this beam.

OF GRAVITY

It is impossible that the power of any motive force should be able at the same time and with the same movement to create a power greater than itself. This is proved by the third of this which says:—'Powers which are equal to each other do not overcome each other'. E 66 r.

If two cords descend with different lengths and with their slants converging or diverging to the point of suspension of the extremities of the beam, then if this beam be equijacent the slants of the two aforesaid cords will be equal one to the other. E 66 v.

What is gravity and whether it is natural or accidental, and one may ask the same concerning levity:

The answer is that both are accidental powers because each always waits for its destruction and one is never born without the other or dies without the other. This is proved by the air which forms in the shape of a bubble or bladder at the bottom of the water, where the fact of its formation immediately creates its levity and creates the weight of the water that is above it. And as soon as the bubble arrives at the surface its levity dies together with the gravity of the water that was above it.

The stone that descends through the water first makes the water

heavy that closes up the beginning of the entrance made by the stone, and makes light the water that rises to fill up the space that the stone leaves as it descends, because that which moves upwards is light.

Whether the space of the water penetrated by the stone is filled by water descending or by water from the side or by water that is below.

<div align="right">E 67 r.</div>

[*Of a heavy body*]

If the angle that is formed by the meeting of the two cords that support a weight is cut by the intercentric line of this weight, then this angle is divided into two other angles, and as these are divided anew by the line of the equality two triangles are then produced, and these will have the same proportion between base and base as there is between angle and angle, and the same proportion between angle and angle as there is between triangle and triangle, and the proportion of triangle to triangle is the same as that of gravity to gravity [the same as those] in which the heavy substance is divided in relation to the two cords by which it is suspended; but the proportion is in inverse ratio because the greatest weight falls on the cord which makes itself the outer side of the lesser triangle.

How many are the centres of a heavy body which is not uniform?

There are three centres of a gravity that is uniformly irregular.

Of which the first is the centre of the natural gravity, the second is the centre of the accidental gravity and the third is the centre of the magnitude of this heavy body.

But the centre of the natural gravity does not lie within the position of equilibrium if the heavy body is not uniform in weight and of suitable shape, such as the spherical or parallel body or others like these.

<div align="right">E 68 v.</div>

OF THE THINGS WHICH DESCEND IN THE AIR

The air becomes condensed before bodies that penetrate it swiftly, acquiring so much more or less density as the speed is more violent or less.

A plank that is uniform in breadth, length, depth and weight will not preserve the slanting movement with which it started through the air that it penetrates for a long space, but will turn back and then again forward and so end its descent with a fluctuating movement. This

springs from the fact that the uniform natural thickness of the air is destroyed because it is condensed under the right angle of the surface which strikes the air and cleaves it open. But on the opposite face of this plank it does the contrary in that it becomes rarefied, and as a consequence the rarefied air is of less resistance, and for this reason this surface shows itself heavier. The rarefaction acquired by the air that is behind this plank is much greater than the density that is produced in front of it. It may be proved why the air is condensed:—the air is condensed before the bodies that penetrate it for when one pushes a part one does not push the whole of that which is in front. This is demonstrated by the flooding that is produced before the prow of a ship.

E 70 V.

[Of the descent of heavy bodies in the air]

Conception

The air becomes as much more rarefied behind the movement of the movable thing as it becomes denser in front of the same movable thing.

Why the slanting descent does not keep its straightness.

The straight line of the oblique descent made by bodies of uniform thickness and weight in air of equal resistance will not be continued by a heavy substance that descends. And this is due to the fact of the air being pressed by the surface of the heavy substance that is penetrating it, and becoming condensed resisting and stopping this surface; whence of necessity the opposite surface of this heavy substance finding itself in rarefied air immediately acquires gravity and falls with more speed than that which is retarded by the thickness of the air condensed by it. And for this reason the impetus to the right made by the movable thing is turned to the left, preserving its slant, up to the point at which the other air is condensed anew beneath it; this air again resists and again turns the left slanting descent to a right descent, then from right to left and from left to right until the point at which the movement ends.

The descent of the beam placed in any slanting position will always be made by a straight line. This is proved by the seventh of this which says:—'Heavy substances of uniform shape and weight which descend through an equal medium will have the same rate of speed'. If therefore a beam of uniform shape and weight be divided into equal and similar

parts their descent will be of equal and similar speed, and what the part does the whole will do.

The adversary says that the whole beam united will not have a descent similar to the descent of its divided parts because the whole gives the whole of its weight slanting to the lower surface, and the part gives the whole of its weight to the surface of the part and there is such speed from surface to surface as there is from the whole to the part.

<div align="right">E 73 r.</div>

OF BODIES NOT UNIFORM IN SHAPE

Of heavy substances not uniform in shape the heavier part will always become the guide of their descent through the air.

With beams of uniform shape at the end of the movement the movable thing will have always preserved the same slanting position that it had at the beginning of the movement.

This is proved by means of the beam suspended on the balance *n m*.

The heavy substance weighs so much less in the air as its movement is more slanting.

And the straight descent of the beam weighs as much less in the air as this beam is less slanting.

<div align="right">E 73 v.</div>

OF THINGS THAT DESCEND IN THE AIR

A heavy substance of uniform thickness and weight, placed in a position of equilibrium will have a straight descent with equal height in each of its parts without ever deviating from the position of its first equilibrium, if the air be motionless and of uniform resistance, and this movement will be very slow as will be proved.

But if the heavy substance of uniform thickness be situated slantwise in air of uniform resistance then its descent will be made slantwise and it will be more rapid than the first aforesaid.

<div align="right">E 74 r.</div>

OF THE WEIGHING OF LIQUIDS

[*Figure*]

The balance *a e g* is formed of two tubes joined at an angle in the lower part, and the water that is enclosed within them is joined having in the one arm a quantity of oil and in the other plain water.

I say that the level of the water in one tube and the other will not remain in a position of equality, nor will the surface of the oil find itself in a position of equality with the surface of the water placed in the opposite tube. This is proved because the oil is less heavy than the water and for this reason it remains above the water, and its heaviness united in the same tube with the heaviness of the water that lies beneath it makes itself equal to the weight of the water that is united to it as a counterweight in the opposite tube. But since it is said that oil is less heavy than water it is necessary, if one should desire to create an equivalent to the weight of the water that is lacking beneath it, that there should be a greater quantity than of this water that is lacking, and that as a consequence it occupies more space in this tube than an equivalent weight of water would have occupied; and therefore the surface of the oil in its tube is higher than the surface of the water in the opposite tube, and the surface of the water that is beneath the oil is lower than the surface of the water opposite. E 74 V.

OF THE DESCENT OF HEAVY BODIES

Of heavy bodies which are not flexible and are of equal weight one with another, there will be the same proportion between the speed of their descent as is that of their uniform bulk.

Whether the air which clothes bodies with itself moves together with these bodies.

The air that clothes bodies with itself moves together with these bodies: this experience shows us when the horse runs along dusty roads.

Whether the movement of the air is as swift as its mover.

The air will never have swiftness equal to that of its mover; and this is shown us by the movements of the dust that I have already mentioned which follows the course of the horse, for after having moved a very short distance it turns back with an eddying movement and thereby consumes its impetus. E 80 r.

[*Of movement*]

First: If a power move a body through a certain space in a certain time the same power will move the half the body in the same time twice the space. Second: Or the same virtue will move the half of this

body through this whole space in half this time. Third (as Second). Fourth: And the half of this virtue will move the half of this body through all this space in the same time. Fifth: And this virtue will move twice this movable body through the whole of this space in twice this time, and a thousand times this movable body through the whole of this space in a thousand such periods of time. Sixth: And the half of this virtue will move this whole body through half of this space in this whole time, and a hundred times this body through the hundredth part of this space in the same time. Seventh: And if separate virtues move two separate movable things though a given space in a given time, the same virtues united will move the same bodies united through this same space in this same time, because in this case the first proportions remain always the same. F 26 r.

OF THE MOVEMENT OF THE AIR ENCLOSED BENEATH THE WATER

Whether the air escapes from beneath the water by its nature or through its being pressed and driven by the water.

The reply is that since a heavy substance cannot be supported by a light one this heavy substance will proceed to fall and seek what may support it, because every natural action seeks to be at rest; consequently that water which surrounds this air above, on the sides and below finds itself all spread against the air enclosed by it, and all that which is above *d e n m*, pushes this air downwards, and would keep it below itself if it were not that the laterals *a b e f* and *a b c d* which surround this air and rest upon its sides came to be a more preponderant weight than the water which is above it; consequently this air escapes by the angles *n m* either on one side or on the other, and goes winding as it rises.

As much force is exerted when an object is moved against the motionless air as when the air is moved against a motionless object.

I have seen movements of the air so violent as to carry away and strew in their course immense forest trees and whole roofs of great palaces; and I have seen this same fury with its whirling movement bore a hole in and hollow out a bank of shingle and carry away in the air gravel, sand and water for more than half a mile.

The same weight will be sustained in the air without movement, if falling there with slanting movement, it is able afterwards to raise itself up very high with a reflex movement.　　　　F 37 V.

How much air is required to raise various heavy objects of different material?

How much water entering into the boat will cause it to sink?

Which air supports more [?less]? That enclosed or rarefied as is the case in cupping glasses? Or in its natural state? Or when compressed, as it is in balls which are inflated by the force of a screw? There can be no doubt that it is the rarefied, then that in its natural state, and the compressed air resists least [?most].

Each part of the volume of the water which falls from the river through the air follows the line in which the impetus was commenced which led it to this fall.　　　　F 47 V.

[*Movement of liquids*]

The natural movements of liquids in the air are swifter and more diffused at the end than at the beginning.

The seminatural movements made by the water between the bed of the river and the air will be of equal speed if the bed of this river is straight and equal in slant and breadth.

The accidental movements made within the air become slower at every stage of height.

The semiaccidental movements made between the bed of the canal and the air upon a bed of uniform slant and width always tend to become slower, but are longer than the simple-accidental because they proceed to support themselves and always lighten themselves of part of their weight.　　　　F 50 V.

First. If a power move a body a certain space in a certain time the same power will move the half of this body in the same time twice this space.

Second. If any force move any movable thing through a certain space in a certain time the same force will move the half of this movable thing through the whole of this space in half this time.

Third. If a force move a body in a certain time a certain space the

same force will move the half of this body in the same time the half of this space.

[Fourth?] If a force move a body in a certain time a certain space it is not necessary that this power move twice this weight in twice the time twice this space, because it might be that this force would not be sufficient to move this movable thing.

[Fifth?] If a force move a body in a particular time a particular space it is not necessary that the half of this force move this same movable body in the same time the half of this space for perhaps it would not be able to move it.

Sixth. If two separate forces move two separate movable things the same forces united will move in the same time the two movable things joined together for the same space because there remains still the same proportion. F 51 v.

Fourth. If a power move a body in a particular time a particular space half the force will move in the same time half the movable thing half this space.

If every movable thing pursues its movement along the line of its commencement what is it that causes the movement of the arrow or thunderbolt to swerve and bend in so many directions whilst still in the air?

What has been said may spring from two causes one of which is that the air which is compressed before the fury of its onset offers resistance to it, and consequently this movement becomes bent and assumes the nature of a reflex movement though it does not proceed in straight lines. Its action is as in the third of the fifth concerning water, where it is shown how sometimes the air issuing out of the beds of the swamps in the form of bubbles comes to the surface of the water with sinuous curving movement. The second manner of sinuous movement of the flash of lightning may arise from the fact that the substance of the thunderbolt discharges itself now to the right and now to the left, now upwards and now downwards, acting in the same way as the spark that leaps from the lighted coal; for if the coal exhales gas from one of its sides it becomes disintegrated by the damp spreading within it and bursting into flame separates these pieces of coal and produces another spark, which at its birth strikes against the rest and drives it

back; and this then does the same again in different directions throwing out a succession of sparks into the air until it is itself consumed. But to me the first explanation pleases most because if the second were true you would see that a single thunderbolt would produce many just as this spark does. F 52 r.

CONCERNING THE LOCAL MOVEMENT OF FLEXIBLE DRY THINGS SUCH AS DUST AND THE LIKE

I say that when a table is struck in different places the dust that is upon it is reduced to various shapes of mounds and tiny hillocks—and this arises from . . .

The dust which when the table is struck is divided into various hillocks descends from the hypotenuse of these hillocks, enters beneath their base and raises itself again round the axis of the point of the hillock, and so moves as to seem a right-angled triangle; and this arises from . . .

When the dusty table is struck at one side observe the manner in which the movement of the dust commences to create the aforesaid hillocks, and how this dust rises to the top of the hillock. F 61 r.

MOVABLE THINGS IN THE AIR

The movement of the air is less in front of the movable thing that penetrates through it than it is behind this movable thing.

The air that fills the void which the movable thing leaves of itself as it penetrates through this air has its whole mass of equal speed to that possessed by this movable thing; but the parts of this air because it is of the nature of a vortex, that is with circling movement in the form of eddies, is much swifter in itself than the movement of the aforesaid movable thing.

Here it seems that because the movable thing has more swiftness of air behind it than in front this air is the cause of the movement of this movable thing, and by the seventh this cannot be.

No movable thing is ever swifter than the swiftness of the power which moves it.

The wave that the air makes before the movable thing which pene-

trates it does not pass almost in front of this movable thing, because this would be contrary to the seventh, the last but one.

The air behind the movable thing turns back revolving in those parts which border on that which flows behind the movable thing.

The air that flows behind the moveable thing which wanders through it is moved by the impetus afforded it by this movable thing; and striking with its great expanding wave upon the other air it turns back, and with a great revolving movement which grows less at its extremities it finally comes to stop and does not follow this movable thing. F 74 r.

WHY THE MOVABLE THING FOLLOWS THE MOVEMENT COMMENCED BY ITS MOVER

No impulse can end immediately but proceeds to consume itself through stages of movement.

The air which was at first behind the hole made by the movable thing in the air accompanies this movable thing only a little way, according to the eighth.

Eighth. The air which successively surrounds the movable thing that is moving through it makes divers movements in itself. This is seen in the atoms that are found in the sphere of the sun when they penetrate through some window into a dark place. If among these atoms one throws a stone in the length of the solar ray one sees the atoms range themselves about the position where the course taken in this air by the movable thing was filled by the air, as is proved in the fifth.

Fifth. Nothing that is not provided with power of sensation moves of itself, but its movement is made by others; and the movement produced acts very briefly in the time and in the space that necessity gives, *as is shown in the fourth.*[1]

Fourth. The air which moves to fill up the vacuum made in it by the movable thing has in itself varying degrees of speed density and movement. F 74 v.

Every movable thing that creates a reflex action ends it course in the line of its incidence.

[1] Words crossed out in MS.

This happens because the movement of its incidence is of greater power than the reflex movement and that which is more powerful has more duration than the less powerful.

The movement of incidence of the movable thing will be more powerful than its reflex movement, because the percussion of the incidence made upon the dense object diminishes in part the impetus united to this movable object, and this diminution does not leave this reflex movement as powerful as it has been said the movement of incidence is. In every stage of movement however the impetus of the movable thing is diminished of itself apart from its percussion with a dense object, and it does not follow that this percussion will not lessen it much more, seeing that if you measure the movement which this movable thing would have made without incidence and the movements produced by many bounds up and down, you will find that the continuous movement in the same spot will be longer than that which is frequently broken by the incidences, even though the beginnings of the impetus in each of them were of equal power one with another. F 75 v.

The more deeply an object is sunk in water the less is it moved by the wind which strikes the part of it that is above the water. This is contrary to Battista Alberti who gives a general rule of how much the wind drives a ship in an hour. F 82 r.

The very rapid friction of two thick bodies produce fire. F 85 v.

An object that has its sides set slantwise in the middle of the course of the water, although the water strikes upon its smooth side, will go in greater bulk towards the side of the slant that is lower.

OF THE AIR

And because as is proved in the seventh, it is not alien to the nature of the air to become compressed and rarefied almost in a moment,— and this is not found possible with water, which keeps its first form,— it is therefore easier for the air at the side of and above the movable thing to descend there in order to fill the vacuum of itself left by this movable thing above itself, than for the air beneath to bend and move

in a long curving line in order to fill up this vacuum; and this is also impossible by the eighth, which proves that every impetus moves this air with it along the line in which this impetus is created, as the wind which moves as much air as its impetus moves, as is seen with the dust stirred by these winds or with the atoms floating in the sun's rays when they are blown about by it. So therefore the air, being driven by the impetus of the heavy substance which descends there, flies by the line of the movement made by its mover, that at the side becomes changed into lateral eddies, and the upper air descends there from above, always filling up the vacuum that the movable thing leaves above of itself at each stage of its movement.

The air below the movable thing which descends through it becomes dense and above it becomes rarefied. F 87 r.

The movement that the air makes in the air compresses itself and the air that it strikes.

Air moved in a body that is thicker than itself compresses itself more than when it moves in other air.

Air moved within a body lighter than itself becomes rarefied.

Water moved within a body lighter than itself comes to be rarefied not in its quality but in the quantity of its dispersion and extension.
 F 88 r.

Of the proportion that the movement of water has which is poured out of the bottom of a very long trench, the exit of which is a hundred times narrower than the breadth and depth of the trench:

It may be asked how much slower will be the movement of the water in the upper part of the trench than the movement of the 'rozza' which is formed of the same breadth as the mouth by which the water issues from the trench. F 95 r.

I have learnt from percussion that the falling movement exceeds the reflex movement. G I r.

OF THE SCIENCE OF WEIGHTS [*with diagram*]

The heavy object which descends freely does not give its weight to any support. This may be proved: *a* is one and *b* is two; it follows that

m supports only two because the excess that *b* which is two has over one is one. And this one finding no resistance in *a* descends freely, for it has no support and not having any support does not have its movement impeded. Therefore *m* the extremity of the balance is not sensible of this excess because that which falls is not supported. G 13 V.

OF THE NATURE OF THE CORDS PLACED IN THE TACKLES

The cords of the tackles will be broken in the contact of the cord of the motive power with the first pulley. This is proved by the ninth of this which says: 'The cords in the tackles which descend always undergo greater strain than those that rise'. And 'Of the cords that descend the last feels less of the force of the motive power than the first'. And 'The cords of the tackles feel more weight in proportion as they are swifter: of the cords that move within the tackles the last is swifter than any of the others.'

QUESTION OF THE WEIGHTS DESCENDING

The question is whether the weights descending in the pulleys give more or less of their weight to the pivots of the tackles as they descend than when they are stationary. G 17 V.

OF THE DIFFERENCES THAT THERE ARE BETWEEN FORCE AND WEIGHT, AND FIRST OF FORCE

Of the spring and counterpoise of equal powers it is always the spring which is worth more, seeing that its power is pyramidal; and its greatest power is at the commencement of its movement. But the counterpoise has a compound power, one part of which is cylindrical and the other pyramidal. The cylindrical is such that the weight is always equal in itself and draws with an equal power both at the beginning of the movement and at the end. But the pyramidal commences in an instant and at a point, and with each degree of movement and of time it acquires volume and speed, its movement being free and swift. But in the slow movement made by the heavy substance the pyramidal power ceases and there only remains the cylindrical

power, which as has been said is worth at the beginning as much as it may be worth at the middle or at the end or in any other part of its movement. G 30 r.

CONCERNING WEIGHTS

If the angle formed by the meeting of two slanting cords which descend to the point of suspension of a heavy body is divided by the centre line of the heavy body, this angle is divided into two parts which will have the same proportion between them as that in which the said heavy body is divided within the two cords.

If the angle formed by the meeting of the two cords that descend to the point of suspension of a heavy body is divided by the intercentric line which passes through this heavy body, this angle is then divided into two other angles, between which there is the same proportion as that from base to base and from angle to angle, and equally from whole triangle to whole triangle; and these proportions resemble those of the weights which the heavy body gives of itself to its supports.

G 39 v.

The staff most uniform in thickness bends with the most perfect curve. G 45 r.

OF THE MOVEMENT OF SHIPS [*Drawings*] b a, d c, f e

These three ships of uniform breadth, length and depth when propelled by equal powers will have different speed of movement; for the ship that presents its widest part in front is swifter, and it resembles the shape of birds and fishes such as the mullet. And this ship opens with its side and in front of it a great quantity of water, which afterwards with its revolutions presses against the last two thirds of the ship. The ship *d c* does the opposite, and *f e* has a movement midway between the two aforesaid. G 50 v.

OF A MOVABLE THING NOT OF UNIFORM WEIGHT
MOVING IN AIR OR WATER

In movable things uniform in substance but not of uniform weight the heaviest part always serves as a guide.

The pyramidal weight uniformly irregular in size which is pushed by the bow with the point forward will turn its base immediately towards the place where the whole is moved. G 51 r.

OF THE MOVEMENT OF THE MOVABLE THING

An arrow shot from the prow of a ship in the direction in which the ship is moving will not appear to stir from the place at which it was shot if the ship's movement be equal to that of the arrow.

But if the arrow from such a ship be shot in the direction from whence it is going away with the above-mentioned rate of speed this arrow will be separated from the ship with twice its movement.

G 54 r.

Of the movement of the movable thing which glides with continuous movement over a movable spot or which being movable flows away.

The movement of the liquid which flows through the bottom of the movable vessel will be in a straight line situated slantwise, the slant being at a greater or less angle according as the movement of the vessel is swifter or slower.

Of the movement made by the place that receives the thing poured out from the vessel.

There is as much force necessary to receive upon the moving place the thing which is poured from the immovable vessel as there is to move the vessel which causes the thing to pour upon an immovable place.

But if the movement of the vessel that pours equals the movement of the place which receives upon it the thing that is poured the movement of the thing that descends is a slanting straight line, as is shown above.

OF THE MOVEMENT OF THE ARROW DRIVEN BY THE BOW

The arrow shot from the centre of the earth to the highest part of the elements will ascend and descend by the same straight line although the elements may be in a movement of circumvolution round their centre.

The gravity which descends through the elements when they are in circumvolution always has its movement to correspond to the direction of the line that extends from the commencing point of the movement towards the centre of the world. G 54 V.

OF THE MOVEMENT OF THE MOVABLE THING

Of the heavy substance descending through the air, the elements that revolve making their entire revolution in twenty-four hours:

The moving substance that descends from the uppermost part of the sphere of fire will make a straight movement as far as the earth although the elements are in perpetual revolving movement round the centre of the world. This is proved:—let b be the heavy substance which descends through the elements which moves from a to descend to the centre of the world m; I say that such heavy substance, although it may make a curved descent in the form of a spiral line, will never deviate from its rectilinear descent by which it advances continually between the place from whence it is separated and the centre of the world; for if it were parted from the point a and descended to b, during the time in which it has descended to b it has been carried to d, the position of the a has become changed to c, and so the movable thing finds itself in the [line of] direction that extends between c and the centre of the world m. If the movable thing descends from d to f, the beginning of the movement moves in the same time from c to f, and if f descends to h it turns at g, and so in twenty-four hours the movable thing drops to the earth below the place from which it was first separated, and such a movement is composite.

If the movable thing descends from the highest to the lowest part of the elements in twenty-four hours its movement is formed of straight and curve. I say straight because it will never deviate from the very short line which extends from the place from which it is separated to the centre of the elements, and it will stop at the lowest extremity of such line of direction, which is always found according to the zenith beneath the place from whence this movable thing is separated. And this movement is curved in itself in all the parts of the line and as a consequence at the end it is curved in all the line. And

from this it comes about that the stone thrown from a tower does not strike the side of the tower before reaching the ground. G 55 r.

OF SIMPLE IMPETUS

Simple impetus is that which moves the arrow or the dart through the air.

Compound impetus is that which moves the stone when it issues from the sling, and this impetus is not of long duration because the noise produced by the revolving movement of the movable thing reveals to us that this movable thing meets with resistance in the air that it penetrates. G 72 v.

OF IMPETUS

Impetus is the impression of movement transmitted by the mover to the movable thing.

Impetus is a power impressed by the mover on the movable thing.

Every impression tends to permanence or desires permanence.

This is proved in the impression made by the sun in the eye of the spectator and in the impression of the sound made by the clapper as it strikes the bell.

Every impression desires permanence as is shown by the image of the movement impressed upon the movable thing. G 73 r.

OF PERCUSSION

The air that is compressed beneath the movable thing as it descends through it in a slanting position flees more from the upper than from the lower part of this movable thing.

Continuous tracts of air are as much rarefied on the one side as they are compressed on the other.

The rarefied part of the air offers so much less resistance as the compressed part offers more resistance. Therefore the back part of the movable thing, *b*, will descend with greater impetus than its front part, and this is the reason why the front *a* which at the outset was below, at the end of the reflex movement is raised up. G 73 v.

OF THE DESCENT OF THE HEAVY BODY

Every natural action is made in the shortest way: this is why the free descent of the heavy body is made towards the centre of the world because it is the shortest space between the movable thing and the lowest depth of the universe. G 75 r.

OF WEIGHT

Every heavy substance when it moves horizontally has only weight in the line of its movement. This is shown by the first part of the movement made by the ball from a mortar, this movement being in a horizontal direction.

But the heavy substance floating in the wind in any direction will have so much more or less gravity round the front than in the beam of the balance, according as the junction of the pendulum of the weight with the arm of the balance is nearer to a right angle.

The revolving movement made rapidly by the weight round the fixed point of its axis will have so much more heaviness in this weight as this revolving movement is more rapid. G 77 r.

OF THE WEIGHT OF THE BEAM OF THE BALANCE

The weight that the beam of the balance has is divided in two parts, of which one tends towards the centre of the world and the other is accidental, because it moves by transverse movement. But the first, which casts its weight towards the centre of the world, has equal lateral weights on either side, and these fix in accordance with their centres of gravity and their distances the mathematical centre of this balance. The second mathematical centre may rather be termed the point of mathematical contact of the pole of the balance with its support, and this is away from the centre of the natural gravity of the balance by as much space as the upper part of this balance exceeds the lower part in weight; for which reason the transverse weight of this balance does not of itself give weight to either of the two above-mentioned centres; and this is proved in the sixth of this which says: —'Every parallel body of uniform thickness and weight placed slant-

wise has in it two divided gravities of which the one tends towards the centre of the world and the other is transverse.' But the one is natural and simple and the other accidental and compound.

But if such body situated in such a way has a free descent in the air the centres of the two gravities will become transformed one into the other during some period of movement; and at the end there will remain one single centre common to all the heavy substance that descends; and thus with straight movement it will penetrate all the air that is below it. G 79 V.

WHAT IS IMPETUS

Impetus is that which under another name is termed derived movement, which arises out of primary movement, that is to say when the movable thing is joined to its mover.

In no part of the derived movement will one ever find a velocity equal to that of the primary movement. This is proved, because at every stage of movement as with the cord of the bow there is a loss of the acquired power which has been communicated to it by its mover. And because every effect partakes of its cause the derived movement of the arrow goes lessening its power by degrees, and thus participates in the power of the bow which as it was produced by degrees is so destroyed.

The impetus impressed by the mover on the movable thing is infused in all the united parts of this movable thing.

And this is shown because all the parts both those internal and those of the surface are of equal movement except as regards the movement of circumvolution, for in this the more impetuous part always revolves round the less impetuous, that is those which are nearer the centre of the movable thing. And the part that was first moved always remains more distant from the beginning of its movement if it is not checked, and this is admitted because it is more potent in its capacity to revolve.

And if one were to say with the adversary that the impetus which moves the movable thing is in the air that surrounds it from the middle backwards, one would deny this, because the air that follows the movable thing is drawn by the movable thing to fill the void left by it, and because also the air that is compressed before the movable thing escapes backwards in the opposite direction.

And if the air turns back it is a manifest proof that it strikes against that which the movable thing draws behind it; and when two things collide the reflex movement of each starts, and these reflex movements are converted into whirling movements which are carried by the air that fills up the vacuum left by the movable body, and it is impossible for the movement of the mover to be increased by the movement of the movable body in the same time, because the mover is always more powerful than the movable thing. G 85 v.

OF MOVEMENT AND OF THE MOVABLE THING

Which will remove the same movable thing a farther distance, a great power with a small movement or a lesser power with a greater movement?

The derived movement made by the same movable thing will be of greater length which has a greater primary movement from the same mover.

This is proved because experience shows us that the same power always has such proportion between its primary movement and the derived movement of its movable thing which . . .

It is proved by the fifth of this which says:—between the various lengths of the primary movement one will find that the various lengths of the derived movement of the same movable thing are in the same proportions as their primary movements, because if the power of the same mover separates the movable thing from itself a space of a finger in one interval of harmonic time, the same power in two intervals of harmonic time will separate the same movable thing twice the same finger's space from itself. And this arises from the fact that the derived movement always has the same proportion as the primary movement.

The impetus is not always produced in the movable thing because not even the mover has always an impetuous movement.

As is shown by the light chariot drawn by oxen over a level tract, for so soon as the oxen end their movement the movement of the chariot is ended. G 86 r.

OF THE FIVE DIRECTIONS OF MOVEMENT

There are five varieties of local movements of which the first is upwards, the second downwards, the third in a horizontal direction, the fourth slanting upwards and the fifth and last slanting downwards.

How the impetus of movable things joined by a cord passes from one movable thing to the other.

The impetus produced by the movable things joined with a cord each of which is reciprocally the mover, of the other will remove the two movable things to a short distance from their first mover.

When of two movable things joined by their two opposite extremities to the same cord the one is less than the other, the sum of their movement will be less than if these movements were equal to each other.

When the larger of two weights joined to a cord is first in movement, the movement of the two joined together will be greater than if the beginning of the movement had originated with the lesser movable thing. G 86 v.

WHAT IS PRIMARY MOVEMENT

Primary movement is that which is made by the movable thing during the time when it is joined to its mover.

OF DERIVED MOVEMENT

Derived movement is that which the movable thing makes in the air after it is separated from its mover.

Derived movement has its origin in primary movement and it never has swiftness or power equal to the swiftness or power of the said primary movement.

The course of this movable thing will be in conformity with the direction of the course of its mover when all the parts of this movable thing have movement equal to the primary movement of their mover.

If all the parts of the movement made by the part of one whole are of equal movement then this movable thing will not revolve; and this movement will receive the whole power of its mover, and it will ob-

serve the proper length that its movement requires, the weight of the movable thing being proportioned to the power of its mover. G 87 r.

OF TACKLE

The ropes of the tackle share in equal parts the weight that they support.

The power that moves the tackle is pyramidal since it proceeds to delay with uniform lack of uniformity down to the last rope.

And the movement of the ropes of this tackle is pyramidal because it proceeds to delay with uniform lack of uniformity from the first cord to the last.

Therefore the rope feels the power of the mover so much more when it is swifter and so much less when it is slower.

The ropes feel the power of their mover so much the more when they are nearer and so much less when they are farther away.

G 87 v.

OF POWER

The same virtue is so much more powerful as it is more concentrated.

This is the case with heat, percussion, weight, force and many other things. And let us speak first of the heat of the sun which imprints itself in a concave mirror and is reflected by it in pyramidal figure, which pyramid acquires proportionately so much more power as it is more constricted. That is that if the pyramid strikes the object with half its length it contracts half its thickness at its foot; and if it strikes it at ninety-nine hundredths of its length it contracts its base by ninety-nine hundredths and increases by ninety-nine hundredths the heat which this base receives from the above-mentioned heat of the sun or of the fire.

Furthermore the percussion of the pyramidal iron will penetrate the penetrable thing struck by its point to a greater extent according as this point is narrower.

The heavy substance also when constricted in less space is of greater weight because a less quantity of air offers resistance to it. Of movement and force we shall speak elsewhere.

So also such other qualities as sweetness, bitterness, sharpness, roughness do the same as has been stated above; and an example of this is shown when any of these increases in quantity mixing itself with snow or water which neither gives it flavour nor takes it away from it but completely deprives it of power. G 89 v.

The greatest strength of the tackle is in the rope that is joined to its moving power. And the least strength will be in the rope that is joined to one of the tackles.

The weight drawn by the ropes that pass through the tackles is divided in equal parts between the ropes joined to these tackles.

That rope of the tackles will be swifter which is nearer to its mover; it follows that the slowest will be that which is farther away from this mover. G 95 v.

If a man be at the bottom of a well which contains twenty thousand braccia of water he will not be conscious of any weight. H 49 [1] v.

Why the movement made by the sieve collects together at the top all the lightest parts? And it is the same with the dredger when one searches for gold in the Ticino by means of a blow, and also with the sweepings of the goldsmith's workshop when they are washed.

H 52 [4] v.

If the part of any substance in the air is greater than that in the water its movement will follow the course of the air. H 59 [11] v.

A straight movement transformed into another without rebound loses its power.

The natural movement will impart the greatest blow which maintains in a straight line the course it has begun. H 61 [13] r.

Such part of water as is in contact with the air will move according to the course of this air although the water upon the bottom move in a contrary direction. H 61 [13] v.

Water which descends from a wide expanse by a straight channel will intersect at its entry from right to left.

And after its entry the part in the centre of the channel will be higher than all the rest of the expanse.

In such another course made by the water in its channel the part of the centre will be lower than the rest of the expanse.

As it follows the same space the depression in the centre changes to a greater height. H 62 [14] r.

The blow is more powerful than the movement and where it is the blow of the water every obstacle is removed: then when the movement is afterwards created it carries with it all the gravity occasioned by the blow and discharges it in the blow made by the rebound, and so from rebound to rebound the force of the violent movement diminishes. Consequently the heaviest of the stones are deposited and not being able to be borne along by the feeble movements which follow they remain there; and the last things which are at the furthest distance from the point at which they started are the lightest things.

H 62 [14] v.

Water that falls nearest the perpendicular has the least power to drive big gravel before it. H 66 [18] r.

All violent movements grow feebler the more they are separated from their cause. H 77 [29] v.

In proportion as the natural movement is separated from its cause it becomes more rapid. H 78 [30] r.

The weight which is at the greatest distance from the perpendicular of its support weighs less. H 80 [32] v.

That part of the blow produced by a continuing cause will be so much the more powerful as it is more distant from the cause of its movement. H 81 [33] v.

[*Weight and Water*]

As much weight of water will escape from its position as the sum of the weight that drives this water.

The weight supported on the water will be as great as the sum of the weight of the water which gives place to these weights.

H 92 [44] r.

The centre of every weight rests under the centre of its support.

H 105 [38 v.] r.

OF MOVEMENT AND PERCUSSION

If someone descends from one step to another by jumping from one to the other and then you add together all the forces of the percussions and the weights of these jumps, you will find that they are equal to the entire percussion and weight that such a man would produce if he fell by a perpendicular line from the top to the bottom of the height of this staircase.

Furthermore if this man were to fall from a height, striking stage by stage upon objects which would bend in the manner of a spring, in such a way that the percussion from the one to the other was slight, you will find that at the last part of his descent this man will have his percussion as much diminished by comparison with what it would have been in a free and perpendicular line, as it would be if there were taken from it all the percussions joined together which were given at each stage of the said descent upon the aforesaid springs. I 14 v.

Pagolo says that no instrument that moves another instrument in contact with it can avoid being moved by it. So if the wheel moves its pinion the pinion will also move this wheel. But such a thing is not general, for though the cog n moves the wheel the wheel will not move the cog n turned against the ground.

The line of the movement made by the course of two objects that strike which does not bend in meeting with the first object is that which strikes the second object more with its reflex movement; and so that will act conversely which bends more in its impact with the first object. I 28 r.

That body which when moved strikes the first object with a greater blow consumes more of its impetus in the percussion, with result that the blow made by the reflex movement will be weaker. And the line of the movement which does not bend at all at its first percussion strikes the second object most. I 28 v.

The leap is always smaller than the descent made by the thing which leaps; and this leap is termed reflex movement, which is always weaker than the straight movement. I 43 v.

[The knife-grinder's wheel]

The pole is worn most on the course in which its mover exerts the greatest force; as is shown by the knife-grinders who go through the cities.

Every pole becomes worn on the side in which its mover applies most force. See a man sharpening knives by turning a wheel with his feet: as he drives his foot down he starts the force which then produces the movement of an entire revolution. One understands clearly that in proportion as this movement is farther removed from its cause it becomes slower and wears away its support less; and each time that the movement is repeated the pressure of the feet renews it with fresh impetus, and again under this impetus the support is consumed, and so it comes about that the pole is worn unequally. 1 45 r.

[Movement—falling and reflex]

I ask whether the movement made by the stone in a continuous line is equal to that movement which is in a reflex line, that is before the rebound and after the rebound. 1 61 [13] r.

OF MOVEMENT

For what reason the mortar does not follow the rule of the carbine: If for a ball that weighs an ounce there be allowed an ounce of powder with which this ball is shot a mile, then the ball constantly increasing in the same substance with each degree of weight, one gives it a proportionate quantity of powder up to a thousand pounds, and increases the size of the machine so that it always takes forty balls, that is to forty times the thickness of this ball, the metal being always half the thickness of this ball; then the carbine increasing in volume in all its particulars from a ball of an ounce to one of a thousand pounds, you will find that the more the ball weighs the farther it travels.

1 84 [36] v.

The movement made by the arm in throwing the stone is twofold; for when the elbow goes forward and the fist with the stone turns back with a circling movement and then goes forward and drops its stone with a sudden stoppage of the arm, this stoppage by its suddenness is followed by a recoil, and produces the effect of percussion in the

air; consequently the movement is much greater than if one were to move the arm in one action and it followed a circular movement in leaving the stone.

OF PERCUSSION

Why the short mortar makes a louder explosion when fired than the long one, as one hears it in drawing the breeches of the small cannon.

1 85 [37] r.

The movement made by the cord is much more rapid near the beginning than near the end. Consequently we may say that as the arrow follows the nature of the greatest movement of the power that drives it, when such power diminishes the arrow is already separated from the cord, and the percussion made by the arms of the cross-bow upon the cord that holds it is made after the departure of the arrow, and therefore this percussion does not increase the movement of this arrow.

1 85 [37] v.

MOVEMENT INCREASED BY IMPETUS AND WEIGHT

This movement is at first increased by impetus, because the more the stone which produces it falls the more speed and gravity it acquires; secondly the more the cord that is unrolled from the part of the circle is unrolled the more distant it becomes from the centre of the movement; consequently the more distant it becomes the more it acquires weight and impetus. 1 91 [43] v.

There are some movements of moving things which continue their direction while receiving percussion in the middle of this movement, and these are of great force.

I ask why field-lances or hunting-whips have a greater movement that the arm. I say that this happens because the hand describes a much wider circle as the arm moves than does the elbow; and in consequence moving at the same time the hand covers twice as much space as does the elbow, and therefore it may be said to be of a speed double that of the movement of the elbow and so it sends things when thrown a greater distance from itself.

Thus you see clearly that the circuit described by the elbow is less by half and its speed is slower by half.

It is true that if one takes from the movement made by the hand an amount equal to that made by the elbow they become of equal slowness. I 99 [51] v.

If the stone moved by the power of its engine follows in the beginning of its movement the greatest power and speed of its mover, why does it not follow this same equality of the first movement without waiting for it to separate as it reduces its speed? If however it should separate immediately what does it profit it to be closely attended by such power? I 100 [52] r.

The power that moves which accompanies the movable thing farthest will cause it to move farthest from the boundary where it is separated from it.

It is almost universally the case that everything which is the cause of movements decreases its power before it separates itself from the thing moved by it.

The mortar only increases its force because in the longer movement which the ball makes in its body more powder is ignited, for it must needs be admitted that this setting on fire occupies a divisible period of time; and the more periods of time it lasts the more powder is ignited, the more the fire is driven through this machine, and the greater the impetus and fury with which it expels the ball.

One asks with regard to the same course of the mover whether it removes the thing moved farthest if it commences with slow movement and continually increases the impetus, or if it commences quickly and then proceeds to slacken, or if it goes at an even pace.
 I 100 [52] v.

I ask whether if two movable things equal in shape weight and substance are of double speed their course will be double the one of the other or no?

Because one sees bows and cross-bows with long arms that have a long and slow range and one sees cross-bows with short thick arms that have a rapid and short range; the percussions of the short make a quick passage in the third part of their movement and the long make a slower one.

In the consideration of this it is necessary to take into account all the mathematical forces; seeing that in the case of these cross-bows there are at work different causes which produce many different effects, for there are found among them some with a great ascent, some with a short one, some long and thin and some fat and short, some wide and some narrow: so they proceed to vary in shape and in power in many different ways. I 101 [53] r.

MOVEMENT AND WEIGHT. BALLS SHOT FROM MORTARS

To test the residuum of power of the things that move and draw the weights by giving them a greater or a less weight see what is the weight which is most distant from its mover.

And let it always be round in shape and of uniform substance, and the balance *m n* should have its arms of equal length and weight, and the centre of the weight which strikes the centre of the movable weight should be always raised to the , and moreover when you have found a weight which recedes more from the beginning of the movement going as rapidly as possible by way of percussion and you reproduce it with a simple weight without percussion, you will be able to discern what difference there is between the causes of the movements when they are due to weight and when merely to percussion. And so with regard to this weight you will proceed to change the things that it moves until you find a weight which is proportionate to the power of this mover, that is the ball which is propelled as far as possible from its motive power. Then weigh one movable thing and the other, and consider the distances where they have been moved, and you will be able to deduce with accuracy the general rule between these two powers.

Then diminish the movable thing by half as those agree to do who have written upon proportions, and you will see that it cannot be that the half less weight will be moved twice as quickly by the same power, that is to say that if it was twice as swift it would go twice as far because the proportion of the movements is as that of the speeds. And if some have said that the more the movable thing is diminished the more rapidly its mover drives it in proportion to its diminution on to infinity, constantly acquiring speed of movement; it would follow that

an atom would be almost as rapid as thought itself, or as the eye which roves in an instant to the height of the stars; and as a consequence its journey would be infinite, because the thing which can diminish infinitely would increase infinitely in swiftness and traverse an infinite distance, because every continuous quantity is divisible to infinity. This opinion however is condemned by reason and also by experience.

It would follow also that if the mortar throws its ball three miles from itself in twenty divisions of musical or harmonic time with a hundred pounds of powder and a thousand balls, that taking a pound of balls it would make with the said powder . . . in the same time. Work by the rule of three, saying if a thousand pounds of stone are thrown to me in two divisions of time, you keeping in imagination the three thousand, saying also if a thousand pounds of balls are thrown to me, at the said distance in twenty divisions of time, in how many divisions of time will the same power throw me a pound of balls. And reckon if a thousand give me twenty what will give me one: and you will find that it will give you $^{2}\%_{1000}$ divisions of time which make about $\frac{1}{50}$ of time. Now if one shoots with powder the weight of a small grain, the experiment will not send the ball farther than the mortar sends its smoke when one begins to fire, and by this reasoning it would be sent a million miles in the time when the thousand pounds of balls go three miles. You investigators therefore should not trust yourselves to the authors who by employing only their imagination have wished to make themselves interpreters between nature and man, but only [to the guidance] of those who have exercised their intellects not with the signs of nature but with the results of their experiments.

<div align="center">I 102 [54] r. and v., 103 [55] r. and v.</div>

OF MOVEMENT. A MAN JUMPING

The heavier the thing the more power attends its movement.

This is seen with jumpers who have their feet joined, who in order to make a greater jump throw back their clenched hands and then move them forward violently as they take off for the jump, finding that by this movement the jump becomes greater.

And there are many who to increase this jump take two heavy stones

in their two hands and use them for the same purpose as they used to use their fists; their leap becomes much greater. 1 104 [56] v.

If a weight falling a distance of ten braccia buries itself a span in the earth how far will it bury itself when it falls two braccia?

1 110 [62] v.

OF MOVEMENT

Albert of Saxony[1] in his 'De Proportione' says that if a power moves a movable thing with a certain speed it will move the half of this movable thing twice as swiftly. This does not appear so to me, for the reason that he does not take into account that this power exerts its ultimate force, and unless it did this, the thing which weighed less would not be in proportion to the force of the mover or of the medium through which it has passed. Consequently it would be a thing floating in the wind and not in straight movement, and it would go less far.

1 120 [72] r.

[*Notes*]

I ask in what part of its curving movement will the cause that moves leave the thing moved or movable.

Speak with Pietro Monti of these ways of throwing spears.

1 120 [72] v.

OF MOVEMENT IN GENERAL

What is the cause of movement. What movement is in itself. What it is which is most adapted for movement. What is impetus; what is the cause of impetus, and of the medium in which it is created. What is percussion; what is its cause. What is rebound. What is the curve of straight movement and its cause.

Aristotle, Third of the Physics, and Albertus [Magnus] and Thomas [Aquinas] and the others upon the rebound, in the Seventh of the Physics, 'De Cœlo et Mundo'. 1 130 [82] v.

[*Weight and movement—experiment*]

There are two balls of the same substance and shape but the one double the other in weight, and I wish to let them fall through two

[1] Albert of Saxony, bishop of Halberstadt (14th century), was a commentator of Aristotle.

tubes so situated that the balls clash together at the end of these tubes. I ask how far each at the beginning of their movement ought to be distant from the meeting of these tubes. I 131 [83] r.

If the stone or the water struck by the movable thing falling upon it follows the reflex movement in the manner that this movable thing would follow by itself after its percussion or no. K I v.

A drop that falls upon a place of uniform density and smoothness will in rebounding scatter its extreme particles in an exact circle; and so conversely . . . K 56 [7] r.

Of movements there are two kinds namely simple and composite.

Of the simple movements none is slower or swifter than the slowness or swiftness of its mover. Composite movements may be either slower or swifter infinitely more so than their mover; and also they may be equal to this mover. K 107 [27] r.

In the case of a stick used to beat with, the slowest movement is in the centre of its length.

When one weight falls to the ground at the same time as another weight, in the percussion which they make the lesser weight leaps into the air. K 107 [27] v.

Nothing movable will ever be swifter than the part of its mover that touches it.

OF THE LEAP OF A MAN

That thing moves more after it is separated from its mover which is moved by a greater power. K 110 [30] r.

Every small movement made by the movable thing surrounded by air maintains itself as it goes by impetus.

A movable thing moved by a slow mover, if it has to move a thing by rubbing it, only moves when joined to its mover. K 111 [31] r.

[*With diagrams*]

Why every substance that possesses gravity either free altogether or in part shows in its whole or in part the natural desire to descend.

The wheel *a b* being fixed in the position that you see, the heavy substance *a* will descend at *b*; and below for this reason the heavy sub-

stance *c* placed above the centre of its axis, will go as near as it can to the centre of the earth; and *m n* does exactly the same below.

L 40 r.

[*Reflex movements*]

The reflex movement will be of greater strength when it is longer.

And that reflex movement will be longer which is produced between more diverse angles.

The reflex movement which is longer is less impeded because it differs little from the movement of percussion, and this percussion has little strength and consequently it loses little of the power of its first mover.

But if the reflex movement is shorter it is a sign that it is more impeded at the place of the percussion, and it differs much from the movement of incidence and consequently the power of the first movement is greatly diminished.

L 42 r.

OF PERCUSSION

The reflex movement will be as much weaker as it is shorter.

That reflex movement will be shorter which is cause by a greater percussion.

That percussion will be of greater power which is made between more equal angles.

Of the percussions made between equal angles that will be of the greater strength which is caused against a more compact object.

And in the percussions made on objects of equal compactness that will be more powerful which has its object of greater resistance.

The spherical body turns so much more in the reflex movement as the percussion is made between the more unequal angles.

L 42 v.

[*Movement—cannonball*]

The smoother the surface of the cannonball the greater the ease with which it will turn in the air as it moves.

In a proposition of this kind one imagines that the cannonball shot from the mortar has to turn itself in the air which it compresses, and if this cannonball is not altogether smooth its curve may occasion difficulty in friction with the air which surrounds it, as I have proved in the fourth concerning frictions.

So when the rebound of this cannonball is made at a more obtuse angle this cannonball will turn more upon itself; and if the ball be lacking in smoothness it will come to fail in speed much more than if it was smooth. L 43 r.

The percussion of each heavy spherical substance will not occasion scars which have between them a proportion resembling that of the slant of the places where they strike.

This proposition would be entirely confirmed by experience if there were not the firm compression of the air driven by the fury of the ball, for this not being of itself swift as is the movement by the mover which drives it becomes compressed, and is the more compressed as it is the more driven. And this is how it comes about that this ball afterwards striking by a line that is not central within the range of the perpendicular [line] *a c* commences the first stage of its slant, and the last ends in the range of the horizontal [line] *a b*. L 43 v. and 44 r.

[*Drawing—ship with sail*]

If the water here were to move as quickly as the air the ship would move like the wind, without a sail; but because the wind is swifter high up than low down therefore the wind has more power on the sail than on the water. L 47 v.

Corn tossed up with a sieve leaps up in the form of a pyramind.

[*Movement, percussion*]

That thing moves more in derived movement which is more accompanied by its mover.

What difference there is between the percussion of the united thing and that which is disunited. L 64 v.

[*Weight and movement*]

If the heavier part of bodies makes itself the guide of their movement, and an arrow be pierced and a portion of quicksilver be placed within it, how will the arrow act and what course will it take on being drawn to a height?

If a lance be made up of pieces arranged together after the manner of an indented box why does it deal a harder blow than a lance formed of a single piece? L 65 v.

RULE OF POWER

If a power move a weight a certain space in a certain time, the half of that power will move that whole body the half of that space in the said time, or all the space in double the time.

Or the whole of that power will move a weight double that first weight half that distance in the same time.

Or it will move the said weight in half the said time half the space.

L 78 v.

Man and every animal undergoes more fatigue in going upwards than downwards, for as he ascends he bears his weight with him and as he descends he simply lets it go. L 84 v.

That body will show itself heaviest which meets with the most feeble resistance, and that heavy body will meet with the most feeble resistance in which the centre is farthest removed from the centre-line of its support. L 85 v.

The centre of every gravity that is suspended stands below the central line of the cord that sustains it.

If from the two equal arms of the balance its two cords proceed, the one being double the other in length, as regards the weight and because these cords meet in the same spot in order to support a weight one cord will feel as much more weight than the other as it is longer than the other. M 37 r.

Gravity suspended to a cord is all in all the length of the cord and all in each of its parts. M 40 v.

Why the flat sand being made up of grains dissimilar in shape and size the water that flows above it drives these grains with different strengths of movement:

Just as the bodies differing in weight and shape make different movements in the still air so do the air and water which move between bodies at rest. And this is the reason why the sand loses its flatness through the movement of the water that passes over it; for the water that is moved over the sand performs the same function as the air that is moved over the water. And if one should prove that the bottom of the flat sand makes its waves and becomes uneven through the uneven-

ness of its granules, and that this unevenness cannot occur on the surface of the water which is smitten and is of uniform body, I maintain that the air is full of parts which have dissimilar movement and therefore there is no uniformity in the movement of the parts moved by the contact of the air. M 41 r.

[Ships—Wind and Sea]

I ask whether the wave—or rather whether the ship travels as fast as the wave that bears it or as fast as the wind that drives, it or whether it shares in both the one movement and the other.

And if the mariner has the current favourable and the wind contrary I know if they are of equal strength the ship remains in its first position. M 41 v.

[Resistance of the air]

a	b	c
1	10	9
2	20	18
3	30	27
4	40	36
5	50	45
n	m	s

The line $c\,s$ represents the movement of the gravity $b\,m$ having taken away the resistance of the air $a\,n$.

The air when devoid of clouds and mist starts thick at its base and at each degree of its height it acquires in the form of a pyramid degrees of thinness, as is shown by the line $n\,a$.

And the weight that descends through this air also in each stage of its movement acquires a degree of speed, although I ought first to say that with every degree of time it acquired a degree of movement more than the degree of the time immediately past. This is why I suppose the degrees of the movement to be ten times as powerful as the degrees of the air that resists; consequently we may say that the said ten degrees if one be taken away for the air which offers partial resistance become nine, and the second twenty degrees entering into the denser air has two taken away so that the twenty becomes eighteen, as is shown by the line $b\,m$. M 43 r.

[*Of weights moving through the air*]

If two equal weights are situated vertically one below the other and allowed to fall at the same time these in long descent will consume their interval and will come to touch.

When the air is without mist or clouds you will find that at every degree of height it will acquire a corresponding degree of thinness. So also inversely every degree lower down it will acquire a degree of density. And this is why if two equal bodies are placed one below the other a braccio's space apart, that is they are attached by a thread and let fall together in a long movement they will touch because the one below always finds itself in thicker air than the one above it; and besides this the first has the hard work of opening the air and making the waves in it; part of this escapes upwards and charging strikes with its reflex movement against the second body, but the rest of the air above runs to fill the vacuum which exists behind this body. M 43 V.

Proof of the proportion of the time and movement together with the speed made in the descent of heavy bodies in the shape of a pyramid, because the aforesaid powers are all pyramidal seeing that they commence in nothing and proceed to increase in degrees of arithmetical proportion.

If you cut the pyramid at any stage of its height by a line equidistant to its base, you will find that whatever proportion there be between the height of this section from its base and the whole height of the pyramid, there will be the same proportion between the breadth of this section and the breadth of the whole base. M 44 r.

This happens in the air of uniform thickness.

The heavy body which descends, at each degree of time acquires a degree of movement more than the degree of the time preceding, and similarly a degree of swiftness greater than the degree of the preceding movement. Therefore at each doubled quantity of time the length of the descent is doubled and also the swiftness of the movement.

It is here shown that whatever the proportion that one quantity of time has with another, the one quantity of movement will have the same with the other and similarly one quantity of swiftness. M 44 v.

[*Weight in the air—increase of speed*]

The heavy body which descends freely with every degree of time

acquires a degree of movement, and with every degree of movement it acquires a degree of speed.

Although the equal division of the movement of time cannot be indicated by degrees as is the movement made by the bodies, nevertheless the necessity of the case constrains me to make degrees after the manner in which they are made among musicians.[1]

Let us say that in the first degree of time it [i.e. the heavy body] acquires a degree of movement and a degree of speed, in the second degree of time it will acquire two degrees of movement and two of speed and so it continues in succession as has been said above.

M 45 r.

[*Waves of the air*]

The wave of the air that is produced by means of a body which moves through this air will be considerably swifter than the body that moves it.

What is set forth above happens because as the body of the air is very volatile and moves very easily when a body moves through it it comes to make the first wave in its first movement, and at the same time that wave cannot be produced without it causing another after it and that another. And so this body moving through the air creates beneath it in each stage of time multiplications of waves, which in their flight prepare the path of movement for the movement of their mover.

The wave of the air forming and reforming itself prepares the way of movement for its mover.

The air which is shut up by force becomes heavier than that which is at liberty.

M 45 v.

[*Weight moving through the air*]

The heavy body which has a free descent with every degree of movement acquires a degree of weight.

This arises out of the second of the first which says that 'that body will be heavier which has less resistance'. In this case of free descent of heavy bodies one sees clearly by the example already cited of the wave of the water, that the air makes the same wave beneath the thing which descends, because it finds itself pushed and drawn from the opposite side, that is that it makes a turning wave which helps to drive it down.

[1] Words crossed out in MS.

Now for these reasons the air which flies in front of the weight that drives it shows clearly that it does not resist it and in consequence does not impede this movement; therefore the greater the descent of the wave which travels more rapidly than the heavy body that moves it, the longer the movement of this heavy body continues; and as the last wave becomes more remote the more it prepares the air which touches the weight to a more facile flight. M 46 r.

[*Density of waves. Weight in the air*]

When waves become divided in minute particles that quantity which above is united and powerful comes to descend to the ground.

Things that fall may be continuous quantities such as staffs, beams and suchlike things, and liquid bodies, although these cease to be continuous when their descent is long.

Others are discontinuous such as stones and other bodies separated the one from the other. Others are neuter as would be the grain from the hopper that turns the mill, sand, and similar quantities of minute bodies of which you may make proof at a great height. And mark what a difference there is between the unity of their exit from the hopper and their density when they arrive at the place of their percussion.

If the air were of uniform thickness at each part of its height the bodies which descend would acquire at each stage of their movement equal degrees of speed. M 46 v.

[*Weight. Movement. Waves of water*]

Now we have found that the discontinuous quantity when moving acquires at each stage of its movement a degree of speed; and so in each stage of harmonic time they acquire a length of space from each other, and this acquisition is in arithmetical proportion.

How then are we to account for the continuous quantity of liquid bodies in their descent, since in each interval of harmonic time it pours out the same weight and at each stage of movement it becomes longer and thinner, so that in a long course it shows itself ending in a point as does the pyramid; consequently such liquid body would not fall to earth, but it would rather be that each great mass of this body would remain in the air even though it should be a very great river which was continually rolling away; and experience shows the contrary; for as much as departs above strikes at the same time below. And if the same

weight of this liquid body makes itself thinner it meets with less resistance from the air and consequently acquires speed; and if by being thinner it has acquired speed this same weight would also for this second reason come to make itself longer and in consequence still thinner and so would descend more rapidly; and this would go on in succession to infinity. Therefore either nature or necessity has brought it about that in whatever manner the descent comes to assume the form of a pyramid, it makes intersection by changing its extremities from right to left and commences to divide itself; and the more it descends the more it divides; and thus with many ramifications it comes to lighten itself and to check its irregular movement.

M 47 r. and v.

[*Weights falling in succession*]

If two bodies of equal weight and the same shape fall one after the other from the same height in each degree of time the one will be a degree more distant than the other. M 48 r.

[*Weight. Increase of speed*]

The heavy thing descending freely gains a degree of speed with every stage of movement.

And the part of the movement which is made in each degree of time is always longer successively, the new one than that which preceded it.

It may be clearly shown that what is set forth above is true, for during the same time that the weight *a* descends at *c*, *b* which finds itself fifteen times swifter than *a* has covered fifteen times as much space in its descent. M 49 r.

[*Balances*]

I wish to make a balance with arms of equal length, of which I wish to make one hanging downwards as is shown in *b c* and which weighs at least four ounces; now I ask how much the arm ought to weigh which is straight and how much larger the one ought to be than the other for it to resist it in a position of equilibrium? M 51 r.

[*Bodies falling in succession*]

If the descent is made by two bodies equal in shape and weight of which one has commenced its movement before the other the proportion of their percussions will be as that of the length of their movements. M 52 r.

[*Proportions and projectiles*]

There will be the same proportion of base with base as there is of side with side and height with height.

You will proceed by the rule of three and you will say if the height of the pyramid which I know for certain to be *s c* gives me a braccio for its base; or if a base of a braccio comes from a pyramid of ten braccia, what will another base of sixty five braccia come from?

There arises here an exception, namely that if a ball first goes up a hundred braccia with an ounce of powder it goes through air of greater thickness than would that which rose three thousand braccia, and consequently as that of the said three thousand braccia has been at each hundred braccia in a region of air that is thinner than that before it, it has always acquired more speed.

I wish to know how much higher one small cannon or carbine throws than another, and to do this I train my instrument according to the line *b c* in a firm manner so that it will not alter its angle of elevation. This done, I shall insert so small a quantity of powder that the ball will only be projected two braccia away from the carbine as *b s*, and I shall note where the ball falls, at *n*, then I shall double the charge of powder and see where it falls at *m*; and if I shall find that the base *m c* is double the base *n c* I shall know that the height of the pyramid *h c* is double that of *s c*. M 53 r.

[*How to lift great weights*]

Great weights ought always to be supported by levers as you see done in order to draw the column out of the barge.

a wedge which of itself supports at *a*.

Wedge. Barge. Windlass.

You will give as many turns with the cord to the column as you wish it to have turns to unroll as you draw it. M 56 v.

[*Fall of heavy bodies*]

If many bodies of similar weight and shape are allowed to fall one after the other at equal spaces of time the excesses of their intervals will be equal to each other.

Demonstration

By the fifth of the first which says how the thing that descends at every stage of movement acquires equal degrees of speed.

Therefore for this reason the movement of the last downward becomes much more rapid than that of the first from the beginning.

And by the eighth of the first which says that: the upper pair will have in their interval the same proportion with the interval of the lower pair as the speed of the lower pair has to that of the upper pair, and so conversely the speed with the distances will be as the distances with the speed.

The experiment of the aforesaid conclusion as to movement ought to be made in this way, that is that one takes two balls of similar weight and shape and causes them to drop from a considerable height in such a way that at the inception of their movement they touch one another and that whoever is making the experiment stations himself on the ground in order to watch whether at the time of their fall they have remained touching each other or no. And this experiment should be made many times so that no accident may occur to hinder or falsify this proof—for the experiment might be false whether it deceived the investigator or no. M 57 r. and v.

OF THE RESISTANCE OF THE AIR

That air will become denser which is pressed upon by a greater weight.

Although b is as thick as a yet as it is twice as heavy it makes the air which flies below it twice as dense, and as it becomes denser below it becomes proportionately thinner above. M 58 r.

[Weight, Percussion, Spring]

That weight will show itself lighter which has a greater volume.

That weight will make a less percussion which strikes in its descent with a part more distant from the central line of its gravity, or with a part that yields against the object as though it were pressing upon a spring, or with a part which yields against the thing that strikes the object with a spring or which jumps upon the point of its feet.

M 59 r.

[*Falls of heavy bodies*]

Explanation of the movement of the separated quantity.

Why the natural movement of heavy things at each stage of its descent acquires a degree of speed.

And for this reason such movement as it acquires power shows itself of pyramidal shape, because the pyramid acquires similarly in each degree of its length a degree of breadth, and so such proportion of acquisition is found in arithmetical proportion because the parts that exceed are always equal. M 59 V.

[*Drawing:—two balls*]

These two figures are double in diameter the one of the other and I wish to know how much the one descends more rapidly than the other.

[*Drawing:—two cubes p q*]

Although *p* is eight times *q* nevertheless it is not swifter in its descent than about the double of *q*, which descent will be spoken of here.

Let us say therefore that *q* is three pounds and that the resistance of the air is a pound; consequently the weight which was three becomes two and consequently of the weight *p* there remains two pounds. So of the four dice below which are three pounds each there remain eight pounds and those above are twelve pounds and this makes twenty containing two ten times and so becoming ten times swifter. M 60 r.

If two balls of equal weight and size are placed at a distance of one braccio one above the other and commence their descent at the same moment, always at each stage of movement the interval between them will be of the same size and will remain as shown at *a b*.

If after the descent of a braccio made by one ball you allow another similar one to fall you will find that at each stage of movement there will be a proportionate change in their speed and force.

It is clearly shown how when the ball has fallen from *a* to *c* it has traversed twice the distance that that ball has which has fallen only from *a* to *b*, and therefore it will be twice as swift and powerful and will bury itself twice as deeply as at *b*, and if when descending or indeed when *a* has descended at *d*, *b* shall find itself at *c*, and the power of *d* will not be more than double that of *c* but will be half as much again. And so when *a* is at *e*, *b* will be at *d* and the power of *d* will be

three quarters that of *e*, then four fifths, then six sevenths and so on
to infinity. м 60 v. and 61 r.

[*Projectiles*]

OF MOVEMENT

I wish to know what weight ought to be that of lead which will drive
a ball of a pound of lead a greater distance from itself than any other
weight which is also of lead, the said movers having also the same
movement.

And I wish to know how far a weight equal to that of lead being of
wood will drive in the same movement from itself the above-mentioned
ball of lead.

Among weights of similar shape that will be driven to a greater dis-
tance by the same power which finds itself smaller in shape.

THE CONVERSE

Among the weights of like shape which are driven by the same
power that which is of greater bulk will be of less movement.

Aristotle says that if a power moves a body a certain distance in a
certain time the same power will move half this body twice the distance
in the same time. Therefore the millionth part of this weight will be
driven by the same power a million times this distance in the same
time; or if this weight was an ounce and it was transported a mile in
a period of time the millionth part would be transported a million
miles in the same period. And if you were to say that the air would
make resistance I maintain that in proportion as this body was less in
weight than an ounce the quantity of air would be less that withstood
its course. м 61 v. and 62 r.

[*Movements and proportions*]

Of the movement made by things proportionately to the power
which drives them.

One ought to make the experiment with a cross-bow or other power
which does not grow weaker, and also with balls of the same shape and
of different substances and weights to test which goes farthest away

from its motive power, and then to test with various shapes of various sizes breadths and lengths and to make a general rule.

OF THE CONVERSE

I wish to know what weight the power will have which shall drive to a greatest distance from itself a weight of a pound spherical in shape.

M 62 v.

OF THE POWER OF THE CROSS-BOW

The weight that charges the cross-bow has the same proportion to the weight of the arrow as the movement of the arrow of this cross-bow has to the movement of its cord.

Here one ought to deduct three resistances made by the air, that is the percussion of the bow of the cross-bow made upon the air, and that of the cord; the third is that made against the arrow. And as the cord is thicker so its arrow encompasses it the less. M 63 r.

[*Of wedges*]

Ordinary wedge, immovable because of the mother (madre).

Wedge in sheath of iron for splitting stones.

The force of the wedge is very great because of the percussion, and it acts with marvellous power in dividing the things united and in uniting those divided, in stamping sculptures of metals in bas-relief, in squeezing out the liquids from the places where they are produced, and in drying things that are moist, as well as in many other things as will be shown when treating of them; although it has the same nature as the screw it surpasses it altogether. M 63 v.

OF WEDGES THAT ARE PERMANENT

Wedges are of two kinds of which one is called 'permanent' and the other 'transitive'. The permanent is that in which when the wedge has entered it cannot turn back, and the other enters and departs according to the necessity of the case.

The axe and the hammer which comes to be mother (madre) of its handle wishes to be large above and narrow below, and their handles

ought to be thick below and narrow above, and then with the permanent wedge one ought to widen it above. m 64 r.

[*Movements of water and of sand*]

I ask where the water leaves the sand ribbed and where smooth, where thick and where thin, where pure and where mingled with various particles of straw-wood and leaves.

Water falls from its heights and where it makes the greatest percussion it removes the things which are heaviest and fitted for resistance; and after this percussion it carries the heaviest things by the current that is greater and swifter, and so conversely it carries the lighter things in the part of the water that is slower and has less power.

m 64 v.

I ask where the water leaves its muddy banks, where mixed with sand and where thin and fine so that it slips away and where mixed with roots and wisps of straw and leaves.

We shall speak of the cause of the movement that the sand makes upon its bed and what carries it off and how it moves and where and how it stops, and also of the small and large stones and how they group themselves when they stop all together and also of every other thing that goes rolling upon its bed. m 65 r.

[*Relations of surfaces*]

If two surfaces of different shapes and equal circumferences touch as one is placed upon the other, if that which touches is of like shape and circumference that which does not touch will be of varying shape and of equal circumference. m 65 v.

[*Movements of water and of sand*]

These waves of the sand are changeable together according to the direction of the river.

The water that is swifter is that which wears away the bed of the rivers most. Hence it comes about how when the sand forms those shells, or after the manner of certain undulations it is seen on the surface of the water, how the sand moved by the greater current of the water becomes more sifted.

How water can flow above by one line and below by another, crosswise; as is shown at *a b* and *c d*. m 66 r.

Conception. Of everything that moves the space that it acquires is as great as that which it leaves.

Conception. If one thing is removed from contact with another, the extent of the movement which the part opposite to the said contact makes will be as great as the space that is interposed between the parts that at first were touching. M 66 v.

[*Drawing*]

The way in which the tail of the fish moves in order to drive the fish forward and so also with the eel the snake and the leech.

Conception. If parts of two surfaces touch one another the part of the one that is touched by the other will correspond to that of the other that is touched by the one, or rather there is as much of the first that is touched by the second as there is of the second that touches the first. M 67 r.

[*With drawing*]

Here contend two forces of water and now one conquers and now the other. M 67 v.

[*Cross-bow—relation of weight and movement*]

If the cord of the cross-bow draws four hundred pounds weight upon its notch with the movement of a third of a braccio, as it discharges itself it will draw two hundred pounds with two thirds of a braccio distance from its notch, and a hundred pounds will be removed from its position by such power for a space of one braccio and a third.

And so as much as you shall diminish the weight of the movable thing so the power will cause it to make a greater movement, in such a way that you will always find that the movement of the cord and the movement of the thing moved will be in the same proportion as the weight that drew the cord to the notch was to the weight that was driven by the cord (if the air did not restrain it). M 71 v.

A bow bends half a braccio and has power of one hundred and pulls two hundred braccia; and another has power of two hundred and opens a quarter of a braccio.

Which will discharge its arrow proportionately farther, the one or the other?

And if another opened a hundred times less and was a hundred

times stronger which would carry farthest in proportion with the said arrows? M 72 r.

RULE OF THE PROPORTION OF REBOUNDS

If you twist the cord *n m* twenty times it will uncoil and make thirty nine revolutions in the contrary direction, and will then roll the opposite way and will make thirty-eight; and so in succession it will go on diminishing in arithmetical proportion until its movement ceases.

The length of the first turn will bear the same proportion to the second as the first right twist has to that of the left. M 72 v.

[*Risings of water*]

If the reservoir be of uniform breadth and in all the parts of its height so that it touches the water, and from the bottom water issues forth which may be guided upwards somewhat by the edges of its tube, it will spout up in as great force issuing by a narrow tube as by a thick one, because the water as it issues forth in a thin stream is driven by the thin part that is in the reservoir, and the thick part will be guided and driven by the thick part which is likewise in the said reservoir. M 73 r.

[*Movement and weight. Cross-bow*]

OF MOVEMENT

The length of the movement made by the thing driven by the cross-bow will have the same proportion with the movement of its cord as that of the weight driven to the weight that loads the said cross-bow.

A b is the movement made by the cord of the cross-bow when it is laden and acquires its force.

B c is the contrary movement which the cord makes when it loses its force, and there is the same proportion between the movement that the cord makes in acquiring force and the movement made by the death of the force, as between the weight driven and the weight that is the creator of the force. M 73 v.

If a weight moves the cord of the cross-bow as far as its notch, the half of this weight will pass the half of the movement of such cord, and five sevenths of the weight will create three quarters of the movement of the cord towards the notch.

Now in order to give a uniform weight to the movement of the cord which as it slackens diminishes its degrees of force with each degree of movement, you take away the half of the force; thus if it was four hundred in the beginning and in the last stage nothing, take the half of the pyramidal force which was two hundred and calculate with the weight of the arrow. M 74 r.

OF THE MOVEMENT OF THE ARROW

Although the force of the cross-bow is great at the beginning and nothing in the last stage, nevertheless the movement of the cord through the impetus acquired makes itself swifter towards the end than at the beginning of its movement: wherefore we conclude that the arrow goes to the end of the movement of the cord. M 74 v.

[Of the power of percussion]

Many small blows cause the nail to enter into the wood, but if you join these blows together in one single blow it will have much more power than it had separately in its parts. But if a power of percussion drives a nail entirely into a piece of wood this same power can be divided into ever so many parts, and though the percussion of these occur on the nail for a long time they can never penetrate to any extent in the said wood.

If a ten-pound hammer drives a nail into a piece of wood with one blow, a hammer of one pound will not drive the nail altogether into the wood in ten blows. Nor will a nail that is less than the tenth part [of the first] be buried more deeply by the said hammer of a pound in a single blow although it may be in equal proportions to the first named, because what is lacking is that the hardness of the wood does not diminish the proportion of its resistance, that is that it is as hard as at first.

If you wish to treat of the proportions of the movement of the things that have penetrated into the wood when driven by the power

of the blow, you have to consider the nature of the weight that strikes and the place where the thing struck buries itself. M 83 v. and 84 r.

[*Weight of pyramid*]

If you wish to divide the pyramid in two equal weights divide it lengthwise into four parts and join together the quarter towards the apex and the quarter towards the base; these two parts joined together will be equal in weight and quantity to the two centre parts; that is that one common measure will measure them precisely, as is shown here below. M 85 v.

[*Movement—cross-bow*]

Of the movement made in such manner that the mover ends its course before the cord remains drawn:

This movement will be of like power to that which is made by the cord which remains drawn when the arrow passes out of the cross-bow, provided that the mover finishes its course in pyramidal power, that is great at the beginning and finishes in nothing. The movement of the arrow however which is great at the beginning and also ends in nothing preserves the length of its power of movement more than the cord does, seeing that its movement was capable of being of the length of four hundred braccia and the movement of the cord which drove this arrow was capable only of a third of a braccio.

[*Diagrams*]

Pyramid of the power and movement of the mover.

Pyramid of the power and movement of the thing moved.

If the cord of the cross-bow after the flight that it has given to the arrow remains curved, it is certain that its power at each degree of movement has acquired degrees of slowness and infinite weakness; consequently we may say such power to be pyramidal because it commences at the base and ends in a point.

The arrow also being driven by the cord of the cross-bow is pyramidal, because at each degree of movement it acquires degrees of slowness and feebleness; but because this pyramid is longer than that of its mover, the arrow has parted from the cord before this cord has stopped; even when its mover was in its greatest power. M 90 r. and v.

[Weight and counterpoise. Cross-bow]

Experiment

Here one ought to experiment upon the same counterpoise and with the same fall of this counterpoise, with different weights of its mover and different shapes, and see first what weight being of spherical shape will be that which will be driven to a greater distance from its mover than any other. In addition to this when you have found what this weight will be, which as I have said is spherical in shape, you will then prove how the weight of this movable thing varies in length and is equipped with feathers after the fashion of an arrow. And further such shape of arrow while of the same weight may be made of different substances heavier or lighter in themselves. And where such a shape stops in proportion to the power of its mover, it may then be tried by experiment whether the movement of its mover is increased if the movement made by the thing moved becomes longer or shorter, although this experiment ought first to be made whilst the movable thing is of spherical shape.

And remember the means which are made use of between the mover and the thing moved, that is the weight of the instrument and the other things. M 91 r. and v.

[Movement—Water]

OF THE MOVER OF STABLE POWER

Water

Here the thing moved can never be less rapid than the movement made by its mover. In effect if the thing moved had movement equal to that of its mover the mover could not make percussion with it, and would only be able to move as much weight as was equal to as much of the water as follows the movement of the wave that drives it.

 M 92 r.

[*Counterpoise and cross-bow*]

OF THE MOVER OF POWER CAPABLE OF BEING INCREASED

This movement is the contrary to that of the cross-bow seeing that the mover of this acquires at every stage of movement degrees of impetus, and the cross-bow does the opposite because its cord commences in its force and ends in nothing, whereas the counterpoise as it falls commences in nothing and ends in great power.

Now one understands here that with the great movement that the cord of the cross-bow makes at the commencement of its movement, the arrow which is moved by this impetus does not slacken its movement at the same time as does that of the cord; on the contrary it follows the quality of the first speed and comes to separate itself from the cord before this cord has finished its movement.

And the thing driven by the counterpoise does the opposite, for as it commences slowly and ends with great impetus it will never be able to separate itself as does the cross-bow, that is to say the thing moved, until such mover has finished its own course. M 92 v. and 93 r.

[*Cross-bow*]

OF THE MOVER OF DIMINISHING POWER

If a weight of four hundred pounds draws the cord of the cross-bow over the notch the cord has the force of four hundred pounds and as it slackens it ends in nothingness.

And this diminution of force comes about by stages after the manner of a pyramid of which the projecting parts are equal; consequently we may say that the centre of this pyramid is that which may be called the centre of the force, as the nature of its weight acts in the simple staff, in which if one takes its centre one will find the weight of the whole taking in the same way the centre of the rise of the cord of the cross-bow. And measuring the weight which draws the said cord in this position, one will find that this weight is equal to the weight of all the arrows which could be stretched along the length of the movement that the arrow makes when drawn from the notch of the cross-bow on its last course. And if this arrow were long and thin or short and thick

or if it was a ball of lead consider how you ought to measure it in the whole route of its course. Think about this and make a general rule for it because it is a matter that requires consideration.

<div align="right">M 93 v. and 94 r.</div>

Excessive force against a like resistance profits the projectile nothing. But if the force of the mover should find itself in proportion to its projectile the movement made by the projectile will be in the first stage of its strength. It is as though I were to attempt to draw a bladder filled with wind against the air; for if this were moved by excessive force the air where it strikes would make such resistance through its becoming compressed that the bladder striking upon it there would leap back just as though it had been driven against a wall. But if this bladder were moved by a motive power proportionate in force and movement to the lightness of the said projectile, then this projectile will advance as far forward as its power enables it to drive slowly before it the air that withstands its course.

<div align="right">B.M. 54 r.</div>

There are two different kinds of percussions, simple and complex. Simple is that made by the movable thing in its falling movement upon its object. Complex is the name given when this first percussion passes beyond the resistance of the object which it strikes first, as in the blow given to the sculptor's chisel which is afterwards transferred to the marble that he is carving. This blow also is divided into two others, namely a simple and a double blow. The simple blow has been sufficiently described: the double is that that occurs when the hammer descends with force in its natural movement and flies back rebounding from the greater blow and then creates an inferior blow and makes this percussion in two places with the two opposite sides of the hammer. And this blow grows less and less in proportion to the number of the obstacles which are interposed between it and the final resistance, just as if someone were to strike a book on its front page when they were all touching, the last page would feel the damage very slightly.

<div align="right">B.M. 82 r.</div>

All movements are caused by abundance or dearth, and where there is the greater excess there the movement will be greater. B.M. 132 r.

Movements are of two kinds, of which one is called simple and the

other composite. The simple is divided into two parts, and the one is when the body moves round its axis without change of position, as the wheel or millstone or things like these; the second is when the thing moves from its position without any revolution of itself.[1] The composite movement is that which in addition to moving from its position also moves round its axis, as the movement of the wheels of a waggon or other similar things.

Circular movements are of two kinds of which one is called simple and the other composite. B.M. 140 V.

The straightness of the transverse movement continues in the movable thing as long as the whole of the power given to it by its mover continues.

The straightness fails in the transverse movement because the power which the movable thing acquires from its mover becomes less. B.M. 147 V.

Force is produced by dearth or profusion. It is the child of material movement, the grandchild of spiritual movement, the mother and source of gravity. This gravity is confined within the element of water and of earth, and this force is infinite, for by means of it infinite worlds could be set in motion if it were possible to make the instruments by which this force could be produced.

Force with material movement and weight with percussion are the four accidental powers in which all the works of mortals have their being and their end.

Force has its origin in spiritual movement which courses through the limbs of sentient animals thickening their muscles, and by this process of thickening the muscles become contracted and so draw back the tendons which are connected with them, and from this originates the force that exists in men's limbs.

The quality and quantity of the force in a man will have the power of giving birth to other force, and this will be proportionately so much the greater according as the movement of the one is longer than that of the other. B.M. 151 r.

Gravity and force together with material movement and percussion are the four accidental powers by which the human race in its marvel-

[1] Note in margin, 'progressive movement'.

lous and varied works seems to reveal itself as a second nature in this world; seeing that by the use of such powers all the visible works of mortals have their existence and their death.

Gravity is a power created by movement which transports one element into another by means of force, and this gravity has as much life as is the effort made by this element to regain its native place.

Force and gravity have much in common in all their powers, differing only in the movements of their birth and death. For simple gravity merely dies, that is as it approaches its centre. But force is born and dies in every movement.

The spirit of the sentient animals moves through the limbs of their bodies, and when it finds that the muscles in those it has entered are responsive, it sets itself to enlarge them; and as soon as they enlarge they shorten and in shortening draw back the tendons which are joined to them. And from this arises the force and movement of human limbs. Consequently material movement springs from spiritual.

B.M. 151 V.

No element possesses gravity or levity in its natural state. Gravity and levity are caused by one element being drawn into another.

When an equal quantity of elements naturally contiguous have exchanged places they will offer an equal amount of resistance one to another. B.M. 174 V.

Weight descends for lack of resistance and that resistance which is weak gives way before it more speedily. B.M. 175 V.

No movement can ever be so slow that a moment of stability is found in it.

That movement is slower which covers less distance in the same time.

That movement is swifter which covers a greater distance in the same time.

Movement can extend to infinite degrees of slowness.

And the power of the movement can extend to infinite degrees of slowness and likewise to infinite degrees of swiftness. B.M. 176 V.

No element possesses weight within its sphere, and when by chance an element passes over into a lighter one it instantly creates gravity;

and not being able to be supported there it falls back again into its own element, and there immediately this gravity dies.

Gravity and force which are interchangeably daughters and mother of motion and sisters of impetus and percussion are always fighting against their cause; and after this has been subdued they conquer themselves and die.

Gravity is a particular action which takes place when one element is drawn into another and not being able to be received there attempts with perpetual combat to return to its own place.

Gravity is a particular fortuitous action of one element when drawn into another; it has as much life as there is desire in these elements to return to their own place.

That which moves towards the centre is termed weight and that which flies from it is termed lightness; but each is of equal power and life and movement. B.M. 181 r.

Every heavy body desires to lose its heaviness . . .

Gravity, force, together with percussion, are to be spoken of as producers of movement as well as being produced by it.

Of these three fortuitous powers two have in their birth, their desire and their end one and the same nature. B.M. 184 v.

Of the things that support themselves without movement in the water no part that is above the water has weight of itself. This is proved as follows: if neither the still water has weight of itself nor the things supported by it, and it is proved by the passage that its weight is wanting and also the weight of the water, how then can we suppose that the motionless water which is without weight should support the weight? And if it supports the bodies it does not support their weight which has been consumed, for this weight is ended with the movement of the penetration which it made in this water.

B.M. 267 v.

When anyone wishes to make a bow carry a very long way he should draw himself right up on one foot raising the other so far from it as to create the necessary balance for his body which is thrown forward on the first foot, and he should not have his arm fully extended; and so that he may be better equipped for the hard work he should fit to the

bow a piece of wood which as used in cross-bows should go from the hand to the breast, and when he wishes to discharge the arrow, instantly at the same time he should leap forward and extend the arm that holds the bow and release the cord. And if by dexterity he does all this at the same moment it will travel a very long way.

The reason given for this is as follows:—know that as the leap forward is swift it lends a degree of fury to the arrow, and the extending of the arm because it is swifter lends a second; the driving of the cord being also more swift gives a third. If the other arrows therefore are driven by three degrees of fury and this by the dexterity shown is driven by six it ought to travel double the distance. And I would remind you that you leave the bow relaxed, so that it will spring forward and remain taut. Forster 1 44 r.

CONCERNING WEIGHTS

If there are two men who hold a sheet by its borders in which sheet there is a man who weighs two hundred pounds, and each pulls his end so much that the weight does not touch the ground, know that each of those who are pulling is holding up a weight as great as the man weighs who is in the middle, because he supports half the weight of the man in the centre and half that of the man opposite who is pulling, so it appears that the weight in the centre being two hundred pounds since each of those pulling has two hundred becomes four hundred pounds. Forster 1 48 v.

OF MOVEMENT

Every movement born of movement which is free either divagates or preserves the line of the movement which produces it, except the thunderbolt which descends from the clouds.

For what reason does the club give a greater blow and moves more than the stone? Forster II 32 r.

If a man with his whole strength throws a stone of four pounds twenty braccia, one of one pound would he throw it eighty (MS. eight) braccia or no? One of half a pound would he throw it one hundred and sixty braccia (MS. pounds) or no? And if he does not throw these to such a distance what is the cause? Forster II 33 v.

OF WEIGHT

If you should be with your body in a state of precisely equal balance with the opposite counterpoise and you throw your arms up furiously, holding two weights in your hands, I am in doubt whether your weight would become light or heavy: light I said; by the movement made by its extremities it would wish to follow the impetus commenced, wherefore it uproots the weight and seems to lighten the man; also one may say that the air where the arms strike in its resistance may make heaviness after the manner of the jumper who presses down the ground at the beginning of his jump. Forster II 45 r.

[Sketch—man mounting pair of steps]
I ask: this weight of the man at every stage of movement upon this pair of steps, what weight does it give *a b* and *a c*? Observe its perpendicular under the centre of the gravity of the man.

Forster II 45 v.

OF MOVEMENT

Diagram let *a* be sixteen *b* one.
I say that the resistance of the air will not allow the movement to be in the sixteenth proportion, and this experiment may be made upon fine mud of uniform fluidity by dropping two pieces of draw-plate iron into it of sixteen and of one. Forster II 48 v.

A man in running throws less of his weight on his legs than if he is standing still. And in like manner the horse when running is less conscious of the weight of the man whom he is carrying; consequently many look upon it as marvellous that when a horse is in a race it can support itself upon one foot only. Therefore we may say as regards weight in transverse movement that the swifter this is the less it weighs perpendicularly towards the centre [of the earth]. Forster II 50 v.

The wheel as it turns upon its axle causes part of the axle to become lighter and the other heavier even more than double of what it was at first, not being able to move away from its position. Forster II 51 r.

By the law of the balance mathematically an infinite weight is raised.

Forster II 53 v.

If the cross-bow or other engine drives a hundred braccia from itself a movable thing of a pound which has one degree of size, how far will it drive a pound of half a degree of size? And then of a quarter and then of an eighth. Forster II 57 v.

CONCERNING MOVEMENT

The centre of the world is indivisible, therefore nothing alone being indivisible the centre is equal to nothing. And if one should make a hole which was with its diameter or indeed its centre the diameter of the world, and there were thrown there a weight, the more it were to move the greater would its weight become.

So having arrived at the centre of the earth which has only the name and it being itself equal to nothing, the weight thrown would not find any resistance at this centre but would rather pass and then return.

 Forster II 59 v.

Every heavy thing which descends freely directs its course to the centre of the world; and that which has most weight descends most rapidly and the more it descends the more it becomes swift.

[*Sketch—ship in water*]

The water that is moved from its place by reason of the ship weighs as much as the actual weight of this ship exactly. Forster II 65 v.

[*Diagram*]

If two cords support the same weight and are not equal in perpendicular or slant they will not be equally burdened by this weight, but the one will receive so much more of the weight than the other as the one is shorter than the other and as the angles made by the line of the cords and by the beam above to which they are fixed are greater the one than the other. Forster II 67 v.

OF MOVEMENT

[*Sketches*]

In this circle I wish to experiment in circular movement, that is to place there within things large and small of the same substance, things of equal size of different substances, and keep them mixed or as chance will have it, and see at the end of the movement what position each has chosen.

And I wish to do the same with dust and a blow. Forster II 68 v.

The ball of the bombard shot through the mist makes a much
shorter course and less percussion than that which is shot through the
pure thin air; but it will make a considerably louder report.

I believe also that the arrow shot slanting into water twists as does
the line of sight; and of this I will make a proof by fixing the bow and
shooting in a frame upon which a sheet of paper is stretched, this
paper being over the water; and after you have shot on this paper
without moving the bow or the sheet of paper take away the water
and you will discover the arrow, and by means of a thin line you will
be able to discern if the shaft of the cross-bow and the centre of the
hole made in the paper and the length of the arrow are in the same
line or no; and by this means you will make your general rule.

Forster II 69 v.

If many bodies of equal weight and shape are allowed to drop one
after another at equal intervals of time from the same altitude in such a
way that there may always be one quantity in the air, I say that the
spaces between them will be equal.

If each thing that descends at every stage of movement acquires a
stage of speed, we may say: a to descend to b in six intervals of time,
and b to c in five intervals, and c to d in four, and d to e in three, and
e to f in two, and f to g; and thus the excesses are equal. It is necessary
therefore that as many touch the ground as start above with equal time.

Forster II 70 v.

Whatever the proportion of the number of the cords placed in the
pulley-blocks which draw the weight to those which sustain this
weight, such is that of the weight that moves to that which is moved.

Whatever the proportion of the number of the cords placed in the
pulley-blocks, which pass through the pulley-block of the weight, to
those which sustain this weight, such is that of the gravity suspended
to the weight which sustains it.

As many as are the wheels of the pulley-block, so many times the
mover offers resistance of itself and this on one side only.

Forster II 72 v.

When the two ends of the cord which go out of the pulley are

situated equally the power of the mover will be as that of its re-sistance.

In proportion as the nature of the positions which the cords assume as they issue from the pulleys displays greater variety of shape, so the power of the mover varies to that of its resistance. Forster ii 73 v.

Ascertain always the proportion of the blow in company with the object which has to receive it.

Since one hundred pounds applied at a single blow makes a greater percussion than a million applied one by one, I wish that when you train the battering-ram on the castle you cause the blow to be raised in the air by the simple weight of the men, and then you pull it back after the manner of a catapult or cross-bow, and you will have a good result.
Forster ii 74 r.

Prove what the difference is in giving to the arrow blow and move-ment, or merely blow alone or movement alone as is the custom.

The blow and movement you will give to the middle of the move-ment usually made by the cord of the cross-bow.

The blow alone you will give to the arrow at the end of the move-ment of the cord. The movement alone you will give when in all the movement of the cord you always find the arrow. Forster ii 75 r.

Of the screws of equal thickness that will be most difficult which has most grooves upon it.

And among those screws of equal length, thickness and number of ridges, you will find that the easiest to move which has the greatest number of curves of its ridges.

That screw will be strongest to sustain weights of which the ridges have the less number of curves, but it will be most difficult to move.
Forster ii 77 v.

The screw will keep a straighter course which is rather drawn than driven; that is it keeps its direction better if you pull than if you press.

If you drive or press with the screw, which touches the thing pressed with the extremity of its curves, this screw being forced will bend on the side opposite to this extremity of its curve which presses.
Forster ii 78 r.

I have ten measures of time and ten measures of force and ten measures of movement and ten of weight, and I wish to raise up this weight.

If I double the weight and not the force in the movement it becomes necessary to double the time.

If I double the weight and not the time or the force it becomes necessary to halve the movement.

If I double the weight and not the movement or the time it becomes necessary to double the force.

If I halve the weight and not the movement or the time, the force is halved. Forster II 78 v.

[Drawing]

If you wish to know the weight of the cord that supports the last pulley, multiply always cubically the weight attached to the foot by the number of the pulleys, and the result of this multiplication will be the number of the pounds which this last cord receives from the aforesaid weight attached to its foot.

Let us suppose therefore that this weight attached to the foot is four, then you will say: four pounds multiplied by four the number of the pulleys makes sixteen; and then four times sixteen makes sixty-four; and it is multiplied cubically, and this cord above supports sixty-four pounds by the four attached to the feet; and if there were six such pulleys you would say: four times six are twenty-four, and four times twenty-four are ninety-eight (*sic!*); and this great weight is supported by the last cord with the four pounds attached to the foot.

Here it is shown how the four pounds proceeds to double continually; with the addition of each wheel the previous weight is doubled. Forster II 82 v.

[Drawing]

The cord doubles its natural strength as many times as it is suspended in different parts of its length. Forster II 83 r.

Gravity with suspended cord at every degree of movement makes degrees of weight.

The force that moves gravity on suspended cord will be as great as that which moves this gravity over rollers or balls which are placed

upon a surface that is quite smooth—because each is supported exactly.

But at this point a doubt seems to arise, that is by the fifteenth of the first, where it says that the centre of the gravity of a suspended cord is beneath the centre of this cord, and this centre of the gravity desires as far as possible to approach to the centre of the earth; and if you draw this weight cross-wise, fixed weight makes a revolving movement and raises itself up and goes away from the centre of the earth, and so increases weight in its mover. The weight which is resting on balls on a smooth surface always has its centre at an equal distance from the centre of the world, and consequently it does not increase the resistance in its mover.

The resistance created by friction for the movement of weights is separate and remote from this weight.

Reason

This is shown by the things said before, that is that it is clearly seen that the movement made by the weights along the horizontal line does not of itself offer any other resistance to its mover than its natural friction which it makes with a smooth surface where it touches it; which movement becomes more difficult in proportion as the smooth surface becomes more scoured and rough. And in order to see the truth of this move the said weight upon balls on an absolutely smooth surface: you will then see that it will move without effort.

The weight the movement of which is rendered difficult by the friction which it makes with the smooth surface where it moves, will increase in gravity as it lacks effort in the friction which it has with the smooth surface where it moves.

This is shown as it raises itself on a line that has a considerable slant, for as it were its simple weight is in the force of the mover, and the friction is small. Forster II 86 r. and 85 v.

[Drawing]

Whoever knows how great a weight raises the hundred pounds upwards by this slope knows the capacity of the screw.

If you desire true knowledge of the quantity of the weight required to move the hundred pounds over the sloping road, it is necessary to know the nature of the contact which this weight has with the smooth

surface where it produces friction by its movement, because different bodies have different kinds of friction; because if there shall be two bodies with different surfaces, that is that one is soft and polished and well greased or soaped, and it is moved upon a smooth surface of a similar kind, it will move much more easily than that which has been made rough by the use of lime or a rasping-file. Therefore always when you wish to know the quantity of the force that is required in order to drag the same weight over beds of different slope, you have to make the experiment and ascertain what amount of force is required to move the weight along a level road, that is to ascertain the nature of its friction. And if you neither know this nor wish to make trial of it, set up an obstacle in your way, and that goes changing according to the slope of the road whence this weight ought to be drawn. Seeing that different slopes make different degrees of resistance at their contact; and the reason is that if the weight which ought to move is placed upon level ground and for this reason has to be dragged, undoubtedly this weight will be in the first strength of resistance, because everything rests upon the earth and nothing upon the cord which ought to move it. But if you wish to draw it along a very steep road all the weight which it gives of itself to the cord which sustains it is substracted from the contact of its friction; but as it is necessary to show another more palpable reason:—you know that if one were to draw it upright grazing and touching a wall somewhat, that this weight is almost all upon the cord which draws it and only a minute part rests upon the wall where it rubs. Forster II 87 r. and 86 v.

If the centre of the weight be outside the perpendicular of the centre of the screw which moves it:
This weight will show itself heavier to its mover, and the teeth of the screw together with those of the screw-box which encloses them will be oppositely weighed down by two contrary forces. Forster II 97 r.

Weights work in balances along the line of their perpendicular.
You have in the ninth of my theory that when the weight is attached to the transverse cord within equal angles each extremity of this cord is equally burdened by this weight; moreover the fact of these extremities being at varying distances from this weight does not make any difference. Forster II 99 r.

Why the small gimlet makes its hole without anything to guide it and the large one requires two or three turns for this hole to be made larger. Forster II 100 v.

Let the weight be affixed with as many cords as you wish to the arms of the balances, so that you have only to seek, if it is not the perpendicular of the centre of the weight, in what part it intersects with the arm of the balance which is above it. Forster II 105 r.

[*Diagrams*]

I have affixed three different weights somehow to one of the arms of the balance at three different places chosen by chance, and I would wish on the opposite arm to give a counterpoise to the said weights; which counterpoises are two, that is the one of four pounds and the other of two, and finally I should wish to attach them separately at such a place that they would be equal in weight to three other weights opposite. Forster II 105 v.

[*Diagrams*]

To one of the arms of the balance I have attached three different weights, that is one of one pound, another of two and a third of three pounds, and these said weights are at varying distances from each other as chance may have it; now I have a weight of eight pounds and I would wish to set it upon the opposite balance as counterpoise to these three such weights; I ask in what position it is to be placed to make itself equal to those opposite to it: you will do as you see here below.
 Forster II 106 r.

The centre of any heavy body whatsoever will stand in a perpendicular line beneath the centre of the cord on which it is suspended.

I ask if you were to suspend a pole outside the centre of its length what degree of slant it will assume.

The pole which is suspended outside the centre of its length by a single cord will assume such a slant as will make with its opposite sides together with the perpendicular of the centre of the cord that supports it, two equal acute angles or two equal obtuse angles.
 Forster II 115 r.

[*Sketch*]

If the wheels are of equal height the waggon will move with a sure

degree of force. But if you change the two back wheels for wheels of greater height it will move with greater ease. If however in the case of the first wheels you were to change the wheels in front for some less in height, in such a way that in the same manner the wheels in front were low and those behind high, the first movement will have been made more difficult and harder. Forster II 124 r.

The balance with three equal arms will remain stable of itself in whatever position you may turn it, and the weights will always stand in double proportion, except when one of the arms is in a perpendicular line, because then the proportion will be that of the equality. Take away the perpendicular of the centres of the weights of each arm of this triangular balance, and observe how they stand there with the centre of the balance; and if you find two on one side, take their centre against the centre of the opposite arm and you will see a double proportion of spaces and weights. Forster II 126 r.

If centres of weights are equidistant from their common centre these weights will be equal in equilibrium.

If perpendiculars of centres of weights are equidistant from the perpendicular of their common centre these weights will stand equal in equilibrium if they are equal.

For this reason the centre of the world is always movable through the change in the overflowing of the ocean. Forster II 126 v.

Gravity is all in all the length of its support and all in every part of it.

Why has it been found by experiment that when the pole stands in a slanting line and remains with its parts equidistant to the central line it does not remain slanting but rather becomes horizontal, forming four right angles with the above-mentioned central line? The answer is that it proceeds from the imperfection of the pole. Forster II 128 r.

A weight of one pound falls one braccio and gives a blow of a certain force; the question is asked if a weight of half a pound were to fall double the height, or twice from the first height, or twice the weight from half the height or four times from a quarter of the height, if it would produce the same result. Forster II 130 r.

Every heavy body weighs in the line of its movement.

<div align="right">Forster II 130 v.</div>

[*Diagram*]

Although the time in which the movement of heavy bodies occurs together with the length of this movement is divisible, it does not follow that the act of percussion because made on the surface of these bodies can itself be divided.

Though the figure *s* strikes on the slant *a n* and that it will appear that being fleeting it may not be powerful, it will not fail to be the case that the act of percussion will be much more powerful than if it was a round body and that its rebound will be along the line.

<div align="right">Forster II 131 r.</div>

OF FRICTION

The action of friction is divided into parts of which one is simple and all the others are compound. Simple is when the object is dragged along a plain smooth surface without anything intervening; this alone is the form that creates fire when it is powerful, that is it produces fire, as is seen with water-wheels when the water between the sharpened iron and this wheel is taken away.

The others are compound and are divided into two parts; and the first is when any greasiness of any thin substance is interposed between the bodies which rub together; and the second is when other friction is interposed between this as would be the friction of the poles of the wheels. The first of these is also divided into two parts, namely the greasiness which is interposed in the aforesaid second form of friction and the balls and things like these. Forster II 131 v.

All things and everything whatsoever however thin it be which is interposed in the middle between objects that rub together lighten the difficulty of this friction.

Observe the friction of great weights, which make rubbing movements, how I have shown in the fourth of the seventh that the greater the wheel that is interposed the easier this movement becomes; and so also conversely the less easy in proportion as the intervening thing is thinner as would be any thin greasy substance; and so increasing tiny grains such as millet make it better and easier, and even more the balls

of wood or rollers, that is wheels shaped like cylinders, and as these rollers become greater so the movements become easier.

Forster II 132 r.

That thing which is entirely consumed by the long movement of its friction will have part of it consumed at the beginning of this movement.

This shows us that it is impossible to give or make anything of any absolute exactness, for if you desire to make a perfect circle of the movement of one of the points of the compasses, and you admit or confirm what is set forth above, namely that in the course of long movement this point tends to become worn away, it is necessary to concede that if the whole be consumed in the whole of a certain space of time, the part will be consumed in the part of this time, and that the indivisible in the indivisible time may give a beginning to such consumption.

And thus the opposite point of these compasses which turns in itself over the centre of this circle, at every stage of movement is in process of being itself consumed and of consuming the place on which it rests; whence we may say that the end of the circle is not joined with its beginning, rather the end of such line is some imperceptible part nearer towards the centre of such circle.

The friction made by the same weight will be of equal resistance at the beginning of its movement although the contact may be of different breadths or lengths.

The greatness of the contact made by compact bodies in their friction will have so much more permanence as it is of greater bulk; and so also conversely it will be so much less enduring as it is of less size.

That which is said is shown in the case of the friction made by the head of the handle of the knife, for in equal time it is more perceptible than that which is made by its point. Forster II 133 r. and 132 v.

Impetus transports the movable thing beyond its natural position.

Every movement has terminated length, according to the power which moves it, and upon this one forms the rule.

Every movable thing which acquires velocity in the act of movement is moved under its natural movement, and so conversely when it loses it moves with accidental movement. Forster II 141 v.

[*Sketch*]

Proof how these cords have equal weight.

If the center of the weight is located in the middle of the equal number of cords which support it this weight is equally distributed between each cord.

Here one is supposing the pole to be unbendable, and not taking count in cases like these of the weight of the instrument but only of the weight attached.
<div align="right">Forster II 142 r.</div>

The gravity which is moved in conformity with its natural position with every degree of movement acquires a degree of speed.

And if the gravity shall move in opposition to its natural position with every degree of movement it loses a degree of speed.

In transverse movements the degrees of diminution are in the case of that which goes upward.
<div align="right">Forster II 144 r.</div>

The pole which is suspended at its extremities by two cords divides its weight equally between these cords.

But if one of the cords remains fixed and the other moves towards it, weight moves from this fixed cord and joins itself to the weight of the movable one.

The more a cord is moved towards the centre of the pole the more weight is taken from the other cord.

The weight which is moved within the cords is in the same proportion to the first weights as is the movement made by the cord to the remainder of the pole.
<div align="right">Forster II 150 r.</div>

But if the one cord is fixed and the other moves towards it, weight moves from this fixed cord and is united with that of the movable one.
<div align="right">Forster II 150 v.</div>

The pole which at its extremities is suspended to two cords divides its weight equally between these cords.

But if one of the cords is moved towards the other every degree of movement corresponds to this change of weight.

The weight that moves between the cords has such proportion to the first weights as the movement made by the cord has to the remainder of the pole.

The remainders of the weights which will be left to these cords will

have together such proportion as the opposite spaces which are enclosed between the two cords and the centre of the pole have between them.

<div align="right">Forster II 151 r.</div>

The variety of the weight which this cord acquires by its movement will have such proportion with that of the first weight as its movement has with the remainder of the pole.

And the weights that are changed on the said cords will have together such proportion as the spaces which intervene between the two cords and the centre of the pole have between themselves.

And weights which have remained on the said cords will have together such proportion as oppositely have the spaces that are enclosed between the centre of the pole and the two cords.

The weight which moves between the cords has such proportion to the first weights as the movement made by the cord has to the remainder of the pole.

<div align="right">Forster II 151 v.</div>

The pole which is suspended by two cords at its extremities divides its weight equally between these cords; and although these cords may be moved equally towards the centre of the pole they do not vary their first weight.

But should one of the cords towards the centre of the pole be moved and the other remain fixed at its extremity every degree of movement occasions among them variation of weight; and the remainder of the weights of the cords will have such proportion one with another as have the spaces opposite to them which are enclosed between the centre of the pole and the two cords.

<div align="right">Forster II 152 r.</div>

Such proportion as there is between those spaces which are enclosed between the centre of the length of the suspended pole and the two cords which sustain this pole, such will there be one with another the opposite weights which this pole gives of itself and the cords which support it.

The thing which moves by natural movement at every degree of movement acquires degrees of speed, which degrees will bear the same proportion, the last to the last but one, as the second has to the first.

<div align="right">Forster II 152 v.</div>

The pole which is suspended by the extremities of its length to two cords divides its weight equally between these cords.

But if the one of the cords towards the middle of the length of the pole be moved there will be the same proportion between the weight separated from the stationary cord and joined to that which moved, as between the movement made by the cord and the remainder of the pole which is supported between the two cords.

But if the one of the cords is stationary and the other is moved towards it, weight departs from this stationary cord and unites itself to that which is moved, which has the same proportion to the remaining part of the first weight as the movement made by the cord has to the first space of these cords. Forster II 153 r.

Whoever speaks of arms of a balance means them to be of equal thickness and weight if they are of equal length.

The spaces which are interposed between the centre of the arms and the pole of the balance have between them such proportion as the opposite weights have with them as the one arm serves as counterpoise to the other.

The spaces which are enclosed between the centre of the two arms of the balance and the pole of this balance have between them such proportion as is that which the weights of these arms have between them together with their length. Forster II 154 v.

The centre of the length of each arm of the balance is the true centre of its gravity.

The arms of the balance make of themselves a counterpoise the one to the other; which counterpoise will have with these arms as many varieties as the proportions of these arms will be varied.

That proportion which the one arm of the balance has to its opposite arm such the weight will have with it as this lightens the opposite arm. Forster II 155 v.

The centre of the length of each arm of the balance is the true centre of its gravity.

Arm of balance is said to be that space which is found between the weight attached to this balance and its pole.

That proportion which exists between the spaces that come between

the centres of the arms and the pole of the balance, is as that of the opposite weights which the one arm gives of itself in counterpoise to the other with its own arm which is the counterpoise.

Arms of the balance are said to be those which are found between the centres of the weights affixed to it and the pole of the said balance.

Forster II 157 r.

Where the support makes less resistance there the weight supported by it shows itself heavier; and that part of the support makes less resistance which is more remote from its foundation. Forster II 157 v.

Of the pyramids of equal height the proportion of the weight will be as that of the bases.

Pyramids of varying lengths upon equal bases will be of as many different proportionate weights as their lengths are varying; the pyramids of equal bases with different lengths enclosed in a parallelogram will be of equal weight. Forster II 158 r.

[*Sketch*]

If a chimney-sweeper weighs two hundred pounds how much force does he exert with his feet and back in the chimney?

Forster III 19 v.

[*Sketch*]

I ask why the blow of the hammer causes the nail to jump out.

Forster III 20 v.

The air which closes itself up with fury behind the bodies which move through it offers more resistance than that which remains stationary, consequently the ball when struck covers a greater distance than the jump or the leap can serve as the occasion of.

Forster III 27 r.

Why it is first the blow rather than the movement caused by it; the blow has performed its function before the object has started on its course. Forster III 28 r.

[*Sketch*]

It will be impossible to break that support which is the centre of the gravity placed upon it; and the centre of this itself will be the perpendicular upon the centre of its base. Forster III 29 r.

A blow is an end of movement created in an indivisible period of time, because it is caused at the point which is the end of the line of the movement made by the weight which is the cause of the blow.

Forster III 32 r.

No animal can simply move more weight than is the load that finds itself outside the centre of its support. Forster III 34 r.

The movement made by the arrow in ordinary simple flight will increase as much as the power of the composite movement of a second tethered (?) [*apicata*] flight. Forster III 38 v.

There will be such proportion between the amount of movement of a stone that is moved and that of the thing that is moving, one time more than another, as the time of the moving thing is swifter on the one occasion than on the other. Forster III 39 r.

The infinite movements of the varieties of the instruments which may be constructed for drawing weights will be of equal power in the completed movement of the thing moving and of that moved.

Forster III 40 v.

Define to me why one who slides on the ice does not fall.

Forster III 46 r.

Prove which keeps its movement more, a wheel that revolves on the flat or on an edge.
Prove whether the impetus of the revolving of the wheels acquires force from its mover. Forster III 48 r.

Every free heavy body when falling directs its course to the centre, and that part which weighs most will be nearest to the centre of the world. Forster III 51 r.

As is the proportion one to another of the spaces that are enclosed between the perpendicular of the weight attached to the slanting beam and the perpendiculars of the extremities of this beam, so will be that of the weights of the opposite extremities of the beam. Forster III 51 v.

If two opaque bodies are moved one against the other with intersecting movement the two bodies will seem three; and in like manner

one thing will seem two, and the two without intersecting movement will appear to be four as the wings of birds when flying. Intersected movement. Simple movement. Forster III 55 r.

The centre of gravity of any heavy suspended body will always fall below the centre of its support.

The counterpoise divides with its weight if the beam divides it in half. Forster III 60 r.

If the sea bears down with its weight upon its bed, a man who lay on this bed and had a thousand braccia of water on his back would have enough to crush him. Forster III 66 r.

The desire of every heavy body is that its centre may be the centre of the earth. Forster III 66 v.

Friction produces double the amount of effort if the weight be doubled. Forster III 72 r.

[Sketch]

I ask how great a weight ought to be placed at m in order to draw one hundred pounds at n; and by degrees to ascertain what weight it will be which will overcome the other, giving the cord that goes from the one weight to the other sometimes one twist round the beam, sometimes two or three or four; and similarly if the beam be triangular or square or of a greater number of angles. Forster III 73 v.

I ask which is swifter—a spark going upwards and living or turning downwards in death. Forster III 75 v.

Everything attached or united to bodies that have been struck will move against the place of the blow.

That part of the cord that is twisted over the beam that lies equally, will press the part of the beam more which is nearer to the greater of the two weights that are fastened to the extremities of the cord.
Forster III 77 v.

[Duration of movement of liquid]

The movement of the liquid made in any direction, proceeds as far in the revolution it has commenced as there lives in it the impetus given to it by its first mover. Fogli B 28 r.

In the same space the arrow carries farther straight upwards than it does obliquely, and this arises from the fact that when the direction is upwards the arrow or bullet falls by the line in which it rose and obliquely it forms an arch. Quaderni II 15 r.

[*Law of inertia*]
The thing which moves will be so much the more difficult to stop as it is of greater weight. Quaderni IV 10 v.

The thing which moves itself acquires as much space as it loses. Quaderni IV 15 v.

[*Of long and short steps*]
When one is descending one takes short steps because the weight rests on the hinder foot but when one is ascending one takes long steps because the weight is thrown on to the foot in front.
Quaderni VI 18 r.

That wheel will revolve more easily which has its axis of less thickness. Quaderni VI 21 r.

It is proved how the air does not push the movable thing since it is separated by the power of its mover.

If to the movable thing which separates itself from its mover there was given the perception of the movement of the air which pushed it behind it would happen that the bullet of the carbine in penetrating a leathern bottle full of water would immediately lose its movement at the beginning of its penetration, because instantly the water would close the entrance and separate it from the air which drives it; as to which experience shows to the contrary, seeing that this ball after the said penetration of the water moves for a long time. And if you were to say that the fury of the movement of the air or of the water, through which this bullet passes, which turns to fill up the vacuum from which the bullet departs point by point, is that which forms a wedge between the back of the bullet and the rest of the air which stays behind it; here the reply is that the air is more powerful and more compressed in front of the bullet than that on the opposite side, because this opposite side is the air reflected by the percussion of the bullet. 'The reflection of anything is always of less power than its incidence'; and if you should gainsay me as to this by urging that this power cannot be in-

fused in the body that is moved, because 'no movable thing moves of itself, unless its members exert force in other bodies outside it', as when a man in the centre of a boat pulls the rope attached to the stern of it, in order to give movement to the ship, which work is useless unless this rope is fastened to the bank where he wishes to move, or unless he pushes the oars in the water or the pole on the bottom; therefore the power not being in the air which drives the said bullet it is necessary that it is poured into the bullet; and if it is thus poured what has been said above serves as an example of the result; and in addition to this, this power so poured in would be of equal force through all its sides, because it would be spread equally in equal quantities through all that bullet; this however is not so, and the other premise you do not grant me; let us therefore seek for a third to which no exception can be taken. 'The potency of the mover is separated from it entirely and applied to the body moved by it, and it goes on to consume itself in course of time in penetrating the air which is always compressed before the movable thing'. And this happens because 'every impression is preserved for a long time in the object on which it is impressed', as is seen in the circles created by its percussion within the surface of the water, which move within the water for a long distance, and in the eddies and waves, formed in one spot, and carried by the impetus of the water to another, without their destruction; and radiance creates the same effect in the eye, and sound in the ear. But if you would also say that the air preserves the power of the mover which accompanies it and pushes its movable thing, how are we to reconcile to this the case of the wheel which in a storm of wind turns for a long time, although its mover is separated from it?

It is not air that moves it for as it is equally distributed round its axis as regards its outline and its weight, the wind which embraces it on one side only, if it caresses the half of the wheel which flies from it, opposes and resists the other half of the wheel which moves against it, and consequently the wind which stops the movement as much as it aids it does not render this wheel any service or disservice; therefore the potency of the mover was left imprinted on the outside of the wheel and was not poured into it or into the air that lay about it. If you wish to see the movement the air makes when it is penetrated by a movable thing take an example in the water, that is, underneath its surface, for

it may have mingling with it thin millet or other minute seed which floats at every stage of height of the water; and afterwards place some movable thing within it which floats in the water and you will see the revolution of the water, which ought to be in a square glass vessel shaped like a box. 'Every natural act is communicated from the doer to the object in the shortest possible time'; and the air beaten and compressed by the movable thing that moves within it need not therefore be that which restores the vacuum, for the movable thing makes a succession of vacuums as it flies from it; but it is that which is nearer the opposite side of the movable thing, that is that by which it leaves the path, that continually rarefies the condensation already made; and by means of this rarefaction the before mentioned vacuum is restored. 'Never, in the same time will the greater power be subdued by the lesser power': therefore, the swift movement of the rarefied air in order to fill up the place in the vacuum, caused by the movable thing departing from it, is much weaker than that which is continually being compressed before the movable thing; of which compression the air that is thinner than it will never be the cause. Therefore we have concluded that the movable thing does not move on account of the wave of the air created by the impetus of the mover. And if you wish to say that the flooding of the air which escapes before the movable thing is that which prepares the movement of the movable thing, together with the air, and runs after it in order to restore the rarefaction of the air, to this one replies that this air is here flooded by the movable thing and not by itself, and 'it is impossible that at one and the same time the mover should move the movable thing and the movable thing move its mover': therefore, your reason does not hold, because if the aforesaid flooding were that which had to draw itself after the cause of its movement, 'it is impossible that any thing of itself alone can be the cause of its creation; and those things which are of themselves are eternal'.

<div align="right">Leic. 29 v.</div>

Gravity comes into being when an element is placed above another element thinner than itself.

Gravity is caused by one element having been drawn within another.

<div align="right">Sul Volo (F.M.) 1 r.</div>

Gravity is caused by one element being situated in another; and it moves by the shortest line towards its centre, not by its own choice, not because the centre draws it to itself; but because the mean in which it finds itself cannot withstand it. Sul Volo (F.M.) 2 v.

XX

Mathematics

*'There is no certainty where one can neither apply
any of the mathematical sciences nor any of those
which are based upon the mathematical sciences.'*

As I have shown, here at the side [*diagram*], various ways of squaring
the circles, that is by forming squares of a capacity equal to the capacity
of the circle, and have given the rules for proceeding to infinity, I
now begin the book called 'De Ludo Geometrico', and I give also the
method of the process to infinity. C.A. 45 V. a

A body is something of which the boundaries form the surface.

The surface is not part of the body nor part of the air or water that
surround it, but it is a common boundary in which the body
ends in contact with the air, and the air in contact with the . . .

C.A. 91 V. a

What is that thing which does not give itself, and which if it were to
give itself would not exist?

It is the infinite, which if it could give itself would be bounded and
finite, because that which can give itself has a boundary with the thing
which surrounds it in its extremities, and that which cannot give itself
is that which has no boundaries. C.A. 131 r. b

Surface is the touching-part [contingenzia] of the extremities of bod-
ies, that is it is made by the extremities of the body of the air, together
with the extremities of the bodies which are clothed by this air, and it is
that which completes and forms with this air the boundary of the
bodies surrounded by the air, and completes this air with the bodies
clothed by it, and it does not participate either in the body which sur-
rounds it or in that which is surrounded by it. It is rather the true
common boundary of each of these, and it is that which divides the

MATHEMATICS 613

one body from the other, as one may say the air or the water from the body that is enclosed in these. c.a. 182 r. a

Arithmetic is a mental science and forms its calculations with true and perfect denomination; but it has not the power in its continuing quantities which irrational or surd roots [radici sorde] have, for these divide the quantities without numerical denominaton. c.a. 183 v. a

Surface is a flat figure which has length and breadth and is uniformly without depth. c.a. 246 v. b

A point is not a part of a line. Tr. 63 a
[*With drawing*]
[*To ascertain the width of a river*]
If you would ascertain the exact distance of the breadth of a river proceed as follows:—plant a staff upon the river bank at your side and let it project as far from the ground as your eye is from the ground; then withdraw yourself as far as the span of your arms and look at the other bank of the river, holding a thread from the top of the staff to your eye, or if you prefer it a rod, and observe where the line of sight to the opposite bank meets the staff. b 56 r.

[*With drawing*] [*A level resting on a support from the base of which there is a cord to its ends*]
This is the way that the level should be made: that is it is two braccia long, an inch thick, and square; and it should be of pine so that it may not twist, and have in the top of it a groove of the thickness of a finger and of the same depth. Then moisten the cord and fill the groove with water, and lower first the one end and then the other until the water stands level with the sides. Then proceed to wipe away with the finger the water that flows over the ends of the groove until these become dry, and fix two pieces of iron at *m n*, of the thickness of the cord, and see that one fastens the other and the thing seen. b 65 v.

A thing which moves acquires as much space as it loses.
e 7 v. and 25 v.

OF MECHANICS

Mechanics is the paradise of the mathematical sciences because by means of it one comes to the fruits of mathematics. e 8 v.

OF THE SQUARING OF THE SURFACE OF A SPHERE WITH STRAIGHT MOVEMENT

The knowledge of the aliquot part gives knowledge of its whole; whence it follows that the squaring of the eighth part of the surface of a sphere gives knowledge of what is the square of the whole of this sphere; and let this be the knowledge of the eighth of the sphere: *a b c.*

Second figure. In the second figure *c d e* one divides the eighth part of the spherical surface in parallels of equal breadth and straightens the curve of the two sides *c d* and *d e*; this is done with movement upon a level place.

Third figure. In this third figure there is that which was promised in the second, and the straightened sides *f g* and *g h* are all the parallels of the second, which are enlarged and elongated by means of their movement, because there are the same number of parallels made upon the extended lines *f g* and *g h* (which are equal to each other); the whole being increased the parts also have increased.

Fourth figure. In the fourth figure one makes equal pyramidal divisions as shown in *f g h.*

Fifth figure. In the fifth figure the points of the pyramids are opened and enlarged, the same number of pyramids are reproduced, and the square *n m o p* is formed; but first by movement one straightens the line *i l*, and one has the fourth part of the spherical surface.

The junction of the curves *c d e* straightened at *f g* h forms a rectangle. E 24 r.

DEFINITION OF HELIX

A helix is a single curved line the curve of which is uniformly irregular and it goes revolving round a point at a distance uniformly irregular.

DEFINITION OF HEMISPHERE

A hemisphere is a body produced by a half sphere contained by the circle and the surface of the half sphere.

The movement of the hemisphere commenced by the circumference of its greatest circle ends in the middle of this hemisphere, after having described a spiral curve.

This is proved by the second concerning compound impetus which says: 'Of compound impetus one part will be as much slower than the other as it is shorter', and: 'That will be shorter which is farther distant from the direct line of the movement made by its mover'. Therefore the movement of the hemisphere being made up of the movement of many whole revolutions is of the same movement as a half revolution.

E 34 V.

MENSURATION

When you wish to measure the breadth of a river withdraw from its bank to a somewhat greater distance than the width of the stream and observe some fixed mark on the opposite bank of the river. Let $a\ b$ represent the width of the river, and $a\ c$ the space to which you withdraw from the river, this being somewhat longer than the width of the river.

Next draw at the end of this distance a perpendicular line of whatever length you please, and let this be the line $c\ d$.

And from this [spot] d observe again the mark b, which you noted on the opposite side of the river, and make a mark f^1 upon the [opposite] bank at the point which is in the same line $d\ b$. After having done this bisect the perpendicular line $c\ d$ at the point e and from this point e make another perpendicular line at exact right angles, and make a mark where it intersects the line $d\ f^1$, and from this make the third perpendicular line $g\ f^2$. You will thus have formed the quadrilateral $c\ f^2\ e\ g$, of which you know that the side $c\ f^2$ is equal to $f^2\ b$, because as the point e is in the centre of the line $c\ d$ so the point f^2 is in the centre of the other line $c\ b$; then take $a\ f^2$ (from the bank) from $f^2\ c$, that is $f^2\ h$, and you have remaining $h\ c$, a distance equal to the width of the said river.

E 51 V.

All the pyramids made upon equal bases in parallel spaces are equal to each other.

The greatest pyramid that can be drawn from a cube will be the third of the whole cube.

E 56 r.

The intercentric line is said to be that which starts from the centre of the world and which rising therefrom in one continuous straight line

passes through the centre of the heavy substance suspended in an infinite quantity of space.　　　　　　　　　　　　　　　　E 69 r.

OF THE FIVE REGULAR BODIES

Against some commentators who blame the ancient inventors from whom proceed the grammars and the sciences and campaign against the dead inventors, and why they have not discovered through idleness how to become inventors themselves, and how with so many books they set themselves continually to confute their masters by false arguments:

They say the earth is hexahedral,[1] that is to say cubical, that is to say a body with six bases, and they prove this by saying that there is not among regular bodies a body of less movement or more stable than the cube. And they attribute to fire the tetrahedron, that is the pyramidal body, this being more mobile according to these philosophers than the earth; for this reason they attribute the pyramid to fire and the cube to the earth.

Now if one had to consider the stability of the pyramidal body and to compare it with that of the cube, this cube is without any comparison more capable of movement than the pyramid, and this is proved as follows:

The cube has six sides, the regular pyramid four, and these are placed here in the margin at *a b*; *a* is the cube, *b* the pyramid. In order to define this proof I will take a side of the cube and a side of the pyramid which will be *c d*; I maintain that the cube *c* will be more adapted to a movement of circumvolution than the pyramid *d*. And let *e f*, below, represent the commencement of these movements. I say that as a matter of fact if the base of the cube and the base of the pyramid rest upon the same plane the pyramid will turn the third of its bulk to fall upon its other side, and the cube will turn the fourth part of its circuit to change the other side in order to make a base. From these two demonstrations the conclusion follows that the cube will turn completely with the change of its four sides upon the same plane, while the triangle of pyramid will turn completely with three of its sides upon the same plane. The pentagon turns all its five sides and so the more sides there are the easier is the movement because the figure ap-

[1] MS. has *tetracedronica coe cubica*—presumably a slip of the pen.

proaches more nearly to a sphere. I wish it to be inferred therefore that the triangle is of slower movement than the cube and that therefore one should take the pyramid and not the cube for the earth.

F 27 V.

OF PROPORTION

If from two like wholes there be taken away like parts there is the same proportion between part and part as there is between whole and whole.

It follows that if of these two circles the one is double the other, the quarter portion of the larger is double the quarter portion of the smaller.

And there is the same proportion between one remainder and the other as between one whole and the other.

And the same proportion between part and part as there is between remainder and remainder.

When two circles touch the same square at four points one is double the other.

And also when two squares touch the same circle at four points one is double the other.

G 17 r.

GEOMETRY

The circle that touches the three angles of an equilateral triangle is triple the triangle that touches the three sides of the same triangle.

The diameter of the largest circle made in the triangle is equal to two thirds the axis of the same triangle.

G 17 v.

The proportion of circle to circle is as that of square to square made by the multiplication of their diameter by itself. Now make two squares in such proportion as pleases you, and then make two circles, of which one has for its diameter the side of the greater square, and the other has for its diameter the side of the lesser square.

Thus by the converse of the first proposition you will have two circles which will bear the same proportion one to another as that of the two squares.

G 37 r.

TO OBTAIN THE CUBE OF THE SPHERE

When you have squared the surface of the circle divide the square into as many small squares as you please, provided that they are equal one to another, and make each square the base of a pyramid, of which the axis is the half diameter of the sphere of which you wish to obtain the cube; and let them all be equal. G 39 v.

[Circles and squares]
Circles made upon the same centre will be double the one of the other, if the square that is interposed between them is in contact with each of them. And double the one of the other will be the squares formed upon the same centre, when the circle that is set in between them touches both the squares.

This is proved because of the eight triangles of which the larger square is composed the lesser square contains four.

There is the same proportion between circle and circle that there is between square and square, formed by the multiplication of their diameters.

Of all the parts of circles which may be in contact inside a right angle the greater is always the equal of all the less; and of all the parallels which receive these parts in themselves the greater always contains and is the equivalent of all the small parallels formed in this right angle *a b c*. G 40 r.

DEFINITION OF FOUR GROUPS OF PARALLELS

Parallel figures are of four kinds. The first is enclosed between two straight and equidistant lines; the second is between two equidistant lines of uniform curve; the third is between two equidistant lines of varying curve, such as the parallel lines made around the centre of the circle; the fourth is formed of a single line curved round a point at an equal distance, that is the line of the circumference round the centre of its circle.

And all these lines are of uniform nature since with movement the straight line becomes curved and the curved line becomes straight, by

means of the impressions of the straight planes upon the curved and of the curved upon the straight.

By one of the 'Elements' [of Euclid].

All the rectilinear triangles made upon equal bases and between parallel straight lines are equal to one another. G 59 r.

If from unequal things there be taken away equal parts the remainders will be unequal; not in the former proportion but with a greater excess of the greater quantity. G 69 v.

ARITHMETIC

Every odd number multiplied by an odd number remains odd.
Every odd number multiplied by an even number becomes even.
G 56 v.

[*Of squaring the circle*]

Animals that draw chariots afford us a very simple demonstration of the squaring of a circle, which is made by the wheels of these chariots by means of the track of the circumference, which forms a straight line. G 58 r.

OF SQUARING THE CIRCLE AND WHO IT WAS WHO FIRST HAPPENED TO DISCOVER IT

Vitruvius while measuring the mile by means of many complete revolutions of the wheels that move chariots, extended in his stadia many of the lines of the circumference of these wheels. He learnt these from the animals that are movers of these chariots, but he did not recognise that that was the means of finding the square equal to a circle. This was first discovered by Archimedes the Syracusan who found that the multiplication of half the diameter of a circle by half of its circumference made a rectilinear quadrilateral equal to the circle. G 96 r.

There is no certainty where one can neither apply any of the mathematical sciences nor any of those which are based upon the mathematical sciences. G 96 v.

That force will be more feeble which is more distant from its source.

H 71 [23] v.

Every continuous and united weight which thrusts transversely rests upon a perpendicular support.

If the weight is discontinuous and limited as when it is liquid or granulated, it will make its thrust upon all sides, and making it thus the pressure that is exerted upon the sides serves to lighten that upon the foundations.

H 74 [26] r.

Should the contact which the thing united makes with the earth on which it is supported be not in the line of its motive power, it will prove heavier in proportion as it is farther distant from the line of its motive power.

H 113 [30 r.] v.

The heaviest part of every body that is moved will be the guide of its movement.

H 115 [28 r.] v.

Similarity does not imply equality.

1 16 r.

The fact that a thing may be either raised or pulled causes great difference of difficulty to its mover; for if it is a thousand pounds and one moves it by simply lifting it it shows itself as a thousand pounds, whereas if it is pulled it becomes less by a third; and if it is pulled with wheels it is diminished by as many degrees in proportion to the size of the wheel, and also according to the number of the various wheels. And with the same time and power it can make the same journey, with different degrees of time and power also in the same time and movement; and it does this merely by increasing the number of the wheels, on which rest the axles which would also be increased.

1 17 r.

By the ninth of the second of the Elements, which says that the centre of every suspended gravity stops below the centre of its support, therefore:—

The central line is the name given to what one imagines to be the straight line from the thing to the centre of the world.

The centre of all suspended gravity desires to unite with the central line of its support.

And that suspended gravity which happens to be farther removed from the central line of its support will acquire more force in excess of that of its natural weight.

Now in conclusion I affirm that the water of the spiral eddy[1] gives the centre of its gravity to the central line of its pole, and every small weight that is added on one of its sides is the cause of its movement.

I 22 v.

[The Wonders of Mechanics]
Rule [Diagram]

Pivots of the greatest force serve for the movements that go and return such as those of bells, saws and things of the same nature.

A pound of force at *b* has for result at *m* ten thousand thousands of millions of pounds, and the figure opposite does the same, being of the same nature and only differing in that the wheels are whole as they have to turn always in a single direction. And know that when the first above gives a hundred thousand thousands of millions of turns, that below only gives one complete turn.

These are the wonders of the science of mechanics.

In this manner one may make a bell to swing on a pivot so that it will be sounded by a slight wind, the bell having its opposite weights equal and equidistant from its centre.

I 57 [9] v.

[Diagram]

This arrangement will produce a revolving movement of such duration that it will appear incredible and contrary to nature, because it will make much movement after that of its mover. And it causes the weight *m* to fall from such a height that the wheel gives thirty revolutions and more, and then remains free after the manner of a spinning top; and in order to avoid noise this stone ought to fall upon straw.

And to make one wheel greater than another down in succession the one below the other, is only necessary in order that the rim of the wheel below may not stop and impede the pivot of the other.

I 58 [10] r.

[1] MS. *dele uiti.*

PROPORTION IN ALL THINGS

Proportion is not only found in numbers and measurements but also in sounds, weights, times, positions, and in whatsoever power there may be. K 49 [48 and 15] r.

How one of Xenophon's propositions is incorrect:

If unequal things are taken away from unequal things and these are in the same proportion as the first inequality, the remainders will have the same proportion in their inequality. But if from unequal things equal things are taken away the remainders will still be unequal, but not in the same proportion as before.

Consider these examples: in the first place let the parts taken away be in the same proportion as the wholes, that is let 2 and 4 stand for the two wholes so that the one is double the other. Then take 1 away from 2, there remains 1; take 2 away from 4, there remains 2; and these remainders have the same proportion as the wholes and as the parts taken away. Therefore if 1 be taken from 2 and 2 from 4 there remains the same proportion as at first, that is 1 and 2 which is double as I said before: it would follow that whoever should take away equal things would change the former proportion; that is to say that if from two numbers one of which is double the other such as 2 and 4 you were to take away an equal thing, that is you took 1 from 2 and 1 from 4, there would be left 1 and 3, that is numbers of which one would be three times the other and therefore more than double in difference.

You therefore, Xenophon, who wished to take away equal parts from unequal wholes, believing that although the remainders were unequal they were still in the same proportion as at first, you were deceiving yourself! K 61 [12] r. and v.

DEFINITIONS OF A STRAIGHT LINE

First. A straight line is that of which each part finds itself of equal height.

Second. A curved line is that which has a uniformly varying height towards its extremities which are of equal height.

The first definition and the second are incorrect because a thing of equal height must have every part of its bulk equally distant from the centre of the world. So the curve *f b o* would be straight because it is at a uniform distance from this centre, and the straight line *a b c* would be curved, because every part of its length varies uniformly according to the distance of the parts enclosed within extremities that are at equal distance from the centre of the world.

And if you say that the straight line is that which receives three points of equal height in its extent you still say wrong.

But if you say that a straight line is the shortest between two given points you will give its true definition. K 78 [30] v. and 79 [31] r.

[*With drawings*]

The circle is the equal of a rectangular parallelogram made of the fourth part of its diameter and the whole of its circumference, or you may say of the half of its diameter and of its periphery (circumference).

As though one were to suppose the circle *e f* to be resolved into an almost infinite number of pyramids, and these being then extended upon the straight line which touches their bases at *b d* and the half of the height being thus taken away, so making the parallel *a b c d*, this being precisely equal to the given circle *e f*.

With regard to the circumference of the circle it is desirable to measure the quarter with a piece of bark of cane, in its spiral curve and stretching it out, and to make a rule as to where is the centre of the circle from which the movement of the extremity of the measurement is directed, and similarly the centre of the movement of many of its parts, and to make the general rule.

The circle is a parallel figure, because all the straight lines produced from the centre to the circumference are equal and fall upon the line of the circumference between equal angles and spherical lines. And the same thing happens with the transversal lines of the parallelogram, namely that they fall upon their sides between right angles.

All rectilinear pyramids, and those of curved lines formed upon the same bases and varying uniformly as to the breadth of their length between parallel lines of circumference, are equal.

K 79 [31] v. and 80 [32] r.

Of pyramids of equal bases there will be found the same proportion in the slopes of their sides as that of their heights. L 41 r.

Vitruvius says that small models are not confirmed in any operation by the effect of large ones. As to this, I propose to show here below that his conclusion is false, and especially by deducing the self-same arguments from which he formed his opinion, that is by the example of the auger, as to which he shows that when the power of a man has made a hole of a certain diameter a hole of double the diameter cannot then be made by double the power of the said man but by much greater power. As to this one may very well reply by pointing out that the auger of double the size cannot be moved by double the power, inasmuch as the surface of every body similar in shape and of double the bulk is quadruple in quantity the one of the other, as is shown by the two figures *a* and *n*.
[*Drawing*] *a n.*
Here one removes by each of these two augers a similar thickness of wood from each of the holes that they make; but in order that the holes or augers may be of double quantity the one of the other they must be fourfold in extent of surface and in power. L 53 r. and 53 v.

The right angle is said to be the first perfect among the other angles, because it finds itself at the middle of the extremities of an infinite number of other kinds of angles which differ from it, that is of an infinite number of obtuse angles and an infinite number of acute angles, and all these infinite angles being equal between themselves it finds itself equidistant to each of them, being in the middle. M cover v.

THE THIRD LESSON OF THE FIRST

Triangles are of three kinds, of which the first has three acute angles, the second a right angle and two acute angles, and the third an obtuse angle and two acute angles.

The triangle with three acute angles may be of three different shapes of which the first has three equal sides, the second two equal sides and the third three unequal sides.

And the right-angled triangle may be of two kinds, i.e. with two equal sides and with three unequal sides. M 1 r.

The right-angled triangle with two equal sides is derived from the half of the square. And the right-angled triangle with three unequal sides is formed by the half of the long tetragon [rectangle], and the obtuse-angled triangle with two equal sides is formed by the half of the rhombus cut in its greatest length.

The square is the name applied to a figure of four equal sides which form within them four right angles, that is to say that the lines that compose the angles are equal to each other. M 1 v.

LONG TETRAGON

The long tetragon [rectangle] is a surface figure contained by four sides and four right angles; and although its opposite sides are equal it does not follow from this that the sides which contain the right angle may not be unequal between themselves.

The rhombus is of two kinds: the first is formed by the square and the second by the parallelogram; the first has its opposite angles equal and likewise all its sides equal; its only variation consists in that no side ends in equal angles but with an acute angle and an obtuse angle. M 2 r.

RHOMBOID

The rhomboid is the figure that is formed from the rhombus, but whereas the rhombus is formed from the square the rhomboid is formed from the rectangle. It has the opposite sides and angles equal to each other but none of its angles is contained by equal sides.

Parallel or equidistant lines are those which when extended continuously in a straight line will never meet together in any part. M 2 v.

Every whole is greater than its part.
If [a thing] is neither larger nor smaller it is equal. M 3 r.

OF FIVE POSTULATES

That a straight line may be drawn from one point to another.
That with a centre it is possible to make a circle of any size.
That all right angles are equal to each other.

When a straight line intersects two straight lines and the two angles on one side taken together are less than two right angles these two lines extended on this side will undoubtedly meet.

Two straight lines do not enclose a surface. M 6 r.

THE THIRD LESSON OF THE TENTH

Of the comparison made between the continuous and the definite quantity, and how the continuous may have its parts communicating, that is to say measured by a common measure as would be a measure of one braccio, a measure that goes four times in a line of four braccia, and then three in a length of three braccia; and so forms a unity which enters four times in four numbers and also enters three times in three numbers; and there is the same proportion between four braccia and four numbers as there is between one number and one braccio.

 M 6 v.

OF FIVE [SIX?] POSTULATES

The boundaries of the line are points, the boundaries of the surface are lines and the boundaries of the body are surfaces.

That a straight line may be drawn from one point to another.

And this line may also be extended as much as one pleases beyond these points but the boundaries of this line will always be two points.

That upon the same point one may make many circles.

All right angles are equal to each other.

Parallel lines are those upon which if a transversal line be drawn four angles are formed, which when taken within [on one side?] equal two right angles. M 7 r.

If two squared surfaces have the same proportion to each other as their squares, their sides will be corresponding, that is commensurable in length.

And if there are two squared surfaces of which the sides are commensurable in length it will follow that the proportion between them will be as that of their squares.

And if the squared surfaces are not in the same proportion one to another as are their squares, their sides will be incommensurable in length. M 9 r.

If two things are equal to a third they will be equal to one another.

M 13 r.

If from equal things one takes equal things away the remainders will be equal. M 15 r.

A straight line is that in which if one takes a point in any position outside it, at such a distance that its length may share precisely such a given line, and any straight line be drawn from the said point to each of the said partitions, this line can be divided precisely in the same way by each of these partitions.

Let us say that the line of which the proof has to be made is *b f*, that the given point is *a*, that the space from the point to the extremity of the line is *a b*: and that the lengths (partitions *b*, *c*, *d*, *e*, *f* each of itself is equal to *a b*: I affirm that the line *a c* is double the space *a b*, and the line *a d* is triple, *a e* quadruple and *a f* quintuple. M 13 v. and 14 r.

NINE PROPOSITIONS

The things which are equal to the same thing are also equal to each other. And if to equal things one adds equal things the wholes will still be equal.

And if from equal things one takes away equal things the remainders will still be equal. And if from unequal things one takes away equal things the remainders will be unequal. And if two things are equal to another thing they will be equal to each other. And if there are two things which are each the half of the same thing each will be equal to the other. And if one thing is placed over another and touches it so that neither is exceeded by the other these things will be equal to each other. And every whole is greater than its part. M 16 r.

Geometry is infinite because every continuous quantity is divisible to infinity in one direction or the other. But the discontinuous quantity commences in unity and increases to infinity, and as it has been said the continuous quantity increases to infinity and decreases to infinity. And if you allow yourself to say that you give me a line of twenty braccia I will tell you how to make one of twenty-one. M 18 r.

All the angles made round a point are together equal to four right angles. M 31 v.

[A man's leap]

If a man in taking a leap upon a firm spot leaps three braccia and recoils as he takes his spring a third of a braccio, what would he lack of his first leap?

And in like manner if it was increased by one third of a braccio how much would he have added to his leap? M 55 r.

[Pyramids]

Multiply by itself the root of the number of this pyramid that you wish and detach it towards some angle.

If I wanted the fourth part of the height of the base of this pyramid which corresponds to the fourth part of the length of the pyramid I should say:—four times four are sixteen, and so the piece removed will be one sixteenth of the whole pyramid. And if you take away a part such as the half of the base which corresponds to the half of the length of this pyramid, you will say a half of a half is a quarter; therefore the part taken away will be a quarter of the whole pyramid, and if you multiply the three quarters of the base by the three quarters of the length of the pyramid this will make nine sixteenths of the whole pyramid.

This curved pyramid will find its end by finishing its circles. But if such a pyramid were to go thousands of miles to unite itself you would not be able to complete these circles; employ therefore the scale given.

M 86 v.

[Curved lines and pyramids]

If you cut above a section equidistant to the circle below making use of its centre r, and if you cut below a section equidistant to the circle above making use of its centre a, I wish to know if these two lines be drawn with the same curve at what distance they will join, or if they do not join where they will make their first approach and how distant they will ever be and how near to each other.

I wish as regards two given lines which are curved to find whether they are parallel or no, and if they are not parallel whether they are so arranged as to form a pyramid or no, and if they ought to form a pyramid at what fixed distance from the base their curved sides ought to join.

And for this you will act as follows: detach a part between the base

and the side and let this part be as great of such part of the base as of the side, and the portion may be taken either from the part above or the part below; and if you take it off the part above make it so that the section may be equidistant to the circle below using its centre *r*, and if you remove this portion from below make the section equidistant to the line above using its centre *a*, and if you take away this portion below make the section equidistant to the line above using its centre *a*, and so continuing as the straight pyramid. M 87 r.

[*Geometrical paradox*]

If the angle is the contact of two lines, as the lines are terminated in a point an infinite number of lines may commence at this point, and conversely an infinite number of lines may end together at this point: consequently the point may be common to the beginning and the end of innumerable lines.

And here it seems a strange matter that the triangle is terminated in a point with the angle opposite to the base, and from the extremities of the base one may divide the triangle into an infinite number of parts; and it seems here that as the point is the common end of all the said divisions the point as well as the triangle is divisible to infinity.

M 87 v.

The lines which form the circular parallels cannot be of the same curve because as they complete their circles they will have their contact or intersection in two places.

As regards the curve lines which have to make up the curved parallels, it is necessary that the part and the whole of the one and the part and the whole of the other should be together each of itself equidistant to a single centre. M 89 r.

SPHERICAL ANGLES EQUAL TO RIGHT ANGLES

Every four angles made within the circle of all the space of the circle are equal to four right angles, whether the lines be curved and straight or all straight or all curved.

Every quantity of lines that intersect at the same point will form as many angles round this point as there are lines that proceed from it, and these angles joined together will be equal to four right angles.

M 89 v.

[With diagram]

Pelacani[1] says that the longer arm of this balance will fall more rapidly than the shorter arm because in its descent it describes its quarter circle more directly than the shorter arm does; and that since the natural tendency of weights is to fall by a perpendicular line the more the circle bends the slower will the movement become.

The diagram *m n* controverts this argument in that the descent of the weights does not proceed by circles, and yet the weight of *m* the longer arm falls.

When anything is farther away from its base it is less supported by it; being less supported it keeps more of its liberty, and since a free weight always descends, the extremity of the rod of the balance which is most distant from the point of support, since it is heavy, will descend of itself more rapidly than any other part. MS. 2038 Bib. Nat. 2 v.

[Levers]

In proportion as the extremity of the upper part of the balance approaches more nearly to the perpendicular line than the extremity of the lower part, so much longer and heavier will the lower arm be than the upper arm if the beam be of uniform thickness.

MS. 2038 Bib. Nat. 3 r.

[Suspended bodies]

The suspended body which is of smooth roundness will fall in the line of its centre and will stop under the centre of the cord by which it is suspended.

The centre of the weight of any suspended body will stop in a perpendicular line beneath the centre of its support.

MS. 2038 Bib. Nat. 3 v.

Gravity, force and material movement together with percussion are four accidental powers in which all the visible works of mortals have their being and their death.

Gravity is a certain accidental power which is created by movement and infused into one element which is either drawn or pushed by another, and this gravity possesses life in proportion as this element strives to return to its former state. B.M. 37 v.

[1] According to M. Ravaisson-Mollien the reference is to Biagio Pelacani of Parma (born 1416), whom Tiraboschi calls *filosofo e matematico insigne.*

The redness or yolk of the egg remains in the centre of the albumen without sinking on either side, and it is either lighter or heavier or the same weight as this albumen. If it is lighter it ought to rise above all the albumen and remain in contact with the shell of the egg; and if it is heavier it ought to sink down; and if it is of the same weight it ought to be capable of remaining at one of the ends just as well as in the centre or below it. B.M. 94 V.

The thing moved will never be swifter than its mover. B.M. 121 V.

The boundary of one thing is the beginning of another.
The boundaries of two bodies joined together are interchangeably the surface the one of the other, as water with air. B.M. 132 r.

OF THE ELEMENTS

The bodies of the elements are united and in them there is neither gravity nor lightness. Gravity and lightness are produced in the mixture of the elements.

A point is that which has no centre.

A line is a length (extension) produced by the movement of a point, and its extremities are points.

A surface is an extension made by the transversal movement of a line, and its extremities are lines.

A body is a quantity formed by the lateral movement of a surface, and its boundaries are surfaces.

A point is that which has no centre, and from this it follows that it has neither breadth, length nor depth.

A point is that which has no centre, and therefore it is indivisible from any angle and nothing is less than it is.

A line is a length made by the movement of a point, wherefore it has neither breadth nor depth.

A body is a length and it has breadth with depth formed by the lateral movement of its surface. B.M. 160 r.

[*Definitions*]

A point has no part; a line is the transit of a point; points are the boundaries of a line.

An instant has no time. Time is made by the movement of the instant, and instants are the boundaries of time.

An angle is the contact of two lines which do not proceed in the same direction.

A surface is the movement of a line, and lines are the boundaries of a surface.

A surface has no body; the boundaries of bodies are surfaces.

B.M. 176 r.

A pyramidal body is that of which all the lines that proceed from the angles of its base meet in a point.

And a body such as this may be clothed with an infinite number of angles and sides.

A wedge-shaped body is one in which the lines that issue forth from the angles of the base do not meet in one single point but in the two points which end the line; and this ought not to exceed or fall short.

B.M. 176 v.

An instant has no time, for time is formed by the movement of the instant and instants are the boundaries of time.

A point has no part.

A line is the transit of a point.

A line is made by the movement of a point.

Points are the boundaries of a line.

An angle is the contact of the extremities of two lines.

A surface is formed by the movement of a line moved sideways to the line of its direction.

B.M. 190 v.

[*Propositions*]

Every body is surrounded by an extreme surface.

Every surface is full of infinite points.

Every point makes a ray.

The ray is made up of infinite separating lines.

In each point of the length of any line whatever, there intersect lines proceeding from the points of the surfaces of the bodies and [these] form pyramids.

Each line occupies the whole of the point from which it starts.

At the extremity of each pyramid there intersect lines proceeding

from the whole and from the parts of the bodies, so that from this extremity one may see the whole and the parts.

The air that is between bodies is full of the intersections formed by the radiating images of these bodies.

The images of the figures and colours of each body are transferred from the one to the other by a pyramid.

Each body fills the surrounding air by means of these rays of its infinite images.

The image of each point is in the whole and in the part of the line caused by this point.

Each point of the one object is by analogy capable of being the whole base of the other.

Each body becomes the base of innumerable and infinite pyramids.

That pyramid which is produced within more equal angles, will give a truer image of the body from whence it is produced.

One and the same base serves as the cause of innumerable and infinite pyramids turned in various directions and of various degrees of length.

The point of each pyramid has in itself the whole image of its base.

The centre line of the pyramid is full of the infinite points of other pyramids.

One pyramid passes through the other without confusion.

The quality of the base is in every part of the length of the pyramid.

That point of the pyramid which includes within itself all those that start upon the same angles, will be less indicative of the body from whence it proceeds than any other that is shut up within it.

The pyramid with the most slender point will reveal less the true form and quality of the body from whence it starts.

That pyramid will be most slender which has the angles of its base most unlike the one to the other.

That pyramid which is shortest will transform in greatest variety the similar and equal parts of its base.

Upon the same quality of angles will start pyramids of infinite varieties of length.

The pyramid of thickest point, more than any other will dye the spot on which it strikes with the colour of the body from which it is derived.

<div align="right">B.M. 232 r.</div>

OF THE NATURE OF GRAVITY

Gravity is a fortuitous quality which accrues to bodies when they are removed from their natural place.

OF THE NATURE OF LEVITY

Levity is allied with gravity as unequal weights are joined in the scales, or light liquids are placed beneath liquids or solids which are heavier than they . . . B.M. 264 r.

Take from one of five regular bodies a like body and so that what is left may be of the same shape.

I wish to take a given pentagon from another pentagon and so that the remainder may stay in the form of a pentagon, and they may be bodies and not surfaces.

Reduce the given pentagon into its cube, and proceed thus with the greater pentagon from which you have to extract the lesser; then by the past rules take the lesser cube from the greater cube, and then remake the pentagon from the remainder of this greater cube, which by the aforesaid rules has remained cubed.

That which is here said of the cube is understood of all bodies which touch the sphere with their angles, for what is made in the sphere may be made in the cube. Forster I 5 r.

All bodies have three dimensions, that is breadth, thickness and length.

The changes and manipulations of bodies are six, namely shortening and lengthening, becoming thicker and thinner, being enlarged and compressed.

The surface has breadth and length and is uniformly devoid of thickness.

The board is a flat body and has breadth, length and uniform thickness.

Therefore when the board is of uniform thickness and its surface of uniform quality we may use the table in all its manipulations and divisions in the same manner and with the same rules as we use the above mentioned surfaces. Forster I 12 v.

[*Diagram*]

The regular bodies are five and the number of those participating between regular and irregular is infinite: seeing that each angle when cut uncovers the base of a pyramid with as many sides as were the sides of this pyramid, and there remain as many bodily angles as there are sides.

These angles may be bisected anew and so you may proceed an infinite number of times because a continuing quantity may be infinitely divided.

And the irregular bodies are also infinite through the same rule aforesaid. Forster 1 15 r.

I will reduce to the form of a cube every rectangular body of equidistant sides.—

And first there will be a cylinder.

To get the square of a rectangular board that is longer than it is wide according to a given breadth: ask yourself by how much its size varies.

This may be done by the fifth of this, that is that I shall make of the width or length of this board the cylinder of length equal to the said width or length of the board, and then . . . Forster 1 31 r.

Geometry extends to the transmutations of metallic bodies, which are of substance adapted to expansion and contraction according to the necessities of their observers.

All the diminutions of cylinders higher than the cube keep the name of cylinder. All the diminutions of the cylinder that are lower than the cube are named boards.

The cube, a body of six equal sides contained by twelve equal lines and eight angles of three rectangular sides and twenty-four right angles; which body among us is called a die.

When you wish to treat of pyramids together as regards their increase or diminution, and you treat of cyclinders, cubes or boards which should be of the same height and breadth as these pyramids, then the third of these bodies will remain in the said pyramid; and this you will put concisely. Forster 1 40 v.

METHODS OF MEASURING A HEIGHT

Let *c f* be the tower you wish to measure; go as far away from it as you think desirable and take the range of it, as is shown in *c b a*, which may be the length of an arm and half as high, and work it so that the tower occupies the space *b a*; then turn the line *b a* along the level of the ground, and it occupies as great a space of ground as it occupied in height, and in the space of ground which it has occupied you will find the true altitude of the tower.　　　　　Forster I 48 v.

[*Diagrams*]

If a line falls perpendicularly upon another line it ends between two right angles.

If a straight line falls upon another straight line and passes to the intersection this intersection will stand in the middle of four right angles.

If the two straight lines which intersect together between four right angles shall have their four extremities equidistant to this intersection, it is necessary that these ends be also equidistant from one another.

Forster II 3 v.

If two circles intersect in such a way that the line of the circumference of the one is drawn over the centre of the other as the other is of it, these circles are equal, and the straight lines which pass from the two points of intersection and from the centre to the other intersect together within four right angles, and the circle made upon the two centres will remain divided in four equal parts by such said intersection, and there will be made a perfect square.　　　　Forster II 4 r.

If two three or four equal things are placed upon a thing which is equal to them all, the part of the greater which protrudes will be equal to the sum of the protruding parts of all the lesser ones; and the example is the figure below.　　　　　Forster II 4 v.

ACTUAL PROOF OF A SQUARE

If four circles be so placed as to have their centres situated upon the line of a single circle, in such a way that the line of the circumference

of each is made over the centres of each, undoubtedly these will be equal, and the circle where such intersection is made remains divided in four equal parts, and it is in the proportion of a half to each of the four circles, and within this circle will be formed the square with equal angles and sides. Forster ii 5 v.

Every continuous quantity is divisible to infinity. Forster ii 53 v.

Gravity, force and accidental movement together with percussion, are the four accidental powers with which all the visible works of mortals have their existence and their end.

GRAVITY

Gravity is accidental power, which is created by movement and infused in bodies standing out of their natural position.

HEAVY AND LIGHT

Gravity and lightness are equal powers created by the one element transferred into the other; in every function they are so alike that for a single power which may be named they have merely variation in the bodies in which they are infused, and in the movement of their creation and deprivation.

That body is said to be heavy which being free directs its movement to the centre of the world by the shortest way.

That body is said to be light which being free flees from this centre of the world; and each is of equal power. Forster ii 116 v.

Gravity, force, together with percussion, are not only interchangeably to be called mother and children the one of the other and all sisters together, because they may be produced by movement, but also as producers and children of this movement; because without these within us movement cannot create, nor can such powers be revealed without movement. Forster ii 117 r.

The accidental centre of the gravity that descends freely will always be concentric with the central line of its movement, even though this gravity should revolve in its descent. Forster ii 125 v.

[*Sketch*]

a n forms the groove in the bank a quarter of a braccio on the inside, by means of the grooves or teeth of iron, and these teeth rub against the bases of the bank, and afterwards one seizes the handles of the rake, and the soil that has collected upon it is placed in the box.

Forster III 18 r.

[*Diagram*]

That which is called centre is an indivisible part, and may more readily be considered as round than of any other shape; therefore the first part that surrounds it round is divisible whatever it may be; if it be in the square beaten into a circle it enlarges.　　Forster III 26 v.

[*Sketches*]

The angle is terminated in the point; in the point intersect the images of bodies.　　Forster III 29 v.

[*Sketch*]

WORM OF SCREW

The line *b d* ought to show how much this turns and similarly how much the circle of the line *a o* turns, and take the number that is found between the one number and the other; and upon this make your calculation as is shown here below.

[*Sketch*]

m n is the line that finds itself between *b d* and *a o*, which you will cause to take the direction as shown here below.

[*Sketch*]

c r is the extent to which this line is slanting, that is the extent to which the worm of the screw above turns over and drops.

Forster III 81 v.

[*Sketch*]

Multiply the line *a o* by the line *o p*, and that which results multiply with it that number of the parts of the half-diameter of the screw which finds itself upon the length of the lever; and that which results apportion it.　　Forster III 82 r.

And if you should only know the weight of the thing that you wish to raise with the tackle and did not know how great weight or

force was necessary in order to raise this weight, divide the number of the pounds of your weight by the number of the wheels that there are in the tackle, and that which comes out will be the uncertain weight which will resist the certain with equal forces. Forster III 82 v.

If you wish with certainty to understand well the function and the force of the tackle, it is necessary for you to know the weight of the thing that moves or the weight of the thing moved; and if you would know that of the thing that moves multiply it by the number of the wheels of the tackle, and the total that results will be the complete weight which will be able to be moved by the moving thing.

Forster III 83 r.

Such proportion will the weight have which is suspended by means of the lever through the cord of the windlass to the force that the mover exerts for its suspension, as has the half of the diameter of the windlass to the space that is found upon the lever, between the hand of its mover and the centre of the thickness of the said windlass.

Forster III 83 v.

[Sketch]

If you multiply the number of the pounds that your body weighs by the number of the wheels that are situated in the tackle you will find that the number of the total that results will be the complete quantity of pounds that it is possible to raise with your weight.

Forster III 84 r.

That body of which the parts that are enclosed between the surface and the centre are equal in substance, weight and size, if it be suspended transversely by its opposite extremities will give an equal part of its weight to its supports.

That wheel of which the centre of the axis is the centre of its circle, will in all circumstances perform its functions in perfect balance; and equal bodies suspended from the opposite extremities of its circle will stand in equal counterpoise the one to the other. Forster III 84 v.

[Sketch—tackle]

It can be so made that although the counterpoises are different in weight the one to the other in equal arms of balances, they stand at equal resistance the one to the other: see in the instrument represented

in the equal arms of the upper balances, sixteen [pounds] weight below stands in resistance to eight. Forster III 85 r.

In proportion as the number of the wheels is greater so will the fall of the counterpoise be greater than the rise of the greater weight.

In proportion as the number of the wheels is greater so will the number of the arms of the cord collected by the windlass be greater than that of the weight that is raised. Forster III 85 v.

The pulling of the tackle requires force, weight, time and movement.

OF THE MOVEMENT OF THE CORDS

As many as may be the number of the wheels of the tackle so much will the cord be swifter in its first movement than in its last.

OF THE WEIGHT

In proportion to the number of the wheels so much will the weight sustained be greater than that which supports it. Forster III 86 r.

[*Sketch. 'Cord of the windlass.' 'Multiply that weight by the number of the wheels.'*]

If you wish to ascertain how much cord a windlass will collect after it has passed through the whole or as few as two [turns] of a tackle of four wheels, know that for every braccio that the weight is raised, the windlass will collect four [braccia] by the four wheels of the tackle; and if the wheels were twenty, for every braccio that the weight was raised the windlass would need two braccia of cord.

In the raising of the weight the windlass would need as many times more braccia of cord than the weight would raise, according to the number of the wheels which are collected in the tackle.

Forster III 86 v.

If the wheels are two and you wish to raise the weight one braccio the windlass collects two braccia; the proof is this: let us say *n m* is one braccio, and so *n f* may be another; let us say that I wish to raise the weight *m* one braccio: it is evident that the cord *n m f* which is

wo braccia will be no more in its position and the windlass will gather
up as much again.

In proportion to the number of the wheels that move in the tackles
by so much will the cord of the first movement be swifter than that of
the last. Forster III 87 r.

DEFINITION OF THE NATURE OF THE LINE

The line has not in itself any matter or substance but may more
readily be called an incorporeal thing than a substance, and being of
such condition it does not occupy space. Therefore the intersections of
infinite lines may be conceived of as made at a point which has no
dimensions, and as to thickness, if such a term can be employed, is
equal to the thickness of one single line.

HOW WE CONCLUDE THAT THE SURFACE TERMINATES IN A POINT

An angular surface becomes reduced to a point when it reaches its
angle; or if the sides of this angle are produced in a straight line, then
beyond this angle there is formed another surface, less or equal or
greater than the first. Windsor MSS. R 47

Every point is the head of an infinite number of lines, which com-
bine to form a base, and suddenly from the said base by the same lines
converge to a pyramid showing both its colour and its form.

No sooner is the form created or compounded than suddenly of itself
it produces infinite angles and lines, which lines spreading themselves
in intersection through the air give rise to an infinite number of angles
opposite to one another. With each of these opposite angles, given a
base, will be formed a triangle alike in form and proportion to the
greater angle; and if the base goes twice into each of the two lines of
the pyramid it will be the same with the lesser triangle.

Windsor MSS. R 62

Archimedes has given the square of a polygonal figure, but not of
the circle. Therefore Archimedes never found the square of any figure
with curved sives; but I have obtained the square of the circle minus

the smallest possible portion that the intellect can conceive, that is, the smallest point visible. Windsor: Drawings 12280 v.

If into a vessel that is filled with wine as much water is made to enter as equals the amount of the wine and water which runs out of it, the said vessel can never be altogether deprived of wine. This follows from the fact that the wine being a continuous quantity is divisible to infinity, and therefore if in a certain space of time a particular quantity has poured away, in another equal space of time half the quantity will have poured away, and in yet another a fourth of the quantity; and what is left is constantly being replenished with water; and thus always during each successive space of time the half of what remains will be poured out. Consequently, as it is capable of being divided to infinity, the continuous quantity of the aforesaid wine will be divided during an infinite number of spaces of time; and because the infinite has no end in time there will be no end to the number of occasions on which the wine is divided. Leic. 26 v.

Instrumental or mechanical science is the noblest and above all others the most useful, seeing that by means of it all animated bodies which have movement perform all their actions; and the origin of these movements is at the centre of their gravity, which is placed in the middle with unequal weights at the sides of it, and it has scarcity or abundance of muscles, and also the action of a lever and counter-lever.

Sul Volo 3 r.

XXI

The Nature of Water

'As from the said pool of blood proceed the veins which spread their branches through the human body, in just the same manner the ocean fills the body of the earth with an infinite number of veins of water.'

I‌f a drop of water falls into the sea when this is calm, it must of necessity be that the whole surface of the sea is raised imperceptibly, seeing that water cannot be compressed within itself like air. c.a. 20 r. a

Whether the surface of the air is bounded by the fire, as is the water by the air and the earth by the water, and whether the surface of the air takes waves and eddies as does the surface of the water, and whether in proportion as the body of the air is thinner than that of the water the revolutions of its eddies are greater in number: of the eddies of the water some have their centres filled with air, others with water. I do not know whether it is the same with the eddies of the surface of the fire. Of the eddies of the water all those which begin at the surface are filled with air, and those that have their origin within the water are filled with water; and these are more lasting because water within water has no weight as water has when it is above the air; therefore the eddies of the water round the air have weight and speedily perish.

c.a. 42 r. a

OF THE DELUGES OF THE GREATEST RIVERS

The deluges of rivers are created when the mouths of the valleys cannot afford egress to the waters that they receive from these valleys as rapidly as the valleys receive them.

The progress of the water is swifter when it falls at a greater angle.

643

OF WAVES

The wave is the recoil of the stroke, and it will be greater or less in proportion as the stroke itself is greater or less. A wave is never found alone, but is mingled with as many other waves as there are uneven places in the object where the said wave is produced. At one and the same time there will be moving over the greatest wave of a sea innumerable other waves proceeding in different directions. If you throw a stone into a sea with various shores, all the waves which strike against these shores are thrown back toward where the stone has struck, and on meeting others advancing they never interrupt each other's course. Waves of equal volume, velocity and power, when they encounter each other in opposing motion, recoil at right angles, the one from the stroke of the other. That wave will be of greater elevation which is created by the greater stroke, and the same is true of the converse. The wave produced in small tracts of water will go and return many times from the spot which has been struck. The wave goes and returns so many more times in proportion as the sea which produces it contains a less quantity of water, and so conversely. Only in the high seas do the waves advance without ever turning in recoil. In lesser tracts of water the same stroke gives birth to many motions of advance and recoil. The greatest wave is covered with innumerable other waves moving in different directions; and these have a greater or less depth as they are occasioned by a greater or less power. The greatest wave is covered with various waves, which move in as many different directions as there were different places from which they separated themselves. The same wave produced within a small tract of water has a greater number of other waves proceeding over itself, in proportion to the greater strength of its stroke and recoil from the opposite shores. Greater is the motion of the wave than that of the water of which it is composed. Many waves turned in different directions can be created between the surface and the bottom of the same body of water at the same time. The eddying movements can accompany the direct movements of each wave. All the impressions caused by things striking upon the water can penetrate one another without being destroyed. One wave never penetrates another; but they only recoil from the spot where they strike. C.A. 84 v. a

The movement of water within water proceeds like that of air within air. C.A. 108 v. a

Among irremediable and destructive terrors the inundations caused by rivers in flood should certainly be set before every other dreadful and terrifying movement, nor is it, as some have thought, surpassed by destruction by fire. I find it to be the contrary, for fire consumes that which feeds it and is itself consumed with its food. The movement of water which is created by the slopes of the valleys does not end and die until it has reached the lowest level of the valley; but fire is caused by what feeds it, and the movement of water by its wish to descend. The food of the fire is disunited, and the mischief caused by it is disunited and separated, and the fire dies when it lacks food. The slope of the valley is continuous and the mischief done by the destructive course of the river will be continuous until, attended by its valleys, it ends in the sea, the universal base and only resting place of the wandering waters of the rivers.

But in what terms am I to describe the abominable and awful evils against which no human resource avails? Which lay waste the high mountains with their swelling and exulting waves, cast down the strongest banks, tear up the deep-rooted trees, and with ravening waves laden with mud from crossing the ploughed fields carry with them the unendurable labours of the wretched weary tillers of the soil, leaving the valleys bare and mean by reason of the poverty which is left there.

Among irremediable and destructive terrors the inundations caused by impetuous rivers ought to be set before every other awful and terrifying source of injury. But in what tongue or with what words am I to express or describe the awful ruin, the inconceivable and pitiless havoc, wrought by the deluges of ravening rivers, against which no human resource can avail? C.A. 108 v. b

Prove and draw up the rule for the difference that there is between a blow given by water upon water, and by water falling upon something hard; and consider well also that as water falls upon other water, and it yields space to the blow, the percussion making the water open as it receives the blow, so the same result will occur in a vase when the water which is contained within it has been struck, for it will be the

same as when falling water has struck against a hard substance which resists the blow. c.a. 153 v. d

OF RIVERS AND THEIR COURSES

Among straight rivers which occur in land of the same character, with the same abundance of water and with equal breadth, length, depth, and declivity of course, that will be the slower which is the more ancient.

This may be proved with straight rivers. That will be most winding which is the oldest, and that which winds will become slower as it acquires greater length.

Of waters which descend from equal altitudes to equal depths that will be the slower which moves by the longer way.

Of rivers which are at their commencement that will be the slower which is the more ancient, and this arises from the fact that the course is continually acquiring length by reason of the additional meanderings of the river; and the reason of this is explained in the twelfth section. c.a. 156 r. a

The cause which moves the humours in all kinds of living bodies contrary to the natural law of their gravity, is really that which moves the water pent up within them through the veins of the earth and distributes it through narrow passages; and as the blood that is low rises up high and streams through the severed veins of the forehead, or as from the lower part of the vine the water rises up to where its branch has been lopped, so out of the lowest depths of the sea the water rises to the summits of the mountains, and finding there the veins burst open it falls through them and returns to the sea below. Thus within and without it goes, ever changing, now rising with fortuitous movement and now descending in natural liberty.

So united together it goes ranging about in continual revolution.

Rushing now here now there, up and down, never resting at all in quiet either in its course or in its own nature, it has nothing of its own but seizes hold on everything, assuming as many different natures as the places are different through which it passes, acting just as the mirror does when it assumes within itself as many images as are the objects which pass before it. So it is in a state of continual change,

sometimes of position and sometimes of colour, now enclosing in itself
new scents and savours, now keeping new essences or qualities, show-
ing itself now deadly now lifegiving, at one time dispersing itself
through the air, at another suffering itself to be sucked up by the heat,
and now arriving at the region of cold where the heat that was its guide
is restricted by it.

And as when the hand under water squeezes a sponge so that the
water that escapes from it creates a wave that passes through the other
water, even so does the air that was mingled with the water when the
cold[1] is squeezed out, flee away in fury and drive out the other air;
this then is the course of the wind.

And as the hand which squeezes the sponge under water when it is
well soaked, so that the water pent up within it is compelled to flee
away and therefore is driven by force through the other water and
penetrates it, and this second mass perceiving itself to be struck de-
parts in a wave from its position, even so the new . . . makes . . .

<div style="text-align: right">C.A. 171 r. a</div>

The sharp bends made in the embankments of rivers are destroyed
in the great floods of the rivers because the maximum current drives
the water in a straight course. But as this diminishes it resumes its
winding course, during which it is being continually diverted from
one bank to another, and as it thus grows less the embankment of the
river becomes hollowed out.

But in this lesser depth the water does not move with uniform
course, because the greater current leaps from one hollow to another
of the opposite banks, and the sides of the water which border upon
the embankment have the shortest course.

The rotundities in the islands of shingle formed by the angles of the
embankment trace their origin to the chief eddies of the rivers, which
extend with their revolutions among the concavities and convexities
which are found alternately in the embankments of the rivers; and
from these spring the tiny brooks, interposed between the sandbanks
of the rivers and their embankments, and placed opposite to the hol-
lows of the embankments of these rivers.

[1] MS., *quella del freddo.*

The entry of river into river produces the first meanderings of the river.

The meanderings of rivers in plains are occasioned by the rivers emptying themselves there.

If the winding river be altogether removed from its ancient bed and set in a straight channel, it is necessary that the rivers which pour themselves into it from two sides increase in length on the one side as much as they lose it on the other, the one that acquires length losing in swiftness, this swiftness being transferred to the one that grows shorter.

Cause the lesser rivers to enter into the greater rivers at acute angles; the advantage of this will be that the current of the greater river diverts the line of entry of the lesser river and does not suffer it to strike against the opposite bank.

Should however the lesser river be in flood at the time when the waters of the greater river are low the percussion of the lesser river will break the opposite bank of this greater river.

The largest of the curves of a river in a valley will always have its convex side facing the lower part of the breadth of the valley.

The meanderings of rivers are always greater in proportion as they are nearer to the spot where the lesser river enters the greater.

The waves of earth formed by the embankment of the rivers are continually changing their positions, the former being created anew where the latter have been washed away. c.a. 185 r. b

Prove whether a triangle thrown into still water makes its wave of perfect roundness in the end. c.a. 199 v. b

[*Sketch—figure of bubble resting on water*]
Why the bubbles which the water makes are half-spheres and those of the air are perfect spheres. Why the sides of the base of the half-sphere are spherical rectangles, and the contact which each has with the water does not cause it to form a projection above it but on account of its weight it has to bend and curve. c.a. 209 r. a

[*With drawing*]
The water that falls down from a height, will create a deep pool, which will continually increase, and its banks will often fall in. And

the reason of this is that the water, which falls upon the other water, by the swiftness of its blow and by its weight causes it to give place, and passes down to its depths where it forms a hollow space, and through the stroke and the air, which as it falls is buried with it, it comes to rise up again and raise itself to a height by various channels, which expand like an opening bud, and the stroke of the water upon the bank proceeds in a circle and thus continuing it will gnaw and consume the surrounding shores. c.a. 215 v. d

The air by its nature does not flee away beneath the water; but the water which is supported round about it presses it out of itself and drives it forth.

Therefore one element does not flee away of itself out of the other element, but is driven out by it. c.a. 244 v. a

OF THE FLOW AND EBB OF THE SEA AND ITS VARIETY

The flow and ebb of the sea are due to the course of the rivers, which give the water back again to the sea with slower movement than the movement of their own current; and on this account necessity causes the water to rise to a height. And this river covers up its current again with the swift wave which in its recoil goes to meet the descending current of the river.

The wave of the river flows back against its current when the sea is at its ebb. After the return of the wave to the shore it there acquires new power from the approach of the river.

The flow and ebb of the sea are not caused by the moon or the sun, but by the greatest wave as it advances and falls back. But since the recoil is weaker than the advancing movement, as it is deprived of support, this hesitating movement would consume itself if it were not renewed by the help of the rivers; for these being immediately swollen by the approaching wave of the aforesaid tide, the wave produced by this swollen river becomes added to this ebb, and it strikes the opposite shores of the islands set over against it, and then leaps back, and so returns in its former course, and so continues, as has been said above.

This experience has taught us, for it is seen continually in every river, and especially as it strikes against the sides of its bays.

c.a. 281 r. a

The spiral or rotary movement of every liquid is so much the swifter in proportion as it is nearer to the centre of its revolution.

This that we set forth is a circumstance worthy of note; since movement in the circular wheel is so much slower as it is nearer to the centre of the revolving object. But this same circumstance is shown in the similarity of movement both as to speed and length in each complete revolution of the water, both in the circumference of its greater and of its lesser circle; but the curve of the lesser circle is as much less than that of the greater as the greater circle is more curved than the lesser. And so this water is of uniform movement in all the processes of its revolution, and if it were not so the concavity would instantly be filled up again. But because the lateral weight of this eddying mass [1] is two-fold, such concavity has no permanent movement, and of such duplication of weight the first comes into being in the revolving movement of the water, the second is created in the sides of this concavity, and it supports itself there and finally falls headlong down upon the air which has filled up the aforesaid cavity with itself.

The movements of the air through the air are two, that is straight in the form of a column upwards, and with revolving movement.

But water makes this movement downwards, and makes it in the form of a pyramid, and makes it so much the more swiftly as the pyramid is more pointed. c.a. 296 v. b

OF THE UTILITY OF THE SCIENCE OF WATER

There were many of the chief towns of the districts which, through being placed upon their chief rivers, have been consumed and destroyed by these rivers, as was Babylon by the Tigris, by means of Cyrus . . . and so with an infinite number of regions; and the science of water gives exact information as to their defences. c.a. 305 r. a

Water falling perpendicularly into running water makes a curve as it enters and a curve as it rises. The summit of the part that rises in the air will not be in the centre of the base of this cavity, and this base will be oval. c.a. 343 v. a

[1] MS. *circulazion revertiginosa.*

OF RIVERS

The water falls in whatever is the line of the summit of its wave, and it moves more swiftly where this fall has less slant, and breaks more into foam where it meets with more resistance.

There, according to what has been stated, the waves break against the course of the river and never in the direction of its course, because water falling upon flowing water can never create a rebound upon something that flies away and does not await the stroke; but in the case of the opposite descent towards the course of the water, the water in the wave as it falls against the course of the river does not come upon water which flies away from its stroke, but upon water which is proceeding in the opposite direction to this fall; and consequently as the wave in its fall has four degrees of velocity and the water that comes to meet it is also of four degrees of velocity, the impetus of the wave acquires eight degrees of velocity, and therefore waves of rivers break against their current, and that of the sea breaks against the water that flies back from the shore against which it has struck, and not against the wind that drives it. c.a. 354 r. b

OF THE FLOW AND EBB OF THE WATERS

Every movement of water creates flow and ebb in every part of the river where the swiftness of its course checks it.

This is proved by the fact that where the course of the river is steeper it is swifter; and where it is more level it is slower. Therefore the level sea receives more water than it discharges; for which reason it is necessary for the water of the sea to rise to such a height that its weight overcomes the water that drives it; and then this water which has been driven descends from its height round about the base of the aforesaid hill, and that part which descends against the current mentioned before swells this current up in such a way that the upper part of its water is retarded, until the water that follows becoming more abundant subdues the ebb and creates a new flow. c.a. 354 r. e

The impetus made in the great current of the water preserves its line among the motionless waves as the solar ray may do in the course of the winds.

At one time the wave of the impetus is motionless amid the great current of the water, at another it is extremely swift in the motionless water, that is on the surface of the swamps.

Why does a blow upon the water create many waves? c.a. 354 v. a

The river which has always depth at the centre of its course will keep within its banks.

Where the channel is more confined, there the water runs more strongly than elsewhere, and as it issues from the straight it spreads itself furiously, and strikes and wears away the near banks which lie across its course, and often changes its course from one place to another.

c.a. 361 r. b

The movement of the wind resembles that of the water.

What is the difference between water which is drawn and water which is driven?

Water which is drawn is when the Ocean as it falls draws after it the water of the Mediterranean Sea.

Water driven is that caused by the rivers which, as they come into the sea, drive its water.

Amid all the causes of the destruction of human property, it seems to me that rivers on account of their excessive and violent inundations hold the foremost place. And if as against the fury of impetuous rivers any one should wish to uphold fire, such a one would seem to me to be lacking in judgment, for fire remains spent and dead when fuel fails it, but against the irreparable inundation caused by swollen and proud rivers no resource of human foresight can avail; for in a succession of raging and seething [waves], gnawing and tearing away the high banks, growing turbid with the earth from the ploughed fields, destroying the houses therein and uprooting the tall trees, it carries these as its prey down to the sea which is its lair, bearing along with it men, trees, animals, houses and lands, sweeping away every dike and every kind of barrier, bearing with it the light things, and devastating and destroying those of weight, creating big landslips out of small fissures, filling up with its floods the low valleys, and rushing headlong with insistent and inexorable mass of waters.

What a need there is of flight for whoso is near! O how many cities, how many lands, castles, villas and houses has it consumed!

How many of the labours of wretched husbandmen have been rendered idle and profitless! How many families has it brought to naught, and overwhelmed! What shall I say of the herds of cattle which have been drowned and lost!

And often issuing forth from its ancient rocky beds it washes over the tilled [lands] ... c.a. 361 v. a

Where the channel of the river is more sloping the water has a swifter current; and where the water is swifter it wears the bed of its river more away and deepens it more and causes the same quantity of water to occupy less space.

The shorter the course of the rivers the greater will be their speed. And so also conversely it will be slower in proportion as their course has greater length.

Where the superabundance of the water is not received within the depth of its channel, necessity causes it to fall precipitately outside its banks.

No part of an element possesses weight within its element unless it is either moved within it with impetus, or falls down within it, being drawn by it from within another element. c.a. 365 r. a

The course of a smaller flood of water conforms to that of the larger of the great floods, and changes course and keeps company with it and ceases to delve under the banks.

The proof of this is seen in the Po. For when it is low its water runs many times in cross-currents, and called by the low places and directing its way towards these it takes its course and strikes the bank in its foundations, and hollows these out causing wide destruction. But when it flows in full stream the lesser quantity which formerly with its cross-current had beaten upon the banks and hollowed them, abandons its course, being dragged in company with the greater volume of water and advancing along the line of its base it forbears to damage its banks.

 A 23 v.

The water which falls by the line nearest to the vertical is that which descends most rapidly and gives itself with greatest blow and greatest weight to the spot on which it strikes.

Every stream of water when near to its fall will have the curve of the descent commencing on the surface before it commences in the depth.

<div align="right">A 24 r.</div>

Water is by its weight the second element that encompasses the earth, and that part of it which is outside its sphere will seek with rapidity to return there. And the farther it is raised above the position of its element the greater the speed with which it will descend to it. Its qualities are dampness and cold. It is its nature to search always for the low-lying places when without restraint. Readily it rises up in steam and mist, and changed into cloud falls back again in rain as the minute parts of the cloud attach themselves together and form drops. And at different altitudes it assumes different forms, namely water or snow or hail. Constantly it is buffeted by the movement of the air, and it attaches itself to that body on which the cold has most effect, and it takes with ease odours and flavours.

<div align="right">A 26 r.</div>

It is not possible that dead water should be the cause of movement either of itself or of anything else.

<div align="right">A 43 r.</div>

THE BEGINNING OF THE TREATISE ON WATER

Man has been called by the ancients a lesser world, and indeed the term is rightly applied, seeing that if man is compounded of earth, water, air and fire, this body of the earth is the same; and as man has within himself bones as a stay and framework for the flesh, so the world has the rocks which are the supports of the earth; as man has within him a pool of blood wherein the lungs as he breathes expand and contract, so the body of the earth has its ocean, which also rises and falls every six hours with the breathing of the world; as from the said pool of blood proceed the veins which spread their branches through the human body, in just the same manner the ocean fills the body of the earth with an infinite number of veins of water. In this body of the earth there is lacking, however, the sinews, and these are absent because sinews are created for the purpose of movement, and as the world is perpetually stable within itself no movement ever takes place there, and in the absence of any movement the sinews are not necessary; but in all other things man and the world show a great resemblance.

OF THE SPRINGS OF WATER ON THE TOPS OF MOUNTAINS

Clearly it would seem that the whole surface of the ocean when not affected by tempest is equally distant from the centre of the earth, and that the tops of the mountains are as much farther removed from this centre as they rise above the surface of the sea. Unless therefore the body of the earth resembled that of man it would not be possible that the water of the sea being so much lower than the mountains should have power in its nature to rise to the summit of the mountains. We must needs therefore believe that the same cause that keeps the blood at the top of a man's head keeps water at the summit of mountains.

OF THE HEAT THAT IS IN THE WORLD

Where there is life there is heat, and where there is vital heat there is movement of vapour. This is proved because one sees that the heat of the element of fire always draws to itself the damp vapours, the thick mists and dense clouds, which are given off by the seas and other lakes and rivers and marshy valleys. And drawing these little by little up to the cold region, there the first part halts, because the warm and moist cannot exist with cold and dryness; and this first part having halted receives the other parts, and so all the parts joining together one to another form thick and dark clouds.

And these are often swept away and carried by the winds from one region to another, until at last their density gives them such weight that they fall in thick rain; but, if the heat of the sun is added to the power of the element of fire, the clouds are drawn up higher and come to more intense cold, and there become frozen and so produce hailstorms.

So the same heat which holds up so great a weight of water as is seen to fall in rain from the clouds sucks it up from below from the roots of the mountains and draws it up and confines it among the mountain summits, and there the water finds crevices, and so continuing it issues forth and creates rivers. A 54 V.

If heat is the cause of the movement of moisture cold stops it. This has been already shown by the example of the cold region which stops

the clouds drawn by the hot element. As for the proof that the heat
draws the moisture it is shown as follows:—heat a jug and set it in a
vase with the mouth downwards, and place there some charcoal which
has been lighted. You will see that the moisture as it retires before the
heat will rise and fill the jug with water, and the air which was
enclosed in this jug will escape through its opening.

Also if you take a wet cloth and hold it to the fire you will see the
damp of the cloth leave its place, and that part of the moisture which
has least substance will rise up, drawn by the proximity of the fire
which from its nature rises towards the region of its element. In this
way the sun draws up the moisture.

EXPLANATION OF THE PRESENCE OF WATER AT THE SUMMITS OF THE MOUNTAINS

I say that it is just like the blood which the natural heat keeps in the
veins at the top of the man, and when the man has died this blood
becomes cold and is brought back into the low parts, and as the sun
warms the man's head the amount of blood there increases, and it
grows to such an excess there with the humours as to overload the veins
and frequently to cause pains in the head. It is the same with the
springs which ramify through the body of the earth and, by the natural
heat which is spread through all the body that contains them, the
water stays in the springs and is raised to the high summits of the
mountains. And the water that passes through a pent-up channel within
the body of the mountain like a dead thing will not emerge from its
first low state, because it is not warmed by the vital heat of the first
spring. Moreover the warmth of the element of fire, and by day the
heat of the sun, have power to stir up the dampness of the low places
and draw this to a height in the same way as it draws the clouds and
calls up their moisture from the expanses of the sea. A 56 r.

Of the opinion held by some that the water of some seas is higher
than the highest summits of the mountains and that the water was
driven up to these summits:

Water will not move from one spot to another unless to seek a lower
level, and in the natural course of its current it will never be able to

return to an elevation equal to that of the spot whence it first issued forth from the mountains and came into the light. That part of the sea which by an error of imagination you state to have been so high as to have flowed over the summits of the high mountains for so many centuries, would be consumed and poured out in the water that has issued from these same mountains. You can well imagine that during all the time that the Tigris and the Euphrates have flowed from the summits of the Armenian mountains,[1] one may suppose the whole of the water of the ocean to have passed a great many times through their mouths.

Or do you not believe that the Nile has discharged more water into the sea than is at present contained in all the watery element? Surely this is the case. If then this water had fallen away from the body of the earth, the whole mechanism would long since have been without water. So therefore, one may conclude that the water passes from the rivers to the sea, and from the sea to the rivers, ever making the self-same round, and that all the sea and the rivers have passed through the mouth of the Nile an infinite number of times. A 56 r and v.

OF THE FOAM OF WATER

Water which falls from a height into other water imprisons within itself a certain quantity of air, and this through the force of the blow becomes submerged with it. Then with swift movement it rises up again and arrives at the surface which it has quitted, clothed with a fine veil of moisture spherical in form, and proceeds by circles away from the spot where it first struck. Or the water which falls down upon other water runs away from the spot where it strikes, in various different branches, bifurcating and mingling and interlacing one with another; and some, being hollow, are dashed back upon the surface of the water; and so great is the force of the weight, and of the shock caused by this water, that through its extreme swiftness the air is unable to escape into its own element, but on the contrary is submerged in the manner that I have stated above.

[1] Text is not *de monti eruini*, as given in M. Ravaisson-Mollien's transcript, but *de mōti ermjnj* (*de monti ermini*), as given by Dr. Richter.

WHY RIVERS CHANGE THEIR POSITION AND OFTEN RAISE THEMSELVES AND MOUNT UPWARDS IN VARIOUS PLACES

The movement of water tends always to wear away its support; and the part which is the softest offers the least resistance, and as it vacates its place it leaves various hollows in which the water, whirling round in divers eddies, wears away and hollows out and increases these chasms, and striking against the newly-bared dikes leaps back and strikes upon the banks, consuming and eating away and destroying whatever stands in its path, changing its course in the midst of the havoc it has made, dragging with it in its course the lightest of the soil and then depositing it in the parts that are more tranquil. As it raises its bed the quantity and force of the water is lessened and its fury is transferred to the opposite side, and when it reaches the bank it eats it away and lays its foundations bare until with great destruction it has uncovered new ground. If it should find a plain it covers it, and carrying away and hollowing out it forms a new bed, and if it should come upon buried stones it uncovers them and lays them bare. But it often happens that these, because of their size, make resistance to the impetuous flood, and so after being driven against the rocks that are in the middle of its course it leaps back towards the opposite side, breaking and destroying the opposite bank. A 59 r.

WHY WATER DIGS OUT ROUND PITS WHEN IT FALLS WITH VIOLENCE

Water which falls in the manner stated does not enlarge its pit, for as the fact of it falling perpendicularly shows, there is but little force in the water that drives it from behind, and this is why it falls all broken and in fine spray almost in a perpendicular line. And the air which is amidst this broken water having an almost equal weight above it cannot escape so quickly as not to be submerged by the weight together with the blow. But, since air cannot be disunited from its element without violence, after yielding to the fury of the blow and the weight, it rises again quickly and returns to the surface in round bubbles near to the spot that was struck, and so as it does not move any distance from this spot it does not cause any damage to the banks of the pit. But when the

rushing river, swollen by recent rains, scours its banks, it falls in fury into the lower waters, and no longer as formerly descending peacefully in a shower mingled with air upon the other water but united and strong, strikes and tears open the smitten depths right down to their rocky bed, uncovering and carrying away the buried stones, setting up for itself a new barrier in the shingle carried from the pit which it has made it throws itself upon it and falls back beaten, and divides at the blow into two different streams which separate and form half-circles, devouring and consuming every obstacle and enlarging their bed in the form of a circle.

To put it more exactly—when the rivers are in flood, the falls of the water are less abrupt, and therefore, as the mass of water strikes the lower levels, the water which follows the blow does not hasten with the violence of that which falls, and this being the case it offers resistance and thus offering resistance the water rises and the fall becomes shorter. In consequence it does not imprison so much air, because the lower parts of the water are hardly separated from the rest in its fall and, owing to this, very little air can enter, and therefore the blow and weight of the water meet with no resistance, and the blow proceeds without diminishment right down to the bottom, displacing the gravel that is there and surrounding and clothing the stones with itself and increasing the depth of the pools. A 59 r. and v.

OF THE WAY IN WHICH PITS ARE FORMED IN THE COURSES OF RIVERS

The reason is that in the beds of rivers there are always found stones of different sizes, and as the water, coming to the largest, sinks down behind them and smites the spot on which it falls, the blow dislodges the lesser stones from the spot on which it strikes, and the bed is made larger. As the fall increases it becomes more powerful and hollows out even more the pit which has been begun; and this occurs because the rivers constantly gnaw the mud of their bed and constantly uncover and lay bare rocks of different forms and sizes.

WHY THE SURFACE OF FLOWING RIVERS PRESENTS ALWAYS PROTUBERANCES AND HOLLOWS

The reason of this is that just as a pair of stockings which cover the legs reveal what is hidden beneath them, so the part of the water which lies on the surface reveals the nature of its base, inasmuch as that part of the water which bathes its base, finding there certain protrusions caused by the stones, strikes upon them and leaps up raising with it all the other water which flows above it. A 59 v.

WHY IF IN THE LEVEL BED OF A STREAM THERE IS A SOLITARY ROCK THE WATER BEYOND IT FORMS MANY PROTUBERANCES

The reason of this is that the water which strikes this rock afterwards descends and makes a kind of pit, in which in its course it searches for the hollow and then leaps back to a height and again falls down to the bottom and does the same, so continuing many times, like a ball that is thrown on the ground which before it finishes its course makes many bounds each smaller than the one before it.

WHAT CAUSES THE EDDIES OF WATER

All the movements of the wind resemble those of the water.

Universally all things desire to maintain themselves in their natural state. So moving water strives to maintain the course pursuant to the power which occasions it, and if it finds an obstacle in its path it completes the span of the course it has commenced, by a circular and revolving movement.

So when water pours out of a narrow channel and descends with fury into the slow-moving currents of mighty seas—since in the greater bulk there is greater power, and greater power offers resistance to the lesser—in this case, the water descending upon the sea beats down upon its slow-moving mass, and this cannot make a place for it with sufficient speed because it is held up by the rest of the water; and so the water that descends, not being willing to slacken its course, turns round after it has struck, and continues its first movement in circling eddies, and so

fulfils its desire down in the depth; for in these same eddies it finds nothing more than its own movement, which is attended by a succession of circles one within the other; and by thus revolving in circles its course becomes longer and more continuous, because it meets with no obstacle except itself; and this motion eats away and consumes the banks, and they fall headlong in ruin. . . . A 60 r.

THE EDDIES AT THE BOTTOM OF WATER MOVE IN AN OPPOSITE DIRECTION TO THOSE ABOVE

The reason of this is that, if the circles which above are large become reduced to a point as they are submerged, and then continue their movement in the direction in which it began, the water will at the bottom make a movement contrary to that above when it separates itself from its centre.

Although the sounds which traverse the air proceed from their sources by circular movements, nevertheless the circles which are propelled by their different motive powers meet together without any hindrance and penetrate and pass across one another, keeping always their causes as their centres.

Since, in all cases of movement, water has great conformity with air, I will offer it as an example of the above-mentioned proposition. I say that, if at the same time you throw two small stones into a large lake of still water at a certain distance one from another, you will observe two distinct sets of circles form round the two points where they have struck; and as these sets of circles grow larger they come to meet together and the circles intersect one with another, always keeping as their centres the spots which were struck by the stones. The reason of this is that although some show of movement may be visible there, the water does not depart from its place because the openings made there by the stones are instantly closed; and the movement occasioned by the sudden opening and closing of the water makes a certain shaking which one would define as a quivering rather than a movement. That what I say may be more evident to you, just consider those pieces of straw which on account of their lightness float on the surface of the water and are not moved from their position by the wave that rolls beneath them as the circles widen. This disturbance of the water, there-

fore, being a quivering rather than a movement, the circles cannot break one another as they meet, for, as all the parts of water are of a like substance, it follows that these parts transmit the quivering from one to another without changing their place, for, as the water remains in its position, it can easily take this quivering from the parts near to it and pass it on to other parts near to it, its force meanwhile steadily decreasing until the end. A 61 r.

The winding courses of the water caused by the rebounds of the percussions which they make against the banks will cause the bed of the river below them to be more hollowed out than any other part; and in their percussions they will become of great depth; and the water that is whirled round near to these deep places will serve to undermine and destroy the banks against which it strikes.

One both clearly sees and recognises that the waters which strike the banks of the rivers act in the same way as balls which, when they are struck against walls, rebound from these at angles similar to those at which they strike, and proceed to strike against the opposite sides of the walls. So these waters after having first struck against the one bank, leap back towards the opposite one and strike upon it and hollow it out with vigour, because there is a greater confluence of water in this spot. The reason of this is that the water which leaps back from one bank to another hollows out that part of the bed of the river which finds itself beneath it; and the other water of the river which cannot be received in this low part remains repulsed and thrown back somewhat by the direct course of the river. And having no way of escape, it returns to its natural course, that is, that, as the bed of the river finds itself lower under the winding ways made by the above-mentioned percussions of the waters, this second water, which has lost its adventitious means of escape, resumes its natural course, falls into the lower parts of the river and strikes the banks at the same spot as that which witnessed the percussion of the aforesaid rebounds. As this bank is thus assailed by two entirely different sets of percussions a larger hollow is caused in it, for, while the first strike the bank above, the others descending more steeply devour and lay it bare at its base, and this is the cause of the aforesaid destruction and subsidence of the banks. A 63 v.

OF WATER

No part of the watery element will raise itself or make itself more distant from the common centre except by violence. No violence is lasting.

<div align="right">c 15 r.</div>

THE LEAP OF WATER IS HIGHER IN A BUCKET THAN IN A GREAT LAKE

This is because [confined] water when struck by a blow cannot make its impetus pass from circle to circle as it would in a great lake; and since the water when struck finds near to itself the edges of the bucket, which are harder and more resisting than the other water, it cannot expand itself, and consequently it comes about that the whole of its impetus is turned upwards; and therefore water struck by a stone throws its drops up higher when its waves are confined than when they have a wide space.

<div align="right">c 22 r.</div>

[Of the motion of water]

Water or anything falling upon water causes the water that receives the blow to spread itself out beneath the blow and to surround it, and having passed over the cause of this blow it continues above it in pyramidal shape and then falls back to the common level.

The reason of this is that when a drop of water falls from a roof upon other water, the part that receives the blow cannot find room or escape within the rest of the water with the speed with which it has been attacked, because it would be necessary for it to support too much weight in order to enter under so great a quantity of water. Having therefore to obey its own course as well as the action of that which drives it from its place, and finding that as the adjacent water does not receive the blow and is not ready for a similar flight it cannot penetrate it, it seeks instead the shortest way and flows through the substance that offers it less resistance, namely the air.

And as this first circle that surrounds the place which has been struck closes up with fury, because it was raised above the common surface of the water, it reduces the water that escapes upwards to the form of a pyramid.

And if you think that the water which falls was the same as that which leaps up, make a small stone drop into the water and you will see the water leap up in the same way and not the stone. c 22 v.

Every part of water within other water that is without movement lies equally at rest with that situated at the same level.

Here experience shows that if there were a lake of very great size which lay without movement of wind either entering or departing, and if you were to remove a very small part of the height of the bank which is below the surface of the water, all the water that is above the top of the bank that was cut away will pass through this cutting, but will not set in movement or draw with it out of the lake any part of the water that lay there before this water moved and went away.

In this instance nature is constrained by the workings of its law which lives infused within it, namely, that all the parts of that surface of the waters which are supported by the banks without any opening or exit are situated at an equal distance from the centre of the earth.

c 23 v.

HOW IT IS POSSIBLE FOR LARGE STONES TO BE ROLLED OVER BY WATER

Know that stones are rolled over by water because this water either surrounds or flows over them. If it surrounds them it meets again beyond them and intersects, hollowing out the soil or sand beyond the stone, and this after being thus laid bare begins to roll of itself. And if the water flows over the stone, then after it has done so it falls in the same line, and by the force of its impetus penetrates from the surface to the base of the other water, and gnaws and tugs and drags away the stone from the opposing obstacles with the result that this also begins to roll, and so continues from place to place until it traverses the whole river. And if a lesser stone should stand in its path the water uncovers it by the same process and does the same, and in this way stones are rolled over in the beds of flowing rivers. c 24 v.

A horse or man or any other creature that makes its way through stagnant water of medium depth will cause this water to rise and cover

a quantity of the shore towards which this creature is directing its course.

This may be clearly demonstrated; for if you take a step in this water you will find that it makes a wave which directs its course and moves in the same direction as that in which the creature is travelling; nor does it pause until it has achieved its desire and covered a small part of the shore.

A second step creates another wave which has a similar result, and the same with the third and all the steps; each of itself creating a wave that travels as far as the shore, in such a way that this shore which formerly was uncovered finds itself covered by water over a great distance—then when you have emerged from this water you will see it returning to its former position in swift course. c 25 r.

Waves of rivers that flow against the courses of the winds will be of greater height than others.

The rivers that move against the courses of the winds will have a greater current below than above, as their surface on being driven by the winds becomes slower than it was at first.

The reason of this is that if the rivers, being of equal depth and breadth, are of uniform current at the bottom and on the surface, the resistance made by the wind to the current on the surface must necessarily cause it to turn back, and as it does not suffice these waves to raise themselves a little, falling at last they enter underneath the others and proceed to the bottom. Finding there the other current of the bottom it accompanies it, and as the bank is not capable of containing this increase it is necessary that at the bottom the current doubles itself; if it were not so one would see the water rising far above the banks of the rivers. c 25 v.

The stone placed in the level and smooth beds of flowing rivers becomes the cause of their inequality and deterioration.

When an object which is dropping down strikes upon another object harder than itself it suddenly makes a rebound which is so much greater as it has had a greater fall. When therefore a stone is situated beneath the surface of running rivers, the greater its size the greater is the percussion that takes place when water falls from its summit upon

the beds of the rivers, and on account of this it comes to produce a deeper hollow in the place struck by this water.

After this first percussion many rebounds will follow, and these will become larger in size and less powerful as they are farther removed from the first.

The embankment which sends forth the trunk of the tree that it has nourished, to project into the waves of the rapid rivers, will become the cause of the destruction of the opposite bank.

The cause of this effect is that the water that flows in the rivers always goes leaping from bank to bank. If nothing projects in this bank many lines of water gather there and unite together and leap in a mass on the opposite bank, and twist themselves in with the other lines which they meet with on their way; and having reached the embankment they gnaw and destroy it. And there are yet new lines produced there which leap back and damage the other bank; and so from place to place they begin to form eddies of varying depths, and hence it comes about that straight rivers become winding and crooked.

<div style="text-align: right">c 26 r.</div>

WHAT WATER IS

Of the four elements water is the second least heavy and the second in respect of mobility. It is never at rest until it unites with its maritime element, where, when not disturbed by the winds, it establishes itself and remains with its surface equidistant from the centre of the world. It is the increase and humour of all vital bodies. Without it nothing retains its first form. It unites and augments bodies by its increase.

Nothing lighter than itself can penetrate it without violence.

It readily raises itself by heat in thin vapour through the air. Cold causes it to freeze. Stagnation make it foul. That is, heat sets it in movement, cold causes it to freeze, immobility corrupts it.

It assumes every odour, colour and flavour, and of itself it has nothing. It percolates through all porous bodies. Against its fury no human defence avails, or if it should avail it is not for long. In its rapid course it often serves as a support to things heavier than itself. It can lift itself up by movement or bound as far as it sinks down. It submerges with itself in headlong course things lighter than itself. The mastery

of its course is sometimes on the surface, sometimes in the centre, sometimes at the bottom. One portion rises over the transverse course of another, and but for this the surfaces of the running waters would be without undulations. Every small obstacle whether on its bank or in its bed will be the cause of the falling away of the bank or bed opposite to it. When the water is low it does more damage to the bank in its course than it does when it flows in full stream. Its parts do not weigh upon the parts placed beneath them. No river will ever keep its course in the same direction between its banks. Its upper parts do not impart weight to the lower.

[*An experiment*]

WATER AND AIR

I wish to show you in what manner water can be supported by air while being divided and separated from it. Certainly if you have reason in you, I believe that you will not deny that if there be a leather bag placed at the bottom of the water in a well, so as to touch all its sides, in such a way that the water cannot pass beneath, if this leather bag be filled with air it will not exert less force in rising to the surface of the water to find the other air than the water makes in its desire to touch the bottom of the well. And if this leather bag desires to rise up it will push up the water that is placed above it, and by raising this water it will take its weight from off the bottom of the well. For this reason therefore it is almost as though the well were bottomless.

Where and why the movement of the water ought to hollow out the sand of the surface of the beds of flowing rivers—but to speak first of the percussion on the surface:

The more rapid the current of the water along the slope of a smooth canal the more powerful will be its percussion against whatever opposes it.

For all the elements when removed from their natural position desire to return to it, especially fire, water and earth; and the shorter the line along which this return is made, the straighter its course, and the straighter its course the greater the percussion upon whatever opposes it.

The same effect is produced by the wind blowing through streets of uniform width. c 26 v.

THE ORDER OF THE FIRST BOOK ON WATER

Define first of all what is height and depth, also how the elements are situated one within the other. Then what is solid weight and liquid weight; but first of all what weight and lightness consist of in themselves. Then describe why water moves, and why its motion ceases; then why it becomes slower or more rapid, and in addition to this how it continually descends when in contact with air that is lower than itself; and how the water rises in the air through the heat of the sun and then falls back in rain. Further, why the water springs from the summits of the mountains, and whether any spring of water higher than the ocean can pour forth water higher than the surface of this ocean; and how all the water that returns to the ocean is higher than the sphere of the water: and how the water of the equinoctial seas is higher than the northern waters, and is higher beneath the body of the sun than in any other part of the circle of the equator; for when the experiment is made under the heat of a burning brand, the water boils as the effect of the brand, and the water around the centre of where it boils descends in a circular wave. And how the waters of the north are lower than the other seas, and more so as they become colder, until they are changed into ice. E 12 r.

[*Rivers*]

That river which stretches itself out most by long tortuous windings is the one which becomes filled up most rapidly with matter. This is proved by the twelfth, which says:—the water that loiters most discharges most rapidly the matter that it carries. Therefore the river which by meandering more makes itself longer by means of its twists and turns makes itself so much slower in proportion as it makes itself longer. E 66 v.

Of the difference that exists between the accidents of water and the accidents of air and fire:

Water is not capable in itself of being either condensed or rarefied, but it exists in as great quantity in front of the fish that penetrates it as

behind it, and it opens itself up as much in front of that which penetrates it as it closes up behind this penetrating thing. And the impetus of the fish is of briefer duration than that of the bird in the air, although the muscles of the bird are very powerful in relation to their quantity; because the fish is all muscle and this is very necessary because it is in a heavier substance than the air. But although the water is not itself capable of being condensed it is of a nature to acquire gravity and levity. It acquires gravity at the destruction of the impetus which raises it in the air at the creation of the wave, and levity by the creation of the impetus that lightens the water and causes it to move contrary to the natural course of heavy things.

OF THE VALLEY INTERPOSED BETWEEN THE WAVES

The valley interposed between the waves is lower than the general surface of the water, as one sees when the water turns back in order to fill up the places that have been struck by the water-spouts.

E 71 V.

OF SURFACE EDDIES AND THOSE FORMED AT VARIOUS HEIGHTS OF THE WATER

Of those that take up the whole of this height and of the moving and the fixed. Of the long and the round. Of those that change their movement and those that divide, and those that become merged in those [eddies] to which they unite themselves, and those that are mingled with the falling and reflex water and make it spin around.

Which are the eddies that cause light things to whirl round on the surface and do not submerge them? Which are those that submerge them and cause them to spin round upon the bottom and then deposit them upon this bottom? Which are those that separate the things from the bottom and throw them back to the surface of the water? Which are the slanting eddies, which are the straight, which are the shallow?

F 2 r.

PLAN OF THE TREATISE ON WATER. SWIMMING

When you put together the science of the movements of water remember to put beneath each proposition its applications, so that such science may not be without its uses.

Of the usefulness of the courses that the swimmer ought to follow with regard to the surface revolutions of the waters and as to their eddies which submerge these swimmers. Then how he ought to direct himself when submerged in order to save himself, and so forth.

And at the end of each book notice the things that are most remarkable, as how to break through the thickness of the eddies in any direction. Of what measures one ought to take when swimming in a rough sea, and how to avoid being dashed against the rocks and on the rudders of ships. F 2 v.

Of the things carried by the water, that will make the greatest revolution which is of least size:

This happens because the great revolutions of eddies are infrequent in the currents of rivers and the small eddies are almost numberless, and large objects are only turned round by large eddies and not by small ones, whereas small objects revolve both in small eddies and large.

Of objects equal in length and breadth carried by the current of the waters, those will make fewest revolutions which are deepest.

This happens because these revolutions vary greatly from the surface to the bottom of the water, in which as many revolutions are produced as there is depth to cause them. Wherefore of necessity an object borne by the water when it buries itself deeply is buffeted by many revolutions at different degrees of altitude; and for this reason it remains in a state of hesitance and many times obeys none or if it obeys then it obeys the most powerful.

Of objects equal in shape and size, that which is buried deepest will obey least the revolutions of the water. F 3 r.

Book ten. Of the different recesses and roundnesses that exist in reservoirs, before the exits of the water from these reservoirs, with the

varying rates of speed, sizes, depths and breadths; and the shapes of the holes, high or low, wide or narrow; and the walls thick or thin.

F 4 V.

Book nine. Of the water that passes through a reservoir, of which the walls are full of holes of various sizes, shapes and positions, at different heights, varying from the entrance to the exit and conversely; and so also the reservoir of different shapes, depths, lengths, and breadths; and the water more or less powerful and swift, great and small.

F 5 r.

The flow and ebb is double in the same sheet of water, because it will be many times at the mouth of this sheet of water before there is a decrease in the great sheet of water; this occurs because the wave of the first flow runs strongly in the sheet of water, and during the time when this wave follows its impetus that at the mouth makes its ebb. Before the wave, penetrating into the neck, feels the ebb at this mouth of the sheet of water g a, the flow starts again at this mouth, and in this time the wave, which has penetrated into the neck, pauses, slackening its impetus in proportion as the second penetration by the second wave begins afresh. Thus so many of these waves enter the neck that the sheet of water is raised and its waters come back with impetus behind the ebb that recedes from this mouth, and [this ebb] does not penetrate farther in the third or fourth wave, so that the first water is not thrust out of the entrance.

F 6 v.

In the big wide eddies, the water raises and uncovers the soil heaped up in its centre.

In the small eddies of water, the water bores down and makes a hollow in the centre of the eddy.

Of objects borne by the water upon its bed, the lighter makes a longer path in the same time.

A river does not remain uniform, for after the current it unloads shingle, and after this it produces another current, of which the movement is directed either to the bank or the centre or to as many different spots as there are different slopes of the mounds of shingle left at the bottom by the aforesaid currents.

F 7 r.

The depth of the sheet of water which receives the fall of the water

will always have the shape of a quarter of a hollow sphere, if the soil be of uniform resistance.

And this arises out of what has gone before, where it is stated that the straight course of the water is higher and swifter in the middle than on the sides; and the greater speed sends its fall more forward than does the slower speed. . . . F 7 v.

Given the depth of the fall of the water and its slant, with the power of the wheel that is its object, one seeks the height of the fall of this water in order to make itself equal to the power of the wheel.

The water that strikes upon the objects sometimes leaps up considerably, sometimes only a little, and sometimes it descends, and this arises from the objects being small or large, or the descent in front of these objects being greater or less, or from the current that strikes these objects being more or less powerful. F 8 r.

WATER—QUESTIONS

Why the eddies of the water are hollowed in the centre by their revolution.

Why the impressions produced on the surface of the water will maintain themselves for some time, on being carried by the course of the waters.

Why the movements of the impressions of the waters penetrate each other without change of their first shape.

Rule as to the measurements of water and what breadth, depth, and rapidity of movement a given space of current ought to have in a given time.

Given the resistance of a wheel and given the slant and descent in the fall of the water, one asks how great must its volume be to be equal to the said resistance.

Given the volume of the fall of the water and its length and slant, one asks whether the power of the wheel is equal to this power of the water.

Given the resistance of the wheel and the slant of the water and its volume, one asks the length of the fall. F 9 r.

OF THE MEASURING OF WATER AND IN HOW MANY
WAYS IT CAN VARY

Water that pours out through the same-sized mouth may vary in extent in a greater or less degree in [various] ways, of which the first is that the surface of the water may be either a greater or less distance above the mouth through which it pours, the second that the water passes with greater or less speed beyond the bank where this mouth is made, the third that the side below the thickness of the mouth where the water passes may be either more or less slanting, the fourth in the variety of slant of the sides of this mouth, fifth in the thickness of the lip of this mouth, sixth as to the shape of the mouth, that is whether it be round or square, or rectangular or elongated, seventh according as this mouth is placed at a greater or less slant of bank in its length, eighth as this mouth is placed in a greater or less slant of bank in its height, ninth according as it is situated in the concave or convex parts of the bank, tenth as it may be placed towards the greater or less width of the canal, eleventh if the top of the canal has more speed at the top of the mouth or more slowness than elsewhere, twelfth if the bed have round bosses and hollows opposite to this mouth or higher or lower, thirteenth according to whether the water that passes through this mouth takes the wind or not, fourteenth if the water that falls out of this mouth falls through the air shut in on one side or on all except the front, fifteenth as the water that falls thus enclosed is deep within its vessel or shallow, sixteenth whether the enclosed water which falls makes a long fall or a short one; seventeenth whether the sides of the canal where this water descends are hollow or protuberant or straight or curving. F 9 V.

Of the eddies of water which frequently turn their revolving movement backwards:

Of the falling and the reflex eddies. The eddy sometimes grows in power and diminishes in diameter, and sometimes diminishes in strength and increases in diameter.

The first movement is when the water flows away by its base, as the water that forms the eddy becomes swifter when it is lower, because it has a greater weight of water above it and therefore becomes swifter;

and because the water pushes downwards more than upwards it restricts this void in the eddy more and more; and it bends because it directs itself to whether the sheet of water has its outlet. F 12 r.

Water with an uneven bed makes contrary movements from the surface to the bed. The unevenness in the beds of rivers springs from the bends in the banks or from substances that have fallen from these banks to their feet. F 12 v.

OF THE ACCIDENTAL EDDY

When the hand is turned in circular movement in a vase half-filled with water it causes an accidental eddy which will expose the bottom of this vase to the air, and when its motive power is at rest this eddy will follow the same movement but it will diminish continually until the end of the impetus imparted to it by its motive power. F 13 r.

OF THE HOLLOW AND UTILITY OF EDDIES OF WATER

The eddy with the deeper hollow will be that produced in water of swifter movement.

And that eddy will have a smaller hollow if it is produced in deeper water which has not the same movement but is slower.

And with water of equal speed that will keep a larger hollow where a greater depth of water turns with its movement.

This is said because many times the eddies are produced in a straight current in a great expanse of slowly moving water; and as this water is partly supported by the eddy which revolves in a thin coil between it and the air of the hollow, this lateral water being of great weight pushes upon the sides of the eddy where it is leaning and finding them weak compresses them. F 13 v.

[Of eddies]

If water higher than air acquires weight, as is shown in the seventh of the ninth, why is it that the water of the sides of the eddies is higher than the bottom of the eddy which up to this point is full of air.

You have the fourth of the seventh which proves that every heavy substance is only of weight along the line of its movement and in no other direction; and here you see very deep eddies after the manner of

great pits in rivers, the sides of which are of water, which is everywhere higher than the air of this eddy; and these banks of water are without weight except by this line of their movement, during the time in which they possess the strength given them by their motive power.

What produces eddies and why some are hollow at the centre and others are not.

Whether water poured into the hollow of eddies would fill them or no, or would escape by the bottom and enter into the current at the side.

Which natural eddies are of considerable depth and which of slight depth; which change their position and which do not move; which while moving turn in an opposite direction and which keep their movement in one direction; which become duplicated and which do not; which unite in contrary movements. F 14 V.

OF WATERFALLS

Write first of the simple hollows made by the simple falls of water upon a bed of a uniform substance, and then upon a bed of various substances. Then with obstacles placed in the course that the water takes in its descent, then with obstacles in the place where it has struck, that is, upon its bed; then in its reflex movement, and first at the beginning of its fall. Then describe in what part of the edge of the sheet of water this water will take its course; and what substances will be carried away or deposited in different parts of the bed of this sheet of water; and what will be the speed or slowness of movement of the water in various parts of the surface, and so also from the surface to the bottom at various depths and breadths; and thus you will do as far as the bottom.

F 15 V.

[*Movements of water*]

Of the parts of the same water that rises through the air at different angles, that which has least slant falls back nearer to where it started.

The rising motions of the water which it makes from the bottom to the surface of the sheet of water will never fall back towards the bottom, because not entering into the air and not acquiring weight they cannot penetrate to the bottom, by the seventh of the ninth.

The water always rises and descends with a disconnected movement

of speed, and this is caused by the air that it penetrates and the air that is mingled with it. F 16 v.

OF THE EDDIES OF WATER

It is possible for there to be less depth underneath the current than before it or on the sides.

Let *o c n* be the current and *a* an eddy of double strength according to the ninth concerning eddies. Since in addition to its revolution it strikes against the bank and leaps up into the air, and falling back upon the rest of the water penetrates it and strikes and hollows out the bed in sudden chasm, for, in addition to the force of the blow, there is joined the spiral drilling made by the aforesaid revolution, by means of which what has been shaken by the blow is stirred up and carried away; and it becomes more powerful as it is more turbid.

And this is the most powerful method that can be made use of in order to dislodge and carry away the soil and so create a great chasm.

Beneath the current the bed will become raised when the course of this current dies in stagnant water.

By the sixth of the ninth—where the course of the water fails, there remains that which the water has brought. F 17 v.

Of a volume of water that has struck upon an object, the lower part is the first to strike the bottom and it is instantly reflected to the surface. That which is in the middle does not descend to the bottom, but encountering the first part reflected it strikes upon it, and is knocked and so it also is bent back in the same lines and revolutions.

And the two bodies of water when the lower encounters the higher unite and revolve together at their contact.

Of the water that falls into other water that which is nearest the centre of the fall slants most and that nearest the extremities is the straightest. F 18 v.

SURFACE WAVES

When water strikes other water at a considerable angle the part which strikes first is immediately bent back and delays, and that which succeeds to it veils it with a thin covering and runs swiftly upon that which first slackens and so it is then bent and slackens at the same

spot as the foregoing. And the water that follows does the same upon it, and so in succession each new wave follows its course.

The turbid running water, if it is high at its start and at its entry into the sheet of water, flows for a considerable distance at the height of its first impetus before it buries itself or becomes mingled with the other water. F 19 V.

Definition of the half-cylindrical wave and what part of its volume has a greater or less slant, and how it commences and ends, and where it is more or less wide or more or less high or I would say deep; and the differences that there are in it when it is large or small or swift or slow.

The waters flow one above another without mingling for a long space, when their entrance in the sheet of water is higher and swifter in the one case than in the other. F 20 r.

Where the water has only slight movement the half-cylindrical waves will keep their direction when they intersect.

Where it is swifter they will curve.

And where the rates of speed are unequal their curves will vary towards the end. F 20 v.

Of the eddies one is slower at the centre than on the sides, another is swifter at the centre than on the sides; others there are which turn back in the opposite direction to their first movement.

That eddy is slower at the centre than on the sides which makes a great revolution, and this deposits a considerable quantity of matter in the centre of its circle and leaves it in the form of a mound.

The eddy which is swift at the centre of its revolution carries air and water in its base, which it hollows out and bores down after the fashion of a well. F 21 r.

Every impression of the water is maintained over a long space and this is so much the longer as it is swifter.

Write of the things worthy of remark that are found in water; and what revolutions they make when they are of different shapes and the water makes different revolutions. F 21 v.

Of the different rates of speed of currents from the surface of water to the bottom.

Of the different cross slants between the surface and the bottom.

Of the different currents on the surface of the waters.

Of the different currents on the bed of the rivers.

Of the different depths of the rivers.

Of the different shapes of the hills covered by the waters.

Of the different shapes of the hills uncovered by the waters.

Where the water is swift at the bottom and not above. Where the water is slow at the bottom and swift above.

Where it is slow below and above and swift in the middle. Where it is slow in the middle and swift below and above.

Where the water in the rivers stretches itself out and where it contracts. Where it bends and where it straightens itself.

Where it penetrates evenly in the expanses of rivers and where unevenly. Where it is low in the middle and high at the sides.

Where it is high in the middle and low at the sides.

Where the current goes straight in the middle of the stream. Where the current winds, throwing itself on to different sides.

Of the different slants in the descents of the water. F 23 V.

OF THE WATERS THAT CROSS ONE ANOTHER AT DIFFERENT ANGLES

Of the waters that cross at different angles in their reflex movements, and of those that cross on the summits of the waves; those that cross the descending wave and those that cross in the trough of the waves.

Some cross at different angles, great reflex movement with small reflex movement, and similarly a great wave with a small one, or falling movement with that in the valley or with reflex movement, small with large.

Sometimes there is reflex with falling movement, sometimes valley with wave, sometimes falling movement with reflex, small and large, and at different angles.

Sometimes rapid waters with slow, sometimes eddies with waves or valleys or reflexes, or the falling movements of water-flowing along different lines crossing one another.

Courses by different lines one above the other.

Eddies with different movements which have to meet and enter into one another.

Lengths of different curves of eddies from the surface of the water to its bed as they intersect one another.

Intersection of falling and reflex eddies.

Of the waters that are interposed in any direction between the said accidents of the waters. F 24 r.

[*Books of the Treatise on Water*]

Book nine of the shapes of the eddies.

Book ten of the action of the eddies.

Book eleven of things that aid the eddies.

Book twelve of things that injure the eddies.

Book thirteen of the percussions of the waters one with another as they leap up within the air at different rates of speed.

Book of the waters that spring up within the air at different angles and with the same speed.

Book of the waters that spring up within the air and the different angles.

Water more slanting, striking that less slanting and more powerful and less deep.

Water less deep and more slanting and more powerful than the deeper and less slanting.

Shallow water driven through the air by greater power than the deeper water. F 24 v.

Of the waters falling through the air which intersect with various depths and lengths of movement and power.

The reflex movement will never be of the height of the beginning of the falling movement unless it strikes as does the wave on the rock of the sea. F 25 r.

[*Of the waves*]

In proportion as the waves of the sea are higher than the ordinary height of the surface of its water, so the bottoms of the valleys that lie between the waves are lower; and this is due to the fact that the great fall of the great waves creates the great hollows of the valleys.

F 25 v.

OF THE ELEMENT OF WATER

Here follows the proof of what is said on the opposite page:

I say that no part of the surface of water moves of itself unless it descends, therefore as the sphere of water has not the power to descend in any part of its surface, it follows from the first conception that it does not move of itself. And if you carefully consider each minute particle of this surface you will find it surrounded by other similar particles which are at an equal distance between them from the centre of the earth, and at the same distance from this centre is that particle which is surrounded by them; therefore, by the third conception, that particle of the water will not move of itself because it is surrounded by edges of equal height. And thus every circle formed of such particles makes itself a vessel for the particles enclosed within this circle, which vessel has the circle formed by its edges of equal height; and in this respect this particle resembles all the other similar ones of which the surface of the sphere of the water is composed. Of necessity it will be without movement of itself, and in consequence each being at equal height from the centre of the world, necessity makes their surface spherical, but it is not necessary that they should be spherical below, as reason and experience show.

That which is said of the surface of the water that borders on the air is understood to be said of the surface of the air that borders on the fire, which would be such as often to evaporate after the manner of clouds drawn by the heat of the sun, as does the water drawn through the air by the same heat in the form of clouds; and in the same way the fire drawn by a greater heat than its own, that is to say by the sun, it being proved in the sixth that it is warm by essence and not by virtue, as many would have it.

So having proved by the testimony of these spheres that the flexible elements are spherical, it is my purpose to investigate nature both in its universal aspect and in the particulars of each of its elements, and first of fire, then of air, and then of water. F 26 v.

Book thirty-two. Of the movement that fire makes when it penetrates the water at the bottom of the boiler:

It runs bubbling to the surface of this water by different ways and

according to the movements that the water makes when struck by the penetration of the fire. By means of this experiment you can investigate the hot vapours which are exhaled from the earth and pass through the water, twisting themselves about because the water checks their movement, vapours which afterwards penetrate through the air in straighter movements.

And this experiment you will make with a square glass vessel, keeping your eye at about the centre of one of these walls; and in the boiling water with slow movement you may drop a few grains of panic-grass because by means of the movement of these grains you can quickly know the movement of the water that carries them with it. And from this experiment you will be able to proceed to investigate many beautiful movements which result from one element penetrating into another. F 34 v.

BOOK FORTY-TWO. OF RAIN

The water that falls from the cloud is sometimes dissolved into such minute particles that by reason of the friction that it has with the air it cannot divide the air but seems to change itself into air. Sometimes in descending it multiplies, because it finds the minutest particles of water which by reason of their lightness were of slow descent, and becomes incorporated with them, and at every stage of its descent acquires a new quantity of water. Sometimes the winds bend the rain and so cause its descent to be slanting, and for this reason the descent becomes slow and protracted, and it frequently happens that it is converted into such fine particles that it can no longer descend and so remains in the air.

[*Treatise on water*]
Write how the clouds are formed and how they dissolve, and what it is that causes vapour to rise from the water of the earth into the air, and the cause of mists and of the air becoming thickened, and why it appears more blue or less blue at one time than at another. Write in the same way of the regions of the air and the cause of snow and hail, and how water contracts and becomes hard in the form of ice, and of the new shapes that the snow forms in the air, and of the trees in cold countries with the new shapes of the leaves, and of the pinnacles of ice and hoar-frost that form new shapes of plants with strange leaves, the

hoar-frost serving almost as the dew ready to nourish and sustain the said leaves. F 35 r.

No surface of water that borders upon the air will ever be lower than that of the sea.

The wave that the motive power makes before it in the air or between the surface and the bed of the water is in the shape of a half sphere.

The wave made by the motive power on the surface of the water is in the shape of a half-circle, and towards the bottom it has the shape of a quarter-circle.

Why the movement made by the motive power on the surface of the water makes a wave before it, and does not do so when it moves between the surface of the water and its bed. What one asks occurs because the water of the surface borders on the air, whereas the water that is between the surface of the water and its bed borders on the water that is above and the water that is below. F 41 r.

Of the water that falls from the weirs of rivers, that part will have its straight course shut in which has the most powerful fall:

This comes about because water with a powerful fall hollows out the soil of the spot on which it strikes and deposits it where its course is more feeble than beneath the reflex movement of the water; this as it moves towards the sky becomes more feeble with each degree of its movement until at last it loses all its power.

And as in this reflex action its power ebbs it lets fall below it all the things of weight taken from the spot where it has struck, and after this inundation the water becomes lowered and finds itself shut in between the matter which it formerly carried and the bank from which it has descended.

Of the waters that descend in torrents from the weirs of rivers only that will preserve its straight course beyond this torrent of which the fall was feeblest and slowest.

This happens because that which moves slowly strikes feebly, and therefore it follows that it only raises itself a little from the bed on which it strikes, and in consequence deposits but little in the reflex movement of the water. And this is why after this deluge the bank here

remains low, and all the water that falls follows its course where the bank is lower, and consequently the straight course of all the water of the river will remain with the water that has a feeble fall. F 42 v.

Of the things borne by the water which have part of themselves in the air and part in the water:

If a thing is borne by the water being half in the water and half in the air, and the air moves with a speed equal to the speed of the water, then this movable thing will be in the first stage of swiftness of movement.

If the air is slower than the movement of the water which moves in the same direction as the air, the movement of the movable thing will be slower than if these movements of air and water were equal, and it will be so much slower in proportion as these movements of air and water are more different.

If the movement of the air is swifter than that of the water[1] which moves in the same direction, then this movement of the object will become more rapid, and the more so as this air is swifter than the water.[1]

If the movement of the air against the course of the water is of equal speed to that of this water against the air, the movable thing will follow the course of the water if it has more contact with the water than with the air: it will do the contrary if it has more contact with the air than with the water. F 43 v.

How a leaf is whirled about along different lines in the depth of the water:

This movable thing revolves along different lines, high and low, turning itself over or not turning over, and doing the same in the width of the water which moves it. And this springs from the different movements of the water with its different slanting and eddying courses. Here one may place objects of different shapes, *and one will have made a good experiment in*[2] . . . by the leaves of the trees which are borne in considerable quantities from the surface to the depth of the flowing and transparent waters. F 44 r.

[1] MS. *aria.*
[2] Words erased in MS.

THE ORDER OF THE BOOK

To set forth the conditions of the waters that spring forth within the air, and their percussions made with different degrees of power, quantity, length of movements and variety of slant, I will institute a comparison between the four principal winds, namely: north, south, east and west; and with these conditions I shall equip myself to give information as to the aforesaid movements of the water within the air; as a result this description will be briefer and more expeditious.

F 45 r.

These are the four ways in which the waters moving in the same manner penetrate one another with lines that slant towards the centre of the earth.

These four demonstrations are sufficient to prove the four principal effects that the waters produce as they strike one another within the air. Of which the first is that in which the more slanting penetrates the less slanting, and penetrates it in part and carries with it the part that has been struck.

In the second demonstration the less slanting penetrates the more slanting in part and carries with it the part that has been struck. In the third demonstration the more slanting water carries away with it entirely the less slanting water. The fourth does the opposite, in that the less slanting water carries away with it entirely the more slanting.

F 45 v.

If the earth were [not] spherical no part of it would be uncovered by the sphere of the water.

You will never find a flat piece of the earth without the water upon it being of convex shape standing in the middle of this level surface. And this water will never move towards the extremities of this plain. Therefore upon a surface that is absolutely flat there may be water of varying degrees of depth.

It is impossible to find any flat part in the surface of any very great expanse of water.

The deep recesses in the ocean bed are everlasting, the summits of the mountains are the contrary: it follows that the earth is spherical and all covered with water and that it will be inhabitable.

An object which is carried by the course of the water . . . in the course of less power: if it is slanting below it will move towards the bottom, and so it will move according to the direction of its slant.

Of the objects carried between two currents of water only that one will proceed without being turned upside down which is in the middle of two currents of equal movement.

But that will be in continual revolution over and over which is in the middle of two unequal currents.

An object will not make any lateral revolution when it moves between currents equal in movement; and so conversely. F 52 v.

Of the movement of a thing that slants irregularly in water which has a regular current: it will proceed to turn continually when below the surface of the water, and that in which the slant is regular will not make any turn.

When the upper part of the straight side of the object and the lower part are struck by an equal current this object will make a lateral revolution. F 53 v.

[The percussion of water]

All water after it has struck against an object is divided into four different and principal movements, namely right and left, high and low; and the low movement causes injury to its bed.

Of the four principal movements which water makes as it divides in its reflex action, that will be more rapid which is reflected at a more acute angle. F 54 r.

OF THINGS CARRIED BY THE WATER

Of the things carried by the course of the waters that which has a larger part of itself in the air responds to the movement of the air more than to that of the water; and so conversely that which has a larger part of itself in the water will follow the course of this water more than that of the air.

See in the windings of the canals where the water is swifter below, in the middle, and above, and of this make a book.

The pipe by which water is drawn to a height receives less damage than that pipe along which water is driven; and this is due to the fact

that in the first case the motive power is above and in the second it is below.

Where the water is most rapid, it wears away most the bed on which it rubs.

Where the water is most shut in, it becomes most rapid and in its passage wears away its bed most. F 65 r.

The object always changes the order of the nature of the waves that have been commenced.

The current *a b* has one order and the object which receives its percussion throws it over completely and changes it to another figure.

If you wish to form a correct impression of all the shapes of the waves and the courses of the waters, observe the clear water where it is shallow beneath the rays of the sun, and you will see, by means of this sun, all the shadows and lights of the said waves and of the things carried by the water.

The sphere of the water increases and decreases sensibly or insensibly, according to the greater or less, more universal or less universal deluges of the waters given back to this sphere of the water.

F 65 v.

EDDIES

Eddies are always the intermingling of two streams of water, that is, the falling and the reflex.

All the water which in the currents of the rivers tarries behind the objects in these currents has no other exit than by contact with the aforesaid currents.

The eddies which turn back are always those of the swiftest water.

And the eddies that are turned in the direction that the stream is flowing are those of the water which tarries in the stream's course.

Here the law of the waters in their eddies does not fail, because the water that becomes slow, turns back, and makes the eddies in the opposite direction to its movement, as do the eddies of the swiftest water. And for this reason these eddies, whether of the slow or of the rapid water, mingle together and redouble their power; but not entirely because the slow eddy in mingling with the swift becomes swifter than

at first, and the swift eddy as it embraces and unites with that which is slower acquires slowness.

The hollow in the swift waters caused by the submersion of the eddies will point towards the approach of the waters, and in the slow waters it will point in the direction in which they are flowing.

F 66 r.

COMMENCEMENT OF THE BOOK

A drop is that which does not detach itself from the rest of the water unless the power of its weight is more than its adhesion to the water with which it is joined.

That drop is formed more slowly which has a slower movement of water at its creation.

All the movements made on the surface of water are also made at each successive stage of its depth, and likewise in each part of its length; and this is learnt from the grasses that grow on the beds of the streams.

F 66 v.

Water that falls in the air separates itself with difficulty from its bulk, and the sign of this is found in the curve that it produces and the winding of one of its parts round the other, between which the film of water is interposed.

F 67 r.

If the earth covered by the sphere of the water is more or less heavy than if it were not so covered:

I reply that the heavy substance weighs more which is in the middle of the lighter.

Therefore the earth which is covered by air is heavier than that which is covered by water.

[*Diagram*]

I say:—the centre of gravity of the pyramid being placed at the centre of the earth, it will change its centre of gravity if it is subsequently covered in part by the sphere of the water, and I give an example with two cylindrical weights that are equal and similar, of which one is half in the water and the other entirely in the water: I say that that which is half out of the water is the heavier, as has been proved.

Suppose there to be a straight line equal to the diameter of the

sphere of the water, which touches the surface of the sphere of water in the centre of its length. One asks what is the difference between each of the miles of the descent which the surface of this sphere makes below the said line. F 69 r.

[Centre of the earth and watery sphere]

Because the centre of the natural gravity of the earth ought to be in the centre of the world the earth is always growing lighter in some part, and the part that becomes lighter pushes upwards, and submerges as much of the opposite part as is necessary for it to join the centre of its aforesaid gravity to the centre of the world; and the sphere of the water keeps its surface steadily equidistant from the centre of the world.

Where the sun is straight above, the earth grows light; covered by the air, the waters and the snows have been lacking to it, and on the opposite side the rains and the snows have made the earth heavy again and drive it towards the centre of the world, and thrust the parts that have become lightened to a greater distance from this centre; so therefore the sphere of this water preserves an equality of distance from the centre of its sphere but not of gravity.

Water poured in the air at a concave angle becomes spread out in a sheet, and it remains spread out in a sheet more on the side of the angle where this water makes more contact; and on the opposite side the sheet of water will leap up and make its union at first in the form of an open sheath. F 70 r.

[Water of the sea and of rivers]

The sea beneath the equinox is raised by the heat of the sun, and acquires movement over every part of the hill or portion of the water that rises in order to give equality and restore perfection to its sphere.

If an outlet of water with sixteen ounces descent in each mile yields me sixteen measures of water, how much will the same outlet afford with eight ounces descent per mile?

The revolutions of the cross-eddies acquire size and slowness at each stage of their length.

The convulsions of the reflex movements of the water at the bottom of rivers destroy the circling movements of the longitudinal eddies.

The water of the sea and of the turbid rivers is heavier than the

other waters, and as a consequence offers more resistance to the weights it carries.

The water of the sea offers more resistance because the weight of the salt that is mixed with it is liquefied, and it is inseparable from it without the heat that dries up the water; but the turbid part of the water is separated from it by heat and when the water is at rest. f 70 v.

[*Movement of water in the air and in the water*]

The movement that water makes in the air follows for some distance the line of the sides of the small holes through which it descends. It is not thus with the discontinuous quantity that the stone shows itself to be when thrown by the circular movement of the man's arm; this follows the straight movement; which the water does not do on account of it being spread out in a sheet, for this in a long space of movement collects all the parts of the water together.

The impressions of the movements made by the water within the water are more permanent than the impressions that the water makes within the air; and this takes place because water within water is devoid of weight, as is proved in the fifth, but only the impetus weighs and this moves this water that has no weight until it is itself consumed.

The impressions of the movements of water are more permanent when the water carried by the impetus enters into a sheet of water (*pelago*) with slower movement, and conversely.

The impressions made by the water within the air are destroyed in the first movement that they make towards the earth, because the impetus is consumed in the natural movement that is produced in the water. f 71 r.

OF THE MOVEMENTS OF WATER

The falls of water that intersect in the air become filled with air in their reflex movement.

Of the falls of water which strike each other within the air being of equal thickness, that which descends from a higher part of its reservoir will join itself to the course of that which is lower and will complete its course with it.

Falling water which then runs over terraces breaks its bed very much at the end of these terraces.

This proceeds from the fact that when the current of the water reaches the last stage of these terraces it falls and raises itself from the bottom, burying itself so much the more as its fall is deeper, because the fall is more powerful in great descents than in lesser ones.

All water, when it strikes the bottom or upon another object, divides and runs in different directions.

All water, when it surges up, divides at the surface and runs in different directions, and so much the more as the sheet of water is more tranquil. F 71 V.

The simple movements of the waters are those which act simply with their simple movement of whatever kind it may be.

Composite movements are created by different movements and these are very powerful in different functions.

The wave is slower at the summit than upon its sides.

The falling movement is more rapid than the reflex.

Joined together, the greatest and the least slowness of the waves, that is of the wave in itself with its sides and summits, become equal to the common course of their stream, and this is to be adduced in the conclusions, that is to say to prove them. F 72 r.

[Of the raising of water in nature and by artifice]

If the water which gushes forth from the high summits of the mountains comes from the sea, the weight of which drives it up there so that it is higher than these mountains, why has this portion of water the capacity of raising itself to so great a height, and of penetrating the earth with such difficulty and length of time, while it has not been granted to the rest of the element of water to do the same, although this borders on the air which would not be able to resist it and so prevent the whole from rising to the same height as the aforesaid part?

You who have found such an invention must needs return to the study of natural things, for you will be found lacking in cognate knowledge, and of this you have made great provision by means of the property of the friar of which you have come into possession [?].[1]

[1] Ravaisson-Mollien says: 'Cette phrase signifie peut-être: Si tu as trouvé à inventer une imitation de l'élévation de l'eau dans la Nature, aux cimes des monts, en ayant cru beaucoup t'instruire à cet égard avec le fonds de livres, dessins, etc., du frère [moine] un tel, que tu possèdes, cette instruction-là te trouvera bientôt en défaut, et il te faudra de nouveau étudier les choses de la Nature.'

Water falling into a channel of width equal to the width of the water that falls will make a deep hollow within the surface of the water.

Water falling into [a channel] where the width is greater than the said fall will not make a very great hollow in the surface of the water, on account of the eddies, which cause the water to bend in the hollow caused by this fall.

Water which clears away the bottom on which it hurls itself rapidly or slowly in all its width, depth or narrowness, its seething mass being tossed back by the bed of the watery expanse, is in part caught up again to the surface of the water, there to make its various falling and reflex movements, in part returns to where was its first fall, burying itself there with it and then returning up in lateral eddies, and in part falling back in the middle of the seething mass and spreading itself out with slow movement round the centre of its fall.

F 72 v. and r.

[*Movements of water*]

Between the current and the eddy is the sand.

Between the sand and the eddy is a smooth valley where the eddy turns.

In the eddy are pieces of timber and other light things.

If the air is motionless an object borne on the surface of the water will be slower than one that is below its surface.

Where the water issues forth by a level bed beneath the sluices it hollows out the bed before and behind these sluices. F 77 r.

THINGS CARRIED IN RIVERS

A wide object borne by the current of the river between the surface and the bed of the river, if it should meet with water that is slower than that which bears it and should find itself at that time slanting in the direction of the approaching river, will immediately leap from the bed to the surface of the water; and if this slant is pointing in the opposite direction to the course of the water then in encountering the slow current it will suddenly precipitate itself towards the bottom; and if this slant looks to the right or left of the breadth of the stream

it will throw itself to this right or left side of the stream and so will continue in any direction. F 78 r.

SEA-MUD AND FOSSILS

If the mountains had not remained in great part uncovered by the waters, the courses of the rivers would not have been able to carry so much mud into the sea as exists at a great elevation, mingled with the animals which have been enclosed by it.

The revolutions of the reflex water in returning to the current of its river penetrate it more in its lower parts than on its surface; and this proceeds from the fact that the current, by the seventh, is swifter above than below, and is in consequence more powerful above, and therefore less penetrated by the percussion of this reflex water above than below.

The eddies formed by the percussion of the reflex water in the course of the falling water are of two kinds, of which one is produced towards the bottom and revolves vertically through the length of the stream, the other is upon the surface and revolves right and left through the breadth of the stream. The lower is produced by the falling down again of the seething mass towards the bottom, and that on the surface by the revolving movement striking into the surface current. F 78 v.

Water turns before falling water like the wheel of a mill. F 81 r.

Of the surfaces surrounding the water that is poured through the air from an expanse of water, and also what the water does in these surfaces.

Of the movements of the things that have fallen with the water which moves in the air, and also what they do in this expanse of water.

Of the things that float upon the middle water, and how they become submerged when they find themselves between the centre of the middle water and the fall, and they become submerged together with this fall which takes place in the expanse of water, and strike against the bottom and break in pieces.

Write therefore all the effects of the things that become submerged in any extremity of this middle water, which always submerges its extremities because it is in the centre of all the reflex movements towards the bottom of its expanse of water. F 81 v.

Of the earth. Every heavy substance tends to descend, and the lofty things will not retain their height but with time they will all descend, and thus in time the earth will become a sphere, and as a consequence will be completely covered with water, and the underground channels will remain without movement.

Of the convex wave. If the wave created by the fall of the water of a canal of uniform breadth and depth will be of long movement or no.

Of the concave wave. If the concave wave created by the water that falls abruptly from the open canal under a sluice will be of long movement in a canal of uniform breadth and depth. F 84 r.

Water which runs through a canal of uniform emptiness and fills all its first smooth part, will fill all the other straight and slanting parts and will move with equal swiftness.

The movements of the heavy elements are not to the centre in order to go to this centre, but because the medium in which they are cannot resist them, and when they find resistance in their element this body no longer has weight and does not seek to penetrate to the centre.

Water in air weighs and descends by the shortest path. It divides and opens the air which is below its centre of gravity with all its parts equally, and it does not divide the air that is upon its sides because it is not situated above it. And because of this it makes a hollow in the air of very short length until it reaches that which resists it; and as this resistance is that of water the water that falls through the air no longer seeks to go the centre, because it no longer divides the water as it did with the air; therefore the heavy substance moves downwards where it meets with no resistance, and not in order to go to the centre.

F 86 v.

Write first of all water in each of its movements, then describe all its beds and the substances in them, adducing always the propositions as to the aforesaid waters, and let the order be good as otherwise the work will be in confusion.

Describe all the shapes that water assumes, from its largest to its smallest wave, and their causes. F 87 v.

BOOK NINE. OF THE ACCIDENTAL RISINGS OF WATER

If with a sluice the larger body of water is divided by the narrower and the movement of the water is from the narrower to the larger, the water which rises under the sluice will leap on to the larger water, and by its falling back it will hollow the bed of the canal in several places with different leaps. F 88 r.

[*Treatise on water*]

Describe what water does in each defined instance between its surface and the bottom. And what part of the water is slower or more rapid.

Of the lateral objects placed upon the banks of winding rivers.

Of the intersections that the waves make one with another on being bent back by the opposite banks of the rivers.

Of the elevation of the waves formed by the intersection of other cylindrical waves. F 89 r.

Of the various breadths of the transversal interpositions set in the middle of the breadths of rivers.

Of the various projections of the lateral objects set upon the banks of rivers.

Of the different slants placed in the middle of the widths of rivers.

Of the different juxtapositions of the fronts of the lateral objects placed upon the banks of rivers. F 89 v.

[*Book of the treatise on water*]

If the cylindrical wave shall strike the eddies produced about one of the extended banks, these pent-up eddies will be contracted and acquire great power to excavate beneath the bank and cause it to fall in.

Order of the book.

Put at the beginning what a river can do of equal depth and slant of bed on its bank, where lie objects of various kinds. Then place these objects two by two. Then place them to face the opposite bank, in the same variety, and describe what the waters do when they intersect one another in the centre of the stream, and the obstacle they afford to the water reflected by the opposite bank. And then describe what each does in its bed, that is how it rises and settles itself.

The side of the wave when it makes its rapid falling movement is the end of the slow reflex movement. It follows that the movement of the valley of the wave is swift and the crest of the wave is slow.

F 90 v.

CURRENTS OF RIVERS

If the course of the river is contracted on one of its sides it produces a half-cylindrical wave which is swift; and the eddies which are produced between the contracted bank and the cylindrical wave occasion the laying bare and crumbling away of this contracted bank.

If the banks should contract equally on each side of the current and opposite, then the cylindrical waves will intersect, and after this intersection they will descend and strike upon the bank and cause it to fall headlong.

But if the contraction of one bank should be lower than that of the other, then the upper cylindrical wave can enter under the lower.

Here it is necessary, in the commentary, to define the distances of the contractions of the banks and their breadths. F 91 r.

[*Of canals, rivers and eddies*]

The bank which is made to curve inwards in order to give greater breadth to the canal is the cause of the sudden forming of an eddy, and this bores down and makes a deep hole at the base of the bank and so becomes the cause of its fall.

This is proved by the first of the third, which shows that the river in acquiring sudden breadth of space acquires also sudden breadth of water, and the water thus widened comes also to lower itself in depth; and so it suddenly creates a current which hurls itself upon the bank where it has been widened, and striking it divides itself into two eddies, one of which (the more powerful, as *c b a*) in order to be enclosed throws itself vigorously straight towards the bottom; and by the ninth which says that as the eddy will be most easily penetrated which has the lips of its mouth least slanting, it will have them quite straight.

Water brings about the fall of that bank of which the canal acquires a sudden breadth.

If the canal gains on each side sudden breadth it produces eddies on

each side; if these are united at the centre of the breadth of this canal it will make of itself a sudden and great depth.

All these figures have to result from experience. F 91 v.

[Cylindrical waves]

The more the half-cylindrical wave moves the more it descends, and the more it spreads itself out the swifter it becomes.

When there are two unequal cylindrical waves of which the larger comes into existence before the smaller, this smaller wave intersects the larger and passes above it. And this happens because the larger which is created first, when it is opposite to the smaller, is spread out and lowered, and the lesser which strikes it, being high, strikes the lowness of the greater one, and not finding any obstacle as high as itself runs over it and falls headlong on the opposite side and follows its initial impetus.

But if the lesser of the unequal cylindrical waves starts higher in the river than the greater, then this greater follows its natural course, and the lesser follows the course of the greater. F 92 r.

If the cylindrical waves clash and do not intersect as far as the centre, the middle part which clashes leaps back and passes above the part that does not clash.

When two cylindrical waves of equal size and power clash absolutely they each turn back completely without any penetration one of the other.

But if the cylindrical waves are unequal in size, neither the larger nor the smaller will observe their law, because the larger does not bend and the lesser unites with the larger.

But if when the waves are equal the rise of the one is before that of the other, their blows will not be delivered with equal power; consequently the course of the second will bend before that of the first. F 92 v.

Water that moves between a bank and a straight smooth bed will not make a wave of any kind.

What is thus stated takes place because a wave is only created by a reflex movement, and the reflex movement arises from the percussion of the falling movement which is made upon the particular object at

the bottom or the sides of the canal; and if in these places there are no particular objects then by what has been said it will not create any wave, this water being made by minute upward movements which only raise themselves a little from the bottom, so that they do not make waves by coming to the surface.

The simple half-cylindrical wave is formed upon some small object that is joined to the bank; the water that strikes it there makes a long wave in the shape of a half-column which takes its course slantwise towards the opposite bank, and dies there and is reborn.

Let *a* be the object, placed upon the bank *a o* of the canal *n o m p*.

I say that the water which strikes upon this object will make a wave which by its being continually reformed will also make itself continuous; and it would be always so if it were not interrupted by the common course of the water of the canal, which all strikes on this wave and drives it unceasingly in every stage of its length, so that at the end it directs it according to its ordinary course. F 93 v.

[*Currents and falls of water*]

In water of ordinary speed the middle water will have tiny ripples.

The water that is interposed between the mean of the surface and its bed is not of the nature of the mean; whereas this mean of the surface receives the percussion of the falling and the reflex; for the one and the other to be within the boundary falls upon the other water, making percussion of the air as of a heavy thing, and as a heavy thing it penetrates within the other water struck by it.

The water falls at first, rises up again, and raises itself with its semi-cylindrical wave above the semi-cylindrical wave opposite which made its fall more slanting. F 94 r.

[*The current of rivers*]

Water that descends in a straight river moves always by a slanting course, from the centre to the opposite banks and from these opposite banks to the centre of the river. This is proved by the ninth of this where it is stated:—The course of straight rivers is always higher in the centre of their width and upon the sides than it is between the centre of their width and these sides. And this was proved by the seventh in which it was stated:—The water of straight rivers never flows in a straight line because it is so much swifter as its obstruction is

farther removed from the banks. And this was confirmed where I said:—Where the falling movement is impeded there the reflex movement is created; and by the tenth of this: Always between the falling and the reflex movement is the maximum depression in the expanse of the rivers; and by the eleventh:—After the last height of the reflex water there is produced the beginning of the falling movement; and by the twelfth:—The falling movement of the waters does not change into the reflex movement without percussion against the bed or the bank of the river. Where the water strikes the bed or the bank of the river there the soil of the bed or the bank of the river becomes raised.

Always under the falling movement the bed of the river becomes raised and its height is restored under the reflex movement.

The lateral slants of the waters which move continually in straight rivers are of a greater or less degree [of slant] according as these waters have a more or less rapid current. G 14 V.

[*Density of water—fresh and salt*]
HOW THE OCEAN DOES NOT PENETRATE WITHIN THE EARTH

The Ocean does not penetrate within the earth, and this we learn from the many and varied springs of fresh water which in various places of this Ocean penetrate from the bottom to its surface. The same thing also is shown us by the wells, made at a distance of more than a mile from the said Ocean, which are filled with fresh water; and this takes place because the fresh water is lighter than the salt water and as a consequence more penetrating.

Which weighs more, water that is frozen or water that is not frozen?

Fresh water penetrates more into salt water than salt water does into fresh water.

That fresh water penetrates farther into salt water than salt water does into fresh is shown us by a thin cloth, dry and old, that hangs with its opposite ends at an equal depth in two different bodies of water, of which the surfaces are equally low; you will then see how the fresh water will raise itself so much higher up on this piece of cloth than the salt water, as it is lighter than it. G 38 r.

OF THE MOVEMENT OF A RIVER WHICH SHOOTS FORTH SUDDENLY UPON ITS DRY BED

The course that the water takes when issuing from a lake into a dry river-bed is so much slower or swifter as the river is wider or more confined or in a more level position in one place than in another.

By what is set forth the flow and ebb of the sea which enters from the Ocean into the Mediterranean, and of the rivers that contend with it, raises their waters so much the more or less as the sea is more or less confined. G 48 r.

WHY WATER IS SALT

Pliny says in his second book, in the hundred and third chapter, that the water of the sea is salt because the heat of the sun scorches and dries up the moisture and sucks it up, and thereby greatly increases the salt savour of the sea.

But this cannot be admitted, because if the saltness of the sea were caused by the heat of the sun there is no doubt that the lakes and pools and marshes would be more salt in proportion as their waters have less movement and depth, but, on the contrary, experience shows us that the waters of these marshes are entirely free from saltness. It is also stated by Pliny in the same chapter that this saltness might arise be-cause, after the subtraction of every sweet and tenuous portion such as the heat readily draws to itself, the more bitter and coarser portion will be left behind, and in consequence the water on the surface is sweeter than that at the bottom. But this is contradicted by the reasons given above, whence it follows that the same thing would happen with marshes and other tracts of water which become dried up by the heat. It has also been said that the saltness of the sea is the sweat of the earth, but to this we may reply that then all the springs of water which penetrate through the earth would be salt.

The conclusion therefore is that the saltness of the sea is due to the numerous springs of water, which in penetrating the earth find the salt mines, and dissolving parts of these carry them away with them to the Ocean, and to the other seas from whence they are never lifted by the clouds which produce the rivers. So the sea would be more salt in our times than it has ever been at any time previously; and if it

were argued by the adversary that in an infinite course of time the sea would either become dried up or congealed into salt, to this I reply that the salt is restored to the earth by the setting free of the earth which is raised up together with the salt it has acquired, and the rivers restore it to the earth over which they flow.

But—to express this better—if it be granted that the world is everlasting it must needs be that its population also will be everlasting; and that therefore the human race has perpetually been and will be consumers of salt; and if the whole mass of the earth were composed of salt it would not suffice for human food. And for this reason we are forced to conclude either that the substance of the salt is everlasting as is the world, or that it dies and is renewed together with the men who consume it. But since experience teaches us that it does not die, as is shown from the fact of fire not consuming it, and from water becoming more salt in proportion as it is dissolved in it, and from the fact that when water evaporates the original quantity of salt remains, there must needs pass through human bodies as urine or perspiration or the other excretions that are found there as much salt as is brought every year into the cities. And therefore we may say that the rains which penetrate through the earth are what carry back underneath the foundations of cities and their peoples through the passages of the earth the saltness taken from the sea; and that the change in the position of the sea which was over all the mountains has left the salt in the mines that are to be found in these mountains.

As a third and last reason we may say that salt is in all created things; and we may learn this from passing water through ashes and the refuse of things which have been burnt, and from the urine of animals and the excretions which proceed from their bodies, and the earth into which by corruption all things are changed.

G 48 v. and 49 r.

OF THE CHANGES OF THE EARTH [1]

The subterranean courses of the waters like those which are made between the air and the earth are those which unceasingly wear away and deepen the beds of their courses.

[1] MS. *della vibratio della terra.*

The soil carried away by the rivers is deposited in the ultimate parts of their courses; or rather the soil carried away by the high courses of the rivers is deposited in the ultimate descents of their movements.

Where fresh water is rising to the surface of the sea it is a manifest portent of the creation of an island which will be uncovered more slowly or more rapidly as the quantity of the water that rises is less or greater in amount. And this island is produced by the quantity of earth or deposit of stones made by the subterranean course of the water in the places through which it flows. G 49 v.

HOW WATER CONSUMES AS IT FALLS

The falls that the waters make at their banks always wear away the bases of these banks and cause them to fall headlong on their foundations. This is proved:—if the height of the bank *a c* from which falls the water *a n*, striking and consuming the place struck *m n c*, be the centre of the percussion upon which are divided the reflex movements *n m o* and *n c b*, which in each direction consume the bank that is chafed by their revolving movements, then as the banks find themselves thus consumed their supports collapse on the side on which their prop fails.

The water which falls from *a b* to *n m* will proceed to deepen all the bed from where it falls as far as the lowest level of the place where it falls, from *a b* to *c d*. G 50 v.

WHETHER THE WATER CAN RISE FROM THE SEA TO THE TOPS OF THE MOUNTAINS

The water of the sea cannot penetrate from the roots to the summits of the mountains which border upon it but only raises itself as far as the aridity of the mountain [1] draws it. And if on the contrary the rain which penetrates from the summit of the mountain to its roots which border on the sea, descends and softens the opposite slope of the same mountain, and draws the water continually as does the syphon which pours through its longest side, it must be this which draws up to a height the water of the sea; thus if *s n* were the surface of the sea and

[1] MS. *monte*. So Richter. Ravaisson-Mollien reads *mondo*.

the rain descends from the summit of the mountain *a* to *n* on one side of it and descends on the other side from *a* to *m*, this without doubt would be the method of distillation of a filter or as happens through the tube called a syphon; and the water which has softened the mountain by the great rain which descends from the two opposite sides would constantly attract the rain *a n* on its longest side together with the water of the sea, if the side of the mountain *a m* were longer than the side *a n*; but this cannot be because no part of the earth that is not submerged by the ocean can be lower than this ocean. G 70 r.

[*With drawings*]

These convolutions must be made with coloured water falling blindly into clear water. G 90 v.

Running water has within itself an infinite number of movements which are greater or less than its principal course.

This is proved by the things supported within two streams of water which are equal to the water in weight. If the waters are clear they show well the true movement of the waters that conducts them, because sometimes the fall of the wave towards the bottom bears them with it so that they strike upon this bottom; and they would be reflected back with it to the surface of the water if the floating body were spherical; but it frequently happens that the wave does not bear them back, because they are wider or narrower in one direction than in the other, and being thus irregular in shape they are struck upon the side that is largest by another reflex wave which proceeds to roll over and over this movable thing which moves wherever it is carried, its movement being sometimes swift and sometimes slow, and turning sometimes to right and sometimes to left, at one instant upwards at another downwards, turning over and turning back upon itself, now in one direction and now in another, obeying all the forces that have power to move it, and in the struggles carried on by these moving forces going always as the booty of the victor. G 93 r.

There can be no flow and ebb unless several rivers discharge themselves in the same expanse of water. G 95 r.

In the course of the year the amount of the water that rises will be as great as of that which descends in the rivers and the air. H 29 v.

[*Course of rivers*]

All the things which are lighter than sand will be left in the lower part of the river underneath the beginning of the fall of the wave.

Where the water has least movement the surface of the bottom will be of the finest mud or sand.

Where the course of turbid water meanders among the gnarled roots of thickets it will deposit much sand or mud through the many twists of its eddies. H 30 r.

OF THE COURSES OF MILLS

The water which gives less weight to its course is swifter.

The water which is swifter drives its wheel faster.

That gives less weight to its course which is straighter.

The water of the mills ought to strike the blades of the wheels at right angles.

That water which flows with less slant will strike the wheel farther from the perpendicular of its fall.

That water which strikes farther from the perpendicular of its fall gives a less blow. H 30 v.

The wave created by the percussion of water upon the bed of a river will make a movement from below contrary to that from above.

The wave is slower at the end of its elevation than at any other part.

The parts of the wave which move most swiftly will be near the end of its fall.

The sand remains higher underneath the highest part of the wave than under its lower part. H 31 r.

When a stone is thrown into still water it will create ripples that expand equally if the water is of uniform depth.

If two stones are thrown one near to the other within the space of a braccio, the circles of the water will increase equally one within the other without the one destroying the other.

But if the bottom is not level the circles will not expand in uniform movement except on the surface.

When an object of long shape is thrown into water it will create an oval undulation.

A round object thrown into running water will create an oval undulation in two movements. H 31 v.

Where the water is higher it has more weight upon its bed and its course is more undulating.

That part of the bed or of the bank which projects with the sharpest angles into the straight course of the waters suffers most damage in the flow of the water. H 35 v.

Water which strikes on an angle deepens the former sides. H 36 r.

Every part of the surface of the water desires to be situated at an equal distance from the centre of the elements, and if one part of the surface be raised above another this so happens because of the contrary movements which are taking place between it and the bottom.

H 37 r.

Where the current is in the centre of the full stream the ridge will not be between the point of union of the eddies and of where the water rebounds; it is all deep.

The large pebbles remain in the deepest part of the current.

H 37 v.

Where the channel of the water grows narrower it digs its bed deeper and flows more swiftly. H 38 r.

Iron which receives continually the impact of flowing water never rusts but is consumed by being burnished. H 39 r.

In proportion as the object dividing the water is more distant from the surface it leaves less sand behind it. H 39 v.

Where one body of water joins another at a sharp angle it will make a great depth. H 40 v.

[*Of things carried by the water*]
Where the water makes less movement there when laden it deposits its weight. H 46 v.

If a long object uniform in weight and thickness finds itself in the middle of an even descent, its length will move according to the length of the course of the water.

When a long object moves in a channel midway between the middle and the contact of the bank it will move slantwise.

The long object which is nearer to the side than to the centre will proceed to revolve upon the water. H 47 r.

Where water has less movement there it deposits its weight more lightly.

The eddies of water after it has struck the ground at an angle turn in contrary movement. H 47 v.

Water will be in perpetual movement if its surface is not equidistant from the centre of the earth.

Sand and other light objects follow and obey the twists and turns of the eddies of the water while the large stones move in a straight line. H 50 [2] r.

Water which falls into smooth water causes it to become slanting, consequently its descent becomes swifter. H 50 [2] v.

Measure the height of the falling water and multiply it by the height to which you wish to raise it, and as many times as the extent of the fall of the water enters into the height to which it has been raised, so many times is it thinner than that which rises; and this is the last and greatest amount that can be raised. H 51 [3] v.

Water which rises continually because of the movement of other water will be so much the thinner as that which moves it is of greater length. H 52 [4] r.

Turbid water does more harm to the banks than clear water, and more at the base than at the top, because it is heavier and thicker. H 52 [4] v.

The line of the water which has the greater movement breaks that of the lesser movement and buries itself beneath it.

That part of the sand which is nearest to the impact of the falling water will be finer than the rest.

The large shingle will be farthest away from the blow. H 53 [5] r.

I ask whether the water which emerges underneath comes from the surface or no.

The first depth will be where the sum of the blow of the second water makes its way into the course of the eddies; the lesser where the second base is, is where the revolving water encounters it in its course.

H 53 [5] v.

After the descent of water that which was above remains below; the lower part becomes changed into the upper part.

After the most rapid descent of the water the lower part remains of more rapid movement than the upper part. H 54 [6] r.

Of waters that flow upon beds of equal slant that will have the less depth which has the greater breadth.

Of waters that flow between banks of equal breadth that will have less depth which possesses the more rapid course. H 54 [6] v.

Water in its movement drags with it the air which borders on it.

And the bed offers more resistance: this is why it moves more on the surface than at the bottom.

All the upper part of the water which finds itself at the beginning of its fall will be lower than the other after this fall. H 55 [7] r.

Water which flows in falls of equal slant will move more strongly at the bottom of the canal than at its surface. H 56 [8] v.

Waters which fall from the same level with an equal slant in an equal length of movement will be of equal swiftness. H 58 [10] v.

Of waters which fall from the same level by channels of equal slant, that will have the swifter course which has the greater length.

Of waters which fall the same distance from the same level, that will be slower which is longer. H 59 [11] r.

The percussion of the water upon the wheel will be at the highest degree of its power when it strikes within equal angles.

The percussion made between equal angles will be of the greatest power when the current of the water and the movement of the wheel are in the same direction. H 63 [15] r.

The sand moved by two light currents of water settles itself upon the steep bank in a square ridge. H 63 [15] v.

Water which has struck against a round body will create equal hollows beyond the sides of this body.

Gravel dug up by the blows of the water will settle where the movements made by the blows meet.

That face of the triangle which is interposed between more nearly equal angles in the course of the water will be the cause of a great hollow in the water that strikes there. H 64 [16] r.

Water which moves by a uniform slant will be swifter at the surface than at the bottom.

The wave that is caused by a blow will be higher at the beginning than in the middle.

Waves that are caused by the wind will be higher in the middle than at the beginning; that is the fourth [will be higher] than the third. H 67 [19] v.

These back-currents eat away the banks of the canals; you will therefore make screens of wood to extend for the whole of their impact. H 68 [20] r.

[*Movement of water*]

Water which exceeds the general depth and breadth of rivers moves in contrary movement.

The wave of the water will swell between the cause of the movement and its end.

Water which moves by reason of the undulation of the wind will make a contrary movement at the bottom to that at the surface.

Water does not weigh less crosswise than in the line of its perpendicular.

Every movement of liquid weighs more in the direction in which through a hole of equal size its vase empties itself more rapidly; the centre of the bottom of the vase receives a greater weight of water than any other place. H 68 [20] v.

The free movement made by the upper part of water will not make angles of any kind except in the percussion.

All the upper lines made by the movement of water are curved.

The wave follows the movement of the air which touches it.

The object enclosed between the air and the wave does not follow the movement of the one or the other.

The water that is expelled from the spot which the vessel occupies weighs as much as all the remainder of the ship which displaces it.

H 69 [21] r.

Streams of water equal in current and angle of descent which move one against the other, penetrate and pass through each other without turning aside from their natural course. H 69 [21] v.

Water which moves against motionless water attacks and destroys its bank.

The water with the greater movement penetrates and traverses the lesser movement of other water, like air. H 70 [22] r.

The line made by the course of water after its percussion leaps back at equal angles. H 71 [23] r.

The farther water is away from its bed the freer will it be in its natural movement. H 72 [24] r.

Where the water has a stronger current the shingle is larger. All the detached shingle will turn its largest side slantwise against the course of the water. H 74 [26] v.

All light things gather together in the centre of the eddies that is at the bottom. H 75 [27] r.

Every portion of water desires its parts to be as the whole element, equally distant from its centre. H 76 [28] r.

The water which flows near the bed of the stream between the banks will be slower than the rest because of the percussions made by the eddies. H 77 [29] v.

[Error as to buying water]

You who buy water by the ounce know that you may greatly deceive yourselves. In fact if you take an ounce in stagnant water and an ounce in flowing water, against the hole of your ounce, an ounce near the surface, one near the bottom, one across the current . . .

In proportion as the natural movement separates itself from its cause so it becomes more rapid. H 78 [30] r.

That wheel of the water will be better turned when the water that turns it does not leap back after its percussion.

The blow will be of the greatest force when the movement which causes it is straighter and longer. H 79 [31] v.

[*Sand and water*]

All the hollows of the furrows visible in the sand will be between equal angles, according to the movement of the water. H 80 [32] r.

OF SAND

The wave is less sloping and of slower movement in its rise than in its descent. H 81 [33] r.

The surface of the water of rivers desires to be equidistant from the centre; as it leaps it weighs down and consumes the bed because it grows thicker in the course of its intersections and increases in weight as it enters the air, and in consequence falls and bursts through the bed. H 81 [33] v. and 82 [34] r.

In water that has no movement the leaves that ranged through every part of the water rest upon its bed. H 82 [34] r.

The back-currents which are formed in the midst of the expanse of the falling water are situated between the leap of the water and its banks. H 82 [34] r.

The back-currents made by the water after the expense of its fall will be between the surface and the bottom, between the upper and the lower part. H 83 [35] r.

If the beds of two canals are of equal slant and breadth, and contain an equal volume of water, and one is restricted to two thirds of its breadth in the middle of its course and the other is uniform in breadth, I ask which will discharge more water.

Water that falls into other water strikes against its bed and raises itself farther in the air than does the general surface, and then falls back and lessens its bounds. H 83 [35] v.

The lines of the water as it leaps after its percussion will not be in a straight course but will bend in a curve. H 84 [36] r.

A straight canal of uniform depth and slant will make within a short time a deeper hollow in its centre than near the bank.

The water in the middle of straight canals flows more rapidly than it does at the sides.

Where the water has more movement it is lighter if it is of the same height.

Water which has been pent up will burst the bank and the bottom after its fall. H 84 [36] v.

Every canal of water of uniform declivity, depth and breadth, which is pent up for a certain space, will burst its bed and its bank after the passage of this restricted area.

This is due to the fact that where water is pent up it rises behind this barrier and after passing through this narrow place it presses on furiously; as it descends it comes upon the water below which does not flow and so it receives a check. After this it follows the line of its descent and goes to the bottom and burrows there and turns with a circular movement towards the banks, and hollowing these out from below it makes them fall in ruin, as is shown in the drawing above.

H 85 [37] r.

[*With drawing*]

Water below obeys its natural course less than that above.

This comes about because the water that borders on the air is not made heavy by any weight, so that simply and without any restraint it obeys its natural course *c d*.

That below is weighted and pressed and acts as is shown at *a b*. See that as it forms an angle at *a* and above at *c* it cannot form anything but a curved line.

All the waters some distance below the surface intersect after their percussion. H 85 [37] v.

That water will turn in contrary course which exceeds the general breadth and depth of the rivers.

Waters of equal breadth and unequal depth will be of equal movement on the surface.

Among the currents of water of equal slant that which is the straightest will be the swiftest. H 87 [39] r.

Water which exceeds in depth or breadth the general breadth and depth of the river will turn against its first course. H 87 [39] v.

[*Method*]
Remember when discoursing about water to adduce first experience and then reason. H 90 [42] r.

Of streams of water equal in length, breadth and declivity, the swiftest will be the one of greatest depth. H 92 [44] v.

All the movements of streams of water which are equal in depth and declivity will be more swift at the surface than at the bottom, and more at the centre than at the sides. H 93 [45] r.

Water, which is the vital humour of the terrestrial machine, moves by its own natural heat. H 95 [47 v.] r.

[*The circulation of water*]
The water which from the lowest depths of the sea entering by the force of its mover is driven to the high summits of the mountains, there finding the severed veins, hurls itself headlong and returns by the shortest way to the depths of the sea; and again it raises itself through the ramification of its veins and again falls back, and thus, coming and going, sometimes high and sometimes low, inwards and outwards, it revolves with natural or accidental movement after the manner of a screw, while the water that is poured away through its severed branches and falls back upon itself rises again through its courses and returns to the same points of descent. H 101 [42 r.] v.

Where three currents of water meet together there will be created a sudden depth, for they rise and acquire weight and then movement with force, and this breaks in the percussion that it makes upon the bottom. I 61 [13] v.

[*Of the fall of a river*]
If the bottom of the bed of the river from which the water hurls itself is hollow in the centre, the water which moves from the sides and directs itself towards this centre will raise itself before falling.

If the river as it flows strikes against some rock, it will leap up, and the place that it strikes in its fall will be of the nature of a well.

1 62 [14] r.

If the rock in a river projects above and divides the course of the water which rejoins after this rock, the interval that is found to exist between the rock and the reunion of the water will be the place where the sand becomes deposited.

But if the rock that divides the course of the waters is covered by the flowing waters only in its lower parts, the water that passes above will fall behind it and form a hollow at its feet and cause it to turn; and the water that falls headlong into this chasm turns in vortex upwards and downwards, for the uniting of the two streams of water which had been divided by the rock does not suffer the water immediately to pursue its journey. 1 67 [19] v.

Every natural and continuous movement desires to preserve its course on the line of its inception, that is however its locality varies it proceeds according to its beginning.

This movement aforesaid occurs in the course of rivers, which always attack and destroy whatever opposes the direct line of their course.

But if these rivers were straight, with equal breadth, depth and slant, you would find that with each degree of movement they would acquire degrees of speed.

Consequently if there is a change or difference in their slant there is a difference in their course; and where there is less inequality in breadth they become deeper; and given an equal slant, where they are wider they become slower. Therefore the waters which desire a straight course, and to make themselves swifter at each stage of their movement, finding the places through which they pass wider and deeper become slower and break the bed or the bank. 1 68 [20] r.

WATER AND AIR

The movement of the rebound of water is swifter than that of the percussion when the water that strikes is much mingled with the air.

1 68 [20] v.

For the air is capable of being compressed, and the more it is compressed the more it has weight within the other air; and the greater its weight the greater its percussion against its object, as is seen with the winds which are constrained from great breadth to pass through a narrow defile of the mountains: if there were no opening above them they would not fill up the spaces of the things in front of them, but they are able to expand above with great facility because there are great spaces between the hills . . . and below readily, and the wind flies easily towards the height. Remember how Augustus made a vow in Gaul to the wind Cirrius because for just such an impetus he had to lose his army, and there he made a temple. 1 68 [20] v., 69 [21] r. and v.

Water will leap up far higher than it has fallen, through the violent movement caused by the air which finds itself shut in within the bubbles of the water, and which afterwards rises and floats like bells upon the surface of the water. Returning to the place where it strikes, the water is again submerged by the blow, so that the air finds itself hemmed in between the water which drives it down and that which encounters it, and being pressed upon with such fury and violence suddenly bursts through the water which serves it as a covering, and like a thunderbolt emerging from the clouds so this air emerges from the water carrying with it a part of the water[1] which previously formed its covering. 1 69 [21] v.

[Water in canals]
When water in some part of its passage through a narrow canal becomes wider it immediately becomes shallow and swifter because it finds a slope where it moves vigorously. And along the course it has commenced it directs itself to the foot of its dike and strikes it.

After which percussion it turns upwards and proceeds with a whirling movement hollowing out the foundation of the bank until it returns upwards. And this process of hollowing it out gives it the shape of the hull of a ship, narrow at the commencement and the end and in the centre deep and wide. 1 70 [22] r.

[Eddies]
Here arise the bubblings or wellings up of water in the middle of

[1] MS. has *aria,* air.

the higher eddies. And it may be asked whether the movement of the eddies starts because it runs towards the percussion of the water, which is lower than in any other adjacent part; or because the thrust of the water that flows in the centre of the breadth of the surface is that which as it strikes the other waters raises them and makes a hill with the other water, and then returns towards its entry in the expanse of water; or if the water struck by the other waters in its stream and pressed by it gushes up and leaps back to the place from which the current comes.

I 71 [23] r.

BEGINNING OF THE BOOK OF WATER

The name *pelago* (sea, large lake) is applied to an area large and deep in form in which the waters lie with little movement. *Gorgo* (whirlpool) is of the same nature as the *pelago* except for a certain difference, and this is that the waters that enter into the *pelago* do so without percussions while those of the *gorgo* are made up of great falls and bubblings up and surgings occasioned by the continuous revolutions of the waters. *Fiume* (river) is that which occupies the site of the lowest part of the valleys and which flows continuously. A torrent is that which flows only with rains: it also makes its way in the low parts of the valleys and joins itself to the rivers.

Canal is the term applied to waters regulated within their banks by human aid. *Fonti* (sources) is the name given to the birthplaces of rivers. *Argine* (bank) is that which with its abrupt height withstands the widening of rivers canals and torrents. The *ripa* (bank) is higher than the *argine*. The *riva* (shore) is lower than the *argine*. The *spiaggia* (beach) is among the lowest of the parts which form boundaries with the waters. *Lago* (lake) is that in which the waters of the rivers assume great width. *Paludi* (marshes) are stagnant waters. *Grotte* (caves) are hollows formed in the banks of rivers by the course of the river; their length follows the line of the course of the water; they have some depth and also find their way under the foundations of the bank, losing their shape as they near the end of their course. Caverns are of the shape of ovens which enter far beneath the bank, and the waters in them are in a state of wild turmoil and are constantly increasing.

Pozzi (wells) are the sudden depths of rivers. *Stagni* (pools) are the

places of refuge for the waters of floods or storms, their beds being firm and thick so that the soil can neither drink in nor dry up these waters. *Baratri* (chasms) are also places where the water suddenly becomes deep. *Procelle* (storms) are tempests of water. *Polulamenti e surgimenti* (bubblings and wellings up) are the beginnings of the waters; but the former come from below upwards and the latter merely in transverse movement which falls from some grotto. *Sommergere* (submersion) is understood to refer to things which enter under the water; *intersegatione dacque* (intersection of waters) takes place when one river cuts the other.[1] I 72 [24] r. and v.

When the general courses of the rivers are contracted, as they issue from the valleys and enter amid the defiles of the mountains, the water will heap itself up in its wide part; and it will make great descent and movement through the said contracting of the mountains, and after passing the middle of this contracted part it will make a great hollow, and then having entered again in the broad part it will lack depth, in just such proportion as the wide part increases in such a way that the waters become of equal course.

And the said depth will be lacking after the leap of the waters, because it will become filled up with shingle beneath the greater altitude of the leap of the said waters.

If the fall is of the same width as the river, the water that strikes the bottom will leap up and then fall back again by each line that departs from the centre of the surging mass, and the farther they descend from this surging mass the more they spread out. And part is moved by the course of the stream, and as a consequence it is necessary for it to make three movements, each of which consumes a considerable portion of the foot of the bank.

For that which descends from the summit of the surging mass throws itself towards the bottom, and since such descent is slanting it acquires a movement towards the bottom of the bank; and as this descent follows in part the general movement of the river, this surging mass falls with a threefold descending movement, one proceeding downwards, another towards the bank, another towards the course of the river. And all three consume the base of the bank, by reason of the

[1] A list of words is added, descriptive of movement of water.

great displacement occasioned by so much impetus; for if the river were to flow for a long way hugging the bank it would be able to find some stone which at some spot would protect a piece of this bank near to it; but this movement proceeds downward towards the bottom, forward towards the bank, downward towards the course of the stream, in such a way that each stone is struck by three different movements and on three different sides.

From which it follows that if the soil is friable it crumbles away in a short time. 1 74 [26] v., 75 [27] r.

[*Of the movement of water—bubbles*]

When one sees mountains rising in the running waters, rising in the form of bubbles, it serves as a sign of the great depth from which these bubbles spring after the percussion made by the water upon the bottom; and by the speed of its rebound it bores through and penetrates the other water and then turns towards the surface of the running water and passes through it, rising up in this way; thereafter acquiring weight it loses its first impetus and falls down again by each line round its centre, and returns again towards its bed. 1 76 [28] v.

CURRENTS

Of the difference water makes in its course if its sides strike on a strand, a bank, or other water, that is in passing by a piece of stagnant water or running water crosswise.

One should also observe what differences there are in rivers if they fall upon beds of different natures, namely upon stone or earth, or tufa or clay, sand or mud, or stagnant or running water, and this crosswise or slanting or opposite, or by the same line as the water itself, that is by the line of the same current but slower or swifter than that which it strikes, or more level or more slanting.

OF EDDIES

One asks why the percussion of water within water makes lines of circular movements and eddies, and its leap is not straight as is that other which beats upon its shores and banks.

Why bubbles are not continuous when the falls of the water are:

The reason is that the water which flows above after falling is swifter than that which flows below; and when that below precipitates itself in some chasm it raises itself towards the surface with almost the same impetus, and sometimes subdues and overcomes the water that flows above and sometimes is subdued by it.

Being thus in a state of equilibrium as to its power of movement sometimes one conquers and sometimes the other.

<div style="text-align: right">I 77 [29] r. and v.</div>

Things lighter than water do not follow the course of the rebound and intersection of the water, but pass along the centre of its current or near the parts as they are found at the entrance of the currents, and are not impeded unless by equal pressure, because if the right wave of the rebound meets with the left, it is necessary, if they are of equal power, that the place of their percussion be thrown back equally.

Consequently things in this place which move upon the water, not being driven more by one percussion than by the other remain in the same line of current. But if one of the forces of the wave be greater than the other, that is by the swiftness of its current, I do not mean force arising from a greater quantity of water, for if the one water was much less thick than the other this would not matter: for let us suppose one body of water to be less than double the other in volume and to acquire double its speed; now since these bodies of water clashing together are of equal size in their contact, as I have proved in the third of the fifth, the larger being a square braccio and the lesser of a half braccio, the lesser does not strike the greater unless it is in its half, and in the same way the greater strikes the lesser with its half, so that the contacts made by the percussions are equal in quantity and unequal in that the power is double, the speed of the one being double that of the other.

OF THE EDDIES

Sometimes there are many eddies which have a great current of water in the middle of them, and the more they approach the end of the current the greater they are. These are created on the surface by the waters that turn back after the percussion that they make in the most rapid current, for the front portions of these waters, being themselves

slow, on being struck by the swift movement, are suddenly transformed into the said speed. Consequently the water which touches them behind is attached and drawn by force, and torn away from the other, so that it turns all in succession, one (wave) following the other with a like swiftness of movement, if it were not that such current at first cannot receive it so that at any rate it does not rise above it, and as this cannot be it is necessary for it to turn back and consume in itself these swift movements. From that time the said eddies with various revolving movements proceed to consume the impetus that has been begun. And they do not remain in the same positions, but after they have been formed thus, turning, they are borne by the impetus of the water in the same shape, in which they come to make two movements; the one is made in itself by its own revolution, the other as it follows the course of the water which is carrying it along all the time that it is destroying it. 1 78 [30] r. and v., 79 [31] r.

[*Air and water*]

The water which by a slight movement encloses, a little way below its surface, the air which is submerged with it, turns with a slight impetus out of the surface, carrying with it such covering of water that being of equal weight with this air it stands above it in the form of a half-spherical figure.

But if this air is submerged with impetus it comes back out of the water with fury for the length of the movement made beneath the water; and pressed by its weight it leaps out of the water, breaks its surface with its impetus and flows on with straight course after the manner of wind emerging from bellows which discharges itself in a stream through the air; and therefore it does not, as does the former as it floats upon the water, remain enveloped in its surface.

1 80 [32] v.

How all the air which leaps back with the water does not remain on the surface but by its impetus submerges itself anew amid the revolutions of the waters:

How the movements of the waters among the other waters are not obliged to move more by a straight line than a curved one, and how after leaping back as they wished these waters are not obliged to be at rest, but in order to return to a low place and with a revolving move-

ment they go attending the course of the river until they have dis-
charged the air that is enclosed within them on the surface of the
sheet of water. 1 81 [33] r.

[Of water flowing into water]

BEND OF CURRENT

If the entry of the water into the sheet of water (pelago) is of circular
shape the concavity of its base will be of the form of a crescent, receiv-
ing the shingle within its circumference or within the two horns of this
figure.

I ask whether if the current should make some bend it will become
hollow at the bottom or in the middle or above, and the same thing as
regards the leaps which follow afterwards against the bank of the rivers,
the bed being of uniform substance, and also as to the bank where it is
raised, where it leans and the methods of effecting its repair.

1 81 [33] v.

[Of falling water]

I ask as to the shape that water assumes in the different slants of its
descent in each of its falls, and what shape the concavity will have when
the water strikes upon a bed of uniform substance; and I ask as to the
shape the shingle will take which is left after the percussion of each of
these, and the remedies when they are injured. 1 82 [34] r.

HOW TO STRAIGHTEN RIVERS WHEN THEY HAVE A SLOW COURSE

Because the straighter the river the swifter will its course be, and the
more vigorously will it gnaw and consume the bank and its bed, it is
therefore necessary either to enlarge these rivers considerably or to send
them through many twistings and turnings or to divide them into a
number of branches.

And if the river through many twistings and turnings becomes slow
and marshy through its many detours you ought then to straighten it,
in such a way that the waters acquire sufficient movement and do not
cause destruction to the banks or dikes; and if there should be depth
near to some dike you ought to fill up the spot with gabions together

with fascines and shingle, so that it may not become hollowed out by
movement under the dike, and so by causing it to crumble the river
may afterwards proceed to make a bend in your land or villa and there
straighten its course. I 82 [34] v.

[*Of the earth carried by water*]

When the water in the floods commences to find a place where it
can flow, it begins with its feeble inundation to strip and carry away
the lightest things, and deposits them where its course becomes feeble,
then as it grows it carries away the heavier things such as sand, and
carries them over the former things and there leaves them, and even
though the water should not increase, by the mere fact of its continu-
ance it proceeds by degrees to carry away the things from the place
where it flows; but by reason of their weight it cannot carry them so
far forward as the first lighter things, and if it then carries away the
heavier things it deposits them proportionately near to the spot from
whence it took them.

How to restore the soil to the places that have been uncovered and
stripped bare by the courses of the waters on a hill or mountain or in
sandy places.

For the rains, or to provide an outlet for other waters, one ought to
construct canals or mouths of rivers, for the places where they pass in
so great current that they tend to become turbid by reason of the earth
they carry with them and to be changed; then when they are at the
place where you wish that they rid themselves of the soil, these canals
of water are divided into many small channels of water, after the man-
ner of furrows, and their violence is lessened and they grow clear again.

 I 83 [35] r.

[*Of flowing water*]

Where the river is constricted, it will have its bed stripped bare of
earth, and the stones or tufa will remain uncovered by the soil.

Where the river widens, the small stones and the sand will be
deposited.

Where the river widens considerably, there will be discharged the
mud or the ooze and bits of timber and other light things.

Where several currents of water run together, there will instantly be
formed a hollow that will be navigable.

Where the waters separate, the sand and ooze will be deposited and the bed will be raised in the shape of the half of a ship inverted.

Beneath the rebounds of the water, there will be formed hills of sand or stones.

Beneath the repercussions, that which rests under the rebound will become raised.

Where the water finds the place higher, which forms an obstacle beneath it, it makes a greater and higher wave and then forms a deeper hollow. I 83 [35] v.

Where you find much sand you will find at the end of it in front or behind shingle or bare tufa.

Sand is discharged when waters meet in their course, for in such a spot nothing can remain that offers resistance to a current so reinforced; light waves drop their sand at the sides of the said current, and the sand as the current becomes less swift forms a cover to the shingle.

Sometimes the lesser floods carry branches covered with leaves from the plains and deposit them in their small movements, and then, becoming stronger, heap sand upon the edges of these branches and still increasing carry there shingle and tall large stones. I 84 [36] r.

[The rebounds of water]

The rebounds that water makes which rise through the percussion of water which has fallen upon other water, are not carried between the equal angles of its percussion, but will leap to the surface by the shortest way, through the air that was submerged together with the water.

I 84 [36] v.

If a stone is thrown into still water it will form circles equidistant from their centre; but if into a moving river the circles formed will lengthen out and be almost oval in shape, and will travel on together with their centre away from the spot where it was first made, following the course of the [stream] . . . I 87 [39] r.

OF WAVES

The waves are of [twelve] kinds, of which the first is made in the upper parts of the waters; the second is made above and below by the same path; the third is made above and below by contrary paths, and is

not in the centre; the fourth is made so that from its centre upwards it
runs in one direction and from this centre downwards it makes the
opposite movement; the fifth flows downwards and not upwards; the
sixth flows downwards and above has a contrary movement; the
seventh is that of the submersions of waters by means of a spring that
enters into the earth; the eighth is that of the submersions by means of
eddies which are narrow above and wide below; the ninth is that of the
eddies wide at the surface and narrow at the base; the tenth is of cylin-
drical eddies; the eleventh of eddies that bend in regular curves[1]; the
twelfth is of the slanting eddies. Make here all the waves together, and
all the movements by themselves, and all the eddies by themselves.
Arrange thus the series in order separated one from the other. And so
also the rebounds of how many kinds they are in themselves and also
the falls. And set down the differences that there are in turbid waters,
in their movements and percussions, and those that are clear; and
similarly in waters that are violent and those that are sluggish; in those
that are swollen and those that are shallow; and between the fury of
pent-up rivers and those with a wide course; and of those that run over
great stones or small ones or sand or tufa; and of those that fall from a
height striking upon different stones with various leaps and bounds,
and of those that fall by a straight path touching and resting upon a
level bed; and of those that fall from a great height alone through the
air; and of those that fall through the air in shapes that are round or
thin or wide or separated or united. And then write down the natures
of all the percussions: on the surface, in the centre, and at the bottom,
and of their different slants, and the different natures of the objects and
different shapes of the objects.

And if you give movement to a sheet of water, whether by opening
its sluices above, or in the middle, or below, show the differences that
are caused by it falling or moving on the surface, and what effect it
makes in entering with such fall upon the ground or in stagnant water,
and how that by which it is moved at first maintains itself in a channel
level or uneven, and how it produces all at once eddies and their re-
cesses, as one sees in the basins of Milan, and the nature of the sudden
rush of the rivers, and so also with those that grow little by little; of
the waters also that cannot in the great floods pass through the arches

[1] MS. *dequal nacuita.*

of the bridges which surmount them, and how the water that passes through these arches increases the impetus through having a great weight above. 87 [39] v., 88 [40] r. and v.

[The water of mills]

I ask whether if the impetus of the waters that turn the mills creates a protuberance either across above or below near the place of percussion, this percussion will have the same force as if this water ran in a straight line. 1 89 [41] r.

OF WATER

Rivers when straight flow with a much greater impetus in the centre of their breadth than they do at their sides.

When the water has struck on the sides of rivers with equal percussion, if it find a part of the river narrower it will leap towards the middle of the river and these waves will make a new percussion between themselves; as a consequence they will return again towards the banks, equally, and that water of conical shape, which is enclosed between the first percussion made upon the bank and the second made in the centre of the stream, will slacken at its base and be swift near to its crest. Striking the bottom they will afterwards rise equally to the height of the intersection; but always that of the centre will be swifter than that which leaps back.

Water which moves along an equal breadth of river and on an equal bed will have as many different thicknesses as there are different slants in the bed where it runs; and by as much as it is swifter in one place than another so proportionately it will be more shallow.

 1 105 [57] v., 106 [58] r.

OF MOVEMENT

Water which falls from the height of a fathom will never return to the same height except in small drops, which will leap much higher because the motion of leaping back will be much more rapid than that of the descents. In fact when the water falls it buries with it a great quantity of air, and after the (other) water has been struck it leaps back towards its surface with a force which creates a movement almost as rapid as was that of the descent; but not actually so for the reason

given in the second of the seventh, where it is stated that the movement of the rebound will never be so swift as was the descent of the substance which rebounds; or thus:—a succeeding rebound will never be equal to that which precedes it. So that in consequence the rebound which the water makes proceeds from the base where it has been created, almost with the speed of the descent that has given it birth; and in addition to this there is added to it a second momentum which augments this motion, namely that of the air that is submerged by the fall of the water. This air clothed around with water bounds up with fury and leaps into its element like wind driven by the bellows; it carries with it the last of the water which is close to the surface, and by such an increase causes it to leap up much farther than its nature demanded.

<div style="text-align: right">1 108 [60] v., 109 [61] r.</div>

The farther the circular wave is removed from its cause the slower will it become. 1 114 [66] r.

[*The meeting of water-courses*]

If the courses of two lines of water which cross each other in the middle or in a part of their river-beds pass either the one into the other or the one over the other, do they then each leap back after the percussion? Certainly they leap, because it is impossible for the two bodies to pass one through the other.

But after the two bodies have clashed together they will widen themselves at their point of contact, and after having struck they will recoil to an equal distance from the centre of the percussion. And that body which goes upwards follows its nature, and the other body below the centre of the impact which would wish to go downwards and cannot, increases that above. 1 114 [66] v.

EXPERIMENT OF THE REBOUNDS OF WATER IN A LEVEL CHANNEL

Make one side of the channel of glass and the remainder of wood; and let the water that strikes there have millet or fragments of papyrus mixed in it, so that one can see the course of the water better from their movements. And when you have made the experiment of these rebounds fill the bed with sand mixed with small shingle; then smooth

this bed and make the water rebound upon it; and watch where it rises and where it settles down.

Then make the bank on the wooden side of mud, and watch its effects through the glass, and make it again in flowing water.

I 115 [67] r.

[Movements of water]

If the water was a quantity endowed with sense [1] as it is a continuous one, the movement that it makes between the extreme elevations and depressions of its waves would be unequal.

In effect the part that rises acquires degrees of slowness in each degree of movement, in such a way that at its greatest elevation it is in the extreme stage of slowness.

And afterwards in descending it acquires degrees of speed in every degree of movement, so that at its lowest depth it acquires greater movement; therefore the resistance that ends its descent is that which receives the hurt, and that which ends the height of its elevation has no hurt.

But if the quantity is continuous: the continuous quantity has equal movements when its river is of equal size and depth, because being all united together it is necessary that in all the parts of its movement each part draws and is drawn, pushes and is pushed, or drives and is driven. And it is necessary that this be with equal movement and power; and if it were not so the water would multiply more where it was slowest and would fail where it had most movement.

I 115 [67] v., 116 [68] r.

Where the water divides it rises; and afterwards as it falls down again it strengthens its course by the increased descent that follows.

Where the waters join they rise; and then the near movement that follows becomes slow. I 116 [68]

When in the courses of rivers there are two currents of water, commencing the one far from the other, which meet in a place where they clash together, they will rise up after this percussion, and their bed will be but little consumed because they depart from it; and afterwards they will fall back again as they separate, and fall asunder, and falling back

[1] MS. *disscreta.*

again they will strike and scrape upon their bed. By reason then of this percussion, which beats and scrapes the bed with its movement, a depth will be produced there; and this happens in the great currents of rivers.

<div align="right">1 117 [69] r.</div>

[*The height and depth of the waves*]

OF THE SUMMIT OF THE WAVES

The greatest elevation of the waves will not wear away its bed beneath itself; in effect it touches it but little, by the fifth of the sixth which says that everything weighs by the line of its movement; from which we may say that this wave moves towards the air that flies from its percussion and weighs towards the air. If however the amount of friction is slight, it will have but little force and will consume the bed but little.

HOW WAVES ATTAIN THEIR GREATEST DEPTH

Whatever obstacle forms the chief cause in breaking the straight course of the water will be most consumed and displaced by it.

Therefore we may say that if the air were the cause why the straightness of the elevation of the wave is broken it would be consumed by this percussion of water. But this air is not the cause of the breaking of such a course; the only cause of it is the force which the water acquires as it emerges from its element. And it would relax its pace in such a position if it were a sensitive quantity, but being as it is a continuous quantity it is necessary that one body of water pushes and the other draws, because they are united. 1 117 [69] v.

If the water moves more swiftly in the falling of the wave than in its rising, and at what point this water delays most.

The water that moves in the formation of the waves will find itself of as great speed during its ascent as that of its descent, and it will have as much in the middle of its lowest depth as that of its greatest height. And if it was not of equal movement it would not be of equal depth or breadth; and if however it was of equal length and depth but not of equal movement it would form a great height in the place where it slackened most. 1 118 [70] r.

The water flows more strongly at the sides of a covered rock than above it and after it has passed it, and for this reason it twists the waves made by its rebounds, producing on its surface crescent-shaped figures. 1 123 [75] r.

[*The different sorts of rebounds of water*]

The rebounds of the waters are of two kinds, that is they are formed from two causes; one is that of the lumps of the bed on which the water passes, the other is when the parts of the water that strike against the lumpy parts of the bank leap back to the opposite bank. These masses of water on striking leap back to the opposite bank and press and drive themselves upon the first wave that they meet, and swelling leap towards the sky; and each flies equally from the place where it has struck, until another wave drives it back and afterwards another drives it forward.

So in succession they fill the surface of the rivers with a trellis pattern, always raising themselves to the positions of the above-mentioned percussions. 1 127 [79] v.

[*Rule as to rebounds: experiment*]

I ask concerning the rebound: if the first rebound is ten braccia tell me how far will the second be. Dye the ball so that it marks the spot where it strikes upon the marble or other hard substance, study the position of each of the rebounds in succession, and so deduce the rule. 1 128 [80] r.

If you throw sawdust down into a running stream, you will be able to observe where the water turned upside down after striking against the banks throws this sawdust back towards the centre of the stream, and also the revolutions of the water and where other water either joins it or separates from it; and many other things. K 1 r.

WATER AND NATURE

Water is nature's carter, it transforms the soil and carries to . . . a great part . . . double. K 2 r.

RIVERS

Simple movement: Many rivers there are that increase their waters at every state of movement without loss.

Simple movement: Many there are that lose without ever acquiring.

Composite movement: And there are a considerable number which acquire more than they lose.

Composite movement: And a considerable number lose more than they acquire. K 60 [11] v.

I have written in how many ways water hollows out the bottom, and in how many ways it deposits earth upon the bottom. And the same of the banks: where it raises them and where it forms them, and in how many ways it hollows out the soil of the banks, and the estates where during its floods it goes spreading itself beyond its banks.

K 65 [18] r.

The eddies of water are always produced in the middle water.

The middle water is that above the mouth of the water which is bent across near to where it runs into the canal.

The middle water is that between the water that is falling and that which is thrown back. K 93 [13] v.

Should two streams of water encounter each other and then bend together in the same flight, the middle water will be found beyond this flight upon the current that has less power.

The surface of the water which bends in leaving the straight line of its course for the lateral outlet will be always higher in the centre than at the sides. K 94 [14] r.

Of the water that is poured through a hole of uniform size situated at the bottom of its reservoir, the part that is nearest to the wall of this hole will have greater height and greater movement than the lateral part. K 94 [14] v.

When water is poured in different streams from one reservoir into another that will be higher above its hole which is poured through a hole of less width, and the proportion of the height will be the same as that of the width of the holes. K 94 [15] r.

When two streams of water encounter each other and then pour through the same channel to the bed of a river, eddies are created there on the right hand and on the left, and sometimes these eddies of the right and left become reunited. K 96 [16] r.

The water which moves in a river is either summoned or driven or moves of itself. If it is summoned or as one may say requisitioned what is it that requisitions it? If it is driven what is it that drives it? If it moves of itself this shows it to have a reasoning power; but in bodies which undergo continual change of shape it is impossible that there should be reasoning power, for in these bodies there is no judgment. K 101 [21] v.

RIVERS AND BANKS

All the embankments of rivers against which the waters strike ought to be so much the more slanting as the percussion of the water is of greater power.

Water rises higher upon the bank against which it strikes when it finds this bank more slanting; and consequently descends with greater impetus to strike against the opposite bank. K 102 [22] v.

What difference there is between the percussion of the same quantity of water when it falls through the air or falls shut up in a conduit:

The water which falls in a perpendicular line becomes shrill at some stage of its descent. When it falls through a conduit this is left empty, and here the air fights with the water as will be said in its place. You should not forget however to say that this descent of the water is checked by the condensation of the air in the conduit where the water is. K 103 [23] v.

If the waters that enter into a reservoir or issue forth from it have the holes of exit equal to the holes of entry, and the fall of the entry is longer than that of the exit, the entry will then be greater than the exit until the water of the basin rises, and then they will become equal. K 104 [24] r.

And if the fall of the entry is more beneath the surface than the fall of the exit, although they are of the same size, the entry will be greater than the exit until their powers equalise themselves.

But if in this case the exit covers a longer space of the surface than the entry does then the exit will be greater than the entry.

<div align="right">K 104 [24] v.</div>

What shape will the same quantity of water moving along the same slant have in order that it may be as swift as possible?

Let it have that which will make least contact with the bottom, that is a half-circle.

That water will be swifter when the part that makes eddies through striking upon the bottom and the sides is less in bulk than the rest; and this is the greatest river.

<div align="right">K 105 [25] r.</div>

[*Relation of wave and wind*] [*Diagram*]

The wave increases because the wind increases.

D b e f the wind, strikes e f the water, and causes it to overflow; d a e c the second part of the same wind finds c e prepared to overflow, having come from e f, and comes behind it with its power; and doubles the power t v e f and so makes the wave double.

<div align="right">K 106 [26] v.</div>

Whether the percussion made by the water upon its object, is equal in power to the whole mass of the water that strikes when it finds itself in the air, or no.

Which is the easier, to raise the sluice of the mill with the water flowing, up or down or across, or when the water is still.

<div align="right">K 117 [37] r.</div>

Vessels of equal capacity and full of water in double proportion and which empty themselves by holes made in their lowest depth, in each degree of time will change the degrees of proportions in the copiousness of their discharges.

I maintain that if at the commencement of the discharge the water is of double quantity, the amount of the discharge is immediately double in the one case what it is in the other, varying immediately; in such a way that if the descents are divided in six stages in the lesser vessel and twelve in the larger one, when the lesser vessel has had a drop of five stages and the greater five also, this lesser vessel is left with one stage of height of water and the larger with seven, which is in proportion seven times as great.

<div align="right">K 128 [48] r.</div>

[*Fall of water*]

Water which falls in the form of a pyramid by a perpendicular line upon a level surface will leap up again to a height and will end its point towards the base of this pyramid, and will then intersect and pass beyond it and fall down. L I r.

[*Air replacing water*]

Why the air which fills up the void in a globe from whence the water emerges, enters with the same impetus as that of the water which is poured out. Whatever is resting upon this water turns in contrary movement to that of the water. L 17 v.

[*Rivers*]

The long thing of uniform thickness swells as much in its two opposite sides as it is lowered in its two other opposite sides.

Here the water which is confined in the parallel river increases as much in height as it is lacking in breadth; consequently as it falls it hollows out the place where it has struck.

The parallel rivers may at some part of their length be confined in two ways, namely between their surface and their bed or upon their opposite sides. L 30 r.

[*Falls of water*]

When two streams of water meet at an extremely sharp angle the more powerful hollows out its side of the base most, and makes a sudden depth.

This is the true way of giving the fall while conserving the bank to the water which descends from the said bank. L 31 v.

[*The course of rivers*]

The beds of the rivers uncovered naturally, do not give true indications of the nature and quantity of the objects carried by the waters, because in the deep waters many places are filled with sand, and afterwards in the particular lateral courses of the rivers these deposits of sand are borne above the shingle on which they rested or laid bare beneath, so causing the continual subsidence of the raised bank of this sand which by reason of its lightness accompanies it in its course and is then deposited where the current of the water becomes more tranquil.

The twistings of rivers in flood are such as to burst every dike and all the order that the river keeps when low. L 32 r.

[*Falls and courses of water*]

Water that has fallen with great impetus from its dam reproduces the twistings of the rivers according to the line of its fall, but when the waters subside, although the line *a b* keeps its place even if this river should swell again, the canal *a b* will become filled with sand, and the volume of the water will follow its natural course. L 32 v.

[*Water in percussion*]

When water strikes it rises, and it acquires weight in proportion as it leaps out of its common surface; this fallen back upon, the other water strikes it and penetrates as far as its bed, which it consumes perpetually; and such a hollow is formed in the length of the sides of the object struck.

To guard against this a flat surface may be formed round any column which has a firm base and is of such breadth that the water that falls back is compelled to find it. L 33 r.

The less curved the bank where the leap of the river strikes it the farther removed will the second leap be from the spot from which the first departed. L 36 v.

The eddies of rivers are of several kinds; of these some are hollow in the centre after the manner of a concave pyramid; others full in the centre like a raised cone; some throw things up from the bottom, others submerge things borne on the surface of the water; and the one creates a hollow underneath the bank which forms its side, the other fills it up.

These eddies serve the purpose by their revolutions and delays of equalising the excessive speed of the rivers; and as therefore the eddies at the side are not sufficient, by reason of the narrowness of the rivers, it becomes necessary that new kinds of eddies should be created which shall turn the water over from the surface to the bottom and at various different angles; of these some meet at the bottom and churn up all the soil which the eddy of the surface has in course of time deposited. And the other eddies do the same against the banks of the rivers.

 B.M. 30 v.

A book of how to drive back armies by the fury of floods caused by the letting loose of waters.

A book of how to inundate armies by closing the outlets of the valleys.

A book to show how the waters bring down in safety logs hewn in the mountains.

A book of how boats are forced against the rush of the rivers.

A book of how to raise great weights by the simple increase of the waters.

A book of how to guard against the rush of rivers so that cities may not be struck by them. B.M. 35 r.

Of the inequality in the hollow of a ship.

Book of the inequality of the curve of the sides of ships.

Book of the inequality in the position of the helm.

Book of the inequality in the keel of ships.

Book of the difference in the holes through which water is poured out.

Book of the water contained in vessels with air and of its movements.

Book of the motion of water through a syphon.

Book of the clashing together and concourse of water proceeding from different directions.

Book of the varying shapes of the banks along which the rivers pass.

Book of the various shoals formed below the locks of the rivers.

Book of the twistings and bendings of the currents of the rivers.

Book of the different places whence the waters of the rivers are derived.

Book of the shapes of the banks of the rivers and their permanence.

Book of the perpendicular fall of water upon various objects.

Book of the course of water when impeded in various positions.

Book of the various shapes of the obstacles which impede the course of the waters.

Book of the hollow or rotundity formed at the bottom round the various obstacles.

Book of how to conduct navigable canals over or beneath the rivers which intersect them.

Book of the soils which drink up the waters of the canals and of the means of protection.

Book of the creation of channels for rivers which quit their bed when it is filled up with soil. B.M. 45 r.

[*Of water*]

This wears away the lofty summits of the mountains. It lays bare and carries away the great rocks. It drives away the sea from its ancient shores for it raises its base with the soil that it carries there. It shatters and devastates the high banks; nor can any stability ever be discerned in these which its nature does not suddenly bring to naught. It seeks out with its rivers every sloping valley where it may carry off or deposit fresh soil. Wherefore many rivers may be said to be those through which all the element has passed, and the sea has gone back many times to the sea, and no part of the earth is so high but that the sea has been at its foundations, and no depth of the ocean is so low but that the loftiest mountains have their bases there. And so it is sometimes sharp and sometimes strong, sometimes acid and sometimes bitter, sometimes sweet and sometimes thick or thin, sometimes it is seen bringing hurt or pestilence, sometimes health-giving, sometimes poisonous. So one would say that it suffers change into as many natures as are the different places through which it passes. And as the mirror changes with the colour of its object so it changes with the nature of the place through which it passes:—health-giving, noisome, laxative, astringent, sulphurous, salt, incarnadined, mournful, raging, angry, red, yellow, green, black, blue, greasy, fat, thin. Sometimes it starts a conflagration, sometimes it extinguishes one; is warm and is cold; carries away or sets down, hollows out or raises up, tears down or establishes, fills up or empties, raises itself up or burrows down, speeds or is still, is the cause at times of life or death, of increase or privation, nourishes at times and at times does the contrary, at times has a tang of salt, at times is without savour, at times submerges the wide valleys with great floods. With time everything changes. B.M. 57 r.

At times it goes twisting to the northern parts, eating away the base of its bank; at times it overthrows the bank opposite on the south; at times it turns towards the centre of the earth consuming the base which supports it; at times leaps up seething and boiling towards the

sky; at times revolving in a circle it confounds its course; at times it extends on the western side robbing the husbandmen of their tilth; at times it deposits the soil it has carried away in the eastern parts. And thus at times it digs out, and at times fills in where it has taken away and where it has made a deposit. Thus without any rest it is ever removing and consuming whatever borders upon it. So at times it is turbulent and goes ravening in fury, at times clear and tranquil it meanders playfully with gentle course among the fresh verdure. At times falls from the sky in rain or snow or hail; at times forms great clouds out of fine mist. At times moved of itself, at times by the force of others; at times gives increase to things that are born by its life-giving moisture, at times shows itself either fetid or full of pleasant odours. Without it nothing can exist among us. At times it is bathed in the hot element and dissolving into vapour becomes mingled with the atmosphere, and drawn upwards by the heat it rises until having found the cold region it is pressed closer together by its contrary nature, and the minute particles become attached together. And as when the hand under water squeezes a sponge which is well saturated so that the water shut up in it as it escapes through the crevices is driven into the rest and drives this from its position by its wave, so it is with the cold which the warm moisture compresses, for when it has reduced it to a more solid form the air that is pent up within it breaks by force the weakest part, and hisses just as though it was coming out of bellows when they are pressed down by an insupportable weight. And thus in various positions it drives away the lighter clouds which form obstacles in its course. B.M. 57 V.

... stage of declivity. Water initiates its own movement.

Book of the various ways of levelling waters.

Book of how to divert rivers from places where they do damage.

Book of how to straighten the course of rivers which cover too much ground.

Book of how to divide rivers into many branches and make them fordable.

Book of how waters pass through seas with different movements.

Book of how to deepen the beds of rivers by different currents of water.

Book of how to control rivers so that the small beginnings of the damage they cause may not increase.

Book of the different movements of waters which pass through channels of different forms.

Book of how to prevent the small rivers diverting a larger one as their waters strike it.

Book of how to ascertain the lowest level in the current of the surface of rivers.

Book of the origin of rivers which flow from the lofty summits of the mountains.

Book of the variety of the movements of waters in their rivers.

B.M. 122 r.

[*Why the beds of straight rivers are deeper in the centre than at the sides*]

The current of a straight river is higher in the centre than at the sides, and rises towards the sky with greater waves and turns in greater depth towards the centre of the earth.

And this occurs because the current is the clashing together or intersection of the reflex movement of the waves, which leap back after striking against the bank and running back to the opposite bank clash with the contrary movements, and these resisting each other and neither being able to penetrate into the other leap back high out of the water, and then falling back—having acquired weight while in the air—plunge beneath the water there where they strike it.

B.M. 135 v.

How rivers widen their valleys and wear away the roots of the mountains at their sides:

The bases of the hills as their valleys grow deeper are bent back towards the course of the river, as though they should wish to demand back from the speeding river the soil of which it has despoiled them.

This proceeds from the nineteenth of this treatise which says: the current of the river eats away the base of the mountain on one side where it strikes and gives it back to the opposite side to which it is deflected.

In great valleys the river changes its bed.

The rivers in great valleys make greater changes in their beds in proportion as they are farther away from the roots of the mountains. This is proved by the ninth of this which says: the largest rivers flow through the largest valleys which have been made by them, and by reason of their size they are continually consuming the waves that flow from their banks, carrying them always back to the current of the river.

OF CHANGES IN THE MOUTHS OF RIVERS

The mouths of rivers are continually bending and descending behind the course of their principal stream, and this proceeds from the former [rule] which says: water takes away with its wave from the bank where it strikes and gives back to the opposite bank where it is deflected.

Valleys are continually growing deeper.

Valleys continually grow wider and deeper and rivers continually change their position. B.M. 161 r.

PERCUSSION OF WATER FALLING UPON DIVERS OBJECTS

The water which falls in a perpendicular line through a round pipe upon a level place will make a circumambient wave round the site of its percussion, within the circumference of which the water will move very rapidly and be spread very thinly round about this place which has been struck, and at the end it will strike into the wave produced by it which seeks to return to the place of the percussion.

B.M. 167 v.

Water is that which serves the vital humour of this arid earth.

It is the cause which moves it through its veins contrary to the natural course (desire) of weighty things; it is like that which moves the humours in all kinds of living bodies, and . . .

And as the water is driven up from the lower part of the vine towards its severed stems and afterwards falls back to its roots, penetrates these and rises again anew, so from the lowest depth of the sea the water rises to the tops of the mountains, and falls down through their burst veins and returns to the sea and rises again anew. Thus up

and down, in and out, unresting, now with fortuitous, and now with natural motion, now in its liberty and now constrained by its mover, it goes revolving and, after returning in force to its mover, rises again anew and then falls anew; so as one part rises the other descends.

Thus from the lowest depths of the sea the water rises up to the summits of the mountains and falls down low through the burst veins, and at the same time other water is rising: so the whole element ranges about and makes its passage many times through the rivers that fall into the sea.

At one time it becomes changed to the loftiest clouds, and afterwards it is pent up within the deep caverns of the earth.

It has nothing of itself, but moves and takes everything, as is clearly shown when it is distilled.

Thus hither and thither, up and down, it ranges, never resting at all in quietude, always flowing to help wherever the vital humour fails.

Now taking away the soil, now adding to it, here depositing logs there stones here bearing sand there mud, with nothing stable in bed or bank:

Now rushing on with headlong course, now descending in tranquillity, now showing itself with fierce aspect, now appearing bright and calm, now mingling with the air in fine spray, now falling down in tempestuous rain; now changed to snow or storms of hail, now bathing the air with fine rain; so also now turning to ice and now hot; never keeping any stability; now rising aloft in thin cloud, compressing the air where it shuts it in, so that it moves through the other air after the fashion of a sponge squeezed beneath the water, when what is enclosed within it is driven out through the rest of the water.

<div align="right">B.M. 210 r.</div>

The heat that is poured into animated bodies moves the humours which nourish them.

The movement made by this humour is the conservation of itself and the vivification of the body which contains it.

Water is that which serves the vital humour of the arid earth; it is poured within it, and flowing with unceasing vigour through the spreading veins it replenishes all the parts that depend of necessity on this humour.

THE NATURE OF WATER

And it flows from the vast depths of the mighty ocean in the deep wide caverns that lie hid within the bowels of the earth, whence through the spreading veins upwards against its natural course in continual ascent to the high summits of the mountains it returns through the burst veins to the deep.

Water is that which serves the vital humour of the arid earth; and the cause which moves it through the veins is just that which moves the humours in all the different species of animated bodies.

<div style="text-align: right">B.M. 234 r.</div>

Water which serves as the vital humour of the arid earth and for this same cause moves through the spreading veins, is poured into it and works within it as does the blood in human bodies.

The same cause moves the water through its spreading veins as that which moves the blood in the human species, and as through the burst veins in the top of a man the blood from below issues forth, so through the burst veins in the summits of the mountains the waters from below are poured out.

Water after having issued forth from the veins of the earth is abandoned by the moving cause which led it there.

Water in falling from the high summits observes in its movement the desire of all the other heavy things.

<div style="text-align: right">B.M. 234 v.</div>

And that which with the utmost admiration of those who contemplate it raises itself from the lowest depth of the sea to the highest summits of the mountains, and pouring through the broken veins returns to the shallow parts of the sea, and again rises with swiftness and returns in like descent, and thus in course of time its whole element circulates.

So from high to low, so passing in and out, now with natural and now with fortuitous movement it proceeds, together and united. So with continual revolution it goes ranging round, after the manner of the water of the vine, which as it pours through its severed branches and falls back upon its roots rises again through the passages, and falling back returns in a similar revolution.

The water which sees the air through the broken veins of the high summits of the mountains, is suddenly abandoned by the power which

led it there; and when the water escapes from the forces which raise it to a height it resumes in liberty its natural course.

In the same way, so does the water that rises from the low roots of the vine to its lofty summit, and falling through the severed branches upon the primal roots mounts anew to the place whence it fell.

B.M. 235 r.

Water is just that which is appointed to serve as the vital humour of this arid earth, and the cause which moves it through its spreading veins, contrary to the natural course of heavy things, is just what moves the humours in all the species of animated bodies.

This it is which to the complete stupefaction of the beholders rises from the lowest depths of the sea to the highest summits of the mountains, and pouring out through the burst veins returns to the depths of the sea and rises again swiftly and again descends as aforesaid. So from the outer parts, to the inner, so turning from the lower to the higher, at times it rises in fortuitous movement, at times rushes down in natural course. So combining these two movements in perpetual revolution it goes ranging through the channels of the earth.

B.M. 236 v.

OF THE WEIGHT OF THE WATER

Either the water has weight or it has not weight. And if it has weight, why does not it bend the leaves borne on the bed where it rests? And if it does not bend them, it does not give its gravity to the bottom of the water. And if it does not give its gravity, what supports it? Its bed supports it, but it does not receive weight, because it is proved that water has no weight except above an element lighter than itself such as air and fire, and other liquids such as oil and the like. And if this is the case, why does a vase in the air weigh more when full of water than when full of air? The water does not weigh on their sides, but the vase when filled has weight in the air, which it would not have under water except to the extent of the weight of the material of which the vase is made. And the sea does the same upon its vase the earth, and the shores uncovered to the air are the lips of the vase that receives it. Which vase, being conjoined to the rest of the earth, throws its weight upon the air of its antipodes in the increase

of the sea, because such antipodean seas balance each other in their
weights through being opposite; and the inequality produced their
weights, and from this caused the sea to be changing its position con-
tinually, the centre of gravity of the earth together with the water
also changing its position. B.M. 266 v.

[*Drawings*]

Because *n c* is of a width similar to *a o*, and in like manner because
m i is slightly less, these waters will be almost all at one level.

Forster III 32 v.

The water *a b* will be very considerably higher than the water *d e*.

The water *r m* will be almost equal, and the part *o* of the back-cur-
rent will be extremely shallow and will hollow out the bed; *p* will be
higher by reason of the percussion, *x* lower at the mill . . .

Forster III 33 r.

SIGNS OF HIDDEN DEPTHS OF WATER

When within the smooth water you see a spreading eddy there is a
fall and rebound of water. Forster III 40 r.

MOVEMENT OF WATER

Why do the lines of the water pouring into a hole not direct them-
selves to its centre? Forster III 75 v.

Why do the circles of the water not break when they intersect?

Forster III 76 r.

Why the water is higher in one part of the sea or river than in an-
other, and why in many rapidly moving eddies the water is lower in
the centre of the eddies than at the sides.

On the Movements of Liquids by Galen. Quaderni II 16 r.

Water cannot move of itself unless it descends, and if it moves with-
out descending it is moved by something else, and if it moves without
being moved by anything else it is a reflex movement and of short life.

Quaderni II 16 v.

On how to bend the course of a river through its valley.

And you who desire to control the course of the river and to be obeyed by it, you only need to cause its current to bend, for where this bends it wears away the bottom and draws after it all the rest of the water of its river. *Quaderni* IV 2 r.

WHAT IS THE CURRENT OF WATER

The current of water is the concourse of the reflections which rebound from the bank of the river towards its centre, in which concourse the two streams of water thrown back from the opposite banks of the river encounter each other; and these waters as they encounter each other produce the biggest waves of the river, and as these fall back into the water they penetrate it and strike against the bottom as though they were a substance heavier than the rest of the water, and rub against the bottom, ploughing it up and consuming it, and carrying off and transporting with them the material they have dislodged. And therefore the greatest depth of the water of a river is always below the greatest current.

It is possible for water in a brief time to perforate and make a passage through stone. *Quaderni* IV 2 r.

Watch the movement of the surface of water, how like it is to that of hair, which has two movements, one following the undulation of the surface, the other the lines of the curves: thus water forms whirling eddies, part following the impetus of the chief current, part the rising and falling movement. *Windsor: Drawings* 12579 r.

The movement of the wave is swifter than the movement of the water that produces it. This is seen by throwing a stone into still water, for it creates around the spot where it strikes a circular movement which is swift, and the water which creates this circular swelling does not move from its position nor do the objects which float on the surface of the water. *Leic.* 14 v.

[*With drawing of section of river in which are the words 'Arno', 'Rifredi', 'Mugnone'*]
When a lesser river pours its waters into a greater and this greater

flows from the opposite bank, the course of the lesser river will be bent
by the onset of the greater. And this occurs because when this greater
river fills up the whole of its bed with water it comes to form an eddy
under the mouth of this river, and thus drives with it the water that
has been poured out by the lesser river. When the lesser river pours
its waters into the greater river which has its current crossing the
mouth of the lesser river, its waters will bend in the direction of the
current of the greater river. Leic. 15 r.

DIVISIONS OF THE BOOK

Book 1 of water in itself
Book 2 of the sea
Book 3 of the springs
Book 4 of rivers
Book 5 of the nature of the depths
Book 6 of the objects
Book 7 of different kinds of gravel
Book 8 of the surface of water
Book 9 of the things that move in it
Book 10 of the means of repairing [the banks of] rivers
Book 11 of conduits
Book 12 of canals
Book 13 of machines turned by water
Book 14 of how to make water ascend
Book 15 of the things which are consumed by water. Leic. 15 v.

FROM 'THE ORDER OF THE BOOK OF WATER'

Whether the flow and ebb are caused by the moon or sun, or are the
breathing of this machine of the earth. How the flow and ebb differ in
different countries and seas.

How in the end the mountains will be levelled by the waters, seeing
that they wash away the earth which covers them and uncover their
rocks, which begin to crumble and are being continually changed into
soil subdued alike by heat and frost. The waters wear away their bases

and the mountains bit by bit fall in ruin into the rivers which have worn away their bases, and by reason of this ruin the waters rise in a swirling flood and form great seas.

How in violent tempests the waves throw down every light thing and suck much earth into the sea, which causes the water of the sea to be turbid over a wide space.

How loose stones at the base of wide steep-sided valleys when they have been struck by the waves become rounded bodies, and many things do the same when pushed or sucked into the sea by these waves.

How the waves quiet down and make long stretches of calm water within the sea without any movement when two opposite winds meet together at this spot; thus at these meeting places various shapes made up of calm sea are visible surrounded by the tiny waves of a moderate sea. Leic. 17 v.

PROPOSITIONS

Water of itself does not move unless it descends.

That water will be highest which is farthest removed from the centre of its sphere. And that surface of water is said to be lowest which is nearest to the centre of its sphere.

No surface of water which is contiguous to the air is lower than the surface of its sphere. The waters of the salt seas are fresh at their maximum depth. The waters range with perpetual movement from the lowest depths of the seas to the topmost summits of the mountains, not following the law of heavy things; and in this instance its action resembles that of the blood of animals which is always moving from the sea of the heart and flowing towards the summit of their head; and so when a vein there has burst open, as one sees if a vein bursts in the nose, the whole of the blood from below rises up to the height where the vein has burst.

When the water gushes forth from the burst vein in the earth it follows the law of other things which are heavier than the air and so always seeks the low places.

That water will be swifter which descends by the less slanting line. And that water will be slower which moves along a more slanting line.

The Nile and the other rivers of great size have very many times poured out the whole of the element of water and restored it to the sea. The veins flow with infinite ramifications through the body of the earth. The waters assume as many different natures as the places are different through which they pass. If it were possible to make a well which should pass through the earth on the opposite side and for a river to descend through this well, the head of the river which entered there first would descend through this well and pass the centre of the elements without making any reflex movement, and it would pour as much water on the far side of this centre as it had from the opposite side.

And if, because of some deep valley, the line on the opposite side of the well were shorter than on this side, this water would fill up the valley, however large it was, until it equalled the weight of the water in the well, although in some part the centre (of gravity) of the water and of the earth united together would move somewhat from its first position through the weight of the water, which would be increased on the opposite side of the earth where it was not at first. The centre (of gravity) of the water and earth joined together is moved when the weight of the sea moves because it is carried by the winds.

Leic. 21 v.

THIRTY-NINE CASES

How the bottoms of rivers and ditches become trampled by big animals and this causes the muddy waters to escape and they thus leave in their course the soil in which they were loitering. How in the manner described above canals may be constructed through level lands. How to convey away the soil from canals which have become choked up with mud by the opening of certain sluices which are moved upwards by the canal.

How one ought to straighten rivers. How one ought so to provide that rivers do not sweep away other men's possessions. How one ought to maintain the beds of rivers. How one ought to maintain the banks. How the banks when broken should be repaired. How one ought to regulate the impetus of rivers in order to strike terror into the enemy so that he may not enter the valleys of this river to damage them.

How the river in order to be crossed by your army ought to be con-

verted into many small branches. How one ought to ford rivers below the rows of horses so that they may protect the infantry from the rush of the water.

How by the use of wine-skins an army is able to cross a river by swimming. How the shores of all the seas that touch one another are of equal height, and are the lowest part of the land which meets the air. Of the manner of swimming of fishes; of the way in which they leap out of the water as may be seen with dolphins, for it seems a marvellous thing to make a leap upon something which does not stand firm but slips away.

Of the manner of swimming of animals of long shape such as eels and the like. Of the way of swimming against the currents and great falls of rivers. Of the way in which fishes swim when they are round in shape. How animals which do not have the hoof cleft asunder are not able to swim. How all the other animals which have feet with toes are by nature able to swim, except man. In what way a man ought to learn to swim. Of the way in which a man should rest upon the water. How a man ought to defend himself against the whirlpools or eddies of the waters which suck him down to the bottom. How a man when sucked down to the bottom has to seek the reflex current which will cast him out of the depths. How he ought to propel himself with his arms. How he ought to swim on his back.

How he can only remain under water for such time as he can hold his breath.

How by an appliance many are able to remain for some time under water. How and why I do not describe my method of remaining under water for as long a time as I can remain without food; and this I do not publish or divulge on account of the evil nature of men who would practice assassinations at the bottom of the seas by breaking the ships in their lowest parts and sinking them together with the crews who are in them; and although I will furnish particulars of others they are such as are not dangerous, for above the surface of the water emerges the mouth of the tube by which they draw in breath, supported upon wine-skins or pieces of cork.

How the waves of the seas continually consume their promontories and rocks. How the shores of the seas grow continually towards the

centre of the sea. The reason why the gulfs of the seas are created. The cause why the gulfs become filled up with earth or seaweed.

The cause why round about the shores of the seas there is found a large high bank called the mound of the sea.

Why the waves are higher when they touch the bottom nearer to the shore than they are on the high sea.

How at the mouths of certain valleys the gusts of wind strike down upon the waters and scoop them out in a great hollow, and carry the water up into the air in the shape of a column and of the colour of cloud.

And this same thing I once saw taking place on a sand-bank in the Arno, where the sand was hollowed out to a depth of more than a man's stature, and the gravel of it was removed and whirled a great distance apart, and assumed in the air the form of a mighty campanile; and the summit of it grew like the branches of a great pine, and then it bent on meeting the swift wind which passed over the mountains.

How the wave is least towards the approaching wind because the bank serves it as a shield.

How the water that finds itself between the percussions of the waves of the sea becomes changed into mist.

Of eddies wide at the mouth and narrow at the base.

Of eddies very wide at the base and narrow above.

Of eddies of the shape of a column.

Of eddies formed between two masses of water that rub together.

Leic. 22 v.

How waves do not penetrate one another but leap back from the place where they have struck; and every reflex movement flies away at equal angles from the striking place.

The reflex movement of water within water will always be of the same shape as its falling movement. By this reflex movement I do not mean that which springs back within the air but that which follows along its surface.

As the wave of the sand moves considerably more slowly than the wave of the water that produces it, so the wave of the water created by the wind is much slower than the wave of the wind that produces it, that is the wave of the air. The wave of the air performs the same

function within the element of fire as does the wave of the water within the air, or the wave of the sand, that is earth, within the water; and their movements are in the same proportion one to another as is that of the motive powers within them.

The more powerful current will cleave asunder the less powerful and pass through the middle of it. Currents of equal power which clash together leap back from the site of their percussion. A whole mass of water in its breadth, depth and height is full of innumerable varieties of movements, as is shown on the surface of water of a moderate degree of turbulence, in which one sees continually gurglings and vortices, with various eddies formed of the more turbid water from the bottom that rises to the surface. How every seven years the waters of the Adige rise and then fall, and it makes a famine as it rises. Leic. 23 r.

How water has tenacity in itself and cohesion between its particles. This is seen from the fact that a drop before separating itself from the remainder stretches itself out as far as it can, and offers resistance in its union until it is conquered by the excessive weight of the water which is continually increasing upon it. How water serves as a magnet for other water. This is seen in the process of a drop becoming detached from the remainder, this remainder being stretched out as far as it can through the weight of the drop which is extending it; and after the drop has been severed from this mass the mass returns upwards with a movement contrary to the nature of heavy things. It may be seen how the larger drop of water instantly takes up into itself the smaller drops which come into contact with it; and the minute particles of moisture diffused through the air act in the same way, for they become compressed, making themselves a magnet one for another until at last their weight so increases as to conquer the resistance of the air that first sustained them, and so they descend in the form of rain.

It may be shown with a bubble of water how this water is of such uniform fineness that it clothes an almost spherical body formed out of air somewhat thicker than the other; and reason shows us this because as it breaks it makes a certain amount of noise. Leic. 23 v.

It is possible to devise obstructions which will preserve the embankment against the friction of the current.

You should therefore cause blocks of coarse shingles to be constructed ten braccia apart; and let them be ten braccia wide with height varying according to the height of the embankment and of a thickness of three braccia. And they should be set to slant in the direction from which the water comes; and each of itself will serve as a shield to the water and throw it back towards the centre of the stream.

When the obstruction covered by the water slants very considerably in the direction from which the water comes, the stroke of the water will only cause a small hollow in front of this obstruction and it will deposit a considerable quantity of soil behind it.

If the obstruction is entirely upright and the water flows over it it will form a deep hollow in front of it and will only deposit a small amount of soil behind it. And if the obstruction has a lesser obstruction in front of it which leans against it there will be no hollow in front of this lesser obstruction for so far as its bulk extends. If the obstruction have another near behind it the hill of sand will be suddenly cut and dug out in a new hollow.

How the rivers, in their great floods, fill up all their greatest depths with sand or stones, except the places where the river is confined, as when it passes through the arches of bridges or other constricted places; and it does this because behind these arches it strikes against the front of their columns, and rises in a swirling flood, and raises itself, and so with fury makes up for the delay that has taken place before the said bridge or other object. Leic. 24 r.

If the obstructions of the waters are permanent the deep places of the rivers caused by them will also be permanent. And if the obstruction of these waters is movable the deep places caused by it will also be movable. And if the movable obstruction is near the bank of the river it immediately will become the cause of bending the whole river; and this is due to the fact that the water which passes between the obstruction and the bank hollows out this bank. And even though the obstruction proceed upon the bed of the river behind the current of the waters, it does not follow that the concavity already made in the bank will not proceed continually to grow and increase because

of the water that ranges within it, as is shown by the fourth of the third; and that the water which leaps back from it to the opposite bank will not create another similar concavity in this bank; and this will then proceed continuously to increase, and then it returns leaping back beneath the first concavity; and so it proceeds time after time until this impetus is consumed amid the universal current of the river.

Leic. 24 v.

TWELVE CASES

These are the cases that have to stand in the beginning:

The air which is submerged together with the water which has struck upon the other water returns to the air, penetrating the water in sinuous movement, changing its substance into a great number of forms. And this occurs because the light thing cannot remain under the heavy, rather is it continually pressed by the part of the liquid which rests upon it; and because the water that stands there perpendicular is more powerful than the other in its descent, this water is always driven away by the part of the water that forms its coverings, and so moves continually sideways where it is less heavy and in consequence offers less resistance, according to the fifth of the second. And because this has to make its movement by the shortest way it never spreads itself out from its path except to the extent to which it avoids that water which covers it above.

When the air enclosed within the water has arrived at its surface it immediately forms the figure of a half-sphere, and this is clothed with an extremely thin film of water. This occurs of necessity because water has always cohesion in itself, and this is the more potent as the water is more sticky; and this air having reached the opening of the surface of the water and not finding there any further weight to press upon it, raises its head through the surface of the water with as great a weight of water joined to it as the aforesaid tenacity can have; and it stops there in a perfect circle as the base of a half sphere, which has the aforesaid perfection because its surface has been uniformly expanded by the uniform power of the air. And it cannot be more than a half-sphere because spherical bodies attain their greatest width at their diameter; and if this air that is enclosed were more than a half-sphere the base would be less than where the diametral line is,

and consequently the arc of this half-sphere would not have shoulders or real resistance in its weakest, that is its widest part, and therefore it would come about that it would break in this spot of its greatest width, because the weakest part of any arc is always the end of its greatest width.

The air emerges with impetus in spherical form clothed with an extremely thin film of water, away from the body of the water; and this air by reason of the weight that it has acquired cannot pour itself into the other air, but held back by the adhesiveness of the water with which this film was formed falls down again by its excess of weight, continually growing in circumference, because the amount of the air which at first was in the whole of the aforesaid spherical body is afterwards reduced by half, and this is of itself capable of containing all this air, so that this spherical body goes on descending so far towards the surface of the water that it unites with it, finding there as I have said before greater width than in its own diametral line.

Nor has the air clothed with a thin film of water perfect sphericity in the aforesaid instance, because the part of the water with which this air is clothed, is heavier where it is more perpendicular to the centre of the circle, which makes itself the base of this half-sphere, and therefore in this position it lowers itself more; because that part of a thing supported in its extremities is so much weaker as it is more distant from its foundation, and that thing descends more rapidly which has the weaker support. That part of the air clothed by a film of water will be of most perfect sphericity which is least in size; this is proved by the reason stated above, because these bodies are clothed with films of equal thickness: for if the air that escaped from the surface of the water was small in amount it raised up a small quantity of this film, and clothed itself in it; and since its lesser [1] altitude is nearer its foundation than was that of a greater, it maintains itself more than this greater. The air which is subdued by the weight of the film of water which clothes it penetrates in minute particles through this film, and these, for the reason stated, cannot be separated from their state of connection or adhesion to it, and therefore through the weight it has thus acquired it descends from the sides of this body, and remains

[1] MS. has *maggiore*.

joined to the base of the middle sphere of air from whence it descended.

It breaks the middle sphere of the air clothed by the water in the third part of its curve; this is proved with the arches of walls, and therefore I will not treat of it in these notes, but I will place it in the book where it is necessary.

That part of the water is higher which is more remote from the centre of the sphere of fire and of the air and of the water, but not of the earth, because this has not a mathematical spherical shape; and for this reason the centre of its gravity is not concentric with the centre of the spheres of the other three elements.

The water of itself does not move unless it descends: therefore, when it is in its sphere it does not have one part of itself lower than another, and therefore of itself it will not move unless it is moved by others: and the two aforesaid proofs are sufficient to prove that water is spherical and of itself without movement; and as a consequence all the waters that move of themselves are lower at one extremity than at the other, that is in their surface; so finding the descent it runs there because there is no support for it there.

How the air can never of itself remain beneath the water but always wishes to be above in its contact: in proof of this let it be supposed that there are three elements and that the earth is nothing and that one allows a quantity of water to fall through the air; this cannot stay above the air, because the weaker liquid body cannot support the heavier, and consequently the air since it is a body thinner than the water and therefore is not able to support it will give it place; and this it will continue to do until the water has reached its lowest depth, that is assuming that it has not become evaporated or changed into air through its long friction with the air; but let us suppose that so much turns that a part arrives there: I say that after consuming its impetus between the reflex and falling movements which it would make around its centre it would come to a stop at this centre under all the sphere of air equally, because the centre of the elements is the lowest part that can be found in them, since the lowest is that part which is farthest removed from the greatest height of its whole. This is the conception.

Water attracts other water to itself when it touches it: this is proved

from the bubble formed by a reed with water and soap, because the hole, through which the air enters there into the body and enlarges it, immediately closes when the bubble is separated from the reed, running one of the sides of its lip against its opposite side, and joins itself with it and makes it firm.

Also a small drop enters into the body of the other water. If you should grant me by the proof of these bubbles of water that water has tenacity though it be small and thin, you grant me that that which makes the part will make its whole.

The bubble formed within the air by a reed, through which it is blown, does not fall in spherical shape, when it becomes detached because its excess of water runs below and makes it heavier there than elsewhere, and consequently the movement there is hurried, and breaks it above at a third. Leic. 25 r.

Every current has three central lines, which are situated in the middle of its greatest power: of these one is at the contact made by the water with the bed that receives it; the second is at the middle of its depth and width; the third is formed on the surface; but that of the middle is the principal one for it guides the whole course and divides all the reflex movements and turns them to their appointed directions. The higher central line of the current of the water is the upper line of the falling movement, and the lower of the reflex whirling movement, that is that which turns itself over and falls down upon the falling movement upon which it takes its leap; but let us leave the revolutions of the waters and their changes from below upwards as far as concerns these definitions, and speak only of the water remaining on the surface, that is as far as concerns its central lines. The central line of the surface of the current is always in the most prominent part of the water which surrounds the object struck by it; and the central line is only that which after striking upon a smooth-faced object falls back upon itself. The central line of the bottom of the current after striking upon the smooth object, is turned over towards the centre of the earth, and rambles about so much in scraping the bed that it makes a hollow large enough to contain its revolutions; and all the other lateral lines slope to the bed and hollow it. [To consider] whether the wave of the water causes the formation of the wave of sand above its bed or

whether the wave of the bed is the cause of the wave on the surface of the water. [To consider the] difference between the waves, from knowing their depth: which may always be discovered between the falling and the reflex movement of the waters. [To consider] how the least depth within the banks of any expanse of water will be found at the end of its reflex movement. How also the least depths of rivers will be found at the sides of the currents where they unite with other currents. [To consider] how in between two currents there are always shallows. The highest part of the surface of the water that strikes the object will strike it in its centre if it be of smooth front or pointed with sides of equal slant and length. But unless the angle is in the middle of the front of the object the highest elevation of the wave that strikes it will no longer be in the centre of this front but opposite to the aforesaid angle. The water of the surface that is moved in tiny ripples by the wind, always moves so much more swiftly than the wave of the water, in proportion as the wave is swifter than the natural movement of the water, and as the natural movement of the water is swifter than the wave of the sand, and as the wave of the sand is swifter than the wave of the earth that forms the river bank. But I ought first to say that the movement of the free air is so much swifter than the movement of the air that strikes the water, because that part of the wind that strikes the water is checked by the resistance of the surface of the water. All the waves of the sand which travel with the water are as much slower than the waves of the sand that travel with the wind as the movement of the water is slower than the movement of the wind. *Leic. 25 v.*

In these eight sheets there are seven hundred and thirty conclusions as to water.

When the wave has been driven on to the shore by the force of the wind it forms a mound by putting its upper part at the bottom, and turns back on this until it reaches the spot where it is beaten back anew by the succeeding wave which comes below it and turns it over on its back, and so overthrows the mound and beats it back again on the shore mentioned before; and so continues time after time; turning now to the shore with its upper movement and now with its lower fleeing away from it.

How it is not possible to describe the process of the movement of water unless one first defines what gravity is and how it is created or dies.

As the wave after striking on the sea shore turns back along the bed of the sea behind its mound, it encounters the following wave which comes from the high sea, and breaks itself upon it and divides itself; part leaping towards the sky and then falling down and turning back, part towards the bed of the sea; and this continues towards the sea, carrying with it the lower part of the water that struck upon it. Were it not for it doing thus the seaweed and the wrack of the tempests would not be able to be carried from one shore and deposited upon another. If the water of the sea turns towards the sea above its bed after the percussion made upon its shore, how can it carry with it the shells, molluscs, 'buovoli', snails and other similar things produced in the bed of the sea, and throw them upon this shore? This movement of the aforesaid things towards the shore commences when the percussion of the falling wave divides the reflex wave into the aforesaid two parts, for the things raised from the bottom often leap up in the wave that returns to the shore, and being solid bodies are driven towards the mound, which then draws them back with it towards the sea; and so continues in succession until the storm begins to abate, and stage by stage it leaves them where the greater wave reaches, that is that as the succeeding wave does not return to the same mark where it had deposited the booty that it carried, this booty remains where it has been left by the wave; and this process continues as the waves grow less. There remain the things cast up by the sea within the space that lies between the first mound of the wave upon the shore and the mound made by the wave that comes from the deep sea. If the whole sea rests and supports itself upon its bed the part of the sea rests upon the part of the bed: and as water possesses gravity when out of its element it ought to weigh down and press upon the things that rest on its bed. But we see the contrary, for there the seaweed and grass that grows in these depths are not bent or crushed upon the bottom but cleave it directly as though they were growing within the air.

So we arrive at the conclusion that all the elements, though they are without weight in their own sphere, possess weight away from their

sphere, that is away towards the sky, but not away towards the centre of the earth; because if it proceeds away towards this centre it finds an element heavier than itself, with its thinnest and lightest part touching an element lighter than itself, and the heavier part of the element is so placed as to be near the element that is heavier than itself.

How water when transformed becomes changed into wind which is so much drier as the process of transformation is more complete.

How wind is generated by the coagulation of the water within the air, for the air hastens to where there is a lack of it, and so it flees from where it is in excess. How the air has a greater volume where there is more wind, because the air there is thicker.

How the winds are strongest in the moist seasons, and more so in the rains than in clear weather. How great winds proceed from the mountains that are covered with snow; and to this the sailors bear witness for they experience it every day. And this is brought about through the fact of the snow becoming dissolved in the air, and being dissolved in very fine particles; hence philosophers say that there are dry land vapours; as to which I have nothing to say.

How the wind, proceeding from the cloud, is not exhaled in a circle through every line away from the cloud, because it acquires more weight than the air through which it passes, and so of necessity is bent to the ground as are all the things that are heavier than the air, and it rambles through it, driven by that which follows, which is created behind it, or by the impetus it has acquired from its past movement.

Leic. 26 v.

That water may have tenacity and cohesion together is quite clearly shown in small quantities of water, where the drop, in the process of separating itself from the rest, before it falls becomes as elongated as possible, until the weight of the drop renders the tenacity by which it is suspended so thin that this tenacity, overcome by the excessive weight, suddenly yields and breaks and becomes separated from the aforesaid drop, and returns upwards contrary to the natural course of its gravity, nor does it move from there any more until it is again driven down by the weight which has been reformed. From this proposition two conclusions follow, of which the first is that the drop has cohesion and nerve-structure in common with the water with which

it is joined; secondly that the water drawn by force breaks its co-hesion, and the part that extends to the break is drawn up by the remainder in the same manner as is the iron by the magnet. The same is seen with water passing through a filter, for the greater weight of the water that is outside the vessel draws back the lesser weight of the water which this filter holds back curved within the vessel.

One may offer a proof of the tenacity of water and set it out in proportion, thus:—if a drop of water of two grains is supported by water of the volume of half a drop by how much will a pound be sup-ported? And in this way we shall arrive near the truth. The sand weighs more than the water; and if there be left within the air in continuous line a quantity of sand and a quantity of water, separated from the sand but of the same weight as the sand, without doubt the movement of the sand will be slower than that of the water; and this comes about because the lower part of the water draws down the water that is joined to it above, and consequently it makes itself all one body and weighs all together upon the air, which opens below to give it place. This does not happen however with the sand, for in itself it is all separated and loose, and the whole of the amount falls with the same speed that one of its grains would, as they are all equal. So that we may conclude that the continuous descent of the water as it falls through the air proceeds with the speed that its weight requires, because it is a united and continuous quantity; and the sand of the same weight which descends from the same position of the water only proceeds with as much speed as is required by the weight of one of its medium-sized grains, for those that are larger descend more swiftly than those of medium size, and the less descend more slowly.

For if water has in itself adhesiveness and a tendency to unite, the water that is poured from a siphon, being surrounded by air, does not draw itself after that of the siphon; and experience shows us that un-less the outlet of the water of the siphon is lower than its entrance into the pipe, the water that continues below its outlet from the pipe will never draw itself after that of the vessel. If in the descent of the water within the air the water above, which drives it downwards, does not descend there with the same speed or a greater, that below will divide itself from that above, if it is swifter.

How the water that descends through the air breaks because the

air through which it passes divides it. How the water which is divided as it descends continuously through the air has a medium of spray, which extends from one divided part to the other, and binds them up together. How all the volume of the water which descends through the air in continuous quantities, is constrained to descend with equal movement, because where it made itself swifter it would separate itself from the part that was slower, and where it made itself slower it would be doubled and multiplied by the part that was swifter. How as great a weight of water is displaced as the weight of the thing that is supported by this water. How in the same slant, the water will make itself so much slower in its movement as it is lower upon its bed. How water made to gyrate in swift movement in a vessel by the hands of him who is whirling it round becomes extremely concave at the centre.

Of the great difference there is when water is whirled in a vessel, according to whether the hand is held near to the centre of this vessel or near the larger circle of the surface of the water. How the hand drawn frequently across the vessel up and down produces strange movements and surfaces of different heights. What water does when made to gyrate in an oval vessel. What water does when made to gyrate in a vessel with corners. What water does in a vessel that is struck from below. What water does in a vessel that is struck at the side. What water does in a vessel when the spot is struck on which it is standing.

Of the music of water falling into its vessel. Leic. 27 r.

How nothing evaporates except by means of moisture, which after having been evaporated preserves in itself the nature of the body in which it was infused. How the rumbling produced by the earthquake in the body of the earth proceeds from the destruction of places, torn open by force by the winds which continually strike upon the beds of their great caverns or lakes, covered and shut in within the earth.

But the tempest of the sea, snatched from its shores and borne far over the sea will be turned back, and especially if there is great depth there; and this happens because during a storm the wave of the sea does not penetrate to its great depths; and if it should chance to reach there it changes its movement. The water of the sea during a storm

makes a great movement on its bed in a different direction from that of its surface.

The dams of rivers if not of too great width may be made in this manner: a stake such as pile-drivers use should be fixed every three braccia, as big as possible and the bigger the better; and their tops should be of uniform height. On these a log of the shape of a beam should be fastened very firmly; next long trunks with all their branches should be taken and laid upon the aforesaid beam, and they should be fastened to it by using one of the branches as a hook; and this process should be repeated as often as possible, placing the branches towards the coming of the water; and they should then be loaded with shingle and stones; and after the first flood it is left grounded. But remember to fix the branches so that they are raised up and make them fall with the others. And if the river should be narrow you set the beam across from one bank to the other and fix it well; and set the aforesaid branches to lean upon it fastened with their natural hooks. The beam here is only for the purpose of holding the heads of the logs so that they do not drop down; and the branches which stand against the course of the river laden with stones, are not allowed to push this beam or bend its direction because it is held by their natural hooks, and their buried branches do not allow them to move or to tear away the said hooks.

How the diverting of rivers ought to be carried on when the water has completely lost the fury of its current, that is when it shows itself tired. How with a small dam a river may be diverted by aiding and increasing the line where it shows that it wishes to turn of itself.

How a river may be diverted by a few stones if one understands the line of its current; and this movement may be made in the aforesaid line of the water. How the dams of the river should never be formed by placing stakes in deep places but in the more shallow places. How the dams of the rivers when formed of masonry ought to be constructed in the deepest parts of the rivers, so that they may be less in the power of the water which undermines them. How the dams of the rivers ought to be made in the fields away from the rivers and then the said river be directed against them. How the bridges ought also to be made in the fields in that part where it is afterwards intended to direct the river. Leic. 27 v.

The ramifications of the springs of water are all joined together in this earth, as are those of the blood in other animals; and they are in continual revolution, and thus vivified they are perpetually wearing away the places in which they move, both those within the earth and those on the surface of it; and the rivers universally pour out much more water now than formerly: for which reason the surface of the sea is somewhat lowered towards the centre of the world as it has had to fill up the vacuum caused by this increase in these springs; of which I shall speak presently. The heat of the fire generated within the body of the earth warms the waters which are pent up within it in the great caverns and other hollow places; and this heat causes these waters to boil and pass into vapour and raise themselves up to the roofs of the said caverns, and penetrate through the crevices in the mountains up to their greatest height, where coming upon the cold it is suddenly changed into water, as one sees happen in a retort, and goes falling down again and forming the beginnings of rivers which are afterwards seen descending from them. But when the great frosts drive back the heat towards the centre of the world, this heat becomes more powerful and causes a greater vaporisation of the aforesaid water; and this vapour heating the caverns round which it moves in circles cannot form itself into water as it usually does: as is seen in the making of aqua vitæ, for unless the vapour of the wine passed through fresh water it would not change into aqua vitæ, but would go back and become at last so much condensed as to break down every obstacle. We may say the same of water heated in the bowels of the earth, which not finding in its passage places of such freshness as harmonises with it, does not form itself into water as formerly, but condenses and hardens like fire multiplied and condensed within a mortar, which becomes harder and more powerful than the substance that contains it, and so unless it be suddenly dissolved in smoke it instantly hurls itself forward, breaking and destroying whatever opposes its growth. It is the same with the aforesaid steam from the water, for it bursts forth within the bowels of the earth in divers places; ranging about and roaring with great tumult until it reaches the surface; and with a mighty earthquake makes whole regions tremble, and often makes mountains fall in ruin, and lays waste cities and lands in divers parts, and with a mighty hurricane bursts its way forth through the

cracks in the earth which it has made; and so by thus escaping it consumes its own might. The wind is formed by the water in the air through the processes of the dissolving and the formation of clouds; that is that when the cloud is dissolved it becomes changed into air and increases in its bulk fitfully and irregularly, since the process of its dissolution does not work uniformly; because the cloud is in itself of varying thinness and density, consequently the part that is thinnest is dissolved most rapidly, and the thick part offers most resistance to this process: this therefore is the cause why the movement of this wind does not proceed uniformly.

And when the cloud is created it also generates wind, since every movement is created from excess or scarcity; therefore in the creation of the cloud it attracts to itself the surrounding air, and so becomes condensed, because the damp air was drawn from the warm into the cold region which lies above the clouds; consequently as it has to make water from air which was at first swollen by it, it is necessary for a great quantity of air to rush together in order to create the cloud; and since it cannot make a vacuum, the air rushes in to fill up with itself the space that has been left by the [former] air, which was first condensed and then transformed into a dense cloud. In this circumstance the wind rushes through the air, and does not touch the earth, except on the summits of the high mountains; it cannot draw the air from the earth, because there would then be a vacuum between the earth and the cloud; and it draws but little air through the traverse and draws it more abundantly through every line. I have already had an opportunity of observing this process; and on one occasion above Milan, over in the direction of Lake Maggiore, I saw a cloud shaped like a huge mountain, made up of banks of fire, because the rays of the sun which was then setting red on the horizon had dyed it with their colour.

This great cloud drew to itself all the little clouds which were round about it. And the great cloud remained stationary, and it retained the light of the sun on its apex for an hour and a half after sunset, so enormous was its size. And about two hours after night had fallen there arose a stupendous storm of wind.

And this, as it became closed up, caused the air which was pent up within it, being compressed by the condensation of the cloud, to burst

through and escape by the weakest part, rushing through the air with incessant tumult, acting in the same way as a sponge when squeezed by the hand underneath the water, for the water with which it is soaked escapes between the fingers of the hand that squeezes it, and rushes swiftly through the other water. So it is with the cloud, driven back and compressed by the cold that clothes it round, driving away the air with its own impetus, and striking it through the other air, until the heat that is mingled with the moisture of the cloud that has drawn it to so great a height flies back towards the centre of the cloud, escaping the cold which is its contrary, and having approached towards the centre becomes powerful, and consequently takes fire and makes a sudden emission of damp steam, which surrounds it and creates a furious wind that moves with the fire thrown out by the increasing pressure of the steam; and thus fire is expelled from the cloud as is the flame from the mortar, by the wind increasing behind it; and so this flame compressed by the cloud issues forth, and spreads through the air, with the more radiance in proportion as the fire of which it is formed is more concentrated and of greater heat: and this is the thunderbolt which afterwards ruins and smashes in pieces whatever opposes its destined course.

I have already seen fire created under the water with the movement of a wheel which whirled its arms; and it will do the same at any depth however great.

If the river be turned at the upheaval of the earthquake, it will no longer run forwards but will return into the body of the earth, as does the river Euphrates; and let this serve for any of those at Bologna who lament over their rivers. Leic. 28 r.

That water will rise higher with its wave than the common surface of the water of the lake, when it is nearer the spot at which it falls into the lake. When the waters from different parts meet together in a hole that is in the bed of the river this water will be bored through as far as the entrance of the hole, and the cavity so made will be filled with air as far as the bed of the water.

The revolving movement cannot be continued strictly below the water unless this revolving mass of water has air in the middle of it. That water will form a sudden hollow in its bank of earth which

strikes within equal angles at any object that projects from this bank. The rain that parts from the cloud does not all fall on the earth: this is due to its friction with the air that it penetrates, because in the course of this friction it becomes consumed either altogether or in great part and pours itself into the above-mentioned air; and often one sees the clouds descend towards the earth and immediately become cut short in the manner of a horse's tail and remain invisible; and they are changed into wind. Leic. 28 v.

Where the straight course of the water is impeded, there sudden depth will be produced. This occurs because when the course of the water is impeded it is making percussion against an obstacle that impedes it, and because no movable thing can immediately end and consume its impetus, but it must be retained by the body which it penetrates; and also it does not end in this immediately after the percussion, seeing that every percussion is made upon the surfaces of the bodies which are struck; therefore, the penetration of movable things within their objects is a consequence born after their percussion, in which the impetus of the movement is consumed.

The penetration of the movable things within their objects will be of as much less length than their reflex movement made in the same space of the falling movement, as the thing penetrated is thicker than the medium, where this reflex movement is made. Now the water when its straight movement is impeded strikes the object that impedes it, and immediately, not being able to penetrate it, is reflected at almost equal angles; after which percussion it divides and escapes by different lines from the spot where it struck; of these that which raises itself in the air acquires weight, and falls back and penetrates the other water as a heavy thing; after which it strikes and consumes the bed of the river; but in the process of penetration it is struck by the water which flows beneath its surface, and from stage to stage is driven back in threefold movement towards the place where it first struck.

There are three positions of the movement that the water makes on being reflected from its percussion within the water penetrated by it: the first movement is towards the bed of the water; the second is towards the place where the water is moving; the third is whirling movement after the manner of a screw, boring continually the bank

and the bed on which it rubs, and always gathering fresh force from the water that follows in succession, thrown back from the bank, which descends upon it from the air, and resubmerges it anew with itself at the bottom.

Here then is a percussion, and the movable thing after having struck the object remains in the position where it was when it made the percussion; and the object struck follows the same line and extent of the course of which the striker was deprived. This happens because in this instance the weights are equal in size, weight and substance, and to the weight of the movable thing has been joined the power of the impetus of which the object was deprived, and it only rested with its natural weight; this is so, because no impetus is consumed immediately, and because the body that strikes is accustomed to make the reflex movement when it finds an object that offers resistance; but here reflex movement is not produced, because the object immediately flies away, bearing with it the power and impetus of its striker; and because always the movable thing, which does not attach itself to its object, is accustomed to finish the remainder of its destined movement in the reflex movement, which starts immediately it has finished its percussion. Here they do not become fixed, because they are of spherical body and of equal substance. It does not advance farther because it has exhausted its impetus in its percussion, and has given it to the object struck; it does not spring back, for it has nothing to serve as a foundation for its spring, after the manner of a man who wishes to jump from a board which is placed on the pavement on top of several pieces of a beam which has been sawn up; for as he gathers impetus for the leap, this impetus communicates itself to and unites with the board which flies away as though upon wheels; and he who would fain leap deprived of the impetus of the leap, is left in the same position in which he was when he formed the intention of leaping; so that from this we may conclude that the impetus can be immediately separated from the body where it was created and pour itself into the object which it has struck.

But if the body struck be lighter than its striker, the length of the movement destined for this striker will be as much shorter as the impetus which is divided from it, attaching itself to the body struck, is diminished. That is, if the body struck was a pound and the striker

two pounds, I affirm that the percussion will take away half the impetus and the movement of its striker, and the body struck having only half the power of impetus will take a medium course, but so much more than that made by the striker which follows it as it is lighter than it, and there is less resistance of air; excepting the power of the resistance of the air which is measured by drawing the same movable thing with double power; and if the movements are not of double length, that which is lacking has been taken away from them by the resistance of the air, which may be said to resist in the same proportion as the aforesaid movable thing is lacking in movement when driven by double the power there was at first. And if the object struck was much lighter than the striker, the air will offer much resistance to the movement of the body struck. And if the body struck is double the body that strikes it, its movement will be in the subduplicate ratio of the reflex movement of its striker. And if the bodies which strike are equal and similar and of equal movement and power, then their reflex movements will be equal in length and power. But if the movement of similar and equal bodies be unequal then their reflex movement will be unequal. Leïc. 29 r.

OF THE VORTICES OR EDDIES WHICH THE AIR MAKES IN WATER

It often happens that when one wind meets another at an obtuse angle, these same winds circle round together and twine themselves together into the shape of a huge column, and becoming thus condensed the air acquires weight. I once saw such a hollow column assume the shape of a man above the sand of the sea shore, where these winds were ranging round together and digging stones of a considerable size from this hollow, and carrying sand and seaweed through the air for the space of a mile and dropping them in the water, whirling them round and transforming them to a dense column which formed dark thick clouds at its upper extremity; and beyond the summits of the mountains these clouds were scattered and followed the direct course of the wind when it was no longer impeded by the mountains.

[*Of the movement of water*]

That thing is lower which is nearer to the centre of the earth; therefore that will be higher which is more remote from this centre.

Every quantity of water will move towards its lower extremity; and where these extremities are of equal height, this water will not in itself have any movement.

Here it is proved by these two propositions that the waters of the seas which are contingent will never of themselves have movement; and how of necessity they are of spherical surface.

Therefore water that moves of itself has one of its extremities lower than the others; and that which does not move is of the same height in its extremities.

A corollary follows which says that water does not move of itself unless it descends. Leic. 30 v.

The variety of the positions and rates of speed of the waters within their rivers is caused by the variety of the slant of their bed. The variety of the slant of the beds of rivers is caused by the variety of the swiftness of the current of the waters.

Water of itself does not move unless the slant of the bed draws it to itself: what therefore was the cause of this slant of the bed different from its first general slant? For I allow myself to understand that the movements more or less of the waters in the rivers were caused only by the greater and less slants of the beds, as I have set forth above.

And if the first bed of the river was formed with uniform width, slant and straightness, what was the cause of the varying of such conditions as regards the bed? For it is here shown that the water which moves above them must of necessity be of uniform current. The matter which makes the water of the rivers turbid is that which after being carried some distance settles upon their beds, and raises them, and changes the slant of the bed; and in this way it causes the variation in the courses of the waters. And from this we conclude that the water is the cause of the variation of its bed, and that the bed then of necessity changes the courses of the waters in greater or less speed; which variety of courses is then the most powerful cause of varying all the bed of its river; and so it is concluded:—The bed of the rivers is varied by the matter that the course of the water deposits there;

and the variety in the course of the waters is further varied by the irregularity in the bed of the river.

A drop of water that falls in a place of uniform density and smoothness will splash in such a way that the edges of its mark will be at an equal distance from its circumference; and so conversely if it should not fall in a level place. Leic. 33 r.

The centres of the sphericity of water are two: the one is of the universal watery sphere, the other of the particular.

That of the universal is that which serves for all the waters that are without movement, which are in themselves in great quantity such as canals, ditches, ponds, fountains, wells, stagnant rivers, lakes, marshes, swamps and seas; for these although of different depth in themselves have the boundaries of their surfaces equidistant from the centre of the world, as are the lakes situated at the tops of high mountains, as above Pietra Pana and the lake of the Sybil at Norcia, and all the lakes which form the sources of great rivers, as the Ticino from Lake Maggiore; the Adda from Lake Como; the Mincio from Lake Garda; and the Rhine from Lake Constance and Coire, and from the lake of Lucerne; and as Trigon which passes through Africa Minor, which carries with it the water of three swamps at different altitudes one after another: of which the highest is Munace, the middle one is Pallas and the lowest is Triton. Again, the Nile has its source in three very high lakes in Ethiopia: it runs to the north and discharges itself into the Egyptian sea with a course of four thousand miles, and its shortest and most direct line which is known measures three thousand miles; it issues forth from the Mountains of the Moon from divers and unknown beginnings; and comes upon the said lakes high above the watery sphere at an altitude of about four thousand braccia, that is a mile and a third, in order to allow for the Nile falling a braccio in every mile. And the Rhone issues from the lake of Geneva and flows first west then south with a course of four hundred miles, and empties its waters in the Mediterranean sea.

The centre of a particular sphere of water is that which occurs in the tiniest particles of dew, which are seen in perfect roundness clustering upon the leaves of the plants on which it falls; it is of such lightness that it does not flatten itself upon the spot on which it rests, and it

is almost supported by the atmosphere that surrounds it, so that it does not itself exert any pressure or form any foundation; and for this reason its surface is drawn to itself equally from every side with equal force; and so each part runs to meet another with equal force, and they become magnets one of another, with the result that of necessity each becomes of perfect roundness, forming its centre therefore in the middle at an equal distance from each point of its surface, and being pulled asunder equally by each part of its gravity, always placing itself in the middle between opposite parts of equal weight. But as the weight of this particle of water comes to be increased, the centre of the curved surface immediately emerges from this portion of water, and makes its way towards the centre of the common sphere of the water; and the more the weight of this drop increases the nearer the centre of the said curve approaches towards the centre of the earth.

Leic. 34 v.

I have seen in the case of two small canals each of a breadth of two braccia, which serve as a line of demarcation between the road and the estates, how their waters clashed together with unequal force, and then united, and bent at a right angle, and passed underneath a small bridge by this road and continued their course. But what I want to refer to in them is the fact that they formed there a flow and ebb, with a height of a quarter of a braccio, caused, now by one, now by the other canal, as will be stated. The first canal, being the more powerful, subdued the onrush of the water of the opposite canal, and by adding to it from the opposite direction caused it to swell up; and then the water coming above this from the swollen river, rose up in such a way as to acquire so much weight from the more sluggish water that it overcame the impetus and power of the water which at first was more powerful, and so drove it back with great fury; and consequently the victor, re-doubling the impetus of its movement, entered with an undulation extending over more than a hundred feet into the more powerful canal, which at that time retarded and held up such of its waters as were at the boundary of the conquering wave. And from this wave upwards the river massed together so much water that after the end of the aforesaid impetus of the wave, these waters gained the victory and drove back the first waters; and so they continued in succession,

without ever retarding the movement of that third canal in which they were united under the aforesaid bridge.

For this canal had four different movements, of which the first and second were with greater or less current, and the others according as it varied from the right to the left bank. The variation from the greater to the less current occurred when one of the streams of water made itself victor over the other, for as this other is turned back together with that which drives it an abundance of water is created under the bridge. The fall of the water under this bridge took place when the one stream of water which conquered the other had almost consumed its impetus and the opposing stream was left with its force already exhausted; the water under the bridge was then extremely low. The changing across of the current from the right to the left bank occurred when the water on the right or the left was victor, that is when the water on the right was victor the current struck against the left bank, and when the current in the canal on the left was victor it struck upon the right bank underneath the aforesaid bridge.

And if this ebb and flow created within so small a quantity of water has a variation of a quarter of a braccio, what will it be in the great channels of the seas which are shut in between the islands and the mainland?

It will be so much the more in proportion as its waters are greater.

Leic. 35 r.

OF THE WAVES OF WATER

The wave of water created by the wind is slower than the wind that moves it, and swifter than the current of the water that produces the wind; of this there is an example in the waves of the meadows.

The wave of the water created by the descent of the rivers is slower than the current of the water that produces it; and this happens because the wave in such rivers is formed from the bottom of this river, or from its sides, and it stands as firm as is the firmness of the object that produces it, while the water, which continually forms itself into a wave, is continually escaping from this wave.

There are many occasions when the wave of the water and that of the wind have the same course; and many occasions when they are contrary, intersecting at right angles or often at acute angles.

The movement of the falling wave penetrates into the movement of the wave recoiling. The wave of the water in a circular vessel runs from the edge to the centre and is then bent back from the centre to the edge and from the edge to the centre; and so it continues in succession.

The wave of a triangular vessel, or a vessel with sides, has not uniformity of time, because its sides and angles are not equidistant from the centre of the vessel.

The circle of the wave made by an object in running water will be oval in shape. Leic. 36 v.

XXII

Hydraulics

'To make water rise and remain upon the ascent.'

[*With drawing of pump*]

For the bath of the duchess Isabella; *a* Spring.

Made for the stove or bath of the duchess Isabella; *a* is in this position because the screw does not turn with its socket. c.a. 104 r. b

[*With drawings*]

Water raised by the force of the wind.

This syringe has to have two valves, one to the pipe which draws the water and the other to that which ejects it.

Method of making water rise to a height.

In this way one will make water rise through the whole house by means of conduit pipes. c.a. 386 r. b

OF THE FALL OF A RIVER

[*With sketch*]

If you should wish to know what the fall of a river is in each mile without employing any other instrument for observing levels, you should follow this method:—Be careful to choose a part of the river which has the most conformity with the general range of the course of which you wish to know the fall, and take in it a hundred braccia of bank of which the beginning and the end are marked by two rods, as is shown above in *a b*, and at the beginning *a* launch a bladder, oak-apple, or small piece of cork, and observe how many beats of time the aforesaid object travelling with the descending wave takes to arrive at the end of the journey of the hundred braccia, and then measure many other courses, some slower and some more rapid, and afterwards measure the fall of the hundred braccia with the instrument

771

for observing levels. And by this process, having measured different reaches of the water, you will then know how to speak only for over a hundred paces of a bank; and by observing how many beats of time your oak-apple has taken to traverse this course you will be able to calculate the fall that it makes per mile. Tr. 56 a

[*With drawing of apparatus for raising water*]

If you wish to make water rise a mile and to cause it to rest upon a mountain do as is represented above. And if you wish the stream of water to be as big as your leg make the conduit as big as your thigh. And if it is to rise a mile make it also descend two miles, and then the violence of the water which is found between b and c will be so great that it will draw up the water which is found in d e and will turn the wheel of the water pump. And you must know that no air can enter into the water chamber by the water pump, seeing that every time that the screw of the water pump turns back, the valve which is at the bottom of the reservoir closes, and even if it were not so well stopped up it could not admit the air because it finds itself two braccia under water, and consequently could not admit air unless it first admit the two braccia of water. When you wish to fill the conduit you must first of all have a small lake filled with rains, and stop up with clay the pipes at the base of it, that is at c and e, and then let this lake discharge itself into the conduit. When the water has risen half a braccio up the wheel close the box tightly and then at the same time unstop the conduit at its base in c and make the wheel four braccia. B 26 r.

[*Drawing of machine*]

To raise water. B 54 r.

[*Hydraulic machine*]

If twelve ounces of water produce thirty thousand revolutions of a machine in an hour we believe that twenty-four ounces will produce sixty thousand revolutions per hour of the same machine if it has the same fall, and that the output will be double what it was at first.

H 90 [42] v.

[*Drawing*]

OF THE INSTRUMENT ABOVE

Let *a b* be stagnant water, let *a c* be a screw which is turned by the distaff *z*, and the said screw carries the water into the chamber *c f*, and from the said chamber a siphon tube proceeds which carries the water to another chamber which is round the centre of the wheel of the first movement, and from there the eight spokes take the water, which after it has fulfilled its function falls back to the spot from whence it started.

Forster I 41 r.

[*Drawing*]

a the instrument above:

m keeps *c* unstopped as long as it falls, and when *m* departs *c* closes, and when *m* comes to the bottom *s* goes to the top and draws after it the water of the well.

Forster I 41 v.

[*Drawings*]

The water after issuing from the pump runs by the line *a c*, and pauses at *s*, and there makes counterpoise and falls down together with the lever *n m*, and draws up fresh water, of which part goes in counterpoise and part remains up by the line *b f*.

The water departs from the centre *a* and flows in *b*, and from *b* as far as *c* it makes a level lever, and from *c* it rises by the wheel of the screw gently and returns to the centre *c*; and make it with sixteen spokes.

Let *a b* be the level of the earth, *p* is the lever of *m*, *q* is that of *n*, and thus first one then the other after the manner of bellows perform their function.

This as far as relates to the cause of its movement has similarity with that above, and it varies only in that screw in the centre which conducts the water upwards.

Forster I 42 r.

[*Drawings*]

Here the water having ascended by the screw will arrive by the pipe *s* at the point *a*, and from *a b* it will make equidistant lever, and from *b n* will return to the first screw, and will always repeat the same process, and above all it makes it wider at the end than at the beginning.

The screw *a* gives the water to the screw *b*, and the screw *b* gives movement with the same water to the screw *a*. Forster 1 42 v.

[*With drawings*]

The water that falls from the mouth *g* comes from the chamber *j* pressed by the lead *d*, and when the chamber *f* is empty the water will be raised into the chamber *a* by a valve which opens inwards. Consequently as the part below becomes lighter and the part above heavier it suddenly turns right over and the lead *c* presses the chamber *a* and so it is always in motion. Forster 1 45 v.

The left chamber sends its water from *f* in *b* and in this *b* there is a valve opening inwards, by means of which the chamber *c b a* comes to be filled, and the air escapes by *a n*; but make the mouth *a* higher than the other part so that the water may not pour out. The chamber *d* will be full of air and the part *e* will be lead. When the chamber *a b c* shall be full it will turn right over and the lead will remain above and will press the water on the left, and by the time that the water has made its exit the lead will have gone below and the chamber will receive the water from the right through *m s*. Forster 1 46 r.

[*With drawings*]

To make water rise and remain upon the ascent. Forster 1 50 v.

This water rises by way of a pump, and after issuing forth at the extremity of this pump it runs by the lever from *c a* and from *f b*, and having arrived at the extremity of the said lever the water that follows creates counterpoise. Forster 1 51 r.

The water rises by the screw *a b* and falls in the chamber *c*, and from there it is drawn off by the siphon *b f* and carried into the chamber *p*, and from there until counterpoise is made in *s*, and then it falls into the stagnant water below.

This wheel with the lever *a n* will turn and draw the water with the circle. But see that when the buckets are ten you make twelve of the lever and one of the counterlever. Forster 1 51 v.

XXIII

Canalization

*'Every large river may be led up the highest
mountains on the principle of the siphon.'*

CANAL OF FLORENCE

[*Plan on which are the words Florence, Prato, Pistoia, Serravalle, Lago,
Lucca, Pisa*]

Let sluices be constructed in the Val di Chiana at Arezzo, so that in
summer when there is a shortage of water in the Arno the canal will
not become dried up, and let this canal be twenty braccia wide at the
bottom and thirty at the surface and the general level two braccia or four,
because two of these braccia serve the mills and the meadows. This will
fertilise the country, and Prato, Pistoia and Pisa, together with Florence
will have a yearly revenue of more than two hundred thousand ducats,
and they will supply labour and money for this useful work, and the
Lucchesi likewise. Since the Lago di Sesto will be navigable make it
pass by way of Prato and Pistoia and cut through at Serravalle and go
out into the lake, for then there will be no need of locks or supports,
which are not permanent but require a constant supply of labour to
work them and to maintain them. c.a. 46 r. b

And know that this canal cannot be dug for less than four denari
per braccio, paying each labourer at the rate of four soldi per day. And
the time of construction of the canal should be between the middle of
March and the middle of June, because the peasants are not then
occupied with their ordinary work, and the days are long and the heat
does not prove exhausting. c.a. 46 v. a

[*Plan of canal ascending hill by means of locks*]
[*Below*: 10 *braccia deep and* 8 *wide*]

Every large river may be led up the highest mountains on the prin-
ciple of the siphon.

If the river *c d b* sends out a branch at the point *a* and it falls back again at the point *b*, the line *a b* will have so much greater pressure than the line *a c* that it will be able to take away so much of it as will serve to lead ships up mountains. c.a. 108 v. a

If a canal of water passes beneath another river with a bend like that of a knee, it exerts pressure in its desire to lift the cover of its conduit. Now I ask what weight is required to resist the weight of the water that wishes to proceed in its course. c.a. 199 v. b

OF A GOVERNOR OF RIVERS

In order to enable each large river to maintain itself within its banks, it is necessary for an official to be appointed with authority to command the people who live near to it, and so to effect repairs whenever it has burst its banks.

OF THE MAINTAINING OF RIVERS

The river which has the straightest course will best keep within its banks. c.a. 297 r. b

A trabocco is four braccia, and a mile is three thousand of these braccia, and the braccio[1] is divided into twelve inches ... and the water of the canals has a fall of two inches in every hundred trabocchi. Therefore fourteen inches of fall are necessary in two thousand eight hundred braccia of movement of the said canals. It follows that fifteen inches of fall give the necessary momentum to the current of the water of the said canals, that is one and a half braccio to the mile; and by this we may conclude that the water which is taken from the river of Villefranche and is lent to the river of Romorantin would require ...

Where by reason of its lowness a river cannot enter into another it is necessary to raise it by a dam to such a height that it can descend into the one which was the higher at first.

From Romorantin as far as the bridge at Saudre it is called the Saudre; and from that bridge as far as Tours it is called the Cher.

[1] Braccio—nearly two English feet.

[*Map of rivers*] Mon Ricardo. Romorantin. Tours. Amboise. Blois. Lyons.

You will make a test of the level of that canal which is to lead from the Loire to Romorantin by means of a channel one braccio wide and one braccio deep.

[*Map of rivers*] Era (Loire). Scier (Cher). Villefranche. Bridge of Saudre. Saudre. Ship.

On the Eve of Sant' Antonio I returned from Romorantin to Amboise, and the King [of France] [1] departed two days before from Romorantin. c.a. 336 v. b

The canals of Milan have a fall of one braccio or thereabouts in every mile. And an inch a mile is found sufficient in respect to the surface movement of the water.

Moreover reckoning a fall of a braccio in every mile, in a space of four hundred miles it would become necessary for the water to turn back, because the world . . . c.a. 352 v. a

Let the Guild of the Wool Merchants construct the canal and take the receipts, making the canal pass by way of Prato, Pistoia, Serravalle and empty itself into the lake; and it will be without locks and more permanent and will produce more revenue from the places through which it passes. c.a. 398 r. a

The roots of the willows do not suffer the banks of the canals to be destroyed; and the branches of the willows, nourished during their passage through the thickness of the bank and then cut low, thicken every year and make shoots continually, and so you have a bank that has life and is of one substance. F I r.

When the pool that is [provided] for the month of June is empty, stop up the mouths and bend the river which has poured itself into it, and give it its outlet in the fall of the mill. F 13 r.

Make a lock to the narrow canal that comes from the sea, in order to be able to close it against storms and the tide and to open it at the ebb. F 16 r.

[1] MS. *di fran* crossed out.

IN ORDER TO DEEPEN A CANAL

Make this in the book of the aids, and in order to prove it cite the propositions that have been proved. And this is the true order, because if you wished to supply a help to each proposition it would still be necessary for you to make new instruments in order to prove this utility; and by so doing you would confuse the order of the forty books and so also the order of the figures; thus you would have to blend practice with theory, which would cause confusion and lack of continuity. F 23 r.

A great weight may be deposited upon a ship without the use of windlasses, levers, ropes, or any force:

In order to deposit each very heavy weight that is all in one piece upon a floating barge, it is necessary to draw this weight to the shore of the sea, setting it lengthwise to the sea at the edge of the shore. Then a canal should be made to pass beneath this weight and to project as far beyond it as the half of the length of the barge which is to carry this weight; and in like manner the width of this canal should be regulated by the width of the barge, which should be filled with water and drawn beneath the weight. And then after the water has been baled out the ship will rise to such a height as to raise the said weight from the ground of itself. Thus laden you will then be able to draw it to the sea and lead it to the place that is prepared for it. F 49 v.

OF THE CANAL OF MARTESANA

By the making of the Martesana canal the amount of water in the Adda is lessened owing to it being distributed over many districts in order to supply the meadows. A remedy for this would be to make many small channels because the water which has been drunk up by the earth does no service to anyone, nor any injury because it has been taken from no one; and by the construction of such channels the water which before was lost returns again and is once more of service and use to mankind. And unless such channels have first been constructed it is not possible to make these runlets in the lower-lying country. We should say therefore that if such channels are made in the Martesana,

the same water, drunk in by the soil of the meadows, will be sent back upon the other meadows by means of runlets, this being water which had previously disappeared; and if there were a scarcity of water at Ghiara d'Adda and in the Mucca and the inhabitants were able to make these channels it would be seen that the same water drunk in by the meadows serves several times for this purpose. F 76 v.

CANALS CONCAVE AND CONVEX

It is possible that in a canal concave in its length the water flows with uniform depth.

It is impossible for the water in a convex canal to flow with uniform volume although the canal is of uniform width. F 88 v.

THE CANAL OF MARTESANA

A fall of two inches every hundred trabocchi, and these hundred trabocchi are four hundred and fifty braccia.

The greatest depth of the rivers will be beyond the current where the water is at rest. H 65 [17] r.

The more the water falls, the more it leaps.

On the second day of February, 1494, at the Sforzesca I have drawn twenty-five steps, each of two thirds of a braccio high and eight braccia wide.

The greatest depth of water will be between the percussion and the gurglings which result from it. H 65 [17] v.

No sluice should be narrower than the general width of the canal, because the water in this event forms eddies and breaks the bank.
 H 76 [28] v.

[Estimate for canal]

The canal which is sixteen braccia in width at the bottom and twenty at the top may be said to average eighteen braccia over its whole width; and if it is four braccia in depth and costs four denari per square braccio it will cost per mile for excavation alone nine hundred ducats, the square braccio being calculated in ordinary braccia.

But if the braccia are such as are used to measure land, of which

every four are four and a half, and if the mile consists of three thousand ordinary braccia and these are converted into those used to measure land, then these three thousand braccia lose a quarter so that there remain two thousand two hundred and fifty braccia; and therefore at four denari the braccio the mile comes out at six hundred and seventy five ducats; at three denari per square braccio the mile works out at five hundred and six and a quarter ducats, and therefore the excavation of thirty miles of the canal will work out at fifteen thousand one hundred and eighty seven and a half ducats. H 91 [43] r.

The water that falls over its embankments lays them bare and breaks them down on the opposite side. H 116 [27 v.] r.

GARDEN OF BLOIS

[*With diagram*]

 a b is the conduit of Blois, made in France by Fra Giocondo; *b c* is what is lacking in the height of this conduit; *c d* is the height of the garden of Blois; *e f* is the fall of the siphon *b c e f*; *f g* is where this siphon discharges into the river.[1] K 100 [20] r.

RIVERS AND CANALS

[*With drawing*]

 To ensure that the mouths of the canals which hollow themselves out from the rivers do not become filled up with shingle, and also to prevent the shingle from remaining in the middle of the dam that has been constructed against it, it should be made with a transverse descent.
 K 101 [21] r.

[*Canal of the Ticino*]
[*Diagram*]

 The declivity of the canal with the small outlets at its bottom.
[*Diagram*]

 All the water *a b* is that which enters into the canal having outlet

[1] This technical note as to the work of the Veronese architect Fra Giocondo in the garden of the château of Blois was most probably written by Leonardo while at Milan during the French occupation, the information having been supplied him by some member of the French court.

through the openings placed at the bottom; and all the water *a c* is that which enters in the canal having the openings near the surface of the water. The water *c b* having no outlet does not move its mass, and not moving it does not enter into the other mass but [this other] will go into the Ticino.

And in order thus to raise the openings make the course of the water more [less?] slanting, and make the course slower in consequence. Then this course in the same time draws a less quantity of water in the canal, and the mills receive less than at first although they receive the whole of it, and the outlets become full of impurities and choked up.

However I shall maintain the water in the canal at a height of one braccio and a half as at first, and the outlets at the bottom as at first, and I shall let in the water by degrees.

K 109 [29-30] r. and 108 [28] v.

[*Notes with drawing of section of Loire*]

LOIRE RIVER OF AMBOISE

The river is higher behind the bank *b d* than beyond this bank.

Island where there is a part of Amboise.

The river Loire which passes by Amboise passes by *a b c d*, and after passing the bridge *c d e* doubles back on its course by the canal *d e b f*, in contact with the embankment *d b* which comes between the two opposite movements of the above-mentioned river *a b c d*, *d e b f*. Then it turns back by the canal *f l g h n m* and reunites with the river from which it was formerly divided, which passes by *k n* and makes *k m r t*. But when the river is swollen it then runs all in one direction, passing the embankment *b d*. B.M. 269 r.

[*French canal—project*]

The main channel of the river does not take the turbid water, but this water runs in ditches on the outside of the town with four mills at the entrance and four at the exit; and this will be constructed by damming the water above, at Romorantin.

The water may be dammed up above the level of Romorantin at such a height that it works many mills in its descent.

The river at Villefranche may be led to Romorantin, and this may be done by the people who live there, and the timbers which form their houses may be taken on boats to Romorantin, and the river may be damned up at such a height that the water can be led down to Romorantin by an easy gradient.

[*Sketch map of Loire with tributaries*]

If the river *m n*, a tributary of the river Loire, were turned into the river of Romorantin with its turbid waters it would enrich the lands that it irrigated and make the country fertile, so that it would supply food for the inhabitants and it would also serve as a navigable canal for purposes of commerce.

HOW THE RIVER IN ITS COURSE SCOURS THE BED OF THE STREAM

By the ninth of the third: that which is swifter consumes its own bed more, and conversely the water that is slower leaves more behind of that which causes it to be turbid.

Therefore when the rivers are in spate you ought to open the floodgates of the mills so that the whole course of the river may . . . there should be many floodgates for each mill so that . . . may open and give a greater impetus and thus the whole bed will be scoured.

And let the sluice be made movable like the one that I devised in Friuli, where when the floodgate was open the water which issued forth from it hollowed out the bottom; and below the two sites of the mills there should be one of these floodgates, one with movable sluices being placed below each of the mills. B.M. 270 v.

Here there are, my lord, many gentlemen who will undertake this expense between them, if so be that they are allowed to enjoy the use of the waters, the mills and the passage of ships; and when the price shall have been repaid them they will give back the canal of the Martesana.

Forster III 15 r.

That a river which has to be diverted from one place to another ought to be coaxed and not coerced with violence; and in order to do this it is necessary to build a sort of dam projecting into the river and then to throw another one below it projecting farther; and by proceed-

ing in this way with a third, a fourth, and a fifth, the river will discharge itself in the channel allotted to it, or by this means it may be turned away from the place where it has caused damage, as happened in Flanders according to what I was told by Niccolò di Forzore.

[*With drawing*] How one ought to repair by means of a screen a bank struck by the water, as below the island of Cocomeri. Leic. 13 r.

FROM 'THE ORDER OF THE BOOK OF WATER'

No canal which issues forth from rivers will be permanent unless the water of the river from which it has its origin is entirely closed up, as is the case with the canal of Martesana and that which issues from the Ticino.

The canals ought always to be provided with sluices, so that excessive floods may not damage or destroy the bank and the water may always maintain itself in the same volume. Leic. 18 r.

How in order to twist the line of the water one should make a twist in the line of the bank with a few stones: By the fourth of the second, where it was proved that the line of the water of the rivers was a concourse of the reflex movements of the water that has struck upon its banks, and has there multiplied and raised itself and hollowed out its bed beneath itself. And this is what would occur if anyone set out to twist the bank when the river a certain space above had shown that it wished to bend, and then had not continued this bending process, and you were to follow it up again gradually and minister to its first desire with an almost imperceptible curve; and thus you will proceed to make your attempt. But if you should try to bend the water in the direct line of its strength all your work will be in vain, because it will break every obstacle. And if with your lock you raise the level of the water so high that it swallows up so much in itself that the current loses its impetus in the expanse of water that has been formed, this can have a good result, and, by the fifth of the first, it will fill up all its bed with mud. But make it so that the water does not run along the bank.

Leic. 27 v.

[*Of diverting a river and protecting a house*]

I have a house upon the bank of the river, and the water is carrying off the soil beneath it and is about to make it fall in ruin; consequently

I wish to act in such a way that the river may fill me up again the cavity it has already made, and strengthen the said house for me. In a case such as this we are governed by the fourth of the second, which proves that 'the impetus of every movabe thing pursues its course by the line along which it was created'; for which reason we shall make a barrier at the slant *n m*, but it would be better to take it higher up at *o p,* so that all the material from your side of the hump might be deposited in the hollow where your house is; and the material from the hump *k* would then do the same, so that it would serve the need in the same winter. But if the river were great and powerful the said barrier would have to be made in three or four attempts, the first of which, made in the direction that the water is approaching, ought to project beyond its bank a fourth part of the width of the river; then, below this, you should make another, distant as far as the summit of the leap that the water makes when it falls from the first barrier,—for in this summit of its leap the water leaves the summit of the mound made by the shingle which was hollowed out by the first percussion, made by the water when it fell from the first barrier upon its bed. And this second dam extends halfway across the breadth of the river. The third should follow below this, starting from the same bank, and at the same fixed distance from the second as the second was from the first; and it follows its length as far as three-quarters of the width of the river. And so you will proceed with the fourth dam which will close the whole river across. And from these four dams or barriers there will result much greater power than if all this material had been formed into one barrier, which in uniform thickness would have closed the whole width of the stream. And this happens by the fifth of the second, where it is proved that the material of one single support, if it be quadrupled in length, will not support the fourth of that which it used formerly to support, but much less.

[*Drawing*]

I find that the water, that falls at the foot of the dams of rivers, places material towards the approach of the water, and carries away from the foot of the dam all the material on which it strikes as it falls. Now I could wish that it would place the material where it falls, and thereby bank up and fortify this dam: which thing might be done in this way—						Leic. 32 r.

XXIV

Experiments

'Take away that yellow surface which covers
the orange and distil it in a retort until the
extract is pronounced perfect.'

AN EXPERIMENT WITH THE SENSE OF TOUCH

If you place your second finger under the tip of the third in such a way that the whole of the nail is visible on the far side, then anything that is touched by these two fingers will seem double, provided that the object touched is round.
<div align="right">C.A. 204 v. a</div>

I take a vessel filled with wine and I draw off the half and fill it up again with water: in consequence the vessel will contain half wine and half water.

Then I draw off half again and then fill up with water, wherefore there remains . . .

Since every continuous quantity is divisible to infinity, if a quantity of wine be placed in a vessel through which water is continually passing it will never come about that the water which is in the vessel will be without wine.
<div align="right">C.A. 218 r. b</div>

TO KNOW THE NORTH SIDE OF THE MAGNET

If you wish to find the part of the magnet that naturally turns towards the north get a large tub and fill it with water; and in this water place a wooden cup and set in it the magnet without any more water. It will remain floating in the manner of a boat, and by virtue of its power of attraction it will immediately move in the direction of the north star; and it will move towards this, first turning itself with the cup in such a way that it is turned towards this star, and will then move through the water and touch the edge of the tub with its north side, as before mentioned.
<div align="right">E 2 r.</div>

[With drawing]

This globe should be a half or a third of a braccio in diameter; and it should be of clear glass and filled with clear water with a lamp in the middle, with the light in about the centre of the globe, and when suspended in the centre of a room it will give a great light.

F 23 V.

[Sphericity of water. Experiment]

A drop of dew with its perfect round affords us an opportunity of considering some of the varied functions of the watery sphere; how it contains within itself the body of the earth without the destruction of the sphericity of its surface. For if first you take a cube of lead of the size of a grain of millet, and by means of a very fine thread attached to it you submerge it in this drop, you will perceive that the drop will not lose any of its first roundness, although it has been increased by an amount equal to the size of the cube which has been shut within it.

F 62 v.

[Light and heat. Sun and mirrors]

Whether the greater light with less heat causes concave mirrors to reflect rays of more powerful heat than a body of greater heat and less light.

For such an experiment a lump of copper should be heated and placed so that it may be seen through a round hole, which in size and distance from the mirror is equal to the heated copper.

You will thus have two bodies equal in distance but differing in heat and differing in radiance, and you will find that the greater heat will produce a reflection of greater heat in the mirror than the aforesaid flame.

We may say therefore that it is not the brightness of the sun which warms but its natural heat.

It is proved that the sun in its nature is warm and not cold as has already been stated.

The concave mirror although cold when it receives the rays of the fire reflects them hotter than the fire.

A ball of glass when filled with cold water sends out from itself rays caught from the fire which are even hotter than the fire.

From the two experiments referred to, it follows, as regards this warmth of the rays that issue from the mirror or from the ball of

cold water, that they are warm of their own essence, and not because the mirror or ball are hot. And in this case the same thing happens when the sun has passed through the bodies which it warms by its own essence. And from this it has been concluded that the sun is not hot, whilst by the experiments referred to it has been proved that it is extremely hot,—from the experiment which has been mentioned, of the mirror and of the ball which being cold and taking the rays of the heat of the fire convert them into warm rays because the primary cause is warm. And the same thing happens with the sun, which being itself warm, in passing through these cold mirrors reflects great heat.

F 85 v.

HOW TO MEASURE THE THINNESS OF WATER. EXPERIMENT

You will discover the various degrees of thinness of the waters by suspending at a uniform depth of the opposite ends a strip of old linen cloth, which should be dry, and which should penetrate on each side as far as the bottom of two vases filled with the two different kinds of water with which you wish to make your experiment. Then these waters will rise a certain distance on the cloth and will proceed gradually to evaporate, and as much as has been the evaporation of that which has risen up, so much will it rise again from the rest until the vase is dried up. And if you refill the vase the water will all rise in the piece of cloth with imperceptible slowness, and so as has been said it will gradually become dried up. And by this means the piece will remain full of the rest of the water which has evaporated, and in this way, by means of the weights that have been acquired, you will be able to tell which water holds more earth in solution than the other.

G 37 v.

OF THE SIPHON WITH MERCURY FOR MAKING FIRE

Since the more the water in the vessel diminishes the more its surface is lowered, and the more the surface of the water is lowered the less swiftly the siphon flows, but if the siphon descends at the same time as the surface of the water that supports it, without doubt the movement of the water which pours through will always be equal in itself, therefore in order to make this equality let us make the vessel

n in position above the bath of mercury *m*. This vessel *n* is a boat which supports the siphon which penetrates below from the air into the mercury. And this mercury proceeds to rise through the siphon *n s t* into the vessel *f*. And in proportion as the surface of this mercury descends so the boat which rests upon it descends at the same time as the siphon, which is formed of fine burnished copper and falls into a vessel, and this when it acquires the requisite weight falls and thereby creates fire by its impact. G 48 r.

One may finds by experiment whether if untarnishable varnish be melted by the fire it moves from slanting positions if it is not of great thickness,—this varnish after it has been liquefied should be smoothed constantly with a brush. G 73 v.

[*The flowing of liquids*]

If a cask is filled four braccia high with wine and throws the wine a distance of four braccia away, when the wine has become so lowered that it has dropped to a height of two braccia in the cask, will it also throw the wine through the same pipe a distance of two braccia, that is whether the fall, and the range that the pipe can throw, diminish in equal proportion or no.

If from the cask when full two jugs are filled through the pipe in an hour, when the cask is half full it ought for this reason to fill only one jug in an hour, if pouring from the same pipe.

This rule with all the other similar ones about waters which are poured through pipes ought to be put at the commencement of the instruments, in order to be able through various rules the better to proceed to the proofs of these instruments. 1 73 [25] r.

[*Good or poor mathematician*]

In order to make trial of anyone and see whether he has a true judgment as to the nature of weights, ask him at what point one ought to cut one of the two equal arms of the balance so as to cause the part cut off, attached to the extremity of its remainder, to form with precision a counterpoise to the opposite arm. The thing is never possible, and if he gives you the position it is clear that he is a poor mathematician. M 68 v.

Cause an hour to be divided into three thousand parts, and this you

will do by means of a clock by making the pendulum lighter or
heavier. B.M. 191 r.

FIRE

If you wish to make a fire which shall set a large room in a blaze
without doing any harm you will proceed thus: first perfume the air
with dense smoke of incense or other strongly smelling thing, then
blow or cause to boil and reduce to steam ten pounds of brandy.

But see that the room is closed altogether, and throw powder of
varnish among the fumes and this powder will be found floating upon
the fumes; then seize a torch and enter suddenly into the room and
instantly everything will become a sheet of flame. Forster I 43 r.

Take away that yellow surface which covers the orange and distil
it in a retort until the extract is pronounced perfect.

Close up a room thoroughly and have a brazier of copper or iron
with a fire in it, and sprinkle over it two pints of brandy a little at a
time in such a way that it may be changed into smoke. Then get
someone to come in with a light and you will see the room suddenly
wrapped in flame as though it was a flash of lightning, and it will
not do any harm to anyone. Forster I 44 v.

[Experiment with waves of water and of air] *[With figures]*

Place yourself in a boat and construct an enclosure *n m o p* and fix
within it two pieces of board *s r* and *t r*,[1] and make a blow at *a* and
see whether the broken wave passes with its suitable part as far as *b c*.[2]

And from the result of the experiment which you make with the
wave cut off by the circular wave of the water, may be inferred what
happens with that portion of the wave of air which passes through the
airhole through which the human voice passes when confined in a box;
as I heard at Campi from a man who had been shut up in a cask with
the bunghole left open. Quaderni III 12 v.

[1] As figure shows, these two pieces of board are placed opposite to each other at
right angles to the sides of the enclosure and are each about a third of its width.

[2] The lines *b a*, *c a* form an acute angle with equal arms which pass through the
ends of the two boards *s r* and *t r* and continue to the points *b* and *c*, which are near
the sides of the enclosure.

XXV

Inventions

'O speculators about perpetual motion, how many vain chimeras have you created in the like quest? Go and take your place with the seekers after gold.'

[*With drawing*]
Method of drying up the marsh at Piombino. C.A. 139 r. c

[*Diagrams*]
Here there is need of a clock to show the hours, minutes and seconds (*l'ore punti e minuti*).

For measuring how great a distance one goes in an hour with the current of the wind.

For learning the quality and density of the air and when it will rain.

For reckoning the mileage of the sea. C.A. 249 v. a

[*With drawing*]
This is the way to dredge a harbour, and the plough *m n* will have in front of it spikes shaped like ploughshares and knives, and this plough will be used to load a large cart with mud. The cart will have its back perforated after the manner of a net in order that the water may not be shut within the box; and the said plough is to be moved along above the place where the mud is to be dug out, and along with it a barge; and when it has reached the bottom the windlass *b* will draw it underneath the windlass *a*, and the windlass *a* will raise it up when it is full as far as its beam, in such a way that there will be room for the barge to go underneath it and take the mud from the plough; and so this plough will be able to dislodge the mud from the bottom and unload it upon the barge which is placed underneath it.

C.A. 307 r. b

Make to-morrow out of various shapes of cardboard figures descend-

ing through the air, falling from our jetty; and then draw the figures and the movements made by the descent of each, in various parts of its descent. C.A. 375 r. c

[*With drawings*]

These scissors open and shut with a single movement of the hand.

Scissors used by the bonnet-makers for cutting cloth. Rapid in the action of opening and shutting like the others.

This [tool] has in itself so much more ease in its movement because the user does not have to adjust the spring or curve, as is the case with those scissors which are all in one piece. With these it is not necessary to wait in order to cut the threads of the cloth, or to bend by force the spring which is in the heel of the scissors.

This closes at the same rate of speed as the rest; but opens much more rapidly. C.A. 397 v. a

[*Drawing of apparatus with ropes and pulleys*]

Method of raising and lowering the curtains of the treasures of silver of the lord. Tr. 6 a

[*With drawing of tube descending from surface of water to cover mouth of man in diving dress*]

This instrument is employed in the Indian Ocean in pearl fishing; it is made of leather with numerous rings so that the sea may not close it up. And the companion stands above in the boat watching, and this [diver] fishes for pearls and corals, and he has goggles of frosted glass and a cuirass with spikes set in front of it. B 18 r.

A WAY OF SAVING ONESELF IN A TEMPEST OR SHIPWRECK AT SEA

[*With drawing*]

It is necessary to have a coat made of leather with a double hem over the breast of the width of a finger, and double also from the girdle to the knee, and let the leather of which it is made be quite air-tight. And when you are obliged to jump into the sea, blow out the lappets of the coat through the hems of the breast, and then jump into the sea.

And let yourself be carried by the waves, if there is no shore near at hand and you do not know the sea.

And always keep in your mouth the end of the tube through which the air passes into the garment; and if once or twice it should become necessary for you to take a breath when the foam prevents you, draw it through the mouth of the tube from the air within the coat.

<div align="right">B 81 V.</div>

[Alarum-clock] [With drawing]

A clock to be used by those who grudge the wasting of time.

And this is how it works:—when as much water has been poured through the funnel into the receiver as there is in the opposite balance this balance rises and pours its water into the first receiver; and this being doubled in weight jerks violently upwards the feet of the sleeper, who is thus awakened and goes to his work. B 20 V.

[Drilling machine]

In order to drill through a beam it is necessary to hold it suspended and drill from below upwards so that the hole may empty of itself, and you should make this canopy so that the sawdust may not fall upon the head of him who turns the screw; and see that the turners rise at the same time as the said screw. And make the hole first with a fine auger and then with a larger one. B 47 V.

[Drawing]

A sledge for use in mud. And make the part that comes upon the ground united in order that it may not get stuck in the mud.

<div align="right">B 49 V.</div>

[Drawing]

A sledge for use in mountainous and rocky places. And do not make the part that touches the ground united, so that it may be less difficult to drag; for the less the weight touches the less difficult it is to move.

<div align="right">B 50 r.</div>

[Timepiece. With drawing]

Four springs for a timepiece, so that when one has finished its course the other commences, and as the first turns the second remains motionless. And the first is fixed above the second like a screw, and when it is fixed the second spring takes the same movement completely and so do all. B 50 V.

[With drawing] [Paddle-boat]

Barge made of beams and covered over above. But make a large

wheel of oars concealed within it, and make a furrow from one end of it to the other, as appears in *a*, where the wheel can touch the water.

<div align="right">B 76 v.</div>

[To make concrete] *[With drawings]*

a is a box which can open and empty itself, and in it you can make a concrete formed of fine pebbles and chalk. Let these blocks dry on the ground and then place them one upon another under the water, in order to form a dam against the rush of the water.

Frames filled with gravel and twigs of birch, that is a layer of twigs *[sketch]* placed vertically in this direction and a layer of gravel, then a layer in this contrary direction *[sketch]* and then a layer of gravel, and thus you will construct it bit by bit.

<div align="right">B 79 v.</div>

OF PROPORTION

See if there are a number of small stones of different sizes whether the heaviest goes farthest when one throws it, then try alone with the same instrument and force, and see whether it travels a greater or less distance alone than when accompanied. And whether also if the stones are all of the same form and weight, like the balls of an air-gun, and are thrown by the same force in the same time they travel the same distance.

BELLOWS WITHOUT LEATHER AND MERELY OF WOOD

These bellows are like a sugar loaf and have a partition which divides them lengthwise in two parts. One—that is the upper part—is filled with water; that below is filled with air. The water falls down into the cubic space of the air through a small hole which is near the socket, and the increase of the water drives the air through the mouth of the bellows. Any scarcity of water in the upper part is filled by means of a valve which admits the air, and so also with the others; and this is the most serviceable type of bellows that can be used.

<div align="right">B 81 r.</div>

Webbed glove for swimming in the sea. *[With drawing]*

<div align="right">B 81 v.</div>

[Water bellows] [Drawings]

These are kinds of bellows without leather and they are of admirable utility and extremely durable. And their method of use is as follows:—The bellows is always from the centre downwards full of water, that is *M N*, and in the continual revolution of the bellows *N* rises until it reaches the air hole *S T* which is made in the outside of the second covering, as appears in the instrument below, and comes to meet with the said pipe *S T* the hole *o* which is in the reservoir *N*, and as much as is the volume of water that goes from *N* to *M* so much air enters through the hole *o* in the reservoir *N*, and as much air is driven out of the reservoir *M* as *N* gives it of water. And the air which is driven out from *M* by the water is that which blows the bellows. The said bellows should be of oak because this resists water for the longest time, and have inside it a coating of turpentine and pitch, so that when it is not in use the part above which is out of the water does not come to open; and this type of bellows is turned by the weight of a man walking above on the steps.

It would also be extremely useful to cause it to turn by the force of a fall of water.

The base of the bellows below the tube *S T* remains fixed, and the rest turns there within as a case would within its cover.

Use salt water so that it may not become foul in the bellows.

<div align="right">B 82 r.</div>

[With drawings of machine]

To produce a marvellous wind. <div align="right">E 33 v.</div>

The current will be so much the more abundant as the small doors open with less descent. (*discesa?* MS. *dissci . . .*)

The whole space of the small doors is equal to the whole space of the width of the pipe. <div align="right">E 34 r.</div>

MACHINE FOR EXCAVATING EARTH

[Drawing]

Here the calculation of the power is not at present fixed.

But you, reader, have to understand that this has a use, which arises by means of the saving of time, which saving springs from the fact

that the instrument which conveys the earth up from below is always in the act of carrying it and never turns back. The adversary says that in this case it takes as long to turn round in a useless circle as to turn back at the end of the forward action. But since the additional spaces of time that are interposed between the spaces of useful time are equal in this and in all other inventions, it is necessary to search here for a method whereby the time may be spent in as vigorous and effective a method of work as possible, which will be by inventing a machine that will take more earth; as will be shown on the reverse of this page.

The winch *n* as it turns causes a small wheel to revolve, and this small wheel turns the cogged wheel *f*, and this wheel *f* is joined to the angle of the boxes which carry the earth from the swamp and discharge themselves upon the barges. But the two cords *m f* and *m b* revolve round the pole *f*, and make the instrument move with the two barges against *m*, and these cords are very useful for this purpose.

The pole is so made as to descend to as great a depth as the wheel has to descend in order to deepen the water of the marsh. E 75 v.

As the attachment of the heavy body is further from the centre of the wheel the revolving movement of the wheel round its pivot will become more difficult although the motive power may not vary.

The same is seen with the time of clocks, for, if you place the two weights nearer or farther away from the centre of the timepiece, you make the hours shorter or longer. F 7 v.

[Magnifying glasses]

Lens of crystal thickness, at the sides the twelfth part of an inch. This lens of crystal should be free from spots and very clear; and at the sides it ought to be the thickness of a twelfth of an inch, that is to say of the one hundred and forty-fourth part of a braccio, and thin in the centre according to the sight that it ought to serve for, that is to say according to the proportion of those lenses which agree with it; and let it be worked in the same mould as these lenses. The width of the frame will be one sixth of a braccio and its length one quarter of a braccio; consequently it will be three inches long and two wide, that is to say a square and a half. And this lens should be held at a distance of a third of a braccio from the eye when used, and it should be the

same distance from the letter that you are reading. If it is farther away this letter will appear larger, so that the ordinary type of print will seem like a letter on an apothecary's chest.

This lens is suitable for keeping in a cabinet; but if you wish to keep it outside make it one eighth of a braccio long and one twelfth wide.

<div align="right">F 25 r.</div>

[A pedometer] [Figure]

In order to know how far one goes in an hour take the potter's wheel constructed as you see, and place above the instrument, of which the centre may be upon a circular line which turns exactly five braccia, the diameter being one and $\frac{12}{22}$ braccia. Then tightly close the instrument, have harmonic time, smear all the inside of the instrument with turpentine, turn the wheel uniformly and notice where the top layer of dust has stuck to the turpentine, and see how many revolutions the wheel has made and in how many beats of harmonic time. And if the wheel has made two revolutions in one beat of time, which amounts to ten braccia, that is to say the three-hundreth part of a mile, you will be able to say that this instrument has moved a mile in three hundred beats of time, and that an hour is one thousand and eighty beats of time; which will make three miles an hour and one hundred and eighty three-hundredth parts.

<div align="right">F 48 v.</div>

[A decoration]

If you make small pipes after the manner of goosequills, which are opaque and white with a coating of black within and then transparent, and with sardonyx outside and then transparent; and let all the thick portion of the pipes be made up of these mixtures, and then moisten them and press them and leave them to dry in the press; if you press them flat they will give one effect, if you press them into a rectangle they will give another and similarly if you press them into a triangle; but if you press them in front or folded in different ways you will also do well.

And if in the transparent part exposed to the sun you make with a small style a mixture of different colours, especially of black and white opaque, and yellow of burnt orpiment, you can make very beautiful patterns and various small stains with lines like those of agate.

<div align="right">F 55 v.</div>

LAMP

[*Drawing*]

Lamp in which as the oil becomes low the wick rises.

And this proceeds from the fact that the wheel which raises the wick rests upon the oil. As the oil diminishes so the wheel descends, and as it descends it revolves by means of the thread that is wrapped round its axle, and the cogs of the wheel push the toothed pipe that receives the wick.

It will also do the same if *a* the axle of the wheel does not descend, and the only descent is that of the light object *b* which floats upon the oil, for this light object descends at the same time as the surface of the oil, and causes the wheel to turn, and this by means of its cogs pushes up the aforesaid cogged pipe with a slow movement.

G 41 r.

THE MINT OF ROME

[*With drawings*]

This can also be made without a spring, but the screw above must always be joined to the part of the movable sheath.

No coins can be considered as good which have not the rim perfect; and in order to ensure the rim being perfect it is necessary first that the coins should be absolutely round.

In order to make this it is necessary first to make the coin perfect in weight, breadth and thickness; therefore you must first have many plates made of this [uniform] breadth and thickness drawn through the same press, and these should remain in the form of strips, and from these strips you should stamp out the round coins after the manner in which sieves are made for chestnuts, and these coins are then stamped in the way described above.

The hollow of the mould should be uniformly and imperceptibly higher at the top than at the bottom.

This cuts the coins of perfect roundness, thickness and weight, and saves the man who cuts and weighs, and saves also the man who makes the coins round.

They pass therefore merely through the hands of the worker of the plate and the stamper, and they are very fine coins. G 43 r.

OF PERCUSSION

Among the accidental forces of nature, percussion greatly exceeds each of the others created by the motive powers of heavy bodies in equal time with equal movement, weight and force. This percussion is divided into simple and compound. Simple is that in which the motive power which is the striker is joined with the movable thing at its junction at the place struck; compound is that in which the movable thing as it strikes does not end its movement at the place of its impact, as does the hammer which strikes the die that stamps the coins. And this compound percussion is much weaker than simple percussion, for if the flat end of the head[1] of the hammer were to attach itself to the coin which it had to stamp and which it had struck upon the mould where was the impression, so that on this flat end of the head of the hammer there had been engraved the relief that was on the coin in reverse, the impression would be more definite and clear on the side struck with simple movement than on the side where the percussion is compound; as with the coin that remains struck in the die where the hammer has struck it in its descent, the percussion being reflected and thrown back against the front of the hammer.

G 62 v.

SIPHON CLOCK. SLOW TIME-FUSE

[*Of the siphon*]

A preparation of mercury drawn through very fine copper of the shape of a siphon, the sides through the length of which the liquid rises and falls being of imperceptible thickness, will be seen to form a time-piece after the manner of an hourglass, and this is the slowest and most graduated descent that can be made, so much so that it may happen that in an hour not one grain of the mercury passes from one vessel to the other.

And the surface of its container is sensitive by reason of the opacity of the mercury, the skin of this mercury becoming imperceptibly lowered with the descent that occurs as the siphon discharges itself; and by this means you will be able to create a fire which by means of per-

[1] MS. *bocha.*

cussion will generate itself at the end of a year or more, and this without any sound down to the moment of the creation of the fire.

And it is shown in the margin at the foot of the fourth page (folio 48 r.) how one ought to fix or set up this vessel, which by the power observed gives the result which is promised us at the end. G 44 v.

TO KNOW HOW FAR A SHIP TRAVELS IN AN HOUR

The ancients have employed different methods in order to discover what distance a ship traverses in each hour. Among them is Vitruvius who expounds one in his work on architecture, but his method is fallacious like the others. It consists of a wheel from a mill touching the ocean waves at its extremities, and by means of its complete revolutions describing a straight line which represents the line of the circumference of this wheel reduced to a condition of straightness. But this device is only of value on the smooth still surface of lakes; should the water move at the same time as the ship with an equal movement the wheel remains motionless; and if the movement of the water be either more or less swift than that of the ship, then the wheel will not have a movement equal to that of the ship, so that such an invention has but little value.

Another method may be tested by experiment over a known distance from one island to another, and this is by the use of a light board which is struck by the wind, and which comes to slant to a greater or less degree as the wind that strikes it is swifter or less swift, and this is in Battista Alberti.

As regards the method of Battista Alberti which is founded upon an experiment over a known distance from one island to another, such an invention will work successfully only with a ship similar to that with which the experiment has been tried, and it is necessary that it should be carried out with the same freight and the same extent of sail, and with the sail in the same position, and the waves of the same size. But my method serves with every kind of ship, whether it be with oars or sail; and whether it be small or large, narrow or long, high or low, it always serves. G 54 r.

[With drawing]

KEY OF THE BATH OF THE DUCHESS

Show all the ways of unlocking and releasing. Put them together in their chapter. I 28 v.

BATH

To warm the water of the stove of the duchess add three parts of warm water to four parts of cold water. I 34 r.

[With ground plan of Castle of Milan]
A way of flooding the castle. I 38 v.

DRESS FOR CARNIVAL

To make a beautiful garment take fine cloth and give it a strong-smelling coat of varnish made of oil of turpentine; and glaze it with eastern [scarlet] kermes, having the stencil perforated and moistened to prevent it from sticking. And let this stencil have a pattern of knots, which should afterwards be filled in with black millet, and the background with white millet. I 49 [I] v

[With drawing]
Water-clock which sounds twenty-four hours and the water falls half a braccio.
Water-clock which shows the value [of time]. L 23 v.

[With drawing]
Water-clock.

[With drawing of press]
To press wine and oil in casks bound with iron. L 27 r.

[Drawings]
Machines for drying the trenches where the water has overflowed.
L 69 v.

CAMP-BED

[*With sketch*]

Four straps for the length and eight across.

And each of the straps to be buckled at one end and nailed at the other. L 70 r.

[*Movable bridge*]
[*Drawings*]

Bridge to draw horizontally with a windlass.

Let *a* be a pulley *b* the windlass.

c n will be a pavement of flagstones which has a tube beneath it through which the chain passes.

This is the front of the said bridge.

Here is a bridge which carries with it little wheels, and another, better, which travels on small wheels that remain fixed in one position.

a b is the part of the bridge that projects out of the wall; *b c* is the part that remains within. M 55 v.

[*Fittings of a stove*]

This is the lattice which comes between the eyes and the fire of the stove.

All the transparent part (*il netto*) has a breadth of a braccio and a quarter; and there are six thin boards but it is better that they should be of thin brass.

The opening two braccia high and the transparent part one braccio and a quarter wide.

You should divide it in height in two parts, so as to be able at will to open below and not above, in order to warm the legs.

In the lower part you should use six boards, so that they are wider below than above in order to be able to put the feet to warm; above there should be eight, to be able to put the hands which are narrower.
 M 86 r.

[*Diagram*]

To make a pair of compasses diminish or increase a portion of their measurement with equal proportion in each part.

Bind it spirally with a screw which has as much of it smooth as enters in the compasses and all the rest is carved spirally; and this screw

may be changed at different places throughout the length of the compasses, because at different places there are holes equally distant from the extremities of these compasses, into which the screw can enter halfway as at *a*, a quarter as at *b*, and one eighth as at *c*; and so it proceeds through the whole, and it is bound by the nut *h* of this screw.

Forster I 4 r.

METHOD OF THE SMALL COMPARTMENTS OF THE ROUND MACHINE GIVEN BELOW

[*Drawing*]

Make it so that the buckets which are plunging with the mouth downwards have such an opening that the air cannot escape; it will also be a good thing that the covered exits to the buckets should be of terracotta so that they may be better able to pass beneath the water; and of copper would be best of all. Forster I 50 v.

[*Sketch of loom*]

Threads for weaving ought to be two braccia long.

[*Sketch*]

Thus one ought to lay the warp. Forster II 49 v.

Moreover you might set yourself to prove that by equipping such a wheel with many balances, every part however small which turned over as the result of percussion would suddenly cause another balance to fall, and by this the wheel would stand in perpetual movement. But by this you would be deceiving yourself; for as there are these twelve pieces and only one moves to the percussion, and by this percussion the wheel may make such a movement as may be one twentieth part of its circle, if then you give it twenty-four balances the weight would be doubled and the proportion of the percussion of the descending weight diminished by half, and by this the half of the movement would be lessened; consequently if the first was one twentieth of the circle this second would be one fortieth, and it would always go in proportion, continuing to infinity.

Forster II 89 v.

Whatever weight shall be fastened to the wheel, which weight may

be the cause of the movement of this wheel, without any doubt the centre of such weight will remain under the centre of its axis.

And no instrument which turns on its axis that can be constructed by human ingenuity will be able to avoid this result.

O speculators about perpetual motion, how many vain chimeras have you created in the like quest? Go and take your place with the seekers after gold. Forster ii 92 v.

[*Diagram*]

To try again the wheel which continually revolves.

I have many weights attached to a wheel at various places: I ask you the centre of the whole sum of the weight.

I take a wheel revolving on its axis, upon which are attached at various places weights of equal gravity, and I would wish to know which of these weights will remain lower than any of the others and at what stage it will stop. I will do as you see above, employing this rule for four sides of the circle, and that where you will see greater difference upon the arms of the balance, that is that experiment which will throw you the sum of one of the gravities more distant from the pole of the balance, that will go on and become stationary below; and if you want all the details repeat the experiment as many times as there are weights attached to the wheel. Forster ii 104 v.

If you wish to make a boat or coracle strong, take . . . (*allume splumie*) and of these make fine cords and weave them together and do as one weaves the sacks after making oil of walnut, and of this cover your boat as you would with leather. Take from what is in the house, and test this by combing as with the sinew of the ox . . .
 Forster iii 35 r.

PAPER ON WHICH IT IS POSSIBLE TO DRAW IN BLACK WITH THE SALIVA

Take dust of oak-apple and vitriol and reduce it to a fine powder and spread this over the paper after the manner of varnish; then write on it with a pen dipped in the saliva and it will become as black as ink.

TO ADD WATER TO WHITE WINE AND SO CAUSE IT TO BECOME RED

Crush an oak-apple to a fine powder and stand it for eight days in white wine, and in the same way dissolve vitriol in water, and let the water and the wine settle well and become clear each of itself, and strain them well; and when you dilute the white wine with this water it will turn red.　　　　　　　　　　　　　　　Forster III 39 v.

[*Sketch*]

To weigh the force that goes to turn the millstone with its corn.

Forster III 46 v.

[*Sketch*]

To measure a fall of water.　　　　　　　　　　Forster III 47 r.

[*Sketch*]

For taking away and placing in position rafters for the framework of houses and for their roofs.　　　　　　　　Forster III 56 v.

[*Sketch*] [*Self-closing gate*]

On one side is the shutter.

Forster III 58 r.

OF THE INSTRUMENT

Anyone who spends one ducat for the pair may take the instrument, and he will not be paying more than half a ducat as a premium to the inventor of the instrument and one grosso for the operator; but I have no wish to be an under-official.　　　　　　　Forster III 61 v.

[*With drawing*]

Dry or moist vapour-bath, very small and portable, weighing twenty-five pounds.　　　　　　　　　　　　　　　Quaderni II 9 v.

[*With drawings*]

A method of ascertaining how far water travels in an hour. This is done by means of harmonic time, and it could be done by a pulse if the time of its beat were uniform; but musical time is more reliable in such a case, for by means of it it is possible to calculate the distance that an object carried by this water travels in ten or twelve of these

beats of time; and by this means it is possible to make a general rule for every level canal. But not for rivers, for when these are flowing underneath the surface they do not seem to be moving above.

Leic. 13 v.

[*Drawing: with note 'lathe for potters'*]

How many miles an hour with a wind; and here one may see with the water of the mill which moves it how many revolutions the wheel which is about five braccia makes in an hour; and so you will make the true rule away from the sea, making the wheel go one, two, and then three times in the hour; and by this means you will regulate it exactly, and it will be true and good. Leic. 28 r.

[*Meat-roasting jack*]

Water which is blown through a small hole in a vessel in which it is boiled is blown out with fury and is entirely changed into steam, and by this means meat is turned to be roasted. Leic. 28 v.

[*Drawing: wheel on shaft with counterpoise on suspended looped cord*]

In order to see how many miles a ship can go in an hour have an instrument made which moves upon a smooth wheel together with this wheel, and so adjust the counterpoise that moves the wheel as to cause it to move for an hour; and you will be able to see how many revolutions this wheel makes in the hour. The revolution of the wheel may be five braccia, and it will make six hundred revolutions in a mile. And the glass should be varnished or soaped on the inside, so that the dust that falls from the hopper may attach itself to it; and the spot where it strikes will remain marked; and by this means you will see and be able with certainty [to discern] the exact height where the dust struck, because it will remain sticking there. Leic. 30 r.

XXVI

Warfare

'When besieged by ambitious tyrants I find a means of offence and defence in order to preserve the chief gift of nature, which is liberty.'

'I can noiselessly construct to any prescribed point subterranean passages either straight or winding, passing if necessary underneath trenches or a river.'

[*How to make a pontoon*]

Since every river current is swifter in the centre of its breadth than at its sides, and flows faster on its surface than in its bed when the course is equal, and a movable bridge made upon barges is in itself weaker in the middle of its length than towards the extremities, therefore I conclude that as the greater weakness of the bridge is accompanied by the greater percussion of the water this bridge will break in the centre.

Make it so that in the movement of the bridge the length of the barges will always find itself in line with the current, when the movement will be so much easier as the barges receive less percussion from the water. C.A. 176 r. c

[*Fortification*]

The tower must needs be massive as far as the end of the scarp, then in order that powder may not be thrown there you must make the windows high.

A WAY TO MAKE A CUIRASS

If you place between two thicknesses of cloth scales of iron[?] [1] and with this make a doublet you may take it as certain that no point will ever be able to penetrate. C.A. 358 v. a

[1] MS. *f*. (*ferro?*)

Again a bombard that takes a projectile weighing a hundred pounds is of considerably more use in the field than a small cannon, for that with pieces of rock inflicts considerable damage upon the enemy, and the small cannon or rather its ball, being of lead, does not rebound after the first blow by reason of its weight, and on this account it is less useful.

If you set an arrow so that it is just in equilibrium on top of a stone which seems on the point of falling over, you will perceive that a large bombard if discharged at a distance of ten miles from this arrow will cause such a tremor of the ground as to make the said arrow fall, or the stone upon which it is balanced.

Again if you discharge a small bombard in a courtyard surrounded by a convenient wall, any vessel that is there or any windows covered with cloth or linen will all be instantly broken; and even the roofs will be somewhat heaved up and start away from their supports, the walls and ground will shake as though there was a great earthquake, and the webs of the spiders will all fall down, and the small animals will perish, and every body which is near and which is possessed of air will suffer instant damage and some measure of loss.

But this small bombard should be discharged without its shell or if you so desire after the fashion of the curtall;[1] and it will cause women to miscarry and also every animal that is with young, and the chicks will perish in their shells. c.a. 363 v. d

Having to make mounds of earth on the two opposite sides of the river this is the most expeditious manner in which it can be done, provided you have men with hand-barrows:

Allowing six shovelfuls to each hand-barrow, and casting the earth at a great distance:

The diggers d enter underneath a shovelful, always drawing themselves back, and the diggers b make another second shovelful below, that is deeper down, always going forward; and if there were two other similar lines of diggers these would go beneath the third and fourth shovelful, and so successively they would be able to continue from hand to hand.

[1] MS. *cortaldo*. 'Curtall, a kind of cannon with a comparatively short barrel, in use in the sixteenth and seventeenth centuries.' *Oxford English Dictionary*.

Here many men become fatigued merely by taking loads for so great a distance, so that we have to consider whether it is better that the men should remain in one spot and throw the soil from one to another, or should all be employed in digging and throwing, or whether some should be carriers of this soil and others throwers. For as regards the place where this earth is discharged it requires as much effort for the shovelful of the first or of the second to reach it in one way as in the other: nothing therefore need be considered here except the convenience and endurance of the workers. C.A. 370 r. b

[*With sketch of cannon*]

The mouth one eighth of its diameter thick, and at its union with the tail one quarter of its diameter thick. Tr. 61 a

If you are attacked by night in your quarters or if you fear to be, take care to have mangonels in readiness which can throw iron caltrops; and, if you should be attacked, hurl them in among the enemy and you will gain time to set your men in order against their assailants, the outwitted enemies, who because of the pain caused by the wounds in their feet, will be able to effect little. And the plan of your attack you will make thus:—divide your men into two squadrons and so encircle the enemy; but see to it that you have soles to your shoes and that the horses are shod with iron, as I have said before, since the caltrops will make no distinction between your men and those of the enemy, and see that each mangonel throws a cartload of the said caltrops.

HOW TO PROTECT ONESELF FROM CALTROPS

If you wear between the foot and the sole of the shoe a sole of cloth woven of cords of cotton of the thickness of a finger you will be safe from caltrops, which will not thrust themselves into your feet.

If you wish to be safe from light shifting sand upon the galleys, have heavy river sand strewn upon the gangway and where you have to set your feet; and pitch will fix this, and keep sacks always in readiness for when they may be needed. Tr. 88 a

You should make caltrops of plaster with the arch of iron and the moulds in three parts, and then the points should be filed. [*Below*—

sketches of three caltrops with four points and of one with eight, each
of the four being duplicated close together—below this is written
'double caltrop'.]

These caltrops should be kept in a leather bag by the side of each
person, so that if the expected victory should be changed to a defeat
through the strength of the enemy, the fact of these being scattered
behind them would be the cause of checking the speed of the horses
and of bringing about the unhoped-for victory.

But lest in retreating this crop should be the cause of a similar mis-
take for yourselves, you should first have made ready the irons for the
horses in the form represented below, and have nailed between the
iron and the horse's foot a plate of steel as thick and wide as the above-
mentioned horse's iron.

And in the case of foot-soldiers they should have iron plates fastened
to the soles of their shoes, not tied tightly, so that they may be able
easily to raise their heels and take steps and run when necessary with-
out any restraining obstacle, and the knot that is left loose should be
as it is represented here below.

Moreover if you have a small bag of them by the side of each naval
combatant and they are then thrown by hand on the enemy's galleys
or ships they will be sowing the seed of the approaching victory; but
you should have the shoes bound with iron, as was said above, and
covered over below with tiny points, in order that if it should come
about that soft soap be thrown upon your ship you will be able to
keep your feet, even though the enemy should throw chalk in the
form of powder in such a dense cloud as to devastate the air which is
breathed into the lungs.

You should set up four stations at four positions in the length of the
ship, and at each of the four stations let there be a small barrel with a
certain quantity of water, and large syringes which serve to force the
water out through many small holes, so that the water may become
changed into spray and may thus accompany the dust of the chalk
and draw it downwards.

[*Three sketches—below*]

syringe; iron sole for shoes; iron for horse for caltrops. **Tr. 90 a**

[Drawing of fire-ball]

This ball as it is thrown becomes extinguished, and as it reaches the ground the canes which are bound at the top with linen cloth that has been set alight are driven into it, thus igniting the powder which is all round a piece of tow that has been soaked in turpentine, the rest of it being wrapped in hemp which also has been soaked in turpentine, oil of flax, and pitch, and the wrappings should be thin in order that the flames may get the air, for otherwise you will do nothing.

4 r.[1]

RHOMPHEA

This *rhomphea* can be drawn with army horses, as the ancients drew other instruments.

This [*small drawing of instrument*] is attached to the centre of a piece of plank, or piece of chain, or stout cord, that is fastened to a lump of stone heavier than the plank and so drawn behind the plank, which on the front edge is full of spontoons of the length of a cubit, and the said plank will be twelve braccia long, and its surface is studded with nails.
B 7 r.

SCORPIONS

A scorpion is a machine which can hurl stones, darts and arrows; and if it is made large it will be suitable for breaking the machines of the enemy.

Other authors are of opinion that a scorpion is a poisoned arrow which however little it may touch the blood causes instant death. And it is said that this weapon was found among the Scythians, others say among the inhabitants of Candia. The brew was made of human blood and serpent's venom. This weapon should not be used except against traitors, for it comes from them.
B 7 v.

CATAPULT

The catapult according to Nonius and Pliny is an instrument invented by that Ticlete,[2] which threw a dart of three cubits, and with

[1] The notes on instruments of warfare in this manuscript, B of the Institut, are extensively derived from the *De re militari* of Roberto Valturio.

[2] Tiglath Pileser? (Ravaisson-Mollien).

iron on three sides, thrown by means of wood released from the contraction of twisted sinews.

A bit of thin steel also springing back when released will have power to drive a dart swiftly when it stands in its course. B 8 r.

RHOMPHEA

The *rhomphea* is an instrument which throws out long brands of burning wood; it was used among the Thracians according to Aulus Gellius, and by the men of other nations it was called *flammea*.

THE BOW

The bow is said to have been invented by the inhabitants of Arcadia, some say by Apollo; those of Candia call it Scythian as coming from Scythia. And it is much in use among the eastern peoples. They make arrows of canes for these bows, and in their battles there are sometimes so many of them in the air that the day becomes so darkened as to seem like night. So for this reason they have a hatred of the clouds and the rain and the winds no less, because they divert the course of their arrows; and these causes often bring treaties and peace among them. B 8 v.

The spikes (*murici*) or caltrops (*triboli*) are for use on the field of battle, in order to scatter them on the side on which there is reason to expect the assault of the enemy, and also for throwing among the enemy when they follow up their victory.

The *scalpro* was a sharpened iron used to prick and control elephants. Livy in the Seventh Book of the Carthaginian War says that many more elephants were killed by their own governors than by the enemy. For when these beasts got enraged with them the governor with a mighty blow thrust the sharp *scalpro* between the ears where the neck joins the spinal column; and this was the most rapid death that could be given to so huge a beast.

The *veruina* according to what I find in a comedy of Plautus [1] is a long spear with a sharp iron point for hurling.

[1] The reference is to Plautus's *Bacchides,* Act 4, Scene 8, l. 46. Si tibi est machaera, et nobis veruina est domi.

The *soliferreo* is a kind of weapon entirely of iron which the soldiers used to throw at their first assault. Livy mentions it in the fourth book of the Macedonian War.

Fonda (sling) is made of a double cord and is somewhat wide where it is bent, and being weighted with a stone and then turned twice in rapid succession by the arm it releases one of the cords, and the stone flies with a noise through the air as if it proceeded from a catapult. Flavius [1] says that it is found among the inhabitants of the Balearic Isles, that they have supreme skill in the use of it, and that the mothers do not allow their children any other kind of food than what has been brought down by them as a mark with a stone shot from a sling. Pliny on the other hand says that this sling was invented by the Syrophoenician peoples.

Glande are leaden balls shot with catapults and slings. B 9 r.

Auctori according to Celidonius are sickle-shaped weapons with a cutting edge on one side only and the length of a braccio. They have the handle forked after the fashion of the tail of a swallow. They are not carried in a sheath but bare, attached to the girdle.

Danish are a rather long kind of hatchet: they are said to have been much in use among the Danish peoples. But what has to be taken into account with respect to instruments of warfare made of iron is that that which has been steeped in oil will have a fine edge, and that which has been immersed in water will be rough and brittle. Those which are soaked in the blood of a goat will be the hardest. Oil, white lead and pitch preserve iron from all rust.

Falce (scythe) is of iron, crescent-shaped, and with a staff fastened to one of its horns. This weapon was much in use among the Thracians and in naval combats no less than on land. It was afterwards converted for the use of husbandmen and peasants.

They were used by the Romans upon their ships; unheard of in size and skilfully manipulated by means of ropes they severed the ropes of the lateen yards as though they were razors, and caused the sails to fall at the same time as the yards, so that what ought to have been a help to the enemy was a great hindrance to them.

Fragilicha is a ball half a foot across, filled with small barrels made

[1] Flavius Josephus? (Ravaisson-Mollien).

of paper and crammed with pepper, sulphur and . . . of Corsica (*conocorsico*). And whoever receives the smell of it falls in a swoon; and in the centre of this ball is the powder of a bombard which when kindled sets fire to all the barrels, and when it is first thrown among the troops with a sling the fire catches a wisp of straw, and the sparks proceed to spread over a space of a hundred braccia. B 9 V.

CAR WITH SCYTHES

[*Drawing*]
These cars armed with scythes were of various kinds and often did no less injury to friends than they did to enemies, for the captains of the armies thinking by the use of these to throw confusion into the ranks of the enemy created fear and loss among their own men. Against these cars one should employ bowmen, slingers and hurlers of spears, and throw all manner of darts, spears, stones and bombs, with beating of drums and shouting; and those who are acting thus should be dispersed in order that the scythes do not harm them. And by this means you will spread panic among the horses and they will charge at their own side in frenzy, despite the efforts of their drivers, and so cause great obstruction and loss to their own troops. As a protection against these the Romans were accustomed to scatter iron caltrops, which brought the horses to a standstill and caused them to fall down on the ground from pain, leaving the cars without power of movement. B 10 r.

FOR PASSING A RIVER

You ought when you wish to make the passage of a river with an army to make use of wine-skins attached to the saddle, and, as the horses are not able to swim much on account of the waves leaping up, you should carry an oar fastened to the neck behind so that [the rider] can work it when necessary. B 10 V.

[*With drawings: flammea, pilocrotho, arzilla, crusida, lampade, astula*]
The *flammea* is a ball put together in this manner: Let the following things be boiled together, the ashes of willow, saltpetre, aqua vitæ, sulphur, incense, and melted pitch with camphor, and a skein of

Ethiopian wool which after merely being soaked in this mixture is twisted into the shape of a ball and filled with sharp spikes and thrown on ships with a cord by means of a sling.

This is called Greek fire, and it is a marvellous thing and sets fire to everything under the water. Callimachus the architect was the first to impart it to the Romans, by whom it was afterwards much employed and especially by the Emperor Leo, when the eastern peoples came against Constantinople with an infinite number of ships which were all set on fire by this substance.

Pilocrotho, arzilla, crusida, flammea, lampade, although they differ are nevertheless almost of the same substance, and their fire is similar to that spoken of above, that is of the *flammea* except for the addition to the said composition of liquid varnish, oil of petroleum, turpentine and strong vinegar, and these things are first all squeezed together and then left in the sun to dry, and afterwards twisted about a hempen rope and so reduced to a round shape. Afterwards it is drawn with a cord, and some bury the point of a dart in it, transfixing it after having wetted the dart, some bury very sharp nails within it; and a hole is left in the said ball or mass for the purpose of setting it on fire and all the rest of it is smeared with resin and sulphur. Our forefathers made use of this compound pressed tightly together and bound to the end of a spear, in order to ward off and resist the impetuous fury of the enemy ships.

Lucan says that Caesar used to make this fire in order to throw it by means of lamps upon the ships of the Cerusci, a people of Germany; he burnt not merely the said ships, but the buildings constructed upon the borders of the sea were consumed by a similar fire. B 30 V.

The *folgorea* is a mortar with an opening in its tail circular in form, in the centre of which occurs a thin *chanicula* [chamber?] of iron finely perforated, with the hollow of it filled with fine powder; and it is made thus for two reasons, first, that when it reaches the centre of this ball, the fire, which passes through the chamber, lights in an instant all the rest of the powder that finds itself pressed within this ball, secondly, so that the hole of the mortar may not become worn. And this round opening will not resist the might of the powder unless it is made of fine copper, but the rest may be made with four

parts tin to every hundred of copper, and this is the best machine
that it is possible to make. B 31 r.

The *clotonbrot* is a ball thrown by a *trabiculo*, that is a lesser
mangonel which is a braccio high and filled with the ends of cartridges
packed all together in a tiny space. It is used for throwing into a
bastion and there is no remedy that avails against its pestilential effect,
but for this purpose its use would be a mistake because it does damage
to you as well as to the enemy. And if you throw six or eight of these
balls among the enemy you will certainly be the victor, so it is good
to throw it in the midst of them, and light the fuse within which will
at last set fire to the centre of all the sticks.
This is for ships.
When the ships are engaged, have fuses to keep the enemy back,
and at that moment throw balls full of lighted fuses among the
enemy, that is to say upon the ships, and the enemy being occupied
in protecting themselves from the fire will abandon their defences.
 B 31 v.

*[With drawing of two cannon placed vertically with stand between
them]*
Whoever wishes to make trial which is the better must raise them
on end and two judges should be in the centre, and after first firing
the one it must be noted how much time there is from the explosion
to the return of the ball to the ground and then the same is done with
the other and the one which takes longer will have the honour.

But see that the tubes are of equal length, that the touch-holes work
freely, that the balls are of the same weight, and the powder is from
the same keg. B 32 r.

[With drawing]
If you wish to be able to ford a river with your army when you
please you will proceed as follows:—make a boat of osiers of willow
and make it with the brims double in such a way that they open from
below, and fill the body of it with gravel. And when you are at the
place that you wish, open the store of gravel from below so as to cause
it to fall to the bottom; after doing this close the receptacle and return
to the bank to reload. You will need to have a number of these

machines, but the actual body of the boat should be bound outside with oxhide to prevent it falling to the bottom.

[With drawing]

To make an airgun which shoots with marvellous force you should proceed as follows:—stretch a steel wire the width of a finger on a wire-drawing machine by means of a windlass; then temper it, and beat round about it two plates of fine copper which you stretch on the wire-drawing machine. Then half to half solder them together with silver, wind thick copper wire about it and then smooth it with a hammer, but first solder it. And do this three or four times in the same way. And make [the airgun] two braccia long and make it so that it can shoot a dart of a third of a braccio which is of steel. B 32 v.

The *architronito* is a machine of fine copper, an invention of Archimedes, and it throws iron balls with a great noise and fury. It is used in this manner:—the third part of the instrument stands within a great quantity of burning coals and when it has been thoroughly heated by these it tightens the screw *d* which is above the cistern of water *a b c*; and as the screw above becomes tightened it will cause that below to become loosened. And when consequently the water has fallen out it will descend into the heated part of the machine, and there it will instantly become changed into so much steam that it will seem marvellous, and especially when one sees its fury and hears its roar. This machine has driven a ball weighing one talent six stadia.

 B 33 r.

[Fire-ball] *[With drawing]*

This ball should be made of melted pitch, sulphur and tow of hemp rubbed together so that when it burns the enemy may not carry off the invention.

This ball should be two and a half braccia in height and filled with tubes which can throw a pound of balls, and these should be coated with pitch within the tubes so that they do not fall.

The tubes should be a braccio in length, and made of pasteboard after the manner of spokes, and the space between them should be filled with plaster and wadding; and the ball should be thrown upon the bastions by means of a mangonel.

The centre of it will be a cannon-ball to which the tubes serve as

good epaulets, or a hollow ball of bronze which may be partly filled with powder, with its circumference perforated so that the fire is able to penetrate to the tubes; and the ball should be all tied up on the outside except for a hole to serve as a passage for the fire. B 37 r.

[*With drawings*]

Cortalds (short pieces of artillery) are good against big ships.

The serpentine (*passavolante*) is useful for light galleys in order to be able to attack the enemy at a distance. It can throw four pounds of lead and ought to be as long as forty cannon balls.

This spontoon will fasten the instrument into the ship if the blow is great.

This *zepata* is good for setting fire to ships which have kept a block-ade after having besieged some harbour or other ships in the harbour, and it should be made thus: first wood a braccio above the water, then tow, then powder as used for a bombard, then tiny faggots and so gradually larger ones; and put iron wires and burning rags on the top; and when you have the wind as you want it direct the rudder. And as the fire *m* spreads in the ship the bent wires will set fire to the powder, and it will do what is necessary.

It is also useful for setting fire to bridges at night, but make its sail black. B 39 v.

NAMES OF WEAPONS

Acinace. Acinace is the name of this knife: it was so called among the Scythians and Medes, according to the statement of Acro.

Daga. This among the Ligurians was called daga.

Ensis. Gladius. Ensis and *gladius* are a kind of weapon, and, accord-ing to Quintilian in the tenth book of his Institutions, they are the same thing.

According to Pliny in the sixth book of Natural History, the *gladius* was invented by the Lacedaemonians.

According to Varro, when the *gaesum* (javelin) became obsolete the *gladius* was used in its place. It has been called *aclis* because it was used for the destruction and death of the enemy.

Spada, ensis, and *gladius* are names of arms universally known and especially among the ancients.

Arpa. Arpa, according to Lucan in the ninth [book], is said to be a sword of the shape of a sickle with which Perseus slew the Gorgon. The bows were called *manubaleste*. B 41 r.

Lingula, according to what Naevius says in one of his tragedies called *Ceisonia*, was the name of a small knife of the shape of a bird's tongue.

Machaera is a kind of long weapon with one part of it sharpened. Caesar mentions it in the second of his Commentaries.

Stragula is a kind of lance for throwing and for using with the hand. Caesar mentions this also in the second of his Commentaries.

Doloni are a kind of weapon mentioned by Plutarch in the life of Gracchus.

Others are of the opinion that *doloni* are whips with daggers concealed in their handles.

Sica is a small knife used by *assassins* in ancient times, who were called *sicarii* from the name of the knife according to Quintilian in the ninth book of the Institutions. [1] B 41 v.

Pugio, according to Pompeius Festus, is a short double-pointed knife.

Varro says that *pugio* is the name given to a long lance with iron.

Clunade (*clunaculum*) is a sacrificial knife.

Secespita is a long knife with a round handle made of a piece of ivory and ornamented with gold and silver. It is used by the high priests and the flamens for the sacrifices.

Some say it is the axe (*scura*) and some that its edge resembles that of the manara.

Mucro is identical with *ensis* and *gladius*, according to Priscian in the second book of the Ars Grammatica.

Aclides, according to the opinion of Servius, are a kind of weapon so ancient as to have been entirely overlooked in war. Nevertheless we read that they were pieces of wood, some half a cubit in length and some circular; and in them were fixed iron points which were sharp and projected; and they were hurled among the enemy with a cord or leathern thongs, and he who received the blow soon knew who had given it. B 42 r.

[1] cf. 'per abusionem sicarios etiam omnes vocamus, qui caedem telo quocumque commiserint.' Quint. 10, 1, 12.

Telo (*telum*) was the word generally applied by the ancients to all those things which in war were suitable to be thrown with the hands, such as darts, clubs, arrows, spears, lances, stakes and stones.

Veruto. The *veruto* (*verutum*) (javelin), according to Nonius Marcellus, is a small weapon and very straight.

Fusti. Fusti (*fustis*) (club) were the first weapons that the human race used, and they are today called stakes by countryfolk; and their points were somewhat charred.

Baculo. The *baculo* (*baculum*) is a stick without a hook to it with which unhappy slaves were beaten.

Haste (*hasta*) (spear) is said to have been invented by the Lacedaemonians. They are excellent and . . .? (*plestante*) when made of ash or hazel, but better still when made from the service tree, because this is more supple and flexible.

Astili are the smaller lances which are thrown deftly with the hands.

Cuncti (*conti*) are very long and stout pikes without iron but having their point sharpened. Lucan makes mention of them.

Lancea. Pliny says of the lance that it was invented by the Aetolians. Varro says that *lancia* is a Spanish word. B 42 v.

Pilo (*pilum*) was a spear in use among the Romans, resembling the *gaesum* of the Gauls and the *sarissa* of the Macedonians. And these spears were divided in their length in two equal parts and the heads were placed at each end. They were joined together with fish glue and at every half cubit bound with gut. Writers say that these spears were so perfect that if they were suspended by a cord in the form of a balance they did not bend. And if one first draws it back and then drives it forward with fury there is no armour of sufficient strength to resist it. They were much in use among the Bretons.

Giese (*gaesum*) is a weapon used by the people of Gaul, and they are no less useful for hurling than for use in any other way.

Ruma, pilum, rumex and *telum* resemble each other and resemble also the sparus of the Gauls.

Jaculo (javelin) is said to have been invented by Ætolus the son of Mars, and to this Hermes, Varro, Pompeius Festus bear witness, affirming that javelins are rude and fashioned by rustics of poor mean condition but suitable for scattering on all sides. B 43 r.

Sarissa. Sarissa, according to Pompeius [Festus], is a Macedonian spear.

Gabina. Gabina is the name given by the Illyrians to a certain kind of weapon of the shape of a hunting-spear (*venabulum*) or pike.

Securis (battle-axe) is called also *semicuris* or *semiquiris.*

Tragula. Tragula is a spear with a very sharp point of the shape of a javelin or dart which can be thrown by the hand according to Varro, Pompeius, and Caesar in the fifth of the Commentaries.

Clava. Clava [club] is a kind of weapon which was used by Hercules, and it was so called because it was a big strong stick studded with sharp nails, and this in these rude times would be considered a very magnificent weapon.

Cathegia. [Boomerang?] Some believe this clava to have been the *cathegia* which Horace calls *caia* and that the *cathegia* was a kind of dart in use among the Gauls which comes back at the wish of the thrower. According to Virgil it was greatly in use among the Germans; the knights made a great use of it against the infantry. B 43 V.

Dolabra, that is, double-cutting.

It is called two lips (*labbri*) after what Livy states in the eleventh book [1] of the Punic War, where he relates that Hannibal sent five hundred Africans armed with these in order to lay waste to their foundations the walls of a town.

Bipenna. This weapon is so called because it has a sharp edge on both sides. The term is usually applied to it by Quintilian, in the first book of the Institutions. B 44 r.

The cross was invented among the Germans, and this weapon is said to be in the front rank of deadly weapons, seeing that if it is thrown either with a cord or without among the ranks of the enemy it never falls there in vain. And this because it runs edgewise through the air and if it does not catch the enemy with one of its points it catches him with two, or not finding the enemy there it is driven into the ground, where it inflicts no less damage upon the enemy than if it

[1] As M. Ravaisson-Mollien has stated, the passage referred to is in Book XXI, para. xi, but as however Books XI to XX have been lost, Book XXI follows X. '. . . tum Hannibal occasionem ratus, quingentos ferme Afros cum dolabris ad subruendum ab imo murum mittit.'

struck the horses and the footsoldiers. From four to six of these are carried round the belt when one goes into the combat.

[*Drawing of caltrops with cord and thong*]

This method was much in use among the Jews and the neighboring peoples of Syria. And they throw them with cords and long thongs among the enemy on finding themselves vanquished and routed by them; whereby they being thrown down are made to cease their course.

And they also sow them upon their own line.

Telico. These were in use among the first men; and they were made of cane, that is to say that having taken a piece of cane with two knots they split one through the middle and used it as the feather of the arrow; and the other they made into a point and filled it with earth so as to weight it, and they threw these by means of a cord. B 44 v.

Scourge (*flagellum*). This also was among the number of the primitive and rustic arms.

Scythian arrow. The arrow is a simple weapon which was much in use among the Arabs. It was invented by the Scythians, and consists of a piece of green wood of which the end has been burnt; and it may be thrown either by means of a cord or without. If it is held it may be used also as a javelin.

Ganci, ruffili and *roncili* are maritime weapons in use among pirates. By means of hooks they are accustomed to grapple the edges of ships, and if any of the ship's defenders should approach them they wound them and drive them before them, and then return to the edges where they were before and dig them deep into the ships so that they cannot escape. B 45 r.

Sirile is a very long spear; it was found among the Numidians. They often used it in order to throw down their enemies, and they rode on horseback without saddle or stirrup, armed only with a doublet stuffed with cotton over which were fastened the hooks of the long sirile; and [the enemy] taken by surprise were easily thrown down.

Cariffe is a broad spear with which one can attack from afar. And if it should come about that the combustible ball should be captured, the soldier can start it by striking it with the sharp iron point that is at the

head of the spear, and thus recovering it would scourge the wretched soldiers [of the enemy].

Miricide is a spear three braccia in length, and five braccia and a half when extended: the soldiers use it in the way in which rustics thresh corn.

Malcoli, according to Ammianus Marcellinus, are a kind of dart or arrow. The stem is of cane and where the cane ends a distaff is joined like that used for spinning, and on this distaff the iron is fixed. Tow steeped in pitch should be placed in the hollow of the said distaff, and it should be set fire to and thrown gently so that the rush of the air may not extinguish it. Some say that within this cavity there should be an inexhaustible store which should consist of resin, sulphur, and saltpetre which should have been liquified with oil of laurel, or some say petroleum oil[1] and fat of duck, and marrow of meat, and fennel, and sulphur, resin and camphor with . . . [rasa?] and tow. This mixture among the ancients was called combustible, that is something suitable to burn, also tow, fat, and petroleum. B 45 V.

The *Manara* was much in use among the Romans.

Irish and English bows. But the Irish in place of one corner of the bow have a piece of sharpened iron of the length of a cubit.

The English and the Irish are almost the same length, that is four braccia each.

Syrian bow, made of horns of buffalo.

German bow, made of two pieces of steel and how they are set.

The dart of the cross-bow works in this manner: namely, when the arrow issues forth from the cord and passes over the roller, the ring at the extremity of the arrow causes it to leap back after it has struck; but the iron continues and performs its function.

The dart of the bow by which the arrow remains attached to the cord is an awl a quarter of a braccio in length, all of iron finely tempered; the feathers of the tail come away from the arrow as it flies on its way. Some there are which make a prick resembling that of a needle full of poison. B 46 r.

[*Drawing—soldier on horseback galloping*]

This is a mounted carabineer which is an extremely useful inven-

[1] MS. *olio petrolio.*

tion. The said carabineers should be provided with pouches full of rolls of plain paper filled with powder, so that by frequently inserting them they subdue the excessive numbers of the enemy. And these carabineers should stand in squadrons as do cross-bowmen, so that when one part fires the other loads; but first make sure that you have accustomed the horses to such noises; or else stop up their ears.

Order of mounted cross-bowmen on the open field: *m n* are cross-bowmen who as they turn left draw back loading, *r t* are those who go forward with cross-bows loaded, and these four files are for one route; *a b* are four files of cross-bowmen who turn with bows unloaded in order to load them anew; *c d* are those who come upon the enemy with their bows loaded; and this arrangement of eight lines is employed in open field.

And have it so that those who have unloaded come through the centre, so that if sometimes they have been routed by the enemy the cross-bowmen who are loaded, holding themselves on the flanks, may cause greater fear to these same enemies.

Order of mounted carabineers:

See that they are well supplied with guns with a thin single fold of paper filled with powder with the ball within, so that they have only to put it in and set alight. Being thus ready they will have no need to turn as have the cross-bowmen when they are preparing to load. B 46 v.

If anyone had formed the design of capturing a tower situated on the sea, he would cause one of his followers to take service with the commander, and when the guard was withdrawn he would affix to the battlements the rope-ladder given him by the enemy and would fill the walls with soldiers. In order to prevent this, you should divide the tower into eight sets of staircases, spiral in shape, and divide into eight parts the ramparts and the soldiers' dwellings below; then, if one of the mercenaries should be disposed to be a traitor, the others cannot hold communications with him, and the section of the rampart will be so small that there will not be able to be more than four there. The commander, whose quarters are above those of all the others, can drive them out by attacking them from the machicolations, or shut them up by means of the portcullis and then put smoke at the entrance

to the spiral staircases. On no account is it necessary that any alien soldier should lodge with the commander, but only his own family.

<div style="text-align: right">B 48 r.</div>

The confederate of the scaler of the wall should carry with him a ball of strong thread when he takes service with the commander, and when the opportunity comes the guard will draw up with this thread a coil of strong twine which has been given him by the scaler, and then with the twine he may draw up the rope which will afterwards be useful for drawing up the rope-ladder as shown above. B 50 r.

NAMES OF ENGINEERS

Callias of Rhodes.[1] Epimachus the Athenian.[2] Diogenes, philosopher, of Rhodes.[3] Calcedonius of Thrace. Febar of Tyre.[4] Callimachus, architect, master of fire.[5]

Fireball worked up:—take tow smeared with pitch and turpentine and linseed oil and twist it round about in such a way as to make a ball; and over it place hemp soaked in turpentine of the second distilling. And when you have made the ball make four or six holes in it as large as the thickness of your arm, and fill these with fine hemp soaked in turpentine of the second distilling and powder for the bombard; then place the ball in the bombard.

[*An arrow of fire*] [*Drawing*]

This is a dart to be shot by a great cross-bow laid flat, and the two

[1] Greek architect, of Arados. Built a great crane for the Rhodians which was intended to hook up and raise in the air the battering engine (ἐλέπολις) used by assailants. (Vitruvius X, 16, 5.)

[2] Architect employed by Demetrius Poliorcetes to construct a battering engine so large that the machines of Callias were useless against it. (Vitruvius X, 16, 4.)

[3] (Diognetus—Ravaisson-Mollien.) Identical perhaps with Diognetes who according to Plutarch (Life of Demetrius) on being appealed to by the Rhodians in this emergency constructed subterranean trenches in which the ἐλέπολις of Epimachus became embedded, thus forcing Demetrius to raise the siege.

[4] See B 51 r.

[5] Sculptor, painter, architect. Famous for his bronze casts (Pliny XXXIV, 8, 19). Inventor according to Vitruvius (IV, 1, 19) of the Corinthian capital; according to Pausanias (I, 26, 7) of a method of boring marble and a lamp of gold which used to burn day and night before the statue of Athene in the temple of Athene in the Acropolis, the wick being formed of some kind of asbestos that was never consumed. It is to this invention that the words 'master of fire' have reference.

corners have the things which produce fire bound in linen cloth; and as the point buries itself the corners are pressed closer together and set fire to the powder and the tow that is soaked in pitch. This weapon is good for use against ships and wooden bastions and other similar constructions; and no one will make good work in this business of burning unless the fire is kindled only after the dart has struck, because, if you should wish to light the fire before, the violence of the wind will extinguish it on its way. B 50 v.

[*With drawings*]

A method of warding off the battering-ram with a bale of straw soaked in vinegar.

A method of intercepting the stroke of a battering-ram.

Heliopolim, a mural machine (battering-ram).

Cetra, a mural machine (battering-ram).

Febar of Tyre made use of this instrument in order to shatter the walls of Gades.

Flemisclot, a mural machine (battering-ram).

In order to make green fire take verdigris and soak it in oil of turpentine and pass it through the filter.

A way to make a cart on rollers which run upon a board or floor or hard ground: and this is for use to move heavy weights for a short distance. B 51 r.

This bombard ought to be somewhat wider at the mouth in order that the stones as they come out of it may scatter, and one ought to take a shell[?] (*cocone*) formed of the root of an oak in order to have a half ball for the bombard, and this will have a good effect in desperate cases. B 54 r

[*With drawing*]

Of the way in which when the battle is begun by scaling the walls one may draw beams up above the top of the battlements, and then by giving them a push cause them to fall upon the ladders and the assailants; and the method of drawing the said beams rapidly should be made use of in the manner shown here. B 55 r.

[*With drawing*]

To show how with a mangonel one can throw a great quantity of

burning wood upon ships together with pitch, or if you wish with stones or even with powder from a mortar, mixed with straw and vinegar.

Let these pieces of wood be bound and interwoven with fine iron wire fastened together with a chain. B 55 V.

[With drawing]

How one ought to defend oneself against a furious attack by soldiers who are attacking a hill fort. Namely by taking barrels and filling them with earth and rolling them down the slope upon the enemy, for these will be of great benefit to those who have despatched them. B 56 r.

[With drawings]

This shield should be made of fig-wood inside, with cotton of the thickness of a quarter of a braccio outside it, and outside the cotton it will be well to put fustian with a coat of varnish; or if you make the outside of cotton and the inside of isinglass and tragacanth and varnished, with half the amount of cotton, plain and compressed, with nails going from one surface to another, it will be satisfactory, and you can dry it in a press.

These balls should be filled with small dust of sulphur which will cause people to become stupefied.

This is the most deadly machine that exists: when the ball in the centre drops it sets fire to the edges of the other balls, and the ball in the centre bursts and scatters the others which catch fire in such time as is needed to say an Ave Maria, and there is a shell outside which covers everything.

The rockets of these balls should be made of paper, and the space between each filled with plaster ready to be moulded, mingled with the clippings of cloths. And they should be set alight with a pair of bellows which will cause the flame to extend to the centre of the ball among the powder, which separates at a considerable interval from each other all the balls filled with rockets.

Wheel full of tubes of carbines for foot-soldiers. B 59 r.

HOW TO SCALE A FORTRESS BY NIGHT

[*With drawings*]

If you have not any information from within as to who will draw up the rope-ladders, you will ascend first by placing these irons in the crevices a braccio's space apart in the manner shown above.

And when you are at the top, fix the rope-ladder where you see here the iron *m*; let it be bound with tow so that you do not make any sound and there remain. Then if it should seem that you ought to draw up other ladders, do so; if not, cause the assailants to ascend quickly. The hook which is attached to a brace of ropes has above it a ring to which is fixed a rope, and this is drawn up by a jack to the iron above, and to this you attach a second time the hook of the above-mentioned braces.

These ladders are made to carry two men. They are also useful for a tower where you are afraid lest the rope-ladder may be detached by the enemy; they should be driven so far into the wall that three eighths [of a braccio] is buried and one eighth is free. These pyramidal irons should be half a braccio in length and their distance apart half a braccio. B 59 V.

[*With drawings*]

SACKS FOR USE IN CROSSING OVER WATER

It is also necessary to reflect how one ought at one's convenience to make the passage of rivers. First set a man upon two bags bound together, then if you find the bottom to be suitable and that the river is dangerous through the rapidity of its course make use of the method represented below.

If the river is dangerous by reason of its current you should set two lines of horses across the river at a distance of six braccia one from the other, and the horses in the lines should be so near as almost to touch each other, and the line or company of horses should have their heads turned towards the current of the water, and this is done solely in order to check and break the fury and impetus of the water. And between the one company and the other pass the soldiers both those with and those

without arms. The company that is higher up the stream should be made up of the bigger horses in order to be better able to stem the rush of the river, that lower down serves to hold up the soldiers when they fall, and to act as a support for them as they make the passage.

<div align="right">B 60 v.</div>

[*With drawing*]

Make shelters by interlocking shields to withstand the fury of masses of arrows.

The method in which the Germans when in close order link together and interweave their long lances against the enemy, stooping down and putting one of the ends on the ground and holding the other part in their hands.

[*With drawings*]

If the water is so high that infantry and cavalry cannot pass, the river should be diminished by leading off many streams, as Cyrus, King of the Persians, did at the taking of Babylon upon the river Ganges [*sic*] which at its maximum breadth is ten thousand braccia, Alexander likewise upon the same river, Caesar upon the river Sicoris.

If it should come to pass that the river was so deep that one could not cross it by fording, the captain ought to make a sufficient number of streams to carry off the water and afterwards give it back below to the river, and in this way the river would come to be lowered and could be crossed with ease. Alexander employed this method in India against King Porus at the passage of the river Hydaspes, and Caesar did the same in Gaul (and also in Spain) upon the river Loire; having arranged his cavalry in two companies he caused the soldiers to pass through the middle of them. Hannibal did the same on the Po with elephants.

<div align="right">B 61 r.</div>

[*With drawings*]

The Egyptians, the Ethiopians and the Arabs in crossing the Nile are accustomed to fasten bags or wine-skins to the sides of the forequarters of the camels in the manner shown below.

In these four rings in the net the baggage-camels put their feet.

The Assyrians and the inhabitants of Euboea accustom their horses to carry sacks in order to be able at will to fill them with air. They carry them instead of saddle-bows above and at the side and well covered

with plates of dressed leather, so that a quantity of arrows will not penetrate them, since they are no less concerned about a safe means of escape than the hazard of victory. Thus equipped a horse enables four or five men to cross at need. B 61 v.

[*How infantry cross rivers*]

If it should come to pass that infantry have to pass a river which is dangerous by reason of the force of its current, this is a sure way:—let the soldiers join arms one with another and form themselves into a line after the manner of a stockade, linked together by their arms; and let these files advance along the line of the water and let no one go across its course, and this is a sure way because the first being above the water is the one who sustains its first onset, and if he was alone the water would throw him down, but all the others below him hold him up and use him as their shield; and so by this means one after another they cross in safety. So it is with all: and if the fall of the river is from right to left each man in the file as he proceeds from the first to the second bank ruffles the course of the stream with his right shoulder, and on his left he has the right shoulder of his companion and the flowing water. B 62 r.

NAVICULA

[*With drawings*]

The small boats in use among the Assyrians were made of thin branches of willow, plaited over rods also of willow, arranged in the shape of a small boat, plastered over with fine dust soaked in oil or turpentine and so reduced to a state of mud; this was impervious to water and was not cleft asunder by blows because it always remained supple.

Caesar covered this kind of small boat with oxhide when crossing the Sicoris, a river of Spain, according to the testimony of Lucan.[1]

[*With drawing*]

The Spaniards, the Scythians and the Arabs, when they wish to con-

[1] The reference is to Lucan's *Pharsalia* IV, 130, etc.

> Utque habuit ripas Sicoris camposque reliquit,
> Primum cana salix madefacto vimine parvam
> Texitur in puppim, caesoque inducta iuvenco
> Vectoris patiens tumidum superenatat amnem.

struct a bridge very quickly, bind the hurdles formed out of willow upon bags or wine-skins of oxhide, and so cross in safety. B 62 v.

The Germans, in order to asphyxiate a garrison, use the smoke of feathers, sulphur and realgar, and they make the fumes last seven and eight hours.

The chaff of corn also makes fumes which are thick and lasting, as does also dry dung; but cause it to be mixed with *sanza*, that is with the pulp of crushed olives, or, if you prefer it, with the dregs of the oil.

B 63 v.

[*With drawing*]

How to discharge a torrent of water on the back of an army and the bridges and walls of a town.

If you wish to submerge a battlefield or to break through walls without the use of cannon and have the use of a river, do as is represented above. That is you set piles as high as the bank of the river and put them half a braccio apart or farther if you have wider planks; then set these planks between each of the piles and so fill up [the spaces]. When these are filled up raise the connecting rod *M*, then *a* the upper part of the plank will go forward and *b* the lower part of the plank will go back. In this way the parts of the said plank will be edgewise and the water will be free to escape. And make the sluices all to open at the blow of a carbine or other signal so that they may all open at the same time, in order that the flow of the water upon the object which opposes it may be driven by a greater blow and a more impetuous force. And if the river have a steep descent make one of these every half mile, and let each of the panels open by means of a rope to insure them working together, and in order that he who unlocks them may be in safety.

B 64 r.

[*With drawing*]

A METHOD OF CONSTRUCTING A BASTION [AT NIGHT]

If you should be making a bastion at night and have need of light, place these lights inside lanterns and raise them up on the top of long poles, in order that the enemy by firing at the lights may not touch the sappers. And the lights should be of oil so that they may last some time, and the lanterns should be balanced in lamp-stands in this way [*draw·*

ing in text] so that they do not upset when they are raised. And remember that the poles must be painted black and only erected at sunset, so that the light is scarcely visible and the raising of it up is hardly seen by the enemy. And it should be done as noiselessly as possible, and there should be one overseer with a staff for every five sappers, so that the work may be rapid. B 70 r.

In what way one may storm a bastion which has been made in order to close a passage.

Make portable sections of bastions for a furious attack by the men; these should be filled with hay and they should be pointed in front in order that the blows of the artillery may do no damage, and joined together so as to make the bastion of such a size as to engage all the mouths of the artillery and the discharge from the bridges, they will be able to engage the enemy with advantage. B 75 v.

[How to attack a fortress by subterranean galleries] [With drawings]

Rod filled with rockets for encountering the enemy at the outlet of a subterranean gallery [that opens] from below upwards, which will clear the ground of the men within the entrance.

Rod with rockets for placing in a gallery that leads into a cellar which would be in a fortress and would be well guarded.

m a b. The way of a winding gallery that will deceive the enemy when besieged.

We can clearly understand that all those who find themselves besieged, employ all those methods which are likely to lead to the discovery of the secret stratagems of the besieger. You therefore who seek by subterranean ways to accomplish your desire, reflect well how your enemy will be on the alert, and how if you should make a gallery on one side he will make a trench up to your [gallery], and this will be well guarded by day and by night, for it will be supposed that the secret way as is natural, has its outlet in the said gallery.

When therefore by your digging operations you show that you wish to come out in one particular spot, and by making the circuit of the fortress you come out at the opposite side, as it is shown above in *m b a*, *b* will be when you are almost at the outlet in a cellar that is *a*. You will have a great reserve of men who on the breaking of the wall that is between you and the cellar . . .

When you have made your gallery almost to its end and it is near to a cellar, break through suddenly and then thrust this [rod] in front of you filled with rockets if you find defenders there, but if not do not set fire to them lest you make a noise. B 78 r.

[*With drawings*]

Stlocladle. Place in the centre powder formed of dried fungi.

These balls filled with rockets are to be thrown within the bastions of the enemy.

The *stlocladle* is a ball a foot wide which is made up of hemp and fish-glue and is covered with the tails of rockets, and these tails do not exceed in length the length of a finger, and each tail is of fine copper veined or of sized pasteboard, and all the said tails have their extremities pierced by a tiny hole, and they are all attached to a copper ball which is full of many paths after the manner of a labyrinth, filled with powder; and the said paths are full of holes that cross them which meet with the holes of the rockets.

Then one sets fire to it by means of a bellows and the fire hurls itself through eight holes so that no one can control it or . . . [*ariegi?*], and when the fire has penetrated to the centre the rockets begin suddenly one after another with a dreadful din to spit forth their deadly missiles. If you wish to make use of it on a galley make the rockets of pasteboard, and fill the space between each with pitch mixed with powdered sulphur; and this will serve three purposes: first it will do harm with the rockets, second it will kindle a fire there which cannot be put out, and will burn the wood, and (third) no one will be able to approach it because of the great stench.

Buffonico. The *buffonico* is an instrument set at the end of a lance. It is two braccia long and an eighth of a braccio thick. It is shod with iron and has a thin tube with the sight placed on the extremity through which it passes to the fire.

First of all fill the cannon with the powder well crammed, pressed, and beaten through the mouth *a b*, then make a small hole an eighth of a braccio long and insert a small tube with a very fine hole. The powder should be fine and mixed with dust of lead made with a file or by fire; and it will cause great terror and loss to the horses and to the enemy. B 80 v.

Vinea. The *vinea* is a machine which makes the road and levels the embankments. B 82 V.

[*With drawing of tank*]

These take the place of the elephants. One may tilt with them. One may hold bellows in them to spread terror among the horses of the enemy, and one may put carabineers in them to break up every company. B 83 V.

THAT MURAL ENGINE WHICH MAKES THE LOUDER NOISE HAS THE LESS FORCE

This is proved by the ninth, 'Concerning Percussion', which says: of things movable, in proportion to the power of the mover and the resistance of the medium, that which in like movement strikes with a larger part of itself will make a louder noise and a less violent impact; and that on the other hand which strikes with a less part of itself will make a less noise and penetrate farther into the place where it has struck. An example has been cited of a sword striking first with the flat and then with the edge, for in the one case the stroke makes a great noise and penetrates a very little way and in the other it penetrates a long way and makes but little noise. As the flame therefore is in proportion to the projectiles driven by the pieces of ordnance which are thus in the medium proportioned to them, that flame which separates least after emerging from the piece of ordnance will be that which will drive the ball out with most impetus, and the flame that separates rapidly will do the contrary.

OF PIECES OF ORDNANCE THAT HURL MANY BALLS AT ONE DISCHARGE

A piece of ordnance which throws a ball a distance proportionate to its force, will in the same time throw six of the same balls a sixth part of the aforesaid distance. E 27 V.

OF PIECES OF ARTILLERY AND THE WEIGHTS OF PROJECTILES PROPORTIONATE TO THEIR FORCE

Of the chambers or receptacles for powder of pieces of artillery one finds three varieties of shapes; of which one is wide at the bottom and

narrow at the mouth; another narrow at the bottom and wide at the mouth; the third is of uniform width.

There are four [?five] places at which one sets fire to pieces of artillery. Of these one is the extreme upper part of the bottom of the chamber; another is at the middle of the bottom of this chamber; the third is as far removed from the bottom of this chamber as half the diameter of the circle of this bottom; the fourth receives the fire in the same position as the third but in the centre of the thickness of the powder; in the fifth the chamber is round and the fire is set in the centre of the chamber. But this instrument and the others which set the powder alight in very quick time ought to be of fine substance and well compressed. This compression occurs very rarely when the cast is of great thickness, because in the case of these the metal remains liquid longer in proportion as they are thicker, and because the parts of it which are most distant from the centre of this thickness are those which are compressed first. E 28 r.

[*Ancient military terms*]

Chiliarch = captain of thousand

Prefects = captains

Legion = six thousand and sixty three men. H 95 [47] v.

[*Of the trajectory of a bombard*]

If a bombard hits a mark in a straight line at ten braccia how far will it fire at its greatest distance?

And so conversely if it fires three miles at its greatest distance how far will it carry in a straight line?

If a bombard fires at different distances with different curves of movement, I ask in what section of its course will the curve attain its greatest height. I 128 [80] v.

[*Bombards*]

If with its maximum power a bombard throws a ball of a hundred pounds three miles, how far will it throw one of two hundred or three hundred or any other weight more or less than a hundred?

If a bombard with four pounds of powder throws a ball weighing four pounds two miles with its maximum power, by how much ought I to increase the powder for it to carry four miles?

If with four pounds of powder a bombard hurls a ball of four pounds two miles how far will six pounds of powder hurl it? I 130 [82] r.

Of the movement of the cannon-balls of bombards, and of the nature of the stock and breech of these bombards.

Whether the ball moved by force will have a greater movement than that which is moved with ease or no.

Whether if a bombard can throw a ball of a hundred pounds it is better to put two balls of fifty pounds for one and make the stock narrow, or rather with the stock wide to throw one ball of a hundred pounds.

If the bombard can throw two or three balls with ease I ask whether it is better to make the ball long or no.

If a bombard throws a weight of a hundred pounds a distance of a mile, how far will it throw a hundred balls of one pound at one discharge?

Whether it is better for the bombard to be narrow at the mouth and wide at the foot, or narrow at the foot and wide at the mouth.

I 133 [85] v.

If the bombard rests on the ground or a stump, or straw or feathers, what difference will there be in the recoil?

If two bombards can be fired in opposite directions if the breach of the one be placed against that of the other in a straight line.

If the bombard is fired at sea or on the land what difference there will be in its power.

What difference there is between the movements made upwards or crosswise, or in damp or dry weather, or when it is windy or rainy or with snow falling, either against or across or in the direction of the course of the ball?

Where the ball makes most rebounds—upon stones, earth or water.

How the smooth ball is swifter than the rough one.

Whether the ball revolves in the air or no.

Of the nature of the places struck by these balls. I 134 [86] r.

For a bastion to have spring in it, it should have a layer of fresh willow branches placed in the soil at intervals of half a braccio.

K 93 [13] r.

[*Powder for a bomb-ketch*]

One pound of charcoal

eleven ounces of sulphur

five pounds of saltpetre.

And mix it well and moisten it with good brandy, and dry it in the sun or at the fire. Then pound it until one cannot see a speck of sulphur or saltpetre but it is all black and uniform and fine, and moisten it again with the brandy and keep it so. Dry it in the sun in grains and crush just so much as can be placed upon the hole, and this will be sufficient. L 4 v.

[*For digging trenches*]

[*With plan*]

At this commencement of the excavations of the trenches you have to place men according to the marks shown. And first of all make the excavation as far as possible from the place where the earth is tossed. For example, the earth is excavated at *a g*, it is carried along the line *r c*, unloaded by the line *c f*, and then the man turns back along the line *f d* and loads by the line *r d*, being always in movement.

There is no other movement here as useful as that which removes the soil from the place where the line *r c* is marked. L 24 r.

[*Fortifications*]

The wall fifteen feet thick at the base and thirteen above.

The trench forty two braccia wide at the bottom, fifty at its mouth; twenty braccia in height, with water four braccia deep. L 29 r.

Fifteen steps and a span from the battlements to the water, that is from the beginning of the battlements, and these steps are the distance from one extremity of the palms of the hands to the other, opening them as far as one can upon a rectilineal measure. And there are eight braccia and a sixth from the said beginning of the battlements to the summit of the turret. L 67 v.

[*Of digging a trench*]

Width of trench and its depth. Diameter of wheel and thickness of beam and cord. And position of men who turn it and number of men who work this wheel. How many there are in position and what weight they draw at one time, and how much time is required to fill and move

in order to empty and turn, and similarly how many shovelfuls one man digs out in an hour, and what a shovelful weighs, and how far he throws it away from himself either upwards, across or downwards, beyond the hillock. L cover r.

Which will fire the farthest, powder double in quantity or in quality or in fineness? M 53 v.

DRAWBRIDGE

[*Drawing*]
 Plan of drawbridge which Donnino showed me.
 And because *c* and *d* drive downwards, the space *a b* becomes twisted, consequently it ought to be strengthened by a thick iron bar bent over the wood on the opposite side. M 53 v.

[*Bombards and cross-bows*]
 If the bombard has a recoil of a quarter of a braccio how much will it lose in front of its true and suitable range?
 If the unlocking of the cross-bow is made with the cross-bow fixed or driven forward or drawn back, what will it lose or gain upon its natural range?
 Which of these bombards throws farthest and how far? M 54 r.

[*Breeches of bombards*]
 That part of the bronze is most compressed within its mould which is most liquid.
 And that is most liquid which is hottest, and that is hottest which comes first out of the furnace. One ought therefore always to make first in the casting that part of the cannon which has to receive the powder before that which has to contain the muzzle.
 A long breech is an embarrassment and fills up space uselessly and unserviceably and causes loss of speed. M 54 v.

[*Mines*]
 If you wish to find out where a mine runs set a drum over all the places where you suspect the mine is being made and on this drum set a pair of dice, and when you are near the place where the mining is the dice will jump up a little on the drum, through the blow given underground in digging out the earth.

There are some who having the advantage of a river or swamps upon their land have made a great reservoir near the place where they suspect that the mine may be made, and have made a tunnel in the direction of the enemy, and having found them have unlocked the waters of the reservoir upon them and drowned a great number of people in the mine. M.S. 2037 Bib. Nat. 1 r.

The shields of footsoldiers ought to be of cotton spun into thread and made into cords; these should be woven tightly in a circle after the fashion of a buckler.

And if you so wish the threads should be thoroughly moistened before you make cords of them, and then smeared with the dross of iron reduced to powder.

Then plait it in cords a second time with two, then with four, then with eight, and soak them every time in water with borax or linseed or the seed of quinces. And when you have made your cord weave the shield. And if you make a doublet let it be supple, light and impenetrable. MS. 2037 Bib. Nat. 7 r.

If it should happen when a town is besieged that the mines made by the enemy have not penetrated within it, you should place men with the greatest possible care at intervals of ten braccia in that quarter in which your suspicions centre, with their ears on the ground, and as soon as the tremor of the sound reaches them, let them make a very deep trench crosswise, which will be ready to swallow up the mine when it comes upon it. Then have ready a vessel of iron or copper perforated at the bottom, and in the hole have placed the nozzle of a smith's bellows, and then cover over the mouth with a plate of iron, perforated in many places, and fill it with fine feathers; and you turn the mouth in the direction of the mine when it is discovered and blow with the bellows, after having first caused the bellows to be mixed with sulphur and burnt, and the smoke that issues forth will drive away the enemy.

If however you do not wish to make the above-named trench within the circuit of the walls, in order not to interfere with the rounds of the soldiers who are defending the walls, you should make a drill as was shown above, and with this at intervals of two braccia you make a hole six braccia in depth, and make these in a circular line within the walls

following the circle of the walls, and let it be as long as you suspect the mine to be. And every hour you excavate these holes one by one and measure them afresh within with a rod, comparing with them the former measurements of the holes, and if the rod should sink down then know that the mine is there and cause them to dig there and there make your defence.

Or if you do not wish to make the test with the rod in order to discover a mine, go every hour with a light above each hole, and when you come to the hole which is above the mine the light will be immediately extinguished. MS. 2037 Bib. Nat. 8 v.

When besieged by ambitious tyrants I find a means of offence and defence in order to preserve the chief gift of nature, which is liberty; and first I would speak of the position of the walls, and then of how the various peoples can maintain their good and just lords. MS. 2037 Bib. Nat. 10 r.

Of the power of the bombard and the resistance of the object struck, that is that the ball will subdue a wall of one braccio and of two braccia and so of any thickness. Forster II 6 r.

OF MOVEMENT

Prove in the model of the mangonel, which does not become exhausted as does the cross-bow, and mark with the same weight to what distances the different weights thrown by it are carried, and further in respect of the throwing of the same weight see how to vary the counterpoise for the mangonel. Forster II 8 r.

Remember that the more powder there is in the carbine the more the length of the barrel is diminished, so that you have to pay attention to the proportions of your forces. Forster II 39 r.

If you wish to escape from a city or other closed-in place, fill the door-lock with powder from the carbines and set fire to it; also when about to scale walls it will be useful in driving the enemies from the battlements with its blaze. Forster II 49 r.

What substance is it which offers most resistance to the percussion of the bombard, i. e. to its passage? Forster II 53 r.

[*Drawing*]

Length ten braccia; ball an inch thick and ten long; the shape should taper somewhat.

Forster II 56 v.

OF MOVEMENT

That bombard discharges its ball to the farthest distance from itself which breaks its obstacles most.

Forster II 57 r.

Of the bombards narrow at the base and wide at the mouth, and so of those straight and those curved, and similarly of the tails narrow at the end and wide at the mouth; and the proof is by the flames when it is discharged.

Forster II 58 r.

OF PERCUSSION

Make a rule to apply to every description of ball, of iron as of lead or stone, how you ought to increase or diminish the amount of powder.

Forster II 62 r.

OF THE SPEED OF BOMBARDS WITH EQUAL TIME, POWDER AND WEIGHT OF BALL

Of many bombards equal in respect of powder and ball, that from which in equal time there is kindled a greater quantity of fire, will hurl its ball more swiftly and to a greater distance.

Of balls of equal weight that which is the swifter will seem heavier and will produce a greater percussion.

Forster II 71 r.

If the bombard has its stone flattened like a cheese, and the hollow of the bombard has a like shape, and the centre—the centre of the tail—does not encounter the centre of the stone, so that it goes revolving through the air, it will undoubtedly be exceedingly swift.

For if you take a ball of six ounces and a wheel of like weight without angles at its edges, you will see how much greater a distance the one will be sent by its mover than the other; and this is also due in part to the revolving of its additional substance. And this happens because as the balls are equal in weight, from being round it strikes more air and finds more resistance, and from being flattened it enters

upon the air edgewise and penetrates it more rapidly, and more rapidly moves through it. Forster II 72 r.

[*War Machines: with drawing*]

When this is going through its own ranks, it is necessary to raise the machinery that moves the scythes, in order to prevent their doing any harm to anyone.

How the armoured car is arranged inside.

It will need eight men to work it and make it turn and pursue the enemy.

This is good to break through the ranks, but it must be followed up.
 B.M. Drawings

Naval Warfare

*'Construct it so that the wine-skin which serves
as a boat, and the implements and the man who
is there, shall be midway between the surface
and the bottom of the sea.'*

[Notes relating to a submarine attack]

Do not impart your knowledge and you will excel alone.

Choose a simple youth and have the dress stitched at home.

Stop the galleys of the captains and afterwards sink the others and fire with the cannon on the fort.

[With drawings of parts of the apparatus]

Everything under water, that is all the fastenings.

Here stands the man. Doublet. Hose. Level frame.

[With drawing of small boat under poop of large]

When the watch has gone its round, bring a small skiff under the poop and set fire to the whole all of a sudden.

[With drawing of boat and chain]

To fasten a galley to the bottom *m* on the side opposite to the anchor.

[With drawing of figure in diving dress (half length)]

A breastplate of armour together with hood, doublet and hose, and a small wine-skin for use in passing water, a dress for the armour, and the wine-skin to contain the breath, with half a hoop of iron to keep it away from the chest. If you have a whole wine-skin with a valve from the [?ball MS. *da pal* . . . *?palla*], when you deflate it, you will go to the bottom, dragged down by the sacks of sand; when you inflate it, you will come back to the surface of the water.

A mask with the eyes protruding made of glass, but let its weight be such that you raise it as you swim.

Carry a knife which cuts well so that a net does not hold you prisoner.

Carry with you two or three small wine-skins, deflated, and capable of being inflated like balls in case of need.

Take provisions as you need them, and having carefully wrapped them up hide them on the bank. But first have an understanding about the agreement, how the half of the ransom is to be yours without deduction; and the store-room of the prisons is near to Manetti, and payment may be made into the hand of Manetti, that is, of the said ransom.

Carry a horn in order to give a signal whether or no the attempt has been successful.

You need to take an impression[1] of one of the three iron screws of the workshop of Santa Liberata, the figure in plaster and the cast in wax.

[*With drawing of figure of man in diving dress. His right arm extended holds a staff which touches a square of cork. Two bags suspended from shoulders*]

It separates from the dress if it should be necessary to break it.

Cork which is to be fixed midway between the surface and the bottom.

Bags of sand.

Carry forty braccia of rope fastened to a bag of sand.[2] C.A. 333 v. a

I will destroy the harbour.

Unless you surrender within four hours you will go to the bottom.

[*Notes with drawings of three heads showing diving apparatus fitted over the nostrils*]

Have the said bag for your mouth ready for use when you are in the sea—for was not this your secret?

[1] MS. has *protare* for which Piumati in his transcript of the Codice Atlantico reads *portare*. I have adopted Müller-Walde's reading, *prontare* for *improntare*.

[2] Alvise Manetti was sent by the Venetian senate on a legation to the Turks, which lasted from October 1499 to the end of March 1500, to attempt some arrangement for the surrender of the Venetian prisoners who were removed from Constantinople to Lepanto after the capture of that fortress by the Turks in August 1499. Already in February 1500 a despatch from Manetti had arrived in Venice which showed that his endeavours were not likely to reach a successful issue. It was presumably at about this time that Leonardo, who was then in Venice, set himself to devise some method of securing the release of the prisoners through the agency of Manetti, and also to consider a plan for destroying the enemy's ships in the harbour by piercing them below the water-line.

Try it first for four hours.

Pack-thread.

Of bronze, which is fastened with a screw that has been oiled, it should have been made in a mould. c.a. 346 r. a

[*Drawing of buoy, below which, connected by a long bar, that moves freely on swivels, hangs what is apparently a very large awl or borer. At the side of the buoy a long tube is fastened so that one end projects just above it; it is bound by a number of rings, and its lower end terminates in a sort of bag, which is apparently fixed over the mouth of the diver. A dotted horizontal line shows that this is level with the top of the borer*]

Line to find the middle.

In case you have to make use of the sea make an armour of copper by setting the plates one above another thus: [*drawing*]. That is, one inside the other, so that a hook may not grapple you.

Measure first the depth, and if you see that it will be sufficient merely to bore without sinking the ship, pursue that course; otherwise fasten it in the way indicated.

Hole by which the water makes its exit when the ring is lowered.

Oars. Twelve braccia the lever. Twelve braccia. For the final turn you need a bent lever. In order to turn this screw use a pair of slippers with heels, or hooks, so that the foot may stand firm.

These are the implements which belong to it; but construct it so that the wine-skin which serves as a boat, and the implements and the man who is there, shall be midway between the surface and the bottom of the sea; and have a valve put in this wine-skin, so that when it is deflated it will sink to the bottom where your station is, and the hands will serve as oars.

The way of wings.

The smoke of [. . .] for use as an opiate.

Take seed of darnel as remedy, and [. . .] spirits of wine in cotton. Some white henbane. Some teasel.

Seed and root of *mappello*[?],[1] and dry everything; mix this powder with camphor and it is made.

[1] *Mappello,* an as yet unidentified tree or shrub. In a passage in c.a. 214 r. a it is said to grow plentifully in the Valsasina, which is to the south of Lake Como.

Deadly smoke (*fumo mortale*):
Take arsenic and mix with sulphur or realgar.
Remedy rose water.
Venom of toad, that is, a land-toad.
Slaver of mad dog and decoction of dogwood berries.
Tarantula from Taranto.
Powder of verdigris or of chalk mixed with poison to throw on ships. C.A. 346 v. a

GREEK FIRE

Take charcoal of willow, and saltpetre, and aqua vitæ, and sulphur, pitch, with incense and camphor and Ethiopian wool, and boil them all up together. This fire is so eager to burn that it will run along wood even when it is under water. You should add to the mixture liquid varnish, petroleum,[1] turpentine, and strong vinegar, and mix everything together and dry it in the sun or in an oven when the bread has been taken out, and then stick it round hempen or other tow, moulding it to a round form and driving very sharp nails into every side of it. Leave however an opening in this ball to serve for a fuse, and then cover it with resin and sulphur.

This fire moreover, when fixed to the top of a long lance, which has a braccio of its point covered with iron in order that it may not be burnt by it, is useful for avoiding and warding off the hostile ships in order not to be overwhelmed by their onset.

Throw also vessels of glass filled with pitch on to the ships of the enemy when their crews are engaged in the battle, and by then throwing similar lighted balls after these you will have it in your power to set every ship on fire. Tr. 43 a

Ships made of beams.
Ships made of osier twigs woven and bound with leather for privateers.

In order to fight against walls which face the sea or towers, withdraw the galleys, and before they come to the encounter raise the oars within so that the edges touch together, and move the ship with the

[1] MS. *olio petrolio.*

oars of the back part; in this manner it will seem one only, upon which you will set tower and fort strong and suitable for carrying any artillery that will be serviceable for the battle.　　　　　　Tr. 71 a

[*With drawing*]

These cortalds should be placed upon stout ships, and these two cortalds will have—fastened by a strong chain or a new rope soaked in water—a scythe twelve braccia long and a foot wide at the centre, and with the back of the blade of the thickness of a finger; and one ought to be able to fire both of them at the same time.　　　　B 49 r.

[*With drawing*]

To throw poison in the form of powder upon galleys.

Chalk, fine sulphide of arsenic, and powdered verdigris may be thrown among the enemy ships by means of small mangonels. And all those who, as they breathe, inhale the said powder with their breath will become asphyxiated.

But take care to have the wind so that it does not blow the powder back upon you, or to have your nose and mouth covered over with a fine cloth dipped in water so that the powder may not enter. It would also be well to throw baskets covered with paper and filled with this powder from the crow's nest or the deck of the ship.　　　　B 69 v.

[*With drawings*]

Ship with scorpions suitable for cutting the ropes of the big ships; from one tip of the sickles to the other should be four braccia; and the sickle should be of the shape of a crescent, one foot at its maximum width and of the breadth of a finger.　　　　B 76 r.

[*With drawings*]

Circunfulgore. The *circunfulgore* is a naval machine invented by the inhabitants of Majorca. It is formed of a circle of bombards, of as many as you please provided that the number is not uneven, since in order that the blow may be a vigorous one and yet the vessel may not spring back it is necessary that one bombard should serve as a support and obstacle of another, and in order to effect this it is necessary to set fire at the same instant to two bombards placed opposite to each other, so that if one wishes to flee on one side the other opposes it.

B 82 v.

[*With drawing*]

Lances of considerable length fitted with short rockets should be placed within the edges of the ships, and these may be set on fire by means of a thin cord which comes down the length of the pole as far as the hand. B 83 r.

HOW TO STAVE IN THE BOWS OF A SHIP

[*With drawing*]

It is necessary first that they be engaged, that is fastened together in such a way that you for your part can unlock yourself at your pleasure, so that when the ship goes to the bottom it may not drag yours with it. Let this be done as follows:—draw a weight up to a height and then release it; and as it falls it will give such a blow as a pile-driver gives, and in falling it will draw back the head of a beam which is in equilibrium when upright, and as the head of the aforesaid beam comes back the end that is below advances and staves in the bow of the ship. But see to it that the beam has a cutting edge so that as it rushes to give the stroke the water does not offer resistance to it. And above all see that the chains which hold the ships fastened together are such as can at your pleasure be severed from your side, so that the enemy's ship when it sinks may not drag you down with it.

B 90 v.

[*Drawing*]

If in a battle between ships and galleys the ships are victors because of the height of their mast-heads, you should draw the lateen yard almost up to the top of the mast and attach to the extremity of this yard—at the end that is which projects towards the enemy—a small cage wrapped at the bottom and all round with a large mattress stuffed with cotton to prevent it from being damaged by bombs.

Then draw down the other end of the lateen yard by means of the capstan, and the cage at the opposite end will go up to such a height that it will be far above the mast-head of the ship, and you will easily be able to drive out the men who are within it.

But it is necessary that the men in the galley should go to the oppo-

site side so that they may counterbalance the weight of the men posted in the cage of the lateen yard. MS. 2037 Bib. Nat. 1 v.

[*Drawing*]

If you wish to build a fleet for action you should make use of these ships in order to ram the enemy's ships, that is, make ships a hundred feet [1] in length and eight feet wide and arrange them so that the rowers of the left oars sit on the right side of the ship and the rowers of the right oars on the left side, as is shown at *M* (*figure*), in order that the leverage of the oars may be longer. And this ship should be a foot and a half in thickness, that is made of beams fastened inside and outside by planks set crosswise.

And let the vessel have fastened to it a foot below the water's edge a spike shod with iron of the weight and size of an anvil. And by the might of the oars this vessel will be able to draw back after it has struck the first blow, and will then hurl itself forward again with fury and deal the second blow and then the third, and so many others as to destroy the ship. MS. 2037 Bib. Nat. 3 r

[*Drawing*]

Shape of the vessel [?bomb-ketch] which carries the mortars described above. And I would specially remind you to aim the cannonballs attached to scythes towards the mast-head where many ropes unite and where the scythes will be effective.

The scythes should be four braccia long and four braccia from one point to the other. And they should be shot among the ropes of the big ships so as to make the sails fall down. And let the ketch which carries them carry a sufficient quantity; and let it be of stout beams so that the cannon from the ships may not break them in pieces; and let the cannon-balls be of two hundred pounds.

 MS. 2037 Bib. Nat. 4 v.

[*Drawings*]

Of the means of defence in case the enemy should throw soft soap, or caltrops, or small boards studded with nails, or similar things upon the ships.

[1] Dimensions here given in feet, more usually in braccia. According to Fanfani's Dictionary, a foot was about 30 centimetres, and a braccio (fiorentino) was 58 centimetres.

You should do this:—keep, when you go into the combat, on your feet, underneath your shoes, iron soles, divided in the middle as is shown in the drawing above, so that it is possible to bend the feet; and the underside of these soles should have the form of a rasping file, or be filled with blunted points of nails, in order to prevent the soap from causing the foot to slip and so making the man fall down flat; and, as they are of iron, the small boards and caltrops will be thrown in vain. MS. 2037 Bib. Nat. 6 v.

A SCORPION

[*Figures*]

This machine is so constructed that the scythe springs up when it is discharged; and the ships which carry scythes should be of this sort, namely without either mast or sail and with a great quantity of oars so that they may be swift; without a sail because the sail, mast and cordage would interfere with the working of the great scythe. The machine is called a scorpion because of its resemblance to one and because of the damage it inflicts with its tail. Mantelets are fixed over the rowers in order that the masts, that is to say the mast-heads, or rather the combatants at the mast-heads, may not be able to do them any injury; and these should be covered with moist hides because of the fire thrown by the enemy.

A way of protecting against it is for ships to be provided with chains of rope to a height of six braccia.

[*Figure*] This ship is to serve as a defence against cannon, and it attacks the other ships with its cannon; it is covered with sheet metal [1] as a protection against fire, and bristling with points of nails so that the enemy may not leap upon it with impunity. MS. 2037 Bib. Nat. 8 r.

[*Drawing*]

Some of the combatants in the Tyrrhenian Sea employ this method: they fasten an anchor to one end of the lateen yard and a rope to the other, and this rope at the bottom end is attached to another anchor. In the fight they hook the first anchor to the oars of the enemy's ship and by the force of the capstan draw it to the side.

[1] MS. *coperto di tole.*

And they throw soft soap and tow, dipped in melted pitch and set alight, on the side to which the anchor was first made fast, so that in order to escape from this fire the defenders of the ship have to flee to the opposite side; and by doing so they rendered assistance to their assailants, for the galley was drawn to the side more easily because of this counterpoise. MS. 2037 Bib. Nat. 9 r.

[*Drawing*]

I have found in the history of the Spaniards how, in their wars with the English, Archimedes the Syracusan, who was then living at the court of Ecliderides, King of the Cirodastri, ordered that for maritime combats the ships should have tall masts, and on the tops of these he placed a small yard forty feet in length and a third of a foot wide, having at one end of it a small anchor and at the other a counterpoise.

To the anchor was attached twelve feet of chain, and to the chain as much rope as would reach from the chain to the base of the mast-top where it was fixed by a small rope, going down from this base to the base of the mast where a very strong capstan was placed, and there the end of the cord was fastened. But to go back to the use of the machine, I say that below this anchor there was a fire which with a loud roar threw out its rays and a shower of burning pitch, and as this shower fell upon the enemy's mast-top it compelled the men stationed there to abandon their post; and consequently the anchor being lowered by means of the capstan touched the sides of the mast-top, and thus instantly cut the rope placed at the base of the mast-top to support the rope which went from the anchor to the capstan. And drawing the ship . . . MS. 2037 Bib. Nat. 9 v.

How by an appliance many are able to remain for some time under water. How and why I do not describe my method of remaining under water for as long a time as I can remain without food; and this I do not publish or divulge on account of the evil nature of men who would practice assassinations at the bottom of the seas, by breaking the ships in their lowest parts and sinking them together with the crews who are in them; and although I will furnish particulars of others they are such as are not dangerous, for above the surface of the water

emerges the mouth of the tube by which they draw in breath, supported upon wine-skins or pieces of cork.[1] Leic. 22 v.

Speak with the Genoese about the sea.[2] Leic. 26 v.

[1] These lines are an excerpt from a passage to be found in full in the section on The Nature of Water. A similar practice has been followed in the case of one or two lines reproduced in the sections entitled Music, Personalia and Dated Notes.

[2] This is one of those enigmatic notes which have given rise to conjecture. It undoubtedly may refer to naval preparations, which were being taken by the Genoese as part of Ludovic Sforza's concerted schemes of defence against the assaults with which he was threatened. As he knew of Leonardo's study of marine warfare he would find him a very suitable agent to send on such a mission. This is incontestable. But the fact remains that this sentence, which is all that exists to connect Leonardo with Genoa, is a comparatively slight foundation for the structure of hypothesis that has been raised upon it.

XXVIII

Comparison of the Arts

*'If you know how to describe and write down
the appearance of the forms, the painter can
make them so that they appear enlivened with
lights and shadows which create the very ex-
pression of the faces; herein you cannot attain
with the pen where he attains with the brush.'*

How painting surpasses all human works by reason of the subtle
possibilities which it contains:

The eye, which is called the window of the soul, is the chief means
whereby the understanding may most fully and abundantly appreciate
the infinite works of nature; and the ear is the second, inasmuch as it
acquires its importance from the fact that it hears the things which the
eye has seen. If you historians, or poets, or mathematicians had never
seen things with your eyes you would be ill able to describe them in
your writings. And if you, O poet, represent a story by depicting it
with your pen, the painter with his brush will so render it as to be
more easily satisfying and less tedious to understand. If you call paint-
ing 'dumb poetry', then the painter may say of the poet that his art is
'blind painting'. Consider then which is the more grievous affliction, to
be blind or to be dumb! Although the poet has as wide a choice of sub-
jects as the painter, his creations fail to afford as much satisfaction to
mankind as do paintings, for while poetry attempts to represent forms,
actions and scenes with words, the painter employs the exact images of
these forms in order to reproduce them. Consider, then, which is more
fundamental to man, the name of man or his image? The name
changes with change of country; the form is unchanged except by
death.

And if the poet serves the understanding by way of the ear, the
painter does so by the eye, which is the nobler sense.

I will only cite as an instance of this how if a good painter represents the fury of a battle and a poet also describes one, and the two descriptions are shown together to the public, you will soon see which will draw most of the spectators, and where there will be most discussion, to which most praise will be given and which will satisfy the more. There is no doubt that the painting, which is by far the more useful and beautiful, will give the greater pleasure. Inscribe in any place the name of God and set opposite to it His image, you will see which will be held in greater reverence!

Since painting embraces within itself all the forms of nature, you have omitted nothing except the names, and these are not universal like the forms. If you have the results of her processes we have the processes of her results.

Take the case of a poet describing the beauties of a lady to her lover and that of a painter who makes a portrait of her; you will see whither nature will the more incline the enamoured judge. Surely the proof of the matter ought to rest upon the verdict of experience!

You have set painting among the mechanical arts! Truly were painters as ready equipped as you are to praise their own works in writing, I doubt whether it would endure the reproach of so vile a name. If you call it mechanical because it is by manual work that the hands represent what the imagination creates, your writers are setting down with the pen by manual work what originates in the mind. If you call it mechanical because it is done for money, who fall into this error—if indeed it can be called an error—more than you yourselves? If you lecture for the Schools do you not go to whoever pays you the most? Do you do any work without some reward?

And yet I do not say this in order to censure such opinions, for every labour looks for its reward. And if the poet should say, 'I will create a fiction which shall express great things', so likewise will the painter also, for even so Apelles made the Calumny. If you should say that poetry is the more enduring,—to this I would reply that the works of a coppersmith are more enduring still, since time preserves them longer than either your works or ours; nevertheless they show but little imagination; and painting, if it be done upon copper in enamel colours, can be made far more enduring.

In Art we may be said to be grandsons unto God. If poetry treats

of moral philosophy, painting has to do with natural philosophy; if the one describes the workings of the mind, the other considers what the mind effects by movements of the body; if the one dismays folk by hellish fictions, the other does the like by showing the same things in action. Suppose the poet sets himself to represent some image of beauty or terror, something vile and foul, or some monstrous thing, in contest with the painter, and suppose in his own way he makes a change of forms at his pleasure, will not the painter still satisfy the more? Have we not seen pictures which bear so close a resemblance to the actual thing that they have deceived both men and beasts?

If you know how to describe and write down the appearance of the forms, the painter can make them so that they appear enlivened with lights and shadows which create the very expression of the faces; herein you cannot attain with the pen where he attains with the brush. MS. 2038 Bib. Nat. 19 r. and v., 20 r.

How he who despises painting has no love for the philosophy in nature:

If you despise painting, which is the sole imitator of all the visible works of nature, it is certain that you will be despising a subtle invention which with philosophical and ingenious speculation takes as its theme all the various kinds of forms, airs and scenes, plants, animals, grasses and flowers, which are surrounded by light and shade. And this truly is a science and the true-born daughter of nature, since painting is the offspring of nature. But in order to speak more correctly we may call it the grandchild of nature; for all visible things derive their existence from nature, and from these same things is born painting. So therefore we may justly speak of it as the grandchild of nature and as related to God himself. MS. 2038 Bib. Nat. 20 r.

That sculpture is less intellectual than painting, and lacks many of its natural parts:

As practising myself the art of sculpture no less than that of painting, and doing both the one and the other in the same degree, it seems to me that without suspicion of unfairness I may venture to give an opinion as to which of the two is the more intellectual, and of the greater difficulty and perfection.

In the first place, sculpture is dependent on certain lights, namely

those from above, while a picture carries everywhere with it its own light and shade; light and shade therefore are essential to sculpture. In this respect, the sculptor is aided by the nature of the relief, which produces these of its own accord, but the painter artificially creates them by his art in places where nature would normally do the like. The sculptor cannot render the difference in the varying natures of the colours of objects; painting does not fail to do so in any particular. The lines of perspective of sculptors do not seem in any way true; those of painters may appear to extend a hundred miles beyond the work itself. The effects of aerial perspective are outside the scope of sculptors' work; they can neither represent transparent bodies nor luminous bodies nor angles of reflection nor shining bodies such as mirrors and like things of glittering surface, nor mists, nor dull weather, nor an infinite number of things which I forbear to mention lest they should prove wearisome.

The one advantage which sculpture has is that of offering greater resistance to time; yet painting offers a like resistance if it is done upon thick copper covered with white enamel and then painted upon with enamel colours and placed in a fire and fused. In degree of permanence it then surpasses even sculpture.

It may be urged that if a mistake is made it is not easy to set it right, but it is a poor line of argument to attempt to prove that the fact of a mistake being irremediable makes the work more noble. I should say indeed that it is more difficult to correct the mind of the master who makes such mistakes than the work which he has spoiled.

We know very well that a good experienced painter will not make such mistakes; on the contrary, following sound rules he will proceed by removing so little at a time that his work will progress well. The sculptor also if he is working in clay or wax can either take away from it or add to it, and when the model is completed it is easy to cast it in bronze; and this is the last process and it is the most enduring form of sculpture, since that which is only in marble is liable to be destroyed, but not when done in bronze.

But painting done upon copper, which by the methods in use in painting may be either taken from or altered, is like the bronze, for when you have first made the model for this in wax it can still be either reduced or altered. While the sculpture in bronze is imperish-

able this painting upon copper and enamelling is absolutely eternal; and while bronze remains dark and rough, this is full of an infinite variety of varied and lovely colours, of which I have already made mention. But if you would have me speak only of panel painting I am content to give an opinion between it and sculpture by saying that painting is more beautiful, more imaginative, and richer in resource, while sculpture is more enduring, but excels in nothing else.

Sculpture reveals what it is with little effort; painting seems a thing miraculous, making things intangible appear tangible, presenting in relief things which are flat, in distance things near at hand.

In fact, painting is adorned with infinite possibilities of which sculpture can make no use. MS. 2038 Bib. Nat. 25 v. and 24 v.

One of the chief proofs of skill of the painter is that his picture should seem in relief, and this is not the case with the sculptor, for in this respect he is aided by nature. C.A. 305 r. a

[Of poetry and painting]

When the poet ceases to represent in words what exists in nature, he then ceases to be the equal of the painter; for if the poet, leaving such representation, were to describe the polished and persuasive words of one whom he wishes to represent as speaking, he would be becoming an orator and be no more a poet or a painter. And if he were to describe the heavens he makes himself an astrologer, and a philosopher or theologian when speaking of the things of nature or of God. But if he returns to the representation of some definite thing he would become the equal of the painter if he could satisfy the eye with words as the painter does with brush and colour, [for with these he creates] a harmony to the eye, even as music does in an instant to the ear.

Quaderni III 7 r.

[Painting and sculpture]

Why the picture seen with two eyes will not be an example of such relief as the relief seen with two eyes; this is because the picture seen with one eye will place itself in relief like the actual relief, having the same qualities of light and shade. Quaderni III 8 r.

XXIX

Precepts of the Painter

*'Painting is concerned with all the ten attributes
of sight, namely darkness, brightness, substance
and colour, form and place, remoteness and
nearness, movement and rest; and it is with
these attributes that this my small book will be
interwoven.'*

WHICH is the more difficult: light and shade or good design?

I maintain that a thing which is confined by a boundary is more
difficult than one which is free. Shadows have their boundaries at cer-
tain stages, and when one is ignorant of this his works will be lacking
in that relief which is the importance and the soul of painting. Design
is free, in so much as if you see an infinite number of faces they will be
all different, one with a long nose and one with a short; the painter
therefore must also assume this liberty, and where there is liberty
there is no rule. MS. 2038 Bib. Nat. 1 r.

PAINTING

The mind of the painter should be like a mirror which always takes
the colour of the thing that it reflects, and which is filled by as many
images as there are things placed before it. Knowing therefore that you
cannot be a good master unless you have a universal power of repre-
senting by your art all the varieties of the forms which nature pro-
duces,—which indeed you will not know how to do unless you see
them and retain them in your mind,—look to it, O Painter, that when
you go into the fields you give your attention to the various objects,
and look carefully in turn first at one thing and then at another, mak-
ing a bundle of different things selected and chosen from among
those of less value. And do not after the manner of some painters who
when tired by imaginative work, lay aside their task and take exercise

857

by walking, in order to find relaxation, keeping, however, such weariness of mind as prevents them either seeing or being conscious of different objects; so that often when meeting friends or relatives, and being saluted by them, although they may see and hear them they know them no more than if they had met only so much air.

MS. 2038 Bib. Nat. 2 r.

The various contrasts of the different degrees of shadows and lights often cause hesitation and confusion to the painter who aspires to imitate and reproduce the things that he sees. The reason is that if you see a white cloth side by side with a black one, it is certain that the part of this white cloth which is next to the black will seem whiter by far than the part that is next to something whiter than itself, and the reason of this is proved in my Perspective.

OF THE NATURE OF THE FOLDS OF DRAPERIES

That part of the fold which is farthest from the ends where it is confined will return most closely to its original form. Everything naturally desires to remain in its own state. Drapery being of uniform density and thickness on the reverse and on the right side, desires to lie flat; consequently, whenever any folds or pleats force it to depart from this condition of flatness, it obeys the law of this force in that part of itself where it is most constrained, and the part farthest away from such constraint you will find return most nearly to its original state, that is to say, lying extended and full. MS. 2038 Bib. Nat. 4 r.

The body of the atmosphere is full of an infinite number of the pyramids composed of radiating straight lines which are caused by the boundaries of the surfaces of the bodies in shadow that are found there, and the farther they are away from the object which produces them the more their angle becomes acute. And although they intersect and interlace in their passage, nevertheless they do not become confused with each other but proceed with divergent course, spreading themselves out and becoming diffused through all the surrounding air.

And they are of equal power among themselves, all equal to each, and each equal to all, and by means of them are transmitted the images of the objects, and these are transmitted all in all, and all in

each part; and each pyramid receives of itself in each of its smallest parts the whole form of the object which produces it.

MS. 2038 Bib. Nat. 6 v.

PRECEPTS OF PAINTING

Let the sketches for historical subjects be rapid, and the working of the limbs not too much finished. Content yourself with merely giving the positions of these limbs, which you will then be able at your leisure to finish as you please. MS. 2038 Bib. Nat. 8 v.

Among shadows of equal strength that which is nearest to the eye will seem of less density. MS. 2038 Bib. Nat. 9 v.

All colours in distant shadows are indistinguishable and undiscernible.

In the distance all colours are indistinguishable in shadows, because an object which is not touched by the principal light has no power to transmit its image through the more luminous atmosphere to the eye, because the lesser light is conquered by the greater.

For example, we see in a house that all the colours on the surface of the walls are visible instantly and clearly when the windows of the house are open; but, if we go out of the house and look through the windows at a little distance in order to see the paintings on the walls, we shall see instead of them a uniform darkness.

The painter ought first to exercise his hand by copying drawings by good masters; and having acquired facility in this under the advice of his instructor, he ought to set himself to copy good reliefs, following the rules given below.

OF DRAWING FROM RELIEF

He who draws from relief ought to take his position so that the eye of the figure he is drawing is on a level with his own. And this should be done whenever a head has to be drawn from nature, because generally figures or people whom you meet in the streets all have their eyes at the same level as yours, and if you make them higher or lower you will find that your portrait will not resemble them.

OF THE WAY TO DRAW FIGURES FOR HISTORIES

The painter ought always to consider, as regards the wall on which he intends to represent a story, the height of the position where he intends to place his characters, so that when he makes studies from nature for this purpose he should have his eye as much below the thing that he is drawing as the said thing appears in the picture above the eye of the spectator: otherwise the work will be deserving of censure.

WHY A PAINTING CAN NEVER APPEAR DETACHED AS DO NATURAL THINGS

Painters oftentimes despair of their power to imitate nature, on perceiving how their pictures are lacking in the power of relief and vividness which objects possess when seen in a mirror, though as they allege they have colours that for clearness and depth far surpass the quality of the lights and shadows of the object seen in the mirror, arraigning herein not reason but their own ignorance, in that they fail to recognise the impossibility of a painted object appearing in such relief as to be comparable to the objects in the mirror, although both are on a flat surface unless they are seen by a single eye. And the reason of this is that when two eyes see one thing after another, as in the case of $a\ b$ seeing $n\ m$, m cannot entirely cover n because the base of the visual lines is so broad as to cause one to see the second object beyond the first. If however you close one eye as s, the object f will cover up r, because the visual line starts in a single point and makes its base in the first object, with the consequence that the second being of equal size is never seen.

MS. 2038 Bib. Nat. 10 r.

Every bodily form as far as concerns the function of the eye is divided into three parts, namely substance, shape and colour. The image of its substance projects itself farther from its source than its colour or its shape; the colour also projects itself farther than the shape, but this law does not apply to luminous bodies.

The above proposition is clearly shown and confirmed by experience, for if you see a man near at hand you will be able to recognise the character of the substance of the shape and even of the colour, but,

if he goes some distance away from you, you will no longer be able to recognise who he is because his shape will lack character, and if he goes still farther away you will not be able to distinguish his colour but he will merely seem a dark body, and farther away still he will seem a very small round dark body. He will appear round because distance diminishes the various parts so much as to leave nothing visible except the greater mass. The reason of this is as follows:—We know very well that all the images of objects penetrate to the imprensiva[1] through a small aperture in the eye; therefore if the whole horizon *a d* enters through a similar aperture and the object *b c* is a very small part of this horizon, what part must it occupy in the minute representation of so great a hemisphere? And since luminous bodies have more power in darkness than any others it is necessary, since the aperture of the sight is considerably in shadow, as is the nature of all holes, that the images of distant objects intermingle within the great light of the sky, or if it should be that they remain visible they appear dark and black, as every small body must when seen in the limpidity of the air. MS. 2038 Bib. Nat. 12 v.

[Images in the air]

All bodies together and each of itself fill the surrounding air with an infinite number of their images which are all in all this air, and all in the parts of it, bearing with them the nature of the body, the colour and the form of their cause.

Perspective is the bridle and rudder of painting.

MS. 2038 Bib. Nat. 13 r.

Shadows which you see with difficulty, and whose boundaries you cannot define—but which you only apprehend and reproduce in your work with some hesitation of judgment—these you should not represent as finished or sharply defined, for the result would be that your work would seem wooden.

OF REFLECTION

Reflections are caused by bodies of a bright nature and of a smooth and half-opaque surface, which when struck by the light drive it back again to the first object like the rebound of a ball.

[1] Imprensiva, see Vol. I, Optics, pp. 237-8.

OF WHERE THERE CANNOT BE LUMINOUS REFLECTION

All solid bodies have their surfaces covered by various degrees of light and shadow. The lights are of two kinds: the one is called original the other derived. Original I call that which proceeds from the flame of the fire, or from the light of the sun, or of the atmosphere. Derived light is the light reflected. But, to return to the promised definition, I say that there is no luminous reflection on the side of the body which is turned towards objects in shadow such as shaded scenes, meadows with grasses of varying height, green or bare woods—for these, although the part of each branch turned to the original light is imbued with the attributes of this light, have nevertheless so many shadows cast by each branch separately, and so many shadows cast by one branch on another, that in the whole mass there results such a depth of shadow that the light is as nothing; hence objects such as these cannot throw any reflected light upon bodies opposite to them.

MS. 2038 Bib. Nat. 14 v.

WHY THE REPRESENTING OF GROUPS OF FIGURES ONE ABOVE ANOTHER IS TO BE AVOIDED

This custom, which is universally adopted by painters for the walls of chapels, is by right strongly to be censured, seeing that they represent one composition at one level with its landscape and buildings, and then mount to the stage above it and make another, and so vary the point of sight from that of the first painting, and then make a third, and a fourth, in such a way that the work on the one wall shows four points of sight, which is extreme folly on the part of such masters.

Now we know that the point of sight is opposite the eye of the spectator of the composition, and if you were to ask me how I should represent the life of a saint when it is divided up in several compositions on the same wall, to this I reply that you ought to set the foreground with its point of sight on a level with the eye of the spectators of the composition, and at this same plane make the chief episode on a large scale, and then by diminishing gradually the figures and buildings upon the various hills and plains, you should represent all the incidents of the story. And on the rest of the wall up to the top you

should make trees large as compared with the figures, or angels if these are appropriate to the story, or birds or clouds or similar things; but otherwise do not put yourself to the trouble for the whole of your work will be wrong.

Figures in relief in the act of movement will in their standing position seem naturally to fall forward. MS. 2038 Bib. Nat. 16 r.

The youth ought first to learn perspective, then the proportions of everything, then he should learn from the hand of a good master in order to accustom himself to good limbs; then from nature in order to confirm for himself the reasons for what he has learnt; then for a time he should study the works of different masters; then make it a habit to practise and work at his art.

How the first picture was nothing but a line which surrounded the shadow of a man made by the sun upon a wall.

How historical pictures ought not to be crowded and confused by many figures.

How old men should be shown with slow listless movements, with the legs bent at the knees when they are standing up, with the feet parallel and separated one from another, the spine bent low, the head leaning forward, and the arms not too far apart.

How women should be represented in modest attitudes, with legs close together, arms folded, and with their heads low and bending sideways.

How old women should be represented as bold, with swift passionate movements like the infernal furies, and these movements should seem quicker in the arms and heads than in the legs.

Little children should be represented when sitting as twisting themselves about with quick movements, and in shy, timid attitudes when standing up.

How one ought not to give drapery a confusion of many folds, but only make them where it is held by the hands or arms, and the rest may be suffered to fall simply where its nature draws it: and do not let the contour of the figure be broken by too many lines or interrupted folds.

How draperies should be drawn from nature: that is, if you wish to represent woollen cloth draw the folds from the same material, and if it is to be silk, or fine cloth, or homespun, or of linen or crape, show the different nature of the folds in each; and do not make a costume as many make it upon models covered with pieces of paper or thin leather, for you will be deceiving yourself greatly.

MS. 2038 Bib. Nat. 17 v.

OF THE THREE KINDS OF PERSPECTIVE

Perspectives are of three kinds. The first has to do with the causes of the diminution or as it is called the diminishing perspective of objects as they recede from the eye. The second the manner in which colours are changed as they recede from the eye. The third and last consists in defining in what way objects ought to be less carefully finished as they are farther away. And the names are these:

Linear Perspective
Perspective of Colour
Vanishing Perspective.

OF THE FEW FOLDS IN DRAPERIES

How figures when dressed in a cloak ought not to show the shape to such an extent that the cloak seems to be next to the skin; for surely you would not wish that the cloak should be next to the skin, since you must realise that between the cloak and the skin are other garments which prevent the shape of the limbs from being visible and appearing through the cloak. And those limbs which you make visible, make thick of their kind so that there may seem to be other garments there under the cloak. And you should only allow the almost identical thickness of the limbs to be visible in a nymph or an angel, for these are represented clad in light draperies, which by the blowing of the wind are driven and pressed against the various limbs of the figures.

OF THE WAY TO PRESENT DISTANT OBJECTS IN PAINTING

It is evident that the part of the atmosphere which lies nearest the level ground is denser than the rest, and that the higher it rises the lighter and more transparent it becomes.

In the case of large and lofty objects which are some distance away from you, their lower parts will not be much seen, because the line by which you should see them passes through the thickest and densest portion of the atmosphere. But the summits of these heights are seen along a line which, although when starting from your eye it is projected through the denser atmosphere, yet since it ends at the highest summit of the object seen, concludes its course in an atmosphere far more rarefied than that of its base. And consequently the farther away from you this line extends from point to point the greater is the change in the finer quality of the atmosphere.

Do you, therefore, O painter, when you represent mountains, see that from hill to hill the bases are always paler than the summits, and the farther away you make them one from another let the bases be paler in proportion, and the loftier they are the more they should reveal their true shape and colour. MS. 2038 Bib. Nat. 18 r.

How the atmosphere should be represented as paler in proportion as you show it extending lower:

Since the atmosphere is dense near the ground, and the higher it is the finer it becomes, therefore when the sun is in the east and you look towards the west, taking in a part to the north and to the south, you will see that this dense air receives more light from the sun than the finer air, because the rays encounter more resistance. And if your view of the horizon is bounded by a low plain, that farthest region of the sky will be seen through that thicker whiter atmosphere, and this will destroy the truth of the colour as seen through such a medium; and the sky will seem whiter there than it does overhead, where the line of vision traverses a lesser space of atmosphere charged with thick vapours. But if you look towards the east the atmosphere will appear darker in proportion as it is lower, for in this lower atmosphere the luminous rays pass less freely.

How shadows are distributed in different positions, and of the objects situated in them:

If the sun is in the east and you look towards the west you will see that all the things which are illuminated are entirely deprived of shadow, because what you are looking at is what the sun sees.

And if you look to the south and the north you will see that all the bodies are surrounded by light and shade, because you are looking both at the part that does not see and the part that sees the sun. And if you look towards the pathway of the sun all the objects will present their shaded side to you because this side cannot be seen by the sun.

OF THE WAY TO REPRESENT A NIGHT SCENE

Whatever is entirely deprived of light is all darkness. When such is the condition of night, if you wish to represent a scene therein, you must arrange to introduce a great fire there, and then the things which are nearest to the fire will be more deeply tinged with its colour, for whatever is nearest to the object partakes most fully of its nature; and making the fire of a reddish colour you should represent all the things illuminated by it as being also of a ruddy hue, while those which are farther away from the fire should be dyed more deeply with the black colour of the night. The figures which are between you and the fire will appear dark against the brightness of the flame, for that part of the object which you perceive is coloured by the darkness of the night, and not by the brightness of the fire; those which are at the sides should be half in shadow and half in ruddy light; and those visible beyond the edge of the flames will all be lit up with ruddy light against a dark background. As for their actions, show those who are near it making a screen with hands and cloaks as a protection against the unbearable heat, with faces turned away as though on the point of flight; while of those farther away you should show a great number pressing their hands upon their eyes, hurt by the intolerable glare.

MS. 2038 Bib. Nat. 18 v.

Why of two objects of equal size the painted one will look larger than that in relief:

This proposition is not so easy to expound as many others, but I will

nevertheless attempt to prove it, if not completely then in part. Diminishing perspective demonstrates by reason that objects diminish in proportion as they are farther away from the eye, and this theory is entirely confirmed by experience. Now the lines of sight which are between the object and the eye are all intersected at a uniform boundary when they reach the surface of the painting; while the lines which pass from the eye to the piece of sculpture have different boundaries and are of varying lengths. The line which is the longest extends to a limb which is farther away than the rest, and consequently this limb appears smaller; and there are many lines longer than others, for the reason that there are many small parts one farther away than another, and being farther away these of necessity appear smaller, and by appearing smaller they effect a corresponding decrease in the whole mass of the object. But this does not happen in the painting, because as the lines of sight end at the same distance it follows that they do not undergo diminution, and as the parts are not themselves diminished they do not lessen the whole mass of the object, and consequently the diminution is not perceptible in the painting as it is in sculpture.

MS. 2038 Bib. Nat. 19 r.

HOW WHITE BODIES OUGHT TO BE REPRESENTED

When you are representing a white body surrounded by ample space, since the white has no colour in itself it is tinged and in part transformed by the colour of what is set over against it. If you are looking at a woman dressed in white in the midst of a landscape the side of her that is exposed to the sun will be so dazzling in colour that parts of it, like the sun itself, will cause pain to the sight, and as for the side exposed to the atmosphere—which is luminous because of the rays of the sun being interwoven with it and penetrating it—since this atmosphere is itself blue, the side of the woman which is exposed to it will appear steeped in blue. If the surface of the ground near to her be meadows, and the woman be placed between a meadow lit by the sun and the sun itself, you will find that all the parts of the folds [of her dress] which are turned towards the meadow will be dyed by the reflected rays to the colour of the meadow; and thus she becomes changed into the colours of the objects near, both those luminous and those non-luminous.

HOW TO REPRESENT THE LIMBS

Make muscular such limbs as have to endure fatigue, and those which are not so used make without muscles and soft.

OF THE ACTION OF FIGURES

Make figures with such action as may be sufficient to show what the figure has in mind; otherwise your art will not be worthy of praise.

MS. 2038 Bib. Nat. 20 r.

OF THE CHOICE OF THE LIGHT WHICH GIVES A GRACE TO FACES

If you have a courtyard which, when you so please, you can cover over with a linen awning, the light will then be excellent. Or when you wish to paint a portrait, paint it in bad weather, at the fall of the evening, placing the sitter with his back to one of the walls of the courtyard. Notice in the streets at the fall of the evening when it is bad weather the faces of the men and women—what grace and softness they display! Therefore, O painter, you should have a courtyard fitted up with the walls tinted in black and with the roof projecting forward a little beyond the wall; and the width of it should be ten braccia, and the length twenty braccia, and the height ten braccia; and you should cover it over with the awning when the sun is on it, or else you should make your portrait at the hour of the fall of the evening when it is cloudy or misty, for the light then is perfect.

WHY FACES AT A DISTANCE APPEAR DARK

We see clearly that all the images of the visible things both large and small which serve us as objects enter to the sense through the tiny pupil of the eye. If, then, through so small an entrance there passes the image of the immensity of the sky and of the earth, the face of man—being almost nothing amid such vast images of things, because of the distance which diminishes it—occupies so little of the pupil as to remain indistinguishable; and having to pass from the outer surface to

the seat of the sense through a dark medium, that is, through the hollow cells which appear dark, this image when not of a strong colour is affected by the darkness through which it passes, and on reaching the seat of the sense it appears dark. No other reason can be advanced to account for the blackness of this point in the pupil; and since it is filled with a moisture transparent like the air, it acts like a hole made in a board; and when looked into it appears black, and the objects seen in the air, whether light or dark, become indistinct in the darkness.

OF SHADOWS IN THE FAR DISTANCE

Shadows become lost in the far distance, because the vast expanse of luminous atmosphere which lies between the eye and the object seen suffuses the shadows of the object with its own colour.

WHY A MAN SEEN AT A CERTAIN DISTANCE CANNOT BE RECOGNISED

Diminishing perspective shows us that in proportion as an object is farther away the smaller it becomes. And if you look at a man who is at the distance of a bowshot away from you and put the eye of a small needle close to your eye, you will be able through this to see the images of many men transmitted to the eye, and these will all be contained at one and the same time within the eye of the said needle. If then the image of a man who is distant from you the space of a bowshot is so transmitted to your eye as to occupy only a small part of the eye of a needle, how should you be able in so small a figure to distinguish or discern the nose or mouth or any detail of the body?

And not seeing these you cannot recognise the man, since he does not show you the features which cause men to differ in appearance.

OF ATTITUDES

The pit of the throat is above the foot. If an arm be thrown forward the pit of the throat moves from above the foot, and if the leg is thrown backwards the pit of the throat moves forwards, and so it changes with every change of attitude. MS. 2038 Bib. Nat. 20 v.

HOW TO REPRESENT A TEMPEST

If you wish to represent a tempest properly, consider and set down exactly what are the results when the wind blowing over the face of the sea and of the land lifts and carries with it everything that is not immovable in the general mass. And in order properly to represent this tempest, you must first of all show the clouds, riven and torn, swept along in the path of the wind, together with storms of sand blown up from the sea shores, and branches and leaves caught up by the irresistible fury of the gale and scattered through the air, and with them many other things of light weight. The trees and shrubs should be bent to the ground, as though showing their desire to follow the direction of the wind, with their branches twisted out of their natural growth and their leaves tossed and inverted. Of the men who are there, some should have fallen and be lying wrapped round by their garments and almost indistinguishable on account of the dust, and those who are left standing should be behind some tree with their arms thrown round it to prevent the wind from dragging them away; others should be shown crouching on the ground, their hands over their eyes because of the dust, their garments and hair streaming in the wind. Let the sea be wild and tempestuous, and between the crests of its waves it should be covered with eddying foam, and the wind should carry the finer spray through the stormy air after the manner of a thick and all-enveloping mist.

Of the ships that are there, some you should show with sail rent and the shreds of it flapping in the air in company with the broken halyards, and some of the masts broken and gone by the board, and the vessel itself lying disabled and broken by the fury of the waves, with some of the crew shrieking and clinging to the fragments of the wreck. You should show the clouds, driven by the impetuous winds, hurled against the high mountain tops, and there wreathing and eddying like waves that beat upon the rocks; the very air should strike terror through the murky darkness occasioned therein by the dust and mist and thick clouds.

OF HOW TO REPRESENT SOMEONE WHO IS SPEAKING
AMONG A GROUP OF PERSONS

When you desire to represent anyone speaking among a group of persons you ought to consider first the subject of which he has to treat, and how so to order his actions that they may be in keeping with this subject. That is, if the subject be persuasive, the actions should serve this intention; if it be one that needs to be expounded under various heads, the speaker should take a finger of his left hand between two fingers of his right, keeping the two smaller ones closed,[1] and let his face be animated and turned towards the people, with mouth slightly opened, so as to give the effect of speaking. And if he is seated let him seem to be in the act of raising himself more upright, with his head forward. And if you represent him standing, make him leaning forward a little with head and shoulders towards the populace, whom you should show silent and attentive, and all watching the face of the orator with gestures of admiration. Show the mouths of some of the old men with the corners pulled down in astonishment at what they hear, drawing back the cheeks in many furrows, with their eyebrows raised where they meet, making many wrinkles on their foreheads; and show some sitting with the fingers of their hands locked together and clasping their weary knees, and others—decrepit old men—with one knee crossed over the other, and one hand resting upon it which serves as a cup for the other elbow, while the other hand supports the bearded chin.

MS. 2038 Bib. Nat. 21 r.

How to heighten the apparent relief in a painting by the use of artificial lights and shadows:

In order to increase the relief in a picture you should make it your practice to place between the figure represented and that adjacent object which receives its shadow, a line of bright light in order to divide the figure from the object in shadow. And in this same object you will make two bright parts which shall have between them the shadow cast upon the wall by the figure placed opposite: and do this frequently with the limbs which you desire should stand out somewhat from

[1] MS. has *serate*. M. Ravaisson-Mollien gives *searate*, and translates as though it were 'separate'.

their body; and especially when the arms cross the breast, show how between the line of incidence of the shadow of the arm upon the breast and the real shadow of the arm, there remains a streak of light which seems to pass through the space that is between the breast and the arm. And the more you wish the arm to seem detached from the breast the broader you must make this light. And always make it your aim so to arrange bodies against their backgrounds that the parts of the bodies that are in shadow end against a light background, and the part of the body that is illuminated ends against a dark background.

OF THE SURROUNDING OF BODIES WITH VARIOUS SHAPES OF SHADOW

Take care that the shadows cast upon the surfaces of bodies by different objects are always undulating with varying curves produced by the variety of the limbs that create the shadows and of the object that receives the shadow.

OF THE ESSENTIAL NATURE OF SHADOW

Shadow partakes of the nature of universal things which are all more powerful at their beginning and grow weaker towards the end. I refer to the beginning of all forms and qualities visible or invisible, and not of things brought from small beginnings to a mighty growth by time, as a great oak would be which has its feeble beginning in a tiny acorn; though I would rather say the oak is most powerful at the spot where it is born in the ground, for there is the place of its greatest growth. Darkness, therefore, is the first stage of shadow and light is the last. See, therefore, O painter, that you make your shadow darkest near to its cause and make the end of it become changed into light so that it seems to have no end.

How the shadows cast by particular lights should be avoided because their ends are like their beginnings:

The shadows cast by the sun or other particular lights do not impart grace to the body to which they belong, but rather leave the parts separated in a state of confusion with a visible boundary of shadow and

light. And the shadows have the same strength at the end that they had at the beginning. MS. 2038 Bib. Nat. 21 v.

WHAT SHADOW AND LIGHT ARE

Shadow is the absence of light; it is simply the obstruction caused by opaque bodies opposed to luminous rays. Shadow is of the nature of darkness, light is of the nature of brightness. The one hides and the other reveals. They are always in company attached to the bodies. And shadow is more powerful than light for it impedes and altogether deprives objects of brightness, whereas brightness can never altogether drive away shadow from bodies, that is from opaque bodies.

What difference there is between a shadow inseparable from a body and a cast shadow:

An inseparable shadow is one which is never parted from the illuminated bodies, as is the case with a ball, for when it is in the light it always has one of its sides covered by shadow and this shadow never separates from it through any change in the position of the ball. A cast shadow may or may not be produced by the body itself. Let us suppose the ball to be at a distance of a braccio from the wall and the light to be coming from the opposite side: this light will throw just as broad a shadow upon the wall as upon the side of the ball that faces the wall. Part of a cast shadow will not be visible when the light is below the ball, for its shadow will then pass towards the sky and finding there no obstruction in its course will become lost. MS. 2038 Bib. Nat. 22 r.

A WAY TO STIMULATE AND AROUSE THE MIND TO VARIOUS INVENTIONS

I will not refrain from setting among these precepts a new device for consideration which, although it may appear trivial and almost ludicrous, is nevertheless of great utility in arousing the mind to various inventions.

And this is that if you look at any walls spotted with various stains or with a mixture of different kinds of stones, if you are about to invent some scene you will be able to see in it a resemblance to various

different landscapes adorned with mountains, rivers, rocks, trees, plains, wide valleys and various groups of hills. You will also be able to see divers combats and figures in quick movement, and strange expressions of faces, and outlandish costumes, and an infinite number of things which you can then reduce into separate and well-conceived forms. With such walls and blends of different stones it comes about as it does with the sound of bells, in whose clanging you may discover every name and word that you can imagine.

OF THE TEN ATTRIBUTES OF SIGHT WHICH ALL FIND EXPRESSION IN PAINTING

Painting is concerned with all the ten attributes of sight, namely darkness and brightness, substance and colour, form and place, remoteness and nearness, movement and rest; and it is with these attributes that this my small book will be interwoven, recalling to the painter by what rules and in what way he ought by his art to imitate all things that are the work of nature and the adornment of the world.

HOW THE PAINTER OUGHT TO PRACTISE HIMSELF IN THE PERSPECTIVE OF COLOURS

As a means of practising this perspective of the variation and loss or diminution of the proper essence of colours, take, at distances a hundred braccia apart, objects standing in the landscape, such as trees, houses, men and places, and in front of the first tree fix a piece of glass so that it is quite steady, and then let your eye rest upon it and trace out a tree upon the glass above the outline of the tree; and afterwards remove the glass so far to one side that the actual tree seems almost to touch the one that you have drawn. Then colour your drawing in such a way that the two are alike in colour and form, and that if you close one eye both seem painted on the glass and the same distance away. Then proceed in the same way with a second and a third tree at distances of a hundred braccia from each other. And these will always serve as your standards and teachers when you are at work on pictures where they can be applied, and they will cause the work to be successful in its distance.

But I find it is a rule that the second is reduced to four-fifths the size of the first when it is twenty braccia distant from it.

OF UNDULATING MOVEMENTS AND EQUIPOISE IN HUMAN FIGURES AND FIGURES OF ANIMALS

Whenever you make a figure of a man or of some graceful animal remember to avoid making it seem wooden; that is it should move with counterpoise and balance in such a way as not to seem a block of wood.

Those whom you wish to represent as strong should not be shown thus except in their manner of turning their heads upon their shoulders. MS. 2038 Bib. Nat. 22 v.

OF LINEAR PERSPECTIVE

Linear perspective has to do with the function of the lines of sight, proving by measurement how much smaller is the second object than the first and the third than the second, and so on continually until the limit of things seen. I find by experience that if the second object is as far distant from the first as the first is from your eye, although as between themselves they may be of equal size, the second will seem half as small again as the first; and if the third object is equal in size to the second, and it is as far beyond the second as the second is from the first,[1] it will appear half the size of the second; and thus by successive degrees at equal distances the objects will be continually lessened by half, the second being half the first—provided that the intervening space does not amount to as much as twenty braccia; for at the distance of twenty braccia a figure resembling yours will lose four-fifths of its size, and at a distance of forty braccia it will lose nine-tenths, and nineteen-twentieths at sixty braccia, and so by degrees it will continue to diminish, when the plane of the picture is twice your own height away from you, for if the distance only equals your own height there is a great difference between the first set of braccia and the second.

[1] MS. has 'third'.

OF PLACING A FIGURE IN THE FOREGROUND IN AN HISTORICAL COMPOSITION

You should make the figure in the foreground in an historical composition proportionately less than life size according to the number of braccia that you place it behind the front line, and then make the others in proportion to the first by the rule above.

I give the degrees of the things seen by the eye as the musician does of the sounds heard by the ear:

Although the things seen by the eye seem to touch as they recede I will nevertheless found my rule on spaces of twenty braccia, as the musician has done with sounds, for although they are united and connected together he has nevertheless fixed the degrees from sound to sound, calling these first, second, third, fourth and fifth, and so from degree to degree he has given names to the varieties of the sound of the voice, as it becomes higher or lower.

A method of making the shadow on figures correspond to their light and their shape:

When you make a figure and wish to see whether the shadow corresponds to the light, and is neither redder nor yellower than is the nature of the essence of the colour which you wish to show in shadow, you should do as follows: with a finger make a shadow upon the illuminated part, and if the accidental shadow made by you is like the natural shadow made by your finger upon your work, it will be well then by moving the finger nearer or farther off, to make the shadows darker or lighter, comparing them constantly with your own.

MS. 2038 Bib. Nat. 23 r.

WHY AN OBJECT WHEN PLACED CLOSE TO THE EYE WILL HAVE ITS EDGES INDISTINCT

All those objects opposite to the eye which are too near to it will have their edges difficult to discern, as happens when objects are near to the light and cast a large and indistinct shadow, even so this does when it has to judge of objects outside it: in all cases of linear perspective its action is similar to that of light. The reason of this is that the eye has

one principal line [of vision] which dilates as it acquires distance, and embraces with exactness of perception large things far away as it does small things close at hand. The eye however sends out a multitude of lines on either side of this principal centre-line, and these have less power to discern correctly as they are farther from the centre in this radiation. It follows therefore when an object is placed close to the eye that at that stage of nearness to the principal line of vision this is not capable of distinguishing the edges of the object, and so these edges must needs find themselves amid the lines that have but a poor power of comprehension. Their part in the functions of the eye is like that of setters at the chase, who start the prey but cannot catch it. So while they cannot themselves apprehend them they are a reason why the principal line of vision is diverted to the objects touched by these lines.

It follows therefore that the objects which have their edges judged by these lines are indistinct. MS. 2038 23 v.

OF THE WAY TO LEARN WELL BY HEART

When you wish to know anything well by heart which you have studied follow this method:—When you have drawn the same thing so many times that it seems that you know it by heart try to do it without the model; but have a tracing made of the model upon a thin piece of smooth glass and lay this upon the drawing you have made without the model. Note well where the tracing and your drawing do not tally, and where you find that you have erred bear it in mind in order not to make the mistake again. Even return to the model in order to copy the part where you were wrong so many times as to fix it in your mind; and if you cannot procure smooth glass to make a tracing of the object take a piece of very fine parchment well oiled and then dried, and when you have used it for one drawing you can wipe this out with a sponge and do a second.

OF THE WAY TO REPRESENT A SCENE CORRECTLY

Take a piece of glass of the size of a half sheet of royal folio paper, and fix it well in front of your eyes, that is between your eye and the object that you wish to portray. Then move away until your eye is two-

thirds of a braccio away from the piece of glass, and fasten your head by means of an instrument in such a way as to prevent any movement of it whatsoever. Then close or cover up one eye, and with a brush or a piece of red chalk finely ground mark out on the glass what is visible beyond it; afterwards copy it by tracing on paper from the glass, then prick it out upon paper of a better quality and paint it if you so desire, paying careful attention to the aerial perspective.

A WAY OF LEARNING HOW TO PLACE A FIGURE WELL

If you wish thoroughly to accustom yourself to correct and good positions for your figures, fasten a frame or loom divided into squares by threads between your eye and the nude figure which you are representing, and then make the same squares upon the paper where you wish to draw the said nude but very faintly. You should then place a pellet of wax on a part of the network to serve as a mark which as you look at your model should always cover the pit of the throat, or if he should have turned his back make it cover one of the vertebrae of the neck. And these threads will instruct you as to all the parts of the body which in each attitude are found below the pit of the throat, below the angles of the shoulders, below the breasts, the hips and the other parts of the body; and the transverse lines of the network will show you how much higher the figure is above the leg on which it is posed than above the other, and the same with the hips, the knees and the feet. But always fix the net by a perpendicular line and then see that all the divisions that you see the nude take in the network, the nude that you draw takes in the network of your sketch. The squares you draw may be as much smaller than those of the network in proportion as you wish your figure to be less than life size: then keep in mind in the figures that you make, the rule of the corresponding proportions of the limbs as the network has revealed it to you, and this should be three and a half braccia in height and three wide, at a distance of seven braccia from you and one from the nude figure.

MS. 2038 Bib. Nat. 24 r.

HOW THE MIRROR IS THE MASTER OF PAINTERS

When you wish to see whether the general effect of your picture corresponds with that of the object represented after nature, take a mirror and set it so that it reflects the actual thing, and then compare the reflection with your picture, and consider carefully whether the subject of the two images is in conformity with both, studying especially the mirror. The mirror ought to be taken as a guide—that is, the flat mirror—for within its surface substances have many points of resemblance to a picture; namely, that you see the picture made upon one plane showing things which appear in relief, and the mirror upon one plane does the same. The picture is one single surface, and the mirror is the same.

The picture is intangible, inasmuch as what appears round and detached cannot be enclosed within the hands, and the mirror is the same. The mirror and the picture present the images of things surrounded by shadow and light, and each alike seems to project considerably from the plane of its surface. And since you know that the mirror presents detached things to you by means of outlines and shadows and lights, and since you have moreover amongst your colours more powerful shadows and lights than those of the mirror, it is certain that if you but know well how to compose your picture it will also seem a natural thing seen in a great mirror. MS. 2038 Bib. Nat. 24 v.

Of the poor excuse made by those who falsely and unworthily get themselves styled painters:

There is a certain class of painters who though they have given but little attention to study claim to live in all the beauty of gold and azure. These aver—such is their folly!—that they are not able to work up to their best standard because of the poor payment, but that they have the knowledge and could do as well as any other if they were well paid.

But see now the foolish folk! They have not the sense to keep by them some specimen of their good work so that they may say, 'this is at a high price, and that is at a moderate price and that is quite cheap', and so show that they have work at all prices.

MS. 2038 Bib. Nat. 25 r.

OF AERIAL PERSPECTIVE

There is another kind of perspective which I call aerial, because by the difference in the atmosphere one is able to distinguish the various distances of different buildings when their bases appear to end on a single line, for this would be the appearance presented by a group of buildings on the far side of a wall, all of which as seen above the top of the wall look to be the same size; and if in painting you wish to make one seem farther away than another you must make the atmosphere somewhat heavy. You know that in an atmosphere of uniform density the most distant things seen through it, such as the mountains, in consequence of the great quantity of atmosphere which is between your eye and them, will appear blue, almost of the same colour as the atmosphere when the sun is in the east. Therefore you should make the building which is nearest above the wall of its natural colour, and that which is more distant make less defined and bluer; and one which you wish should seem as far away again make of double the depth of blue, and one you desire should seem five times as far away make five times as blue. And as a consequence of this rule it will come about that the buildings which above a given line appear to be of the same size will be plainly distinguished as to which are the more distant and which larger than the others.

HOW THE PAINTER IS NOT WORTHY OF PRAISE UNLESS HE IS UNIVERSAL

We may frankly admit that certain people deceive themselves who apply the title 'a good master' to a painter who can only do the head or the figure well. Surely it is no great achievement if by studying one thing only during his whole lifetime he attain to some degree of excellence therein! But since, as we know, painting embraces and contains within itself all the things which nature produces or which result from the fortuitous actions of men, and in short whatever can be comprehended by the eyes, it would seem to me that he is but a poor master who makes only a single figure well.

For do you not see how many and how varied are the actions which are performed by men alone? Do you not see how many different

kinds of animals there are, and also of trees and plants and flowers? What variety of hilly and level places, of springs, rivers, cities, public and private buildings; of instruments fitted for man's use; of divers costumes, ornaments and arts?—Things which should be rendered with equal facility and grace by whoever you wish to call a good painter.

OF DRAWING

Which is better—to draw from nature or from the antique? And which is more difficult—the lines or the light and shade?

MS. 2038 Bib. Nat. 25 v.

OF STUDYING AS SOON AS YOU ARE AWAKE OR BEFORE YOU GO TO SLEEP IN BED IN THE DARK

I have proved in my own case that it is of no small benefit on finding oneself in bed in the dark to go over again in the imagination the main outlines of the forms previously studied, or of other noteworthy things conceived by ingenious speculation; and this exercise is entirely to be commended, and it is useful in fixing things in the memory.

How the painter ought to be desirous of hearing every man's opinion as to the progress of his work:

Surely when a man is painting a picture he ought not to refuse to hear any man's opinion, for we know very well that though a man may not be a painter he may have a true conception of the form of another man, and can judge aright whether he is hump-backed or has one shoulder high or low, or whether he has a large mouth or nose or other defects.

Since then we recognise that men are able to form a true judgment as to the works of nature, how much the more does it behove us to admit that they are able to judge our faults. For you know how much a man is deceived in his own works, and if you do not recognise this in your own case observe it in others and then you will profit by their mistakes. Therefore you should be desirous of hearing patiently the opinions of others, and consider and reflect carefully whether or no he who censures you has reason for his censure; and correct your work

if you find that he is right, but if not, then let it seem that you have not understood him, or, in case he is a man whom you esteem, show him by argument why it is that he is mistaken.

How in works of importance a man should not trust so entirely to his memory as to disdain to draw from nature:

Any master who let it be understood that he could himself recall all the forms and effects of nature would certainly appear to me to be endowed with great ignorance, considering that these effects are infinite and that our memory is not of so great capacity as to suffice thereto.

Do you therefore, O painter, take care lest the greed for gain prove a stronger incentive than renown in art, for to gain this renown is a far greater thing than is the renown of riches.

For these, then, and other reasons which might be given, you should apply yourself first of all to drawing, in order to present to the eye in visible form the purpose and invention created originally in your imagination; then proceed to take from it or add to it until you satisfy yourself; then have men arranged as models draped or nude in the way in which you have disposed them in your work; and make the proportions and size in accordance with perspective, so that no part of the work remains that is not so counselled by reason and by the effects in nature.

And this will be the way to make yourself renowned in your art.

An object which is represented in white and black will appear in more pronounced relief than any other: and therefore I would remind you, O painter, that you should clothe your figures in as bright colours as you can, for if you make them dark in colour they will be only in slight relief and be very little visible at a distance. This is because the shadows of all objects are dark, and if you make a garment dark there will be only a slight difference between its lights and shades, whereas with the bright colours there are many grades of difference.

MS. 2038 Bib. Nat. 26 r.

OF THE WAY TO FIX IN YOUR MIND THE FORM OF A FACE

If you desire to acquire facility in keeping in your mind the expression of a face, first learn by heart the various different kinds of

heads, eyes, noses, mouths, chins, throats, and also necks and shoulders. Take as an instance noses:—they are of ten types: straight, bulbous, hollow, prominent either above or below the centre, aquiline, regular, simian, round, and pointed. These divisions hold good as regards profile. Seen from in front, noses are of twelve types: thick in the middle, thin in the middle, with the tip broad, and narrow at the base, and narrow at the tip, and broad at the base, with nostrils broad or narrow, or high or low, and with the openings either visible or hidden by the tip. And similarly you will find variety in the other features; of which things you ought to make studies from nature and so fix them in your mind. Or when you have to draw a face from memory, carry with you a small notebook in which you have noted down such features, and then when you have cast a glance at the face of the person whom you wish to draw you can look privately and see which nose or mouth has a resemblance to it, and make a tiny mark against it in order to recognise it again at home. Of abnormal faces I here say nothing, for they are kept in mind without difficulty.

OF THE GAMES IN WHICH DRAUGHTSMEN SHOULD INDULGE

When you, draughtsmen, wish to find some profitable recreation in games you should always practise things which may be of use in your profession, that is by giving your eye accuracy of judgment so that it may know how to estimate the truth as to the length and breadth of objects. So in order to accustom the mind to such things let one of you draw a straight line anywhere on a wall; and then let each of you take a light rush or straw in his hand, and let each cut his own to the length which the first line appears to him when he is distant from it a space of ten braccia, and then let each go up to the copy in order to measure it against the length which he has judged it to be, and he whose measure comes nearest to the length of the copy has done best and is the winner, and he should receive from all the prize which was previously agreed upon by you. Furthermore you should take measurements fore-shortened, that is, you should take a spear or some other stick and look before you to a certain point of distance, and then let each set himself to reckon how many times this measure is contained

in the said distance. Another thing is to see who can draw the best line one braccio in length, and this may be tested by tightly drawn thread.

Diversions such as these enable the eye to acquire accuracy of judgment, and this is the primary essential of painting.

WHETHER IT IS BETTER TO DRAW IN COMPANY OR NO

I say and am prepared to prove that it is much better to be in the company of others when you draw rather than alone, for many reasons. The first is that you will be ashamed of being seen in the ranks of the draughtsmen if you are outclassed by them, and this feeling of shame will cause you to make progress in study; secondly a rather commendable envy will stimulate you to join the number of those who are more praised than you are, for the praises of the others will serve you as a spur; yet another is that you will acquire something of the manner of anyone whose work is better than yours, while if you are better than the others you will profit by seeing how to avoid their errors, and the praises of others will tend to increase your powers.

MS. 2038 Bib. Nat. 26 v.

OF THE PROPER TIME FOR STUDYING THE SELECTION OF SUBJECTS

The winter evenings should be spent by youthful students in study of the things prepared during the summer; that is, all the drawings from the nude which you have made in the summer should be brought together, and you should make a choice from among them of the best limbs and bodies, and practise at these and learn them by heart.

OF ATTITUDES

Afterwards in the ensuing summer you should make choice of some one who has a good presence, and has not been brought up to wear doublets, and whose figure consequently has not lost its natural bearing, and make him go through various graceful and elegant movements. If he fails to show the muscles very clearly within the outlines

of the limbs, this is of no consequence. It is enough for you merely to obtain good attitudes from the figure, and you can correct the limbs by those which you have studied during the winter.

HOW IT IS NECESSARY FOR THE PAINTER TO KNOW THE INNER STRUCTURE OF MAN

The painter who has acquired a knowledge of the nature of the sinews, muscles, and tendons will know exactly in the movement of any limb how many and which of the sinews are the cause of it, and which muscle by its swelling is the cause of this sinew's contracting, and which sinews having been changed into most delicate cartilage surround and contain the said muscle. So he will be able in divers ways and universally to indicate the various muscles by means of the different attitudes of his figures; and he will not do like many who in different actions always make the same things appear in the arm, the back, the breast, and the legs; for such things as these ought not to rank in the category of minor faults.

OF THE CHOICE OF BEAUTIFUL FACES

Methinks it is no small grace in a painter to be able to give a pleasing air to his figures, and whoever is not naturally possessed of this grace may acquire it by study, as opportunity offers, in the following manner. Be on the watch to take the best parts of many beautiful faces of which the beauty is established rather by general repute than by your own judgment, for you may readily deceive yourself by selecting such faces as bear a resemblance to your own, since it would often seem that such similarities please us; and if you were ugly you would not select beautiful faces, but would be creating ugly faces like many painters whose types often resemble their master; so therefore choose the beautiful ones as I have said, and fix them in your mind.

MS. 2038 Bib. Nat. 27 r.

OF THE LIFE OF THE PAINTER IN HIS STUDIO

The painter or draughtsman ought to be solitary, in order that the well-being of the body may not sap the vigour of the mind; and more

especially when he is occupied with the consideration and investigation of things which by being continually present before his eyes furnish food to be treasured up in the memory.

If you are alone you belong entirely to yourself; if you are accompanied even by one companion you belong only half to yourself, or even less in proportion to the thoughtlessness of his conduct; and if you have more than one companion you will fall more deeply into the same plight.

If you should say, 'I will take my own course; I will retire apart, so that I may be the better able to investigate the forms of natural objects', then I say this must needs turn out badly, for you will not be able to prevent yourself from often lending an ear to their chatter; and not being able to serve two masters you will discharge badly the duty of companionship, and even worse that of endeavouring to realise your conceptions in art.

But suppose you say, 'I will withdraw so far apart that their words shall not reach me nor in any way disturb me'. I reply that in this case you will be looked upon as mad, and bear in mind that in so doing you will then be solitary.

If you must have companionship choose it from your studio; it may then help you to obtain the advantages which result from different methods of study. All other companionship may prove extremely harmful. MS. 2038 Bib. Nat. 27 v. and r.

Of the method of learning aright how to compose groups of figures in historical pictures:

When you have thoroughly learnt perspective, and have fixed in your memory all the various parts and forms of things, you should often amuse yourself when you take a walk for recreation, in watching and taking note of the attitudes and actions of men as they talk and dispute, or laugh or come to blows one with another, both their actions and those of the bystanders who either intervene or stand looking on at these things; noting these down with rapid strokes in this way,[1] in a little pocket-book, which you ought always to carry with you. And let this be of tinted paper, so that it may not be rubbed out; but you should change the old for a new one, for these are not things to be

[1] Sketch of figure in text of MS.

rubbed out but preserved with the utmost diligence; for there is such an infinite number of forms and actions of things that the memory is incapable of preserving them, and therefore you should keep those [sketches] as your patterns and teachers.

HOW ONE OUGHT FIRST TO LEARN DILIGENCE RATHER THAN RAPID EXECUTION

If as draughtsman you wish to study well and profitably, accustom yourself when you are drawing to work slowly, and to determine between the various lights, which possess the highest degree and measure of brightness, and similarly as to the shadows, which are those that are darker than the rest, and in what manner they mingle together, and to compare their dimensions one with another; and so with the contours to observe which way they are tending, and as to the lines what part of each is curved in one way or another, and where they are more or less conspicuous and consequently thick or fine; and lastly to see that your shadows and lights may blend without strokes or lines in the manner of smoke. And when you shall have trained your hand and judgment with this degree of care it will speedily come to pass that you will have no need to take thought thereto.

MS. 2038 Bib. Nat. 27 v.

OF JUDGING YOUR OWN PICTURE

We know well that mistakes are more easily detected in the works of others than in one's own, and that oftentimes while censuring the small faults of others you will overlook your own great faults. In order to avoid such ignorance make yourself first of all a master of perspective, then gain a complete knowledge of the proportions of man and other animals, and also make yourself a good architect, that is in so far as concerns the form of the buildings and of the other things which are upon the earth, which are infinite in form; and the more knowledge you have of these the more will your work be worthy of praise; and for those things in which you have no practice do not disdain to draw from nature. But to return to what has been promised above, I say that when you are painting you should take a flat mirror

and often look at your work within it, and it will then be seen in reverse, and will appear to be by the hand of some other master, and you will be better able to judge of its faults than in any other way.

It is also a good plan every now and then to go away and have a little relaxation; for then when you come back to the work your judgment will be surer, since to remain constantly at work will cause you to lose the power of judgment.

It is also advisable to go some distance away, because then the work appears smaller, and more of it is taken in at a glance, and a lack of harmony or proportion in the various parts and in the colours of the objects is more readily seen.

THIS RULE OUGHT TO BE GIVEN TO CHILDREN WHO PAINT

We know clearly that the sight is one of the swiftest actions that can exist, for in the same instant it surveys an infinite number of forms; nevertheless it can only comprehend one thing at a time. To take an instance: you, O Reader, might at a glance look at the whole of this written page, and you would instantly decide that it is full of various letters, but you will not recognise in this space of time either what letters they are or what they purport to say, and therefore it is necessary for you if you wish to gain a knowledge of these letters to take them word by word and line by line.

Again, if you wish to go up to the summit of a building it will be necessary for you to ascend step by step, otherwise it will be impossible to reach the top. So I say to you whom nature inclines to this art that if you would have a true knowledge of the forms of different objects you should commence with their details, and not pass on to the second until the first is well in your memory and you have practised it. If you do otherwise you will be throwing away time, and to a certainty you will greatly prolong the period of study. And remember to acquire diligence rather than facility. MS. 2038 Bib. Nat. 28 r.

OF THE CONFORMITY OF THE LIMBS

Further I remind you to pay great attention in giving limbs to your figures, so that they may not merely appear to harmonize with the

size of the body but also with its age. So the limbs of youths should have few muscles and veins, and have a soft surface and be rounded and pleasing in colour; in men they should be sinewy and full of muscles; in old men the surface should be wrinkled, and rough, and covered with veins, and with the sinews greatly protruding.

How little children have their joints the reverse of those of men in their thickness:

Little children have all the joints slender while the intervening parts are thick; and this is due to the fact that the joints are only covered by skin and there is no flesh at all over them, and this skin acts as a sinew to gird and bind together the bones; and a flabby layer of flesh is found between one joint and the next, shut in between the skin and the bone. But because the bones are thicker at the joints than between them, the flesh as the man grows up loses that superfluity which existed between the skin and the bone, and so the skin is drawn nearer to the bone and causes the limbs to seem more slender. But since there is nothing above the joints except cartilaginous and sinewy skin, this cannot dry up, and not being dried up it does not shrink. So for these reasons the limbs of children are slender at the joints and thick between the joints, as is seen in the joints of the fingers, arms, and shoulders which are slender and have great dimples; and a man on the contrary has all the joints of fingers, arms, and legs thick, and where children have hollows men have the joints protruding.

OF THE DIFFERENCE OF THE MEASUREMENTS IN BOYS AND MEN

I find a great difference between men and small boys in the length from one joint to another; for whereas the distance from the joint of the shoulder to the elbow, and from the elbow to the tip of the thumb, and from the humerus of one of the shoulders to the other, in a man is twice the head, in a child it is only once, because nature fashions the stature of the seat of the intellect for us before that of its active members.

OF THE RENDERING OF THE LIGHTS

Make first a general shadow over the whole of the extended part which does not see the light; then give to it the half shadows and the strong shadows, contrasting these one with another.

And similarly give the extended light in half-tone, adding afterwards the half-lights and the high lights and contrasting these in the same manner. MS. 2038 Bib. Nat. 28 v.

In what way you ought to make a head so that its parts may fit into their true positions:

To make a head so that its features are in agreement with those of a head that turns and bends, use these means: you know that the eyes, eyebrows, nostrils, corners of the mouth and sides of the chin, jaw, cheeks, ears and all the parts of a face are placed at regular positions upon the face, therefore when you have made the face, make lines which pass from one corner of the eye to the other; and so also for the position of each feature. Then having continued the ends of these lines beyond the two sides of the face, observe whether on the right and the left the spaces in the same parallel are equal. But I would specially remind you that you must make these lines extend to the point of your vision.

The way to represent the eighteen actions of man: [these are] rest, movement, speed; erect, leaning, seated, bending, kneeling, lying down, suspended; carrying, being carried, pushing, dragging, striking, being struck, pressing down and raising up.

You will treat first of the lights cast by windows to which you will give the name of restricted light; then treat of the lights of landscape to which you will give the name of free light; then treat of the light of luminous bodies.

HOW TO MAKE AN IMAGINARY ANIMAL APPEAR NATURAL

You know that you cannot make any animal without it having its limbs such that each bears some resemblance to that of some one of the other animals. If therefore you wish to make one of your imaginary

animals appear natural—let us suppose it to be a dragon—take for its head that of a mastiff or setter, for its eyes those of a cat, for its ears those of a porcupine, for its nose that of a greyhound, with the eyebrows of a lion, the temples of an old cock and the neck of a water-tortoise.

OF DRAWING AN OBJECT

See that when you are drawing and make a beginning of a line, that you look over all the object that you are drawing for any detail whatever which lies in the direction of the line that you have begun.

MS. 2038 Bib. Nat. 29 r.

How a figure is not worthy of praise unless such action appears in it as serves to express the passion of the soul:

That figure is most worthy of praise which by its action best expresses the passion which animates it.

HOW ONE OUGHT TO REPRESENT AN ANGRY FIGURE

An angry figure should be represented seizing someone by the hair and twisting his head down to the ground, with one knee on his ribs, and with the right arm and fist raised high up; let him have his hair dishevelled, his eyebrows low and knit together, his teeth clenched, the two corners of his mouth arched, and the neck which is all swollen and extended as he bends over the foe, should be full of furrows.

HOW TO REPRESENT A MAN IN DESPAIR

A man who is in despair you should make turning his knife against himself, and rending his garments with his hands, and one of his hands should be in the act of tearing open his wound. Make him with his feet apart, his legs somewhat bent, and the whole body likewise bending to the ground, and with his hair torn and streaming.

OF THE GRACE OF THE LIMBS

The limbs should fit the body gracefully in harmony with the effect you wish the figure to produce; and if you desire to create a figure

which shall possess a charm of its own, you should make it with limbs graceful and extended, without showing too many of the muscles, and the few which your purpose requires you to show indicate briefly, that is without giving them prominence, and with the shadows not sharply defined, and the limbs, and especially the arms, should be easy, that is that no limb should be in a straight line with the part that adjoins it. And if the hips which form as it were the poles of the man, are by his position placed so that the right is higher than the left, you should make the top shoulder-joint so that a line drawn from it perpendicularly falls on the most prominent part of the hip, and let this right shoulder be lower than the left.

And let the hollow of the throat always be exactly over the middle of the joint of the foot which is resting on the ground. The leg which does not support the weight should have its knee below the other and near to the other leg.

The positions of the head and arms are numberless, and therefore I will not attempt to give any rule; it will suffice that they should be natural and pleasing and should bend and turn in various ways, with the joints moving freely so that they may not seem like pieces of wood.

HOW THE CAST SHADOW IS NEVER EQUAL IN SIZE TO ITS CAUSE

If as experience shows luminous rays come from a single point, and proceed in the form of a sphere from this point radiating and spreading themselves through the air, the farther they go the more they are dispersed; and an object placed between the light and the wall is always reproduced larger in its shadow, because the rays that strike it have become larger by the time they have reached the wall.

MS. 2038 Bib. Nat. 29 v.

OF THE ARRANGEMENT OF THE LIMBS

As regards the arrangement of the limbs, you should bear in mind that when you wish to represent one who by some chance has either to turn backwards or on one side, you must not make him move his feet and all his limbs in the same direction as he turns his head; but

you should show the process spreading itself and taking effect over the four sets of joints, namely those of the foot, the knee, the hip, and the neck. And if you let his weight rest on the right leg, you should make the knee of the left bend inwards; and the foot of it should be slightly raised on the outside, and the left shoulder should be somewhat lower than the right; and the nape of the neck should be exactly above the outer curve of the ankle of the left foot, and the left shoulder should be above the toe of the right foot in a perpendicular line. And always so dispose your figures that the direction in which the head is turned is not that in which the breast faces, since nature has for our convenience so formed the neck that it can easily serve the different occasions on which the eye desires to turn in various directions; and to this same organ the other joints are in part responsive. And if ever you show a man sitting with his hands at work upon something by his side, make the chest turn upon the hip joints.

OF THE SHADOW CAST BY A BODY SITUATED BETWEEN TWO EQUAL LIGHTS

A body which finds itself placed between two equal lights will put forth two shadows, which will take their direction equally according to the lines of the two lights. And if you move the body farther away or bring it nearer to one of the lights, the shadow which points to the nearer light will be less deep than that which points to the one more remote.

THE BODY NEARER TO THE LIGHT WILL CAST THE LARGER SHADOW, AND WHY

If an object placed in front of a particular light be very near to it you will see it cast a very large shadow on the opposite wall, and the farther you remove the object from the light the smaller will the shadow become.

WHY A SHADOW WHICH IS GREATER THAN ITS CAUSE WILL BE OUT OF PROPORTION

The want of proportion of the shadow which is greater than its cause, arises from the fact that as the light is less than its object it can-

not be at an equal distance from the extremities of the object, and the part which is at a greater distance increases more than those which are nearer, and therefore the shadow increases.

WHY A SHADOW WHICH IS BIGGER THAN THE BODY THAT CAUSES IT HAS INDISTINCT CONTOURS

Atmosphere which surrounds a light almost partakes of the nature of this light in brightness and in warmth; the farther away it recedes the more it loses this resemblance. An object which casts a large shadow is near to the light and finds itself lit up both by the light and by the luminous atmosphere, and consequently this atmosphere leaves the contours of the shadow indistinct. MS. 2038 Bib. Nat. 30 r.

THE WAY TO REPRESENT A BATTLE

Show first the smoke of the artillery mingled in the air with the dust stirred up by the movement of the horses and of the combatants. This process you should express as follows: the dust, since it is made up of earth and has weight, although by reason of its fineness it may easily rise and mingle with the air, will nevertheless readily fall down again, and the greatest height will be attained by such part of it as is the finest, and this will in consequence be the least visible and will seem almost the colour of the air itself.

The smoke which is mingled with the dust-laden air will as it rises to a certain height have more and more the appearance of a dark cloud, at the summit of which the smoke will be more distinctly visible than the dust. The smoke will assume a bluish tinge, and the dust will keep its natural colour. From the side whence the light comes this mixture of air and smoke and dust will seem far brighter than on the opposite side.

As for the combatants the more they are in the midst of this turmoil the less they will be visible, and the less will be the contrast between their lights and shadows.

You should give a ruddy glow to the faces and the figures and the air around them, and to the gunners and those near to them, and this glow should grow fainter as it is farther away from its cause. The figures which are between you and the light, if far away, will appear

dark against a light background, and the nearer their limbs are to the ground the less will they be visible, for there the dust is greater and thicker. And if you make horses galloping away from the throng, make little clouds of dust as far distant one from another as is the space between the strides made by the horse, and that cloud which is farthest away from the horse should be the least visible, for it should be high and spread out and thin, while that which is nearest should be most conspicuous and smallest and most compact.

Let the air be full of arrows going in various directions, some mounting upwards, others falling, others flying horizontally; and let the balls shot from the guns have a train of smoke following their course. Show the figures in the foreground covered with dust on their hair and eyebrows and such other level parts as afford the dust a space to lodge.

Make the conquerors running, with their hair and other light things streaming in the wind, and with brows bent down; and they should be thrusting forward opposite limbs, that is, if a man advances the right foot, the left arm should also come forward. If you represent anyone fallen you should show the mark where he has been dragged through the dust which has become changed to blood-stained mire, and round about in the half-liquid earth you should show the marks of the trampling of men and horses who have passed over it.

Make a horse dragging the dead body of his master, and leaving behind him in the dust and mud the track of where the body was dragged along.

Make the beaten and conquered pallid, with brows raised and knit together, and let the skin above the brows be all full of lines of pain; at the sides of the nose show the furrows going in an arch from the nostrils and ending where the eye begins, and show the dilatation of the nostrils which is the cause of these lines; and let the lips be arched displaying the upper row of teeth, and let the teeth be parted after the manner of such as cry in lamentation. Show someone using his hand as a shield for his terrified eyes, turning the palm of it towards the enemy, and having the other resting on the ground to support the weight of his body; let others be crying out with their mouths wide open, and fleeing away. Put all sorts of armour lying between the feet of the combatants, such as broken shields, lances, swords, and other things like these. Make the dead, some half-buried in dust, others with

the dust all mingled with the oozing blood and changing into crimson mud; and let the line of the blood be discerned by its colour, flowing in a sinuous stream from the corpse to the dust. Show others in the death agony grinding their teeth and rolling their eyes, with clenched fists grinding against their bodies and with legs distorted. Then you might show one, disarmed and struck down by the enemy, turning on him with teeth and nails to take fierce and inhuman vengeance; and let a riderless horse be seen galloping with mane streaming in the wind, charging among the enemy and doing them great mischief with his hoofs.

You may see there one of the combatants, maimed and fallen on the ground, protecting himself with his shield, and the enemy bending down over him and striving to give him the fatal stroke; there might also be seen many men fallen in a heap on top of a dead horse; and you should show some of the victors leaving the combat and retiring apart from the crowd, and with both hands wiping away from eyes and cheeks the thick layer of mud caused by the smarting of their eyes from the dust.[1]

And the squadrons of the reserves should be seen standing full of hope but cautious, with eyebrows raised, and shading their eyes with their hands, peering into the thick, heavy mist in readiness for the commands of their captain; and so too the captain with his staff raised, hurrying to the reserves and pointing out to them the quarter of the field where they are needed; and you should show a river, within which horses are galloping, stirring the water all around with a heaving mass of waves and foam and broken water, leaping high into the air and over the legs and bodies of the horses; but see that you make no level spot of ground that is not trampled over with blood.

MS. 2038 Bib. Nat. 31 r. and 30 v.

HOW HIGH THE POINT OF SIGHT SHOULD BE PLACED

This point ought to be at the same level as the eye of an ordinary man; and the end of the flat country which borders upon the sky should be made of the same height as the line where the earth touches the horizon, except for the mountains which are in liberty.

MS. 2038 Bib. Nat. 31 r.

[1] MS. has *per lamor della polvere.*

HOW SMALL FIGURES OUGHT CONSEQUENTLY TO BE LEFT UNFINISHED

I say that when objects appear of minute size, it is due to the said objects being at a distance from the eye; and when this is the case, there must of necessity be a considerable quantity of atmosphere between the eye and the object, and this atmosphere interferes with the distinctness of the form of the objects, and consequently the minute details of these bodies will become indistinguishable and unrecognisable.

Therefore, O painter, you should make your lesser figures only suggested, and not highly finished; for if you do otherwise, you will produce effects contrary to those of nature, your mistress.

The object is small because of the great space which exists between the eye and it. This great space contains within itself a great quantity of atmosphere; and this atmosphere forms of itself a dense body which interposes and shuts out from the eye the minute details of the objects.

WHAT BACKGROUND A PAINTER SHOULD CHOOSE FOR HIS WORKS

Since one sees by experience that all bodies are surrounded by shadow and light it is expedient, O painter, that you so dispose the part illuminated that it is outlined against a dark object, and that in the same way the part of the body in shadow is outlined against a bright object. And this rule will be a great help to you in giving relief to your figures.

OF DRAWING

When you have to draw from nature stand three times as far away as the size of the object that you are drawing.

Why does a painting seem better in a mirror than outside it?

HOW IN ALL TRAVELS ONE MAY LEARN

This benign nature so provides that over all the world you find something to imitate.

OF SHADOW

Where the shadow is bounded by light, note carefully where it is lighter or darker, and where it is more or less indistinct towards the light; and above all I would remind you that in youthful figures you should not make the shadows end like stone, for the flesh retains a slight transparency, as may be observed by looking at a hand held between the eye and the sun, when it is seen to flush red and to be of a luminous transparency.

And let the part which is brightest in colour be between the lights and the shadows. And if you wish to see what depth of shadow is needed for the flesh, cast a shadow over it with your finger, and according as you wish it to be lighter or darker, hold your finger nearer or farther away from the picture, and then copy this shadow.

OF HOW TO DEPICT A WILD LANDSCAPE

Those trees and shrubs which are more split up into a quantity of thin branches ought to have less density of shadow. The trees and the shrubs which have larger leaves cast a greater shadow.

MS. 2038 Bib. Nat. 31 v.

HOW ONE OUGHT TO ARRANGE THE LIGHT UPON FIGURES

The disposition of the light should be in harmony with the natural conditions under which you represent your figure; that is, if you are representing it in sunlight, make the shadows dark with great spaces of light, and mark the shadows of all the surrounding bodies and their shadows upon the ground. If you represent it in dull weather, make only a slight difference between the lights and the shadows, and do not make any other shadow at the feet. If you represent it within doors, make a strong difference between the lights and shadows and show the shadow on the ground, and if you represent a window covered by a curtain and the wall white there should be little difference between the lights and shadows. If it is lit by a fire you should make the lights ruddy and powerful and the shadows dark; and the shadows should be sharply defined where they strike the walls or the floor, and the

farther away they extend from the body the broader and larger should they become. And if it be lit in part by the fire and in part by the atmosphere, make the part lit by the atmosphere the stronger, and let that lit by the fire be almost as red as fire itself. And above all let the figures that you paint have sufficient light and from above, that is all living persons whom you paint, for the people whom you see in the streets are all lighted from above; and I would have you know that you have no acquaintance so intimate but that if the light fell on him from below you would find it difficult to recognise him.

THE ORDER OF LEARNING TO DRAW

First of all copy drawings by a good master made by his art from nature and not as exercises; then from a relief, keeping by you a drawing done from the same relief; then from a good model; and of this you ought to make a practice.

AT WHAT HEIGHT THE LIGHT SHOULD BE IN ORDER TO DRAW FROM NATURE

When you are drawing from nature the light should be from the north, so that it may not vary; and if it is from the south keep the window covered with a curtain so that though the sun shine upon it all day long the light will undergo no change. The elevation of the light should be such that each body casts a shadow on the ground which is of the same length as its height.

WHY BEAUTIFUL COLOURS SHOULD BE IN THE LIGHTS

Since we see that the quality of colours becomes known by means of light, it is to be inferred that where there is most light there the true quality of the colour so illuminated will be most visible, and where there is most shadow there the colour will be most affected by the colour of the shadow. Therefore, O painter, be mindful to show the true quality of the colours in the parts which are in light.

MS. 2038 Bib. Nat. 33 r.

OF LIGHT AND SHADE

Each part of the surface of a body is in part affected by the colour of the thing opposite to it.

Example

If you set a spherical body in the midst of different objects, that is, so that on the one side it has the light of the sun and on the side opposite there is a wall illuminated by the sun, which may be green or some other colour, the surface on which it is resting being red and the two transverse sides dark, you will see the natural colour of this object take on the hues of those colours which are over against it. The strongest will be that proceeding from the light, the second that from the illuminated wall, the third that of the shadow. There yet remains however a portion which will take its hue from the colour of the edges.

The supreme misfortune is when theory outstrips performance.

In the choice of figures aim at softness and delicacy rather than that they should be stiff and wooden.

HOW THE CONDITION OF THE ATMOSPHERE AFFECTS THE LIGHTS AND SHADOWS

That body will present the strongest contrast between its lights and shadows which is seen by the strongest light, such as the light of the sun or at night by the light of a fire; but this should rarely be employed in painting, because the work will remain hard and devoid of grace.

A body which is in a moderate light will have but little difference between its lights and shadows; and this comes to pass at the fall of the evening, or when there are clouds: works painted then are soft in feeling and every kind of face acquires a charm.

Thus in every way extremes are injurious. Excess of light makes things seem hard;[1] and too much darkness does not admit of our seeing them. The mean is excellent.

[1] MS. has *il tropo lume fa crudo.* So also Dr. Richter. The text of M. Ravaisson-Mollien has *facendo* in place of *fa crudo.*

OF SMALL LIGHTS

The lights cast from small windows also present a strong contrast of light and shadow, more especially if the chamber lit by them is large; and this is not good to use in painting.

MS. 2038 Bib. Nat. 33 v.

The painter who draws by practice and judgment of the eye without the use of reason, is like the mirror that reproduces within itself all the objects which are set opposite to it without knowledge of the same.

C.A. 76 r. a

That countenance which in a picture is looking full in the face of the master who makes it will always be looking at all the spectators. And the figure painted when seen below from above will always appear as though seen below from above, although the eye of the beholder may be lower than the picture itself.

C.A. 111 v. b

OF THE PARTS OF THE FACE

If nature had only one fixed standard for the proportions of the various parts, then the faces of all men would resemble each other to such a degree that it would be impossible to distinguish one from another; but she has varied the five parts of the face in such a way that although she has made an almost universal standard as to their size, she has not observed it in the various conditions to such a degree as to prevent one from being clearly distinguished from another.

C.A. 119 v. a

As the body with great slowness produced by the length of its contrary movement turns in greater space and thereby gives a stouter blow, whereas movements which are continuous and short have little strength—so study upon the same subject made at long intervals of time causes the judgment to become more perfect and the better to recognise its own mistakes. And the same is true of the eye of the painter as it draws farther away from his picture.

C.A. 122 v. a

A picture or any representation of figures ought to be done in such a way that those who see them may be able with ease to recognise from

their attitudes what is passing through their minds. So if you have to represent a man of good repute in the act of speaking, make his gestures accord with the probity of his speech; and similarly if you have to represent a brutal man, make him with fierce movements flinging out his arms towards his hearer, and the head and chest protruding forward beyond the feet should seem to accompany the hands of the speaker.

Just so a deaf mute who sees two people talking, although being himself deprived of the power of hearing, is none the less able to divine from the movements and gestures of the speakers the subject of their discussion.

I once saw in Florence a man who had become deaf, who could not understand you if you spoke to him loudly, while if you spoke softly without letting the voice utter any sound, he understood you merely from the movement of the lips. Perhaps, however, you will say to me: 'But does not a man who speaks loudly move his lips like one who speaks softly? And since the one moves his lips like the other, will not the one be understood like the other?' As to this I leave the decision to the test of experience. Set someone to speak softly and then [louder], and watch the lips. c.a. 139 r. d

How from age to age the art of painting continually declines and deteriorates when painters have no other standard than work already done:

The painter will produce pictures of little merit if he takes the works of others as his standard; but if he will apply himself to learn from the objects of nature he will produce good results. This we see was the case with the painters who came after the time of the Romans, for they continually imitated each other, and from age to age their art steadily declined.

After these came Giotto the Florentine, and he—reared in mountain solitudes, inhabited only by goats and such like beasts—turning straight from nature to his art, began to draw on the rocks the movements of the goats which he was tending, and so began to draw the figures of all the animals which were to be found in the country, in such a way that after much study he not only surpassed the masters of his own time but all those of many preceding centuries. After him art again declined,

because all were imitating paintings already done; and so for centuries it continued to decline until such time as Tommaso the Florentine, nick-named Masaccio, showed by the perfection of his work how those who took as their standard anything other than nature, the supreme guide of all the masters, were wearying themselves in vain. Similarly I would say about these mathematical subjects, that those who study only the authorities and not the works of nature are in art the grandsons and not the sons of nature, which is the supreme guide of the good authorities.

Mark the supreme folly of those who censure such as learn from nature, leaving uncensured the authorities who were themselves the disciples of this same nature! c.a. 141 r. b

OF COMPOSING HISTORICAL SUBJECTS

Of not regarding the limbs of the figures in historical subjects, as many do who in making whole figures spoil their arrangement. For when you make figures one behind another, see that you draw them in their entirety, so that the limbs which are seen appearing beyond the surface of the first figure may retain their natural length and position.

c.a. 160 r. a

When a man running wishes to use up the impetus which is carrying him on, he prepares a contrary impetus which is brought into operation by his leaning backwards; this is capable of proof, for if the impetus carries the moving body forward with a momentum represented by four, and the impulse of the moving body to turn and fall back has a momentum of four the one momentum will neutralise the other which is contrary to it, and so the impetus is used up.

PAINTING

The surface of each body takes part of the colour of whatever is set against it. The colours of the objects in light are reproduced on each other's surface at different spots according to the varieties in the positions of these objects. [*Diagram*] Let *o* be a blue object in light, which alone by itself faces the space *b c* of the white sphere *a b c d e f*, and

tinges it blue; and let *m* be a yellow object which is reflected on the space *a b* in company with the blue object *o*, and tinges it green, by the second of this which shows that blue and yellow together produce a most beautiful green, etc.—and the rest will be set forth in the Book on Painting. In that book it will be demonstrated, by transmitting the images of the bodies and colours of the things illuminated by the sun through a small round hole in a dark place on to a smooth surface which in itself is white. But everything will be upside down.

C.A. 181 r. a

THE LIFE OF THE PAINTER IN THE COUNTRY

The painter requires such knowledge of mathematics as belongs to painting, and severance from companions who are not in sympathy with his studies, and his brain should have the power of adapting itself to the tenor of the objects which present themselves before it, and he should be freed from all other cares.

And if while considering and examining one subject a second should intervene, as happens when an object occupies the mind, he ought to decide which of these subjects presents greater difficulties in investigation, and follow that until it becomes entirely clear, and afterwards pursue the investigation of the other. And above all he should keep his mind as clear as the surface of a mirror, which becomes changed to as many different colours as are those of the objects within it, and his companions should resemble him in a taste for these studies, and if he fail to find any such he should accustom himself to be alone in his investigations, for in the end he will find no more profitable companionship.

C.A. 184 v. c

OF THE ORDER TO BE OBSERVED IN STUDY

I say that one ought first to learn about the limbs and how they are worked, and after having completed this knowledge one ought to study their actions in the different conditions in which men are placed, and thirdly to devise figure compositions, the studies for these being taken from natural actions made on occasion as opportunities offered; and one should be on the watch in the streets and squares and fields,

and there make sketches with rapid strokes to represent features, that is for a head one may make an *o*, and for an arm a straight or curved line, and so in like manner for the legs and trunk, afterwards when back at home working up these notes in a completed form.

My opponent says that in order to gain experience and to learn how to work readily, it is better that the first period of study should be spent in copying various compositions made by different masters either on sheets of paper or on walls, since from these one acquires rapidity in execution and a good method. But to this it may be replied that the ensuing method would be good if it was founded upon works that were excellent in composition and by diligent masters; and since such masters are so rare that few are to be found, it is safer to go direct to the works of nature than to those which have been imitated from her originals with great deterioration and thereby to acquire a bad method, for he who has access to the fountain does not go to the water-pot.

C.A. 199 v. a

These rules are to be used solely in testing figures; for every man in his first compositions makes certain mistakes, and if he does not become conscious of them he does not correct them; therefore in order to discover mistakes you should test your work and where you find there mistakes correct them, and remember never to fall into them again. But if you were to attempt to apply all these rules in composition you would never make a beginning and would cause confusion in your work.

These rules are intended to help you to a free and good judgment; for good judgment proceeds from good understanding, and good understanding comes from reason trained by good rules, and good rules are the children of sound experience, which is the common mother of all the sciences, and arts. If therefore you bear well in mind the precepts of my rules you will be able merely by the accuracy of your judgment to criticize and discern every error in proportion in any work, whether it is in the perspective or in the figures or other things. C.A. 221 v. d

All the limbs of every kind of animal should correspond with its age, that is, the young should not show their veins or nerves as most [painters] do in order to show their dexterity in art, spoiling the whole by mistakes in the limbs.

All the parts of an animal should correspond with the whole, that is, when a man is short and thickset you must see that each of his limbs is short and thickset.

Let the movements of men be such as are in keeping with their dignity or meanness. C.A. 345 v. b

Make your work to be in keeping with your purpose and design; that is, when you make your figure you should consider carefully who it is and what you wish it to be doing.

In order to produce an effect of similar action in a picture of an old man and a young, you must make the action of the young man appear more vigorous in proportion as he is more powerful than the old man, and you will make the same difference between a young man and an infant.

If you have to represent a man either as moving or lifting or pulling, or carrying a weight equal to his own weight, how ought you to fit the legs under his body? C.A. 349 r. b

Painters oftentimes deceive themselves by representing water in which they render visible what is seen by man; whereas the water sees the object from one side and the man sees it from the other; and it frequently happens that the painter will see a thing from above and the water sees it from beneath, and so the same body is seen in front and behind, and above and below, for the water reflects the image of the object in one way and the eye sees it in another. C.A. 354 r. d

We consider as a monstrosity one who has a very large head and short legs, and as a monstrosity also one who is in great poverty and has rich garments; we should therefore deem him well proportioned in whom the parts are in harmony with the whole. C.A. 375 r. c

OF THE ERROR WHICH IS COMMITTED IN JUDGING AS TO THE LIMBS

The painter who has clumsy hands will reproduce the same in his works, and the same thing will happen with every limb unless long study prevents it. Do you then, O painter, take careful note of that part in yourself which is most mis-shapen, and apply yourself by study to

remedy this entirely. For if you are brutal, your figures will be the same and devoid of grace, and in like manner every quality that there is within you of good or of evil will be in part revealed in your figures.

<div align="right">A 23 r.</div>

When you draw nudes be careful always to draw the whole figure, and then finish the limb which seems the best and at the same time study its relation to the other limbs, as otherwise you may form the habit of never properly joining the limbs together.

Take care never to make the head turn the same way as the chest nor the arm move with the leg; and if the head is turned towards the right shoulder make all the parts lower on the left side than on the right, but if you make the chest prominent and the head turning on the left side, then make the parts on the right side higher than those on the left.

<div align="right">A 28 v.</div>

Note in the movements and attitudes of the figures how the limbs and their expressions vary, because the shoulder blades in the movements of the arms and shoulders alter considerably the position of the backbone; and you will find all the causes of this in my book of Anatomy.

OF SHADOWS AND LIGHTS

You, who reproduce the works of nature, behold the dimensions, the degrees of intensity, and the forms of the lights and shadows of each muscle, and observe in the lengths of their figures towards which muscle they are directed by the axis of their central lines.

<div align="right">E 3 r.</div>

OF THE BACKGROUND OF THE FIGURES IN PAINTING

The background that surrounds the figures in any subject composition ought to be darker than the illuminated part of these figures, and lighter than their part in shadow.

<div align="right">E 4 r.</div>

That every part of a whole should be in proportion to its whole: thus if a man has a thick short figure that he should be the same in every one of his limbs, that is, with short thick arms, big hands, fingers thick and short, with joints of the same character and so with the rest.

And I would have the same understood to apply to all kinds of animals and plants; thus, in diminishing the parts, do so in proportion to their size, as also in enlarging.

OF HOW TO PAINT WIND

In representing wind, in addition to showing the bending of the boughs and the inverting of their leaves at the approach of the wind, you should represent the clouds of fine dust mingled with the troubled air. E 6 v.

OF THE REQUISITES OF PAINTING

The first requisite of painting is that the bodies which it represents should appear in relief, and that the scenes which surround them with effects of distance should seem to enter into the plane in which the picture is produced by means of the three parts of perspective, namely the diminution in the distinctness of the form of bodies, the diminution in their size, and the diminution in their colour. Of these three divisions of perspective, the first has its origin in the eye, the two others are derived from the atmosphere that is interposed between the eye and the objects which the eye beholds.

The second requisite of painting is that the actions should be appropriate and have a variety in the figures, so that the men may not all look as though they were brothers. E 79 v.

OF VARIETY IN FIGURES

The painter ought to strive at being universal, for there is a great lack of dignity in doing one thing well and another badly, like many who study only the measurements and proportions of the nude figure and do not seek after its variety; for a man may be properly proportioned and yet be fat and short or long and thin, or medium. And whoever does not take count of these varieties will always make his figures in one mould, so that they will all appear sisters, and this practice deserves severe censure.

OF THE ORDER OF ACQUIRING THIS UNIVERSALITY

It is an easy matter for whoever knows how to represent man to afterwards acquire this universality, for all the animals which live upon the earth resemble each other in their limbs, that is in muscles, sinews and bones, and they do not vary at all, except in length or thickness as will be shown in the Anatomy. There are also the aquatic animals, of which there are many different kinds; but with regard to these I do not advise the painter to make a fixed standard, for they are of almost infinite variety; and the same is also true of the insect world. G 5 v.

REPRESENTATION OF A DELUGE

The air was dark from the heavy rain which was falling slantwise, bent by the cross-current of the winds, and formed itself in waves in the air, like those one sees formed by the dust, the only difference being that these drifts were furrowed by the lines made by the drops of the falling water. It was tinged by the colour of the fire produced by the thunder-bolts wherewith the clouds were rent and torn asunder, the flashes from which smote and tore open the vast waters of the flooded valleys, and as these lay open there were revealed their depths [1] the bowed tops of the trees.

Neptune might be seen with his trident in the midst of the waters, and Æolus with his winds should be shown entangling the floating trees which had been uprooted and were mingled with the mighty waves.

The horizon and the whole firmament was overcast and lurid with the flashings of the incessant lightning.

Men and birds might be seen crowded together upon the tall trees which over-topped the swollen waters, forming hills which surround the great abysses. G 6 v.

[1] Dr. Richter reads *vertici*. I have followed M. Ravaisson-Mollien in reading *ventri*. MS. has *vertri*.

OF THE ERROR MADE BY THOSE WHO PRACTISE WITHOUT SCIENCE [1]

Those who are enamoured of practice without science are like a pilot who goes into a ship without rudder or compass and never has any certainty where he is going.

Practice should always be based upon a sound knowledge of theory, of which perspective is the guide and gateway, and without it nothing can be done well in any kind of painting.　　　　　　　　G 8 r.

Of the lights on the lower extremities of bodies packed tightly together, such as men in battle:

Of men and horses labouring in battle, the different parts should be darker in proportion as they are closer to the ground on which they are supported; and this is proved from the sides of wells, which become darker in proportion to their depth, this being due to the fact that the lowest part of the well sees and is seen by a lesser amount of the luminous atmosphere than any other part of it. And the pavements when they are the same colour as the legs of the men and horses will always seem in higher light within equal angles than will these same legs.　　　　　　　　G 15 r.

HOW TO PASS JUDGMENT UPON A PAINTER'S WORK

First you should consider the figures whether they have the relief which their position requires, and the light that illuminates them, so that the shadows may not be the same at the extremities of the composition as in the centre, because it is one thing for a figure to be surrounded by shadows, and another for it to have the shadows only on one side. Those figures are surrounded by shadows which are towards the centre of the composition, because they are shaded by the dark figures interposed between them and the light; and those are shaded on one side only which are interposed between the light and the main group, for where they do not face the light they face the group, and there they reproduce the darkness cast by this group, and where they do not face the group they face the brightness of the light, and there they reproduce its radiance.

[1] At margin of MS., 'See first the [Ars] Poetica of Horace'.

Secondly, you should consider whether the distribution or arrangement of the figures is devised in agreement with the conditions you desire the action to represent.

Thirdly, whether the figures are actively engaged on their purpose.

G 19 r.

OF PAINTING

A very important part of painting consists in the backgrounds of the things painted. Against these backgrounds the contour lines of such natural bodies as possess convex curves will always reveal the shapes of these bodies, even though the colours of the bodies are of the same hue as the background.

This arises from the fact of the convex boundaries of the objects not being illuminated in the same manner as the background is by the same light, because frequently the contours are clearer or darker than the background.

Should however these contours be of the same colour as the background, then undoubtedly this part of the picture will interfere with the perception of the figure formed by these contour lines. Such a predicament in painting ought to be avoided by the judgment of good painters, since the painter's intention is to make his bodies appear detached from the background; and in the above-mentioned instance the contrary occurs, not only in the painting but in the objects in relief. G 23 v.

AN INDICATION WHETHER A YOUTH HAS AN APTITUDE FOR PAINTING

There are many men who have a desire and love for drawing but no aptitude for it, and this can be discerned in children if they are not diligent and never finish their copies with shading.

The painter is not worthy of praise who does only one thing well, as the nude, or a head, or draperies, or animal life, or landscapes, or such other special subject; for there is no one so dull of understanding that after devoting himself to one subject only and continually practising at this, he will fail to do it well. G 25 r.

[*The representation of things in movement*]

Of the imitation of things which though they have movement in their own place, do not in this movement reveal themselves as they are in reality.

Drops of water when it rains, a winder, the turning-wheel, stones under the action of water, firebrands whirled round in a circle, proceed continuously, among things which are not in continuous movement.

G 35 r.

THE BOUNDARIES OF BODIES ARE THE LEAST OF ALL THINGS

The truth of this proposition is proved by the fact that the boundary of the substance is a surface, which is neither a part of the body enclosed by this surface nor a part of the atmosphere which surrounds this body, but is the medium interposed between the atmosphere and the body, as is proved in its place.

But the lateral boundaries of these bodies are the boundary line of the surface, which line is of invisible thickness. Therefore, O painter, do not surround your bodies with lines, and especially when making objects less than their natural size, for these not only cannot show their lateral boundaries, but their parts will be invisible, from distance.

G 37 r.

OF PAINTING

The high lights or the lustre of any particular object will not be situated in the centre of the illuminated part, but will make as many changes of position as the eye that beholds it. H 90 [42] v.

Painters have a good opportunity of observing actions in players, especially at ball or tennis or with the mallet when they are contending together, better indeed than in any other place or exercise. I 48 v.

It is the extremities of all things which impart to them grace or lack of grace. I 92 [44] v.

Men and words are actual, and you, painter, if you do not know how to execute your figures, will be like an orator who does not know how to use his words. K 110 [30] v.

It is a necessary thing for the painter, in order to be able to fashion the limbs correctly in the positions and actions which they can represent in the nude, to know the anatomy of the sinews, bones, muscles and tendons in order to know, in the various different movements and impulses, which sinew or muscle is the cause of each movement, and to make only these prominent and thickened, and not the others all over the limb, as do many who in order to appear great draughtsmen make their nudes wooden and without grace, so that it seems rather as if you were looking at a sack of nuts than a human form or at a bundle of radishes rather than the muscles of nudes. L 79 r.

In all things seen one has to consider three things, namely the position of the eye that sees, the position of the object seen and the position of the light that illumines this body. M 80 r.

[*With sketch*]
In the last folds of the joints of any limb everything which was in relief becomes a hollow, and similarly every hollow in the last of the said folds is changed into a protuberance when the end of the limb is straightened.

He who has not knowledge of this, often makes very great mistakes through relying too much upon his own skill, and not having recourse to the imitation of nature. And such variation is found more in the middle of the sides than in front and more behind than at the sides. B.M. 44 r.

The painter contends with and rivals nature. Forster III 44 v.

[*On draperies*]
Variety in the subjects. The draperies thin, thick, new, old, with folds broken and pleated, *cride dolci* [?soft lights], shadows obscure and less obscure, either with or without reflections, definite or indistinct according to the distances and the various colours; and garments according to the rank of those who are wearing them, long and short, fluttering or stiff in conformity with the movements; so encircling the figures as to bend or flutter with ends streaming upwards or downwards according to the folds, clinging close about the feet or separated from them, according as the legs are shown at rest or bending or twisting or striking together within; either fitting closely or separating from the joints,

according to the step or movement or whether the wind is represented.

And the folds should correspond to the quality of the draperies whether transparent or opaque.

[*Repetition—the greatest defect in a painter*]

The greatest defect in a painter is to repeat the same attitudes and the same expressions . . . in one . . .

[*On draperies*]

On the thin clothes of the women in walking, running and jumping, and their variety.

[*Notes on painting*]

And in painting make a discourse on the clothes and other raiments.

And you, O painter, who desire to perform great things, know that unless you first learn to do them well and with good foundations, the work that you do will bring you very little honour and less gain, but if you do it well it will produce you plenty of honour and be of great utility. Quaderni IV 15 r.

When the subject of your picture is a history make two points, one of the eye and the other of the light, and make the latter as far distant as possible. Windsor: Drawings 12604 r.

Nature of movements in man. Do not repeat the same actions in the limbs of men unless the necessity of their action constrains you.
 Windsor: Drawings 19149 v.

OF A DELUGE AND THE REPRESENTATION OF IT IN PAINTING

Let the dark, gloomy air be seen beaten by the rush of opposing winds wreathed in perpetual rain mingled with hail,[1] and bearing hither and thither a vast network of the torn branches of trees mixed together with an infinite number of leaves. All around let there be seen ancient trees uprooted and torn in pieces by the fury of the winds. You should show how fragments of mountains, which have been already stripped bare by the rushing torrents, fall headlong into these very torrents and choke up the valleys, until the pent-up rivers rise in flood and

[1] MS. *gravza.* I have followed Dr. Richter's suggestion *gragnuola.*

cover the wide plains and their inhabitants. Again there might be seen huddled together on the tops of many of the mountains many different sorts of animals, terrified and subdued at last to a state of tameness, in company with men and women who had fled there with their children. And the fields which were covered with water had their waves covered over in great part with tables, bedsteads, boats and various other kinds of rafts, improvised through necessity and fear of death, upon which were men and women with their children, massed together and uttering various cries and lamentations, dismayed by the fury of the winds which were causing the waters to roll over and over in mighty hurricane, bearing with them the bodies of the drowned; and there was no object that floated on the water but was covered with various different animals who had made truce and stood huddled together in terror, among them being wolves, foxes, snakes and creatures of every kind, fugitives from death. And all the waves that beat against their sides were striking them with repeated blows from the various bodies of the drowned, and the blows were killing those in whom life remained.

Some groups of men you might have seen with weapons in their hands defending the tiny footholds that remained to them from the lions and wolves and beasts of prey which sought safety there. Ah, what dreadful tumults one heard resounding through the gloomy air, smitten by the fury of the thunder and the lightning it flashed forth, which sped through it, bearing ruin, striking down whatever withstood its course! Ah, how many might you have seen stopping their ears with their hands in order to shut out the loud uproar caused through the darkened air by the fury of the winds mingled together with the rain, the thunder of the heavens and the raging of the thunderbolts! Others were not content to shut their eyes, but placing their hands over them, one above the other, would cover them more tightly in order not to see the pitiless slaughter made of the human race by the wrath of God.

Ah me, how many lamentations! How many in their terror flung themselves down from the rocks! You might have seen huge branches of the giant oaks laden with men borne along through the air by the fury of the impetuous winds. How many boats were capsized and lying, some whole, others broken in pieces, on the top of men struggling to escape with acts and gestures of despair which foretold an awful

death. Others with frenzied acts were taking their own lives, in despair of ever being able to endure such anguish; some of these were flinging themselves down from the lofty rocks, others strangled themselves with their own hands; some seized hold of their own children, and with mighty violence slew them at one blow; some turned their arms against themselves to wound and slay; others falling upon their knees were commending themselves to God.

Alas! how many mothers were bewailing their drowned sons, holding them upon their knees, lifting up open arms to heaven, and with divers cries and shrieks declaiming against the anger of the gods! Others with hands clenched and fingers locked together gnawed and devoured them with bites that ran blood, crouching down so that their breasts touched their knees in their intense and intolerable agony.

Herds of animals, such as horses, oxen, goats, sheep, were to be seen already hemmed in by the waters and left isolated upon the high peaks of the mountains, all huddling together, and those in the middle climbing to the top and treading on the others, and waging fierce battles with each other, and many of them dying from want of food.

And the birds had already begun to settle upon men and other animals, no longer finding any land left unsubmerged which was not covered with living creatures. Already had hunger, the minister of death, taken away their life from the greater number of the animals, when the dead bodies already becoming lighter began to rise from out the bottom of the deep waters, and emerged to the surface among the contending waves; and there lay beating one against another, and as balls puffed up with wind rebound back from the spot where they strike, these fell back and lay upon the other dead bodies.

And above these horrors the atmosphere was seen covered with murky clouds that were rent by the jagged course of the raging thunderbolts of heaven, which flashed light hither and thither amid the obscurity of the darkness.

The velocity of the air is seen by the movement of the dust stirred by the running of a horse; and it moves as swiftly to fill up the void left in the air which had enclosed the horse as is the speed of the horse in passing away from the aforesaid space of air.

But it will perhaps seem to you that you have cause to censure me for having represented the different courses taken in the air by the move-

ment of the wind, whereas the wind is not of itself visible in the air; to this I reply that it is not the movement of the wind itself but the movement of the things carried by it which alone is visible in the air.

The divisions

Darkness, wind, tempest at sea, deluge of water, woods on fire, rain, thunderbolts from the sky, earthquakes and destruction of mountains, levelling of cities.

Whirlwinds which carry water and branches of trees and men through the air.

Branches torn away by the winds crashing together at the meeting of the winds, with people on the top of them.

Trees broken off laden with people.

Ships broken in pieces dashed upon the rocks.

Hail, thunderbolts, whirlwinds.

Herds of cattle.

People on trees which cannot bear them: trees and rocks, towers, hills crowded with people, boats, tables, troughs and other contrivances for floating,—hills covered with men and women and animals, with lightnings from the clouds which illumine the whole scene.

<div align="right">Windsor: Drawings 12665 v.</div>

DESCRIPTION OF THE DELUGE

First of all let there be represented the summit of a rugged mountain with certain of the valleys that surround its base, and on its sides let the surface of the soil be seen slipping down together with the tiny roots of the small shrubs, and leaving bare a great part of the surrounding rocks. Sweeping down in devastation from these precipices, let it pursue its headlong course, striking and laying bare the twisted and gnarled roots of the great trees and overturning them in ruin. And the mountains becoming bare should reveal the deep fissures made in them by the ancient earthquakes; and let the bases of the mountains be in great part covered over and clad with the débris of the shrubs which have fallen headlong from the sides of the lofty peaks of the said mountains, and let these be mingled together with mud, roots, branches of trees,

with various kinds of leaves thrust in among the mud and earth and stones. And let the fragments of some of the mountains have fallen down into the depth of one of the valleys, and there form a barrier to the swollen waters of its river, which having already burst the barrier rushes on with immense waves, the greatest of which are striking and laying in ruin the walls of the cities and farms of the valley. And from the ruins of the lofty buildings of the aforesaid cities let there rise a great quantity of dust, mounting up in the air with the appearance of smoke or of wreathed clouds that battle against the descending rain.

But the swollen waters should be coursing round the pool which confines them, and striking against various obstacles with whirling eddies, leaping up into the air in turbid foam, and then falling back and causing the water where they strike to be dashed up into the air; and the circling waves which recede from the point of contact are impelled by their impetus right across the course of the other circling waves which move in an opposite direction to them, and after striking against these they leap up into the air without becoming detached from their base.

And where the water issues forth from the said pool, the spent waves are seen spreading out towards the outlet; after which, falling or descending through the air, this water acquires weight and impetus; and then piercing the water where it strikes, it tears it apart and dives down in fury to reach its depth, and then recoiling, it springs back again towards the surface of the lake accompanied by the air which has been submerged with it, and this remains in the slimy foam [1] mingled with the driftwood and other things lighter than the water, and around these again are formed the beginnings of the waves, which increase the more in circumference as they acquire more movement; and this movement makes them lower in proportion as they acquire a wider base, and therefore they become almost imperceptible as they die away. But if the waves rebound against various obstacles then they leap back and oppose the approach of the other waves, following the same law of development in their curve as they have already shown in their original movement. The rain as it falls from the clouds is of the same colour as these clouds, that is on its shaded side, unless, however, the rays of the sun

[1] Richter's transcript (§609) is 'vissci cholla', and he reads 'nella *uscita* colla sciuma'. The MS. has, I think, 'visscichosa', which I have taken as a variant of 'vischiosa'.

should penetrate there, for if this were so the rain would appear less dark than the cloud. And if the great masses of the débris of huge mountains or of large buildings strike in their fall the mighty lakes of the waters, then a vast quantity of water will rebound in the air, and its course will be in an opposite direction to that of the substance which struck the water, that is to say the angle of reflection will be equal to the angle of incidence.

Of the objects borne along by the current of the waters, that will be at a greater distance from the two opposite banks which is heavier or of larger bulk. The eddies of the waters revolve most swiftly in those parts which are nearest to their centre. The crests of the waves of the sea fall forward to their base, beating and rubbing themselves against the smooth particles which form their face; and by this friction the water as it falls is ground up in tiny particles,[1] and becomes changed to thick mist, and is mingled in the currents of the winds in the manner of wreathing smoke or winding clouds, and at last rises up in the air and becomes changed into clouds. But the rain which falls through the air, being beaten upon and driven by the current of the winds, becomes rare or dense according to the rarity or density of these winds, and by this means there is produced throughout the air a flood of transparent clouds which is formed by the aforesaid rain, and becomes visible in it by means of the lines made by the fall of the rain which is near to the eye of the spectator.[2] The waves of the sea that beats against the shelving base of the mountains which confine it, rush [3] foaming in speed up to the ridge of these same hills, and in turning back meet the onset of the succeeding wave, and after loud roaring return in a mighty flood to the sea from whence they came. A great number of the inhabitants, men and different animals, may be seen driven by the rising of the deluge up towards the summits of the hills which border on the said waters.

Waves of the sea at Piombino all of foaming water.

[1] MS., *e ttal confreghatione trita in minute partichule la dissciente acqua.*

[2] MS., 'ce p(er) quessto si gienera infrallaria vna innondatione di trassparēti *nuvoli la quale effacta dalla p(r)edetta pioggia e inquassta si fa manifessta mediante i liniameti* fatti dal disscieso della pioggia che e vicina all ochio che la vede'. The words printed in italics are wanting in the text as given by Dr. Richter (§609).

[3] Dr. Richter reads *saranno* (for MS. *sarrano*), but the text is, I think, *scorrano*, presumably for *scorrono*.

Of the water that leaps up—[of the place where the great masses fall and strike the waters] [1]—of the winds of Piombino.

Eddies of winds and of rain with branches and trees mingled with the air.

The emptying the boats of the rain water.

Windsor: Drawings 12665 r.

[1] The sentence within brackets is crossed through in the MS.

XXX

Colour

'Make the perspective of the colours so that it is not at variance with the size of any object, that is, that the colours lose part of their nature in proportion as the bodies at different distances suffer loss of their natural quantity.'

OF COLOURS

Of colours of equal whiteness that will seem most dazzling which is on the darkest background, and black will seem most intense when it is against a background of greater whiteness.

Red also will seem most vivid when against a yellow background, and so in like manner with all the colours when set against those which present the sharpest contrasts. c.A. 184 v. c

The more white a thing is the more it will be tinged with the colour of the illuminated or luminous object. c.A. 262 r. c

But in the far distance that object will show itself most blue which is darkest in colour. c.A. 305 r. a

Every object that has no colour in itself is tinged either entirely or in part by the colour [of the object] set opposite to it. This may be seen by experience, for every object which serves as a mirror is tinged with the colour of the thing that is reflected in it. And if the object which is in part tinged is white, the portion of it that is illumined by red will appear red, and so with every other colour whether it be light or dark.

Every opaque object that is devoid of colour partakes of the colour of that which is opposite to it: as happens with a white wall.

A 19 v.

OF COLOUR AND FRAGRANCE

Note how spirit (*acqua vite*) collects in itself all the colours and scents of the flowers; and if you wish to make azure, put cornflowers and then wild poppies. B 3 V.

[*Of distant colour*]

The variation in the colours of objects at a great distance can only be discerned in those portions which are smitten by the solar rays.
C 12 V.

As regards the colours of bodies there is no difference at a great distance in the parts which are in shadow. C 13 r.

A dark object will appear more blue when it has a larger amount of luminous atmosphere interposed between it and the eye, as may be seen in the colour of the sky. C 18 r.

[*A discussion on the colours of shadows*]

PAINTING

Colours seen in shadow will reveal more or less of their natural beauty in proportion as they are in fainter or deeper shadow.

But if the colours happen to be in a luminous space they will show themselves of greater beauty in proportion as the luminosity is more intense.

Adversary

The varieties in the colours of shadows are as numerous as the varieties in colour of the objects which are in the shadows.

Reply

Colours seen in shadow will reveal less variety one with another according as the shadows wherein they lie are deeper. There is evidence of this from those who from a space without peer within the doorways of shadowy temples, for there the pictures clad as they are in divers colours all seem robed in darkness.

So therefore at a long distance all the shadows of different colours appear of the same darkness.

Of bodies clad in light and shade it is the illuminated part which reveals the true colour. E 18 r.

No white or black is transparent. F 23 r.

PAINTING

Since white is not a colour but is capable of becoming the recipient of every colour, when a white object is seen in the open air all its shadows are blue; and this comes about in accordance with the fourth proposition, which says that the surface of every opaque body partakes of the colour of surrounding objects. As therefore this white object is deprived of the light of the sun by the interposition of some object which comes between the sun and it, all that portion of it which is exposed to the sun and the atmosphere continues to partake of the colour of the sun and the atmosphere, and that part which is not exposed to the sun remains in shadow, and partakes only of the colour of the atmosphere.

And if this white object should neither reflect the green of the fields which stretch out to the horizon nor yet face the brightness of the horizon itself, it would undoubtedly appear of such simple colour as the atmosphere showed itself to be. F 75 r.

OF THE ACCIDENTAL COLOURS OF TREES

The accidental colours of the leaves of trees are four, namely shadow, light, lustre and transparency.

OF THE VISIBILITY OF THESE ACCIDENTAL COLOURS

The accidental parts of the leaves of plants will at a great distance become a mixture, in which the accidental colour of the largest will predominate. G 24 r.

OF PAINTING

The colour of the object illuminated partakes of the colour of that which illuminates it. G 37 r.

The surface of every body participates in the colour of the body that illuminates it:

And in the colour of the air that is interposed between the eye and this body, that is to say in the colour of the transparent medium interposed between the object and the eye.

Among colours of the same quality, the second will never be of the same colour as the first; and this proceeds from the multiplication of the colour of the medium interposed between the object and the eye.

G 53 V.

Of the various colours other than blue, that which at a great distance will resemble blue most closely will be that which is nearest to black, and so conversely the colour which least resembles black will be the one which at a great distance will most retain its natural colour.

Accordingly, the green in landscapes will become more changed into blue than will the yellow or the white, and so conversely the yellow and the white will undergo less change than the green, and the red still less. L 75 V.

The shadow of flesh should be of burnt *terra verde*. L 92 r.

The image imprinted in a mirror partakes of the colour of the said mirror. B.M. 211 V.

The surface of every dark body will participate in the colour of the bodies placed against it. Forster III 74 V.

The surface of every opaque body will be capable of participating and will be tinged with the colour of the bodies placed against it.

Forster III 75 r.

PAINTING

[*The apparent colours of smoke on the horizon*]

The density of smoke from the horizon downwards is white and from the horizon upwards it is dark; and, although this smoke is in itself of the same colour, this equality shows itself as different, on account of the difference of the space in which it is found.

Quaderni IV 3 r.

[*Colour of flame*]

As flame extends it becomes yellow in its upper part, then saffron in colour, and this ends in smoke. Quaderni IV 10 v.

PAINTING

The surface of every opaque body participates in the colour of its object.

The surface of the opaque body is the more completely steeped in the colour of its object, in proportion as the rays of the images of these objects strike the objects at more equal angles.

And the surface of opaque bodies is more steeped in the colour of their object, in proportion as this surface is whiter, and the colour of the object more luminous or illuminated. Quaderni VI 22 r.

WHETHER THE COLOURS OF THE RAINBOW ARE CREATED BY THE SUN

The colours of the rainbow are not created by the sun, because in many ways these colours are produced without the sun, as happens when you hold up a glass of water close to the eye, for in the glass of it there are the tiny bubbles which are usually seen in glass that is imperfectly refined. And these bubbles although they are not in sun-light will produce on one side all the colours of the rainbow; and this you will see if you place the glass between the atmosphere and your eye in such a way as to be in contact with the eye, the glass having one side exposed to the light of the atmosphere, and on the other the shadow of the wall on the right or left side of the window, which side does not matter. So by turning this glass round you will see the afore-said colours round about these bubbles in the glass. And we will speak of other methods in their place.

HOW THE EYE HAS NO SHARE IN THE CREATION OF THE COLOURS OF THE RAINBOW

The eye in the experiment described above would seem to have some share in the creation of the colours of the rainbow, because the bub-

bles in the glass do not display these colours except through the medium of the eye. But if you place this glass full of water on the level of the window, so that the sun's rays strike it on the opposite side, you will then see the aforesaid colours producing themselves, in the impression made by the solar rays which have penetrated through this glass of water, and terminated upon the floor in a dark place at the foot of the window; and since here the eye is not employed we clearly can say with certainty that these colours do not derive in any way from the eye.

OF THE COLOURS FOUND IN THE FEATHERS OF CERTAIN BIRDS

There are many birds in the various regions of the world in whose feathers most radiant colours are seen produced in their different movements, as is seen happen among us with the feathers of peacocks, or on the necks of ducks or pigeons.

Moreover on the surface of ancient glass found buried, and in the roots of radishes which have been kept a long time at the bottom of wells or other stagnant water [we see] that each of these roots is surrounded by a sequence of colours like those of the rainbow. It is seen when some oily substance has spread on the top of water; as also in the solar rays reflected from the surface of a diamond or beryl. Also, in the facet of the beryl, every dark object which has as its background the atmosphere or other clear object is surrounded by this sequence of colours interposed between the atmosphere and the dark object; and so in many other ways which I leave because these suffice for this present theme. Windsor: Drawings 19150 r.

XXXI

Landscape

'Describe landscapes with wind and water and at the
setting and rising of the sun.'

WITHIN the spaces between the rain one sees the redness of the sun, that is of the clouds interposed between the sun and the rain.

The waves interposed between the rain and the eye never reveal to the eye the image of the darkness of this rain, and this is due to the fact that the side of the wave is not seen nor does it see the rain.

And the clouds are of dark purple. c.a. 38 r. b

Of things seen through the mist the part which is nearest to the extremities will be less visible, and so much less when they are more remote. c.a. 76 r. b

A mountain that stretches above a city which raises dust in the form of clouds, but the colour of this dust is varied by the colour of these clouds; and, where the rain is thickest, the colour of the dust is least visible; and, where the dust is thickest, the rain is least visible; and, where the rain is mingled with the wind and the dust, the clouds created by the rain are more transparent than those of the dust.

And when the flames of the fire are mingled with clouds of smoke and steam this creates dark and very thick clouds.

The rest of this discourse will be treated of clearly in the book of painting.

[With drawing]

The trees, smitten by the course of the winds, bend towards the place where the wind is moving, and after the wind has passed they bend in the opposite movement, that is in the reflex movement.

The mighty fury of the wind, driven by the avalanches of the mountains above the yawning caverns, by means of the avalanches of the mountains which formed a covering to these caverns. c.a. 79 r. c

When rain is falling from broken clouds one sees the shadows of these clouds upon the earth interrupted by the part of the earth that is illuminated by the sun.

OF THE RAINBOW

When the sun is lower the arc has a larger circle, and when it is higher it will be the contrary.

When the sun is in the west, hidden behind some small and thick cloud, then this cloud will be surrounded by a ruddy splendour.

C.A. 97 v. a

Why towers and campaniles at a great distance, although of uniform thickness, seem like inverted pyramids.

This arises from the fact that the lower tracts of air being thick and misty veil them more completely, and the more an object is veiled the more the perception of its extremities is lost, and consequently the perception of the object tends to concentrate about its central line.

C.A. 130 v. b

WHERE SHADOW IS LESS THAN LIGHT

In the houses of a city, where one observes that the divisions between them are clear when it is misty below, if the eye is above the level of the houses the lines of vision, as they descend in the space that is between house and house, plunge into mist which is more dense and therefore, being less transparent, seems whiter; and if one house is higher than another the reality is more to be discerned in the thinner air, and therefore they seem more indistinct in proportion as they are less [1] elevated.

C.A. 160 r. a

This came about by reason of the clouds interposed between the earth and the sun, wherefore being in the west it grew red and with its ruddy glow lit as with a haze all the things visible to it, but so much more or less in proportion as these things were nearer or more remote.

C.A. 165 v. b

At the first hour of the day the atmosphere in the south near to the horizon has a dim haze of rose-flushed clouds; towards the west it grows darker, and towards the east the damp vapour of the horizon

[1] MS. *più.*

shows brighter than the actual horizon itself, and the white of the houses in the east is scarcely to be discerned, while in the south, the farther distant they are, the more they assume a dark rose-flushed hue, and even more so in the west; and with the shadows it is the contrary, for these disappear before the white.

[. . . .] in the east, and the tops of the trees are more visible than their bases, since the atmosphere is thicker lower down, and the structure becomes more indistinct at a height.

And in the south, the trees may scarcely be distinguished by reason of the vapour which darkens in the west and grows clear in the east.

C.A. 176 r. b

OF PAINTING IN THE COUNTRY

If between the eye and the horizon there intervenes the slope of a hill that drops towards the eye, and the eye finds itself at about the middle of the height of the slope then the hill will acquire darkness with every stage of its length. This is proved by the seventh of this which says; that plant will show itself darker which is seen more below; therefore the proposition is confirmed, because the hill shows from the centre downwards all its plants in the parts which are as much illumined by the brightness of the sky, as the part which is in shade is shaded by the darkness of the earth. For which reason it is necessary that these plants should be of moderate darkness, and from this point on towards the bases of the hills the plants are continually becoming brighter through the converse of the seventh proposition, for by this seventh proposition the nearer such plants are to the summit of the hill the more of necessity they become darker. And it follows that this darkness is not proportionate to the distance, from the eighth proposition which says: that thing will show itself darker which finds itself in finer air; and by the tenth: that will show itself darker which borders on the brighter background.

C.A. 184 v. c

OF CITIES OR OTHER BUILDINGS SEEN IN THE EVENING OR MORNING IN THE MIST

Buildings seen at a great distance in the evening or morning through mist or heavy atmosphere, have only such portions in light as are

illuminated by the sun which is then near the horizon, and the parts of those buildings which are not exposed to the sun remain almost the same dim neutral colour as the mist.

Why the higher things situated at a distance are darker than the lower ones even though the mist is of uniform thickness:
Of the things situated in mist or any other dense atmosphere, whether this arise from vapour or smoke or distance, that will be most visible which is the highest, and of things of equal height that will seem darkest which is against a background of the deepest mist. As happens with the eye *h*, which beholding *a b c*, towers of equal height, sees *c* the summit of the first tower at *r*, situated below in the mist at two degrees of depth, and sees the summit of the centre tower *b* in only one degree of mist; therefore the summit *c* will show itself darker than the summit of the tower *b*.　　　　　　　E 3 V.

PAINTING

The landscapes which occur in representations of winter should not show the mountains blue as one sees them in summer, and this is proved by the fourth part of this [chapter], where it is stated that of the mountains seen at a great distance that will seem a deeper blue in colour which is in itself darker; for when the trees are stripped of their leaves they look grey in colour, and when they are with their leaves they are green, and in proportion as the green is darker than the grey, the green will appear a more intense blue than the grey; and by the fifth part of this [chapter], the shadows of trees which are clad with leaves are as much darker than the shadows of those trees which are stripped of leaves as the trees clad with leaves are denser than those without leaves; and thus we have established our proposition.

The definition of the blue colour of the atmosphere supplies the reason why landscapes are a deeper shade of blue in summer than in winter.

The shadows of trees set in landscapes do not seem to occupy the same positions in the trees on the left as in those on the right, and this especially when the sun is on the right or the left. This is proved by

the fourth which states:—opaque bodies placed between the light
and the eye will show themselves entirely in shadow; and by the
fifth:—the eye that is interposed between the opaque body and the
light sees the opaque body all illuminated; and by the sixth:—when
the eye and the opaque body are interposed between the darkness
and the light the body will be seen half in shadow and half in light.

<div style="text-align: right">E 19 r.</div>

OF THE ATMOSPHERE INTERPOSED BETWEEN THE EYE AND THE VISIBLE OBJECT

The object will appear more or less distinct at the same distance, in
proportion as the atmosphere interposed between the eye and this
object is of greater or less clearness.

Since therefore you are aware that the greater or less quantity of
atmosphere interposed between the eye and the object causes the out-
lines of these objects to seem more or less blurred to the eye, you
should represent the stages of loss of definition of these bodies in the
same proportion to each other as that of their distances from the eye
of the beholder. E 79 v.

When the smoke from dry wood comes between the eye of the
observer and some dark space it appears blue.

So the atmosphere appears blue because of the darkness which is
beyond it; and if you look towards the horizon of the sky you will see
that the atmosphere is not blue, and this is due to its density; and so,
at every stage as you raise your eye up from this horizon to the sky
which is above you, you will find that the atmosphere will seem
darker, and this is because a lesser quantity of air interposes between
your eye and the darkness.

And if you are on the top of a high mountain the atmosphere will
seem darker above you, just in proportion as it becomes rarer between
you and the said darkness; and this will be intensified at every succes-
sive stage of its height, so that at the last it will remain blue.

That smoke will appear the bluest which proceeds from the driest
wood, and is nearest to the place of its origin, and when it is seen
against the darkest background with the light of the sun upon it.

<div style="text-align: right">F 18 r.</div>

The smoke that penetrates through the air if it is thick, and rises out of great flame which is fed by damp wood, does not mingle with it but makes itself seem denser above than in the centre, and does this the more when the air is chilly; and the faint gleam that penetrates the air is always warm and always becoming fainter, and of the dust which passes through the air the finest rises the highest. F 88 r.

Although leaves with a smooth surface are for the most part of the same colour on the right side as on the reverse, it so happens that the side exposed to the atmosphere partakes of the colour of the atmosphere, and seems to partake of its colour more closely in proportion as the eye is nearer to it and sees it more foreshortened. And the shadows will invariably appear darker on the right side than on the reverse, through the contrast caused by the high lights appearing against the shadow.

The under side of the leaf, although its colour in itself may be the same as that of the right side, appears more beautiful; and this colour is a green verging upon yellow; and this occurs when the leaf is interposed between the eye and the light which illumines it from the opposite side. Its shadows also are in the same positions as those on the opposite side.

Therefore, O painter, when you make trees near at hand, remember that when your eye is somewhat below the level of the tree you will be able to see its leaves some on the right side and some on the reverse; and the right sides will be a deeper blue as they are seen more foreshortened, and the same leaf will sometimes show part of the right side and part of the reverse, and consequently you must make it of two colours. G 3 r. and 2 v.

When there is one belt of green behind another, the high lights on the leaves and their transparent lights show more strongly than those which are against the brightness of the atmosphere.

And if the sun illumines the leaves without these coming between it and the eye, and without the eye facing the sun, then the high lights and the transparent lights of the leaves are extremely powerful.

It is very useful to make some of the lower branches, and these should be dark, and should serve as a background for the illuminated belts of green which are at some little distance from the first.

Of the darker greens seen from below, that part is darkest which is nearest to the eye, that is to say which is farthest from the luminous atmosphere. G 4 r.

Never represent leaves as though transparent in the sun, because they are always indistinct; and this comes about because over the transparency of one leaf there will be imprinted the shadow of another leaf which is above it; and this shadow has definite outlines and a fixed density. And sometimes it is the half or third part of the leaf which is in the shadow, and consequently the structure of such a leaf is indistinct, and the imitation of it is to be avoided.

The upper branches of the spreading boughs of trees keep nearer to the parent bough than do those below.

That leaf is less transparent which takes the light at a more acute angle. G 4 v.

OF THE PLANTS OF THE FIELDS

Of the plants which take their shadows from the trees which grow among them, those which are in front of the shadow have their stalks lighted up against a background of shadow, and the plants which are in shadow have their stalks dark against a light background, that is against a background which is beyond the shadow.

OF THE TREES WHICH ARE BETWEEN THE EYE AND THE LIGHT

Of the trees which are between the eye and the light, the part in front will be bright, and this brightness will be diversified by the ramification of the transparent leaves—as seen from the under side— with the shining leaves seen from the right side, and in the background, below and behind, the verdure will be dark, because it is cast in shadow by the front part of the said tree; and this occurs in trees which are higher than the eye. G 9 v.

OF DARK LEAVES IN FRONT OF TRANSPARENT ONES

When the leaves are interposed between the light and the eye, then that which is nearest to the eye will be the darkest, and that farthest

away will be the lightest, if they are not seen against the atmosphere; and this happens with leaves which are beyond the centre of the tree, that is in the direction of the light. G 10 v.

OF TREES AND THEIR LIGHT

The true method of practice in representing country scenes, or I should say landscapes with their trees, is to choose them when the sun in the sky is hidden, so that the fields receive a diffused light and not the direct light of the sun, for this makes the shadows sharply defined and very different from the lights. G 11 v.

OF THE SHADOWS OF VERDURE

The shadows of verdure always approximate to blue, and so it is with every shadow of every other thing, and they tend to this colour more entirely when they are farther distant from the eye, and less in proportion as they are nearer.

The leaves which reflect the blue of the atmosphere always present themselves edgewise to the eye.

OF THE ILLUMINATED PARTS OF VERDURE AND OF MOUNTAINS

The part illuminated will show more of its natural colour at a great distance when it is illuminated by the most powerful light. G 15 r.

OF SHADOWS AND LIGHTS ON CITIES

When the sun is in the east and the eye is looking down upon a city from above, the eye will see the southern part of the city with its roofs half in shadow and half in light, and so also with the northern part; but the eastern part will be all in shadow and the western part all in light.

HOW ONE SHOULD REPRESENT LANDSCAPES

Landscapes ought to be represented so that the trees are half in light and half in shadow; but it is better to make them when the sun is

covered by clouds, for then the trees are lighted up by the general light of the sky and the general shadow of the earth; and these are so much darker in their parts, in proportion as these parts are nearer to the middle of the tree and to the earth. G. 19 V

OF TREES IN THE SOUTH

When the sun is in the east, the trees in the south and north are almost as much in light as in shadow, but the total amount in light is greater in proportion as they are more to the west, and the total amount in shadow is greater in proportion as they are more to the east.

OF MEADOWS

When the sun is in the east, the grasses in the meadows and the other small plants are of a most brilliant green, because they are transparent to the sun. This does not happen with the meadows in the west, and in those in the south and north the grasses are of a moderate brilliance in their green. G 20 V.

THE ASPECTS OF LANDSCAPES

When the sun is in the east all the parts of trees which are illuminated by it are of a most brilliant green; and this is due to the fact that the leaves illuminated by the sun within half our hemisphere, namely the eastern half, are transparent, while within the western semicircle the verdure has a sombre hue and the air is damp and heavy, of the colour of dark ashes, so that it is not transparent like that in the east, which is refulgent, and the more so as it is more full of moisture.

The shadows of the trees in the east cover a large part of the tree, and they are darker in proportion as the trees are thicker with leaves. G 21 r.

OF TREES IN THE EAST

When the sun is in the east the trees seen towards the east will have the light surrounding them all around their shadows, except towards the earth, unless the tree has been pruned in the previous

year; and the trees in the south and in the north will be half in shadow and half in light, and more or less in shadow or in light according as they are more or less to the east or to the west.

The fact of the eye being high or low causes a variation in the shadows and lights of trees, for when the eye is above, it sees the trees with very little shadow, and when below with a great deal of shadow.

The different shades of green of plants are as varied as are their species.

G 21 v.

OF THE SHADOWS OF TREES

When the sun is in the east the trees towards the west will appear to the eye with very little relief and of almost imperceptible gradation, on account of the atmosphere which lies very thick between the eye and these trees, according to the seventh [part] of this [treatise]; and they are deprived of shadow, for although a shadow exists in each part of the ramification, it so happens that the images of shadow and light which come to the eye are confused and blended together, and cannot be discerned through the smallness of their size. And the highest lights are in the centre of the trees and the shadows are toward their extremities, and their separation is marked by the shadows in the spaces between these trees when the forests are dense with trees; and in those which are more scattered the contours are but little seen.

G 22 r.

OF TREES IN THE EAST

When the sun is in the east the trees in that quarter are dark towards the centre, and their edges are in light.

OF THE SMOKE OF CITIES

The smoke is seen better and more distinctly in the eastern than in the western quarter when the sun is in the east. This is due to two causes: the first is that the sun shines with its rays through the particles of the smoke, and lightens these up and renders them visible; the second is that the roofs of the houses seen in the east at this hour are in shadow, because their slope prevents them from being lighted by the sun; the same happens with the dust, and both the one and the

other are more charged with light in proportion as they are thicker; and they are thickest towards the middle.
<div align="right">G 22 v.</div>

OF SMOKE AND DUST

When the sun is in the east the smoke of cities will not be visible in the west, because it is neither seen penetrated by the solar rays nor against a dark background, since the roofs of the houses turn the same side to the eye that they show to the sun, and against this bright background the smoke will be scarcely visible. But dust when seen under the same conditions will appear darker than smoke, because it is thicker in substance than smoke, which is made up of vapour.
<div align="right">G 23 r.</div>

[Of trees penetrated by the air]

OF THE OPEN SPACES IN TREES THEMSELVES

The intervening region of the air within the bodies of trees, and the spaces between the trees within the air at a great distance, do not reveal themselves to the eye, for where it requires an effort to discern the whole it would be difficult to distinguish the parts. But it forms a confused mixture, which derives most from that which forms the greatest mass. The open spaces of the tree being made up of particles of illuminated air, and being much less than the tree, one therefore loses sight of them much sooner than one does of the tree; but it does not therefore follow that they are not there. Hence of necessity there comes about a blending of air and of the darkness of the shaded tree, which float together to meet the eye of the beholder.

OF TREES THAT COVER UP THESE OPEN SPACES IN ONE ANOTHER

That part of the tree will show fewer open spaces when it has behind it, between the tree and the air, the greater mass of another tree. So with the tree *a* the open spaces are not covered, nor in *b*, because there are no trees behind. But in *c* there is only open space in the half, that is to say that *c* is covered by the tree *d*, and part of the tree *d* is

covered by the tree *e*, and a little beyond this all the open spaces within the circumference of the trees are lost, and only those at the sides remain. G 25 v.

OF TREES

What outlines do trees show at a distance against the atmosphere which serves as their background? The outlines of the structure of trees against the luminous atmosphere, as they are more remote, approach the spherical more closely in their shape, and as they are nearer, so they display a greater divergence from the spherical form.

So the first tree a[1] as being near to the eye displays the true form of its ramification, but this is somewhat less visible in *b*, and disappears altogether in *c*, where not only can none of the branches of the tree be seen, but the whole tree can only be recognised with great difficulty.

Every object in shadow—be it of whatever shape you please—will at a great distance appear to be spherical; and this occurs because if an object be rectangular, then at a very short distance its angles become invisible, and a little farther off it loses more than it retains of the lesser sides, and so before losing the whole it loses the parts, since these are less than the whole.

So with a man when so situated, you lose sight of the legs, arms and head, before the trunk, and then the extremities of the length become lost before those of the breadth, and when these have become equal there would be a square[2] if the angles remained, but as they are lost there is a sphere. G 26 v.

In the representation of trees in leaf be careful not to repeat the same colour too often, for a tree which has another tree of the same colour as its background, but vary it by making the foliage lighter or darker, or of a more vivid green. G 27 v.

OF THE LIGHTS ON DARK LEAVES

The lights on such leaves as are darkest in colour will most closely resemble the colour of the atmosphere reflected in them; and this is due

[1] MS. contains a sketch of a row of trees seen in perspective.
[2] I have followed Dr. Richter in interpreting a tiny figure in the text as a square. M. Ravaisson-Mollien reads it as *ci*.

to the fact that the brightness of the illuminated part mingling with the darkness forms of itself a blue colour; and this brightness proceeds from the blue of the atmosphere, which is reflected in the smooth surface of these leaves, thereby adding to the blueness which this light usually produces when it falls upon dark objects.

OF THE LIGHTS ON LEAVES OF YELLOWISH GREEN

But leaves of yellowish green do not when they reflect the atmosphere create a reflection which verges on blue; for every object when seen in a mirror takes in part the colour of this mirror; therefore the blue of the atmosphere reflected in the yellow of the leaf appears green, because blue and yellow mixed together form a most brilliant green, and therefore the lustre on light leaves which are yellowish in colour will be a greenish yellow.

OF TREES WHICH ARE ILLLUMINATED BY THE SUN OR BY THE ATMOSPHERE

The trees, illuminated by the sun and by the atmosphere, which have leaves of a dark colour, will be illuminated on one side by the atmosphere alone, and in consequence of being thus illuminated will share its blueness; and on the opposite side they will be illuminated both by the atmosphere and the sun, and the part which the eye sees illuminated by the sun will be resplendent. G 28 v.

The extremities of the branches of trees if not dragged down by the weight of their fruit turn towards the sky as much as possible.

The upper sides of their leaves are turned towards the sky in order to receive nourishment from the dew that falls by night.

The sun gives spirit and life to plants, and the earth nourishes them with moisture. In this connection I once made the experiment of leaving only one small root on a gourd and keeping this nourished with water; and the gourd brought to perfection all the fruits that it could produce, which were about sixty gourds of the long species; and I set myself diligently to consider the source of its life, and I perceived that it was the dew of the night which steeped it abundantly with its mois-

ture through the joints of its great leaves, and thereby nourished the tree and its offspring, or rather the seeds which were to produce its off-spring.

The rule as to the leaves produced on the last of the year's branches is that on twin branches they will grow in a contrary direction, that is, that the leaves in their earliest growth turn themselves round towards the branch, in such a way that the sixth leaf above grows over the sixth leaf below; and the manner of their turning is that if one turns towards its fellow on the right, the other turns to the left.

The leaf serves as a breast to nourish the branch or fruit which grows in the succeeding year. G 32 v.

OF LANDSCAPES

The dark colours of the shadows of mountains at a great distance take a more beautiful and purer blue than those parts which are in light, and from this it follows that when the rock of the mountains is reddish the parts of it which are in light are fawn-coloured, and the more brightly it is illuminated the more closely will it retain its natural colour. I 48 r.

OF SMOKE

Smoke enters into the air in the form of a wave, like that which water makes when its force causes it to burst through other water.

I 106 [58] r.

Reeds in the light are scarcely visible, but between the light and the shade they stand out well.

To represent landscapes, choose when the sun is at the meridian and turn to the west or the east, and then begin your work.

If you turn to the north every object placed on that side will be without shadow, and especially those nearest to the shadow cast by your head, and if you turn to the south every object upon that side will be entirely in shadow.

All the trees which are towards the sun and which have the atmosphere for their background will be dark, and the other trees which have this darkness for their background will be black in the centre and lighter towards the edges. L 87 r.

CLASSIFICATION OF TREES

Low, tall, thin, thick, that is with leaves, dark, light, yellow, red, with branches pointing upwards, with branches that meet the eye, with branches that point downwards, with trunks white, those transparent in the air, those not, those massed together, those spread out.

<div align="right">L 87 v.</div>

The line of equality and that of the horizon are the same.

<div align="right">M 36 v.</div>

Landscapes are of a more beautiful azure when in fine weather the sun is at noon, than at any other hour of the day, because the atmosphere is free from moisture; and viewing them under such conditions you see the trees beautiful towards their extremities and the shadows dark towards the centre; and in the farther distance the atmosphere which is interposed between you and them appears more beautiful when beyond it there is some darker substance, and consequently the azure is most beautiful.

Objects seen from the side on which the sun is shining will not show you their shadows. But if you are lower than the sun you will see what was not seen by the sun, and that will be all in shadow.

The leaves of the trees which are between you and the sun are of five principal shades of colour, namely a green most beautiful, shining and serving as a mirror for the atmosphere which lights up objects that cannot be seen by the sun, and the parts in shadow that only face the earth, and those darkest parts which are surrounded by something other than darkness.

Trees in the open country which are between you and the sun seem much more beautiful than those which have you between the sun and themselves; and this is the case because those which are in the same direction as the sun show their leaves transparent towards their extremities, and the parts that are not transparent, that is at the tips, are shining; it is true that the shadows are dark, because they are not covered by anything.

The trees when you place yourself between them and the sun will only show themselves to you in their clear and natural colour, which is not of itself very conspicuous, and besides this certain reflected lights,

which, owing to their not being against a background that offers a strong contrast to their brightness, are but little in evidence; and if you are at a lower altitude than these, such parts of them may be visible as are not exposed to the sun, and these will be dark.

IN THE WIND

But if you are on the side from whence the wind is blowing, you will see the trees looking much lighter than you would see them from the other sides; and this is due to the fact that the wind turns up the reverse sides of the leaves, which are in all cases much paler than their right sides; and especially will they be very light if the wind blows from the quarter where the sun happens to be, and if you have your back turned to it. B.M. 113 V.

All trees seen against the sun are dark towards the centre; this darkness will take the shape of the tree when it stands apart from others.

The shadows cast by trees on which the sun is shining are as dark as that of the centre of the tree.

The shadow cast by trees is never less in mass than the mass of the tree; but it is larger in proportion as the place where it is thrown slopes more towards the centre of the earth.

A shadow will be thickest towards the centre of a tree when it has fewest branches.

Every branch gets the middle of the shadow of every other branch and as a consequence of all the tree.

The shape of every shadow of branch or tree is clothed with a bright part on the side from which the light comes; this brightness will be of the same shape as the shadow and may extend for a mile from the side where the sun is.

If it should happen anywhere that a cloud casts a shadow on some part of the hills, the trees there will undergo less change than in the distances or plains; for the trees upon the hills have their branches thicker because their growth each year is less than in the plains; therefore as they are of the number of those naturally dark and full of shade the shadows of the clouds cannot make them any darker, and the level spaces that come between the trees which have not lost any shadow

vary very much in tone, and especially those which are other than green, such as cultivated lands or the havoc of mountains or their barrenness or ruggedness.

Where trees are on the skyline they seem of the same colour, unless they are very close together and with thick-set leaves like the pine and similar trees.

When you see trees on the side on which the sun lights them you will see them of almost uniform brightness, and the shadows which are within them will be covered by the illuminated leaves which come between your eye and the shadows.

When trees come between the sun and the eye beyond the shadows which spread out from their centre you will see the green of the leaves in transparence; but this transparence will be broken in many places by the leaves and branches in shadow which come between you and them, and in the upper portions it will be accompanied by many reflections from the leaves. B.M. 114 r.

When the sun is covered by clouds, objects have a low degree of visibility; because there is but little difference between the lights and shadows of the trees and buildings, through them being illuminated by the spaciousness of the atmosphere, which surrounds the objects in such a way that the shadows are few, and these few become fainter and fainter so that their extremities become lost in mist.

The trees in landscapes are of various different shades of green; for in some, such as firs, pines, cypresses, laurels, box and the like, it borders on black; others such as walnuts and pears, vines and young foliage approximate to yellow; others to darker shades of yellow, such as chestnuts, oaks and the like, others redden towards the autumn, these are sorbs, pomegranates, vines and cherry trees; others such as willows, olives, bamboos, and others like these, tend to become white.

 B.M. 114 v.

DESCRIBE LANDSCAPES WITH WIND AND WATER AND AT THE SETTING AND RISING OF THE SUN

All the leaves which hang down towards the ground as the twigs bend, owing to the branches being turned over, straighten themselves

in the current of the winds; and here their perspective is inverted, for if the tree is between you and the quarter from which the wind is coming, the tips of the leaves which are towards you take their natural position, and those opposite which should have their tips the contrary way, from the fact of their being upside down, will be turned with their tips towards you.

Trees in a landscape do not stand out distinctly one from another, because their illuminated parts border on the illuminated parts of those beyond them, and so there is little difference between the lights and the shadows.

When clouds come between the sun and the eye all the edges of their rounded masses are clear, and they are dark towards the centre, and this happens because towards the top these edges are seen by the sun from above while you are looking at them from below; and the same happens with the positions of the branches of the trees; and moreover the clouds, like the trees, through being somewhat transparent are partly bright, and at the edges show themselves thinner.

But when the eye finds itself between the cloud and the sun, the appearance of the cloud is the contrary of what it was before, for the edges of its rounded masses are dark and they are bright towards the centre. And this comes about because you are looking at that part which is also facing the sun, and because these edges have a degree of transparency and reveal to the eye the part that is hidden beyond them, and this not being visible to the sun as are the parts which are turned towards it is necessarily somewhat darker. It may also be that you see the details of these rounded masses from the underside while the sun sees it from above, and since they are not so situated as to give back the brightness of the sun as in the former instance, therefore they remain dark.

The black clouds which are often visible above those that are bright and illuminated by the sun, are thrown into shadow by the other clouds which are interposed between them and the sun.

Again the rounded masses of the clouds that face the sun show their edges dark, because they are silhouetted [1] against a bright background; and to see the truth of this you should observe the top of a cloud which

[1] MS. *canpegiano.*

is entirely light because it is silhouetted against the blue of the atmosphere which is darker than the cloud. B.M. 172 V.

OF MOVEMENT

I ask whether the true movement of the clouds can be recognised by the movement of their shadows, and similarly by the movement of the sun. Forster 11 46 r.

The sun will appear greater in moving water or when the surface is broken into waves than it does in still water. An example is of the light reflected on the strings of the monochord. Windsor: Drawings 12350

OF CLOUDS SMOKE AND DUST AND FLAMES FROM AN OVEN OR BURNING KILN

The clouds do not display their roundnesses except in those parts which are seen by the sun: other roundnesses are imperceptible because they are in the parts in shadow.

If the sun is in the east and the clouds are in the west, the position of the eye being between the sun and the cloud, it sees the edges of the roundnesses which are the component parts of these clouds as dark, and the portions which are surrounded by these darknesses become light. And this proceeds from the fact that the edges of the rounded forms of these clouds face the sky above and around them, so that it is mirrored in them.

The cloud and the tree display no roundness in those of their parts which are in shadow. Windsor: Drawings 12388

The shadows of clouds are lighter in proportion as they are nearer to the horizon. Windsor: Drawings 12391

That part of a tree which is against a background of shadow is all of one tone, and where the trees or branches are thickest there it is darkest because there is less perforation by the air. But where the branches are on a background of other branches there the luminous parts show themselves brighter and the leaves more resplendent, because of the sun which illumines them.

 Windsor: Drawings 12431 V.

PAINTING

The density of smoke below the horizon appears white and above the horizon dark, and even though the smoke is in itself of uniform colour this uniformity will seem to vary, according to the difference of the space in which it is found. Windsor MSS. R 878

XXXII

Light and Shade

*'No substance can be comprehended without light
and shade; light and shade are caused by light.'*

THAT place is most shaded on which the greatest number of shaded
rays converge.

That place which is smitten by the shaded rays at the greatest angle
is darkest.

That place will be most luminous from which the greatest number
of luminous rays are reflected. C.A. 31 v. b

Light is the expeller of darkness. Shadow is the suppression of light.

Primary light is that which is the cause of the lighting of shaded
bodies.

And the derived lights are those parts of bodies which are illumined
by the primary light.

Primary shadow is that side of a body on which the light does not
fall.

Derived shadow is simply the striking of shaded rays.

Each body which creates a concourse of rays fills the surrounding
air with an infinite number of its images.

A shaded and luminous concourse is that mass of rays which emanate
from a shaded and luminous body running through the air without
striking.

Shaded or luminous percussion is that which impedes and cuts above
itself the concourse of shaded and luminous rays. C.A. 116 r. b

The shadow in diaphanous and spherical bodies is darker at the top
than in the hollow, and darker amid the darkness of the derived
shadow of the body of the ball.

Every object seen is surrounded by second objects, and from this it

is known: and in proportion as the second object is farther away than the first so much the more does the first cover it from the eye.

<div align="right">C.A. 125 r. b</div>

Among the things of equal obscurity which are situated at a considerable and equal distance, that will appear more obscure which has its station higher up from the earth.

The edges of a derived shadow will be most distinct where it is cast nearest to the original shadow.

A shaded body will appear of less size when it is surrounded by a very luminous background, and a luminous body will show itself greater when it is set against a darker background: as is shown in the heights of buildings at night when there are flashes of lightning behind them. For it instantly appears, as the lightning flashes, that the building loses a part of its height.

And from this it comes to pass that these buildings appear larger when there is mist, or by night, than when the air is clear and illumined.

<div align="right">C.A. 126 r. b</div>

The breadth and length of shadow and of light, although through foreshortening it may appear less in quantity, will not therefore appear diminished as to quality either in respect of brightness or darkness.

<div align="right">C.A. 144 v. a</div>

All the illuminated parts of a body which see the whole circle of the luminous body will be the more dissimilar in brightness, one from another, as they are nearer to the source of the light. C.A. 150 r. a

The atmosphere is of itself adapted to gather up instantaneously and to leave behind it every image and likeness of whatever body it sees.

When the sun appears in the eastern horizon it permeates at once the whole of our hemisphere and fills it with its luminous semblance.

All the surfaces of solid bodies turned towards the sun or towards the atmosphere illumined by the sun, become clothed and dyed by the light of the atmosphere or of the sun.

Every solid body is surrounded and clothed with light and darkness.

You will get only a poor perception of the detail of a body when the part visible is all the part in shadow, or only the part that is illumined.

The length of the space which exists between the eye and the solid

bodies determines how much the part that is illumined increases, and that in shadow diminishes.

The shape of a body cannot be accurately perceived when its extremities are bounded by something of the same colour as itself, and the eye is between the part in shadow and that in light.

<div align="right">C.A. 179 r. b</div>

No separated shadow can reproduce upon a wall the true form of the body of which it is the shadow, unless the centre of the light is equidistant from the extremities of this body. C.A. 187 v. a

[*Camera Obscura*]

The boundaries of the images of any colour which penetrate through a narrow hole into a dark place will be always of a more powerful colour than its centre. C.A. 190 r. b

Why black painted in juxtaposition with white never seems to show itself more black than where it borders upon black, and white does not show itself more white in juxtaposition with black than with white; as is seen with the images passed through a hole or at the edge of any dark obstacle.

This comes about because the images tinge with their colour the spot on which they fall, and when the different images approach the same spot they make a blend of their colours, and this blend participates more in one colour than in another as the one colour is present in greater quantity than the other.

And the colours are more intense and more sharply defined at their edges than in any other part. C.A. 195 v.

OF THE DARKNESS OF THE SHADOWS OR YOU MAY SAY THE BRIGHTNESS OF THE LIGHTS

Those who have experience use in all intricate things such as trees, meadows, hair, beards and fur, four stages of clearness in order to reproduce the same colour; that is, first a dark foundation, second a blur which has something of the shape of the part, third a clearer and more defined part, fourth the lights more in high parts for movements of the figure [?];[1] it seems however to me that these varieties are

[1] MS., *ilumi più che alte parte moti di figura*

infinite in the case of a continuous quantity, which is in itself divisible
to infinity, and thus I prove it:

[*Two diagrams*]

Let *a g* be a continuous quantity and *d* the light that illumines it.
I refer now to the fourth which says that that part of the illuminated
body will be more luminous which is nearer to the source of its illumi-
nation; *g* therefore is darker than *c* in proportion as the line *d g* is
longer than the line *d c*. And from the conclusion that such grades of
brightness, or if you so prefer of darkness, are not four only, but may
be conceived of as infinite, because *c d* is a continuous quantity, and
every continuous quantity is divisible to infinity, therefore the variety
in the length of the lines that extend from the luminous to the illumi-
nated body is infinite; and the proportion of the lights corresponds
to the lengths of the lines between them, which extend from the centre
of the luminous body to the part of the object which is illuminated by it.

<div align="right">C.A. 199 V. a</div>

THE ACTION OF LIGHT FROM ITS CENTRE

If the whole light were what caused the shadows behind the bodies
placed against it, it would be necessary that that body, which is much
less than the light, should have a pyramidal shadow behind itself, and
as experience does not confirm this, it must be that it is the centre of
the light which performs this function.

HOW NO SPHERICAL BODY CAN CONTINUALLY REVOLVE AS IT MOVES

The cannon-ball from the mortar, if it be of uniform substance, and
its surface be equidistant from its centre, and the fire strikes it in the
middle, as reason would suggest, must needs take its course without
any revolution. Seeing that the fire that expels it is of uniform nature,
it drives equally the air which withstands its course, and as this also is
equal it offers equal resistance.

Example

Thus for example, one sees the moon, which is also a spherical body
and meets with equal resistance, to be much swifter as compared with

the cannon-ball, but nevertheless the dark spots that are on it never change their position, and the fact of this change not appearing, clearly confirms the fact that it does not revolve.

A PROOF HOW OBJECTS COME TO THE EYE

If you look at the sun or other luminous object and then shut your eyes, you will see it again in the same form within your eye for a long space of time: this is a sign that the images enter within it.

C.A. 204 r. a

When the intersection of two columns of shadow produces their derived shadows by means of the two luminous ones, it must follow that four derived shadows are produced, and these shadows are composite, and they intersect at four places; and of these intersections there are two that form simple shadow, and two are of composite shadow, and these two simple shadows are produced where the two lights cannot be seen, and the composite shadows are produced where one of the two lights cannot illumine. But the intersections of the composite shadows are produced always by a single luminous body, and of the simple ones by two luminous bodies, and the right intersection of the composite shadow is produced by the left light, and the left intersection is produced by the right light; but the two intersections of the simple shadows, both the upper and the lower, are produced by the two luminous bodies, that is the light on the right and the light on the left.

C.A. 241 r. c

Many minute lustres continue in the far distance and make themselves perceptible.

THE NATURE OF THE LIGHT THAT PENETRATES THE VENT HOLES

With reference to the light that penetrates the vent holes, it may be doubted whether it reconstitutes with the dilatation of its rays as much breadth of impression beyond the vent hole as the width of the body which is the cause of the rays.

And in addition to this, whether this dilatation has a power equal to that of the luminous body. As regards the first doubt the reply is that the dilatation made by the rays after their intersection recreates as much breadth beyond the vent hole as in front of the vent hole, there being as much space from the luminous body to the vent hole as from the vent hole to the impress of its rays; this is proved by the straightness of the luminous rays, from which it follows that there is the same proportion between their breadth and between the distances at which they intersect.

But power does not proceed in the same proportion; as is proved where it is stated: just such proportion exists between the heat and the radiance in the different luminous rays as between their distances from their source. It is proved therefore that the luminous ray loses in heat and radiance in proportion as it is more remote from its luminous body. It is true however that the composite shadows, being derived, and starting from the edges of these vent holes, break this rule by means of their intersections; and this is treated of fully in the second book concerning shadow. c.a. 241 r. d

The rays of the shaded and luminous images intersect after they have penetrated within the vent holes, turning in opposite directions every part of their thickness. c.a. 241 v. c

The shadow will never show itself of uniform density in the place of its incidence, unless this place be equidistant from the luminous body. This is proved by the seventh which says: that shadow will show itself lighter or darker which is against a darker or lighter background; by the eighth of this: that background will have its parts so much darker or lighter as it is more remote from or nearer to the luminous body; and among the positions at an equal distance from the luminous body that will show itself more illuminated which receives the luminous rays at more equal angles. No matter with what inequality of position a shadow is defined, it will always show itself with its true boundaries equal to the shaded body if the eye rests upon the centre of the luminous body.

That shadow will show itself darker that is more remote from its shaded body. c.a. 241 v. d

The image of the sun is all in all the parts of the objects upon which its rays fall, and all in each particular part.

Why in the far distance a radiance which is long will appear round to us, and the horns of the moon do not follow this rule, and yet the light near by follows as its point indicates. c.a. 243 r. a

PROEM

Having, as I think, sufficiently treated of the natures and different characteristics of primary and derived shadows, and the manner of their incidence, it seems to me that the time has now come to explain the different results upon the various surfaces which are touched by these shadows.

SHADOW IS THE WITHHOLDING OF LIGHT

It seems to me that the shadows are of supreme importance in perspective, seeing that without them opaque and solid bodies will be indistinct, both as to what lies within their boundaries and also as to their boundaries themselves, unless these are seen against a background differing in colour from that of the substance; and consequently in the first proposition I treat of shadows, and say in this connection that every opaque body is surrounded and has its surface clothed with shadows and lights, and to this I devote the first book. Moreover these shadows are in themselves of varying degrees of darkness, because they have been abandoned by a varying quantity of luminous rays; and these I call primary shadows, because they are the first shadows and so form a covering to the bodies to which they attach themselves, and to this I shall devote the second book. From these primary shadows there issue certain dark rays, which are diffused throughout the air and vary in intensity according to the varieties of the primary shadows from which they are derived; and consequently I call these shadows derived shadows, because they have their origin in other shadows; and of this I will make the third book. Moreover these derived shadows in striking upon anything create as many different effects as are the different places where they strike; and of this I will make the fourth book. And since where the derived shadow strikes, it is always surrounded by the

striking of the luminous rays, it leaps back with these in a reflex stream towards its source and meets the primary shadow, and mingles with and becomes changed into it, altering thereby somewhat of its nature; and to this I will devote the fifth book. In addition to this I will make the sixth book to contain an investigation of the many different varieties of the rebound of the reflected rays, which will modify the primary shadow by as many different colours as there are different points from whence these luminous reflected rays proceed. Further I will make the seventh division treat of the various distances that may exist between the point of striking of each reflected ray and the point from whence it proceeds, and of the various different shades of colour which it acquires in striking against opaque bodies. c.a. 250 r. a

In proportion as the luminous body is nearer to the shaded body, it throws out more light if the luminous body is greater than the dark body.

In proportion as the luminous body is more distant from the shaded body and is less than it, it will give more light.

But in proportion as the luminous body being less than the shaded body is more distant from this shaded body it will give more light.

And if the luminous body being greater than the shaded body is moved farther away from the shaded body, the total amount that is illuminated will continue to diminish until it is approximately half.

c.a. 250 v. a

THE ACTION OF COMPOUND SHADOW

The actions of compound shadows are always made up of contrary movements. That is, that if the concourse of luminous rays before arriving at their point of intersection be touched by an opaque body, all the shadows of that body which break in upon the upper ray will show themselves beyond this point of intersection in the percussion of the lower ray, and as the upper ray becomes the lower after the intersection, so the movements which the shaded body makes within this upper ray will show themselves of contrary movement after this intersection; and this will reveal itself in the incidence of the compound shadow upon the pavement, or on a wall that is struck by the sun or other luminous body.

But if the luminous ray is interrupted by the opaque body some distance from its intersection, the percussion of the derived shadow of the opaque body will make a movement similar to that of the opaque body.

And if these rays are interrupted at the actual point of their intersection, then the shadows of the opaque body will be twofold, and they will move with contrary movements one to another before they reach the point of union.

The derived compound shadow is the cause why the percussion of the solar ray when passing through any kind of angle does not leave its impression on this angle; but portions of . . . so much greater or less . . . in proportion as these impressions are more remote from or nearer to these angles. c.a. 277 v. a

The site that is most luminous will vary according to the different positions of the eye and the light; and the shadow will always be immovable, for whatever the change it makes, the eye sees it.

c.a. 322 v. b

No opaque body can be visible unless it is clothed with a shaded and illuminated surface.

The air and every transparent body becomes a passage from the objects to the eye for the images of those bodies which find themselves either within or beyond them.

Derived light should be surrounded by primitive shadow.

Derived shadow will be surrounded by derived light.

Derived light should be surrounded, in whole or in part, by primitive or derived shadows.

Every opaque body has its image all in all and all in every part of the transparence that surrounds it. c.a. 349 v. d

OF PAINTING

Of the shadows—where they ought to be dark; where the shadows ought to be of a middle degree, and the lights where they ought to be clear.

Where they are darker. Where there ought to be glimmers and

reflections, that is lights thrown back in one place, and leaping up again in another.

How lights ought to be so rendered that they draw natural things.

How natural figures when they have intense light on one side seem to be in the deepest shadow on the opposite side.

How men show a small variation from light to shadow when the atmosphere is overcast or the sun is on the point of setting.

For what reason objects as they recede from the eye are perceived poorly and seem to lose clearness of outline, and in the far distance appear blue.

Why things when painted seem greater than they are.

<div style="text-align: right">c.a. 360 r. c</div>

That light is brightest which has the greatest angle.

That shadow is darkest which is produced at a most acute angle.

<div style="text-align: right">c.a. 385 v. c</div>

Primary and derived shadow are deeper when they are caused by the light of the candle than by that of the atmosphere.

The more the derived shadow which is greater enters in the less, the more the cause of the less is more luminous than the greater.

<div style="text-align: right">Tr. 24 a</div>

The edges of the window which are illuminated by two different lights of equal radiance will not throw light of equal quality into the room.

<div style="text-align: right">Tr. 25 a</div>

[*With sketch*]

At the window *a b* the sun enters into the house; this sun will increase the size of the window and lessen the shadow of a man, with the result that when the said man shall approach this shadow of himself, lost in that which carries the true shape of the window, he will see the contact of the shadows lost and confused by the power of the light, close themselves up and not suffer the solar rays to pass . . .

And the shadow made by the man upon the said contact has precisely the effect that is represented above.

<div style="text-align: right">A 1 r.</div>

[*With diagram*]

If you wish to measure a height by the shadow of the sun, take a

stick which may be one braccio, set it up and wait until the sun makes it cast a shadow of two braccia. Then measure immediately the shadow of the tower, and if this is one hundred braccia the tower will be fifty; and this is a good rule. A 6 r.

That part of a shaded body which is illuminated will transmit to the eye the image of its details more distinctly and more rapidly than that which finds itself in shadow. A 20 r.

LIGHT AND SHADE

Among bodies equal in size and distance that which shines the more brightly seems to the eye nearer and larger. c 1 r.

The straight edges of bodies will appear broken when they serve as boundary of a dark space streaked by the percussion of luminous rays. c 1 v.

The body illuminated by the solar rays which have passed through the thick branches of the trees, will cast as many shadows as is the number of the branches interposed between the sun and itself.

The shaded rays which proceed from a pyramidal shaded body will bifurcate when they intersect, and the shadow will be of varying degrees of depth at its points.

A light which is greater than the point and less than the base of the shaded pyramidal body placed in front of it, will cause the shaded body to produce at its percussion a bifurcated shadow of varying degrees of depth.

If a shaded body being smaller than a luminous body casts two shadows, and a shaded body the same size as a luminous body or greater than it casts one, it follows that the pyramidal body of which part is smaller than, part equal to, and part larger than the luminous body, will cast a bifurcated shadow. c 2 r.

The body that receives the solar rays which have passed between the minute ramifications of trees at a great distance will have but a single shadow.

If the body, part in shadow and part in light, be of the shape of a perfect sphere, the base of the luminous pyramid will bear the same pro-

portion to its body as that which the base of the shaded pyramid bears to the shaded body.

In proportion as the percussion made by the convergence of the shadow on the opposite wall is more distant from the luminous body and nearer the source from which it is derived, so much the darker and of more defined contours will it appear. c 2 v.

That luminous body will appear of less radiance which is surrounded by a more luminous background:

I have found that those stars that are nearest the horizon appear larger in form than the others, because they see and are seen by a greater amount of the solar body than when they are above us; and since they see more of the sun they have a greater light. And the body that is most luminous shows itself of greater form, as the sun shows itself in the mist above us, for it seems larger when it is without mist and with the mist it diminishes.

No part of the luminous body is ever visible from the pyramid of pure derived shadow. c 3 r.

[*Movement of shadows*]

If the object is moved slowly before the luminous body and the percussion of the shadow of this object is remote from its object, the movement of the derived shadow will have the same proportion with the movement of the primary, as the space between the object and the light has with that between the object and the percussion of the shadow,—so that when the object moves slowly the shadow is rapid. c 3 v.

That part of the reflection will be brightest in which the reflected rays are shortest.

The darkness caused by a number of shadows intersecting will be in conformity with their cause, which has its beginning and end between smooth surfaces near to each other, of the same quality and directly opposite to each other.

In proportion as the luminous body is greater the course of the luminous and shadow rays will be more mingled together.

This comes about because where the larger number of luminous rays are found, there is most light, and where a lesser number, less light, from which it comes about that the shadow rays enter and mingle with them. c 4 r.

That part of the surface of bodies on which the images of the bodies placed opposite, fall at the largest angle will be tinged most with their colour.

The most luminous part of the illuminated body which encompasses the percussion of the shadow will be that which is nearest to this percussion.

Just as a thing touched by a greater mass of luminous rays becomes brighter, so that will become darker which is struck by a greater mass of shadow rays. c 4 v.

A luminous body will seem more brilliant when it is surrounded by deeper shadow.

The breadth and length of shadow and light, although through fore-shortening they become straighter and shorter, will neither diminish nor increase the quality or quantity of their brightness or darkness.

The function of shadow and of light diminished by foreshortening, will be to shade and illumine an object opposite to it, according to the quality and quantity that appear in this object.

The more a derived shadow approaches its penultimate extremities the deeper it will appear. c 5 r.

Perspective

If you cause the rays of the sun to pass through a small hole of the shape of a star you will see beautiful effects of perspective in the percussion caused by the passage of the sun. c 7 r.

SHADOW AND LIGHT

The forms of shadows are three: for if the substance which casts the shadow is equal in size to the light, the shadow is like a column which has no end; if the substance is greater than the light, its shadow is like a pyramid which grows larger as it recedes and of which the length has no end; but if the substance is smaller than the light the shadow resembles a pyramid and comes to an end, as is seen in the eclipses of the moon. c 7 v.

OF LIGHT

The shape of a luminous body although it has length will at a great distance seem round.

This is shown by the flame of the candle, which although it is long seems round at a great distance; and the same thing may happen with the stars, for even if they were horned like the moon they would seem round by reason of their great distance. c 8 r.

Among bodies equal in size and length and equal also in form and depth of shade, that will appear the smaller which is surrounded by a more luminous background.

A shaded body placed between equal lights will cast as many shadows as there are lights, shadows of which one will be darker than the others as the light situated on the opposite side is nearer this body than the others.

A shaded body equidistant between two lights will cast two shadows, one darker than the other in proportion as one of the lights which cause them is greater than the other. c 8 v.

The places occupied by the shadows caused by a small luminous body are, as regards size, similar and corresponding to those of which the visual rays are cut off.

And when the luminous ray has passed through a small hole and been broken upon some opposing object near at hand, the impress of its percussion resembles more the hole through which it has passed than the luminous body from which it proceeds. c 9 r.

The greater the radiance of the luminous body the deeper will be the shadows cast by the bodies it illuminates.

All the shaded bodies that are larger than the pupil, which interpose between the eye and the luminous body, will show themselves dark.

If the eye be placed between the luminous body and the bodies illuminated by this light, it will see these bodies without any shadow.
 c 10 r.

When a luminous ray has passed through a hole of some unusual shape after a long course, the impression it makes where it strikes resembles the luminous body from which it springs.

It is impossible for the ray born of a luminous spherical body to be able, after a long course, to convey to where it strikes the image of any description of angle that exists in the angular hole through which it passes. c 10 v.

The shape of the derived shadow will always conform to the shape of the original shadow.
A light in the form of a cross thrown on to a shaded body of spherical roundness will produce its shadow in the figure of a cross. c 11 r.

That boundary of the derived shadow is darker which is surrounded by a brighter derived light. c 11 v.

Of things equal in respect of size, brightness, background and length, that which has the smoothest surface will seem largest.
Iron of uniform thickness half of which is heated serves as a proof, for the part that is heated appears larger than the remainder. c 12 r.

[Of broken shadow]
The derived shadow which has as its origin and cause a spherical shaded and luminous body, and is broken by the percussion made by it upon different bodies situated at varying degrees of distance, will appear round to the eye that is in front of it situated near to the centre of the original shadow.
A shaded body of spherical rotundity will cast a circular shadow blended [of light and shade] when it has a shaded body of its own substance interposed between it and the sun. c 12 v.

Among shadows of equal quality that nearest the eye will appear least dark.
That shadow will be darker which is derived from a greater number of different shaded and luminous bodies.
It is impossible that simple derived shadows, which spring from different bodies and are caused by a single light, can ever join or touch each other. c 13 v.

[When adjacent bodies will appear separated]
If many shaded bodies, so near to each other as to be almost touching, are seen against a luminous background at a great distance, they will seem separated by a great space. c 14 r.

[When separated bodies will appear adjacent]

If many luminous bodies are seen in a distant landscape, although they may be separated one from another, they will appear united and joined together.

That part of the air will participate most in its natural darkness which is smitten by the sharpest luminous angle. It is clearly to be understood that where there is a smaller luminous angle there is less light, because the pyramid of this angle has a smaller base, and therefore from this smaller base a lesser number of luminous rays converge at its point.

[Definitions]

Darkness is the absence of light.

Shadow is the diminution of light.

Primitive shadow is that which is attached to shaded bodies.

Derived shadow is that which separates itself from shaded bodies and travels through the air.

Repercussed shadow is that which is surrounded by an illuminated surface.

The simple shadow is that which does not see any part of the light which causes it.

The simple shadow commences in the line which parts it from the boundaries of the luminous bodies. c 14 v.

Rays doubled by intersection in lights and shadows are also of double clearness or obscurity:

Primitive light and derived reflected light, when they surround thick and spherical bodies, become the cause of the boundaries of the primitive shadows of these bodies, being so much more distinct and defined in the part near to the lights as the derived light is clearer than the primitive.

That is said to be primitive light which first lights up shaded bodies, and that is called derived which leaps back from these bodies in those parts which are remote from this primitive light.

That part of the primitive shadow will be more luminous which can see more equally the centres of the derived lights.

One may clearly know that that part of the shaded bodies which is

seen by a greater quantity is the more luminous, and especially if it is illumined by two lights; as is seen with reflected lights which put in their midst the derived shadow made between them by the dense bodies opposite.

Every luminous body illumines with its whole and with its part the part and the whole of the object turned to face it.

This proposition is very evident, for one cannot deny that where the whole pupil of the eye is looking, there every part of it is looking, and the place seen by this pupil acts in the same way towards it.

c 16 v.

The middle of the length of each derived shadow is in a straight line with the middle of the primitive shadow and of the derived light, and the centres of the shaded and luminous bodies.

This necessarily happens, since as the luminous lines are straight, those which pass by the extremities of the shaded bodies enclose within their concourse all that air which through the intervention of this shaded body cannot see the luminous body, and for this reason it becomes dark. As the body is equally enclosed the parts of the shadow become equal in respect to its centre, because all the parts of shaded bodies are also equidistant from their centre, and so every body has a centre in itself.

As the above-named luminous lines are in contact with each extremity of the thing enclosed within them, they are equidistant from the middle of the length of any object that they enclose.

That part of the primitive and derived shadow will be so much less dark as it is more distant from its centre.

This comes about because the more the shadow separates from its centre the more it is seen by a greater quantity of luminous rays, and every man knows that where there is more light there is less shadow.

c 17 r.

OF THE SUN'S REFLECTION UPON THE WATER

If the sun is seen by all the seas which have the day, all these seas are seen by the sun. Therefore all the illumined water makes itself the mirror of the sun; and by its image all in the whole of this water and all in a part it appears to the eye. I ask therefore why when a ship is

travelling and the sun sees itself, the eye does not see the sea all illumined, and why it does not always seem that the sun is travelling along the pathway of the boat.

Definition

The sun makes as many pyramids as there are holes and crevices by which it can penetrate with its rays, and as many as the eyes of the animated beings that look upon it. Therefore as the sun finds itself always the base of each pyramid, the sun mirrored in the water seems to the eye to be as much beneath the water as it is outside it, and this sun thus reflected forms the base of the pyramid which ends in the eye. And this reflected sun will appear as great as the section of the pyramid cut by the surface of the water at *a n* [*figure*]. c 17 v.

Although the shaded and luminous body be of spherical rotundity and equal size, nevertheless its derived shadow will not resemble the rotundity of the body from which it proceeds, but will be of elongated shape if it falls within unequal angles. c 18 r.

[*Of the shapes of shadows*]

The shapes of shadows often resemble the shaded body which is their origin, and often the luminous body which is their cause.

If the shape and size of the luminous body are like that of the shaded body, the primitive and derived shadows will have the shape and size of these bodies, falling within equal angles.

The derived shadow at a certain distance will never resemble the shape of the shaded body from which it proceeds, unless the shape of the light from this illuminating body resembles the shape of the body illuminated by the said light.

Light that is long in shape will cause the derived shadow born from a round body to be wide and low, although it makes its percussion between equal angles.

It is impossible that the shape of the derived shadow should resemble that of the shaded body from which it was born, unless the light that causes it is similar in shape and size to this shaded body. c 18 v.

There will be as much difference in the darkness of two partially shaded rays as between the shadow that results from their blending and its first condition.

It is impossible that from the blending of two complete shadows there should ensue a shadow darker in degree.

It is possible that from the blending of two incomplete shadows may result a perfect shadow *darker in degree than any of the former.*[1]

<div align="right">c 19 r.</div>

Universally all the points that form the extreme points of the pyramidal images of things are continually all in all the air, united and joined together without any intermission.

Necessity causes that nature ordains or has ordained that in all points of the air all the images of the things opposite to them converge, by the pyramidal concourse of the rays that have emanated from these things; and if it were not so the eye would not discern in every point of the air that is between it and the thing seen, the shape and quality of the thing facing it.

That pyramid which proceeds from its base with more unequal angles will be narrower, and will give a less accurate impression of the true width of the base.

Among the many pyramids that are founded upon a single base that will be more powerful which is larger, and that will be larger which has the angles of its base more equal one to the other. c 20 r.

The less the brightness of the derived as compared with that of the original light, the less will its pyramids illumine the spot on which they strike.

The pyramids will illumine the spot on which they strike the less as their angles are finer.

<div align="right">c 20 v.</div>

The farther the derived shadow extends from the primitive the brighter it becomes.

Such proportion as the diameter of the derived shadow has to that of the primitive, you will find between the darkness of the primitive shadow and that of the derived.

If the size of the illuminating body should surpass that of the body which is illumined, it will form an intersection of shadow, beyond which the divided shadows will pass off in two different directions, as though they derived from two different lights.

[1] Words crossed out in MS.

That part of the derived shadow will be darker which is nearer to its source.

The above proposition holds good because, where the larger luminous angle is united to the narrower shaded angle, this luminous angle subdues it and almost changes it to its luminous nature. And so it is presumed that, where the larger shaded angle is united with the narrower luminous angle, the shaded will almost transform to its own nature the luminous that is joined to it. c 21 r.

Of things which are the same in size and colour that which is farther away will seem lighter and less in bulk.

The percussion of the derived shadow is always surrounded by shadow that melts into the luminous background.

That part of the shaded body which is struck by the largest luminous angle will be more illuminated than any other. c 21 v.

When there are several bodies of equal size which are equally distant from the eye, that will appear the smaller which is against a more luminous background.

Every visible body is surrounded by light and shade.

Every perfectly round body when surrounded by light and shade will seem to have one of its sides greater than the other, in proportion as the one is more lighted than the other. c 24 r.

If the visual line that sees the shadow made by the light of the candle has an angle equal to that of the shadow, the shadow will almost seem to function beneath the body that causes it, as does the image of the bodies reflected by the water, for they are as much visible beneath it as above. Even so this shadow will so function that its extremity will appear to be as far below the surface on which it is produced, as the summit of the body which causes it is above this surface, as is seen on a wall. c 25 r.

PERSPECTIVE

The eye that finds itself between the light and shade which surround opaque bodies, will see there the shadow separated from the luminous part pass transversely through the centre of this body.

When two objects are seen within the above-mentioned visual pyramids, in such a way as not to fall short of or protrude beyond these lines, although there be a great intervening space between them, this distance, nevertheless, will never be capable of being seen or recognised by the eye.

The greater the distance between the above-named bodies enclosed within visual pyramidal lines, the more necessary is it that there be a proportionate lack of conformity between them. c 27 r.

OF THE THREE KINDS OF LIGHTS WHICH ILLUMINE OPAQUE BODIES

The first of the lights with which opaque bodies are illumined is called particular, and it is the sun or other light from a window or flame. The second is universal, as is seen in cloudy weather or in mist or the like. The third is the composite, that is when the sun in the evening or the morning is entirely below the horizon. E 3 v.

Among bodies in varying degrees of darkness deprived of the same light, there will be the same proportion between their shadows as there is between their natural degrees of darkness, and you have to understand the same of their lights. E 15 r.

PAINTING

You will note in drawing how among shadows some are indistinguishable in gradation and form; and this is proved by the fifth which says:—spherical surfaces have as many different degrees of light and shadow as there are varieties of brightness and darkness reflected from the objects round them.

That part of an opaque body will be more in shadow or more in light which is nearer to the dark body which shades it, or to the luminous body which gives it light.

The surface of every opaque body partakes of the colour of its object, but the impression is greater or less in proportion as this object is nearer or more remote, and of greater or less power.

Objects seen between light and shadow will appear in greater relief than those which are in the light or in the shadow. E 17 r.

In the position of the eye which sees illuminated such part of plants as behold the light, one plant will never appear illuminated like the other. This is proved as follows:—let *c* be the eye that beholds the two plants *b d* which are illuminated by the sun *a*; I affirm that this eye *c* will not perceive the lights in the same proportion to their shadows in the one tree as in the other; for the tree that is nearer to the sun will show itself more in shadow than that farther away, in proportion as the one tree is nearer than the other to the concourse of the solar rays which come to the eye.

When a tree is seen from below, the eye sees the top of it set within the circle formed by its branches.

Remember, O painter, that the degrees of depth of shade in one particular species of tree vary as much as the sparseness or density of its ramifications. E 18 v.

QUALITY OF SHADOWS

As regards the equal diffusion of light, there will be the same proportion between the degrees of obscurity of the shadows produced, as there is between the degrees of obscurity of the colours to which these shadows are joined.

OF THE MOVEMENT OF SHADOW

The movement of the shadow is always more rapid than the movement of the body which produces it, if the luminous body be stationary. This may be proved:—let *a* be the luminous, *b* the shaded body, *d* the shadow. I say that the shaded body *b* moves to *c* in the same time as the shadow *d* moves to *e*, and there is the same proportion of speed to speed over the same time as there is of length of movement to length of movement. Therefore the proportion of the length of the movement made by the shaded body *b* as far as *c*, to the length of the movement made by the shadow *d* as far as *e*, is such as the above-mentioned speeds of movement have to each other.

But if the luminous body be equal in speed to the movement of the shaded body, then the shadow and the shaded body will be of equal movements one to another. And if the luminous be swifter than the

shaded body, then the movement of the shadow will be slower than the movement of the shaded body.

But if the luminous is slower than the shaded body then the shadow will be swifter than the shaded body. E 30 V.

OF THE PYRAMIDAL SHADOW

The pyramidal shadow produced by the parallel body will be narrower than the shaded body, in proportion as the simple derived shadow is intersected at a greater distance from its shaded body.

OF SIMPLE DERIVED SHADOWS

The simple derived shadows are of two kinds, that is to say one finite in length and two infinite. The finite is pyramidal, and of those that are infinite one is columnar and the other expanding. And all three have straight sides, but the convergent, that is the pyramidal shadow, proceeds from a shaded body that is less than the luminous body, the columnar proceeds from a shaded body equal to the luminous body, and the expanding from a shaded body greater than the luminous body.

OF COMPOUND DERIVED SHADOWS

Compound derived shadows are of two kinds, that is, columnar and expanding. E 31 r.

OF LIGHT AND LUSTRE

The difference that exists between light and lustre that reveals itself on the smooth surface of opaque bodies:—The lights that are produced on the smooth surfaces of opaque bodies will be stationary in stationary bodies, although the eye which sees them moves; but there will be lustres upon the same bodies in as many points of its surface as are the positions upon which the eye rests.

Which bodies are those that have light without lustre?

Opaque bodies which have a thick rough surface will never produce lustre in any portion of their illuminated part.

Which bodies are those that have lustre and have no illuminated part?

Thick, opaque bodies, with smooth surface, are those which have all the lustre in as many places, in the illuminated part, as there are positions that can receive the angle of the incidence of the light and of the eye, but, because such surface reflects all the things that surround the light, the illuminated body is not distinguishable in this part of the illuminated background.

A luminous body of long shape will make the contours of its derived shadow more indistinct than light that is spherical, and this it is that controverts the following proposition:—that shadow will have its contours more distinct which is nearer the primitive shadow, or if you prefer, the shaded body, but of this the long shape of the luminous body is the cause. E 31 V.

OF SHADOW

Derived shadows are of three kinds, of which one is expanding, another in the form of a column, the third converging at the point of the intersection of its sides which continue beyond in infinite length and straightness. And if you should say that this shadow is terminated in the angle formed by the meeting of its sides and does not pass beyond, this is controverted by the fact that, in the first concerning shadows, it was proved that a thing is entirely ended when no part of it exceeds its terminating lines; and, in the case of this shadow, one sees the contrary, inasmuch as where this derived shadow originates, there there are manifestly created the figures of two shaded pyramids which meet at their angles. If however as the adversary says, the first shaded pyramid terminates the derived shadow with its angle, from whence does the second shaded pyramid proceed? The adversary says that it is caused by the angle and not by the shaded body, but this is denied by the help of the second of this, which says:—the shadow is an accident created by the shaded bodies interposed between the position of this shadow and the luminous body.

Thus it has become clear that the shadow is not produced by the angle of the derived shadow but only by the shaded body.

If a spherical shaded body is illumined by an elongated luminous body, the shadow that is produced by the longest part of this luminous

body will have its contours less defined than that produced by the breadth of the same light. And this is proved by what was said before, namely that that shadow is of less defined contours which is created by a greater luminous body, and conversely that shadow is of more defined contours[1] which is lit by a smaller luminous body.

Broken shadows is the term given to those which are seen on a bright wall or other luminous object.

That shadow will seem the darker which is against a lighter ground.

The contours of the derived shadows will be more distinct when they are nearer to the primitive shadow.

The derived shadow will have the contours of its impress more distinct when they cut against the wall within more equal angles.

That part of the same shadow will seem darker which has over against it darker objects; and that will seem less dark which is facing a brighter object. And the bright object when it is larger will shine more brightly.

And that dark object which is of greater bulk will darken the derived shadow most in the place of its percussion. E 32 r.

The surface of every opaque body shares in the colour of surrounding objects.

Shadow is the diminution of light. Darkness is the exclusion of light.

Shadow is divided into two parts, of which the first is called primary shadow and the second derived shadow.

Primary shadow always serves as a basis for derived shadow.

The boundaries of derived shadows are straight lines.

The darkness of the derived shadow diminishes in proportion as it is farther removed from primary shadow.

That shadow will show itself darker which is surrounded by more dazzling brightness, and it will be less evident when it is produced on a darker ground.

Particular light has as a result that it gives better relief to shaded bodies than does universal light; as may be shown by the comparison of the part of a landscape lit by the sun and that shaded by a cloud which is lit merely by the universal light of the air. E 32 v.

The surface of every opaque body partakes of the colour of its object.

[1] MS., *di termini men noti*.

That part of the surface of the opaque bodies partakes most of the colour of its object which is nearest to it. F I V.

That part of a dark object of uniform thickness will show itself thinner which is seen against a more luminous background.

That part of a luminous body of uniform thickness and radiance will seem thicker which is seen against a darker background.

F 22 r.

The ray of the sun after having passed through the bubbles of the surface of the water, sends to the bottom of the water an image of this bubble which bears the form of a cross. I have not yet investigated the cause, but I judge it to be a result of other small bubbles which are clustered together round the larger bubble. F 28 v.

A luminous hole seen from a dark place, though it be of uniform size, will seem to contract considerably when near to any object whatever that is interposed between the eye and this hole.

This statement is proved by the seventh of this, which shows that the contours of any object interposed between the eye and the light will never be seen distinctly, but confused through the air becoming darker near these contours, this darkness becoming more intense the nearer it is to these contours. F 31 r.

Two separated lights will at a certain distance appear joined and united:

In this case it has been held by many who have made a study of perspective, that the air that surrounds these lights at a great distance is so illuminated that it seems of the nature of these lights, and therefore the light and air that surround them appear to be the same body.

What they say is not true, for if it were the case that the air that surrounds these lights at a great distance was so illuminated as to appear all uniformly luminous, this would be more readily discerned near at hand where the exact shape of the light is known than it would be at a distance, and if, in becoming separated, the perception of the exact shape of this light is lost because it suffers a slight decrease in its radiance, how much more would be the diminution and loss of that radiance of the air, which is much less effulgent than the light!

We shall prove therefore that this increase is caused by two images in the eye.

The excessive brilliance of the light when near to the eye diminishes the visual faculty, seeing that the pupil being hurt contracts and so makes itself less, and as the light becomes more separated the injury to the eye ceases to exist, because the light has less brilliance, and so the pupil increases and sees a greater light. F 35 v.

If there are two luminous bodies somewhat near to each other at a great distance they will seem united:

This can happen for two reasons, of which the first is that in being near to these lights one knows instantly the distance or space that separates them, and the images of them that imprint themselves in our eye are still very distinct, and on the other hand their rays do not touch, whilst at a long distance these images look so near that not only their rays but the luminous bodies seem to touch.

Further, at this distance the pupil which at first was contracted becomes enlarged, because the brilliance of the light is not as powerful as when it was near the eye, and so the eye increasing the size of its pupil sees a thing appearing enlarged.

If all the images were to meet in an angle they would meet in a mathematical point, and this being indivisible all the different kinds would seem to you united; being united the sense would not be able to discern any difference. F 36 r.

If some luminous body can be seen through a very small hole made in a piece of paper, approach the luminous body as nearly as possible with the eye; even though it still may be seen in its entirety it will seem so much less than before as this hole is of less size. F 36 v.

If the shape of the waves were in the figure of a half-circle, as are the bubbles of the water, the converging lines of the images of the sun, which emanate from these waves and come to the eye, would be of a very great angle, if this eye were upon the edge of the sea that comes between it and the sun. F 62 v.

Why does every luminous object that is of long shape appear round in the far distance?

It is never a perfect round, but it happens with it as with the leaden

die when beaten and much crushed that it appears round in shape. So this light at a great distance acquires such breadth in every direction, for as that which had been added is equal, and the first stock of light goes for nothing in comparison to what is added, the acquisition makes it appear uniformly round.

And this serves to prove that the horns of every star are imperceptible at a great distance. F 64 r.

OF LIGHTS

The lights which illumine opaque bodies are of four kinds, that is to say, universal, as that of the atmosphere within our horizon, and particular, like that of the sun or of a window or door or other space; and the third is reflected light; and there is also a fourth which passes through substances of the degree of transparency of linen or paper or suchlike things, but not those transparent like glass or crystal or other diaphanous bodies, with which the effect is the same as if there was nothing interposed between the body in shadow and the light that illumines it; and of these we shall treat separately in our discourse.

[*Transparency of leaves*]

The shadows in transparent leaves seen from the underside are the same shadows as those on the right side of this leaf, and the shadow is seen in transparency on the reverse at the same time as the luminous part; but the lustre can never show itself in transparency. G 3 v.

Of trees seen from below and against the light, one behind the other at a short distance, the topmost part of the first will be transparent and clear in great part, and it will stand out against the dark part of the second tree; and so it will be with all in succession which are situated under the same conditions. G 6 r.

The shadows of plants are never black, for where the atmosphere penetrates there cannot be utter darkness. G 8 r.

[*Foliage in light*]

If the light comes from *m* and the eye is at *n*, this eye will see the colour of the leaves *a b* all affected by the colour of *m*, that is of the atmosphere, and that of *b c* will be seen on the underside in transparency, with a very beautiful green colour that verges on yellow.

If *m* is the luminous body which lights up the leaf *s*, all the eyes that see the underside of the leaf will see it of a very beautiful light green because it is transparent.

There will be many occasions when the positions of the leaves will be without shadows, and they will have the underside transparent and the right side shining. G 8 v.

The willow and other similar trees which are pollarded every third or fourth year put out very straight branches. Their shadow is towards the centre where these branches grow, and near their extremities they cast but little shade because of their small leaves and few and slender branches.

Therefore the branches which rise towards the sky will have but little shadow and little relief, and the branches which point downwards towards the horizon spring from the dark part of the shadow. And they become clearer by degrees down to their extremities, and show themselves in strong relief being in varying stages of brightness against a background of shadow.

That plant will have least shadow which has fewest branches and fewest leaves. G 9 r.

The leaf of concave surface seen on the underside from below upward, will sometimes show itself half in shadow and half transparent. Thus let *o p* be the leaf, *m* the light and *n* the eye which will see *o* in shadow, because the light does not strike there between equal angles either on the right side or on the reverse; *p* is lit up on the right side, and its light is seen in transparency on its reverse. G 10 v.

OF SHADOWS ON BODIES

When you represent the dark shadows in shaded bodies, represent always the cause of the darkness, and you should do the same for reflections; this is because the dark shadows proceed from dark objects and the reflections from objects of but little brightness, that is from diminished lights. And there is the same proportion between the illuminated part of bodies and the part lit by reflection as there is between the cause of the light on the bodies and the cause of the reflection.

 G II v.

OF THE UNIVERSAL LIGHT AS LIGHTING UP TREES

That part of the tree will be seen to be clothed in shadows of least obscurity which is farthest away from the earth.

This may be proved:—let $a\ p$ be the tree, $n\ b\ c$ the illuminated hemisphere. The under part of the tree faces the earth $p\ c$, that is on the side o, and it faces a small part of the hemisphere at $c\ d$. But the highest part of the convexity a is visible to the greatest mass of the hemisphere, that is $b\ c$; and for this reason, and because it does not face the darkness of the earth, it remains more illuminated. But if the tree is one thick with leaves, as the laurel, the arbutus, the box or the ilex, then it is different, for though a does not see the earth it sees the darkness of the leaves divided by many shadows, and this darkness is reflected upwards on to the undersides of the leaves above; and these trees have the shadows so much darker as they are nearer to the centre of the tree.

G 12 r.

OF LIGHTS BETWEEN SHADOWS

When drawing any object, remember in comparing the potency of the lights of its illuminated portions, that the eye is often deceived into thinking one brighter than it really is. The reason springs from our comparing them with the parts which border on them, for if there are two parts of unequal degrees of brightness, and the less bright borders on a dark part while the brighter is set against a light background, such as the sky or some similar bright surface, then that which is less bright, or I should say less radiant, will appear more radiant and what was more radiant will seem darker.

G 12 v.

OF THE LIGHTS OF SHADED BODIES

The painter deceives himself many times in representing the principal lights.

G 13 r.

Of representing an arrangement of bodies which receives the particular light of the sun or of another luminous body for its illumination.

G 15 r.

SHADOWS AND LIGHTS OF CITIES

When the sun is in the east and the eye is above the centre of a city, the eye will see the southern part of this city with its roofs half in shadow and half in light, and the same towards the north; but those in the east will be entirely in shadow and those in the west entirely in light. G 19 V.

OF PAINTING

The outlines and forms of each part of bodies in shadow are poorly distinguished in their shadows and lights, but in such parts as are between the lights and shadows parts of these bodies are of the first degree of distinctness. G 32 r.

OF SITUATION

Take careful note of the situation of your figures, for you will have the light and shade different if the object is in a dark place with a particular light, and if it is in a bright place with the direct light of the sun, and different also if it is in a dark place with the diffused light of evening or in dull weather, and if it is in the diffused light of the atmosphere lit by the sun. G 33 V.

That part of the primary shadow will be least dark which is at the farthest distance from its extremities.

The derived shadow which borders on the primary shadow will be darker than this primary shadow. H 66 [18] r.

That place will be most luminous which is farthest away from mountains. H 68 [20] r.

The derived shadow is never like the body from which it proceeds, unless the light is of the shape and size of the body in shadow.

The derived shadow cannot be like the primitive in shape unless it strikes within equal angles. H 76 [28] v.

OF THE LUMINOUS RAYS AND THE POWER OF THEIR
EXTREMITIES

[*Diagram*]

Because the luminous ray is of pyramidal power, and especially when the atmosphere is uniform, it will come about that when two rays emanating from equal lights meet in a straight line, the ray will be everywhere doubled and of uniform power; for where one has the apex of the pyramid the other has its base, as *n m* shows. I 33 r.

The imprint of the shadow of any body of uniform thickness will never resemble the body from whence it proceeds.

Although a shaded body be pyramidal and equally distant in each of its parts from the luminous object, nevertheless that part of the pyramid which is smaller than the light that illumines it will not throw its shadow any distance from its cause. I 37 v.

OF PAINTING

Shadows and lights are observed by the eye under three aspects. One of these is when the eye and the light are both on the same side of the body which is seen; the second is when the eye is in front of the object and the light behind it; and the third is that in which the eye is in front of the object and the light at the side, in such a way that when the line which extends from the object to the eye meets that which extends from the object to the light, they will at their junction [1] form a right angle. K 105 [25] v.

There is another division, namely that of the nature of the reflected object when placed between the eye and the light in different aspects.
 K 106 [26] r.

PAINTING

[*Derived shadow*]

The derived shadow is stronger in proportion as it is nearer to its source.

[1] MS., *cōgūtiō*, and so Dr. Richter. M. Ravaisson-Mollien has *cognition*.

The same quality of shadow seems stronger in proportion as it is nearer to the eye.

The percussion and section of the derived shadow is darker in proportion as it is shorter. K III [31] V.

[*Luminous rays*]

That part of the body will be illuminated which is struck by the luminous rays at more equal angles. M 77 V.

The image of the sun will show itself brighter in the small waves than in the large ones. This happens because the reflections or images of the sun occur more frequently in the small waves than in the large ones, and the more numerous brightnesses give a greater light than the lesser number.

The waves which intersect after the manner of the scales of a fir-cone reflect the image of the sun with the greatest splendour; and this occurs because there are as many images as there are ridges of the waves seen by the sun, and the shadows which intervene between these waves are small and not very dark; and the radiance of so many reflections is blended together in the image which proceeds from them to the eye, in such a way that these shadows are imperceptible. B.M. 25 r.

There are two different kinds of light; the one is called free, the other restricted. The free is that which freely illuminates bodies; restricted is that which illuminates bodies in the same manner, through some hole or window. B.M. 170 V.

Lights are of two different natures, the one separated and the other united to bodies.

Separated is that which illuminates the body, united is the part of the body illuminated by this light; the one light is called primary, the other derived.

And so also there are shadows of two kinds; the one primary the other derived. Primary is that which is fastened to bodies, derived is that which is separated from bodies, bearing in itself to the surface of walls the resemblance of its cause. B.M. 171 r.

A simple shadow is one which does not see any light.

A compound shadow is one which is illuminated by one or more lights. B.M. 248 V.

A sieve through which penetrates the luminous air, at a great distance will seem without holes and entirely luminous.

Forster III 35 v.

Between walls at an equal distance and quality which are seen behind the extremities of an opaque body set over against them, that part of the wall will appear more illuminated which is seen by a greater amount of the pupil. Forster III 36 r.

Among things of equal distance and size that which has the greater light will seem of greater body. Forster III 42 v.

If the illuminated object is the size of the thing that illuminates, and of that where this light is reflected, the quality of the reflex light will have the same proportion to the intermediate light as this second light has to the first, if these bodies are smooth and white.

Forster III 54 r.

The luminous or illuminated object contiguous to the shadow cuts as much as it touches.

There will be as much lacking in the extremities of the shadows of bodies as is touched by the illuminated or luminous field.

Forster III 87 v.

[*Of shadow*]

Shadow is the diminution of light and of darkness, and it is interposed between darkness and light.

Shadow is of infinite obscurity, and this obscurity may be infinitely diminished.

The beginnings and the ends of shadow extend between light and darkness, and they may be infinitely diminished and increased.

Shadow is the expression of bodies and of their shapes.

The shapes of bodies will convey no perception of their quality without shadow.

Shadow partakes always of the colour of its object.

Of the boundaries of shadows: some are like smoke, with boundaries that cannot be perceived, in others they are distinct.

Keep the drawings for the end of the [book on] shadows. They may

be seen in the workshop of Gherardo the miniaturist in San Marco at Florence.

No opaque body is without shadow or light, except when there is a mist lying over the ground when it is covered with snow, or it is the same when it snows in the country; this will be without light and it will be surrounded by darkness.

And this occurs in spherical bodies, because in the case of other bodies which have members, the parts of the members which face each other steep each other in the tone of their surface.

The surface of every body is infused into all the illuminated air which serves as its object.

The surface of opaque bodies has its whole image in all the illuminated air which surrounds it from every quarter.

Make the rainbow in the last book 'On Painting'. But first make the book of the colours produced by the mixture of the other colours, so that by means of these colours used by painters you may be able to prove the genesis of the colours of the rainbow.

Describe how no body is in itself defined in the mirror; but the eye on seeing it in this mirror puts boundaries to it; for if you cause your face to be represented in the mirror the part is like the whole, seeing that the part is all in the whole of the mirror and it is complete in every part of the same mirror; and the same happens with every image of every object set in front of this mirror.

The boundaries of the derived shadow are surrounded by the colours of the illuminated objects which are round the luminous body, the cause of this shadow.

Derived shadow does not exist without primary light: this is proved by the First of this, which states that darkness is the entire privation of light, and shadow is the gradual diminution of darkness and of light; and it partakes so much the more or the less of darkness than of light in proportion as the darkness has been broken up by this light.

What is the cause which makes the boundaries of the shadow confused and indistinct.

Whether it is possible to give the contours of the shadows clear-cut and precise boundaries. Quaderni II 6 r.

[Of luminous bodies]

PAINTING

Of bodies equal in size and distance that which is most luminous tinges most with its essence the opposite object.

Of bodies of equal luminosity that which is largest in outline tinges most of the surface of its object, the distance of all being equal.

Of bodies which are equal in luminosity and size that which is nearest tinges its object most. Quaderni II 16 r.

The reason why we know that light has in itself a single centre is as follows:—we recognise clearly that a large light often outspans a small object, which nevertheless, although it surrounds it much more than twice with its rays, always has its shadow appearing on the first surface and it is always visible.

Let *c f* be the large light and *n* the object in front of it which produces the shadow on the wall, and *a b* the wall; it clearly appears that it is not the large light that will cast the shadow of *n* upon the wall; but since the light has a centre in itself I prove by experiment the shadow is cast upon the wall as is shown at *m o t r*. [*Diagram*]

Why to two or in front of two eyes do three things when represented appear as two.

Why in surveying a direction with two sights the first appears untrue.

I say the eye projects an infinite number of lines, and these attach themselves to or mingle with those that come towards it which emanate from the things seen, and only the centre line of this perceptive faculty is that which knows and judges bodies and colours; all the others are false and deceitful.

And when you place two things at a distance of a cubit one from the other, the nearer being close to the eye, the surface of this nearer one will remain far more confused than that of the second, the reason being that the nearer is overrun by a greater number of false lines than the second and so is more uncertain.

[*Diagram*]

Light acts like this because in the effects of its lines and especially in the working of its perspective it is very similar to the eye; and its

centre ray carries truth in its testing of shadows. When the object placed in front of it is too rapidly subdued by dim rays, it will cast a shadow broad and disproportionately large and ill defined; but when the object that has to produce the shadow cuts the rays of the light and is near the place of percussion, then the shadow becomes distinct; and this especially when the light is at a distance, because the centre ray at a long distance is less interfered with by false rays, seeing that the lines of the eye and the solar and other luminous rays proceeding through the air are obliged to keep a straight course. Otherwise if they were impeded by the atmosphere being denser or more rarefied they would remain bent at some point, but if the air is free from heaviness or humidity they will observe their straight nature, always carrying back to their point of origin the image of the intercepting object, and if it is the eye the intercepting object will be estimated by its colour as well as by its shape and size. But if the surface of the said interposing object shall have within it some small hole that enters into a room dark not on account of its colour but through absence of light, you will see the rays entering through this small hole transmitting there, to the wall beyond, all the traits of their original both as to colour and form, except that everything will be inverted. Windsor: Drawings 19148 v.

The way in which the images of bodies intersect at the edges of the small holes by which they penetrate:

What difference is there between the manner of penetration of the images which pass through narrow apertures and those which pass through wide ones or those which pass at the sides of shaded bodies.

OF THE MOVEMENT OF THE IMAGES OF IMMOVABLE OBJECTS

The images of the immovable objects move by the moving of the edges of that aperture through which the rays of the images penetrate, and this comes about by the ninth [section] which says:—the images of any body are all in all and all in every part of the area that is round about them. It follows that the moving of one of the edges of the aperture by which these images penetrate to a dark place releases the

rays of the images that were in contact with it, and they unite with other rays of those images which were remote from it.

OF THE MOVEMENT OF THE RIGHT OR LEFT OR UPPER OR LOWER EDGE

If you move the right side of the opening the impression on the left will move, being that of the object on the right which entered by this opening, and the same will happen with all the other sides of this opening, and this is proved with the help of the second [section] of this [treatise] which says:—all the rays which carry the images of bodies through the air are straight lines. Therefore as the images of the greatest bodies have to pass through the smallest openings, and beyond this opening to re-form in their utmost expansion, it is necessary that this intersection be uninterrupted. Windsor: Drawings 19149 r.

The images of bodies are all diffused through the air which sees them and all in every part of it.

This is proved:—let *a c* and *e* be objects, of which the images penetrate to a dark place by the small holes *n p*, and imprint themselves on the wall *f i* opposite to these holes; as many impressions will be made at as many different places on this wall as is the number of the said small holes.

OF THE RAYS WHICH CARRY THROUGH THE AIR THE IMAGES OF BODIES

All the smallest parts of the images penetrate one another without occupation the one of the other. . . .

. . . the seventh of this where it is said:—every simulacrum sends forth from itself its images by the shortest line, which of necessity is straight. Windsor: Drawings 19150 v.

Demonstration how every part of light converges in a point.
[*Diagram*]
Although the balls *a b c* have their light from one window, nevertheless if you follow the lines of their shadows you will see that they make intersection and point in the angle *n*. Windsor MS. R 137

Shadow is light diminished by means of the intervention of an opaque body. Shadow is the counterpart of the luminous ray cut off by an opaque body.

This is proved because the shaded ray is of the same shape and size as was the luminous ray in which this shadow projects itself.

Windsor: Drawings 19152 v.

Demonstration and argument why of parts in light some portions are in higher light than others.

[*Diagram*]

Since it is proved that every light with fixed boundaries emanates or appears to emanate from a single point, that part illuminated by it will have those portions in highest light upon which the line of radiance falls, between two equal angles, as is shown above in the lines *a g*, also in *a h*, and similarly in *a l*; and that portion of the illuminated part will be less luminous upon which the line of incidence strikes at two more unequal angles, as may be seen in *b c* and *d*; and in this way you will also be able to discern the parts deprived of light, as may be seen at *m* and *k*.

When the angles made by the lines of incidence are more equal the place will have more light, and where they are more unequal it will be darker.

I will treat further of the cause of the reflection.

Windsor MS. R 575

XXXIII

Perspective

'Perspective is a rational demonstration whereby experience confirms how all things transmit their images to the eye by pyramidal lines.'

SANDRO! you do not say why these second things seem lower than the third.[1]

[*Diagram*]

The eye between two parallel lines will never see them at so great a distance that they meet in a point. c.a. 120 r. d

All the cases of perspective are expressed by means of the five mathematical terms, to wit: point, line, angle, surface and body. Of these the point is unique of its kind, and this point has neither height nor breadth, nor length nor depth, wherefore we conclude that it is indivisible and does not occupy space. A line is of three kinds, namely straight, curved and bent, and it has neither breadth, height nor depth, consequently it is indivisible except in its length; its ends are two points.

An angle is the ending of two lines in a point, and they are of three kinds, namely right angles, acute angles and obtuse angles.

Surface is the name given to that which is the boundary of bodies, and it is without depth, and in such depth as it has it is indivisible as is the line or point, being divided only in respect of length or breadth. There are as many different kinds of surfaces as there are bodies that create them.

Body is that which has height, breadth, length and depth, and in all these attributes it is divisible. These bodies are of infinite and varied forms. The visible bodies are of two kinds only, of which the first is

[1] Fragment probably of a discussion with Botticelli concerning the law of diminishing perspective. References to Sandro [Botticelli] are also to be found in c.a. 313 r. b, p. 555, and *Trattato* (Ludwig) 60.

without shape or any distinct or definite extremities, and these though present are imperceptible and consequently their colour is difficult to determine. The second kind of visible bodies is that of which the surface defines and distinguishes the shape.

The first kind, which is without surface, is that of those bodies which are thin or rather liquid, and which readily melt into and mingle with other thin bodies, as mud with water, mist or smoke with air, or the element of air with fire, and other similar things, the extremities of which are mingled with the bodies near to them, whence by this intermingling their boundaries become confused and imperceptible, for which reason they find themselves without surface, because they enter into each other's bodies, and consequently such bodies are said to be without surface.

The second kind is divided into two other kinds, namely transparent and opaque. The transparent is that which shows its whole self along the whole of its side, and nothing is hidden behind it, as is the case with glass, crystal, water and the like. The second division of bodies of which the surface reveals and defines the shape is called opaque.

This it behoves us to treat of at some length, seeing that out of it are derived an infinite number of cases. c.a. 132 r. b

Perspective

The air is full of an infinite number of images of the things which are distributed through it, and all of these are represented in all, all in one, and all in each. Consequently it so happens that if two mirrors be placed so as to be exactly facing each other, the first will be reflected in the second and the second in the first. Now the first being reflected in the second carries to it its own image together with all the images which are represented in it, among these being the image of the second mirror; and so they continue from image to image on to infinity, in such a way that each mirror has an infinite number of mirrors within it, each smaller than the last, and one inside another.

By this example, therefore, it is clearly proved that each thing transmits the image of [itself] to all those places where the thing itself is visible, and so conversely this object is able to receive into itself all the images of the things which are in front of it.

Consequently the eye transmits its own image through the air to all the objects which are in front of it, and receives them into itself, that is on its surface, whence the understanding takes them and considers them, and such as it finds pleasing, these it commits to the memory.

So I hold that the invisible powers of the images in the eyes may project themselves forth to the object as do the images of the object to the eye.

An instance of how the images of all things are spread through the air may be seen in a number of mirrors placed in a circle, and they will then reflect each other for an infinite number of times, for as the image of one reaches another it rebounds back to its source, and then becoming less rebounds yet again to the object, and then returns, and so continues for an infinite number of times.

If at night you place a light between two flat mirrors which are a cubit's space apart, you will see in each of these mirrors an infinite number of lights, one smaller than another, in succession.

If at night you place a light between the walls of a [room], every part of these walls will become tinged by the images of this light, and all those parts which are exposed to the light will likewise be directly lit by it; that is when there is no obstacle between them to interrupt the transmission of the images.

This same example is even more apparent in the transmission of solar rays, which all [pass] through all objects, and consequently into each minutest part of each object, and each ray of itself conveys to its object the image of its source.

That each body alone of itself fills the whole surrounding air with its images, and that this same air is [able] at the same time to receive into itself the images of the countless other bodies which are within it, is clearly shown by these instances; and each body is seen in its entirety throughout the whole of the said atmosphere, and each in each minutest part of the same, and all throughout the whole of it and all in each minutest part; each in all, and all in every part. c.a. 138 r. b

OF PAINTING

The true knowledge of the form of an object becomes gradually lost in proportion as distance decreases its size. c.a. 176 v. b

[With drawing]

Body formed from the perspective by Leonardo Vinci, disciple of experience.

This body may be made without the example of any other body but merely with plain lines. c.a. 191 r. a

Among the various studies of natural processes, that of light gives most pleasure to those who contemplate it; and among the noteworthy characteristics of mathematical science, the certainty of its demonstrations is what operates most powerfully to elevate the minds of its investigators.

Perspective therefore is to be preferred to all the formularies and systems of the schoolmen, for in its province the complex beam of light is made to show the stages of its development, wherein is found the glory not only of mathematical but also of physical science, adorned as it is with the flowers of both. And whereas its propositions have been expanded with much circumlocution I will epitomise them with conclusive brevity, introducing however illustrations drawn either from nature or from mathematical science according to the nature of the subject, and sometimes deducing the results from the causes and at other times the causes from the results; adding also to my conclusions some which are not contained in these, but which nevertheless are to be inferred from them; even as the Lord who is the Light of all things shall vouchsafe to reveal to me, who seek to interpret this light—and consequently I will divide the present work into three parts.

Light, when in the course of its incidence it sees things which have been turned against itself, retains their images in part. This conclusion is proved by results, because the vision as it looks upon the light has a measure of fear. Even so after the glance there remain in the eye the images of vivid objects, and they make the place of lesser light appear in shadow until the eye has lost the trace of the impression of the greater light. c.a. 203 r. a

METHODS OF PERSPECTIVE

If you wish to represent a figure in the corner of a dwelling which shall appear to have been made in a level place, get someone to strip naked, and with the light of a candle make their shadow fall as you

wish in the said corner, and draw the outline of it with charcoal; but your sight will wish to be in the spot exactly through a hole placed where the light passed, and again the light of the window after its work will wish to come by the said line, so that the walls joined together in the corner will not be any darker on account of the shadow, the one than the other.

THE LIGHT IN THE OPERATION OF THE LAW OF PERSPECTIVE DOES NOT DIFFER FROM THE EYE

That the light has not any difference from the eye as regards losing the thing which is behind the first object is due to this reason: you know that in swiftness of movement and in concourse of straight lines the visual ray and the ray of light resemble each other. As an example: suppose you hold a coin near to the eye, that space which exists between the coin and the boundary of the position, will be more capable of expansion, in proportion as the part of the boundary of the position which is not visible to the eye is the greater, and the nearer the coin is brought to the eye the more the boundary of the position will be filled up.

OF LIGHT

Of the eye. The same process may be seen with light, for as you bring the said coin nearer or remove it farther from this light you will see the shadow on the opposite wall growing larger or failing, and if you wish an example let it be in this form: have many bodies of different things placed in a large room, then take in your hand a long pole with a piece of charcoal at the point and mark with that on the ground and along the walls all the outlines of the things[1] as they appear against the boundaries of the wall.

Of the light. Then at the same distance and height place a light, and you will see the shadows of the said bodies covering as much of the wall as the part that found itself enclosed within the marks made by the charcoal placed at the point of the pole.

[1] Reading cose. MS. has *delle pariete*.

Experiment

If you wish to see a similar experiment place a light upon a table, and then retire a certain distance away, and you will see that all the shadows of the objects which are between the wall and the light remain stamped with the shadow of the form of the objects, and all the lines of their length converge in the point where the light is.

Afterwards bring your eye nearer to this light, using the blade of a knife for a screen so that the light may not hurt your eye, and you will see all the bodies opposite without their shadows, and the shadows which were in the partitions of the walls will be covered as regards the eye by the bodies which are set before them. c.a. 204 v. b

Of things of equal size situated at an equal distance from the eye, that will appear the larger which is whiter in colour.

Equal things equally distant from the eye will be judged by the eye to be of equal size.

Equal things through being at different distances from the eye come to appear of unequal size.

Unequal things by reason of their different distances from the eye may appear equal. c.a. 221 v. c

Many things of great bulk lose their visibility in the far distance by reason of their colour, and many small things in the far distance retain their visibility by reason of the said colour.

An object of a colour similar to that of the air retains its visibility at a moderate distance, and an object that is paler than the air retains it in the far distance, and an object which is darker than the air ceases to be visible at a short distance.

But of these three kinds of objects that will be visible at the greatest distance of which the colour presents the strongest contrast to itself.

c.a. 249 r. c

PERSPECTIVE

That dimness (il mezzo confuso) which occurs by reason of distance, or at night, or when mist comes between the eye and the object, causes the boundaries of this object to become almost indistinguishable from the atmosphere. c.a. 316 v. b

An object placed between the eye and an object of dazzling white-ness loses half its size. C.A. 320 v. b

MIRRORS

If you place a candle between two tall mirrors shaped like curved roofing tiles in the manner here shown [*drawing*], you will see every-thing that offers resistance melted in this candle with the help of these mirrors. C.A. 338 r. a

If you wish to furnish a proof of how things seen by the eye diminish, it is necessary to fix the eye on the centre of the wall, and the curve of the wall will then give you the true clearness of the things seen.

When the cause of the shadow is near the place where it strikes and distant from the light, you will see the shape of the cause of the severed rays clearly upon the wall. C.A. 353 r. b

Among things of equal size, that will show itself less in form which is farther away from the eye. C.A. 353 v. b

PERSPECTIVE

It is asked of you, O painter, why the figures which you draw on a minute scale as a demonstration of perspective do not appear—not-withstanding the demonstration of distance—as large as real ones, which are of the same height as those painted upon the wall.

And why [representations of] things, seen a short distance away, notwithstanding the distance, seem larger than the reality. Tr. 66 a

WALL OF GLASS

Perspective is nothing else than the seeing of an object behind a sheet of glass, smooth and quite transparent, on the surface of which all the things may be marked that are behind this glass; these things approach the point of the eye in pyramids, and these pyramids are cut by the said glass. A I V.

Citation of the things that I ask to have admitted in the proofs of this my perspective:—I ask that it may be permitted me to affirm that

every ray which passes through air of uniform density proceeds in a direct line from its cause to its object or the place at which it strikes.

OF THE DIMINUTION OF OBJECTS AT VARIOUS DISTANCES

A second object as far removed from the first as the first is from the eye will appear half the size of the first, although they are of the same size.

A small object near at hand and a large one at a distance, when seen between equal angles will appear the same size.

I ask how far away the eye can see a non-luminous body, as for instance a mountain. It will see it to advantage if the sun is behind it, and it will seem at a greater or less distance away according to the sun's place in the sky. A 8 v.

Perspective is a rational demonstration whereby experience confirms how all things transmit their images to the eye by pyramidal lines. By pyramidal lines I mean those which start from the extremities of the surface of bodies, and by gradually converging from a distance arrive at the same point; the said point being, as I shall show, in this particular case located in the eye, which is the universal judge of all objects. I call a point that which cannot be divided up into any parts; and as this point which is situated in the eye is indivisible, no body can be seen by the eye which is not greater than this point, and this being the case it is necessary that the lines which extend from the object to the point should be pyramidal. And if anyone should wish to prove that the faculty of sight does not belong to this point, but rather to that black spot which is seen in the centre of the pupil, one might reply to him that a small object never could diminish at any distance, as for example a grain of millet or panic-seed or other similar thing, and that this thing which was greater than the said point could never be entirely seen. A 10 r.

No object can be of so great a size as not to appear less to the eye at a great distance than a smaller object which is nearer.

A wall surface is a perpendicular plane represented in front of the common point at which the concourse of the pyramids converges. And

this wall surface performs the same function for the said point as a flat piece of glass upon which you drew the various objects that you saw through it, and the things drawn would be so much less than the originals, as the space that existed between the glass and the eye was less than that between the glass and the object.

The concourse of the pyramids created by the bodies will show upon the wall surface the variety of the size and distance of their causes.

All these planes which have their extremities joined by perpendicular lines forming right angles must necessarily, if of equal size, be less visible the nearer they rise to the level of the eye, and the farther they pass beyond it the more will their real size be seen.

The farther distant from the eye is the spherical body, the more it is seen. A 10 V.

As soon as ever the air is illuminated it is filled with an infinite number of images, caused by the various substances and colours collected together within it, and of these images the eye is the target and the magnet. A 27 r.

PRINCIPLE OF PERSPECTIVE

All things transmit their image to the eye by means of pyramids; the nearer to the eye these are intersected the smaller the image of their cause will appear. A 36 v.

If you should ask how you can demonstrate these points to me from experience, I should tell you, as regards the vanishing point which moves with you, to notice as you go along by lands ploughed in straight furrows, the ends of which start from the path where you are walking, you will see that continually each pair of furrows seem to approach each other and to join at their ends.

As regards the point that comes to the eye, it may be comprehended with greater ease; for if you look in the eye of anyone you will see your own image there; consequently if you suppose two lines to start from your ears and proceed to the ears of the image which you see of yourself in the eye of the other person, you will clearly recognise that these lines contract so much that when they have continued only a little way beyond your image as mirrored in the said eye they will touch one another in a point. A 37 r. and v.

The thing that is nearer to the eye always appears larger than another of the same size which is more remote. A 38 r.

Perspective is of such a nature that it makes what is flat appear in relief, and what is in relief appear flat. A 38 v.

The perspective by means of which a thing is represented will be better understood when it is seen from the view-point at which it was drawn.

If you wish to represent a thing near, which should produce the effect of natural things, it is impossible for your perspective not to appear false, by reason of all the illusory appearances and errors in proportion of which the existence may be assumed in a mediocre work, unless whoever is looking at this perspective finds himself surveying it from the exact distance, elevation, angle of vision or point at which you were situated to make this perspective. Therefore it would be necessary to make a window of the size of your face or in truth a hole through which you would look at the said work. And if you should do this, then without any doubt your work will produce the effect of nature if the light and shade are correctly rendered, and you will hardly be able to convince yourself that these things are painted. Otherwise do not trouble yourself about representing anything, unless you take your view-point at a distance of at least twenty times the maximum width and height of the thing that you represent; and this will satisfy every beholder who places himself in front of the work at any angle whatever.

If you wish to see a proof of this quickly, take a piece of a staff like a small column eight times as high as its width without plinth or capital, then measure off on a flat wall forty equal spaces which are in conformity with the spaces; they will make between them forty columns similar to your small column. Then let there be set up in front of the middle of these spaces, at a distance of four braccia from the wall, a thin band of iron, in the centre of which there is a small round hole of the size of a large pearl; place a light beside this hole so as to touch it, then go and place your column above each mark of the wall and draw the outline of the shadow, then shade it and observe it through the hole in the iron. A 40 v.

In Vitolone there are eight hundred and five conclusions about perspective. B 58 r.

PERSPECTIVE

No visible body can be comprehended and well judged by human eyes, except by the difference of the background where the extremities of this body terminate and are bounded, and so far as its contour lines are concerned no object will seem to be separated from this background. The moon, although far distant from the body of the sun, when by reason of eclipses it finds itself between our eyes and the sun, having the sun for its background will seem to human eyes to be joined and attached to it. c 23 r.

Perspective comes to aid us where judgment fails in things that diminish. c 27 v.

[Of perspective in nature and in art]

It is possible to bring about that the eye does not see distant objects as much diminished as they are in natural perspective, where they are diminished by reason of the convexity of the eye, which is obliged to intersect upon its surface the pyramids of every kind of image that approach the eye at a right angle. But the method that I show here in the margin cuts these pyramids at right angles near the surface of the pupil. But whereas the convex pupil of the eye can take in the whole of our hemisphere, this will show only a single star; but where many small stars transmit their images to the surface of the pupil these stars are very small; here only one will be visible but it will be large; and so the moon will be greater in size and its spots more distinct. You should place close to the eye a glass filled with the water mentioned in [chapter] four of book 113 'Concerning Natural Things', water which causes things congealed in balls of crystalline glass to appear as though they were without glass.

Of the eye. Of bodies less than the pupil of the eye that which is nearest to it will be least discerned by this pupil—and from this experience it follows that the power of sight is not reduced to a point.

But the images of objects which meet in the pupil of the eye are spread over this pupil in the same way as they are spread about in the air; and the proof of this is pointed out to us when we look at the

starry heavens without fixing our gaze more upon one star than upon another, for then the sky shows itself to us strewn with stars, and they bear to the eye the same proportions as in the sky, and the spaces between them also are the same. E 15 v.

Natural perspective acts in the opposite way, for the greater the distance the smaller does the thing seen appear, and the less the distance the larger it appears. But this invention constrains the beholder to stand with his eye at a small hole, and then with this small hole it will be seen well. But since many eyes come together to see at the same time one and the same work produced by this art, only one of them will have a good view of the function of this perspective and all the others will only see it confusedly. It is well therefore to shun this compound perspective, and to keep to the simple which does not purport to view planes foreshortened but as far as possible in exact form.

And of this simple perspective in which the plane intersects the pyramid that conveys the images to the eye that are at an equal distance from the visual faculty, an example is afforded us by the curve of the pupil of the eye upon which these pyramids intersect at an equal distance from the visual faculty. E 16 r.

OF EQUAL THINGS THE MORE REMOTE APPEARS LESS

The practice of perspective is divided into [two] parts, of which the first treats of all the things seen by the eye at whatsoever distance, and this in itself shows all these things diminished as the eye beholds them, without the man being obliged to stand in one place rather than in another, provided that the wall does not foreshorten it a second time.

But the second practice is a combination of perspective made partly by art and partly by nature, and the work done according to its rules has no part that is not influenced by natural and accidental perspective. Natural perspective I understand has to do with the flat surface on which this perspective is represented; which surface, although it is parallel to it in length and height, is constrained to diminish the distant parts more than its near ones. And this is proved by the first of what has been said above, and its diminution is natural.

Accidental perspective, that is that which is created by art, acts in

the contrary way; because it causes bodies equal in themselves to increase on the foreshortened plane, in proportion as the eye is more natural and nearer to the plane, and as the part of this plane where it is represented is more remote from the eye. 　　　　E 16 v.

THE PERSPECTIVE OF THE DISAPPEARANCE OF THE OUTLINES OF OPAQUE BODIES

If the true outlines of opaque bodies become indistinguishable at any short distance they will be still more invisible at great distances; and since it is by the outlines that the true shape of each opaque body becomes known, whenever because of distance we lack the perception of the whole we shall lack yet more the perception of its parts and outlines. 　　　　E 80 r.

OF PAINTING AND PERSPECTIVE

There are three divisions of perspective as employed in painting. Of these the first relates to the diminution in the volume of opaque bodies; the second treats of the diminution and disappearance of the outlines of these opaque bodies; the third is their diminution and loss of colour when at a great distance.

OF THE PERSPECTIVE OF THE DIMINUTION OF OPAQUE BODIES

Among opaque bodies of equal magnitude, the diminution apparent in their size will vary according to their distance from the eye which sees them; but it will be in inverse proportion, for at the greater distance the opaque body appears less, and at a less distance this body will appear greater, and on this is founded linear perspective. And show secondly how every object at a great distance loses first that portion of itself which is the thinnest. Thus with a horse, it would lose the legs sooner than the head because the legs are thinner than the head, and it would lose the neck before the trunk for the same reason. It follows therefore that the part of the horse which the eye will be able last to discern will be the trunk, retaining still its oval form, but rather approximating to the shape of a cylinder, and it will lose its thickness

sooner than its length from the second conclusion aforsaid. If the eye
is immovable the perspective terminates its distance in a point; but if
the eye moves in a straight line the perspective ends in a line, because
it is proved that the line is produced by the movement of the point, and
our sight is fixed upon the point, and consequently it follows that as the
sight moves the point moves, and as the point moves the line is pro-
duced. E 80 v.

Of objects of equal size placed at equal distances from the eye the
more luminous will appear the greater.

Of equal objects equally distant from the eye the more obscure will
appear the less. F 36 r.

Of things removed an equal distance from the eye that will appear
to be less diminished which was at first more.

Of things removed from the eye at an equal distance from their first
position, that is less diminished which at first was more distant from
this eye.

And the proportion of the diminution will be the same as that of the
distances at which they were from the eye before their movement.
 F 60 v.

SIMPLE PERSPECTIVE

Simple perspective is that which is made by art upon a position
equally distant from the eye in each of its parts.

Complex perspective is that which is made upon a position in which
no two of the parts are equally distant from the eye. G 13 v.

PERSPECTIVE

If two similar and equal things be placed one behind the other at a
given distance, the difference in their size will appear greater in pro-
portion as they are nearer to the eye which sees them. And conversely
there will appear less difference in size between them as they are
farther removed from the eye.

This is proved by means of the proportions that they have between
their distances, for if there are two bodies with as great a distance from
the eye to the first as from the first to the second this proportion is

called double; because if the first is one braccio distant from the eye and the second is at a distance of two braccia, the second space is double the first, and for this reason the first body will show itself double the second. And if you remove the first to a distance of a hundred braccia and the second to a hundred and one braccia, you will find that the first is greater than the second by the extent to which a hundred is less than a hundred and one, and this conversely.

The same thing also is proved by the fourth of this, which says: in the case of equal things there is the same proportion of size to size as that of distance to distance from the eye that sees them. G 29 v.

DISCOURSE ON PAINTING

Perspective as it concerns Painting is divided into three chief parts, of which the first treats of the diminution in the size of bodies at different distances. The second is that which treats of the diminution in the colour of these bodies. The third of the gradual loss of distinctness of the forms and outlines of these bodies at various distances.

Perspective employs in distances two opposite pyramids, one of which has its apex in the eye and its base as far away as the horizon. The other has the base towards the eye and the apex on the horizon. But the first is concerned with the universe, embracing all the mass of the objects that pass before the eye, as though a vast landscape was seen through a small hole, the number of the objects seen through such a hole being so much the greater in proportion as the objects are more remote from the eye; and thus the base is formed on the horizon and the apex in the eye, as I have said above.

The second pyramid has to do with a peculiarity of landscape, in showing itself so much smaller in proportion as it recedes farther from the eye; and this second instance of perspective springs from the first.

[*Perspective of disappearance*]

In every figure placed at a great distance you lose first the knowledge of its most minute parts, and preserve to the last that of the larger parts, losing, however, the perception of all their extremities; and they become oval or spherical in shape, and their boundaries are indistinct.

G 53 v.

The eye cannot comprehend a luminous angle when close to itself.

<div align="right">H 71 [23] r.</div>

PERSPECTIVE

The shadows or reflections of things seen in moving water, that is to say with tiny waves, will always be greater than the object outside the water which causes them.

The eye cannot judge where an object high up ought to descend.

<div align="right">H 76 [28] v.</div>

No surface will reveal itself exactly if the eye which see it is not equally distant from its extremities. H 81 [33] r.

OF ORDINARY PERSPECTIVE

An object of uniform thickness and colour seen against a background of various colours will appear not to be of uniform thickness.

And if an object of uniform thickness and of various colours is seen against a background of uniform colour, the object will seem of a varying thickness.

And in proportion as the colours of the background, or of the object seen against the background, have more variety, the more will their thickness seem to vary, although the objects seen against the background may be of equal thickness. I 17 v.

A dark object seen against a light background will seem smaller than it is.

A light object will appear greater in size when it is seen against a background that is darker in colour. I 18 r.

If the eye be in the middle of a course with two horses running to their goal along parallel tracks, it will seem to it that they are running to meet one another.

This that has been stated occurs because the images of the horses which impress themselves upon the eye are moving towards the centre of the surface of the pupil of the eye. K 120 [40] v.

PAINTING

Foreshorten, on the summits and sides of the hills, the outlines of the estates and their divisions; and, as regards the things turned towards you, make them in their true shape. L 21 r.

Among things of equal velocity, that will appear of slower movement which is more remote from the eye.

Therefore that will appear swifter which is nearer to the eye.

<div align="right">B.M. 134 V.</div>

[*Aerial perspective*]

In the morning the mist is thicker up above than in the lower parts because the sun draws it upwards; so with high buildings the summit will be invisible although it is at the same distance as the base. And this is why the sky seems darker up above and towards the horizon, and does not approximate to blue but is all the colour of smoke and dust.

The atmosphere when impregnated with mist is altogether devoid of blueness and merely seems to be the colour of the clouds, which turn white when it is fine weather. And the more you turn to the west the darker you will find it to be, and the brighter and clearer towards the east. And the verdure of the countryside will assume a bluish hue in the half-mist but will turn black when the mist is thicker.

Buildings which face the west only show their illuminated side, the rest the mist hides.

When the sun rises and drives away the mists, and the hills begin to grow distinct on the side from which the mists are departing, they become blue and seem to put forth smoke in the direction of the mists that are flying away, and the buildings reveal their lights and shadows; and where the mist is less dense they show only their lights, and where it is more dense nothing at all. Then it is that the movement of the mist causes it to pass horizontally and so its edges are scarcely perceptible against the blue of the atmosphere, and against the ground it will seem almost like dust rising.

In proportion as the atmosphere is more dense the buildings in a city and the trees in landscapes will seem more infrequent, for only the most prominent and the largest will be visible.

And the mountains will seem few in number, for only those will be

seen which are farthest apart from each other, since at such distances the increases in the density creates a brightness so pervading that the darkness of the hills is divided, and quite disappears towards their summits. In the small adjacent hills it cannot find such foothold, and therefore they are less visible and least of all at their bases.

Darkness steeps everything with its hue, and the more an object is divided from darkness the more it shows its true and natural colour.

<div align="right">B.M. 169 r.</div>

Equal things equally distant from the eye will be judged to be of equal size by this eye.

OF PERSPECTIVE

The shaded and the illuminated parts of opaque bodies will be in the same proportion of brightness and darkness as are those of their objects [that is of the body or bodies which project upon them].

<div align="right">Forster II 5 r.</div>

OF PERSPECTIVE

Of things of equal size that which is farther away from the eye will appear of less bulk. Forster II 15 v.

OF PERSPECTIVE

When the eye turns away from a white object which is illuminated by the sun, and goes to a place where there is less light, everything there will seem dark. And this happens, because the eye that rests upon this white illuminated object proceeds to contract its pupil to such an extent that whatever the original surface that was visible they will have lost more than three quarters of it, and thus lacking in size they will also be lacking in power.

Though you might say to me:—a small bird then would see in proportion very little, and because of the smallness of its pupils the white there would appear black. To this I should reply to you that we are here paying attention to the proportion of the mass of that part of the brain which is devoted to the sense of sight, and not to any other thing. Or—to return—this pupil of ours expands and contracts according to the brightness or darkness of its object, and since it needs an interval

of time thus to expand and contract, it cannot see all at once when
emerging from the light and going to the shade, nor similarly from the
shade to what is illuminated; and this circumstance has already de-
ceived me when painting an eye, and from it I have learnt.

Forster II 158 v.

Among equal things the more remote will seem the smaller; and the
proportion of the diminutions will be as that of the distances.

Quaderni IV 10 r.

[*Perspective of colours*]

Make the perspective of the colours so that it is not at variance with
the size of any object, that is that the colours lose part of their nature
in proportion as the bodies at different distances suffer loss of their nat-
ural quantity.　　　　　　　　　　　　　　　　　　Quaderni VI 18 r.

XXXIV

Artists' Materials

'Amber is the latex of the cypress tree.'

SINCE walnuts are covered with a certain thin skin which derives its nature from the husk, unless you peel this off when you are making the oil this husk will tinge the oil, and when you use it in your work the husk becomes separated from the oil and comes to the surface of the picture, and this is what causes it to change. C.A. 4 v. b

TO MAKE RED ON GLASS FOR FLESH COLOUR

Take rubies of Rocca Nera or garnets and mix with *lattimo*,[1] also Armenian bole is good in part. Tr. 71 a

Sap of spurge and milk of the fig tree as a dissolvent. H 65 [17] r.

You will make good ochre if you employ the same method that one uses to make white lead. H 94 [46] v.

VARNISH

Take cypress [oil] and distil it, and have a large jug and put the distilled essence in it with so much water as to make it the colour of amber, and cover it over well so that it does not evaporate; and when it has dissolved add in this jug of the said essence so that it shall be as liquid as you desire. And you must know that the amber is the latex of the cypress tree.

And since varnish is the gum of juniper, if you distil the juniper the said varnish can be dissolved in this essence in the manner spoken of above. Forster 1 43 r.

Tap a juniper tree and water its roots, and mix the latex that exudes

[1] *Lattimo*, a substance which has the colour of milk, used by glaziers. *Neri Art. Vetr.* (Fanfani).

with oil of walnut and you will have perfect varnish made with varnish, and this same you will make from the cypress, and you will then have varnish of the colour of amber, beautiful and famous for its quality. Make it in May or April.　　Forster 1 44 v.

TO MAKE POINTS FOR COLOURING IN SECCO

Temper with a little wax and it will not flake. And this wax should be dissolved with water, so that after the white lead has been mixed this water having been distilled may pass away in steam and the wax only remain, and you will make good points. But know that it is necessary for you to grind the colours with a warm stone.

Forster II 159 r.

OIL

Seed of mustard pounded with oil of linseed.　　Forster III 10 v.

Make oil from seed of mustard, and if you wish to make it more easily mix the seed after grinding it with oil of linseed, and put it all under a press.　　Forster III 40 r.

FOR STAMPING MEDALS

Paste [is made] of emery mixed with spirits of wine, or iron filings with vinegar, or ashes of walnut-leaves, or ashes of straw rubbed very fine.

The diamond is crushed [by being] wrapped up in lead and beaten with a hammer, the lead being several time spread out and folded up again, and it is kept wrapped up in paper so that the powder may not be scattered. Then melt the lead, and the powder rises to the surface of the lead when it has melted, and it is afterwards rubbed between two plates of steel so that it becomes a very fine powder; afterwards wash it with aqua fortis and the black coating of the iron will be dissolved and will leave the powder clean.

Lumps of emery can be broken up by placing them in a cloth folded many times and hitting it on the side with a hammer; and by this means it goes into flakes bit by bit and is then easily crushed; and if you place it on the anvil you will never break it on account of its size.

The grinder of enamels ought to practise in this way upon plates of

tempered steel with a steel press, and then place it in aqua fortis which dissolves all the steel that is eaten away and mingled with this enamel and makes it black, with result that the enamel remains purified and clean.

If you grind it upon porphyry this porphyry is consumed and becomes mingled with the enamel and spoils it, and aqua fortis will never free it from the porphyry because it cannot dissolve it.

If you wish to make a beautiful blue, dissolve with tartar the enamel you have made and then take off the salt.

Brass vitrified makes a fine red. Sul Volo Cover [1] v.

XXXV

Commissions

*'Works of fame by which I could show to those who
are to come that I have been.'*

[MEMORANDUM of order of events in the Battle of Anghiari, drawn
up apparently for consultation by Leonardo in the composition of his
picture on the wall of the Council Chamber of the Palazzo della
Signoria at Florence.]

[Lead]ers of the Florentines.

Neri di Gino Capponi.
Bernardetto de' Medici.
Niccolò da Pisa.
Count Francesco.
Micheletto.
Pietro Gian Paolo.
Guelfo Orsino.
Messer Rinaldo degli Albizi.

You should commence with the oration of Niccolò Piccinino to the
soldiers and exiled Florentines, among whom was Messer Rinaldo
degli Albizi. Then you should show him first mounting his horse in
full armour and the whole army following him: forty squadrons of
horse and two thousand foot soldiers went with him.

And the Patriarch at an early hour of the morning ascended a hill
in order to reconnoitre the country, that is the hills, fields and a valley
watered by a river; and he saw Niccolò Piccinino approaching from
Borgo San Sepolcro with his men in a great cloud of dust, and having
discovered him he turned to the captains of his men and spoke with
them.

And having spoken he clasped his hands and prayed to God; and
presently he saw a cloud, and from the cloud St. Peter emerged and

spoke to the Patriarch. Five hundred cavalry were despatched by the Patriarch to hinder or check the enemy's attack.

In the foremost troop was Francesco, son of Niccolò Piccinino, and he arrived first to attack the bridge which was defended by the Patriarch[?] [1] and the Florentines.

Behind the bridge on the left he sent the infantry to engage our men who beat off the attack. Their leader was Micheletto who [. . .] was the officer of the watch at the court. Here at this bridge there was a great fight: the enemy conquer and the enemy are repulsed.

Then Guido and Astorre his brother, lord of Faenza, with many of their men, reformed and renewed the combat, and hurled themselves upon the Florentines with such vigour that they regained possession of the bridge, and pushed their advance as far as the tents.

Opposite to these came Simonetto with six hundred cavalry to harass the enemy, and he drove them again from the spot and reoccupied the bridge.

And behind him came another company with two thousand cavalry, and so for a long time the battle swayed.

And then the Patriarch to throw disorder into the ranks of the enemy sent forward Niccolò da Pisa and Napoleone Orsino, a beardless youth, and with them a great multitude of men, and then was done another great deed of arms.

And at this time Niccolò Piccinino pushed up another unit of his followers, and this caused yet another advance by our men; and had it not been for the Patriarch throwing himself into the midst and sustaining his commanders by words and deeds the enemy would have driven them in flight.

And the Patriarch made them set up certain pieces of artillery on the hill, by means of which he spread confusion among the infantry of the enemy. And this disorder was so great that Niccolò began to call back his son and all his followers and they started in flight towards the Borgo. And at this spot there occurred a great slaughter of men, and none escaped save those who were the first to fly or those who hid themselves.

The passage of arms continued until the going down of the sun,

[1] MS. has PP.

and the Patriarch busied himself in withdrawing his troops and burying the dead, and afterwards he set up a trophy.

C.A. 74 r. b and 74 v. c

MONUMENT OF MESSER GIOVANNI GIACOMO DA TRIVULZIO [1]

Cost of the work and material for the horse

A courser, life size, with the rider, requires for the cost of the metal	ducats	500
And for the cost of the iron work which goes inside the model, and charcoal, wooden props, pit for the casting, and for binding the mould, including the furnace where it is to be cast	ducats	200
For making the model in clay and afterwards in wax	ducats	432
And for the workmen who polish it after it has been cast	ducats	450
Total	ducats	1582

Cost of the marble for the tomb

Cost of the marble according to the design. The piece of marble which goes under the horse which is 4 braccia long and 2 braccia 2 inches wide and 9 inches thick, 58 hundredweight, at 4 lire 10 soldi per hundredweight	ducats	58
And for 13 braccia 6 inches of cornice, 7 inches wide and 4 inches thick, 24 hundredweight	ducats	24
And for the frieze and architrave which is 4 braccia 6 inches long, 2 braccia wide and 6 inches thick, 20 hundredweight	ducats	20
And for the capitals made of metal of which there are 8, 5 inches square and 2 inches thick: at the price of 15 ducats each they come to	ducats	120
And for 8 columns of 2 braccia 7 inches, 4½ inches thick, 20 hundredweight	ducats	20

[1] For a discussion of the evidence relating to the project for a sepulchral monument of Marshal Trivulzio of which this is an estimate, see the author's *Mind of Leonardo* (Cape, 1928), pp. 336-9.

And for 8 bases, 5½ inches square and 2 inches high 5
hundredweight ducats 5

And for the stone, where it is upon the tomb, 4 braccia
10 inches long, 2 braccia 4½ inches wide, 36 hundred-
weight ducats 36

And for 8 feet of pedestals, which are 8 braccia long,
6½ inches wide, 6½ inches thick, and 20 hundred-
weight ducats 20

And for the cornice that is below, which is [. . .]
braccia 10 inches long, 2 braccia 5 inches wide and
4 inches thick, 32 hundredweight ducats 32

And for the stone of which the recumbent figure (il
morto) is to be made, which is 3 braccia 8 inches long,
1 braccia 6 inches wide, 9 inches thick, 30 hundred-
weight ducats 30

And for the stone that is beneath the recumbent figure,
which is 3 braccia 4 inches long, 1 braccia 2 inches
wide, 4½ inches thick ducats 16

And for the slabs of marble interposed between the
pedestals, of which there are 8—9 braccia long, 9
inches wide, 3 inches thick—8 hundredweight ducats 8

Total ducats 389

Cost of the work upon the marble

Round the base of the horse there are 8 figures at 25
ducats each ducats 200

And in the same base are 8 festoons with certain other
ornaments, and of these there are 4 at the price of 15
ducats each, and 4 at the price of 8 ducats each ducats 92

And for squaring these stones ducats 6

Further for the large cornice, which goes below the base
of the horse, which is 13 braccia 6 inches at 2 ducats
per braccio ducats 27

And for 12 braccia of frieze at 5 ducats per braccio ducats 60

And for 12 braccia of architrave at 1½ ducats per braccio ducats 18

And for 3 rosettes which form the soffit of the monument,
at 20 ducats the rosette ducats 60

And for 8 fluted columns at 8 ducats each	ducats	64
And for 8 bases at one ducat each	ducats	8
And for 8 pedestals, of which there are 4 at 10 ducats each, which go above the corners, and 4 at 6 ducats each	ducats	64
And for squaring and framing the pedestals at 2 ducats each, there being eight	ducats	16
And for 6 tables with figures and trophies at 25 ducats each	ducats	150
And for making the cornices of the stone which is beneath the recumbent figure	ducats	40
For making the recumbent figure, to do it well	ducats	100
For 6 harpies with candlesticks, at 25 ducats each	ducats	150
For squaring the stone on which the recumbent figure rests, and its cornice	ducats	20
Total	ducats	1075

The total of everything added together is ducats 3046.

C.A. 179 v. a

The Labours of Hercules for Pier F. Ginori.
The Garden of the Medici.[1] C.A. 288 v. b

Francesco.
Antonio: lily and book.
Bernardino: with Jesus.
Lodovico: with three lilies on his breast, with crown at his feet.
Bonaventura: with seraphim.

[1] From the juxtaposition of these two notes in the manuscript the first may perhaps be interpreted as a reference to an intended commission, probably for a work in sculpture, to be executed or studied for among the casts in that Garden of the Medici in the piazza di San Marco, where in the time of Il Magnifico an Academy of the Arts existed under the charge of the sculptor Bertoldo. Its existence is referred to by Vasari in his lives of Donatello and Torrigiano. The fact of Leonardo having worked for a time in this garden is borne witness to in the short biography of him written just before the middle of the sixteenth century by a Florentine known as the Anon mo Gaddiano:

'He lived as a youth with Lorenzo de' Medici Il Magnifico who in order to make provision for him set him to work in the garden of the piazza of San Marco in Florence.'

[*Diagram for Altarpiece*]

Giovita		Faustino
San Piero	Our Lady	Paolo
Elisabetta		Santa Chiara
Bernardino		Lodovico
Bonaventura		Antonio da Padua
San Francesco		

Santa Chiara: with the tabernacle.
Elisabetta: with queen's crown.[1] I 107 [59] r.

[*Notes apparently relating to some commission*]
Ambrogio de Predis.
San Marco.
Board for the window.
Gaspari Strame.
The saints of the chapel.
The Genoese at home. L I r.

[*Note with drawing—apparently of mechanism of stage scenery*]
a b, c d is a hill which opens thus: *a b* goes to *c d* and *c d* goes to *e f*; and Pluto is revealed in *g*, his residence.

When Pluto's paradise is opened then let there be devils placed there in twelve pots to resemble the mouths of hell.

There, there should be Death, the Furies, Cerberus, many nude Putti in lamentation. There fires made in various colours. . . .

B.M. 231 V.

[1] Following on his identification of the names at the head of the two lists as those of the two patron saints of Brescia, Dr. Emil Möller has put forward reasons for regarding this sketch as intended for an altar-piece for S. Francesco at Brescia, which he believes to have been contemplated by Leonardo in the year 1479. (See *Repertorium für Kunstwissenschaft*, xxxv.)

[For heraldic devices—with drawings]

MESSER ANTONIO GRI, VENETIAN, COMPANION OF ANTONIO MARIA

On the left side let there be a wheel, and let the centre of it cover the centre of the horse's hinder thigh-piece, and in this centre should be shewn Prudence dressed in red, representing Charity, sitting in a fiery chariot, with a sprig of laurel in her hand to indicate the hope that springs from good service.

On the opposite side let there be placed in like manner Fortitude with her necklace in hand, clothed in white which signifies . . . and all crowned, and Prudence with three eyes.

The housing of the horse should be woven of plain gold, bedecked with many peacocks' eyes, and this applies to all the housings of the horse and the coat of the man.

The crest of the man's helmet and his hauberk of peacocks' feathers, on a gold ground.

Above the helmet let there be a half-globe to represent our hemisphere in the form of a world, and upon it a peacock with tail spread out to pass beyond the group, richly decorated, and every ornament which belongs to the horse should be of peacocks' feathers on a gold ground, to signify the beauty that results from the grace bestowed on him who serves well.

In the shield a large mirror to signify that he who really wishes for favour should be mirrored in his virtues. B.M. 250 r.

CHRIST

Count Giovanni, of the household of the cardinal of Mortaro.
Giovannina, face of fantasy; lives at Santa Caterina at the hospital.
Forster II 3 r.

Alessandro Carissimo of Parma for the hand of Christ.
Forster II 6 r.

One who was drinking and left the cup in its place and turned his head towards the speaker.

Another twists the fingers of his hands together and turns with stern brows to his companion.

Another with hands opened showing their palms raises his shoulders towards his ears and gapes in astonishment.

Another speaks in the ear of his neighbour, and he who listens turns towards him and gives him his ear, holding a knife in one hand and in the other the bread half divided by this knife.

Another as he turns holding a knife in his hand overturns with this hand a glass over the table.

Another rests his hands upon the table and stares.

Another breathes heavily with open mouth.

Another leans forward to look at the speaker and shades his eyes with his hand.

Another draws himself back behind the one who is leaning forward and watches the speaker between the wall and the one who is leaning.[1]

<div align="right">Forster II 62 v. and 63 r.</div>

Cristofano da Castiglione lives at the Pietà, he has a fine head.

<div align="right">Forster III 1 v.</div>

The Florentine morel of Messer Mariolo, a big horse, has a fine neck and a very fine head.[2]

White stallion belonging to the falconer has fine haunches, is at the Porta Comasina.

Big horse of Cermonino belongs to Signor Giulio. Forster III 88 r.

[*With drawing of foreleg with measurements*]

The Sicilian of Messer Galeazzo.

Make this the same within, with the measure of all the shoulder.

<div align="right">Windsor: Drawings 12294</div>

[*With drawing of horse*]

The big jennet of Messer Galeazzo. Windsor: Drawings 12319

[These verses, presumably sent to Leonardo by an admirer of his art, are the evidence of his having painted a portrait of Lucrezia Crivelli, a lady of the Milanese Court]

[1] Description of action of figures in 'The Last Supper'.

[2] MS. *Morel fiorentino di miser Mariolo*. Morel, a dark-coloured horse (Murray). As the manuscript in which these notes occur bears references to the years 1493 and 1494 they may refer to studies for the equestrian statue of which a model was erected in the latter year.

Ut bene respondet naturae ars docta: dedisset
 Vincius, ut tribuit cetera, sic animam.
Noluit, ut similis magis haec foret: altera sic est:
 Possidet illius Maurus amans animam.
Hujus, quam cernis, nomen Lucretia: divi
 Omnia cui larga contribuere manu.
Rara huic forma data est: pinxit Leonardus: amavit
 Maurus: pictorum primus hic: ille ducum.
Naturam et superas hac laesit imagine divas
 Pictor: tantum hominis posse manum haec doluit.
Illae longa dari tam magnae tempora formae:
 Quae spatio fuerat deperitura brevi.
Has laesit Mauri causa: defendet et ipsum
 Maurus: Maurum homines laedere diique timent.[1]

<div align="right">C.A. 167 V. C</div>

[1] How well the master's art answers to nature. Da Vinci might have shown the soul here, as he has rendered the rest. He did not, so that his picture might be the greater likeness; for the soul of the original is possessed by Il Moro, her lover.

This lady's name is Lucrezia, to whom the gods gave all things with lavish hand. Beauty of form was given her: Leonardo painted her, Il Moro loved her—one the greatest of painters, the other of princes.

By this likeness the painter injured Nature and the goddesses on high. Nature lamented that the hand of man could attain so much, the goddesses that immortality should be bestowed on so fair a form, which ought to have perished.

For Il Moro's sake Leonardo did the injury, and Il Moro will protect him. Men and gods alike fear to injure Il Moro.

XXXVI

Sculpture

*'As practising myself the art of sculpture no less
than that of painting, and doing both the one and
the other in the same degree.'*

[*Notes made in preparation for a statue*]

Of that at Pavia[1] the movement more than anything else is deserving of praise.

It is better to copy the antique than modern work.

You cannot combine utility with beauty as it appears in fortresses and men.

The trot is almost of the nature of the free horse.

Where natural vivacity is lacking it is necessary to create it fortuitously.

<div align="right">C.A. 147 r. b</div>

The sculptor cannot represent transparent or luminous things.

<div align="right">C.A. 215 v. d</div>

All the heads of the large iron pins.[2]

<div align="right">C.A. 216 v. a</div>

How the eye cannot discern the shapes of bodies within their boundaries except by means of shadows and lights; and there are many sciences which would be nothing without the science of these shadows and lights: as painting, sculpture, astronomy, a great part of perspective and the like.

As may be shown, the sculptor cannot work without the help of

[1] The reference is to the antique bronze equestrian statue representing Odoacer, King of the Goths, according to the Anonimo Morelliano, Gisulf according to Antonio Campo the historian of Cremona, which was removed by Charlemagne from Ravenna to Pavia and stood in the Piazza del Duomo until the time of its destruction, which occurred in a revolutionary outbreak in 1796. It was called Regisole, the name being derived from the reflections of the sun's rays on the gilded bronze. Petrarch in a letter to Boccaccio says of it that 'it was looked upon as a masterpiece of art by all good judges'.

[2] The words are at the side of a drawing in red chalk representing a horse in an attitude of walking seen within a frame.

shadows and lights, since without these the material carved would remain all of one colour; and by the ninth of this [book] it is shown that a level surface illumined by uniform light does not vary in any part the clearness or obscurity of its natural colour, and this uniformity of colour goes to prove the uniformity of the smoothness of its surface. It would follow therefore that if the material carved were not clothed by shadows and lights, which are necessitated by the prominences of certain muscles and the hollows interposed between them, the sculptor would not be able uninterruptedly to see the progress of his own work, and this the work that he is carving requires, and so what he fashioned during the day would be almost as though it had been made in the darkness of the night.

OF PAINTING

Painting, however, by means of these shadows and lights comes to represent upon level surfaces scenes with hollows and raised portions, separated from each other by different degrees of distance and in different aspects. C.A. 277 V. a

Measurement of the Sicilian [horse], the leg behind, in front, raised and extended. C.A. 291 V. a

OF STATUES

If you wish to make a figure of marble make first one of clay, and after you have finished it and let it dry, set it in a case, which should be sufficiently large that—after the figure has been taken out—it can hold the block of marble wherein you purpose to lay bare a figure resembling that in clay. Then after you have placed the clay figure inside this case make pegs so that they fit exactly into holes in the case, and drive them in at each hole until each white peg touches the figure at a different spot; stain black such parts of the pegs as project out of the case, and make a distinguishing mark for each peg and for its hole, so that you may fit them together at your ease. Then take the clay model out of the case and place the block of marble in it, and take away from the marble sufficient for all the pegs to be hidden in the holes up to their marks, and in order to be able to do this better, make the case

so that the whole of it can be lifted up and the bottom may still remain under the marble; and by this means you will be able to use the cutting tools with great readiness. <div align="right">A 43 r.</div>

OF THE BLOW OF SCULPTORS

Because the time of the blow is indivisible, like the contact caused by this blow, its operation is of such swiftness that time does not permit this blow to transfer itself to the foundations of the things struck with sufficient swiftness to prevent the blow being already dead in its upper parts, like the mason who breaks a stone in his hand with a hammer without violence or damage to the hand.

And this is why, after the iron *a b* has been struck by the blow of the hammer in its upper part *a*, this part has obeyed the nature of the blow rather than transferred it to its base *b*, so that the extremity is enlarged more than the base.

And from this it follows that sculptors work to better effect upon their marbles when they rough-hew with a pointed hammer than with a chisel struck by the hammer.

A sharp sword will also cut a roll in the air. <div align="right">c 6 v.</div>

[*Sculpture*]

When you have finished building up the figure you will make the statue with all its surface measurements. <div align="right">Quaderni III 3 r.</div>

Some have erred in teaching sculptors to surround the limbs of their figures with wires, as though believing that these limbs were of equal roundness at each part at which they were surrounded by these wires.

<div align="right">Quaderni VI 10 r.</div>

XXXVII

Casting

*'Of the horse I will say nothing because I know
the times.'*

. . . the cold will have sufficient thickness to touch the plaster, and
you pour out the rest and fill with plaster and then break the mould,
and put the iron pins across, boring through the wax and plaster, and
then clean the wax at your leisure; afterwards put it in a case, and
put a mould of plaster over it, leaving the air holes and the mouth for
the casting. Through this mouth turn the mould upside down, and
after it has been heated you will be able to draw out the wax contained
within it; and you will be able to fill up the vacuum which remains
with your liquefied material, and the thing cast will become hollow.
But in order to prevent the plaster from becoming broken while being
rebaked you must place within it what you know of. c.a. 352 r. c

[*With drawing of apparatus*]

This is the way in which the forms rapidly dry and are continually
turned like roasts. Tr. 29 a

HOW CASTS OUGHT TO BE POLISHED

You should make a bunch of iron wire as thick as fine string and
scrub them with it with water, but keeping a tub beneath so that it
may not cause mud below.

HOW TO REMOVE THE ROUGH EDGES OF THE BRONZE

You should make an iron rod which may be of the shape of a large
chisel, and rub it along the edges which remain upon the casts of the
guns and which are caused by the joins in the mould; but see that the
rod is a good weight and let the strokes be long and sweeping.

TO FACILITATE THE MELTING

First alloy part of the metal in the crucible and then put it in the furnace: this being in a molten state will make a beginning in the melting of the copper.

TO GUARD AGAINST THE COPPER COOLING IN THE FURNACE

When the copper begins to cool in the furnace proceed instantly as soon as you see this to slice it up with a stirring pole while it is in a paste, or if it has become entirely cold, cut it as you would lead with broad large chisels.

FOR THE MAKING OF A LARGE CAST

If you have to make a cast of a hundred thousand pounds, make it with five furnaces with two thousand pounds for each, or as much as three thousand pounds at most. Tr. 47 a

HOW THE BOARD SHOULD BE PLACED WHICH SUPPORTS THE MORTAR

The board that serves as a guide to the shape of the mortar ought therefore to be reduplicated from the centre backwards by the breadth of a great plank, to the end that it should not become twisted, and where this board has the impress of the frames and form of the cannon is the face not the edge, and when you add the tallow burnish this face with a pig's tooth so that it may be solid, and let the tallow be finely strained in order that as it turns it may not make marks.

WHAT TO DO IN ORDER TO BREAK UP A LARGE MASS OF BRONZE

If you wish to break a large mass of bronze suspend it first, then make a wall round it on the four sides in the shape of a hod for bricks, and make a great fire there; and when it is quite red-hot give it a blow with a great weight raised above it and do this with great force.

[With two sketches]

OF CASTING MANY SMALL CANNON AT THE SAME TIME

Make the courses for the bronze as is shown here just now; and keep *d b c* stopped up, but leave the course *a* entirely open; and when that is full unstop *b*, and when that is full unstop *c*, and then *d*; and the door of the courses should be of brick, the thickness of three fingers and well covered with ashes and then it is opened with the pincers; and branches of the courses when they also are cast ought to be divided with small plates of iron covered with earth before they are fastened.

Tr. 48 a

HOW TO MAKE LEAD COMBINE WITH OTHER METAL

If you wish for the sake of economy to put lead with the metal, and in order to lessen the amount of the tin which is necessary, first alloy the lead with the tin and then put above the molten copper.

OF A NECESSITY FOR MELTING IN A FURNACE

The furnace should be between four pillars with strong foundations.

OF THE THICKNESS OF THE COATING

The coating ought not to exceed the thickness of two fingers, and it ought to be laid on in four thicknesses over the fine clay and then well prepared, and it should be annealed only on the inside and then given a fine dressing of ashes and cattle dung.

OF THE THICKNESS OF THE MORTAR

The mortar ought to carry a ball of six hundred pounds and more, and by this rule you will take the measure of the diameter of the ball and divide it in six parts, and one of these parts will be its thickness at the muzzle, and it will always be half at the breech. And if the ball is to be of seven hundred pounds one seventh of the diameter of the ball will be its thickness at the muzzle, and if the ball is to be eight

hundred it will be the eighth of its diameter at the muzzle, and if nine hundred one eighth and one half of it, and if one thousand one ninth.

OF THE LENGTH OF THE TUBE OF THE MORTAR

If you wish it to throw a ball of stone, make the length of the tube as six or up to seven times the diameter of the ball; and if the ball is to be of iron make this tube up to twelve times the ball, and if the ball is to be of lead make it up to eighteen times. I mean when the mortar is to have its mouth fitted to receive within it six hundred pounds of stone ball and over.

OF THE THICKNESS OF SMALL CANNON

The thickness of small cannon at the muzzle ought not to exceed from a third to a half of the diameter of the ball, nor the length from thirty to thirty six times its diameter. Tr. 49 a

OF LUTING THE FURNACE ON THE INSIDE

The furnace ought before you put the metal in it to be luted with earth from Valenza, and over that ashes.

OF RESTORING THE METAL WHEN IT SEEMS ON THE POINT OF COOLING

When you see that the bronze is on the point of becoming congealed take wood of the willow cut into small chips and make up the fire with it.

THE CAUSE OF ITS CONGEALING

I say the cause of this congealing is often derived from there being too much fire and also from the wood being only half-dried.

TO KNOW THE CONDITION OF THE FIRE

You will know when the fire is good and suitable by the clear flames, and if you see the points of these flames turbid and ending in much

smoke do not trust it, and especially when you have the molten metal almost in fluid state.

WHAT KINDS OF WOOD ARE SUITABLE

Wood is suitable when it is the young willow, or if willow cannot be procured get alder, and let each branch be young and well dried.

OF ALLOYING THE METAL

The metal used for bombards must invariably be made with six or even eight parts to a hundred, that is six parts of tin to one hundred of copper, but the less you put in the stronger will be the bombard.

WHEN THE TIN SHOULD BE ADDED TO THE COPPER

The tin should be put with the copper when you have the copper changed into a fluid state.

HOW THE PROCESS OF MELTING MAY BE EXPEDITED

You can expedite the process of melting when the copper is two-thirds changed to a fluid state. With a chestnut rod you will then be able frequently to manage to stir the remainder of the copper which is still in one piece amid the melted part. Tr. 50 a

THE FINE EARTH OF THE BOMBARDS

Take the dust of wool clippings and fix it on a wall in thin plaster so that it drives well. Then pound it and sift in fine powder, and to fifty parts of this powder add ten parts of brick, not over-baked and well pounded and sifted, also a small quantity of fine wool clippings or fustian cloth; and then to this compound add six parts of ashes which you will sift when moistened with water well salted; and this you will apply liquid and thin two or three times with a plasterer's brush, leaving it every time to dry without fire. Also it would be advisable to add first to this mixture ashes of burnt ox-dung moistened with salt water.

OF THE TALLOW

The tallow ought to be applied mixed with soot from a blacksmith, and as fine as you can, or if you desire ashes of ox-dung.

OF THE FRAMES

The frames should be made almost to the limit of the cord as though [one were winding] a peg-top, and above this the frames should be completed with fine earth and polished with the said tallow and soot, and the ornaments should be of wax.

THE FRAME

The frame of the tail ought to have as its final covering a square in which are brickdust and ashes with salt water. Or it is even better to apply ashes of ox-dung with salt water over the said frame.

OF DIRECTING THE FRAME

The frame should first be put in the trench with grappling-hooks as you saw before, then annealed little by little, emerging in the manner somewhat of the colour of brick (*di poi lau* [?] *con uno negnietto*) striking softly bit by bit, and where you hear it resound bind with iron wire, but in order not to go astray place it to turn everywhere.

EARTH SUITABLE FOR GENERAL USE

The earth to be generally used ought to be that of which bricks are made, mixed with ox-dung or clippings of woollen cloth. Tr. 51 a

The bottom of the stove, three rows of unbaked bricks of ordinary clay and an inch and a half of ashes, the vault one layer of unbaked bricks of Valenza clay and another layer of baked bricks.

Loose earth [?] [1] should be put with the ashes.

The wood of the frame of the bombards should be covered an inch deep in cinders.

[1] MS. *i calossi*

Hoare's Ital. Dict. art. *loscio* has *terra loscia*, loose earth.

The mouth of the stove, that is where the flame enters, ought to be of large bricks of Valenza clay.

Each of two flues ought to be for the half of the window for the entrance of the flame. Tr. 54 a

NOTES ON USE OF 'SAGOMA' [1]

Let the plumb-line be extended in two directions opposite to the centre of the poles *a c*, and let the plane surface be formed of plaster (MS. *osseg* = *gesso*) little by little under the movement of the 'sagoma'.

And when the pavement is entirely finished the whole should be corrected again minutely with the 'sagoma'; and this 'sagoma' when used on the prepared surface (MS. *otasseg* = *gessato*) should be used with the greatest possible care. G 14 r.

[*Of friction of the sagoma*]

The friction of the polishing instrument against its surface ought not to be done with the edge of the instrument, except when first preparing the said surface. But when it is necessary to refine this surface then the instrument ought not to be of less width than half the surface. This may be proved: suppose *f e d c* to be the said polishing instrument and *f e n m* the smoothed surface. I maintain that if this polishing instrument were to have only one cutting edge, as in *d c* with *a b*, it would have far greater weight when the perpendicular line was upon the part *d c* of the smoothed surface than when it was on the position *f e* of the said surface. And for this reason it would wear away the rubbed parts much more if it were straight than if it were slanting. And the concaveness of this surface would be unequal, such inequality as cannot be formed by the great contact of the polishing instrument with the surface which it polishes.

But it would be better that the instrument and the surface should be the equal the one of the other, for when one of the sides of the instrument was in the middle of the said surface its extremity would receive all the accidental weight of this instrument.

[1] A mould, also 'an instrument for smoothing and polishing a surface'—Ravaisson-Mollien.

But the polishing instrument with one cutting edge is necessary, merely in order to give the form to its smoothed surface by means of three or four movements, which should make it entirely perfect.

G 16 r.

The cogs that cause the movement of the *sagoma* set in their grooves.

G 37 r.

The *sagoma* should be as that used on the road of Fiesole—with water.

Because it is necessary that in proportion as the said instrument is lowered so it wears itself away, and as after having been lowered it becomes very strong it is therefore necessary to make the pulleys with nuts so that screws turn within them, and that it shuts and opens between *a c* as *b* shows between *a c*, and that these rings which form nuts for the screws should be drawn with the cords *d e f g*. G 43 v.

VARNISH OF THE FIRED SURFACE [1]

Mercury with Jupiter and Venus:[2] after the paste has been made it should be worked upon the *sagoma* continully until Mercury is entirely separated from Jupiter and Venus. G 46 v.

USE OF THE SAGOMA

Let the concavity be pressed with the instrument first several times backwards and forwards before it is varnished, then the varnish should be applied to the moist surface, and go over it with the sieve; use the mould two or three times, then expose it to the furnace, and when it acquires lustre immediately apply the mould while it is hot.

The centre of the revolution of the mould upon the structure ought to be fixed, and such that it can be raised and lowered, and moved forward and backward, so that its . . . falls upon the centre of the mould.

The base of the oven should be of the same shape as that of the object placed in the oven; and it is well that it should be of one piece

[1] *Vernicie della igna.*

[2] i.e., according to Richter, quicksilver with iron and copper.

of tufa stone, so that it can resist like an anvil the transverse percussion of the heavy mould which strikes it. G 47 r.

Let the wood of the *sagoma* be well covered over with pitch (MS. *otaicepni = inpeciato*) so that it may not bend. G 51 v.

In the polishing instrument there is a space left in order to be able to insert the lead moulding, and so that one may be able to change these from time to time as they are consumed. And so with the emery, one will guide the 'male' of the fired surface to perfection, and upon this one will afterwards print the copper (MS. *emar = rame*) after it has been made absolutely smooth.

N, surface, is of Saturn[1] and it serves for the process of smoothing conjoined with the motive power, m below, in margin.

The motive power is Neptune.

This will keep the object to be polished below and the polishing instrument above; and the pole will find itself above, and so this pole not being weighed down as is that of the instrument represented above will come to maintain itself, and as it is not able to consume itself the process will be complete.

Moreover the thing polished will support above itself the substance which polishes it, and the polishing instrument being of lead may be recast and adjusted many times.

The mould may be of Venus, Jupiter or Saturn, and often cast back into the lap of its mother, and it may be worked over with fine emery; and the mould may be of Venus and Jupiter plastered over Venus.

But first you will put to the test Venus and Mercury mixed with Jupiter, and manage so that Mercury may escape, and then roll them up tightly so that Venus and Jupiter become blended in Neptune as thinly as possible.

[Figure]

This ought to be upside down, in order that the mould may weigh upon the surface it treats with a perpendicular weight. Thus the centre of the object in circumvolution will not consume itself, in order not to have the weight upon itself; and apart from this the polishing process will serve to receive and support it, as I have said in the first instance. G 53 r.

[1] Lead, Richter.

HOW TO MAKE A CURVE WHICH LEAVES THE PLATE PARALLEL PRECISELY

Have a frame of stout walnut wood upon which build a square frame with raised centering, and upon this are fixed both ends of the drawn plate, which is separated at the end from the sides of the wall, carrying and holding with it all the plates that are nailed above. And this frame should always be with the above-mentioned dark plates.

G 74 V.

STUCCO

Cover with stucco the boss of the . . . (*ingnea?*) of plaster, and let this be made of Venus and Mercury [1] and smear this boss well over with a uniform thickness of the blade of a knife, doing it with a rule (*sagoma?*) and cover this with the body of a bell so that it may drip, and you will have again the moisture with which you formed the paste: dry the rest well and then fire it, and beat or burnish it with a good burnisher, and make it thick towards the side.

Powder the glass to a paste with borax and water, and make stucco; then drain it off so as to dry it, then varnish it with fire so that it shines well. G 75 V.

If you wish to make a large thin metal plate of lead, make a smooth level surface and fill it with glowing coals and melt lead in it, and then with a smooth rake take away the coals and allow it to cool and it is made. Forster II 46 V.

When you wish to cast in wax burn off the scum with a candle and the cast will come without holes.

Grind verdigris with rue many times together with juice of lemon and keep it from Naples yellow. Forster II 64 V.

The steel is first beaten well for the length, then broken in squares, and these are placed one above another and well covered with earth of Valenza and powdered talc, and it is dried over a slow fire and gradually heated; and when it has been thoroughly heated both inside

[1] Ingnea, Venus and Mercury are written backwards in the text, i.e. they appear as aengni, erenev and oirucrem. Dr. Richter suggests that Venus and Mercury may mean 'marble' and 'lime' of which stucco is composed.

and out then the fire exerts its force and makes it become molten. But first insert flakes of iron, then have the earth gradually removed and beat it lengthwise; and this is good steel. Forster III 33 v.

Dry earth sixteen pounds; a hundred pounds of metal; moistened earth twenty; moisten the hundred of metal which adds four pounds of water; one of wax, one pound of metal somewhat less; cloth clippings with earth measure for measure. Forster III 36 v.

Two ounces of plaster to a pound of metal; [oil of] walnut eases it at the curve. Forster III 37 r.

TO MAKE A PLASTER CAST FOR BRONZE

Take for every two cupfuls of plaster one of burnt ox-horn, and mix them together and make the cast. Forster III 39 v.

FOR CASTING

Tartar burnt and powdered with plaster and used in casting causes such plaster to adhere together when it is annealed; then it is dissolved in water. Forster III 42 v.

For mirrors, thirty of tin upon a hundred of copper; but first clarify the two metals and plunge them in water and granulate them, and then fuse the copper and put it upon the tin. Forster III 87 v.

MOULD OF THE HORSE

Make the horse upon legs of iron, strong and firm in a good foundation. Then rub it with tallow and give it a good coating, letting it dry thoroughly layer by layer. And by this you will increase its thickness by the breadth of three fingers. Then fix and bind it with iron according to need. Besides this hollow out the mould, then get it to the required thickness, and then fill up the mould again by degrees and continue until it is entirely filled. Then bind it round with its irons and strap it up, and anneal it on the inner side where it has to touch the bronze.

OF MAKING THE MOULD IN PIECES

Mark upon the horse when finished all the pieces of the mould with which you wish to cover the horse, and after the clay has been laid on cut it to correspond in every piece, so that when the mould is finished you can take it off and then replace it in its first position with its catches by the countersigns.

The square block *a b* will go between the cover and the core, that is in the hollow space where the liquefied bronze is to be; and these square blocks of bronze will keep the spaces between the mould and the cover at an equal distance, and for this reason these blocks are of great importance.

The clay must be mixed with sand.

Take wax to give back and to pay for what has been used.

Dry one layer after another. Make the outer mould of plaster in order to save time in drying and the cost of wood; and with this plaster fasten the iron bands outside and inside for a thickness of two fingers; make terra cotta.

And this mould you will take a day to make; half a boat-load of plaster will serve you.

Good.

Stop it up again with paste and clay, or white of egg and brick and rubble. Windsor: Drawings 12347 r.

Three irons which bind the mould[1]

If you wish to make casts rapidly and simply, make them with a box of river sand moistened with vinegar.

After having made the mould upon the horse you will make the thickness of the metal in clay.

Note in alloying how may hours are needed for each hundred-weight. In casting each keep the furnace with its fire closed up. Let all the inside of the mould be saturated with linseed oil or turpentine. Then take a handful of powdered borax and hard rosin with aqua vitae and put a coat of pitch over the mould so that while underground the damp may not [injure it?].

In order to manage the large mould make a model of the small mould; make a small room in proportion.

[1] I have followed Richter's order of arrangement in this passage.

Make the vents in the mould while it is upon the horse.

Hold the hoofs in tongs and cast them with fish-glue.

Weigh the parts of the mould to find out what amount of metal it will take to fill them, and give so much to the furnace that it may supply each part with its quantity of metal; and this you will ascertain by weighing the clay of that part of the mould to which the quantity in the furnace has to correspond. And this is done so that the furnace that is for the legs fills them and does not have to supply metal for the head from the legs which would be impossible.

Cast at the same casting as the horse the little door (*sportello*) of the Windsor: Drawings 12350

XXXVIII

Architecture

'If anyone wishes to go through the whole place by the high-level roads, he will be able to use them for this purpose, and so also if anyone wishes to go by the low-level roads.'

IF THE usual width of the river is that of one arch construct this bridge with three, and do this in order to allow for the floods.

C.A. 46 v. a

[*Ground-plan of castle with lake and boats on it*]

[*The palace of the prince ought to have a piazza in front*] [1]

The rooms which you mean to use for dancing or to make different kinds of jumps or various movements with a crowd of people, should be on the ground floor, for I have seen them collapse and so cause the death of many. And above all see that every wall, however thin it may be, has its foundations on the ground or on well-planted arches.

Let the mezzanines of the dwellings be divided by walls made of narrow bricks, and without beams because of the risk of fire.

All the privies should have ventilation openings through the thickness of the walls, and in such a way that air may come in through the roofs.

Let the mezzanines be vaulted, and these will be so much the stronger as they are fewer in number.

Let the bands of oak be enclosed in the walls to prevent them from being damaged by fire.

Let the privies be numerous and be connected one with another, so that the smell may not spread through the rooms, and their doors should all close automatically.

[*Plans*] Kitchens. Pantry.

[1] Words crossed out in MS.

1033

[*Plans*] Kitchens. Stable. Eighty braccia wide and a hundred and twenty braccia long in ground plan. Combats by means of the boats, that is the combatants may be upon the boats. Ditch forty braccia. Road below.

At the angle *a* should be the keeper of the stable.

The largest division of the front of this palace is in two parts, that is the width of the court is half the length of the aforesaid front.

<div align="right">C.A. 76 v. b</div>

[*With plan*]

Stable for the Magnifico, for the upper part, one hundred and ten braccia long and forty braccia wide.

[*With plan*]

Stable for the Magnifico, for the lower part, one hundred and ten braccia long, and forty braccia wide, and it is divided into four rows for horses, and each of these rows is divided into thirty-two spaces, called intercolumnar, and each intercolumnar space has a capacity for two horses, between which is interposed a swing-bar.

This stable therefore has a capacity for a hundred and twenty-eight horses.

<div align="right">C.A. 96 v. a</div>

[*Town-planning*]

Give me authority whereby without any expense to you it may come to pass that all the lands obey their rulers, who . . .

The first renown will be eternal together with the inhabitants of the city built or enlarged by him.

Let the bottoms of the reservoirs which are behind the gardens be as high as the level of the gardens, and by means of discharge-pipes they will be able to bring water to the gardens every evening every time that it rises, raising the joint half a braccio; and to this let the senior officials be appointed.

[*With plan*] Canal. Weir. Garden.

And nothing is to be thrown into the canals, and every barge is to be obliged to carry away so much mud from the canal, and this is afterwards to be thrown on the bank.

[*With plan*] Construct in order to dry up the canal and to clean the (lesser) canals.

All people obey and are swayed by their magnates, and these mag-

nates ally themselves with and are constrained by their lords in two ways, either by blood-relationship or by the tie of property; blood-relationship when their sons, like hostages, are a surety and a pledge against any suspicion of their faith; the tie of property when you let each of them build one or two houses within your city, from which he may draw some revenue; and [*in addition to this*][1] he will draw from ten cities of five thousand houses with thirty thousand habitations, and you will disperse so great a concourse of people, who, herding together like goats one upon the back of another filling every part with their stench, sow the seeds of pestilence and death.

And the city will be of a beauty equal to its name, and useful to you for its revenues and the perpetual fame of its growth.

The municipality of Lodi will bear the expense, and keep the revenue which once a year it pays to the Duke.

To the stranger who has a house in Milan it will often befall that in order to be in a more imposing place he will go and live in his own house; and whoever is in a position to build must have some store of wealth, and in this way the poor people will become separated by such settlers, and when these . . . assessments will increase and the fame of its greatness. And even if he should not wish to reside in Milan he will still remain faithful, in order not to lose the profit of his house at the same time as the capital. c.a. 65 v. b

[Architectural drawings: ground plans]

Buttery. Kitchen. Family.

He who is stationed in the buttery ought to have behind him the entrance to the kitchen, in order to be able to do his work expeditiously; and the window of the kitchen should be in the front of the buttery so that he may extract the wood.

The drawing that I have made has a larger façade behind than in front, whereas it should be the opposite.

The large room for the family away from the kitchen, so that the master of the house may not hear their clatter; and the kitchen may be convenient for washing the pewter so that it may not be seen being carried through the house.

[1] Words crossed out in MS.

Large room for the master. Room. Kitchen. Larder. Guard Room. Large room for the family.

Larder, logs, kitchen and hen-coop (? *pollaro*) and hall, and the apartment will be or ought to be in contact for the convenience that ensues; and the garden and stable, manure and garden, in contact. The large room for the master and that for the family should have the kitchen between them, and in both the food may be served through wide and low windows, or by tables that turn on swivels.

The wife should have her own apartment and hall (*sala*) apart from that of the family, so that she may set her serving-maids to eat at another table in the same hall. She should have two other apartments as well as her own, one for the serving-maids the other for the wet nurses, and ample space for their utensils.

I wish to have one door to close the whole house. c.a. 158 v. a

The hall for the festival should be situated so that you come first into the presence of the lord, and then of the guests, and the passage should be so arranged that it enables you to enter the hall without passing in front of the people more than one may wish; and over on the other side opposite to the lord should be situated the entrance of the hall and a convenient staircase, which should be wide, so that the people in passing along them may not push against the masqueraders and damage their costumes, when going out . . . the crowd of men . . . with such masks . . . this hall . . . two rooms side by side . . . right double . . . of this an exit . . . collection and one for the masqueraders. c.a. 214 r. b

[A plan for laying out a water-garden]

The staircase is one braccio and three quarters wide and it is bent like a knee, and altogether it is sixteen braccia with thirty two steps half a braccio wide and a quarter high; and the landing where the staircase turns is two braccia wide and four long, and the wall which divides one staircase from the other is half a braccio; but the breadth of the staircase will be two braccia and the passage half a braccio wider; so that this large room will come to be twenty-one braccia long and ten and half braccia wide, and so it will serve well; and let us make it eight braccia high, although it is usual to make the height tally with the width; such rooms however seem to me depressing for

they are always somewhat in shadow because of their great height, and the staircases would then be too steep because they would be straight.

By means of the mill I shall be able at any time to produce a current of air; in the summer I shall make the water spring up fresh and bubbling, and flow along in the space between the tables, which will be arranged thus [*drawing*]. The channel may be half a braccio wide, and there should be vessels there with wines always of the freshest, and other water should flow through the garden, moistening the orange trees and citron trees according to their needs. These citron trees will be permanent, because their situation will be so arranged that they can easily be covered over, and the warmth which the winter season continually produces will be the means of preserving them far better than fire, for two reasons: one is that this warmth of the springs is natural and is the same as warms the roots of all the plants; the second is that the fire gives warmth to these plants in an accidental manner, because it is deprived of moisture and is neither uniform nor continuous, being warmer at the beginning than at the end, and very often it is overlooked through the carelessness of those in charge of it.

The herbage of the little brooks ought to be cut frequently so that the clearness of the water may be seen upon its shingly bed, and only those plants should be left which serve the fishes for food, such as watercress and other plants like these.

The fish should be such as will not make the water muddy, that is to say eels must not be put there nor tench, nor yet pike because they destroy the other fish.

By means of the mill you will make many water-conduits through the house, and springs in various places, and a certain passage where, when anyone passes, from all sides below the water will leap up, and so it will be there ready in case anyone should wish to give a shower-bath from below to the women or others who shall pass there.

Overhead we must construct a very fine net of copper which will cover over the garden and shut in beneath it many different kinds of birds, and so you will have perpetual music together with the scents of the blossom of the citrons and the lemons.

With the help of the mill I will make unending sounds from all

sorts of instruments, which will sound for so long as the mill shall continue to move. C.A. 271 v. a

[The dimensions of a temple]

You ascended by twelve flights of steps to the great temple, which is eight hundred feet in circumference and is built in the shape of an octagon. At the eight corners were eight large plinths a braccio and a half in height and three in width and six in length at the base, with an angle in the centre which served as the foundation for eight large pillars that rose to a height of twenty-four braccia above the base of the plinth, and on top of these stood eight capitals three braccia each [in length] and six wide. Above these followed architrave, frieze and cornice, four braccia and a half in height, carried on in a straight line from one pillar to another, and thus it surrounded the temple with a circuit of eight hundred braccia; between each of the pillars, as a support to this entablature, there stood ten large columns of the same height as the pillars, three braccia thick above their bases which were one braccio and a half in height.

You ascended to this temple by twelve flights of steps, the temple being upon the twelfth, built in the shape of an octagon, and above each angle rose a large pillar, and between the pillars were interposed ten columns of the same height as the pillars, which rose twenty-eight and a half braccia above the pavement. At this same height were placed architrave, frieze and cornice, which formed a circuit round the temple, eight hundred braccia in length and of uniform height. Within this circuit at the same level towards the centre of the temple at a distance of twenty-four braccia rise pillars and columns, corresponding to the eight pillars of the angles and the columns placed in the façade. And they rise to the same height as those already mentioned, and above these pillars the continuous architrave goes back towards the pillars and columns first spoken of. C.A. 285 r. c

Our ancient architects or such . . . commencing first of all with the Iti, who according to the discourses of Diodorus Siculus were the first builders and constructors of great cities, and of fortresses and buildings both public and private which had distinction, nobility and grandeur; and by reason of this their predecessors beheld with amazement and

stupefaction the lofty and immense engines which seemed to them . . .

<div align="right">

c.a. 325 r. b
</div>

An inverted arch is better for making a support than an ordinary one, because the inverted arch finds a wall below it which resists its weakness, while the ordinary arch finds where it is weakest nothing but air. Tr. 13 a

WHAT IS AN ARCH?

An arch is nothing other than a strength caused by two weaknesses; for the arch in buildings is made up of two segments of a circle, and each of these segments being in itself very weak desires to fall, and as the one withstands the downfall of the other the two weaknesses are converted into a single strength.

OF THE NATURE OF THE WEIGHT IN ARCHES

When once the arch has been set up it remains in a state of equilibrium, for the one side pushes the other as much as the other pushes it; but if one of the segments of the circle weighs more than the other the stability is ended and destroyed, because the greater weight will subdue the less. a 50 r.

[With architectural drawing and plan]

Ground plan of the pavilion which is in the middle of the labyrinth of the duke of Milan.

Pavilion of the garden of the duchess of Milan.[1]

[With plan and drawing of fortification]

GROUND PLAN OF RAVELIN

With this square bastion you should make only two towers in order that having . . . that one may not impede the other; and at each tower you should make a bridge entering into the ravelin as is shown in the

[1] A document recently found at Como bearing the date March 28, 1490, consists of a contract for the supply of stone for a pavilion which 'Maestro Lionardo painter and architect' was to construct in Milan.

drawing. The diameter of the square bastion should be a hundred braccia, and the diameter of each tower should be thirty braccia.

The ravelins should be open within so that being so the enemy cannot maintain himself there, but is exposed to attack from the towers.

B 12 r.

[*With architectural drawing*]

If you have your family in your house, make their habitations in such a way that at night neither they nor the strangers to whom you give lodging are in control of the egress of the house; in order that they may not be able to enter in the habitation where you live or sleep, close the exit *m*, and you will have closed the whole house. B 12 v.

[*With drawing of section of wall of a house*]

C is a stove which receives heat from the kitchen chimney by means of a copper flue two braccia high and one wide, and a stone is put over the place in summer in order that it may be possible to use the stove; *b* will be the place for keeping salt, and at the division *a* there will be an opening of a passage into the chimney for hanging up salted meats and such like things; and in the ceiling there will be many flues for the smoke, with different exits at the four sides of the chimney, so that if the north wind should begin to be troublesome the smoke may find an outlet on the other side. And the smoke proceeds to spread itself through the numerous flues and to cure salted meats; tongues and sausages and things like these it brings to perfection. But see to it that when you push the small door *a* a window opposite opens, which gives light to the little room; and this will be done by means of a rod joined to the door and the window in this way. B 14 v.

[*With ground plan of fortress*]

A way of a fortress with double moat. And the spurs which pass from the principal wall to the Garland serve two uses: that is they form a buttress and they help in part to render it possible to defend the base of the Garland when the principal wall has been thrown down.

B 15 r.

[*Note with plan of section of town showing high- and low-level roads*]

The roads [marked] *m* are six braccia higher than the roads [marked] *p s*, and each road ought to be twenty braccia wide and have

a fall of half a braccio from the edges to the centre. And in this centre at every braccio there should be an opening one braccio long and of the width of a finger, through which rain-water may drain off into holes made at the level of the roads *p s*. And on each side of the extremity of the width of this road there should be an arcade six braccia broad resting on columns. And know that if anyone wishes to go through the whole place by the high-level roads, he will be able to use them for this purpose, and so also if anyone wishes to go by the low-level roads.

The high-level roads are not to be used by waggons or vehicles such as these but are solely for the convenience of the gentlefolk. All carts and loads for the service and convenience of the common people should be confined to the low-level roads.

One house has to turn its back on another, leaving the low-level road between them. The doors *n* serve for the bringing in of provisions such as wood and wine and suchlike things. The privies, the stables and suchlike noisome places are emptied by underground passages, situated at a distance of three hundred braccia from one arch to the next, each passage receiving its light through the openings in the streets above. And at every arch there should be a spiral staircase; it should be round because in the corners of square ones nuisances are apt to be committed. At the first turn there should be a door of entry into the privies and public urinals, and this staircase should enable one to descend from the high-level to the low-level road.

The high-level roads begin outside the gates, and when they reach them they have attained a height of six braccia. The site should be chosen near to the sea or some large river, in order that the impurities of the city which are moved by water may be carried far away.

<div align="right">B 16 r. and 15 v.</div>

[*Architectural*]

The earth which is dug out from the cellars ought to be raised at one side so as to construct a terrace garden at the same level as the hall; but see that between the earth of the terrace garden and the wall of the house there is an intervening space, so that damp may not spoil the principal walls.

<div align="right">B 19 v.</div>

[With drawing and ground plan of church]

This edifice is inhabited both in the upper and in the lower part. The entrance to the upper part is by way of the campaniles, and it goes along the level on which rest the four drums of the dome, and the said level has a parapet in front of it. And none of these drums communicates with the church but they are entirely separate. B 24 r.

Let the street be as wide as the universal height of the houses.

B 36 r.

[Castle of Milan]
[With drawing]

The moats of the castle of Milan within the Garland are thirty braccia; the ramparts are sixteen braccia high and forty wide, and this is the Garland.

The outer walls are eight braccia thick and forty high, and the inner walls of the castle are sixty braccia, which would please me entirely if it were not that I should wish to see that the bombardiers who are in the walls of the Garland do not issue forth in the secret inner way, that is in *S*, but lower themselves one at a time as appears in *m f*.

Since good bombardiers always aim at the embrasures of fortresses, and can if they break a single embrasure in the said Garland enter like cats through this breach and make themselves masters of all the towers, walls, and secret passages of the Garland, therefore if the embrasures are *m f* and it shall come about that a mortar bursts one of these embrasures and the enemy enters within, they will not be able to pass farther but may be beaten back and driven away by a soldier stationed in the machicolations above; and the passage *f* ought to be continued through all the walls from three quarters downwards and without having any exit above, either in the walls or the towers, except that by which one enters, which will have its beginning within the fortress; and the above-mentioned secret passage *f* ought not to have any airhole on the outside but to get its light on the side of the fortress through the frequent loopholes. B 36 v.

HOW TO MAKE A CLEAN STABLE

[With drawing]

The way in which one should construct a stable: you will first di-

vide its width in three parts, its length does not matter; and these three divisions should be equal, each being six braccia wide and ten high. The centre part should be for the use of the master of the stable, the two at the sides for the horses, each requiring for width three braccia and for length six braccia, and being half a braccio higher in front than behind.

The manger should be two braccia from the ground, the beginning of the rack three braccia, and the top of it four braccia.

To attempt however to keep my promise, namely to make the said place contrary to the usual custom clean and neat: as to the upper portion of the stable, that is, where the hay is, this part should have at its outer end a window six [? braccia] high and six wide, by which hay can easily be brought up to the loft as is shown in the machine *E*; and this should be erected in a place six braccia in breadth and as long as the stable, as is shown in *K p*. The other two parts, which have the first between them, are each divided into two parts. The two towards the hay are four braccia, and are entirely for the use and passage of the stable attendants; the other two which extend to the outside walls are two braccia, as is shown in *S R*, and these are for the purpose of giving the hay to the manger, by means of funnels narrow at the top, and broad above the mangers, so that the hay may not be stopped on the way. They should be well plastered and cleaned, as they are represented where it is marked 4 *f s*. In order that the horses may be given water the troughs should be of stone, so made as to be able to be uncovered as are boxes by raising their lids. B 39 r.

A building ought always to be detached all round in order that its true shape can be seen. B 39 v.

[Drawing of castle showing staircases]

Here are five staircases with five entrances; and one is not visible to another and when anyone is in one he cannot go into another; and it is a good system for those who are maintained there, in that it prevents them from mingling with each other, and being separated they will be ready for the defence of the tower: this can be either round or square.

 B 47 r.

[With drawing]

Ten spiral staircases round a tower. B 47 v.

[*With plan of ravelin*]

The ramparts placed in front of the doors of the ravelin should be solid, except for the winding staircase placed in the centre in order to connect with the battlements above, and one enters into this staircase by subterranean passages. B 49 v.

[*With drawings*]

A represents the upper church of San Sepolcro at Milan.
B is the part of it below the ground. B 57 r.

[*With drawing*]

Where you do not wish to have a portico round the whole of a courtyard, but that only one or two of the four sides should have the portico, make the others also with the same arrangement of columns, and surround the arches with an architrave on the inner side which descends as far as the bases of the columns.

And make the windows within the said architraves, and in the same way place the chief beams within the rooms in such a manner as to come between one window and the other. B 67 v.

[*With drawing*]

Double staircase. One for the commander of the castle, the other for the garrison. B 68 v.

OF ARCHITRAVES OF ONE OR MORE PIECES

Architraves of several pieces are stronger than those of merely one piece, if these pieces are so placed that their lengths point to the centre of the earth. This is proved from the fact that the stones have their marking, or vein, usually crosswise, that is in the direction of the opposite horizons of the same hemisphere, and this is the contrary to the vein, of plants which have. . . . G 52 r.

[*Of arch and support*]

The continuous quantity bent by force into a curve pushes itself in the direction of the line into which it desires to return. H 35 v.

That part of the continuous quantity will make a greater movement which is more distant from the part which moves less.

That side of the support of which the upper part is the heavier will bend in a curve towards its centre. H 36 v.

The sides of every defined quantity which has been raised in a pyramidal heap will be of the slant of the angular diameter of the perfect square. H 37 r.

[For decorating a room]

The narrow moulding at the top of the room—thirty lire.

For the moulding below this, I reckon each panel at seven lire, and, in expenses on azure, gold, white-lead, gypsum, indigo and size, three lire; time—three days.

The subjects under these mouldings with their pilasters, twelve lire for each.

I estimate the cost of enamel, azure and gold, and other colours at one lira and a half.

I allow five days for studying the composition, the small pilaster and other things.

Item for each small arch—seven lire.

Cost of azure and gold—three and a half lire.

Time—four days.

For the windows—one and a half lire.

The large cornice below the windows—sixteen soldi the braccio.

Item for the Roman historical compositions—fourteen lire each.

The philosophers—ten lire.

The pilasters—one ounce of azure, ten soldi.

For gold—fifteen soldi.

I estimate [this azure and gold] at two and a half lire.

H 125 [18 v.] r. and 124 [19 r.] v.

[Drawing of church with section of ground plan]

Both lower and upper part of this edifice are usable, as in San Sepolcro, and it is similar in its upper and lower parts except that the upper part has the cupola *c d* and the lower the cupola *a b*. As you enter the lower church you descend ten steps, and when you go up into that above you ascend twenty steps, which reckoning each as a third of a braccio comes to ten braccia. This then is the distance there is between the level of the one church and of the other.

MS. 2037 Bib. Nat. 4 r.

[*With architectural drawing*]

Here a campanile neither can nor ought to be made.

Rather must it stand separate, as it does in the cathedral, or at San Giovanni in Florence; and so also the cathedral at Pisa, for there the campanile may be seen by itself round in shape and standing apart, as also is the cathedral. And each by itself can reveal its perfection.

If however anyone should desire to make it part of the church he should make the lantern-tower serve as a campanile, as it does in the church of Chiaravalle. MS. 2037 Bib. Nat. 5 v.

Mills should not be built by stagnant water, nor by the side of the sea, because the storms choke up with sand every canal that is made upon its shores. B.M. 63 v.

[*Foundations*]

The first and most essential requisite is stability.

As regards the foundations of the component parts of temples and other public buildings, their depths should bear the same relation one to another as do the weights which are to rest upon them.

Each section of the depth of the earth in a given space is arranged in layers, the layers having each a heavier and a lighter part, the heavier being at the bottom.

This comes from the fact that these layers are formed by the sediment from the water discharged into the sea by the current of the rivers which are poured into it.

The heaviest part of this sediment was the part that was discharged first, and this process continued.

And this is the action of the water when it becomes stationary, and it is carrying it away at first where it moves.

These layers of soil are visible in the banks of rivers which in their continuous course have sawn through and divided one hill from another in a deep defile, wherein the level of the waters has receded from the shingle of the banks, and this has caused the substance to become dry and to be changed to hard stone, especially such mud as was of the finest texture. And this leads us to conclude that each part of the earth's surface was once the centre of the earth, and so conversely.

OF CRACKS IN WALLS WIDE AT THE BASE AND NARROW
AT THE TOP AND THEIR CAUSE

A wall will always crack when it does not dry uniformly at the same time.

A wall of uniform thickness does not all become dry at the same time unless it is in contact with an equal medium; thus if a wall be so built that part of it touches a damp mound while the rest is exposed to the atmosphere, this latter part will become somewhat contracted while the damp portion will retain its original size.

For the part which becomes dried by the atmosphere draws itself together and shrinks, and the part in contact with the damp does not become dry, and the dry part readily breaks away from the damp part as this has not the coherence necessary for it to follow the movement of the part that is in process of becoming dry.

OF CRACKS IN THE FORM OF ARCHES WIDE ABOVE
AND NARROW BELOW

Those arched cracks wide above and narrow below have their origin in walled-up doorways, which contract more in length than in width in proportion as their height is greater than their breadth, and as the joins of the mortar are more numerous in the height than in the breadth. B.M. 138 r.

When either a complete dome or a half dome is vanquished above by an insupportable weight, the vault will burst asunder, the crack being small in the upper part and broad below, and narrow on the inner side and wide on the outer side, after the manner of the skin of a pomegranate or orange which splits into many parts lengthwise, for the more it is pressed upon from the opposite ends, the wider asunder will those parts of the joints open which are farthest away from the cause of the pressure. And for this reason the arches of the vaults of any apse should never be loaded more than the arches of the building of which it forms a part, especially because that which weighs most presses most heavily upon the parts below it and drives them down upon their foundations; but this cannot happen with lighter things such as the aforesaid apses. B.M. 141 v.

Make first a treatise of the causes which bring about the collapse of walls, and then, separately, a treatise of the remedies.

Parallel cracks are constantly appearing in buildings erected in mountainous places where the rocks are stratified and the stratification runs obliquely, for, in these oblique seams, water and other moisture often penetrates, bearing with it a quantity of greasy and slimy earth; and since this stratification does not continue down to the bottom of the valleys the rocks go slipping down their slope, and never end their movement until they have descended to the bottom of the valley, carrying with them after the manner of a boat such part of the building as they have severed from the rest.

The remedy for this is to build numerous piers under the wall which is slipping away, with arches from one to another, and well-rooted [?]¹ [?buttressed] and let the pillars have their bases firmly set in the stratified rock so that they may not break away.

In order to find the immovable part of the aforesaid stratum, it is necessary to sink a shaft through it to a great depth beneath the foot of the wall, and in this shaft to polish a smooth surface of the breadth of a hand from the top to the bottom of the side on which the hill slopes down. At the end of some time this smooth portion made on the side of the shaft will show very plainly which part of the mountain is moving.

B.M. 157 r.

OF STONES WHICH BECOME SEPARATED FROM THEIR MORTAR

Stones which are built up with an equal number from bottom to top and laid with an equal quantity of mortar, will settle down equally as the moisture which softens the mortar evaporates.

Cracks in walls will never be parallel unless the part of the wall which is separated from the rest does not descend.

WHAT LAW IT IS WHICH IMPARTS STABILITY TO BUILDINGS

Stability of buildings results from a law the converse of the two foregoing, namely that the walls should be built up all equally in equal

¹ MS. *abarbanati.*

stages, which should embrace the whole circuit of the building and the total thickness of the walls no matter of what kind; and although the thin wall dries more rapidly than a thick one it will not have to break as the result of the weight which it may acquire from one day to another; for if a double quantity of it were to dry in one day, a wall of double the thickness would dry in two days or thereabouts, and so a slight difference in weight would be balanced by a slight difference of time.

OF THE POSITION OF FOUNDATIONS AND IN WHAT PLACES THEY ARE A CAUSE OF DESTRUCTION

When the crack in a wall is wider at the top than at the bottom it is a clear sign that the source of the destruction of the wall lies outside the perpendicular of the crack. B.M. 157 V.

OF THE CAUSE OF THE COLLAPSE OF PUBLIC AND PRIVATE BUILDINGS

Walls collapse as a result of cracks which are either vertical or slanting. Cracks which proceed vertically are caused by new walls being built in conjunction with old walls either vertically or with toothings fitted into the old walls; for as these toothings cannot offer any resistance to the insupportable weight of the wall joined on to them they must needs break and allow the new wall to settle down, in which process it will sink a braccio in every ten, or more or less according to the greater or smaller quantity of mortar used for the stones in the construction, and whether the mortar is very liquid or not. And remember always to build the walls first and then add the facing stones, because unless this is done, since the subsidence of the wall in settling will be greater than that of the outer shell, the toothings set in the sides of the wall will necessarily be broken, because the stones used for facing the walls being larger than the stones used in their construction will of necessity take a less quantity of mortar in their joints, and therefore the subsidence will be less. But this cannot happen if the facing of the wall is added after the wall has had time to dry. B.M. 158 r.

TRANSPORTATION OF HOUSES

[*With diagrams*]

Let the houses be transported an 1 arranged in order, and this can be done with ease because these houses are first made in parts upon the open places, and are then fitted together with their timbers on the spot where they are to remain.

Let fountains be made in each piazza.

Let the countryfolk dwell in parts of the new houses when the court is not there. B.M. 270 v.

[*Drawing*]

Cover of the preaching place of the castle. Forster II 70 v.

That angle will have the greatest power of resistance which is most acute, and the most obtuse will be the weakest. Forster II 87 v.

FOUNDATION

[*With drawing*]

Here it is shown how the arches made in the sides of the octagon push the columns of the angles outwards, as is shown in the line *h c* and in the line *t d*, which push the column *m* outwards, that is they exert pressure to drive it from the centre of this octagon.

 Forster II 93 r.

[*Sketch*]

That part of the bulk of the lower support will be more weighed down upon which is nearer the centre of the weight supported by it.

 Forster III 13 v.

[*Sketch*]

That in the canals nothing be thrown, and that these canals go straight to the houses. Forster III 23 v.

The hall of the court is one hundred and twenty-eight steps long and its breadth is twenty-seven braccia. Forster III 49 v.

[*Sketch*]

The height of the walls of the courtyard should be half its length, that is if the courtyard be forty braccia the house ought to be twenty

high in the walls of the said courtyard, and this courtyard should be
half the width of the whole front. Windsor: Drawings 12585 v.

[*Water-stair in the Sforzesca*]

When the descent from the floodgates has been so hollowed out that
at the end of its drop it is below the bed of the river, the waters which
descend from them will never form a cavity at the foot of the bank,
and will not carry away soil in their rebound, and so they will not
proceed to form a fresh obstacle but will follow the transverse course
along the length of the base of the floodgate from the under side.
Moreover if the lowest part of the bank which lies diagonally across the
course of the waters be constructed in deep broad steps after the man-
ner of a staircase, the waters which as they descend in their course are
accustomed to fall perpendicularly from the beginning of this lowest
stage, and dig out the foundations of the bank, will not be able any
longer to descend with a blow of irresistible force.

And I give as an example of this the stair down which the water falls
from the meadows of the Sforzesca at Vigevano, for the running water
falls down it for a height of fifty braccia. Leic. 21 r.

[*With drawing*]

Stairs of Vigevano, below the Sforzesca, with one hundred and thirty
steps a quarter of a braccio high and half a braccio wide, down which
the water falls without wearing away anything as it finishes its fall;
and by these stairs so much soil has come down as to have dried up a
swamp, that is by having filled it up; and it has formed meadows from
swamps of great depth. Leic. 32 r.

XXXIX

Music

'Music which is consumed in the very act of its birth.' (TRATTATO I 29)

MUSIC has two ills, the one mortal the other wasting; the mortal is ever allied with the instant which follows that of the music's utterance, the wasting lies in its repetition, making it seem contemptible and mean.

<div align="right">C.A. 382 v. a</div>

[*With drawing*]

This is the manner of movement of the bow of the viol-player; and if you make the notches of the wheel in two different sizes[?] (*tempi*), so that one set of teeth are less than the other and they do not meet together as is seen in *a b*, the bow will have an equal movement, otherwise it will go in jerks. But if you make it in the way I say the pinion *f* will always move equally.

<div align="right">B 50 V.</div>

[*Drawing*]

Here you make a wheel with pipes that serve as clappers for a musical round called a Canon, which is sung in four parts, each singer singing the whole round. And therefore I make here a wheel with four cogs so that each cog may take the part of a singer.

<div align="right">B.M. 137 V.</div>

I have several cords drawn in octaves the one above the others, and I wish that each may be drawn a finger more than before. I ask what weight will that be which will draw it, being of equal size or of double size, and what sound will remain.

<div align="right">Forster II 35 V.</div>

Of the music of water falling into its vessel.

<div align="right">Leic. 27 r.</div>

With the help of the mill I will make unending sounds from all sorts of instruments, which will sound for so long as the mill shall continue to move.

<div align="right">C.A. 271 V. a</div>

XL

Tales

'I will create a fiction which shall express great things.'

A CERTAIN man gave up associating with one of his friends because the latter had a habit of talking maliciously against all his friends. This friend whom he had left was once reproaching him, and after many complaints besought him to tell him the reason that had caused him to lose the recollection of so great a friendship as theirs; to which he made reply: I am not willing to be seen in your company any more because I like you, and I do not wish that by talking maliciously to others of me who am your friend, you may cause them to form a bad impression of you, as I have, through your talking maliciously to them of me who am your friend. Consequently as we have no more to do with each other it will appear that we have become enemies, and the fact that you talk of me maliciously, as is your habit, will not be so much worthy of rebuke as if we were constantly in each other's company.

<div align="right">C.A. 306 v. b</div>

Dear Benedetto,—To give you the news of the things here from the east, you must know that in the month of June there appeared a giant who came from the Libyan desert. This giant was born on Mount Atlas, and was black, and he fought against Artaxerxes with the Egyptians and Arabs, the Medes and Persians; he lived in the sea upon the whales, the great leviathans and the ships. When the savage giant fell by reason of the ground being covered over with blood and mire, it seemed as though a mountain had fallen; whereat the country [shook] as though there were an earthquake, with terror to Pluto in Hell, and Mars fearing for his life fled for refuge under the side of Jove.[1]

[1] MS., *Marte temēdo dela vita sera fugito sotto lato dj giove*. These words in Leonardo's writing occur at the side and are not found in the transcript of the Italian edition. I have ventured to insert them where they seemed to fit the sense best, and also to change the order of some of the sentences which are written in the margin.

And from the violence of the shock he lay prostrate on the level ground as though stunned; until suddenly the people believing that he had been killed by some thunderbolt, began to turn about his great beard; and like a flock of ants that range about hither and thither furiously among the brambles beaten down by the axe of the sturdy peasant, so these are hurrying about over his huge limbs and piercing them with frequent wounds.

At this the giant being roused and, perceiving himself to be almost covered by the crowd, suddenly on feeling himself smarting from their stabs, uttered a roar which seemed as though it were a terrific peal of thunder, and set his hands on the ground and lifted up his awe-inspiring countenance; and then placing one of his hands upon his head, he perceived it to be covered with men sticking to the hairs after the fashion of tiny creatures which are sometimes harboured there, and who, as they clung to the hairs and strove to hide among them, were like sailors in a storm who mount the rigging in order to lower the sail and lessen the force of the wind; and at this point he shook his head and sent the men flying through the air after the manner of hail when it is driven by the fury of the winds, and many of these men were found to be killed by those who fell on them like a tempest. Then he stood erect, trampling upon them with his feet.

C.A. 311 r. a

Note.—This and the two pieces that follow seem parts of a fantastic tale written in the form of letters.

The black visage at first sight is most horrible and terrifying to look upon, especially the swollen and bloodshot eyes set beneath the awful lowering eyebrows which cause the sky to be overcast and the earth to tremble.

And believe me there is no man so brave but that, when the fiery eyes were turned upon him, he would willingly have put on wings in order to escape, for the face of infernal Lucifer would seem angelic by contrast with this.

The nose was turned up in a snout with wide nostrils and sticking out of these were quantities of large bristles, beneath which was the arched mouth, with the thick lips, at whose extremities were hairs like

those of cats, and the teeth were yellow; and from the top of his instep he towered above the heads of men on horseback.

And as his cramped position had been irksome, and in order to rid himself of the importunity of the throng, his rage turned to frenzy, and he began to let his feet give vent to the frenzy which possessed his mighty limbs, and entering in among the crowd he began by his kicks to toss men up in the air, so that they fell down again upon the rest, as though there had been a thick storm of hail, and many were those who in dying dealt out death. And this barbarity continued until such time as the dust stirred up by his great feet, rising up in the air, compelled his infernal fury to abate, while we continued our flight.

Alas, how many attacks were made upon this raging fiend to whom every onslaught was as nothing. O wretched folk, for you there avail not the impregnable fortresses, nor the lofty walls of your cities, nor the being together in great numbers, nor your houses or palaces! There remained not any place unless it were the tiny holes and subterranean caverns where after the manner of crabs and crickets and creatures like these you might find safety and a means of escape. Oh, how many wretched mothers and fathers were deprived of their children! How many unhappy women were deprived of their companions! In truth, my dear Benedetto, I do not believe that ever since the world was created there has been witnessed such lamentation and wailing of people, accompaned by so great terror. In truth, the human species in such a plight has need to envy every other race of creatures; for though the eagle has strength sufficient to subdue the other birds, they yet remain unconquered through the rapidity of their flight, and so the swallows through their speed escape becoming the prey of the falcon, and the dolphins also by their swift flight escape becoming the prey of the whales and of the mighty leviathans; but for us wretched mortals there avails not any flight, since this monster when advancing slowly far exceeds the speed of the swiftest courser.

I know not what to say or do, for everywhere I seem to find myself swimming with bent head within the mighty throat and remaining indistinguishable in death, buried within the huge belly.

<div style="text-align: right">C.A. 96 v. b</div>

[*A fantasy (in Brobdingnag)*]

He was blacker than a hornet: his eyes were as red as a burning fire

and he rode on a big stallion six spans across and more than twenty long; with six giants tied to his saddle bow and one in his hand which he gnawed with his teeth; and behind him came boars with tusks sticking out of their mouths, perhaps ten spans.　　I 139 [91] r.

The gentle friar was charmed and delighted: he has already obliged the philosophers to search for our cause in order to feed the intellect.
　　　　　　　　　　　　　　　　　　　　　　　　　　　M 80 v.

A workman who was in the habit of often going to wait upon a certain lord without having any petition to make to him, was asked by the lord what his purpose was in coming; he replied that he went there to have one of the pleasures that he could not have, for it gave him pleasure to look at people who were grander than himself, as is the way with common folk, whereas the lord could only look at people who were of less account than himself, and consequently lords were cut off from this pleasure.　　　　　　　　Forster III 34 v.

XLI

Jests

*'You should often amuse yourself when you take
a walk for recreation, in watching and taking note
of the attitudes and actions of men as they talk and
dispute, or laugh or come to blows one with another,
both their actions and those of the bystanders who
either intervene or stand looking on at these things.'*

A JEST

A PRIEST while going the round of his parish on the Saturday before
Easter in order to sprinkle the houses with holy water as was his cus-
tom, coming to the studio of a painter, and there beginning to sprinkle
the water upon some of his pictures, the painter turning round with
some annoyance asked him why he sprinkled his pictures in this man-
ner. The priest replied that it was the custom and that it was his duty
to act thus, that he was doing a good deed and that whoever did a
good deed might expect a recompense as great or even greater; for so
God had promised that for every good deed which we do on the
earth we shall be rewarded a hundredfold from on high. Then the
painter, having waited until the priest had made his exit, stepped to
the window above and threw a large bucket of water down on to his
back, calling out to him:—'See there is the reward that comes to you
a hundredfold from on high as you said it would, on account of the
good deed you did me with your holy water with which you have
half ruined my pictures'. C.A. 119 r. a

The Franciscan friars at certain seasons have periods of fasting, dur-
ing which no meat is eaten in their monasteries, but if they are on a
journey, as they are then living on almsgiving, they are allowed to eat
whatever is set before them. Now a couple of these friars travelling
under these conditions chanced to alight at an inn at the same time as

a certain merchant and sat down at the same table, and on account of the poverty of the inn nothing was served there except one roasted cockerel. At this the merchant as he saw that it would be scant fare for himself turned to the friars and said:—'On days like these if I remember rightly you are not permitted in your monasteries to eat any kind of meat.' The friars on hearing these words were constrained by their rule to admit without any attempt at argument that this was indeed the case: so the merchant had his desire and devoured the chicken, and the friars fared as best they could.

Now after having dined in this wise all three table-companions set out on their journey together, and having gone a certain distance they came to a river of considerable breadth and depth, and as they were all three on foot, the friars by reason of their poverty and the other from niggardliness, it was necessary according to the custom of the country that one of the friars who had no shoes and stockings should carry the merchant on his shoulders; and consequently the friar having given him his clogs to hold took the man on his back. But as it so happened the friar when he found himself in the middle of the stream bethought himself of another of his rules, and coming to a standstill after the manner of St. Christopher raised his head towards him who was weighing heavily upon him and said:—'Just tell me, have you any money about you?' 'Why you know quite well that I have,' replied the other. 'How do you suppose a merchant like me could travel about otherwise?' 'Alas!' said the friar, 'our rule forbids us to carry any money on our backs'; and he instantly threw him into the water.

As the merchant was conscious that this was done as a jest and out of revenge for the injury he had done them he smiled pleasantly and pacifically, and blushing considerably from shame he endured their revenge. c.a. 150 v. b

If Petrarch loved the laurel so much it was because it is good with sausages and thrushes; I don't attach any value to their trifles.

 Tr. 1 a

Frati santi spells Pharisees.[1] Tr. 63 a

[1] MS. *farisei.*

A WORD SAID BY A YOUNG MAN TO AN OLD ONE

On an old man openly reviling a young one and boldly proclaiming that he had no fear of him, the young one made answer that his advanced age served him better as a protection than either his tongue or his strength. Tr. 71 a

JEST

Why the Hungarians keep the double cross. H 62 [14] v.

A man wishing to prove on the authority of Pythagoras that he had been in the world on a former occasion, and another not allowing him to conclude his argument, the first man said to the second:—'And this is a token that I was here on a former occasion, I remember that you were a miller.' The other who felt provoked by his words agreed that it was true, for he also remembered as a token that the speaker had been the ass which had carried the flour for him.

A painter was asked why he had made his children so ugly, when his figures which were dead things he had made so beautiful. His reply was that he made his pictures by day and his children at night.

 M 58 v.

A sick man who was at the point of death heard someone knocking at the door, and on his asking one of his servants who it was who was knocking at the door, this servant made answer that it was someone who called herself Madame Bona.

Whereat the sick man raised his arms to heaven and praised God with a loud voice, and then told the servants to let her in immediately in order that he might see a good woman before he died, because in all his life he had never seen one. Forster II 30 v.

It was said to someone that he should rise from his bed because the sun had already risen; to which he made answer:—'If I had to make as long a journey and to do as much as he I too should have already risen; but as I have such a short way to go I do not wish to get up yet awhile.' Forster II 31 r.

XLII

Fables

*'The mirror bears itself proudly, holding the queen
mirrored within it, and after she has departed the
mirror remains abject.'*

THE privet on feeling its tender branches, laden with new fruit, pricked
by the sharp claws and beak of the troublesome blackbird, complained
to her with pitiful reproaches, beseeching her that even if she plucked
off her delicious fruit she would at any rate not deprive her of her
leaves which protected her from the scorching rays of the sun, nor
with her sharp claws rend away and strip bare her tender bark.

But to this the blackbird replied with insolent rebuke:—'Silence!
rude bramble! Know you not that Nature has made you to produce
these fruits for my sustenance? Cannot you see that you came into the
world in order to supply me with this very food? Know you not, vile
thing that you are, that next winter you will serve as sustenance and
food for the fire?' To which words the tree listened patiently and not
without tears.

But a short time afterwards the blackbird was caught in a net, and
some boughs were cut to make a cage in order to imprison her, and
among the rest were some cut from the tender privet to serve for the
rods of the cage; and these on perceiving that they would be the cause
of the blackbird being deprived of liberty rejoiced and uttered these
words:—'We are here, O blackbird, not yet consumed by the fire as
you said; we shall see you in prison before you see us burnt.'

The laurel and the myrtle, on seeing the pear-tree being cut down,
cried out with a loud voice:—'O pear-tree, where are you going?
Where is the pride that you had when you were laden with ripe fruit?
Now you will no longer make shade for us with your thick foliage.'
Then the pear-tree replied:—'I am going with the husbandman who
is cutting me down and who will take me to the workshop of a good

1060

sculptor, who by his art will cause me to assume the form of the god Jove, and I shall be dedicated in a temple and worshipped by men in place of Jove. While you are obliged to remain always maimed and stripped of your branches which men shall set around me in order to do me honour.'

The chestnut seeing a man upon the fig-tree bending its branches down towards himself and picking off their ripe fruit and putting it in his mouth, tearing it asunder and crushing it with his hard teeth, shook its boughs and said in a mournful whisper:—'O fig-tree, how much less favoured by Nature are you than I. Look how with me my sweet children all are arranged in close order, clothed first with a fine jacket over which is set the hard rough husk; and not content with conferring such benefits on me she has given them a strong dwelling, and set about it sharp close prickles so that the hands of man may not be able to harm me.' At this the fig-tree and her children began to laugh, and when they had finished laughing she said:—'Know that man is of such a disposition that, as you have found, by means of rods and stones and sticks thrown into your branches he will deprive you of your fruit, and after it has fallen will crush it with his feet or with stones, in such a way that your offspring will issue forth from their armoured house crushed and bruised. But I am touched carefully by his hands and not as you are with sticks and stones.'

The idle fluttering moth, not contented with its power to fly wherever it pleased through the air, enthralled by the seductive flame of the candle, resolved to fly into it, and its joyous movement was the occasion of instant mourning. For in the said flame its delicate wings were consumed, and the wretched moth having fallen down at the foot of the candlestick, all burnt, after much weeping and contrition, wiped the tears from its streaming eyes, and lifting up its face exclaimed:—'O false light, how many are there like me who have been miserably deceived by you in times past! Alas! If my one desire was to behold the light, ought I not to have distinguished the sun from the false glimmer of filthy tallow?'

A nut which found itself carried by a crow to the top of a lofty campanile, having there fallen into a crevice and so escaped its deadly beak, besought the wall by that grace which God had bestowed upon

it in causing it to be so exalted and great, and so rich in having bells of such beauty and of such mellow tone, that it would deign to give it succour; that insomuch as it had not been able to drop beneath its old father's green branches and lie in the fallow earth covered by his fallen leaves the wall would not abandon it, for when it found itself in the fierce crow's cruel beak it had vowed that if it escaped thence it would end its days in a small hole. At these words the wall, moved with compassion, was content to give it shelter in the spot where it had fallen. And within a short space of time the nut began to burst open and to put its roots in among the crevices of the stones, and push them farther apart and throw up shoots out of its hollow, and these soon rose above the top of the building; and as the twisted roots grew thicker they commenced to tear asunder the walls and force the ancient stones out of their old positions. Then the wall too late and in vain deplored the cause of its destruction, and in a short time it was torn asunder and a great part fell in ruin.

The ape on finding a nest of small birds approached them with great joy, but as they were already able to fly he could only catch the smallest. Filled with joy he went with it in his hand to his hiding place; and having commenced to look at the tiny bird he began to kiss it; and in his uncontrollable affection he gave it so many kisses and turned it over and squeezed it, until he took away its life. This is said for those who by being too fond of [1] their children bring misfortune upon them.

<div align="right">c.a. 67 r. a</div>

The unhappy willow, on finding herself unable to enjoy the pleasure of seeing her slender boughs attain to such a height as she desired, or even point towards the sky, because she was continually being maimed and lopped and spoiled for the sake of the vine or any other tree which happened to be near, summoned up all her faculties and by this means opened wide the portals of her imagination, remaining in continual meditation, and seeking in the world of plants for one wherewith to ally herself which could not need the help of her branches. So continuing for a time with her imagination at work, the thought of the gourd suddenly presented itself to her mind, and all her branches quivered in her intense joy, for it seemed to her that she had found the

[1] MS. *per non gastigare.*

right companion for the purpose she desired, because the gourd is by nature more fitted to bind others than to be bound herself. After coming to this conclusion she lifted up her branches towards the sky and waited, on the look out for some friendly bird to serve as the intermediary of her desire. Among the rest she descried the magpie near to her and said to him:—'O gentle bird, by the refuge you have lately found among my branches at dawn, when the hungry, cruel, and rapacious falcon has wished to devour you,—by that rest you have often found in me when your wings craved rest,—by those delights you have enjoyed among my branches in amorous dalliance with your companions,—I entreat you to go and seek out the gourd and obtain from her some of her seeds, telling her that I will care for whatever is born from them as though they were my own offspring, and in like manner use all such words as may incline her to the like purpose, though to you who are a master of language there is no need for me to give instruction. If you will do this I am content to let your nest be in the fork of my boughs together with all your family without payment of any rent.' So the magpie, after stipulating with the willow for certain further conditions, the most important being that she should never admit upon her boughs any snake or polecat, cocked his tail and lowered his head, and casting himself loose from the bough let himself float on his wings; and beating about with these in the fleeting air, seeking hither and thither, and guiding himself by using his tail as a rudder, he came to a gourd, and after courteously saluting her obtained by a few polite word the seeds for which he sought. On taking these back to the willow he was welcomed with joyful looks; and then scraping away with his foot some of the earth near the willow he planted the grains with his beak round about her in a circle.

These soon began to grow, and as the branches increased and opened out they began to cover all the branches of the willow, and their great leaves shut away from it the beauty of the sun and the sky. And all this evil not sufficing, the gourds next began to drag down to the ground in their rude grip the tops of the slender boughs, twisting them and distorting them in strange shapes. Then the willow after shaking and tossing herself to no purpose to make the gourds loose their hold, and vainly for days cherishing such idle hopes, since the grasp of the gourds was so sure and firm as to forbid such thoughts, seeing the

wind pass by, forthwith commended herself to it. And the wind blew hard; and it rent open the willow's old and hollow trunk, tearing it in two parts right down to its roots; and as they fell asunder she vainly bewailed her fate, confessing herself born to no good end.

Some flames had already lived for a month in a glass-furnace when they saw a candle approaching in a beautiful and glittering candlestick. They strove with great longing to reach it; and one of their number left its natural course and wound itself into an unburnt brand upon which it fed, and then passed out at the other end by a small cleft to the candle which was near, and flung itself upon it, and devouring it with the utmost voracity and greed consumed it almost entirely; then desirous of prolonging its own life, it strove in vain to return to the furnace which it had left, but was forced to droop and die together with the candle. So at last in lamentation and regret it was changed to foul smoke, leaving all its sisters in glowing and abiding life and beauty.

Wine, the divine liquor of the grape, finding itself in a golden richly chased cup upon Mahomet's table, after being transported with pride at such an honour, was suddenly assailed by a contrary feeling, and said to itself:—'What am I doing? What is it that I am rejoicing at? Cannot I see that I am near to my death, in that I am about to leave my golden dwelling in this cup and enter into the foul and fetid caverns of the human body, to be there transformed from a sweet fragrant nectar to a foul and disgusting fluid? And such an evil not sufficing, I must needs lie for a long time in foul receptacles with other noisome and putrid matter evacuated from the human intestines.' It cried to heaven demanding vengeance for such injury and that an end might be put to such an insult, so that since that part of the country produced the most beautiful and finest grapes in the whole world these at least should not be turned into wine. Then Jove caused the wine which Mahomet drank to rise in spirit up to the brain, and to infect this to such a degree as to make him mad; and he committed so many follies that when he came to his senses he made a decree that no Asiatic should drink wine; and thus the vine and its fruits were left at liberty.

As soon as the wine has entered into the stomach it commences to swell up and boil over; and then the spirit of that man commences to

abandon his body, and rising as though towards the sky it reaches the brain, which causes it to become divided from the body; and so it begins to infect him and to cause him to rave like a madman; and so he perpetrates irreparable crimes, killing his own friends.

c.a. 67 r. b

The rat was being besieged in its tiny house by the weasel which with unceasing vigilance was awaiting its destruction, and through a tiny chink it was considering its great danger. Meanwhile the cat came and suddenly seized hold of the weasel and immediately devoured it. Thereupon the rat, profoundly grateful to its deity, having offered up some of its hazel-nuts as a sacrifice to Jove, issued forth from its hole in order to repossess itself of the liberty it had lost, and was instantly deprived of this and of life itself by the cruel claws and teeth of the cat.

c.a. 67 v. a

Fable of the tongue bitten by the teeth.

The cedar, arrogant by reason of its beauty, despising the plants which were round about it, caused them to be all removed from its presence, and then the wind, not meeting with any obstacle, tore it up by the roots and threw it on to the ground.

The ant having found a grain of millet, the grain as it felt itself seized by it cried out:—'If you will do me the great favour of allowing me to fulfil my desire to germinate I will give you of myself a hundred-fold.' And so it was.

The spider, having found a bunch of grapes, which because of its sweetness was much visited by bees and various sorts of flies, fancied that it had found a spot very suitable for its wiles. And after having lowered itself down by its fine thread and entered its new habitation, there day by day, having ensconced itself in the tiny holes made by the spaces between the various grapes in the bunch, like a robber it assaulted the wretched animals which were not on their guard against it. But after some days had passed the keeper of the vineyard cut this bunch off and placed it with the others, and it was pressed with them. And the grapes therefore served as trap and snare for the deceiving spider as well as for the flies whom he had deceived.

The traveller's joy, not remaining contented in its hedge, commenced to pass across the high road with its branches and to attach itself to the opposite hedge; whereupon it was broken by the passers-by.

The ass having fallen asleep upon the ice of a deep lake, the heat of its body caused the ice to melt, and the ass being under water awoke to his great discomfort, and was speedily drowned.

A certain patch of snow, finding itself clinging to the top of a rock which was perched on the extreme summit of a very high mountain, being left to its own imagination began to reflect and to say within itself:—'Shall I not be thought haughty and proud for having placed myself in so exalted a spot, being indeed a mere morsel of snow? And for allowing that such a vast quantity of snow as I see around me should take a lower place than mine? Truly my small dimensions do not deserve this eminence; and in proof of my insignificance I may readily acquaint myself with the fate which but yesterday befell my companions, who in a few hours were destroyed by the sun; and this came about from their having placed themselves in a loftier station than was required of them. I will flee from the wrath of the sun, and abase myself, and find a place that befits my modest size.'

Then throwing itself down, it began to descend, rolling down from the lofty crags on to the other snow; and the more it sought a lowly place, the more it increased in bulk, until at last ending its course upon a hill, it found itself almost the equal in size of the hill on which it rested, and it was the last of the snow which was melted that summer by the sun.

This is said for those who by humbling themselves are exalted.

The hawk, being unable to endure with patience the way in which the duck was hidden from him when she fled before him and dived beneath the water, desired also to follow in pursuit beneath the water; and getting its wings wetted it remained in the water; and the duck raised herself in the air and mocked at the hawk as it drowned.

The spider, wishing to capture the fly in its secret web, was cruelly slain above it by the hornet.

The eagle, wishing to mock at the owl, got its wings smeared with bird-lime and was captured by man and killed.　　　c.a. 67 v. b

THE CEDAR

The cedar, having conceived the desire of bearing on its summit a large and beautiful fruit, set itself to carry it into effect with all the powers of its sap; which fruit after it had grown was the cause of making the tall and slender summit bend down.

THE PEACH-TREE

The peach-tree, being envious of the great quantity of fruit that it saw its neighbour the nut-tree bearing, decided to do the same, and loaded itself with its fruit to such an extent that the weight of this fruit threw it down, uprooted and broken, level with the ground.

THE NUT-TREE

The nut-tree, displaying to the passers-by upon the road the richness of its fruit, every man stoned it.

When the fig-tree stood without fruit no one looked at it. Wishing by producing this fruit to be praised by men, it was bent and broken by them.

The fig-tree, standing near to the elm, and perceiving that her boughs bore no fruit themselves, yet had the hardihood to keep away the sun from her own, unripe figs, rebuked her, saying:—'O Elm, are you not ashamed to stand in front of me? Only wait until my children are fully grown and you will see where you will find yourself.' But when her offspring were ripe a regiment of soldiers came to the place, and they tore off the branches of the fig-tree in order to take her figs, and left her all stripped and broken.

And as she thus stood maimed in all her limbs the elm questioned her saying:—'O Fig tree, how much better was it to be without children than to be brought by them to so wretched a pass?' c.a. 76 r. a

The fire rejoicing in the dried wood which it had found in the fire-place, and having taken hold of it, perceiving itself to have grown enormously above the wood and to have made itself of considerable

size, commenced to exalt its gentle and tranquil soul in puffed-up and insupportable pride, making itself almost believe that it had drawn the whole of the superior element down into the few logs. And commencing to fume and fill all the fireplace round about it with explosions and showers of sparks, already the flames which had become big were all in conjunction making their way towards the air; then the highest flames striking upon the bottom of the saucepan above . . .

A vestige of fire which had remained in a small lump of charcoal among the warm embers, was very scantily and poorly nourished by the small quantity of nutriment that was left there. When the superintendent of the kitchen arrived there in order to perform her usual work of preparing the food, having placed the logs on the hearth, and having succeeded by means of a sulphur-match in getting a small flame from the charcoal though it was almost extinct, she set it among the logs which she had arranged and took a saucepan and set it over it and without any misgivings went away from it.

Then the fire, after rejoicing at the dried logs placed upon it, began to ascend and drive out the air from the spaces between the logs, twining itself in among them in sportive and joyous progress, and having commenced to blow through the spaces between the logs out of which it had made delightful windows for itself, and to emit gleaming and shining flames, it suddenly dispels the murky darkness of the closed-in kitchen, and the flames having already increased began to play joyfully with the air that surrounded them, and singing with gentle murmur they created a sweet sound. C.A. 116 v. b

The thrushes rejoiced greatly on seeing a man catch the owl and take away her liberty by binding her feet with strong bonds. But then by means of bird-lime the owl was the cause of the thrushes losing not only their liberty but even their life. This is said of those states which rejoice at seeing their rulers lose their liberty, in consequence of which they afterwards lose hope of succour and remain bound in the power of their enemy, losing their liberty and often life. C.A. 117 r. b

While the dog was asleep on the coat of a sheep, one of its fleas, becoming aware of the smell of the greasy wool, decided that this must be a place where the living was better and more safe from the teeth

and nails of the dog than getting his food on the dog as he did. Without more reflection therefore it left the dog and entering into the thick wool began with great toil to try to pass to the roots of the hairs; which enterprise however after much sweat it found to be impossible, owing to these hairs being so thick as almost to touch each other, and there being no space there where the flea could taste the skin. Consequently after long labour and fatigue it began to wish to go back to its dog which however had already departed, so that after long repentance and bitter tears it was obliged to die of hunger. c.a. 119 r. a

Once upon a time the razor emerging from the handle which served it as a sheath, and placing itself in the sun, saw the sun reflected on its surface, at which thing it took great pride, and turning it over in its thoughts it began to say to itself:—'Am I to go back any more to that shop from which I have just now come away? No surely! It cannot be the pleasure of the gods that such radiant beauty should stoop to such vile uses! What madness would that be which should induce me to scrape the lathered chins of rustic peasants and to do such menial service? Is this body made for actions such as these? Certainly not! I will go and hide myself in some retired spot, and there pass my life in tranquil ease.'

And so having hidden itself away for some months, returning one day to the light and coming out of its sheath it perceived that it had acquired the appearance of a rusty saw, and that its surface no longer reflected the sun's radiance. In vain with useless repentance it bemoaned its irreparable hurt, saying to itself:—'Ah how much better would it have been to have let the barber use that lost edge of mine that had so rare a keenness! Where now is the glittering surface? In truth the foul insidious rust has consumed it away!'

The same thing happens with minds which in lieu of exercise give themselves up to sloth; for these like the razor lose their keen edge, and the rust of ignorance destroys their form.

A stone of considerable size, only recently left uncovered by the waters, stood in a certain spot perched up at the edge of a delightful copse, above a stony road, surrounded by plants bright with various flowers of different colours, and looked upon the great mass of stones which lay heaped together in the road beneath. And she became filled

with longing to let herself down there, saying within herself:—'What am I doing here with these plants? I would fain dwell in the company of my sisters yonder'; and so letting herself fall she ended her rapid course among her desired companions. But when she had been there for a short time she found herself in continual distress from the wheels of the carts, the iron hoofs of the horses and the feet of the passers-by. One rolled her over, another trampled upon her; and at times she raised herself up a little as she lay covered with mud or the dung of some animal, and vainly looked up at the place from whence she had departed as a place of solitude and quiet peace.

So it happens to those who, leaving a life of solitude and contemplation, choose to come and dwell in cities among people full of infinite wickedness.

<div align="right">c.a. 175 v. a</div>

As the painted butterfly was idly wandering and flitting about through the darkened air a light came within sight, and thither immediately it directed its course, and flew round about it in varying circles marvelling greatly at such radiant beauty. And not contented merely to behold, it began to treat it as was its custom with the fragrant flowers, and directing its flight it approached with bold resolve close to the light, which thereupon consumed the tips of its wings and legs and the other extremities; and then dropping down at the foot of it, it began to consider with astonishment how this accident had been brought about; for it could not so much as entertain a thought that any evil or hurt could possibly come to it from a thing so beautiful; and then having in part regained the strength which it had lost, it took another flight and passed right through the body of the flame, and in an instant fell down burned into the oil which fed the flame, preserving only so much life as sufficed it to reflect upon the cause of its destruction, saying to it:—'O accursed light! I thought that in you I had found my happiness! Vainly do I lament my mad desire, and by my ruin I have come to know your rapacious and destructive nature.'

To which the light replied:—'Thus do I treat whoever does not know how to use me aright.'

This is said for those who when they see before them these carnal and worldly delights, hasten towards them like the butterfly, without

ever taking thought as to their nature, which they know after long usage to their shame and loss.

The flint on being struck by the steel marvelled greatly and said to it in a stern voice:—'What arrogance prompts you to annoy me? Trouble me not, for you have chosen me by mistake; I have never done harm to anyone.' To which the steel made answer:—'If you will be patient you will see what a marvellous result will issue forth from you.'

At these words the flint was pacified and patiently endured its martyrdom, and it saw itself give birth to the marvellous element of fire which by its potency became a factor in innumerable things.

This is said for those who are dismayed at the outset of their studies, and then set out to gain the mastery over themselves and in patience to apply themselves continuously to those studies, from which one sees result things marvellous to relate. c.a. 257 r. b

The lily planted itself down upon the bank of the Ticino, and the stream carried away the bank and with it the lily. h 44 r.

The oyster being thrown out with other fish near to the sea from the house of a fisherman, prayed to a rat to take him to the sea; the rat who was intending to devour him bade him open, but then as he bit him the oyster squeezed his head and held it; and the cat came and killed him. h 51 [3] v.

The pen has necessary companionship with the penknife, and moreover useful companionship for the one without the other is ineffective.
 l cover v.

When the crab had placed itself beneath the rock in order to catch the fish that entered underneath it, the wind came with ruinous downfall of the rocks, and these by rolling themselves down destroyed the crab.

The spider had placed itself among the grapes to catch the flies that fed on them. The time of vintage came and the spider was trodden under foot together with the grapes.

The vine that has grown old upon the old tree falls together with the destruction of this tree. It was by reason of its bad company that it failed together with it.

The torrent carried away so much earth and stones in its bed that it was then obliged to change its position.

The net which was accustomed to catch fish was destroyed and carried away by the fury of the fish.

The ball of snow the more it rolled as it descended from the mountains of the snow was continually more and more increasing its size.

The willow which by reason of its long shoots and by growing so as to surpass every other plant had become the companion of the vine which is pruned every year, was also itself always mutilated.

<div align="right">B.M. 42 V.</div>

The water on finding itself in the proud sea, its element, was seized with a desire to rise above the air; and aided by the element of fire having mounted up in thin vapour, it seemed almost as thin as the air itself; and after it had risen to a great height it came to where the air was more rarefied and colder, and there it was abandoned by the fire; and the small particles being pressed together were united and became heavy; and dropping from thence its pride was put to rout, and it fell from the sky, and was then drunk up by the parched earth, where for a long time it lay imprisoned and did penance for its sin.

<div align="right">Forster III 2 r.</div>

The light above the candle is fire in a chain; consuming that it consumes itself.

The wine consumed by the drunkard, this wine revenges itself upon the drinker. <div align="right">Forster III 21 r.</div>

The ink is arraigned for its blackness by the whiteness of the paper, which sees itself soiled by it.

The paper on seeing itself all spotted by the murky blackness of the ink grieves over it; and this ink shows it that by the words which it composes upon it it becomes the cause of its preservation.

<div align="right">Forster III 27 r.</div>

The fire, when heating the water placed in the cooking-pot, says to the water that it does not deserve to stand above the fire, the king of the elements; and so it wishes by the violence with which it boils to drive away the water from the cooking-pot; this, therefore, in order to show it honour by obeying it, descends below and drowns the fire.

Forster III 30 r.

The knife, an artificial weapon, deprives man of his nails—his natural weapon.

The mirror bears itself proudly, holding the queen mirrored within it, and after she has departed the mirror remains abject.

Forster III 44 v.

The heavy iron is reduced to such a state of thinness by the file that a breath of wind suffices to carry it away. Forster III 47 r.

The plant complains of the dry and old stick which was placed at its side and of the dry stakes that surround it; the one keeps it upright, the other protects it from bad companions. Forster III 47 v.

XLIII

A Bestiary

*'Nature has given such power of understanding to
animals that in addition to the perception of what
is to their own advantage they know what is to the
disadvantage of the enemy.'*

LOVE OF VIRTUE

THE lark is a bird of which it is told that if it is taken into the pres-
ence of anyone who is ill, then if the sick person is going to die the
bird turns away its head and does not look at him. But if the sick per-
son is going to recover, the bird never takes its eyes off him, and is the
cause of all his sickness leaving him. Similarly the love of virtue never
regards a mean or bad thing, but always rather dwells among things
honest and virtuous, and repatriates itself in noble hearts like birds in
green forests upon flowery branches. And this love reveals itself more
in adversity than in prosperity, acting as does light which shines most
where it finds the darkest spot.[1] H 5 r.

ENVY

Of the kite one reads that when it sees that its children in the nest
are too fat it pecks their sides out of envy and keeps them without
food.

CHEERFULNESS

Cheerfulness is characteristic of the cock, for it rejoices over every
little thing and sings with varied and joyous movements.

[1] The allegories about animals in this Manuscript are derived from early bestiaries.
The extent of Leonardo's debt to his sources is set forth by Gerolamo Calvi in *Il
Manoscritto H di L da V. Il 'Fiore di Virtu' e L'Acerba di Cecco d'Ascoli.* Archivio
Storico Lombardo Anno XXV Fasc. XIX 1898.

SADNESS

Sadness may be compared to the raven, which on seeing its newborn children white, departs with great grief and abandons them with sad lamentations, and does not give them any food until it discerns a few black feathers. H 5 v.

PEACE

Of the beaver one reads that when it is pursued, knowing this to be on account of the virtue of its testicles for medicinal uses, not being able to flee any farther it stops, and in order to be at peace with its pursuers bites off its testicles with its sharp teeth and leaves them to its enemies.

ANGER

It is said of the bear that when he goes to the beehives to take the honey from them, the bees commence to sting him, so that he leaves the honey and rushes to avenge himself; and wishing to take vengeance upon all those who are biting him he fails to take vengeance on any, with result that his course becomes changed to frenzy, and in his exasperation he throws himself upon the ground, vainly trying to defend himself with his hands and feet. H 6 r.

GRATITUDE

The virtue of gratitude is said to be found especially in the birds called hoopoes, which being conscious of the benefits they have received from father and mother in life and nourishment, when they see these becoming old make a nest for them and cherish them and feed them, plucking out their old and shabby feathers with their beaks, and by means of certain herbs restoring their sight, so that they return to a state of prosperity.

AVARICE

The toad feeds on earth and always remains lean because it never satisfies itself, so great is its fear lest the supply of earth should fail.

H 6 v.

INGRATITUDE

The pigeons serve as a symbol of ingratitude; for when they are of an age no longer to have need of being fed, they commence to fight with their father, and the combat does not end until the young one has driven his father out and taken his wife and made her his own.

CRUELTY

The basilisk is so exceedingly cruel that when it cannot kill animals with the venom of its gaze it turns towards the herbs and plants, and looking fixedly upon them makes them wither up. H 7 r.

MAGNANIMITY

Of the eagle it is said that it never has so great a hunger that it does not leave of its prey to those birds which are round about; and as these are not able to forage for themselves it is necessary that they pay court to the eagle, since by this means they are fed.

CORRECTION

If the wolf while prowling warily round some cattle-stall should chance to set his foot in a trap so that he makes a noise, he bites his foot off in order to punish himself for his mistake. H 7 v.

BLANDISHMENTS

The siren sings so sweetly as to lull the mariners to sleep, and then she climbs upon the ships and kills the sleeping mariners.

PRUDENCE

The ant from its natural sagacity provides in the summer for the winter, killing the seeds after having gathered them, in order that they may not germinate, and then in time it eats them.

MADNESS

As the wild bull hates the colour red the hunters drape in red the trunk of a tree, and the bull charges it furiously and gets his horns fixed in it, and then the huntsmen kill him.　　　　　H 8 r.

JUSTICE

We may compare the virtue of justice to the king of the bees, who orders and arranges everything on a system, because some bees are ordered to go among the flowers, others are ordered to work, others to fight with the wasps, others to take away the dirt, others to accompany and attend the king. And when he becomes old and has no wings they carry him, and if any one of them fail in his duty he is punished without any forgiveness.

TRUTH

Although partridges steal each other's eggs nevertheless the children born from these eggs always return to their true mother.　　　H 8 v.

FIDELITY OR LOYALTY

The cranes are so faithful and loyal to their king that at night when he is asleep some pace up and down the meadow to keep guard over him from a distance; others stand near at hand, and each holds a stone in his foot, so that if sleep should overcome them the stone would fall and make such a noise that they would be wakened up. There are others who sleep together around the king, and they do this every night taking it in turn so that their king may not come to find them wanting.

DECEIT

The fox when he sees a flock of magpies or jackdaws or birds of this kind, instantly throws himself on the ground with mouth open in such a way as to seem dead: the birds think to peck at his tongue and he bites off their heads.　　　　　H 9 r.

A LIE

The mole has very small eyes and always remains underground; it lives as long as it stays in concealment, and as soon as ever it comes to the light it instantly dies, because it becomes known—So it is with a lie.

FORTITUDE

The lion never feels fear; on the contrary it fights with a stout heart in fierce combat against the crowd of hunters, always seeking to injure the first who has injured him.

FEAR OR COWARDICE

The hare is always timid, and the leaves that fall from the trees in autumn keep it always in fear and often cause it to flee. H 9 v.

MAGNANIMITY

The falcon only preys on large birds, and it would let itself die before it would feed on the young or eat putrid flesh.

VAINGLORY

As regards this vice we read of the peacock being more subject to it than any other creature, because it is always contemplating the beauty of its tail, spreading it out in the form of a wheel and attracting to itself by its cries the attention of the surrounding animals.

And this is the last vice that can be conquered. H 10 r.

CONSTANCY

For constancy the phoenix serves as a type; for understanding by nature its renewal it is steadfast to endure the burning flames which consume it, and then it is reborn anew.

INCONSTANCY

The swift is put for inconstancy, for it is always in movement, since it cannot endure the slightest discomfort.

TEMPERANCE

The camel is the most lustful animal that there is, and it will follow the female a thousand miles, but if it lived continually with its mother or sister it would never touch them, so well does it know how to control itself. H 10 V.

INTEMPERANCE

The unicorn through its lack of temperance, and because it does not know how to control itself for the delight that it has for young maidens, forgets its ferocity and wildness; and laying aside all fear it goes up to the seated maiden and goes to sleep in her lap, and in this way the hunters take it.

HUMILITY

Of humility one sees the supreme instance in the lamb, which submits itself to every animal. And when they are given as food to lions in captivity they submit themselves to them as to their own mothers, in such a way that it has often been seen that the lions are unwilling to kill them. H 11 r.

PRIDE

The falcon from its haughtiness and pride thinks to overcome and lord it over all the other birds of prey, because it wishes to reign alone: and many times the falcon has been seen to attack the eagle the queen of birds.

ABSTINENCE

The wild ass if when going to the spring to drink it should find the water muddy, has never so great a thirst as to cause it not to abstain from drinking and wait until the water grows clear.

GLUTTONY

The vulture is so given up to gluttony that it would go a thousand miles in order to feed on carrion, and this is why it follows armies. H 11 V.

CHASTITY

The turtle-dove never wrongs its mate; and if the one dies the other observes perpetual chastity, and never rests upon a green branch or drinks of clear water.

LEWDNESS

The bat by reason of its unbridled lewdness does not follow any natural law in pairing, but male goes with male, female with female, as they chance to find themselves together.

MODERATION

The ermine because of its moderation eats only once a day, and it allows itself to be captured by the hunters rather than take refuge in a muddy lair, in order not to stain its purity. H 12 r.

THE EAGLE

The eagle when it is old flies so high that it scorches its feathers; and nature consents that it renews its youth by falling into shallow water.

And if its young ones cannot bear to gaze at the sun it does not feed them. No bird that does not wish to die should approach its nest. The animals go much in fear of it but it does not harm them. It always leaves them a portion of its prey.

THE *LUMERPA*. FAME

This is born in Asia Magna and shines so brightly that it absorbs its shadows. And in dying it does not lose this light, and the feathers never fall out. And the feather which is detached ceases to shine.

H 12 v.

THE PELICAN

This bears a great love to its young; and if it finds them slain in the nest by a serpent it pierces itself to the heart in their presence, and by bathing them with a shower of blood it restores them to life.

THE SALAMANDER

The salamander in the fire refines its rough skin.—For virtue.

It has no digestive organs and does not seek any other nourishment than fire, and often in this it renews its rough skin.

THE CHAMELEON

This lives on air and it is there at the mercy of all the birds. And in order to be safer it flies above the clouds, and there finds an air that is so rarefied as to be incapable of supporting any bird that would follow it.

At this height there flies nothing save that to whom it is given by the heavens: it is there that the chameleon flies. H 13 r.

ALEPO. FISH

The *alepo* cannot live out of water.

OSTRICH

For armies, food of commanders.

It extracts nourishment from iron; hatches eggs by its gaze.

SWAN

The swan is white without any spot, and sings sweetly as it dies; this song ends its life.

STORK

It cures itself of sickness by drinking salt water. If it finds its companion in fault it abandons her. When it is old its young ones brood over it and nourish it until it dies. H 13 v.

GRASSHOPPER

This with its song puts the cuckoo to silence. It dies in oil and is revived in vinegar. It sings through the burning heats.

BAT

For vice which cannot endure where virtue is.

This loses its sight more where the light has more radiance, and becomes more blinded the more it looks at the sun.

PARTRIDGE

This changes from female to male and forgets its former sex. Out of envy it steals the eggs of others and hatches them, but the young ones follow their true mother.

SWALLOW

This by means of celandine opens the eyes of its little ones when blind. H 14 r.

OYSTER—FOR TREASON

This opens completely when the moon is full: and when the crab sees it it throws a piece of stone or a twig into it and thus prevents it from closing up, so that it serves the crab for a meal.

So it may be with the mouth when it tells its secret, that it puts itself at the mercy of the indiscreet listener.

BASILISK—CRUELTY

This is shunned by all the serpents; the weasel fights with it by means of rue and slays it. Rue for virtue.

ASP

This carries sudden death in its fangs; and in order not to hear the enchantments it stops up its ears with its tail. H 14 v.

DRAGON

This twines itself round the legs of the elephant, and it falls upon him and both die. And in dying it has its revenge.

VIPER

This in pairing buries her mouth and at the end clenches her teeth and kills her husband; afterwards the sons having waxed big within her body tear open her belly and slay their mother.

SCORPION

The saliva spat out upon the scorpion when fasting slays it after the manner of abstinence from gluttony, which carries away and puts an end to the illnesses that proceed from this gluttony, and opens the path to the virtues. H 15 r.

CROCODILE—HYPOCRISY

This animal seizes a man and instantly kills him; and after he is dead it mourns for him with a piteous voice and many tears, and having ended its lament it cruelly devours him. It is thus with the hypocrite, whose face is bathed with tears over every slight thing, showing himself thus to have the heart of a tiger; he rejoices in his heart over another's misfortunes with a face bedewed with tears.

TOAD

The toad shuns the light of the sun: if however it be kept in it by force it puffs itself out so much as to hide its head below and deprives itself of its rays. So acts whoever is the enemy of clear and radiant virtue, who cannot maintain itself in its presence save by force, with puffed-up courage. H 17 r.

THE CATERPILLAR—FOR VIRTUE IN GENERAL

The caterpillar which through the care exercised in weaving round itself its new habitation with admirable design and ingenious workmanship, afterwards emerges from it with beautiful painted wings, rising on these towards heaven.

THE SPIDER

The spider brings forth out of herself the delicate and subtle web which gives back to it as its reward the prey that it has taken.

H 17 v.

THE LION

This animal with its resounding roar rouses its cubs on the third day after their birth and teaches them the use of all their dormant senses, and all the wild creatures which are in the forest flee away.

One may liken these to the children of virtue who are wakened by the sound of praise: their studies grow in distinction, raising them continually more and more, and at the sound all that is evil flees away, shunning those who are virtuous.

The lion also covers over his tracks so as to leave nothing to indicate his course to his enemies. So it is well for captains that they should conceal the secrets of their minds, in order that the enemy may have no conception of their plans.

H 18 r.

TARANTULA

The bite of the tarantula fixes a man in his purpose, that is in what he was thinking about when he was bitten.

LONG-EARED OWL AND LITTLE OWL

These punish those who have a skirmish with them by depriving them of life; and nature has so ordained in order that they may be fed.

H 18 v.

THE ELEPHANT

The great elephant has by nature qualities which rarely occur among men, namely probity, prudence, and the sense of justice and of religious observance. Consequently when there is a new moon they go to the rivers, and there having solemnly purified themselves they proceed to bathe, and after thus saluting the planet they go back to the woods. And when they are ill they throw themselves upon their backs and

toss up plants toward heaven as though they wished to offer sacrifice. They bury their tusks when they drop out from old age. Of these two tusks they use one to dig up roots in order to feed themselves and keep the point of the other sharp in order to fight with it.

When they are conquered by the hunters and overcome by fatigue the elephants clash their tusks, and having thus broken them off use them for their ransom.

They are mild in disposition and are conscious of dangers.

If one of them should come upon a man alone who has lost his way he puts him back peacefully in the path from which he has wandered. If he should come upon the man's footprints before he sees him he fears a snare, and so he stops and blows through his trunk as he shows them to the other elephants; and these then form themselves into a company and advance cautiously.

These animals always proceed in companies. The oldest goes in front and the next oldest remains the last, and thus they enclose the company.

They fear shame and only pair at night and secretly, and do not rejoin the herd after pairing until they have first bathed themselves in the river.

They do not fight over their females as other creatures do.

It is so peaceable that its nature does not allow it willingly to injure creatures less powerful than itself. If it should chance to meet a drove or flock of sheep it puts them aside with its trunk so as to avoid trampling upon them with its feet; and it never injures others unless it is provoked. When one of them has fallen into a pit the others fill the pit with branches, earth and stones, so that they raise the floor in such a way that it may easily make its escape. They have a great dread of the grunting of pigs and retreat hastily before it, causing no less damage with their feet to each other than to their enemies. They delight in rivers and are always wandering about in their vicinity; but on account of their great weight they are unable to swim. They devour stones, and the trunks of trees are their most welcome food. They hate rats. Flies are much attracted by their smell, and as they settle on their backs they wrinkle up their skin, deepening its tight folds, and so kill them.

When they are crossing rivers they send their young towards the

fall of the stream, and standing themselves up stream they break the united course of the water so that the current may not carry them away.

The dragon throws itself under the elephant's body, twines its tail round its legs and clings to its ribs with wings and claws and bites open its throat. The elephant falls on top of it and the dragon bursts open; thus it revenges itself by the death of its enemy.

<div align="right">H. 19 r. and v., 20 r. and v.</div>

THE DRAGON

These band themselves together in companies and twine after the manner of roots, cross swamps with their heads raised and swim towards where they find better pasture; and if they did not thus combine they would be drowned.—So the union is made.

<div align="right">H 20 v. and 21 r.</div>

SERPENTS

The serpent, a very large animal, when it sees a bird in the air inhales its breath with such vigour as to draw the birds into its mouth. Marcus Regulus the Consul of the Roman army was with his army attacked by such a monster and almost routed. After the creature had been slain by a catapult it was found to measure a hundred and twenty-five feet, that is sixty-four and a half braccia:[1] its head towered above all the trees in a wood. H 21 r.

THE BOA

This is a great snake which twines itself round the legs of the cow in such a way that it cannot move, and then it sucks it so as almost to dry it up. One of the species was killed on the hill of the Vatican in the time of the Emperor Claudius, and it had a whole boy inside it whom it had swallowed. H 21 r. and v.

THE ELK—CAPTURED WHEN ASLEEP

This beast is a native of the island of Scandinavia. It has the shape of a great horse except for the differences caused by the great length of

[1] It is not always possible to harmonize Leonardo's measurements.

the neck and ears. It crops the grass going backwards, for its upper lip
is so long that if it were to feed while going forward it would cover
up the grass. It has its legs without any joints and so when it wishes
to go to sleep it leans against a tree; and the hunters after having re-
connoitred the spot at which it is accustomed to sleep saw the tree
almost through, and when afterwards it leans against it as it sleeps it
falls in its sleep and so the hunters take it. Every other method of
capturing it is bound to fail because it runs with incredible speed.

H 21 V.

BONASUS—IT INJURES AS IT FLIES

This is a native of Paconia, and it has a neck with a mane like a
horse: in all other respects it resembles a bull except that its horns bend
inwards to such an extent that it cannot butt with them. This is why
its only refuge is in flight, in which it voids its excrement a distance of
four hundred braccia from its course, and wherever this touches it
burns like fire.

LIONS, LEOPARDS, PANTHERS, TIGERS

These keep their claws in sheath and never put them out except
when on the back of their prey or an enemy.

LIONESS

When the lioness defends her cubs from the hands of the hunters,
in order not to be affrighted by the spears she lowers her eyes to the
ground, so that her cubs may not be taken prisoners through her flight.

H 22 r.

LION

This animal which is so terrible fears nothing more than the noise
of empty carts and in like manner the crowing of cocks, and when it
sees these it is much terrified, gazes at their combs with a look of fear
and is strangely perturbed even though its face is covered.

THE PANTHER IN AFRICA

This has the shape of a lioness, but it is taller in the leg and slimmer
and longer and quite white, marked with black spots after the manner

of rosettes; all the animals are fascinated by these as they gaze at them and they would remain standing there always if it were not for the terror of its face; being conscious of this therefore it hides its face, and the animals that are round about it take courage and draw near so as to be able the better to enjoy so much beauty: it then suddenly seizes on the nearest and instantly devours it. H 22 v. and 23 r.

CAMELS

The Bactrian have two humps, the Arabian one. They are swift in battle and very useful for carrying burdens. This animal is a great observer of rule and proportion, for it does not move at all if its load is larger than it is accustomed to, and if it is taken too long a journey it does the same and stops suddenly, so that the merchants are obliged to make their lodging there. H 23 r.

TIGER

This is a native of Hyrcania; it bears some resemblance to the panther from the various spots on its skin; and it is an animal of terrifying speed. When the hunter finds its cubs he carries them off instantly, after placing mirrors at the spot from which he has taken them, and then immediately takes to flight upon a swift horse.

The panther when it returns finds the mirrors fixed to the ground and in looking at these it thinks that it sees its own children, until by scratching with its paw it discovers the fraud and then following the scent of its cubs it pursues the hunter. And as soon as the hunter sees the tigress he abandons one of the cubs, and this she takes and carries it to her lair and instantly sets off again after the hunter, and this is repeated until he gains his boat. H 23 v. and 24 r.

CATOBLEPAS

It is found in Ethiopia near to the principal source of the Niger. It is an animal which is not very large. It is sluggish in all its limbs and has the head so large that it carries it awkwardly, in such a way that it is always inclined towards the ground; otherwise it would be a very great pest to mankind, for anyone on whom it fixes its eyes dies instantly. H 24 r.

BASILISK

It is found in the province of Cyrenaica and is not more than twelve fingers long. It has a white spot on its head of the shape of a diadem. It drives away every serpent by its whistling. It resembles a snake but does not move by wriggling, but extends itself straight forward from its centre. It is said that on one occasion when one of these was killed by a horseman's spear and its venom flowed over the spear, not only the man died but the horse did also. It spoils the corn, not only that which it touches but that upon which it breathes; it scorches the grass and splits the stones. H 24 r. and v.

WEASEL

This on finding the den of the basilisk kills it with the smell of its urine by spreading this about, and the smell of this urine often kills the weasel itself.

THE *CERASTE*

These have four small movable horns; and when they wish to feed they hide the whole of their body except these tiny horns under the leaves, and as they move these it seems to the birds that they are little worms wriggling about, and so they instantly descend and peck at them. And then the ceraste immediately wraps itself round them in a circle and so devours them. H 24 v.

AMPHISBOENA

This has two heads, one in its usual place the other at its tail, as though it was not sufficient for it to throw its poison from one place only.

JACULO

This stations itself in trees and hurls itself like a dart, and transfixes the wild beasts and slays them.

THE ASP

There is no remedy for the bite of this animal except instantly to cut away the part affected. Pestilential though it is this animal has so strong an affection for its companion that they always go in pairs. And

if by a mischance one of them should be slain the other pursues the murderer with incredible speed, and is so alert and eager for vengeance as to overcome every obstacle. It will pass through a whole troop seeking only to wound its enemy, traversing any distance, and the only ways of avoiding it are by crossing over water or by a very rapid flight. Its eyes turn inwards and it has large ears, and its hearing guides it more than its sight. H 25 r.

ICHNEUMON

This animal is the mortal enemy of the asp. It is a native of Egypt, and when it sees an asp near to its place it runs instantly to the mud or slime of the Nile and covers itself with it entirely, and then after drying itself in the sun smears itself again with mud, and thus drying itself time after time covers itself with three or four coats like coats of mail; after this it attacks the asp and struggles with it determinedly, until it seizes its opportunity and flies at its throat and chokes it.

H 25 v.

CROCODILE

This is a native of the Nile. It has four feet and is dangerous both on land and in the water. It is the only land animal that is without a tongue, and it bites merely by moving its upper jaw. It grows to a length of forty feet, it has claws, and is covered with hide that will withstand any blow. It remains on land by day and in the water by night. When it has had its meal of fish it goes to sleep on the bank of the Nile with its mouth open, and then the bird called *trochilus*, a very small bird, runs immediately to its mouth, and hopping about among its teeth in and out proceeds to peck at the remains of its food, and causing it entrancing pleasure thereby tempts it to open its mouth more widely, and in so doing it falls asleep. No sooner does the ichneumon perceive this than it flings itself into its mouth, pierces its stomach and intestines, and so finally kills it. H 25 v. and 26 r.

DOLPHIN

Nature has given such power of understanding to animals that in addition to the perception of what is to their own advantage they

know what is to the disadvantage of the enemy; as a consequence the dolphin knows both the power of a cut from the fins which it has on its back, and the tenderness of the belly of the crocodile, hence when they fight it glides underneath it, pierces its belly and so kills it.

The crocodile is terrifying to those who flee from him and an utter coward when he is being pursued. H 26 r.

HIPPOPOTAMUS

This when it feels itself becoming overloaded looks about for thorns or where there are the fragments of split canes, and there it rubs a vein so hard as to burst it open, and then having allowed as much blood to flow as may be necessary it besmears itself with mud and so plasters up the wound. It has almost the shape of a horse, with cloven hoofs, twisted tail, boar's tusks, and neck with flowing mane. The hide cannot be pierced except when it is bathing. It feeds on corn that grows in the fields, and makes its way into them backwards, so that it may appear that it has just emerged.

IBIS

This bears a resemblance to a stork, and when it feels ill it fills its crop with water and makes an injection with its beak.

STAG

This when it feels itself bitten by the spider called *phalangium* eats crabs and rids itself of the poison. H 26 v.

LIZARD

This when it fights with serpents eats sow-thistles and gains its freedom.

THE SWALLOW

This gives sight to its blind young with the juice of the celandine.

WEASEL

This when it chases rats eats first of rue.

WILD BOAR

This cures its diseases by eating ivy.

SERPENT

This when it wishes to renew itself casts its old slough, commencing by the head: it transforms itself in a day and a night.

PANTHER

This will still fight with the dogs and the hunters after its entrails have fallen out. H 27 r.

CHAMELEON

This always takes the colour of the object on which it is resting; as a consequence they are often devoured by the elephants together with the leaves on which they are resting.

CROW

This when it has slain the chameleon purges itself with laurel.

H 27 v.

XLIV

Allegory

*'Loyalty. The cranes in order that their king may
not perish by their keeping bad guard stand round
him at night holding stones in their feet. Love, fear
and reverence—write these upon the three stones of
the crane.'*

A MAN on seeing a large sword at another man's side said to him:—
'Oh you poor fellow! I have been watching you now for a long time
tied to this weapon. Why don't you release yourself since your hands
are free, and thus regain your liberty?' To this the other made answer:
—'This is not your affair, and in any case it is an old state of things.'
The first feeling himself insulted said:—'I look on you as having a
knowledge of so few matters in this world that I supposed that any-
thing I could tell you would rank as new.' C.A. 13 r. d

Where fortune enters there envy lays siege and strives against it,
and when this departs it leaves anguish and remorse behind.

When fortune comes seize her with a firm hand. In front, I counsel
you, for behind she is bald. C.A. 76 v. a

A SIMILE OF PATIENCE

Patience serves as a protection against wrongs as clothes do against
cold. For if you put on more clothes as the cold increases it will have
no power to hurt you. So in like manner you must grow in patience
when you meet with great wrongs, and they will then be powerless to
vex your mind. C.A. 117 v. b

The spider, thinking to find repose within the keyhole, finds death.
 C.A. 299 v. b

A simile. A vessel of unbaked clay when broken may be remoulded, but not one that has passed through the fire. Tr. 68 a

Fame should be represented in the shape of a bird, but with the whole figure covered with tongues instead of feathers. B 3 v.

By the cloth that is held by the hand in the current of a running stream, in the water of which it leaves all its impurities, is meant that . . .

By the thorn upon which are grafted good fruits is meant that which is not of itself predisposed to virtue, yet by the help of an instructor produces the most useful virtues.

One pushes down another: by these cubes [1] are represented the life and conditions of mankind. G 89 r.

Envy wounds by base calumnies, that is by slander, at which virtue is filled with dismay. H 60 [12] v.

Good Report soars and rises up to heaven, for virtuous things find favour with God. Evil Report should be shown inverted, for all her works are contrary to God and tend towards hell. H 61 [13] r.

The goldfinch will carry spurge to its little ones imprisoned in a cage: death rather than loss of liberty. H 63 [15] v.

[For an allegorical representation]

Il Moro with the spectacles and Envy represented with lying Slander, and Justice black for Il Moro.

Labour with the vine in her hand. H 88 [40] v.

The ermine with mud.

Galeazzo between time of tranquillity and flight of fortune.

The ostrich which with patience produces its young.

Bars of gold are refined in the fire. H 98 [44 bis v.] r.

Magnanimity. The falcon only takes the large birds, and will die rather than eat flesh that has become tainted.

Constancy. Not he who begins but he who endures.

H 101 [42 v.] r.

Loyalty. The cranes in order that their king may not perish by their keeping bad guard stand round him at night holding stones in their

[1] MS. has a diagram with dice.

feet. Love, fear and reverence—write these upon the three stones of the cranes. H 118 [25 v.] r.

The bee may be likened to deceit, for it has honey in its mouth and poison behind. I 49 [1] v.

[*For an allegorical representation*]
Il Moro as the figure of Fortune, with hair and robes and with hands held in front, and Messer Gualtieri with act of obeisance plucks him by the robes from below as he presents himself before him.

Also Poverty as a hideous figure running behind a youth, whom Il Moro covers with the skirt of his robe while he threatens the monster with his gilded sceptre. I 138 [90] v.

The evil that does not harm me is as the good that does not help me.
The rushes which hold back the tiny blades of straw when they are drowning. M 4 r.

[*With drawing of faggot*]
To place in the hand of ingratitude:
Wood feeds the fire that consumes it. MS. 2038 Bib. Nat. 34 r.

FOR INGRATITUDE

[*With drawing of man blowing out candle*]
When the sun appears which drives away the general darkness, you extinguish the light that drives away the particular darkness, for your necessity and convenience. B.M. 173 r.

Ivy is the [emblem] of longevity. Windsor: Drawings 12282 v.

Truth	the sun
falsehood	a mask
innocence	
malignity	

Fire destroys falsehood, that is sophistry, and restores truth, driving out darkness.

Fire is to be put for the destroyer of every sophistry and the revealer and demonstrator of truth, because it is light, the banisher of darkness which is the concealer of all essential things.

TRUTH

Fire destroys all sophistry, that is deceit; and maintains truth alone, that is gold.

Truth in the end cannot be concealed.

Dissimulation profits nothing. Dissimulation is frustrated before so great a judge.

Falsehood assumes a mask.

Nothing is hidden beneath the sun.

Fire is put for truth because it destroys all sophistry and lies, and the mask for falsity and lying by which the truth is concealed.

<div align="right">Windsor: Drawings 12700 v.</div>

[*Sketch. Figures seated on clouds. Rain. Ground below strewn with implements*]

On this side Adam and on that Eve.

Oh human misery! of how many things do you make yourself the slave for money! Windsor: Drawings 12698 r.

This Envy is represented making a contemptuous motion towards heaven, because if she could she would use her strength against God. She is made with a mask upon her face of fair appearance. She is made wounded in the eye by palm and olive. She is made wounded in the ear by laurel and myrtle, to signify that victory and truth offend her. She is made with many lightnings issuing forth from her, to denote her evil speaking. She is made lean and wizened because she is ever wasting in perpetual desire. She is made with a fiery serpent gnawing at her heart. She is given a quiver with tongues for arrows, because with the tongue she often offends; and she is made with a leopard's skin, since the leopard from envy slays the lion by guile. She is given a vase in her hand full of flowers, and beneath these filled with scorpions and toads and other venomous things. She is made riding upon death, because envy never dying has lordship over him; and death is made with a bridle in his mouth and laden with various weapons, since these are all the instruments of death.

In the moment when virtue is born she gives birth to envy against herself, and a body shall sooner exist without a shadow than virtue without envy. Oxford Drawings, Part ii. No. 6

Pleasure and Pain are represented as twins, as though they were joined together, for there is never the one without the other; and they turn their backs because they are contrary to each other.

If you shall choose pleasure, know that he has behind him one who will deal out to you tribulation and repentance.

This is pleasure together with pain, and they are represented as twins because the one is never separated from the other.

They are made with their backs turned to each other because they are contrary the one to the other. They are made growing out of the same trunk because they have one and the same foundation, for the foundation of pleasure is labour with pain, and the foundations of pain are vain[1] and lascivious pleasures.

And accordingly it is represented here with a reed in the right hand, which is useless and without strength, and the wounds made with it are poisoned. In Tuscany reeds are put to support beds, to signify that here occur vain dreams, and here is consumed a great part of life: here is squandered much useful time, namely that of the morning when the mind is composed and refreshed, and the body therefore is fitted to resume new labours. There also are taken many vain pleasures, both with the mind imagining impossible things, and with the body taking those pleasures which are often the cause of the failing of life; so that for this the reed is held as representing such foundations.

Oxford Drawings, Part ii. No. 7

[1] MS., *vanj* not *varj*.

XLV

Prophecies

'Creatures shall be seen upon the earth who will always be fighting one with another, with very great losses and frequent deaths on either side. These shall set no bounds to their malice . . . O Earth! what delays thee to open and hurl them headlong into the deep fissures of thy huge abysses and caverns, and no longer to display in the sight of heaven so savage and ruthless a monster?'

COMMON HABIT

SOME poor wretch will be flattered, and these same flatterers will always be to him deceivers, robbers and assassins.

THE PERCUSSION OF THE SUN'S DISC

Something will appear which will cover over the person who shall attempt to cover it.

OF MONEY AND GOLD

That shall come forth from hollow caves which shall cause all the nations of the world to toil and sweat with great agitation, anxiety and labour, in order to gain its aid.

OF THE FEAR OF POVERTY

The malevolent and terrifying thing shall of itself strike such terror into men that almost like madmen, while thinking to escape from it, they will rush in swift course upon its boundless forces.

OF ADVICE

He who shall be most necessary to whoever has need of him will be unknown, and if known will be held of less account. C.A. 37 v. c

OF SNAKES CARRIED BY SWANS

Serpents of huge size will be seen at an immense height in the air fighting with birds.

OF CANNON WHICH COME FORTH OUT OF A PIT AND FROM A MOULD

There shall come forth from beneath the ground that which by its terrific report shall stun all who are near it, and cause men to drop dead at its breath, and it shall devastate cities and castles.

C.A. 129 V. a

OF CHRISTIANS

There are many who hold the faith of the Son and only build temples in the name of the Mother.

OF FOOD WHICH HAS BEEN ALIVE

A large part of the bodies which have had life will pass into the bodies of other animals, that is the houses no longer inhabited will pass piece-meal through those which are inhabited, ministering to their needs and bearing away with them what is waste; that is to say that the life of man is made by the things which he eats, and these carry with them that part of man which is dead.

OF MEN WHO SLEEP UPON PLANKS MADE FROM TREES

Men will sleep and eat and make their dwelling among trees grown in the forests and the fields.

OF DREAMING

It shall seem to men that they see new destructions in the sky, and the flames descending therefrom shall seem to have taken flight and to flee away in terror; they shall hear creatures of every kind speaking human language; they shall run in a moment, in person, to divers

parts of the world without movement; amidst the darkness they shall see the most radiant splendours. O marvel of mankind! What frenzy has thus impelled you! You shall hold converse with animals of every species, and they with you in human language. You shall behold yourselves falling from great heights without suffering any injury; the torrents will bear you with them as they mingle in their rapid course.

OF ANTS

Many communities there will be who will hide themselves and their young and their victuals within gloomy caverns, and there in dark places will sustain themselves and their families for many months without any light either artificial or natural.

OF BEES

And many others will be robbed of their store of provisions and their food, and by an insensate folk will be cruelly immersed and drowned. O justice of God! why dost thou not awake to behold thy creatures thus abused?

OF SHEEP, COWS, GOATS AND THE LIKE

From countless numbers will be stolen their little children, and the throats of these shall be cut, and they shall be quartered most barbarously.

OF NUTS, OLIVES, ACORNS, CHESTNUTS, AND THE LIKE

Many children shall be torn with pitiless beatings out of the very arms of their mothers, and flung upon the ground and then maimed.

OF CHILDREN WHO ARE WRAPPED IN SWADDLING BANDS

O cities of the sea, I behold in you your citizens, women as well as men, tightly bound with stout bonds around their arms and legs by

folk who will have no understanding of our speech; and you will only be able to give vent to your griefs and sense of loss of liberty by making tearful complaints, and sighs, and lamentation one to another; for those who bind you will not have understanding of your speech nor will you understand them.

OF CATS THAT EAT RATS

In you, O cities of Africa! your own sons shall be seen torn to pieces within their own houses by most cruel and savage animals of your country.

OF ASSES WHICH ARE BEATEN

O neglectful Nature, wherefore art thou thus partial, becoming to some of thy children a tender and benignant mother, to others a most cruel and ruthless stepmother? I see thy children given into slavery to others without ever receiving any benefit, and in lieu of any reward for the services they have done for them they are repaid by the severest punishments, and they constantly spend their lives in the service of their oppressor.

DIVISION OF THE PROPHECIES

First of things which relate to the reasoning animals, second those which have not the power of reason, third of plants, fourth of ceremonies, fifth of customs, sixth of propositions, decrees or disputes, seventh of propositions contrary to Nature (as to speak of a substance which the more there is taken from it is the more increased), and reserve the weighty propositions until the end, and begin with those of less import, and show first the evils and then the punishments, eight of philosophical things. C.A. 145 r. a

OF FUNERAL RITES AND PROCESSIONS AND LIGHTS AND BELLS AND FOLLOWERS

The greatest honours and ceremonies shall be paid to men without their knowledge. C.A. 145 v. a

All the astrologers will be castrated, that is the cockerels.

C.A. 367 v. b

CONJECTURE

Arrange in order the months and the ceremonies which are performed, and do this for the day and for the night.

OF REAPERS

There will be many who will be moving one against another, holding in their hands the sharp cutting iron. These will not do each other any hurt other than that caused by fatigue, for as one leans forward the other draws back an equal space; but woe to him who intervenes between them, for in the end he will be left cut in pieces.

OF SILK-SPINNING

There shall be heard mournful cries and loud shrieks, hoarse angry voices of those who are tortured and despoiled and at last left naked and motionless; and this shall be by reason of the motive power which turns the whole.

OF PLACING BREAD WITHIN THE MOUTH OF THE OVEN AND DRAWING IT OUT AGAIN

In all the cities and lands and castles, villages and houses, men will be seen who through desire of eating will draw the very food out of each other's mouths, without their being able to make any resistance.

OF PLOUGHED LAND

The earth will be seen turned upside down and facing the opposite hemispheres, and laying bare the holes where lurk the fiercest animals.

OF SOWING

Then a great part of the men who remain alive will throw out of their houses the victuals they have saved, as the free booty of the birds and beasts of the field, without taking any care of them.

OF THE RAINS WHICH CAUSE THE RIVERS TO
BECOME MUDDY AND CARRY AWAY THE SOIL

There will come from out the sky that which will transport a great part of Africa which lies beneath this sky[1] towards Europe, and that of Europe towards Africa; and those of the provinces will mingle together in great revolution.

OF BRICK-KILNS AND LIME-KILNS

At the last the earth will become red after being exposed to fire for many days, and the stones will become changed to ashes.

OF WOOD THAT IS BURNT

The trees and shrubs of the vast forests shall be changed to ashes.

OF BOILED FISH

Creatures of the water will die in boiling water.

THE OLIVES WHICH DROP FROM THE OLIVE-TREES
GIVE US THE OIL WHICH MAKES LIGHT

There shall descend with fury from the direction of the sky that which will give us nourishment and light.

OF HORNED AND TAWNY OWLS WITH WHICH ONE
GOES FOWLING WITH BIRD-LIME

Many will perish by fracturing their skulls, and their eyes will almost start out of their heads on account of fearsome creatures which have come forth out of the darkness.

OF FLAX WHEREBY PAPER IS MADE OUT OF RAGS

That shall be revered and honoured and its precepts shall be listened to with reverence and love, which was at first despised and mangled and tortured with many different blows.

[1] MS., *si mostra a esso cielo.*

OF BOOKS WHICH INCULCATE PRECEPTS

Bodies without souls shall by their sayings supply precepts which shall help us to die well.

OF THOSE WHO ARE BEATEN AND SCOURGED

Men will hide themselves within the bark of hollow trees, and there crying aloud they will make martyrs of themselves by beating their own limbs.

OF WANTONNESS

And they will go wild after the things that are most beautiful to seek after, to possess and make use of their vilest parts; and afterwards, having returned with loss and penitence to their understanding, they will be filled with great admiration for themselves.

OF THE AVARICIOUS

Many there will be who with the utmost zeal and solicitude will pursue furiously that which has always filled them with awe, not knowing its evil nature.

OF MEN WHO AS THEY GROW OLDER BECOME MORE MISERLY, WHEREAS, HAVING BUT A SHORT TIME TO STAY, THEY OUGHT TO BE MORE GENEROUS

You will see that those who are considered to be of most experience and judgment, in proportion as they come to have less need of things, seek and hoard them with more eagerness.

OF A DITCH (GIVE THIS AS AN INSTANCE OF FRENZY OR CRAZINESS OR MADNESS OF THE BRAIN)

There will be many busied in the practice of taking from that thing which increases the more the more they take from it.

OF WEIGHT PLACED ON A FEATHER-PILLOW

And with many bodies it will be seen that as you raise your head from them they will increase perceptibly, and when the head that has been lifted up returns, their size will immediately diminish.

OF CATCHING LICE

There will be many hunters of animals who the more they catch the fewer they will have; and so conversely they will have more in proportion as they catch less.

OF DRAWING WATER WITH TWO BUCKETS BY A SINGLE ROPE

And many will be busying themselves with a thing which the more they draw it up will tend the more to escape in the contrary direction.

OF SIEVES MADE OF THE SKIN OF ANIMALS

We shall see the food of animals pass through their skins in every way except through the mouth, and penetrate through the opposite side until it reaches the level ground.

OF THE LIGHTS THAT ARE CARRIED BEFORE THE DEAD

They will make light for the dead.

OF THE LANTERN

The fierce horns of powerful bulls will protect the light used at night from the impetuous fury of the winds.

OF FEATHERS IN BEDS

Flying creatures will support men with their feathers.

OF MEN WHO PASS ABOVE THE TREES WEARING WOODEN STILTS

The swamps will be so great that the men will go above the trees of their countries.

OF THE SOLES OF SHOES WHICH ARE OF LEATHER

Over a great part of the country men shall be seen walking about on the skins of large animals.

OF SAILING

There will be great winds through which the eastern things will become western, and those of the south mingled together in great measure by the course of the winds will follow these through distant lands.

OF THE WORSHIPPING OF PICTURES OF SAINTS

Men shall speak with men who shall not hear them; their eyes shall be open and they shall not see; they will speak to them and there shall be no reply; they will ask pardon from one who has ears and does not hear; they will offer light to one who is blind, and to the deaf they will appeal with loud clamour.[1]

OF DREAMING

Men shall walk without moving, they shall speak with those who are absent, they shall hear those who do not speak.

OF THE SHADOW THAT MOVES WITH MAN

There shall be seen shapes and figures of men and animals which shall pursue these men and animals wheresoever they flee; and the movements of the one shall be as those of the other, but it shall seem a thing to wonder at because of the different dimensions which they assume.

[1] MS., *faran lume a [chi] è orbo [. . .] sordi con gran [. . .] ore.*

OF THE SHADOW CAST BY THE SUN AND OF THE REFLECTION IN THE WATER SEEN AT ONE AND THE SAME TIME

Many times one man shall be seen to change into three and all shall proceed together, and often the one that is most real abandons him.

OF WOODEN COFFERS WHICH ENCLOSE MANY TREASURES

Within walnuts and other trees and plants there shall be found very great treasures which lie hidden there.

OF EXTINGUISHING THE LIGHT WHEN ONE GOES TO BED

Many by forcing their breath out too rapidly will lose the power of sight, and in a short time all power of sensation.

OF THE BELLS OF MULES WHICH ARE CLOSE TO THEIR EARS

There shall be heard in many parts of Europe instruments of various sizes making divers melodies, causing great weariness to those who hear them most closely.

OF ASSES

The many labours shall be repaid by hunger, thirst, wretchedness, blows and goadings.

OF SOLDIERS ON HORSEBACK

Many shall be seen carried by large animals with great speed, to the loss of their lives and to instant death. In the air and on the earth shall be seen animals of different colours, bearing men furiously to the destruction of their lives.

OF STARS ON SPURS

By reason of the stars you will see men moving as swiftly as any swift animal.

OF A STICK WHICH IS A DEAD THING

The movement of the dead shall cause many who are living to flee away with grief and lamentation and cries.

OF TINDER

With stone and iron things will be rendered visible which were not previous seen.

OF OXEN WHICH ARE EATEN

The masters of the estates will eat their own labourers.

OF BEATING THE BED TO REMAKE IT

To such a pitch of ingratitude shall men come that that which shall give them lodging without any price shall be loaded with blows, in such a way that great parts of the inside of it shall be detached from their place, and shall be turned over and over within it.

OF THINGS WHICH ARE EATEN WHICH ARE FIRST PUT TO DEATH

Those who nourish them will be slain by them and scourged by barbarous death.

OF THE WALLS OF CITIES REFLECTED IN THE WATER OF THEIR TRENCHES

The high walls of mighty cities shall be seen inverted, in their trenches.

OF THE WATER WHICH FLOWS IN A TURBID STREAM MINGLED WITH EARTH, AND OF DUST AND MIST MINGLING WITH THE AIR, AND OF THE FIRE WHICH MINGLES ITS HEAT WITH EACH

All the elements shall be seen confounded together, surging in huge rolling mass, now towards the centre of the earth, now towards the

sky, at one time coursing in fury from the southern regions towards the icy north, at another time from the east to the west, and so again from this hemisphere to the other.

AT ANY POINT ONE MAY MAKE THE DIVISION OF THE TWO HEMISPHERES

All men will suddenly change their hemisphere.

EVERY POINT FORMS A DIVISION BETWEEN THE EAST AND THE WEST

All the animals will move from the east to the west, and so also from the north to the south.

OF THE MOVEMENT OF THE WATERS WHICH CARRY LOGS THAT ARE DEAD

Bodies without life will move of themselves and will carry with them innumerable generations of the dead, plundering the possessions of the living inhabitants.

OF EGGS WHICH BEING EATEN CANNOT PRODUCE CHICKENS

Oh! how many will those be who will never be born.

OF FISHES WHICH ARE EATEN WITH THEIR ROES

Endless generations will perish through the death of the pregnant.

OF THE BEASTS FROM WHOM CHEESE IS MADE

The milk will be taken from the tiny children.

OF THE LAMENTATIONS MADE ON GOOD FRIDAY

In all the parts of Europe there shall be lamentations by great nations for the death of one man.

OF THE HAFTS OF KNIVES MADE OF RAMS' HORNS

In the horns of animals shall be seen sharp irons, which shall take away the lives of many of their species.

OF THE NIGHT WHEN ONE CANNOT DISTINGUISH ANY COLOUR

It shall even come to pass that it will be impossible to tell the difference between colours, for all will become black in hue.

OF SWORDS AND SPEARS WHICH OF THEMSELVES NEVER DO ANY HARM TO ANYONE

That which of itself is gentle and void of all offence will become terrible and ferocious by reason of evil companionship, and will take the lives of many people with the utmost cruelty; and it would slay many more if it were not that these are protected by bodies which are themselves without life, which have come forth out of pits—that is by cuirasses of iron.

OF GINS AND SNARES

Many dead will move with fury, and will take and bind the living, and will set them before their enemies in order to compass their death and destruction.

OF THE PRECIOUS METALS

There shall come forth out of dark and gloomy caves that which shall cause the whole human race to undergo great afflictions, perils, and death. To many of those who follow it, after much tribulation it will yield delight; but whosoever pays it no homage will die in want and misery. It shall bring to pass an endless number of crimes; it shall prompt and incite wretched men to assassinate, to steal, and to enslave; it shall hold its own followers in suspicion; it shall deprive free cities of their rank: it shall take away life itself from many; it shall make men torment each other with many kinds of subterfuge, deceits, and treacheries.

O vile monster! How much better were it for men that thou shouldst go back to hell! For this the vast forests shall be stripped of their trees; for this an infinite number of creatures shall lose their lives.

OF FIRE

From small beginnings shall arise that which shall rapidly become great; and it shall have respect for no created thing, but its power shall be such as to enable it to transform almost everything from its natural condition.

OF SHIPS THAT FOUNDER

There shall be seen huge bodies devoid of life, carrying great numbers of men with fierce speed to the destruction of their lives.

C.A. 370 r. a

OF WRITING LETTERS FROM ONE COUNTRY TO ANOTHER

Men from the most remote countries shall speak one to another and shall reply.

OF THE HEMISPHERES WHICH ARE INFINITE AND DIVIDED BY AN INFINITE NUMBER OF LINES, IN SUCH A WAY THAT EVERY MAN HAS ALWAYS ONE OF THESE LINES BETWEEN HIS FEET

Men shall speak with and touch and embrace each other while standing each in different hemispheres, and shall understand each other's language.

OF PRIESTS WHO SAY MASS

Many shall there be who in order to practise their calling shall put on the richest vestments, and these shall seem to be made after the manner of aprons.

OF FRIARS WHO HOLD CONFESSION

The unhappy women of their own accord shall go to reveal to men all their wantonness and their shameful and most secret acts.

OF THE CHURCHES AND HABITATIONS OF FRIARS

There will be many who will abandon work and labour and poverty of life and possessions, and will go to dwell among riches and in splendid buildings, pretending that this is a means of becoming acceptable to God.

OF THE SELLING OF PARADISE

A countless multitude will sell publicly and without hindrance things of the very greatest value, without licence from the Lord of these things, which were never theirs nor in their power; and human justice will take no account of this.

OF THE DEAD WHO ARE TAKEN TO BE BURIED

The simple folk will carry a great number of lights to light up the journeys of all those who have wholly lost the power of sight. O human folly! O madness of mankind! These two phrases stand for the commencement of the matter.

OF THE DOWRIES OF MAIDENS

And whereas at first young maidens could not be protected from the lust and violence of men, either by the watchfulness of parents or by the strength of walls, there will come a time when it will be necessary for the fathers and relatives of these maidens to pay a great price to whoever is willing to marry them, even although they may be rich and noble and exceedingly beautiful. Herein it seems certain that Nature desires to exterminate the human race, as a thing useless to the world and the destroyer of all created things.

OF THE CRUELTY OF MAN

Creatures shall be seen upon the earth who will always be fighting one with another, with very great losses and frequent deaths on either side. These shall set no bounds to their malice; by their fierce limbs a great number of the trees in the immense forests of the world shall be laid level with the ground; and when they have crammed themselves

with food it shall gratify their desire to deal out death, affliction, labours, terrors and banishment to every living thing. And by reason of their boundless pride they shall wish to rise towards heaven, but the excessive weight of their limbs shall hold them down. There shall be nothing remaining on the earth or under the earth or in the waters that shall not be pursued and molested or destroyed, and that which is in one country taken away to another; and their own bodies shall be made the tomb and the means of transit of all the living bodies which they have slain. O Earth! what delays thee to open and hurl them headlong into the deep fissures of thy huge abysses and caverns, and no longer to display in the sight of heaven so savage and ruthless a monster?

OF SAILING IN SHIPS

The trees of the vast forests of Taurus and of Sinai, of the Apennines and of Atlas, shall be seen speeding by means of the air from east to west, and from north to south, and transporting by means of the air a great quantity of men. Oh, how many vows! How many deaths! What partings between friends and relatives shall there be! How many who shall nevermore behold their own lands or their native country, and shall die unsepulchred and their bones be scattered in divers parts of the world!

OF REMOVING ON ALL SAINTS' DAY

Many shall leave their own dwellings, and shall carry with them all their goods and go to dwell in other lands.

OF ALL SOULS' DAY

How many will there be who will mourn for their dead ancestors, carrying lights for them!

OF FRIARS WHO BY SPENDING ONLY WORDS RECEIVE GREAT RICHES AND BESTOW PARADISE

Invisible money will cause many who spend it to triumph.

OF BOWS MADE FROM THE HORNS OF OXEN

Many there will be who by means of the horns of cattle will die a painful death. c.a. 370 v. a

Behold a thing which is valued the less the more one has need of it. It is advice. c 19 v.

And many have made a trade in deceits and feigned miracles, cozening the foolish herd, and if no one showed himself cognizant of their deceits they would impose them upon all. f 5 v.

FOR WELL-DOING

By the branch of the nut-tree which is struck and beaten just when it has brought its fruit to perfection, is represented those who as the sequel of their illustrious works are struck by envy in divers ways.
 g 88 v.

All these things which in the winter are concealed and hidden beneath the snow, will be left bare and exposed in summer:—said of a lie which cannot remain hidden. i 39 v.

You will see the lion tribe tearing open the earth with hooked claws, and burying themselves in the holes that they have made, together with the other animals which are in subjection to them.

There shall come forth from the ground creatures clad in darkness who shall attack the human race with tremendous onslaughts, and it shall have the blood poisoned by their fierce bites even while it is devoured by them.

There shall also hurtle through the air a tribe of dreadful winged creatures who shall attack both men and beasts, and feed upon them with loud cries:—They shall fill their bellies full of crimson blood.
 i 63 [15] r.

You will see the blood streaming forth from the rent flesh of men and bedewing the surface parts.

You will see men with so cruel a malady that they will tear their flesh with their own nails:—This will be the itch.

You will see plants continuing without leaves, and rivers standing still in their courses.

The water of the sea shall rise above the high summits of the mountains towards the sky, and it shall fall down again on to the dwellings of men:—That is as clouds.

You will see the greatest trees of the forests borne by the fury of the winds, from the east to the west:—That is across the sea.

Men shall cast away their own food:—That is in sowing.

<div align="right">1 63 [15] v.</div>

The generation of men shall come to such a pass as not to understand one another's speech:—That is a German with a Turk.

You will see fathers giving up their daughters to the sensuality of men, and rewarding them, and abandoning all their former care:— When the girls are married.

Men shall come forth out of the graves changed to winged creatures, and they shall attack other men, taking away their food even from their hands and tables:—The flies.

Many there will be who will flay their own mother and fold back her skin:—The tillers of the ground.

Happy will be those who give ear to the words of the dead:—The reading of good works and the observing of their precepts.

<div align="right">1 64 [16] r.</div>

Feathers shall raise men towards heaven even as they do birds:— That is by letters written with their quills.

The works of men's hands will become the cause of their death:— Swords and spears.

Men will pursue the thing they most fear:—That is they will be miserable lest they should fall into misery.

Things severed shall be united and shall acquire of themselves such virtue that they shall restore to men their lost memory:—That is the papyrus sheets, which are formed out of severed strips and preserve the memory of the thoughts and deeds of men.

You shall behold the bones of the dead by their rapid movement directing the fortunes of their mover:—The dice.

Oxen shall by their horns protect the fire from death:—The lantern.

The forests will bring forth young who will become the cause of their death:—The handle of the hatchet. 1 64 [16] v.

Men will deal rude blows to that which is the cause of their life:—They will thrash the grain.

The skins of animals will make men rouse from their silence with loud cries and oaths:—Balls for playing games.

Many times the thing that is severed becomes the cause of great union:—That is the comb made up of split canes, which unites the threads in the silk.

The wind which passes through the skins of animals will make men leap up:—That is the bagpipes, which cause men to dance.

 1 65 [17] r.

OF NUT-TREES WHICH ARE BEATEN

Those which have done best will be most beaten, and their children will be carried off and stripped or despoiled, and their bones broken and crushed.

OF SCULPTURE

Alas! whom do I see? The Saviour crucified again.

OF THE MOUTH OF MAN WHICH IS A TOMB

There shall come forth loud noises out of the tombs of those who have died by an evil and violent death.

OF THE SKINS OF ANIMALS WHICH HAVE THE SENSE OF FEELING OF WHAT IS WRITTEN THERE

The more you converse with skins covered over with sentiments, the more you will acquire wisdom.

OF PRIESTS WHO BEAR THE HOST IN THEIR BODIES

Then almost all the tabernacles where dwells the *Corpus Domini* will be plainly visible, walking about of themselves on the different roads of the world. 1 65 [17] v.

And those who feed the air will turn night into day:—Tallow.

And many creatures of the earth and of the water will mount up among the stars:—The Planets.

You shall see the dead carrying the living in divers parts of the world:—The chariots and ships.

From many the food shall be taken away out of their mouths:—From ovens.

And those who have their mouths filled by the hands of others, shall have the food taken away out of their mouths:—The oven.

 1 66 [18] r.

OF CRUCIFIXES WHICH ARE SOLD

I see Christ again sold and crucified, and his saints suffering martyrdom.

OF DOCTORS WHO LIVE UPON THE SICK

Men will come to such a state of misery that they will be grateful that others should profit by their sufferings, or by the loss of their true riches, that is health.

Of the religion of the Friars who live by means of the Saints, who have been dead for a long time:
Those who are dead will after a thousand years be those who will make provision for many of the living.

OF STONES CHANGED INTO LIME WITH WHICH PRISON WALLS ARE BUILT

Many things which have previously been destroyed by fire will deprive many men of their liberty. 1 66 [18] v.

OF CHILDREN WHO TAKE THE BREAST

Many Franciscans, Dominicans, and Benedictines will eat that which has recently been eaten by others, and they will remain many months before being able to speak.

OF COCKLES AND SEA-SNAILS CAST UP BY THE SEA WHICH ROT WITHIN THEIR SHELLS

How many shall there be who after they are dead will lie rotting in their own houses, filling all the air around with their foul stench!

1 67 [19] r.

PLANT WITH ROOTS UPWARDS

For someone who would be on the point of coming to the end of all possessions and favour.

OF JACKDAWS AND STARLINGS

Those who trust themselves to inhabit near him, and these will be in great crowds, will almost all die a cruel death, and one will see fathers and mothers together with their families being devoured and slain by cruel animals.

1 138 [90] v.

OF PEASANTS WHO WORK IN THEIR SHIRTS

Shadows will come from the East which will tinge with much darkness the sky that covers Italy.

OF THE BARBERS

All men will take refuge in Africa.

1 139 [91] r.

OF THE SHADOW CAST BY MAN AT NIGHT WITH A LIGHT

There shall appear huge figures in human shape, and the nearer to you they approach the more will their immense size diminish.

K 50 [1] v.

OF MULES WHICH CARRY RICH BURDENS OF SILVER AND GOLD

Many treasures and great riches will be laid upon four-footed animals, which will carry them to divers places. L 91 r.

Those will be drowned who give light for divine service:—
The bees which make the wax of the candles.

The dead will come forth from under the earth, and by their fierce movements will drive innumerable human creatures out of the world:—
The iron which comes from under the earth is dead, and it makes the weapons wherewith so many men have been slain.

The greatest mountains, even though they are remote from the sea borders, will drive the sea from its place:—
That is by the rivers which carry down the soil they have taken from the mountains and deposit it upon the sea shores; and where the earth comes the sea retires.

The water fallen from the clouds will so change its nature as to remain for a long space of time upon the slopes of the mountains without making any movement. And this will happen in many and divers regions:—
The snow that falls in flakes which is water.

The great rocks of the mountains will dart forth fire, such that they will burn up the timber of many vast forests and many beasts both wild and tame:—
The flint of the tinder-box, which makes a fire that consumes all the loads of faggots of which the forests are cleared, and with this the flesh of beasts is cooked.

Oh! how many great buildings will be ruined by reason of fire:—
By the fire of the guns.

The oxen will become in great part the cause of the destruction of cities; and so also will horses and buffaloes:—
They draw the guns.

Many there will be who will wax great in their destruction:—
The ball of snow rolling over the snow.

There will be a great host who, forgetful of their existence and their name, will lie as though dead upon the spoils of other dead creatures:—
By sleeping upon the feathers of birds.

The east shall be seen to rush into the west, the south into the north, whirling themselves round about the universe with great noise, fury and trembling:—
The wind from the east which will rush into the west.

The rays of the sun will kindle fire on the earth, whereby that which is beneath the sky will be set alight; and, beaten back by that which impedes them, they will return downwards:—
The burning-glass kindles the fire with which the oven is heated, and this has its base standing beneath its vaulted roof.

A great part of the sea will fly towards the sky, and for a long time it will not return:—
That is in clouds. B.M. 42 V.

OF CORN AND OTHER SEEDS

Men shall throw away out of their houses those victuals which were meant for the sustenance of their lives:—[That is by sowing.]

OF TREES WHICH GIVE SAP TO GRAFTED SHOOTS

Fathers and mothers shall be seen to bestow much more attention upon their step-children than upon their own children.

OF THE THURIFER WITH INCENSE

Some shall go about in white vestments with arrogant gestures threatening others with metal and fire, which yet have never done them any harm. B.M. 212 V.

OF KIDS

The time of Herod shall return; for the innocent children shall be torn away from their nurses and shall die of great wounds at the hands of cruel men. Forster II 9 v.

OF THE MOWING DOWN OF GRASS

Innumerable lives will be extinguished, and innumerable vacant spaces created upon the earth.

OF THE LIFE OF MEN WHO EVERY TEN YEARS ARE CHANGED IN BODILY SUBSTANCE

Men will pass when dead through their own bowels.

OF SKINS

Many animals . . . Forster II 34 r.

OF LEATHER BOTTLES

The goats will carry wine to the cities. Forster II 52 v.

OF SHOEMAKERS

Men will take a pleasure in seeing their own works worn out and destroyed. Forster II 61 v.

OF BEES

They live together in communities. They are drowned in order that their honey may be seized.

Many and very great communities will be drowned in their own dwellings. Windsor: Drawings 12587 r.

Snow in summer shall be gathered on the high mountain peaks and carried to warm places, and there be let to fall down, when festivals are held in the piazza in the time of summer. Sul Volo 14 [13] r.

XLVI

Personalia

'O Leonardo, why do you toil so much?'

To WRITE thus clearly of the kite would seem to be my destiny, because in the earliest recollections of my infancy it seemed to me when I was in the cradle that a kite came and opened my mouth with its tail, and struck me within upon the lips with its tail many times. c.a. 66 v. b

Pray hold me not in scorn! I am not poor!
Poor rather is the man who desires many things.
Where shall I take my place? Where in a little time from henceforth you shall know. Do you answer for yourself! From henceforth in a little time . . . c.a. 71 r. a

If it is said that the King lacks seventy-two ducats of revenue when this water is drawn off from San Cristoforo. . . .
This His Majesty knows: what he gives me he takes from himself.
But in this instance nothing will be taken from the King, but it will be taken away from him who has stolen it, because of the regulation of the exits which the thieves of the water have enlarged.
If it should be said that this causes loss to many, it amounts to nothing more than taking away from the thieves what they have to restore.
And indeed the magistrate continually takes this away again without any thought of me, and it exceeds five hundred ounces of water, whereas for me it is fixed only at twelve ounces.
And if it should be said that this right of water of mine is worth a considerable sum in the year, the ounce here when the canal is so low is let at only seven ducats of four lire each, one per ounce per year, and this amounts to seventy.
If they say that this hinders navigation this is not true, because the mouths which serve for this irrigation are above the navigation.

c.a. 93 r. a

1122

The Medici created and destroyed me. (*li medici mi creorono e disstrussono.*)[1] C.A. 159 r. c

Note as to the moneys I have had from the King on account of my salary from July 1508 until April 1509. First 100 crowns, then another 100, then 70, then 50 and then 20, and then 200 francs, a franc being worth 48 soldi. C.A. 192 r. a

Tell me if ever, tell me if ever anything was built in Rome . . .
 C.A. 216 v. b

AT ROME

At old Tivoli. Hadrian's Villa.[2] C.A. 227 v. a

Find Ligny (*Ingil*) [3] and tell him you will wait for him at Rome (*a morra*),[3] and will go with him to Naples (*in lo panna*).[3] See that you make the donation (*e no igano dal*),[3] and take the book of Vitolone, and the measurements of the public buildings. Have two trunks covered ready for the muleteer; bed-spreads will do very well for the purpose; there are three of them but you will leave one at Vinci. Take the stoves from the Grazie. Get from Giovanni Lombardo the [model of] the theatre of Verona. Buy some table-cloths and towels, hats, shoes, four pairs of hose, a great coat of chamois hide, and leather to make new ones. The turning-lathe of Alessandro. Sell what you cannot carry. Get from Jean de Paris the method of colouring in tempera, and the way

[1] This interpretation is due to Gerolamo Calvi, who considers the note to have been written in the last years of Leonardo's life, either when on the point of departing from Rome or in France. His patron Giuliano de'Medici had died and the Medici Pope, Leo X, had failed to give him any employment commensurate with his powers. He thus sets in terse antithesis this destruction of his hopes and the fact that Lorenzo il Magnifico was his first patron. The latter statement is confirmed by the testimony of the Anonimo Gaddiano:—'*stette da giovane col Magnifico Lorenzo de'Medici, et dandolj provisione per se il faceva lavorare nel giardino sulla piaza di san Marcho dj Firenze, et haveva 30 annj, che dal detto Magnifico Lorenzo fu mandato al duca di Milano.*'

The sentence has also been held to refer to the medical profession to whom on occasion he alludes with marked asperity. In MS. F 96 v. he characterises them as 'destroyers of life'. In Arundel MS. 147 v. he speaks of men being chosen to be doctors for diseases about which they do not know.

[2] On the same page of MS. occurs the line
 Laus Deo 1500 *a di* [. . .] *marzo.*
The juxtaposition does not however warrant any supposition as to a visit to Rome of about this date.

[3] In MS. these words, presumably for reasons of secrecy, were written backwards.

of making white salt, and tinted papers either single or with many folds, and also his box of colours. Learn how to work flesh tints in tempera. Learn how to melt gum into lacquer-varnish. Take seed of . . . (*fotteragi*), of white cudweed[?] (*gniffe*) and of garlic from Piacenza. Take the 'De Ponderibus'. Take the works of Leonardo of Cremona. Carry the charcoal-burner which belongs to Giannino. Take the seed of lilies, of common lady's mantle, and of water-melon. Sell the boards of the scaffolding. Give the stove to whoever stole it. Learn levelling, how much soil a man can dig out in a day. c.a. 247 r. a

A certain ignoramus puffed up in obscurity, as is the gourd or the melon through excess of moisture or the plum swollen by the heavy showers. No! you have not described him well, don't you know [. . .]; he is an absolute fool [. . .] shaven head; but he lacks the cabbage [1] or the leaf of a gourd to loosen the scurf.

Say on, Sandro! [2] How does it strike you? I tell you what is true, and I have not made a success of it. c.a. 313 r. b

[*A list of drawings*]
 Many flowers drawn from nature.
 A head full-face with curly hair.
 Various Saint Jeromes.
 The measurements of a figure.
 Drawings of furnaces.
 A head of the duke.
 Many drawings of knots.
 Four drawings for the altar-piece of Sant' Angelo.
 A little history of Girolamo da Feghine.
 A head of Christ done with the pen.
 Eight Saint Sebastians.
 Many studies of angels.
 A chalcedony.
 A head in profile with beautiful hair.
 Some bodies in perspective.
 Some instruments for ships.

[1] *Il cavolo* (cabbage). Compare perhaps *mangiare il cavolo co' ciechi* (to have business with very silly people). Hoare, Ital. Dict.
[2] The reference may be to Sandro Botticelli.

Some machines for water.
A head-portrait of Atalanta raising her face.
The head of Hieronymo da Feglino.
The head of Gian Francesco Boso.
Many throats of old women.
Many heads of old men.
Many nudes, whole figures.
Many arms, legs, feet, and positions.
A Madonna, finished.
Another, almost in profile.
The head of the Madonna ascending into Heaven.
The head of an old man, very long.
A head of a gipsy woman.
A head with a hat on.
A history of the Passion made in a mould.
A head of a girl with tresses gathered in a knot.
A head with a coiffure.
A head of a youth, full face, with beautiful hair. c.a. 324 r. a

All the animals languish, filling the air with lamentations. The woods
fall in ruin. The mountains are torn open, in order to carry away the
metals which are produced there. But how can I speak of anything
more wicked than [the actions] of those who raise hymns of praise to
heaven for those who with greater zeal have injured their country and
the human race? c.a. 382 v. a

These piles should be from a third to half a braccio in thickness and
about two and a half braccia long; they should be of oak or alder, that
is of some close-grained wood, and most important of all they should
be green. I have watched the repair of part of the old walls of Pavia
which have their foundations in the banks of the Ticino. The piles there
which were old and were of oak were as black as charcoal, those which
were of alder had a red colour like Brazil-wood; they were of consid-
erable weight and as hard as iron, without any blemish. And when you
wish to drive in these piles you should make the beginning of the hole
for it with an iron stake. b. 66 r.

[Dated Note. Thefts of pupil. Pageant ararnged by Leonardo]

On the twenty-third day of April 1490 I commenced this book and recommenced the horse.

Giacomo came to live with me on St. Mary Magdalene's Day,[1] 1490, when ten years of age. Thievish, lying, obstinate, greedy.

The second day I had two shirts cut out for him, a pair of hose and a doublet, and when I put money aside to pay for these things he stole the money from the wallet, and it was never possible to make him confess, although I was absolutely convinced. 4 lire.

On the following day I went to supper with Giacomo Andrea, and the other Giacomo had supper for two and did mischief for four, for he broke three flagons, spilt the wine, and after this came to supper where I . . .

Item, on the seventh day of September he stole a style worth twenty-two soldi from Marco who was with me. It was of silver, and he took it from his studio. After the said Marco had searched for it a long time he found it hidden in the box of the said Giacomo. 2 lire 1 soldo.

Item, on the twenty-sixth day of the following January when I was in the house of Messer Galeazzo da Sanseverino in order to arrange the pageant at his tournament, and certain of the pages had taken off their clothes in order to try on some of the costumes of the savages who were to appear in this pageant, Giacomo went to the wallet of one of them as it lay on the bed with the other effects, and took some money that he found there. 2 lire 4 soldi.

Item, a Turkish hide had been given me in the same house by the Master Agostino of Pavia in order to make a pair of boots, and this Giacomo stole it from me within a month and sold it to a cobbler for twenty soldi, and with the money as he has himself confessed to me he bought aniseed comfits. 2 lire.

Item, further on the second day of April Giovanni Antonio chanced to leave a silver style upon one of his drawings, and this Giacomo stole it from him, and it was worth twenty-four soldi. 1 lira 4 soldi.

The first year: a cloak 2 lire, 6 shirts 4 lire, 3 doublets 6 lire, 4 pairs of hose 7 lire 8 soldi, a suit of clothes lined 5 lire, 24 pairs of shoes 6 lire 5 soldi, a cap 1 lira, laces for belt 1 lira. c 15 v.

[1] Twenty-second of July.

When I was at sea in a position equally distant from a level shore and a mountain, the side on which the shore was, seemed much farther off than that of the mountain.[1] L 77 v.

Like a eddying wind scouring through a hollow, sandy valley, and with speeding course driving into its vortex everything that opposes its furious onset . . .

Not otherwise does the northern blast drive back with its hurricane . . .

Nor does the tempestuous sea make so loud a roaring when the northern blast beats it back in foaming waves between Scylla and Charybdis, nor Stromboli nor Mount Etna when the pent up, sulphurous fires, bursting open and rending asunder the mighty mountain by their force, are hurling through the air rocks and earth mingled together in the issuing belching flames. . . .

Nor when Etna's burning caverns vomit forth and give out again the uncontrollable element, and thrust it back to its own region in fury, driving before it whatever obstacle withstands its impetuous rage. . . .

And drawn on by my eager desire, anxious to behold the great abundance of the varied and strange forms created by the artificer Nature, having wandered for some distance among the overhanging rocks, I came to the mouth of a huge cavern before which for a time I remained stupefied, not having been aware of its existence, my back bent to an arch, my left hand clutching my knee, while with the right I made a shade for my lowered and contracted eyebrows; and I was bending continually first one way and then another in order to see whether I could discern anything inside, though this was rendered impossible by the intense darkness within. And after remaining there for a time, suddenly there were awakened within me two emotions, fear

[1] In the sketch that accompanies this note a vessel is seen proceeding from a mountainous shore to one more low-lying. The note is designated by M. Ravaisson-Mollien 'an optical delusion'. Its major interest is in the biographical question it raises. That Leonardo was himself once at sea in a position equally distant between a level and a mountainous shore, both visible at once, is here clearly stated. In discussing the interpretation of the Armenian letters in the Codice Atlantico (*The Mind of L. da V.*, p. 232, etc.) I have shown that the experience is such as would befall a traveller journeying from Khelindreh, the medieval port of Armenia, mentioned in Leonardo's text as Calindra, to Cyprus, which is referred to in a passage in the Windsor Manuscripts, 'setting out from the coast of Cilicia towards the south you discover the beauty of the island of Cyprus'.

and desire, fear of the dark threatening cavern, desire to see whether there might be any marvellous thing therein. B.M. 155 r.

O powerful and once living instrument of constructive Nature, thy great strength not availing thee, thou must needs abandon thy tranquil life to obey the law which God and time ordained for all-procreative Nature! To thee availed not the branching, sturdy dorsal fins wherewith pursuing thy prey thou wast wont to plough thy way, tempestuously tearing open the briny waves with thy breast.

O how many times the frightened shoals of dolphins and big tunnyfish were seen to flee before thy insensate fury; and thou, lashing with swift, branching fins and forked tail, didst create in the sea sudden tempest with loud uproar and foundering of ships; with mighty wave thou didst heap up the open shores with the frightened and terrified fishes, which thus escaping from thee were left high and dry when the sea abandoned them, and became the plenteous and abundant spoil of the neighbouring peoples.

.

O Time, swift despoiler of created things! How many kings, how many peoples hast thou brought low! How many changes of state and circumstance have followed since the wondrous form of this fish died here in this hollow winding recess? Now, destroyed by Time, patiently it lies within this narrow space, and, with its bones despoiled and bare, it is become an armour and support to the mountain which lies above it.
 B.M. 156 r.

O how many times hast thou been seen amid the waves of the mighty, swelling ocean, towering like a mountain, conquering and overcoming them! And with black-finned back ploughing through the salt waves with proud and stately bearing! [1] C.A. 265 r. a

Tell me if anything was ever made . . . B.M. 251 v.

[1] This passage is placed here because of its evident connection with the two that precede it. They may be a personal reminiscence or an imaginary tale.

There are three versions of this passage in the manuscript:—

Oh quante volte fusti tu veduto in fra l'onde del gonfiato e grande occeano, col setoluto e nero dosso, a giusa di montagna, e con grave e superbo andamento.

E spesse volte eri veduto in fra l'onde del gonfiato e grande occeano, e col superbo e

EXPENSES FOR CATERINA'S BURIAL

For three pounds of wax	s.	27
For the bier	s.	8
Pall upon the bier	s.	12
Carrying and setting up of cross	s.	4
For the carrying of the dead	s.	8
For four priests and four clerks	s.	20
Bell, book, sponge	s.	2
For the gravediggers	s.	16
To the ancient	s.	8
For the licence and the officials	s.	1
		106
For the doctor		5
Sugar and candles	s.	12
		123

Forster II 64 v.

If liberty is dear to you, may you never discover that my face is love's prison. Forster III 10 v.

Finally through anger he has wounded the image of his God; think if I had found him.

And that which he cannot eat he sells, in order by these coins to be able to have command over the other men. Forster III 85 r.

[*Vices hard to extirpate*]

And in this case I know that I shall make few enemies, for no one will believe what I can say of him. For there are few whom his vices displease, in fact only those who are by nature averse to these vices. And many hate their fathers and break off friendships when they are

grave moto gir volteggiando in fralle marine acque. E con setoluto e nero dosso, a guisa di montagna, quelle vincere e soprafare.

Oh quante volte fosti tu veduto in fra l'onde del gonfiato e grande occeano, a guisa di montagna quelle vincere e soprafare, e col setoluto e nero dosso solcare le marine acque, e con superbo e grave andamento.

It is the same indefatigible patience seen in the attempt here in the armoury of words to fashion the thought to more exact expression, of the purpose of the mind which explains why there are sometimes so many studies for the same figure in Leonardo's drawings.

reproved for their vices; instances to the contrary have no weight with them, nor has any human counsel. Quaderni II 14 r.

[Wealth of words a difficulty]

I have so many words in my mother-tongue that I ought rather to complain of the lack of a right understanding of things, than of a lack of words with which fully to express the conception that is in my mind. Quaderni II 16 r.

I have wasted my hours.[1] Quaderni III 12 v.

I once saw how a lamb was licked by a lion in our city of Florence, where there are always from twenty-five to thirty of them, and they bear young. With a few strokes of his tongue the lion stripped off the whole fleece with which the lamb was covered, and having thus made it bare he ate it. Quaderni IV 9 v.

Tell me if anything similar was ever made: you understand, and that is enough for the present.[2] Quaderni IV 15 v.

Blue colour of the atmosphere . . . may be seen, as I myself saw it, by anyone who ascends Mon Boso [Monte Rosa], a peak of the chain of Alps that divides France from Italy. . . . The hail that accumulates there in summer I found very thick in the middle of July. Leic. 4 r.

In the mountains of Parma and Piacenza, multitudes of shells and corals filled with wormholes may be seen still adhering to the rocks.

When I was making the great horse at Milan a large sack of those which had been found in these parts was brought to my workshop by some peasants, and among them were many still in their original condition. Leic. 9 v.

There are, in many places, springs of water which rise for six hours and sink for six hours; and I have myself seen one above Lake Como called Fonte Pliniana. Leic. 11 v.

[1] Note written on the right-hand lower corner of a page that contains mathematical and architectural drawings, and others anatomical of the generative functions, with acoustical note and memoranda.

[2] This is on the same page with reduction of periphery of quadrant to straight line and calculation of spheres.

On one occasion above Milan, over in the direction of Lake Maggiore, I saw a cloud shaped like a huge mountain made up of banks of fire, because the rays of the sun which was then setting red on the horizon had dyed it with their colour. This great cloud drew to itself all the little clouds which were round about it. And the great cloud remained stationary, and it retained the light of the sun on its apex for an hour and a half after sunset, so enormous was its size. Leic. 28 r.

XLVII

Letters

*'There is not a man who is capable—and you may
believe me—except Leonardo the Florentine who is
making the bronze horse of the Duke Francesco;
and you can leave him out of your calculations alto-
gether, for he has a work to do which will last him
the whole of his life, and indeed I doubt whether he
will ever finish it, so great it is.'*

BERNARDO DI SIMONE.

As I told you in days past you know that I am without any . . . of
the friends . . . and the winter . . . which requires your deeds.

<div align="right">C.A. 4 v. b</div>

Dearest father,

On the last of the past month I had the letter you wrote to me which
in a brief space caused me pleasure and also sorrow. I was pleased at
learning from it that you were in good health, for which God be
praised. I was filled with sorrow at hearing of your discomfort.

<div align="right">C.A. 62 v. a</div>

[Fragment of letter written while at Rome]

I have satisfied myself that he accepts commissions from all and has
a public shop; for which reason I do not wish that he should work for
me at a salary, but that he should be paid for the works that he does
for me; and since he has workshop and house from the Magnifico he
should be obliged to give precedence to the works for the Magnifico
before all.

<div align="right">C.A. 92 r. b</div>

THE DIVISIONS OF THE BOOK

The preaching and persuasion of faith.
The sudden inundation down to its end.

The ruin of the city.

The death of the people and their despair.

The pursuit of the preacher and his liberation and benevolence.

Description of the cause of this fall of the mountain.

The havoc that it made.

The avalanche.

The finding of the prophet.

His prophecy.

The inundation of the lower parts of western Armenia, the channels in which were formed by the cutting of Mount Taurus.

How the new prophet showed that this destruction occurred as he had foretold.

Description of Mount Taurus and of the river Euphrates. To the Devatdar of Syria, lieutenant of the sacred Sultan of Babylon:

The recent unforeseen event which has occurred in these our northern parts which I am certain will strike terror not only into you but into the whole world shall be revealed to you in its due order, showing first the effect and then the cause.

Finding myself in this part of Armenia in order to discharge with devotion and care the duties of that office to which you have appointed me, and making a beginning in those parts which seem to me to be most suitable for our purpose, I entered into the city of Calindra which is near to our borders. This city is situated on the sea-coast of that part of the Taurus range which is separated from the Euphrates and looks westward to the peaks of the great Mount Taurus. These peaks are of such a height that they seem to touch the sky, for in the whole world there is no part of the earth that is higher than their summit, and they are always struck by the rays of the sun in the east four hours before day. And being of exceedingly white stone this shines brightly and performs the same office for the Armenians of these parts as the beautiful light of the moon would in the midst of the darkness; and by reason of its great height it outstretches the highest level of the clouds for a space of four miles in a straight line.

This peak is visible from a great part of the west illuminated by the sun after its setting during the third part of the night. And it is this which among you in calm weather has formerly been thought to be a

comet, and seems to us in the darkness of the night to assume various shapes, sometimes dividing into two or three parts, sometimes long and sometimes short. And this proceeds from the fact that the clouds on the horizon come between part of this mountain and the sun, and by their cutting these solar rays the light of the mountain is broken by various spaces of clouds and therefore its brightness is variable in shape.

Why the mountain shines at its summit half or a third of the night, and seems a comet after sunset to those who dwell in the west, and before sunrise to those who dwell in the east.

Why this comet seems variable in shape, so that at one time it is round, at another long, at another divided into two or three parts, at another united, and sometimes invisible and sometimes becoming visible again. C.A. 145 V. a

OF THE SHAPE OF MOUNT TAURUS

I am not justly to be accused of idleness, O Devatdar, as your strictures seem to intimate, but your unbounded affection which has caused you to confer these benefits upon me has constrained me to employ the utmost care in seeking out and diligently investigating the cause of so momentous and so startling an occurrence, and for this time was necessary.

In order now to make you well acquainted with the cause of so great an effect it is necessary that I shall describe the nature of the place, and then I will proceed to the event, by which process I believe you will be fully satisfied.

Do not distress yourself, O Devatdar, at my delay in replying to your urgent request, because the matters about which you have asked me are of such a nature as cannot well be expressed without lapse of time, and especially because in wishing to expound the cause of so great an effect it is necessary to describe exactly the nature of the place, and you will afterwards be able by means of this easily to satisfy yourself as to the above-mentioned request.

I will omit any description of the shape of Asia Minor, or of what seas or lands they are which determine the aspect of its surface, knowing as I do your diligence and care in your studies to be such that you will already have acquired this knowledge; I pass on therefore to

furnish you with an account òf the true shape of Mount Taurus which
has been the scene of so surprising and destructive a catastrophe, for
this may serve to advance our purpose.

It is this Mount Taurus which, according to many, is said to be the
ridge of the Caucasus, but, wishing to be quite clear about this, I set
myself to interrogate some of the inhabitants of the shores of the
Caspian Sea; and they inform me that although their mountains bear
the same name these are of greater height, and they confirm this
therefore to be the true Mount Caucasus, since Caucasus in the Scythian
tongue means 'supreme height'. And in fact nothing is known of the
existence either in the east or the west of any mountain of so great a
height, and the proof of this is that the inhabitants of those countries
which are on the west see the sun's rays illuminating part of its summit
for a fourth part of the longest night, and similarly with the countries
which are on the east.

OF THE STRUCTURE AND DIMENSIONS OF MOUNT TAURUS

The shadow of this ridge of the Taurus is so high that in the middle
of June when the sun is at the meridian it reaches to the borders of
Sarmatia, which are twelve days' journey, and in mid-December it
extends as far as the Hyperborean Mountains, which are a month's
journey to the north. And the side that faces the way the wind blows
is full of clouds and mists, because the wind which is cleft in twain
as it strikes against the rock and closes up again beyond it, carries with
it in this way the clouds from all parts and leaves them where it strikes,
and it is always full of thunderbolts through the great number of clouds
which are gathered there, and this causes the rock to be all fissured and
filled with huge débris.

This mountain at its base is inhabited by a very opulent people; it
abounds in most beautiful springs and rivers; it is fertile and teems
with everything that is good and especially in those parts which have a
southern aspect. After an ascent of about three miles, you come to
where begin the forests of great firs and pines and beeches and other
similar trees; beyond for a space of another three miles you find mead-
ows and vast pastures, and all the rest as far as the beginning of the

peak of Taurus is eternal snow, for this never disappears in any season, and it extends at this height for about fourteen miles in all. From the point where the peak begins for about a mile the clouds never pass, so that they extend for about fifteen miles with a height of about five in a straight line. As far beyond or thereabouts we find the summit of the peaks of Taurus, and here from about half way upwards we commence to find the air grow warm, and there is no breath of wind to be felt and nothing can live there very long. Nothing is brought forth there except some birds of prey, which nest in the deep gorges of the Taurus and descend below the clouds to seek their prey upon the grassy hills. It is all bare rock from above where the clouds are, and the rock is of a dazzling whiteness, and it is not possible to go to the lofty summit because the ascent is rough and dangerous. c.a. 145 v. b

People were to be seen who in a state of great excitement were bringing together all sorts of provisions upon vessels of all descriptions hastily put together as necessity dictated.

The gleaming of the waves was not visible in the parts that reflected the dark rain and the clouds. But where they reflect the flashes produced by the thunderbolts, as many gleams were seen caused by the images of these flashes as were the waves that reflected them to the eyes of the spectators. And the number of the images caused by the flashes of the lightning upon the waves of the water increased in proportion to the distance of the eyes of the spectators. Similarly also the number of the images diminished in proportion as they were nearer to the eyes which saw them; as is proved in the definition of the radiance of the moon and of our maritime horizon, when the sun is reflected there with its rays and the eye which receives this reflection is at a great distance from this sea. c.a. 155 r. b

I wished to keep him to eat with me, as . . .

He went to eat with the bodyguard, and through this not only did he spend two or three hours at table, but very frequently the remainder of the day was spent in going about with a gun amid the ruins killing birds.

And if any of my servants entered the workshop he abused them, and if anyone reproved him he said that he was working for the arsenal

cleaning armour and guns. As regards money, right from the very beginning of the month he was very eager to get hold of it.

And in order not to be disturbed he left the workshop and made himself one in his room, and worked for others, and so at last I had to tell him . . .

As I saw that he was very little in the workshop and consumed a good deal, I sent a message to him that if it pleased him I would strike a bargain with him for whatever he made, and have it valued, and I would then give him as much as we agreed upon: he took counsel with his neighbour and gave up his room, selling everything and came to look for . . .

This other has hindered me in anatomy before the Pope, traducing me, and also with the hospital; and he has filled the whole of this Belvedere with workshops for mirrors, and workmen, and he has done the same in the apartment of the master Giorgio.

He never did any work without discussing it every day with Giovanni, who then spread the news of it and proclaimed it everywhere, stating that he was a master of such art; and as regards the part which he did not understand he announced that I did not know what I wanted to do, thus shifting the blame of his ignorance upon me.

I cannot make anything secretly because of him, for the other is always at his elbow, since the one room leads into the other. But his whole intent was to get possession of these two rooms in order to get to work on the mirrors. And if I set him there to make my model of a curved one he would publish it.

He said that he had been promised eight ducats per month, to commence from the first day that he set out, or at latest from when he had his interview with you, and that you agreed to this. c.a. 182 v. c

My most beloved brother,[1]

This is sent merely to inform you that a short time ago I received a letter from you from which I learnt that you have had an heir, which circumstance I understand has afforded you a great deal of pleasure. Now in so far as I had judged you to be possessed of prudence I am now entirely convinced that I am as far removed from having an accurate judgment as you are from prudence; seeing that you have been

[1] Reference, according to Beltrami, is to Domenico who was born in 1484.

congratulating yourself in having created a watchful enemy, who will strive with all his energies after liberty, which can only come into being at your death. c.a. 202 v. a

You wished the utmost evil to Francesco and have let him enjoy your property in your life; to me you do not wish great evil . . .

To whom have you wished better? To Francesco or to me? To you he wishes it, and he gives mine after me so that I cannot act according to my wish, and he knows that I cannot alienate my heir. He wishes then to demand from my heirs and not as F., but as one entirely alien, and I as one entirely alien will receive him and his.

Have you given such money to Leonardo? No. Oh what excuse whether feigned or true will you be able to give for having drawn him into this trap, except to take him and his money. And I will not say anything to him as long as he lives. You do not wish therefore to repay the money lent on your account to his heirs; but you wish that he should pay over the revenues that he has from this possession.

Oh why do you not allow him to enjoy them during his life, since afterwards they would return to your children, and he cannot live many years?

If then you take into account that I may do that, you will wish that I was the heir, because I should not be able as heir to demand from you the moneys which I had had from Francesco. c.a. 214 v. a

As I have in my letters rejoiced with you many times over your prosperous fortunes so I know now that you as a friend will share my sorrow at the miserable condition to which I am reduced; for the fact is that in these last days I have had so many anxieties, so many fears, dangers and losses, as have also the wretched country-folk, that we have come to envy the dead.

And certainly I for my part cannot imagine that since first the elements by their separation made order out of chaos, they can ever have united their force or rather their frenzy to work such destruction to mankind, as has now been seen and experienced by us; so that I cannot imagine what could further increase so great a misfortune as this that we have experienced in a space of ten hours. First we were assailed and buffeted by the might and fury of the winds, and then followed the avalanches from the great snow-covered mountains which

have choked up all these valleys, and caused a great part of this city to fall in ruins. And, not content with this, the tempest has submerged with a sudden deluge of water all the lower parts of the city; and beyond all this there was added a sudden storm of rain and a furious hurricane, laden with water, sand, mud, and stones all mingled together with roots, branches, and stumps of various trees; and every kind of thing came hurtling through the air and descended upon us, and finally a great fire—which did not seem to be borne by the wind but as though carried by thirty thousand devils—has burnt up and destroyed all this country and has not yet ceased. And the few of us who remain are left in such a state of dismay and fear that, like those who are half-witted, we scarce dare to hold speech one with another, but giving up even the attempt at work we stay huddled together in the ruins of some of the churches, men and women small and great all mingled together like herds of goats; and but for certain people having helped us with provisions we should all have died of hunger. Now you can understand the state we are in; and yet all these evils are as nothing by comparison with those which threaten us within a brief space of time.

I know that you as a friend will have a fellow-feeling for my misfortunes, even as I in my former letters have shown myself glad at your prosperity.[1] c.a. 214 v. d

[*Drafts of parts of a letter to the Venetian Senate concerning the defences of the Isonzo against the Turks*][2]
My most illustrious Lords,

As I have perceived that the Turks cannot invade Italy by any part of the mainland without crossing the river Isonzo . . . and although I know that it is not possible to devise any means of protection which shall endure for any length of time, I cannot refrain from bringing to your notice the fact that a small number of men aided by this river might do the work of many, seeing that where these rivers . . .

I have formed the opinion that it is not possible to make a defence

[1] From the subject matter of this letter it would seem to have been written at about the same time as those to the Devatdar of Syria.

All this letter is crossed out in MS. Passages in brackets have been crossed out severally in addition.

in any other position which would be of such universal efficacy as that made over this river.

In proportion as the water is more turbid it is heavier, and as it is heavier it is the swifter in its descent, and that substance which is swifter makes more impression upon its object.

They will approach by night if they are suspicious of . . .

An armed force cannot prevail against these if it is not united, and if it is united it can only be in one particular place, and being thus united in one particular place it is either weaker or stronger than the enemy; and if it be weaker and this be discerned by the enemy by means of its spies they will pass by treachery . . .

(I having) my most illustrious lords (examined closely the river of the Isonzo) having the conditions (and in addition to this having been informed) by the country-folk (I have been informed) how from whatever side (the country-folk) the enemy may arrive.

My most illustrious Lords—As I have carefully examined the conditions of the river Isonzo, and have been given to understand by the country-folk that whatever route on the mainland the Turks may take in order to approach this part of Italy they must finally arrive at this river, I have therefore formed the opinion that even though it may not be possible to make such defences upon this river as would not ultimately be ruined and destroyed by its floods . . .

My most illustrious Lords—As I have (well considered the conditions of the river) recognised that by whatever side of the mainland the Turks may think to approach our Italian lands they must needs finally arrive at them by the river Isonzo . . .

OF CHANGING THE POSITION OF THE RIVER

Of what may be said against its permanence, and what the logs which are brought by the rivers will break.

To this I reply that all the supports should be equal in height with the lowest depth of the banks; so if the river should come to rise to this height it will not enter in the woods near to the bank, and not

entering there it will not be possible for it to carry away any logs, and so the river will flow with only its own water in mere turbulence.

And if it rises above its bank, as has been seen this year when it rose about four braccia above the lower bank, it carries very great logs with it, bearing them floating along accompanying its course, and then leaves them resting firmly fixed against the larger trees which are of such a kind as to offer resistance, and they remain caught in the branches.

If however they are borne along on the river it is because they have few or no branches and float on the surface and do not touch the toothed barrier which I have set up.

When the great floods come which carry logs and very large trees they will pass four or five braccia above the tops of these defences, and the signs of this are seen by the objects left fixed to the branches of the trees when it has risen.

When the water has no current it will easily and speedily become choked up with faggots, for those which have fallen into it will be always turning back . . .[1] C.A. 234 v. c

So greatly did I rejoice, most illustrious Lord, at your much wished-for restoration to health that I found my own malady had almost left me at the news of your Excellency's recovery. But I am extremely sorry that I have not been able entirely to satisfy your Excellency's desires, through the malice of this rogue, as regards whom I have never omitted to do anything which I possibly could which might be of service to him. In the first place, his salary was always paid him before it was due,

[1] I have ventured to change the order of a few of the sentences of this letter as they occur in the edition published by the Accademia dei Lincei, in the attempt to enhance the sense of continuity.

On the same page is a slightly drawn sketch or plan of road and river communications with the words *ponte di goritia* (bridge of Gorizia) and *vil pagho alta alta*. The last word refers presumably to the nature of the land, the first is identical with Wippach (Italian Vipacco), the name of an eastern tributary of the Isonzo and also of a village under which it flows, which lies on a spur of the hills some twenty kilometres west of Gorizia. From the position of Wippach it would seem to dominate the road across the mountains from Laibach to Gorizia, which would be the probable route that would be taken by an army advancing from the east to cross the Isonzo at Gorizia. Wippach lies some four kilometres to the south of this road and is connected with it by two roads running north-east and north-west.

which I believe he would gladly deny if it were not that I had the signature witnessed by the hand of the interpreter. And as I saw that he would not work for me unless he could not find any work to do for others, and that he sought for this diligently, I urged him to have his meals with me and to work with his files near to me, for besides this being economical and good for his work it would help him to acquire Italian; and so he always promised to do but he was never willing to do it. He acted in this way because that German Giovanni who makes mirrors was every day in his workshop, and wanted to see and understand all that was being done and then talked about it everywhere, finding fault with what he did not understand. And also because he went to dine with the men of the Pope's guard, and then went out with them with guns to kill birds in the ruins, and pursued this course from dinner-time until the evening. And if I sent Lorenzo to him to urge him to work he got in a rage with him, and told him that he wasn't going to have so many masters over him, and that he was at work upon your Excellency's Wardrobe. So two months passed and the thing still went on, until one day happening to find Gian Niccolò of the Wardrobe I asked him whether the German had finished his work for Il Magnifico, and he told me that it was none of it true because he had only given him two guns to clean. After this when I expostulated with him he left the workshop and began to work in his own room, and wasted a lot of time in making another vice and files and other instruments with screws, and made shuttles there to twist silk and gold, which he hid whenever any of my people went in, and this with a thousand oaths and revilings, so that none of them were willing to go there any more.

So greatly did I rejoice, most illustrious Lord, at your much wished-for restoration to health that my own malady almost left me. But I greatly regret that I have been unable to satisfy the desires of your Excellency, entirely through the malice of that German rogue, as regards whom I have left nothing undone which I thought might give him pleasure. And firstly because I invited him to take up his abode and have meals with me, so that I could always see what work he was doing and could easily correct his errors, and moreover he would acquire Italian and so be able to speak it easily without an interpreter, and most important of all the moneys due to him could always be paid

before the time, as always has been. Then he asked that he might have the models finished in wood just as they were to be in iron, and wished to carry them away to his own country. But this I refused, telling him that I would give him a drawing of the width, length, thickness and outline of what he had to, and so we remained at enmity.

The second thing was that in the room where he slept he made himself another workshop with new screw-vices and instruments, and there worked for others. Afterwards he went to dine with the Swiss of the Guard where there are plenty of idlers, but he beat them all at it. Then he used to go out and more often than not two or three of them went together with guns to shoot birds among the ruins, and this went on until the evening.

Finally I discovered that it was this master Giovanni who made mirrors who had brought all this about and this for two reasons; first because he had said that my coming here had deprived him of the countenance and favour of your Lordship which always . . ., and the other reason is because he says the room of this iron-worker would suit him for working at mirrors, and he has given proof of this, for besides setting him against me he has made him sell all his effects and leave his workshop to him, and he has established himself there now with a number of assistants making many mirrors to send to the fairs.

<div align="right">C.A. 247 v. b</div>

My Lords, Fathers, Deputies,—Just as for the doctors, the tutors and guardians of the sick, it is necessary that they should understand what man is, what life is, and what health is, and how a parity or harmony of elements maintains this, and in like manner a discord of these ruins and destroys it; and anyone who has acquired a good knowledge of these conditions will be better able to effect cures than one who is without it . . .

You know that medicines when well used restore health to the sick: they will be well used when the doctor together with his understanding of their nature shall understand also what man is, what life is, and what constitution and health are. Know these well and you will know their opposites; and when this is the case you will know well how to devise a remedy—

You know that medicines when well used restore health to the sick, and he who knows them well will use them well when he also knows what man is, and what life and the constitution are, and what health is. Knowing these well he will know their opposites, and being thus equipped he will be nearer to devising a remedy than anyone else. In just the same way a cathedral in need of repair requires a doctor-architect who understands well what a building is, and on what rules the correct method of construction is based, and from whence these rules are derived, and into how many parts they are divided, and what are the causes which hold the structure together, and make it permanent, and what the nature of weight is and what the desire of strength, and how these should be interwoven and bound up together, and what effect their union produces. Whoever shall have a true knowledge about the above-named things will satisfy you both by his intelligence and his work.

So for this reason I shall endeavour without disparaging and without defaming anyone to satisfy you partly by arguments and partly by demonstration, sometimes revealing the effects from the causes, sometimes confirming the reasoning from experience, fitting with them certain of the principles of the architects of old time and the evidence of the buildings they constructed and [showing] what were the reasons of their destruction or their permanence.

And I shall show at the same time what is the first [law] of weight, and what and how many are the causes which bring ruin to buildings, and what is the condition of their stability and permanence.

But in order not to be diffuse to your Excellencies I will speak first of the invention of the first architect of the cathedral, and will show you clearly what was his purpose, confirming this by the building which has been commenced, and when I have made you understand this you will be able clearly to recognise that the model which I have constructed possesses in itself that symmetry, that harmony, and that regularity which belongs to the building already begun.

What a building is, and where the rules of sound construction derive their origin, and what and how many are the parts that belong to these. . . .

Either I or some other who may expound it better than I, choose him, and set aside all partiality. c.a. 270 r. c

Though the marble should be delayed for ten years I do not wish
to wait for my payment beyond the term of the end of my work.

<div align="right">C.A. 277 V. a</div>

So greatly did I rejoice, most illustrious Lord, at your much wished
for restoration to health that my own malady almost left me, for which
God be praised. But I am extremely sorry that I have not been able
entirely to satisfy your Excellency's desires, through the malice of this
German rogue, as regards whom I have left nothing undone which I
thought would give him pleasure.

And in the first place his money was always paid in full before the
date of the month at which his salary was due; secondly I invited him
to lodge and board with me; for which purpose I was prepared to set
up a table at the foot of one of these windows, where he could work
with his file and finish the things he had made below; and by this
means I should always see the work that he did and it could be cor-
rected with ease. And besides this he would learn the Italian language
and so be able to speak it easily without an interpreter. C.A. 283 r. a

[Fragments of a letter to Ludovic Sforza]

I do not regret so much my being. . . .

I regret very much my being in want, but I mourn for it the more
because it has been the means of preventing me from carrying out my
desire, which has always been to obey your Excellency.

I regret very much that you should have requisitioned me and found
me in want, and that the fact of my having to gain my living should
have hindered me.

I regret very much that the fact of my having to gain my living
should have prevented me from continuing the work which your
Highness has entrusted to me: but I hope that within a short time I
shall have earned so much as to be able with a tranquil mind to sat-
isfy your Excellency, to whom I commend myself. If your Highness
thought that I had money, you were deceived, for I have had six
mouths to feed for thirty-six months, and I have had fifty ducats.

It may be that your Excellency did not give any further orders to
Messer Gualtieri, believing that I had money. C.A. 315 V. a

I suspect that the poor return I have **made for** the great benefits

that I have received from your Excellency, may have made you some-
what indignant with me, and thus it is that I have written so many
letters to your Lordship and have never had a reply. I now send Salai
to you, to explain to your Lordship that I am almost at the end of the
lawsuit that I have had with my brothers, and that I expect to find
myself with you this Easter, and to bring with me two pictures of the
Madonna, of different sizes, which have been made either for our Most
Christian King, or for whomsoever your Lordship pleases. I should be
very glad to know on my return there where I am to take up my
abode, as I would not give any more trouble to your Lordship; and
also, as I have been working for the Most Christian King, whether my
salary is to continue or not.

I am writing to the President about that water which the King
granted me, and of which I was not given the possession, because at
that time there was a shortage in the canal by reason of the great
drought, and because its outlets were not being regulated; but he gave
me a definite promise that when this was done I should be put in pos-
session, so that I beseech your Lordship not to be unwilling now that
the outlets are regulated to remind the President of my suit, namely
that I should be given possession of this water, for when I am estab-
lished there I look forward to constructing machines and devices which
should be a source of great pleasure to our Most Christian King. Noth-
ing else occurs to me. I am always at your commands. c.a. 317 r. b

Piacenza is a place of resort like Florence.

Illustrious Commissioners of Buildings! hearing that your Excellen-
cies have resolved upon the construction of certain great works in
bronze, I propose to offer you certain counsels on the subject. First
then take care not to act so swiftly and hastily in awarding the com-
mission that by your speed you put it out of your power to make a
good choice both of subject and of a master, as Italy has a number of
men of capacity. Some fellow, that is, who by his incompetence may
afterwards afford occasion to your successors to cast blame on your-
selves and your generation, judging that this age was poorly equipped
either with men of good judgment or good masters, seeing that other
cities and especially the city of the Florentines were almost at this very
same time enriched with such beautiful and great works in bronze,

amongst these being the gates of their baptistery. Florence indeed, like Piacenza, is a place of resort, where many visitors congregate, and these when they see its beautiful and stately works of art form the impression that the city must have worthy inhabitants, seeing that these works serve as evidence of this; but they form quite a different impression if they see a great expenditure in metal wrought so poorly that it would be less of a reproach to the city if the doors were of plain wood, for then the material would have cost little and therefore would not seem to require a great degree of skill.

Now, the parts principally sought for in cities are their cathedrals, and, as one approaches these, the first objects which meet the eye are their doors by which one enters into the churches.

Beware, gentlemen of the Commission, lest the too great speed, whereby you desire, with such swiftness as I perceive you use, to allot the commission for so important a work, may become the reason why what was intended for the honour of God and of men may prove a great dishonour to your judgment and to your city, where as it is a place of distinction and of resort there is an innumerable concourse of visitors. This disgrace would befall you if by your negligence you put your trust in some braggart who, by his subterfuges or by the favour here shown him, were to be awarded such a commission by you as should bring great and lasting shame both to him and to you.

I cannot help feeling angry when I reflect upon the sort of men who have made me a confidant of their desire to embark upon such an undertaking, without giving a thought to their capacity for it—not to say more.

One is a maker of pots, another of cuirasses, a third makes bells and another collars for them, another even is a bombardier; yet another is in the Duke's household and boasts that he is by way of being an intimate acquaintance of Messer Ambrogio Ferrere, and that he has some influence and has made certain promises to him, and if this does not satisfy you he will get on his horse and ride off to the Duke, and will get such letters from him that you will never be able to refuse him the work.

But consider to what straits the poor masters who by study have made themselves competent to execute such works are reduced, when

they have to contend against fellows like these! What hope have they of being able to look for reward for their talent!

Open your eyes and try to ensure that your money is not so spent as to purchase your own shame. I can assure you that from this district you will get nothing except the works of hard, mean, or clumsy masters. There is not a man who is capable—and you may believe me—except Leonardo the Florentine who is making the bronze horse of the Duke Francesco; and you can leave him out of your calculations altogether, for he has a work to do which will last him the whole of his life, and indeed I doubt whether he will ever finish it, so great it is.

C.A. 323 r. b

Here is one whom the Lord has invited from Florence to do this work for him and he is a capable master, but he has so much, oh! so much, to do that he will never finish it.

What do you imagine is the difference between seeing a beautiful object and an ugly one? Quote Pliny. C.A. 323 v. b

[Fragment of letter to Ludovic Sforza] (*MS. Sheet torn vertically*)

And if you give me some further commission for any [. . .]
for the reward of my service for I am unable to [. . .]
certain drafts because they have revenues from [. . .]
who can adjust them properly more than I can [. . .]
not my art which I wish to change and [. . .]
given some clothing.

My Lord, knowing the mind of your Excellency to be
 occupied [. . .]
to remind your Lordship of my small matters, and I
 should have maintained silence [. . .]
that my silence should be the cause of making your Lord-
 ship become angry [. . .]
my life to your service I hold myself ever ready to obey [. . .]
Of the horse I will say nothing because I know the
 times [. . .]
to your Lordship how my salary is now two years
 in arrear of [. . .]

with two masters whose salaries and board I have always
paid [. . .]
that at last I found that I had advanced the said work
about fifteen lire [. . .]
works of fame by which I could show to those who are to
come that I have been [. . .]
does everywhere; but I do not know where I could spend
my work in order to [. . .]
I have been occupied with gaining a living
Through not being informed in what condition I find
myself as it [. . .]
you remember the commission to paint the Camerini [. . .]
I conveyed to your Lordship only requesting from you [. . .]

C.A. 335 V. a

Amid the whirling currents of the winds were seen a great number
of companies of birds coming from distant lands, and these appeared
in such a way as to be almost indistinguishable, for in their wheeling
movements at one time all the birds of one company were seen edge-
wise, that is showing as little as possible of their bodies, and at another
time showing the whole measure of their breadth, that is full in face;
and at the time of their first appearance they took the form of an
indistinguishable cloud, and then the second and third bands became
by degrees more clearly defined as they approached nearer to the eye
of the beholder.

And the nearest of the above-mentioned bands dropped down low
with a slanting movement, and settled upon the dead bodies, which
were borne along by the waves of this great deluge, and fed upon
them, and so continued until such time as the buoyancy of the inflated
dead bodies came to fail, and with slow descent they sank gradually
down to the bottom of the waters.[1] C.A. 354 V. b

Illustrious President, I am sending Salai, my pupil, to you as the
bearer of this, and you will learn from his own mouth the reason of
my great . . .

Illustrious President,—Having often remembered the promises made
to me by your Excellency, I have several times thought of insuring

[1] See Note on page 1139.

myself by writing and reminding you of the promise made to me at my last departure, namely as to the possession of those twelve ounces of water granted to me by the Most Christian King. Your Lordship knows that I did not enter into possession of it, because at the time when it was granted to me there was a dearth of water in the canal, partly on account of the great drought and partly because the outlets had not yet been regulated. But your Excellency promised me that when this had taken place I should have my expectations fulfilled. Consequently when I was given to understand that the canal had been regulated I wrote several times to your Lordship and to Messer Girolamo da Cusano who has the deed of gift in his keeping, and I wrote also to Corigero, but have never had any reply.

I am now sending to you as bearer of this [letter] Salai, my pupil, to whom your Lordship will be able to tell by word of mouth all that has occurred as regards the matter in which I am petitioning your Excellency.

I expect to be with you this Easter as I am almost at the end of my lawsuit, and I shall bring with me two Madonna pictures which I have begun, and which considering the time at my disposal I have brought to a very fair state of completion. Nothing else occurs to me. . . .

My Illustrious Lord [Antonio Maria], the affection which your Excellency has always shown to me and the benefits which I have received from you are continually in my thoughts.

I have a suspicion that the small response I have made for the great benefits which I have received from your Excellency may have made you somewhat incensed with me; and that this is the reason why I have never had any reply to the many letters that I have written to your Excellency. I am now sending Salai to you to explain to your Lordship that I am almost at the end of my litigation with my brothers, and that I hope to be with you this Easter, and to bring with me two pictures of the Madonna of different sizes, which I have begun for the Most Christian King or for whomsoever else it shall please you. I shall be very glad to know on my return there where I am to have my lodging, because I would not wish to give any more trouble to your Lordship, and further whether seeing that I have been engaged in work for the Most Christian King my salary is to continue or not. I

am writing to the President of that water which the king granted me, of which I was not given possession on account of the scarcity in the canal due to the great drought, and to the fact of the outlets not having been regulated; he promised me however that as soon as this was done I should be put in possession; so that I beseech you if you should happen to meet the said President not to think it irksome, now that these outlets are regulated, to remind him to have me put in possession of this water, since I am given to understand that in great measure it rests with him. Nothing else occurs to me. I am always at your commands.

Good day to you, Messer Francesco, God knows why when I have written you so many letters you have never made me a single reply. Just wait until I come to you, by God, for I will make you write so much that you will perhaps be sorry for it.

Dear Messer Francesco, I am sending Salai to you in order to learn from his Excellency the President what conclusion has been reached in the matter of the regulation of the water, since at my departure the order for the outlets of the canal had been set in hand; because the illustrious President promised me that my claim should be settled so soon as ever this adjustment had been made. It is now a considerable time since I learnt that the canal was set in working order and likewise its outlets, and I wrote immediately to the President and to you, and then repeated my letters, but have never had any reply. Will you therefore have the kindness to write and inform me what has taken place, and unless it is actually on the point of settlement, will you for my sake be so kind as to exert a little pressure on the President and also on Messer Girolamo da Cusano, to whom please commend me, and also offer my respects to his Excellency? c.a. 372 v. a

I have one who having promised himself things from me which were not at all what he deserved, and being baulked of his presumptuous desire has tried to turn all my friends from me. And because he has found them wise and not pliant to his will, he has threatened me that he will spread such a report [1] about me as will deprive me of my benefactors. For this reason I have informed your Lordship of this, so

[1] *relazione*, (MS., . . . *zione*).

that when this fellow attempts to sow the usual scandals he may find no ground suitable for sowing to receive the thoughts and acts of his evil nature. Consequently if he should try to make your Lordship the instrument of his wicked and malicious nature he may be left baulked of his desire. C.A. 389 v. d

[Draft of letter to Ludovic Sforza, 1482 (circa)]

Most Illustrious Lord, having now sufficiently seen and considered the proofs of all those who count themselves masters and inventors of instruments of war, and finding that their invention and use of the said instruments does not differ in any respect from those in common practice, I am emboldened without prejudice to anyone else to put myself in communication with your Excellency, in order to acquaint you with my secrets, thereafter offering myself at your pleasure effectually to demonstrate at any convenient time all those matters which are in part briefly recorded below.

1. I have plans for bridges, very light and strong and suitable for carrying very easily, with which to pursue and at times defeat the enemy; and others solid and indestructible by fire or assault, easy and convenient to carry away and place in position. And plans for burning and destroying those of the enemy.

2. When a place is besieged I know how to cut off water from the trenches, and how to construct an infinite number of bridges, mantlets, scaling ladders and other instruments which have to do with the same enterprise.

3. Also if a place cannot be reduced by the method of bombardment, either through the height of its glacis or the strength of its position, I have plans for destroying every fortress or other stronghold unless it has been founded upon rock.

4. I have also plans for making cannon, very convenient and easy of transport, with which to hurl small stones in the manner almost of hail, causing great terror to the enemy from their smoke, and great loss and confusion.

9. And if it should happen that the engagement was at sea, I have plans for constructing many engines most suitable either for attack or defence, and ships which can resist the fire of all the heaviest cannon, and powder and smoke.

5. Also I have ways of arriving at a certain fixed spot by caverns and secret winding passages, made without any noise even though it may be necessary to pass underneath trenches or a river.

6. Also I can make armoured cars,[1] safe and unassailable, which will enter the serried ranks of the enemy with their artillery, and there is no company of men at arms so great that they will not break it. And behind these the infantry will be able to follow quite unharmed and without any opposition.

7. Also, if need shall arise, I can make cannon, mortars, and light ordnance, of very beautiful and useful shapes, quite different from those in common use.

8. Where it is not possible to employ cannon, I can supply catapults, mangonels, *trabocchi* and other engines of wonderful efficacy not in general use. In short, as the variety of circumstances shall necessitate, I can supply an infinite number of different engines of attack and defence.

10. In time of peace I believe that I can give you as complete satisfaction as anyone else in architecture in the construction of buildings both public and private, and in conducting water from one place to another.

Also I can execute sculpture in marble, bronze or clay, and also painting, in which my work will stand comparison with that of anyone else whoever he may be.

Moreover, I would undertake the work of the bronze horse, which shall endue with immortal glory and eternal honour the auspicious memory of the Prince your father and of the illustrious house of Sforza.

And if any of the aforesaid things should seem impossible or impracticable to anyone, I offer myself as ready to make trial of them in your park or in whatever place shall please your Excellency, to whom I commend myself with all possible humility. c.a. 391 r. a

[*Fragment of letter*]

All the evils that exist or that ever have existed set in train by this man would not satisfy the desire of his malignant spirit.

[1] MS., *carri coperti*.

No length of time would suffice me to unfold this man's nature to you, but I am fully convinced that . . . H 137 [6 v.] r.

To release my salary, not to give out the works in a block, but to bring about that the chief official be he who by the use of my instruments curtails all the superfluous and cumbersome inventions of those of whom one makes use. L 91 r.

> To my most illustrious Lord, Ludovic,
> Duke of Bari,
> Leonardo da Vinci, Florentine,
> Leonardo . . .[1] Forster III 62 v.

May it please you to look at a model[2] which may be of advantage both to you and to me and its usefulness may extend to those who will be the cause of our usefulness. Forster III 68 r.

Most Illustrious, most Reverend, and my Unique Lord, The Lord Ippolito, Cardinal of Este, My Supreme Lord, at Ferrara.

Most Illustrious and Most Reverend Lord,

A few days ago I arrived from Milan, and finding that one of my elder brothers refuses to carry out the provisions of a will made three years ago when our father died: as also no less because I would not seem to myself to fail in a matter that I consider most urgent, I cannot forbear to request of your most Reverend Highness a letter of commendation and favour to Ser Raphaello Hieronymo, who is now one of the members of our illustrious Signoria before whom my case is being tried; and more particularly it has been referred by his Excellency the Gonfaloniere to the said Ser Raphaello, so that his Lordship may be able to reach a decision and bring it to completion before the coming of the festival of All Saints.

And therefore, my Lord, I beseech you, as earnestly as I know how and am able, that your Highness will write a letter to the said Ser Raphaello in that happy and engaging manner that you have the art

[1] Opening words of letter written presumably before September 1494 at which date Ludovic was proclaimed Duke of Milan.

[2] The model here referred to may be that of the equestrian statue exhibited in Milan on the occasion of the marriage of the Emperor Maximilian with Bianca Maria Sforza in the year 1493.

of, commending to him Leonardo Vincio, your most humble servant, as I call myself and always wish to be; requesting and urging that he may be desirous not only to do me justice but to do so with kindly urgency; and I have no doubt at all from many reports that have reached me that inasmuch as Ser Raphaello is most kindly disposed to your Highness the matter will then proceed *ad votum*. And this I shall attribute to the letter of your most Reverend Highness, to whom once more I commend myself.[1] *Et bene valeat.*

Florence 18 September 1507.

E.V.R.D.

Your most humble servant,
Leonardus Vincius, *pictor.*

[1] Text in Marchese G. Campori: Nuovi Documenti per la Vita di Leonardo da Vinci. 'Atti e Memorie della R. Deputazione di storia patria di Modena,' 1865.

XLVIII

Dated Notes

'This winter of the year 1510 I look to finish all this anatomy.'

ON THE second day of April 1489 the book entitled 'Of the Human Figure'. Fogli B 42 r.

In eighty-nine [the year 1489] there was an earthquake in the sea of Satalia near to Rhodes. Leic. 10 v.

On the twenty-third day of April 1490 I commenced this book and recommenced the horse. c 15 v.

On the last day but one of February.
Thursday on the twenty-seventh of September.
The master Tommaso has returned, he has worked for himself down to the last day but one of February.
On the eighteenth day of March 1493 Giulio the German came to live with me.

Antonio, Bartolomeo, Lucia, Piero, Lionardo.

On the sixth day of October. Forster III 88 v.

On the sixteenth day of July.
Caterina[1] came on the sixteenth day of July 1493. Forster III 88 r.

1493.
On the first day of November we made up our accounts. Giulio had to pay for four months and the master Tommaso for nine. The master

[1] Caterina was the name of his housekeeper. See note as to household accounts of 29 January 1494 (p. 1157). There is a note in Forster MS. II as to the expenses of Caterina's burial: (see p. 1129) Caterina was the name of Leonardo's mother and conjecture may feed upon these facts.

Tommaso afterwards made six candlesticks: ten days. Giulio some fire-tongs: fifteen days. Then Giulio worked for himself up to the twenty-seventh of May, and worked for me at a lifting-jack until the eighteenth day of July, afterwards for himself until the seventh day of August, and in this month, a day for a lady, then for me for two locks until the twentieth day of August. H 106 [37 r.] v.

[Accounts]
 On the twenty ninth day of January 1494.

Cloth for hose	four lire of five soldi	
Lining	sixteen soldi	
Making	eight soldi	
Salai	eight soldi	
Ring of jasper	thirteen soldi	
Sparkling stone	eleven soldi	
Caterina	ten soldi	
Caterina	ten soldi	H 64 [16] v.

On the 2nd day of February 1494 at the Sforzesca I have drawn twenty-five steps each of two thirds of a braccio and eight braccia wide. H 65 [17] v.

On the twenty-fifth day of August twelve lire from Polyxena.

On the fourteenth day of March 1494 Galeazzo came to live with me, agreeing to pay five lire a month for his keep, paying on the fifteenth day of each month.

His father gave me two Rhenish florins.

On the fourteenth day of July I had two Rhenish florins from Galeazzo. H 41 r.

Vineyards of Vigevano. On the 20th day of March 1494. And in the winter they are covered with earth. H 38 r.

On the fifth day of September 1494 Giulio began the lock of my small study. H 105 [38 v.] r.

To-morrow morning on the second day of January 1496 I will make the thong and the attempt. C.A. 314 r. b

[*Salaino expenses* 1497]
 The cloak of Salai the fourth day of April 1497

4 braccia of silver cloth	15 lire	4 soldi
green velvet for the trimming	9 lire	
ribbons		9 soldi
small rings		12 soldi
for the making	1 lira	5 soldi
ribbon for the front		5 soldi
stitching		
here for his grossoni [1] 13	(26 lire	5 soldi)

[*In chalk*] Salai stole the soldi. L 94 r.

Monday I bought forty-six braccia of cloth, thirteen lire, fourteen and a half soldi, on the seventeenth day of October 1497. 1 49 [1] v.

On the first day of August 1499 I wrote here of movement and weight. c.a. 104 r. b

Dovecot at Urbino. 30 July 1402 (1502) L 6 r.

First day of August 1502.
At Pesaro, the Library. L cover r.

Make a harmony with the different falls of water as you have seen at the fountain of Rimini, as you have seen on the eighth day of August 1502. L 78 r.

St. Mary's Day, the middle of August, at Cesena, 1502. L 36 v.

Porto Cesenatico on the sixth day of September 1502 at fifteen hours.
 How bastions ought to project beyond the walls of towns to be able to defend the outer slopes so that they may not be struck by the artillery. L 66 v.

Memorandum how on the eighth day of April 1503 I Lionardo [2] da Vinci lent Vante [Attavante] the miniaturist four gold ducats in gold. Salai took them to him and gave them into his own hand. He undertook to repay me within forty days.
 Memorandum how on the above-mentioned day I gave Salai three

[1] Grossone—an old Tuscan coin—value about 30 centesimi (Fanfani).
[2] Leonardo, like Shakespeare, spelt his name in more than one way.

gold ducats which he said he needed, in order to get a pair of rose-coloured stockings with their adornments.

And I have still to give him nine ducats, against which he owes me twenty ducats, that is seventeen lent at Milan and three at Venice.

Memorandum how I gave Salai twenty-one braccia of cloth for making shirts, at ten soldi the braccio: which I gave him on the twentieth day of April 1503. B.M. 229 v.

On the morning of St. Peter's Day, on the twenty-ninth day of June 1504, I took ten ducats, of which I gave one to Tommaso my servant to spend. C.A. 71 v. b

On the ninth day of July 1504, on Wednesday at seven o'clock, died, at the Palace of the Podestà, Ser Piero da Vinci, notary, my father, at seven o'clock; he was eighty years old, he left ten sons and two daughters. B.M. 272 r.

On Wednesday, at seven o'clock, died Ser Piero da Vinci, on the ninth day of July 1504.

On Friday the ninth day of August 1504 I took ten ducats from the cupboard. C.A. 71 v. b

1504

On Friday the ninth day of August 1504 I drew ten gold florins.

On the morning of Saturday the third day of August 1504 Jacopo the German came to stay with me in my house; he arranged with me that I should allow him a carline a day for his expenses.

Have given Friday the ninth day of August fifteen grossoni, that is five florins five soldi.

Has given me one gold florin on the twelfth day of August.

Have given on the fourteenth day of August three grossoni to Tommaso.

And on the eighteenth day of the said [month] five grossoni to Salai.

On the eighth day of September six grossoni to the steward to spend, that is the day of Our Lady.

On the sixteenth day of the said September four grossoni to Tommaso, on Sunday. B.M. 271 v.

The *cortona* a bird of prey . . . I saw going to Fiesole above the place of the Barbiga in 5 (the year 1505) on the fourteenth day of March.

Sul Volo (F.M.) 18 [17] v.

1505, on the evening of Tuesday the fourteenth day of April Lorenzo came to live with me; he said that he was seventeen years of age.

And on the fifteenth day of this April I had twenty-five gold florins from the Treasurer of Santa Maria Nuova. Sul Volo 18 v.

Book entitled 'Of Transformation', that is of one body into another without diminution or increase of substance. Forster 1 3 r.

Begun by me, Leonardo da Vinci, on the twelfth day of July 1505.

Forster 1 3 v.

Begun at Florence in the house of Piero di Braccio Martelli, on the 22nd day of March, 1508.[1] B.M. 1 r.

Begun at Milan on the 12th day of September 1508. F 1 r.

On a day of October 1508 I had thirty crowns. I lent thirteen to Salai to complete his sister's dowry, and I have seventeen remaining.

F cover 2 r.

[*Of Squaring the Circle*]

1509, April 28

Having for a long time sought to square the angle of two curved sides, that is the angle *e*, which has two curved sides of equal curve, that is curve created by the same circle: now in the year 1509, on the eve of the calends of May, I have solved the proposition at ten o'clock on the evening of Sunday. I know therefore (as is shown on the reverse of this page *A*) that the surface *a b* taken from its position and given the same value with the portion *c* as the rectilinear triangle *d c* corresponds exactly to the curvilinear triangle *e c*, I would call it the curvilinear triangle *a b d*. Therefore that square of the triangle *e* will be found in the rectilinear triangle *c d*.

Windsor MSS. (Beltrami: *Documenti e memorie*, 201)

[1] Opening words of Manuscript (see Page 41).

[With drawing, washed with green and sepia, of sluices showing water flowing through the outlets]
Canal of San Cristoforo at Milan made on the third day of May 1509. C.A. 395 r. a

1510. On the twenty-sixth day of September Antonio broke his leg. He must not move for forty days. G cover r.

This winter of the year 1510 I look to finish all this anatomy.
 Fogli A 17 r.

Monbracco above Saluzzo, a mile above the Certosa, at the foot of Monte Viso, has a mine of stratified stone, white as marble of Carrara and flawless, and hard as porphyry or even harder. My gossip the master Benedetto the sculptor has promised to send me a tablet for the colours; on the fifth day of January 1511. G I v.

On the tenth day of December at nine o'clock in the morning the place was set on fire.

On the eighteenth of December 1511, at nine o'clock in the morning, this second conflagration was started by the Swiss at Milan, at the place called DCXC. Windsor: Drawings 12416

[Sketch-Plan. 'Room of the tower of Vaneri']

On the ninth day of January 1513. Quaderni II 7

I departed from Milan for Rome on the 24th day of September, 1513, with Giovanni, Francesco de' Melzi, Salai, Lorenzo and il Fanfoia. E I r.

[With drawings of segments of circles and mathematical calculations]
Finished on the seventh day of July, at the twenty-third hour, in the Belvedere, in the study given to me by the Magnifico, 1514.
 C.A. 90 v. a

At the Bell at Parma, on the twenty-fifth day of September, 1514.[1]
 E 80 r.

[1] I have followed Richter in interpreting the words *alla campana* as having reference to an Inn. Ravaisson-Mollien thinks that *campana* may perhaps be a variant of *campagna*, and translates *A Parme, à la campagne*. In a passage in the Leicester MS., written,

Il Magnifico Giuliano de' Medici set out on the ninth day of January 1515 at daybreak from Rome, to go and marry a wife in Savoy.

And on that day came the news of the death of the King of France.[1]

<div align="right">G COVER V.</div>

DIMENSIONS

San Paolo at Rome has five naves and eight columns, and its width inside its naves is 130 braccia, and from the steps of the high altar to the gate 155 braccia, and from these steps to the end wall behind the high altar 70 braccia, and the porch is 130 braccia long and 17 braccia wide.

Made on the . . . day of August, 1516. C.A. 172 v. b

Ascension Day at Amboise, in Cloux, May 1517. C.A. 103 r. b

On the twenty-fourth of June, the day of St. John, 1518, at Amboise, in the palace of Cloux. C.A. 249 r. a

according to Calvi, between 1504 and 1506, Leonardo refers to the multitude of shells and corals sticking to the rocks which are to be seen in the mountains of Parma and Piacenza. The passage has the air of being based on first-hand knowledge. If the suggestion *campagna* be accepted it might be that Leonardo was revisiting some of his old haunts. The text, however, really only establishes his presence at Parma on the date mentioned. As such, it proves that his stay in Rome was interrupted. Dated references attest his presence there on the seventh of July 1514, and as late as August 1516. The visit to Parma may possibly have been connected with the fact that Parma was one of the papal cities of which Giuliano de' Medici, Leonardo's patron in Rome, had been made the governor.

[1] Louis XII died on the first of January 1515.

XLIX

Books

'In youth acquire that which may requite you for the deprivations of old age; and if you are mindful that old age has wisdom for its food, you will so exert yourself in youth, that your old age will not lack sustenance.'

SEE Aristotle 'De Coelo' and 'De Mundo'. C.A. 97 V. a

[*References to books from a list of memoranda*]
 Book of Pandolfino.
 Library of San Marco.
 Library of Santo Spirito.
 Lactantius of the Daldi.
 Book of Maestro Palago the hospital superintendent.
 Grammar of Lorenzo de' Medici.
 Book of Maso.
 Learn multiplication from the root from Maestro Luca.
 My map of the world which Giovanni Benci has.
 Map of the world of Giovanni Benci.
 Country round about Milan in a print. C.A. 120 r. d

Book of Arithmetic Il Quadriregio
Pliny Donatus
Bible Justinus
De Re Militari Guido
First Decade Dottrinale
Third Decade Morgante
Fourth Decade John de Mandeville
Guido De Onesta Voluttà
Piero Crescentio Manganello

Cronica Desidero	On the Preservation of the Health
Letters of Ovid	Ciecho d' Ascoli
Letters of Filelfo	Albertus Magnus
The Sphere	Rhetorica Nova
The Jests of Poggio	Cibaldone
Of Chiromancy	Æsop
Formulary of Letters	Psalms
Fiore di Virtù	On the Immortality of the Soul
Lives of the Philosophers	Burchiello
Lapidary	Il Driadeo
Letters of Filelío	Petrarch C.A. 210 r. a

BIBLIOGRAPHICAL NOTES

The existence of this list of books on a page of the Codice Atlantico affords fair ground for the supposition that Leonardo was enumerating the books which he possessed.

Marchese Girolamo d'Adda, from whose erudition as displayed in a rare tract—*Leonardo da Vinci e la sua Libreria—note di un Bibliofilo*, Milano 1873—the notes that follow are mainly derived, has suggested that as Leonardo uses the Italian and not the classical form of the names of classical authors he may be supposed to be referring to Italian translations. I cannot think that this inference necessarily holds, any more than it would in the case of a modern writer who might use the forms Virgil and Horace in a list of books. There were, however, in existence Italian translations of all the classical works mentioned, and any of these may have been in Leonardo's possession. D'Adda's wealth of bibliographical knowledge causes his descriptions of the various works in the list to serve as an 'open sesame' to Leonardo's library. The notes that follow fall by contrast under the censure that Leonardo invoked on those who make epitomes:—

BOOK OF ARITHMETIC—Perhaps La nobel opera de arithmetica ne la qual se tracta tutte cosse a mercantia pertinente facta per Piero Borgi da Veniesia. Venice 1484. The name Maestro Piero dal Borgo occurs in Arundel MS. (B.M.) fol. 190 v. (see p. 1181). The

two notes that follow refer to a book, viz. 'to have my book bound' and 'show the book to Serigatto'.

PLINY—Historia naturale di C. Plinio Secondo tradocta di lingua latina in fiorentina per Christoforo Landino. 1476 Venetiis.

BIBLE—Earliest Italian version: Biblia volgare historiata. Venecia 1471.

DE RE MILITARI—Valturio? Roberti Valturii de re militari libri XII 1472. Bologna 1483.

FIRST, THIRD AND FOURTH DECADES [OF LIVY]—Earliest Italian version: Tito Livio volgarizzato. Roma 1476.

GUIDO—D'Adda suggests Guido da Cauliaco, author of treatise on surgery:—Guidonis de Cauliaco Cyrurgia. Venetiis 1498.

PIERO CRESCENTIO—writer on agriculture: Ruralium commodorum lib. XII. Petri de Crescenciis 1471. Il Libro della Agricultura di Pietro Crescentio. Florentiæ 1478.

QUADRIREGIO—the Four Realms:—Love, Satan, Vices, Virtues—poem composed in imitation of the Divina Commedia by Federico Frezzi of Foligno. Perugia 1481. Firenze, no date.

DONATUS—Ælius Donatus, author of a short Latin syntax, 'De Octo Partibus Orationis'. Many editions in 15th century.

JUSTINUS—a Roman historian who made an epitome of the general history of Trogus Pompeius.

GUIDO—Richter suggests Guido d'Arezzo:—monk—tenth century—inventor of tonic sol-fa musical system. Many Italian libraries possess MS. copies of his Micrologus De Disciplina Artis Musicæ.

DOTTRINALE—perhaps Doctrinal de Sapience by Guy de Roye, Archbishop of Sens. Latin text 1388. French trans. Geneva 1478, and many others.

MORGANTE—Il Morgante Maggiore. Romantic epic by Luigi Pulci. Il Morgante 23 canti. Per Luca Venetiano stampatore 1481. Il Morgante Maggiore 28 canti, Firenze 1482, and many others.

JOHN DE MANDEVILLE—There were many editions of the Travels. Earliest are Le liure appelle Mandeuille 1480, and Tractato delle piu maravigliose cosse e piu notabili, che si trovano in le parte del mondo vedute . . . del cavaler Johanne da Mandavilla . . . Mediolani . . . 1480.

DE ONESTA VOLUTTÀ—Treatise by Il Platina (Bartolomeo Sacchi) Opusculum de obsoniis ac honesta voluptate. Rome about 1473, Venice 1475.
Trans. Platyne. De Honesta Voluptate è Valetudine. Friuli 1480, Venice 1487.

MANGANELLO [The Mangle?]—A savage satire against women in imitation of the Sixth Satire of Juvenal. Author a Milanese of the same name. Venice about 1500.

CRONICA DESIDERO—D'Adda suggests Cronica d'Isidoro: Comensa la cronica de sancto Isidoro menore, con alchune additione caciate del texto ed istorie della Bibia e del libro de Paulo Oroso . . . Ascoli 1477, Friuli 1480.

LETTERS OF OVID—Liber Epistolarum. In Monteregali 1473. Le Pistole di Ovidio tradotte in prosa. Napoli, no date. Epistole volgarizzate . . . Bressa 1489. El libro dele Epistole di Ovidio in rime volgare per messere Dominico da Monticelli toschano. Bressa 1491.

LETTERS OF FILELFO—Francesco Filelfo, Italian humanist. Philelphi epistolarum liber primus (libri XVI), about 1472. Epistolarum familiarum (libri XXXVII), Venice 1500.

THE SPHERE—D'Adda suggests a work by Gregorio Dati: Trattato della sfera, degli elementi, e del globo terrestre in ottava rima Cosenza 1478, or Spaera mundi of Joannis de Sacrobusto. Ferrara 1472.

THE JESTS OF POGGIO—Many editions in Latin and Italian from 1470.

OF CHIROMANCY—Brunet mentions:—Ex divina philosophorum academia coltecta: chyromantica scientia naturalis ad dei laudem

finit . . . Venetiis, about 1480. Chyromantica scientia naturalis. Padue 1484.

FORMULARY OF LETTERS—Formulario de epistole vulgare missive e responsive e altri flori de ornati parlamenti al principe Hercule d'Esti duca di Ferrara composto . . . da Bartolomio miniatore suo affectionato e fidelissimo servo. Bologna, no date. Venice 1487.

FIORE DI VIRTÙ (Flowers of Virtue)—A collection of moral tales and fables composed about 1320. Fiore di virtu che tratta di tutti i vitii humani . . . et come si deve acquistare la virtu. Venetia 1474.

LIVES OF THE PHILOSOPHERS—Perhaps El libro de la vita de philosophi ecc. by Diogene Laertio. Venetiis 1480.

LAPIDARY—Perhaps a translation of the Latin poem De Lapidibus of Marbodeus, or of the Mineralium Libri V of Albertus Magnus, 1476.

ON THE PRESERVATION OF THE HEALTH—Perhaps Arnaldus de Villanova Regimen Sanitatis, 1480, or Ugo Benzo di Siena Tractato utilissimo circa la conservatione de la sanitade. Mediolani 1481.

CIECHO D'ASCOLI—Francesco (diminutive ciecho) Stabili, burnt for heresy in 1347—author of L'Acerba, a speculative philosophical poem. 'In questo poema dice trovansi delineate le origini di molti trovati moderni, ed in particolare della circulazione del sangue.'

ALBERTUS MAGNUS—Perhaps Opus De Animalibus Romæ, 1478, or Liber secretorum de virtutibus herbarum lapidum et animalium, Bononiæ 1478, or Incomenza el libro chiamato della vita ecc. Napoli 1478.

RHETORICA NOVA—Laurencius Guilelmus de Saona:—Rhetorica Nova. Cambridge 1478. St. Albans 1480.

CIBALDONE—Opera de lexcellentissimo physico magistro Cibaldone electa fuori de libri autentici di medicina utilissima a conservarsi sano. Towards the end of the fifteenth century (Brunet).

ÆSOP—Fabulae de Esopo historiate. Venice 1481, 1490. Brescia 1487. Æsopi vita et fabulae, latine, cum versione italica et allegoriis Fr. Tuppi. Neapoli 1485.

PSALMS—El Psalterio de David in lingua volgare. Venetiis 1476.

ON THE IMMORTALITY OF THE SOUL—Marsilio Ficino. Theologia platonica, sive de animarum immortalitate. Florentine 1482.

BURCHIELLO—Li Sonetti del Burchiello fiorentino faceto et eloquente in dire cancione e sonetti sfogiati. Bononiæ 1475.

IL DRIADEO—Poem in ottava rima by Luca Pulci, elder brother of Luigi. Il Driadeo composto in rima octava per Lucio Pulcro. Florentiæ 1478. An edition printed in Florence in 1481 has 'Il Driadeo compilato per Luigi Pulci', and the title-page of that of 1489 has 'Il Driadeo di Luigi Pulci'. The edition printed in Venice, 1491, has 'Il Driadeo d'amore di Luca Pulci'. One that was printed in Florence towards the year 1500 has on the last page 'Qui finisce Il Driadeo compilato per Luca Pulci, Al Magnifico'.

PETRARCH—Many editions, commencing with Sonetti, Canzoni et Trionphi. Venetiis 1470.

[*Notes about books from a page of memoranda*]

The Algebra which is in the possession of the Marliani, written by their father.

A book which treats of Milan and its churches—to be had at the last stationer's on the way to Corduso.

Get Messer Fatio to show you [the book] on Proportions.

Get the Friar of the Brera to show you the 'De Ponderibus'.

On Proportions by Alchino, with annotations by Marliano from Messer Fatio.

The book by Giovanni Taverna which Messer Fatio has.

A treatise on the heavenly bodies by Aristotle translated into Italian.

Try to see Vitolone which is in the library at Pavia and treats of mathematics.

A nephew of Gian Angelo the painter has a book about water which belonged to his father. c.a. 225 r. b

The Letters of Phalaris[1] (*Pistole di Falaride*). c.a. 234 r. a

There is a complete Archimenides in the possession of the brother of Monsignor of Sant' Agosta in Rome. The latter is said to have given it to his brother who lives in Sardinia. It was formerly in the library of the duke of Urbino and was carried off from there in the time of the duke Valentino.[2] c.a. 349 v. f

Ammianus Marcellinus affirms that seven hundred thousand volumes of books were burnt in the siege of Alexandria in the time of Julius Caesar.[3] Tr. 1 a

Donatus.
Lapidarius.
Pliny.
Abacus.
Morgante. Tr. 2 a

Horace[4] has written of the velocity of the heavens.
Concave mirrors.
Books from Venice.
The author of an Italian-Latin Dictionary.
Knives from Bohemia.
Vitruvius.
Meteora.[5]

[1] Epistole di Falaride tradotte dal Latino di Fr. Accolti Aretino in volgare da Bartol. Fonzio fiorentino, 1471, is probably the edition here referred to. R. Bentley's Dissertation on Phalaris (1697) showed the letters to have been written by a sophist or rhetorician (possibly Adrianus of Tyre) several hundred years after the death of Phalaris.

[2] Caesar Borgia, Duke of Valentinois, expelled the Montefeltro dynasty from Urbino in the year 1497. The Duke Guidobaldo recovered possession at the beginning of October 1503, ten days after the sudden death of Pope Alexander VI had shattered the fabric of Caesar Borgia's kingdom.

[3] Ammianus Marcellinus: continued the history of the Empire at the point where Tacitus left off. A. M. historiarum libri qui extant XIII Rome, 1474.

[4] The reference, according to M. Ravaisson-Mollien, is probably to an Italian of this name who was secretary to Pope Nicholas V, wrote poetry and translated Homer.

[5] Meteora. An Italian translation of Aristotle's treatise is referred to in the Codice Atlantico. The translation must have been in manuscript.

Archimedes: On the centre of gravity.

Anatomy: Alessandro Benedetto.[1]

The Dante of Niccolo della Croce.

Philosophy of Aristotle.

Messer Ottaviano Pallavicino for his Vitruvius.

Go each Saturday to the hot house and you will see the nudes.

Blow out a pig's lung and see whether it increases in length and breadth, or in breadth and diminishes in length.

Albertuccio[2] and Marliano[3]: De Calculatione.

Alberto[4] De cœlo et mundo—from Fra Bernardino.

From Messer Mafeo[5]—why the Adige rises for seven years and falls for seven. F COVER 1 V.

Avicenna: On liquids.

Posidonius[6] composed books about the size of the sun.

 F COVER 2 R.

Enquire for Vitruvius at the stationer's. F COVER 2 V.

Of the increase of the Nile, a small work by Aristotle.

 K 52 [3] V.

Alberto da Imola: Algebra. K 75 [27] V.

Messer Vincenzo Aliprandio who lives near the inn of the Corso has Giacomo Andrea's Vitruvius. K 109 [29-30] V.

Borges will get the Archimedes of the bishop of Padua for you, and Vitellozzo that of Borgo San Sepolcro. L 2 R.

[1] A profound student of the medical science of the Greeks. Died in 1525. (R.-M.)

[2] Albert the Little. Ravaisson-Mollien suggests the reference is to Leon Battista Alberti in contradistinction to Albertus Magnus who is mentioned in the following line.

[3] Giovanni Marliano, physician to Gion Galeazzo Sforza. Died 1483. Wrote 'De proportione motuum in velocitate'. (R.-M.)

[4] Albertus Magnus.

[5] Perhaps Raphaël Maffei de Volterra who wrote an attempt at an encyclopaedia. (R.-M.)

[6] Stoic philosopher. Works lost. Cicero studied under him. Richter has shown that Leonardo must have derived his knowledge from Strabo, who refers to Posidonius as having explained why the sun looked larger when rising or setting, than during the rest of its course.

Archimedes from the bishop of Padua. L 94 V.

Hermes the philosopher.[1] M cover V.

Of local movement.
Suisset, that is the Calculator.[2]
Tisber.
Angelo Fossombrone.[3]
Alberto.[4] M 8 r.

Pliny states that wool after having been boiled in vinegar is impenetrable.

Virgil says that the shield was white and without praises, because among the Athenians the true praises, which were such as were confirmed by the mouths of witnesses, formed the subject matter for the painters of shields; and these were made of stag bone bound together, set crosswise, and made smooth with . . . MS. 2037 Bib. Nat. 7 V.

Lucretius in the third book of his De Rerum Natura:—the hands, the nails, and the teeth were the weapons of ancient man. They used also as a standard a bunch of grass tied to a pole.

Tryphon of Alexandria, who passed his life at Apollonia a city of Albania. MS. 2037 Bib. Nat. 8 V.

Archimedes: 'De Ponderibus' [cited]. B.M. 16 r. and 17 r.

Euclid [cited]. B.M. 16 V.

'Ex ludis rerum mathematicarum' [cited as the title of a work by Leone Battista Alberti]. B.M. 66 r.

Roger Bacon done into print. B.M. 71 V.

Vitolone in San Marco. B.M. 79 r.

[1] This refers to the author of what are known as the Hermetic Books, which constituted a complete canon of ancient Egyptian religion, arts and science.
[2] Richard Suiseth, Cistercian, called the Calculator, was, according to M. Ravaisson-Mollien, a fourteenth-century English mathematician and astronomer who is stated by Leibnitz to have introduced mathematics into scholastic philosophy.
[3] Angelo Fossombrone was a fifteenth-century Italian mathematician.
[4] Alberto. The reference is presumably to Albertus Magnus.

Il Vespucci wishes to give me a book of geometry. B.M. 132 v.

On meeting with Lorenzo de' Medici I shall ask about the treatise on water of the bishop of Padua. B.M. 135 r.

Search in Florence for the Ramondina. B.M. 192 v.

Take the Ramondina.[1] Leic. 2 r.

The master Stefano Caponi, the physician, lives at the Piscina, he has Euclid: 'De Ponderibus'. Forster III 2 v.

Nonius Marcellus, Festus Pompeius, Marcus Varro.[2] Forster III 8 r.

The master Giuliano da Marliano has a fine herbal. He lives opposite to the Strami, the carpenters. Forster III 37 v.

[1] In the introduction to his edition of the Leicester Manuscript, Gerolamo Calvi suggests that these two lines refer to the search for and possession of a copy of one of the works of Ramon Lull, the Majorcan philosopher and mystic. This seems to offer a probable explanation of lines which otherwise form an enigma. An edition of Lull's *Ars generalis ultima* was printed in Venice in the year 1480, others of his works appeared in Rome and Barcelona. Leonardo may however have been in quest of one of his manuscripts. The so-called 'Lullian method', an attempt to supply a mechanical aid to the mind in the acquisition of knowledge by combinations formed by revolving circles, was dismissed in a couple of sentences by Francis Bacon: 'Any sciolist may make some show and ostentation of learning. Such was the art of Lullius'. The 'doctor illuminatus', as he was styled, is to-day a mere name in the history of philosophy, and such interest as exists in him centres in his work as poet and mystic. His latest biographer, Professor Peers, devotes a chapter each to his romances *Blanquerna* and *Felix* and a single page to his formidable *Ars Generalis*. But although the mechanical contrivances associated with the 'Lullian method' sufficed deservedly to discredit it, Lull as a thinker broke from the restraints of the schoolmen, and as the titles of certain chapters in his treatises serve to show, the workings of his curiosity concerning the laws of operation of natural forces offer many parallels to the writings of Leonardo. The field of his activities in science included geometry, astronomy, physics, chemistry, anthropology, the causes of wind and rain, the laws of navigation, and warfare. He was not unlike Roger Bacon in the extraordinary scope of his scientific interests; the two lines in which Leonardo expresses his desire to possess a work of Ramon Lull may be paralleled with the sentence, also in the Arundel Manuscript B.M. 71 v, 'Roger Bacon done into print'. Leonardo may very probably have owed the first awakening of his interest in the work of both to the fact of his association in study with Fra Luca Pacioli, who belonged to the Franciscan order, as did also Lull and Bacon, and who was therefore the more likely to have acquaintance with their works.

[2] Nonius Marcellus and Sextus Pompeius Festus were Roman Grammarians of about the fourth century A.D. Brunet (Manuel du Libraire) mentions an edition of the three authors printed at Parma in 1480.

The heirs of the master Giovanni Ghiringallo possess the works of Pelacano. Forster III 86 r.

Speculum of the master Giovanni Francesco.
Galen: De Utilità. Fogli B 2 r.

Have a translation made of Avicenna: On the Utilities.
The book on the science of machines precedes the book: On the Utilities. Quaderni I 13 v.

See: Concerning Ships by Messer Battista [Alberti], and Frontinus: Concerning Aqueducts.[1] Leic. 13 r.

Theophrastus: Concerning the Flow and Ebb. Concerning Whirlpools, and Concerning Water. Leic. 16 v.

[1] Alberti Leon. Batt. Incipit de re aedificatoria, Florentiæ 1485. Book V ch. 12 treats of ships and their parts.

Vitruvius, De Arch., et Frontinus, De Aquæductibus, Florentiæ 1513. The earliest edition of Sextus Julius Frontinus' chief work: De aquæductibus urbis Romæ commentarius. Its author had been appointed superintendent of the aqueducts at Rome.

L

Miscellaneous

*'The duke lost his State, his personal possessions
and his liberty, and none of his enterprises have been
completed.'*

Pandite iam portas miseri et subducite pontes
 Nam Federigus adest quem Gebelina sequor.
Dic quid fulmineis euertis menia bombis?
 Stabunt pro muris pectora colligenum.
Diruta cesserunt nostris tua menia bombis:
 Diruta sic cedent pectora pectoribus.[1]

(Throw open now the gates, ye wretched ones, and lift up the draw-
bridges, for Federigo approaches whom I the Ghibellina follow! Say
why thou overturnest thy ramparts with murderous bombs? The
hearts of the host will stand in defence of the walls. Your ramparts
overthrown have yielded to our bombs, so let your hearts overthrown
yield to our hearts.) C.A. 28 r. b

The action of cutting the nostrils of horses is a practice worthy of
derision. And these fools observe this custom, almost as though they
believed nature to be lacking in necessary things, in regard to which
men have to be her correctors.

Nature has made the two holes in the nose, each of which is half the
width of the pipe from the lungs by which the hard breathing goes
out; and if these holes were not there the mouth would suffice for this
abundance of breathing.

And if you should ask me why nature has made the nostril thus in
animals, when the breathing through the mouth is sufficient, my reply

[1] The lines refer to the siege of Colle, taken by storm from the Florentines in
November 1479 by the Duke of Calabria and Federigo Duke of Urbino. The Ghibellina
is the name of a piece of artillery (see Calvi *MSS. di L.*, p. 45).

would be that the nostrils are made for the purpose of their being used when the mouth is occupied with masticating its food. c.a. 76 r. a

> Se voi star sano, osserva questa norma:
> non mangiar sanza voglia, e cena leve;
> mastica bene, e quel che in te riceve,
> sia ben cotto e di semplice forma.
> Chi medicina piglia, mal s'informa;
> guarti dall'ira e fuggi l'aria grieve;
> su diritto sta, quando da mensa leve;
> di mezzogiorno fa che tu non dorma.
> El vin sia temprato, poco e spesso,
> non for di pasto nè a stomaco voto;
> non aspectar, nè indugiare il cesso;
> se fai esercizio, sia di picciol moto.
> Col ventre resupino e col capo depresso
> non star, e sta coperto ben di notte;
> el capo ti posa e tien la mente lieta,
> fuggi lussuria, e attienti alla dieta.

(If you would keep healthy, follow this regimen: do not eat unless you feel inclined, and sup lightly; chew well, and let what you take be well cooked and simple. He who takes medicine does himself harm; do not give way to anger and avoid close air; hold yourself upright when you rise from table and do not let yourself sleep at midday. Be temperate with wine, take a little frequently, but not at other than the proper meal-times, nor on an empty stomach; neither protract nor delay the [visit to] the privy. When you take exercise let it be moderate. Do not remain with the belly recumbent and the head lowered, and see that you are well covered at night. Rest your head and keep your mind cheerful; shun wantonness, and pay attention to diet.)

c.a. 78 v. b

A nude by Perugino. c.a. 97 r. a

TO MELT PEARLS

If you wish to make a paste out of small pearls take the juice of some lemons and put them to soak in it, and in a night they will be dis-

solved. And when it has all settled throw away the lemon juice and put fresh, and do this two or three times, so that the paste may be very fine. Then wash the said paste with clear water a sufficient number of times for it to lose all trace of the lemon juice. After doing this let the paste dry so that it turns to powder. Then take white of egg, beat it well and leave it to settle, and then moisten the said powder with this so that it becomes a paste again.

And from this you can make pearls as large as you wish, and leave them to dry. Then place them in a small turning lathe and polish them, if you wish with a dog's tooth, or if you prefer with a polishing stick of crystal or chalcedony.

And polish it until it has the same lustre that it had before. And I believe that if you dissolve mother-of-pearl you get the same result as with the pearls. C.A. 109 v. b

Book of Pandolfino—knives—pen for ruling—to dye the cloak—Library of St. Mark's—Library of Santo Spirito—Lattanzio Tedaldi—Antonio Covoni—book of Messer Paolo, the hospital superintendent—boots shoes and hose—varnish—boy to serve as a model—grammar of Lorenzo de' Medici—Giovanni del Sodo—Sansovino—ruler—very sharp knife—spectacles—*rotti fisici*—repair the labyrinth[?] (*l'abernucco*)—book of Tommaso—the small chain of Michelangelo—learn how to multiply roots from Messer Luca—my map of the world which Giovanni Benci has—slippers—clothes from the excise man—red Spanish leather—map of the world of Giovanni Benci—a print of the country round Milan—marketing books—bow and cord—Tanaglino—Moncatto. C.A. 120 r. d

Prophecy of Lionardo da Vinci.[1] C.A. 194 v. a

To bring a crucifix into a room. C.A. 207 r. a

The Venetians have boasted of their power to spend thirty-six millions of gold in ten years in the war with the Empire, the Church, the Kings of Spain and of France, at three hundred thousand ducats a month. C.A. 218 r. a

[1] This line is written vertically on a page of pure mathematics.

Messer Battista dall' Aquilo, the Pope's private chamberlain, has my book in his hands. c.a. 287 r. a

TO MAKE SCENT

Take fresh rose-water and moisten the hands, then take the flower of lavender and rub it between the hands, and it will be good.

c.a. 295 r. a

If on delight your mind should feed.

(*Se di diletto la tua mente pasce.*) c.a. 320 r. b

OF A BLOW THE CAUSE OF FIRE

If you beat a thick bar of iron between the anvil and the hammer with frequent blows upon the same spot, you will be able to light a match at the spot which has been struck. c.a. 351 v. b

I will say one word or two or ten or more as pleases me, and I wish that in that time more than a thousand persons say the same in that same time, so that they may immediately say the same as me. And they will not see me nor perceive what I say.

These will be the hours enumerated by you, for when you say one, all those who enumerate the hours as you do will say the same number as you at the same time. c.a. 384 r. a

[*With sketch of flock of birds rising in flight*]

This stratagem was employed by the Gauls against the Romans, and so great a mortality ensued that all Rome was dressed in mourning.

Tr. 18 a

Sea water filtered by mud or clay deposits in it all its saltness. Woollen stuffs spread over the sides of ships absorb the fresh water. If it be distilled by means of a retort sea water becomes of first excellence, and by making use of a cooking stove in his kitchen any one can, with the same wood as he cooks with, distil a greater quantity of water if the retort is a large one. Tr. 44 a

One may make of wood thin grained boards, which will seem like camlets and watered silks and with various fixed marks. F 2 r.

When a horse is moving in water it creates less foam when it is more submerged and more foam when less submerged. This proceeds from the fact that the legs when less submerged are less impeded, and consequently move more rapidly and drive the water more with their great hoofs than with their knees and thighs. G 11 r.

Remember the solderings which were used to solder the ball of Santa Maria del Fiore. G 84 v.

To lock with a key a sluice at Vigevano. H 1 r.

A nun lives at the Dove at Cremona who is a good maker of straw plaits, and a friar of San Francesco. H 62 [14] v.

[*Memoranda*]
 Needle. Niccolò.
 Thread.
 Ferrando.
 Jacopo Andrea.
 Canvas.
 Stone.
 Colours.
 Brushes.
 Palette.
 Sponge.
 Panel of the Duke. H 94 [46] r.

[*Sun dial*]
 To measure the stages of the time by the sun. H 97 [45 r.] v.

[*Viticulture*]
 The peasant seeing the usefulness of the products of the vine gives it many props in order to keep up its branches; and after the fruit has been gathered he takes away the poles and allows them to fall; making a bonfire of the supports. H 112 [31 r.] v.

[*List of household utensils*]
 New tin ware.
 Six small bowls.
 Six bowls.

Six large plates.
Two medium-sized plates.
Two small plates.
Old tin ware.
Three small bowls.
Four bowls.
Three square tiles.
Two small bowls.
One large bowl.
One plate.
Four candlesticks.
One small candlestick.
Three pairs of sheets of four widths each.
Three small sheets.
Two table cloths and a half.
Sixteen coarse table cloths.
Eight shirts.
Nine woollen cloths.
Two towels.
One basin. H 137 [6 r.] v.

[Sensibility of the hair of the ox]
The hair of the ox placed in stagnant water in summer acquires
sensation and life and movement of itself, and also the power of fear
and flight and perception of pain. And the proof is that if it is pressed
it twists and releases itself. Place it again in the water, as before it takes
to flight and removes itself from the danger. K 81 [1] r.

SCENTLESS OIL

To take away the smell from oil:
Take some crude oil and put ten pints of it in a vessel. Make a
mark on the vessel according to the height of the oil, and then pro-
ceed to add a pint of vinegar, and boil until the oil has gone down as
low as the mark that was made. By this means you will be sure that
the oil has come back to its first amount and that all the vinegar has
evaporated, and has carried all the bad smell away with it.

I believe that it is possible to do the same with nut oil, and with every other oil which has a bad smell. κ 112 [32] v.

If you have some strong glue, half tepid and half cold, and only slightly liquid, and press paste of vermicelli on it, congealed and solidified, and of any colour you like, this will make very beautiful twists, and the parts of them will be exactly like thin narrow ribbons.
κ 118 [38] r.

Decipimur votis et tempore fallimur: et mos
 Deridet curas; anxia vita nihil.
(We are deceived by our vows and deluded by time, and habit derides our cares; the anxious life is nothing.) L cover r.

[*Events in Milan in* 1500]
 Paolo di Vannocco at Siena.
 Domenico Chiavaio.
 The small hall above for the apostles.
 Buildings by Bramante.
 The governor of the castle made prisoner.
 Visconti dragged away and then his son slain.
 Gian della Rosa robbed of his money.
 Borgonzo began and was unwilling and so fortune deserted him.
 The duke lost his State, his personal possessions and his liberty, and none of his enterprises have been completed.[1] L cover v.

[1] The note 'buildings by Bramante', in view of the fact that those which follow relate to untoward events consequent upon the imprisonment of Ludovic Sforza, refers possibly to the fact of various works designed by Bramante being left uncompleted, e.g. according to Amoretti one side only of the Canonica di S. Ambrogio was built, and the columns for the rest lay there for upwards of a century. According to the same authority the reference to the governor of the castle was in all probability to the French governor, who on the return of the French was thrown into prison for having surrendered to Ludovic when his troops reoccupied the city; he cites the names of two Visconti from Arluno's chronicle who were carried off as captives into France for having taken the side of the Duke; Gian della Rosa he identifies with Giovanni da Rosate, professor at Pavia, the Duke's physician and astrologer; and Borgonzo with Brugonzio Botta, the administrator of the ducal revenue, whose house was pillaged by the French partisans on his flight.

The notes end with Leonardo's laconic epitaph upon the fallen fortunes of Ludovic Sforza, who at the time they were written was a prisoner at Loches in Touraine, where he remained until his death.